MANET/VELÁZQUEZ

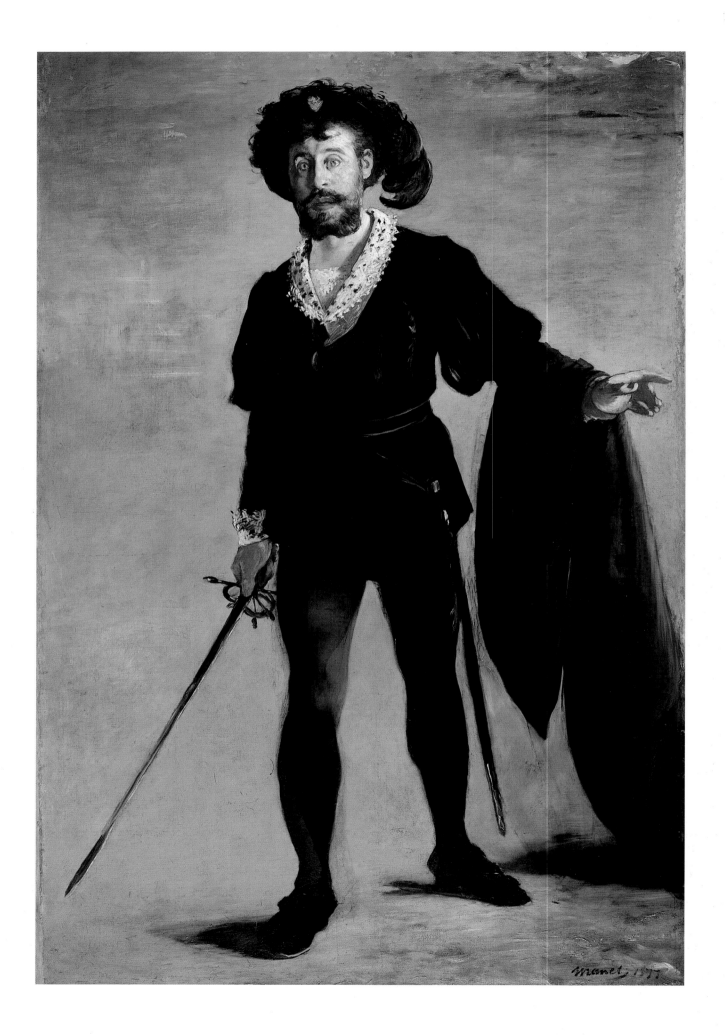

MANET/VELÁZQUEZ

The French Taste for Spanish Painting

Gary Tinterow and Geneviève Lacambre

with Deborah L. Roldán and Juliet Wilson-Bareau

and Jeannine Baticle, Marcus B. Burke, Ignacio Cano Rivero,
Mitchell A. Codding, Trevor Fairbrother, María de los Santos García Felguera,
Stéphane Guégan, Ilse Hempel Lipschutz, Dominique Lobstein,
Javier Portús Pérez, H. Barbara Weinberg, and Matthias Weniger

The Metropolitan Museum of Art, New York
Yale University Press, New Haven and London

This volume has been published in conjunction with the exhibition "Manet/Velázquez: The French Taste for Spanish Painting" held at the Musée d'Orsay, Paris (September 16, 2002, to January 12, 2003), and at The Metropolitan Museum of Art, New York (March 4 to June 8, 2003).

accenture is the proud sponsor of the exhibition.

The exhibition was organized by The Metropolitan Museum of Art and the Réunion des Musées Nationaux/Musée d'Orsay.

An indemnity has been granted by the Federal Council on the Arts and the Humanities.

Published by The Metropolitan Museum of Art, New York

John P. O'Neill, Editor in Chief
Cynthia Clark and Margaret Donovan, Editors, with the assistance of Philomena Mariani
Bruce Campbell, Designer
Gwen Roginsky and Sally VanDevanter, Production, with the assistance of Jill Pratzon
Minjee Cho, Desktop Publishing

Translations from French by Jane Marie Todd and Translate-A-Book, Oxford, U.K., and by Alexandra Bonfante-Warren, Jean Coyner, Lory Frankel, and Mary Laing

Translations from Spanish by Suzanne L. Stratton-Pruitt and Translate-A-Book, Oxford, U.K.

Typeset in Fournier by Di Vincenzo Design, Dobbs Ferry, New York
Printed on 130 gsm R-400
Separations by Professional Graphics, Inc., Rockville, Illinois
Printed by Brizzolis Arte en Gráficas, Madrid
Bound by Encuadernación Ramos, S.A., Madrid
Printing and binding coordinated by Ediciones El Viso, S.A., Madrid

Jacket/cover illustrations: front—detail of cat. no. 139, Édouard Manet, *Mlle V . . . in the Costume of an Espada*; back—cat. 72, Diego Rodríguez de Silva y Velázquez, *The Jester "Don Juan de Austria."*
Frontispiece: cat. 159, Édouard Manet, *Faure in the Role of Hamlet*;
p. viii: cat. 73, Diego Rodríguez de Silva y Velázquez, *The Jester Pablo de Valladolid*; p. x: cat. 224, James McNeill Whistler, *Arrangement in Flesh Color and Black: Théodore Duret*

Cataloguing-in-publication data is available from the Library of Congress.

ISBN: 1-58839-038-1 (hc), 1-58839-040-3 (pbk) (The Metropolitan Museum of Art)
ISBN: 0-300-09880-4 (Yale University Press)

Contents

Curators of the Exhibition

Geneviève Lacambre

Conservateur Général
Musée d'Orsay, Paris

Gary Tinterow

Engelhard Curator of European Paintings
The Metropolitan Museum of Art, New York

ASSISTED BY

Deborah L. Roldán

Research Associate
The Metropolitan Museum of Art, New York

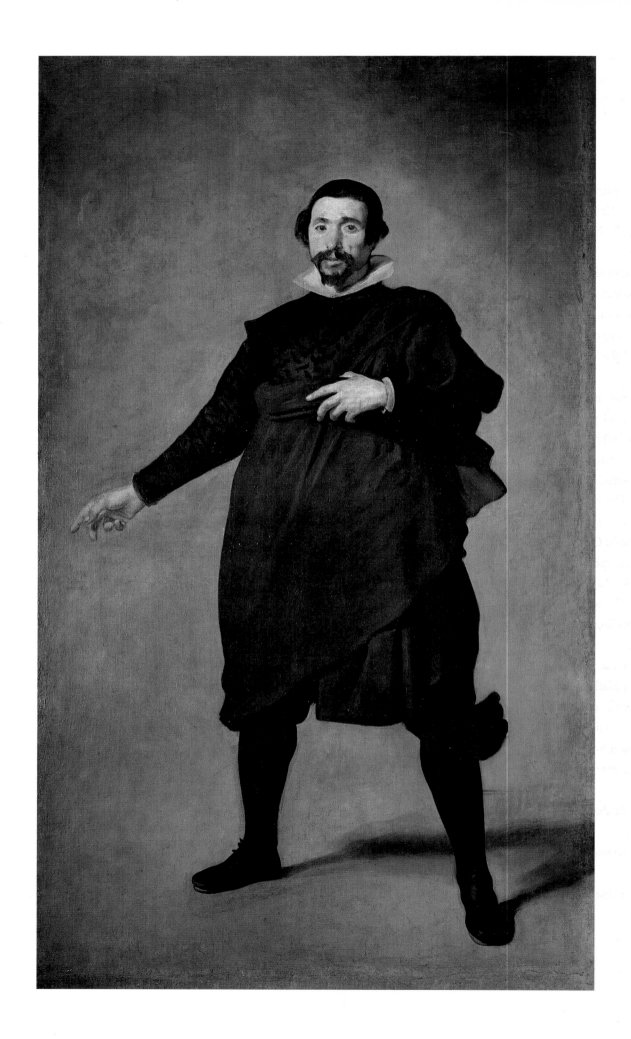

Directors' Foreword

Once again The Metropolitan Museum of Art, the Musée d'Orsay, and the Réunion des Musées Nationaux have collaborated on a major project. In 1994 our institutions presented to the public in Paris and New York the epochal exhibition "Origins of Impressionism." This time the subject is the intriguing question of the influence of a foreign school on some of the most innovative French painters of the nineteenth century. Entirely unexpected, the impact of Spanish art was a cultural phenomenon that was remarked upon by all perceptive writers and artists. As Baudelaire wrote, the arrival in France of Spanish art "had the effect of increasing the volume of general ideas that you had to have about art."

Like "Origins of Impressionism," this exhibition traces the roots of modernism in mid-nineteenth-century French Realism. Rather than the bright palette favored by the Impressionists, the emphasis here is on black as a color. But the rapid, incisive, and allusive manner of painting that Manet borrowed from Velázquez contributed to the development of the Impressionist aesthetic of the sketch, and it helped free French artists from the polished technique that they had inherited from the Neoclassical painters. Once Velázquez supplanted Raphael on the throne of high art, the world of painting was made anew.

The realization of this exhibition in Paris and New York was made possible by the close collaboration of the Museo Nacional del Prado, in the form of its directors, first Fernando Checa and then Miguel Zugaza, its trustees, and its curators. We wish to record our gratitude to that august institution and to express how much we have enjoyed working with Sr. Zugaza.

The Metropolitan Museum wishes to express its sincere thanks to Accenture for its outstanding support of the exhibition and the exhibition's special Web site. We are also indebted to the Federal Council on the Arts and the Humanities for its kind assistance toward the realization of this project.

Finally we thank the curators of the exhibition—Geneviève Lacambre and Gary Tinterow, assisted by Deborah L. Roldán—for conceiving such a fascinating exhibition and for realizing it in such a glorious fashion. Like all worthy endeavors, this one surmounted many obstacles. Thanks to the participants' perseverance and rigor, the result is even greater than the idea.

Philippe de Montebello
Director
The Metropolitan Museum of Art

Serge Lemoine
Director
Musée d'Orsay

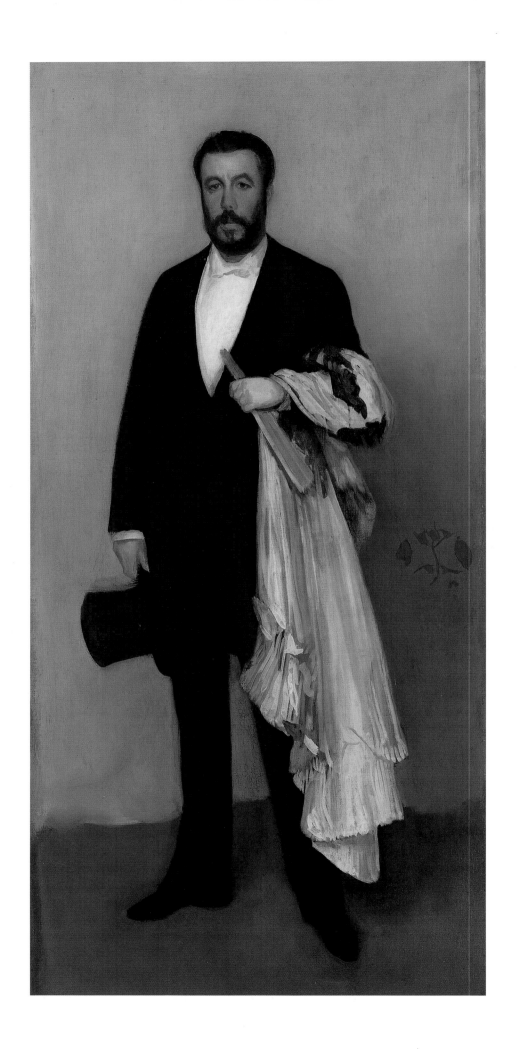

Sponsor's Statement

Accenture is pleased to collaborate with The Metropolitan Museum of Art as the sponsor of the exhibition "Manet/Velázquez: The French Taste for Spanish Painting."

"Manet/Velázquez" examines the impact of Spanish painting on French artists during the first half of the nineteenth century. As the title indicates, at the core of the exhibition is the "Spanish" work of Édouard Manet, whose career thoroughly reveals the importance of Spanish painting at midcentury. The exhibition also investigates the profound influence that the works of the Spanish masters and Manet and his circle had on such major American artists as James McNeill Whistler, Thomas Eakins, Mary Cassatt, William Merritt Chase, and John Singer Sargent. This is the first time an exhibition of this scale and depth has been organized around this subject. It promises to be extraordinary.

To ensure that the exhibition reaches the widest possible audience, Accenture and the staff at the Metropolitan Museum have adapted "Manet/Velázquez" for the Internet. We have used the latest technology to create an online experience that not only allows visitors to examine and compare artworks but also to view them in their proper historical and cultural contexts.

The site is meant to serve as a model for future exhibition Web features and as an electronic version of an intimate nineteenth-century artists' salon where visitors can gather and share the insights of the French artists who were fascinated by Spain. We hope you will visit this innovative Web site at www.metmuseum.org.

As the world's leading management consulting and technology services organization, Accenture is in the business of putting great minds and innovative ideas together to deliver breakthrough results. On behalf of our 75,000 Accenture people around the world, I invite you to explore "Manet/Velázquez: The French Taste for Spanish Painting." We hope you enjoy this very special exhibition.

Joe W. Forehand
Chairman & CEO
Accenture

Acknowledgments

In 1997 Henri Loyrette spoke to his colleagues at The Metropolitan Museum of Art and the Museo Nacional del Prado about an exhibition that would juxtapose the work of Manet with that of Velázquez, on the lines of "Millet et Van Gogh" (1998–99), a project then being planned. The enterprise was undertaken by Geneviève Lacambre, Conservateur Général at the Musée d'Orsay, and Gary Tinterow, Engelhard Curator of European Paintings at the Metropolitan Museum; in their hands it began to evolve into a larger examination of the phenomenon of Hispanisme— enthusiasm for things Spanish—in France in the nineteenth century, with Manet occupying a central, but not solitary, position. Over the next five years the organizers accrued many debts in the realization of the exhibition. It is our distinct pleasure to record our gratitude here.

First and foremost, we thank our directors and administrators past and present—Philippe de Montebello and Mahrukh Tarapor at the Metropolitan Museum; Henri Loyrette, Dominique Viéville, and Serge Lemoine at the Musée d'Orsay; Fernando Checa, Miguel Zugaza, and Eduardo Serra at the Museo Nacional del Prado; Irène Bizot, Françoise Cachin, Philippe Durey, Francine Mariani-Ducray, and Bénédicte Boissonnas at the Réunion des Musées Nationaux— for their support and for the resources placed at our disposal.

Without the collaboration of the many lenders, no exhibition would be possible. Their names are given in the List of Lenders, and we heartily thank all who have helped. Several ardent supporters deserve special recognition: Malcolm Rogers, George Shackleford, and Elliot Davis in Boston; James Wood, Douglas Druick, and Gloria Groom in Chicago; Everett Fahy and Keith Christiansen, George Goldner and Colta Ives, and Morrison Heckscher and H. Barbara Weinberg at the Metropolitan; Mitchell A. Codding and Marcus B. Burke at the Hispanic Society, New York; Anne d'Harnoncourt and Joseph Rishel in Philadelphia; Earl A. Powell and Philip Conisbee in Washington; Jean-Louis Augé in Castres; Vincent Pomarède in Lyon; Jean-Pierre Cuzin and Françoise Viatte in Paris; Miguel Zugaza and Xavier Bray in Bilbao; Laurent Salomé in Rouen; Mikhail Piotrovsky in St. Petersburg; and Neil MacGregor in London.

In Spain several individuals made special contributions to the success of the exhibition: Placido Arango, Miguel Angel Cortes, Carmen Giménez, Bernardo Laniado, Gabriele Finaldi, Manuela Mena, and Javier Portús Pérez. We thank them all.

We are especially pleased that the catalogue includes contributors from France, Spain, and the United States, among them senior art historians who have pursued the subject for many years, such as Jeannine Baticle and Ilse Hempel Lipschutz, as well as younger writers such as María de los Santos García Felguera and Javier Portús Pérez. All of the contributors have aided greatly in the formation of the exhibition, but we wish to give special thanks to Juliet Wilson-Bareau, assisted by David C. Degener, for sharing her wealth of information and experience.

The exhibition's administration was carried out in New York, and that heavy responsibility was discharged with grace and aplomb by Deborah L. Roldán. In addition to supervising loans, Ms. Roldán accumulated a vast archive of information on the subject of French and American Hispanisme; her extensive Chronology has been drawn from this immense resource. Every aspect of the exhibition and catalogue has been informed by her intelligence, and the organizers and the catalogue contributors are all deeply in her debt. We thank as well those who have assisted her in

the organization of the exhibition, especially Kathryn Calley Galitz, Lucía Martínez, Elizabeth A. Pergam, Catherine Donnellier, Gina Guerra, and Rebecca A. Rabinow. The catalogue project was overseen by John P. O'Neill, Editor in Chief and General Manager of Publications. It was superbly edited by Cynthia Clark and Margaret Donovan, with the assistance of Philomena Mariani. The volume was produced by Gwen Roginsky and Sally VanDevanter, assisted by Jill Pratzon; Bruce Campbell designed the publication and Minjee Cho was in charge of desktop publishing. The printing was overseen by Gwen Roginsky.

In Paris Geneviève Lacambre was ably assisted by Dominique Lobstein. At the Réunion des Musées Nationaux the project was followed by Anne Freling, Isabelle Mancarella, and their colleagues. The French edition of the catalogue was produced by Marie-Dominique de Teneuille, assisted by Julie Lecomte, with Katia Lièvre and Évelyne Simonin, under the direction of Béatrice Foulon.

Finally, to our many friends and colleagues, we extend our warmest thanks: Geneviève Aitken, Magali Albert, Adeline de Almeida, René Andioc, Monique Antilogus, Philippe Arbaizar, Bärbel Arnold, Sylvie Aubenas, Colin Bailey, Joseph Baillio, Claire Barbillon, Dominique Bardin, Pierre Bazin, Sylvain Bellenger, Laurence Berthon, Hannah Betts, Claude Bouret, Guy Boyer, Dominique Brachlianoff, Christien Briend, Janet F. Briner, Jonathan Brown, Bernadette Buiret, Monique Bussac, Helene Bussers, Benoît Castillon du Perron, Jean-Loup Champion, Béatrice de Chancel-Bardelot, Stanley Chapman, Amanda Clifford, Steven A. Cohen, Florence E. Coman, Robert Contini, Patrick Cooney, Malcolm Cormack, Odile Cortet, Nicola Costaras, M. Margarita Cuyàs i Robinson, Odile Delenda, Marie-Colette Depierre, Gioia Diliberto, Anne Distel, Sylvie Du Bois, Caroline Durand-Ruel Godfroy, Mark Evans, Lee-Anne Famolare, Rupert Featherstone, Diane P. Fischer, Enriqueta Frankfort-Harris, Barbara Dayer Gallati, Lionel Gallois, Chantal Georgel, Véronique Gérard-Powell, Judith Geskó, Marlies Giebe, Eric Gillis, Ana María Gutiérrez, Hartwig Hänsel, E. Heller, Margaret Hempel, Frère Jean Hilaire, Erica Hirschler, Ay-Whang Hsia, Edward Impey, Adam Kalinowski, Stephan Kemperdick, Elaine Kilmurray, John T. Kirk, Patrick Lastavel, Marie-Hélène Lavallée, Patrick Le Chanu, Thomas Lederballe, Stéphane Loire, Mario-Andreas von Lüttichau, James Macdonald, Delphine Maeyaert, Françoise Maison, Joël Maleau, Laure de Margerie, Caroline Mathieu, José Manuel Matilla Rodríguez, Gudrun Maurer, Andrew McClellan, Peter Meller, Mitchell Merling, Olivier Meslay, Rainer Michaelis, Christine Minas, Jean-Pierre Mohen, Dorothy Moss, Richard Ormond, Michael Pakenham, Malcolm Park, Robert McDonald Parker, Carole Parnaso, Sylvie Patin, Yves Pellet, Janet Pennington, Sophie Piétri, Anne Pingeot, Gilles Poizat, Jean-Jacques Renaudet, Claudie Ressort, Elisabeth Rey, José R. Roldán, Almudena Ros, Nathalie Roux, Francis Russell, Peter Scheel, Michael Schweiger, Jean-Claude Serrier, Darrel Sewell, Mark Simpson, Janice Sorkow, Gail Stavisky, Madeleine de Terris, Agurtxane Urraca, Joost van der Auwera, Laurent Veyssière, Florence Vielfaure, Bodo Vischer, Nathalie Volle, Gregor J. M. Weber, and Guy Wildenstein.

Geneviève Lacambre
Gary Tinterow

List of Lenders

Contributors to the Catalogue

Jeannine Baticle
*Conservateur en chef honoraire des Musées
Nationaux, Paris*

MBB Marcus B. Burke
Curator, The Hispanic Society of America, New York

Ignacio Cano Rivero
Curator, Museo de Bellas Artes, Seville

Mitchell A. Codding
Director, The Hispanic Society of America, New York

DD David C. Degener
Independent researcher

TF Trevor Fairbrother
Independent curator and art historian, Boston

MSGF María de los Santos García Felguera
Professor, Universidad Complutense, Madrid

Stéphane Guégan
*Responsable des colloques et conférences, Musée
d'Orsay, Paris*

GL Geneviève Lacambre
*Conservateur général honoraire, Musée d'Orsay,
Paris*

Ilse Hempel Lipschutz
*Professor Emerita, Vassar College, Poughkeepsie,
New York*

DL Dominique Lobstein
Chargé d'études documentaires, Musée d'Orsay, Paris

JPP Javier Portús Pérez
Curator, Museo Nacional del Prado, Madrid

DLR Deborah L. Roldán
*Research Associate, The Metropolitan Museum of
Art, New York*

GT Gary Tinterow
*Engelhard Curator of European Paintings,
The Metropolitan Museum of Art, New York*

H. Barbara Weinberg
*Alice Pratt Brown Curator, American Paintings and
Sculpture, The Metropolitan Museum of Art, New York*

MW Matthias Weniger
*Research Curator for Spanish Painting, Staatliche
Kunstsammlungen Dresden, Gemäldegalerie Alte
Meister, Dresden*

JW-B Juliet Wilson-Bareau
Independent art historian, London

MANET/VELÁZQUEZ

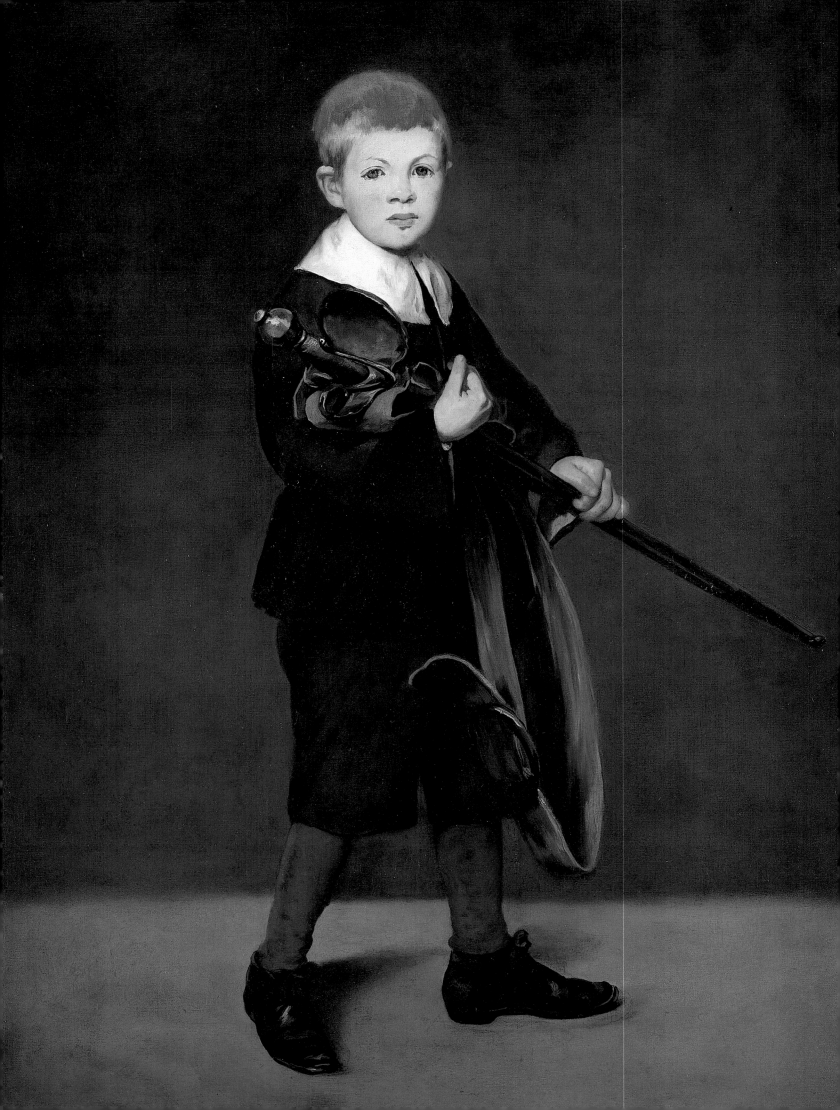

Raphael Replaced: The Triumph of Spanish Painting in France

Gary Tinterow

In 1804, at the dawn of the French Empire, there were no more than a handful of Spanish paintings in public collections in France; in 1838 King Louis-Philippe inaugurated the Galerie Espagnole at the Louvre, placing on view the four hundred paintings in his personal collection that were then attributed to Spanish masters.[1] Writing about the painterly style in 1861, the Goncourt brothers could name only "the two great painters,"[2] Rembrandt and Tintoretto, while in 1889 the elder Goncourt, Edmond, wrote of "true painting, which comprises three men: Rembrandt, Rubens, Velázquez."[3] How is it that Velázquez, an "unknown" according to André Félibien's 1688 treatise on painting,[4] came to be recognized as one of the supreme artists of all time—"the most painterly painter who ever lived," according to Théophile Thoré in 1857; "the painter of painters," according to Manet?[5] How is it that in France the school of Spanish painting passed from almost complete obscurity to the pinnacle of esteem in less than fifty years, to the extent that in 1852 the Louvre would spend more money to obtain Murillo's *Immaculate Conception* than it had on any other previous acquisition? And why would an ambitious young painter like Édouard Manet devote most of his early career to an intense investigation of the styles of Goya and Velázquez before he had even traveled to Spain?

This exhibition proposes to draft a response to these question as it charts the means by which French collectors and museums came to acquire works by Spanish masters and the ways in which nineteenth-century French artists and writers came to understand, appreciate, and emulate Spanish painting of the Golden Age. It will map a fascinating shift in the paradigm of painting, from Idealism to Realism, from Italy to Spain, from Renaissance to Baroque, from carefully finished, porcelain-like surfaces (*léchées*) to an "excessive emphasis on brushy technique" ("l'outrance de la cuisine")[6]—the foundation of the Impressionists' aesthetic of the sketch. Above all, it will demonstrate that it was direct contact with Spanish art—sometimes of great quality, sometimes mediocre, and sometimes not even Spanish—that fired the imagination of French artists and contributed to the triumph of Realism in the 1860s.

THE EIGHTEENTH CENTURY AND THE CREATION OF THE MUSÉE DU LOUVRE

"For I don't remember hearing about them: is that because no great Painters have come from their country?" André Félibien underscored contemporary late-seventeenth-century prejudices and ignorance of Spanish painting in his early treatise, framed as an interview. In

1. I wish to acknowledge the research assistance of Deborah L. Roldán, who has contributed many new ideas and much documentation to this exhibition and to this essay. I would also like to thank Kathryn Calley Galitz for her significant contributions to this essay.

2. "les deux grands peintres." Goncourt 1989, vol. 1, p. 726: September 8, 1861. In 1887 Edmond Goncourt modified the entry to record "I must say that I am unfamiliar with the Vélasquezes in Madrid; I don't know the famous *Tapestry Workers*." ("Je dois dire que je ne connais pas les Vélasquez de Madrid, que je ne connais pas les fameuses *Ouvrières en tapisserie*.")

3. "la vraie peinture, qui compte trois hommes: Rembrandt, Rubens, Velázquez." Goncourt 1889, vol. 3, p. 294: July 12, 1889.

4. "inconnu." Félibien 1725, vol. 4, p. 175 (originally published in 1685).

5. "le plus peintre qui ait jamais existé." See Thoré's review of the 1857 Art Treasures Exhibition in Manchester, England, "Trésors d'art en Angleterre," quoted in Jowell 1971, p. 222. "le peintre des peintres." Letter from Manet to Henri Fantin-Latour, Madrid, September 3, 1865, in Manet 1991, p. 43.

6. Goncourt 1989, vol. 3, p. 617: August 12, 1891. Speaking of Turner, Goncourt wrote of "that excessive emphasis on brushy technique, the technique, I will say it again, that comprises the work of the great painters, whose names are Rembrandt, Rubens, Velasquez, Tintoretto" ("l'outrance de la cuisine, de cette cuisine, je le répète, qui est toute la peinture des grand peintres qui se nomment Rembrandt, Rubens, Velasquez, le Tintoret").

Fig. 1.1 (cat. 133) Édouard Manet, *Boy with a Sword*, 1860–61. Oil on canvas, 51⅛ x 36¾ in. (131.1 x 93.4 cm). The Metropolitan Museum of Art, New York, Gift of Erwin Davis, 1889 (89.21.2)

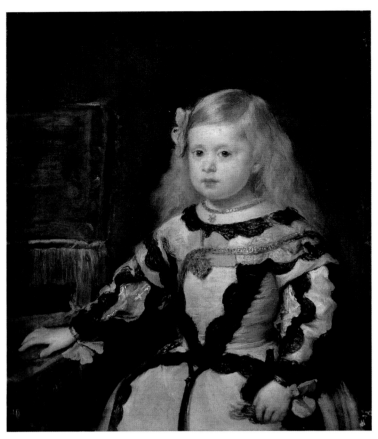

Fig. 1.2 (cat. 78) Workshop of Diego Rodríguez de Silva y Velázquez, *Infanta Margarita*, ca. 1653. Oil on canvas, 27½ x 23 in. (70 x 58 cm). Musée du Louvre, Paris

contrast to the "fine manner" ("bel air") of Italian art, Félibien found in Spanish art nothing more than a "natural resemblance" ("la naturelle ressemblance") and hence works of the second rank.[7] Throughout most of the eighteenth century, the only Spanish works in the French royal collection were *The Burning Bush* by Collantes (Musée du Louvre, Paris, inv. 924) and a suite of twenty small Habsburg portraits (fig. 1.2) produced in Velázquez's studio, ordered in 1655 by Anne of Austria, daughter of Philip III of Spain, wife of Louis XIII, and mother of Louis XIV. Installed as a frieze in the Salle des Bains of Anne of Austria's apartment at the Palais du Louvre, they were difficult to access and rarely seen.[8] This would change in the 1780s. After the sole public art gallery in Paris, the Galerie de Luxemburg, closed in 1779, Charles-Claude Flahaut, comte de la Billarderie d'Angiviller (1730–1809), the general director of the king's buildings for Louis XVI, set out to transform the Grande Galerie of the Louvre, which had been used for the display of military maps and models of the principal cities and harbors of France, into a royal picture gallery organized on scientific principles.[9] The project was mired in disagreement on how to dispose the space and to provide light for the Grande Galerie, but while d'Angiviller wrestled with architects and artists he simultaneously sought to acquire

paintings to augment the collection (fig. 1.3). Although much vaunted in Paris as the greatest princely collection in Europe, the holdings of the king of France, kept principally at Versailles, were in fact spotty: rich in works of the Italian Renaissance, the representation of the northern Baroque schools—Flemish, Dutch, and French—was uneven, despite the presence of great masterpieces such as Rubens's Marie de' Medici cycle. The perpetual wars of the seventeenth and eighteenth centuries were a constant drain on the treasury, leaving little money for art acquisitions. In 1772, for example, the Crown was unable to buy the entire Crozat collection, a remarkable assemblage of some five hundred Italian Renaissance, northern Baroque, and eighteenth-century French paintings formed by two generations of collectors.[10] The nineteen thousand drawings were eventually purchased by the state, but the paintings went to Catherine II of Russia, who was in fact forming the finest collection of European paintings in the world, more diverse and comprehensive than that of the kings of Spain or the prince-electors of Saxony.

D'Angiviller worked hard to redress the loss of the Crozat collection, buying two hundred pictures for the royal collection between 1775 and 1789 and spending nearly one million livres.[11] Essentially a military man who had served as a mentor to the young Louis XVI, d'Angiviller had a broad culture, a curious mind, and friends who were artists. He was conscious of the absence of Spanish painting in France. In 1779 he wrote to the French ambassador in Madrid, "I know there must be paintings by the great masters lost and forgotten in the attics of Spain, which the dealers have yet to explore. It occurred to me that one ought to

7. "Car je me souviens pas d'en avoir oüi parler: aussi n'est-il guères sortis de grands Peintres de leur päis?" Quoted by Bernard Dorival, "Velázquez et la critique d'art française aux XVIIe et XVIIIe siècle," in *Varia Velazqueña* 1960, vol. 1, p. 527.

8. Only seven of the twenty can be identified today: six are at Versailles and the famous *Infanta* (fig. 1.2) has been at the Louvre since at least 1813. J.-B.-P. Lebrun noted that "there were several in the Louvre, portraits of the House of Austria. Because the paintings were abandoned, some were ruined by neglect, and these were sold, unframed, at the Nesle sale." ("il en existait plusieurs dans le Louvre, représentant les portraits de la maison d'Autriche. Ces tableaux ayant étés abandonnés, le manque de soins en détruisant une partie, qui fut vendue, sans châssis, à la vente du dépôt de Nesle.") The Nesle sale was held at the Hôtel de Nesle from July 24, 1797, to January 12, 1798. Lebrun 1809, vol. 2, p. 22.

9. The collection of military maps and models is now divided between the Hôtel des Invalides, Paris, and the Palais des Beaux-Arts, Lille.

be able to find inexpensive Titians, Velázquezes, Murillos, etc., which would enhance the king's magnificent collection at little cost. Please let me know if you foresee being able to find . . . any paintings or other curiosities."[12] D'Angiviller was perhaps unaware of the recent decree prohibiting the export of works of art, issued by the prime minister of Spain, the conde de Floridablanca.[13] In the end, d'Angiviller did not purchase anything in Spain, but he did manage to acquire Spanish works in Paris.

Like artists, academicians, and other connoisseurs, d'Angiviller knew the few Spanish paintings found in the houses of the thirty to forty important Parisian private collectors of his day.[14] Although Spanish pictures were never numerous, they were conspicuous on account of their rarity. The most important group of old-master pictures in Paris could be found at the Palais Royal, where the collection of the ducs d'Orléans was displayed. Philippe II (1674–1723), duc d'Orléans and grandson of Louis XIV, was an avid patron of the arts who used his position as regent (and de facto monarch of France) for the five-year-old King Louis XV to advance his holdings.[15] The 1733 catalogue of the Orléans collection listed nine Spanish paintings: *The Finding of Moses* by Velázquez (now attributed to Honthorst; Castle Howard, Yorkshire); seven canvases by Ribera; and a work by Luis de Vargas (1502–1568). These pictures could be seen on application until the Revolution; in 1791, to finance his political career, Louis-Philippe-Joseph d'Orléans (1747–1793), called Philippe Égalité (great-grandson of Philippe II), sold his paintings to speculators, who put

10. Many of the most important works derived from the collection of Queen Christina of Sweden, purchased by Pierre Crozat in 1721. Most are now divided between the Hermitage, St. Petersburg, and the Pushkin Museum, Moscow. The 1757 *Voyage pittoresque de Paris* by A.-N. Dézallier d'Argenville lists two Spanish paintings in the Crozat collection: a Ribera, "an oval painting depicting the bust of an old man, by L'Espagnolet; it is engraved in the Cabinet des Aiguilles" ("un tableau ovale représant un buste de vieillard, par l'Espagnolet; il est gravé dans le Cabinet d'Aguilles," p. 127), and a Moro, "portrait . . . of an old man" ("portrait . . . d'un vieillard," p. 118). The Ribera (L'Espagnolet) *Saint Bartholomew* is now at Pavlovsk Palace; the Murillo *Holy Family* was acquired by Crozat only in 1756, at the sale of the duc de Tallard, and hence is not mentioned by Dézallier d'Argenville; it is now at the Hermitage, St. Petersburg.
11. McClellan 1994, p. 61.
12. "Je sais qu'il y a des tableaux des grands maîtres perdus et oubliés dans les

Fig. 1.3 Hubert Robert, *The Grande Galerie of the Louvre between 1801 and 1805*. Oil on canvas, 14⅝ x 18⅛ in. (37 x 46 cm). Musée du Louvre, Paris

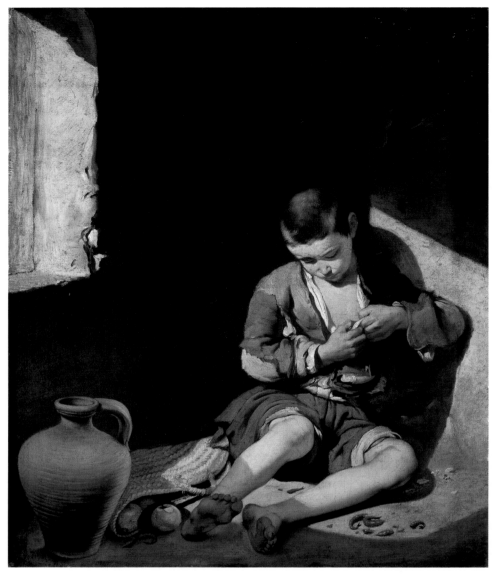

Fig. 1.4 Bartolomé Esteban Murillo, *Beggar Boy (The Flea-Picker)*, 1650. Oil on canvas, 53 x 39¼ in. (134 x 100 cm). Musée du Louvre, Paris

them on display and sale in London between 1793 and 1800. As Francis Haskell and others have observed, the presence of the Orléans collection in London in the 1790s fueled a renewed interest in old-master paintings on the part of collectors and influenced the practice of painting by contemporary artists in England.

The Spanish paintings purchased by d'Angiviller all came from French private collections. A number of pictures by Murillo, equally divided among devotional pictures and genre scenes, had been in the country for many years. *Beggar Boy* (fig. 1.4),[16] the first of Murillo's celebrated pictures of poor children and street urchins, came from the collection of Jean-Louis Gaignant, former secretary of the king and receveur de consignations, who also owned a *Rest on the Flight into Egypt* (State Hermitage Museum, St. Petersburg). *The Holy Family* was purchased from the comte de Serrant.[17] *The Virgin of the Rosary* had been acquired by the sieur de Langlois in Seville, passing to Randon de Boisset and the comte de Vaudreuil before d'Angiviller bought it in 1784.[18] Two small pictures on obsidian, *Christ on the Mount of Olives* and *Saint Peter before Christ at the Column* (figs. 2.6, 2.7), were also purchased from the sale of the comte de Vaudreuil (1740–1817), a court official, favorite of Queen Marie-Antoinette, and close friend of Madame Vigée-Lebrun.[19] It cannot be a coincidence that the dealer on most of these transactions was Jean-Baptiste-Pierre Lebrun (1748–1813), the canny husband of Élisabeth Vigée-Lebrun and one of the major figures in the Parisian art world. D'Angiviller distrusted Lebrun and generally preferred to rely on the dealer Alexandre-Joseph Paillet as agent.[20] But Lebrun clearly had an interest in Spanish painting, and special knowledge as well. Much later, in the autumn of 1807, Lebrun traveled to Spain and purchased fifteen important pictures that he sold at auction in Paris in 1810. Included in the sale was Ribera's majestic *Holy Family with Saints Anne and Catherine of Alexandria*, purchased by Lebrun in Italy and now at The Metropolitan Museum of Art (fig. 1.5).[21] He understood the opportunity perfectly: "Spain is a rich storehouse of the art of every school. My admiration soon inspired in me the desire to

greniers en Espagne, je sais que les marchands n'y ont pas encore penetré. J'avois pensé qu'on avrait pu trouver à bon marcher des Titiens, des Velasquets, des Murillos, etc., et qu'on pourroit augmenter facilement et fortifier la magnifique collection du Roi le tout à bon marché; marquez moi je vous prie si vous prévoyés pouvoir trouver dans des maisons particulières dans des gardemeubles des tableaux ou autres curiosités." McClellan 1994, p. 63. Original French passage provided to me by Professor McClellan.

13. Works by dead rather than living artists were restricted; the decree came as a result of the active market in works by Murillo, primarily on behalf of English dealers and collectors. For the text of

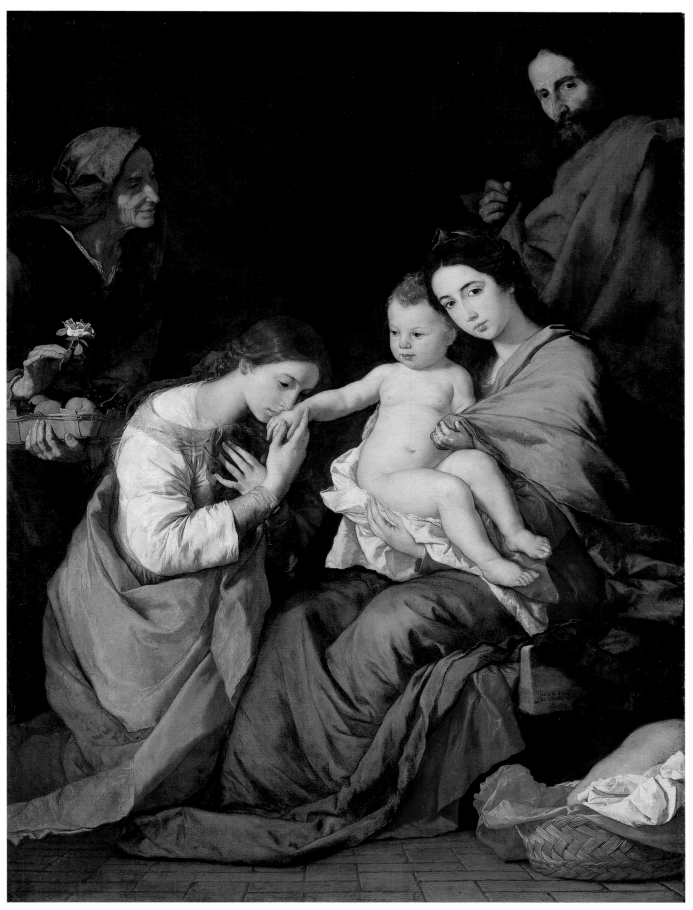

Fig. 1.5 (cat. 62) Jusepe de Ribera, *The Holy Family with Saints Anne and Catherine of Alexandria*, 1648. Oil on canvas, 82¼ x 60¼ in. (209.6 x 154.3 cm). The Metropolitan Museum of Art, New York, Samuel D. Lee Fund, 1934 (34.73)

Fig. 1.6 (cat. 50) Bartolomé Esteban Murillo, *Boy with a Dog*, before 1660. Oil on canvas, 27⅕ x 23⅝ in. (70 x 60 cm). State Hermitage Museum, St. Petersburg

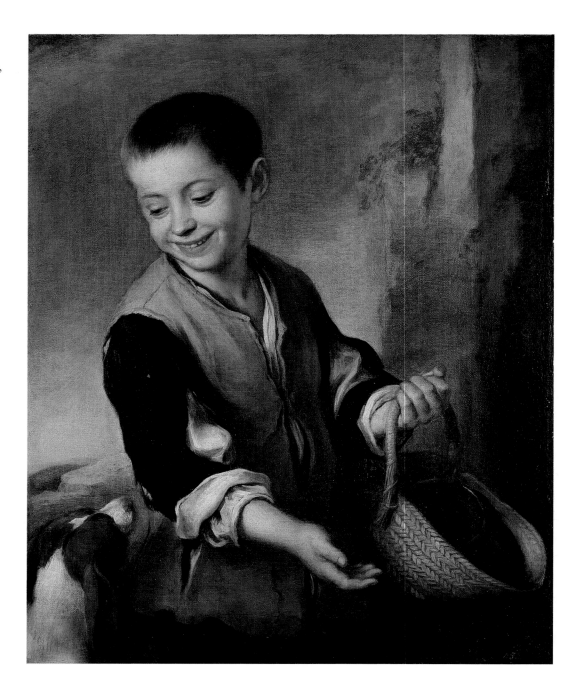

the decree, see the Chronology: 1779. Floridablanca was an early patron of Goya.

14. According to Colin Bailey, "Hébert noted fifteen picture cabinets in 1766; Dezallier d'Argenville's *Voyage pittoresque* of 1778 listed twenty-nine; Thiéry's *Almanach* referred to some thirty-eight picture cabinets in 1785." Bailey 2002, p. 16.

15. In 1721 he was able to siphon off the cream of Queen Christina of Sweden's collection, buying 123 works, some previously owned by the emperor Rudolf II (Pierre Crozat acquired many of the rest of Christina's pictures).

16. Musée du Louvre, Paris, inv. 933. Sold at the Gaignant sale, Paris, lot 8 (December 1768 or February 14, 1769)

wrest from oblivion several celebrated masters who are unknown to all outside of Spain; but my plan encountered great obstacles: 1. It is forbidden to allow paintings by the Spanish masters to leave the country. 2. Almost all of the collections are entailed, and are being ruined out of ignorance. 3. The convents own many paintings, but they do not part with them readily, and the huge offers that they have often received render acquisitions nearly impossible."[22]

There were other Murillos in France that d'Angiviller did not buy. Early in the century there were three in the collection of the comtesse de Verruë.[23] *Boy with a Dog* (fig. 1.6) belonged to the duc de Choiseul; at his sale in 1772 it was purchased for Catherine II of Russia by her agent, Prince Galitzin. Choiseul—foreign minister, minister of war, and minister of the navy for Louis XV—was an avid collector advised by the dealer Jean-François Boileau, who himself bought the *Marriage at Cana* (fig. 1.9) at the sale of the prince de Conti's collection in 1777. In 1795 two Murillos were sold by the minister and con-

troller of finances of Calonne, who had left France for England in 1787.[24] There were also paintings by Murillo in certain provincial collections.[25]

Given the presence of a dozen or more works by Murillo in Parisian collections and the regular appearance of individual paintings at auction, d'Angiviller's purchases for the royal collection are not surprising. It would appear that every prominent collection had a Murillo or two. Despite Félibien's withering commentary in 1688, most of the later eighteenth-century dictionaries of art include favorable mentions of Murillo. A.-J. Dézallier d'Argenville wrote an entire section on "Napolitains et Espagnols" in his 1745 *Abrégé de la vie des plus fameux peintres* (Summary of the lives of the most famous painters), which he based on "new memoirs that I have received from Spain"[26]—Antonio Palomino's *Lives of the Eminent Spanish Painters and Sculptors* (1724). Dézallier d'Argenville greatly valued the work of "the famous Murillo" and bragged that he personally owned one of his "extremely rare" drawings: "there is much truth in it."[27] "He brought his art to such a stage that his paintings are now extremely sought after in all of Europe: people appreciate the velvety painting, fresh brushwork, wonderful flesh tones, a striking understanding of color, a truth to life eclipsed only by nature itself, those successful passages that shine discreetly in areas that ought to be dappled with the brightest lights, in short, everything to do with color is perfect; a little more propriety, a happier and more discriminating choice of the nobility of antique figures, would raise this master's painting to the highest rank."[28]

Dézallier d'Argenville was equally complimentary of Velázquez, if not as well informed. With typical bias, he dismissed the lowly realism of Velázquez's early work, and attributed the voyage to Italy as the transforming event that "ennobled Velázquez's thoughts"; "he immediately abandoned low subjects to take on history and portraits. . . . His talent for rendering nature so freely caused Velasquez to be called a second Caravaggio. We find in his works the energy of the Greeks, the Romans' propriety, the tender and pleasing manner of the Venetians. We may even say that Velasquez transformed himself in so many ways, that if we didn't have the works of the ancients, despite the great number we have, we would find the same taste in the small number of paintings that we have by his hand."[29] Dézallier d'Argenville mentioned the frieze of portraits at the Louvre, the large *Saving of Moses* (not by Velázquez) in the Orléans collection at the Palais Royal, and some curious portraits in Franche-Comté.[30] He did not know the one truly exceptional Velázquez in France in the eighteenth century, *Democritus* (fig. 1.7). Although the location of the work between 1692 and 1789 is unknown, it appeared at the bureau of finances in Rouen in 1789 and was deposited in the abbey of Saint-Ouen in 1790. Purchased by the painter Lemonnier in 1797 and donated to the Musée des Beaux-Arts in Rouen in 1822 as a Ribera, it retained that attribution until 1881.

The absence of firsthand experience of Velázquez hobbled French eighteenth-century critics, who contented themselves to copy the sentiments of Palomino and Dézallier d'Argenville. Like them, the abbé de Fontenay considered him "a second Caravaggio."[31] Papillon de la Ferté noted that Velázquez "sought as well to capture the particular spirit and movements of the person he was painting."[32] The most insightful remarks were made not at the end of the century but at the beginning, by the great connoisseur and collector Pierre-Jean Mariette, who commented that Velázquez's paintings were "executed with inconceivably bold brushstrokes and, at the proper distance, created a surprising effect, even producing a perfect illusion."[33] From this statement one could imagine that Mariette had

for 1,544 livres; offered by Lebrun at the Radix de Sainte-Foy sale, Paris, lot 1, April 22–24, 1782, bought in at 3,000 livres, purchased by Lebrun for 3,600 livres, and sold on December 22, 1782, for 4,200 livres to d'Angiviller for the crown.

17. Musée du Louvre, Paris, inv. 930. Purchased from him in 1786 for 22,000 livres.

18. Lebrun acquired it for d'Angiviller at the Vaudreuil sale, Paris, November 24, 1784. Since 1939 it has been on deposit at the Musée Goya, Castres (inv. 929). D'Angiviller bought thirty-six paintings for the crown at the Vaudreuil sale. Bailey 2002, p. 185.

19. Musée du Louvre, Paris, inv. 931, 932. Formerly owned by Justino de Neve (1685) and the elector of Cologne (d. 1761), these two pictures were purchased by Lebrun for d'Angiviller for 2,001 livres at the Vaudreuil sale, Paris, November 24–25, 1784. On Vaudreuil, see Bailey 1989 and Bailey 2002, pp. 170ff. Vaudreuil hoped to replace d'Angiviller as director of the Bâtiments du Roi. Bailey 2002, p. 191.

20. McClellan 1994, p. 67. McClellan (pp. 236–37 n. 79) cites a fascinating but probably typical letter of March 1786 from Lebrun to d'Angiviller: "The protection with which you honor [Paillet] becomes daily more injurious to me" ("La protection dont vous l'honorez [Paillet] me devient de jour en jour plus préjudiciable").

21. See Bailey 1984, no. 63.

22. "L'Espagne est une mine de richesse de l'art, formée de toutes les écoles. Mon admiration me donna bientôt le désir d'arracher à l'oubli plusieurs maîtres célèbres qui sont inconnus de tout ce qui n'est pas l'Espagne; mais de grands obstacles s'opposaient à mes projets: 1. Il est défendu de laisser sortir des tableaux des maîtres espagnols. 2. Les collections sont presque toutes substituées, et périssent par ignorance. 3. Les couvents possèdent beaucoup de tableaux; mais ils s'en détachent difficilement, et les offres immenses qu'on leur a souvent faites rendent les acquisitions presque impossibles." Lebrun 1809, vol. 1, pp. vj–vi [sic].

23. *The Laughing Boy* (now National Gallery, London), *The Flower Girl* (Dulwich Picture Gallery, London), and *The Good Shepherd* (Lane Collection, London). *The Infant Saint John the Baptist and the Lamb* (National Gallery, London) belonged in 1750 to the comte de Lassay and later to the comte de la Guiche; it was sold in Paris in 1771, in 1792, and again in 1801. Madrid–London 1982–83, pp. 175–76, no. 35.

Fig. 1.7 (cat. 70) Diego Rodríguez de Silva y Velázquez, *Democritus*, ca. 1629. Oil on canvas, 38⅝ x 31⅞ in. (98 x 81 cm). Musée des Beaux-Arts, Rouen

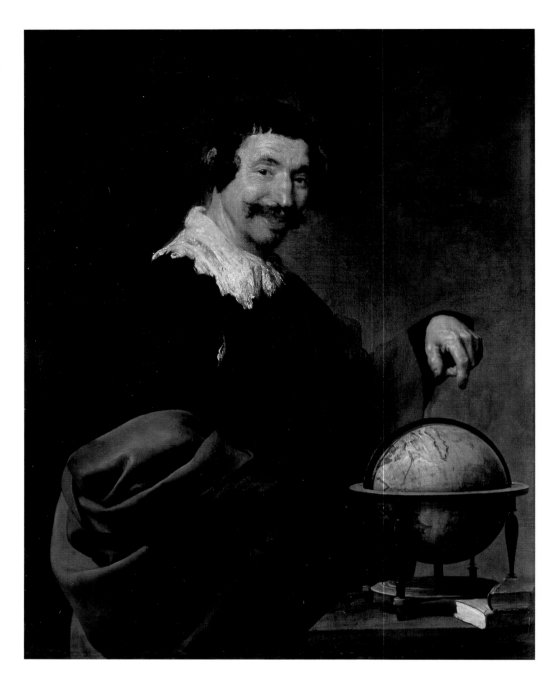

24. *Holy Family* (formerly private collection, Biarritz) and *Virgin and Child* (Norton Simon Museum, Pasadena).

25. A *Virgin and Child* (Dresden) was sold with the Pasquier collection in Rouen in 1755. Seven works attributed to Murillo appeared in the 1757 sale of the duc de Tallard in Besançon. Guillaume Bouton of Toulouse bought in Spain a sketch by Murillo for *The Liberation of Saint Peter* (Národní Galerie, Prague). See Claudie Ressort, "Murillo et les amateurs français," in Paris 1983, pp. 52–53, 54.

26. "nouveux mémoires que j'ai reçus d'Espagnes." A.-J. Dézallier d'Argenville 1745–52, vol. 1, p. 343.

27. "le fameux Murillo." Ibid., p. 335. "extrêmement rare"; "on y trouve une grande vérité." Ibid., p. 345.

seen Velázquez's *The Fable of Arachne* or *The Spinners* (fig. 4.11), although there is no evidence that he had traveled to Spain. He did, however, spend the years 1717–18 in Vienna, home of many marvelous portraits by Velázquez, some with striking still lifes and dogs. It is also said that Mariette owned a work by Velázquez.[34]

Assessing Ribera's early impact and presence in France is more difficult. Born in Valencia, Ribera saw his entire career play out in Italy; even if he himself insisted on his Spanish identity, he was always considered a member of the Italian school. With Caravaggio's premature death in 1610, Ribera became a principal exponent of that tenebrist style, and his presence in Naples enabled his work to be known by almost all of his contemporaries in Italy and even the North: Rubens and Rembrandt both owned works by him. Much of his time was spent on commissions from the viceroy of Naples, the court in Madrid, or various religious institutions in Spain; hence, apart from some drawings and his well-known prints, there was little that might be seen in France. Four works by

"L'Espagnolet" listed in the 1793 catalogue of the Muséum Français were reattributed by the time the 1800 catalogue was printed; in addition, none of the seven works attributed to Ribera in the Orléans collection in the Palais Royal are considered today to be by him. Inevitably, however, the French artists who traveled to Rome would go on to Naples and study Ribera's work there. The *Pietà* at the Certosa di San Martino (fig. 2.35) was copied by countless French artists, including Fragonard and Guillaume Guillon Lethière, who later acted as artistic adviser to Lucien Bonaparte during his residency as French ambassador to Spain. As early as 1699, Roger de Piles, who actually visited Spain, wrote of Ribera's preference for "melancholy subjects."[35] Works such as the *Pietà* and the famous *Martyrdom of Saint Philip* (Museo del Prado, Madrid) were thought, especially in France, to represent the dark and Spanish side of Ribera's sensibility. But in fact, many of the violent compositions attributed to Ribera in eighteenth- and nineteenth-century France have been revealed to be works by other artists, among them Luca Giordano (1632–1705).

If Murillo was fairly well known and well represented in private collections in France in the eighteenth century; if Velázquez was esteemed but not visible; if Ribera was famous as a Neapolitan artist, with no great works in France; then Zurbarán and El Greco were completely unknown. The impressive *Saint Francis* (fig. 1.8) was the sole picture by Zurbarán in France before 1800. Despite its large size, it was found in an attic in the convent of the "Collinettes" in Lyon before 1793 and bought, as a Ribera, at public sale sometime before 1797 by the painter and art dealer Jean-Jacques de Boissieu.[36]

Such was the appreciation of the Spanish school in France at the end of the eighteenth century. It is telling that in Diderot's great *Encyclopédie* of 1758–68, eight schools of painting are identified in Europe and not one is Spanish. The author, Louis de Jaucourt, identified them as "Roman, Flor-

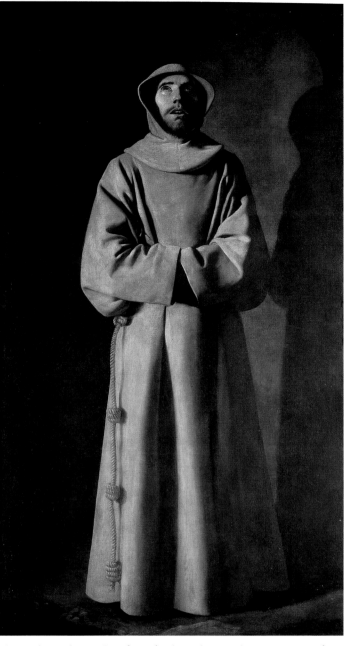

Fig. 1.8 (cat. 90) Francisco de Zurbarán, *Saint Francis*, ca. 1650–60. Oil on canvas, 82¼ x 43¼ in. (209 x 110 cm). Musée des Beaux-Arts, Lyon

entine, Lombard, Venetian, German, Flemish, Dutch, and French."[37] In 1816 the French connoisseur Frédéric Quilliet, who was very active in Spain during the French occupation, commented on this absence in his *Dictionnaire des peintres espagnols* (Dictionary of Spanish painters): "Who would believe that M. le chevalier de Jaucourt, a scholar as genuinely learned as he is charming, did not even mention this in his entry *Painting* in the Encyclopedia! Who could believe that in this wellspring of knowledge, you would find no trace of these many paragons of every school and every type?"[38]

Nevertheless, the Murillos that sold in France at the end of the eighteenth century went for very high prices, much higher than those for the putative Velázquezes and comparable to prices achieved by works of esteemed painters such as Rubens. The value of the Murillos

28. "Ce fut alors qu'il porta son art au point que ses tableaux sont extrêmement recherchés dans toute l'Europe: on y trouve une peinture moëlleuse, un pinceau frais, des carnations admirable, une entente de couleur que surprend, une vérité qui ne peut être effacée que par la nature même, de ces passages heureux qui font briller avec prudence les endroits qui doivent être piqués des plus grandes lumières, enfin toute la partie du coloris est parfaite; un peu plus de correction, un choix plus heureux et tiré de la noblesse des têtes antiques, mettroient les tableaux

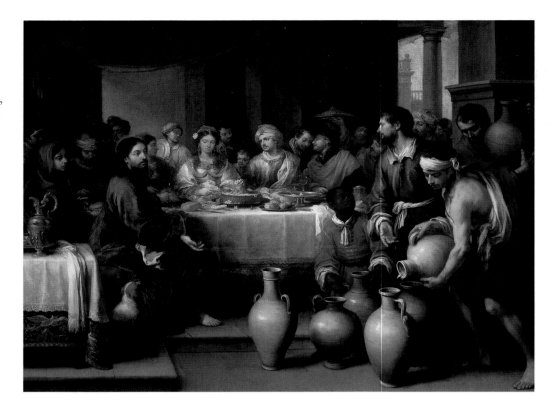

Fig. 1.9 Bartolomé Esteban Murillo, *The Marriage at Cana*, 1665–75. Oil on canvas, 70½ x 92½ in. (179 x 235 cm). Barber Institute of Fine Arts, University of Birmingham, England

de ce maître au plus haut degré." Ibid., pp. 343–44.

29. "annoblirent les pensées de Velasquez, il quitta aussitôt les sujets bas pour s'attacher à l'histoire et au portrait. . . . Velasquez par son talent de rendre la nature avec tant de liberté, fut nommé un second Caravage. On trouve dans ses ouvrages l'énergie des Grecs, la correction des Romains, la tendre et agréable manière des Vénitiens. L'on peut dire même que Velasquez se transformoit en tant de manières, que si les ouvrages des anciens nous manquoient malgré la grande quantité que nous en avons, on retrouveroit le même goût dans le petit nombre de tableaux que nous possédons de sa main." Ibid., p. 331.

30. "There are several portraits of Ladies of the family of the Baron de Vauteville that remain unfinished and that Père Courtois, known as Le Bourguignon, completed later." ("On voit plusieurs portraits de Dames de la famille du Baron de Vauteville qui sont restés imparfaits et que le père Courtois appellé le Bourguignon a achevés dans la suite.") Ibid., p. 335.

31. "un second Caravage." Abbé de Fontenay 1776, vol. 2, p. 715, quoted by Dorival in *Varia Velazqueña* 1960, vol. 1, p. 530.

32. "voulait encore saisir l'esprit et les mouvements particuliers de la personne qu'il peignait." Papillon de la Ferté 1776, vol. 1, p. 462, quoted by Dorival in *Varia Velazqueña* 1960, vol. 1, p. 530.

33. "touchés avec une hardiesse inconcevable et qui, à leur distance, faisaient un effet surprenant, et qui allaient jusqu'à

had been established by English collectors, who had been actively acquiring them throughout the century, either in Spain or through Flemish intermediaries. Concurrently, English painters such as Gainsborough and Reynolds admired Murillo's effects and emulated his subjects—genre paintings featuring young children—in their own "fancy pictures." The same was not true in France. It is thought that Watteau may have studied Murillo's *Marriage at Cana* (fig. 1.9) in the Jean de Julienne collection, but it is difficult to find echoes of Sevillian painting in the work of eighteenth-century French artists. Even artists who worked in Spain, including Louis-Michel van Loo, Jean Ranc, and Charles-Joseph Flipart, did not betray in their own art any interest in the technique of Spanish masters of the seventeenth century.[39]

THE REVOLUTIONARY LOUVRE AND THE MUSÉE CENTRAL DES ARTS

Political events prevented d'Angiviller from realizing his project for a royal museum in the Grande Galerie. But when the Muséum Français opened at the Louvre on August 10, 1793, the first anniversary of the storming of the Tuileries and the capture of Louis XVI, the public gallery he had envisioned finally could be seen. Ten Spanish paintings were listed in a catalogue that included most of the easel paintings in the former royal collection: the five Murillos purchased by d'Angiviller and four works by Ribera.[40] As Andrew McClellan recounts, the National Assembly had even greater ambitions for the new institution than d'Angiviller had ever conceived.[41] The holdings of the museum were immediately linked to the stature of the new government and the very identity of the French nation. Thus the vagaries and insufficiencies of a collection that had been formed through the caprice of royal taste had to be corrected to represent the complete history of art. The new minister of the interior, Jean-Marie Roland, made this clear to the painter Jacques-Louis David (1748–1825): "This museum must demonstrate the nation's great riches. . . . France must

extend its glory through the ages and to all peoples: the national museum will embrace knowledge in all its manifold beauty and will be the admiration of the universe. By embodying these grand ideas, worthy of a free people . . . the museum . . . will become the most powerful demonstration of the French Republic."[42] David echoed these sentiments in 1794: "The museum is not supposed to be a vain assemblage of frivolous luxury objects that serve only to satisfy idle curiosity. What it must be is an imposing school."[43] David was lobbying to allow artists to copy in the national museum and to make the instruction of French artists, rather than the enjoyment of connoisseurs, the principal mission of the institution. This logic would of course lead to the modern Musée du Louvre. As an ideology, however, these same sentiments would sanction the seizure of hundreds of works of art as war loot during Napoleon's various European campaigns. Indeed, it was through war, occupation, confiscation, and tribute that the Spanish school at the Louvre would initially be extended beyond its inauspicious beginnings.

The first hint of what was to come transpired immediately after French forces defeated Austria in the summer of 1794 and annexed Flanders (modern-day Belgium) to France. By September, 150 paintings from the occupied territory had been unpacked in Paris. The first to arrive were Rubens's three immense altarpieces, *Descent from the Cross, Raising of the Cross,* and *The Crucifixion.* Cecil Gould has suggested that the eye of the dealer Lebrun can be detected in the choice of plunder from Belgium, although the lists were drawn up by a number of different government officers.[44] The presence in Paris of these celebrated and monumental works sent the French into paroxysms of eloquence. Luc Barbier, an officer who escorted the shipment, explained that "For too long these masterpieces have been soiled by the gaze of servitude. It is in the bosom of a free people that the legacy of great men must come to rest. . . . The immortal works of Rubens, van Dyck, and the other founders of the Flemish school are no longer on alien soil . . . they are today delivered to the home of the arts and of genius, the land of liberty and equality, the French Republic."[45] David's friend F. A. de Boissy d'Anglas could envision a Paris that was the "capital of the arts; imagine the inestimable advantages of becoming the home of all the treasures of the mind . . . it must be the school of the universe, the hub of human science, and command the respect of the whole world through knowledge and instruction."[46] In 1797, as Napoleon moved down the Italian peninsula, shipments of booty were eagerly awaited in Paris. With the capture of the Vatican, gold was struck. A staggering array of masterpieces— Raphael's *Transfiguration,* Caravaggio's *Descent from the Cross,* and the Roman sculptures of the *Apollo Belvedere* and the *Laocoön*—were removed, placed in giant waxed cylinders or encased in plaster and straw, and hauled to Paris. One observer, French of course, marveled at the spectacle. "The whole town [of Livorno] came out to greet the convoy; everyone was amazed by the power of a nation which, one hundred leagues from native soil . . . had managed to transport such a large and precious cargo across the

produire une illusion parfaite." Mariette 1851–60, vol. 6, p. 43, quoted by Dorival in *Varia Velazqueña* 1960, vol. 1, p. 531.

34. Walsh 1996.

35. "sujets mélancoliques." Piles 1715, p. 333.

36. The painting may have been a diplomatic gift in the seventeenth century from the queen of Spain, Marie-Anne of Austria (1634–1696), second wife of Philip IV and stepmother of Marie-Thérèse of Austria, queen of France, who could have sent it to the Franciscan convent in Lyon. See Lavergne-Durey 1992, p. 104, where the relationships of the queens are reversed.

37. "romaine, florentine, lombarde, vénitienne, allemande, flamande, hollandaise, et francoise [*sic*]" *Encyclopédie* 1758–68, vol. 5, p. 265.

38. "Qui pourrait croire que M. le chevalier de Jaucourt, savant aussi vraiment instruit qu'aimable, n'en ait pas dit un mot dans son article *Peinture* de l'Encyclopédie! Qui pourrait croire que dans ce réservoir des sciences, vous ne trouverez rien qui rappelle ces nombreux émules de toutes les écoles et de tous les genres?" Quilliet 1816, p. xxxi.

39. I thank Colin Bailey for this observation. See also Alisa Luxenberg in Indianapolis–New York 1996–97.

40. The four works by "L'Espagnolet" are *Saint Paul,* no. 3 (location unknown); *Saint Pierre,* no. 9 (now attributed to Mola, Musée du Louvre, Paris, inv. 330); *Un buveur,* no. 310, and *Soldat appuyé sur sa lance,* no. 317 (both now attributed to Fracanzano, Musée de Compiègne). I thank Marie-Martine Dubreuil for this

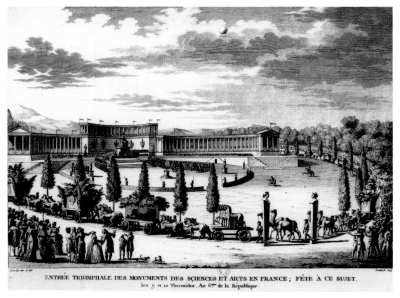

ENTRÉE TRIOMPHALE DES MONUMENTS DES SCIENCES ET ARTS EN FRANCE; FÊTE À CE SUJET. les 9 et 10 Thermidor An 6.me de la République.

Fig. 1.10 Pierre-Gabriel Berthault, *Triumphal Entry of the Monuments of the Arts and Science, 9 and 10 Thermidor Year VII,* 1798. Etching and line engraving, 8⅛ x 11¼ in. (20.7 x 29.7 cm). Musée Carnavalet, Paris

information. One, however, was mistakenly attributed to the Italian painter Domenico Fetti: Collantes's *Burning Bush*, no. 258.

41. My abbreviated account of the early history of the Musée du Louvre follows Andrew McClellan's admirable study (1994), quoted above and below.

42. *Le Moniteur* 14, p. 263, quoted in McClellan 1994, pp. 91–92.

43. David 1794, quoted in McClellan 1994, p. 91.

44. Gould 1965, p. 31.

45. "Trop longtemps, ces chefs-d'oeuvre avaient été souillés par l'aspect de la servitude: est [c'est] au sein des peuples libres que doit rester la trace des hommes célèbres. . . . Les ouvrages immortels de Rubens, de van Dyck et des autres fondateurs de l'école flamande, ne sont plus dans une terre étrangère . . . ils sont aujourd'hui déposés dans la patrie des arts et du génie, dans la patrie [au pays] de la liberté et de l'égalité sainte, dans la république française." Luc Barbier, *Le Moniteur*, 3 vendémiaire an II [1794] (Réimpression, vol. 22, Paris, 1847, p. 27), quoted in McClellan 1994, p. 116.

46. Quoted in McClellan 1994, p. 116.

47. "tout le monde était sorti de la ville pour voir arriver ce convoi; tous ces spectateurs étaient étonnés de la puissance de la [d'une] nation qui, à quatre cents lieues de chez elle . . . avaient enlevé de Rome, et fesait voyager à travers les montagnes de l'Apennin des masses aussi considérables que précieuses, pour en décorer la capitale de son Empire. Qu'elle [sic] nation, disaient—ils, que la [cette] nation française; ils en conservent une si haute idée, que sans employer d'épithête distinctive, et comme s'il n'y avait qu'une dans le monde qui méritât de porter ce titre, ils l'appellent la NATION." Letter published in *La Décade Philosophique*, 20 floréal an V, p. 305, quoted in McClellan 1994, p. 120.

48. "former une collection d'objets d'art plus riche, plus complette [complète], qu'il n'en existe en aucun lieu du monde." Report of the Louvre Conservatoire, 1795, quoted in McClellan 1994, p. 124.

49. Archives Nationales, Paris, AF IV, 1049 (2), quoted in McClellan 1994, p. 140.

50. "L'Apelle moderne"; "un esprit rempli de beautés célestes." "Si tout doit périr, et les productions des hommes et leurs noms; s'il est vrai que tout ce qui fut la richesse, l'honneur et l'amour de tant de siècles doive disparaître pour jamais, le nom fameux de Raphaël est celui de tous les peintres modernes qui surnagera le plus longtemps sur l'océan terrible de l'oubli." Taillasson 1807, quoted by

Apennines from Rome in order to decorate the capital of its empire. What a nation, this France, they said. So impressed were they that they called her THE NATION, as if she were the only one on earth deserving of the title" (fig. 1.10).[47]

The stated goal of the Louvre, now called the Musée Central des Arts, was "to form the richest and most comprehensive collection of art the world has ever known."[48] In pursuing that goal, the individuals entrusted with the museum, often working in concert with the French army, sought to create an illustrated history of art on the walls of the Grande Galerie. There was much discussion and disagreement on the best means to achieve this: old-fashioned amateurs and many artists associated with the ancien régime wanted to illustrate Roger de Piles's seventeenth-century system of comparative connoisseurship, in which works from different countries and epochs would be juxtaposed to elicit formal comparisons; David and other young artists, disdainful of "frivolous" art, wished to show only those works worthy of emulation; academicians and dealers, including the powerful Lebrun, preferred to arrange paintings taxonomically, by national school and in chronological order. This last system prevailed. As the collection grew, and as more and more French officials traveled to Spain, the disparity in representation of the Spanish school at the Louvre became increasingly obvious. However, there were other, ideological, obstacles that also inhibited the full appreciation of Spanish painting.

When, on New Year's Day 1803, the new director of the Musée Central, Dominique-Vivant Denon (1747–1825), invited the new first consul for life, Napoleon Bonaparte, to visit the Grande Galerie, he quite naturally offered to explain the freshly displayed work of Raphael, much of which had been captured by Napoleon's army. "It is like a life of the master of all painters. The first time you walk through this gallery, I hope you will find that this exercise already brings a character of order, instruction, and classification. I will continue in the same spirit for all the schools, and in a few months, while visiting the gallery one will be able to have . . . a history course in the art of painting" (fig. 1.13).[49] Ever since Vasari's *Lives of the Painters* first appeared in 1550, the work of Raphael had been considered a summit of perfection rarely if ever equaled by any other artist at any other time. At the beginning of the nineteenth century, the cult of Raphael reached its apogee in France. In his 1807 *Observations sur quelques grands peintres* (Observations on some major painters), the painter Jean-Joseph Taillasson (1745–1809) calls Raphael "the modern Apelles" and "a spirit filled with celestial beauty." "If all must perish, the works of men and their very names; if it is true that all the wealth, honor, and love of so many centuries must disappear forever, the famous name of Raphaël is, of all modern painters, the one that will float the longest on the terrible ocean of oblivion."[50] Thanks to the power of David and the spreading influence of his students, the veneration of Raphael was extensive, even if David himself was ambivalent about his art. Ingres's obsession with the Italian master, for example, is well known. Speaking of his initial trip to Italy, the elderly Ingres reminisced, "Gentlemen, as for myself, I followed the path of the masters, of Raphael . . . who is not a man, who is a god come down to earth."[51] It was not simply the harmony and equipoise of Raphael's compositions but his ability to idealize while maintaining naturalistic description that endeared him to the generation of Neoclassical painters. As the theorist Quatremère de Quincy wrote, "'Ideal,' in the art of imitation, combined with the word 'beautiful' will thus signify that quality, that perfection, that excellence, whose complete type could never be found in one isolated model."[52] Raphael "brought together, in both substance and details,

all the qualities and conditions that could raise his subject to the height of what we have called the ideal and poetic type."[53] In no small measure, this cult of Raphael would prevent a true appreciation of Spanish painting in France for many years, especially in the precincts of the Académie des Beaux-Arts, as the striking realism of Murillo's beggars and Velázquez's dwarfs, and the exaggerated tenebrism of Zurbarán's hooded monks and Ribera's martyred saints, were anathema to the "beau idéal." Ingres's apologist Amaury-Duval explained this in 1878, writing of Murillo and "of all those great artists who have only ever depicted ugly, hideous things, from which we would avert our eyes if they were in nature."[54] Not until midcentury, when Neoclassicism expired at the hands of Realism, was the Spanish victory complete.

THE FIRST FRENCH SORTIES IN SPAIN

The French embassy in Madrid was frequently inhabited by amateurs of art. As we have seen, in 1779 d'Angiviller asked the French envoy in Spain to be on the lookout for fine paintings. In 1788 Jean-François de Bourgoing (1748–1811), assistant to the French ambassador, published a portrait of Spain that became a well-used guidebook, *Nouveau voyage en Espagne, ou Tableau de l'état actuel de cette monarchie* (New voyage in Spain, or Description of the current state of this monarchy). In it he listed the art that he had seen and admired, including works by Goya, then at the beginning of his career.

Bourgoing was made acting ambassador for eighteen months in 1784 and 1785; he returned to Spain as ambassador in 1792. Ferdinand Guillemardet (1765–1809) followed in 1798. Immediately upon arrival, he commissioned his portrait from Goya, who later said that "he had never done anything better" (fig. 1.11).[55] Guillemardet must have had frequent contact with Goya because it is said that he allowed the artist to have the plates for his satirical set of etchings, *Los Caprichos* (see figs. 6.16–6.18), printed on the embassy press at the Palacio de Superunda.[56] The ambassador returned to France in 1800 with several Goyas: his portrait; a small painting of a woman dressed as a *maja* (fig. 2.23); and at least one complete set of the *Caprichos*, perhaps the very set that Delacroix consulted some twenty years later. Guillemardet's return was shadowed by a cloud of disappointment; official correspondence indicates that he was accused of insensitivity to the Spanish people and their culture. Yet his role in introducing Goya's art to the artists in the circle of Delacroix, his godson, cannot be overestimated.

Even larger clouds darkened the tenure of the next French ambassador, Lucien Bonaparte, brother of the first consul. Thanks to his role in the coup d'état of 18 Brumaire Year VIII (November 9, 1799), Lucien Bonaparte was named minister of the interior and of the arts on December 24, 1799. He would hold that post for less than one year, but in that interval he sent the painter François-Marie Neveu on a mission to Bavaria to choose "in the Elector's various residences and in the public institutions of the city of

Jacques Thuillier, "Raphaël et la France," in Paris 1983–84, p. 24.

51. "J'ai pris le chemin des maîtres, moi, messieurs, celui de Raphael, (et en s'exaltant) qui n'est pas un homme qui est un dieu descendu sur la terre." Amaury-Duval 1993, p. 167.

52. "Idéal, dans l'art de l'imitation, joint au mot beau, signifiera donc, cette qualité, cette perfection, cette excellence, dont le type complet ne sauroit jamais se rencontrer dans un modèle isolé." Quatremère de Quincy 1837, p. 31.

53. "a cumulé, tant pour le fond, que pour les accessoires toutes les qualités, toutes les conditions qui pouvoient élever son sujet à la hauteur; de ce que nous avons appelé le genre idéal et poétique." Ibid., p. 179.

54. "de tous ces grands artistes qui n'ont représenté jamais que des choses laides, hideuses, dont on détournerait les yeux, si elles étaient en nature." Amaury-Duval 1993, p. 298.

55. Quoted by Jeannine Baticle in her catalogue entry for the portrait of Ferdinand Guillemardet, in Madrid 1980, no. 24, p. 78.

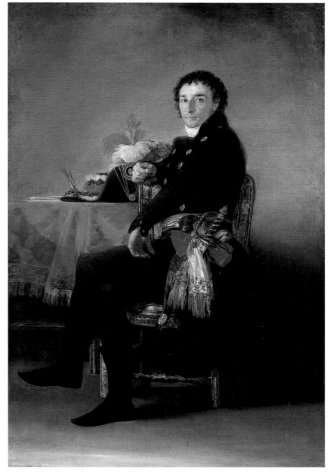

Fig. 1.11 Francisco de Goya y Lucientes, *Ferdinand Guillemardet*, 1798. Oil on canvas, 73¼ x 48⅞ in. (186 x 124 cm). Musée du Louvre, Paris

Fig. 1.12 Mme Soyer, Etching after Murillo's *The Dream of the Patrician* (fig. 1.22), published in Laborde 1806–20, vol. 2, pl. 69

Munich, those objects of art and science that may serve to complete and ornament the museums and libraries of the French Republic."[57] It was with these same acquisitive interests that Lucien left for Madrid on November 8, 1800, after a stormy interview with his brother. On March 21, 1801, Lucien signed the Treaty of Aranjuez (further to the second Treaty of San Ildefonso of 1800), in which France ceded the throne of Tuscany to Louis de Bourbon, son of the duc de Parma and thus son-in-law of the queen of Spain, in return for the transfer of the enormous territory of Louisiana from Spain to France. That same day Lucien wrote Napoleon, "for the treaty of Tuscany I got twenty good paintings from the gallery of Retiro for my gallery, and they are mounting one hundred thousand ecus of diamonds for me. I'll get the same for the peace of Portugal. . . . I will conceal nothing from you upon my return."[58] Manuel Godoy—the "Prince of Peace," prime minister of Spain, and favorite of the queen—noted that Lucien demanded much more—five million—for the Treaty of Badajoz.[59] Mindful of what the French army had done in Flanders and in Italy, the king and queen of Spain were evidently eager to satisfy the French ambassador's appetite and flatter his ego at any cost. In this single residency, the indigent Lucien made a fortune and started his picture gallery in earnest. He commissioned his adviser, the painter Guillaume Guillon Lethière, to buy seventy paintings for 8,000 duros from a dealer named Juan de Aguirre, raising alarms in certain quarters. Bernardo de Iriarte, minister and member of the Real Academia de Bellas Artes de San Fernando, noted that "shortly after the arrival of Lucien Bonaparte to Madrid, I understood, through one of his retinue, that he proposed to acquire them [the seventy paintings]

56. According to Jeannine Baticle, "Goya and the Link with France," in Madrid–Boston–New York 1988–89, p. lxii and n. 76.

57. "dans les différentes demeures de l'Électeur et dans les établissements publics de la ville de Munich, les objets d'art et de science qui peuvent servir à compléter et à embellir les musées et bibliothèques de la République française." Quoted in Edelein-Badie 1997, p. 327.

58. "pour le traité de Toscane j'ai reçu vingt bons tableaux de la galerie du Retiro pour ma galerie, et on fait monter cent mille écus de diamants pour moi. J'en receverai autant pour la paix du

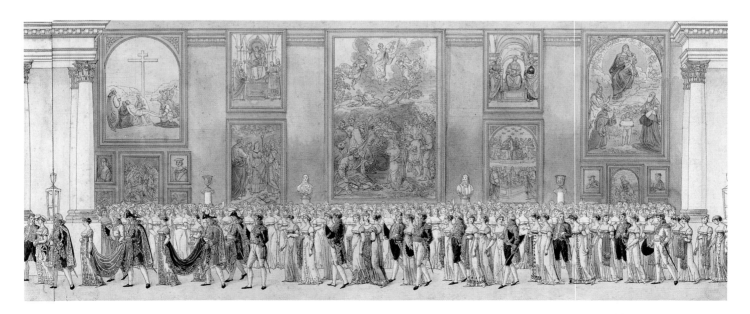

Fig. 1.13 Benjamin Zix, *Wedding Procession of Napoleon and Marie-Louise of Austria through the Grande Galerie of the Louvre, April 2, 1810*, 1810. Pen, brown ink, and brown wash, 67¾ x 9½ in. (172 x 24 cm). Musée du Louvre, Paris

for France, which I regarded as the looting of fine art relics in Spain by the [French] Republic during peacetime."[60] The twenty paintings from the Palacio del Buen Retiro have not yet been identified, nor the seventy paintings purchased from Aguirre, but among them were three paintings by Murillo, one Moro, and a splendid Velázquez, *Lady with a Fan* (fig. 1.14).[61] As the ambassador took leave of the court, the king presented him with a portrait miniature in a rich frame, wrapped with a quantity of uncut diamonds.[62] Upon his return to Paris in November 1801, the paintings were installed in Lucien's princely new residence, the Hôtel de Brienne. By the end of 1803 the paintings would be packed for transport to Italy, as Lucien and his new wife, rejected by Napoleon, took exile in Italy. Lucien's Roman residence would become a meeting place for French artists in Italy, most notably Ingres, until he left in 1814. The collection was sold in London in 1816.

Bonaparte's aide in Madrid was Alexandre-Louis-Joseph de Laborde (1773–1842), whose five-year journey through Spain (1800–1805) culminated in the *Voyage pittoresque et historique de l'Espagne* (Picturesque and historical voyage in Spain, 1806–20). His was the first balanced appreciation of the strength of the Spanish school and of its distinctive character:

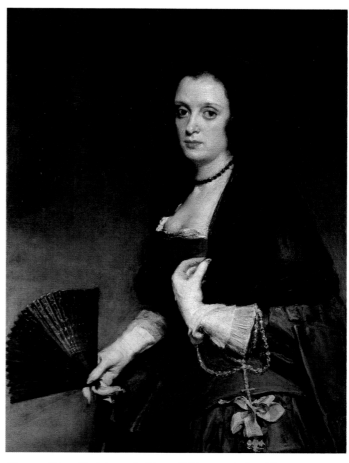

Fig. 1.14 Diego Rodríguez de Silva y Velázquez, *Lady with a Fan*, ca. 1635. Oil on canvas, 37⅜ x 27½ in. (95 x 70 cm). Trustees of the Wallace Collection, London

The reign of Philip III and the countless geniuses of the time who nevertheless all bowed before a few classical names that eclipse them, such as Velasquez, Murillo, Cano, Coello, Zurbaran. This is the period to be studied if one is to know the real Spanish school, which has a particular quality that the other schools do not; it occupies a middle ground between the Italian and Flemish schools: closer to nature than the former, it is nobler than the latter, while partaking of the beauties of both; this school is especially distinguished by its religious paintings, and one recognizes in the paintings of the Spaniards the feelings that these people experience overall for the mysteries of religion; nowhere are ecstasy, unction, and genuine piety expressed so well as in their works, nor mystical passions rendered with more warmth; the heads of their Virgins are wonderfully expressive; their color and effect are both striking, and although the Spanish painters did not apply themselves to secular subjects, which require the study of the nude, when they had occasion to take on such subjects, they distinguished themselves in them.[63]

The luxurious edition included large plates of then-fashionable line engravings reproducing some of the most celebrated paintings discussed. Needless to say, the outlines, beloved of Neoclassical theorists, were completely inadequate to express the essentially painterly character of Spanish Baroque painting (fig. 1.12).

No sooner had Laborde left Spain than another Frenchman established himself as an expert on Spanish painting. Frédéric Quilliet was living in Cadiz by 1806. A writer and art dealer with no visible means of support, he offered to write catalogues for collectors as a means of gaining access to works of art and their owners. Soon he was in the employ of

Portugal. . . . Je ne vous cacherai rien à mon retour." Quoted in ibid., p. 330.

59. Ibid., p. 32. Godoy was granted the title "Prince of Peace" for his negotiations toward the 1795 Treaty of Basel.

60. Sánchez Cantón 1937a, pp. 165–66. See the Chronology: April 1, 1801, for the original quotation.

61. For the paintings, see the Chronology: 1800 and 1816. The two Riberas sold with Bonaparte's collection in 1816 may have been acquired during Lucien's residence in Rome rather than in Madrid. *Lady with a Fan* was for many years visible in the Paris house of Lord Hertford, before the collection was transferred to London.

62. Edelein-Badie 1997, p. 332.

63. "Le règne de Philippe III et les génies sans nombre de cette époque qui se prosternent tous cependant devant quelques noms classiques qui les effacent, tels que Velasquez, Murillo, Cano, Coello, Zurbaran. C'est ce moment qu'il faut étudier par connaître la véritable école espagnole qui a un caractere particulier que n'ont point les

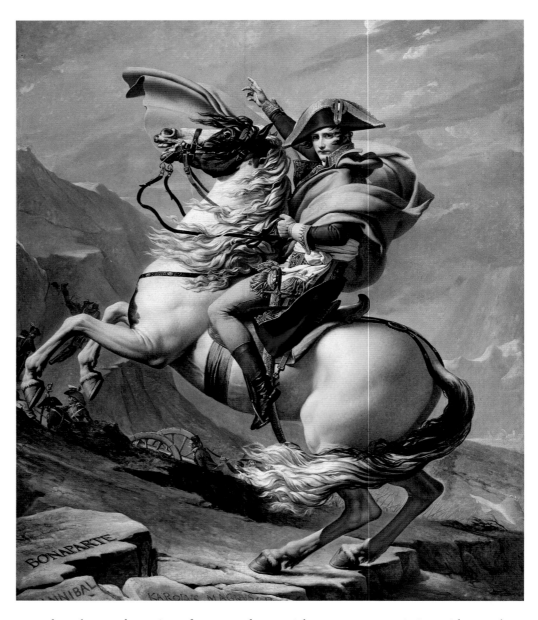

autres écoles; elle tient l'intermédiaire entre l'école italienne et flamande; plus rapprochée de la nature que la première, elle est plus noble que la seconde, et participe des beautés de toutes les deux; cette école se distingue particulièrement dans les peintures sacrées, et l'on reconnaît dans les tableaux des Espagnols les sentiments que ce peuple éprouve en général pour les mystères de la religion; nulle part l'extase, l'onction, la vraie piété, ne sont aussi bien exprimées que dans leurs ouvrages, et les passions mystiques rendues avec plus de chaleur; les têtes de vierges sont d'une expression admirable; le coloris et l'effet en sont frappants, et quoique les peintures espagnols ne se soient point livrés à des sujets profanes, et qui suppose l'étude du nu, lorsqu'ils eurent l'occasion de s'en occuper, ils s'y distinguèrent." Laborde 1806–20, vol. 2, p. 34.

Manuel Godoy. In the spring of 1808, as the Spanish court was negotiating with Napoleon to save their throne, Quilliet was cataloguing the collection of the Palacio Real in Madrid. (Although Quilliet had at one time written anti-Napoleonic pamphlets, he later cooperated with the French occupation.) He traveled with Lebrun during the latter's buying trip in Spain in 1807, he may have assisted Vivant Denon during his Iberian travels, and, most important, he advised Marshal Soult on the sacking of Seville in 1810. In 1816 he published in Paris his *Dictionnaire des peintres espagnols* (Dictionary of Spanish painters), a document influential in the dissemination of knowledge about Spanish painting, albeit little more than a revised translation of Juan Agustín Ceán Bermúdez's 1800 *Diccionario histórico de los más ilustres profesores de las bellas artes en España* (Historical dictionary of the most illustrious exponents of the fine arts in Spain).

THE FRENCH INVASION OF SPAIN

With the treaties of San Ildefonso, Aranjuez, and Badajoz, Napoleon had obtained what he wanted: some valuable properties in the Caribbean and North America as well as Spain's

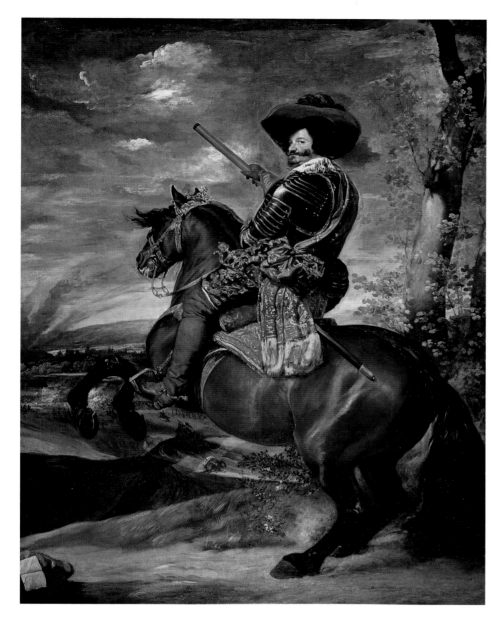

Fig. 1.16 Diego Rodríguez de Silva y Velázquez, *Count-Duke of Olivares on Horseback*, 1622–27? Oil on canvas, 123½ x 94½ in. (314 x 240 cm). Museo Nacional del Prado, Madrid

compliance with his blockade of Britain and British products. Directed by France, Spain even declared war on Britain's ally, Portugal, in 1801, but the Spanish court had little interest in participating in France's empire building. During the Peace of Amiens in 1802, Madrid learned of Napoleon's fickle nature when he ceded the Spanish colony of Trinidad to Britain and sold Louisiana to the United States, in violation of the Treaty of Aranjuez. The Peace of Amiens—peace with the United Kingdom—was short-lived, and in 1804 Napoleon was once again planning an invasion of Britain. When he realized that that would not work, he turned to the east. Defeating the armies of Austria and of Prussia, and liberating Poland, he advanced on Moscow, concluding a peace treaty with Russia. At every opportunity he schemed to isolate England as the single remaining enemy of a French Europe. In 1807 Napoleon sent Marshal Andoche Junot through Spain to capture Lisbon and bar British trading from the continent, only to find that the Portuguese monarchs had fled to Brazil. French troops lingered in Spain, thus provoking a crisis in the Spanish monarchy. King Charles IV, chastened by the defeat of the French and Spanish fleets by the British at Trafalgar, was weary of his French allies but wanted to avoid war at all costs. He knew what he was up against, since David's grand equestrian portrait, *Napoleon Crossing the Alps*, had

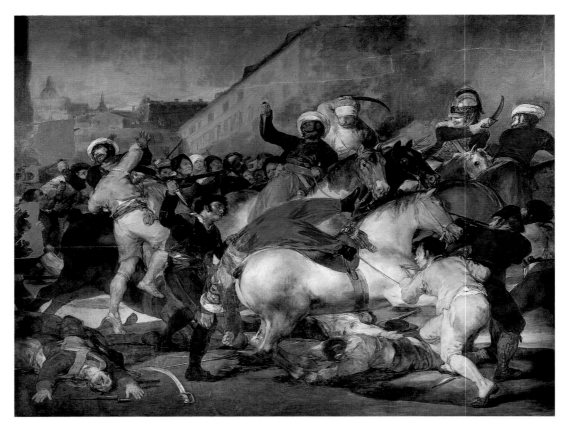

Fig. 1.17 Francisco de Goya y Lucientes, *The Second of May 1808*, 1814. Oil on canvas, 8 ft. 4⅛ in. x 11 ft. 3⅞ in. (255 x 345 cm). Museo Nacional del Prado, Madrid

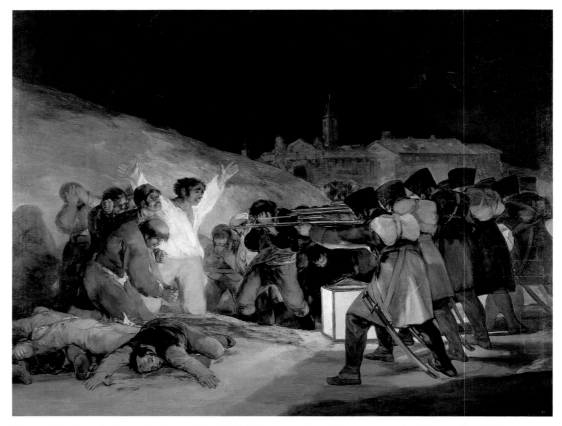

Fig. 1.18 Francisco de Goya y Lucientes, *The Third of May 1808*, 1814. Oil on canvas, 8 ft. 4⅛ in. x 11 ft. 3⅞ in. (255 x 345 cm). Museo Nacional del Prado, Madrid

hung since 1802 alongside the magnificent Velázquezes in the Salon des Grandes Capitaines of the Palacio Real in Madrid (figs. 1.15, 1.16).[64] Spanish prime minister Godoy, royal favorite, was willing to cooperate with France; wanting to undermine Godoy, the infante Ferdinand, the crown prince, had also been in contact with Napoleon's agent (and stepson), Eugène de Beauharnais. Early in 1808 French troops, led by Marshal Joachim Murat, poured into Spain. The people revolted against Godoy the appeaser, and the king abdicated in favor of his son Ferdinand in order to save Godoy from the crowds. Napoleon, displeased, took the king, queen, and Godoy hostage in Bayonne. Lured to Bayonne, Ferdinand was obliged to return the crown to his father, who then abdicated in favor of Napoleon. When people learned of this capitulation, riots broke out in Madrid. The Spanish revolt and the French suppression are commemorated in Goya's great canvases, *The Second of May 1808* and *The Third of May 1808*, painted in 1814 (figs. 1.17, 1.18).

Napoleon named his older brother Joseph king of Spain on June 6, 1808; Spanish resistance was fierce. The opposition held Madrid until the end of the year, when Napoleon himself entered the city on December 4 to place Joseph on the throne. Only three weeks later, Vivant Denon, the director of the Musée Napoléon (formerly the Musée Central des Arts), arrived in Madrid to select twenty paintings for the museum in Paris. The emperor wrote his brother to announce that "Denon would like to take some paintings. I would prefer that you take all those you find in the seized houses and suppressed convents and make me a gift of about fifty masterpieces that the Paris museum lacks. In the proper time and place, I'll give you others [as replacements]. Call Denon in and tell him about this. He can give you suggestions. You're well aware that they must be only good things, and the general opinion is that you are immensely rich in this regard."[65] Evidently Joseph was not cooperative, for Denon complained to the emperor. "If any prince other than Your Majesty's brother had occupied the Spanish throne, I would have approached them [*sic*] in order to add to the museum's collection twenty paintings of the Spanish school that it is absolutely lacking and which would have represented forever a trophy of this most recent campaign."[66] Denon proposed to choose from either the royal collection, the collection of Godoy (who owned, among many others, Goya's *Clothed Maja* and *Naked Maja*), or the collections of the great noble families of Spain. Denon made several lists, and may have acquired some pictures for his personal collection while in Spain. For the next five years, there would be a tug of war between Joseph and his advisers (including at one point Goya) and Denon, who constantly dismissed the proposed confiscations as unworthy of his museum. Joseph's official "gift" did not leave Madrid until 1812. In the meantime, Joseph signed the decree of December 20, 1809, establishing a national museum in Madrid "that the worth of the Spanish painters, who are little known in neighboring countries, should shine." He envisioned a Museo de Pintura in Madrid made up of "whatever paintings are necessary . . . drawn from all public establishments and even our palaces." (The suppression of the religious institutions in 1810 would provide ample resources for the museum.) He also decreed that "a general collection of paintings by the famous masters of the Spanish school will be formed . . . to be presented to our august brother the Emperor of the French. . . . Being a monument to the glory of the Spanish painters, it will serve as a token of the union of the two countries."[67] In 1810 Joseph reconfirmed the 1779 ban on the exportation of works of art.

The French forces were acutely conscious of the great treasures that lay behind the walls of monasteries, convents, cathedrals, and palaces. As the troops advanced on Andalusia,

64. It is often forgotten that this celebrated picture was commissioned by Charles IV in 1800 to commemorate the Treaty of San Ildefonso; the composition may well derive from Velázquez's equestrian portrait of the count-duke of Olivares, which also hung in the Salon des Grandes Capitaines. See Gerard-Powell 1998.

65. "Denon voudrait prendre quelques tableaux. Je préférerais que vous prissiez tous ceux que se trouvent dans les maisons confisquées, et dans les couvents supprimés et que vous me fissiez présent d'une cinquantaine de chefs d'oeuvre que manquent au Muséum de Paris. En temps et lieu, je vous en donnerai d'autres. Faites venir Denon et parles lui dans ce sens. Il peut vous faire les propositions. Vous sentez bien qu'il ne faut que de bonnes choses, et l'opinion est que vous êtes immensément riches en ce genre." Lelièvre 1969, p. 367. See the Chronology: January 15, 1809.

66. "Si tout autre prince que le frère de Votre Majesté eût occupé le trône d'Espagne, je les aurais sollicités pour ajouter à la collection du musée vingt tableaux de l'école espagnole dont elle manque absolument et qui auraient été à perpétuité un trophée de cette dernière campagne." Denon 1999, vol. 2, no. AN78, p. 1351. See the Chronology: January 18, 1809.

67. See also Ignacio Cano Rivero's essay in this publication.

Fig. 1.19 (cat. 59) Jusepe de Ribera, *Saint Sebastian Tended by the Devout Women*, 1621? Oil on canvas, 71 x 91⅛ in. (180.3 x 231.6 cm). Museo de Bellas Artes, Bilbao

68. "tableaux de toutes grandeurs, qui con-
sistuent la base de l'École Espagnole
puisque vous y verrez des Villegas que
l'on doit regarder comme le fondateur de
l'École dont Murillo est le Prince." See
also the essay by Ignacio Cano Rivero.
69. See Gómez Ímaz 1896.

Marshal Jean de Dieu Soult, the commander of the French Army of the South, emerged as a plunderer, much in contrast to the comportment of Joseph Bonaparte at the beginning of his reign. Advised by the ubiquitous Quilliet, who kept his copy of Ceán Bermúdez at hand, Soult effected the transfer of the entire portable patrimony of Seville to a central depot, the Alcázar. On February 7, 1810, Quilliet informed the minister of the interior of Joseph's government that he had identified 819 "paintings of various sizes, which [together] represent the foundations of the Spanish School, since you will see some works by Villegas, who must be considered the founder of the School, all of which the ruler is Murillo."[68] There was little cooperation from the Spanish. Many religious institutions attempted to hide plate and paintings, some families sold works to dealers to avoid having them confiscated, and city fathers planned to place the cathedral treasury on board a ship set to sail if the French advanced. Nevertheless, some 999 confiscated paintings were inventoried at the Alcázar on June 2, 1810. Quilliet had not exaggerated: the Alcázar held works of inestimable quality, including entire cycles by Murillo and Zurbarán.[69] Various selections were made of works to be transferred to the projected museum in Madrid or to the Musée Napoléon in Paris. Among the latter figured *The Battle between Christians and Moors at El Sotillo* by Zurbarán

Fig. 1.20 (cat. 57) Bartolomé Esteban Murillo, *The Immaculate Conception*, ca. 1678. Oil on canvas, 9 ft. 1⅞ in. x 6 ft. 2¼ in. (279 x 190 cm). Museo Nacional del Prado, Madrid

70. According to Ignacio Cano Rivero, 24 by Alonso Cano, 32 by Murillo, and 28 by Zurbarán.

71. Ford 1845.

72. "Je lui [Delaroche] parlais un jour des admirables Murillo du maréchal Soult, qu'il voulait bien me laisser admirer." Delacroix goes on to explain, "except, he said, *that is not serious painting*" ("seulement, disait-il, *ce n'est pas de la peinture sérieuse*"). Delacroix 1932, vol. 2, p. 125: November 30, 1853. This is evidence of the lingering distaste for Spanish realism among French academic artists: the only Spanish artists represented in Delaroche's great hemicycle for the École des Beaux-Arts are Murillo and Velázquez.

73. For the fascinating story of the vicissitudes of this list, see the Chronology: 1808–13. It is interesting, but not surprising, that El Greco never appeared on any version of the list. In the end, only one Velázquez was sent, *Joseph's Coat* (Museo del Prado, Madrid).

74. "Je ne puis vous dissimuler, Monseigneur, que parmi les premiers il se trouve au plus 6 tableaux qui pourront entrer au musée Napoléon et l'on peut s'appercevoir facilement par ce choix combien Sa Majesté le roi d'Espagne a été trompée par les personnes qu'elle avoit chargé du soin de les désigner. Quant aux tableaux recueillis par le domaine extraordinaire de la Couronne, il se trouve dans le nombre deux tableaux du premier ordre et 150 autres qui seront très avantageusement placés dans les palais de Sa Majesté et particulièrement dans les rendez-vous de chasse, cet envoi se composant d'une suite nombreuse de tableaux de Sneyders et de Paul de Vos, artistes qui ont excellé à peindre des animaux et des chasses." Denon 1999, no. 2931. See the Chronology: September 3, 1813.

75. Tulard 1987, p. 752. See also Glover 1974.

(fig. 3.12) and *The Dream of the Patrician* by Murillo (fig. 1.22). Ignacio Cano Rivero's analysis shows that during the French occupation, 173 paintings were permanently removed from Seville.[70] Nearly 200 more were illegally seized by Marshal Soult.

Soult, like the other leading generals in Spain—Sébastiani, de Faviers, and Dessolle—had been given paintings by Joseph as a reward for his military successes. Soult received an enviable selection by Titian, Sebastiano del Piombo, Guido Reni, Van Dyck, Navarrete el Mudo, and Ribera (fig. 1.19). In addition to these, he requisitioned dozens of pictures from the Alcázar to decorate his residence in Seville, the former bishop's palace. When he left Seville, he took them with him. In contrast to the stalled "gift" from Joseph to Napoleon, Soult instantly formed the most important collection of Spanish painting in private, non-Spanish hands. After 1812 Soult's house on the rue de l'Université in Paris became the de facto *galerie espagnole* in France, much frequented by artists. He acquired a total of some 180 Spanish paintings, of which easily the most famous was Murillo's *Immaculate Conception* (fig. 1.20). Proudly showing his collection to the English writer Richard Ford in 1816, he bragged how Murillo's Virgin had saved the lives of two men, whom he did not need to shoot when they acquiesced to his removal of the painting from the Hospital de los Venerables in Seville.[71] It is impossible to imagine the effect of these grand ecclesiastic cycles by Zurbarán and Murillo in a domestic setting, but it must have been overwhelming. Delacroix, for one, thought so: "I was talking to [Delaroche] one day about Marshal Soult's wonderful Murillos, and he was willing to allow me to marvel at them."[72]

JOSEPH'S GIFT TO NAPOLEON

A shipment of fifty paintings destined for the Musée Napoléon finally left Madrid in late summer 1812, just days before Arthur Wellesley (1769–1852), the future duke of Wellington, arrived in the capital. Included with it were another 250 works taken from the principal private collections of Spain.[73] When the cases were opened in Paris in the summer of 1813, Denon, who was as discerning as he was acquisitive, was disappointed. "I cannot conceal from you, Monseigneur, that among the former there are at the most 6 paintings that could go into the Musée Napoléon, and one may easily see from this selection how grievously His Majesty the king of Spain was misled by the persons whom he had charged with the task of selecting them. As for the paintings collected through the Crown's extraordinary lands, there are among them two first-rate paintings and 150 others that will be placed to great advantage in His Majesty's palaces and particularly in the hunting lodges, since this shipment is made up of a numerous group of paintings by Sneyders and Paul de Vos, artists who excelled at painting animals and hunt scenes."[74] Perhaps Denon's disappointment was a reflection of the huge cost to France of the war in Spain: some two hundred thousand French casualties and another sixty thousand allied dead, not to mention the Spanish victims, estimated at three hundred thousand.[75] Denon could not know that within weeks Joseph would leave Madrid with an extensive caravan, led by General Hugo (father of Victor), which would be captured by Wellington at the Battle of Vitoria in June 1813. One hundred sixty-five paintings were seized, including Velázquez's *Waterseller of Seville* (fig. 1.21) and comparably important works by Murillo and Ribera. To this day they remain at Wellington's house in London, the gift of the Spanish king Ferdinand VII, whom Wellington restored to the throne. Most of these paintings came from the private apartments of Joseph Bonaparte

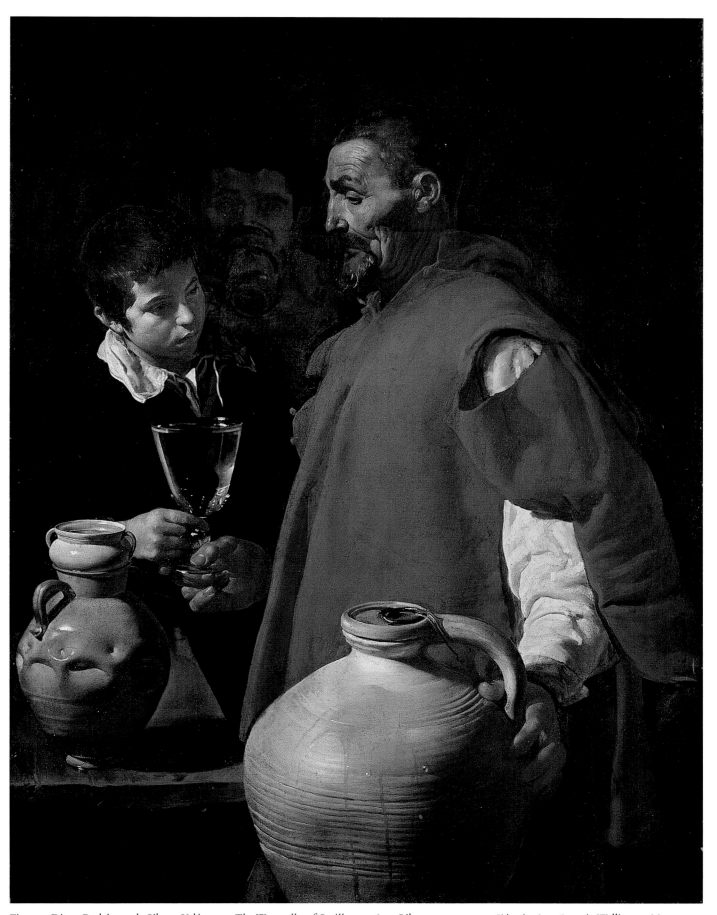

Fig. 1.21 Diego Rodríguez de Silva y Velázquez, *The Waterseller of Seville*, ca. 1620. Oil on canvas, 42 x 31⅞ in. (106.7 x 81 cm). Wellington Museum, Apsley House, London

Fig. 1.22 Bartolomé Esteban Murillo, *The Dream of the Patrician*, 1662–65. Oil on canvas, 7 ft. 7⅛ in. x 17 ft. 1½ in. (232 x 522 cm). Museo Nacional del Prado, Madrid

76. "Lorsque ces peintures seront arrivés à Paris, je les réunirai à plusieurs tableaux de l'école allemande et flamande du 14 et 15e siècle qui sont déjà au musée et je ne doute pas que leur exposition dans une pièce particulière n'intéresse vivement les artistes, en ce qu'elle indique le point d'où la peinture est partie pour produire des merveilles." Denon 1999, no. 2233, October 28, 1811, quoted by Monica Preti Hamard, "L'exposition des 'écoles primitives' au Louvre," in Paris 1999–2000, p. 230.

77. "Parmi les circonstances de l'époque actuelle qui étonneront la postérité, on admirera sans doute par quels sages moyens, après une tourmente politique aussi cruelle que celle que nous venons d'éprouver, tous les beaux-arts ont repris leur activité." Brès 1814, p. 255.

78. This honor is accorded to the 1798 exhibition at the Louvre in Haskell 2000, p. 44.

and his wife at the Palacio Real in Madrid. Nonetheless, Joseph managed to remove to France a small number of pictures for himself, including five Raphaels (three have since been de-attributed), which he kept from the eyes of his greedy brother and his curator, Denon. Some of these works were restituted to Spain, others he took in exile to Philadelphia, where, until 1841, they were frequently lent to public exhibitions. (He left the United States for Florence in 1841 and died there in 1844.) Among these were paintings attributed to Murillo and Velázquez as well as the great equestrian portrait of Napoleon by David (fig. 1.15) and a smaller repetition of it.

As Geneviève Lacambre explains in her essay in this publication, works from Joseph's tribute were first exhibited at the Louvre in Denon's last great manifestation, the 1814 "Exposition des écoles primitives." The aging director himself had traveled to Italy to select the works he would "requisition." "As soon as the paintings arrive in Paris, I will put them together with several paintings of the German and Flemish school of the 14th and 15th century that are already in the museum, and I am sure that the artists will be keenly interested to see them exhibited in their own room, because they show where painting started, that later produced marvels."[76] In the event, the exhibition occurred after Napoleon's abdication in the quickly renamed Musée Royal. "Among the circumstances of the present age that will astonish posterity," wrote the *Mercure de France,* "they will doubtless admire the wise means by which, after a political upheaval as cruel as the one we have just suffered, all the fine arts resumed their activity."[77] This was one of the first modern museum exhibitions to be accompanied by a proper catalogue, with lengthy descriptions and historical notices on the minor works as well as the most important.[78] Some seventeen Spanish paintings, chosen from the three hundred European paintings of all schools recently arrived from Spain as well as from the French royal collection, were included. Although they patently had no relation to the subject of the exhibition, the novelty of the works from Spain drew great interest. Several were spectacular: Ribera's *Bearded Woman* (Palacio Lerma, Toledo); Luis de Morales's

Fig. 1.23 Bartolomé Esteban Murillo, *The Patrician John and His Wife before Pope Liberius (The Foundation of Santa Maria Maggiore in Rome)*, 1662–65. Oil on canvas, 7 ft. 7⅜ in. x 17 ft. 1½ in. (232 x 522 cm). Museo Nacional del Prado, Madrid

Christ before Pilate (Academia de San Fernando, Madrid); Antonio de Pereda's *Dream of the Patrician* (Academia, Madrid). The greatest sensation was made by the large canvases recently given by Soult (but chosen by Denon): Murillo's decorations for Santa María la Blanca in Seville, *Saint Elizabeth of Hungary Nursing the Sick* (fig. 3.13), the two enormous lunettes of *The Foundation of Santa Maria Maggiore in Rome* (figs. 1.22, 1.23), as well as Zurbarán's *Apotheosis of Saint Thomas Aquinas* (Museo de Bellas Artes, Seville). The *Journal des Débats* welcomed the exhibition of these "extremely vigorous" paintings and lamented, "no one was careful to preserve for us a group of portraits by Velasquez that once adorned one of the galleries of the Louvre" (indeed, the *Infanta Margarita* [fig. 1.2] remains at the Louvre). The writer esteemed Velázquez "father and marvel of the Spanish school."[79]

79. "fortes vigoreuses"; "personne n'a pris soin de nous conserver une suite de portraits de Velasquez, qui ornait autrefois l'un des salles du Louvre"; "le père et la mérveille de l'école espagnole." Boutard 1814, pp. 1–4.

80. "La gloire des armées françaises n'a reçu aucune atteinte: les monuments de leur valeur subsistent, et les chefs-d'oeuvres des arts nous appartiennent désormais par des droits plus stables que ceux de la victoire." Quoted in Saunier 1902, p. 85.

RESTITUTION FROM THE LOUVRE AND THE CREATION OF THE MUSEO DEL PRADO

Paris fell to the allied forces of Austria, Britain, Prussia, Russia, and Sweden on March 30, 1814. Wellington was the primary governor of affairs for the allies in Paris; his goals were to defeat Bonaparte and Bonapartism, restore the Bourbons to the throne of France, and put an end to the revolution that had threatened the monarchies and peace of Europe. (France had lost more than two million sons pursuing her empire.) Working with Talleyrand, provisional head of the French government, he supervised the abdication of Napoleon on April 6 and the arrival of Louis XVIII on May 3. Not wishing to humiliate or anger the French people, the allies did not at first insist on restitution of works of art. For their part, the French had attempted to put a clause in the peace treaties prohibiting restitution. Louis XVIII announced on June 4, 1814, "The glory of the French armies remains intact: the monuments to their valor survive, and the masterpieces of the arts now belong to us by rights more enduring than those of victory."[80] But in fact the king had signed a decree on May 14, 1814,

Fig. 1.24 (cat. 111) Eugène Delacroix, *Saint Catalina, Copy after Alonso Cano*, 1824–27. Oil on canvas, 32⅛ x 25⅛ in. (81.5 x 65 cm). Musée des Beaux-Arts, Béziers

Fig. 1.25 Alonso Cano, *Saint Catalina*, 1601–67. Oil on canvas, 32½ x 24⅜ in. (82.5 x 62 cm). Private collection, Switzerland

indicating that all the paintings confiscated from the grandees of Spain and all objects at the Louvre that had been stolen from private individuals should be returned to their previous owners. (He also gave an oral promise to the Prussians that everything plundered from them would be returned in due course.) Denon tried in vain to keep the Murillos that Soult had given to the Louvre on the pretext that they had been gifts to the French marshal from the city of Seville. The reply from the Spanish ambassador was swift and conclusive: "The city of Seville could not give to Marshal Soult what does not belong to it, what has never belonged to it."[81] Nevertheless, Soult was able to retain what he had removed from Spain and kept in his house in Paris because restitution applied only to governmental institutions, not to individuals. In addition, works of art that had been sent to the provincial museums by Denon were exempted.

Negotiations with the dispossessed parties dragged on beyond 1814. After Waterloo (June 1815), however, the allies became less patient. Informed by Denon that he was not authorized to release anything from the Louvre, and would do so only under force, the Prussian army supervised the removal of the loot from the museum throughout 1815.[82] Spanish commissioners received a total of 284 paintings of various schools.[83] Returned as well were the few Spanish paintings that had come from non-Spanish sources, such as the Ribera *Mater Dolorosa* taken from Kassel in 1806 and the Velázquez *Family of the Artist* (now attributed to Mazo, fig. 2.8) taken from Vienna in 1809. These paintings, on view from about 1809 to 1815, were both copied by the young Théodore Géricault (1791–1824) before their return.[84] The collections of the Louvre shrank to unrecognizable dimensions, and recriminations were rampant. At Denon's funeral, Baron Gros repeated the director's famous remark on the subject of restitution: "Let them take them then. But they have no eyes to see them with, France will always prove by her superiority in the arts that the masterpieces were better here than elsewhere."[85]

Fig. 1.26 (cat. 122) Baron François Gérard, *Saint Teresa*, 1828. Oil on canvas, 107⅛ x 37¾ in. (272 x 96 cm). Maison Marie-Thérèse, Paris

Not all of the works that did return to Spain found their way back to their original homes. The paintings taken from religious institutions were generally refitted in their former settings, especially in Seville. But the royal collection did not return to the royal palaces. Instead, much of it was placed in a building, designed in 1787 by Juan de Villanueva as a museum of natural history adjacent to the Palacio del Buen Retiro, which opened in November 1819 as the Real Museo de Pintura y Escultura. As María de los Santos García Felguera and Javier Portús Pérez recount in their essay in this publication, the Real Museo, called after 1869 the Museo del Prado, was the result of attempts since the eighteenth century to establish a royal picture gallery in Madrid. From its opening day the museum presented itself as a definitive display of the Spanish school, with one central gallery devoted to contemporary painters, such as Goya, Paret, and Maella. This followed the concept of the 1809 decree of Joseph Bonaparte. (The initial display of 311 works was drawn entirely from the

Fig. 1.27 El Greco (Domenikos Theotokopoulos), *Crucifixion with Two Donors*, 1585–90. Oil on canvas, 98 x 70⅞ in. (250 x 180 cm). Musée du Louvre, Paris

Fig. 1.28 Jean Laurent, Photographic montage of the installation of Spanish paintings at the Museo del Prado, 1879–85. From Jean Laurent, *Panorama de la Grande Salle du Musée du Prado à Madrid* (n.p., n.d.)

royal collections.) Later, the modern pictures were displaced in favor of works of the Italian Renaissance, chiefly by Titian, whose painterly technique was, after all, a primary source for Velázquez and Murillo. In the aftermath of the French invasion, the Prado became what various monarchs of France and their curators had wanted all along: a definitive display of the Spanish school, related—but subordinate to—works of the Italian Renaissance (fig. 1.28).

Apart from the occasional confrontation with Velázquez's portrait of Innocent X at the Galleria Doria Pamphilj in Rome (see fig. 2.3) or a visit to view the Riberas in Naples, the first fruitful contacts of French artists with Spanish painting occurred in Paris—at the Louvre, at the residence of Marshal Soult, and in the homes of other private collectors. (An important exception to this is David, who borrowed the composition for his *Saint Jerome*, now in Montreal, from a print by Ribera and for his *Napoleon Crossing the Alps* from Velázquez's *Count-Duke of Olivares*; see figs. 1.15, 1.16.) The young artists who saw the art recently arrived from the conquered territories seem to have been attracted to its expressive aspect, the intensely spiritual or mystical component of some Spanish art, a feature that distinguished it from the Italian, Flemish, and French paintings already well known in France. Géricault's copy of the Ribera *Mater Dolorosa*; Gérard's essay in Zurbaránismo, *Saint Teresa* (fig. 1.26); and Delacroix's fascination with Goya's *Caprichos* follow in this vein. Without question, Delacroix's striking *Agony in the Garden* for the Church of Saint-Paul-Saint-Louis (figs. 1.29, 1.30) and Prud'hon's *Christ on the Cross* (fig. 2.34) reflect study of the Spanish paintings in the Soult collection. Delacroix, however, was also interested in purely technical aspects of Spanish painting. About 1824 he copied what he thought was a Zurbarán in the Soult collection (figs. 1.24, 1.25) as well as a portrait of Charles II of Spain by Carreño de Miranda then in the Orléans collection at the Palais Royal. Thinking that the portrait of Charles II he copied was by Velázquez, he wrote in his journal, "This is what I have so long sought, this firm, yet yielding impasto. What we must keep in mind above all *are the hands* . . . if I were to take up my palette this moment, and I'm dying to, that fine Velázquez would obsess me. I'd like to spread some nice oily, thick paint across a brown or red canvas."[86] Delacroix thus identified an aspect of Spanish painting that would preoccupy Manet in the 1860s.

81. "La ville de Séville ne pouvait pas donner à M. le maréchal Soult ce qui ne lui appartenait pas, ce qui ne lui a jamais appartenu." Letter from Alava to Denon, September 24, 1815, in Denon 1999, no. 3543. See the Chronology: September 1815.

82. See Wellington's fascinating and succinct account of the problem of restitution and French intransigence, reprinted in Gould 1965, pp. 131–35.

83. Beroqui 1932, p. 87. Some paintings, such as Ribera's *Bearded Woman* and Murillo's *Adoration of the Shepherds*, may not have been returned until 1818.

84. The inventory of Géricault's studio after his death included a framed "sketch after Vael Laschesse" ("esquisse d'après Vael Laschesse"), lot 21 in the studio sale: "A copy after Valasquez, representing a mother. The painting is framed." ("Une copie d'après Valasquez, representant une mere de famille. Ce tableau est encadré.") Delacroix bought numerous works in Géricault's atelier sale in 1824, most of them copies after works by earlier artists. See the Chronology: 1824 for Delacroix's remark on buying these works. Delacroix's sale in 1863 included, among eighteen paintings by Géricault (lots 222–39), a picture entitled *Les Enfants de Philippe II, d'après Velasquez* (lot 234), measuring 17¾ x 21¼ in. (45 x 55 cm), on the French art market in 2002. I thank Wheelock Whitney for this information. Géricault's copy after Ribera was in a collection in Basel, ca. 1950; see Bazin 1987, vol. 2, no. 363.

85. Gould 1965, p. 123.

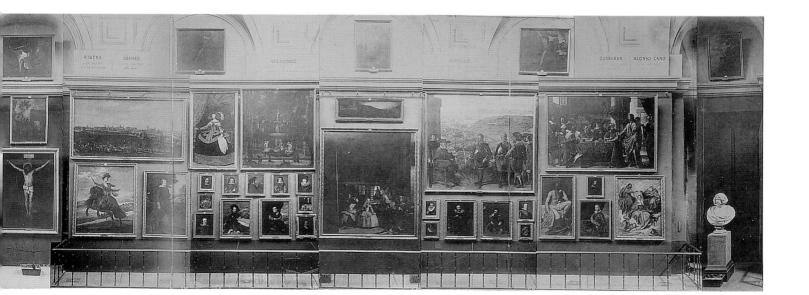

Fig. 1.29 Eugène Delacroix, *The Agony in the Garden*, 1824/27. Oil on canvas, 9 ft. 7¼ in. x 11 ft. 10½ in. (294 x 362 cm). Church of Saint-Paul-Saint-Louis, Paris

86. "Voilà ce que j'ai cherché si longtemps, cet empâté ferme et pourtant fondu. Ce qu'il faut principalement se rappeler, *ce sont les mains* . . . si je prenais la palette en ce moment, et j'en meurs de besoin, le beau Velázquez me travaillerait. Je voudrais étaler sur une toile brune ou rouge de la bonne grasse couleur et épaisse." Delacroix 1932, vol. 1, pp. 72, 74: April 11, 1824.

87. "C'est là seulement que j'ai vu une collection de Velasquez." Mérimée 1831c, p. 74.

With the return of the war loot to Spain, and the subsequent opening of the Museo del Prado, Madrid became a locus for the study of Spanish art. At last in a single building one could find paintings by Murillo (previously seen in several French collections) and Zurbarán (accessible in the Soult collection in France, as well as in churches, monasteries, and convents in Spain) and most importantly Velázquez (whose works had previously been concentrated in the various palaces of the kings of Spain and hence little known). With the exception of the royal collection in Vienna, Velázquez could not be experienced in depth until the Prado opened its doors. Soult, for example, had no Velázquezes in his collection. All that was left at the Louvre was the small portrait of the Infanta Margarita (fig. 1.2). Referring to the Prado in his article of 1831, "Le Musée de Madrid," Prosper Mérimée (1803–1870), future author of the novel *Carmen*, wrote, "It is only here that I have seen a collection of Velasquez."[87]

FRENCH TRAVELERS IN SPAIN

For obvious reasons, there were not many French visitors to Madrid in the years immediately following the Peninsular War. Things changed when Les Cent Milles Fils de Saint

Fig. 1.30 (cat. 53) Bartolomé Esteban Murillo, *The Liberation of Saint Peter*, 1667. Oil on canvas, 7 ft. 9¼ in. x 8 ft. 6⅛ in. (238 x 260 cm). State Hermitage Museum, St. Petersburg

Louis arrived in Spain in 1823: Louis XVIII's huge army came to quell a liberal insurgency, the revolution of 1820, and, once again, to restore Ferdinand VII's absolute monarchy. The Prado published a new catalogue, in French, for the occasion. Among those soldiers were two young Frenchmen who eagerly embraced Spanish art, Louis Viardot (1800–1883) and Isidore-Justin-Séverin Taylor (later Baron Taylor, 1789–1879). Taylor, an artist, began work while he was there on his multivolume *Voyage pittoresque en Espagne, en Portugal et sur la côte d'Afrique, de Tanger à Tétouan* (A picturesque tour of Spain, Portugal, and along the coast of Africa, from Tangiers to Tetuan), published in three volumes beginning in 1826. As Jeannine Baticle reminds us in her essay in this publication, Taylor would return to Spain several times and would be fundamental in the creation of the collection of Spanish painting for King Louis-Philippe d'Orléans.

The expedition of 1823 opened the door to Spain for a new generation. Mérimée's 1831 article on "Le Musée de Madrid" exemplified the renewed interest in Spain and the fresh look at Spanish art. His take on the Prado is already informed by an historical sensitivity. "You can see traces of the 1809 invasion on the walls: you can still clearly read inscriptions written by French and English soldiers." Yet Mérimée was no stranger to cultural arrogance.

88. "On retrouve sur les murs des souvenirs de l'invasion de 1809: des inscriptions tracées par des soldats français et anglais s'y lisent encore distinctement." "Bien souvent les Espagnols, en vous montrant leurs riches collections de tableaux ou leurs magnifiques bibliothèques, soupirent et vous disent tristement: 'Hélas, nous n'avons plus rien. Les Français ont tout emporté.' Moi, je trouverais plutôt que les Français ont eu le tort de laisser tant de trésors d'art qui souvent ne sont pas estimés à leur juste valeur par leurs légitimes propriétaires. Le Musée de Madrid, malgré ce que les Français ont pu prendre, est certainement un des plus riches de l'Europe. . . . On ne voit point au Musée de Madrid ce grand nombre d'ouvrages médiocres qu'au Louvre on est étonné de rencontrer à coté de chefs-d'oeuvre des plus grands maîtres." Ibid., pp. 73–74.

89. "Il faut remarquer que les ouvrages de ce maître sont rares, même en Espagne. J'ai admiré la variété de sa manière"; "la même expression de morgue superbe et d'absence d'idées." Ibid., p. 74.

90. "Aucun tableau, sans en excepter ceux de Rembrandt, n'égale celui-ci pour la science de la perspective aérienne et la distribution magique de la lumiére. . . . Plus on regarde ce tableau et plus il semble vrai. . . . En un mot, le *faire* de l'artiste ne paraît nulle part." Mérimée 1848, quoted by Paul Guinard, "Velázquez et la romantiques français," in *Varia Velazqueña* 1960, vol. 1, p. 570.

91. "Certes, si l'art de peindre n'était que l'art d'imiter la nature, Velázquez serait le premier peintre du monde." Viardot 1835, p. 417, quoted by Guinard in *Varia Velazqueña* 1960, vol. 1, p. 566.

92. "La meilleure école est donc celle où l'imitation touch de plus près à la réalité . . . où l'art s'efface, où la nature se montre. Voilà ce qui me fait dire que Velázquez est le premier des maîtres." Viardot 1835, p. 418.

93. "Un peintre qu'on ne peut admirer qu'en Espagne, c'est Velázquez"; "le plus grand coloriste du monde après Vecelli. Nous le mettrons pour notre part bien au dessus de Murillo, malgré toute la tendresse et la suavité de ce Corrège sévillan. Don Diego Velázquez de Sylva est vraiment le peintre de l'Espagne féodale et chevaleresque, son art est frère de celui de Calderón et ne relève en rien de l'antiquité. Sa peinture est romantique dans toute l'acception du mot." Gautier 1865, quoted by Guinard in *Varia Velazqueña* 1960, vol. 1, p. 570.

"Very often, when the Spaniards show you their rich collections of paintings or their magnificent libraries, they sigh and say sadly, 'Alas, we have nothing left. The French took everything.' It seems to me rather that the French were wrong to leave behind so many art treasures, whose rightful owners often underestimate their true worth. Despite what the French may have taken, the Madrid Museum is undoubtedly one of the richest in Europe. . . . You never see in the Madrid Museum the many mediocre works that in the Louvre you are amazed to see side by side with outstanding pieces by the greatest masters."[88] Velázquez is given pride of place. "It must be noted that this master's works are few, even in Spain. I admired the variety of his manner," even if Mérimée noted too much uniformity in the royal portraits: "that same expression of haughty pride and absence of ideas."[89]

Later Mérimée would extol the *Meninas,* visible from 1819 at the Prado, as the summit of Velázquez's art: "No painting, including Rembrandt's, equals this one for the skill of the aerial perspective and the magical distribution of light. . . . The longer you look at this painting the more real it appears. . . . In a word, the artist's *technique* is nowhere visible."[90] Viardot, in his much longer essay of 1835 on the Prado, respected the same hierarchy but hesitated as to which artist was greater, Murillo or Velázquez: "Of course, if the art of painting were merely the art of imitating nature, Velázquez would be the world's premier painter."[91] (In 1839 Viardot would publish a catalogue of the masterpieces in the collection of 240 Spanish paintings belonging to the Parisian banker Alejandro María López Aguado [1784–1842], the marquis de la Marismas.) Like many critics and artists of his generation, Viardot was not ready to concede that naturalism in itself could constitute high art. Yet the authority of Quatremère de Quincy's "beau idéal" was beginning to erode, thanks to the eclectic taste of Romantic artists like Delacroix. "So the best school is the one in which imitation most nearly approaches reality . . . artistry fades back, and nature appears. This is why I call Velázquez first among the masters."[92] Soon, Velázquez himself would be claimed as a Romantic. "One painter who cannot be appreciated but in Spain, is Velázquez," wrote Théophile Gautier in 1846, "the greatest colorist in the world after Vecelli. As far as we're concerned, he rates well above Murillo, despite all the Sevillian Correggio's tenderness and sweetness. Don Diego Velázquez de Sylva is really the painter of feudal, knightly Spain, his art is akin to Calderón's, with nothing of the antique about it. His painting is Romantic in every sense of the word."[93]

BARON TAYLOR AND LOUIS-PHILIPPE'S GALERIE ESPAGNOLE

King Louis-Philippe, often called an opportunist by his detractors, seized several opportunities to form, in the mid-1830s, the largest collection of Spanish painting outside of Spain. As Jeannine Baticle explains in her essay, Louis-Philippe, formerly the duc de Chartres, was an ardent Hispanophile. He had visited Spain, had traveled extensively in Latin America, and was married to a cousin of Ferdinand VII, Marie-Amélie de Bourbon; his son, the duc de Montpensier, would marry the sister of Spain's Queen Isabella II. After Ferdinand VII's death in 1833, the Spanish government was thrown into turmoil as the king's brother, Don Carlos, fought with forces aligned with Ferdinand's infant daughter, the future Queen Isabella II. In 1835 monasteries and convents reestablished under Ferdinand were once again suppressed, by the liberal government of Juan Álvarez y Mendizábal. As a result a large number of important works of art were once again potentially available, and the Spanish state

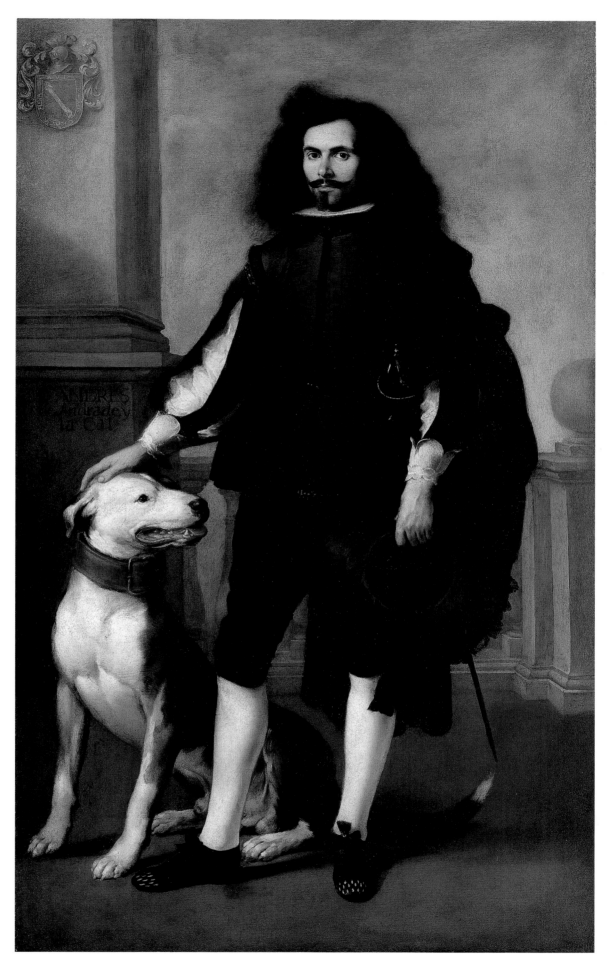

Fig. 1.31 (cat. 52)
Bartolomé Esteban
Murillo, *Don Andrés
de Andrade y la Cal*,
ca. 1665–72. Oil on
canvas, 79 x 47 in.
(200.7 x 119.4 cm).
The Metropolitan
Museum of Art,
New York, Bequest of
Collis P. Huntington,
by exchange, 1927
(27.219)

94. "Le roi avait décidé qu'il formerait, pour la donner à la France, une galerie complète de peintures espagnoles, dont nous connaissons bien les maîtres, mais à peine les oeuvres." Dumas 1837.

95. According to *La Presse*, October 6, 1837, "The paintings of the Spanish school, which Baron Taylor bought on behalf of the government and are intended for the Musée du Louvre, arrived in Marseille on the steamship *Etna*, which was waiting three months on the Catalonian coast, to attain this precious cargo; the paintings must be sent on to Paris at once." ("Les tableaux de l'école espagnole, achetés par M. le baron Taylor pour le compte du gouvernement et destinés pour le musée du Louvre sont arrivés à Marseille sur le bateau à vapeur *l'Etna*, qui était resté trois mois sur les côtes de la Catalogne pour atteindre cette précieuse cargaison; les tableaux doivent être incessamment expédiés pour Paris.")

seemed incapable of policing exportation. At the end of 1835 Louis-Philippe sent Baron Taylor to Spain on a buying expedition. As Alexandre Dumas stated in *La Presse* in 1837, "The king had decided to put together, as a gift to France, a complete gallery of Spanish paintings, whose masters we know well, but whose works, very little."[94] Taylor was by all accounts a remarkable individual: indefatigable writer; proselytizer for the preservation of medieval monuments; brilliant impresario at the Théâtre Français, where he produced the premiere of Victor Hugo's Spanish drama, *Hernani*, in 1830; and the individual responsible for the acquisition of the obelisk of Luxor now in the Place de la Concorde. With the painters Pharamond Blanchard (1805–1873) and Adrien Dauzats (1804–1868) he remained in Spain, his second homeland, according to Dumas, until April 1837, acquiring more than four hundred pictures, for which he paid a total of 1,327,000 francs. The Academia voiced objections to the dubious exportation in vain. Works were assigned lesser attributions in order to diminish their importance, and crates were transported to Marseille on a waiting French ship.[95] (After he had completed his mission in Spain, Taylor went to London, where he bought the celebrated Murillo portrait *Don Andrés de Andrade y la Cal* [fig. 1.31], among other Spanish paintings.)

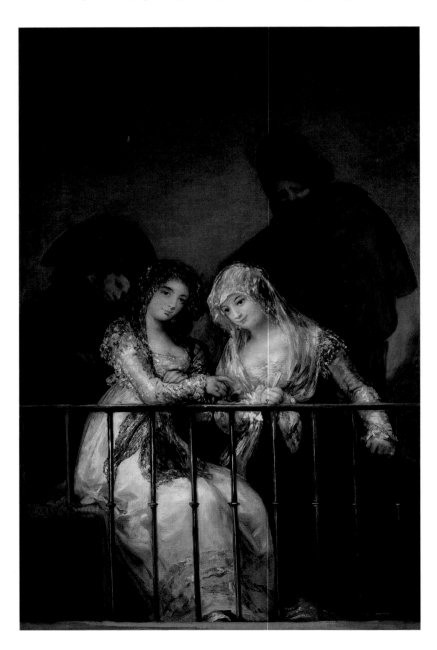

Fig. 1.32 (cat. 14) Attributed to Francisco de Goya y Lucientes, *Majas on a Balcony*, ca. 1812–35. Oil on canvas, 76 x 49½ in. (193 x 125.7 cm). The Metropolitan Museum of Art, New York, H. O. Havemeyer Collection, Bequest of Mrs. H. O. Havemeyer, 1929 (29.100.10)

The collection, with a few Italian and Northern pictures, was installed in the Louvre in 1837 and opened to the public on January 7, 1838. Situated in the first-floor Galeries de la Colonnade, it remained on view until January 1, 1849 (Louis-Philippe was dethroned in the revolution of February 1848). With additions made during these years, including the collection of 220 works bequeathed in 1842 to Louis-Philippe by the eccentric English collector Lord Standish, the number of Spanish paintings on view at the Louvre exceeded that at the Prado.

Louis-Philippe's Galerie Espagnole constituted a fascinating development in the history of the fine arts in France. On many levels it appears to have been a monumental compensatory act: compensation for the sale of the famed Orléans collection at the end of the eighteenth century; compensation for the restitution of the war loot in the Louvre after 1814; compensation for the alleged illegitimacy of the Orléans monarchy. There was even an element of expiation for previous sins: "France paid for what it owns with the gold of government funds," wrote journalist Léon Gozlan. "She bought, which is nobler and more enduring than conquering; and the gallery promised to the people will be as rightful as many

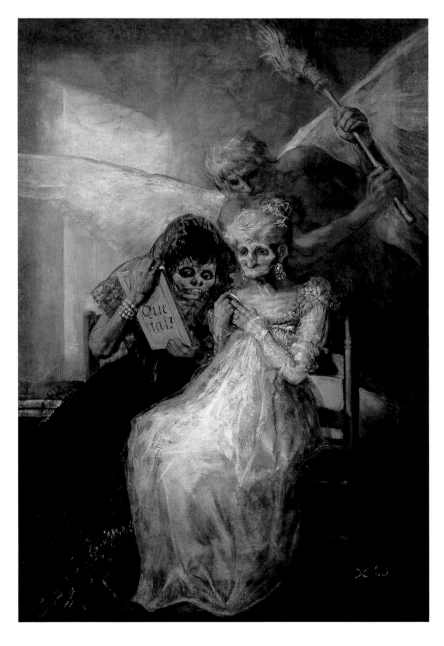

Fig. 1.33 Francisco de Goya y Lucientes, *Old Women (Time)*, ca. 1808–12. Oil on canvas, 71¼ x 49¼ in. (181 x 125 cm). Musée des Beaux-Arts, Lille

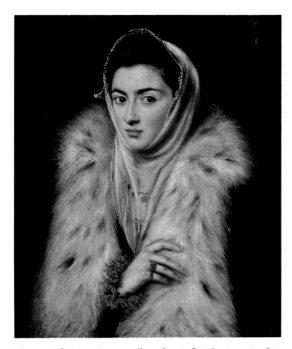

Fig. 1.34 El Greco (now attributed to Sofonisba Anguissola), *Lady in a Fur Wrap* (now *Portrait of Caterina Micaela, Duchess of Savoy*), 1577–80. Oil on canvas, 24½ x 19½ in. (62.5 x 48.9 cm). Glasgow Museums, The Stirling Maxwell Collection, Pollock House

a hero's gallery."[96] Oddly enough, the entire collection, though acquired with government funds (*la liste civile*, civil list), was "returned" to the Orléans family as compensation after the loss of the throne in 1848. "That marvelous Spanish Museum," lamented Baudelaire, "that the stupid French Republic, in its excessive respect for property, returned to the Orléans princes."[97] It was sold in a series of spectacular auctions in London in 1853 (Louis-Philippe died in exile in 1850); the dispersal augmented the great national collections already established in capitals throughout Europe—Berlin, Budapest, Dresden, London, Munich, St. Petersburg, and Vienna. Soon works from the Galerie Espagnole would grace the walls of collectors in the New World.[98] The collection itself was wildly uneven: none of the nineteen paintings attributed to Velázquez is unreservedly considered so today. "Unable to afford quality, they decided to fall back on quantity," jeered Alexandre Decamps.[99] But the nearly eighty pictures by Zurbarán, including *The Battle between Christians and Moors at El Sotillo* (fig. 3.12), *The Adoration of the Magi* (Musée des Beaux-Arts, Grenoble), and a series of female saints (figs. 2.22, 14.32) were outstanding; *Saint Francis in Meditation* (fig. 2.13) quickly became one of the most famous paintings at the Louvre. El Greco was shown in a Parisian museum for the first time, with eight works, of which six, such as the *Crucifixion with Two Donors* (fig. 1.27), are masterpieces. (The so-called portrait of the artist's daughter [fig. 1.34], now thought to have been painted by the female painter Sofonisba Anguissola, captured the public's imagination.) The truly exceptional Goyas had been purchased by Taylor directly or indirectly from Goya's son Javier. Large-scale genre scenes that had decorated Goya's own rooms, they were unlike any others: *Majas on a Balcony* (fig. 1.32) and *The Forge* (fig. 7.19) showed Goya working in a manner previously known only in small prints and miniature-like oil paintings.[100] The force of a painting like *Old Women* (fig. 1.33) was so strong that it was kept off view, perhaps because the satire was too corrosive. Perfectly timed, the establishment of the collection and the opening of the galleries at the Louvre capitalized on the Romantic vogue for things Spanish. As Gautier, himself a great partisan, explained, "the Romantic school made [Spain] fashionable again, with Victor Hugo's *Les Orientales*, Alfred de Musset's tales, Mérimée's novellas, and his *Théâtre de Clara Gazul*."[101]

IMPACT OF THE GALERIE ESPAGNOLE

"The Spanish museum had the effect," wrote Baudelaire in 1846, "of increasing the volume of general ideas that you had to have about art . . . a museum of foreign art is an international place of fellowship, where two peoples, observing and studying each other in a more relaxed fashion, come to know each other and fraternize without arguing."[102] The presence of the collection at the Louvre conferred a definitive status on Spanish painting, a stature that it had never truly owned outside of Spain. In 1837 Gautier could question teasingly, "Does a Spanish school exist?"[103] To which the prosaic *Journal des Demoiselles* answered: "You know, mademoiselles, that His Majesty Louis-Philippe has at last achieved the completion of our picture gallery, already incontestably one of the richest

96. "La France a payé avec l'or de la liste civile ce qu'elle possède. Elle a acheté, ce qui est plus noble et plus durable que de conquérir; et cette galerie promise au peuple sera aussi légitime que bien des galeries de héros." Gozlan 1837, p. 111.

97. "Ce merveilleux Musée espagnol que la stupide République français, dans son respect abusif de la propriété, a rendu aux princes d'Orléans." Quoted by Louis Réau, "Velázquez et son influence sur la peinture française du XIXe siècle," in Paris 1963c, p. 98.

98. See the appendix by Matthias Weniger on the inventory marks on the pictures formerly in the Galerie Espagnole.

99. "On a voulu, ne pouvant payer les qualités, se retirer sur la quantité." Decamps 1838.

100. The Goya *Majas* (cat. 14) is a copy of the authentic version that was exhibited in the Galerie Espagnole. See Juliet Wilson-Bareau's essay on the thorny question of attribution of the works bought by Taylor from Goya's son Javier.

101. "l'école romantique remit [l'Espagne] à la mode par les orientales de Victor Hugo, les contes d'Alfred de Musset, le théâtre de Clara Gazul et les nouvelles de Mérimée." Gautier 1850, p. 1, quoted in Lipschutz 1972, p. 184.

in the world. The four schools, Italian, Flemish, French, and Spanish, are now represented there."[104] Spanish painting had finally gained a consideration equivalent to that of the other historic schools. All of the critics of the day sketched definitions of the school; the arguments ran along the familiar lines, but never before had they been so elogious. According to Henri Blaze de Bury, "What characterizes the Spanish school is power, animation, life; a luxury of color that seduces you, the exuberance of overflowing vigor. Moreover, as everyone knows, it never idealizes; and to be convinced of this fact, it is enough to compare for a moment Raphaël's Madonnas with Murillo's Virgins."[105] "Therefore, let us expect," wrote Gozlan,

> the no doubt short-lived triumph of the Spanish school over the French and Italian schools, which, we repeat, will survive this attempt upon their acknowledged sovereignty unscathed . . . it will be proven . . . that Italy's influence has hitherto been but a prejudice; that countless painters, immured in their cloisters, hidden in palace attics . . . almost none of them in touch with that eternal Italy from which, please God, we will one day be free; that these painters, in their isolation, beneath their hair shirts, in their poverty or their well-founded contempt for other nations, found an energy of talent, a magnificence of palette, an austerity of line, a skill of composition that are theirs and theirs alone, as much as their harsh accents, brown faces, hot blood, and resounding names. This reality leaps to the eye if we but scan the surface of that ocean of paintings spread out in the Louvre's galleries. We are crushed beneath those paintings, as by the African sun at high noon.[106]

Above all, critics noted difference. Charles Blanc recalled the effect of visiting the Spanish rooms at the Louvre. "When the frivolous mass of visitors, after crossing the hall of Henry II, suddenly entered the great room dedicated to the Spaniards, coming up against that formidable painting [Zurbarán's *Saint Francis*; fig. 2.13] placed as if intentionally in the bright light from a casement window, a shudder of astonishment, almost fright, went through the crowd. It was as if amid some worldly music, they had unexpectedly heard the gloomy, resonant strains of the *Dies Irae*."[107] Gautier also saw an otherworldly aestheticism—"no other nation has borrowed less from antiquity"[108]—that gave inspiration to a poem:

> *Oh, Zurburan's monks, you white Carthusians who slip silently*
> *Through shadows across the tiles of the dead,*
> *Murmuring "Our Fathers" and "Hail Marys" beyond counting.*
>
> *What sin are you expiating with such great remorse,*
> *Oh, tonsured ghosts, ghastly faced wretches,*
> *What can your body have done, that you treat it so?*[109]

Painters responded immediately to the Galerie Espagnole. Millet wrote of his excitement on seeing "the opening of a gallery full of the greatest Spanish masters, where there are things that are impossible to describe. The saintly expressions of several monks by

102. "Le musée espagnol est venu augmenter le volume des idées générales que vous devez posséder sur l'art . . . un musée étranger est une communion internationale, où deux peuples, s'observent et s'étudiant plus à l'aise, se pénètrent mutuellement, et fraternisent sans discussion." Baudelaire 1992, p. 73: "Salon de 1846."

103. "Existe-t-il . . . une école espagnole?" Gautier 1837.

104. "Vous savez, mesdesmoiselles, que Sa Majesté Louis-Philippe est enfin parvenue à compléter notre galerie de tableaux, déjà sans contredit l'une des plus riches du monde. Les quatre écoles, italienne, flamande, française et espagnole y sont maintenant représentées." Savignac 1838, p. 59.

105. "Le caractère de l'école espagnole, c'est la puissance, l'animation, la vie; un luxe de couleur qui vous entraîne, une exubérance de sève qui déborde. Du reste, on le sait, elle n'idéalise guère; et pour se convaincre de cette vérité, il suffit de comparer un instant les madones de Raphaël avec les vierges de Murillo." Blaze de Bury 1837, pp. 535–36.

106. "Attendons-nous donc au triomphe, sans doute passager, de l'école espagnole sur les écoles française et italienne, lesquelles, nous le répétons, subiront sans dommage cette atteinte portée à leur souveraineté reconnue . . . il sera démontré . . . que la tutelle de l'Italie n'a été jusqu'ici qu'un préjugé; que d'innombrables peintres, murés dans des cloîtres, cachés dans les combles des palais . . . presque tous sans communication avec cette éternelle Italie, dont nous sortirons un jour, s'il plait à Dieu; que ces peintres ont trouvé dans leur isolement, sous leur cilice, dans leur pauvreté ou dans leur juste mépris pour les autres nations, une énergie de talent, une magnificence de coloris, une austérité de dessin, une science de composition qui sont à eux, à eux seuls, comme leur accent rocailleux, leur visage brun, leur sang chaud et leur nom sonore. Cette vérité jaillit aux yeux, en effleurant seulement la surface de cet océan de tableaux étalés dans les salles du Louvre. On est écrasé sous cette peinture, comme par le soleil d'Afrique en plein midi." Gozlan 1837, p. 113.

107. "Quand le monde frivole des visiteurs, après avoir traversé la salle de Henri II, entrait tout à coup dans la grande pièce consacrée aux Espagnols et venait se heurter contre cette formidable peinture placée comme tout exprès au grand jour d'une croisée, il y avait parmi la foule un mouvement de stupeur et presque d'effroi. On eût dit qu'au milieu

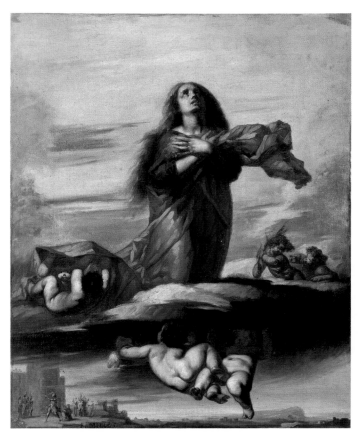

Fig. 1.35 (cat. 189) Jean-François Millet, *The Assumption of Saint Barbara*, 1841. Oil on canvas, 36⅜ x 29⅞ in. (92.5 x 73.5 cm). Musée des Beaux-Arts, Angers

Fig. 1.36 (cat. 64) Luca Giordano (formerly attributed to Jusepe de Ribera), *The Ecstasy of Saint Mary Magdalen*, ca. 1660–65. Oil on canvas, 100¾ in. x 76 in. (256 x 193 cm). The Hispanic Society of America, New York

d'une musique mondaine, on entendait subitement retenir les sons lugubres du *Dies Irae*." Blanc et al. 1869, no. 122 (Zurbarán issue), pp. 3–4, quoted in Guinard 1939, pp. 32–33.

108. "aucune autre nation n'a moins emprunté à l'antiquité." Gautier 1850, p. 2.

109. Moines de Zurburan, blanc chartreux qui dans l'ombre / Glissez silencieux sur les dalles des morts, / Murmurant des *Pater* et des *Ave* sans nombre.
Quel crime expiez-vous par de si grands remords, / Fantômes tonsurés, bourreaux à face blême, / Pour le traiter ainsi, qu'a donc fait votre corps? Quoted in Guinard 1939, p. 32.

110. "l'ouverture d'une galerie remplie des plus grands maîtres espagnols, où il se trouve des choses impossibles à décrire. Plusieurs moines de Zurbaran et de Murillo sont ce qu'on peut imaginer de plus incroyable comme expression de sainteté; leur regard n'a plus rien de terrestre; c'est l'amour brûlant des séraphins." Moreau-Nélaton 1921, vol. 1, p. 30. See the Chronology: July 21, 1838.

111. "Par une réaction bien concevable contre le goût pseudo-classique qui régnait alors en peinture comme en poésie, on

Zurbaran and Murillo are utterly incredible; there is no longer anything earthly about their gaze, it is the burning love of the seraphim."[110] His devotional pictures *The Assumption of Saint Barbara* (figs. 1.35, 1.36) and *The Virgin of Loreto (Notre-Dame-de-Lorette)* (fig. 1.37) are deeply marked with the sensibility of Zurbarán and Murillo; his portraits of the late 1830s and early 1840s recall the black-robed sobriety of the court of Philip IV. Corot was moved to emulate Zurbarán's saintly monks, painting several pictures directly inspired by works at the Louvre (figs. 1.38, 1.39); throughout the 1840s, many of his figure paintings are marked by a naïveté that may in part derive from Spanish prototypes. Chassériau copied a number of pictures in the Galerie Espagnole, attracted not to Velázquez, Murillo, and Zurbarán but to sixteenth-century Mannerist painting—Sánchez Coello, Pantoja de la Cruz, and Morales—a taste unimaginable in the previous generation. As Stéphane Guégan explains in his essay in this publication, Chassériau and like-minded artists such as Jules Ziegler (1804–1856) developed an "Ingrisme noir" by melding current practice with Spanish prototypes. Gautier noted this phenomenon in 1850: "With an understandable reaction against the pseudo-classical taste that dominated both painting and poetry at that time, they turned to the Middle Ages, to cathedrals, steel-clad barons, monks buried in their habits, and no country more than Spain achieved this knightly and Catholic ideal."[111] Underlining the anti-classicist component of Hispanism, Gautier also alludes, in speaking of feudal and Catholic Spain, to the picturesque country beloved of the Romantic writers and genre painters, among them Dauzats, Alexandre Decamps (1803–1860), Alfred Dehodencq (1822–1882), and later artists such as Ribot (fig. 1.40) (see cats. 107, 195, 198).

GUSTAVE COURBET AND THE EMERGENCE OF REALISM

The Hispanism of Gustave Courbet (1819–1877) took a different tack. Eschewing historicism, he attempted to adopt the sensibility of Spanish naturalism as well as the painterly technique of Velázquez in his depictions of everyday life. Jules Champfleury, Courbet's loyal critic and friend, constantly evoked Spanish painting in his discussion of the artist's current work. "If you put his portrait *Man with a Cello* [figs. 1.41, 1.42] in the Spanish museum," he wrote in 1848, "it would hang there, proud and calm, with no fear of the Velasquezes and the Murillos."[112] Of the deeply Spanish *Burial at Ornans* (fig. 1.43) that stirred controversy at the 1851 Salon, Champfleury considered that "with its composition and arrangement of groups, Courbet was already breaking with tradition. Though he was unacquainted with Velasquez's wonderful canvases, he was in agreement with that illustrious master, who placed figures next to one another without worrying about laws laid down by pedantic and mediocre minds. Only those who know Velasquez can understand Courbet. Had the Parisians been more familiar with the works of Velasquez, they would undoubtedly have been less angry about *The Burial at Ornans*."[113] Courbet's enormous *The Artist in His Studio* (fig. 1.44), shown in the artist's personal pavilion in 1855, is, among many other things, an examination of Velázquez's depiction of space in *Las Meninas*. One therefore concurs with Champfleury when he writes, "perhaps, by rehabilitating the modern and with the excellent working methods that overlie his representation of the modern, the master [Courbet] will facilitate the arrival of a noble and great Velasquez, a mocking and satirical Goya."[114] Characteristically, Courbet used the Spanish masters to aggrandize his own stature vis-à-vis

Fig. 1.37 (cat. 190) Jean-François Millet, *The Virgin of Loreto (Notre-Dame-de-Lorette)*, 1851. Oil on canvas, 91⅜ x 52⅛ in. (232 x 132.5 cm). Musée des Beaux-Arts, Dijon

the classicists in the academy (and on the Salon jury): "Ribera, Zurbaran, and especially Vélasquez, I admire them. . . . As for Raphaël, while of course he made some interesting portraits, I find no thought in his paintings. That's probably what our so-called idealists adore about him. The 'ideal'! Ho! Ho! Ho! Ha! Ha! Ha! What humbug! Ho! Ho! Ho! Ha! Ha! Ha!"[115] And when it served him, Courbet would just as easily turn on a Spanish master in order to assert his status as a victim. "I'll make a *Stonebreaker* [*casseur de pierre*], Murillo makes a flea smasher [*casseur de poux*]. Therefore, I am a Socialist and Murillo is a good, honest man. It's incredible!"[116] Courbet made an unpublicized and, to date, largely unexamined trip to Madrid in the late summer of 1868.[117]

s'était tourné vers le moyen âge, les cathédrales, les barons bardés de fer, les moines ensevelis dans leurs frocs et nul pays mieux que l'Espagne ne réalisait cet idéal chevaleresque et catholique." Gautier 1850, p. 1.

112. "On mettrait dans le musée espagnol son portrait d'*Homme à la basse* qu'il resterait fier et tranquille, sans craindre les Velasquez et Murillo." Champfleury 1848, reprinted in Champfleury 1973, pp. 153–54. When Champfleury reprinted this review in his *Souvenirs et portraits de*

Fig. 1.38 (cat. 98) Camille Corot, *Man in Armor*, ca. 1868–70. Oil on canvas, 28⅞ x 23¼ in. (73 x 59 cm). Musée du Louvre, Paris

Fig. 1.39 (cat. 97) Camille Corot, *Saint Francis (Franciscan Kneeling in Prayer)*, ca. 1840–45; retouched ca. 1870. Oil on canvas, 18⅞ x 13⅜ in. (48 x 34 cm). Musée du Louvre, Paris

Fig. 1.40 (cat. 195) Théodule-Augustin Ribot, *Still Life with Eggs*, ca. 1865–75. Oil on canvas, 20⅝ x 36⅜ in. (52.4 x 92.5 cm). Van Gogh Museum, Amsterdam

Fig. 1.41 (cat. 100) Gustave Courbet, *The Cellist (Self-Portrait)*, 1847. Oil on canvas, 46⅛ x 35½ in. (117 x 89 cm). Nationalmuseum, Stockholm

Fig. 1.42 (cat. 99) Gustave Courbet, *Man with the Leather Belt (Portrait of the Artist)*, 1845–46? Oil on canvas, 39⅜ x 32¼ in. (100 x 82 cm). Musée d'Orsay, Paris

jeunesse of 1872, he cut the favorable comparisons to Rubens and the Spanish painters (ibid., p. 153 n. 1).

113. "par la composition et l'arrangement des groupes, Courbet rompait déjà avec la tradition. Sans connaître les admirables toiles de Velasquez, il se trouve d'accord avec l'illustre maître, qui a placé des personnages les uns à côté des autres, et ne s'est pas inquiété des lois posées par des esprits pédants et médiocres. Qui n'a pas l'intelligence ce Velasquez ne saurait comprendre Courbet. Si les Parisiens connaissaient davantage les oeuvres de Velasquez, ils se seraient sans doute moins fâchés contre l'*Enterrement à Ornans*." Champfleury, "Courbet en 1860," in *Grandes figures d'hier et d'aujourd'hui* (1861), reprinted in Champfleury 1973, p. 182.

114. "le maître [Courbet], avec sa réhabilitation du moderne et les excellentes procédés dont il recouvre la représentation du moderne, facilitera peut-être l'arrivée d'un Velasquez noble et grand, d'un Goya railleur et satyrique." Ibid., pp. 182–83.

115. "Ribera, Zurbaran, et surtout Vélasquez, je les admire. . . . Quant à monsieur

MANET AND REALIST FIGURE PAINTING

In 1861, the year that the twenty-nine-year-old Édouard Manet first saw his work accepted by the Paris Salon, Courbet was the central protagonist in the battle to determine the direction of Realist figure painting. As the critic Jules Castagnary (1830–1888) saw it, Courbet "truly defined the new movement."[118] However, it is seldom recalled by modern historians that the critical discourse on Courbet's style was rooted in comparisons with Spanish seventeenth-century painting, a school that had been so amply displayed at the Galerie Espagnole, but that, since 1848, was no longer visible. "In his power and variety," wrote Castagnary, "I find him very like Velasquez, the great Spanish naturalist; but with this slight difference: Velasquez was a courtier of the court, Courbet is a Velasquez of the people."[119]

Throughout the 1860s Manet engaged in an extended examination of Spanish prototypes, from Murillo to Zurbarán, from Velázquez to Goya. The resulting paintings, most of which are included in this exhibition, have traditionally been seen in the context of a larger project to reconcile the processes of old-master painting with the painting of modern life. After all, Manet also drew inspiration from Giorgione's *Fête champêtre* (now attributed to Titian; Musée du Louvre, Paris), from Rubens's marriage portraits, and from Titian's grand Venuses. But Manet's interest in Spanish painting was more flagrant, and in the end, more fruitful. It almost certainly derived from the example of Courbet. Defending the Master of Ornans, Champfleury wrote in 1861 that "The Spaniards, Murillo and Velasquez chief

Fig. 1.43 Gustave Courbet, *Burial at Ornans*, 1849–50. Oil on canvas, 10 ft. 2⅛ in. x 21 ft. 11 in. (311.5 x 668 cm). Musée d'Orsay, Paris

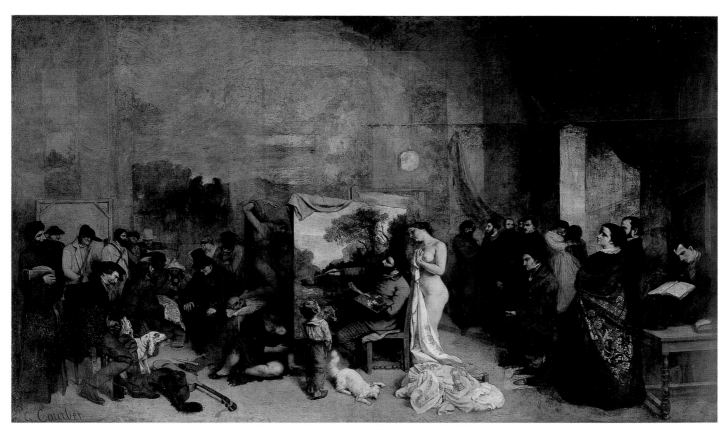

Fig. 1.44 Gustave Courbet, *The Artist in His Studio*, 1854–55. Oil on canvas, 11 ft. 10⅛ in. x 19 ft. 7½ in. (361 x 598 cm). Musée d'Orsay, Paris

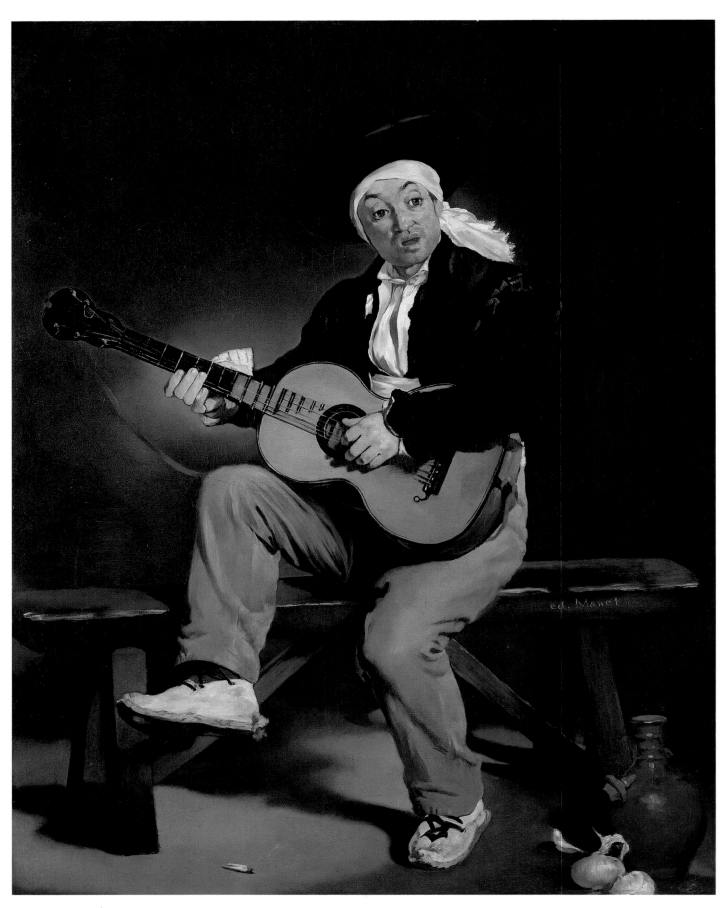

Fig. 1.45 (cat. 131) Édouard Manet, *The Spanish Singer (The "Guitarero")*, 1860. Oil on canvas, 58 x 45 in. (147.3 x 114.3 cm). The Metropolitan Museum of Art, New York, Gift of William Church Osborn, 1949 (49.58.2)

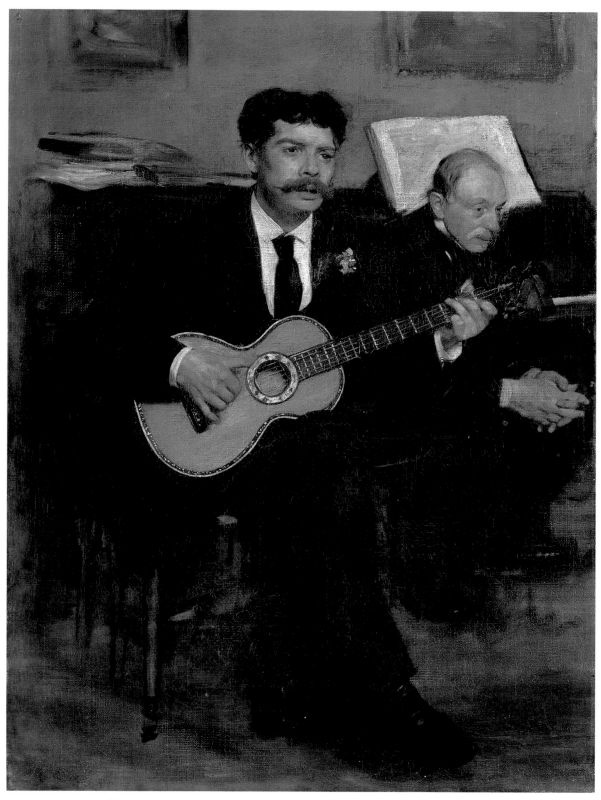

Fig. 1.46 (cat. 106) Hilaire-Germain-Edgar Degas, *Lorenzo Pagans and Auguste De Gas*, ca. 1871–72. Oil on canvas, 21½ x 15¾ in. (54.5 x 40 cm). Musée d'Orsay, Paris

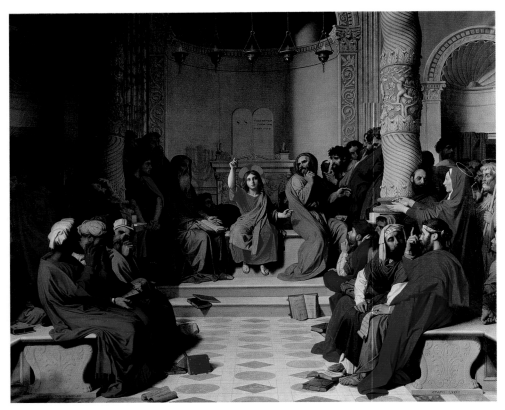

Fig. 1.47 Jean-Auguste-Dominique Ingres, *Jesus among the Doctors*, 1842–62. Oil on canvas, 8 ft. 8⅜ in. x 10 ft. 4 in. (265 x 320 cm). Musée Ingres, Montauban

Raphaël, il a fait sans doute quelques portraits intéressants, mais je ne trouve dans ses tableaux aucune pensée. C'est probablement pour cela que nos préten-dus idéalistes l'adorent. L'idéal! Oh! oh! oh! ah! ah! ah! Quelle balançoire! Oh! oh! oh! ah! ah! ah! ah!" Courbet, preface to the catalogue of his 1855 exhibition, quoted in T. Silvestre 1856, p. 268.

116. "Je fais des *Casseurs de pierres*, Murillo fait un casseur de poux. Je suis un social-iste et Murillo un honnête homme, c'est incroyable." Letter from Courbet to Francis Wey, January 1, 1852, comparing his *Stonebreakers* to Murillo's *Young Beg-gar* in the Louvre and objecting to the politicization of his art; in Courbet 1996, p. 98. Special thanks to Kathryn Calley Galitz for calling this to my attention.

117. As recently discovered by Alisa Luxenberg. See Luxenberg 2001.

118. "a véritablement décidé le mouvement nouveau." Castagnary 1892, vol. 1, p. 148.

119. "Pour cette puissance et cette variété, je le rapprocherais volontiers de Velasquez le grand naturaliste espagnol; mais avec une nuance: Velasquez était un courtisan de la cour, Courbet est un Velasquez du peuple." Ibid., p. 149.

120. "Les Espagnols, Murillo et Velasquez en tête, ont peint des mendiants, des

among them, painted beggars, tramps, and legless cripples the same size as the grandees and infantas of Spain."[120] Can it be a coincidence that Manet painted beggars and orphans and gave them the stature of Spanish princes?

Manet's Salon debut in 1861 came with the cheerful *Spanish Singer* (figs. 1.45, 1.46) of which Gautier wrote, "Velasquez would salute him with a friendly wink and Goya would have asked him for a light for his *papelito*."[121] (He also exhibited an austere, though conven-tional, portrait of his parents [Musée d'Orsay, Paris].) The painting won an honorable men-tion, perhaps through the intervention of Delacroix, as well as the admiration of a group of young artists: "MM. Legros, Fantin, Karolus Durand [*sic*], and others, looked at each other in amazement, racking their brains and asking themselves, as in those fairy plays with trap doors, where could M. Manet have come from? The Spanish musician was painted in a cer-tain strange, new way, to which the amazed young painters believed they knew the secret, a style of painting that is a cross between the so-called Realist and so-called Romantic."[122] *The Spanish Singer* thus provoked the beginning of *la bande Manet*, though not because of the subject but rather on account of the style of painting. The following year, providing the sharpest possible contrast with contemporary practice, Ingres, eighty-two years old, exhib-ited the *Jesus among the Doctors* (fig. 1.47), no doubt intended as a rebuke to wayward young artists. It was the last gasp of the cult of Raphael.[123]

In her essay on Manet and Spain in this publication, Juliet Wilson-Bareau explains in detail the artist's engagement with the country and its painters. It is worthwhile to emphasize that this involvement took place at a time when the vogue for Spain had reached new heights in theater (Verdi's opera *Don Carlos*), in literature (Gautier's *Militona*), and even in the

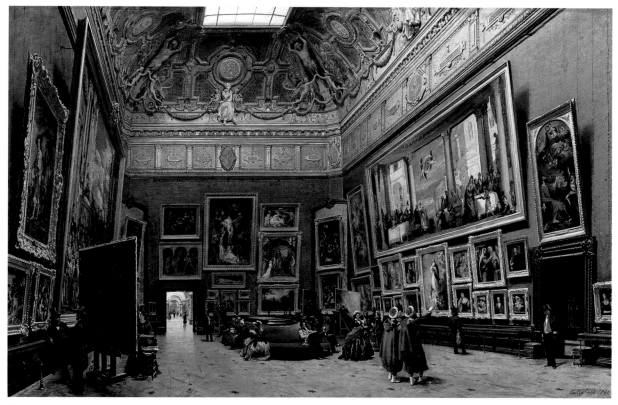

Fig. 1.48 Giuseppe Castiglione, *The Salon Carré at the Musée du Louvre*, 1861. Oil on canvas, 27⅛ x 40½ in. (69 x 103 cm). Musée du Louvre, Paris

Tuileries palace (the empress, Eugenia de Montijo de Guzmán [1826–1920], was a Spanish noblewoman). For all that, the collection of Spanish paintings at the Louvre, now deprived of the Galerie Espagnole, had shrunk back to the core of a dozen, mostly motley, works. The purchase of Murillo's *Immaculate Conception* from the Soult collection (fig. 1.48) in 1852 was once again an act of compensation, this time for the loss of Louis-Philippe's collection after his removal from the throne. In 1859 an additional five works were acquired from the Soult estate, and pertinent additions were made throughout the 1860s. By now, however, there were a large number of Spanish paintings in France. The sales of the Galerie Espagnole, as well as the Soult and Aguado collections, disseminated hundreds of works, some of which remained or returned to France. In addition, provincial museums—in Grenoble, Lyon, Caen, and Rouen—had made important acquisitions. Private collections in Paris, such as those of the comte de Pourtalès-Gorgier or Lord Hertford, were accessible to interested individuals. An artist of Courbet's generation had vivid memories of the Galerie Espagnole; Manet was only sixteen when it closed. Nevertheless, he had ample opportunity to examine fine works in Paris, long before his trip to Spain. In the summer of 1857 many French artists crossed the Channel to see the Art Treasures Exhibition in Manchester, England, no doubt the greatest exhibition of old-master painting ever held. On display were nearly one hundred Spanish paintings, including thirty-one by Murillo and twenty-four by Velázquez.

Manet's engagement with Spanish art came at a time when the battle for the direction of modern painting erupted into the open. The Salon of 1863 marked the turning point. The liberal critic Théophile Thoré, a champion of Realism, wrote of the emptiness of much contemporary art: "One must first leave at the door of the Salon all ambitious aspirations

pouilleux, des culs-de-jatte de la même taille que les grands et infantes d'Espagne." Champfleury 1973, p. 163.

121. "Velasquez le saluerait d'un petit clignement d'oeil amical, et Goya lui demanderait du feu pour allumer son papelito." Gautier 1861, p. 1017.

122. "MM. Legros, Fantin, Karolus Durand [*sic*] et autres, se regardèrent avec étonnement, interrogeant leurs souvenirs et se demandent, comme dans les féeries à trappes, d'où pouvait sortir M. Manet? Le musicien espagnol était peint d'une certaine façon, étrange, nouvelle, dont les jeunes peintres étonnés croyaient avoir le secret, peinture qui tient le milieu entre celle dite réaliste et celle dite romantique." Desnoyers 1863, pp. 40–41.

123. Yet even Ingres, when recommending a commission for a young student in 1846, had written of Velázquez as "an admirable painter, and so little known in France." Letter from Ingres to Cavé, Paris, Archives Nationales F21:42, Dossier "Leleux," quoted in Boime 1971 (1986 rpt.), pp. 31, 617 n. 55.

124. "Il faut d'abord laisser à la porte du Salon toute aspiration trop ambitieuse vers l'art véritable, en tant qu'il exprime les profondeurs de la vie humaine, les [des] idées, les sentiments [humains] et les passions, ou même les splendeurs de la nature, beauté, lumière, forme et couleur. . . . L'école française, telle qu'elle apparaît au Salon de 1863, ne signifie rien. Elle n'est plus religieuse, ni philosophique; point historique, ni poétique; elle manque à la fois de vieille tradition et de jeune imagination." Thoré 1870, p. 369. The discussion here is excerpted from my essay "Paris, Capital of the Nineteenth Century," to be published in *The Art of Paris*, New York: Abbeville Press, forthcoming.

125. "Velasquez, avouons-le, et beaucoup de ses contemporains semblent avoir cherché surtout l'imitation extérieure de la nature dans toute sa vérité; aussi la langue espagnole et la langue italienne ont-elles un mot pour qualifier ces habiles reproducteurs de la nature, *naturalista, peintre naturaliste.*" Thoré 1835a, p. 63. See also Jowell 1971.

126. "École classique, école romantique, école naturaliste, toutes les trois sont d'accord sur le point de départ: la nature est la base de l'art. Seulement, l'école classique [Ingres and his accolytes Flandrin and Amaury-Duval; Baudry; Bouguereau; Cabanel; and Gérôme] affirme que la nature doit être corrigée au moyen des indications fournies par l'antique ou par les chefs-d'oeuvre de la Renaissance. La réalité la trouble et lui fait peur. Sous prétexte de l'épurer, de l'idéaliser, elle l'atténue ou la déforme; c'est toujours de l'amoindrissement, quand ce n'est pas toujours de la convention pure. L'école romantique [followers of Delacroix, Chassériau, Ary Scheffer, and Horace Vernet] affirme que l'art est libre; que la nature doit être interprétée librement par l'artiste rendu libre. Elle n'a pas peur de la réalité, mais elle y échappe en la travestissant selon les caprices de l'imagination; c'est toujours de l'à peu près, quand ce n'est pas toujours du somnambulisme. L'école naturaliste affirme que l'art est l'expression de la vie sous tous ses modes et à tous ses degrés, et que son unique but est de reproduire la nature en l'amenant à son maximum de puissance et d'intensité: c'est la vérité s'équilibrant avec la science." "Pour la première fois depuis trois siècles, la société française est en voie d'enfanter une peinture française qui soit faite à son image à elle, et non plus à l'image des peuples disparus; qui décrive ses aspects et ses moeurs, et non plus les aspects et les moeurs de civilisations évanouies; qui, enfin, sur

toward a true art, an art that expresses the depth of human life, ideas, feelings, and passion, or even the splendors of nature, beauty, light, form, and color. . . . The French school as it appears in the Salon of '63 signifies nothing. It is no longer religious nor philosophical; historical nor political; it lacks both tradition and young originality."[124] Thoré called on French artists to emulate the naturalism he admired in the art of the Dutch and Spanish seventeenth-century painters. His preference was for distinctly humanist art, and he saw an analogy between the naturalism of Dutch painting and the democratic values he imputed to that society. Needless to say, that analogy would be strained in the absolutist, Catholic court of Philip IV, where Velázquez thrived. So for Spanish art Thoré posited a different set of characteristics: its "inspiration" and "vitality" arose from its Christian roots. Thoré felt that the importance of Christianity lessened as the century progressed, displaced by emphasis on imitating the natural world: "Let's admit it, Velasquez and many of his contemporaries seem to have sought above all to imitate nature's outward appearance in all its truth; this is why the Spanish and Italian languages have a word to describe these skillful reproducers of nature, *naturalista, naturalist painter.*"[125] This style, Thoré thought, was perfectly suited to the materialist culture of nineteenth-century France.

Castagnary, another Realist partisan, discerned in 1863 three principal schools of current practice:

> All three schools, classical, Romantic, and naturalist, agree on their starting point: nature is the basis of art. Except that the classical school [Ingres and his acolytes Flandrin and Amaury-Duval; Baudry; Bouguereau; Cabanel; and Gérôme] maintains that nature must be corrected along the lines provided by the antique or by the masterpieces of the Renaissance. Reality troubles and frightens it. Claiming to purify it, idealize it, it diminishes or deforms it; there is always a lessening, if not always pure convention. The Romantic school [followers of Delacroix, Chassériau, Ary Scheffer, and Horace Vernet] maintains that art is free; that nature must be interpreted freely by artists who have become free. It does not fear reality, but evades it by disguising it according to the whims of its imagination; it is always approximate, if not always sleepwalking. The naturalist school [Courbet, Millet, and the landscapists Rousseau and Corot] maintains that art is the expression of life in all its manifestations and in every degree, and that its sole aim is to reproduce nature by bringing it to its greatest power and intensity: here, truth and skill are in equilibrium.

According to Castagnary, the first two schools had already reached maturity, their principal proponents were dead or past their prime, but there was real promise for the naturalist (commonly understood as Realist) school. "For the first time in three centuries, French society is in the process of giving birth to a French style of painting, in its own image, no longer in the image of long-ago peoples; which describes its own appearances and customs, no longer the appearances and customs of vanished civilizations; which, in short, in all its aspects, bears the imprint of its luminous grace, and its lucid spirit, penetrating and clear-sighted."[126] "May posterity," Castagnary hoped, "in a few hundred years, consider it the equal of Spanish painting, so energetic and fierce, of Dutch painting, so intimate and domestic, and of Italian painting, the purest, most harmonious, and dazzling to ever blossom beneath a beautiful sky!"[127]

Variously called Realism or Naturalism, this new French style, as practiced by the emerging leader Édouard Manet, was conjugated with Spanish verbs. As Paul Mantz saw it in 1868,

The frankness of tone and the bravura brush of the Spanish Guitar Player *and the* Boy with a Sword *[figs. 1.45, 1.1, respectively] recalled the masters of seventeenth-century Spain. Since then M. Manet has strayed from these healthy practices . . . he has taken an unusual fancy to black tones, and his ideal consists of opposing them to chalky whites so as to present on the canvas a series of more or less contrasting blobs. This manner, new to France, was formerly used in Spain. El Greco and Goya himself sometimes played this game, but the former had seen Venice and even his shadows remained golden; the latter was very resourceful and he knew, fine printmaker that he was, how blacks and whites set each other off; these two masters understood, moreover, that color is a language, and they sought hazy, strident, or dramatic effects in order to translate an emotion.*[128]

In fact, the very distinction that Mantz draws here reveals the change in Manet's style brought about by his trip to Spain in 1865.

In one of his most spontaneous and enthusiastic letters, Manet wrote to his friend Henri Fantin-Latour (1836–1904) of his revelation at the Prado:

How happy it would have made you to see Vélasquez who all by himself makes the journey worthwhile. . . . He is the painter of painters; he didn't surprise me, he enchanted me. . . . The most extraordinary piece in this splendid oeuvre and possibly the most extraordinary piece of painting that has ever been done is the picture described in the catalogue as a portrait of a famous actor at the time of Philip IV [fig. 1.49]; the background disappears, there's nothing but air surrounding the fellow, who is all in black and appears alive; and the spinners, *the fine portrait of Alonzo Cano;* las Meninas *(the dwarfs) [sic], another extraordinary picture; the philosophers, both amazing pieces; all the dwarfs, one in particular seen sitting full face with his hands on his hips [Don Sebastian de Morra,* Museo del Prado, Madrid, inv. 1202*], a choice picture for a true connoisseur; his magnificent portraits—one would have to go through them all, they are all masterpieces. . . . Then there's Goya, the most original next to the master whom he imitated too closely in the most servile sense of imitation. But still he's tremendously spirited. The museum has two fine equestrian portraits by him, done in the manner of Vélasquez, though much inferior. What I've seen by Goya so far hasn't greatly appealed to me; in a day or so I'm to see a splendid collection of his work at the Duke of Ossuna's.*[129]

Above all, Manet was struck by Velázquez's use of paint, which he emulated as soon as he returned to Paris (after a two-week stay, because he could not stomach Spanish food). One is reminded of Delacroix's response to Spanish painting forty years earlier: "This is what I have so long sought, this firm, yet yielding impasto. . . . I'd like to spread some nice oily, thick paint across a brown or red canvas."[130] Although Manet did not put it into words, this is what he articulated in his pictures over the next decade (not allowing himself, of course, to be an imitator "in the most servile sense of imitation"; figs. 1.49–1.51).

toutes ses faces, porte l'empreinte de sa grâce lumineuse, de son esprit lucide, pénétrant et clair." Castagnary 1892, vol. 1, pp. 104–6.

127. "Puisse-t-elle, dans quelques centaines d'années, balancer, aux regards de la postérité, la peinture espagnole, si énergique et si farouche, la peinture hollandaise, si intime et si familière, la peinture italienne, la plus pure, la plus harmonieuse, la plus rayonnante qui se soit jamais épanouie sous un beau ciel!" Ibid., p. 106.

128. Mantz 1868, p. 362, quoted in Holt 1981, p. 461.

129. "Quelle joie c'eût été pour vous de voir ce Vélasquez qui à lui tout seul vaut le voyage; les peintres de toutes les écoles qui l'entourent au musée de Madrid et qui y sont très bien représentés semblent tous des chiqueurs. C'est le peintre des peintres; il ne m'a pas étonné mais m'a ravi. . . . Le morceau le plus étonnant de cet oeuvre splendide et peut-être le plus étonnant morceau de peinture que l'on ait jamais fait est le tableau indiqué au catalogue, portrait d'un acteur célèbre au temps de Philippe IV; le fond disparaît, c'est de l'air qui entoure ce bonhomme tout habillé de noir et vivant; et les *fileuses*, le beau portrait d'Alonzo Cano, *las Meninas* (les nains), tableau extraordinaire aussi, ses philosophes, étonnants morceaux—tous les nains, un surtout assis de face les poings sur les hanches, peinture de choix pour un vrai connaisseur, ses magnifiques portraits, il faudrait tout énumérer, il n'y a que des chefs-d'oeuvre. . . . Et Goya, le plus curieux après le maître, qu'il a trop imité dans le sens le plus servile d'imitation. Une grande verve cependant. Il y a de lui au musée deux beaux portraits équestres dans la manière de Vélasquez, bien inférieurs toutefois. Ce que j'ai vu de lui jusqu'ici ne m'a pas plu énormément; je dois en voir ces jours—ci une magnifique collection chez le duc d'Ossuna [sic]." Letter from Manet to Fantin-Latour, Madrid, September 3, 1865, Manet 1988, pp. 43–44.

130. "Voilà ce que j'ai cherché si longtemps, cet empâté ferme et pourtant fondu. . . . Je voudrais étaler sur une toile brune ou rouge de la bonne grasse couleur et épaisse." Delacroix 1932, vol. 1, pp. 72, 74: April 11, 1824.

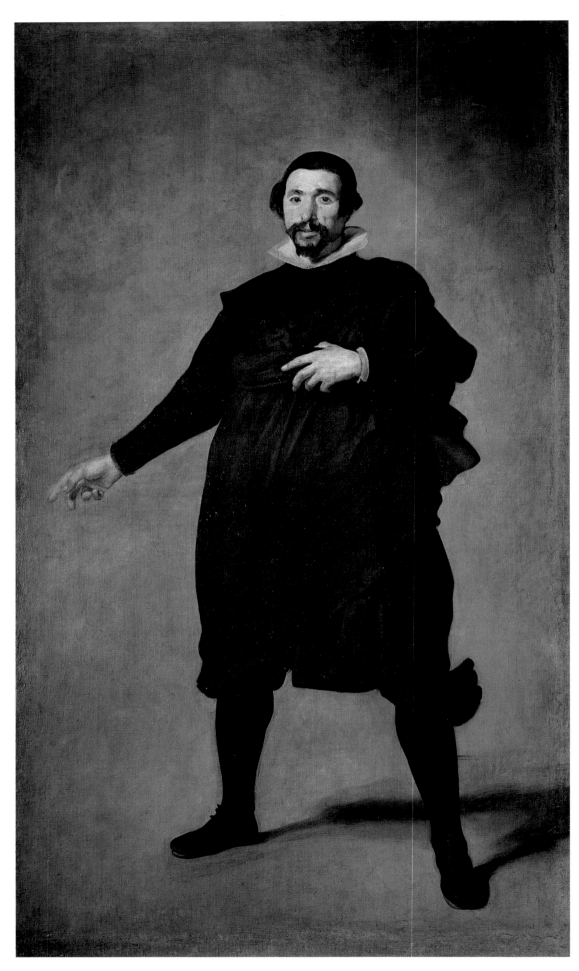

Fig. 1.49 (cat. 73) Diego
Rodríguez de Silva y
Velázquez, *The Jester Pablo
de Valladolid*, ca. 1632–35.
Oil on canvas, 84 x 49¼ in.
(213.5 x 125 cm). Museo
Nacional del Prado, Madrid

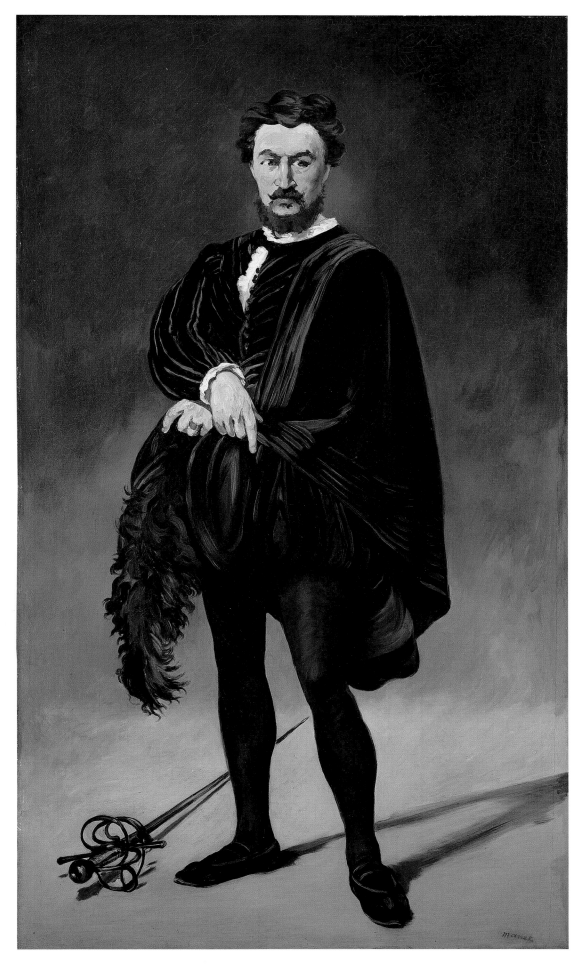

Fig. 1.50 (cat. 150) Édouard
Manet, *The Tragic Actor
(Rouvière as Hamlet)*,
1865–66. Oil on canvas,
73¾ x 42½ in. (187.2 x
108.1 cm). National Gallery
of Art, Washington, D.C.,
Gift of Edith Stuyvesant
Gerry

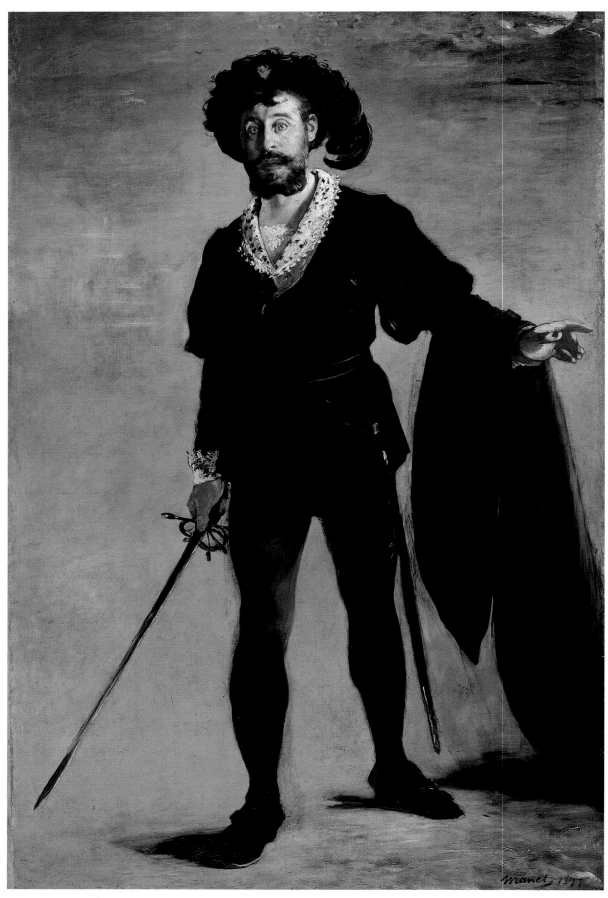

Fig. 1.51 (cat. 159) Édouard Manet, *Faure in the Role of Hamlet*, 1876–77. Oil on canvas, 76⅛ x 51¾ in. (194 x 131.5 cm). Museum Folkwang Essen

DEGAS AND THE NEW PAINTING

Edgar Degas (1834–1917) met Manet for the first time in 1862, when both were making copies after the *Infanta Margarita* in the Louvre (figs. 1.52, 1.53). Very soon, Manet would replace Gustave Moreau (1826–1898) as Degas's unwitting mentor. For the rest of the decade, Degas engaged in a friendly rivalry with the slightly older but much more experienced artist, borrowing exhibition strategies, style, and subjects (for example, Manet's *Incident at a Bullfight* [see cat. 141] was transformed into Degas's *Steeplechase* [1866, reworked 1880–81, National Gallery of Art, Washington, D.C.]). It has long been noted that Manet and Degas were equally committed to scenes of modern life and that both were equally involved with the art of the old masters. It is less frequently remarked that Degas passed through a period of Hispanism at this same time. Degas's portrait of his aunt's family, *The Bellelli Family* (fig. 1.54), is at once a reflection of Goya's *Family of Charles IV* and of *Las Meninas* (figs. 1.55–1.58)—"the theology of painting"[131]—seen through the lens of "Ingrisme noir." The conception of the picture, begun in 1858 and completed by 1867, predates Degas's meeting with Manet; he was probably encouraged to look at Spanish prototypes by his good friend the painter Léon Bonnat (1833–1922), who recalled, "I was raised in the cult of Velasquez. When I was very little, in Madrid, my father, on those dazzling days that you see only in Spain, sometimes took me to the Prado Museum, where we would linger for a long time in the Spanish galleries."[132] It is obvious that for a painting like *Lorenzo Pagans and Auguste De Gas* (fig. 1.46), Degas thought of Manet's *Spanish Singer* as he depicted the Spanish singer Pagans so admired by his father. But it has not been observed that Degas's handling of paint in a number of pictures of the 1860s and 1870s may derive from his

131. Theodore Reff notes that for the Romantics of Gautier's generation and for the Realists of Manet's, *Las Meninas* was "la théologie de la peinture" (the theology of painting); this expression, attributed to Luca Giordano, was often repeated in the nineteenth century; cf. Stirling-Maxwell 1855 and Viardot 1839. Theodore Reff, "Les vies des maîtres anciens dans les oeuvres de jeunesse de Degas," in Colloque Degas 1989, pp. 192, 200.

132. "J'ai été élevé dans la culte de Velasquez. J'étais tout jeune, à Madrid, mon père, par les journées radieuses comme on n'en voit qu'en Espagne, me menait parfois au musée du Prado, où nous faisions de longues stations dans les salles espagnoles." Bonnat 1898, p. 177.

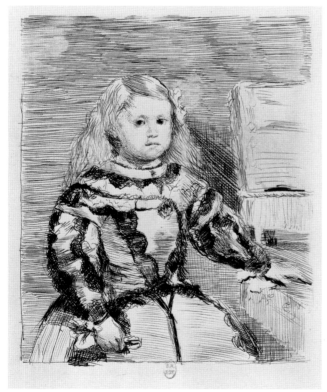

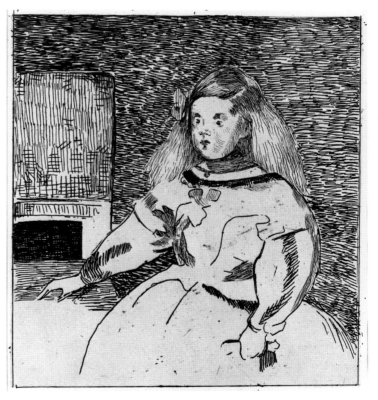

Fig. 1.52 (cat. 103) Hilaire-Germain-Edgar Degas, *Infanta Margarita, Copy after Velázquez*, 1861–62. Etching and drypoint, first state, 5¼ x 4¼ in. (13.2 x 10.8 cm). Bibliothèque Nationale, Département des Estampes, Paris

Fig. 1.53 (cat. 182) Édouard Manet, *Infanta Margarita, Copy after Velázquez*, 1861–63. Etching, only state, plate 9 x 7½ in. (22.9 x 18.9 cm), sheet 11⅛ x 9½ in. (28.4 x 24.1 cm). Baltimore Museum of Art, Lucas Collection

Fig. 1.54 Hilaire-Germain-Edgar Degas, *The Bellelli Family*, 1858–67. Oil on canvas, 78¾ x 98⅜ in. (200 x 250 cm). Musée d'Orsay, Paris

133. "le boueux tendre de Velasquez."
 Goncourt 1887–96, vol. 5, pp. 88–89:
 February 13, 1874.

134. "Rien, non rien ne peut donner l'idée de
 Velasquez. Nous en parlerons tout de
 même au retour, avec le reste." Letter
 from Degas to Bartholomé from Madrid,
 September 8 [1889], in Degas 1931,
 letter 92, pp. 138–39.

attempt to imitate Velázquez's use of paint—"Velasquez's soft muddiness"[133]—via Manet's example. A prime example of this is the portrait of his sister, Thérèse De Gas, in which she wears a mantilla (figs. 1.60, 1.61). The same application of fluidly scumbled paint may be found in the repetition of the portrait of Pagans (Museum of Fine Arts, Boston) and other portraits of the mid-1870s, including the magnificent *Duchess de Montejasi with Her Daughters Elena and Camilla* (private collection). Here one finds the obsession with black, noted above in Mantz's review of Manet's work, as well as the suggestion of motion famously associated with Velázquez. Degas's great portrait of Tissot (fig. 1.59)—with the exception of *The Bellelli Family*, the largest of the period—not only refers to the setting of *Las Meninas* but, like it, also suggests the arrest of a single moment. Degas himself would not visit Spain until 1889, but the trip was an epiphany. "Nothing, no, nothing, can convey the idea of Velasquez. Nevertheless, we'll talk about him, along with everything else, when I return."[134] When Degas was forming his private collection during the 1890s, he made a special effort to buy works by El Greco. (At the end of the century, El Greco occupied a position similar to that of Velázquez one hundred years earlier: celebrated but unknown.) He bought a *Saint Ildefonso* from the collection of the painter Millet at his sale on April 25, 1894, and the extraordinary *Saint Dominic* (Museum of Fine Arts, Boston) from Zacharie Astruc in 1896.

Fig. 1.55 Francisco de Goya y Lucientes, *The Family of Charles IV*, 1800–1801. Oil on canvas, 9 ft. 2¼ in. x 11 ft. ¼ in. (280 x 336 cm). Museo Nacional del Prado, Madrid

Louis-Edmond Duranty's Realist manifesto *La nouvelle peinture* (The new painting; 1876) nowhere mentions Spanish painting as a source for the new movement. It is thought that much of Duranty's text was dictated by Degas; perhaps Degas, out of rivalry with Manet, wished to minimize a characteristic so closely asssociated with Manet at a time when Manet refused to join Degas and friends in the Impressionist exhibitions. Nevertheless, by the mid-1870s Naturalism and Realism had become the norm, and painterly excess—the Goncourts' "l'outrance de la cuisine"—was commonplace. References to Spanish painting were everywhere, yet largely unseen. Manet's *The Balcony*, Eva Gonzalès's *Box at the Théâtre des Italiens*, Mary Cassatt's *In the Loge* (figs. 1.62, 1.63) are all obviously retakes of Goya's *Majas on a Balcony* (fig. 1.32); the paintings by Cassatt and Gonzalès,

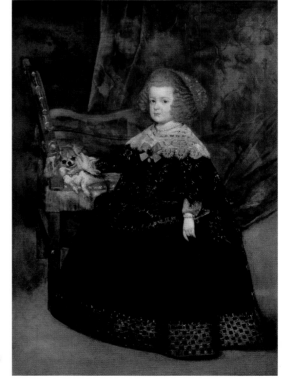

Fig. 1.56 (cat. 47) Juan Bautista Martínez del Mazo, *Infanta María Teresa*, 1644–45. Oil on canvas, 58¼ x 40½ in. (148 x 102.9 cm). The Metropolitan Museum of Art, New York, Rogers Fund, 1943 (43.101)

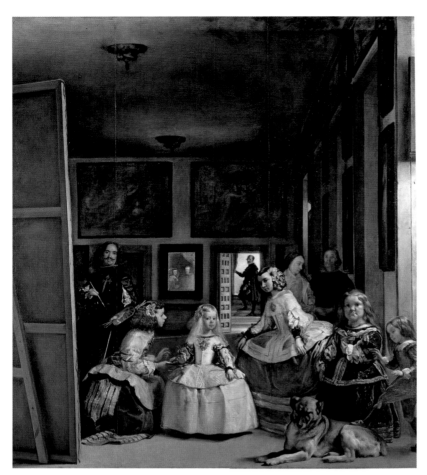

Fig. 1.57 Diego Rodríguez de Silva y
Velázquez, *Las Meninas*, 1656–57. Oil on
canvas, 10 ft. 5¼ in. x 9 ft. ⅛ in. (318 x 276 cm).
Museo Nacional del Prado, Madrid

(Opposite) Fig. 1.59 (cat. 105) Hilaire-Germain-
Edgar Degas, *James Tissot*, 1867–68. Oil on canvas,
59½ x 44⅛ in. (151 x 112 cm). The Metropolitan
Museum of Art, New York, Rogers Fund, 1939
(39.161)

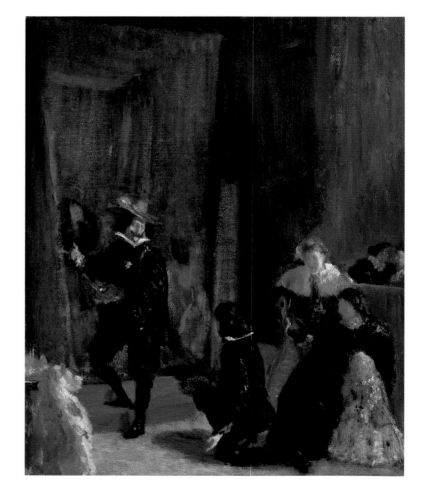

Fig. 1.58 (cat. 102) Hilaire-Germain-Edgar Degas, *Variation on
Velázquez's "Las Meninas,"* 1857–58. Oil on canvas, 12¼ x 9⅞ in.
(31.2 x 25.1 cm). Bayerische Staatsgemäldesammlungen, Munich

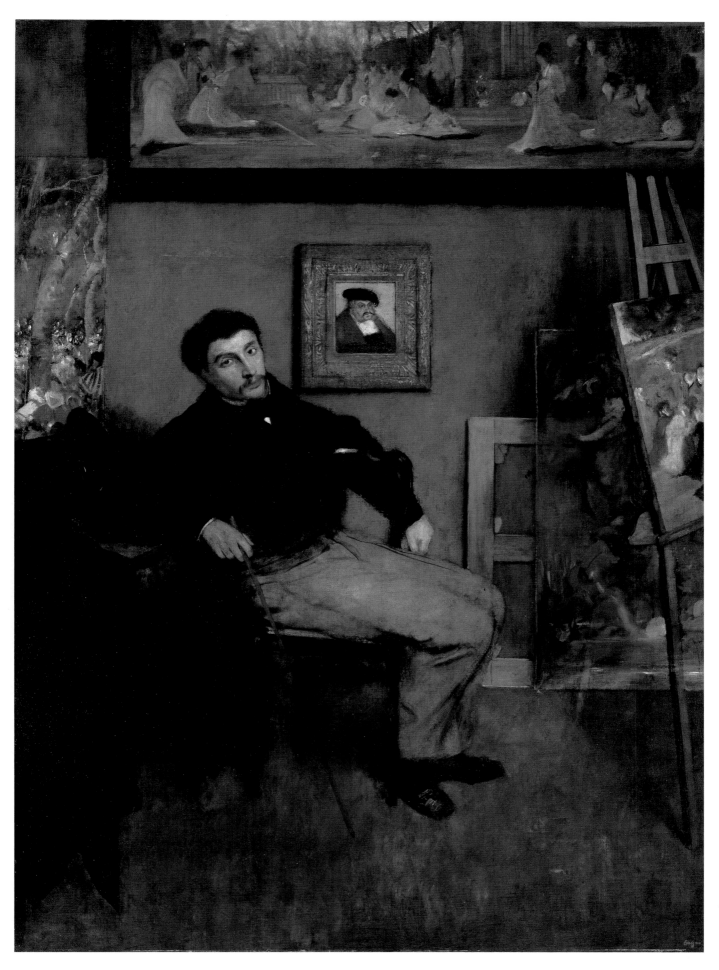

Fig. 1.60 (cat. 144) Édouard Manet,
Woman at Her Window, also called
Angélina, ca. 1860–64. Oil on canvas,
36¼ x 28¾ in. (92 x 73 cm). Musée
d'Orsay, Paris, Bequest of Gustave
Caillebotte, 1891

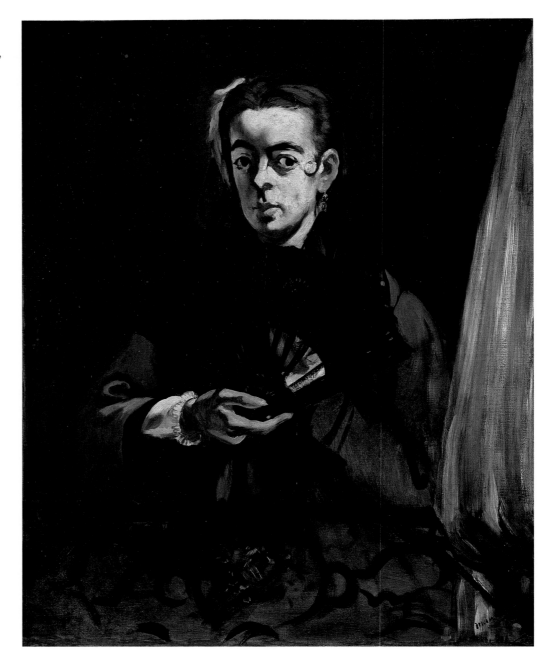

however, depend as much on the example of Manet as of Goya. Hispanism and Manet's work
of the 1860s were often melded into one amalgam, then fused with another. Renoir's 1864
portrait of Romaine Lacaux (fig. 1.64) looks at Velázquez's *Infanta Margarita* at the Louvre;
his 1868 *The Clown (James Bollinger Mazutreek)* (Rijksmuseum Kroller-Müller, Otterloo)
looks at Velázquez through Manet; and his *Madame Henriot in Men's Costume* (1875–76,
Columbus Museum of Art, Ohio) looks through Manet to Velázquez via Watteau. All the
while the idea of Spanish painting continued to evolve. Goya's Black Paintings—without
question the most radically abbreviated, and private, of his works—were exhibited in France
in a striking display at the Paris Exposition Universelle of 1878, where they were immedi-
ately understood in terms of contemporary art: "These canvases, painted with amazing
audacity, are arousing a great deal of criticism and are the object of much debate. Unques-
tionably, the impressionist painters like them, but they must remind them that Goya, who
made these works at the end of the last century and the beginning of the present century,

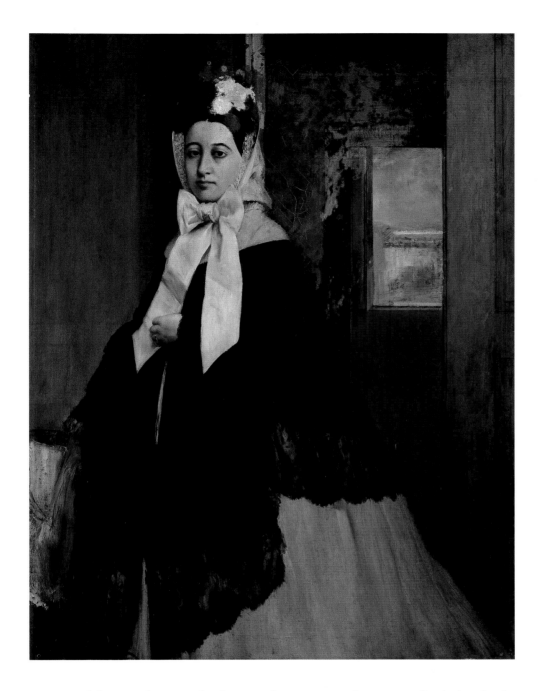

Fig. 1.61 (cat. 104) Hilaire-Germain-Edgar Degas, *Thérèse De Gas*, ca. 1862–63. Oil on canvas, 35 x 26⅜ in. (89 x 67 cm). Musée d'Orsay, Paris

anticipated them, and was unafraid to greatly exaggerate the system of painting that he was trying to have us accept."[135] The confluence of the discovery of the Black Paintings with the high-keyed palette of Impressionism (encouraged by Japanese prints) and the emergence of new Symbolist imagery would propel Goya, and Goya's imitators, to the beginning of the next century.

As Manet followed Monet into Impressionism, a new generation of foreign-born painters began to see Spanish art through Manet's eyes. James McNeill Whistler (1834–1903) encountered Manet in the early 1860s through his friends Fantin-Latour, Carolus-Duran (1837–1917), and Alphonse Legros (1837–1911), and it can be argued that he brought as much of an appreciation of Spanish art to the circle of friends as he took from the example of Manet. His *Harmony in Gray and Green: Miss Cicely Alexander* (fig. 1.65) is an innovative realization of a Spanish infanta transported to the court of Kyoto, while his portrait of Théodore Duret is an homage to Manet (fig. 10.11). When artists like Mary Cassatt (1844–1926),

135. "Ces toiles, peintes avec une audace étonnante, soulevent bien des critiques et sont l'objet de bien des discussions. Elles plaisent sans nul doute aux peintres impressionnistes, mais elles doivent leur rappeler que Goya, qui a fait ces oeuvres à la fin du siècle dernier et au commencement du siècle actuel, les avait devancés, et n'avait pas craint d'exagérer de beaucoup le système de peinture qu'il cherchait à nous faire accepter." Bréban 1878, p. 126.

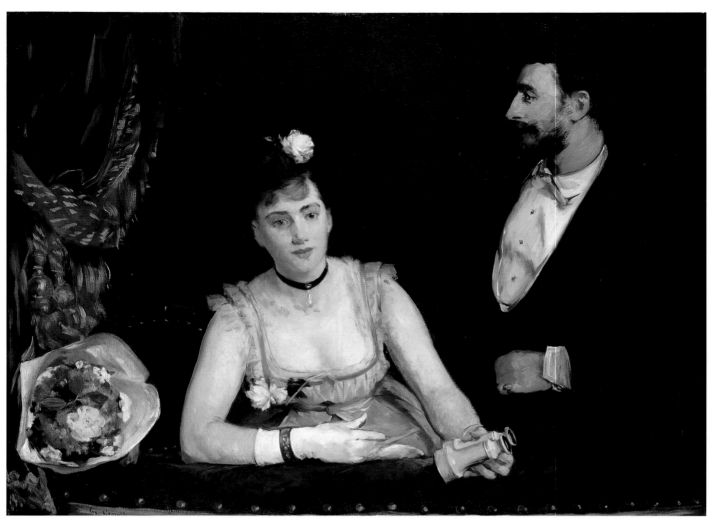

Fig. 1.62 (cat. 123) Eva Gonzalès, *A Box at the Théâtre des Italiens*, 1874. Oil on canvas, 38⅛ x 51⅛ in. (98 x 130 cm). Musée d'Orsay, Paris, Gift of Jean Guérard, the artist's son, 1927

Thomas Eakins (1844–1917), and John Singer Sargent (1856–1925) arrived in Paris, studying with masters as diverse as Jean-Léon Gérôme (1824–1904), Bonnat, and Carolus-Duran, they inevitably turned to Spanish painters for inspiration (fig. 1.66). And if they had not yet seen Madrid, they went. No longer was a tour of Italy obligatory; Spain was the source. Yet Spanish art was no longer what it had been one hundred years before, an esteemed but isolated school; it had been transformed by the French taste for Spanish painting into a foundation of modern art.

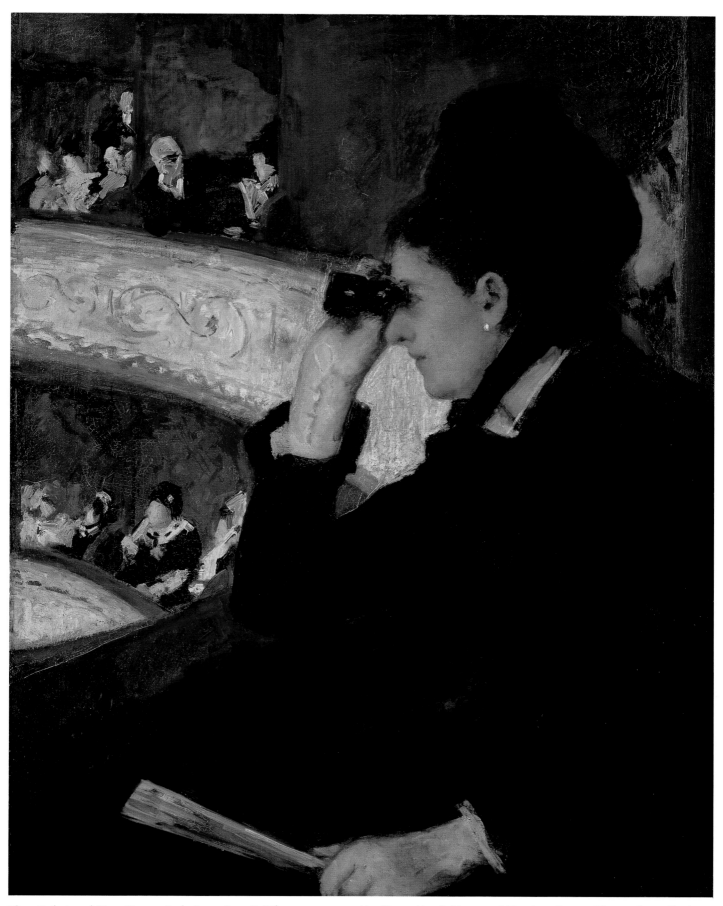

Fig. 1.63 (cat. 202) Mary Cassatt, *In the Loge*, 1877–78. Oil on canvas, 32 x 26 in. (81.3 x 66 cm). Museum of Fine Arts, Boston, The Hayden Collection, Charles Henry Hayden Fund

Fig. 1.64 (cat. 194) Pierre-Auguste Renoir, *Romaine Lacaux*, 1864. Oil on fabric, 31⅞ x 25½ in. (81.3 x 65 cm). Cleveland Museum of Art, Gift of the Hanna Fund

Fig. 1.65 (cat. 222) James McNeill Whistler, *Harmony in Gray and Green: Miss Cicely Alexander*, 1872–74. Oil on canvas, 74⅞ x 38½ in. (190.2 x 97.8 cm). Tate, London, Bequeathed by W. C. Alexander, 1932

Fig. 1.66 (cat. 216) John Singer Sargent, *The Daughters of Edward Darley Boit*, 1882. Oil on canvas, 87⅛ x 87⅛ in. (221.9 x 222.6 cm). Museum of Fine Arts, Boston, Gift of Mary Louisa Boit, Julia Overing Boit, Jane Hubbard Boit, and Florence D. Boit in memory of their father, Edward Darley Boit, 1919

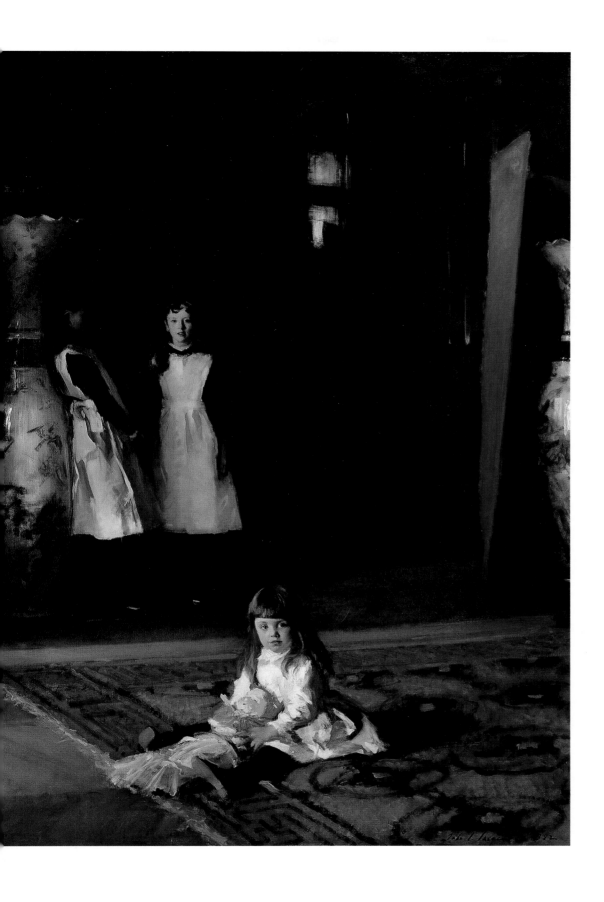

Fig. 2.1 (cat. 78) Workshop of Diego Rodríguez de Silva y Velázquez, *Infanta Margarita* (detail of fig. 1.2)

The Discovery of the Spanish School in France

by Geneviève Lacambre

1. Quoted in Lipschutz 1988, p. 57.

I t is hardly surprising that political events played a decisive role in spreading the influence of Spanish painting or that, in due course, the results of this dissemination surfaced in the work of nineteenth-century French artists.

The degree of impact ranged from extensive to minimal. It was dependent, according to the period, upon factors such as export bans, military conquests, and suppressions of religious orders, exploited by Napoleon's commander Marshal Jean de Dieu Soult and others under the Empire, as well as by Baron Isidore-Justin-Séverin Taylor's mission to assemble Spanish works of art for the creation of Louis-Philippe's Galerie Espagnole. In addition, there were the momentary reappearances, at great public sales, of works that had been buried, or virtually so, in private collections. These sales included works from the collection of Alejandro María Aguado, banker and former aide-de-camp to Soult, offered in 1843; Soult's own holdings, in 1852, on the eve of the dispersal in London of works owned personally by Louis-Philippe; and the collection of Comte Alexandre de Pourtalès-Gorgier, in 1865. It is worth recalling Théophile Thoré's grumbles in *L'Artiste* (1836) on the subject of Soult's prestigious and legendary collection, assembled in Andalusia under the Empire, and the conditions Soult imposed on visitors. Thoré's complaint is real enough, though couched in terms of restraint: "M. Soult agrees with commendable readiness to admit visitors to his gallery by written appointment. Artists, though, don't like making such requests . . . and they cannot analyze these wonderful paintings in a single visit, taking copies or making sketches and studies; so the works are, as I said before, lost to art."[1] Indeed, Thoré had in mind that the collection assembled during the military campaigns of the Empire would have to come back to the nation; however, it is also true that some curious artists, Delacroix among them, were allowed to work at Soult's.

Nevertheless, museums have proven to be the best places for artists to study the great works of the past. The pioneering role of France in the creation and development of these institutions, in both Paris and the provinces, is clearly attested—as is its hand in the establishment of the Museo del Prado in Madrid (opened in 1819), the obligatory destination for many a French painter, especially from the 1850s onward (for discussion of the creation of the Prado, see the essay by Javier Portús Pérez and María de los Santos García Felguera in this publication).

The influence of Spanish paintings held by French museums is exemplified by the first Zurbarán to be acquired by a French museum (Lyon, 1807): his *Saint Francis* (fig. 2.2), for example, spawned countless versions of cowled monks. Its previous

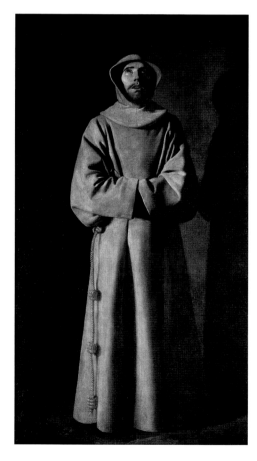

Fig. 2.2 (cat. 90) Francisco de Zurbarán, *Saint Francis*, ca. 1650–60. Oil on canvas, 82¼ x 43¼ in. (209 x 110 cm). Musée des Beaux-Arts, Lyon

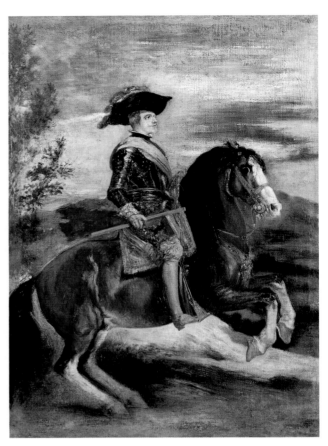

Fig. 2.3 (cat. 199) Amédée Ternante-Lemaire, *Pope Innocent X, Copy after Velázquez*, 1846. Oil on canvas, 51⅛ x 44⅛ in. (131 x 112 cm). Musée National des Châteaux de Versailles et de Trianon, on deposit at the French Embassy, Vatican City

Fig. 2.4 (cat. 191) Gustave Moreau, *Philip IV on Horseback, Copy after Velázquez*, 1859. Oil on canvas, 34½ x 25 in. (87.5 x 63.5 cm). Musée Gustave-Moreau, Paris

owner, the painter Jean-Jacques de Boissieu (1736–1810), had purchased it in 1794. In similar fashion, the Rouen artist Anicet-Charles-Gabriel Lemonnier (1743–1824, laureate of the Prix de Rome, 1772) managed to purchase Velázquez's *Democritus* (then attributed to Ribera; fig. 1.7) in 1797. In 1822 he donated it to the Musée de Rouen, which he had a major role in running beginning in 1800.

Outside France the traditional study tour of Italy could be the means of discovering Ribera in Naples or Rome. More important, in Rome artists would find Velázquez, whose *Pope Innocent X* (Galleria Doria Pamphilj) was frequently copied (fig. 2.3), while in Florence his *Philip IV on Horseback* (Palazzo Pitti) fascinated Gustave Moreau (fig. 2.4) as much as the Van Dycks and the Titians did. Consequently, it is important to evaluate as precisely as possible which works were accessible to artists in various countries, but especially in France. Written sources, though they provide evidence of influence by familiarizing us with the names of painters, discussing their lives and suggesting places to visit, are no real substitute for the works—or at least reproductions of them—that were actually in the eye of the public, including artists. While those reproductions do not convey colors or brushwork, we can glean at least the subject matter and the general composition.

Furthermore, it must be understood that in Paris in 1793, as in Madrid thirty years later, galleries exhibited paintings out of their original contexts, with the result that they came to be judged more on their aesthetic quality, their technique, and their effect than on the subject matter. With a few exceptions, that is particularly true of the Spanish school, as much in Spain as

in other European countries. About 1800, works of art were still to be found in their original locations in churches, palaces, and monasteries, fulfilling their original functions; in previous centuries, diplomatic gifts served as one of the rare means of transmission.

The huge upheavals following the French Revolution liberated a considerable number of paintings, many of which entered the circuit of art lovers and museums. Before the Revolution, Paris could claim few Spanish works accessible to the public. When the Muséum Français opened in the Louvre in 1793, the catalogue[2]—which did not distinguish between schools and listed the paintings according to position in the bays of the main gallery—mentioned only nine Spanish works, issuing from royal collections: five were by Murillo, whose name was spelled "Morillos" or "Murillos." Descriptions were approximate: in the ninth right-hand bay, next to Rembrandt and Titian, was Murillo's *Virgin of the Rosary* (fig. 2.5) (whose title at the time, *Woman with Child Holding a Rosary*, exploited a sense of realism echoed in *Child Sitting in the Sun*, soon to be known as *Beggar Boy* or even *The Flea-Picker* [fig. 2.32]).

Other works in the catalogue were attributed to "L'Espagnolet" (Lo Spagnoletto), an attribution later rejected.[3] His name, Joseph (Jusepe de) Ribera, was cited only once alongside his better-known byname; thus we find, in the second bay, *A Drinker* by "Joseph Ribera, known as L'Espagnolet," not far from *Soldier Leaning on His Lance* by "L'Espagnolet." Alongside the latter hung *School for Young Ladies* by "M. J. Crespy, known as L'Espagnol (Lo Spagnolo)."[4] And nearby—the first sign of the constant problem of whimsical attributions—Collantes's *Burning Bush*, from Louis XIV's collection, lurked behind the name of the Italian artist Domenico Feti.

Subsequent catalogues contained no Spanish paintings, and it was not until 1801 (edition of 25 Messidor Year IX)[5] that we light upon a few Murillos, even though he was the most consistently represented Spanish artist at the Louvre. Listed in the main gallery were two small works on obsidian, *Christ on the Mount of Olives* (fig. 2.6) and *Saint Peter before Christ at the Column* (fig. 2.7).[6] The presentation of the Musée Central des Arts, as it was now called, was completed in 1802 (18 Ventôse Year X) according to the description of the Grand Salon,[7] where "newly restored paintings" were grouped next to works garnered in Italy. Now we find Murillo's *Beggar Boy* and *Virgin of the Rosary* (in the catalogue given the title *Holy Family*) with the Christ Child playing with a rosary. The religious nature of the subject has been identified.

Beginning in 1810, the catalogue of the Musée Napoléon (the renamed Musée Central) was organized by schools, to which each artist was allocated; Italy and Spain were grouped together, more because of the very small number of Spanish works than through ignorance.[8] Alongside the five Murillos of the old stock were several new entries. One was Velázquez's *Family of the Artist* (fig. 2.8), then thought to be by the master himself but undoubtedly the work of his son-in-law Juan Bautista Martínez del Mazo. This painting was brought from Vienna after Napoleon's victory of 1809 (later handed over to commissioner Rosa, curator of the Vienna gallery, on September 9, 1815).[9] The lively scene, a sort of intimist pastiche of

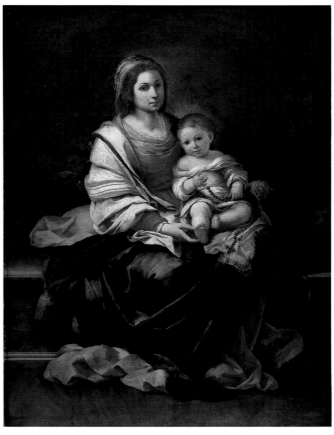

Fig. 2.5 Bartolomé Esteban Murillo, *The Virgin of the Rosary*, ca. 1650. Oil on canvas, 63 x 49¼ in. (160 x 125 cm). Musée Goya, Castres

2. *Catalogue des objets contenus dans la galerie du Muséum français* (Paris, 1793). See Marquet de Vasselot 1927, no. 105.

3. See the Chronology: 1793.

4. Marquet de Vasselot 1927, no. 316.

5. Ibid., no. 114.

6. See Meslay 2001.

7. Marquet de Vasselot 1927, no. 121. This catalogue was organized alphabetically, by artists' names.

8. Ibid., nos. 129–34 (in 1814 and 1815, Napoleon's name disappears from the title page). In these catalogues, Italian schools are listed separately by city or region, including the Spanish school, while the German, Flemish, and Dutch schools are classed together.

9. Archives des Musées Nationaux, 1 DD 53, p. 86 (no. 208).

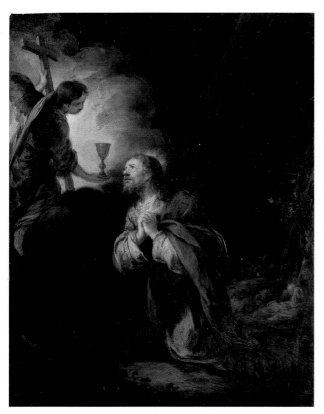

Fig. 2.6 Bartolomé Esteban Murillo, *Christ on the Mount of Olives*, ca. 1670. Oil on obsidian, 14 x 10⅜ in. (35.7 x 26.3 cm). Musée du Louvre, Paris

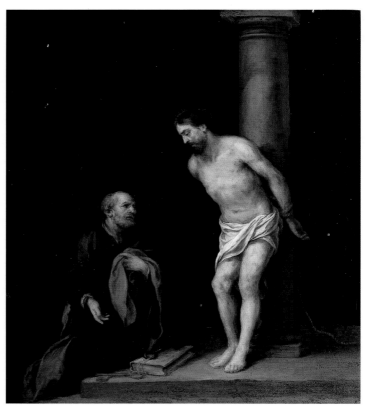

Fig. 2.7 Bartolomé Esteban Murillo, *Saint Peter before Christ at the Column*, ca. 1670. Oil on obsidian, 13¼ x 12⅛ in. (33.7 x 30.7 cm). Musée du Louvre, Paris

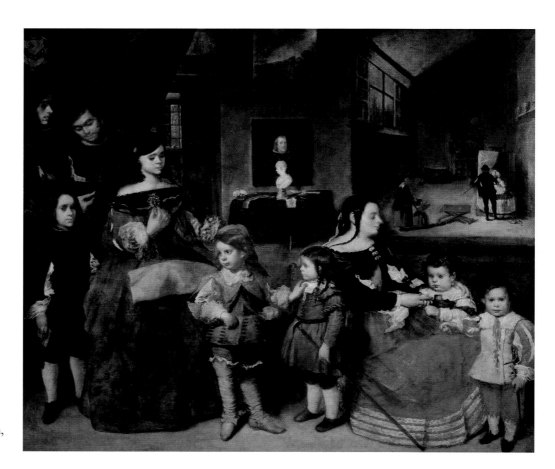

Fig. 2.8 Juan Bautista Martínez del Mazo, *Family of the Artist*, 1664–65. Oil on canvas, 58¼ x 68¾ in. (148 x 174.5 cm). Kunsthistorisches Museum, Vienna

Las Meninas, is described in the inventory of the Musée Napoléon: "The artist depicts himself in his studio painting the portrait of the archduchess Maria Anna, second wife of Philip IV, king of Spain."[10] Of the two Riberas mentioned,[11] one, *Mater Dolorosa,* was returned to Brunswick in 1815; the other, *Adoration of the Shepherds,* was donated by the king of Naples in 1802 as a replacement for paintings removed from San Luigi dei Francesi in Rome by Neapolitan forces. This major work was not restituted in 1815 and remained the Louvre's sole permanent acquisition of Spanish painting from the Consulate and the Empire.

The tempestuous conquests in Spain also left a temporary imprint upon the Louvre. Pictures from all the schools poured into Paris from Spain during 1813. Most of these, seized from the noble families and religious orders of Spain, were adjudged to be, on the whole, mediocre.[12] Fifty additional works, all by Spanish artists, arrived as a "gift" from Joseph Bonaparte—"sent by His Majesty the King of Spain."[13] Although there was a full reserve stock, what was actually shown to the public in the Grand Salon between July 25, 1814, and September 1815 was very limited, according to the three catalogues of those two years (during which the museum adopted its title of "Royal" before briefly reverting to "Musée Napoléon" for the edition of April 1815,[14] which coincided with the Hundred Days).

Fig. 2.9 (cat. 126) Jean-Jacques Henner, *Henriette Germain,* 1874. Oil on canvas, 15¾ x 12⅝ in. (40 x 32 cm). Musée National J. J. Henner, Paris

In addition to Collantes's *Burning Bush* from the old stock—the artist having been correctly identified and the painting hung with his other work—sixteen Spanish pictures recently from Spain were displayed. Eleven of them originated from King Joseph; four, of a very large format (three Murillos and one Zurbarán), were donated by Marshal Soult in May 1813, judiciously selected by Vivant Denon, director-general of French museums, from the collection Soult had brought back to Paris from Andalusia.[15] The last was a curiosity: Ribera's *Bearded Woman,* from the collection of San Istevan Medina Coeli.[16]

Thus, during a few months the public was treated to a small number of works from Spain by Spanish artists, although those displayed were often both large in size and remarkable in quality. Admittedly, after Napoleon's defeat, the commissioners for the restitution of Spanish works—Lacoma, Desjobert, and Arango—proved particularly efficient from the start. Conde Fernán Núñez, ambassador and representative of Spain at the Congress of Vienna, had named the painter Francesco Lacoma (1784–1819) as "representative of the Grandees of Spain," defining these as "the ten first families of Madrid." Lacoma knew France well; he had enjoyed a traveling scholarship for five years and won a medal at the 1810 Salon for his floral paintings. On May 7, 1814, Charles Desjobert, French vice-consul—later consul—at Madrid, drew up a list of works to be returned, corresponding to the lot forwarded from Madrid on March 18, 1813. After verification at the Louvre, on May 15, 1814, Lacoma and Desjobert signed the documentation relating to 230 works—the very first restitution to be initiated after Louis XVIII's decree of May 8, 1814, ordering the return of artworks taken from the German states and Spanish nobles. Packing was completed on September 28, 1814 (credit for nineteen crates had been sought as early as June 20, 1814). The crates were then expedited to Bayonne, where they were made available to the Spanish ambassador. They arrived in Madrid at year's end, under the supervision of a certain Arias, who submitted an invoice for his labors in December 1814.[17]

Seven works, however, were retained in Paris, with the agreement of the commissioners. Only one, described in the inventory as "an old woman who has grown a beard and is suckling

10. "L'artiste s'est représenté dans son atelier faisant le portrait de l'archiduchesse Marie-Anne, 2e femme de Philippe IV roi d'Espagne." Ibid., 1 DD 16, no. 1213, p. 123; 58¼ x 66⅞ in. (148 x 170 cm).

11. The author of the catalogue proposes a fanciful biography: "Espagnolet (Giuseppe Ribera, known as L'), born 1593. True name unknown: *Ribera* (in French, *shore*), merely indicates his birthplace. Spanish School." ("Espagnolet (Giuseppe Ribera, dit l'), né en 1593. On ignore le nom de cet artist. *Ribera* (en français *rivage*) désigne seulement l'endroit où il naquit. École espagnole").

12. Archives des Musées Nationaux, 1 DD 16. Of 110 paintings inventoried in "Italian Schools: Supplement," only Ribera appears in alphabetical order, represented by two titles, including two "imitations" (p. 134 E). Four other works (later associated with Murillo and Velázquez) occur among the fifty or so unknowns listed in due course (p. 134 J–N); a *Christ at the Column,* by an imitator of Morales (p. 134 Q) has accidentally found its way among the pictures shipped by the king of Spain: see n. 13.

13. Ibid., p. 134 O–T, under the title "Spanish School: Supplement," are fifty-five works; these include, besides the Morales cited in n. 12, the four paintings donated by Soult in 1813.

14. Marquet de Vasselot 1927, nos. 138–40 (the same text, but the two earlier versions bear the words "Musée royal"

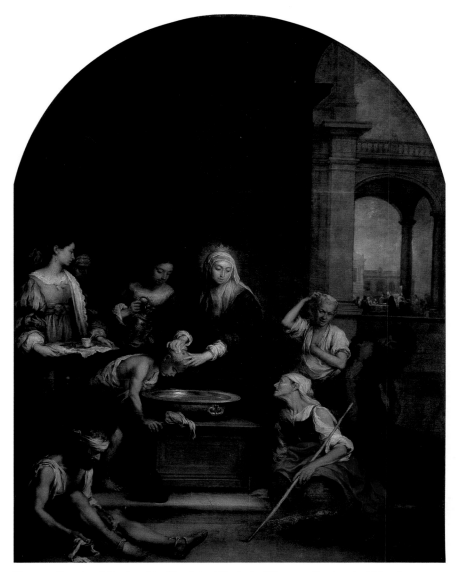

Fig. 2.10 Bartolomé Esteban Murillo, *Saint Elizabeth of Hungary Nursing the Sick*, 1672. Oil on canvas, 10 ft. 8 in. x 8 ft. ¼ in. (325 x 245 cm). Church of the Hospital de la Caridad, Seville

on the title page; the third, dated April 1815, "Musée Napoléon").

15. Denon 1999, nos. 2809, 2825.

16. Archives des Musées Nationaux, 1 DD 53: "Recueil des procès-verbaux de remise de tableaux."

17. Denon 1999, nos. 3123, 3234, 3308.

18. "Une vieille femme à qui il est venu de la barbe et qui allaite un enfant." Archives des Musées Nationaux, 1 DD 16, p. 134 A; no. 22; 76¾ x 48 in. (195 x 122 cm).

19. "Ce tableau est en restauration et l'on se propose de le copier pour l'École de Médecine." Ibid., 1 DD 53, p. 3. The copy mentioned is no longer at the École de Médecine, Paris.

20. "Et le même jour ont été enlevés par violence deux Morillos représentant la fondation de Sainte Marie Majeure en deux tableaux et indiqués dans l'inventaire sous les nᵒˢ 83 et 84 du catalogue du Salon." Ibid., 1 DD 53, p. 10. The

a child," was by a Spanish artist, in this case Ribera.[18] According to the records, "This painting is undergoing restoration, and it is proposed to make a copy for the École de Médecine."[19] It soon appeared in the catalogue of works exhibited in the Grand Salon (editions of July 1814 and 1815), in which mention is made of two Latin inscriptions revealing that the person in question was Magdalena Ventura, "a prodigy of nature." The painting would not be released to Spain until September 24, 1815, during the second major round of restitutions, which took place on September 23, 24, and 25. The Ribera was then one of forty-seven of the works sent to the Musée Napoléon by Joseph Bonaparte to be returned, along with the three Murillos from Soult's collection. Murillo's *Saint Elizabeth of Hungary Nursing the Sick* was sent back on September 23 by force, and the same could be said for the other two. The records declare, "Two Murillos, depicting the foundation of S. Maria Maggiore [figs. 1.22, 1.23], and inventoried as nos. 83 and 84 of the Salon catalogue, were forcefully removed."[20] Part of the contention may have concerned the fact that the museum had gone to great expense to fit these two vast lunettes with rectangular gold frames and decorative quoins. September 29, 1815, saw the departure of the fourth picture donated by Soult: "M Lacoma removed from the gallery

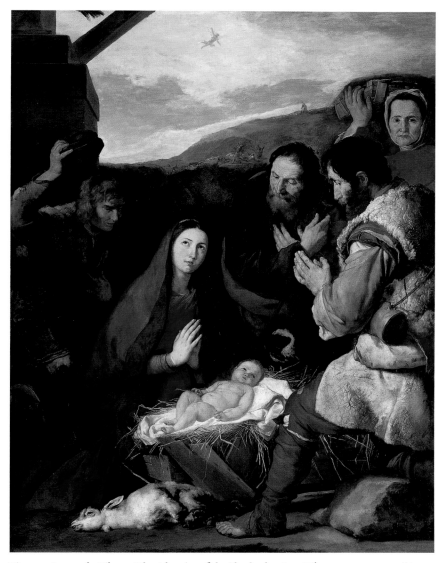

Fig. 2.11 Jusepe de Ribera, *The Adoration of the Shepherds*, 1650. Oil on canvas, 94 x 74¼ in. (239 x 181 cm). Musée du Louvre, Paris

of the Musée royal *Saint Thomas of Aquin* [*sic*] *with the Doctors of the Church* [fig. 3.9], by Zurbarán."[21] Two final Spanish works left Paris on October 3, 1815. All would be handed over at Madrid in the course of 1816.

A few masterpieces would quit France permanently. The four pictures in Soult's collection had been fêted by the press, and Murillo's *Saint Elizabeth of Hungary Nursing the Sick* (fig. 2.10) remained vivid in popular memory. Throughout the nineteenth century, it could still be admired at the Academia de Bellas Artes de San Fernando in Madrid. (It has since returned to Seville.) Louis Viardot wrote a long and enthusiastic description of the painting, noting particularly how "this composition brings together the extremes of Murillo's subjects: the filth and poverty, the verminous raggedness, of his young beggars, and the grandeur—simple, noble, and sublime—of his saints. Hence springs the charm of perpetual contrast and a high sense of moral purpose. . . . In this work, the composition is magnificent . . . the lines display a boldness and purity defying all censure, while the colors have that magical brilliance whose secret is known to Murillo alone."[22] Charles Blanc returned to this description in the first edition of his *Histoire des peintres de toutes les écoles* (History of the painters of

numbers refer to the 1814 and 1815 catalogues.

21. "M. Lacoma a enlevé de la galerie du musée royal *St Thomas d'Aquin* [*sic*] *au milieu des Docteurs de l'Eglise*, par Zurbaran." Ibid., 1 DD 53, p. 11. See Paris 1999–2000, pp. 241–43 n. 104.

22. "Ce sujet réunissait merveilleusement les deux manières extrêmes de Murillo: la misère sale, déguenillée et vermineuse de ses petits mendiants; la grandeur simple, noble et sublime de ses saints. De là naît aussi le charme d'un perpétuel contraste et d'une haute moralité. . . . Dans ce tableau, l'ordonnance de la scène est magnifique . . . , le dessin d'une hardiesse et d'une pureté qui défient toute censure, la couleur, de cet éclat magique don't Murillo seul a le secret." Viardot 1843, pp. 174–75, where he develops earlier comments from his biography of

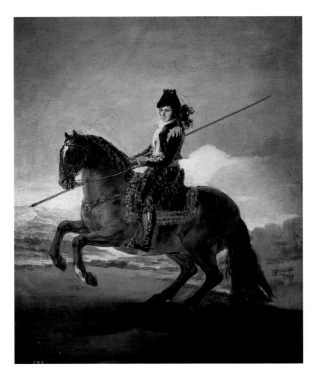

Fig. 2.12 (cat. 5) Francisco de Goya y Lucientes, *A Picador*, ca. 1792?, reworked ca. 1808. Oil on canvas, 22½ x 18½ in. (57 x 47 cm). Museo Nacional del Prado, Madrid

Murillo in *Notice sur les principaux peintres de l'Espagne* (1839).

23. "En 1814, le maréchal Soult offrit à Louis XVIII trois tableaux de Murillo que lui avait donnés la ville de Séville: ces tableaux ont été admirés au Louvre, ainsi qu'une autre peinture de ce maître, à l'exposition de la même année; en 1815 on les rendit à l'Espagne." Anon. 1834b, pp. 209–10.

24. Anon. 1834a, pp. 353–54.

all the schools), dreaming, albeit unsuccessfully, of exhibiting a copy of the painting in his Musée Européen in 1872–73.

In a Louvre bled dry during the Restoration, the best works from the old stock were regrouped. Velázquez's *Infanta Margarita* (fig. 2.1) appeared in the catalogue for 1816. The little four-year-old princess, her eyes sparkling with life, would ever afterward cast her spell upon visitors, including artists such as Jean-François Millet and Jean-Jacques Henner (fig. 2.9). This work is presently attributed to Velázquez's workshop, but who is to say he did not have a hand in it? It was closely scrutinized as a genuine work: Henner, a great admirer, analyzed its palette—natural earth tones rather than yellow, and silvery hues—which he adopted in turn when painting skin tones.

The Spanish school and the leading masters of the Golden Age made their mark, even in the popular press. The tumultuous period of the Empire had proved an inspiration for French publications, sometimes illustrated, such as Jean-Baptiste-Pierre Lebrun's 1809 catalogue of Spanish paintings, or packed with information and anecdotes, such as Frédéric Quilliet's *Dictionnaire des peintres espagnols* (Dictionary of Spanish painters), published in 1816. The latter, appearing in the first days of the Restoration and dedicated to the duc de Berry, was a veritable compilation of the work of earlier Spanish historians. A few lithographs were published in Madrid in 1826, under the direction of José de Madrazo, by French copyists who had traveled to work on the spot: Pierre-Jules Jollivet, Pharamond Blanchard, and Baron Taylor, for instance. The subjects were usually from the Spanish royal collections, notably from paintings by Velázquez. Yet there is no evidence for the popularity of the lithographs in France, and the most likely vehicle for the transmission of Spanish influence remains the popular illustrated press.

In its second year of publication, the *Magasin Pittoresque*, founded in 1833 and abundantly illustrated with some five hundred engravings each year, began to attract the public's attention to Spanish artists. First came Murillo, the Spanish artist best represented at the Louvre. The magazine reproduced his *Beggar Boy*, which hung with the Italian works at the end of the museum's main gallery. (Although this display combined the southern schools of Spain and Italy, everyone was clear about the geographical distinctions.) As reproduced in the magazine, the picture served as a pretext for the study of the behavior and physique of poor children. It was followed by a brief biography of the painter, then the list of his works in the Louvre's collection. By way of a somewhat muddled valediction came this statement, no doubt inspired by nostalgia: "In 1814, Marshal Soult offered Louis XVIII three pictures by Murillo, which the city of Seville had presented to him. These pictures were admired at the Louvre, as well as another by this master, during the exhibition of the same year. In 1815, they were returned to Spain."[23]

The *Magasin Pittoresque* featured numerous biographies of painters. Twelve appeared in 1834: two Flemings, three Italians (including Leonardo da Vinci), four Frenchmen (Greuze, Poussin, Watteau, and one living artist, Delaroche), and—forming a substantial proportion of this glittering assembly—three Spaniards. The Spanish group consisted of Murillo, already mentioned; Ribera, illustrated by his *Adoration of the Shepherds* (fig. 2.11) from the Louvre;[24] and Goya, who had died six years earlier at Bordeaux and who "would have loved to have

reincarnated Velázquez." Goya was already well known by art lovers and artists, particularly Delacroix, for his *Caprichos,* from which the three illustrations for the article were taken. Among them was the self-portrait on the frontispiece (fig. 5.6), indispensable to any examination of the man, his character, and the incidents in his life. As there were no Goyas at the Louvre, a few works from the Museo del Prado in Madrid were cited but not reproduced: "a portrait of Charles IV, another of the queen on horseback, a *picador*" (fig. 2.12). A glimpse of Goya's unusual technique for decorating the walls of his "delicious villa" may have suggested some ideas to those weary of the cultured classicism of Jacques-Louis David and his school: "Sometimes he threw a mixture of colors into a cauldron and hurled them violently against a huge, whitewashed wall. He delighted in creating impressive scenes of contemporary history from this chaotic mass of splashes."[25]

This fanciful description, though it does show a vague acquaintance with the artist's residence, the Quinta del Sordo, on the outskirts of Madrid, reminds us that, at the end of his life, Goya had frequented artistic circles in Bordeaux,[26] in particular that of the young Adrien Dauzats, a pupil of Lacour's at the École de Dessin. According to Philippe Burty, "On occasion an old man would come into the classes, a deaf Spaniard with uncouth features, a turned-up nose, and a mouth like a satyr; he would shake the hand of his old friend Lacour and watch the pupils at work through his double spectacles. This was Francisco Goya y Lucientes, the immortal creator of *Los Caprichos.*"[27]

The young artist's encounters with Goya may well have some connection with the interest shown in Goya by the mission of Baron Taylor, authorized by Louis-Philippe late in 1835 to purchase works of art in Spain, of which Dauzats was a member.[28] Goya's work was certainly available on the market, as Javier Goya, his son, had recently decided to sell the works

25. "aurait espéré faire revivre Velázquez"; "un portrait de Charles IV, un portrait de la reine à cheval, un *picador*"; "délicieuse villa"; "Quelquefois il jetait dans une chaudière des couleurs mêlées, et les lançait avec violence contre un vaste mur blanchi; il se plaisait à faire sortir de ce chaos d'éclaboussures des scènes imposantes de l'histoire contemporaine." These quotations from Anon. 1834c, p. 324.
26. Worth mentioning, too, is *Le Mariage burlesque* by Jean-Louis Gintrac (published in *L'Artiste,* 1834), after a Goya tapestry. Gintrac, a native of Bordeaux, had traveled in Spain. See Paris 1935, no. 322; Lipschutz 1988, p. 95; Sanchez and Seydoux 1998, vol. 1, nos. 1834–95.
27. "Quelquefois un vieillard, un Espagnol sourd, aux traits rudes, au nez en l'air et à la bouche satyrique, venait au cours, serrer la main de son vieil ami Lacour et regarder, sous ses doubles lunettes, les travaux des élèves. C'était Francisco Goya y Lucientes, l'immortel auteur de *los Capricios.*" Burty 1877, pp. 162–63. The chapter on Adrien Dauzats (d. 1868) dates from 1869.
28. See Plazaola 1989, pp. 121–43.

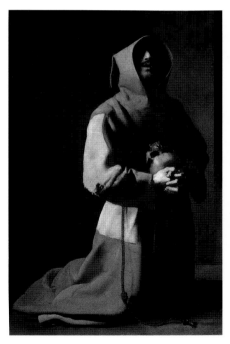

Fig. 2.13 (cat. 85) Francisco de Zurbarán, *Saint Francis in Meditation,* ca. 1635–40. Oil on canvas, 60 x 39 in. (152 x 99 cm). National Gallery, London

Fig. 2.14 E. Forest (after Francisco de Zurbarán), *Saint Francis,* 1837. Lithograph published in *L'Artiste* 14 (1837)

Fig. 2.15 Charles Blanc, *Monk at Prayer,* 1869. Engraving by A. Masson in Blanc et al. 1869, n.p.

Fig. 2.16 (cat. 196) Théodule-Augustin Ribot, *The Torture of Alonso Cano*, 1867. Oil on canvas, 59 x 82¼ in. (150 x 209 cm). Musée des Beaux-Arts, Rouen

29. Sanchez and Seydoux 1998, vol. 1, nos. 1837–97.

30. *Notice des tableaux de la Galerie Espagnole exposés dans les salles du Musée Royal au Louvre* (Paris, 1838). See Baticle and Marinas 1981, with the revision of the 1838 fourth edition, and the current location of paintings.

31. "sous la restauration, par l'auteur d'un dictionnaire biographique des peintres espagnols." Quilliet 1816, p. xxxvi.

32. "précis sur l'histoire des beaux-arts en Espagne." Anon. 1838d, pp. 17–19, illustrated with portraits of Velázquez and Murillo.

he had inherited. Nonetheless, Taylor and his colleagues showed considerable boldness in appreciating a painter whose abilities were still seriously questioned; in a similar manner, they had exploited the political situation to acquire so many Zurbaráns, an artist sorely missed in France since the departure from the Louvre in 1815 of the painting Soult had donated.

After years of scarcity, the sudden influx of hundreds of works from beyond the Pyrenees that resulted from the success of the Taylor mission was bound to accelerate the assimilation of Spanish art. Even before the galleries holding the new acquisitions were opened to the public in 1838, amid a great burst of excitement, Zurbarán's *Saint Francis in Meditation* (fig. 2.13) was reproduced in *L'Artiste* (fig. 2.14).[29] The choice was a judicious one, as its striking realism and somber, romantic qualities made it one of the most admired works in the collection of the Galerie Espagnole. The catalogue of 1838 was conscientiously compiled:[30] artists were presented in alphabetical order, each with biographical details, and categorized by school— Cordova, Seville, Castile, Granada, or Valencia. Not included in this classification by school were Antonio Viladomat y Manalt, who was born and died in Barcelona, and Zurbarán himself. The *Magasin Pittoresque* noted this new method of classification and compared it with that undertaken "under the Restoration, by the author of a biographical dictionary of Spanish painters" (with three schools only: Valencia, Madrid, and Seville).[31] The editor indicated as well, though not mentioning it by name, that his habitual source of reference was none other than Quilliet's book. Regretting that there is no "proper summary of the history of the fine arts in Spain,"[32] he informed his readers on the three leading artists of Quilliet's choice, drawing to their attention for the first time the opulent lifestyle of Velázquez, traveler and court painter.

The years following 1838 witnessed the revival of interest not only in "art tours" to Spain but also in Spanish painting. Reproductions and publications multiplied: in the wake of studies by Prosper Mérimée and Théophile Thoré came those of men like Louis Viardot or Théophile

Gautier. Copyists discovered a wealth of models to exploit, as can be seen from Dominique Lobstein's study in this publication (see Appendix 1). Lifesize color reproductions of religious works in the Galerie Espagnole found their way into the most modest village churches,[33] while the success of other Spanish works in the Louvre was confirmed; as a group, they established a fierce rivalry with Prud'hon's *Assumption of the Virgin* (1819, Musée du Louvre, Paris). Of course, copies after Murillo were to be found in the greatest numbers, his *Immaculate Conception*[34] as much as his *Virgin of the Rosary*.[35] The popularity of religious works arose from the re-Christianization of France and the construction of many new churches. Velázquez, all the same, continued in the ascendancy, and was even introduced by Paul Delaroche into his vast hemicycle for the École des Beaux-Arts, completed in 1841: among the sixty-nine leading artists representing every age, Murillo is the fourth from left, Velázquez, eleventh.

Few copyists have left their mark on the history of art, yet some, who have had to undergo training in this discipline as part of civil service requirements, have gone on to make successful careers. Visitors standing before the *Virgin of the Rosary*, still in the church at Avaray (Cher), are doubtless unaware that this was one of the first works of Rosa Bonheur, who would later specialize in animal paintings. The copy was commissioned from the civil list of Louis-Philippe in 1844.[36] We also come across the name of the landscapist Antoine Chintreuil and that of Nicolas-François-Octave Tassaert, whose suave style is probably more Spanish than it appears.[37]

Since the end of the eighteenth century, many artists had been attracted to inspirational or remarkable episodes in the lives of the old masters, a tendency perfectly in harmony with the development of the museums. Paintings dealing with the lives of Spanish artists, however, appeared only after the opening of the Galerie Espagnole (if one excepts the picture shown at the 1822 Salon by Joseph Beaume, a specialist in historical genre scenes, under the title *The Slave of Velázquez*).[38] Even if their numbers remained modest compared with the real favorites—the Italians were ten times more numerous, the French three times—the twenty subjects inspired by the lives of Spanish artists dating from the 1839 Salon onward provide a fresh indicator of the growth in appreciation. Of a total of six connected with Murillo, five with Velázquez, four with Ribera, four with Zurbarán, and one with Alonso Cano, spread over the thirty years following (no more appeared after 1870), eight date from before 1849: Ribera and Zurbarán are level with three works each, and Murillo, with his uneventful life, boasts only two. For the 1840 Salon, Joseph-Nicolas Robert-Fleury even entered two subjects drawn from the lives of Murillo and Ribera without clarifying the episodes involved. A reproduction in *Magasin Pittoresque* the following year indicates that he painted Murillo as a child drawing on a wall and about to be chastised by a monk armed with a whip.[39]

Jules Laure presented his *José de Ribera (Known as Lo Spagnoletto) and Juana* at the 1839 Salon, and Henri Baron's *Ribera's Childhood*,[40] later engraved by Robert Nanteuil, appeared in 1841. One is led to wonder if Robert-Fleury's *Subject Drawn from the Life of Ribera* is not the work that inspired the anonymous illustration in chapter 9—devoted to Spanish painters—of *Les peintres célèbres* (The famous painters) by F. Valentin.[41] Published at Tours by Mame, it belonged to that class of slim, elegant, leather-bound volumes presented at prize givings to

Fig. 2.17 (cat. 82) Anonymous (formerly attributed to Diego Rodríguez de Silva y Velázquez), *Portrait of a Monk*, 1633. Oil on canvas, 36⅜ x 28⅞ in. (92.5 x 73.5 cm). Musée du Louvre, Paris

33. For instance, at Cély-en-Bière (Seine et Marne) a copy (LP 581, shipment of 1844) of Murillo's *Christ at the Column* is still in a good state of preservation. The artist was Mlle Giraudeau. This is in fact the *Ecce Homo* (now at El Paso) of the Galerie Espagnole.

34. Baticle and Marinas 1981, no. 152; 81½ x 48⅞ in. (207 x 124 cm), now attributed to a pupil of Murillo (National Gallery, London). Copies of this work are still in situ: e.g., one by Ternante (LP 5152) sent in 1842 to Souvigny (Allier), presently in the new chapel of the Priory Church of Saints Peter and Paul (which also contains the tomb of the duc de Bourbon); another, by Mlle Levol (LP 7318), sent in 1849 to the Abbey Church of Saint-Saulve, Montreuil-sur-Mer.

35. Deposited by the Louvre (inv. 929) at the Musée Goya, Castres.

36. Inventory LP, Louvre; LP 6039, decision of August 17, 1844, presented to the church at Avray [*sic*] in the diocese of Blois on September 3, 1844. These copies, listed in the same inventory, are somewhat more numerous than those of Murillo's *Immaculate Conception* (Galerie Espagnole), of which there are between twelve (of the same dimensions) and nineteen (of the same subject, perhaps with variations).

37. His copy of *Virgin of the Rosary*

Fig. 2.18 (cat. 79) Workshop of
Diego Rodríguez de Silva y
Velázquez, *Gathering of Gentlemen*.
Oil on canvas, 18⅝ x 30⅝ in. (47.2 x
77.9 cm). Musée du Louvre, Paris

Fig. 2.19 (cat. 129) Édouard Manet,
*The Little Cavaliers, Copy after
Velázquez*, 1859–60? Oil on canvas,
18 x 29¾ in. (47 x 78 cm). Chrysler
Museum of Art, Norfolk, Va., Gift
of Walter P. Chrysler, Jr.

(LP 7391, decision of December 12,
1847) was dispatched to Chenonceaux
in 1859; meanwhile, it was listed in the
Louvre's catalogue, produced by
Frédéric Villot, along with other works
of the Spanish school (inv. 934); see
Villot 1853 and subsequent editions.

38. Salon of 1822, no. 52. The subject mat-
ter, detailed in the handbook, is the dis-
covery by Philip IV, on Velázquez's
staircase, of the talent of the latter's
slave, Juan de Pareja (1606–1670), a
discovery that led to Pareja's emancipa-
tion. Joseph Beaume turned to Giotto at
the Salon of 1846, and to the van Eyck
brothers for that of 1850–51. See Roman

instruct Christian youth. In it we learn that Ribera, at the height of his fame, had refused to be
tempted by two alchemists, indicating all the gold he could obtain by selling a single picture.[42]
The author, writing after the Aguado sale and the inauguration of the Galerie Espagnole,
maintains Quilliet's division into three schools and details the lives of Velázquez, Ribera,
Murillo, and Cano, merely citing Zurbarán's name among a number of others. The old French-
language works by Alexandre de Laborde and Quilliet virtually ignored Zurbarán, as the
Magasin Pittoresque of 1838 remarked when offering its readers a biography devoid of anec-
dote.[43] It was only later that he began to inspire other painters. For the Salon of 1848,
Ferdinand Wachsmuth entered *The Youth of Zurbarán*; Alfred Bourdier and Désiré Laugée,
for 1850–51, painted his death.[44] Finally, when Victor-Jacques Renault, in 1867, entered
Zurbarán Painting the Monk at Prayer, he must have had in mind the famous *Saint Francis* of the

Fig. 2.20 Francisco de Zurbarán, *Saint Bonaventure at the Council of Lyon*, ca. 1629. Oil on canvas, 98½ x 88½ in. (250 x 225 cm). Musée du Louvre, Paris

Fig. 2.21 (cat. 127) Alphonse Legros, *Making Amends*, 1868. Oil on canvas, 70½ x 68⅞ in. (179 x 175 cm). Musée d'Orsay, Paris

Galerie Espagnole (fig. 2.13) or, even more likely, the engraving published in the *Histoire des peintres de toutes les écoles* with the title *Monk at Prayer* (fig. 2.15).[45]

Certain subjects intrigued artists, such as the slave of Velázquez (reprised by Jean-Baptiste Dehaussy at the 1857 Salon) or Ribera's early career. Two works featuring Ribera are known through reproductions, so we can clearly see that Léon Bonnat's *Ribera Painting at the Door of the Aracoeli, Rome*[46] is quite different from Baron's treatment of 1841, which is set in a park. As for the *Torture by Wedges*, by Théodule Ribot, which deals with a nasty moment in Alonso Cano's life, it would have escaped a straightforward analysis of titles had it not also been exhibited under another name (*The Torture of Alonso Cano*; fig. 2.16).

At this point in time, with the serial publication of Blanc's *Histoire des peintres de toutes les écoles* beginning about 1849, the position of Spanish art changed completely. This involved not only the museums, that is, in terms of the accessibility of works to the public and to artists, but also the availability of books. Granted, with the departure of Louis-Philippe the Louvre had lost its Galerie Espagnole, as well as the Standish collection; the latter had also contained a substantial number of Spanish works and had been the scene of a certain amount of copying.[47] The paintings and drawings that Frank Hall Standish had assembled in Seville had been bequeathed to Louis-Philippe in 1842, returned to his family in 1850, and sold off in London in 1853. But the void at the Louvre was gradually filled by the purchase of both minor and major works. The first two, in 1851, were thought to be by Velázquez. One was the portrait of an ecclesiastic (fig. 2.17) and

Fig. 2.22 (cat. 86) Francisco de Zurbarán, *Saint Lucy*, ca. 1636. Oil on canvas, 45¼ x 26¾ in. (115 x 68 cm). Musée des Beaux-Arts, Chartres

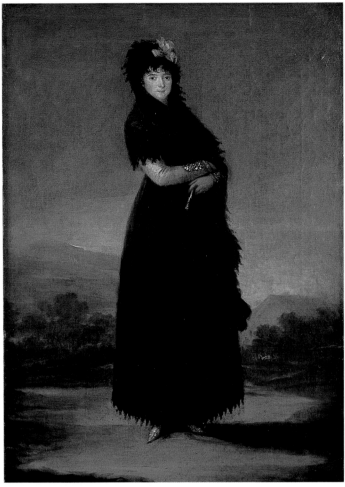

Fig. 2.23 (cat. 13) Francisco de Goya y Lucientes, *Woman in Spanish Costume*, ca. 1797–99? Oil on canvas, 20½ x 13⅜ in. (52 x 34 cm). Musée du Louvre, Paris, Bequest of Louis Guillemardet, 1865

Fig. 2.24 (cat. 192) Henri Regnault, *Countess de Barck*, 1869. Oil on canvas, 23⅝ x 17⅜ in. (60 x 44 cm). Musée d'Orsay, Paris

d'Amat 1987, pp. 19–20, of whose unpublished papers I have made extensive use.

39. Reproduced in 1841, p. 117, with the caption: "Salon of 1840—Murillo as a Child, by Robert-Fleury."

40. Roman d'Amat 1987, pl. 3, after Tenint 1841. See also Pierre Rosenberg, "De Ribera à Ribot," in Naples–Madrid–New York 1992, pp. 153–54 (Madrid ed.), who notes, in addition, at the 1843 Salon, an *Enlèvement de la fille de Ribera* *(Kidnapping of the Daughter of Ribera)*, by Cottrau.

41. Valentin 1846, facing p. 205, which relates the episode of Ribera and the alchemists.

42. This anecdote is recounted in similar terms in Anon. 1842b, p. 293, which deals with the Spanish school in the Musée de Nantes. This subject also inspired a picture by Aze, a student of Robert-Fleury, at the 1859 Salon.

43. Anon. 1838c, pp. 65–66. These contained a reproduction drawing of Zurbarán's *Saint with Arrow* (no. 400 in the Galerie Espagnole, currently in the Musée de

had a history dating back to Toledo in the 1600s. The second, *Gathering of Gentlemen* (fig. 2.18), was to delight Manet (fig. 2.19). Then, in 1852, came the announcement of the public sale of the Soult collection, which had had art lovers drooling ever since Thoré's descriptions of it in the 1835 *Revue de Paris*. Only a privileged few, Delacroix among them, had enjoyed a preview.

It is no secret that the Louvre had, on two occasions, tried without success to buy important works from Soult's collection,[48] some of which left France for England in 1835. In the posthumous sale of May 19, 1852, Murillo's *Immaculate Conception* (fig. 2.30) resurfaced. The Louvre had desperately wanted it in 1835, and now it achieved its ambition. The price was a record one, and the museum catalogue of 1864 contains a description by Frédéric Villot of the circumstances. Louis-Napoleon, then president of the Republic, "generously came to the aid of the Museum . . . decreeing a sum of 615,300 francs for the purchase of Murillo's celebrated painting of the Immaculate Conception."[49] The arrival of the picture had a stunning effect on the countless copyists studying in the Louvre.

A large program of acquisitions was initiated under the Second Empire. Worth mention is the result of the financial arrangement made with the state on the death of Soult's son in 1858, when five enormous paintings were handed over to the Louvre. One was by the elder Herrera, two by Murillo, and two by Zurbarán. One of the latter, *Saint Bonaventure at the Council of*

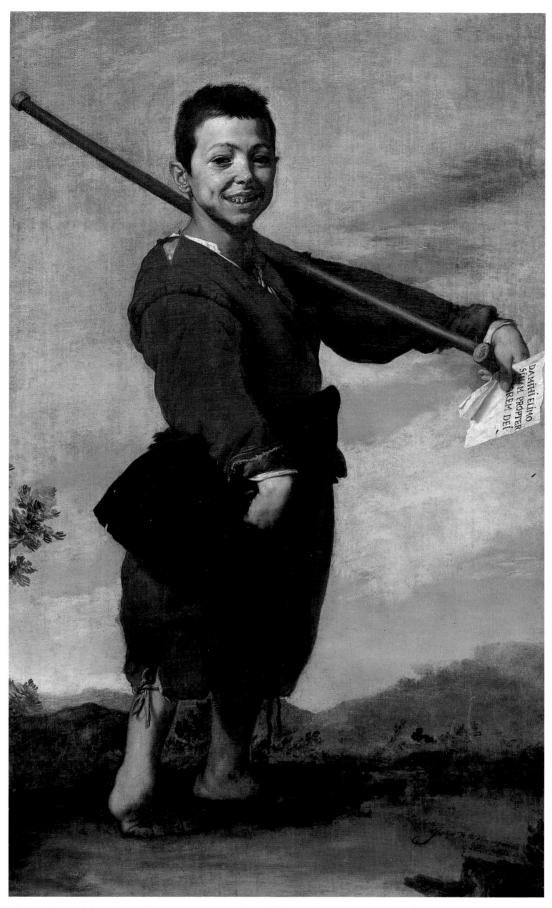

Fig. 2.25 (cat. 61) Jusepe de Ribera, *The Beggar (The Clubfoot)*, 1642. Oil on canvas, 64½ x 37 in. (164 x 93.5 cm). Musée du Louvre, Paris, Bequest of Louis La Caze, 1869

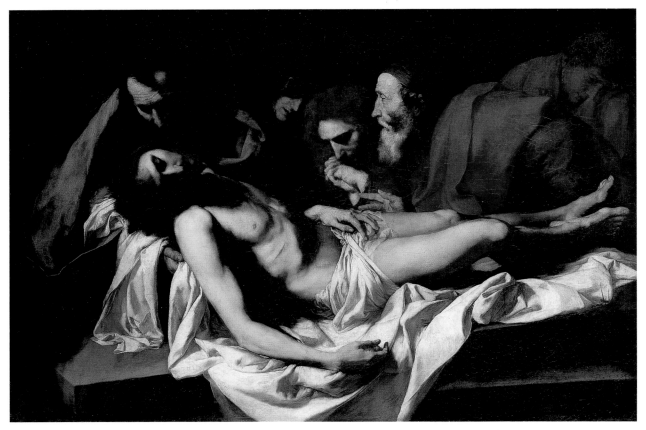

Fig. 2.26 Jusepe de Ribera, *The Deposition*, ca. 1625–50. Oil on canvas, 50 x 71½ in. (127 x 182 cm). Musée du Louvre, Paris

Fig. 2.27 (cat. 197)
Théodule-Augustin
Ribot, *The Samaritan*,
1870. Oil on canvas, 44⅛ x
57⅛ in. (112 x 145 cm).
Musée d'Orsay, Paris

Fig. 2.28 Jusepe de Ribera, *Saint Paul the Hermit*, ca. 1625–50. Oil on canvas, 77½ x 60¼ in. (197 x 153 cm). Musée du Louvre, Paris

Fig. 2.29 Léon Bonnat, *Job*, 1880. Oil on canvas, 63⅜ x 50¾ in. (161 x 129 cm). Musée Bonnat, Bayonne

Fig. 2.30 (cat. 57) Bartolomé Esteban Murillo, *The Immaculate Conception*, ca. 1678. Oil on canvas, 68½ x 74¾ in. (174 x 190 cm). Museo Nacional del Prado, Madrid

Fig. 2.31 (cat. 96) Théodore Chassériau, *Christ Carrying the Cross, Copy after Luis de Morales*, ca. 1838. Oil on canvas, 30⅛ x 18¾ in. (76.5 x 47.5 cm). Musée Municipal, La Rochelle, on deposit from the Louvre

Lyon (fig. 2.20), fascinated Alphonse Legros so much that his *Making Amends* (fig. 2.21) virtually plagiarized it in subject matter, composition, and format.

Some of the major works removed from Seville under the Empire at last became truly available. The interest in Zurbarán, so prolifically represented in the Galerie Espagnole, was strengthened by the acquisition in 1867, at a sale by Soult's legatees, of the *Saint Apollonia*, one of his highly appealing studies of female saints. In fact, the Louvre lagged behind the Musée de Montpellier, which had obtained Zurbarán's *Saint Agatha* at the Soult sale of 1852, while the Musée de Chartres was still able, for a modest price, to purchase his *Saint Lucy* (fig. 2.22) at the 1876 sale of the Camille Marcille collection. Zurbarán remained a bargain compared with Murillo.

The Louvre also benefited from several important bequests. One, by Louis Guillemardet, a friend of Delacroix, led to the acquisition in 1865 of two Goyas: the portrait of his father and *Woman in Spanish Costume* (fig. 2.23), "painted in Madrid in 1799," as we learn from the museum catalogue completed in 1877 by Vicomte Both de Tauzia;[50] Henri Regnault recalls this work in his portrait *Countess de Barck* (fig. 2.24). Another legacy was that of Dr. Louis La Caze, an art lover who freely allowed visits to his collection. The La Caze lot, which came to the Louvre in 1869, included, besides outstanding Watteaus and Chardins, several Spanish works, such as Ribera's *Beggar* (fig. 2.25). A special room on the Louvre's second story, on the west side of the Cour Carrée, was set aside for this collection. But one could find in the Grande Galerie Riberas of intense chiaroscuro, such as *The Deposition* (fig. 2.26), which entered the collection in 1868; it is echoed by Ribot's *Samaritan* (fig. 2.27). Later, in 1875, Ribera's *Saint Paul the Hermit* (fig. 2.28) came to the Louvre and was certainly noticed by Bonnat (fig. 2.29).

The arrival, in 1852, of Murillo's *Immaculate Conception* (fig. 2.30) produced a striking effect on innumerable copyists studying at the Louvre, who were far greater in number than those who had obtained official commissions. The registers of copyists are unfortunately incomplete, but the small amount of information to be gleaned from the one relating to the Spanish paintings is significant. Covering the period from 1851 to the start of 1857, it lists only four names of Spanish artists—Murillo, Velázquez, Ribera, and Morales— alongside six Italians, emphasizing the disproportion of Spanish works in the Louvre collections themselves.[51]

Thirteen paintings, including five Murillos, were the object of 742 copying requests, not all of which, presumably, were granted. These varied from applications to copy the entire work to those for details only. The absolute record is held by Murillo, with 597 requests. The *Immaculate Conception*,[52] acquired on May 19, 1852, solicited 167 applications in less than five years, more than half in the first year. Beginning on May 21, thirty were registered, with twenty-two more before the end of the month. Not all the copyists could work at the same time; the "observations" column laconically notes twenty-two abandonments in this brief ten-day period. Seven are explained by the entry "dead," which suggests that delays for new vacancies must have been considerable. The most frequent demands thereafter concerned four Murillos: *Beggar Boy* (124 requests;

Fig. 2.32 Bartolomé Esteban Murillo, *Beggar Boy (The Flea-Picker)*, 1650. Oil on canvas, 53 x 39¼ in. (134 x 100 cm). Musée du Louvre, Paris

Fig. 2.33 (cat. 93) François Bonvin, *The Little Chimney-Sweep*, 1845. Oil on canvas, 8¼ x 10⅝ in. (22 x 27 cm). Château-Musée, Boulogne-sur-Mer

fig. 2.32), *The Rest on the Flight into Egypt*[53] (123; now *Holy Family*, called the *Virgin of Seville*, inv. 930), an *Immaculate Conception* (now *Apparition of the Virgin of the Immaculate Conception to Six Persons of Rank*, inv. 927) purchased under Louis XVIII (113),[54] and, finally, the *Virgin of the Rosary* (66), which had lost much of its popularity under Louis-Philippe. François Bonvin's *Little Chimney-Sweep* (fig. 2.33) clearly echoes Murillo's popular *Beggar Boy*.

In second place for copy requests after the works by Murillo, the three paintings by Velázquez totaled ninety-seven requests: forty-three for the *Infanta Margarita* (including that of Fantin-Latour, November 23, 1854), and thirty-seven and seventeen respectively for the new acquisitions *Portrait of a Monk* (fig. 2.17)[55] and *Portrait of Velázquez and Others* (fig. 2.18; now *Gathering of Gentlemen*, inv. 943).[56] For Ribera the number was thirty-eight (thirty-six for *The Adoration of the Shepherds*; fig. 2.11, inv. 939), and for Morales, ten (*Christ Carrying the Cross*, which attracted the attention of Chassériau; fig. 2.31).[57]

It is interesting to compare these statistics with the best Italian "scores" over the same period: Correggio's *Jupiter and Antiope* received 146 requests; Titian's *Entombment of Christ*, 142; Raphael's *La Belle Jardinière*, 124; and Veronese's *Disciples at Emmaus*, 112, at a time when the *Mona Lisa* managed only 50.

The register containing the French, Flemish, and a few Dutch schools covers a period three times longer (1851–71).[58] There were 262 requests for Greuze's *Broken Pitcher*, ranking second only to the four most popular Murillos, whereas Prud'hon's *Assumption* (with 206 requests) comes in almost even with Murillo's *Virgin of the Rosary*. Two Rubens—*Lot and His Daughters* (169) and *The Adoration of the Magi* (163)—were followed by Prud'hon's *Christ on the Cross* (132; fig. 2.34). The academic techniques of the Neoclassicists and the Ingres school had gone out of fashion. Murillo, Prud'hon, Greuze, and Rubens were the new favorites, for various reasons (not necessarily the same as those that led to commissions from institutions and

Strasbourg under the title *Saint Ursula*). See Baticle and Marinas 1981, pp. 248–49.

44. Laugée's picture, *The Death of Zurbarán*, acquired by the state and sent to the Musée de Saint-Quentin, has disappeared, lost during the destruction of the town in 1917. Letter from the mayor, August 7, 2000.

45. Blanc et al. 1869, no. 122 (Zurbarán issue), p. 7.

46. Roman d'Amat 1987, pl. 14, after *L'Illustration* 50 (1867), p. 62.

47. Eugène Trouvé was commissioned to make the copy of Murillo's *Saint Nicholas*, in the Standish collection, on January 29, 1850. The copy was delivered before July 10, 1850, and was sent to the Church of Fontenay-aux-Roses in the Paris suburbs (Archives Nationales, F21/158).

48. See the Chronology: 1823, 1830, and 1835. On the LP inventory of Louvre works, we find, in fact, LP 1534, Murillo, *The Immaculate Conception*; LP 1535, ditto, *The Healing of the Paralytic*; LP 1536, L'Espagnolet, *Saint Peter in Chains* (actually by Murillo). These three works were acquired by the king from the Soult collection, for 500,000 francs, with this annotation in the margin in red ink: "The agreement made on April 13, 1835, between M le C[on]te de Montalivet and M le M[aréch]al Soult, was rescinded on May 23, 1835, and the three works in question restored on the 25 of the same month to M le M[arqu]is de

Fig. 2.34 Pierre-Paul Prud'hon, *Christ on the Cross*, 1822. Oil on canvas, 8 ft. 11⅞ in. x 5 ft. 5⅛ in. (274 x 165.5 cm). Musée du Louvre, Paris

public authorities, for whom religious subjects were a matter of necessity). A mixture of sentiment and realism determined the success of Murillo's *Beggar Boy* and Greuze's *Broken Pitcher*.

At the end of 1871, a new demand for copies arose. Charles Blanc, then director of Beaux-Arts, in pursuing his policy of encouraging a taste for international art, set up a Musée des Copies, also known as the Musée Européen. Because the collections of the École des Beaux-Arts could not supply the need, he set artists to work in all the galleries of Europe, bought paintings, and centralized those scattered throughout the provinces. The determination to achieve an encyclopedic coverage of the subject that drove him to complete the *Histoire des peintres de toutes les écoles* was now translated into real paintings and living colors. Spain naturally had its place, with some thirty copies.[59]

And so, at the Palais des Champs-Élysées, Paris, for a brief period ending in 1874, nineteen copies of Velázquez's works from the Prado were on display, including Henri Regnault's version of *The Surrender of Breda*. Prior to this time, the *Crucifixion* copied by Charles Porion between 1853 and 1855 at Madrid[60] had itself served between 1864 and 1870 as model for seven state commissions, which gives an indication of the growing admiration for Velázquez toward the end of the Second Empire. Further evidence is offered by the story of the painter Jean-Baptiste Guignet (1810–1857). In a difficult financial situation, he had won the sympathy of the authorities in 1856 when he offered five copies made at the Prado "in my enthusiasm for Velázquez," as he wrote. He had gone to Spain to paint a historical work commissioned in 1852; justifying the expedition, he said, "To make my painting as perfect as I possibly could, I decided to work in Madrid, under the influence of the great Spanish masters."[61]

Some copyists were real specialists. Alexandre Prévost provided up to seven Velázquez copies, as well as one of Goya's *Majas on a Balcony*, and, on Blanc's alternative recommendation, one of Murillo's *Saint Elizabeth of Hungary Nursing the Sick*. Unfortunately, both these copies arrived after the Musée des Copies had closed. The legendary Murillo that so fascinated Blanc had already been the object of a commission from Hippolyte Lazerges on July 12, 1872; the commission, however, had been canceled, the artist judging that "the political state of Spain makes it impossible to make the copy."[62]

Two or three copies originally made in the Galerie Espagnole were acquired for the Musée des Copies: a *Saint Francis in Prayer*, after Zurbarán, by Anatole-Henri de Beaulieu; a *Woman in Gloves*, presented by the widow of Sébastien Cornu in 1872, which could, perhaps, be a means of authenticating one of the as yet to be identified Velázquezes; and a so-called *Charles IV* by Carreño de Miranda, copied by Adolphe Brune (possibly a copy of a *Charles II* from the Galerie Espagnole).[63] As for Ribera, he was represented by a *Pietà*

Dalmatie, on his receipt, and acting in the name of the Marshal." ("Le marché passé le 13 avril 1835 entre Mr le Cte de Montalivet et Mr le M[aréch]al Soult, a été résilié le 23 mai 1835 et les trois tableaux dont il est question rendus le 25 du même mois à Mr le M[arqu]is de Dalmatie, sur son reçu, et agissant au nom du maréchal").

49. "généreusement au secours du Musée . . . en décrétant une somme de 615,300 fr pour l'acquisition du célèbre tableau de la *Conception* de Murillo." Villot 1864, p. liii.

50. Both de Tauzia 1877, nos. 533, 534.

51. Archives des Musées Nationaux, *LL 26.

52. Villot 1853 (and subsequent editions), no. 546a. The register of copyists refers to the numbers allotted in Villot's Louvre catalogue, Spanish and Italian schools.

53. Ibid., no. 548 (inv. 930); 5 ft. 8 in. x 9 ft.

(fig. 2.35) from the Church of the Certosa di San Martino, Naples, copied at the beginning of the century by Guillaume Guillon Lethière (1760–1832) and lent by the Musée de Dijon. In addition, Blanc ordered a copy from Jacques-Émile Lafon of Ribera's *Saint Stanislaus and the Christ Child* (Galleria Borghese, Rome), while a copy by Fortune-Sèraphin Layraud of *The Martyrdom of Saint Bartholomew* (Museo del Prado) arrived too late.[64] Finally, a copy of Velázquez's *Portrait of Léon X* [*sic*] (Palazzo Pitti, Florence) by Charles Steuben (1788–1856) was acquired at a public sale on December 28, 1871. In 1874 most of the copies were transferred to the École des Beaux-Arts, shortly after the installation of Philippe de Chennevières as director in the final days of 1873; they were placed among the reserves, or their use was restricted to student copyists.[65]

The public now had little choice but to search through the reproductions in Blanc's *Histoire des peintres de toutes les écoles*. Issued in 631 installments over the course of more than two decades, the *Histoire des peintres* originated against the euphoric backdrop of a Second Republic aiming to educate its citizens through the use of illustrations. The first issues were timed to coincide with the Exposition Nationale of 1849, the theme of which was the products of agriculture and industry. Installments of eight large pages appeared at the rate of two per month, in the form of "monographs on the painters of the seven major schools," including the Spanish. Connections of schools with specific regions or cities were omitted.

Fig. 2.35 Jusepe de Ribera, *Pietà*, 1637. Oil on canvas, 8 ft. 8 in. x 5 ft. 6⅞ in. (264 x 170 cm). Church of the Certosa di San Martino, Naples

Depending on his status, an artist might have half or a whole issue—or even several consecutively—devoted to him. Each essay began with a portrait of the painter, below which appeared his school and subject matter, followed by birth and death dates. Subjects were classified as landscape, portraiture, genre, mythology, religious (as opposed to devotional, a categorization employed in connection with Cano and Murillo), or sacred (used for Ribera's works).

Each biography, illustrated with wood engravings, concluded with an invaluable rubric of "research and information," comprising a catalogue of works in galleries (with details of locations) and private collections, plus a glimpse at prices in public sales. The tailpiece was a facsimile signature. Blanc participated actively in editing the publication from the first issue but did not take over running it until about 1853. In the first years, he authored monographs on Ribera (1850), Velázquez (1852), Murillo (1853), Zurbarán (1854), and Cano (1856). After 1856 the number of authors multiplied. Paul Mantz wrote two articles; Louis Viardot, one; William Bürger (pseudonym of Théophile Thoré), seven; and Paul Lefort, sixteen. Lefort's contribution included the biographies of El Greco and the Herreras, as well as Goya, for

9 in. (172 x 298 cm.) Villot indicates that it was obtained from M. Lom in 1817; the latest Louvre catalogue (Louvre 1981) explains that it originated from the Soult collection.

54. Ibid., no. 546 (inv. 927).

55. Ibid., no. 556 (inv. 942).

56. Ibid., no. 557 (inv. 943).

57. Ibid., no. 545 (inv. 926), acquired in 1824, now classed as anonymous.

58. Archives des Musées Nationaux, *LL 22.

59. See Duro 1985. His study embraces 199 copies of all schools, with current locations where known.

60. Archives Nationales F21/104. He had copied numerous works by Velázquez at the Prado. The copy of *Count-Duke of Olivares on Horseback* (fig. 12.4) had been shipped to the Musée de Laval in 1856 and was not returned for the Musée des Copies.

61. "Pour donner à ma composition toute

Fig. 2.36 Georges de La Tour, *The Hurdy-Gurdy Player*, 17th century. Oil on canvas, 63¾ x 41⅜ in. (162 x 105 cm). Musée des Beaux-Arts, Nantes

which he was indebted to the outstanding work by Charles Yriarte that appeared in 1867.[66]

Around 1861, the various installments of the *Histoire des peintres* began to be collected together into volumes (fourteen in all), organized by school, updated when possible—especially after major public sales—and expanded with an appendix that, in the case of Spain, detailed fifty less-illustrious painters. The Spanish school was honored with an entire volume (published in 1869), clearly segregated from the Italians, as it had been in the Louvre catalogues from 1852 onward and in the galleries themselves after 1848.[67] It is interesting to note the changes to the illustrations among the editions. Significantly for the Spanish school, the engraving of Murillo's highly admired *Saint Elizabeth of Hungary Nursing the Sick* appeared in the bound edition after 1872, although it was missing from the issues numbered 102 and 103 of 1853 and in the edition of 1869. Doubtless in the intervening years a reproduction of this popular masterpiece had become available in Paris.

In the monograph on Velázquez, a wood engraving titled the *Infante Don Carlos* (actually *Baltasar Carlos on Horseback* [figs. 4.15, 4.16]) is taken from Goya's etching, which is easily recognizable, but the reader of 1851 is not informed of it; it is not identified until later, in the edition of 1877, where one can read this commentary in the list of paintings in the Prado: "This is the portrait etched by Goya, here reproduced in facsimile."[68] Information became more refined over the years, especially once Blanc established direct contacts with Spain for the *Gazette des Beaux-Arts*, which he founded in 1859, prior to his trip of 1862. Similarly, the *Magasin Pittoresque* made use of Nicolas Henneman's Talbotype[69] when it illustrated "*Velázquez's Wife*, by Velázquez," from the Prado in 1856,[70] as had William Stirling-Maxwell in 1848, for *Annals of the Artists of Spain*. In 1887 the Braun publishing house produced the *Catalogue général des photographies inaltérables au charbon et héliogravures* (General catalogue of permanent carbon photographs and heliogravures), which presented a wide selection of 141 Spanish paintings from the Prado and 26 from the Academia de Bellas Artes de San Fernando, including Goya's *Naked Maja* and *Clothed Maja*, and, of course, Murillo's *Saint Elizabeth of Hungary Nursing the Sick*, of which there is a complete view and three details. But the choice of engravings found in Paul Lefort's *La peinture espagnole* (Spanish painting, 1893), a manual published by the Biblothèque de l'Enseignement des Beaux-Arts (Paris, the former Maison Quantin), remained faithful to the big names of the century. Plate 55, for instance, was "Velazquez, *Portrait of Innocent X* (Galleria Doria Pamphilj, Rome)," and plate 98, "Murillo, *Saint Elizabeth of Hungary Tending the Sick* (Academy of San Francisco) [*sic*]."[71] Also featured was Cano's small statue of St. Francis of Assisi (Treasury, Toledo Cathedral), which had so fascinated Zacharie Astruc in 1864 that he made a copy of it.

All in all, the *Histoire des peintres de toutes les écoles* was an exemplary and seminal publication, an attempt to base the history of art on individual artists and works. The earlier written sources were all used but in a truly critical manner; for example, the assertions of Joachim

la perfection dont je pourrais être susceptible, c'est à Madrid et sous l'impression des maîtres de la puissante école Espagnole que je suis allé l'exécuter." Duro 1985, p. 294.

62. "l'état politique de l'Espagne rend impossible l'achèvement de la copie." Ibid., p. 298.

63. See Baticle and Marinas 1981, nos. 39–40.

64. Ibid., p. 297.

65. See Chennevières 1979, pp. 96–97.

66. The Musée Gustave-Moreau possesses a collection of paper-covered, unbound issues allowing some conjectures concerning publication date. Ribera is the focus of no. 22; Velázquez, nos. 68 and 69; Murillo, nos. 102 and 103; Zurbarán, no. 122; Cano, no. 171; Juan de Joanes, no. 269.

67. Blanc et al. 1869. The complete collection of fourteen volumes was published between 1861 and 1876.

68. "C'est le portrait que Goya a gravé à l'eau-forte et que nous avons reproduit

von Sandrart concerning Murillo's supposed voyages to America and Italy are refuted.[72] There is also a proper analysis of works from the point of view of technique, with, on occasion, a warning to artists. For example, concluding his study of Murillo, Blanc says, "Sometimes Estaban's effects, normally soft and warm, degenerate into insipidness. Perhaps it is dangerous to copy Murillo; it may encourage carelessness and lack of detail. The result might be a banality of composition, from which the original is rescued by its charm and its brilliant use of color. But if we ought not to imitate Murillo, we can admire him in complete safety."[73] Perhaps academic painters such as Alexandre Cabanel and Adolphe-William Bouguereau failed to heed this counsel.

In the *Histoire des peintres* each school received a general introduction; Blanc edited the overview of the Spanish school. His concern was to discover the school's fundamental characteristics and to trace its links with political and social history. For him, the originality of Spanish art derived from two sources: Catholicism and the science of color. He put particular emphasis on the power of the clergy in the homeland of the Inquisition: "Spanish art recognizes no form of ugliness but sin—the deformity of the soul. Consequently it has no awareness of the *beau idéal,* the archetypal truth of forms; or, if not completely ignoring it, disdains it, because it is commanded to respect the almighty figure of God even in bodies devoid of beauty and in the most fallen of natures."[74]

Finally, the publication's art historians, though milder than modern critics, did not fail to question traditional attributions. Thus, in the monograph on Juan Bautista Martínez del Mazo, W. Bürger (Théophile Thoré) mentioned the reassignment to Mazo of a Velázquez in the Prado (*María Teresa of Austria*) and adds a brief list of attested works with the comment, "There may well be a certain number of portraits by Mazo that have found their way to England under the guise of Velázquezes."[75]

Fig. 2.37 (cat. 1) Claudio Coello, *The Penitent Magdalen,* ca. 1665–70. Oil on canvas, 23⅞ x 20⅜ in. (60.5 x 51.8 cm). Musée d'Art Thomas Henry, Cherbourg-Octeville

ici en fascimilé." Blanc et al. 1869, nos. 68–69 (Velázquez issues), p. 16.

69. Madrid 2000, p. 15.

70. *Le Magasin Pittoresque* 24, no. 21 (1856), p. 165.

71. The misspelling of the place-name—Francisco for Fernando—is a printer's error. For other works from the same gallery, particularly the two other Murillos of the Soult collection returned to Spain in 1815 (plates 96, 97, shown with frames), the spelling is correct.

Fig. 2.38 (cat. 7) Francisco de Goya y Lucientes, *The Cannibals,* ca. 1800–1808. Oil on panel, 12⅞ x 18½ in. (32.7 x 47 cm). Musée des Beaux-Arts et d'Archéologie, Besançon

Fig. 2.39 (cat. 17) Eugenio Lucas Velázquez (formerly attributed to Francisco de Goya y Lucientes), *The Fight*, after 1840? Oil on tinplate, 8⅝ x 12¾ in. (22 x 32.5 cm). Musée des Beaux-Arts et d'Archéologie, Besançon

Fig. 2.40 (cat. 18) Eugenio Lucas Velázquez (formerly attributed to Francisco de Goya y Lucientes), *The Victim*, after 1840? Oil on tinplate, 8⅝ x 12⅝ in. (22 x 32 cm). Musée des Beaux-Arts et d'Archéologie, Besançon

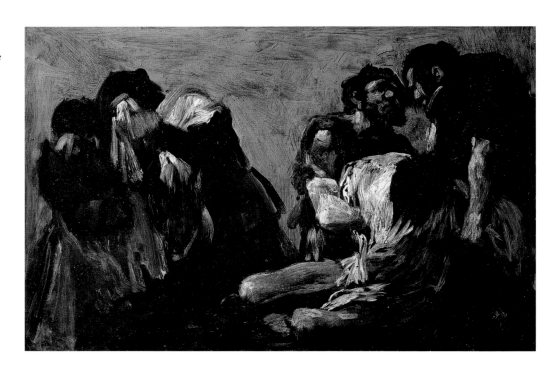

72. Blanc et al. 1869, no. 102 (Murillo issue), p. 4.

73. "Quelquefois le pinceau d'Estaban est fondu jusqu'à la mollesse; le plus souvent, il est chaud et vaporeux. Peut-être est-il dangereux de copier Murillo: on risquerait de tomber dans la rondeur et le défaut d'accent; on contracterait une banalité d'exécution dont l'original se sauve par le charme et l'éclat du coloris. Mais s'il ne faut point imiter Murillo, on peut l'admirer sans crainte." Ibid., no. 103 (Murillo issue), p. 15.

Radical changes of attribution abound, not only with regard to the Spanish school. Errors stem not only from ignorance but also from false assumptions about the nature of Spanish art in general. To nineteenth-century critics, any dramatic use of light suggests Ribera, whereas in fact the work might be a Velázquez—like the *Democritus* (fig. 1.7) in the Musée de Rouen— or a Luca Giordano. For one painting, the *Self-Portrait of Velázquez* (from the Galerie Espagnole),[76] of which the Musée de Quimper possesses an excellent copy by Jules Breton,[77] doubts had already arisen at the sale of 1853. It is now attributed to Simon Vouet. And if Charles Blanc, self-confident, made use of it as a portrait of Velázquez at the front of the 1851 monograph on the artist, it disappeared from later editions, replaced by a different likeness.

The Hurdy-Gurdy Player (fig. 2.36) has a typical history. Then known in French as *Le Joueur de Vielle*, it was acquired in 1810, with the François Cacault collection, as a Murillo. Considered one of the finest pieces of this outstanding group, it was hung in the mayor's office before being installed in the museum proper in 1830. The *Magasin Pittoresque* reproduced it in 1842, with, by a curious error, Ribera's name under the engraving[78]—a mistake that was immediately corrected in the errata of the same year.[79] The text confirms the attribution to Murillo: "The figure, painted lifesize, is distinguished by the naturalism and verve found in all Murillo's work."[80] In 1838 Stendhal hesitated to assign it to Velázquez.[81] Léonce de Pesquidoux, writing twenty years later, saw it as "the last word in Spanish realism."[82] Twentieth-century catalogues also suggested Zurbarán. Even Herrera was considered. Finally, in 1931, rechristened *Le Vielleur*, the painting was classified as one of the masterpieces of "Lorrainese realism," among the "daylight" paintings of Georges de La Tour. Wretchedly clothed, dirty, and wrinkled, Georges de La Tour's musician exhibits the physical characteristics of poverty discernible in Murillo's *Beggar Boy* and echoed in *The Stonebreakers* by Gustave Courbet.

Artists scrutinized at length work by, or thought to be by, Spanish artists, leafing through illustrated magazines and collecting engravings—the setting of Manet's *Émile Zola* (fig. 9.91) serves as a good example. They also scoured the museums, not only in Paris and Madrid but also, as did Jean-François Millet, that of Cherbourg, with its fine stock of work (after 1835) by Murillo and Claudio Coello (fig. 2.37). Nor did the trend of the early part of the century show signs of slackening. We can scarcely forget that Napoleon III's wife, Eugénie de Montijo, was Spanish. If an ousted queen of Spain took refuge in Paris in the late 1800s, she was not alone; emigrés followed in her wake, bringing with them paintings that lined the coffers of the art trade.

Some artists, not content with copies, became collectors in their own right, like Gigoux, who enriched the Musée de Besançon (figs. 2.38–2.40), or Bonnat, who founded the Musée Bonnat in his native Bayonne. Marcel Briguiboul,[83] one of those pupils of Léon Cogniet who knew how to read Spanish painting, copied Velázquez at the Prado; in 1881 he purchased the important Goyas that are today the masterpieces of the museum in Castres, in southwest France. Degas's collection also included a few Spanish works after the 1890s.[84] One of these had belonged to Jean-François Millet and appeared in the sale of his widow's effects on April 24 and 25, 1894. Lot 261, sold for 2,000 francs, was described as "*The Bishop* by Theotocopuli, known as El Greco"; in reality it was *Saint Ildefonso*,[85] currently in the National Gallery of Art, Washington, D.C. According to the sale catalogue, the painting was "A first-class work by the Master, highly admired by Millet. In connection with this painting, we call to mind the preface in the catalogue to the Millet sale [following the artist's death in 1875], where M. Tillot quotes the Master's own words: 'There,' he would often exclaim during his final illness, pointing to the El Greco hanging near his bed, 'is a painting that is undervalued. The artist is scarcely known. Well, I don't know many works that can touch it. I'll say just one thing more: it takes plenty of heart to paint a picture like that.'"[86]

Millet's brief remark confirms Charles Blanc's judgment in his introduction to the volume of the *Histoire des peintres de toutes les écoles* that deals with the Spanish school: "What a monstrous error has been committed by those who have seen in Spanish painting nothing but a powerful though vulgar materialism, a mere talent for form and execution. Nowhere, on the contrary, will you find a stronger dose of spirituality."[87]

74. "Ne reconnaissant d'autre laideur que le péché, qui est la difformité de l'âme, l'art espagnol ignore le beau idéal, c'est-à-dire la vérité typique des formes, ou, s'il ne l'ignore point, il le dédaigne, parce qu'il lui est commandé de respecter, sous les disgrâces du corps, dans les natures les plus déchues, la grande figure de Dieu." Ibid. (introduction), p. 10.

75. "Il se pourrait encore qu'un certain nombre de portraits peints par Mazo fussent égarés en Angleterre sous le nom de Velázquez." Ibid. (Mazo issue), p. 3.

76. Baticle and Marinas 1981, no. 31.

77. Arras–Quimper–Dublin 2002, no. 1, repr. p. 45.

78. Anon. 1842b, p. 293.

79. *Le Magasin Pittoresque* 10, no. 51 (1842), p. 408.

80. "la figure, de grandeur naturelle, se distingue par le naturel et la verve que l'on trouve dans tous les tableaux de Murillo." Anon. 1842b, p. 292.

81. Stendhal 1838, vol. 1, p. 327.

82. "le dernier mot du réalisme espagnol." Pesquidoux 1857, pp. 56–57.

83. See Castres 1999, pp. 123–27.

84. See New York 1997–98, nos. 599, 600, p. 67. Note also the copy of *Menippus*, after Velázquez, in the second sale of Degas's collection, November 15–16, 1918, lot 4, "modern school."

85. Jeannine Baticle will recognize traces of our evening conversations here. My heartfelt thanks to her for having so kindly put all her knowledge at my disposal.

86. "Oeuvre capitale de maître, très appréciée de Millet. Nous rappelons, au sujet de ce tableau, la préface du catalogue de la vente Millet (en 1875) où M. Tillot cite ces paroles de maître: 'Voilà, disait-il souvent dans sa dernière maladie, en montrant le tableau du Greco, accroché auprès de son lit, une peinture qui est peu appréciée, l'auteur en est à peine connu. Eh bien! je connais peu de tableaux qui me touchent, je ne dirais pas davantage, mais autant; il fallait avoir bien du coeur pour faire une oeuvre comme celle-là.' Toile. Haut., 1m.10 cent.; large.,65 cent." Millet 1894, no. 261.

87. Blanc et al. 1869 (introduction), p. 11.

Seville's Artistic Heritage during the French Occupation

Ignacio Cano Rivero

The private galleries are few, and every day becoming less. Many were broken up in the universal ruin entailed by the invasion and subsequent troubled times; when neither person nor property was safe, when the sources of income failed, and everything which could be converted into money was sold.

Richard Ford, *Hand-book for Travellers in Spain*, London, 1845

A TREASURE DISCOVERED: SEVILLE AND ITS PAINTERS

Despite the economic decline Seville suffered in the second half of the seventeenth century, the city possessed a particularly rich artistic heritage when Napoleon's troops entered it in 1810. Indeed, only a few years earlier, in the final decades of the eighteenth century, foreign travelers who had begun to visit Seville described in glowing terms the paintings in the city's churches and collections. However, the real discovery of Seville as a city worthy of admiration for its art and for its evocative atmosphere came a few years later, as the painful consequence of the French invasion (fig. 3.2).

Since the beginning of the sixteenth century, the Spanish crown had held a trading monopoly with the Americas through the Casa de Contratación in Seville. The consequent economic boom attracted merchants to the city; with them came artists and works of art—to be seen in the houses, convents, and churches of Seville—from all over Europe, particularly Italy and Flanders. The result was the development in the seventeenth century of an important school of painting that included such great artists as Diego Velázquez, Alonso Cano, Francisco de Zurbarán, Francisco de Herrera (the Elder), Juan de Valdés Leal, Bartolomé Esteban Murillo, and Juan de Roelas. This period became known as the Golden Age of painting in Seville.

The presence of the court of the Bourbon king Philip V in the royal palace, the Alcázar, from 1729 to 1733 brought to the city courtiers who did not admire its seemingly old-fashioned appearance, its mixture, among streets and buildings, of Roman and Arab elements, Mudejar, Gothic, and Renaissance architecture, and examples of full-blown Baroque style. During that same time, however, attention began to focus on the work of Murillo, stimulating a strong taste among princely collectors and their attendants, many of whom came from France, Italy, and England.[1] Such admiration resulted in the exportation of numerous paintings, particularly those by Murillo. In 1779 this trade compelled Charles III to issue an order prohibiting the removal of paintings from Spain.[2] As early as the seventeenth century, most of the pictures by this great artist that had left Spain were concentrated in Antwerp,

I would like to thank The Sterling and Francine Clark Art Institute, Williamstown, Mass., and its staff, especially Michael Ann Holly and director Michael Conforti. I would also like to express my gratitude to Marcus Burke, Patrick Lenaghan, Fernando López Barrau, Virginia Marqués, Olivier Meslay, Enrique Pareja, and Enrique Valdivieso, as well as to the staff at the Frick Art Reference Library, the Hispanic Society of America, the Archivo Histórico Nacional de Madrid, and the Archivo del Real Alcázar in Seville. I extend particular thanks to Deborah L. Roldán and H. Barbara Weinberg.

1. García Felguera 1989b. This rigorous study gives crucial information about the changing history of Murillo's renown. Among the earliest reactions of Murillo's contemporaries is that of the Seville chronicler Fernando de la Torre Farfán, who, in 1671, described him as "our Apelles of Seville." With regard to the painting *Saint Anthony of Padua*, in Seville Cathedral, he wrote that "someone claimed to have seen a bird trying to settle on it so as to peck at the flowers— Madonna lilies—[depicted] in a vase." Quoted in García Felguera 1989b, p. 33.

2. The decree issued in 1779 by the minister, the conde de Floridablanca, prohibiting the export of paintings can be read in its entirety in Ponz 1776–94, vol. 9, *Carta última* (final letter), pp. 290–93. Also quoted elsewhere, including in Montesa 1927, p. 301.

Fig. 3.1 Bernardo Simón de Pineda (architect), Pedro Roldán (sculptor), Main altar of the Church of the Hospital de la Caridad, Seville, begun in 1664

3. Cf. García Felguera 1989b, p. 47. For a more detailed account of how Spanish paintings were brought to England in the eighteenth century, see also Hugh Brigstocke, "El descubrimiento del Arte español en Gran Bretaña," in Oviedo 1999–2000, pp. 5–25. Cf. also Allan Braham, "El Greco to Goya: The Taste for Spanish Paintings in Britain and Ireland," in London 1981. On the presence of Spanish paintings in France, see also Bernard Dorival, "Obras españolas en las colecciones francesas del siglo XVIII," in Granada 1976–78, vol. 3, pp. 67–94.

4. See Ponz 1776–94, vol. 9, letter XVII, p. 174.

5. From the late eighteenth century, successive laws were passed allowing the appropriation of the possessions of religious institutions, particularly buildings and agricultural land that covered a large part of the country and consisted of land suitable for exploitation. The most prominent of these laws, and those that had the greatest consequences, were the decrees issued by the liberal minister Juan Álvarez y Mendizábal in 1835 and 1836, which affected not only the land but also the buildings and the artistic heritage of the religious orders, whose property passed into state ownership. Besides ideological considerations, the confiscations were clearly economic: paying off public debt at the expense of the church. Cf. Juan José Martín González, "Problemática de la desamortización en el arte español," in Valladolid 1978, pp. 15–30.

6. Antonio Ponz (1725–1792) was a key contributor to the historiography of Spanish painting. His *Viaje de España* (Travels in Spain), a description of Spanish art published in eighteen volumes from 1772 to 1794, has been a valuable source for art historians and researchers. After concentrating on theology, Ponz studied painting in Valencia and Madrid. He lived in Italy from 1751 to 1759, and on his return to Spain dedicated himself to painting but most especially to cataloguing the manuscripts in the monastery of El Escorial. Upon the decree ordering the expulsion of the Jesuits, he was commissioned to compile an inventory of the paintings belonging to that religious order and to select those that might serve as models for the students at the Academia de San Fernando in Madrid. His work in preparing the inventory formed the basis of his monumental account, which, though omitting Granada and Murcia, constitutes a key reference work, being the only geographical record of the visual arts in Spain

Fig. 3.2 Anonymous, *View of Seville in the Eighteenth Century*. Print. Private collection

from whence they were sold to buyers in Germany and France. Gary Tinterow has discussed the Murillos in France in the eighteenth century (see p. 6 in this publication); the trade with England was perhaps even more important. Murillo's celebrated *Self-Portrait* (National Gallery, London) was taken there by the widow of the dealer Sir Daniel Arthur, who had come to Spain from Ireland in the early eighteenth century. In 1729 the British ambassador, Lord Harrington, returned to his native country with *The Epiphany* (Toledo Museum of Art, Ohio) and *The Virgin and Child with Saint Rosalia of Palermo* (Museo Thyssen-Bornemisza, Madrid). The number of paintings by Murillo in England by the mid-eighteenth century contributed to his renown and increased the demand for his work. *The Holy Family* (Chatsworth House, Derbyshire), acquired by the duke of Devonshire, and *The Infant Christ Asleep on the Cross* (Sheffield City Art Gallery), which in 1766 was in the possession of Charles Jennings in London, were among the works to be seen in England.[3]

Contemporary reports refer to ways of evading the ban on exports,[4] but such legal restrictions, together with the burgeoning international political conflict, reduced the commercial traffic in works of art between Spain and the rest of Europe, at least until the early nineteenth century. This allowed Sevillian and Spanish collectors to acquire paintings that filled newly created art galleries and formed the nuclei of collections that, in the final decades of the eighteenth century, were coming into being in Seville and in Spain's major cities. With the entry of French troops into Spain early in the nineteenth century, the art trade underwent a radical change, and two men played decisive roles in the fate of Seville's artistic heritage. One was Frédéric Quilliet, an obscure figure who had resided in Spain for some years and who organized the large-scale seizure of works of art in Seville; the other was Jean de Dieu Soult, general and marshal of France, who removed

over one hundred paintings from the city. This corpus constituted the finest works by the seventeenth-century painters of Seville; while a few of them were exhibited in the Louvre, most were dispersed on the art market after Soult's death in 1851, through the sales of his collection.

FROM THE EXPULSION OF THE JESUITS TO THE CREATION OF PICTURE GALLERIES

In the final years of the eighteenth century, a series of events led to a traffic in works of art that focused attention on Seville's artistic treasures. One factor in this traffic was the great quantity of paintings that figured among the possessions confiscated from the Jesuits; another was the rise of a fresh phase of collecting. Both effectively created an environment that set the scene for the events of 1810 and later.

The expulsion of the Jesuits from Spain in 1767 and the transfer of the possessions of the religious order to public ownership was the first instance of direct intervention on the part of Spanish political powers in the church's great holdings, which included many works of art. The expulsion established a precedent for the dissolution of the religious communities subsequently ordered by Joseph Bonaparte in 1809 and for the systematic confiscation of property that many religious institutions were to suffer, most intensively from 1835 onward.[5]

The official redistribution of property after the Jesuits' expulsion was carried out by Antonio Ponz, a minor painter and prominent historian and writer.[6] Called to Seville by Charles III, he was instructed to examine all the paintings in the dissolved religious institutions and assess the artistic heritage.[7] Noted for their emphasis on physical images as a means of expressing devotion, the Jesuits had among the paintings that hung in their churches and in the rooms of their institutions works by Roelas, Pacheco, Velázquez, Cano, Zurbarán, Herrera, and Valdés Leal. All of these now passed into public ownership. Some were deposited in the Academia de las Tres Nobles Artes (Academy of the Three Noble Arts), which was founded in 1769, along the lines of the Real Academia de Bellas Artes de San Fernando in Madrid, while others were taken to the Alcázar, where, under the supervision of the Academia, they formed part of the first public art gallery in Seville (fig. 3.3).[8] Housed in the elegant rooms of the Alcázar, recently rebuilt after the earthquake of 1755, the works could be seen by students and teachers at certain times of day.[9] The main criterion for the selection of paintings for display was the estimation of the benefit that they would bring to pupils in their artistic education. The Academia de las Tres Nobles Artes was very influential in the diffusion of the new academic aesthetic, and among the works on display, besides the paintings that had formerly belonged to the Jesuits,[10] were plaster copies of classical sculpture that the painter Anton Raphael Mengs had brought from Italy and that Charles III had presented to the academy in 1775.[11] Prize-winning

before the French invasion. Ponz was made secretary of the academy in 1776.

7. Carriazo 1929, letter VII, p. 159. In particular, on the orders of the marqués de Grimaldi.

8. From the Jesuit Casa Profesa came *Christ among Angels*, attributed to Céspedes, which had hung in the refectory, and the series of paintings illustrating scenes from the life of St. Ignatius by Valdés Leal, from the cloister (eight are now in the Museo de Bellas Artes, Seville). From the Colegio de San Hermenegildo came a painting of the Multiplication of the Loaves and Fishes by Herrera the Elder (from the refectory), and from the Noviciado de San Luis came *The Adoration of the Magi* by Velázquez (after its sojourn in the Alcázar, it was transferred in 1807 to the royal collections). In about 1800, Ceán Bermúdez mentioned seeing there a half-length portrait of St. Hermenegild by Céspedes and an Immaculate Conception by Roelas. See Ceán Bermúdez 1800, vol. 1, p. 324, vol. 4, p. 233.

Fig. 3.3 The Salón Gótico, the Alcázar, Seville

Fig. 3.4 After David Roberts, *View of Italica*. Engraving. Private collection, Seville

paintings from two examination competitions, held in 1778 and 1783, were also exhibited. The winner of the 1783 competition was José de Rubira, for his copy of Murillo's *Holy Family*, in the collection of the marqués del Pedroso (now in the Museo de Bellas Artes, Seville); the award was a reflection of the interest that this Sevillian painter was attracting at the time.[12] From 1788 the Alcázar also became the home of sculpture from Italica, an ancient Roman town near Seville that had been unearthed in excavations carried out by Francisco de Bruna and the conde del Águila. In addition, it housed some of the Roman remains that came to light in the course of work on buildings in Seville, as happened in 1796, for example, when the foundations of the Church of San Ildefonso collapsed (fig. 3.4). It is difficult today to imagine the sheer variety of pieces—Islamic along with Christian works of the medieval, Renaissance, and Baroque periods—that were to be seen in the rooms of the Alcázar. When Charles IV took up residence there in 1796, a complex system of lighting was installed, which included colored lanterns and candles in the state rooms and gardens.[13]

Beginning in the 1760s various forces, including the academicism that permeated social and cultural circles in Seville, influenced the formation of great private collections. Although some were inventoried after the death of their owners, most were not systematically documented. For this reason, contemporary descriptions of the Sevillian collections, however brief, are illuminating,[14] as are reports by certain foreign travelers who came to Seville in the years 1770–1800. Prominent both for the paintings they contained and for their sheer size were the collections of the conde del Águila and of Francisco de Bruna. Unlike older collections of the seventeenth century and earlier, these collections were not inherited but were formed by, and according to the tastes of, their current owners and represented the two artistic tendencies of the time: the profoundly Baroque on the one hand, and the fashionable academicism with its roots in classical culture on the other.

Francisco de Bruna formed a varied art collection and an extensive library that, on his death, was incorporated into the Biblioteca Real, Madrid. He owned Roman sculpture and inscriptions, Oriental pieces, a coin collection, and a gallery of some one hundred fifty paintings, as well as drawings. The wide range of paintings included works by Velázquez, the Flemish painter Brueghel, and the Italians Veronese and the Carracci. Although most of the attributions given in documents cannot be relied on, they provide insight into the tastes of the collector.

The conde del Águila's collection is known to us today thanks to surviving inventories made after his death. It consisted of over 200 drawings and 243 paintings, 130 of which were by Sevillian painters of the sixteenth century and later. A lesser number were attributed to Italian painters—among them Guido Reni, Carlo Maratta, and the Bassanos—and to

9. "between October 1 and March 1 from 6 to 8, and until the end of May from 7 to 9, the school will be closed on account of the oppressive heat in this country, but on feast days in the morning they can come to draw in the rooms of the Alcázar, where the paintings (from the establishments of the expelled Jesuits) are temporarily on display, together with plaster [copies of] statues." ("entre el 1 de octubre al 1 de marzo de 6 a 8, y hasta fin de mayo de 7 a 9, que cerrará la escuela por las grandes calores de este país, pero los días de fiesta por la mañana podrán asistir a dibujar en los salones del Alcázar donde están colocadas las pinturas de temporalidades (de las Casas de los jesuitas expulsados) y las estatuas de yeso.") Archivo del Real Alcázar, Seville, box 152, file 30.

10. The fullest description of the subject matter and the arrangement of the paintings in the rooms is that given by Nicolás de la Cruz y Bahamonde, the conde de Maule in 1803. See Cruz y Bahamonde 1806–13, vol. 14, pp. 240–41.

11. Ibid., pp. 242–43.

12. Matute y Gaviria 1887, vol. 3, p. 22. Now in the Museo de Bellas Artes, Seville, inv. E630P.

13. Archivo del Real Alcázar, Seville, box 152, expte. 37.

14. Among the most important written references are those by Antonio Ponz, Juan Agustín Ceán Bermúdez, and Nicolás de la Cruz y Bahamonde, conde de Maule.

15. Attributed since the eighteenth century to Velázquez and later to Murillo;

Flemish painters. The collection also included a few examples of works by the seventeenth-century Madrid school along with many contemporary works. The conde also owned an interesting collection of archaeological pieces, and sculpture and medals from the Americas. After his death, the collection was gradually sold. Aniceto Bravo, a well-known local collector, acquired more than forty canvases, and Baron Taylor, on his mission to purchase Spanish paintings for Louis-Philippe's Galerie Espagnole in 1835–37, bought from him *The Adoration of the Shepherds*[15] (National Gallery, London) and Murillo's famous *Virgin of the Girdle* (private collection, Paris).

Another notable—and older—collection, housed in the Casa de Pilatos, property of the marqués de Tarifa, was renowned for its archaeological artifacts. For the past two centuries or so it had held such remarkable examples as the colossal statues that stood in the main courtyard and the numerous classical statues that filled the rooms (fig. 3.5).[16] Among other exceptional collections in Seville during the late eighteenth and early nineteenth centuries were those of the marqués de Loreto, Donato de Aranzana, and the marqués del Pedroso.

Foreign travelers who recorded their impressions of the city also contributed to making the Seville school of painting and the city's artistic riches known outside Spain. Among the accounts written before the French invasion is that of Richard Twiss,[17] who in 1775 described the most important paintings in various churches and gave details of Bruna's collection, which Joseph Townsend also saw in 1786–87. Sir Hew Whiteford Dalrymple came to Seville in December 1774 during the time of his military posting in Gibraltar and wrote descriptions of the paintings there.[18] A Frenchman, Alexandre de Laborde,[19] author of several early-nineteenth-century travel chronicles, mentioned various Murillos in the cloister of the Convento de San Francisco in Seville, which can still be seen today. Although there was widespread interest in Murillo, other painters were becoming known, and the idea of the existence of a Spanish school of painting—with Seville as one of its main centers—was taking shape. A contemporary description of Murillo as "incomparable" exemplifies the new aesthetic that captivated these travelers and that was to culminate in Romanticism. Murillo was so admired that "his absence could be felt in the galleries of the kings of France, may he finally find a place in the Musée National Français."[20]

FRÉDÉRIC QUILLIET IN SPAIN

Descriptions given by travelers and other reports that came from Spain portrayed a country with a rich artistic heritage, and one that also offered many opportunities for art dealing. Attracted by these circumstances, Frédéric Quilliet came from France to make his appearance in the Spanish art world even before Joseph Bonaparte ascended the throne in 1808. Despite the influence he came to exercise over Spain's artistic heritage, particularly the role he played in the confiscation of paintings in Seville, Quilliet has been little studied as a person. Accounts of his life portray him as a controversial figure, evasive and disconcerting.[21] He was in Cadiz from 1806, where he lived on the mezzanine of the house of Antonio Alcalá Galiano, son of a famous seaman and henceforth Quilliet's inseparable friend, whose

Fig. 3.5 Sculpture displayed at the palace of the duque de Alcalá, called the Casa de Pilatos, Seville

today it is attributed to an anonymous Neapolitan painter. Cf. London 2000, p. 36.

16. For information on the collections of the "Casa de Pilatos," the palace of the duque de Alcalá, see Lleó 1987 and Lleó 1989. See also J. Brown and Kagan 1987, and Engel 1903.

17. Richard Twiss (Rotterdam, 1747– London, 1821) was the son of a British art dealer who had settled in the Netherlands. As a young man he completed his education by undertaking the customary Grand Tour. Besides *Travels through Portugal and Spain in 1772 and 1773* (Dublin, 1775), he was the author of such travel books as *A Tour in Ireland in 1775* (London, 1776) and *A Trip to Paris in July and August 1792* (London, 1793). As a result of his extensive education, his observations are particularly valuable and illustrative.

18. Sir Hew Whiteford Dalrymple (1759–1839) wrote *Travels through Spain and Portugal in 1774* (London, 1777) in the form of a travel diary, recording impressions and events on a daily basis.

19. Laborde also wrote an early work on the mosaics of the ancient Roman town of Italica, near Seville: *Description d'un pavé de mosaïque découvert dans l'ancienne ville d'Italica* (Paris, 1802). His most distinguished works, however, are *Itinéraire descriptif de l'Espagne* (Paris, 1809) and the monumental *Voyage pittoresque et historique de l'Espagne* (Paris, 1806–20),

with 900 engravings, including some of seventeenth-century paintings. See also the discussion in Gary Tinterow's and Geneviève Lacambre's essays in this publication.

20. "sue falta se hacía sentir en la pinacoteca de los reyes de Francia y que, por fin, ocupa un lugar en el Museo Nacional Francés." This is the judgment of the diplomat Jean-François de Bourgoing, who traveled in Spain between 1777 and 1795. He witnessed many changes and came into contact with almost all of the country's social classes as he studied its language and customs. See Bourgoing, "Un paseo por España durante la Revolución francesca," in García Mercadal 1999, vol. 5, p. 536.

21. For a better and more detailed understanding of Frédéric Quilliet's years in Spain and his activities there, see Saltillo 1926, Saltillo 1933, Antigüedad 1987b, Antigüedad 1999, Rose Wagner 1983, and Archivo Históricos Nacional Madrid (henceforth AHN), Sección Consejos, file 17787.

22. Alcalá Galiano 1886.

23. "comerciante de objetos de lujo." Quilliet 1818. The sale took place on April 15, 16, and 17, 1818, after being on view in Lebrun's gallery in Paris. On this occasion, 303 paintings, as well as books, were sold. Another, smaller sale, in Paris on March 15 and 16, 1819, is also recorded (Lugt 9532).

24. "aunque no supiese dibujar ni un ojo." Alcalá Galiano 1886, vol. 1, p. 111.

25. "era poeta, místico, pintor, anticuario, orador, actor trágico, comerciante, en fin, politécnico e indudablemente espión y esplorador [sic] antes de la llegada de los franceses, sus paisanos, en Madrid." *Manifiesto de D. Antonio de Capmany en respuesta a la contextación de D. Manuel José Quintana* (Cadiz, 1811), p. 22 (Colección Arteche, Biblioteca del Senado, Madrid). Quoted in Saltillo 1933, p. 10.

26. Major-General Lord Blayney relates a meeting with Quilliet in 1810: "While at a dinner one day with Colonel Vial, I was waited on by a Monsieur Guillet [sic] who, with a profusion of compliments, informed me that he had prepared apartments for me in his house. . . . On enquiring into the character of this person, I found it was not one of the best; but being aware that the French . . . abuse each other without cause, I paid little attention to the report . . . and though I strongly suspected that he was intended to be placed as a spy over me, I prepared to take up my quarters in his house." Blayney 1814, vol. 1, pp. 269–78, quoted in Rose Wagner 1983, p. 285.

memoirs give a few details of the Frenchman's character.[22] Nothing is known of Quilliet's education, and he is described as "trader in luxury goods," an occupation in which he was engaged many years later, as revealed in the catalogue of his estate sale in Paris on April 15, 16, and 17, 1818.[23] He seems to have been daring and extroverted; he made no secret of the fact that he was an enemy of Napoleon and of the French Revolution. He also boasted of his knowledge of art, "even though he could not even draw an eye."[24]

In 1806, on his way to Madrid with Alcalá Galiano, Quilliet paid his first visit to Seville Cathedral. In the Spanish capital he soon made a name for himself, as shown by a combative political publication that featured a descriptive caricature of the Frenchman: "He was a poet, a mystic, a painter, an antiquarian, a public speaker, a tragic actor, a dealer—all in all, a polymath and doubtless a spy and an explorer before the arrival of the French, his countrymen, in Madrid."[25] His notoriety as a spy quickly spread.[26] Quilliet immediately launched into tireless activity in Madrid, which began with the making of important inventories. On January 1, 1808, he completed the inventory of the collection of paintings owned by Manuel Godoy.[27] This inventory bore the title *Collection des tableaux de S.A.S. le Prince de la Paix, Géneralissime Grand Amiral,*[28] and drawing it up gave Quilliet the opportunity to broaden his knowledge of Spanish painting and, possibly, to set his sights on the post of commissioner of fine arts.[29] The richness of the collection and the expectation that its sale created were recorded in correspondence between the well-known English antiquarian William Buchanan and Mr. Wallis, his agent in Spain.[30]

Quilliet next set about making an inventory of the paintings in the Palacio Real in Madrid.[31] In the meantime, Napoleon, taking advantage of the weak Spanish monarchy and having subdued the revolt in Madrid on May 2, 1808, proceeded to impose his political grip on Spain by installing his brother Joseph Bonaparte as the new king. Quilliet's inventory, *Description des tableaux du Palais de S.M.C. par son très humble et fidèle serviteur Frédéric Quilliet,*[32] was dated June 17, 1808. At the end of July, the French, defeated at the Battle of Bailén, were forced to leave Madrid, and Quilliet went into hiding; he wrote a political pamphlet against Napoleon entitled *Bonaparte démasqué* (Bonaparte unmasked).[33] Once discovered, he was incarcerated in the monastery of El Escorial along with other captured Frenchmen. There, surrounded by the richest collection of sixteenth-century Italian painting outside Italy, he formed a strong friendship with the monks. (Ironically, when Quilliet returned to El Escorial in the summer of 1810 it was to confiscate the works of art it contained. Destined for the Museo de Pinturas in Madrid, they were transported under Quilliet's orders in a picturesque caravan of carts that contained hundreds of masterpieces.)

In December 1808 Napoleon returned to Spain with 250,000 soldiers, and Madrid surrendered immediately, on December 2. Indiscriminate sacking and pillage of works of art ensued, permitted as part of the spoils of war.[34] Napoleon, alarmed at the resistance of the many monks who were actively opposed to the new political regime, also carried out his intention of disbanding the monasteries. Frenchmen returned to Madrid, and with them came Quilliet,[35] who, after three years in Spain, had not only become an authoritative connoisseur of the history of Spanish painting but also had acquired a profound knowledge of the best works in the royal art collections. He knew southern Spain thanks to a journey that he undertook with the French artist and antiquarian Jean-Baptiste-Pierre Lebrun, whom he may have met at Godoy's residence in 1807[36] or more likely in Seville itself. Using Juan Agustín Ceán Bermúdez's book as a guide to the artworks of Seville, they had visited the

Cartuja (Carthusian monastery) de las Cuevas and the Hospital de los Venerables Sacerdotes (a home for elderly priests), where Quilliet tried to buy Murillo's portrait of Justino de Neve (National Gallery, London) for 20,000 francs.[37] The memoir by Alcalá Galiano makes clear how useful Ceán Bermúdez's book was in locating the most interesting works of art and, indirectly, indicating those paintings that would later be secured as a matter of priority.[38] The travelers also visited the collection of paintings by Zurbarán belonging to the Cartuja de Jerez de la Frontera, which Quilliet later sent to Madrid (from Madrid, three of the monastery's paintings were taken to Paris, to hang in the Musée Napoléon).[39] Some of the paintings that Quilliet helped Lebrun to acquire at this time were purchased by Quilliet at Lebrun's estate sale in Paris.[40]

At the end of November 1808, Vivant Denon, director-general of museums in France, left Paris for Spain to obtain what had been requisitioned for the Musée Napoléon. After a brief stay in Madrid and Valladolid, he returned to Paris on January 18. Given that he and Quilliet were in the same place and shared similar interests, it is highly likely that they met between December 1808 and January 1809. Denon was probably instrumental in buoying up Quilliet's dubious reputation in Spain, swiftly putting him in charge of works of art in the royal residences.[41] Quilliet was given his own quarters in the Palacio Real in Madrid, where he stored and studied paintings that caught his interest.[42]

However, having been denounced as a spy, Quilliet was soon accused of stealing canvases from the royal palaces. To remove any evidence that certain items were missing, witnesses claimed, he ordered that the identification numbers be erased from the paintings that had come from the Palacio del Buen Retiro.[43] Quilliet allegedly sold these paintings "with the help of the painter Napoli and Juan Miñan [Maignien], a French dealer and an English painter whose name [the witness] did not recall." The latter bought from the marqués de Santiago three canvases—all by Murillo[44]—that, through Wallis, were sold in England for more than 400,000 reales. The restorer Palomino testified that Quilliet and Miñan were in possession of twenty-three canvases that they had acquired from Godoy's residence for 36,000 reales. From this house they were also said to have taken canvases packed in small cases, removing them when the workers went for their meal break. Other witnesses stated that "on eight to ten occasions"[45] Quilliet ordered them to transfer canvases from Godoy's home to that of the Danish ambassador. Although he did not formally accuse Quilliet, all these activities caused Joseph Bonaparte to dispense with his services. Quilliet was involved in another lawsuit in August 1811. A M. Denné, one of Quilliet's compatriots, was keeping some of Quilliet's pieces—pietra dura tabletops and a manuscript—until they could be sold. Because of the risks involved in dealing in stolen goods, and because the reputation of the accused was already seriously damaged, Denné wrote to the relevant authority: "If the stated objects belong to the government, it would be advisable if you apprised me of this fact, given the bad faith in which Quilliet acts."[46]

Despite the controversy and mystery surrounding Quilliet, his interest in Spanish art manifested itself in two important books: *Dictionnaire des peintres espagnols* (Dictionary of Spanish painters), which he published at his own expense in Paris in 1816, and *Le arti italiane in Ispagna* (Italian artists in Spain), published in Rome in 1825.[47] The *Dictionnaire*, a wide-ranging work the purpose of which was to make Spanish painting known in France, is in fact little more than a translation of Ceán Bermúdez's *Diccionario histórico de los más ilustres profesores de las bellas artes en España* (Historical dictionary of the most illustrious exponents

27. On Godoy's collection, see Rose Wagner 1983.

28. AHN, Sección Estado, file 3.227, cited in Beroqui 1933, p. 60.

29. "My inactivity is an affliction, and I don't wish to die of boredom. If Your Lordship does not consider me worthy of a Commissionership, although I have long held such a position in France, I leave you to decide my fate, but at least let me have something to do." ("Je suis affligé de mon inaction, et je voudrois pas mourrir d'ennui. Si V.A.S. ne me croit pas proppre à un Comissariat, quoique j'aie exercé longtemps en France cette branche, je vous laisse décider de mon sort, mais qu'au moins je sois occupé.") Letter from Quilliet to Godoy, February 11, 1808, in Rose Wagner 1983, p. 263. In a more expressive vein, he wrote in a laudatory poem: "Godoy's my hero, my Prince; /The King, The Master of Thunder; /And me, I'm a Commissioner!" ("C'est mon héros, mon Prince, Godoy; /Le Roy, Le Maitre du Tonnerre; /et moi, Le Commissaire!") Ibid.

30. Buchanan 1824, vol. 2, pp. 225–30.

31. Biblioteca del Palacio Real, II, 3.269. Published and transcribed in its entirety in Sancho 2001.

32. In his memoirs, Quilliet's friend Alcalá Galiano lamented that sometimes during these visits the palace was mistreated, mentioning in shocked tones a ball that took place in the Queen Mother's bedroom. See Alcalá Galiano 1886, vol. 1, p. 181.

33. A copy of the Spanish translation made by Alcalá Galiano is in the Archivo del Servicio Histórico Militar, Madrid, Colección del Fraile, vol. 872, no. 3216.

34. On the looting in Europe by Napoleon's forces, see Wright 1984.

35. His residence was located at No. 1 Calle Fuencarral, on the corner of Calle de Santa Brígida. AHN, Sección Consejos, file 17787.

36. Lebrun wrote Godoy in September 1807, asking to see his collection, a request that initially was repeatedly denied. Lebrun also expressed an interest in writing a book on the Spanish school of painting, similar to the one that he had written on Flemish painting. Álvarez Lopera 2001, p. 20.

37. Quilliet 1816, p. 100.

38. See Alcalá Galiano 1886, vol. 1, p. 319.

39. Quilliet 1816, p. 407. From the high altar at the Cartuja de Jerez came *The Annunciation*, *The Adoration of the Shepherds*, *The Adoration of the Magi*, and *The Circumcision* (Musée de Grenoble), *The Battle between Christians and Moors at El Sotillo* (fig. 3.12), *The Virgin of the Rosary with Carthusians*

(Muzeum Narodowe, Poznań), *The Apotheosis of Saint Bruno* (Museo de Cádiz), and *The Virgin of the Immaculate Conception with Saints Anne and Joachim* (fig. 7.20); the last painting belonged to another altarpiece. The problematic location of the paintings has recently been studied by Benito Navarrete Prieto, "Aportaciones a los Zurbaranes de la Cartuja de Jerez," in Algueró et al. 1998, pp. 19–55.

40. Among them were various paintings of children by Villavicencio and a work by Guevara from the Church of San Alberto in Seville. Quilliet 1816, pp. 227, 230.

41. See Quilliet 1825a, pp. 9–20.

42. Ibid., p. 111 n. 6.

43. Among them were works by Titian, two flower paintings by Brueghel, a painting by Orrente with scenes from the life of Christ, *The Blessing of Isaac* by [Jacopo] de Bassano, two works by Jordán [Giordano?], and *Saint Catherine* by Titian, as well as other works that he does not mention. Cited in Antigüedad 1999, pp. 72–73. AHN, Sección Consejos, file 17787, and Archivo General de Palacio, Gobierno Intruso, box 19, file 32.

44. AHN, Sección Consejos, file 17787.

45. "unas ocho o diez veces." Saltillo 1933, pp. 34–35.

46. "si los objetos citados son del gobierno, por la mala fe con que siempre procede Quilliet, estimaré que V. E. se sirva preventirme." Ibid., pp. 36–37.

47. See Quilliet 1809, 1816, 1825a, 1825b, 1837–38 for his known literary output, as well as *Précis sur l'Espagne*, a manuscript dated January 1808, and the following manuscript inventories of collections of paintings: *Collection des tableaux de S.A.S. le Prince de la Paix, Géneralissime Grand Amiral*, January 1808, AHN, Sección Estado, file 3.227, no. 1, and *Description des tableaux du Palais de S.M.C. par son très humble et fidèle serviteur Frédéric Quilliet*, dated June 27, 1808, Biblioteca del Palacio Real, Madrid.

48. Despite its subject matter, *Le arti italiane in Ispagna*, published in Italian and French (both Rome, 1825), is a book that is little known in Spain. I was able to consult the Italian edition in the Clark Art Institute, Williamstown, Mass., and both versions at the Hispanic Society of America, New York.

49. The decree, published in the *Gaceta de Madrid* on December 20, 1809, is published in Gómez Ímaz 1896.

50. Antigüedad 1987b, p. 72, gives document references of the Archivo General de Palacio, Registro de Expedientes (Ministerio del Interior), 1809–10, file 2209, December 20, 1809, exp. 301, fol. 22.

of the fine arts in Spain), which appeared in Madrid in 1800; the only additions were commentaries in which Quilliet expressed his own frank opinions and described some of his activities while in Spain. The book was widely used from the 1830s onward, when Spanish painting became fashionable in France. At the auction of Quilliet's estate in 1818, lot 310 included "A large number of copies of the *Dictionnaire des peintres espagnols*; a work in one volume. In octavo, by F. Quilliet." A copy also appeared in the auction of Denon's collection, held in 1826.[48] Quilliet's publishing activities continued in 1837–38 with a *Guide méthodique de Rome et de ses environs* (Systematic guide to Rome and its environs), published in Italy, where he resided until 1833 as consul of Ancona.

By decree on August 23, 1809, the religious orders were abolished, and two depositories were set up in dissolved monasteries in Madrid to house over 1,500 confiscated paintings, a selection of which was presented to various generals. Others were forcibly handed over to Napoleon for his museum in Paris, while the sale of other paintings and objects of value increased the income of Joseph Bonaparte's exhausted government.

The remaining paintings were destined for the Museo de Pinturas in Madrid, established by decree of Joseph Bonaparte on December 20, 1809.[49] In emulation of the Louvre in Paris, its collections were to represent the various national schools. The idea of such a museum had taken root in Spain at the end of the eighteenth century. Quilliet's knowledge of Spanish painting, which had led to his being put in charge of the royal art collections, was also the passport to his involvement in the establishment of the Museo de Pinturas. His control over the museum was effective as soon as the decree was issued, as shown by a document in which he requested the restoration of the former Convento del Rosario, which had been converted into a depository for confiscated paintings.[50]

THE ANDALUSIAN CAMPAIGN AND THE PLUNDER OF SEVILLE'S ART TREASURES

In January 1810 the French army launched a campaign to conquer Andalusia. The Junta Central, the government of the resistance, and the army set off to defend Cadiz, leaving Seville vulnerable. The French troops were thus able to enter the city, which fell on February 1 without a fight; Seville remained under French occupation until August 1812. Quilliet had recently asked the minister of the interior to include him in the southern campaign, arguing the necessity of safeguarding southern Spain's artistic patrimony. The minister duly appointed him artistic attaché in Andalusia, with responsibility for collecting "all the paintings that are to be found in the dissolved monasteries, or that may be of value to the government"—such as those belonging to the opponents of the new regime. For this, Quilliet was to rely on the army's support.[51]

French troops swiftly advanced toward the south. The city council of Seville "on January 20, 1810, packed up and put under guard all the best silverware and the most valuable vestments in the cathedral so as to send them elsewhere should the French reach Seville."[52] When the French troops took the city, the religious orders were suppressed by law, and religious and charitable communities were ordered to hand over detailed lists of valuable objects in their possession. Many monks and nuns left the convents and monasteries, sending their jewelry and paintings to Cadiz; the Capuchins and the Convento de San Antonio sent theirs with the cathedral treasures (fig. 3.6).[53] Many individuals did the same.

Countless families fled the city, leaving their houses to the mercy of the occupiers. In a letter written from Seville and dated February 7, 1810, Quilliet reported to the minister of the interior on the works of art that he had found in Seville, enthusiastically describing the painters and even the number of pictures that he considered worthy of acquisition: "Besides the Alcázar, the Archbishop's Palace, and the Cathedral, this work has revealed 80 churches of all kinds—monasteries, convents and parish churches, hermitages and hospital churches, etc. You will find 819 paintings of various sizes, which represent the basis of the Spanish School, since you will see some works by Villegas, who must be considered the founder of the School whose ruler is Murillo."[54]

The troops lodged in the monasteries and, although the monks had been assured that their property would be protected, the monks themselves who remained were forcibly expelled. Contemporary accounts related that the French "sacked and destroyed many monasteries, even though the government took preventive measures, posting guards and gathering up silver."[55] Even so, the occupation of Seville did not involve the violence visited on other cities.

There are also many known instances of works of art being sold in Seville before the troops entered the city, as well as in secret during the occupation. Spanish and foreign—particularly English—dealers and agents, middlemen and individuals, collectors, officials, and clerks were involved in this initial phase of the dispersal of paintings. Names such as Manuel López Cepero, Antonio Bravo, and the collector Nathan Wetherell stand out in the period before the French arrived. During these years large numbers of paintings were acquired and subsequently exported, not only from Seville but also from the whole of Spain. Particularly conspicuous was the increase in the number of Spanish works auctioned in London around 1810.[56]

A decree ordering that paintings from throughout the city be taken to the Alcázar was issued in Seville on February 11.[57] A number of those paintings were selected to make up the "Seville school" at the Museo de Pinturas in Madrid. A second group of paintings was destined for the Musée Napoléon in Paris. The pictures—compiled from a consultation of the index of Ceán Bermúdez's *Diccionario*—were obtained under Quilliet's direction. However, Félix González de León, a faithful chronicler of the events that occurred in the city during the first decades of the nineteenth century, also reported that "not a few [of the paintings] were taken or seized by those government commissioners to appropriate them for themselves. In this way the priceless collection of fine paintings in the possession of the monasteries was dispersed and lost."[58] The seized works came not only from dissolved monasteries but also from hospitals and brotherhoods, which was at odds with the original intention of the decree relating to the creation of the Museo de Pinturas in Madrid.

While in Seville, Joseph Bonaparte used the Alcázar (fig. 3.7) as his official residence, and those who came with him lodged in the city's large houses and palaces. The Alcázar was furnished and hung with many paintings from convents and churches.[59] To the French, Seville seemed filled with antiquated buildings, its narrow streets and Moorish architecture

Fig. 3.6 Bartolomé Esteban Murillo, *Virgin and Child* (known popularly as the *Virgin of the Napkin*), 1665–66. Oil on canvas, 26⅜ x 28⅜ in. (67 x 72 cm). Museo de Bellas Artes, Seville, formerly in the Convento de Capuchinos, Seville

51. "todos los cuadros, que se encontraran en conventos suprimidos, o de que pueda disponer el gobierno." From the order of February 8, 1810, quoted in Saltillo 1933, p. 13.

52. "el día 20 de enero de 1810 encajonó y guardó toda la plata y los vestuarios de primera clase de la Catedral para enviarla fuera si los franceses llegaban a Sevilla." Archivo Municipal de Sevilla (AMS), Sección 14, *Crónicas de D. Félix González de Léon*, January 20, 1810. The *Crónicas* of González de León contains an account of this episode, describing what the writer saw when he was in the city. Although it sometimes does not accurately explain the reasons for what occurred, the information given is adequately complemented by documents (in the AHN) relating to these events—resulting in the administrative activity of the new government, which was particularly zealous in the sphere of artistic heritage.

53. Velázquez y Sánchez 1994, p. 98, and AMS, Sección 14, *Crónicas*, January 25, 1810, fol. 6.

54. "Ce travail outre l'Alcazar, le Palais Episcopal, & la Catédrale présente 80 temples de toute hierarchie, moines, nonains, paroisses, Ermitages, hospitaux &. Vous y trouverez 819 tableaux de toutes grandeurs, qui consistuent la base de l'École Espagnole puisque vous y verrez des Villegas que l'on doit regarder comme le fondateur de l'École dont Murillo est le Prince." Letter from

Frédéric Quilliet to the Spanish minister of the interior, Seville, February 7, 1810. AHN, Sección Consejos, file 17787.

55. "que saquearon y destruyeron muchos conventos, si bien el gobierno impidió mucho, poniendo guardias y recogiendo la plata." AMS, Sección 14, *Crónicas*, February 1, 1810.

56. See Glendinning 1989a and Fernández García 1998–99.

57. The decree is published in Gómez Ímaz 1896.

58. "no pocas se extrajeron y robaron por los mismos comisionados por el gobierno para recogerlas y de este modo se repartió y perdió la grande riquísima colección de bellísimas pinturas que poseían los conventos." AMS, Sección 14, *Crónicas*, February 1, 1810.

59. AMS, Sección 14, *Crónicas*, April 12, 1810, fol. 34–35.

60. These projects were undertaken by a certain M. Mayer, general contractor of the army, who reaped the benefit of the operations. Velázquez y Sánchez 1994, p. 113.

Fig. 3.7 Anonymous, *Interior of the Alcázar*. Colored engraving

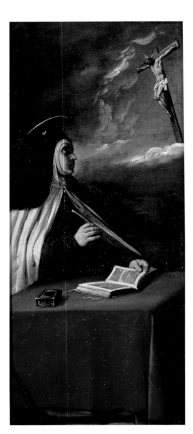

Fig. 3.8 Alonso Cano, *The Vision of Saint Teresa*, 1629. Oil on canvas, 38⅜ x 16¼ in. (98 x 42 cm). Colección Forum Filatélico

evoking images of an Oriental city. Since the city's grander residences and palaces also appeared inadequately furnished and ill equipped, they were subjected to improvements and renovations. In addition, the new government undertook to enlarge the city's squares and widen its streets; in the process a few religious buildings, such as the Church of Santa Cruz and the Convento de Religiosas de la Encarnación, were knocked down.[60] The Church of San Alberto "was preserved because this was where booty from the altars and furniture from the monasteries were kept before they were sold."[61]

Quilliet was aware, from the lists of paintings in his possession, that many works had been purloined. In correspondence with the minister of the interior, he itemized what was missing. Foremost were seventeen paintings by Murillo from the Convento de Capuchinos that, he wrote, had been hidden or assigned to individuals for safekeeping.[62] A work by Alonso Cano (fig. 3.8) and several by Zurbarán had been removed from the Convento de San Alberto. The Convento de la Merced Calzada had already sold everything apart from three Murillos, while the Convento del Carmen Calzado had sold a *Virgin of the Rosary* by Murillo for a ridiculous price—250 piastres—"the buyer had then sold it for 300, and so on." The enumeration continued: the Colegio de San Buenaventura, which was reluctant to admit outsiders, had entrusted paintings to its trustees; a fortnight earlier—before the city had been taken—the Convento de San Francisco had refused an offer of 60,000 piastres for seven Murillos that hung there. At the Monasterio de la Cartuja de las Cuevas e Italica, a large collection of archaeological artifacts—medals, busts, and heads—from Italica had recently been sold for 9,000 reales by Père Georges, a French friar of the order of St. Jerome from the Monasterio de San Isidoro del Campo, to the English dealer Nathan Wetherell, who had been based in the city for some years and who was one of the most active collectors of the time.[63] Some institutions, like the Colegio de Santo Tomás and the Hermandad de la Caridad (Confraternity of Charity), attempted to delay handing over requisitioned paintings. Quilliet, with cutting irony, related to the minister some of these incidents: the large

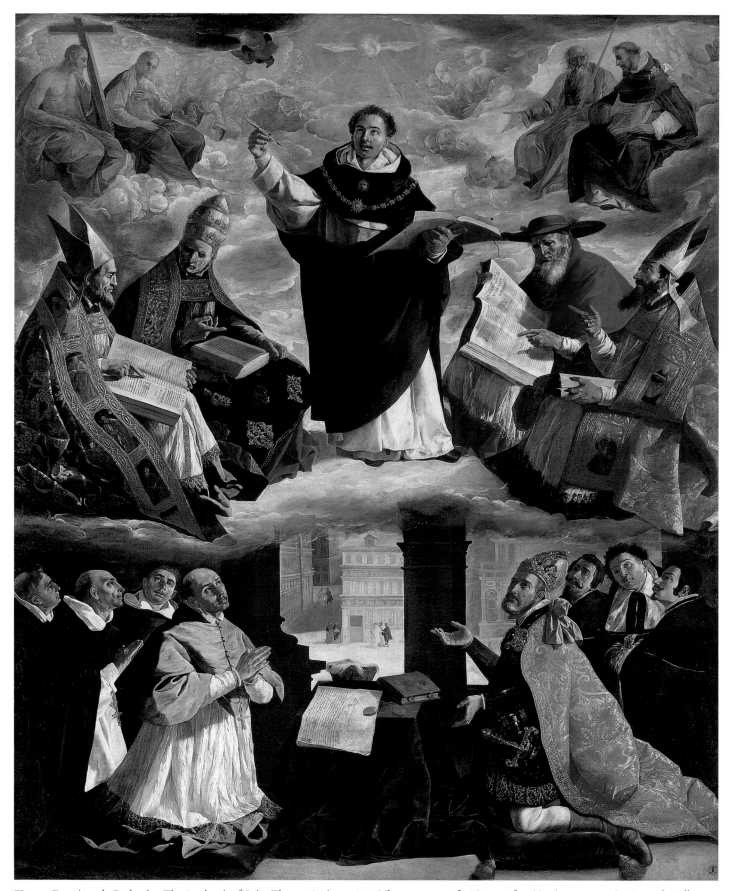

Fig. 3.9 Francisco de Zurbarán, *The Apotheosis of Saint Thomas Aquinas*, 1631. Oil on canvas, 15 ft. 6 in. x 12 ft. 3⅛ in. (473 x 375 cm). Museo de Bellas Artes, Seville

61. "se conservó porque en ella se hizo el depósito para venderlos de los despojos de los altares y muebles de todos los conventos." AMS, Sección 14, *Crónicas*, February 1, 1810. Despite this account, there is no record of any sale of lesser works having taken place in Seville, unlike Madrid.

62. Quilliet gives precise details of the paintings belonging to the Convento de Capuchinos and their mysterious fate. Of almost twenty Murillos that made up the collection, all except *The Miracle of the Porciúncula* (Wallraf-Richartz-Museum, Cologne) were saved from seizure. Stored in the Alcázar, the painting was taken to Madrid and, upon its return to Seville, was given to the painter Manuel Cabral Bejarano in payment for restoring the paintings. Of the rest of the Murillos, *The Guardian Angel* was also not returned to the convent; instead, it was presented to Seville Cathedral in thanks for having sent the paintings to Cadiz together with the cathedral's own possessions. Nor was *Saint Michael* restored to the convent; after its disappearance, it was sold to an individual at the Kunsthistorisches Museum, Vienna, where it came to light in 1986.

63. Letter from Quilliet to the Spanish minister of the interior, February 4, 1810, AHN, Sección Consejos, file 17787.

64. Gestoso y Pérez 1912, p. 85, relates the discovery of a letter describing the travels and tribulations of one of the restituted canvases.

65. See letter from Quilliet to the Spanish minister of the interior, April 20, 1810, cited in Saltillo 1933, p. 26, in which Quilliet expresses his exasperation with the "cabeza de hidra" (hydra-head) Jesuit.

66. The inventory was published in Gómez Ímaz 1896 and, more recently, in Lipschutz 1988, pp. 338–50.

67. See Moreno Alonso 1995, p. 63.

68. Saltillo 1933, p. 28.

69. Written in Quilliet's unmistakable hand is an undated list itemizing the "paintings taken to Madrid from the Alcázar of Seville."
Murillo: *The Resurrection of Christ* (now Academia de San Fernando, Madrid); *The Indulgence of the Porciúncula* (Wallraf-Richartz-Museum, Cologne); *Moses Striking the Rock* (Hospital de la Caridad, Seville); *The Multiplication of the Loaves and Fishes* (fig. 3.16); *Saint John of God* (Hospital de la Caridad, Seville); *Saint James Feeding the Poor* (Academia de San Fernando, Madrid); *The Christ Child Distributing Bread* (fig. 14.15). Alonso Cano: *The Presentation of the Virgin in the Temple*; *David with the Head of Goliath*; *Joseph and Potiphar's Wife*;

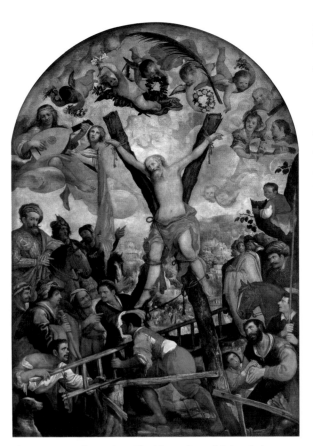

Fig. 3.10 Juan de Roelas, *The Martyrdom of Saint Andrew*, 1610–15. Oil on canvas, 17 ft. 4¾ in. x 11 ft. 4¼ in. (530 x 346 cm). Museo de Bellas Artes, Seville, formerly in the Capilla de los Flamencos of the Colegio de Santo Tomás

paintings of the Colegio de Santo Tomás had not been relinquished because of their size; *The Apotheosis of Saint Thomas Aquinas* by Zurbarán (fig. 3.9) and *The Martyrdom of Saint Andrew* by Roelas (fig. 3.10) had been cut from their frames and hidden in the cathedral, where they were nevertheless found by the French, who took them to the Alcázar.[64] Despite the use of subtle diplomacy, the Hermandad de la Caridad was forced to surrender its Murillos. In Quilliet's absence from Seville, the Hospital de los Venerables Sacerdotes had managed to get back from the Alcázar its famous *Immaculate Conception* (fig. 1.20); this aroused the blind rage of Quilliet, who with Lebrun had admired this work in 1807 and made an unsuccessful attempt to buy it. In insulting tones, Quilliet accused the retired priests of taking the painting "to warm [their] congealed blood," and requested that henceforth all possible means be used to retrieve paintings that had been hidden or removed from the Alcázar by their rightful owners. Other paintings, among them the *Saint Lazarus* by Villegas Marmolejo from the altarpiece of the church of the Hospital de San Lázaro, had also been returned to their owners. But possibly his starkest invective was reserved for the Jesuit superior, who had prevented the few paintings that remained in his church—those on the high altar and one of the side altars—from being handed over.[65]

Quilliet and his henchmen had worked quickly and shrewdly, however, and 999 paintings confiscated from churches and monasteries were taken to the Alcázar before June 2, 1810, when an inventory was made.[66] Like that of a museum, the inventory records each painting's title, artist, dimensions, and the room in which it was located; sometimes items were arranged in series or in groups. Although many of the thirty-nine rooms in which the paintings were kept were simply packed full of canvases, some of the most famous works were organized for public display. On the ground floor, Room 1 (fig. 3.11), for example, contained fifty-two paintings, among which were the Murillos from the Hospital de la Caridad and the series of paintings of St. Jerome by Valdés Leal. In Room 2 were *The Apotheosis of Saint Thomas Aquinas* and the series of paintings by Zurbarán from the Colegio de San Buenaventura. There were also other large-scale paintings, such as *The Apotheosis of Saint Hermenegild* by Herrera the Younger (fig. 4.9). In Room 4, it appears that the paintings were more densely displayed, and their quality more uneven. This unprecedented picture gallery was opened to the public on Sundays and feast days, and the excitement that it stimulated can only be surmised.[67]

Because of ongoing problems with the condition of the buildings in Madrid, where the paintings were to be housed, the Alcázar in Seville appears to have fulfilled the role of art museum by default. The very idea of centralizing culture was at odds with the creation of an official museum in Seville, however, and the legislation that made Seville a depository of paintings to supply Madrid and Paris seems to have stood in the way of the Alcázar becoming a true art museum. Nevertheless, there is no doubt that, while the paintings remained in the Alcázar, it became a magnet for students and visitors who were able to make the journey there. The absence of detailed descriptions or any visual record of the place may be due both to prudence in a politically unstable climate and to a defensive stance regarding the paintings' former owners.

In keeping with the decree of 1809, the transfer of confiscated paintings designated for the museum in Madrid and for the Musée Napoléon in Paris went ahead.[68] The twenty-seven paintings that comprised the first consignment destined for Madrid were dispatched from Seville on January 12, 1811.[69] Ill fated, the carriage broke down in Carmona, a village near Seville.[70] Taking advantage of an expedition accompanying Marshal Mortier, duc de Trévise, the paintings finally left for Madrid on April 17, 1811, where they arrived at the beginning of May. However, the works had still not been unpacked

Fig. 3.11 The Salón Bajo, the Alcázar, Seville

on July 23.[71] (This selection did not include those paintings that, against Quilliet's wishes, had been removed from the Alcázar by Soult.)

Quilliet confirmed that he had "taken from Andalusia 39 paintings, of which 12 were by Zurbarán, 2 of which have been set aside for H. M. the Emperor." In effect, twenty-seven of the paintings sent to Madrid came from the Alcázar of Seville, while the twelve Zurbaráns left behind were later brought to Madrid from the Cartuja de Jerez. All of these were stored in the Convento del Rosario upon their arrival in Madrid along with the paintings that had been confiscated from the churches, convents, and monasteries of that city (by virtue of the decree of December 29, 1809, establishing the museum of paintings).[72] The most valued Spanish paintings were selected to be taken to the Musée Napoléon in Paris as part of the splendor of the Empire. A commission, formed by the painters Francisco de Goya and Mariano Salvador de Maella and the restorer Manuel Napoli, selected a total of fifty-seven pictures that were delivered to the emperor in the name of the king of Spain, Joseph Bonaparte.[73] To this representation of Spanish painting in Paris was later added the group of pictures donated to the Louvre by Marshal Soult upon his return from Spain, which for the most part came from Seville.

The paintings of the school of Seville that figured among the gifts to the Musée Napoléon were the following: three works by Zurbarán that had belonged to the Cartuja de Jerez, *The Battle between Christians and Moors at El Sotillo* (fig. 3.12), *The Adoration of the Magi*, and *The Circumcision* (figs. 7.12, 7.13); and two Murillos, *The Adoration of the Shepherds*, which had come from the royal collection (Museo del Prado, Madrid), and an

Jesus and the Woman of Samaria. Juan del Castillo: *The Virgin with Saint Dominic* (private collection; sold at Christie's London, 1990); *Saint Peter and Saint Paul*; *The Coronation of the Virgin*. Herrera the Elder: *The Flight of the Heretics before the Holy Sacrament*; *The Last Supper*. Herrera the Younger: *The Multiplication of the Loaves and Fishes* (Archbishop's Palace, Madrid, as Herrera the Elder). Pablo de Céspedes: *Christ in the Desert*. Bocanegra: *Saint Sebastian*. Francisco Varela: *Saint James on Horseback*. Iriarte: *Saint Francis of Paola*. Villegas: *Saint Lazarus*. Luis de Vargas: *Presentation of Christ in the Temple* (Museo de Bellas Artes, Seville). Fray Sánchez Cotán: *Ecstasy of Saint Francis* (Seville Cathedral). Pedro de Moya: *Landscape with Hermits*. Valdés Leal: *Saint Joseph, the Virgin, and Angels*; *The Death of Saint Jerome*. AHN, Sección Consejos, file 17787.

70. Apparently the crates had been tampered with. Ibid.

71. Ibid.

72. AHN, Sección Consejos, file 17787, contains numerous notes, many of them undated. One of them records the list of paintings stored in the Convento del Rosario, as well as a list of thirty-five

Fig. 3.12 (cat. 87) Francisco de Zurbarán, *The Battle between Christians and Moors at El Sotillo*, ca. 1638. Oil on canvas, 10 ft. 11⅞ in. x 6 ft. 3¼ in. (335 x 191.1 cm). The Metropolitan Museum of Art, New York, Kretschmar Fund, 1920 (20.104)

Fig. 3.13 Bartolomé Esteban Murillo, *Saint Elizabeth of Hungary Nursing the Sick*, 1672. Oil on canvas, 10 ft. 8 in. x 8 ft. ½ in. (325 x 245 cm). Church of the Hospital de la Caridad, Seville

works from El Escorial. A letter signed by Manuel Napoli concerning the selection of paintings to be sent to Paris included a reference to two paintings from the Cartuja de Jerez. One, Zurbarán's *Battle between Christians and Moors at El Sotillo* (fig. 3.12), is now in the collection of The Metropolitan Museum of Art, New York; the other is Zurbarán's *Virgin of the Rosary with Carthusians*, now in the Muzeum Narodowe, Poznań.

73. See Beroqui 1933, p. 57.

74. See Martín García 1993. Odile Delenda has made impressive progress in locating these works in recent years. One such example is the *Saint Catalina* by Alonso Cano (fig. 1.25). See Madrid 2002a, p. 158. Two works by Zurbarán that came to light as a result of the 1998 Seville exhibition are *The Flight into Egypt* and *The Virgin Mary Giving the Mercedarian Habit to Saint Peter Nolasco*. See Seville 1998. Other recent examples include *Christ Served by the Angels* and the *Last Judgment*, both by Francisco Pacheco, acquired in the last few years by the Musée Goya, Castres. See Jean-Louis Augé, "Velázquez et la France," in Castres 1999, pp. 11–22.

Fig. 3.14 Francisco de Zurbarán, *Saint Hugo in the Refectory*, ca. 1645–55. Oil on canvas, 8 ft. 9 in. x 10 ft. 5 in. (268 x 318 cm). Museo de Bellas Artes, Seville, formerly in the Sacristía de la Cartuja de Sevilla

Immaculate Conception "in the style of Ribera." Among the paintings by Alonso Cano that went to Paris were a *Crucifixion* and a *Christ at the Column* that had been in the Godoy collection (Academia de San Fernando, Madrid). To all of these pictures in Paris were shortly added those given by Marshal Soult: *The Apotheosis of Saint Thomas Aquinas* by Zurbarán (fig. 3.9); two pictures by Murillo painted for the Church of Santa María la Blanca, *The Dream of the Patrician* and *The Patrician John and His Wife before Pope Liberius (The Foundation of Santa Maria Maggiore in Rome)* (figs. 1.22, 1.23); and the celebrated *Saint Elizabeth of Hungary Nursing the Sick* (fig. 3.13), also by Murillo, painted for the Hospital de la Caridad of Seville, where it is found today.

By the time the French retreated from Seville in August 1812, 173 paintings had disappeared from the Alcázar of Seville, a fact that is demonstrated by comparing the inventory of 1810 with that of 1813. Among those 173 paintings, 32 were works by Murillo, 24 were attributed to Alonso Cano in the inventories, and 28 were by Zurbarán. To these must be added many other Sevillian works that were removed from the churches and convents and were not recorded among those looted from the Alcázar, thereby significantly adding to the total. To this day some of these works continue to surface on the art market or in French collections.[74]

The paintings destined for the Musée Napoléon left Madrid for Paris on May 26, 1813, and arrived two months later. As stipulated by Joseph Bonaparte, who closely followed the proceedings, the list of paintings was to be signed by the treasury minister, the minister of the interior, and the superintendent-general of the royal house, and approved by himself,

possibly to delay their dispatch from Madrid. The fact that the final selection of paintings was found to be incomplete was attributed to embezzlement on Quilliet's part.[75] Although Joseph Bonaparte left Madrid in March 1813, he made sure that the paintings followed him. In July the paintings reached Paris.[76] These works were later supplemented by Marshal Soult's donation to the new king of France, Louis XVIII,[77] from which several paintings were exhibited in the Louvre upon his arrival on May 3, 1814.

By the time of Napoleon's decisive defeat at Leipzig on October 16–19, 1813, Spain had begun to recover from the trauma of the French occupation, but until the French loss at Waterloo, negotiations for the return of its property were unsuccessful. Despite the resistance of Louis XVIII, the Spanish ambassador de Álava sought to retrieve not only those paintings that had been chosen for the emperor but also those donated by Soult. Denon, now director of the Louvre, objected, arguing that all the paintings had formed part of the selection made for Napoleon. By October 1815, however, the paintings that had for such a short time belonged to the former emperor finally left Paris, together with four that Soult had given to the Louvre and three that had been seized from the houses of certain noble Spanish families. For reasons of safety, the paintings were transported by sea; they were received on June 30, 1816, by the Academia de San Fernando, which undertook the return of paintings to the relevant institutions and requested the return of those that remained in France as they were undergoing restoration (for more information on the restitutions, see Geneviève Lacambre's essay in this publication).[78] In Spain, some churches, such as the Church of Santa Cruz, had closed down completely, while other monasteries and convents were seriously impoverished by their losses, as was the Convent de San Francisco, which would never see the return of its exceptional group of paintings by Murillo. The Convento de la Merced Descalza, which had possessed the largest number of paintings by Zurbarán, also experienced the loss of almost all its paintings. The Cartuja de las Cuevas also lost its painting cycle by Zurbarán that had decorated the sacristy of the church, among them *Saint Hugo in the Refectory* (fig. 3.14). The Merced Calzada, the Cartuja de Jerez, the Church of San Alberto, the Convento de Santa Paula, and the Hospital de la Caridad saw their collections of paintings impoverished both in terms of their artistic value and their iconographic integrity. While many convents and monasteries lost everything, some were able to recoup a portion of their artistic treasures. None of the collections, however, were restituted in their entirety.

SEVILLIAN PAINTINGS IN SOULT'S COLLECTION

Marshal Soult, about whom much more is known than has come to light about Quilliet, lives on in the collective memory of Spain because of his role as head of the French army during the Peninsular War (1808–14) and the seizure of works of art. In France, by contrast, his reputation is that of an illustrious individual who contributed to the military glories of the Empire.[79] Thanks to the favor that he enjoyed with Napoleon, he was able to act with impunity, even when he fell afoul of laws laid down by the king, Napoleon's brother Joseph Bonaparte. Although there had been early objections to the plunder inflicted on the entire peninsula,[80] the French forces yearned to take Seville, with its renowned artistic riches that promised a rich booty.[81] Soult effectively made the most of the opportunity following his entry into Seville on February 1, 1810. In addition to seizing paintings from churches that had not been affected by the enforced dissolution of religious communities, he took for

75. Beroqui 1933, p. 68.
76. See M. Madrazo 1945, p. 59.
77. See Denon 1999, vol. 2, no. 3539.
78. "According to the note written by Mr. Lavallée to the conde de Pradel, minister of the royal house, what was violently removed from the museum by the commissioners of Spain were 284 paintings and 108 various objects." ("según la nota pasada por Mr. Lavallée al Conde de Pradel, ministro de la Caso Real, lo sacado del Museo con violencia pour los comisionados de España, fueron 284 cuadros y 108 objetos diversos.") Beroqui 1932, p. 87.
79. Jean de Dieu Soult (1769–1851), one of the most brilliant military strategists of the Napoleonic era, was minister of war under Louis XVIII, who, like Charles X, made him a maréchal (marshal) and a Peer of the Realm. In addition, he served as minister of war under Louis-Philippe, who elevated him to the rank of marshal-general, a rare distinction. He served several times as president of the council of ministers, until he retired for reasons of health in 1847.
80. The writer, philosopher, and historian Antonio Capmany records this in his expressively titled *Centinela contra franceses* (A Lookout against the French), published in Madrid in 1808. In English, *An Account of the Operation of the British Army and of the State and Sentiments of the People of Portugal and Spain during the Campaigns of the Year 1808 & 1809, in a Series of Letters*, by Rev. James Wilmot Ormsby, was published in London in 1809. Several French soldiers were known to have protested against the actions of their commanding officers, while the plunderers justified their actions with the suggestion that they aided the appreciation of Spanish painting and safeguarded the paintings from a worse fate.
81. Looting in Spain during the French invasion, even before French troops reached Seville, was widespread, occurring in Saragossa, Toledo, El Escorial, and Madrid. By contrast, other cities, such as Valencia, managed to avoid that fate.

82. "By a decree of December 27, 1809, His Majesty gave to the Maréchal, Duke of Dalmatia, six excellent paintings from the depositary at El Rosario; namely: Jesus carrying the Cross, executed by Sebastiano del Piombo (Hermitage, St. Petersburg), St. Irene and St. Sebastian by Ribera (Museo de Bellas Artes, Bilbao), Abraham and the Angels by El Mudo (National Gallery, Dublin), a Madonna and Child by Guido (Reni), a St. Jerome by Van Dyke, a dº [sic] by César de Ticiano (Titian)." ("Por decreto de 27 de diciembre de 1809 concedió S. M. al Mariscal duque de Dalmacia seis excelentes pinturas del depósito del Rosario; a saber: Jesús con la Cruz a cuestas de Sebastián del Piombo, Santa Irene y San Sebastián de Ribera, Abraham y los Ángeles del Mudo, la Virgen y Jesús de Guido, San Gerónimo de Vandik, el dº [sic] del César de Ticiano.") Archive of the Palacio de Oriente, Register-General of Decrees (1809–10), fol. 85, December 20, 1809. See Mercader Riba 1983, p. 552.

83. On October 23, 1810, the treasury minister also granted the army paymaster, Mr. Cochart, a license to export no fewer than 111 paintings. Ibid.

84. Ponz 1776–94, vol. 9, pp. 189–90.

85. See Liverpool 1990–91, pp. 19–23.

86. On this series, see Valdivieso 1988, pp. 179–85. They consist of The Conversion of Saint Augustine by Saint Ambrose (Saint Louis Art Museum), according to the Getty Index of Provenance, and The Miracle of the Bees (Museo de Bellas Artes, Seville). Both were originally connected to Marshal Soult.

himself paintings that were being stored in the Alcázar. He also operated on the fringes of the law by which the religious communities had been dissolved and by which the Museo de Pinturas was to be created. Soult's interest in art appears to have had more to do with the kudos of military victory than any cultural inclination, though the quantity and quality of the paintings that he gathered seem to indicate a predilection for the Seville school, of which Murillo was the greatest exponent.

Shortly before the fall of Seville, Soult had been presented with a selection of six paintings from the hundred that Joseph Bonaparte had ordered to be reserved by the minister of the interior for the purpose of rewarding military leaders.[82] Soon afterward, Marshal Soult's representative, a M. Barrillon, asked permission to export those paintings to France, together with a further fifteen. Despite several decrees prohibiting the export of works of art from Spain, he finally obtained authorization to do so on August 22, 1810. The anti-exportation law does not seem to have been widely enforced.[83]

After the expulsion of the archbishop of Seville, Soult chose as his residence the archbishop's palace, a Baroque building that Antonio Ponz described as "sumptuous, but built in a style full of tasteless ornaments" (fig. 3.15).[84] Among the works that were to be found there, and that disappeared during Soult's sojourn in Seville, was Murillo's *Virgin and Child* (today in the Walker Art Gallery, Liverpool).[85] This painting was the focal point of an altarpiece dedicated to the life of St. Ambrose that Archbishop Ambrosio Spínola had commissioned in 1673 for the chapel beneath the palace; the altarpiece also contained a series of seven paintings by Valdés Leal.[86] Among accounts of the sumptuous palace, Ceán Bermúdez mentions a series of enormous paintings that he attributed to Herrera the Elder that depicted *The Israelites Receiving Manna*, *Moses Striking the Rock*, *The Marriage at Cana*, and *The Multiplication of the Loaves and Fishes*.[87] Although these works appeared in the catalogue of the sale of Soult's estate in 1852 (where they were attributed to Herrera the Younger), they have not come down to us today.[88]

Through his activities in Spain, Soult amassed one of the most brilliant private collections of his time, and one in which Spanish painting was the principal component. At the 1852 sale, his collection included a total of 109 paintings by Spanish artists. The majority—78—represented the Seville school, and included 15 Murillos and 15 Zurbaráns, as well as 7 paintings by

Fig. 3.15 Salón Principal, Archbishop's Palace, Seville, built 1604

Alonso Cano, Herrera, and others.[89] Apart from Murillo, Soult had an obvious predilection for Zurbarán, a painter who up until that time was relatively little known. Some of Zurbarán's paintings—those with a more complex composition and those that were perhaps the least typical of his output though undoubtedly the most beautiful—were later chosen for the Louvre. There were also 22 works in the sale by the Italian school, some of which came from Spain. *Christ Carrying the Cross* (State Hermitage Museum, St. Petersburg) by Sebastiano del Piombo, for example, had been taken by Quilliet from El Escorial to Madrid in December 1809 together with hundreds of other works of art. Soult's collection also included 23 paintings by the Flemish school. Not listed in the auction catalogues were paintings that Soult bequeathed to his heirs or that he donated to the Louvre or sold, some within a few years of his return to France.

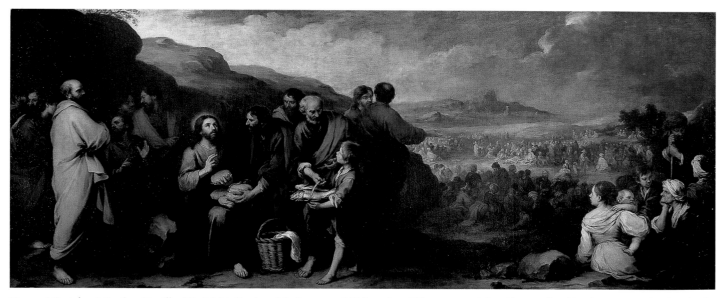

Fig. 3.16 Bartolomé Esteban Murillo, *The Multiplication of the Loaves and Fishes*, 1671. Oil on canvas, 8 ft. 2½ in. x 19 ft. 4¼ in. (250 x 590 cm). Church of the Hospital de la Caridad, Seville

Soult acquired most of these works by removing them from the depository in the Alcázar, before the French troops left Seville in 1813. He chose and extracted complete series, such as the eight paintings by Murillo from the Hospital de la Caridad. Considered masterpieces, they included *Saint Elizabeth of Hungary Nursing the Sick* (fig. 3.13), *Christ Healing the Paralytic at the Pool of Bethesda* (National Gallery, London), *The Return of the Prodigal Son* (National Gallery of Art, Washington, D.C.), *Abraham and the Three Angels* (fig. 14.34), and *The Liberation of Saint Peter* (fig. 1.30). The only works that remained in the church, due to their large size, were *The Multiplication of the Loaves and Fishes* (fig. 3.16) and *Moses Striking the Rock*. He also took the best paintings by Murillo from the small cloister of the Convento de San Francisco, dividing them equally between himself and Baron Mathieu de Faviers, quartermaster-general of the French army; they are today dispersed throughout the world.[90] Soult himself appropriated *Saint Junípero and the Pauper* (Musée du Louvre, Paris), *Saint Salvador de Horta and the Inquisitor of Aragon* (Musée Bonnat, Bayonne), *Brother Julián de Alcalá and the Soul of Philip II* (Sterling and Francine Clark Art Institute, Williamstown, Mass.), and *The Angels' Kitchen* (Musée du Louvre, Paris). The general received the following paintings: *The Blessed Giles Levitating before Pope Gregory IX* (North Carolina Museum of Art, Raleigh), *The Ecstasy of Saint James before the Cross* (Musée des Augustins, Toulouse), and *The Death of Saint Clare* (Gemäldegalerie, Dresden). Another acquisition, the *Immaculate Conception* (fig. 1.20), was originally in the Hospital de los Venerables Sacerdotes.

From the Alcázar, Soult also took paintings by Zurbarán that had been in the possession of various religious institutions: from the high altar of the Convento de la Merced Descalza, *Saint Apollonia* (Musée du Louvre, Paris) and *Saint Lucy* (fig. 2.22), and from the transept, *Saint Anthony Abbot* (private collection, Madrid) and *Saint Lawrence* (State Hermitage, St. Petersburg). From the convent church of San Buenaventura, he took *Saint Bonaventure at the Council of Lyon* (fig. 2.20), *Saint Bonaventure on His Bier* (Musée du Louvre, Paris), and Herrera the Elder's *Last Communion of Saint Bonaventure* (Louvre). Other pictures by Zurbarán that he took from the Alcázar include *The Apotheosis of Saint Thomas*

87. Ceán Bermúdez 1800, vol. 2, p. 279.
88. To this series belongs *The Multiplication of the Loaves and Fishes* in the Musée d'Amiens, destroyed in 1918. See Castres 1992, p. 58. It should not be confused with *The Multiplication of the Loaves and Fishes* by Herrera the Elder, owned by the Academia de San Fernando, now in the archbishop's palace in Madrid. It came from the refectory of the Jesuit Colegio de San Hermenegildo. After the expulsion of the Jesuits in 1768, it was taken to the Alcázar and in 1810 it was to be found in Room 25, no. 417. It then went to Madrid, where it remains today.
89. Soult 1852a and 1852b.
90. For information on Murillo's works, including aspects of their history, see Angulo Íñiguez 1981. On the history of the series from the small cloister of the Convento de San Francisco, see ibid., vol. 2, pp. 3–18.

91. On Soult's Zurbaráns, see Jeannine Baticle, "Zurbarán y Francia," in Peréz Sanchez 1999, pp. 177–88.

92. The attribution to either Herrera the Elder or his son is uncertain, though the auction catalogue (Soult 1852a) indicates that the biblical series from the archbishop's palace was executed by the former.

93. On the reconstruction of the altarpiece and the present location of the paintings that made up the altarpiece, see Wethey 1955, pp. 35, 41, 146–47, and Wethey 1983, pp. 43, 113–15; Baticle 1979, pp. 123–24; Ingamells 1985, pp. 373–76; and Valencia 2000, pp. 52–55.

94. See Álvarez Lopera 2001, p. 25.

95. It could equally well have been taken by Mathieu de Faviers. See Angulo Íñiguez 1981, vol. 2, p. 45.

96. See Serrera 1999. See also Gotteri 1993.

97. Serrera 1999, p. 148, citing Archivo de la Catedral de Sevilla, Autos capitulares, 1810, fol. 54.

98. Serrera 1999 believes that it may be a different painting in the Fogg Art Museum, Cambridge, Mass.

99. In the 1852 Soult auction a painting of this title was attributed to Pacheco. The dimensions are the same as those of a painting of this title in the Alcázar inventory (Room 14, no. 316) but attributed to Alonso Cano.

100. When Denon was later unwilling to return the paintings Soult had donated to the Louvre, Soult argued that the letters demonstrated that the paintings were "gifts" from the city of Seville to the marshal. See Denon 1999, vol. 2, no. 3541.

101. See Velázquez y Sánchez 1994, p. 116.

102. "desplegando una fastuosidad regia; pero las esculturas y los cuadros de los conventos aparecían como objetos de arte en el adorno de los salones, chocando esta irreverncia a los menos preocupados del convite, dando triste idea de la integridad y pundonor de Soult, sus despojos de templos y casas benéficas, a título de párias á la Francia Imperial." Ibid., p. 119.

Aquinas (fig. 3.9); *Saints Romanus and Barulas* (Art Institute of Chicago), which came from the high altar of the Church of San Román in Seville; and paintings of the archangel Gabriel and Saint Agatha (both Musée de Montpellier).[91] Besides the biblical series from the archbishop's palace by Herrera the Elder, he also removed *Saint Basil Dictating His Doctrine* (Musée du Louvre, Paris).[92] Despite cases of uncertain attribution, some of the paintings in Soult's collection brought recognition beyond the Pyrenees for the first time to Spanish painters such as Sebastián de Llanos Valdés, Pedro de Camprobín, José Antolínez, and Sebastián Gómez.

A large proportion of the paintings that Soult took back with him to France do not appear in the inventory of those in the Alcázar but were simply plundered from the churches of Seville. From the church of the Convento de Santa Paula he seized the complete set of eight paintings that Alonso Cano created for the altar of St. John the Evangelist.[93] Those that survive are *Saint John with the Poisoned Chalice* and *Saint James the Apostle* (both Musée du Louvre, Paris), *Saint John Giving Communion to the Virgin* (Palazzo Bianco, Genoa), *Saint John's Vision of God* (John and Mable Ringling Museum of Art, Sarasota), and *Charity* and *Faith* (present location unknown; 1852 Soult sale, lots 49 and 50, respectively, described as "School of Cano"). His interest in Cano led him to obtain *Saint Agnes*, which had belonged to the Convento de San Alberto; it came from Godoy's collection[94] and was destroyed in 1945 in the tragic fire in the Staatliche Museen, Berlin. We also deduce that he took Murillo's *The Dream of the Patrician*, *The Patrician John and His Wife* (figs. 1.22, 1.23), and *The Triumph of the Eucharist* (Lord Farringdon Collection, Buscot Park, Farringdon, England) from the Church of Santa María la Blanca.[95]

A visit to Seville Cathedral presented Soult with the opportunity to add to his collection. Expressing his desire to obtain some paintings in the possession of the cathedral, Soult contacted the prefect of Seville, Don Blas de Aranza, who, as the chapter's minutes record, ordered the cathedral chapter to hand over some paintings to Soult.[96] At a meeting on June 22, 1810, the cathedral treasurer related that, the night before, Aranza told him that on that day five paintings were to be removed from the cathedral, one of them being Murillo's *Birth of the Virgin* (Musée du Louvre, Paris). Under such pressure, the churchwarden was instructed by the cathedral chapter to hand over the paintings. As recorded in the official letter in which he acknowledged receipt of the paintings,[97] Soult received the already-mentioned *Birth of the Virgin*, a *Resting Virgin* (usually identified as *The Holy Family with the Infant Saint John the Baptist*, Wallace Collection, London);[98] *The Death of Abel*,[99] *Saint Peter*, and *Saint Paul*, all of them at the time thought to be by Murillo, although the attribution of the majority is today uncertain. The existence of an official letter can be explained by Soult's desire to dress up in legal or formal terms what was in reality theft or extortion.[100]

Contemporary accounts describe the luxurious life that Soult led in the archbishop's palace in Seville, including lavish parties at which guests could see the splendor of his lifestyle.[101] Besides a party on August 15, 1810, Soult also gave a ball on December 2, on the anniversary of Napoleon's coronation, "displaying a regal sumptuousness; but the sculptures and paintings from the convents and monasteries looked as if they were no more than works of art used to decorate the rooms. Such irreverence shocked the more level-headed guests, and gave a lamentable idea of Soult's integrity and honor, and of his plunder of churches and charitable foundations in the name of the pariahs of Imperial France."[102]

From 1812, a number of these works hung in Soult's residence in Paris on the rue de

l'Université; his gallery of paintings caused a great sensation. Contemporary descriptions of it were published, such as the account Delacroix wrote in 1824 in his journal.[103] Information given in the auction catalogue allows us to deduce the location of most of the paintings in the various rooms. With written permission it was possible to view the paintings; Soult specified the times when visitors would be admitted to his residence.[104] To counter criticism leveled by his own compatriots regarding the methods by which he had acquired the paintings, Soult donated to the Louvre some of the most famous works in his collection, which figure in the Louvre's inventory of 1814:[105] *The Dream of the Patrician* and *The Patrician John and His Wife*; paintings by Murillo from Santa María la Blanca (which were extolled by Quilliet); the painting by Murillo listed as number one in the Alcázar inventory, *Saint Elizabeth of Hungary Nursing the Sick* from the Hospital de la Caridad; and *The Apotheosis of Thomas Aquinas* by Zurbarán. As Ilse Hempel Lipschutz points out, given their dimensions, Soult may have made this donation because the paintings were difficult to house in his Paris residence, although they were in fact selected by the director of the Louvre, Vivant Denon.[106] For this reason Soult may have sold Murillo's *Angels' Kitchen*, another large-scale painting, to the Louvre at a later date.

In 1823 Soult engaged the services of William Buchanan to sell a few paintings, including the *The Immaculate Conception* by Murillo, for 250,000 francs, though the transaction ultimately failed. From 1830 he began to negotiate the sale of his collection to the French state. The sale never took place, but in 1835 he entered into negotiations with Louis-Philippe for the sale of *Christ Healing the Paralytic at the Pool of Bethesda* and *The Liberation of Saint Peter*; these were attributed by Soult to Ribera, although both are by Murillo and came from the Hospital de la Caridad.[107] The asking price was 500,000 francs for both, but the deal collapsed.

The principal dispersion of most of the works in Soult's collection occurred at the auction of May 19, 21, and 22, 1852, after Soult's death. Pre-sale viewing created high expectations, as newspapers of the time recorded.[108] The Louvre finally acquired *The Immaculate Conception*, now paying 586,000 francs, the underbidders being representatives of Nicholas I, czar of Russia, and Isabella II, queen of Spain. Five paintings, all of them originating from Seville, remained in the possession of Soult's family and were given to the French state in 1858 to pay off a debt.[109] In 1867 another sale of sixteen paintings was held; it included three Murillos, three Zurbaráns, one Legot, one Herrera the Younger, and one Núñez de Villavicencio.[110]

Of the paintings that left Seville in Soult's convoy, the only ones restored to Spain were those that Soult gave to the Louvre on his return to France and that were thus affected by the terms of the Congress of Vienna (1814–15). The presence of such a quantity of paintings in France, combined with the trade generated and the stories surrounding Soult and his collection, only served to heighten the nascent French taste for one of the most typically Spanish schools of painting.

103. Delacroix 1932, vol. 1, p. 91.
104. See Lipschutz 1988, p. 63.
105. Ibid., p. 258.
106. Ibid., p. 57.
107. Numbers 4 and 7 (Lower Room) in the Alcázar inventory.
108. See *Galignani's Messenger*, May 22 and 24, 1852.
109. By Murillo, *The Angels' Kitchen* and *The Birth of the Virgin*; by Zurbarán, *Saint Bonaventure on His Bier* and *Saint Bonaventure at the Council of Lyon*; and by Herrera the Elder, *Saint Basil Dictating His Doctrine*. Each of these entered the Musée du Louvre, Paris.
110. Horsin-Déon 1866.

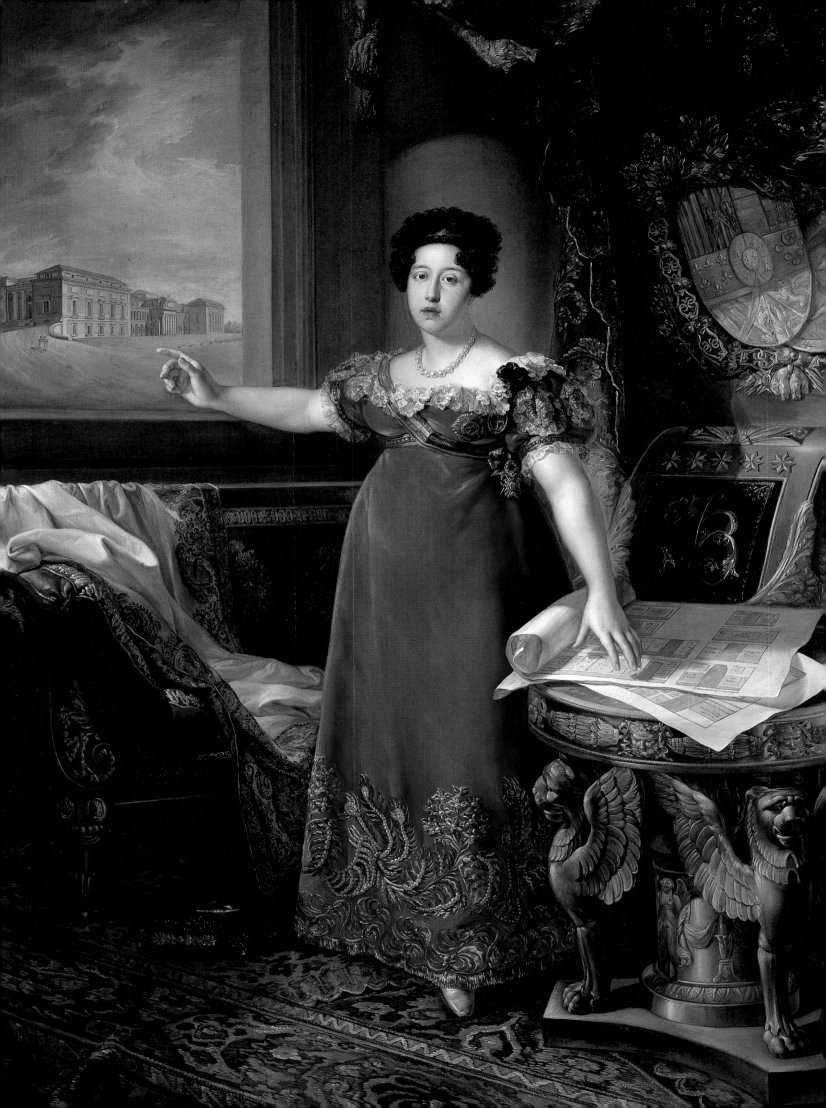

The Origins of the Museo del Prado

María de los Santos García Felguera and Javier Portús Pérez

In the nineteenth century, one of the main sources of knowledge of Spanish painting—both for artists and for the general public—was the Museo del Prado in Madrid. Painters of such different origins and with such divergent styles as Wilkie, Lundgren, Zorn, Chase, Courbet, Sargent, Israëls, Regnault, Degas, Monet, and Manet, among many others, visited the Prado and expanded their knowledge of Spanish painting.[1] In addition, they discovered there a painter—Diego Rodríguez de Silva y Velázquez (fig. 4.2) —whose work could truly not satisfactorily be seen anywhere else and whose influence on them all was strong.

The Prado, which opened to the public in November 1819 (fig. 4.3), was created as the result of a decision by King Ferdinand VII to select the finest paintings from his own collection and display them in the building that had been designed by Juan de Villanueva at the end of the previous century to house an academy of natural history.[2] The reasons behind this royal decision—which would prove to be one of the best and most forward-thinking acts of the king's controversial reign—have been the subject of much discussion. The suggestion by Richard Ford, one of the first English writers on Spanish art, that Ferdinand wanted to clear his palaces of paintings so as to be able to decorate the walls with wallpaper,

1. For an overview of these visitors, see Javier Portús Pérez, "Un museo para los pintores," in Madrid 1996d.
2. Academia de Historia Natural. On the early years of the museum's history, see Beroqui 1933; M. Madrazo 1945; Gaya Nuño 1969; and Pérez Sánchez 1977.

Fig. 4.2 C. Nanteuil, *Velázquez, Self-Portrait.* Lithograph. Published in *L'Artiste*, 1851, ser. 5, vol. 5 (following p. 210)

Fig. 4.3 South facade of the Museo del Prado, ca. 1830. Anonymous lithograph. Photo courtesy Museo Nacional del Prado, Madrid

Fig. 4.1 Bernardo López, *Isabella of Braganza*, 1829. Oil on canvas. Museo Nacional del Prado, Madrid

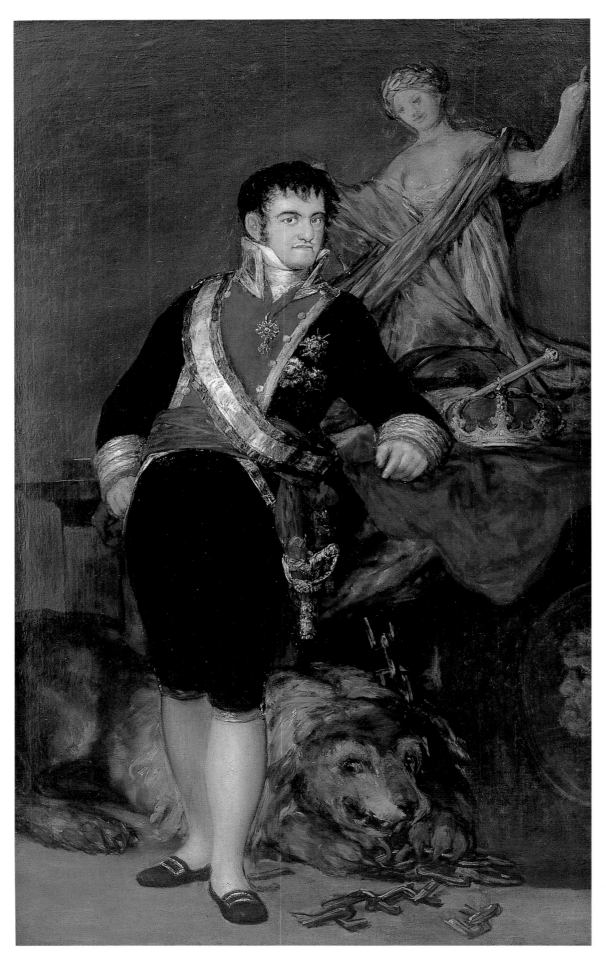

Fig. 4.4 Francisco de
Goya y Lucientes,
Ferdinand VII, 1814.
Oil on canvas, 88¼ x
49 in. (225.5 x 124.5 cm).
Museo Municipal,
Madrid

was in fact not the case.[3] Over the years, others have mentioned the role played by Ferdinand's consort, Isabella of Braganza, in the establishment of the Prado. Her contribution to the foundation of the museum is firmly documented in, among other examples, a funeral oration and a portrait of her by Bernardo López (fig. 4.1). In the painting the queen is shown gesturing with one hand toward the museum building and pointing with the other to some papers on which the intended disposition of the paintings on the gallery walls is sketched. Such concrete evidence aside, the truth is that Ferdinand decided to part with his best paintings so that they might be publicly exhibited and bore the great cost that this initiative entailed. This act on the king's part was in tune with new attitudes toward the concept of national heritage that were sweeping through Europe as a result of the French Revolution. But Ferdinand (fig. 4.4) was also showing himself to be a worthy successor to generations of Habsburg kings who had built up valuable art collections.

When it was established in 1819, the Prado contained no more than 311 paintings; there was much to be done before it could be said to contain a comprehensive and coherent collection. Over the next two decades, works of art from the royal collections were transferred to the museum, and the process of forming a major national art gallery was not completed until the middle of the century. Indeed, until 1868 the Prado and its contents belonged to the crown, and its holdings consisted exclusively of works that had either come from the royal residences or had been purchased for the museum by successive monarchs. As we examine the main factors that guided the creation of the Prado and shaped the first ten years of its existence, we find that they were governed not only by nationalist sentiments but also by the desire to gain international recognition for Spain's artistic heritage.

TOWARD A COMPREHENSIVE COLLECTION OF SPANISH ART

Alongside the basic intention to exhibit the great artistic riches of the royal collections lay a more focused goal—to bring to the notice of a European audience the quality and nature of the Spanish school. The catalogue published when the museum opened to the public in 1819 shows that the only works on display were those of Spanish artists.[4] The 311 paintings that figure in the catalogue were hung according to a decorative criterion rather than thematically, chronologically, by painter, or by style. The only exception was the room leading into the central gallery, where the works of such contemporary painters as Goya, Luis Paret, and Mariano Maella were grouped. While it is clear from the catalogue that the wider diffusion of Spanish painting was seen as a priority, it is also true that the central gallery—the most important space, from both a symbolic and a practical point of view—was reserved, soon after the museum opened, for the Italian school (fig. 4.5). This pride of place was to continue for several decades.

The 1819 catalogue compiled by Ferdinand's court painter, Luis Eusebi, was followed by four others. These were necessary not only because the exhibition space continued to expand, but also because the catalogues were the only means by which a visitor could identify the unlabeled paintings. Interestingly, the 1823 catalogue was written in French (coinciding with the arrival in Madrid of the French military expedition known as the Cent Mille Fils de Saint Louis [One Hundred Thousand Sons of Saint Louis]). That of 1828 was published in separate Spanish, French, and Italian editions. These official publications reflect the museum's mission to make known its treasures beyond Spain, and the determination

3. On the improbability of this hypothesis, see Anes 1996, p. 88.
4. Madrid 1819.

Fig. 4.5 Jean Laurent, Photographic montage of the installation of Italian paintings at the Museo del Prado, 1879–85. From Jean Laurent, *Panorama de la Grande Salle du Musée du Prado à Madrid* (n.p., n.d.)

with which it pursued this end from the earliest years of its existence. Indeed, it was foreign visitors and copyists who were given favored access to the collection.

Another indicator of the mission with which the Prado came into being was its early acquisitions policy. In 1820 Ferdinand VII purchased from the painter Agustín Esteve *The Holy Trinity* (fig. 4.6), one of Jusepe de Ribera's masterpieces. The following year the king struck a deal with Manuel López Cepero, a well-known collector from Seville, who received several paintings from the royal collections in exchange for two masterpieces by Zurbarán, *Saint Peter Nolasco's Vision of the Crucified Saint Peter* and *Saint Peter Nolasco's Vision of the Heavenly Jerusalem*. In 1826 the king acquired *The Visitation* and *The Coronation of the Virgin* from Vicente Maçip, a Valencian artist, which were then attributed to his son Juan de Juanes, who was considered one of the pioneers of modernism in Spanish painting. In 1827 he bought from

Fig. 4.6. Jusepe de Ribera, *The Holy Trinity*, 1632/1635–36. Oil on canvas, 89 x 46½ in. (226 x 118 cm). Museo Nacional del Prado, Madrid

the sculptor Valeriano Salvatierra a splendid work by El Greco, *The Holy Trinity* (figs. 4.7, 4.8). Two years later *The Death of Mary Magdalen*, by José Antolínez, and *The Assumption of the Virgin*, now attributed to Juan Martín Cabezalero, joined his collection. This concentration on Madrid High Baroque paintings culminated with the acquisition, in 1833, of *The Apotheosis of Saint Hermenegild* (fig. 4.9), one of the most important works not only of Francisco de Herrera the Younger but also of mid-seventeenth-century Spanish painting in general. A Crucifixion by Velázquez (fig. 4.10), which the duque de San Fernando had presented to the king, was assigned to the museum in 1829. All of these important works of art were clearly acquired with the express purpose of creating a comprehensive historical overview of Spanish paintings for public exhibition in the Museo del Prado. Furthermore, with the exception of the paintings by Ribera, Velázquez, and Vicente Maçip, all of them were by artists who were otherwise poorly represented in the royal collections, which contained only one portrait by El Greco and, of works by Zurbarán, only those paintings executed for the Palacio del Buen Retiro.

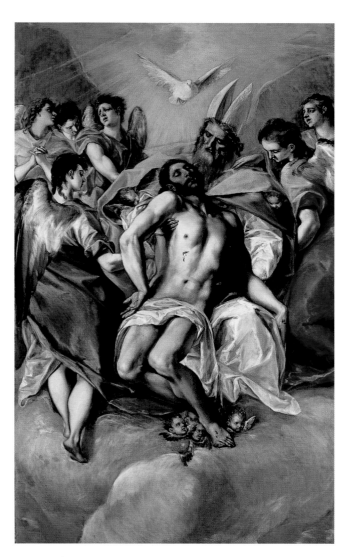

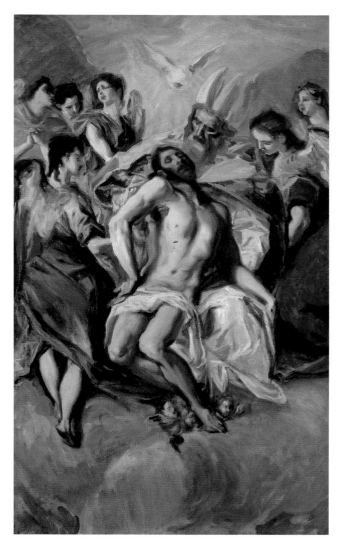

Fig. 4.7 El Greco (Domenikos Theotokopoulos), *The Holy Trinity*, 1577–79. Oil on canvas, 118 x 70½ in. (300 x 179 cm). Museo Nacional del Prado, Madrid

Fig. 4.8 (cat. 220) John Singer Sargent, *The Holy Trinity, Copy after El Greco*, 1895. Oil on canvas, 31⅛ x 18½ in. (80 x 47 cm). Private collection, New York

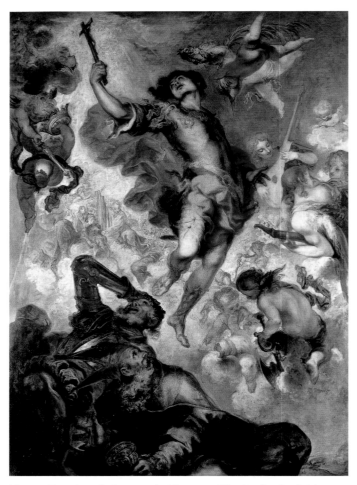

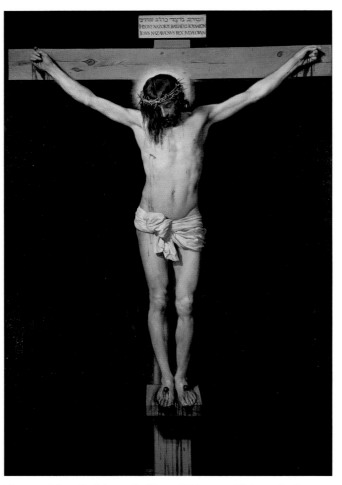

Fig. 4.9 Francisco de Herrera the Younger, *The Apotheosis of Saint Hermenegild*. Oil on canvas, 129 x 90⅛ in. (328 x 229 cm). Museo Nacional del Prado, Madrid

Fig. 4.10 Diego Rodríguez de Silva y Velázquez, *Christ on the Cross*. Oil on canvas, 49¼ x 66⅓ in. (125 x 169 cm). Museo Nacional del Prado, Madrid

An intimate relationship has continued to exist between the Spanish school and the Museo del Prado, which has been variously expressed over the years. The museum's awareness of its role as the repository of Spanish painting has been reflected as much by its ongoing acquisitions policy as by the way in which its collections are laid out and by its program of temporary exhibitions. For many foreigners, the museum has come to be regarded as a repository of the masterworks of Spanish painting. Indeed, many nineteenth-century writers—for instance, Louis Viardot and Richard Ford (see discussion below)—though well aware of its rich collections of the work of other artists, equated the Prado with the history of Spanish art itself. No other institution in the world illustrates the history of Spanish painting so precisely and through so many masterpieces. There are also certain artists, such as Velázquez, whose style and output can only truly be studied there. Paradoxically, if any museum could demonstrate the absence of national boundaries during the modern era of painting in Europe, it was the Prado, whose collections embrace masterpieces by Flemish, Italian, French, and Spanish artists that were commissioned or collected by centuries of Habsburg and Bourbon royalty. Visiting the Spanish royal collections, painters of different nationalities were able to view the work of masters from whom they could learn. While in

Madrid in 1628–29, for example, Rubens, a Fleming, learned much of the technique of Titian, an Italian; and Velázquez, a Spaniard, had the opportunity to see paintings by various artists and examine their style. The painting that best encapsulates the significance of the royal collections in this sense and the fundamental aspect of the Western artistic tradition is Velázquez's *Fable of Arachne* or *The Spinners* (fig. 4.11). In this work, the brilliance of Titian, Rubens, and Velázquez come together, in homage to the artist's two masters. A century later, Goya was to learn from all of them. The process did not stop there. As this exhibition demonstrates, the French painter Édouard Manet engaged at the Prado in an artistic dialogue that enriched not only his own style but also the development of modern painting.

The museum's nationalist stance, which at its inception was both promoted from within the country and encouraged from without, was not an isolated phenomenon in the history of museums. Many institutions have been guided by such criteria (one conspicuous case being that of the Rijksmuseum, Amsterdam, in the nineteenth century). These same criteria—the idea of creating an artistic overview and the concept of national schools of painting—have defined the historiography of art from its nineteenth-century origins up to the present day and still govern the formation of museums and the writing of monographs.

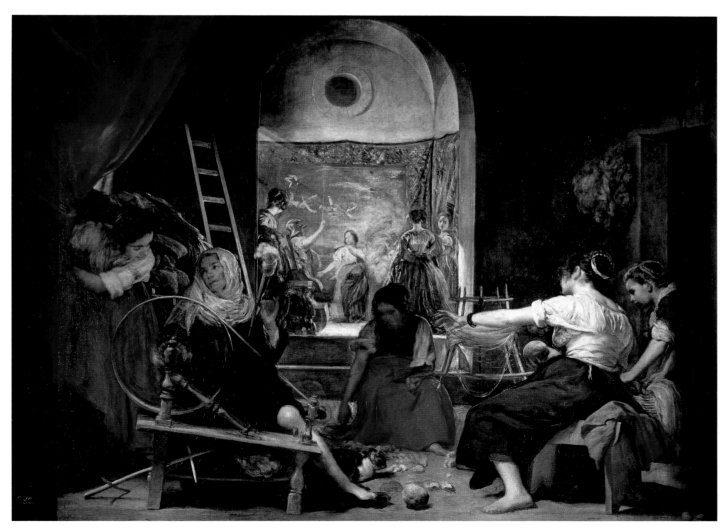

Fig. 4.11. Diego Rodríguez de Silva y Velázquez, *The Fable of Arachne* or *The Spinners*, 1657. Oil on canvas, 86⅛ x 113¾ in. (220 x 289 cm). Museo Nacional del Prado, Madrid

The Royal Collections and the Treasures of the Aristocracy

The origin of the Prado should be seen not only as issuing from the new attitudes to national heritage that spread throughout Europe from the end of the eighteenth century but also from the existence of the royal collections themselves. It is striking that a king—Ferdinand VII—who, of all Spanish rulers, least cared for art should have created an institution whose purpose was to make known the greatest treasures of his collection and whose existence would be so instrumental in bringing Spanish painting to the attention of a wider public.

The royal holdings amassed in the Prado are in fact the culmination of a tradition of collecting on a large scale that began with Isabella and Ferdinand in the fifteenth century and that sometimes reached extraordinary dimensions. That tradition should not be seen exclusively as reflecting the taste of successive monarchs or their appreciation of art. Art was a symbol of royal power, and art collections formed part of the trappings of royalty. The paintings and other artifacts in royal hands were not reserved for private enjoyment but were shown to visitors, in turn bestowing prestige on their owners. This function of art, at least from the sixteenth to the eighteenth centuries, also applied to palaces and to religious buildings with royal connections, such as the monastery of El Escorial.

From its creation, El Escorial served to show to the world the power, the learning, and the faith of its builder and of the Habsburg dynasty. Philip II (r. 1556–98) himself, on various occasions, acted as guide to certain visitors and left precise written instructions on how guests should be shown around the palace in his absence.[5] Throughout the seventeenth century El Escorial was a standard port of call for every foreigner of any standing who came to the Spanish court, making the journey into the mountains not only to admire the monastery for its size and its architecture but also to see its paintings and its library. In the 1650s, Philip IV (r. 1621–65) even turned his attention to reorganizing the painting collections, assisted by Velázquez, among others. In addition, a major initiative to make known the history and the contents of the palace through written accounts included milestones such as *La fundación del monasterio de San Jerónimo el Real* (The founding of the monastery of Saint Jeronimo the Royal, 1604) by Fray José de Sigüenza, a seminal work of Spanish art-historical writing, and *Descripción del monasterio de San Lorenzo el Real del Escorial* (Description of the monastery of San Lorenzo the Royal at El Escorial, 1657) by Fray Francisco de los Santos, which went through several editions during the second half of the seventeenth century, each updated with details of new additions to the collection and of changes to the location where existing works were hung.[6]

Although its collections were not given the same treatment as those in the monastery of El Escorial, the Real Alcázar in Madrid, the seat of the royal court, was also visited by educated foreigners. The Alcázar contained a splendid collection of paintings, including masterpieces by Titian, Rubens, Velázquez, the Carracci, Reni, Ribera, and others, which are now among the most important paintings in the Prado. Although the palace was divided theoretically into public and private areas, visitors of a certain social standing were given access to most of the building so as to admire the paintings that it contained. Diaries kept by two such guests to the palace, during the reigns of Philip IV and Charles II (r. 1665–1700), document the experience. Cassiano dal Pozo, for example, the learned Roman patron whose

5. Jesús Sáenz de Miera, "La magnificencia del Rey Prudente y la Fama de El Escorial," in Madrid 1998–99, p. 117.
6. Álvarez Turienzo 1985.

protégé was Nicolas Poussin and whose influence on the development of the art of his age was so extensive, came to Madrid in 1626 with Cardinal Francesco Barberini. His diary of his diplomatic mission with the cardinal records a visit to the Alcázar and describes the rooms and paintings that made the greatest impression on him.[7] Among these were the mythological scenes that Titian had painted for Philip II, which were hung in the most private of Philip IV's apartments. This series of paintings had close associations with the history of the Spanish monarchy, and it was considered appropriate to show them to illustrious people, despite the fact that they were displayed in such intimate surroundings. In the 1660s, together with other paintings of nudes, they were exhibited in what were known as the "Titian vaults," and it was there that the Medici Cosimo III saw them when he visited Madrid in 1668.[8]

Buen Retiro, another royal palace, was built in the 1630s on the outskirts of Madrid as an annex to the court. Its splendid art collection consisted mostly of contemporary works. The decoration of the palace involved not only the best painters working in Madrid at the time but also French artists active in Rome, among them Claude Lorrain and Poussin, and the Italians Giovanni Lanfranco, Massimo Stanzione, and Artemisia Gentileschi. These works were not exclusively for the pleasure of the king and his court but were also intended to convey to all and sundry his power and magnificence. Buen Retiro, like El Escorial and the Alcázar, was of tremendous interest to foreigners when they came to Madrid, including art dealers like Robert Bragrave, whose diary describes a visit to the palace in the winter of 1654–55.[9]

As Cassiano dal Pozzo's diary shows, it was not only paintings in royal collections that were used as instruments of prestige; members of the nobility were opening the doors to their treasures too. Like royalty, and in emulation of it, the Spanish high aristocracy had accumulated a large corpus of very important paintings, many of them of excellent quality. The conde de Monterrey, the marqués de Leganés, Don Luis de Haro, and the duques of Alcalá were among the most significant collectors of their time in Europe. Some of them readily showed off their paintings, and it was in such aristocratic circles that the idea of organizing a collection on museological principles took root. The leaders in this respect were the almirantes of Castile at the end of the seventeenth century. They kept their paintings—by Rubens, Titian, Raphael, Guido Reni, Ribera, Sebastiano del Piombo, Andrea del Sarto, and the Bassanos, among others—in a palace next to the Prado de San Jerónimo, in Madrid.[10] What distinguished their collection, however, was not so much its excellence as the way it was displayed: the paintings were grouped by theme, by artist, or by school. Thus one room was dedicated to landscapes, another to Rubens, another to Spanish painters, and so on. The collection also had a kind of curator, the painter Juan de Alfaro y Gómez. The palace was a genuine museum, arranged along art-historical lines that showed an appreciation of distinct artistic styles and of national schools of painting. There was also a room dedicated to the art of painting, with a laudatory inscription and a selection of masterpieces. A museum arranged in such a way could, of course, only have been designed for public exhibition, and the painter and writer Antonio Palomino tells of the prestige that it acquired.[11] A similar situation applied to the palace owned in the mid-eighteenth century by the condes of Altamira in Morata de Tajuña, in the province of Madrid. The collection there, which originated with the paintings amassed by the marqués de Leganés during the reign of Philip IV, was also arranged according to theme. In what was symbolically the most

7. Volk 1981.
8. Magalotti 1933, pp. 123–26.
9. See J. Brown and Elliott 1981, p. 113.
10. On this collection, see Burke and Cherry 1997, vol. 1, pp. 892–962.
11. Palomino 1724 (1986 ed.), p. 263.

12. On this room, see Portús Pérez 1998, pp. 144–45.

13. María de los Santos García Felguera, "Niños afortunados," in Madrid 2001.

14. "Desearía yo que en este Real palacio se hallasen recogidas todas las preciosas pinturas que hay repartidas en los demás sitios reales y que estuviesen puestas en una galería digna de tan gran monarca, para poder formarle a vuestra merced, bien o mal, un discurso que desde los pintores más antiguos de que tenos noticia guiase el entendimiento del curioso hasta los últimos que han merecido alguna alabanza, con el fin de comprender la diferencia esencial que hay entre ellos y hacer con esto más claras mis ideas." Letter from Mengs to Antonio Ponz, quoted in Ponz 1776–94 (1988 ed.), vol. 2, p. 325. See Tomlinson 1993.

15. Géal 1999.

important room, portraits of painters and poets were displayed alongside verses alluding to the correspondence between the art of poetry and the art of painting, one of the tenets of the humanist theory of art.[12]

DEVELOPMENT OF THE COLLECTIONS AND CONNOISSEURSHIP IN THE EIGHTEENTH CENTURY

During the eighteenth century, with the spread of new attitudes toward history and heritage during the Enlightenment, the Spanish royal collections grew richer: royal portraits continued to be commissioned, and frescoes and other painted decoration were needed for the new palaces that were being built. Paintings by old masters were still purchased, albeit less intensively than in the previous century and for different reasons. The focus was no longer on Raphael and Titian or other Venetian painters but on the Spanish school. The greatest beneficiary of this change was Murillo, who provided Queen Isabella Farnese with a magnificent collection in the years 1729 to 1733, when the court was based in Seville.[13] The Valencian painter Juan de Juanes also attracted the attention of the Spanish monarchy.

The sequence in which the paintings in the royal palaces were hung and their placement on the walls continued to be dictated by their decorative value and by considerations of propriety rather than by any art-historical criterion. Anton Raphael Mengs, the influential German painter who worked at the Spanish court beginning in 1761, took issue with this approach. He recommended that the most important paintings dispersed in various royal residences be brought together in the Palacio Real in Madrid to form an art gallery: "It is my desire that all the fine paintings that are dispersed in other royal residences be gathered together in this royal palace, and that they be hung in a gallery fit for so great a king, to create for Your Honor, for better or worse, a discourse that, starting with the earliest painters known to us and continuing to the most recent that are worthy of praise, will enlighten the understanding of those who are interested in art, in order to grasp the essential difference between these artists and thereby clarify my ideas."[14]

Fig. 4.12 Fernando Brambilla, *Rotunda of the Museo del Prado*, 1840. Lithograph. Museo Nacional del Prado, Madrid

This approach to the display of paintings, with the implicit idea of creating a museum, did not come to fruition until the opening of the Museo del Prado in the nineteenth century (fig 4.12). However, other projects that had taken wing in Spain throughout the eighteenth century shared this aim of interpreting the artistic heritage in art-historical terms. Their common denominator was the desire to trace the history of Spanish painting and to identify the particular characteristics of the Spanish school.[15] *El parnaso español pintoresco laureado* (The great Spanish painters) by Antonio Palomino, a comprehensive compilation of the lives of artists who were born or who worked in Spain, was published in 1724—evidence that there was such a thing as a "history" of painting in Spain. In the second half of the eighteenth century several notable publications appeared. *Viage de España* (Travels in Spain) by Antonio Ponz is a monumental register of the country's rich cultural heritage in eighteen volumes (1776–94). The *Diccionario histórico de los más ilustres profesores de las*

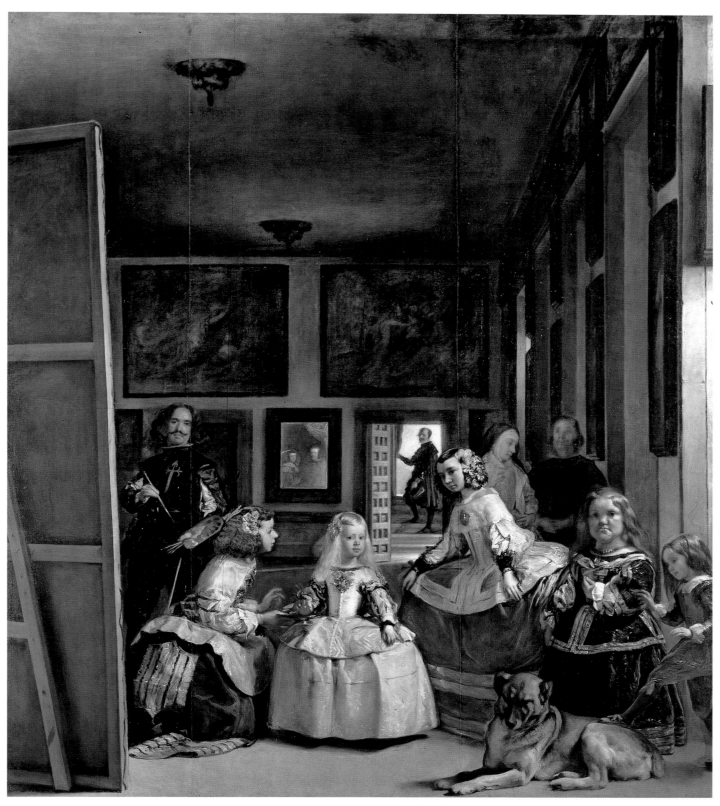

Fig. 4.13 Diego Rodríguez de Silva y Velázquez, *Las Meninas*, 1656. Oil on canvas, 125¼ x 108⅛ in. (318 x 276 cm). Museo Nacional del Prado, Madrid

Fig. 4.14 (cat. 24) Francisco de Goya y Lucientes, *Las Meninas, Copy after Velázquez*, ca. 1785? Etching, aquatint, drypoint, and burin, 16 x 12¾ in. (40.5 x 32.5 cm). Bibliotheca Nacional de España, Madrid

bellas artes en España (Dictionary of the most illustrious exponents of the fine arts in Spain) by Juan Agustín Ceán Bermúdez was published in 1800; containing biographies of a large number of artists, it took a modern historical approach and was outstandingly comprehensive. Its rigor and factual detail make it an essential work of reference even today.

Striving to identify key figures in the history of Spanish painting, comparable to those of the Italian school, Palomino and Ceán Bermúdez encountered the work of Velázquez, which was then under reappraisal. Although Mengs had certainly been attracted by this Sevillian painter, he had considered him limited by his interest in naturalism and his work far removed from the ideals of beauty to which painting should aspire. It was left to Spanish intellectuals and artists to show that Velázquez was worthy of appreciation. Palomino and Ceán Bermúdez dedicated lengthy and eulogistic biographies to him. The most prestigious writer on Velázquez, however, was Gaspar Melchor de Jovellanos, a leading figure of the Spanish Enlightenment. In works such as his *Elogio de las bellas artes* (In praise of the fine arts, 1782) and his essay on the sketch for *Las Meninas* (1789, fig. 4.13), he praised Velázquez for his naturalism (in line with the tenets of the Enlightenment) and made him a hero of Spanish art, holding him up as a model for young artists seeking truth in nature. Goya throughout his career explicitly and implicitly recognized the great debt that he owed Velázquez, whose paintings he reproduced in his earliest series of prints (fig. 4.14).[16] In the fresco decoration of the Hall of Mirrors in the Palacio Real in Madrid, executed by the court painter Francisco Bayeu, the central scene depicts the apotheosis of Hercules; it is flanked by allegories of Philosophy, Painting, Music, and Poetry. Significantly, Painting is represented by a woman seated next to an easel and holding a canvas with a sketch of *Aesop* by Velázquez.[17]

DISCOVERING SPAIN'S ARTISTIC HERITAGE

Even with this reassessment of Spanish painting in general, and of Velázquez in particular (figs. 4.15, 4.16), during the second half of the eighteenth century, the Spanish school remained virtually unknown outside Spain.[18] Only a few foreign travelers had the opportunity to form a conception of the history of Spanish art.[19] Spanish writers began to demand greater recognition for Spanish artists in the history of European painting. (Indeed, the keen interest in the history of Spanish painting evident at the end of the eighteenth century should also be seen in the context of a wider consideration of the country's contribution to European culture as a whole.)

Ponz's book helped to serve that purpose, as did the accounts of such travelers as Joseph Townsend, Caimo, and Swinburne, among others. It was of course the royal collections, containing vast numbers of paintings, that best illustrated a wide variety of periods and schools. Prints of the most important works in the palaces were made. The Compañía para el Grabado de los Cuadros de los Reales Palacios (Company for the Engraving of Paintings

16. Vega et al. 2000.
17. Morales y Marín 1979, pp. 83–84.
18. García Felguera 1991, pp. 19–41.
19. For instance, the English diplomat and patron Baron Grantham. See Glendinning et al. 1999.

in the Royal Palaces), according to future Spanish prime minister Manuel Godoy, was set up in 1789 to "encourage throughout the kingdom the study of the great Spanish and foreign paintings and to make more widely known the Spanish old masters, who are known slightly or not at all in most of Europe."[20] This undertaking began with the ambitious intention of reproducing ninety-five paintings, but only slightly more than fifty were eventually made, of paintings not only by Spanish artists but also by Italian and French painters. Nevertheless, the main emphasis remained on paintings by the Spanish school: ten works by Ribera were among those reproduced, as were one by Zurbarán, another by Alonso Cano, six by Murillo, one by Juan Carreño, and fifteen by Velázquez, who was thus established as the brightest star in the galaxy of Spanish painters represented in the royal collection.

Despite evidence of a nascent desire to make the royal collections accessible to the public, it should be understood that the "public" was not a broad sector of the population with intellectual leanings but rather people who belonged to various social elites. There is no evidence that the royal palaces were opened indiscriminately; we know that whoever was presented at court, at least during the eighteenth century, had free access to many of the palatial rooms, yet this certainly applied only to a relatively small group of people. There is nothing to suggest that the Spaniards had developed any specific interest in art history. Moreover, a large urban middle class that demanded public access to works of art, as developed in Paris,

20. "favorecer en todo el reino el estudio de los grandes modelos nacionales y extranjeros y extender la noticia y la gloria de la antigua escuela española, poco o nada conocida en los más de Europa." Manuel Godoy would become a favorite of Charles IV. See Juan Carrete Parrondo, "El grabado en el siglo XVIII," in Carrete Parrondo et al. 1987, pp. 564ff, and Carrete Parrondo 1979.

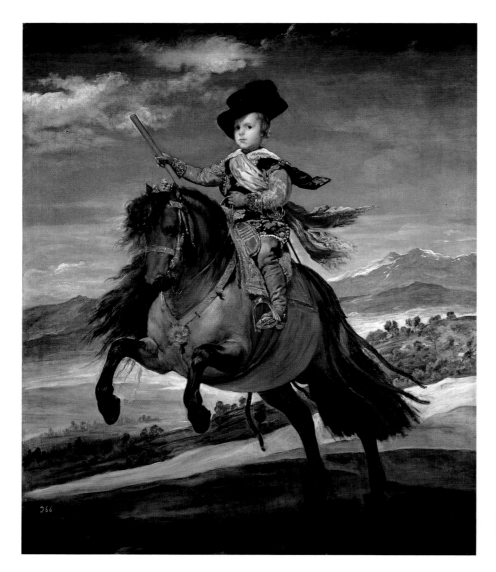

Fig. 4.15 Diego Rodríguez de Silva y Velázquez, *Baltasar Carlos on Horseback*, 1634–35. Oil on canvas, 82½ x 68½ in. (209.5 x 174 cm). Museo Nacional del Prado, Madrid

Fig. 4.16 (cat. 21) Francisco de Goya y Lucientes, *Baltasar Carlos, Prince of Spain and Son of Philip IV, Copy after Velázquez*, by December 1778. First edition, etching and drypoint, 13¾ x 8⅝ in. (35 x 22 cm). The Metropolitan Museum of Art, New York, Bequest of Grace M. Pugh, 1985 (86.1180.899)

21. See Géal 1998, pp. 36ff.
22. "el mérito de los célebres pintores españoles, poco conocidos de las naciones vecinas." Antigüedad 1987b, p. 69.
23. Martínez Friera 1942.
24. Anes 1996, p. 82.

for example, did not exist in Spain. In fact, artistic patronage in Spain continued to be the preserve of the church, the court, the aristocracy, and an emerging, though still small, middle class. As a result, the Compañía para el Grabado enjoyed only limited success: wide public demand was simply nonexistent.

CREATING THE FIRST PUBLIC ART MUSEUM IN SPAIN

By the second half of the eighteenth century many of these developments fostered the notion among the Spanish ruling classes that here was a very rich artistic heritage, one that expressed a common history and was worth preserving, studying, and publicizing. The efforts of intellectuals like Ponz and Jovellanos[21] were highly effective in Spain, and similar attitudes were taking root throughout western Europe, notably in France, where the concept of a national heritage was embraced most intensely. From the mid-eighteenth century, French intellectuals had demanded access to the royal collections as a civil right. This new social attitude culminated, after the French Revolution, in the creation of the Musée du Louvre, a predecessor of which opened in August 1793 and became the focal point for the general enjoyment of a common heritage. The establishment of the Museo del Prado must also be seen in this wider European context.

Indeed, the first plans to open a public art museum in Spain are connected with Napoleon's brother Joseph (fig. 4.17), who briefly ruled the country. On December 20, 1809, he announced plans for an art museum that was to be filled with works originating from convents, monasteries, and royal and aristocratic palaces; the purpose of this institution, among other things, was to show "the merit of the great Spanish painters who are but little known among neighboring nations."[22] He also ordered that fifty paintings by Spanish artists be selected and presented to his brother. At the time, Napoleon's lieutenants were engaged in similar activities in Belgium, Italy, Poland, and Germany.

Fig. 4.17 Baron François Gérard, *Joseph Bonaparte, Roi d'Espagne*, 19th century. Oil on canvas. Musée Fesch, Ajaccio

Although the fall of Joseph Bonaparte in 1814 put an end to this particular project, the idea was not abandoned. Ferdinand VII initially gave the task of establishing a museum in Madrid to the Real Academia de Bellas Artes de San Fernando, making available the Palacio de Buenavista on the Plaza de Cibeles. The academy was unable to bear either the cost or the responsibility, however, and in August 1814 the undertaking was dropped.[23] On November 29 of that year the king's councilors wrote to Ferdinand VII about the complex situation, expressing concern regarding the costs the nation would incur while acknowledging that such an institution would "honor and distinguish a nation," as it would show "good taste, enlightenment, and splendor" and would be instrumental "in the progress and advancement of the Arts and Sciences." The councilors also stated that, should the king be willing to countenance the costs involved, it would be preferable to use the building in the Paseo del Prado.[24]

The notion that a museum was a useful and valuable institution that bestowed prestige on the country had firmly taken root not only

Fig. 4.18 Juan de Villanueva, *Building on the Paseo del Prado*. From Laborde 1806–20, vol. 2, pl. 53

in Spain but in the rest of Europe, mainly as a cultural legacy of the French Revolution. Such institutions were seen as emblems of the ideal of universal access to cultural wealth. In Spain the cultural climate was such that paintings and sculptures could be taken without question from royal palaces and put on public display for the enjoyment of both Spaniards and foreigners. At the end of the eighteenth century the Academia de San Fernando had on several occasions even requested paintings from Charles IV. Kings like Ferdinand VII, a firm believer in absolute power, with little interest in artistic and cultural matters, were fully aware of the benefits that could be derived from the public exhibition of a national asset. While the paintings themselves continued to fulfill the same function—as demonstrations of royal power—that they had in the reign of Philip II or Philip IV, in this new social climate they performed this role in a building open to all sectors of society rather than in a royal palace that admitted only people of a certain social rank. Paintings were also valued for different reasons: in the age of the Habsburgs, their value had been personal or dynastic, whereas now it was associated with the notion of a common heritage, the prestige of which was a matter of pride not only for the king but also for the entire nation.

FRENCH GUIDES: MÉRIMÉE, VIARDOT, AND CLÉMENT DE RIS

The foundation of the Prado gave public access to an exceptional artistic treasury, allowing Spaniards and foreigners alike to see and appreciate the work of the most important representatives of the Spanish school. However, it was not easy to find one's way around such a huge museum (fig. 4.18), especially for the many foreign visitors. Various books written in France and Britain served as guides and spread the fame of the Spanish school. Among the visitors was the French man of letters Prosper Mérimée, author of *Carmen*. In 1831 one of his *Lettres* appeared in the Parisian periodical *L'Artiste*, on the subject of the "Musée de Madrid," which he described as one of the richest in Europe. Mérimée had just spent a

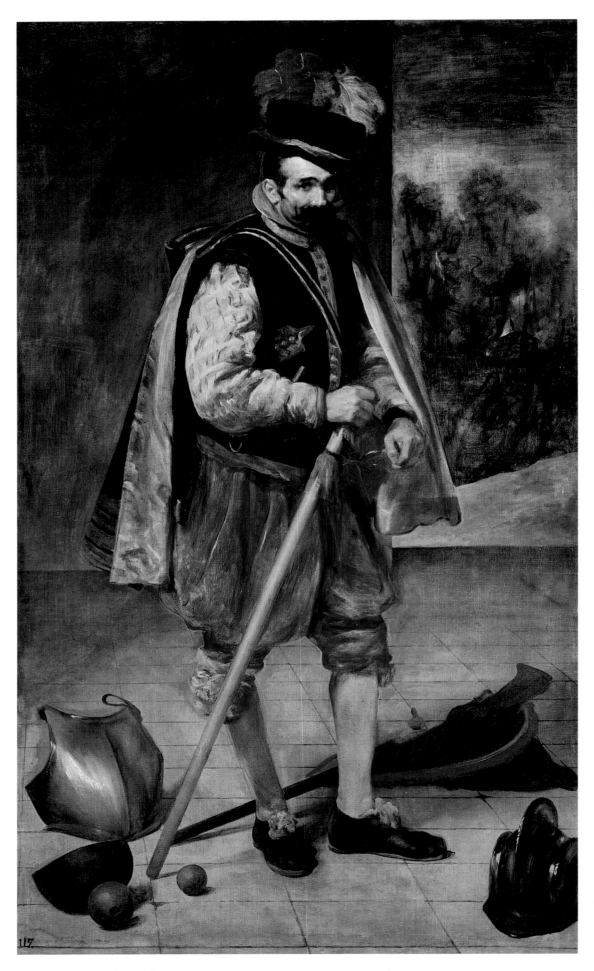

Fig. 4.19 (cat. 72) Diego
Rodríguez de Silva y
Velázquez, *The Jester "Don
Juan de Austria,"* ca. 1632.
Oil on canvas, 82⅛ x 49 in.
(210 x 124.5 cm). Museo
Nacional del Prado, Madrid

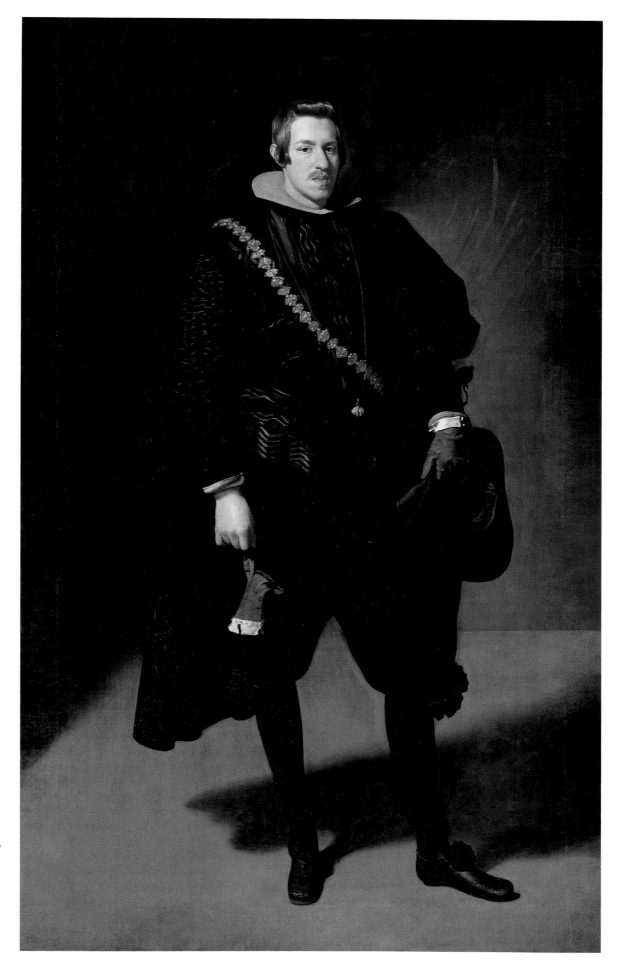

Fig. 4.20 (cat. 69) Diego
Rodríguez de Silva y
Velázquez, *Infante
Don Carlos*, ca. 1626.
Oil on canvas, 82⅛ x
49⅛ in. (210 x 126 cm).
Museo Nacional del
Prado, Madrid

Fig. 4.21 Anonymous, *Sala de la Reina Isabel*, view 1, 1889. Photo courtesy Museo Nacional del Prado, Madrid

Fig. 4.22 Anonymous, *Sala de la Reina Isabel*, view 2, 1889. Photo courtesy Museo Nacional del Prado, Madrid

considerable length of time in Spain, often visiting the Museo del Prado, and the short article was full of relevant information on its brief history (the building, its opening hours, the kind of people who went there, and so on). Mérimée's remarks also contained his opinions on the works of Velázquez and Murillo. Velázquez, for instance, was admired for his stylistic scope as well as his portraits (attributed to him, in passing, were those of Charles IV and his

family). Mérimée also praised the landscapes, discussed the composition of *The Surrender of Breda (The Lances)*, and took nature as a point of reference when speaking of both Velázquez and Murillo. In his portraits (figs. 4.19, 4.20), "did he [Velázquez] not scrupulously imitate nature," wrote Mérimée, while Murillo "sought his models in the nature that he saw before him, and no painter, I believe, is more inventive." Besides these two artists, Mérimée mentioned Ribera, Alonso Cano, and Zurbarán, but little else. For him, other Spanish painters belonged to "this endless succession of wretched daubers whose works are as little known as the names of their creators."[25]

L'Artiste had a very large circulation in France, and, thanks to Mérimée, many people in that country became aware of the Prado. However, the book that had the widest repercussion in France and that offered the first detailed study of Spanish artists was *Les musées d'Espagne, d'Angleterre, et de Belgique* (The museums of Spain, England, and Belgium) by Louis Viardot, which appeared twelve years later, in 1843.[26] Viardot's interest in Spain began in 1823, when he took part in a French military expedition, the Cent Mille Fils de Saint Louis, which marched into Spain to restore Ferdinand VII to the throne. Viardot maintained a close interest in the country and through his writing pro-

Fig. 4.23 Anonymous, *Sala de Murillo*, ca. 1910. Photo courtesy Museo Nacional del Prado, Madrid

vided an introduction for French visitors to the Prado during the second half of the nineteenth century.[27] Like Mérimée before him, Viardot was spellbound by what he saw in the Prado (figs. 4.21–4.23) and enthused by Spanish painters.[28] He, too, did not come to grips with them all—"so many artists whose names can never be found in our museum catalogues, nor in travelers' accounts," he wrote.[29] Both he and Mérimée concentrated on the giants, Velázquez and Murillo, limiting themselves to the mention of only a few others (not, however, El Greco).

While discovering a fascinating collection of paintings unknown outside Spain, the two classically educated Frenchmen were uncomfortable when confronted by certain Spanish themes, by what they considered to be the "excessive" realism of Spanish painting, a trait that also characterized Spanish literature.[30] In Murillo's *Holy Family with a Bird* (fig. 4.24), Viardot saw only a carpenter, his wife, and a mischievous child, not St. Joseph, the Virgin Mary, and the Christ Child; he experienced the same reaction before a mythological theme like the Forge of Vulcan. Forced to choose a painting, Mérimée opted for Murillo's *Vision of Saint Bernard* (fig. 4.25), though not exactly for its religious subject: "I do not believe there is a painting that is more capable of making a devout—if young—monk sin. The Virgin is so pretty—such beauty that the eyes of the ungodly will never see—that the devil could quite easily excite the senses! Read Lewis's *The Monk*."[31] This selection is in keeping with the desire on the part of the author of *Carmen* to see the "private room" in the museum[32]—though, contrary to his expectations, the painting did not strike him as indecent but simply elicited his admiration as a lover of good painting.

25. "n'a t'il fait en cela qu'imiter la nature avec scrupule"; "il a cherché ses modèles dans la nature qu'il avait sous les yeux, et aucun peintre, je crois, n'est plus original"; "cette interminable série de méchants barbouilleurs dont les ouvrages sont aussi peu connues que les noms." Mérimée 1831c, pp. 73–75. Years later Mérimée returned to the subject of Spanish artists in a commentary on William Stirling-Maxwell's *Annals of the Artists of Spain*. See Mérimée 1848.

26. In 1834 Viardot had already published an article, "Le musée de Madrid" (*Revue Républicaine*), followed by *Études sur l'histoire des institutions, de la littérature, du théâtre et des beaux-arts en Espagne* in 1835, and later, in 1852, *Les musées d'Espagne*. He also published reports on Spain in the press.

27. In 1840 Viardot married a Spaniard—the singer Paulina García—and henceforth devoted himself to literature. He also wrote the text that accompanied the engravings produced by the Galerie Aguado. See Gavard and Viardot 1839.

28. Viardot and Mérimée may also have been influenced by Baron Taylor's *Voyage pittoresque en Espagne, en Portugal et sur la côte d'Afrique, de Tanger à Tétouan*

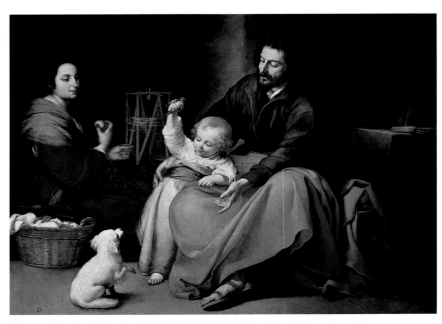

Fig. 4.24 Bartolomé Esteban Murillo, *The Holy Family with a Bird*, ca. 1650. Oil on canvas, 56¾ x 74 in. (144 x 188 cm). Museo Nacional del Prado, Madrid

Both Mérimée and Viardot were great connoisseurs of painting; in a small way Mérimée was even something of a painter, and while in Madrid made copies of works by Velázquez, Murillo, and Goya. Both paid homage to the Spanish artists' painterly skills. As Mérimée wrote of Velázquez's portraits, "Sometimes . . . they are finished with minute care; at others, they seem to be more loosely treated, painted only so as to create an effect; whichever it is that he chose, he always admirably succeeded in reproducing the tone and freshness of flesh." As to the landscapes, they were "admirable sketches, of remarkable tone and effect."[33]

Viardot was also very much taken with Velázquez, whom he believed was the foremost Spanish painter, precisely by virtue of those painterly skills that allowed him to capture the most perfect illusion. Mérimée sorely missed this focus on technical quality in the book by the Scottish traveler William Stirling-Maxwell (*Annals of the Artists of Spain*, London, 1848): "I would have preferred . . . that he [Stirling-Maxwell] had added . . . technical details on the Spanish masters' working methods. Those of the colorists can be taught and are worth studying."[34]

Both Mérimée and Viardot proposed that Spanish painters be taken as models by the French painters of their time. Viardot remarked that the Spanish old masters were capable of depicting, in a single painting, the sublime alongside the ridiculous (a touchstone of Romantic art theory). He cited as examples two paintings by Murillo, *The Angels' Kitchen* (fig. 14.60) and *Saint Elizabeth of Hungary Nursing the Sick* (fig. 3.13), in which noble and beautiful figures appear next to others that are humble, ugly, even repulsive.[35] As Charles Blanc wrote some years later, "Contrast is the driving force of Spanish art. We have also seen, in our own day, French Romanticism, based on contrast! [But] no one has put it to use so often and with such success as Murillo."[36]

In France, knowledge of the Museo del Prado was amplified by *Le Musée Royal de Madrid*, a book by Louis Clément de Ris published in Paris in 1859. More detailed than Viardot's effort, it mentioned the works that had been brought to Madrid from El Escorial and assessed the museum as incomplete yet full of masterpieces. Clément de Ris took a close interest in museums in France, and this perspective led him to draw comparisons between the Prado and the Louvre, identifying aspects of the Prado's collection that are still considered important today: Venetian painting, works by Titian, and paintings by Joachim de Patinir, as well as *Lucrecia* by Andrea del Sarto and *The Cardinal* by Raphael. Like Viardot and Mérimée, Clément de Ris placed Velázquez and Murillo squarely above other painters: "two isolated characters, in whom one finds little that is rooted in the past and whose successors hardly span a generation."[37] While he also held Ribera in esteem, other painters did not greatly stimulate his interest, which may be why Clément de Ris, unlike Viardot, did not

(1826–32), which described the Prado in highly charged terms, a habit the French writers were to emulate. Taylor admired Velázquez more than any other painter.

29. "tant d'artistes dont le nom ne s'est jamais trouvé dans les catalogues de nos musées, ni dans les rélations de nos voyageurs." Viardot 1835, p. 400.

30. Mérimée, for example, found the picaresque novel *La vida de El Laʒarillo de Tormes* (1554) both "admirable and disgusting."

31. "Je ne crois pas qu'il soit un tableau plus capable de faire pécher un moine dévot, mais jeune. La Vierge est si jolie et montre tant de beautés que l'on cache aux profanes, que le diable a beau jeu pour exciter les sens! Lisez le *Moine* de Lewis." Mérimée 1831c, p. 75.

32. On this and other "private rooms," see Portús Pérez 1998 and Madrid 2002b.

33. "Parfois . . . ils sont finis avec un soin minutieux; d'autres paraissent de facture plus libre, peints seulement pour produire des sensations; quelle que soit la manière choisie, il a toujours réussi à reproduire de façon admirable la couleur et la carnation des chairs"; "esquisses admirables, d'une couleur et d'un effet prodigieux."

34. "J'aurais préféré . . . qu'il [Stirling-Maxwell] eût ajouté . . . des détails techniques sur les procédés des maîtres espagnols. Les procédés des coloristes peuvent s'enseigner et valent la peine qu'on les étudie." Mérimée 1848, pp. 642–43.

believe in the existence of a Spanish school with its own distinct characteristics. He did comment, however, on the unique qualities of both El Greco and Goya, singling out *The Dead Christ* by El Greco as "the best work by this remarkable artist, who died a madman,"[38] and stressing the innate genius that saved Goya from his poor technique. Finally, Clément de Ris considered the building itself, which he found rather ugly, as well as the way in which the works were hung, which he deemed lacking in order. Nevertheless, he praised the paintings' good state of preservation and the quality of the restoration that had been carried out on them.

BRITISH VISITORS: FROM FORD TO STIRLING-MAXWELL

Richard Ford, in *A Hand-book for Travellers in Spain and Readers at Home*, published in London in 1845, called the Museo del Prado "the finest gallery in the world."[39] The author, who probably knew Spain better than anyone else in his time, did not hold back when praising or criticizing Spanish painters. Velázquez, whose renown continued to grow through such attention, was praised above all others for his truth and vitality,[40] and Murillo was commended for his vibrant palette. Ribera, who did not stimulate Ford's enthusiasm, seems to rank some distance below the two great painters. As for El Greco, Ford found him flamboyant and "unequal," as did most people of the time.[41]

For Ford, as for others, the key to understanding Velázquez was "nature": "Nature was his guide, truth his object and man his model."[42] This vision of nature had no room for the supposed "Italian ideal" that some saw in the works of Philip IV's court artist, nor did it play a role in those by Murillo: as Ford graphically summarized it, the Virgin never descended to visit Velázquez's workshop any more than cherubs fluttered around his palette, and Murillo's depictions of the Christ Child and of angels were none other than "pretty mortal babes," Spaniards and Andalusians, to be precise. Continuing with such parallels, Ford identified Vulcan in *The Forge* as "a mere Gallician blacksmith" and, like Viardot, saw in *The Holy Family with a Bird* only "pleasing scenes of a domestic family, where sports of graceful children attract the delightful attention of affectionate parents."[43]

Ford was a great promoter for the museum when he stated that, unlike the work of Raphael, Titian, and Murillo, the paintings of Velázquez could only really be known by going there: "Madrid is the only home of the mighty Andalucian, for here is almost his entire work."[44] Indeed, when speaking of other schools, such as the Italian, represented in the Prado, Ford unashamedly dismisses paintings that are today considered masterpieces: "The opening *Rotunda* contains rubbish: . . . an allegory by J[uan] Ba[utista] Mayno, 1609–1649, an imitator of P[aolo] Veronese, and friend of Lope de Vega."[45]

Like Clément de Ris, Ford found fault with the building that housed these works, describing it as a "huge lumbering commonplace edifice," with an upper floor that was "paltry, low, unarchitectural." His opinion of the catalogue compiled by Pédro de Madrazo and published in 1843 was no better, bemoaning that "the reader will obtain very little aid." He preferred Viardot's book, "another common guide in the hands of the uninformed," with "many lively clever *intuitive* and very French criticisms." Moreover, he hailed the restoration and

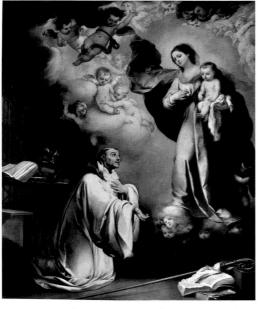

Fig. 4.25 Bartolomé Esteban Murillo, *The Vision of Saint Bernard*, 1650–70. Oil on canvas, 122½ x 98 in. (311 x 249 cm). Museo Nacional del Prado, Madrid

35. He also compared the composition of *The Angels' Kitchen*, which he found eccentric and anticlassical, to the way in which Romantic painters built up their pictures. Viardot 1835, pp. 419–31.

36. "Le contraste est le grand ressort de l'art espagnol. Aussi a-t-on vu de nos jours le romantisme français, basé sur le contraste! personne ne l'a plus souvent mis en oeuvre et avec plus de bonheur que Murillo." Blanc et al. 1869, p. 10. Also Gautier et al. 1864, p. 302.

37. "deux personnalités isolées, auxquelles on trouve bien peu de racines dans le passé et dont les successeurs ont à peine duré une génération." Clément de Ris 1859.

38. "la meilleure oeuvre de ce singulier artiste, mort fou." Ibid.

39. Ford 1845 (1966 ed.), vol. 3, p. 1110.

40. An article on Velázquez in the *Penny Cyclopaedia* (Ford 1843) is reprinted in London 1974.

41. "what he did well, was excellent, while what he did ill, was worse than anybody else." Ford 1845 (1966 ed.), vol. 3.

42. Ibid, p. 1120.

43. Ibid, pp. 1118, 11121.

44. Ibid, p. 1115.

45. Ibid, p. 1113.

46. Ibid, pp. 1108, 1112, 1111.

47. Stirling-Maxwell 1848, vol. 1, p. xxi.

48. Stirling-Maxwell's historical works include *The Cloister Life of the Emperor Charles V* (1852) and *Don John of Austria* (1883). On Stirling-Maxwell, see E. Harris 1964b; MacCartney 1999; and Madrid 2000.

49. *Legends of the Saints*, by Mrs. Anna Jameson, appeared in 1848 as part of *Sacred and Legendary Art* and concentrated on Murillo and the depiction of various sacred themes. *A Hand-book of the History of the Spanish and French Schools of Painting* by Edmund Head, a diplomat who had been in Seville in 1833, also appeared that year. This scholarly account, which begins with the Middle Ages and goes up to José de Madrazo, was overshadowed by the publication of Stirling-Maxwell's book. In 1854 Head worked on the English translation of Franz Kugler's *Handbuch der Kunstgeschichte* (1842).

50. Stirling-Maxwell 1848, vol. 1, p. 14.

51. Ibid., p.15.

52. Ibid., p. 9.

53. Ibid.

54. Ibid., p. 41.

55. Stirling-Maxwell 1873.

56. The French edition, *Velasquez et ses oeuvres* (Paris, 1865), includes a catalogue by Théophile Thoré (under the pseudonym W. Bürger).

cleaning of paintings that were carried out in France as the work of "demigods compared to their unmechanical imitators in Spain," whom he summarily dismissed.[46]

Ford's *Hand-book* often made the journey to Spain in the luggage of British visitors. One of the travelers who used it as a guide was a Scot, William Stirling-Maxwell, for whom it was "one of the most popular books in our language."[47] Stirling-Maxwell, a landowner and lover of books, art, and history,[48] also wrote his own study that did a great deal to disseminate knowledge of Spanish painters in the British Isles and beyond. His was one of three tomes published in Britain in 1848 that concerned Spanish art.[49] *Annals of the Artists of Spain* was the most complete exploration of Spanish art to have appeared at the time and immediately became the standard English work on Spanish painting. A second edition—revised, updated, and expanded—was published in 1891 and soon thereafter was translated into French and German.

Stirling-Maxwell, like Richard Ford, was a true Hispanicist. He traveled to Spain several times, owned works of art (paintings, prints, drawings, and books), read voraciously, and at the age of thirty published the first scholarly, multivolume work on Spanish art. Full of facts and information, and written with a striking sense of humor, Stirling-Maxwell's *Annals* was, among other things, the first investigation to be made of royal commissions and collections and of the dispersal in Europe of Spanish paintings.

Covering a wide period of time (from the Middle Ages to Goya), an enormous range of subject matter (from painting to embroidery and silverwork), and a large number of artists, the *Annals* paid as much attention to biographical detail as to archival documents. Religion appears as one of the principal keys to understanding Spanish art—"The sobriety and purity of imagination which distinguished the Spanish painters"[50]—and accounts for the predominance of church patronage as well as the fear, during the Inquisition, of departing from established norms in the depiction of sacred subjects. Closely related to religion is "the character of the Spanish people," as the author noted, "the proverbial gravity."[51]

Stirling-Maxwell describes Velázquez and Murillo as "the Homer and the Virgil of the Spanish school."[52] The two Spanish painters were the perfect alternative to Raphael's *Transfiguration*—Velázquez as court portraitist, "the living and moving captains and spearmen," Murillo as a painter of religious subjects, with his "thirsty multitudes flocking to the rock that gushed in Horeb."[53] Both painters brought pleasure in equal measure, to the most demanding and critical eye as well as to the least informed, because each artist always closely observed nature. In Stirling-Maxwell's opinion, however, they were not the equal of such artists as Titian or Van Dyck because the people they portrayed—"the degenerate nobility of the court of Philip IV and the clergy and gentry of Seville"[54]—were less illustrious than the other artists' subjects.

The *Annals* was the first book on the subject of art history to be illustrated not only with engravings (which was not unusual) but also with photographic plates attached to the pages (which was new and absolutely exceptional). Sixty-six calotypes and Talbotypes made up the fourth volume (*Talbotype Illustrations to the Annals of the Artists of Spain*), printed by Nicolas Henneman, William Henry Fox Talbot's assistant, in their studio in Reading. Stirling-Maxwell went on to compile the first two catalogues of prints made of the work of Velázquez and Murillo,[55] and published *Velázquez and His Works* in 1855,[56] the text of which elaborates on that of the *Annals*.

Beyond the Prado: Lefort and the Painters

The equivalent to Stirling-Maxwell's book was not published in France until 1869. Comprehensive and well illustrated, the *Histoire des peintres de l'École espagnole* (History of the painters of the Spanish school) formed part of the fourteen-volume *Histoire des peintres de toutes les écoles* (History of the painters of all the schools), which was edited by Charles Blanc and published from 1861 to 1876.[57] The text on the Spanish school was written by Paul Lefort, whose prolific writing on Spanish art included various articles on the Museo del Prado.[58] Departing from customary preferences for Velázquez and Murillo, he took a keen interest in El Greco, which changed the way that this painter from Crete was seen in France.[59]

Unlike Stirling-Maxwell, the French authors chose not to take a scholarly approach and did not draw on documentary sources. Like their compatriot Prosper Mérimée before them and Théophile Gautier later, they instead asked why Spanish artists painted as they did. Tempered by the contemporary debate concerning Neoclassicism and Romanticism, they found Spanish painting as striking as the work of the Le Nain brothers or Dutch art. They approached seventeenth-century Spanish art in the same terms that they did modern French painting, speaking of the depiction of ugliness, of the relativity of academic canons, of freedom, and of "multifaceted beauty," while in their mind's eye they saw the paintings hung on the walls of the current Paris Salon.

When Lefort discussed El Greco in 1869, he seemed to have in mind Delacroix, the arch-Romanticist: "He is a daring, enthusiastic colorist, too taken by strange contrasts, odd shades, which ever more audacious, result in throwing everything off course, and then in sacrificing everything in the quest for effect."[60] The novelist Champfleury had mounted a comparable defense for Courbet's *The Cellist (Self-Portrait)* (fig. 1.41), exhibited in the Salon of 1848; his support was, however, based on the subject's similarity to figures that Velázquez and Murillo had painted, figures of whom Courbet's musician would not be afraid if he found himself with them.[61] When he turned to the defense of *Burial at Ornans* (fig. 1.43), Champfleury put forward the same arguments, invoking Netherlandish painters as well and concluding that "Whoever does not understand Velázquez cannot understand Courbet."[62]

The subject matter and technique of Spanish painting had a freedom that appealed to Romantics and Realists, Delacroix and Champfleury in equal measure. Its disregard for the academic notions that had determined Italian and French painting attracted them. And it offered the possibility of depicting a court jester with as much care as a king, of placing a humble friar next to a shining angel, and of valuing color over draftsmanship. It was these contemporary concerns that enabled nineteenth-century French writers and artists to approach Spanish painting with great passion.

57. Blanc et al. 1869. The volume contains contributions by Charles Blanc, W. Bürger (pseudonym of Théophile Thoré), Paul Mantz, Louis Viardot, and Paul Lefort. In 1863 Blanc published an article, "Vélasquez à Madrid," in the *Gazette des Beaux-Arts* (vol. 15, pp. 67–74). Earlier, Édouard Laforge had published *Des arts et des artistes en Espagne jusqu'à la fin du XVIIIe siècle* (Lyon, 1859), which also did much to make the Prado known in France.

58. See Blanc et al. 1869. Lefort was the author of *La peinture espagnole* (1893) and other books on Velázquez (1888), Murillo (1892), and the prints of Goya (1877). For his writings on the Prado, see Lefort et al. 1896, which contains articles that appeared in the *Gazette des Beaux-Arts*, and is based in large part on P. Madrazo 1843.

59. Álvarez Lopera 1987.

60. "C'est un coloriste audacieux, enthousiaste, trop épris des oppositions étranges, des teintes singulières, qui, de hardiesse en hardiesse, en arrive à tout dubordonner, puis à tout sacrifier à la recherche de l'effet." Lefort 1893.

61. "You could hang his portrait *Homme à la Basse* in the Spanish museum, and he would still stand proud and calm, with no fear of the Velasquez paintings and the Murillo." ("On mettrait dans le musée espagnol son portrait d'*Homme à la Basse* qu'il resterait fier et tranquille, sans craindre les Velasquez et le Murillo.") Champfleury 1973, p. 154.

62. "One can understand Ostade, Teniers … Ornans." ("On comprend Ostade, Teniers … Ornans.") Ibid., pp. 163, 182.

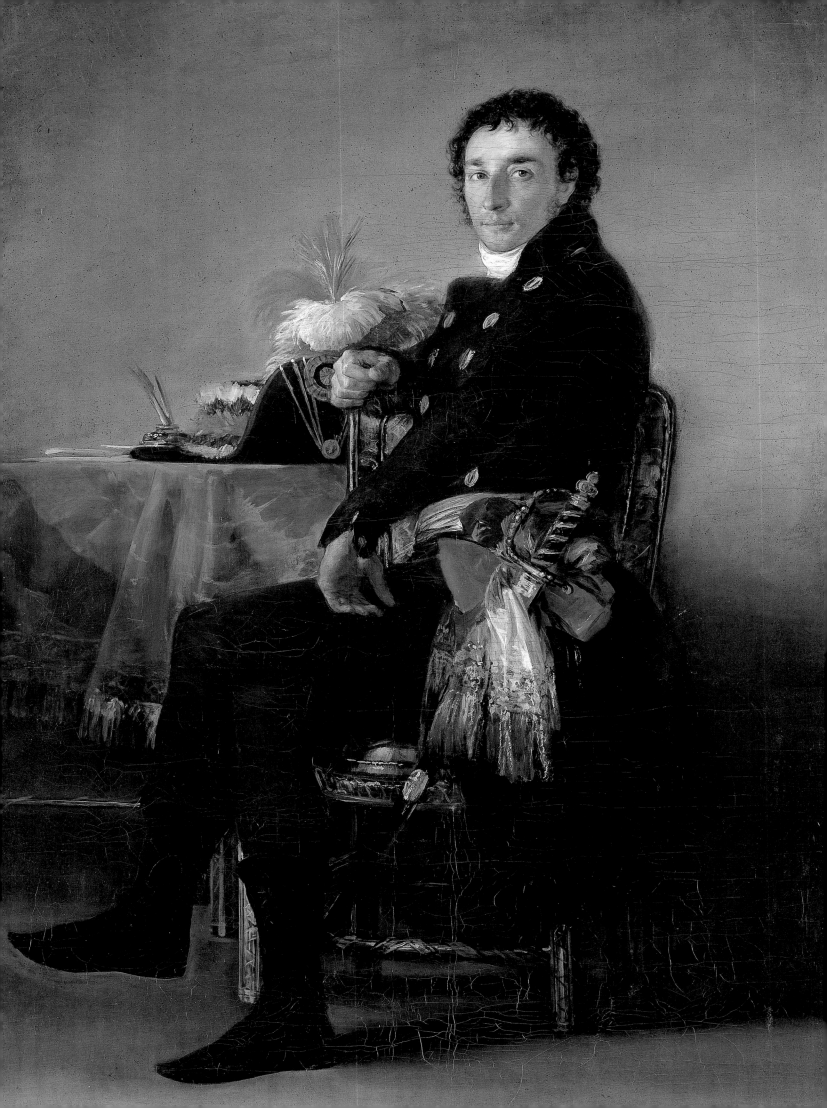

Goya and France

Juliet Wilson-Bareau

The notebook that Francisco de Goya y Lucientes (1746–1828) began as a student in Italy has thrown light on the art he saw in that country and the influence it had on his work.[1] His relationship with French art is, however, less easy to define. He arrived in Bordeaux in 1824 and, except for two months in Paris that year and two brief trips to Madrid in 1826 and 1827, remained there until his death on April 16, 1828. The only direct evidence that Goya may have visited France before 1824 is found in the very early Italian notebook. At the bottom of one page, Goya wrote the names of cities: "Tolon Abila Mars[a]," that is, Toulon, Avignon (?), and Marseille.[2] Another page contains a name and address in Marseille written by a different hand in a macaronic mixture of French, Italian, and Spanish: "a Monsieur Baudoin en Case de SS.[rs] Tarteiron & figlio a Marseille." Below it, Goya rewrites the information in French: "A Monsieur Baudoin chez Messieurs Tartairon [sic] & fils a Marseille."[3] Like other addresses in the notebook, this probably represents a business contact that Goya would have used to draw money on his journey.[4]

Before 1775, when Goya went to live and work in Madrid, Italian art was the predominant influence in his paintings; it is particularly strong, for instance, in the majestic series of murals executed in 1773–74 in the Cartuja de Aula Dei, a Carthusian monastery near Saragossa.[5] Since the first half of the eighteenth century, however, French art had played a leading role at the Bourbon court in Madrid, and its impact would have been felt in artistic centers throughout the country. The sophisticated classicism of seventeenth-century French painting evidently influenced Goya as he devised his religious subjects. For one of his first commissions in Saragossa—a series of large murals on religious themes for the chapel of the Casa de Sobradiel (1770–72)—he used prints by Michel Dorigny after the seventeenth-century French artist Simon Vouet as models.[6] He also, during the 1780s, probably knew prints after such French artists as Poussin and David. And his painting *Saint Francis Borgia Attending a Dying Impenitent* (1788, Valencia Cathedral) reflects the direct influence of a Madrid altarpiece by Michel-Ange Houasse.[7] In his highly original interpretation of this theme, Goya depicts monsters and demons for the first time in his work.

Another important influence that may have strengthened the French influence on Goya was Luis Paret, the most "rococo" of eighteenth-century Spanish artists. Paret, who was half French, worked under the patronage of the Infante Don Luis (the brother of Charles III), whom Goya painted with his family in 1783 and 1784. Goya would certainly have known Paret's work, which may have been responsible for a marked shift in the mid-1780s in the character of his sketches for tapestry cartoons. Executed in a style reminiscent of Watteau and Boucher, these are marked by a lighter tonality and a detailed, delicate handling (figs. 5.2, 5.3).[8]

The author is particularly indebted to Manuela Mena Marqués and Gudrun Maurer in Madrid and to Philippe Arbaizar, Eric Gillis, and Claudie Ressort in Paris for their very generous assistance.

1. Madrid–London–Chicago 1993–94, pp. 92–103, 343; Madrid 1994a; Juliet Wilson-Bareau, "The Roots of Goya's Realism," in Copenhagen 2000b, pp. 53–71.
2. Madrid 1994a, p. 39.
3. Ibid., p. 161.
4. The Tarteirons were a Protestant family in Marseille. Major players in maritime transport and industrialists with international banking connections, they owned a soap factory administered by the Catholic firm of Baudoin. See Carrière 1973, pp. 138, 247, 294; Ferran n.d., pp. 118–24. Research was carried out and information very generously supplied by Mme Gertrude Cendo and the Archives Municipales de la Ville de Marseille.
5. Gassier and Wilson 1971, nos. 42–48.
6. Ibid., nos. 10–12. For the engraving by Dorigny, see Madrid 1996e, p. 103, no. 56.
7. Sánchez Cantón 1951, pp. 29–30, 41–42, figs. 7–9, 17–19; Madrid–London–Chicago 1993–94, pp. 146–51, 349, no. 17; Bordeaux–Paris–Madrid 1979–80, p. 123, no. 61; Manuela B. Mena Marqués, "Goya y Maella en Valencia: Religiosidad ilustrada y tradición," in Valencia 2002, pp. 96–99.
8. Compromised in his relationship with the Infante Don Luis, Paret was exiled to Puerto Rico by Charles III in 1775, but he was back in Bilbao in 1778. In 1780 he submitted his history painting *The Prudence of Diogenes* as part of his application for membership in the Real Academia de San Fernando in Madrid, to which city he returned in 1787. See Bordeaux–Paris–Madrid 1979–80, pp. 92–94 (Academy picture); see also *La Tienda* (*The Shop*) in Saragossa 1996, pp. 132–33 (formerly Infante Don Luis; now Museo Lázaro Galdiano, Madrid).

Fig. 5.1 Francisco de Goya y Lucientes, *Ferdinand Guillemardet*, 1798. Oil on canvas, 73¼ x 48⅞ in. (186 x 124 cm). Musée du Louvre, Paris. Bequest of Louis Guillemardet, the subject's son, 1865

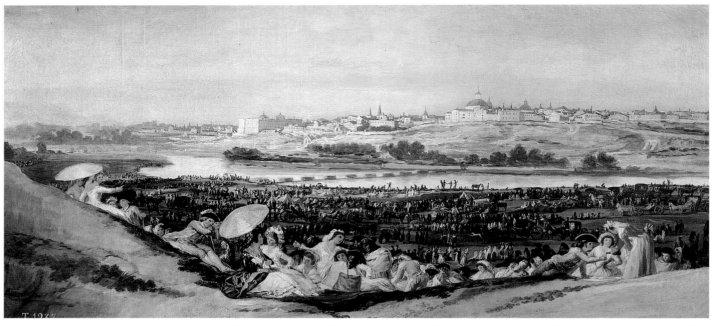

Fig. 5.2 (cat. 4) Francisco de Goya y Lucientes, *The Meadow of San Isidro*, May–June 1788. Oil on canvas, 16½ x 35⅜ in. (42 x 90 cm). Museo Nacional del Prado, Madrid

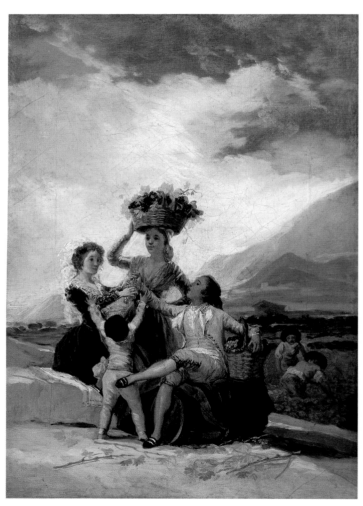

Fig. 5.3 (cat. 3) Francisco de Goya y Lucientes, *Autumn* or *The Grape Harvest*, 1786. Oil on canvas, 13⅜ x 9½ in. (34 x 24.1 cm). Sterling and Francine Clark Art Institute, Williamstown, Mass.

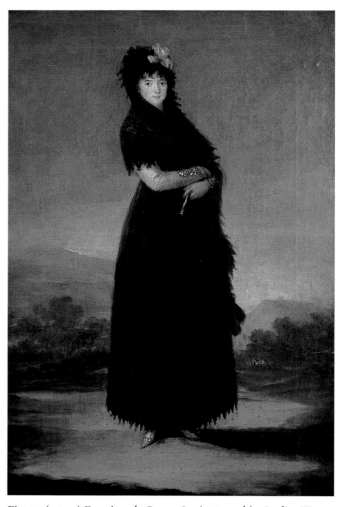

Fig. 5.4 (cat. 13) Francisco de Goya y Lucientes and/or Studio, *Woman in Spanish Costume*, ca. 1797–99? Oil on canvas, 20½ x 13⅜ in. (52 x 34 cm). Musée du Louvre, Paris, Bequest of Louis Guillemardet, 1865

Two years before the French Revolution, Goya decided to learn French, his avowed reason being that his friend Martín Zapater liked the language. On November 14, 1787, he wrote, or attempted to write, in French to Zapater: "Je vais hazarder, Mon cher Ami, de vous Ecrire en françois[.] Parce que je sçais que vous aimes cette langue, Je me suis mis dans lidee de lapprendre, je ne sçai si je reussirai, je vous envoye mes premiers essais. . . ." ("My dear Friend, I am going to attempt writing to you in French[.] Since I know you love this language, I have taken it into my head to learn it, I don't know if I will succeed, I am sending you my first attempts. . . .").[9] French was the language of European commerce and diplomacy. As Goya rose slowly but surely to the rank of first court painter, he would have had many opportunities to meet foreign envoys and visitors to Madrid. In the 1780s and 1790s he maintained close friendships with many *ilustrados,* Spanish intellectuals who were sympathetic to the ideas of the Enlightenment and who looked to France for the latest philosophical and cultural trends. He was particularly close to the poet and playwright Leandro Fernández de Moratín, who visited France on several occasions and was briefly in Paris during the French Revolution. After the Directory dispatched the regicide Ferdinand Guillemardet to Spain as its ambassador in 1798, Goya painted a splendid portrait of him (fig. 5.1) and exhibited it at the Real Academia de Bellas Artes de San Fernando in July 1799. Although by that time Goya was completely deaf, his lively representation of Guillemardet suggests a sympathetic interaction between the two men. Recalled to Paris in 1800, the ambassador took the portrait with him and perhaps also a small canvas later described in a legal document as "Another little picture, also by Goya, a work that is very delicately painted and represents a lady richly and elegantly attired in Spanish dress. A picture painted in Madrid in 1799" (fig. 5.4).[10]

Goya as Printmaker

The *Caprichos,* the most influential of Goya's works in France, had such a powerful impact largely because of the nature of their medium. Prints were the only means by which visual images could be duplicated and disseminated in large numbers. They were used to reproduce paintings, to ornament literary works, and to illustrate scientific and practical handbooks and manuals. The myriad engraved plates of Diderot's great *Encyclopédie,* a cornerstone of Enlightenment culture, completed in 1772, underline the importance of the engraver and his art. Parisian engravers were brilliant technicians, and their often very large reproductive or allegorical engravings demonstrate that, despite the constraints of their chosen medium, they could produce aesthetically superb images. That the Spanish court sent its best engravers to Paris to perfect their technique indicates the importance of French practice. Goya, who came to maturity in the Age of Enlightenment, was trained as an artist by studying and copying prints; he once described himself as a "pupil of José Luzán in Saragossa, who taught him the principles of drawing by giving him the best prints in his collection to copy; he spent four years with him. . . ."[11] Goya's personal print collection came to include examples by several major artists, including ten etchings by Rembrandt and a good many works by Piranesi. He owned one print by the French artist Charles-Joseph Flipart, who worked in Spain, and two landscapes by an unidentified member of the Pérelle family.[12]

On Paret, see Indianapolis–New York 1996–97, pp. 274–78.

9. Goya 1982, p. 177, no. 100; Goya 1981, p. 287, no. 139. Goya added a postscript in equally fractured French: "I'm afraid you may need a dictionary to decipher these phrases and if you haven't got one I'll send you mine." ("Je crains que tu es besoin dun dictionaire pur deviner ses mots si tu nen â pas, je tenverrai le mien.") In his next letter a fortnight later he had given up, telling Zapater that while he could understand spoken French, it all cost him too much effort.

10. "Un autre petit tableau de ce même artiste Goya, oeuvre très délicatement touchée, représentant une dame en riche et élégant costume Espagnol. Tableau peint à Madrid en 1799." Archives des Musées Nationaux, Paris, Musée du Louvre (P8 1865 22 juillet).

11. "discípulo e don José Luzan en Zaragoza, con quien aprendió los principios de dibujo, haciéndole copiar las estampas mejores que tenia; estuvo con el cuatro años . . ." (autobiographical note written for the catalogue published for the reopening of the Real Museo del Prado in March 1828; see Madrid 1828b, pp. 67–68 [catalogues were also published in French and Italian]).

12. Goya's print collection is listed in Sánchez Cantón 1946, Appendix III, pp. 90–91, 106. On Flipart and his most celebrated engraving, see Alisa Luxenberg, "Figaros and Free Agents: Some Perspectives on French Painters in Eighteenth-Century Spain," in Indianapolis–New York 1996–97, p. 43. French prints also formed part of the collection of Ceán Bermúdez; see Madrid 1996e, no. 25.

Fig. 5.5 (cat. 23) Francisco de Goya y Lucientes, *Infante Don Fernando, Copy after Velázquez*, ca. 1785? Etching, aquatint, drypoint or burin, roulette, and burnisher, first state, 11 x 6¾ in. (28 x 17 cm). Bibliothèque Nationale de France, Département des Estampes, Paris

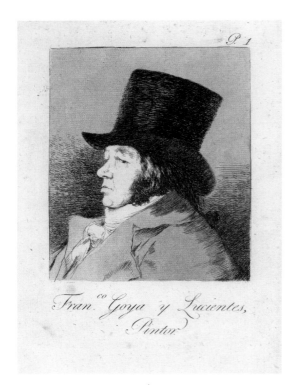

Fig. 5.6 (cat. 25) Francisco de Goya y Lucientes, *Los Caprichos, No. 1: Francisco Goya y Lucientes, Pintor*, 1799, first edition. Etching, aquatint, drypoint, and burin, 8⅝ x 6 in. (22 x 15.3 cm). The Metropolitan Museum of Art, New York, Gift of M. Knoedler & Co., 1918 (18.64.1)

Although Goya was not a professional engraver but a painter, as the frontispiece of the *Caprichos* (fig. 5.6) unequivocally declares, he did produce some designs for engraving by professionals in the 1770s and 1780s.[13] But the role in which he both innovated and excelled was that of the *peintre-graveur*, a term coined by French writers in the 1860s to denote a practitioner of etching. That is, instead of leaving the production of his prints to highly trained professionals using the traditional engraver's tools, Goya elected to make them himself by means of the much speedier techniques of etching and aquatint. These methods allowed him great freedom of expression and effectively abolished the boundary between painting and drawing, on the one hand, and the multiplicative arts like printmaking, on the other. Goya was known in France above all for these original prints, which form a substantial part of his oeuvre; some 130 were published during his lifetime, and almost as many after his death.[14]

Goya's first attempt at printmaking was both reproductive and original. In response to a growing demand that Spain's artistic treasures be more widely known—and encouraged by Antonio Ponz, secretary of the Real Academia, and by Juan Agustín Ceán Bermúdez, an *ilustrado* with a particular interest in art—several young painters decided to make etchings reproducing the masterpieces in the royal collections. Goya chose to copy the works of Velázquez, the Spanish artist most admired by connoisseurs at the court. The task gave him access to the originals in the royal palace, which he was able to study to his own artistic advantage. Goya's etched *Copies after Velázquez* (fig. 5.5) were handsome interpretations rather than slavish copies. Advertised in two groups in the *Gaceta de Madrid* in July and December 1778, respectively, they were shown that year at the Real Academia, where they attracted immediate attention. The Austrian representative in Madrid sent a set of the prints to Prince Wenzel Anton Kaunitz, the Austrian high chancellor in Vienna, together with a favorable report on the initiative of "their Author who is a painter, not an engraver, and who has been the first to attempt this form of printmaking."[15] Simultaneously, Lord Grantham, the English ambassador to Spain from 1771 to 1779, learned about Goya's project, became enthusiastic, and sent five sets of his prints to England in August 1778.[16] The copperplates were acquired by the Real Calcografía, the official copperplate printing establishment, in 1792 and were reprinted at various times throughout the nineteenth century.[17]

THE *CAPRICHOS*

Goya did not return to etching for almost two decades, but when he did, it was in the context of another innovative initiative. During his convalescence from a near-fatal illness contracted in 1792–93, he was inspired to paint a series of small pictures on disparate themes, ranging from the comic to the sublime (fig. 5.7).[18] While these works are remarkable expressions of Goya's thoughts and feelings, they were also made very much in anticipation of a sale. The themes reflect not only the contemporary appetite for dramatic scenes but also the artist's deep interest in the social problems that concerned Gaspar Melchor de Jovellanos, Juan Meléndez Valdés, and other *ilustrados*.

In 1796 Goya began a series of humorous sketchbook drawings that gradually developed into a sequence of satirical images.[19] Moratín returned to Spain that year, no doubt bearing prints and books collected on his travels in France, England, and Italy. His journal indicates that he and Goya saw each other often, and it was perhaps with him that Goya planned and executed an ambitious set of prints.[20] A celebrated preparatory drawing for the frontispiece, dated 1797, shows "the Author" sleeping or dreaming at his worktable; by the end of 1798 Goya's set of eighty prints was complete.[21] It opened with a new frontispiece, a self-portrait bearing the artist's name and occupation: *"Fran.ᶜᵒ Goya y Lucientes, Pintor"*; the original one, now captioned *El sueño de la razón produce monstruos (The Sleep of Reason Produces Monsters)*, was repositioned as number 43, halfway through the series (fig. 6.3).

The publication was announced in the press in February 1799 as a *Colección de estampas de asuntos caprichosos* (Collection of prints of fanciful subjects). Never given a formal title, the publication was simply known as the *Caprichos de Goya*.[22] Drawing on such well-known precedents for artistic license and ambiguity as Giambattista Tiepolo's *Capricci* and *Scherzi di fantasia*, the title reflects Goya's aim, stated in the advertisement, of offering a view of society that, while based on components of the real world, combines them arbitrarily and idiosyncratically. His etchings were intended, in the artist's own words, to visually convey "the censure of human error and vice" that was generally regarded as the domain of rhetoric and poetry. Goya thus places his enterprise on a par with that of his enlightened literary friends.

Etching was a natural vehicle for social and political satire. The French Revolution produced a flood of images in both France and Britain that circulated among the educated classes in Spain despite stringent censorship.[23] Such satirical works habitually used fantastical or grossly humorous images to make their points, and Goya drew on this tradition, which served to disguise the deeper, more serious layers of meaning in his prints. His preparatory drawings for the *Caprichos* show that the first plates to be made were delicately etched and lighthearted, satirizing human behavior with extremely literal depictions of witchcraft. In the published work, most of these are placed in the second half of the volume after the *Sleep of Reason* image with its bats and owls. As Goya warmed to his theme and mastered the techniques of etching and aquatint, he progressed to ever more incisive satire in plates in which deeply bitten lines and varied tones interacted dramatically with the whiteness of the paper. The precision of his draftsmanship parallels the penetrating analysis of his targets, while the often almost abstract quality of his chiaroscuro perfectly expresses his underlying theme: the struggle between light and dark, reason and unreason, knowledge and ignorance (see, for example, figs. 5.26, 5.29, 6.14, 6.16–6.18). The intelligence of Goya's satirical imagery and the brilliance and sophistication of his technical language give the *Caprichos* their lasting and universal power.

Although Goya disclaimed any intention of targeting particular individuals, his contemporaries seem to have responded to the *Caprichos* as they did to conventional satirical

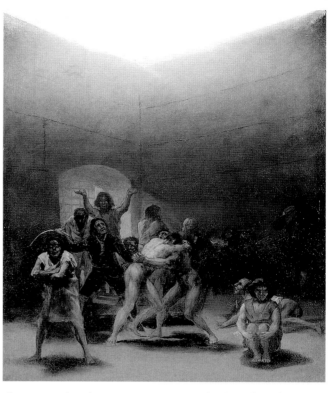

Fig. 5.7 Francisco de Goya y Lucientes, *Yard with Madmen (Corral de locos)*, 1794. Oil on tin-plated iron, 16⅞ x 12⅜ in. (42.9 x 31.4 cm.). Meadows Museum, Southern Methodist University, Dallas, Algur H. Meadows Collection

13. For the drawings made by Goya as models for engravings in 1777 (*Don Quixote*) and 1788 (*Homage to Charles Lemaur*), see Madrid 1996e, pp. 113, 116, nos. 71, 72, 76.

14. *Los Desastres de la guerra* (eighty plates) and *Los Proverbios* (eighteen plates) were published in Madrid in 1863 and 1864, respectively. Additional prints of *La Tauromaquia* (seven plates) and of the *Disparates* or *Proverbios* (*Proverbs*) (four plates) were published in Paris in 1876 and 1877, respectively, the former as part of a complete edition of forty plates, the latter as plates inserted into issues of the journal *L'Art* with a series of articles by Charles Yriarte (see Yriarte 1877).

15. "leur Auteur qui n'est pas Graveur mais Peintre, et qui a le premier hazardé ici cette façon de graver." Velázquez 1963, pp. 175–76; Juretschke 1970–, vol. 13, no. 12, p. 80.

16. See Glendinning et al. 1999, p. 601.

17. See Glendinning 1989b.

18. See Gassier and Wilson 1971, pp. 108–12, nos. 325–30; Madrid–London–Chicago 1993–94, pp. 189–209.

19. Gassier 1973, pp. 45–137; London 2001, pp. 47–78.

20. Fernández de Moratín 1968, pp. 174–76, 185–212 *passim*; Baticle 1971, pp. 111–14.

21. On January 17, 1799, Goya was paid for four copies of the *Caprichos* purchased by the duke of Osuna; see Gassier and Wilson 1971, Appendix V, p. 384.

22. The title appears on the spine of early copies in contemporary bindings; see T. Harris 1964, vol. 2, p. 62; Madrid 1996e, p. 179, no. 168. The press announcement is reproduced in T. Harris 1964, vol. 1, p. 103; Wilson-Bareau 1981, p. 24; Madrid 1996e, p. 178, no. 165; for English translations, see López-Rey 1953, vol. 1, pp. 78–79; Glendinning 1977, p. 49, reprinted in Tomlinson 1994, pp. 141–42.

23. Los Angeles–Paris 1988–89; London 2001, pp. 91ff. *passim*.

24. "un livre de caricatures à l'anglaise." Albert Blanc, *Mémoires politiques et correspondance diplomatique de J. de Maistre*

prints and caricatures. Madrid no doubt buzzed with gossip about the identities of so many sharply characterized and comical figures. Several sets of "explanations" circulated with the prints; one of them, which did not identify individuals, was generally supposed to have come from Goya himself. The fame of the work spread rapidly, and by 1808 a copy, described by the French author and statesman Joseph-Marie de Maistre as "a book of caricatures in the English manner," had reached St. Petersburg.[24] In an article published in Cadiz in 1811, Gregorio González Azaola, one of Goya's colleagues at the court in Madrid, noted that "from ambassadors down to artists and travelers, there is no recent arrival in Madrid who has not tried to meet Goya and obtain a copy of this work." The same writer made clear that the *Caprichos* operated on several levels: "The majority of ordinary people who have seen them take them to be merely absurd extravaganzas of their author." But, wrote Azaola, "Their subtlety is such that even the sharpest minds do not perceive the whole of their moral point at the first perusal."[25]

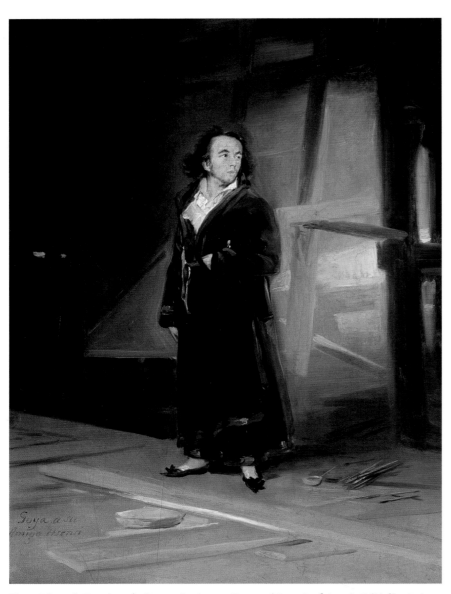

Fig. 5.8 (cat. 6) Francisco de Goya y Lucientes, *Presumed Portrait of Asensio Juliá (Su Amigo Asensi)*, ca. 1798. Oil on canvas, 21½ x 16⅛ in. (54.5 x 41 cm). Museo Thyssen-Bornemisza, Madrid

BONAPARTE IN SPAIN

The years from 1800 to 1808 were years of uneasy calm in Spain. Charles IV's prime minister, Manuel Godoy, ousted the last liberal minister in 1801, Jovellanos was imprisoned, then banished, and Ceán Bermúdez went into exile. Goya had been named first court painter in October 1799 after a series of spectacular artistic successes, including the fresco decoration of the royal hermitage church of San Antonio de la Florida, carried out with his assistant Asensio Juliá (fig. 5.8), and a new series of royal portraits. His magnificent *Family of Charles IV* (fig. 1.55), in which the painter depicted himself, as Velázquez had in *Las Meninas* (fig. 4.13), was completed in 1801. In the same year he painted a splendid pair of royal portraits intended to be given to Napoleon in exchange for David's *Napoleon Crossing the Alps* (fig. 1.15), and he portrayed Godoy, now married to the condesa de Chinchón, as the all-powerful generalissimo (fig. 5.9).[26] Yet Goya was to receive only one other royal commission in his lifetime, for part of a decorative scheme in the palace.[27] His influential friends and enlightened patrons had fallen from power, and he was effectively sidelined. In 1803, perhaps to secure his position, Goya negotiated the "gift" of the copperplates and 240 unsold

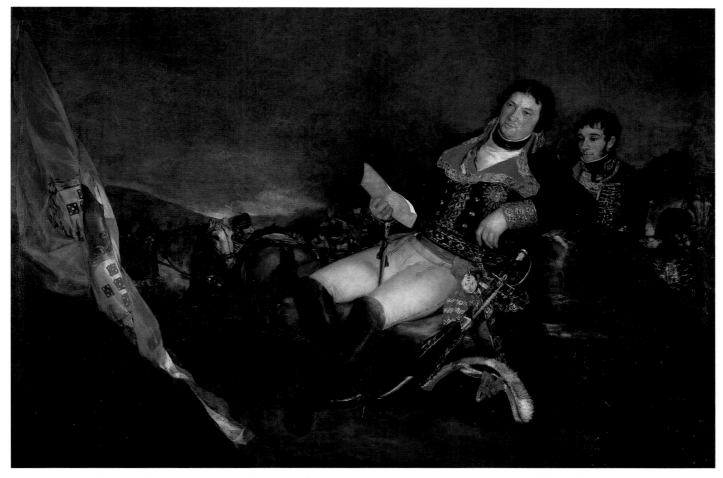

Fig. 5.9 Francisco de Goya y Lucientes, *Manuel Godoy*, 1801. Oil on canvas, 70⅞ x 105⅛ in. (180 x 267 cm). Museo de la Real Academia de Bellas Artes de San Fernando, Madrid

copies of the *Caprichos* to the king in exchange for a travel allowance that would enable his son Xavier to study art abroad. In his offer, Goya made the astonishingly inflated claim that "the plates will yield five or six thousand books of prints"; remarking that "foreigners are most anxious to acquire them," he stated that he did not want the plates to fall into their hands after his death.[28]

Napoleon Bonaparte started to plan his move into Spain in 1807, and in 1808 matters came to a head. As French troops began to occupy the northern areas of the country, Ferdinand, the son of Charles IV and heir to the throne, attempted to negotiate with Napoleon. Rumors spread, and a mob ransacked Godoy's residence at Aranjuez. In response to a threat on Godoy's life, Charles abdicated in mid-March; Ferdinand entered Madrid in triumph on March 24, a day after Napoleon's general Joachim Murat had occupied the city. Five days later, the Real Academia commissioned Goya to paint an equestrian portrait of the new king, Ferdinand VII. The canvas was completed but not yet dry on October 2, just before Goya left for Saragossa. The intervening months had been trying for *madrileños*. In rapid succession, Napoleon coaxed Charles and his wife, María Luisa, to Bayonne; Ferdinand, persuaded to follow them, was imprisoned by the French at Valençay; and Charles and his wife retired to Rome. On June 6 an imperial decree installed Napoleon's brother Joseph Bonaparte on the Spanish throne. By then, French troop movements in Madrid on May 2 and reprisals and executions on the following day had triggered the popular

(Paris, 1859), p. 306, cited in Glendinning 1977, p. 63.

25. "desde los embaxadores hasta los artistas y viageros que ultimamente llegaban á Madrid, no había uno que no procurase conocer al autor, y hacerse con un exemplar de esta obra"; "El vulgo de los curiosos ha estado creyendo que solo representaban rarezas su autor"; "Su delicadeza es tal, que los sugetos de mas agudo entendimiento no suelen comprender la primera vez todo el sentido moral de algunas de ellas." E. Harris 1964a; Glendinning 1977, p. 60.

26. For Goya's royal portraits (Gassier and Wilson 1971, nos. 781, 782), see Madrid 1996c, pp. 102–3, nos. 38, 39. For Godoy, see Véronique Gerard-Powell, "El retrato de Godoy, generalísimo de las Fuerzas Armadas," in Artola et al. 2002, pp. 227–37; Rose-de Viejo et al. 2001, pp. 154–56.

27. Gassier and Wilson 1971, no. 1568; Indianapolis–New York 1996–97, no. 20: *Saint Isabella of Portugal Attending the Sick*.

28. "Pueden tirar las laminas cinco a seis mil libros"; "Los estrangeros son los que

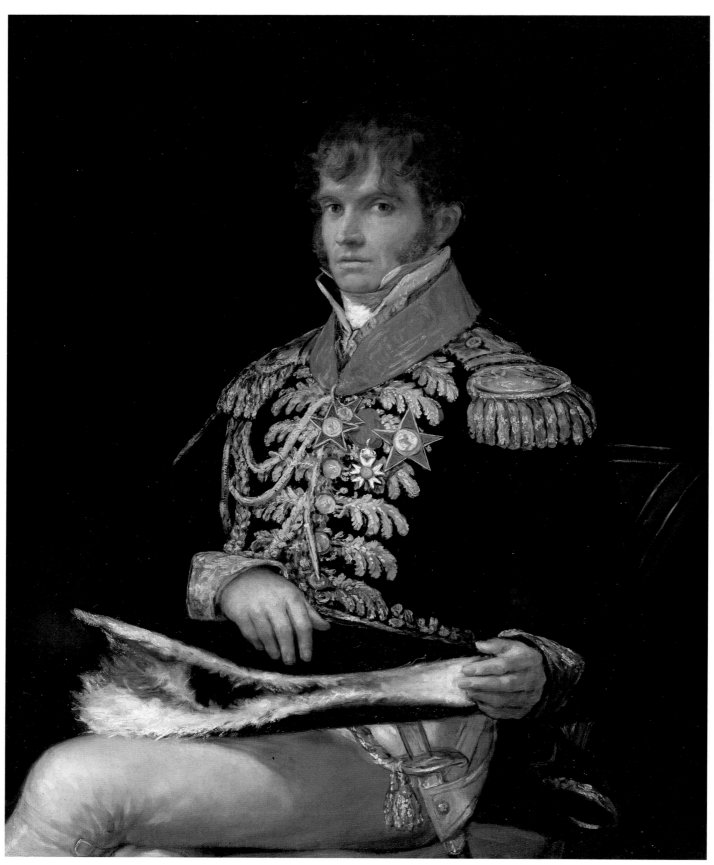

Fig. 5.10 (cat. 9) Francisco de Goya y Lucientes, *General Nicolas Guye*, March–September 1810. Oil on canvas, 41¼ x 33⅜ in. (106 x 84.7 cm). Virginia Museum of Fine Arts, Richmond, Gift of John Lee Pratt

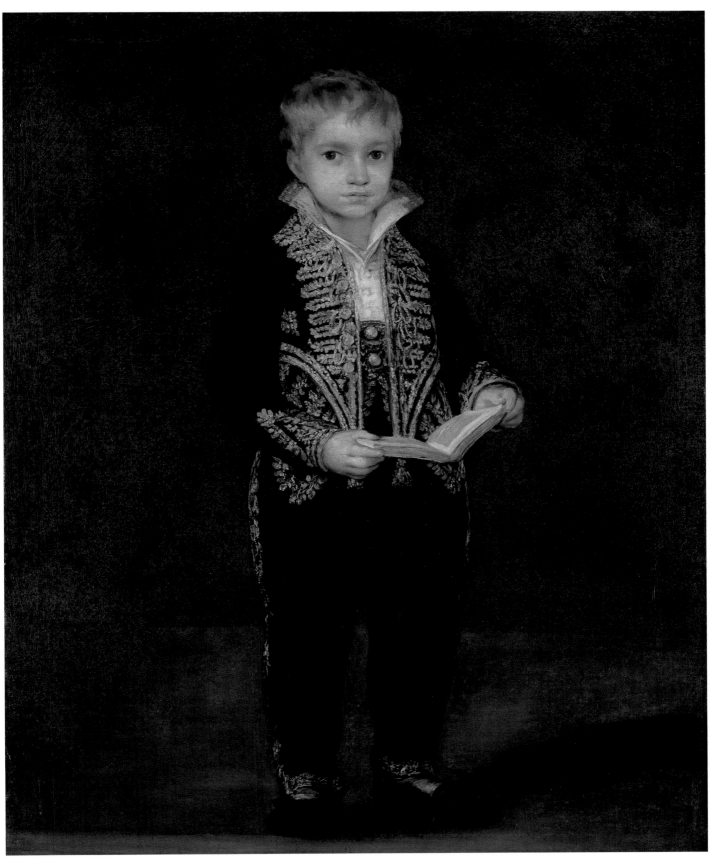

Fig. 5.11 (cat. 10) Francisco de Goya y Lucientes, *Victor Guye*, 1810? Oil on canvas, 40¾ x 33¼ in. (103.5 x 84.5 cm). National Gallery of Art, Washington, D.C., Gift of William Nelson Cromwell

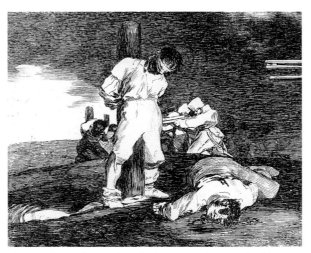

Fig. 5.12 (cat. 34) Francisco de Goya y Lucientes, *The Disasters of War, No. 15: Y no hai remedio (And It Can't Be Helped)*, ca. 1810–11. Working proof; etching, drypoint, and burin, 5⅝ x 6⅝ in. (14.2 x 16.8 cm). The Metropolitan Museum of Art, New York, Harris Brisbane Dick Fund, 1932 (32.62.17)

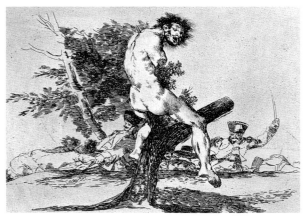

Fig. 5.13 (cat. 35) Francisco de Goya y Lucientes, *The Disasters of War, No. 37: Esto es peor (This Is Worse)*, ca. 1812–14. Etching, lavis, drypoint, and burin, 6⅛ x 8⅛ in. (15.7 x 20.8 cm). The Metropolitan Museum of Art, New York, Purchase, Rogers Fund and Jacob H. Schiff Bequest, 1922 (22.60.25 [37])

Fig. 5.14 (cat. 37) Francisco de Goya y Lucientes, *The Disasters of War, No. 47: Así sucedió (This Is How It Happened)*, ca. 1812–14. Etching, drypoint, burin, and lavis, 6⅛ x 8⅛ in. (15.6 x 20.9 cm). The Metropolitan Museum of Art, New York, Purchase, Rogers Fund and Jacob H. Schiff Bequest, 1922 (22.60.25 [47])

uprising that became the brutal war of independence, which was not concluded until June 1813.

Goya's visit to Saragossa in October 1808 was at the invitation of the Aragonese general José Palafox y Melci, who wanted the artist to record the damage the French had caused during a siege that English forces eventually lifted. No works have survived from that visit, but the journey through war-torn Spain left its mark on Goya's later work. He was back in Madrid by May 1809. An *Allegory of Madrid* (Museo Municipal, Madrid) that he painted for the town council underlines the changing fortunes of war: the original profile image of the new French monarch was replaced by the word CONSTITUCIÓN when Joseph left Madrid in July 1812, restored when he returned in December, and covered again by the word CONSTITUCIÓN in 1813, and finally by a portrait of Ferdinand VII, when he returned to Madrid in March 1814.[29]

Goya was forced during these years to reconcile his sympathy for French Enlightenment ideals and their supporters in Spain with the urgent demands of Spanish patriotism. On the one hand, he painted portraits of a leading French general and his young nephew (figs. 5.10, 5.11) and of several *afrancesados* (Spaniards who actively collaborated with the French regime), many of whom were his friends. On the other, in 1810 he signed and dated the first etchings of a series that he was to call *Fatales consequencias de la sangrienta guerra en España con Buonaparte. Y otros caprichos enfaticos* (Fatal consequences of the bloody war in Spain with Bonaparte. And other allegorical *caprichos*), now known as *The Disasters of War* (figs. 5.12–5.14, 9.73, 9.74). To scenes of war and of the famine that ravaged Madrid in 1811–12, Goya added a series of enigmatic allegorical *caprichos*. He was never able to publish these prints, but he pulled a great number of proofs, from which two complete sets were made, one with a handwritten page bearing Goya's title.[30] After English forces under Wellington expelled the French from Spain in 1813, the artist received a grant from the regency to commemorate the historic events in the paintings *The Second of May 1808* and *The Third of May 1808* (figs. 1.17, 1.18), but the repressive regime that followed ensured that these two masterpieces were not exhibited in Goya's lifetime.

Upon Ferdinand VII's restoration, Goya was subjected with other palace officials to a purge. He escaped from it unscathed, thanks to support from friends who testified that he had never collaborated with the enemy. A year later, the Inquisition looked into Goya's role as the author of two "obscene paintings"—the *Clothed Maja* (fig. 14.21) and the *Naked Maja* (fig. 14.22)—found among Godoy's sequestered property. No action was taken, but the artist's position remained insecure. In 1816 the set of thirty-three prints on the subject

Fig. 5.15 (cat. 40) Francisco de Goya y Lucientes, *La Tauromaquia*, *No. 28: El esforzado Rendon picando un toro . . . (The Forceful Rendon Stabs the Bull with the Pica . . .)*, 1815–16. Etching, burnished aquatint, and burin, 10 x 14 in. (25.5 x 35.6 cm). The Metropolitan Museum of Art, New York, Rogers Fund, 1921 (21.19.28)

Fig. 5.16 (cat. 41) Francisco de Goya y Lucientes, *La Tauromaquia, No. 33: La desgraciada muerte de Pepe Illo en la plaza de Madrid (The Unfortunate Death of Pepe Illo in the Bullring at Madrid)*, 1815–16. Etching, aquatint, drypoint, and burin, 9¾ x 14 in. (24.9 x 35.5 cm). The Metropolitan Museum of Art, New York, Rogers Fund, 1921 (21.19.33)

of bullfighting known as *La Tauromaquia* (figs. 5.15, 5.16) was published, and Goya embarked on a strange new series of large *caprichos* that he titled *Disparates (Follies)*. These prints developed from the "allegorical *caprichos*" that Goya added to *The Disasters of War* (see, for example, number 72 of *The Disasters*). The series remained incomplete and, like *The Disasters of War*, unpublished. During the difficult years of absolute, unconstitutional rule in Spain, Goya continued to paint portraits and the occasional religious commission, but he turned more and more to his albums of drawings. He was also busy with printmaking, no doubt in the hope of being able to publish his critique—albeit cloaked in allegory—of the regime; in 1819 he tried his hand at the new technique of lithography.[31]

Goya's virtual exclusion from active service for the court after 1800 thus left him free to pursue his personal artistic interests. An inventory drawn up in 1812 after the death of his wife includes paintings and drawings from this period that are among his most important original works.[32] These include a series of still-life paintings that probably decorated a dining room (fig. 14.73), such impressive large canvases as the *Majas on a Balcony* (1808–12, private collection) and the *Old Women* listed in the inventory, under the title *El Tiempo*, as an allegory of Time (fig. 1.33), and a smaller scene from the picaresque novel *El Lazarillo de Tormes*. These and other works identified in the inventory were probably made to decorate the artist's home, although Goya may not have been able to resist selling one or more of them (see page 155).

In February 1819 Goya decided to leave his home and studio in the city and purchased a quinta (country property)

Fig. 5.17 Francisco de Goya y Lucientes, *Saturn*, ca. 1820–23. Oil on canvas, 56½ x 32 in. (143.5 x 81.4 cm). Museo Nacional del Prado, Madrid

más las desean y por temor de que recaigan en sus manos despues de mi muerte quiero regalarselas al Rey mi Señor para su Calcografía." Letter to Cayetano Soler, July 7, 1803, in Goya 1981, p. 360, no. 223, p. 477, no. CVIII.

29. Today, the cartouche bears the simple inscription *DOS/DE/MAYO* (SECOND/OF/MAY). Tomlinson 1994, pp. 179–80, repr. For the later changes, see also Gassier and Wilson 1971, p. 261.

30. Céan Bermúdez owned the most complete set (British Museum, London). See Wilson-Bareau 1981, pp. 43–50.

31. See Madrid 1990a, pp. 53–63.

32. Sánchez Cantón 1946, pp. 84–89, 105–6; Salas 1964b; Gassier and Wilson 1971, p. 381, Appendix I.

33. Yriarte 1867, pp. 91–96, 140–41; Gassier and Wilson 1971, pp. 384–85, Appendix VI; Glendinning 1986. For a full list of references, see Moreno de las Heras 1997, p. 303, no. 108.

34. See Madrid–London–Chicago 1993–94, pp. 189–221, 272–91, 314–21.

35. Goya mentions Cardano in letters to his friend Joaquín María Ferrer. See Florisoone 1966, pp. 327–32; Sayre 1966, pp. 113–14, letters II, III; Goya 1981, pp. 389–90, nos. 272, 273; Madrid 1990a, pp. 47–54, 60.

36. "la difficulté qu'il a à parler et à entendre le français le retient souvent chez lui, d'où il ne sort que pour visiter les monuments et se promener dans les lieux publiques." Núñez de Arenas 1950, pp. 234–35; Sayre 1971, pp. 12–13,

on the outskirts of Madrid. His son Xavier had become the legal owner of all his father's pictures when the family property was inventoried and divided in 1812. (Some of these pictures are marked with an *X* and an inventory number.) Perhaps as a replacement for the large canvases among these, which Goya had probably left in Madrid, the artist covered the walls of his new home with the extraordinary murals that have come to be known as the *Pinturas negras* (Black Paintings) (fig. 5.17).[33] In them, Goya refashioned on a monumental scale the darkest images from all his previous works, ranging from those of the 1790s (the small *caprichos* painted after his illness, the witchcraft pictures painted in 1797–98 for the Osuna family, the *Caprichos* prints) to the compelling images of violence and brutality (fig. 2.38) and of religious fanaticism and madness that appear in several small paintings (Real Academia de San Fernando, Madrid) and in his later allegorical etchings.[34] Few people probably visited the quinta during Goya's lifetime or in the years after his death, but the Black Paintings survived on its walls, adding to the artist's legend. They were detached in the 1870s and were shown in Paris in 1878 at the Exposition Universelle, where they astonished those who saw them.

GOYA IN BORDEAUX—DELACROIX IN PARIS

A brief liberal interlude, starting in early 1820, during which Ferdinand VII was forced to accept the Constitution of Cadiz, was cut short in April 1823 when the French military unit known as the One Hundred Thousand Sons of Saint Louis (Cent Mil Fils de Saint Louis) entered Spain to restore the king to absolute power. A period of extreme repression followed, during which Goya went into hiding. When an amnesty was declared, he sought and obtained permission to travel to France for his health. He went first to Bordeaux, where many of his exiled friends were living, and from there directly to Paris, where he arrived in late June 1824. His two-month stay in the capital may have been motivated by a desire to investigate the latest developments in printmaking, since José Cardano, the lithographer with whom he had worked in Madrid, was now active there.[35] In Paris, where all foreigners were subject to surveillance, a police report into Goya's activities indicates that "because of his difficulties in speaking and understanding French, he often stays at home, going out only to see the sights and take a walk in public places."[36] He may well have visited the Salon, where Constable's *The Haywain* and Delacroix's *The Massacres at Chios* were attracting the attention of connoisseurs. The only tangible traces of Goya's stay in Paris are the portraits of his friend Joaquín María Ferrer and Ferrer's wife (private collection) and a *Corrida* believed to have been painted for them there (fig. 5.18).[37]

Goya returned to Bordeaux in September. During his first winter there, he executed a series of miniatures on ivory in a highly original painterly technique, which he likened to that of Velázquez (figs. 5.19, 5.20).[38] Far

Fig. 5.18 (cat. 12) Francisco de Goya y Lucientes, *Bullfight: Suerte de vara*, 1824. Oil on canvas, 19⅝ x 24 in. (50 x 61 cm). The J. Paul Getty Museum, Los Angeles

Fig. 5.19 Francisco de Goya y Lucientes, *Nude Reclining against Rocks*, 1824–25. Carbon black and watercolor on ivory, 3⁷⁄₁₆ x 3⅜ in. (8.7 x 8.6 cm). Museum of Fine Arts, Boston, Ernest Wadsworth Longfellow Fund

Fig. 5.20 Francisco de Goya y Lucientes, *Woman with Clothes Blowing in the Wind*, 1824–25. Carbon black and watercolor on ivory, 3⁹⁄₁₆ x 3¾ in. (9 x 9.5 cm). Museum of Fine Arts, Boston, Bequest of Pamela Askew

more important to him were the ambitious lithographic projects he pursued with the help of the master lithographer Gaulon (fig. 5.21). Although his failing eyesight obliged him to work with a magnifying glass, Goya handled the technique with astonishing freedom and boldness.[39] Late in 1825 Gaulon printed one hundred sets of four large lithographs known as *The Bulls of Bordeaux* (figs. 5.22–5.25). Preoccupied with the idea of selling his prints in Paris, Goya sent a set of the *Bulls* to Ferrer, who seems to have judged them too unconventional to find a ready market and advised the artist instead to print a new edition of the *Caprichos*. Goya declined, saying that he had ceded the plates to the king, that they had already caused him problems with the Inquisition, and that in any case he had new and better ideas. Continued French interest in the *Caprichos* is suggested by Charles Motte's publication in January 1825 of *Caricatures espagnoles*, a set of ten lithographic copies from that series presented in an illustrated wrapper (fig. 5.27). Goya's name evidently meant nothing to the Parisian public, and he had even suggested to Ferrer in 1824 that his lithographs could be sold without giving his name.[40] That name appears nowhere in Motte's publication, and its meticulous, unsigned lithographs, which reverse Goya's images, are now thought to be by Achille Devéria.[41]

Fig. 5.21 Francisco de Goya y Lucientes, *Portrait of Gaulon*, 1824–25. Lithograph, 10⅝ x 8¼ in. (27 x 21 cm). Davison Art Center, Wesleyan University, Middleton, Conn.

Even while Goya was still in Spain, one of his most ardent French admirers had been studying his prints in Paris. Eugène Delacroix was copying figures from the *Caprichos* as early as 1818 or 1819 (figs. 5.26, 5.28), possibly from an album brought from Madrid by Ferdinand Guillemardet. (Guillemardet had witnessed Delacroix's birth certificate, and his sons were close friends of the artist.)[42] By the time of Goya's visit to Paris in 1824, Delacroix had already attempted an etched and aquatinted version of plate 3 of the *Caprichos* (figs. 5.29–5.31), one of the most powerful prints in the series, and he had created the superbly Goyaesque image of a blacksmith (fig. 5.32). A radical Republican, the young Delacroix had a talent for satire and caricature. Several of his violently antimonarchist lithographs were published in journals or as individual prints between 1819 and 1822.[43] The two artists probably never met, but Delacroix was no doubt as intrigued

28 n. 20; Goya 1981, pp. 497–98, nos. CXLVIII, CL.

37. For the portraits, see Bordeaux 1998, p. 84, figs. 2, 3, p. 191, nos. 1, 2. The *Corrida* is stylistically very close to the lithographs known as *The Bulls of Bordeaux* (figs. 5.22–5.25); see Madrid–London–Chicago 1993–94, pp. 330–39, 374–75, nos. 112, 115–18; Álvaro Martínez Novillo, "Les *Taureaux de Bordeaux*," in Bordeaux 1998, pp. 117–34.

Fig. 5.22 (cat. 42) Francisco de Goya y Lucientes, *The Bulls of Bordeaux: El famoso Americano, Mariano Ceballos (The Celebrated American, Mariano Ceballos)*, 1825. Crayon lithograph with scraping, 12¼ x 16 in. (31.2 x 40.5 cm) image. The Metropolitan Museum of Art, New York, Bequest of Mrs. Louis H. Porter, 1946 (46.103)

Fig. 5.23 (cat. 43) Francisco de Goya y Lucientes, *The Bulls of Bordeaux: Bravo toro (A Picador Caught on the Bull's Horns)*, 1825. Crayon lithograph with scraping, 12¼ x 16¼ in. (31.2 x 41.2 cm) image. The Metropolitan Museum of Art, New York, Rogers Fund, 1920 (20.60.2)

Fig. 5.24 (cat. 44) Francisco de Goya y Lucientes, *The Bulls of Bordeaux: Dibersión de España (Spanish Entertainment)*, 1825. Crayon lithograph with scraping, 11⅞ x 16⅜ in. (30.2 x 41.5 cm) image. The Metropolitan Museum of Art, New York, Rogers Fund, 1920 (20.60.3)

Fig. 5.25 (cat. 45) Francisco de Goya y Lucientes, *The Bulls of Bordeaux: Plaza partida (The Divided Ring)*, 1825. Crayon lithograph with scraping, 12 x 16⅜ in. (30.6 x 41.6 cm) image. The Metropolitan Museum of Art, New York, Rogers Fund, 1920 (20.60.4)

Fig. 5.26 (cat. 29) Francisco de Goya y Lucientes, *Los Caprichos, No. 39: Asta su abuelo (As Far Back as His Grandfather)*, 1799. Etching and aquatint, 8⅝ x 6 in. (21.8 x 15.4 cm). The Metropolitan Museum of Art, New York, Gift of M. Knoedler & Co., 1918 (18.64.39)

Fig. 5.27 Charles Motte, publisher, Cover of *Caricatures Espagnoles: Ni plus ni moins [Los Caprichos, No. 41]*, 1825. Lithograph. Bibliothèque Nationale de France, Département des Estampes, Paris

Fig. 5.28 (cat. 116) Eugène Delacroix, *After Goya, Studies of "Los Caprichos," No. 39 [Asta su abuelo, No. 39]*, ca. 1824. Pen and brown ink, 7⅞ x 6 in. (20 x 15.3 cm). Musée du Louvre, Département des Arts Graphiques, Paris

by Goya's themes as he was impressed by Goya's extraordinary ability to capture movement and expression in his figures.

Through his close study of Goya's etchings in numerous sheets of drawings, Delacroix evolved an expressive language that enabled him to blend gritty realism with sinuous energy and a strong sense of the exotic. Laurent Matheron, a writer and art critic in Bordeaux who dedicated his biography of Goya to Delacroix, states that the French

Fig. 5.29 (cat. 26) Francisco de Goya y Lucientes, *Los Caprichos, No. 3: Que viene el Coco (Here Comes the Bogeyman)*, 1799, first edition. Etching and burnished aquatint, 8⅝ x 6 in. (21.9 x 15.4 cm). The Metropolitan Museum of Art, New York, Gift of M. Knoedler & Co., 1918 (18.64.3)

Fig. 5.30 (cat. 113) Eugène Delacroix, *After Goya, Studies of "Los Caprichos," Nos. 3, 5 [Que viene el Coco, No. 3, and Tal para qual, No. 5]*, ca. 1824. Pen and brown ink, 7 x 4¼ in. (17.7 x 10.7 cm). Musée du Louvre, Département des Arts Graphiques, Paris

Fig. 5.31 (cat. 119) Eugène Delacroix, *Interior Scene*, 1820–24. Aquatint, retouched with pen and ink, 7½ x 5⅛ in. (18.9 x 13.1 cm). Bibliothèque Nationale de France, Département des Estampes, Paris

artist was given several of Goya's lithographs, including a portrait of Gaulon (fig. 5.21), in 1848.[44] Yet the virtuoso technique of Delacroix's first important series of lithographs—illustrations for a French translation of Goethe's *Faust* (fig. 6.11), published by Motte in 1828—suggests that he was already well acquainted by that time with Goya's lithographic prints (the "gothic" imagery of the Faust series clearly shows the influence of the *Caprichos*). Delacroix's journal entries for March and April 1824 include references to Goya's prints, lithographs, and caricatures, as well as his own ideas for figures from contemporary life inspired by Michelangelo, Velázquez, and Goya.[45]

THE DIFFUSION OF GOYA'S WORKS IN SPAIN AND ABROAD

In 1808 the French museum director Baron Vivant Denon brought a copy of Goya's *Caprichos* from Spain to France; in 1828, following the sale of his print collection, it entered the Bibliothèque Royale, as the national library was then called.[46] Other copies were in Parisian collections by the 1830s, when motifs from the prints began to appear on the covers of books and sheet music.[47] In 1834 the *Sleep of Reason* (fig. 6.3) was cleverly parodied in a lithograph in *Le Charivari* titled *Un Cauchemar* (*A Nightmare*), which appeared opposite a text that mocked Louis-Philippe as "the most regular citizen in *his* kingdom!" (fig. 6.4).[48] That same year, Édouard Charton's influential *Magasin Pittoresque* published a lengthy article on Goya illustrated with crude but lively wood engravings by Grandville after three of the *Caprichos* prints. Two months later, a curious lithographic reproduction of a sketch for one of Goya's tapestry cartoons appeared in *L'Artiste*.[49] Public interest was increasing, and journals were vying with each other to obtain information from Spain about Goya's life and art.

At the time of Goya's death in April 1828, his easel paintings were widely distributed throughout Spain. They were owned not only by royal and aristocratic collections, but also by civil and religious institutions and individuals and families who had commissioned portraits, purchased "cabinet pictures," or received them as gifts from the artist. His works had also begun to become known and to make their way across Europe, in a pattern closely linked to diplomatic activity. Gustav de la Gardie, the Swedish envoy to Madrid, recounts a visit to Goya's studio—though in the artist's absence—in his diary entry for July 2, 1815.[50] Two celebrated paintings, the *Knife Grinder* and the *Water Carrier* (both 1808–12, Szépmüvészeti Múzeum, Budapest), were sold at auction in Vienna as early as 1820 by Prince Alois Wenzel Kaunitz, the former Austrian ambassador, who probably purchased them on a visit to Madrid in 1815–16.[51] (Goya's *Copies after Velázquez* had found their way to Kaunitz's father in Vienna in 1778 [see page 142].) Guillemardet took his portrait (fig. 5.1) and perhaps another picture (fig. 5.4) to Paris in 1800, while Baron Alquier, his successor as French ambassador in Madrid, acquired one of the many small pictures that Goya sold to the Osuna family.[52] The Russian consul in Cadiz sold Baron Taylor a portrait of Charles III.[53]

Fig. 5.32 (cat. 121) Eugène Delacroix, *A Blacksmith*, 1833. Aquatint, drypoint; second state, 6¼ x 3¾ in. (15.9 x 9.5 cm). The Metropolitan Museum of Art, New York, Purchase, Rogers Fund and Jacob H. Schiff Bequest, 1922 (22.60.13)

38. Sayre 1966, pp. 85, 113–14, letter III; Madrid–London–Chicago 1993–94, pp. 324–29, 372–74, nos. 99–111.

39. Matheron 1858, ch. 11, pp. [93–96]; Matheron 1996, pp. 262–68.

40. Sayre 1966, pp. 113–14, letter III; Goya 1981, p. 389, no. 273.

41. See Florisoone 1958, pp. 134, 136–37; Margret Stuffmann, "Delacroix' Druck-graphik," in Frankfurt 1987–88, p. 26, repr. (*Le Sommeil de la Raison produit des monstres*).

42. Florisoone 1958, p. 140.

43. Athanassoglou-Kallmyer 1991; Barthé-lémy Jobert, "Un graveur et ses thèmes," in Paris 1998, pp. 84–89, nos. 35–38.

44. Matheron 1858, ch. 11, pp. [96], [107], no. 11; Matheron 1996, p. 264. See Delacroix 1864, p. 98, "Eaux-fortes et Lithographies par divers Maîtres," nos. 827–30 (lithographs, including a *Portrait d'homme en buste* [Gaulon] and two *Scènes de tauromachie*). On Matheron, see Nigel Glendinning, "El libro de Laurent Matheron sobre Goya / Le libre de Laurent Matheron sur Goya," in Matheron 1996, pp. 39–119.

45. Delacroix 1980, pp. 57, 61, 62–64: April 7 and 11, 1824.

Fig. 5.33 (cat. 16) Style of Francisco de Goya y Lucientes (Eugenio Lucas Velázquez?), *City on a Rock*, 19th century. Oil on canvas, 33 x 41 in. (83.8 x 104.1 cm). The Metropolitan Museum of Art, New York, H. O. Havemeyer Collection, Bequest of Mrs. H. O. Havemeyer, 1929 (29.100.12)

Fig. 5.34 (cat. 15) Style of Francisco de Goya y Lucientes (Eugenio Lucas Velázquez?), *Bullfight in a Divided Ring*, after 1828? Oil on canvas, 38¾ x 49¾ in. (98.4 x 126.4 cm). The Metropolitan Museum of Art, New York, Catharine Lorillard Wolfe Collection, Wolfe Fund, 1922 (22.181)

Fig. 5.35 (cat. 11) Francisco de Goya y Lucientes, *Young Women (The Letter)*, after 1812. Oil on canvas, 71¼ x 49¼ in. (181 x 125 cm). Musée des Beaux-Arts, Lille

Fig. 5.36 Francisco de Goya y Lucientes, *The Forge*, ca. 1813–18. Oil on canvas, 75¼ x 47⅛ in. (191 x 121 cm). The Frick Collection, New York

46. See Paris 1999–2000, no. 214: *Caricatures gravées à l'eau-forte et au lavis, petit in fol. basane* (see Lipschutz 1972, pp. 58, 321, Appendix C). Acquisition: "Février [1827] Masson S¹ Maurice / Vente Denon . . . 7108 Caricatures de Goya. Petit In f.° 80 Pl.," Bibliothèque Nationale de France, Paris, Département des Estampes, *Registre des acquisitions* (Rés. Ye-88-Pet. Fol.: 1803–1847, fols. 227 verso, 228).

47. Lipschutz 1972, p. 176.

48. "le plus honnête homme de SON royaume!" See ibid., pp. 75–76. Villa 1979, p. 368, no. 12.361, identifies the source of the print as pl. 146 of the *Série politique*, published in *Le Charivari* (February 6, 1834). The lithograph is signed *ME* or *EM*, and the unsigned text cites the *Journal de Judas* as the source of the description of Louis-Philippe (Bibliothèque Nationale, Département des Estampes, Tf 110-pet. fol., vol. 5, 1834, complete issue).

49. See Rose-de Viejo 1997. The lithograph is lettered: *L. Gintrac, d'après le tableau de Goya. Lith. de Frey.*

50. Bjurström 1962, pp. 77–81; see Glendinning 1977, p. 54, for English translation.

51. For the sale of the collection of Prince Alois Wenzel Kaunitz (1774–1848), on March 13, 1820, see the transcript of the *Catalogue des tableaux provenant d'une ancienne Galerie célèbre*, in which nos. 66 to 70 are works by or attributed to Goya, in Frimmel 1914, p. 341. See the discussion of the pictures and bibliographical references in Madrid–London–Chicago 1993–94, pp. 308–11, 370–71, nos. 92, 93.

52. See Madrid–London–Chicago 1993–94, pp. 164–65, 351, no. 21.

53. See Baticle and Marinas 1981, p. 273, Appendix no. 26. After being acquired by the Durlacher firm at the Louis-Philippe sale (see n. 62), the portrait passed into the collection of Lord Dalling and Bulwer. At the sale of his estate at Christie's, February 21, 1873, lot 62, it was again bought by Durlacher.

54. Wilson-Bareau 1996a.

55. For the 1835 inventory, see Águeda 1982; see also Madrid 1996b, pp. 234–35, repr., p. 408, no. 138.

56. Baticle and Marinas 1981, pp. 83–85, no. 103, in the *Notice de la Galerie espagnole*: "Manolas au balcon" (Gassier and Wilson 1971, no. 959); 1812 inventory, no. 24: "unas jóvenes al balcón" (with the *Maja and Celestina on a Balcony,* Gassier and Wilson 1971, no. 958).

57. For the so-called inventory of 1828, see Gassier and Wilson 1971, Appendix II, pp. 381–82; for the probable date of this list (after 1832, perhaps after 1854), see Wilson-Bareau 1996a, p. 166.

58. Gassier and Wilson 1971, no. 953; Wilson-Bareau 1996a, p. 169, fig. 13.

The pictures remaining in Goya's hands at his death devolved to his son, who had by then modernized the spelling of his name to Javier. Javier displayed indecent haste in divesting himself of these works and those that had come to him in the 1812 division of property. An exchange of correspondence with Vicente López, the court painter who acted as the Infante Don Sebastián Gabriel's adviser, provides revealing information about the works that Javier was offering. In addition to such firmly attributed masterpieces as the six *Maragato* panels (ca. 1806, Art Institute of Chicago), these included works that cannot now be identified or whose authenticity has been doubted, among them "six sketches of Bulls" and a "Mass."[54] An inventory of the infante's sequestrated property made in 1835 included a version of the *Majas on a Balcony* (fig. 1.32) derived from Goya's original painting, which still bears the 1812 inventory mark and number.[55] A year later, on August 30, 1836, Javier Goya signed a receipt for the sale of eight paintings to Baron Taylor for Louis-Philippe's projected Galerie Espagnole in the Louvre; among them was the original *Majas* from the 1812 inventory.[56]

When Goya's son offered paintings to the Infante Don Sebastián, he implied that he had inherited very few works. Yet the 1812 inventory lists some eighty paintings (of which an unknown but probably small number had been sold by 1828). A later list of uncertain date includes more than seventy works; some are family portraits, but many others either are not identifiable or are of doubtful authenticity (fig. 5.33).[57] A Mass, probably the same one offered to the Infante Don Sebastián, is on this list along with *Bullfight in a Divided Ring* (fig. 5.34), whose authenticity has been challenged but whose pendant (E. G. Bührle Collection, Zurich) still bears an 1812 inventory number.[58] In short, the status of many paintings that appear to have come from an unimpeachable source—the artist's heir—is

59. On January 10, 1863, Pedro de Madrazo, the brother of Federico, first court painter and director of the Museo del Prado, wrote to Théophile Thoré: "We have had in recent years two very accomplished forgers of paintings by Velázquez and Goya: Alenza and Lucas" ("Nous avons eu dans les dernières années deux fameux falsificateurs des tableaux de Velázquez et Goya: Alenza et Lucas"). Paris, Bibliothèque de l'Arsenal, Thoré Archive, cited by Gisèle Caumont, "Velázquez dans le miroir du XIXe siècle," in Castres 1999, p. 59. See Wilson-Bareau 1996b, pp. 100–101. For references to pastiches and to works attributed to Velázquez from the last quarter of the eighteenth century, see Glendinning et al. 1999.

60. "A voir au Musée Espagnol les deux grandes croûtes peintes comme des enseignes qui portent le nom de Goya, l'on ne se douterait guère que c'est réellement un artiste de premier ordre." Gautier 1838a, p. 1.

61. The Old Women was originally the same size as the two Majas on a Balcony (Gassier and Wilson 1971, nos. 958, 959), but it was later enlarged with added strips of canvas; see Lille–Philadelphia 1998–99, pp. 236–41, no. 52 (Lille ed.).

62. Of the eleven paintings attributed to Goya in the Catalogue of the Pictures Forming the Celebrated Spanish Gallery of His Majesty the Late King Louis Philippe, sold at Christie's in May 1853 (the attribution of a twelfth, no. 512 in the Supplementary Catalogue, was disavowed at the time of the sale), five were acquired by the Durlacher firm. All five reappeared in the sale of the estate of Lord Dalling and Bulwer, Christie's, February 21, 1873, Catalogue of the Valuable Collection of Ancient and Modern Pictures of the Rt. Hon. Lord Dalling and Bulwer, deceased; and a few pictures from different private collections: lots 28 (An Interment), 51 (Portrait of the artist), 62 (Portrait of Charles III), 63 (Youth—a caprichios [sic]), 64 (Age—the companion). All are recorded in the catalogue as "From the Collection of King Louis Philippe."

63. Salas 1931, pp. 175–78. On Carderera's activity in the art market, see MacCartney 1999, pp. 303–9.

now being debated, which means that that source may itself be tainted. The alternatives are limited. Either Goya accepted (and it would have been standard practice, at least before 1800) that a trusted assistant would make replicas and versions of his original pictures or paint "school of Goya" originals, perhaps to a design by the master or with finishing touches added by him. Or Javier, who had received a travel allowance from the court so that he could study as a painter and who described himself on his marriage certificate as *pintor,* actively promoted or passively allowed the making of works purported to be by his father. The difficulty of distinguishing between autograph works by Goya and studio or school pictures was soon complicated by the emergence of fakes and pastiches, which by the middle of the nineteenth century were acknowledged to pose a problem.[59] Moreover, recognition of Goya's paintings, of which very few indisputably authentic works were available at the time, was hindered by an overreliance on his prints. Théophile Gautier, for instance, maintained a virtually unchanging and endlessly recycled view of Goya that was based almost exclusively on the *Caprichos.* Unable to verify the stories that circulated about Goya's unorthodox painting methods, Gautier tended to accept and exaggerate them—and then quickly return to the prints.

The Galerie Espagnole opened in the Louvre on January 7, 1838. Gautier's article "Les Caprices de Goya," which *La Presse* published six months later, begins with a flourish: "Seeing in the Spanish Museum two horrible great pictures daubed like trade signs and ascribed to Goya, one would never guess that he is in fact a first-rate artist."[60] It would be good to know which pictures Gautier had in mind. Of the eight paintings ascribed to Goya and exhibited in the Galerie Espagnole, the only one that deals directly with a trade and might have evoked the idea of a painted sign—given, too, its forceful, even brutal technique—is the picture that was catalogued as *Forgerons* (*Blacksmiths,* now known as *The Forge* [fig. 5.36]), whose pendant, *Femmes de Madrid en costume de Majas* (*Women of Madrid Dressed as Majas*) is today called *Young Women (The Letter)* (fig. 5.35). Neither of these large canvases appeared in the inventory of 1812, whereas the splendid *Manolas au balcon* (*Femmes de Madrid,* now known as *Majas on a Balcony*) was included in the inventory and still bears the mark *X.24.* Furthermore, it has been established that the true pendant of these sparkling young majas was a picture listed among Baron Taylor's acquisitions with the stark title *Vieilles femmes* (*Old Women* [fig. 1.33]).[61] This striking and indisputably authentic canvas was relegated to storage, perhaps because it contrasted too sharply with the religious pictures that filled the gallery or because it was perceived as an allegorical attack on monarchy. The Galerie Espagnole was closed when the July Monarchy collapsed in February 1848; its pictures were returned to Louis-Philippe and sold at Christie's in London in 1853.[62]

Goya's most active aficionado, who had even hoped to become a pupil of the master, was Valentín Carderera y Solano, an artist, art historian, and collector. He kept notes in the 1830s on the whereabouts of Goya's paintings, many of which are now unidentified or unlocated.[63] Carderera was a friend and colleague of Federico de Madrazo y Küntz, who succeeded his father, José de Madrazo, as first court painter and director of the Real Museo del Prado. In his early articles on Goya, published in 1835 and 1838, Carderera built on the biographical note supplied by Javier Goya to the Academia de San Fernando in 1831. Carderera's informative accounts and Javier's text, together with Goya's brief autobiographical note for the 1828 catalogue of the Prado, provided the basic information for the books and

articles subsequently published in France. In October 1846 fresh impetus was given to accounts of Spain and Spanish art when "everyone" (Baudelaire referred ironically to "la littérature française"),[64] led by Gautier and Alexandre Dumas père, and with a cohort of artist-illustrators, went to Madrid to cover the double wedding of the queen of Spain and her sister. William Stirling, the Scottish historian of Spanish art, visited Goya's son and noted many works seen at his home in 1849.[65] But it was only after the death of Javier in 1854 that Madrazo and Carderera began to acquire works from Goya's grandson Mariano. What followed on both sides of the Pyrenees is considered elsewhere in this volume (see the essay "Manet and Spain" in this publication).

64. Baudelaire in *Le Tintamarre* (November 1–6, 1846): see Baudelaire 1975–76, vol. 2, p. 1016.

65. Hugh Brigstocke, "El descubrimiento del arte español en Gran Bretaña" (with Stirling-Maxwell's diaries quoted verbatim in English), in Oviedo 1999–2000, pp. 5–25; Enriqueta Harris, "Velázquez and His Works, by William Stirling," in Stirling-Maxwell 1855 (1999 ed.), pp. 30, 34; London 2001, p. 24.

Fig. 6.1 Vicente López, *Francisco de Goya y Lucientes*, 1826. Oil on canvas, 36⅝ x 29½ in. (93 x 75 cm). Museo Nacional del Prado, Madrid

Goya and the French Romantics

Ilse Hempel Lipschutz

In France the writings of the major and minor *hommes de lettres* during the late 1820s and the early 1830s demonstrate a persistent awareness of the enchantment of Spain, its landscape, its people, its history, and, increasingly, its artists. In a period in which "painting and poetry were sisters," the genuine expression of the true spirit of Spain was sought—and found—in the paintings of its masters.[1]

One artist in particular personified the genius—good and evil—of this Spain: Francisco de Goya y Lucientes (fig. 6.1). The story of Goya's life would have suited the hero of one of Victor Hugo's dramas: a poor artisan's son, he reached the height of aristocratic distinction and was approached by kings, generals, and diplomats for the favor of a portrait; yet he died far from his beloved country and friends, as a political exile. Goya the man, as much as his work, represented many aspects of the *légende espagnole* envisioned by the French Romantics.

Toward the close of the eighteenth century, only one year before the French Revolution in 1789, the publication of *Nouveau voyage en Espagne, ou Tableau de l'état actuel de cette monarchie* (New voyage in Spain, or Description of the current state of this monarchy), by the former minister to Spain Jean-François de Bourgoing, contributed significantly to a broadening of French knowledge of Spain.[2] The important revised fourth edition of 1807 became a most useful manual, prized by members of the Napoleonic armies in Spain; not only could its reader follow the author on a *voyage pittoresque* acquainting him with Spain's geographic and social conditions but he could also, for the first time, gain information on the Spanish artistic nature.

In several instances Bourgoing analyzed the outstanding characteristics of a specific work and its painter. Alert to the cultural currents of his own day as well as to the masterpieces of the past, Bourgoing was one of the first Frenchmen to mention Goya. In the first edition of his *Nouveau voyage* (1788) he observed, "Don Francisco de Goya merits also by his talents an honorable mention, for portraying accurately & agreeably the manners, customs, and games of his country."[3] Here is the Goya of the early period: his luminous cartoons for tapestries and his graceful popular scenes. As Goya's talent evolved and he became a highly successful portrait painter, Bourgoing added a note in the third edition (1803), fifteen years later, that "he also excels in portraiture."[4]

Jean-Baptiste-Pierre Lebrun's influential *Recueil des gravures . . . en Espagne* (Selection of engravings . . . in Spain) appeared in 1809. Even more of an expert in matters of art than the diplomat Bourgoing, Lebrun was tremendously impressed by the Spanish masters. In speaking of Velázquez and his portraits at the court of Madrid, Lebrun also mentioned Goya's engravings thereof, providing one of the earliest French notices of the contemporary Goya. The

This essay is adapted from the author's previous publications (Lipschutz 1963–67, Lipschutz 1972, and Lipschutz 1988).

1. "la peinture et la poésie étaient soeurs." Gautier 1932, vol. 1, pp. 56–57.
2. Bourgoing 1788. A second edition, entitled *Tableau de l'Espagne moderne*, was published in 1797, a third in 1803, and a fourth in 1807.
3. "Don Francisco de Goya mérite aussi une mention honorable par son talent, pour rendre avec fidelité & agrément les moeurs, les costumes, les jeux de sa patrie." Bourgoing 1788, vol. 1, p. 248.
4. "Goya excelle aussi dans le portrait." Bourgoing 1788 (1803 ed.), vol. 1, p. 289.

5. Quilliet 1815–16. *Mercure de France* 69 (1817), pp. 69–72, contains a review of Quilliet's study.

6. *Le Magasin Encyclopédique* (1795–1816) became, from 1817 to 1818, *Les Annales Encyclopédiques*, then the *Revue Encyclopédique* from 1819 until cessation of publication in 1834.

7. *Revue Encyclopédique* 2 (1819), p. 544, in the section "Nouvelles scientifiques et littéraires."

8. Gintrac 1834, p. 236. Gintrac, a mediocre landscape painter from Bordeaux, had known Goya's tapestry cartoons in Madrid. See Guinard 1962, pp. 187, 203.

Fig. 6.2 Jean-Louis Gintrac after Goya, *Un Mariage burlesque*. Lithograph. Published in *L'Artiste*, 1834, ser. 1, vol. 8, following p. 236

Recueil brought to a close what might be considered the "period of preparation" for the French discovery of Spanish painting.

Also worth noting are those publications in which Goya's name did not appear. The eminent *Mercure de France* published lengthy articles on Spanish painters over a period of eight months from December 1815 to July 1816.[5] Condensed and revised, they were reissued in October 1816 as the first French dictionary of Spanish painters, Frédéric Quilliet's *Dictionnaire des peintres espagnols*. Although this small, handy, well-printed book was a modest study, it remained the standard French reference work on Spanish painting throughout the better part of the nineteenth century. Almost every conceivable Spanish artist was included, although Goya, like many other living artists, was not.

Following the example of the *Mercure de France*, most other papers, periodicals, and magazines began to mention various aspects of cultural life in Spain. The *Annales Encyclopédiques*[6] also helped to inform the French about many facets of Spanish art, although the majority of references to it were either incidental to other subject matter or included as brief items in the section "Nouvelles scientifiques et littéraires." By 1819 a reader of the *Revue Encyclopédique* would be acquainted, through a list of living Spanish painters, with the names of José M. Madrazo, Vicente López, and Lomas from Cadiz, but not Goya.[7]

In 1834 Théophile Thoré, who a year later published his "Études sur la peinture espagnole" in the *Revue de Paris,* pointed out the general French ignorance of the Spanish school and the need to bring information about it to the attention of the interested public. In the same year *L'Artiste* made a more constructive contribution toward this goal: a large, full-page lithograph, *Un Mariage burlesque* by Jean-Louis Gintrac (fig. 6.2), reproduced Goya's satire of the wedding cortege of a young woman married to a deformed, fat, and ugly old man. Unfortunately, the editor had no information about the artist, as yet unknown in France.[8]

Goya's fame in France reached its height with the opening of Louis-Philippe's Galerie Espagnole in 1838. This gathering of art, acquired by Baron Isidore-Justin-Séverin Taylor during an eighteen-month "scientific and archeological" mission in Spain, offered probably

the largest showing of Spanish paintings ever seen outside of Spain—412 works, reflecting all schools and all periods of Spanish art. More than eighty-five artists were represented: not only Spain's great painters, from the medieval "primitives" and the early masters to the contemporary Goya (with eight paintings), but also those little known in their own country or renowned in Spain but unheard of abroad.

Critics such as Benoist de Matougues and Baron Taylor looked to the Galerie Espagnole's canvases to understand the character and ideas of the Spanish, their history, and even their literary tradition. Taylor, for example, in his *Voyage pittoresque en Espagne, en Portugal et sur la côte d'Afrique* (1826–32), sought in Goya's work rather generalized national characteristics, even recognizing therein the moods of Spain's great literary tradition, recently discovered and fervently praised by the younger generation of the French Romantics. This "literarization" of a painter's works is striking: the work of art disappears almost completely under the literary reminiscences or overtones that the writer tries to see and feel in it. "No painter took the quality of individuality further than Goya. His manner and his genius are equally eccentric . . . here are the ways of Celestina, Lazarillo de Tormès, and Buscon the adventurer; here is Cervantes. And yet he lacks the famous Spanish novelist's Atticism, finesse, and grace. This is a sad, melancholy, and sometimes raging Cervantes; a Cervantes become skeptical, Voltairian." One might question the absence of "finesse et grace," for which Taylor reproaches Goya (he seems not to know or to disregard all of Goya's early works), but his comment on Goya's lack of "atticisme" is certainly valid. What painter in Goya's time is more alien to the purity of the Greek tradition than this "génie sombre et fantasque" (somber and fantastical genius)?[9]

The Goyesque vision of the world ignited the imagination of the most important French poets of the first years of Romanticism. In Gautier's preface to *Mademoiselle de Maupin*, written in 1834, we see the almost symbolic value that Goya held for young writers of the avant-garde. Gautier scorns the Neoclassical critics of his country for their inability to understand the Romantic movement and cites Goya as one of the painters rejected by their ignorance: "Neither grand features like Michelangelo's, nor curiosities worthy of Callot, nor effects of light and shade after the manner of Goya—nothing could find favor in their eyes."[10]

Though there was apparently little or no direct contact between Goya and the younger generation of the French Romantics while he lived in France (1824–28), his message had already reached them through the *Caprichos*. A volume of them had been brought to France in 1809 by Vivant Denon, curator of the print department at the Bibliothèque Nationale.[11] Another volume may have been in France as early as 1800, brought over by Ferdinand Guillemardet, France's ambassador to Spain (1798–99), whose portrait by Goya today hangs in the Louvre.[12] According to Michel Florisoone, it is possible that Goya gave Guillemardet one of the first examples of *Los Caprichos*, or that the ambassador himself bought one of the thirty-six volumes sold in two days in Madrid. We do know that Delacroix knew and used the *Caprichos*, certainly by 1824 and possibly earlier.[13] By 1825 a demand for the *Caprichos* had been established: in that year an album of ten plates, entitled *Caricatures espagnoles "ni plus ni moins" par Goya*, was published in Paris by Charles Motte. These "caricatures espagnoles" are inverted copies of ten of the *Caprichos* in a faithful but rather crude execution.[14] (This edition must have been made without Goya's knowledge because shortly afterward he refused to grant permission for a Parisian

9. "Aucun peintre n'a porté plus loin que Goya le caractère de l'individualité. Sa manière et son génie sont également excentriques . . . ce sont les moeurs de la Célestine, de Lazarille de Tormès et de l'aventurier Buscon; c'est Cervantès. Cependant, il n'a pas du célèbre romancier d'Espagne, l'atticisme, la finesse et la grâce. C'est Cervantès triste, mélancolique et quelque fois furieux; c'est Cervantès sceptique, devenu Voltairien." Taylor 1826–32, vol. 3, p. 115.

10. "Ni les grand traits à la Michel-ange, ni les curiosités dignes de Callot, ni les effets d'ombre et de clair à la façon de Goya, rien n'a pu trouver grâce devant eux." Gautier 1946, p. 23.

11. Adhémar 1948, p. xiii, and Paris 1935b, pp. xxii, 4.

12. Louvre 1981, p. 115.

13. Florisoone 1958.

14. *Caprichos* nos. 10, 14, 15, 18, 23, 32, 40, 43, 52, and 55.

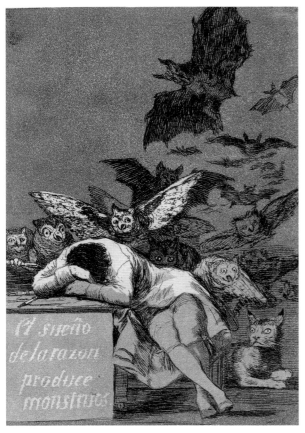

Fig. 6.3 (cat. 30) Francisco de Goya y Lucientes, *Los Caprichos, No. 43: El sueño de la razón produce monstruos (The Sleep of Reason Produces Monsters)*, 1799. First edition, etching and aquatint, 8½ x 6 in. (21.7 x 15.2 cm). The Metropolitan Museum of Art, New York, Gift of M. Knoedler & Co., 1918 (18.64.43)

Fig. 6.4 (cat. 91) Anonymous, *A Nightmare*, 1834. Etching, 12⅛ x 9⅝ in. (32 x 24.5 cm). Bibliothèque Nationale de France, Paris

15. Fontaney stayed in Madrid from January through August 1831 and then January 1833 through March 1834; he wrote travel accounts that appeared in the *Revue des Deux Mondes* between 1831 and 1834, which were subsequently published in book form. See Fontaney 1835.

16. "Jeudi, 8 septembre [1831]. . . . Soirée à l'Arsenal; Mélanie, Louise y sont. Je Leur montre le Goya, puis nous montons chez Marie; mercredi, 9 novembre [1831]. . . . félicitations . . . Barthélemy . . . un gros bonhomme qui dit en regardant Goya: 'Ça ne manque pas de verve.'" Fontaney 1925, pp. 31, 70–71. Barthélemy was from Marseille, a collaborator of the writer Méry and a member of the Bonapartiste and Liberal opposition.

17. See Ad. M. 1831. The author, "Ad. M.," was probably Adelaïde de Montgolfier, according to Núñez de Arenas 1950, pp. 266–67.

edition of the *Caprichos* on the grounds that he had given ownership of the original plates to the king of Spain, Charles IV.) On February 6, 1834, a biting political cartoon with the caption *Un Cauchemar* (*A Nightmare*; fig. 6.4) appeared in *Le Charivari*; it is a close transposition of *Caprichos* plate number 43, *El sueño de la razón produce monstruos (The Sleep of Reason Produces Monsters*; fig. 6.3).[14]

In 1830 a young writer, Antoine Fontaney, who had gone to Madrid as secretary to the ambassador to Spain, the duc François d'Harcourt, brought back a volume of Goya's *Caprichos*;[15] in his *Journal intime* he tells of later showing it to the habitués of Charles Nodier's gatherings at the Arsenal, although he neglects to mention anyone's reaction to it. "Thursday, September 8 [1831]. . . . Evening at the Arsenal; Melanie, Louise were there. I showed them the Goya, then we went up to see Marie." A few months later Fontaney records having brought it to the group gathered around the *femmes de lettres* Madame Belloc and Adelaïde de Montgolfier: "Wednesday. November 9 [1831] . . . congratulations . . . Barthélemy . . . a big, simple man who, looking at the Goya, said, 'It's not without vitality.'"[16]

Madame Belloc, one of the many women writers of the period, was of Irish origin, the former Louise Swanton. She translated numerous English works into French, alone or in collaboration with her friend the writer Adelaïde de Montgolfier (of the inventor's family). The latter had in fact already "discovered" Goya earlier the same year: she is in all probability the author of the penetrating pages on Goya in the review of Slidell's *Voyage en Espagne* published in the *Revue Encyclopédique*.[17] In it, endeavoring to describe the beauty

Fig. 6.5 (cat. 27) Francisco de Goya y Lucientes, *Los Caprichos, No. 7: Ni asi la distingue (Even Thus He Cannot Make Her Out)*, 1799. Etching, aquatint, and drypoint, 7⅞ x 5⅞ in. (20 x 15 cm). Bibliothèque Nationale de France, Département des Estampes, Paris

Fig. 6.6 (cat. 112) Eugène Delacroix, *After Goya, Studies of "Los Caprichos," no. 7*, ca. 1824. Pen and brown ink, graphite, 7 x 4¼ in. (17.7 x 10.7 cm). Musée du Louvre, Département des Arts Graphiques, Paris

Fig. 6.7 (cat. 32) Francisco de Goya y Lucientes, *Los Caprichos, No. 69: Sopla (Blow)*, 1799. Etching, aquatint, drypoint, and burin, 8⅜ x 6 in. (21.4 x 15.2 cm). The Metropolitan Museum of Art, New York, Gift of M. Knoedler & Co., 1918 (18.64.69)

Fig. 6.8 (cat. 117) Eugène Delacroix, *After Goya, Studies of "Los Caprichos," Nos. 26, 27, 29, 35, 69*, ca. 1824. Pen and brown ink on off-white laid paper, laid down, 8¼ x 7⅛ in. (22.1 x 18 cm). Fogg Art Museum, Harvard University Art Museums, Bequest of Frances L. Hofer

Fig. 6.9 (cat. 31) Francisco de Goya y Lucientes, *Los Caprichos, No. 66: Allá vá eso (There It Goes)*, 1799. First edition, etching, aquatint, and drypoint, 8¼ x 6⅝ in. (21 x 16.7 cm). The Metropolitan Museum of Art, New York, Gift of M. Knoedler & Co., 1918 (18.64.66)

Fig. 6.10 (cat. 114) Eugène Delacroix, *After Goya, Studies of "Los Caprichos," Nos. 11, 31, 33, 66*, ca. 1824–26. Pen and brown ink, 12½ x 8⅛ in. (31.8 x 20.7 cm). Musée du Louvre, Département des Arts Graphiques, Paris

Fig. 6.11 (cat. 120) Eugène Delacroix, *Mephistopheles Aloft, from "Faust"* *(Paris, 1828)*. Lithograph, second state, with lettering, 10¾ x 9½ in. (27.3 x 24 cm). The Metropolitan Museum of Art, New York, Rogers Fund, 1917 (17.12)

of the Spanish woman, the grace of the Madrileña, the vivacity and fire of the Sevillana, the writer at last refers readers to Goya as the only painter to give a "just idea" of his country, calling him a Spanish Rabelais, serious and alarming, armed with pencil and paintbrush, whose work is too little known. Describing at length several of the *Caprichos*, the author emphasized the anecdotal value of Goya's bitter criticism of Spain's social institutions.

Even Delacroix, however perceptive a painter, reacted in a similar manner to Goya's work, using it to interpret a vision of Spain (figs. 6.5–6.8). When he visited the southern Spanish port of Algeciras in 1832 he did not experience this Andalusian town and its inhabitants in a direct, personal reaction but interpreted them through the other artist's work: "All of Goya was palpitating around me."[18]

An anonymous article of 1834 published in the *Magasin Pittoresque* once again pointed out the *actualité* of the *Caprichos*. Perhaps the most explicit article on Goya to appear before Gautier's later studies, it was illustrated with several reproductions of plates from the *Caprichos*; yet even this well-informed author saw in Goya's disillusionment and monstrous hallucinations merely an excellent framework for an analysis of contemporary Spanish mores. "His caricatures, which he called his *Caprices*, are better known outside Spain than his paintings: although his hatred of prejudice and corruption, and his patriotism are only thinly disguised in them, they are not all easily intelligible to foreigners. Some good commentaries on Goya's satirical works would make an excellent framework for a description of modern Spanish customs."[19]

But the *Caprichos* go far beyond mere documentary information on Spain, or even a harshly satirical interpretation of its social and political ills. Aspects of the *Caprichos* that puzzled many of the conservative critics—and were ignored by most of them—echoed in the works of some of the foremost young Romantic writers and painters; although they may not have been as deeply perturbed or upset by Goya's hallucinatory visions, engendered by the "sleep of reason," as were later generations from Baudelaire to Malraux, their writings testify to the impact of Goya's images. These were indeed the years when the "Romantic agony" reached a new climax. Writers and artists found in horror-laden themes new sources of inspiration; not overly anguished by them, they seemed almost to delight in exploiting the visual and emotional impact to the utmost. Sir Walter Scott effectively analyzed this attraction to the horrible when he observed in Ann Radcliffe's gothic novels "the author's primary object, of moving the reader by ideas of impending danger, hidden guilt, supernatural visitings—by all that is wonderful."[20] Numerous were the examples, from printed page to painted canvas, from the Scottish north to the Mediterranean south, in which French Romantic poets found their *romantisme noir* already expressed.

Where are these themes more hauntingly translated into visual reality than in Goya's oeuvre? His fearsome specters and their terrible acts left a deep impression on many

Fig. 6.12 Louis Boulanger, Illustration for Victor Hugo's "La Ronde du Sabbat." Bibliothèque Nationale de France, Département des Estampes, Paris

18. "Tout Goya palpitait autour de moi." Delacroix 1936–38, vol. 5, p. 200.

19. "Ses caricatures, qu'il appelait ses *Caprices*, sont plus connues hors d'Espagne que ses tableaux: quoique sa haine des préjugés et des abus, et son patriotisme, n'y soient que légèrement voilés, elles ne sont pas toutes faciles à comprendre pour les étrangers. De bons commentaires sur les oeuvres satiriques de Goya seraient un excellent cadre pour décrire les moeurs espagnoles modernes." Anon. 1834c, p. 324. Three wood engravings show the essential motifs (in reverse) from three *Caprichos* plates: nos. 1, 39, and 51.

20. Sir Walter Scott, "Prefatory Memoir to the Novels of Mrs. Ann Radcliffe" (1824), quoted in H. Hugo 1957, p. 347.

21. It was Gautier's sensitive study of Goya and his *Caprichos* entitled "Les Caprices de Goya," appearing in the journal *La Presse* of July 5, 1838, that fully revealed this master to the French public and marked the beginning of a new period of French knowledge and interpretation of Goya. The article was published later

Romantic writers and artists. Delacroix's illustrations of *Faust* reflect this melding of certain visual images of Goya's *Caprichos* with verbal images of the poet (figs. 6.9–6.11): Goya's witches and obsessing demons from the world of nightmares are recaptured (as they had been in Delacroix's *Scène du Sabbat* of 1824).

Louis Boulanger, *le peintre-poète*, fused in his work the imagery of the Spanish painter Goya and the French poet Hugo. When he set out in 1828 to illustrate his friend's "La Ronde du Sabbat" (fig. 6.12), his recollection of the *Caprichos* was vivid: in the poem, as in Boulanger's engraving, certain Goyesque affinities are obvious. Hugo's poem, though more Goetheanly vast in concept than are Goya's individual case studies, brings to life some of the very same creatures of the *Caprichos'* haunted world.

The French poet Théophile Gautier openly avowed his indebtedness to Goya's imagery. The artist especially seems to have attracted Gautier's attention before his first journey to Spain in 1840.[21] During that trip, however,

Fig. 6.13 Francisco de Goya y Lucientes, *Los Caprichos, No. 64: Buen viage (Bon Voyage)*, 1799. First edition, etching, aquatint, drypoint, and burin, 8⅝ x 6 in. (21.8 x 15.3 cm). The Metropolitan Museum of Art, New York, Gift of M. Knoedler & Co., 1918 (18.64.64)

Fig. 6.14 Francisco de Goya y Lucientes, *Los Caprichos, No. 32: Por que fue sensible (Because She Was Susceptible)*, 1799. First edition, etching, aquatint, drypoint, and burin, 8⅝ x 6 in. (21.8 x 15.3 cm). The Metropolitan Museum of Art, New York, Gift of M. Knoedler & Co., 1918 (18.64.32)

Fig. 6.15 Charles Motte, publisher, *Caricatures Espagnoles, No. 6: Pour avoir été sensible!/Litho. de C Motte*, 1824. Lithograph. Bibliothèque Nationale de France, Département des Estampes, Paris

Gautier immersed himself in Spanish painting in all its depth and glory, and until his death in 1872 he remained one of its most fervent exponents in innumerable articles published in almost every French newspaper and periodical of his time.

During 1830 and 1831 French poets began to transpose Goya's pictures into their literary images, and the Spanish master's teeming and deformed specters found new haunts in Gautier's "Albertus, ou l'âme et le péché." In this poem, written in 1831 and published a year later, Gautier gives free rein to his exuberant imagination and his love of horror, well tempered by a satiric vein. He delightedly and in minute detail describes at great length all the repulsive trappings of a witch's den and ends by finding in the pages of the *Caprichos* its perfect visual counterpart: "The shadows at the foot of the bed were crawling with strange forms/Incubi, nightmares, specters, heavy and misshappen/A complete collection of Goya and Callot!"[22]

Gautier's linking of Goya and the seventeenth-century French printmaker Jacques Callot seems to be the first occurrence of what remained throughout the Romantic period a frequent coupling of names. These two artists were almost automatically placed in the same *famille d'esprits*, owing to their often common subject matter—the fantastic—and their common technique—the etching. Indeed, are Callot's *Caprices* not one of the definite sources of Goya's *Caprichos*?

Similar elaborations upon disquieting Goyesque visions are found in Victor Hugo's *Notre-Dame de Paris*, of the same year as Gautier's "Albertus." Does Quasimodo himself not appear to have stepped out of Goya's oeuvre? As a matter of fact, there seems to be a close pictorial pattern for the grotesquely deformed Quasimodo in the winged demon of *Caprichos* number 64, *Buen viage* (fig. 6.13), which was known to Hugo and even quoted by him in a poem dated May 1830—the very time at which he was working on the manuscript of the novel. Goya's demon, with his heavy cheekbones, receding jaws, bulbous, almost leprous nose, his mouth twisted into a screaming rictus, neckless and hunchbacked, foreshadows Quasimodo, the "living chimera, squatting, scowling," as he rings the bells of Notre-Dame, his "enormous head and a bundle of ill-adjusted limbs furiously swinging at the end of a rope."[23]

In the beggars' meeting place, the *cour des miracles,* Hugo presents as varied an assortment of repulsively ugly, grotesque human beings, swarming about in confusedly purposeful patterns, as any found in Goya's etchings. Moreover, Hugo's description of the recluse La Sachette, a dejected figure walled in forever in a narrow cell, huddled on the bare stone floor and wrapped in the large folds of a sack, is a literary transposition of Goya's portrayals of women prisoners abandoned to their lonely despair. In *Capricho* number 32, *Por que fue sensible* (figs. 6.14, 6.15), and, especially, in 34, *Las rinde el sueño* (fig. 6.16), a source for Hugo's description of his recluse is quite recognizable: "The cell was small, wider than deep, with coved ceiling, and seen from within resembled the hollow of a large episcopal miter. Upon the stone floor, in one angle, a female was seated, or rather crouched. Her chin rested upon her knees, while her arms and clasped hands encircled

with slight alterations as "Fran[co] Goya y Lucientes," in *Le Cabinet de l'Amateur et de l'Antiquaire* 1 (September 1842). Although it was not included in Gautier's first edition of his travel account to Spain, *Tra los montes* (Paris, 1843), he did include it in the second edition, entitled *Voyage en Espagne* (Paris, 1845). Another version of the article appeared as "Portrait d'artistes: Goya," *L'Artiste* 1 (June 22, 1845), pp. 113–16.

22. "Dans l'ombre, au pied du lit, grouillaient d'étranges formes/Incubes, cauchemars, spectres, lourds et difformes,/Un recueil de Goya et de Callot complet!" Gautier 1932, vol. 1, pp. 131, 180.

23. "chimère vivante, accroupie, renfrogné"; "tête énorme, et un paquet de membres désordonnés, se balançant avec fureur au bout d'une corde." V. Hugo 1904, p. 124.

24. "La cellule était étroite, plus large que profonde, voûtée en ogive, et vue à l'intérieur ressemblait assez à l'alvéole d'une grande mitre d'évêque. Sur la dalle nue qui en formait le sol, dans un angle, une femme était assise ou plutôt accroupie.

Fig. 6.16 Francisco de Goya y Lucientes, *Los Caprichos, No. 34: Las rinde el sueño (Sleep Overcomes Them)*, 1799. First edition, etching, aquatint, drypoint, and burin, 8⅝ x 6 in. (21.8 x 15.3 cm). The Metropolitan Museum of Art, New York, Gift of M. Knoedler & Co., 1918 (18.64.34)

Fig. 6.17 Francisco de Goya y Lucientes, *Los Caprichos, No. 17: Bien tirada está (It Is Well Pulled Up)*, 1799. First edition, etching, aquatint, drypoint, and burin, 8⅝ x 6 in. (21.8 x 15.3 cm). The Metropolitan Museum of Art, New York, Gift of M. Knoedler & Co., 1918 (18.64.17)

Fig. 6.18 Francisco de Goya y Lucientes, *Los Caprichos, No. 31: Ruega por ella (She Prays for Her)*, 1799. First edition, etching, aquatint, drypoint, and burin, 8⅝ x 6 in. (21.8 x 15.3 cm). The Metropolitan Museum of Art, New York, Gift of M. Knoedler & Co., 1918 (18.64.31)

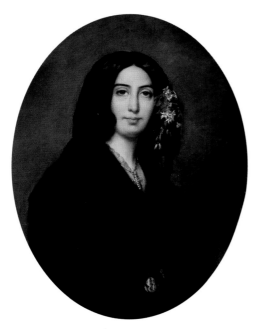

Fig. 6.19 Auguste Charpentier, *George Sand*, 1838. Oil on canvas. Musée de la Vie Romantique, Paris

her legs. Doubled up in this manner, wrapped in brown sackcloth, her long, lank, gray hair falling over her face down to her feet, she presented at first sight a strange figure."[24]

What had been a small overhead lantern in Goya (fig. 6.14) becomes in Hugo a tiny, forbidding, ventlike window, cutting the figure off from the outside world rather than allowing her to communicate with it. Poet of violent contrasts, Hugo captures in his description the same quality of brusque, pitiless lighting seen in the Goya etchings: a ray of light pours through the small vent and harshly delineates two areas, one of deep shadows, the other of stark brightness. Upon this harsh backdrop the figure of La Sachette profiles itself, a "half-real, half-fantastic vision" seen "standing out from the dark ground of the cell, a sort of dun triangle which the ray entering at the window sliced crudely into two shades, one dark, the other bright."[25] Inevitably, Hugo recalls Goya's "sinister" specters of women: "It was one of those specters, half shadow and half light, such as one sees in dreams and in Goya's extraordinary works, pale, motionless, gloomy, cowering on a grave, or leaning against the grating of a dungeon."[26] Hugo had originally used the

by then common qualification of "fantastique" for Goya's oeuvre, as a variant of the manuscript reveals; since the character Hugo was trying to evoke was not, however, of a fantastic nature, he changed his adjective to "extraordinaire."

These excerpts also reveal the French fascination with the Spanish woman, whose fire, vivacity, and irresistible charm, in various incarnations, were evoked by virtually every French Romantic writer. An important milestone in French literary Romanticism, and one of the most striking examples of a French poet mirroring the work of a Spanish painter, was Alfred de Musset's *Contes d'Espagne et d'Italie* (Tales of Spain and Italy)—sparkling in its Mediterranean local color—published in 1830. Fascinated by the graceful charm of the Spanish woman, Musset found her image in Goya's *Caprichos* number 17, *Bien tirada está* (fig. 6.17), and particularly in number 31, *Ruega por ella* (fig. 6.18). These plates were not merely points of departure for flights of the poet's fancy, nor even a simple means of graphic comparisons, but a direct source of inspiration for the poems "Madrid" and "L'Andalouse." In both poems the image in *Caprichos* number 31 can be followed line by line: Musset's verses faithfully reflect Goya's dark-haired, willowy young woman adjusting the stocking on her shapely exposed leg, the old woman of the etching guarding her again in the poem, a *dueña* now. Musset was so enthralled with this plate that he copied it with the greatest exactness; his drawing, owned by his descendant Roger Legras de Grandcourt de Musset, is strikingly close to Goya's original.[27]

With the unerring intuition of a woman in love, George Sand (fig. 6.19) well sensed the fascination that Goya's lighthearted and graceful *majas* exerted upon Musset's imagination. In 1834, after returning from their momentous and tragic journey to Italy, she confessed in her *Journal* how she dreamt of recapturing her lover's devotion: if only she could be transformed into one of Goya's lithesome creatures, Musset would again turn toward her. Yet, accepting reality's duress, she will at least copy some of these drawings for him and thus hold, be it for only a fleeting moment, his attention: "As for me, I will amuse myself—amuse myself?—by slavishly copying a few of those pretty women of Goya's. I'll send them to my poor angel when I leave; perhaps he won't refuse them."[28]

George Sand's introduction to Goya's work reveals the close relationships among the Parisian intelligentsia of the 1830s. In 1834 the editors of the *Revue des Deux Mondes*, at the instigation of the *Revue*'s founder, François Buloz, decided to publish likenesses of all major contributors to the journal. Delacroix (figs. 6.20, 6.21) was asked to portray his friend George Sand. At the very first sitting he showed her Goya's *Caprichos* and, with his usual perceptiveness of his friends' sensitivities, then spoke of Musset more than of Goya, including Musset's undeniable talent for drawing, called to mind by Goya's little volume. Indeed, he could not have been more correct—Musset had already painstakingly copied some of these prints, as noted above. We do not know George Sand's reaction to Goya's haunting collection. The only point amplified in her *Journal* concerns Delacroix's personal references to Musset: "This morning I posed at Delacroix's. . . . Delacroix showed me the Goya collection. He spoke to me of Alfred in that connection, and said that he would have made a great painter if he had wanted to."[29]

Son menton était appuyé sur ses genoux, que ses deux bras croisés serraient fortement contre sa poitrine. Ainsi ramassée sur elle-même, vêtue d'un sac brun qui l'enveloppait toute entière à large plis, ses longs cheveux gris rabattus par devant tombant sur son visage le long de ses jambes jusqu'à ses pieds, elle ne présentait au premier aspect qu'une forme étrange." Ibid. p. 180. In the margin of Hugo's autograph of *Notre-Dame de Paris* are two small pen drawings by the author in which he tries out the interplay of light and shadow on La Sachette's figure and the overall "pyramidal" lines circumscribing it. One cannot recognize echoes of Goya's plates in this sketch, however. Victor Hugo, Bibliothèque Nationale, ms. acquisitions nouvelles 13, fols. 163–64.

25. "découpée sur le fond ténébreux de la cellule, un espèce de triangle noirâtre, que le rayon de jour venant de la lucarne tranchait crûment en deux nuances, l'une sombre, l'autre éclairée." V. Hugo 1904, p. 180.

Fig. 6.20 (cat. 110) Eugène Delacroix, *Study for "The Massacres at Chios": Head of an Old Woman*, 1824. Oil on canvas, 17¾ x 13⅛ in. (45.1 x 33.3 cm). Musée des Beaux-Arts, Orléans

26. "C'était un des spectres, mi-partis d'ombre et de lumière, comme on en voit dans les rêves et dans l'oeuvre extraordinaire de Goya, pâles, immobiles, sinistres, accroupis sur une tombe ou adossés à la grille d'un cachot." Ibid., and Bibliothèque Nationale, ms. acquisitions nouvelles 13, fol. 164. The grillwork of La Sachette's cell also forms part of the background of Goya's *Capricho* no. 34.

27. Paris 1957, p. 85, nos. 360–62. I cannot agree with this catalogue's dating of the Musset drawing as 1834. The poems that are an exact transposition of no. 31 of the *Caprichos* are dated 1830, and it seems more plausible that Musset's drawing was made at the same time he composed the poem.

28. "Moi, je vais m'amuser, m'amuser? m'appliquer à copier servilement quelques-unes de ces jolies femmes de Goya. Je les enverrai à mon pauvre ange, quand je partirai; il ne les refusera peut-être pas." Sand 1926, pp. 3–4: November 25, 1834. See also Escholier 1932.

29. "Ce matin j'ai posé chez Delacroix. . . . Delacroix m'a montré le recueil de Goya. Il m'a parlé d'Alfred à propos de cela, et m'a dit qui'il aurait fait un grand peintre, s'il eût voulu." Sand 1926, p. 4. The original autograph of this text differs slightly from the one in the published *Journal:* "Ce matin j'ai posé chez Lacroix. . . . Lacroix m'a montré le recueil de Goya. Il m'a parlé d'Alfred et m'a dit qu'il aurait fait un grand peintre, s'il eut voulu" ("This morning I posed at Lacroix's. Lacroix showed me the Goya collection. He spoke to me of Alfred and said that he would have made a great painter if he had wanted to"). George Sand, "Correspondance" F3163, vol. 2, fol. 199, recto and verso, Spoelberch de Lovenjoul collection, Chantilly.

Fig. 6.21 (cat. 109) Eugène Delacroix, *Orphan Girl in a Cemetery*, 1823–24. Oil on canvas, 25¾ x 21⅜ in. (65.5 x 54.3 cm). Musée du Louvre, Paris, Étienne Moreau-Nélaton Bequest

In the *Caprichos* French writers found not only new imagery but also new principles. At times grotesque and even cruel, at times picturesque or merely realistic, Goya's images ranged from aged *dueñas* hovering over graceful young women to witches and dwarfs, gnomes and monsters—all the satanism of black Romanticism that surged through many Romantic literary works, from Gautier's "Albertus" to Boulanger's "Ronde du Sabbat." Goya's takeoffs on social injustices and on the blind self-sufficiency of the nobles must have been cherished by those who were preoccupied with the social and political problems stirring France in the 1830s (and who reveled in the lampooning of a pear-shaped Louis-Philippe). French Romantics, however, were not struck primarily, as were later generations, by Goya's biting social satire. In the *Caprichos* they discovered fresh techniques of representation and a different attitude toward the subject: exact drawing gave

way to strong chiaroscuro, the controlled shadings and nuances of engraving were replaced by the passionate blacks and whites of aquatint—and the artist as an observer became the artist as an active participant. Yet for all their enthusiasm for Goya, this generation was sensitive mostly to the picturesque, almost superficial values of his work; they did not allow themselves to be perturbed—as others would be a decade later—by this master's tragic sense of life. The critics and writers of the 1830s did not attempt to interpret the work of art, nor to analyze its aesthetic qualities, but rather considered it a visualized illustration of their own verbal imagery. They searched Goya's oeuvre for what they considered essentially Spanish characteristics, and in it they found mirrored and confirmed many of their own preconceived images of Spain. There they found the portrait of the Spanish woman that they dreamt of, as well as a pictorial expression of their own "Romantic agony."

The Galerie Espagnole of Louis-Philippe

Jeannine Baticle

The opening of King Louis-Philippe's Galerie Espagnole at the Louvre in 1838 occurred within a political and cultural context that stretched back to the time of the French Revolution. As the duc d'Orléans, Louis-Philippe (fig. 7.2) belonged to a family that had long dreamed of occupying the French throne in place of the Bourbons: they were republican merely out of ambition. It is with this concealed aim that Philippe Égalité (1747–1793), Louis-Philippe's father, had in 1792—despite his enormous fortune—become a member of the Convention Nationale and had advocated the execution of King Louis XVI. (His own collection of artworks at the Palais Royal, renowned for its quality, was sold the same year to the Belgian banker Walkiers for 700,000 francs.) Like his father, Louis-Philippe (1773–1850) at first sided with the revolutionaries, serving at the age of nineteen as a general at the Battle of Valmy. But soon afterward, in late 1793, he deserted the army and joined the Austrian opponents of the First Republic. In the chaos of those terrible years, he traveled first throughout Europe and then to America; he would not see France again for twenty years.

Louis-Philippe had many connections with Spain during this period. His mother had been exiled to Catalonia by the Directory, and he stayed for a year (1798–99) in Havana, a Spanish colony, where he learned to speak Spanish fluently. In Palermo, in late 1809, acting with the idea of forging an alliance with the Bourbons, Louis-Philippe married Marie-Amélie de Bourbon (fig. 7.3), the niece of King Charles IV of Spain and cousin of Ferdinand VII. From June to October 1810 he spent time in Cadiz, the only Spanish seaport that would never be taken by Joseph Bonaparte's armies. Offering his services to the Cortes, Louis-Philippe told the Spanish legislators that he considered himself the "infante of Spain" and wished to rule Spanish America. The English occupying Cadiz forcefully refused, however, and he left Andalusia. While there, he most likely saw certain works by Zurbarán from the Cartuja (Carthusian monastery) of Jerez de la Frontera that had been confiscated by the French and would later be displayed at the Galerie Espagnole.

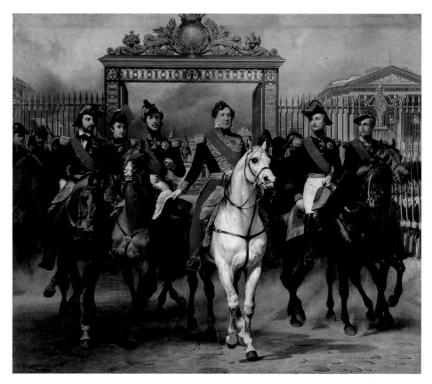

Fig. 7.2 Horace Vernet, *Louis-Philippe and His Sons Riding Out from the Château de Versailles*, 1846. Oil on canvas, 12 ft. ½ in. x 12 ft. 11⅛ in. (367 x 394 cm). Musée National des Châteaux de Versailles et de Trianon, Versailles

Fig. 7.1 (cat. 85) Francisco de Zurbarán, *Saint Francis in Meditation* (detail of fig. 2.13)

Fig. 7.3 Louis-Joseph Noyal, *Marie-Amélie de Bourbon (1782–1866), Princess of the Two Sicilies, Queen of the French*, 1800–1825. Oil on canvas, 101⅛ x 71⅛ in. (257 x 182 cm). Musée National des Châteaux de Versailles et de Trianon, Versailles

Although the Bourbons of France and Spain had been very closely united politically and personally in the eighteenth century, the masterpieces of the Spanish Golden Age housed in the palaces, churches, and monasteries of the Iberian Peninsula were then almost unknown to French art lovers, with the exception of a few travelers. This was especially true of Velázquez's works, which, under the reign of Charles III (1759–88), were granted little importance at the Palacio Real in Madrid. Hence, before 1789, *Las Meninas* (fig. 4.13) was hung in the private apartments of the future queen María Luisa. In France, it was not until 1782, under Louis XVI, that the first important Spanish work of art, Murillo's famous *Beggar Boy* (fig. 1.4), was purchased for the royal collections.

Yet, oddly enough, French diplomats and their retinues did not hesitate to visit Spain during the First Empire, even just prior to Napoleon's invasion. In 1806 Comte Alexandre de Laborde published volume 1 of his four-volume *Voyage pittoresque et historique de l'Espagne* (Picturesque and historical journey to Spain), in which he was the first Frenchman to describe from personal observation the beauty of the Zurbaráns from Jerez. In Granada in 1807, he joined his sister Nathalie de Noailles and Chateaubriand, who was amazed to discover the Alhambra, which would later inspire his novel *Les aventures du dernier Abencérage* (The adventures of the last Abencerraje). At the same time, merchants also crossed the Pyrenees to acquire Spanish paintings. In 1807 one of the most notable of these was the French art dealer Jean-Baptiste-Pierre Lebrun (for a fuller discussion, see Gary Tinterow's and Ignacio Cano Rivero's essays in this publication).

A host of important French writers who were to have personal knowledge of Spain were born at the turn of the century. "This century was two years old," wrote Victor Hugo (fig. 7.4) of the year of his birth. Prosper Mérimée (fig. 7.5) followed in 1803, and George Sand (fig. 7.6) in 1804. Both Hugo and Sand lived in Madrid as children. Hugo's father, a general, lodged in the magnificent Palacio Masserano, which remained for his son a dazzling memory. The child fell in love with the daughter of Joseph Bonaparte's mistress: in 1811 this girl, named Pepita, was the subject of a ravishing portrait by Goya. In 1808 Sand and her pregnant mother had joined her father, Maurice Dupin, an aide-de-camp to Marshal Joachim Murat in Madrid. They lived for about two months at the Palacio Real in Manuel Godoy's former apartments. Thirty years later, Sand and Frédéric Chopin traveled to Catalonia and the Balearic Islands; in 1841 she wrote *Hiver à Majorque* (Winter in Majorca). Sand was very close to Louis Viardot, the future translator of *Don Quixote*, who had joined the 1823 expedition of the duc d'Angoulême—the Cent Mille Fils de Saint Louis (One Hundred Thousand Sons of Saint Louis)—to help restore Ferdinand VII to absolute power. In Madrid, Viardot discovered the new Museo del Prado, which had opened in 1819, and he himself was to publish an article in 1834 calling for the creation of a Spanish museum in Paris. Mérimée, the author of *Carmen*, visited Spain seven times during his life. In 1825 he published a collection of comic plays, *Le théâtre de Clara Gazul* (The theater of Clara Gazul), which he presented as the work of a Spanish actress and which enjoyed a remarkable

Fig. 7.4 French school, 19th century, *Victor Hugo (1802–1885), about 1830*, ca. 1830. Oil on canvas, 26 x 38⅛ in. (66 x 98 cm). Musée National des Châteaux de Versailles et de Trianon, Versailles

Fig. 7.5 Anonymous, *Prosper Mérimée (1803–1870), Author, Senator*, 19th century. Albumen print. Musée d'Orsay, Paris

success. Finally, in 1830 Hugo's play *Hernani, ou L'honneur castillan* (Hernani, or Castilian honor) revolutionized the theater.

Paradoxically, painters of the French school seemed to find Spanish art less appealing than did their literary compatriots. Neoclassicism still had many adherents, even though the fashion for *costumbrismo* (a style featuring traditional Spanish subjects) was spreading among minor painters. Nevertheless, some French painters, including Delacroix, traveled to Spain. Returning to Europe after a trip to Morocco in 1832, the artist visited Andalusia, and in Seville he made sketches after Zurbarán's painting of monks at the Monasterio de Santa María de las Cuevas. In Paris, Delacroix had the opportunity to visit the mansion of Marshal Jean de Dieu Soult, which was more accessible to art lovers than has been claimed. There he found magnificent Zurbaráns and Murillos, most taken from Seville during the French occupation, although some had been purchased (see Ignacio Cano Rivero's essay). In 1832 Soult was named prime minister and proposed that the state acquire some of his Murillos; he was turned down because the cost was considered too high. In addition, the gallery belonging to the banker Alejandro María López Aguado contained more than two hundred paintings attributed to the Spanish school, including a few masterpieces. Its highlights were catalogued in 1839 by Viardot in *Galerie Aguado, choix des principaux tableaux de la galerie de M. le Marquis de las Marismas* (Aguado Gallery, selection of the principal paintings of the gallery of the marquis de las Marismas) with illustrations by the engraver Charles Gavard (fig. 7.9). But the most significant efforts to bring Spanish art to France were to come from Louis-Philippe.

In July 1830, at the age of fifty-seven, Louis-Philippe finally managed to thrust the Bourbons aside and to become king of France. During his reign, known as the July Monarchy (1830–48), Spain remained at the center of his dynastic preoccupations, because King Ferdinand VII precipitated a problem in the succession to the Spanish throne. Two

Fig. 7.6 Jean-Denis Nargeot, *Portrait of George Sand in a Medallion* (detail), 19th century. Engraving. Musée Eugène Delacroix, Paris

Fig. 7.7 Federico de Madrazo y Küntz, *Adrien Dauzats (1804–1868)*, *Painter*, second quarter 19th century. Oil on canvas, 20⅛ x 17⅜ in. (51 x 44 cm). Musée National des Châteaux de Versailles et de Trianon, Versailles

Fig. 7.8 Federico de Madrazo y Küntz, *Isidore-Justin-Séverin*, *Baron Taylor (1789–1879)*, *Inspecteur des Beaux-Arts*, 1838. Oil on canvas, 24 x 19¾ in. (61 x 50 cm). Musée National des Châteaux de Versailles et de Trianon, Versailles

Fig. 7.9 Charles Gavard, Frontispiece to Louis Viardot, *Galerie Aguado, choix des principaux tableaux* . . . , 1839. Engraving, 7½ x 6½ in. (19.1 x 16.5 cm)

daughters had been born during Ferdinand's four marriages—the elder, Isabella, in 1830—and the king abrogated the Salic law just before his death in 1833 so that she could reign. He thereby provoked the fury of his younger brother, Carlos María Isidro, who declared himself king of Spain under the name of Charles V, setting off the political and social upheaval of the Carlist civil wars (1833–68). In addition, the liberal party, violently under attack between 1820 and 1833, fomented insurrections that swept the banker Juan Álvarez y Mendizábal to power in 1835. The fiercely progressive Mendizábal played a role in drafting the July 1835 decree abolishing the Jesuit order, the Inquisition, and the monasteries; he was named prime minister in September. Draconian "exclaustration" (secularization) laws followed in October 1835, along with the sale of church property to benefit the state.

Louis-Philippe was quick to recognize the ramifications of these developments, realizing that they could afford him the opportunity to purchase a number of major paintings for the Spanish museum in Paris that he so ardently desired. As his agent for this task, he selected Isidore-Justin-Séverin Taylor (fig. 7.8), the son of an Englishman and a Belgian aristocrat. Born in Brussels in 1789, Taylor came to France with his parents during the Revolution. Under the Empire, he was first a student of the painter Joseph-Benoît Suvée, then a soldier, and rallied behind Louis XVIII in 1815. Charles X made him a baron in 1825, and he was named head of the Théâtre Royal Français the same year. A multifaceted personality, Taylor knew both

Fig. 7.10 Francisco de Zurbarán, *The Annunciation*, ca. 1638–40. Oil on canvas, 105 x 72⅞ in. (267 x 185 cm). Musée de Grenoble

Fig. 7.11 Francisco de Zurbarán, *The Adoration of the Shepherds*, ca. 1638–40. Oil on canvas, 105 x 72⅞ in. (267 x 185 cm). Musée de Grenoble

Fig. 7.12 Francisco de Zurbarán, *The Adoration of the Magi*, ca. 1638–40. Oil on canvas, 104 x 69¼ in. (264 x 176 cm). Musée de Grenoble

Fig. 7.13 Francisco de Zurbarán, *The Circumcision*, ca. 1638–40. Oil on canvas, 104 x 69¼ in. (264 x 176 cm). Musée de Grenoble

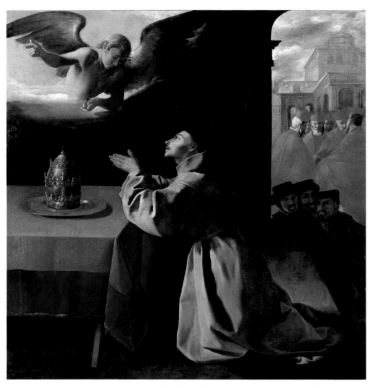

Fig. 7.14 (cat. 83) Francisco de Zurbarán, *Saint Bonaventure Inspired by an Angel Regarding the Election of the Future Pope Gregory X*, also called *Saint Bonaventure Praying*, 1629. Oil on canvas, 94 x 87 in. (239 x 222 cm). Gemäldegalerie Alte Meister, Staatliche Kunstsammlungen, Dresden

Fig. 7.15 (cat. 49) Bartolomé Esteban Murillo, *Self-Portrait*, ca. 1655–60. Oil on canvas, 42⅛ x 30½ in. (107 x 77.5 cm). Private collection, New York

artists and writers. His extraordinary intelligence and skill were crucial in the 1835–37 expedition to Spain to procure art for Louis-Philippe: they enabled him to select essential works from the Spanish school and to maintain useful contacts with those in Spain doing the selling. He also managed to escape customs inspections and the civil war by having the paintings transported by sea on French warships.

In October 1835 Taylor and the painter Adrien Dauzats (fig. 7.7), soon joined by the engraver Pharamond Blanchard, traveled to Andalusia via Portugal and then on to Castille; Taylor and Blanchard would return to France in April 1837, Dauzats in October of that year. In Cadiz, Taylor contacted Antonio Mesas, an artist who had been appointed by the Mendizábal cabinet in 1835 to assemble the paintings from the Cartuja de Jerez, which were then being stored at the Academia de Bellas Artes in Cadiz. In 1836, when these works were offered for sale, Mesas oversaw the transaction. He officially handed over six of the Zurbarán masterworks from Jerez to Taylor for 400,000 reales: the four canvases constituting the Childhood of Christ series (figs. 7.10–7.13), *The Virgin of the Rosary with Carthusians* (Muzeum Narodowe, Poznań), and *The Battle between Christians and Moors at El Sotillo* (fig. 3.12). Mesas kept a share of the profits from the sale. It was the second time in twenty-six years that the unfortunate Carthusians had been deprived of their property; three of these paintings had previously been appropriated for the Musée Napoléon but had been returned in 1815.

In Seville, the always efficient Taylor sought guidance from informed collectors: the dean of the cathedral, the famous canon Manuel López Cepero, who owned nearly two hundred paintings; Aniceto Bravo, whose uncle, it seems, had collected 840 works of art; and the English vice-consul Julian Williams. Many of the paintings that Taylor bought in Seville

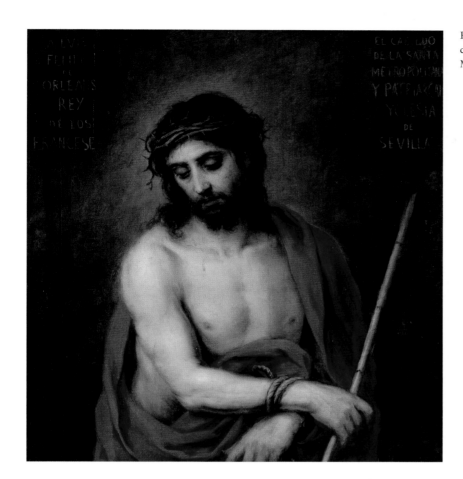

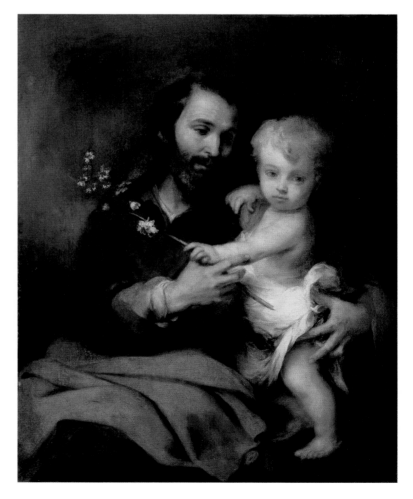

Fig. 7.16 (cat. 56) Bartolomé Esteban Murillo, *Ecce Homo*, ca. 1675. Oil on panel, 33¼ x 31 in. (85.5 x 79 cm). El Paso Museum of Art, Gift of the Kress Foundation

Fig. 7.17 (cat. 55) Bartolomé Esteban Murillo, *Saint Joseph and the Christ Child*, ca. 1670–75. Oil on canvas, 42¼ x 33¼ in. (108 x 84 cm). Bequest of John Ringling, Collection of the John and Mable Ringling Museum of Art, Sarasota, Fla.

Fig. 7.18 (cat. no. 11) Francisco de Goya y Lucientes, *Young Women (The Letter)*, after 1812. Oil on canvas, 71¼ x 49¼ in. (181 x 125 cm). Musée des Beaux-Arts, Lille

Fig. 7.19 Francisco de Goya y Lucientes, *The Forge*, ca. 1813–18. Oil on canvas, 75¼ x 47⅛ in. (191 x 121 cm). The Frick Collection, New York

Fig. 7.20 (cat. 89) Francisco de Zurbarán, *The Virgin of the Immaculate Conception with Saints Anne and Joachim*, ca. 1640. Oil on canvas, 88¾ x 69⅝ in. (225.5 x 177 cm). National Gallery of Scotland, Edinburgh

had become available as a result of the dispersion of church property in 1810. Williams sold Taylor five canvases, most notably Zurbarán's *Saint Bonaventure Inspired by an Angel Regarding the Election of the Future Pope Gregory X* (fig. 7.14), as well as Murillo's famous *Self-Portrait* (fig. 7.15). Bravo was well remunerated for the nine paintings he sold to Taylor, and López Cepero also exchanged a certain number for payment in cash. Another English consul in Cadiz let Taylor have Goya's *Charles III Dressed as a Hunter* (ca. 1788, private collection). The Cathedral of Seville sent Murillo's *Ecce Homo* (fig. 7.16) as a personal gift to Louis-Philippe.

The yield was particularly good in Castille, and especially in Toledo. A receipt dated March 3, 1836, from the convent treasurer of the Hieronymite sisters of the Reina indicates that Taylor paid the convent 50,000 reales for four beautiful compositions by Luis Tristán, one of El Greco's disciples, as well as for El Greco's magnificent *Crucifixion with Two Donors* (fig. 1.27). The Spanish revenue office seems to have closed its eyes. In Madrid, Taylor acquired Murillo's *Saint Joseph and the Christ Child* (fig. 7.17).

Finally, thanks to the young painter Federico de Madrazo y Küntz, who recommended him to Goya's son Javier, Baron Taylor was able to make one of his most sensational acquisitions for the Galerie Espagnole. He purchased eight paintings by Goya for the incredibly low price of 15,000 reales (3,975 francs), including five masterpieces by the painter, who had died in Bordeaux in 1828. These were the original *Majas on a Balcony* (private collection), *Young Women (The Letter)* (fig. 7.18) and *Old Women* (fig. 1.33), *The Forge* (fig. 7.19), and *Lazarillo de Tormes* (private collection). Taylor is also believed to have acquired the portrait of the duchess of Alba (fig. 11.8) through the dukes of Alba; dating to 1797, it is one of Goya's most accomplished portraits, an exemplary work that still continues to fascinate viewers.

The Galerie Espagnole opened on January 7, 1838, in the Galeries de la Colonnade at the Palais du Louvre, which the king "graciously placed at the disposition of Parisians" (see also Gary Tinterow's essay). The reaction from the press was both violent and contradictory. "Put Goya in cartons," *Le Charivari* wrote, "don't put him in museums." Nevertheless, the selection of works was impressive. So impressive that, ever since, art historians on the peninsula have sharply reproached the French and their Spanish agents for depriving Spanish museums and sanctuaries of paintings that are now considered the glory of the Golden Age.

It is impossible, in this short essay, to trace the history of the acquisition of every work displayed in Paris. However, one should note the inequities in the selections made and the different levels of attention that each of the Spanish masters received from art lovers and the public. Of the 440 paintings exhibited, 412 were Spanish; 33 were in storerooms, including Goya's *Old Women*. According to the first edition of the Galerie Espagnole catalogue, published in 1838 in Paris, there were 180 Zurbaráns, only one of them questioned at the time. In reality, many of these works were not by the master's hand, including most of the female saints, 16 small canvases representing missionaries, and a large number of others that cannot be identified. But Zurbarán's major compositions, even while hanging in poorly lit halls, made quite an impression on the art critics. The press remarked less on the subject matter than on the mere presence of the monks—a true obsession among anticlerical journalists. Nevertheless, the admirable *Saint Francis in Meditation* (figs. 2.13, 7.1) was a triumph.

Europe thus first discovered Zurbarán at the Galerie Espagnole (figs. 7.20, 7.21), but the dispersal of Louis-Phillippe's collection in 1853 once again deprived the artist of his due, for

Fig. 7.21 (cat. 88) Francisco de Zurbarán, *The Martyrdom of Saint James*, ca. 1639. Oil on canvas, 99¼ x 73¼ in. (252 x 186 cm). Museo Nacional del Prado, Madrid

the Prado did not hold a major retrospective of his work until 1905. Between 1945 and 1960, two scholars, Paul Guinard and María Luisa Caturla, breathed new life into the study of this painter. In 1960 Guinard published his authoritative monograph, *Zurbarán et les peintres espagnols de la vie monastique* (Zurbarán and the Spanish painters of monastic life). Caturla's manuscript, *Francisco de Zurbarán*, published by Odile Delenda in 1994 and accompanied by previously unpublished archival documents, demonstrates that in France the painter is now considered one of the brightest lights of the Golden Age and not merely a simple mystic.

El Greco and Juan de Valdés Leal were much better represented in the Galerie Espagnole than were Ribera, Murillo, and Velázquez. In addition to El Greco's religious works, Taylor was able to find excellent portraits. The one that enjoyed a sentimental rather than an artistic success was the seductive *Lady in a Fur Wrap* (fig. 1.34), sold by the Madrilenian collector Serafín García de la Huerta. Louis-Philippe's contemporaries wanted to believe that the subject of this portrait was El Greco's daughter; others later claimed she was Caterina Micaela, the second eldest daughter of King Philip II of Spain. It has recently been suggested that the young woman belonged to the high nobility, not to the royal family. Moreover, Infanta Caterina Micaela was fair-haired with blue eyes, while El Greco's angelic model has black hair and bewitching black eyes gleaming with truth and poetry.

The four paintings by Valdés Leal depicting single figures of monks and saints from the order of Saint Jerome are considered to be among the artist's key works; a large canvas illustrating an episode from Jerome's life has disappeared. These originally came from the Hieronymite monastery of Buenavista in Seville; the Musée de Grenoble now houses one of them, *Brother Alonzo de Ocaña* (fig. 7.22), a remarkable, almost modernist example of the creative genius of Valdés Leal.

Ribera, Velázquez, and Murillo, whose works were not as available in the 1830s as they had been at the turn of the nineteenth century, were

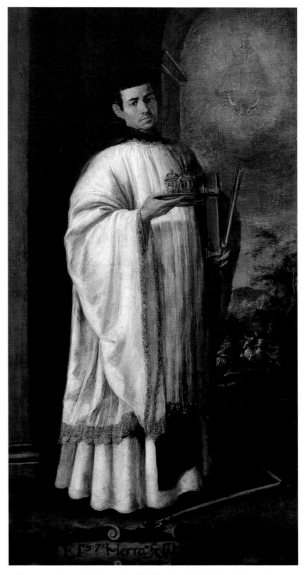

Fig. 7.22 (cat. 67) Juan de Valdés Leal, *Brother Alonso de Ocaña*, ca. 1656–58. Oil on canvas, 98⅜ x 51⅝ in. (250 x 131 cm). Musée de Grenoble

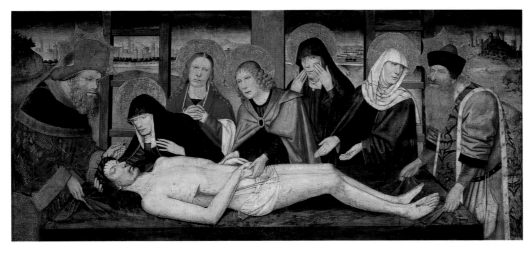

Fig. 7.23 Jaume Huguet, *The Lamentation of Christ*, 1450–75. Oil on canvas, 28¾ x 62¼ in. (73 x 158 cm). Musée du Louvre, Paris

underrepresented, with many examples of false or dubious attributions. Today, only Ribera's *Martyrdom of Saint Bartholomew,* once copied by Millet, is accepted by scholars. Murillo was also not represented with first-rate paintings; none of them could equal those in the collection of Marshal Soult. As for Velázquez, the majority of his canvases belonged at the time to the Prado or to museums in Vienna and England (a few were also in Italy). Taylor therefore had difficulty acquiring a major work by him in Spain. Only the *Count-Duke of Olivares* (fig. 11.1) showed a valuable aspect of Velázquez's art. A beautiful Claudio Coello and three works by Juan Carreño de Miranda, two signed and one dated, completed the Galerie's uneven panorama of the Golden Age.

The Spanish Renaissance schools elicited little interest among the French trio who were sent on the buying expedition. They did not record the names of those who sold Alonso Sánchez Coello's portraits and the religious scenes of Juan Correa de Vivar and Pedro Romana. As for the superb panel by Jaume Huguet, *The Lamentation of Christ* (fig. 7.23), there is no archival document indicating where Taylor procured it, and it does not appear in the 1838 catalogue of the gallery.

The Galerie Espagnole closed on January 1, 1849, a casualty of the stupefying series of events that gripped France from 1848 to 1851. Louis-Philippe was dethroned in February 1848 and fled with his family to England, where he moved into Claremont Castle in Surrey. On December 10, 1848, Louis-Napoleon, the future Napoleon III, was elected president of the Second Republic. Eighteen months later, in August 1850, the fallen king of France died at the age of seventy-seven. In October of the same year, the government of the French Republic acceded to the request of his heirs and returned the Spanish collection to them, on the pretext that the collection had been the former monarch's personal property. (He had paid for the paintings from his own private funds.) By July 1851 all the works had been removed and sent to England. When Baudelaire called the short-lived regime "the stupid French republic," he was not altogether wrong; one can only speculate as to what secret motives drove it to let the works in the Galerie Espagnole leave Paris.

It was not until May 1853 that the collection was sold at Christie's in London. Several important works were repurchased by the duc de Montpensier, fifth son of Louis-Philippe, who in 1846 had married the sister of Queen Isabella II of Spain in Madrid. In 1848 the queen gave the couple the Palacio de San Telmo in Seville, which they occupied in 1850 and which would eventually house a veritable museum. They then built a beautiful winter palace at Sanlúcar de Barrameda near Cadiz. Family alliances allowed the house of Orléans to keep the works repurchased in London until the late nineteenth century. The duc de Montpensier's eldest daughter married her cousin Philippe, the comte de Paris. As a widow, she owned the Château de Randan in Auvergne, to which Zurbarán's Childhood of Christ series from the monastery of Jerez had been transported. After General de Beylié bought the paintings from her, he donated them in 1901 to the Musée des Beaux-Arts in Grenoble. Thus, for the third time, these four admirable compositions crossed the border and finally ended their peregrinations, to the great joy of visitors to the Grenoble museum.

The Goyas from the Galerie Espagnole sold in London in 1853 met various fates. *Majas on a Balcony* and the presumed portrait of Asensio Juliá (fig. 5.8), reclaimed by the Montpensiers, were exhibited at the Palacio de San Telmo until 1897. Then, when the duchesse de Montpensier bequeathed her magnificent home to the archbishopric in Seville, her son Antoine transported the collection to the palace at Sanlúcar de Barrameda. In 1911 the

Parisian art gallery Durand-Ruel purchased both works from him; they are now in private collections. The other prestigious canvases acquired from Javier Goya in 1836—for the sum, as previously mentioned, of 3,975 francs—now adorn the walls of major museums: *The Forge* is in the Frick Collection in New York, *Old Women* and *Young Women* are at the Musée des Beaux-Arts in Lille.

Considering the fact that the Prado, owner of many masterpieces by Goya, recently paid 160 million francs for his portrait of the ravishing countess of Chinchón, one is almost tempted to seek a psychological explanation for why French art lovers and journalists were blind to the master's genius when the Galerie Espagnole opened in 1838. Fortunately, Manet would redress the situation by choosing a replica of Goya's *Majas on a Balcony* (fig. 1.32) as his inspiration for the fine painting *The Balcony*, now in the Musée d'Orsay in Paris (fig. 9.80); bequeathed by Gustave Caillebotte in 1894, it was not exhibited at the Louvre until 1929. It is difficult to precisely measure the aesthetic impact of the Galerie Espagnole paintings on the French school during the second half of the nineteenth century. However, in seeking the origins of Realism, one must also look at the social and political reaction to the July Monarchy and the Second Empire, which were on the whole rather authoritarian regimes.

Today, many visitors to the Louvre express disappointment about how few works by Goya are in the museum's collection. As for Zurbarán, the major Paris retrospective of his paintings in 1988 was a true triumph. The beauty of *The Virgin* and *The Annunciation* from Jerez garnered the most attention, rather than the mysticism of the somber monks, which had been the focus of the well-publicized 1838 opening.

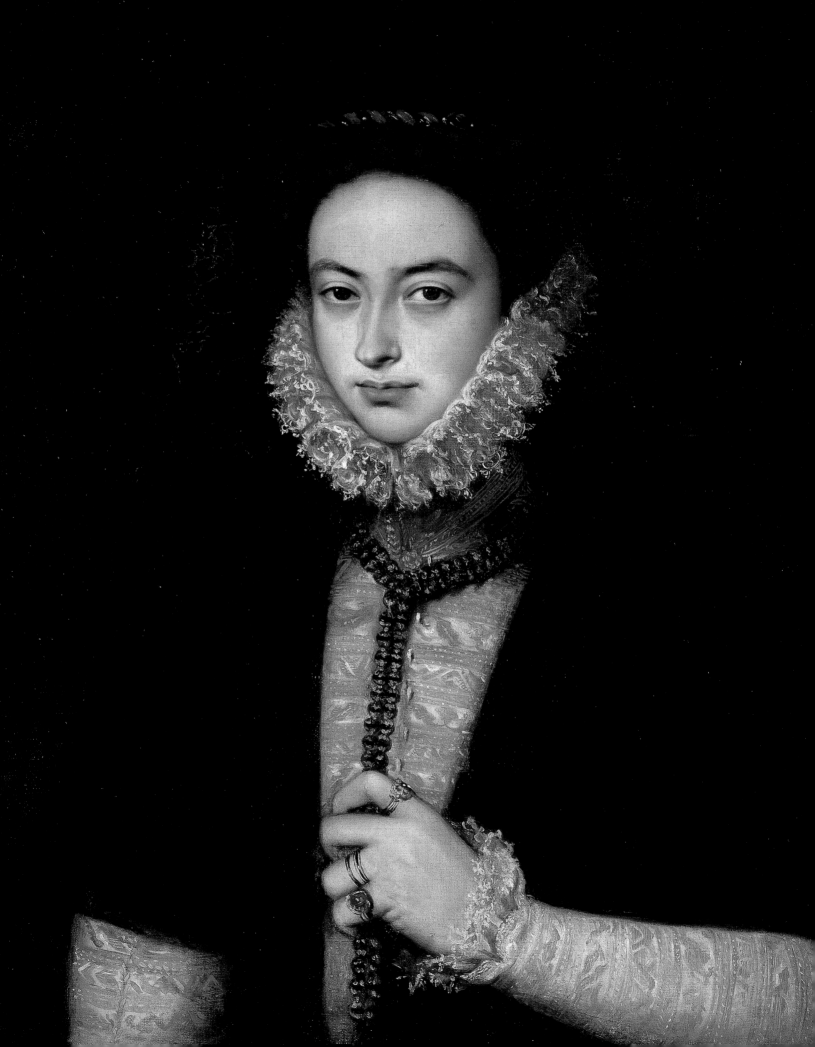

From Ziegler to Courbet: Painting, Art Criticism, and the Spanish Trope under Louis-Philippe

Stéphane Guégan

Spain is the quintessential romantic country; no other nation has borrowed less from antiquity.

Théophile Gautier[1]

The Spanish museum [Galerie Espagnole] had the effect of increasing the volume of general ideas that you had to have about art.

Charles Baudelaire[2]

Victor Hugo's *Choses vues* (Things seen, 1887) has a well-known passage, at once very Parisian and very Spanish, relating the events of the night of February 23–24, 1848. Revolving around Hugo and an old love letter, the scene features the actress Alice Ozy, under the nickname Zubiri, and the painter Théodore Chassériau, under the name Serio. Its participants formed an unusual trio of lovers. In addition to Hugo, there was Alice, a volatile and fickle performer who, during the rule of Louis-Philippe, had been the mistress of the duc d'Aumale, Théophile Gautier, Charles Hugo (the author's son), and many others. The spurious painting incorrectly thought to be El Greco's portrait of his daughter (fig. 8.1) was once owned by her. Alice's lover of the moment, Chassériau, had just placed the finishing touches on the decoration of the Cour des Comptes at the Palais d'Orsay, marking his definitive break from the style of Ingres, which had shaped his development in the early 1830s.

Born in 1819 in Samana, located in the Spanish portion of Santo Domingo, Chassériau would pride himself on that fact only after 1852. During his childhood, he certainly bore to a lesser degree than Hugo the Iberian imprint that would later draw the painter and the writer together. Young Victor's father, General Léopold Hugo, had served in Spain under Jérôme Bonaparte. His son, starting with the poems in *Orientales* (1829) and the plays *Hernani* (1830) and *Ruy Blas* (1838), would reconquer the kingdom lost to France by depicting it as a vivid world of high passions. His works led to a rage for all things Spanish—in painting, in the theater, and in the novel.

Choses vues, despite its title, is at times a work of fiction, a bedroom drama. With a ferocious irony, Hugo turned the young Chassériau into the character of a pitiful rival, paling at the least emotion, as ugly as he was enamored of the thoughtless actress, affected and thus serious, even in his life of a libertine. Alice's lover cuts a pathetic figure, growing more so when Zubiri starts to lay bare one by one the charms of her fetching anatomy in front of the author of *Hernani:*

For their valuable help on this essay, I would like to thank Guillaume Kazerouni, Robert Kopp, Jérôme Moncouquiol, Deborah Roldán, Didier Rykner, and, last but not least, Gary Tinterow.

1. "L'Espagne est le pays romantique par excellence; aucune autre nation n'a moins emprunté à l'antiquité." Gautier 1880, p. 102: August 27, 1850.
2. "Le musée espagnol est venu augmenter le volume des idées générales que vous devez posséder sur l'art." Baudelaire 1975–76, vol. 2, p. 417.

Fig. 8.1 (cat. 95) Théodore Chassériau (formerly attributed to El Greco), *Copy after a Portrait of a Spanish Princess*, ca. 1838. Oil on canvas, 31¼ x 23⅝ in. (80 x 60 cm). Private collection

191

3. "Cette canaille! se trouver mal parce que je montre ma jambe ! Ah bien ! s'il me connaissait seulement depuis six mois, il en aurait eu des évanouissements ! Mais enfin, tu n'es pas un crétin cependant, Serio ! tu sais bien que Zurbaran a fait mon portrait toute nue . . .
– Oui, interrompit languissamment Serio. Et il a fait une grosse femme lourde, une flamande. C'est bien mauvais.
– C'est un animal, reprit Zubiri. Et comme je n'avais pas d'argent pour payer le portrait, il l'offre en ce moment-ci à je ne sais plus qui, pour une pendule!" V. Hugo 1987, p. 1189.

4. See Paris 1997, p. 114.

5. "Ce matin vous mettez le père Ingres en possession des arcanes de Rome et de Florence, Zurbaran aurait dû m'échoir en partage." Gautier 1985–2000, vol. 3, pp. 337–39. Gautier complied with Ziegler's request; see Gautier 1848b.

6. "M. Ziegler s'est placé à la tête d'une école franco-espagnole qui doit prospérer, et, qui, de 1838 à 1850, finira sans doute par tout envahir. Cette école a pour elle la mode, le besoin du changement, et toute une légion d'auxiliaires lui est venue de par-delà les Pyrénées." Mercey 1838, p. 388.

7. "The Spanish school has so far inspired only one imitation; that is the Saint Bartholomew of M. Muller. . . . [T]he head of Saint Bartholomew, completely eloquent of his physical suffering, offers a remarkably beautiful expression of faith and fervor. This painting's composition is expansive and accomplished . . ." ("L'école espagnole n'a pas encore inspiré qu'une imitation; c'est le Saint Barthélemy de M. Muller. . . . [L]a tête de saint Barthélemy, toute empreinte de souffrance physique, offre une expression fort belle de foi et de ferveur. La disposition de ce tableau est large et savante . . ."). Desessarts 1838.

8. "tendances éphémères ou périmées"; "Un an plus tard, l'Ecole espagnole disparaissait dans l'oubli. Cet effondrement subit doit être imputé, d'abord, à la faiblesse des deux protagonistes. Ceux-ci n'avaient ni le génie, ni la persévérance nécessaires à des chefs. Ziégler [sic], dès 1839, commençait à oublier son rôle. Il n'y avait plus rien d'espagnol dans son ambitieuse et médiocre décoration de la Madeleine. Ziégler finit par s'évanouir dans une peinture blafarde et abstraite. La défection de Brune ne fut ni si rapide ni si complète. Mais il ne retrouva plus de succès éclatants et toute originalité disparut dans sa production. Les décorations qu'il a brossées sous le Second Empire, au palais du Luxembourg, ne laissent pas soupçonner les velléités révolutionnaires de son début."

"That scoundrel! feels faint because I show my leg! Well! Had he known me only for six months, he would have had fainting spells! But really, you aren't an idiot, Serio! You know perfectly well that Zurbaran painted me nude . . ."

"Yes," Serio interrupted languidly. "And he painted a big, heavy woman, a Flemish woman. It's quite awful."

"It's an animal," Zubiri rejoined. "And since I didn't have the money to buy the portrait, he offered it that very moment to I forget whom, for a clock!" [3]

This strange "Zurbaran," the forgotten pretext for the bitter lovers' banter, may very well have been another student of Ingres, long linked to Ozy and even longer to Hugo: Jules Ziegler (1804–1856), remembered today as the decorator of the Church of La Madeleine and the inventor of art ceramics in France. Moreover, the painting mentioned in the quoted exchange might be Ziegler's *Venetian Woman* (1844), now at the Château de Malmaison after having belonged to Gautier and to Ozy herself.[4] Early in 1848 Ziegler offered striking evidence of his own Hispanomania, which he shared with Hugo and to which Gautier, with his *Voyage en Espagne* (Wanderings in Spain, 1845), had brilliantly contributed. In a letter dated April 26, the painter asked Gautier to support his painting *Charles V after Preparing His Funeral Rites,* which he had sent to the Salon. This work, today known only by two preparatory drawings in the Musée de Langres, showed the emperor in retirement at the monastery of Yuste, a popular subject under Louis-Philippe that was taken up by Delacroix, Adolphe Brune, and Alfred Arago, among others. According to Ziegler, his painting symbolized not so much Charles's renunciation of temporal authority as the dethronement of Louis-Philippe, the so-called King of the French, who had done so much to make Spanish painting better known to his fellow citizens. In his letter, Ziegler expressed his admiration for the feverish, somber, and cruel art of "Catholic Spain" and alluded to an article that Gautier had written for *La Presse* contrasting these qualities with the paganism of the Italian Renaissance: "This morning you conferred on old Ingres possession of the mysteries of Rome and Florence; Zurbaran would have to fall to my lot."[5]

A FRANCO-SPANISH SCHOOL?

For ten years before he wrote to Gautier—to be precise, since the Salon of 1838—Ziegler had been considered the son of Spanish art, a sort of French Zurbarán. Not without reason: his *Daniel in the Lion's Den* (fig. 8.2), which was given a prominent place in the Salon Carré and was immediately purchased by the city of Nantes, seemed to set off a Hispanic vogue. The critic Frédéric de Mercey promptly forecast a bright future for this trend, which could only be strengthened by the magnificence of Louis-Philippe's Galerie Espagnole, open since January 7 of the same year: "M. Ziegler has taken his place at the head of a Franco-Spanish school bound to do well, and which, from 1838 to 1850, will end up taking over everything. This school has on its side fashion, the need for something new, and an entire legion of auxiliaries has come to its aid from beyond the Pyrenees."[6]

In his important book on painting during the July Monarchy, published in 1914, Léon Rosenthal dwelled on this particular text by Mercey and on the submissions of Ziegler and Brune to the Salon of 1838, curiously omitting Charles-Louis Muller's *Saint Bartholomew,* which Alfred Desessarts found so pleasing.[7] Rosenthal's aim was to define a Hispanic

current, which he nonetheless classified "among the fleeting or out-of-date trends" of the time. Unlike Mercey, he placed little value on what seemed to him no more than a flash in the pan: "A year later, the Spanish school vanished into oblivion. This sudden collapse should be attributed, first of all, to the weakness of its two protagonists. They had neither the talent nor the perseverance necessary for masters. Ziégler [sic], starting in 1839, began to neglect his role. His ambitious and mediocre decoration for the Madeleine had nothing Spanish in it. Ziégler ended up fading away in a pale and abstract painting style. Brune's defection was neither so rapid nor so complete. But he could not reproduce his brilliant successes and his production lost all trace of originality. The decorations he made under the Second Empire, in the Palais du Luxembourg, give no evidence of the revolutionary caprice of his early years."[8]

A passing trend, a momentary fever more than a lasting style—Rosenthal saw the Spanish flowering of 1838 as an explosion having no consequences. Nor did he think that there was any subsequent fallout before the appearance of the first and second generations of Realists: "The Spanish . . . merited a less superficial examination. Instead of merely borrowing certain outward aspects of their practice, what was needed was to penetrate their soul. We will see, soon, what Courbet, Manet, or Ribot came to learn in the austere and somber rooms where Zurbaran, Ribera, Velázquez, and Goya proclaimed their exalted convictions and their intense feeling for life."[9]

The aim of the present essay is to demonstrate that, with respect to the Spanish inspiration that so strongly marked French painting, Rosenthal's positing of a break in continuity[10] is as contrived as the problematic idea of a break between the historical periods of Louis-Philippe and the Second Empire. The case of Jules Ziegler seems a perfect illustration of the link that Rosenthal refuses to see between these two groups of artists—who were admittedly of unequal worth.

The new pictorial Hispanism brought about by Ziegler in 1838 proved to be troubling and divisive. The reason lay less with the value of his *Daniel* than with fears concerning the future excesses of its proponents: "The imitations of the Spanish school have yet to invade the Salon. Here and there can be seen more or less explicit intentions to adopt the style of Ribera and the Zurbarans. Certain artists, in order to prove that they have the science of these painters' colors perfectly in hand, have executed some dark paintings, in which it is difficult to make out anything but darkness. But wait until 1839, and we will then see a flood of monstrous imitations that will wreak more harm to art than all the pastiches of the German and Italian schools could possibly manage."[11]

In following his early Ingresque style with the "energetic naturalism"[12] of the Spanish, Ziegler did all he could to displease his contemporaries. He nonetheless retained the loyalty of some of the first proponents of Spanish painting in France and even converted others to the cause. His supporters ranged from Gautier to Charles Blanc, from Prosper Mérimée, the creator of *Carmen* (1845), to Louis Viardot, the translator of *Don Quixote*.[13] Mercey, as noted, had expressed great enthusiasm for *Daniel*, which he judged in 1838 to be very like Zurbarán

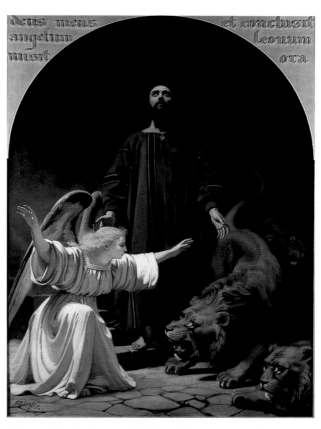

Fig. 8.2 Jules Ziegler, *Daniel in the Lion's Den*, 1838. Oil on canvas, 115⅜ x 83⅞ in. (293 x 213 cm). Musée des Beaux-Arts, Nantes

Rosenthal 1914, pp. 247–48.

9. "Les Espagnols . . . méritaient d'être interrogés d'une manière moins superficielle. Au lieu de leur emprunter quelques pratiques extérieures de métier, il fallait essayer de pénétrer leur âme. Nous verrons, bientôt, ce que Courbet, Manet ou Ribot vinrent apprendre dans les salles âpres et sombres où Zurbaran, Ribera, Velázquez et Goya proclamaient leurs convictions exaltées et leur sentiment intense de la vie." Ibid., p. 248.

10. Lipschutz 1972, p. 212, agrees with Rosenthal's assessment.

11. "Les imitations de l'école espagnole n'ont point encore envahi le Salon. On voit ça et là apparaître des intentions plus ou moins explicites de se rallier à la manière de Ribera et des Zurbaran. Quelques-uns, pour prouver qu'ils possédaient parfaitement la science de la couleur de ces peintres, ont fait des tableaux noirs, où l'on serait en peine de voir autre chose que du noir. Mais attendons 1839, et nous verrons alors surgir de monstrueuses imitations qui feront plus de tort à l'art que n'en eût pu faire tous les pastiches des écoles allemande et italienne." Bourjot 1838.

12. "naturalism énergique." Mercey 1838.

13. A true connoisseur of Spain and its

heritage, Viardot compared the colors employed by Ziegler in the Madeleine's semidome to those of the "warm" Ribera. Viardot 1838.

14. "composition de ce tableau est d'une heureuse conception, et ce sujet, souvent traité, ne l'a jamais été dans de meilleures conditions de simplicité biblique." Amateur 1838.

15. "C'est une composition des plus simples, grand mérite, et, de plus, où ne se voit aucune imitation affectée des anciennes peintures catholiques." Anon. 1838g, p. 85.

16. "La composition est simple. . . . La couleur, pour être brillante, n'en est pas moins fine et harmonieuse, elle a quelques teintes de Murillo et d'Alonso Cano. Le dessin, généralement pur et distingué, a des parties peu correctes ou trop indécises. Un reproche plus grave que l'on pourrait faire à cette oeuvre consciencieuse et même éminente, . . . c'est de manquer à demi l'effet de grandeur et de naïveté qu'elle a cherché, et que nous attendons de M. Ziegler." Haussard 1838.

17. "style sec et guindé des vieux maîtres chrétiens." Thoré 1838, pp. 39–40, which also discusses the critic's reservations.

18. Planche 1855, pp. 112–15.

19. Parallels for *Daniel*'s composition may be found in portrayals of other Christian martyrs, and the blond angel with colored wings suggests that of Murillo's *Annunciation* (Musée de Grenoble). See Mercey 1838, p. 388.

20. "composition vraie, touchante et énergique "; " l'attention des artistes et du public." Deléczue 1838.

21. "Espagne des extrêmes." Adrien Goetz, preface to Mérimée 1846 (2000 ed.).

22. See Gautier 1836.

23. "beauté sincère et vraie." Gautier 1837.

24. "quelque tableau espagnol." Mercey 1838, pp. 387–88.

25. The copy, included in the painter's estate sale in 1857, is today in the Church of Monts, near Tours. Mercey 1852 mentions the painting by Zurbarán.

26. "l'ardeur somber." Gautier 1838c. See also Anon. 1833, pp. 84–85.

27. In the Salon of 1834, Ziegler also showed *An Evangelist* (Cathedral of Condom), which depicted St. Matthew writing his Gospel under divine inspiration. Like *Daniel*, which was exhibited four years later, this work clearly contrasts a graceful angel and a robust holy man, calling to mind the famous precedent of Caravaggio's first version of *Saint Matthew and the Angel* for the altarpiece of the Contarelli Chapel (1602; destroyed). The face and brown tunic of Ziegler's Matthew are, however, more reminiscent of Ribera.

28. See Anon. 1835c, pp. 27ff.

in its image of the intense prophet, dressed in a flowing brown tunic, and very like Murillo in its angel with blond tresses come to calm the lions. In his translation of the mystical dialogue connecting the prophet to God, Ziegler has the angel with colored wings appearing while Daniel is still at prayer. All upward movement, which would tend to connect Daniel and the celestial messenger, as in Tintoretto, has here been set aside. The luminous advent of the angel in that dark den and the powerful hieratic portrayal of the prophet produced a striking reflection of fiery Spain, one that is perhaps later recalled in Manet's *Dead Christ and Angels* (fig. 9.51).

Daniel had its champions even among those looking to renew religious painting. Thus, the critic for *La Quotidienne* was not alone in thinking that the "composition of this painting is well thought out, and the subject, often taken up, has never been treated with a better biblical simplicity."[14] That such simplicity did not go to the extremes of the Pre-Raphaelites, then in vogue, pleased the critic of *L'Artiste*, who also rebelled at the abstraction of the Nazarenes and the followers of Ingres: "It is the simplest of compositions, of great merit, showing not a trace of pretentious imitation of early Catholic paintings."[15] Prosper Haussard, who was more discerning, thought the Hispanic power of the work incomplete: "The composition is simple. . . . The color, for all its brilliance, is no less fine or harmonious, containing some tints of Murillo and Alonso Cano. The drawing, generally pure and elegant, has some awkward or uncertain aspects. A more serious criticism that can be made of this conscientious and even lofty work . . . is that it is greatly lacking in the effect of nobility and naïveté that it sought, and which we expect from M. Ziegler."[16] Théophile Thoré decisively separated "Messrs. Brune, Ziegler, and Muller" from the followers of the "dry and stilted style of the old Christian masters," while still voicing reservations about the mixture of realism, fantasy, and artificial naïveté that characterized *Daniel*.[17] And Gustave Planche attacked the canvas for its want of both verisimilitude and nobility.[18]

In general, the press willy-nilly subscribed to *Daniel*'s combination of a synthetic style and realistic vigor, to its fusion of a dense coloration and a loose technique within a fixed design, which Ziegler linked to the heritage of Zurbarán and, more precisely, to the iconography of *Saint Francis in Meditation* (fig. 2.13).[19] After all, the *Saint Francis*, with its "true composition, touching and energetic," had attracted "the attention of artists and the public" more than any other work in the Galerie Espagnole since its opening.[20] The "Spain of extremes,"[21] of dark dramas and white heat, had been the territory of modern authors since the end of the 1820s, including Chateaubriand, Mérimée, and the young Hugo. As soon as Gautier dreamed of a Villa Medici beyond the Pyrenees[22] and Louis-Philippe offered his subjects four hundred paintings of a "sincere and true beauty,"[23] the same Spain fertilized the new painting once and for all.

DARK WORKS IN THE STYLE OF INGRES

Some individuals did not wait for the opening of Louis-Philippe's gallery before familiarizing themselves with seventeenth-century Spanish painting (see Jeannine Baticle's essay in this publication). The collections of Marshal Jean de Dieu Soult and Alejandro María López Aguado, to mention only two, initiated more than one artist in the field before 1838. Ziegler himself was one of these, as Mercey perspicaciously implied the year *Daniel* was painted, associating the metamorphosis of the student of Ingres with the revelation afforded by "a certain Spanish painting."[24] This work may well have been Zurbarán's *Saint Lawrence*

(1636, State Hermitage Museum, St. Petersburg), which Ziegler saw in the Soult collection and copied almost to scale.[25] Its influence can be discerned as early as 1833, in Ziegler's *Giotto in Cimabue's Studio* (Musée des Beaux-Arts, Bordeaux), which Gautier himself connected to the "somber ardor" of the Iberian masters,[26] and even more strongly in *Saint George Fighting the Dragon* (Musée des Beaux-Arts, Nancy), exhibited at the Salon of 1834.[27] Moreover, *Daniel* had been a long time in the making: on February 14, 1835, *L'Artiste* had announced that a work so entitled would be in the next Salon.[28] *Giotto,* which had already developed the theme of the prodigal son and the cult of genius in its natural state, may also have articulated Ziegler's interest in the Spanish aesthetic—one that had explored the opposition (traditional since Vasari) between a desiccating formalism and an inexhaustible dialogue with nature.[29] In the same period, the young Thoré, in the pages of *L'Artiste,* presented the fate of Zurbarán in similar terms: a true Spanish Giotto, this son of farmers had been safeguarded from false idealism.[30] Thoré neglected to add to this summary portrait Zurbarán's religious mysticism, one of the topoi in discussions of Spanish painters since Alexandre de Laborde, and one of the reasons for the spread of the Spanish style in religious art between 1830 and 1840.

Laborde had established the topos in 1806, declaring of Spanish art: "Nowhere else is ecstasy, unction, true piety as well expressed as in their works, and mystical passions rendered with more warmth."[31] Thirty years later this strain of dominant religiosity would be seen sometimes as an act of faith, sometimes as a sign of obscurantism and servitude toward the church. The anticlerical attitudes of some[32] clashed with the mysticism of others. In the mid-1830s Alexandre de Saint-Chéron, undoubtedly the author of the following remarks, strongly urged the reform of religious art. For him, the painting of old Spain, like that of the German Nazarenes, was not a stimulus to "the immorality or deformity" that characterized the Romantic school of "l'art pour l'art" (art for art's sake) but the model of a "religious, moral inspiration, which [has] given the beggars, the wretched, the lame, the prodigal sons of Murillo the character that exalts them."[33] With this style, painters who could not always summon up faith could still evoke the fervors of old, even at the risk of having to rely on the strong emotions of tenebrism. At the very moment when Romanticism was seeking a second wind, as Mercey noted in 1838,[34] Iberian art appeared to be a possible resource—or, indeed, a point of departure.

At the Salon of 1839 Ziegler exhibited *Saint Luke* (Musée des Beaux-Arts, Dunkirk), a painting on the theme of the inner eye and the elected of God,[35] which Gautier described as the happy marriage of a line worthy of "M. Ingres" and color that "had some correspondence with that of Zurbarán."[36] Alphonse de Cailleux, assistant director of museums, made sure to bring the canvas ("an important work") to the attention of the comptroller of the civil list, who played a decisive role in selecting works to be bought by the crown. Among the works displayed at the Salon, he affirmed it as "a return to the best studies, [having] more prudence in the composition as in the execution and even more vigor and energy in the color. The influence of the new Galerie Espagnole makes itself visibly felt. For a long time the young artists, in distancing themselves from the wise principles of the École, appeared to want to immerse themselves in exaggeration; the Spanish paintings . . . seem to have stabilized their views and recalled them to better principles. The enlightened munificence of the King has been able to give a new direction to these studies; this is another benefit for the artists."[37] Cailleux's proposal went through, and *Saint Luke* was bought at a high price (5,000 francs); it is the most expensive painting in the list of purchases for the civil list of 1839.[38]

29. Curiously, the painting on which Cimabue is working is thought to be *The Road to Calvary,* which entered the Louvre in 1814 and was attributed to Ghirlandaio for a long time before being ascribed to Biagio d'Antonio. But is the painting sufficiently stiff to invoke art before Raphael and its reputed ideal of aesthetic and religious sincerity? Note also that Derain considered it worthy of copying in 1901.

30. Thoré 1835b, pp. 225–26. The idea that Spanish painters, by virtue of their social and artisanal origins, retain more of "l'homme de la nature" (the man of nature) comes up in an article by Jean-Baptiste Boutard forgotten until now: "Used to seeing a more noble nature, made livelier by the passions, having a more beautiful quality, their naive paintings have a certain exaltation, a certain spirit, lacking in Flemish paintings" ("Habitués à voir une nature plus noble, plus animée par les passions, d'un plus beau caractère, leurs peintures naïves ont une certaine élévation, une certaine verve, qui manquait aux tableaux flamands"). Boutard 1817.

31. "Nulle part l'extase, l'onction, la vraie piété ne sont aussi bien exprimées que dans leurs ouvrages, et les passions mystiques rendues avec plus de chaleur." Quoted in Lipschutz 1972, p. 147.

32. See, for example, Beauvoir 1837, pp. 1–3.

33. "l'immoralité ou la difformité"; "inspiration religieuse, morale, qui [a] donné aux mendiants, aux pouilleux, aux paralytiques, aux enfants prodigues de Murillo ce caractère qui les relève." See S.-C. 1836, pp. 38–42.

34. "What can be tried today that has not already been done? What can be invented that is new?" ("Aujourd'hui que peut-on essayer dont on ne soit déjà fatigué? Que peut-on inventer qui ne l'ait déjà été?") Mercey 1838, p. 408.

35. The *Saint Luke* so effectively crystallized religious fervor that the poet Gérard de Nerval remembered it six years later when he came to characterize the Fourierist Journet, of whom Courbet painted a well-known portrait: "Jean Journet prepared his clothing to match his interests. He wears a kind of hooded cloak or dalmatic in a coarse fabric of brown wool that recalls the Byzantine coat of Ziegler's Saint Luke . . . shown at the Salon several years ago" ("Jean Journet s'est arrangé un vêtement en harmonie avec ses occupations. C'est une espèce de caban ou de dalmatique en grosse étoffe de laine brune qui rappelle le paletot byzantin du Saint Luc de Ziegler . . . , exposé au Salon, il y a quelques années"). Nerval 1845.

36. "a des rapports avec celle de Zurbaran." Gautier 1839.

37. "oeuvre capitale"; "un retour à de meilleures études, plus de sagesse dans la composition comme dans l'exécution et même plus de vigueur et d'énergie dans la couleur. L'influence de la nouvelle galerie espagnole s'y fait visiblement sentir. Depuis longtemps les jeunes artistes en s'éloignant des principes sages de l'Ecole paraissaient vouloir se jeter dans l'exagération; les tableaux espagnols . . . semblent avoir fixé leurs idées et les rappeler à de meilleurs principes. La munificence éclairée du Roi a su donner une nouvelle direction aux études; c'est encore un bienfait pour les artistes." *Rapport à Monsieur l'Intendant Général sur l'exposition de 1839* (Archives des Musées Nationaux, Paris, X. 1839).

38. Archives des Musées Nationaux, Paris, X. 1839.

39. Ziegler persisted in making works that combined an Ingresque fidelity with a Spanish sensibility. Discussing his *Our Lady of Snows* (1844, Musée Municipal, Bourbonne-les-Bains), Gautier (1844b) invoked Murillo. Ziegler's *Judith* of 1847 (Musée des Beaux-Arts, Lyon), "with a sure and confident appearance, in the clarity of contours, the dark placement of flesh tones and fabrics, the violent and dark nature of the composition, recalls certain masters of the Spanish school, Alonso Cano or Juan Valdés Leal" ("d'un aspect ferme et décidé, rappelle pour la netteté des contours, la localité rembrunie des chairs et des étoffes, le caractère violent et sombre de la composition, certains maîtres de l'école espagnole, Alonso Cano ou Juan Valdés Leal"). Gautier 1847c, pp. 35–37. And the *Jacob's Dream* in the same Salon combined the Raphael of the Vatican and Ribera, whose *Jacob's Dream* was known through a print by Achille Réveil (repr. in Lipschutz 1972, p. 88).

40. See Sandoz 1982 and Paris–Strasbourg– New York 2002–3.

41. See the account devoted to Comayras in Montauban–Besançon 1999–2000, p. 76, and Baudelaire's remarks concerning him in his review of the Salon of 1845 (Baudelaire 1933).

42. "Les attitudes contournées, les poses frénétiques, les figures baroquement coupées par le cadre, contribuent à donner à cette composition une tournure insolite et barbare dont les fadeurs de la peinture contemporaine nous ont totalement déshabitués. Les petites maîtresses éprises des ivoires, des satins et des meubles cirés à l'encaustique de Paul Delaroche, se détourneront de cette peinture et la trouveront rebutante." Gautier 1838b. For Eugène Appert, who might also be classed among Ingres's students, see Gautier 1844b; Gautier

Fig. 8.3 Théodore Chassériau, *Petra Camara*, 1852. Oil on panel, 12⅛ x 9¼ in. (32.2 x 23.4 cm). Szépművészeti Múzeum, Budapest, Donated by Baron Hatvany, 1916

Flattery aside, Cailleux was right to insist on the curative virtues of Hispanic art. Consider, for example, the production of three of Ingres's students about 1840: Ziegler, Chassériau, and Philippe Comayras. Ziegler continued to paint[39] but also collaborated on the *Galerie morale et religieuse* (Moral and religious gallery), a suite of lithographs printed by Lemercier and published by Victor Delarue from 1836 to 1839. Included among these were a great number of religious images after old masters (Raphael, Carlo Dolci, Philippe de Champaigne), works currently gaining recognition (Velázquez,

Murillo, Cano), and a few contemporary pieces, notably by Ziegler and Émile Signol. Chassériau's debt to Spanish painting was long ago revealed by Marc Sandoz, who studied direct copies as well as more subtle parallels and citations.[40] To this may be added the artist's fascination with Spanish dancers, such as the sinister and ardent Petra Camara (fig. 8.3). There is certainly something of Zurbarán in the portrait of the Dominican friar Jean-Baptiste-Henri Lacordaire (1841, Musée du Louvre, Paris), of Ribera and Murillo in the head of Christ painted a year earlier in the Church of St.-Jean-d'Angély, or in that of St. Francis Xavier, less somber but just as feverish, in the Church of St.-Roch (1853). Even the extraordinarily harmonious *Portrait of Mlle de Cabarrus* (1848, Musée des Beaux-Arts, Quimper) has a quality that brings to mind Spanish moiré fabrics rather than the shiny silks of Ingres. The iconography of *Justice* in the Cour des Comptes can be seen to have some connection with the two famous Vanitas paintings by Juan Valdés Leal in the Church of the Hospital de la Caridad of Seville, before which Gautier stopped in a well-known passage in his *Voyage en Espagne*.

Chassériau left a small portrait in sanguine depicting Comayras (1803–1875) dozing in Ingres's atelier (Musée Carnavalet, Paris). Although he was Chassériau's senior by more than ten years, this illegitimate son of the famous miniaturist Mme Marie-Victoire Jacquotot undoubtedly would have shared his penchant for things Spanish. This

Fig. 8.4 Jacques-François-Gaudérique Llanta (after Jules Ziegler), *The Good Shepherd*, 1839. Lithograph. Bibliothèque Nationale de France, Département des Estampes, Paris

remains difficult to judge, however, as long as Comayras does not receive the attention he deserves.[41] *Ecce Homo* (location unknown), shown at the Salon of 1838, was a definite turning point for this artist, and one that evoked Gautier's enthusiasm: "The twisted positions, the frenzied poses, the figures baroquely cut off by the frame combine to give this composition an unusual and wild aspect for which the tameness of contemporary painting has left us completely unprepared. The little mistresses in love with the ivories, satins, and furniture waxed with the encaustic of Paul Delaroche would turn away from this painting, finding it repulsive."[42]

Although not a student of Ingres, Jacques-François-Gaudérique Llanta is also relevant to this discussion. Llanta's lithograph after Ziegler's painting *The Good Shepherd* (fig. 8.4), although too flat in comparison with its much livelier model, preserved something of that painting's iconic aspect, conferred by the imposing cruciform halo and the inscription in antique letters ("Ego Sum Pastor").[43] Zurbarán's influence is undeniably apparent here.

1845b; and Georges Vigne in Montauban–Besançon 1999–2000.

43. The painting of *The Good Shepherd*, which undoubtedly served as the model for the print of 1839, was in a private collection in Paris, as it is today. In this stripped-down canvas, Christ wears a white tunic covered by a red cloak, respectively symbolizing purity and sacrifice; the same qualities are suggested by the sheep he carries.

44. Eleven years ago, Pierre Rosenberg examined the view of a storied Spain created by French travelers, writers, and painters during the eighteenth and nineteenth centuries. See Pierre Rosenberg, "De Ribera à Ribot," in Naples–Madrid–New York 1992, pp. 147–63 (Madrid ed.). Ilse Hempel Lipschutz has also treated this subject in depth; see, for example, Lipschutz 1972. My remarks are intended to add to their studies.

45. "peinture atroce"; "âpreté féroce"; "peintre à la rude brosse." Gautier 1916–19, vol. 2, p. 115.

46. See Paris–Versailles 1989–90, no. 36. Some years before, the *Saint Jerome Writing* by Jean-Baptiste Deshays (ca. 1765, St. Louis Cathedral, Versailles) had also shown the influence of Ribera.

47. As confirmed by his *Journal* (see, for example, the entry for March 19, 1824), Delacroix shared with Géricault a strong admiration for Velázquez. His debt to Goya, which has likewise received much comment, may extend to his *Medea* (1838, Palais des Beaux-Arts, Lille), whose eyes veiled in shadow recall the effect of mantillas in certain plates of the *Caprichos* (see, for example, *Bellos consejos* [*Good Advice*], no. 15). On the other hand, it seems pertinent to relate the *Saint Sebastian* in the church at Nantua (Salon of 1836) to Ribera's painting on the same subject, engraved by Réveil (reproduced in Lipschutz 1972, p. 88).

48. Contemporary criticism instead emphasized the influence of Italian art on Heim's work; see, for example, Delécluze 1819, p. 183.

49. "Souvenez-vous de l'effrayante impression du regard de saint Hippolyte, le vieillard à cheveux blancs, que deux chevaux furieux entraînent, la tête renversée, à travers les buissons et les épines. C'est du Ribera . . . cela, et sans chercher le pastiche." Saint-Santin (Philippe de Chennevières) 1867, pp. 40–62. Gautier also found parallels with Ribera; see Gautier 1855–56, vol. 1, pp. 263–64.

50. "Ziegler plutôt par l'exécution que par le choix de ses sujets, seulement il est moins sobre et moins contenu, et l'on ne retrouve plus chez lui l'élève de M. Ingres·" Mercey 1838, p. 388.

51. "M. Brune est tombé dans la faute de plusieurs coloristes fascinés par l'exemple de M. Ingres; il a cherché l'unité de l'aspect aux dépens de la vigueur du ton; il a perdu ses propres qualités sans gagner celles du maître." Gautier 1840.

RIBERA, OR THE LOVE OF THE UGLY

It is revealing that Gautier's review of the 1838 Salon associated Comayras with Adolphe Brune (1802–1875), one of Rosenthal's benchmarks, as well as with Valentin, Caravaggio, and Ribera. Like most of the proponents of Romantic tenebrism, Gautier did not follow any one model exclusively. Plurality was the rule, and Spain in its Golden Age was considered not very far from Caravaggio's Rome. In this respect, the Spanish-born Ribera with his long career in Naples served as the perfect connecting link between the two traditions.[44] Linked to the Spanish school by Frédéric Quilliet in 1816, the Neapolitan seemed, so to speak, to be an Italian version of Zurbarán, one more easily adaptable and thus less novel, when works by both appeared in Louis-Philippe's Galerie Espagnole. Yet it would be wrong to think that the attraction of Ribera's art—"cruel painting," of such "ferocious harshness" and "rough brushwork," as Gautier described it in his book of poems *España* (1845)[45]—had been dulled by the end of the eighteenth century, when French painting in fact closely approached that of Ribera for the first time.

Ribera's paintings were familiar to Jacques-Louis David, whose *Saint Jerome* of 1780 verged on a pastiche of the earlier master's work (fig. 8.5). They were less known to his contemporaries and the generation that came to maturity toward the end of the Empire.[46] While the tenebrist vogue reflected in the Salons during the Restoration years was not limited to Géricault and Delacroix,[47] it is more difficult to measure the influence there of Spanish realism, and even of Ribera (aside from the tenebrism passed on from the years 1790 to 1810). Some of the church paintings of François-Joseph Heim (1787–1865), a student of François-André Vincent and a recipient of the Grand Prix de Rome, hint at the Spanish style that would develop fully under Ziegler, who, as it happens, initially studied under Heim.[48] Heim first exhibited at the Salon of 1812, where he won a first-class medal. His second medal came in 1817, most notably for *Joseph's Coat Brought to Jacob* (Musée du Louvre, Paris), which can be seen as the culmination of the tendency toward darkness of emotion and atmosphere in Revolutionary and Consular painting. Such compositions as *The Martyrdom of Saint Hippolytus* (Salon of 1822, formerly collection of the Cathedral of Notre-Dame, Paris), with its strong gestures and fully modeled bodies, helped Heim to make his mark at the beginning of the 1820s. In 1867, with Hispanism at its height, Philippe de Chennevières lavished praise on *The Martyrdom:* "Do you recall the frightful impression of Saint Hippolytus's gaze, the old man with white hair, whom two spirited horses are dragging, head twisted, through thickets and thorns. That comes from Ribera . . . and without looking for pastiche."[49]

From Heim to Brune, there was basically no interruption of continuity. Launching his career with *The Temptation of Saint Anthony* (location unknown), Brune was associated by Mercey in 1838 with the Franco-Spanish school that he himself had defined. In discussing the artist's *Apocalyptic Vision* (1838, location unknown), Mercey noted that Brune was related to "Ziegler by his execution more than by the choice of subjects, except he is less dark and less controlled, and the student of M. Ingres can no longer be seen in his work."[50] Gautier, speaking of *The Dragon of the Isle of Rhodes* (1840, location unknown) two years later, attributed the failure of Brune's less than vigorous art to a desire to correct the master's style: "M. Brune has fallen into the trap of many colorists fascinated by the example of M. Ingres; he has sought overall unity at the expense of vigor of tone; he has lost his own strengths without gaining those of the master."[51] Struck by the memory of the paintings of

Fig. 8.5 (cat. 60) Jusepe de Ribera, *Saint Jerome Listening to the Sound of the Heavenly Trumpet*, 1626. Oil on canvas, 72⅞ x 52⅜ in. (185 x 133 cm). State Hermitage Museum, St. Petersburg

52. "M. Brune a été jadis plus original. – Qui ne se rappelle *L'Apocalypse* et *L'Envie?* " Baudelaire 1975–76, vol. 2, p. 369.

53. "la manière du Caravage et de Ribera." Gautier 1846. For Brune's painting, see Troyes 1989, p. 18.

54. "Les noms de Caravage et de Ribera amènent tout naturellement celui de M. Hippolyte Debon, qui, sous le titre bénin de *Concert dans l'atelier*, nous montre une réunion de sacripants à la mine rébarbative, prêts à vous coiffer de leurs instruments si vous ne trouvez pas la musique à votre goût.—Il est impossible de s'amuser avec un air plus féroce, dans une ombre plus sinistre et plus noire. . . . En art, la force même brutale est une qualité si rare qu'on ne saurait trop l'estimer. M. Fernand Boissard peut aussi se ranger dans les talents réalistes qui s'inspirent de l'école espagnole et cherchent la vérité, l'énergie et la couleur sans grand souci du style et des traditions antiques." Gautier 1846. For Boissard, see, for example, Boisdenier 1856 and Lacambre 1975.

55. In describing this trend, Désiré Laverdant (1842) spoke of the "prettifying of ugliness" ("enjolivement de la laideur"). See also Paris 1997, pp. 50–63. In his obituary of the artist Prosper Marilhat, Gautier evoked a painting by Adolphe Leleux in the Impasse du Doyenné representing "drunks, crowned with ivy, in the style of Velázquez" ("ivrognes, couronnés de lierres, dans le goût de Velázquez"). Gautier 1848a.

56. "Pour lui, pas d'Apollon, pas de Vénus pudique, / Il n'admet pas un seul de ces beaux rêves blancs, / Taillés dans la paros ou dans le pentelique." Gautier 1846.

57. See McWilliam 1993, pp. 196, 222.

58. "à la fois Decamps et Diaz, un peu les Espagnols, et beaucoup les Le Nain, ces grands et naïfs artistes du dix-septième siècle, auxquels la postérité n'a pas encore accordé leur place légitime parmi les meilleurs peintres de l'école française." Thoré 1868, p. 506.

59. See Champfleury 1848.

60. See P. Georgel 1995, p. 19.

1838 and 1840 or, more likely, by reading Gautier, Baudelaire in 1845 professed himself sorry to see the painter giving way to the insipidities common to the Salons at the end of the July Monarchy: "M. Brune was formerly more original.—Who does not remember *The Apocalypse* and *Envy?*"[52]

Brune's flame did not go out completely after 1840, as his painting *Cain Killing Abel* (Musée des Beaux-Arts, Troyes), shown at the Salon of 1846, bears witness. Gautier related this work to "the style of Caravaggio and Ribera"[53] by virtue of its strong modeling and exaggerated chiaroscuro. He also connected Brune with other followers of a powerful style: "The names of Caravaggio and Ribera naturally lead us to that of M. Hippolyte Debon, who, under the benign title *Concert in the Studio* [1846, location unknown], shows us a gathering of scoundrels with barbaric aspect, ready to clobber you with their instruments if you don't find the music to your liking.—It is impossible to find amusement with a more ferocious appearance, in a more sinister or darker shadow. . . . In art, forcefulness, even if brutal, is such a rare attribute that it cannot be overvalued. M. Fernand Boissard might also be placed among the talented realists who are inspired by the Spanish school and seek truth, energy, and color without worrying greatly about style and ancient traditions."[54]

The naturalism that galvanized history painting, primarily in religious scenes, was accepted by Gautier and his fellow critics Thoré, Haussard, and Paul Mantz in genre paintings as well, including the works executed by the Leleux brothers after 1840. The meaning of this proto-Realism, of the boldness rather suddenly ascribed to it, and of its refusal of anecdote (which relates to a certain conception of art for art's sake) have been discussed elsewhere.[55] Neither Adolphe nor Armand Leleux was content to simply paste Spain or the peasants of Navarre onto the landscape of their rustic paintings; each wanted his brushwork to be Spanish as well. Speaking of the former, Gautier evoked the poem he dedicated to Ribera in *España:* "For him, not Apollo, nor chaste Venus, / He admits not one of these lovely white dreams, / Carved from Parian or Pentelic marble."[56]

In the 1840s Romantic Hispanism thus spread its offshoots everywhere, including the beginnings of Realism. Even Fourierist critics turned more openly toward the Spanish school. They would primarily invoke Murillo when they wanted to encourage painting that could convey the personal magnetism of individuals, the energy that linked them with the whole of existence. Or they would note that Ribera, before Delacroix or Nicolas-Toussaint Charlet, had led the way to an art that reflected the sufferings of humanity.[57] Giving an account of Millet's *Oedipus Taken down from the Tree* (National Gallery of Canada, Ottawa) at the time of the Salon of 1847, Thoré swore that he had seen in the artist's studio canvases that recalled "at the same time Decamps and Diaz, the Spanish somewhat, and the Le Nains a great deal, those great, naive artists of the seventeenth century, to whom posterity has yet to award their rightful place among the best painters of the French school."[58] Champfleury, speaking about Courbet in 1848 with the same enthusiasm that their friend Baudelaire had shown for Spanish painting, also confirmed the lasting fertility of Ribera, Velázquez, and Murillo.[59] Both Millet and Courbet (who did not hesitate to copy Ziegler and Victor Schnetz in his early years)[60] would carry on the Spanish trope until the age of Whistler and Manet. From his very first contact with France, the American painter combined the French and Spanish aesthetics. Aside from the example of Courbet, which led to his involvement with Henri Fantin-Latour and Alphonse Legros, Whistler made a copy (commissioned

from a private collector and now lost) of Ziegler's *Saint Luke* when it was in the Musée du Luxembourg.[61]

As for Manet, his works of the 1860s are inseparably linked to the Hispanism of the preceding generation.[62] It is highly likely, for instance, that the artist read Gautier's *Voyage en Espagne:* his *Mlle V . . . in the Costume of an Espada* (fig. 9.34) clearly draws upon terminology Gautier employed there in his comments on bullfighting.[63] More to the point, the very image of Spain portrayed in the *Voyage*—the "ideal Spain that conserves the human specimen in all its primitive integrity"[64]—extends throughout Manet's work. This image so generously supplied the characters, from the *espada* to the dancer, that peopled his paintings, characters that combined the common touch with timeless nobility: "The least beggar is draped in his coat like a Roman emperor in his purple," wrote Gautier while visiting Burgos.[65] Gautier finds, and celebrates, the special nature of the Spanish people only at the bottom of the social scale or at the margins of the middle class, scorning the latter for being oblivious to its national roots. His *Voyage en Espagne,* reprinted numerous times over the course of the century,[66] is not only French Romanticism's most beautiful love letter to the land of Cervantes, El Greco, and Goya; it is also a great text that many artists would subsequently draw on as they sought a mythology that would serve their desire for a different art, free of all idealization. And, as the novelist Huysmans suggested in 1881, perhaps Degas, with *The Little Fourteen-Year-Old Dancer,* was recalling the morbid fascination expressed by Gautier as he stood before the *Christ* in the Cathedral of Burgos or before some other saint's statue, real to the point of hallucination.[67] True and expressive, Romantic, therefore modern.

61. See A. Young et al. 1980, vol. 1, p. 5.
62. Significant in this regard is Gautier's response to Manet's *Spanish Singer* at the Salon of 1861. See Paris 1997, pp. 68–70.
63. See Paris–New York 1983, p. 113.
64. "Espagne idéale qui conserve le type humain dans toute son intégrité primitive." See Gautier 1981, p. 40.
65. "Le moindre mendiant est drapé dans son manteau comme un empereur romain dans sa pourpre." Ibid., p. 91.
66. There were ten printings between 1845 and 1875. See Benassar 1998, p. viii.
67. See Stéphane Guégan, "Clésinger, Degas, De Andrea, etc.: La sculpture aux limites de l'art ou l'hallucination réaliste," in Pesenti Campagnoni and Tortonese 2001, pp. 87–110.

Manet and Spain

Juliet Wilson-Bareau

The impact of Velázquez on the art of Édouard Manet (1832–1883) was profound. Manet was attracted to Velázquez at the beginning of the 1860s by what he saw as the master's bold and simple handling of clean, colorful pigments and by his way of placing figures on a canvas. Manet's very short trip to Spain in 1865 considerably extended his knowledge of the master's work by direct experience of indisputably authentic paintings. In tracing the influence of Velázquez on Manet's art, this essay also addresses the pivotal role played by Goya. Profoundly affected by Velázquez, Goya was able to revitalize the art of his own day with original and modern works that had already inspired such artists as Delacroix. Through them, Manet came to understand how the splendors of a long-lost "Golden Age" could be reinterpreted for the modern world.

During Manet's time, Spanish culture had begun to fascinate French writers and artists. On February 25, 1830, Victor Hugo's *Hernani* (fig. 14.35), a wild tragedy of love and honor set in fifteenth-century Spain, opened with much fanfare in Paris. The Romantics, partisans of the new tendencies exemplified by Hugo's play, found in it another reason to clash with the partisans of the existing "high" style, soon to be dubbed the Classics. In fact, Spain provided a perfect locus for much of the new writing. The author Prosper Mérimée traveled extensively on the peninsula in the same year. His enthusiasm for Spain and its culture, communicated in five articles published between 1831 and 1833,[1] encouraged other writers and artists to visit that little-known and relatively inaccessible land. Delacroix first set foot on Spanish soil in January 1832—by coincidence the same month that Manet was born in Paris.

EARLY INFLUENCES

Manet's family was well-to-do and well connected. His father, Auguste, trained as a lawyer and spent twelve years as director of personnel in the Ministère de la Justice and sixteen as a judge in the Tribunal de Première Instance for the department of the Seine.[2] His mother, born Eugénie-Désirée Fournier, was the goddaughter of Jean-Baptiste-Jules Bernadotte, a general, marshal, and ambassador under Napoleon who became King Charles XIV John of Sweden in 1818. A reasonably wealthy woman in her own right, Eugénie helped to support Édouard for many years, making him loans against his inheritance. Édouard, who married his model and former piano teacher, Suzanne Leenhoff, in 1863, lived with his wife in the same house as his mother from 1866 until his death in 1883.

Manet and his brothers, Eugène (1833–1892) and Gustave (1835–1884), went to good schools, but Édouard was a lackluster student. The years that he spent at the Collège Rollin had two benefits: the baccalaureate, which he earned in 1848,[3] and his acquaintance with

1. Mérimeé 1831a (on an execution), 1831b (on bullfights), 1831c, 1832, and 1833b.
2. For further information on Auguste Manet, see Locke 1991.
3. Darragon 1989, p. 12, believes that Manet owed his baccalaureate to his father's friendship with the school's director.

Fig. 9.1 (cat. 131) Édouard Manet, *The Spanish Singer (The "Guitarero")*, 1860. Oil on canvas, 58 x 45 in. (147.3 x 114.3 cm). The Metropolitan Museum of Art, New York, Gift of William Church Osborn, 1949 (49.58.2)

203

4. The 1913 edition of Proust's reminiscences reveals that Proust left Rollin in 1847 (p. 9), and Arches (1981, p. 314) states that he finished his education at the Collège Henri IV, not at Rollin. Proust published five articles titled "Édouard Manet. Souvenirs" in the *Revue Blanche* in 1897. After his death, A. Barthélemy republished these texts, with significant additions and deletions, as *Édouard Manet: Souvenirs* (Paris, 1913). Proust's recollections, compiled from contemporaneous notes according to the author, are a vivid firsthand, but necessarily partial, account of Manet's life and must be used with caution. For every quotation from Proust the following notes give three citations: the *Revue Blanche* articles, the Caen 1988/Paris 1996 reprint thereof, and the 1913 edition.

5. The departmental archives of Seine-Inférieure preserve the ship's rolls for Manet's voyage. Eleven letters that he wrote to parents and friends during the trip also survive (Manet 1928; Manet 1991, pp. 18–25).

6. Darragon 1989, p. 20.

7. Boime 1971, p. 66. Boime gives a clear account of the relationship between Couture, the Academy, and competing studios (pp. 65–77).

8. "voir Rubens, s'inspirer de Rubens, copier Rubens, Rubens était le dieu." Proust 1897, p. 128; 1988/1996, p. 15; 1913, p. 24.

9. Manet's earliest biographer, Edmond Bazire, lists the cities that Manet visited during these developmental years as Kassel, Dresden, Florence, Munich, Prague, Rome, and Venice (Bazire 1884, pp. 10–12). There is no documentary evidence for Bazire's claims about the German and Austrian sites. Proust speaks rather more broadly on the question, mentioning Belgium, Holland, Germany, and Italy (Proust 1897, p. 133; 1988/1996, p. 22; 1913, p. 31). But he also writes: "the Rubenses in Antwerp, the Rembrandts in Amsterdam, the [Flemish] primitives in Brussels, the Hals in Haarlem, the Albrecht Dürers in Dresden, the Holbeins in Basel made an impression on him" ("les Rubens d'Anvers, les Rembrandt d'Amsterdam, les primitifs de Bruxelles, les Hals de Harlem, les Albert Dürer de Dresde, les Holbein de Bâle l'avaient impressionné"). Proust 1897, p. 26; 1988/1996, p. 26.

10. Meller 2002, pp. 68–110, *passim*.

11. "Manet's eyes played a major role [in his art], and Paris has never known an idle *flâneur* like him or an idler who more usefully engaged in idling" ("Chez Manet, l'oeil jouait un si grand rôle que Paris n'a jamais connu de

Antonin Proust (1832–1905). Proust, another child of the upper middle class who had what was for his milieu an untoward interest in art, became the artist's lifelong friend.[4] Manet's maternal uncle Edmond Fournier is said to have encouraged his nephew's penchant for art, taking him to museums and paying for drawing lessons. When Édouard declared that he wanted to become a painter rather than study law, a family crisis ensued.

After a brief flirtation with a naval career (including six months on a merchant vessel sailing from Le Havre to Rio de Janeiro),[5] Manet obtained his father's permission to pursue a career as an artist. Rejecting Auguste's efforts to have him admitted to the prestigious but tradition-bound École des Beaux-Arts,[6] Édouard preferred to enroll in the studio of Thomas Couture (1815–1879). Couture had painted an enormous canvas, *Romans of the Decadence* (Musée d'Orsay, Paris), that had earned him a gold medal at the 1847 Salon and made him famous at the age of thirty-two. In September 1850 Manet and Proust began their artistic training in Couture's studio, where Manet was to remain on the rolls for six years.

The relatively nonconformist Couture was not part of the Beaux-Arts establishment, and in announcing the founding of his own art school in 1847, he rejected the "spurious classical school" as energetically as he did its "Romantic" rival.[7] Relying for his models on the art of ancient Greece, the Italian Renaissance (especially the Venetian masters), and the Flemish school, he envisioned a viable art for the modern world. Such an art would have noble and allegorical subjects, but would rely on direct observation and a relatively broad, sketchy technique to bring vitality and immediacy to its historical and moral themes. Although Manet only partly embraced Couture's program, he was open to much of his teacher's advice on methods and technique. His lifelong habit of sketching wherever he went, his light palette and embrace of pure colors, and his scorn for academic norms of "finish" all have precedents in Couture's practice.

While Manet was learning the fundamentals of his art with Couture, he was also gaining the widest possible experience of art in all its forms. Proust recounts his regular evening visits to the Académie Suisse, where he could draw and paint unsupervised. He also records Manet's weekend excursions to Fontainebleau forest to see the Barbizon painters at work and a sketching trip to the Normandy coast that Manet took with Couture and other students in 1853. In addition to regular visits to the Louvre, the two young artists met Eugène Devéria, whose enormous painting *The Birth of Henri IV* (Musée du Louvre, Paris), which created a storm at the 1827 Salon, was on display at the Musée du Luxembourg. Echoing Couture, Devéria told them to study the Venetians. Preferring Delacroix's *The Barque of Dante* (1822, Louvre) to Devéria's *Henri IV*, Manet, accompanied by Proust, called on Delacroix to ask permission to copy the work. The master welcomed them, allowed them to copy his painting, and advised them to "look at Rubens, draw inspiration from Rubens, copy Rubens, Rubens was the god," says Proust, paraphrasing Delacroix.[8]

The bewildering mix of influences in Manet's formative works might seem to validate the claims of early biographers that he visited Austria, Belgium, Germany, Holland, and Italy during the years they were being made.[9] There is no documentary evidence for visits to the first three countries, but there is for expeditions to Holland (1852) and Italy (1853 and 1857). Manet's second trip to Italy was probably the single most important event of his student years. The sketchbooks he brought back, full of drawings of works of art and the occasional architectural view, proved to be a lifelong inspiration.[10]

Manet's independence of taste and judgment was apparent from the first. Quick-witted and sharp-tongued, he was also fearless. His eye was supremely sensitive and retentive, whether he was standing before a work of art or out and about on the town.[11] He presumably visited every Salon, other temporary exhibitions, the Exposition Universelle of 1855, and perhaps even sales and private collections, and he was probably making up his mind about everything he saw. Courbet's huge *Burial at Ornans* (fig. 1.43) was one of the events of the 1850–51 Salon; Manet's response to this attempt to invent a new kind of art was, however, ambivalent.[12]

MANET AND THE SPANISH MASTERS IN PARIS (1850–62)

It was perhaps the encounter with Courbet's direct response to individual character that motivated Manet to copy a painting in the Louvre then believed to be by Velázquez. The work had been acquired in February 1850 from a Frenchman who claimed that it had belonged to a titled Spanish family.[13] Frédéric Villot, the Louvre's curator of paintings, catalogued it as *Portrait à mi-corps de Don Pedro Moscoso de Altamira, Doyen de la Chapelle Royale de Tolède, depuis Cardinal (Half-Length Portrait of Don Pedro Moscoso de Altamira, Dean of the Royal Chapel in Toledo, and Later Cardinal)*, but it soon came to be known as *Portrait d'un moine (Portrait of a Monk)* (fig. 9.2). The purchase disappointed some critics and connoisseurs, but others praised it.[14] Certainly the subject himself was unimpressive, and some portions of the painting, especially the hands and the prayer book, were inept.

How could curators and critics accept such an unlikely painting as the work of Velázquez? One reason was that Velázquez was underrepresented in French collections. More important, the first serious effort to catalogue his works dates only from 1855, when William Stirling-Maxwell's *Velazquez and His Works* was published in England.[15]

On January 29, 1850, Manet had registered at the Louvre as a student of Couture. On June 17, 1851, when he asked to copy the Velázquez *Monk*,[16] his name and student card number were entered in the Louvre's register for pictures of the Italian and Spanish school.[17] There is no record that Manet ever completed his copy, and if he did, it has not come down to us. Why might Manet have wanted to copy this work? He was still a beginner, just eighteen months into his art school training. Although the picture is somewhat naive and rather clumsy, the simple handling and clean, unmixed colors have a pleasing effect. The firm modeling of the face, the bold gaze, and the placement of the figure in the picture space would all have satisfied Manet's innate artistic preferences.

The surviving Louvre register covering the Italian and Spanish school is a great help in understanding

flâneur semblable à lui et de flâneur flânant plus utilement"). Proust 1897, p. 132; 1988/1996, p. 20; 1913, p. 29.

12. "Yes, the *Burial* is very good. It can't be said often enough that it is very good, because it's better than anything else. But between ourselves, it still doesn't go far enough. It is too dark" ("Oui, c'est très bien, l'*Enterrement*. On ne saurait dire assez que c'est très bien parce que c'est mieux que tout. Mais, entre nous, ce n'est pas encore ça. C'est trop noir"). Proust 1897, p. 133; 1988/1996, p. 21; 1913, p. 30; and Manet 1991, p. 27.

13. F. Couturier, a French photographer living in Granada, acquired the picture in 1846. Three years later, Couturier sold the picture in Paris, and the new owner offered it to the Louvre. To counter

Fig. 9.2 (cat. 82) Anonymous (formerly attributed to Diego Rodríguez de Silva y Velázquez), *Portrait of a Monk*, 1633. Oil on canvas, 36¼ x 28¾ in. (92 x 73 cm). Musée du Louvre, Paris

objections to its authenticity, Couturier signed a document attesting to the fact that "[s]everal such eminent personalities as Théophile Gauthier, M. Thiers, and others, have seen this picture with me in Granada" ("Plusieurs de nos célébrités, telles que Théophile Gauthier [*sic*], M. Thiers, et autres, ont vu ce tableau avec moi à Grenade"). Eight thousand francs were asked for the painting, for which the Louvre paid 4,500.

14. Cottini 1851, p. 97, accorded the painting "several good points, but the hands are not well realized, the fingers are like sausages. It is a piece that is acceptable for the Louvre, but is not a fine example by this master" ("certaines qualités, mais les mains ne sont pas belles, les doigts sont boudinés. C'est un échantillon qui peut être admis au Louvre, mais ce n'est pas un beau spécimen de ce maître"). Charles Blanc allowed that the picture was "very well painted" ("très-bien peint"), but he doubted that it was "a really authentic Velasquez" ("un Velasquez bien authentique"). See "Don Diégo Velasquez," in Blanc et al. 1869, nos. 68–69 (Velázquez issues), p. 15. Marcy 1867, p. 75, qualified the work as "remarkable" but added that it did not appear to "present all the great qualities associated with Velasquez to whom it is attributed" ("réunir toutes les grandes qualités de Velasquez à qui on l'attribue"). But Gautier said of the *Monk* and the *Gathering of Gentlemen* (fig. 9.5) that, "while they fail to give the full measure of the great Spanish master, they suffice to give an idea of his genius" ("sans donner complètement la mesure du grand maître espagnol, suffisent à faire comprendre son génie"). See "Paris.— L'Art. Le Musée du Louvre," in Marcy 1867, p. 366.

15. The Paris monthly *Revue Britannique* published an anonymous translation of Stirling-Maxwell's book in 1855. Gustave Brunet's translation was published ten years later (Paris, 1865) with notes and a *catalogue des oeuvres* by W. Bürger— that is, Théophile Thoré. See Stirling-Maxwell 1855. For a review of the early history of Velázquez studies, see E. Harris 1987, pp. 148–54.

16. Archives des Musées Nationaux, Paris, *Registre des oeuvres copiées, Écoles italienne et espagnole* (*LL26, f.° 262). The only surviving volume of copies of Spanish paintings covers the years 1851 to 1856 or 1857. The pseudo-Velázquez is listed simply as *"Moine,"* and no inventory number is given (it was Villot cat. no. 556; see Villot 1852). Thirty-seven copies are recorded for the period between June 10, 1851, and July 8, 1856; Manet's name is fifth. Sixteen copies (but

Fig. 9.3 Fernand Lochard, photograph of Manet's lost drawing of the Infanta Margarita, 1883. Bibliothèque Nationale de France, Département des Estampes, Paris. Photo courtesy the author

Fig. 9.4 (cat. 182) Édouard Manet, *Infanta Margarita, Copy after Velázquez*, ca. 1861–63. Etching, only state, 9 x 7½ in. (23 x 19 cm) platemark. Baltimore Museum of Art, George A. Lucas Collection

Manet's activity during his student years, although the loss of the following volume for the period from the end of 1856 into the 1860s poses problems. In some cases, the register indicates that Manet sought permission to copy specific works but does not record whether he finished the copies, which are not now extant. In others, there are copies by Manet of works that belonged to the Louvre, but the extant register does not record his requests for permission to make them. Manet's copy of a work then attributed to Velázquez—the *Gathering of Gentlemen* (fig. 9.5)—falls into the second category, as would the *Infanta Margarita* if he made a copy in oils as well as the drawing, for which permission was not required.[18]

The portrait of the young Infanta Margarita, daughter of Philip IV of Spain, had been in the Louvre since the reign of Louis XIV. A photograph taken in Manet's studio after his death does show a washed or watercolored graphite drawing of the work (fig. 9.3).[19] Manet also made an etching of the same subject (fig. 9.4), but a more famous copy of the *Infanta Margarita* is the etching by Degas (fig. 1.52) that Manet much admired for its boldness.[20] Degas is said to have worked on it in front of the picture, and the reversal of the image in the print supports the notion that he sketched directly on the copperplate. Manet's etching is very different: rather than a lively sketchbook study, it is a deliberately naive, almost schematic interpretation of the painting.

Manet's most remarkable copy "after Velázquez" is his version of the painting now known as the *Gathering of Gentlemen* (fig. 9.5). Acquired as a Velázquez by the Louvre in 1851, the picture was then officially titled *Réunion de portraits (Gathering of Portraits)*.[21] Recently reattributed to Juan Bautista Martínez del Mazo, Velázquez's pupil and son-in-law, it was probably a fragment of such paintings as the *View of Saragossa* (inscribed 1647, Museo del Prado, Madrid), a joint work by Velázquez and Mazo that contrasts a foreground filled with small figures and a vast panorama.[22] Contemporary catalogues and guidebooks identified the two figures on the left facing the spectator as Velázquez and Murillo. Seventeen students and artists registered to copy the *Gathering of Gentlemen* between June 1851 and March 1855,[23] but Manet's name is not among them. Because the painting differs in

Fig. 9.5 (cat. 79) Workshop of Diego Rodríguez de Silva y Velázquez, *Gathering of Gentlemen*. Oil on canvas, 18½ x 30⅜ in. (47 x 77 cm). Musée du Louvre, Paris

Fig. 9.6 (cat. 129) Édouard Manet, *The Little Cavaliers, Copy after Velázquez*, 1859–60? Oil on canvas, 18 x 29¼ in. (47 x 78 cm). Chrysler Museum of Art, Norfolk, Va., Gift of Walter P. Chrysler, Jr.

style and handling from Manet's other known copies and because it seems closely related to a number of pictures known to have been painted about 1859–60, it was most probably made after Manet renewed his registration at the Louvre on July 1, 1859—not as a student but as a full-fledged artist.[24]

Manet's name for his copy of the *Gathering of Gentlemen* was *The Little Cavaliers* (fig. 9.6). It is undated, and the Louvre register that would have recorded his request for permission to make the copy has disappeared.[25] In its bold handling and strong color, the copy can be viewed not only as a symbolic break with Couture's teachings but also as a lesson learned directly from Velázquez—or so Manet believed. J. Cottini harshly criticized the

not Manet's) are recorded as completed. This earliest of Manet's known copies was noted by Amornpichetkul 1989, p. 362.

17. Archives des Musées Nationaux, *Registre des cartes d'élèves 1850–1860* (*LL9, f.° 9). The Louvre registers had two functions. One set of registers tracked the people who copied works in its collections. For each such individual, the registers record name, address, and—for students—the teacher. The other set of registers tracked the works copied, dividing them into broadly defined "schools"—French and Flemish (1851–71: *LL22), Italian and Spanish (1851–57: *LL26), German, Dutch, and English—and within schools by masters and individual works. In practice, there was at least one page for each individual work. When a page was full and no additional page was available, the record was continued in a new volume. The pages for individual works recorded the date of registration; the copyist's name and identification number, with a code specifying whether the copyist was a student or artist; the number identifying the individual copy; and whether the copy was completed (in a column marked "Observations," which may not have been fully maintained). Reff 1964a brought the Louvre registers to the attention of scholars. The evidence for Manet's copies is discussed on p. 556.

18. The Louvre registers document Manet's requests for permission to copy three works: the pseudo-Velázquez *Monk* (June 17, 1851: *LL26, f.° 262, no. 5), Boucher's *Diana at the Bath* (February 25, 1852: *LL22, f.° 141, no. 7), and Rubens's *Portrait of Hélène Fourment* (August 21, 1857: *LL22, f.° 318, no no.). None of these copies is now extant, nor do the registers record that the copies were completed. Of the extant copies by Manet of works in the Louvre, the sole surviving register for the Italian and Spanish school does not record Manet's request for permission to copy the pseudo-Velázquez *Gathering of Gentlemen* or Velázquez's *Infanta Margarita* and *Philip IV.* The last work was acquired too late to have a page in the register. In the other cases, Manet would have requested permission to make the copy before, or more probably after, the dates covered by the register: the *Infanta* (designated in the register as "Marguerite Thérèse") after June 19, 1856, and the *Gathering* (designated in the register as "Portrait de Velasquez et autres personnages" [Portrait of Velasquez and other persons]) after July 1856. In fact, there is no evidence that

Fig. 9.7 (cat. 130) Édouard Manet, *Spanish Cavaliers*, ca. 1859–60. Oil on canvas, 17⅞ x 10⅜ in. (45.5 x 26.5 cm). Musée des Beaux-Arts, Lyon

Fig. 9.8 Édouard Manet, *Spanish Studio Scene*, 1865–70. Oil on canvas, 18⅛ x 15 in. (46 x 38 cm). Private collection, Japan

Manet made painted copies of either of the two portraits.

19. The drawing—no. 244 in Léon Leenhoff's register of works in Manet's studio (Bibliothèque Nationale de France, Paris, Département des Estampes, Rés. Yb³-4649-4°)—is recorded as "Infante Aquarelle / Cadre Dubourg." It was photographed by Fernand Lochard, and the copy bearing Leenhoff's annotations is in one of four such Lochard albums (Bibliothèque Nationale, Estampes, Dc300h-4°, p. 17).

20. Delteil 1919, no. 12; Boston–Philadelphia–London 1984–85, no. 16.

21. Thus Villot 1852, no. 557. For the current attribution to Juan Bautista Martínez del Mazo, see cat. 79.

22. The *View of Saragossa* was then considered to be the joint work of Velázquez and Martínez del Mazo. López-Rey 1963, p. 174, no. 152, attributes it to Mazo. Manet admired the work when he visited Madrid in 1865.

23. Archives des Musées Nationaux, *Registre des oeuvres copiées, Écoles italienne et espagnole* (*LL26, f.° 258). As already

Gathering at the time of its purchase,[26] and his criticism is borne out by technical examination, which reveals that the picture was in poor condition and had been extensively repainted.[27] However, Manet saw what he wanted and needed to see in it. In a comment to Proust, "Now, that's good clean work. It puts you off the brown-sauce school," he contrasted its clarity and economy with Delacroix's rich, dark, "old master" facture.[28] The liveliness of the small figures strung across the canvas against an almost empty ground also pleased him. Manet's achievement is to have created the work that Velázquez himself (rather than his pupil Mazo or an assistant) might have painted: vibrant, full of energy, freely but firmly handled, and so "modern" that his inscription, "Manet d'après Vélasquez," enlarges the name of the master, as if to emphasize that this is a copy and not his own original work.

In other paintings, Manet seems to pastiche his copy of *The Little Cavaliers*. The small canvas known as *Spanish Cavaliers* (fig. 9.7) mixes figures taken from the Louvre's purported Velázquez with the motif of a boy carrying a tray. *Spanish Studio Scene* (fig. 9.8) shows Velázquez himself, palette and brushes in hand, with two cavaliers from the picture posing for the artist as he works on the canvas of the very same painting, the *Gathering of Gentlemen*, placed on the easel before him.[29]

In 1860 Manet signed and dated a canvas known as *The Salamanca Students* (fig. 9.9), which illustrates the tale told by Alain-René Lesage in the preface to his novel *Gil Blas*.[30] A carefully finished work, it combines figures adapted from the *Gathering of Gentlemen* with a

woodland setting derived from studies of the landscape near Gennevilliers, north of Paris, where the Manet family owned considerable property. A picture on the same theme had been shown by Eugène-Ernest Hillemacher at the 1857 Salon, and its success may have inspired Manet's painting as much as his own growing interest in Spain and Spanish subjects.[31]

MANET AND THE SALON

Painters had three reasons for focusing on the Salon. First, it was official, regulated by the French state and run by government officers, and thus the distinctions that painters could win there immediately set them apart from their peers. Second, it received enormous press coverage, including reviews and illustrations in every Paris daily newspaper and weekly. Third, artists regarded the Salon as the best place in which to display their wares to potential buyers, although administrators preferred to promote the event as a display of the best new art in France. Painters whose work had been distinguished at two or more past Salons or who were members of the Legion of Honor could show whatever they wanted. Everyone else had to face an admissions jury, primarily composed of deeply conservative artists who were members of the Académie des Beaux-Arts or of the École des Beaux-Arts faculty.

Every ambitious young artist of the time aimed to be exhibited at the Salon, and Manet was no exception. In the late 1850s, drawing on the example of the great Italian Renaissance masters in the Louvre—Manet's copy after Titian's so-called *Pardo Venus* is one of his most vibrant early works (Musée Marmottan Monet, Paris)—he began several monumental compositions involving the nude. Initially, the themes were mythological or biblical—Danaë, Venus, nymph and satyr, Moses in the bullrushes.[32] Yet it was not one of these ambitious compositions that Manet sent to the 1859 Salon but his *Absinthe Drinker* (fig. 9.10). In early 1859 the painting, which was later cut and reworked, showed a full-length figure of a

Fig. 9.9 Édouard Manet, *The Salamanca Students*, 1860. Oil on canvas, 28⅛ x 36⅛ in. (72.8 x 93 cm). Private collection. Courtesy Sayn-Wittgenstein Fine Art, Inc., New York

mentioned (see n. 18, above), the register refers to the painting as "Portrait de Velasquez et autres personnages."

24. Archives des Musées Nationaux, *Registre des cartes d'artistes* (*LL4, f.° 125); Reff 1964a, p. 556.

25. Manet's name does not appear in the surviving register, which records those who copied the work between its acquisition in 1851 and June 19, 1856.

26. "This picture has suffered wholesale repainting. Most of the figures and much of the sky and ground are completely reworked. . . . The picture has been disastrously restored and virtually nothing remains of the master's hand. . . . In its present state, [it] is not fit to hang in the Louvre" ("Ce tableau est repeint presque d'un bout à l'autre. La plupart des figures, le ciel et les terrains ont été complètement refaits. . . . C'est un tableau déplorablement restauré, dans lequel il ne reste presque plus rien du maître. . . . [Ce] n'est pas un tableau qui, dans l'état où il est, soit digne de figurer au Louvre"). Cottini 1851, pp. 97–98.

27. An X-radiograph and other documents in the picture's file at the Laboratoire des Musées de France were kindly made available to me by Jean-Pierre Mohen.

28. "Ah! cela, c'est net, voilà qui vous dégoûte des ragoûts et des jus." Proust 1897, p. 129; 1988/1996, p. 16; 1913, p. 24; and Manet 1991, p. 27.

29. Rudd 1994 has hypothesized that these two works were once part of the same canvas. This theory will stand or fall, as Rudd observes, on technical examination of the two canvases. He identifies Velázquez's *Cardinal Infante Don Fernando as a Hunter* (Museo del Prado, inv. 1186) as the subject of the painting on the wall in *Velázquez in His Studio*, and Manet's source as the almost full-page engraving in Blanc et al. 1869, nos. 68, 69 (Velázquez issues), p. 5, incorrectly identified as "L'Infant Don Carlos Baltazar."

Fig. 9.10 (cat. 128)
Édouard Manet,
*The Absinthe Drinker
(A Philosopher)*, 1858–59;
reworked ca. 1868–72.
Oil on canvas, 71 x
41⅛ in. (180.5 x 105.6 cm).
Ny Carlsberg Glyptotek,
Copenhagen

Fig. 9.11 (cat. 75) Diego Rodríguez de Silva y Velázquez, *Aesop*, ca. 1638. Oil on canvas, 70⅛ x 37 in. (179.5 x 94 cm). Museo Nacional del Prado, Madrid

Fig. 9.12 (cat. 76) Diego Rodríguez de Silva y Velázquez, *Menippus*, ca. 1638. Oil on canvas, 70½ x 37 in. (179 x 94 cm). Museo Nacional del Prado, Madrid

ragpicker wrapped in a shabby cloak, a stovepipe hat shading his eyes and a bottle at his feet.[33] Employing the scumbling technique that he had learned from Couture, in which paint is dragged over a richly toned ground, Manet drew upon images of antique "philosophers" for the figure, in particular those whom Velázquez had portrayed in his *Aesop* and *Menippus* (figs. 9.11, 9.12).[34]

This early *Absinthe Drinker* draws on the genre of urban "types," which developed from Enlightenment interest in social classes and the conditions of people in society and which flourished in the first third of the nineteenth century.[35] Manet's choice of an alcoholic ragpicker as his subject was probably inspired as much by the poetry and ideas of Charles Baudelaire (figs. 9.13, 9.14) as it was by particular visual sources. The two men knew each

30. Lesage 1788, vol. 1, pp. ix–x. The story tells of two students who stopped to rest on their journey to Salamanca. They found a stone with a strange inscription: "ICI EST ENFERMÉE L'AME DU LICENTIÉ PIERRE GARCIAS" ("Here is interred the soul of Pedro Garcias, licentiate"). One student laughed and walked away; the other reflected, prised up the stone, and found a purse of gold—the author's way of inciting his readers to look for deeper meanings in his story of the adventures of Gil Blas.

31. Hillemacher's painting, *Les Deux Écoliers*

Fig. 9.13 (cat. 170) Édouard Manet, *Baudelaire with a Hat, in Profile I*, 1862 or 1867–68? Etching; first plate, on blue paper, 5⅛ x 3 in. (13 x 7.5 cm) platemark. The Metropolitan Museum of Art, New York, Rogers Fund, 1921 (21.76.23)

Fig. 9.14 (cat. 171) Édouard Manet, *Baudelaire Bare-Headed, Full Face III*, ca. 1867–68. Etching; third state, with banderole, 6⅞ x 4⅛ in. (17.5 x 10.6 cm) platemark. Bibliothèque Nationale de France, Département des Estampes, Paris

other in the 1850s and were in close contact in the 1860s—both before and after Baudelaire left for Brussels in 1864.[36] Committed *flâneurs*, they frequented the same cafés and social salons, and the poet was a welcome guest of Manet's mother. Baudelaire admired Spanish art, particularly Velázquez's paintings and Goya's *Caprichos*, and is said to have preferred the Galerie Espagnole during his frequent visits to the Louvre in his early years. He even briefly owned an alleged Velázquez.[37]

Baudelaire's poem "Ragpickers' Wine," which has been invoked in discussions of Manet's painting,[38] was composed at a time when perceptions of the Spanish master's art were changing. Increasing numbers of Frenchmen were visiting Spain and seeing the masterpieces in the Prado with their own eyes. The critic Théophile Gautier did not value Velázquez's art until his second visit to Spain, in 1846.[39] A visit to the Prado led him to conclude that Velázquez was "one painter who cannot be appreciated but in Spain." What particularly struck him was the Spanish master's embrace of the human condition: "This man of such noble birth, painter in ordinary to kings, queens and royal offspring . . . skilled as he was in representing the sheen of velvet, the luster of silk . . . handles mud and dirt without disgust, lovingly. . . . The company of tramps, beggars, thieves, philosophers, alcoholics—the wretches in the teeming ranks of the underclass—did not at all repel him."[40] Indeed, Baudelaire's ragpicker and Manet's absinthe drinker are both descendants of Velázquez's beggar-philosophers.

Manet invited Couture to see the picture before he sent it to the Salon. Proust reports Couture's reaction: "My friend, there is only one absinthe Drinker here—the artist who produced this crazy painting."[41] This incident put an end to the relationship. More significantly, it helped Manet to eliminate from his practice the traces of Couture's methods that did not advance his own vision. As *The Absinthe Drinker* went through its many subsequent alterations—Manet cut it down, restored it to its original size, and repainted it, adding the glass of absinthe—the artist did virtually nothing to the head and shoulders, and the canvas, however striking, has a curiously unresolved appearance.

In the end, Manet did not make his public debut at the 1859 Salon. The fourteen-man admissions jury, which included Ingres and Delacroix, decided that the work did not merit public display. Their rejection of *The Absinthe Drinker* probably owed less to the fact that it was technically innovative (Manet was still following Couture's methods and technique) and more to the artist's use of a noble formula—the lifesize, full-length "philosopher" figure exemplified in Velázquez's paintings (figs. 9.11, 9.12)—for the ignoble subject of a contemporary down-and-out drunk.[42] Proust, who claimed to have been present with

de Salamanque (see Paris 1857, p. 166, no. 1353), was reproduced in the December 1857 issue of *Magasin Pittoresque* (see Farwell 1981, p. 60).

32. Since it can take several years to complete a large canvas, the date that an artist puts beside his or her signature on a painting tells us little about the period of its execution; it normally commemorates only the completion of the work. X-radiography of some of Manet's largest canvases—*The Surprised Nymph*, which is dated 1861, and the *Déjeuner sur l'herbe* and *Olympia*, which are both dated 1863—reveals that they developed gradually over time and, in the case of the last two works, that Manet transformed "old-master" compositions into subversively modern scenes. See London 1986.

33. See Fonsmark 1985 and 1987 for a detailed account of the picture's development.

34. Goya reproduced these works in his etchings after Velázquez's paintings (figs. 9.59, 9.60).

35. For nineteenth-century interest in the ragpicker and the pictorial genealogy of Manet's *Absinthe Drinker*, see Badesco 1957, pp. 55–56; Claude Pichois (citing a work by Baudelaire's friend Alexandre Privat d'Anglemont) in Baudelaire 1975–76, vol. 1, p. 1048; Hanson 1977, p. 65.

36. Proust (1897, p. 128; 1988/1996, p. 14; 1913, p. 39) comments provocatively on Manet's relationship with Baudelaire.

Baudelaire in Manet's studio when Manet learned the bad news, recounts word for word the long conversation that followed: "'The lesson,' said Baudelaire, 'is that one has to be oneself.' 'That's what I've always told you, my dear Baudelaire,' said Manet. 'Wasn't I being myself in the *Absinthe Drinker*?' 'Well . . . ,' was all Baudelaire could say. 'Oh, fine,' said Manet. 'Now Baudelaire's going to dump on me. Everyone, then.'"[43] Manet learned from the experience. The work that he sent to the next Salon treated a more appealing, directly Spanish subject with such confidence and brio that an official commendation and critical acclaim were his reward.

BUILDING A REPUTATION

If the official Salons were the most prestigious venue for up-and-coming artists, they were by no means the only outlet. Manet often showed his work in commercial galleries in Paris, including those of Louis Martinet (1861–65) and Alfred Cadart (1862, 1864, and 1865). He also participated in a number of provincial and foreign exhibitions during the 1860s, sending a picture to the September 1861 exhibition at the Imperial Academy of Art in St. Petersburg and showing his *Boy with a Sword* (fig. 9.21) at the Brussels Salon in August 1863.

In *The Old Musician* (fig. 9.15), one of several large works no doubt conceived as possible Salon entries but never submitted to a jury,[44] Manet again used the figure of *The Absinthe Drinker* as part of the composition. He did not sign and date the picture until 1862, and, as far as is known, did not exhibit it until the next year, when it was one of fourteen paintings that he sent to a show at Martinet's gallery.[45] This impressive canvas was probably developed over a considerable period of time.[46] Its overall design pays homage to Velázquez's celebrated painting known as *Los Borrachos (The Drunkards)*. Manet could have seen the best reproduction of that work, Goya's lively etching (fig. 9.16), at the Bibliothèque Impériale, as the Bibliothèque Nationale was known under the Second Empire.[47] He applied for permission to study in the print collection in 1858[48] and may even have possessed a copy of Goya's etching. The inventory of his estate shows that he owned prints by Goya,[49] and a print after *Los Borrachos*—perhaps Goya's—appears on the wall behind Émile Zola in the portrait that Manet sent to the 1868 Salon (fig. 9.91). The six figures in *The Old Musician* are spaced across the canvas, as are those in *The Little Cavaliers* and in paintings by the Le Nain family. Manet culled these figures from a variety of diverse sources: the Gypsy model Jean Lagrène, his own drawing after a Hellenistic carving of Chrysippos in the Louvre, Watteau's *Gilles*, and Murillo's urchins, as well as contemporary art—in this case, Henri-Guillaume Schlesinger's *The Stolen Child*, which was exhibited at the 1861 Salon.[50] Schlesinger's picture is now known only from a black-and-white engraving, but it was praised by a contemporary critic for its lively color effects and must have impressed Manet when he saw it at the Salon.

Another equally ambitious but more directly "Spanish" work, *The Gypsies*, may also have been intended for the Salon. Manet destroyed the work, which now survives only in fragments (fig. 9.17), photographs, and two etchings. The larger of the etchings shows the finished picture in reverse (fig. 9.18)[51] and was the first print that Manet published as a member of the Société des Aquafortistes. Randon's caricature (fig. 9.19)—made in 1867, when the painting was included in Manet's solo exhibition—is another record of the lost work. The composition appears to depend on two principal sources: an early painting by Murillo

37. Guinard 1967a; Pichois 1968, vol. 1, pp. 207–11; Pichois 1976, p. 21; Pichois and Ziegler 1987, pp. 200–204.

38. Hanson 1977, pp. 54–55.

39. Gautier visited the Prado the first time he traveled to Spain, in 1840. But he did not describe what he had seen there, with the exception of a few works by Goya, in the accounts of the trip that he published in *La Presse*, the *Revue de Paris*, and the *Musée des Familles*. These texts were published in 1843 under the title *Tra los montes*. The second edition (1845) was published under the title *Voyage en Espagne*. The citations below from Gautier's *Voyage* are from a modern reprint (Paris, 1961).

40. "un peintre qu'on ne peut admirer qu'en Espagne"; "Cet homme d'une si haute aristocratie, peintre ordinaire des rois, des reines et des infantes, . . . si habile à écraser le velours, à faire miroiter la soie . . . manie la boue et la fange sans dégoût, avec amour. . . . La société des gueux, des mendiants, des voleurs, des philosophes, des ivrognes et des misérables de toute nature dont se compose le monde fourmillant de la bohème, ne lui répugne en aucune manière." Théophile Gautier, "Les courses royales à Madrid," *Loin de Paris* (Paris, 1865), n.p., quoted by Paul Guinard, "Velázquez et les romantiques français," in *Varia Velazqueña* 1960, vol. 1, pp. 570–71. Gautier's texts about his 1846 visit to Madrid were first published in the December 1846 and January 1847 issues of the monthly *Musée des Familles* under the title "Voyage en Espagne (10 octobre 1846)."

41. "Mon ami, il n'y a ici qu'un Buveur d'absinthe, c'est le peintre qui a produit cette insanité." Proust also records Manet's response to the incident: "Instead of annoying him, Couture's crude remark amused him. '—Fine, he told me. I was stupid enough to make a few concessions. I laid in my grounds the way he says to. Well, that's it. I'm glad he said what he did. Now I'm free'" ("Cette grossière réflexion au lieu de l'irriter l'avait mis en gaieté. 'Et bien soit,' me dit-il, 'j'ai eu la stupidité de lui faire quelques concessions. J'ai préparé sottement mes dessous selon sa formule. C'est fini. Il a bien fait de me parler comme il m'a parlé. Cela me recampe sur mes pattes'"). Proust 1897, p. 134; 1988/1996, p. 23; 1913, p. 33.

42. The question of Manet's classical sources is the subject of ongoing study by Peter Meller (see Meller 2002).

43. "La conclusion, c'est qu'il faut être soi-même. — Je vous l'ai toujours dit, mon cher Baudelaire, répliqua Manet, mais est-ce que je n'ai pas été moi-même dans le *Buveur d'absinthe?* — Euh ! Euh !

reprit Baudelaire. — Allons, voilà
Baudelaire qui va me débiner. Tout le
monde alors. . . ." Proust 1897, p. 135;
1988/1996, p. 25; 1913, p. 35.

44. The most traditional of these, *The Sur-
prised Nymph* (1859–61, Museo Nacional
de Bellas Artes, Buenos Aires), was sent
to the exhibition at the Imperial Acad-
emy of Art in St. Petersburg mentioned
earlier.

45. This very large show organized by Mar-
tinet in March 1863 included Jacques-
Louis David's replica of his *Coronation
of Napoleon I* of 1805–7 (1808–22, Musée
National du Château de Versailles,
MV 7156) as well as works by Delacroix,
Corot, and Courbet. Manet's paintings
attracted considerable attention, much
of it hostile. An incensed, supposedly
female, "admirer" sent him a set of
drawings caricaturing some of his
works. Long known only from photo-
graphs in the Bibliothèque Nationale de
France (Département des Estampes et
de la Photographie: Yb3-2012 [18]-4°),
the drawings themselves (now in a pri-
vate collection) were sold by Librairie
"A la Venvole," Chartres, catalogue 3
bis, October 2000, no. 597.

46. The painting belongs to the Chester
Dale Collection and can never leave the
National Gallery of Art in Washington.

Fig. 9.15 Édouard Manet, *The Old Musician*, 1862. Oil on canvas, 73¼ x 97¼ in. (186 x 247 cm). National Gallery of Art, Washington, D.C., Chester Dale Collection, 1962

Fig. 9.16 (cat. 22) Francisco de Goya y Lucientes, *Los Borrachos (The Drunkards), Copy after Velázquez,* by December 1778, first edition. Etching, 12⅜ x 16⅞ in. (31.5 x 43 cm). The Metropolitan Museum of Art, New York, Harris Brisbane Dick Fund, 1924 (24.97.1)

known as *Beggar Boy* (fig. 2.32), which had been in the Louvre since 1782, and Velázquez's portrait of Philip IV as a hunter (fig. 9.20), acquired by the Louvre in May 1862. The latter was the subject of a boldly etched copy (fig. 9.27) that Manet made the same year.[52] The seated mother, the close-cropped head of the boy drinking from the water jar, the jar itself (though in a different form), and the straw basket lying on the ground are all derived from the Murillo. From Velázquez, Manet drew the motif of the commanding male figure stand-ing in a relaxed pose in a landscape setting. But in order to retain the distant landscape view on one side, he had to pile the Gypsy's family into a relatively constrained space on the other, which throws the composition off balance. Besides these influences, more or less direct references to Schlesinger's *Stolen Child*, representations of the Holy Family, and images of peasants and Gypsies from the ample literature on "types" can also be identified. It was no doubt the unsatisfactory compo-sition and competing influences that led Manet to destroy the work after showing it in 1867.

Murillo's portrayals of children and Manet's knowledge of Velázquez's portraits are combined in two studies: *Boy with a Sword* (fig. 9.21) and *The Young Lange* (fig. 9.22). The former has always been one of Manet's most admired works. (It was also the first to enter a public collection in America, in 1889.) The simplicity of the image, the appealing solemnity of the young child, and the relatively high "finish" have ensured the picture's lasting popularity. Yet the image is also ambiguous. Is this a contemporary child in fancy dress, or is Manet depicting a Dutch or Spanish figure from the seventeenth century? A

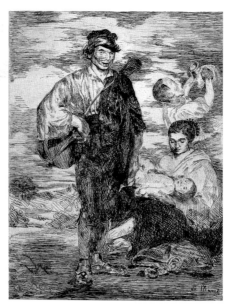

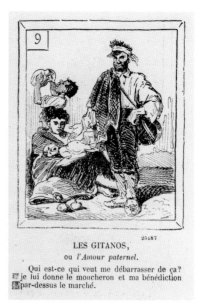

Fig. 9.17 (cat. 135) Édouard Manet, *The Water Drinker (The "Régalade")*, 1861–62; reworked ca. 1868–72. Oil on canvas, 24⅛ x 21⅜ in. (61.8 x 54.3 cm). The Art Institute of Chicago, Bequest of Katherine Dexter McCormick

Fig. 9.18 (cat. 169) Édouard Manet, *The Gypsies*, 1862. Etching; second state, 12%₆ x 9%₆ in. (31.9 x 23.8 cm) platemark. S. P. Avery Collection, Print Collection, Miriam and Ira D. Wallach Division of Art, Prints, and Photographs, The New York Public Library, Astor, Lenox, and Tilden Foundations

Fig. 9.19 G. Randon, Caricature published in *Le Journal Amusant*, June 29, 1867. Woodcut. Bibliothèque Nationale de France, Paris. Photo courtesy the author

sketchbook that he used in Italy in 1857 reveals a direct and very surprising source for the motif: the frescoes by Benozzo Gozzoli in the Camposanto at Pisa, one of which, copied by Manet, shows a boy stepping forward carrying a tray. The same stance is also found, in reverse, in the majestic *Circumcision* (fig. 7.13) by Zurbarán that hung until 1848 in the Galerie Espagnole.[53]

It is not clear why Manet's boy bears such an enormous weapon. Allegorical meanings have been proposed—most recently, the child as a travesty of Amor with the Sword of Mars or Cupid with the Sword of Alexander.[54] But the sword was also a device to occupy the child and help him to hold the pose, something that was critical for Manet—and torture for his models. The model for this work has always been identified as Léon, Suzanne Leenhoff's illegitimate son, and the date of the painting has always been given as 1861. However, Manet, Suzanne, and Léon had been living together since the summer of 1860, and it is therefore perfectly possible that the work dates from that year. Such a dating would accord better with Léon's still rather babyish features (in late 1861 he would have been almost ten years old); it would also bring the picture into a closer and more coherent relationship with the presumed date of *The Little Cavaliers* (ca. 1859–60) and with the related *Spanish Cavaliers* and *The Salamanca Students* (dated 1860) (figs. 9.7, 9.9).[55]

The other child portrayed, in a study bearing a dedication by Manet to the boy's mother, has traditionally been known as "le petit Lange" (the young Lange boy). The nature of the Lange family's connection with Manet remains unknown, but the artist's engagement with the solemn little boy is electrifying. Standing in an undefined setting, probably outdoors, with a riding crop and what look like scarlet reins in his right hand, the child has the presence and dignity of a young infante by Velázquez. The cutoff pants (the same garment worn in *Boy with a Sword*) are set off by the crisp white collar and cuff. The boy stands rock solid on

It has therefore rarely been seen within the context of other Manet paintings of the period.

47. In November 1856 the Bibliothèque acquired eighty-nine prints by Goya, including his etching after *Los Borrachos*, from a Mr. Aznarez (Registre des Acquisitions: Rés. Ye-88-Pet. Fol.: 1848–1907, no. 1930, November 20, 1856). They probably came from the estate of Goya's son Javier (who died in 1854) via Valentín Carderera, who was in Paris at the time and who was negotiating through William Stirling-Maxwell to sell prints.

48. Manet's autograph letter to the curator of prints at the Bibliothèque Impériale is dated November 25, 1858 (Bibliothèque Nationale de France, Département des Estampes et de la Photographie, Rés. Ye-118).

49. For the inventory of 1883, see Rouart and Wildenstein 1975, vol. 1, p. 27, "Estimation des pastels [et divers]: *Deux [portefeuilles] contenant des eaux-fortes de Goya.*"

50. For Manet's painting and its sources, see Hanson 1977, pp. 60–64; Washington 1982–83, pp. 174–89, nos. 59–65; Fried 1996, pp. 29–34.

51. The rare, small etching, reproducing the composition the right way round, may show an early stage of the painting or record a lost sketch. Guérin 1944, no. 20; J. Harris 1970/1990, no. 17; Ingelheim 1977, no. 16.

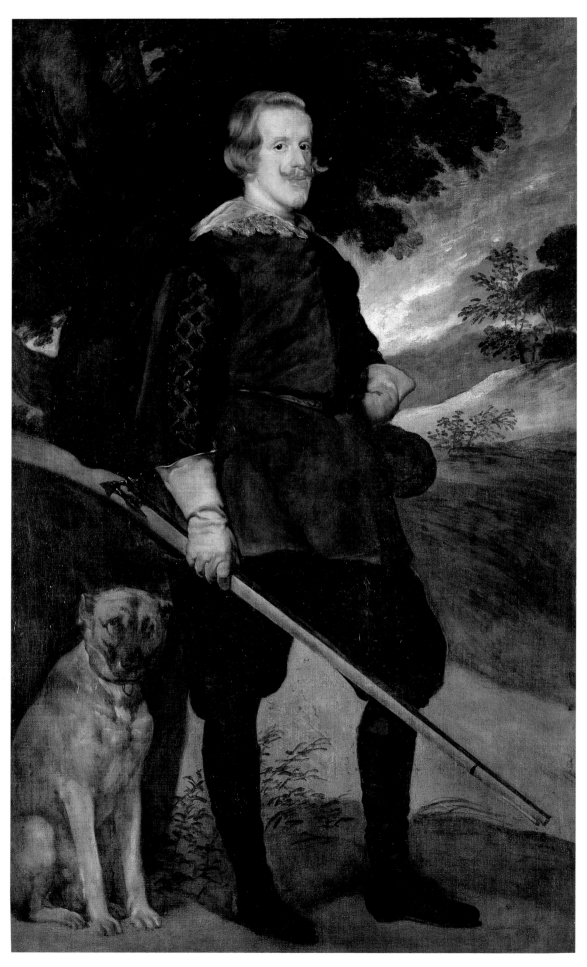

Fig. 9.20 (cat. 77)
Workshop of Diego
Rodríguez de Silva y
Velázquez, *Philip IV as
a Hunter*, ca. 1632. Oil
on canvas, 78¼ x 47¼ in.
(200 x 120 cm). Musée
Goya, Castres, on
deposit from the Musée
du Louvre, Paris

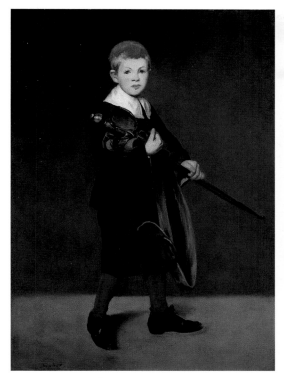

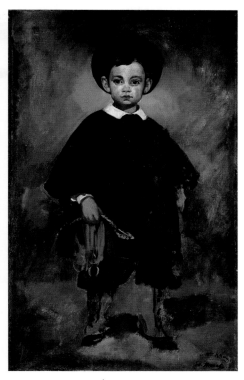

Fig. 9.21 (cat. 133) Édouard Manet, *Boy with a Sword*, 1860–61. Oil on canvas, 51⅛ x 36¾ in. (131.1 x 93.4 cm). The Metropolitan Museum of Art, New York, Gift of Erwin Davis, 1889 (89.21.2)

Fig. 9.22 (cat. 134) Édouard Manet, *The Young Lange*, ca. 1861. Oil on canvas, 46⅛ x 28 in. (117 x 71 cm). Staatliche Kunsthalle Karlsruhe

his buttoned, gaitered legs, but the most astonishing aspect of the painting is that actually nothing is solid, nothing defined, apart from the child's head. The rest of the figure is broadly brushed over traces of a previous painting whose shapes and colors show through the rough strokes that seem to conjure the child out of thin air. This is painting magic: a firm contour here; a dabbed, loose area there; a fluid line; a patch of color—and the child springs to life and remains an unforgettable presence. The lesson of Velázquez, as then understood by Manet, has been learned well.

In the 1860s, Manet was to invent a new kind of painting, which got off to an auspicious start at the 1861 Salon. The jury accepted both his submissions: a portrait of his mother and father (1860, Musée d'Orsay, Paris) and a lifesize genre subject that Manet called *Espagnol jouant de la guitare (Spaniard Playing a Guitar)* in the Salon catalogue and later titled *Le Chanteur espagnol (The Spanish Singer)* (fig. 9.1). To compound the confusion, he called his etching of the painting *Le Guitarero* [*sic*] (fig. 9.25)—perhaps in acknowledgment of the ringing endorsement that Gautier had given the painting in his review of the 1861 Salon.[56] If Manet had consciously set out to paint an eye-catching, crowd-pleasing success, he could not have chosen a more attractive subject. While the guitar was recognized at the time as a symbol of Spain,[57] the model's pose was a picturesque fiction,[58] and his clothes an attractive but inauthentic hodgepodge of elements from Manet's costume basket.

Some writers found the painting excessively "realistic" and criticized Manet's heavy-handed application of paint, but the work surprised and delighted several important contemporaries of Manet: "A painting that showed *A Spanish Guitar Player* stopped a group of young painters in their tracks. They stared at the picture in wonder. It was signed with a name they did not know—*Manet*. These young men, who included Legros, Fantin, and Karolus Durand,

52. Manet's etching, which freely interprets (and reverses) the painting, was completed and offered for sale as print no. 4 in the first issue of *Eaux-fortes modernes*, published by the Société des Aquafortistes on September 1, 1862. An accurate but inexpressive etching by W. Houssoullier appeared in Blanc 1863, facing p. 74.

53. Meller 2002, pp. 72, 75, 92; Rouart and Wildenstein 1975, vol. 2, D90. George Mauner, "Manet et la vie silencieuse de la nature morte," in Paris–Baltimore 2000–2001, p. 48 (Paris ed.), suggests another possible source. For the Zurbarán, see Baticle and Marinas 1981, pp. 217–18, no. 339, and Gerard-Powell 2000, pp. 70–71, no. 6.

54. Meller 2002, p. 92. For other views, see Paris–New York 1983, pp. 75–76, and Mauner in Paris–Baltimore 2000–2001, pp. 48–50.

55. Also suggesting an early date for the *Boy with a Sword* is the fact that Manet copied the painting in no fewer than four separate etchings, one of which was said by Alphonse Legros to have been his very first attempt with this medium, made with Legros's help. J. Harris 1970/1990, nos. 24–28; Paris–New York 1983, nos. 15–17.

56. "Caramba! Here is a Guitar Player who has not just stepped off the stage of the Comic Opera and whom one is not likely to see on the cover of some 'Spanish' sheet music. But Vélasquez would salute him with a friendly wink, and Goya would ask him for a light for his *papelito*. How he bawls . . . as he strums away. We feel that we actually hear him. . . . This lifesize full-length figure, with its rich surface, bold brushwork, and very lifelike coloration, displays a good deal of talent" ("Caramba! voilà un *Guitarrero* qui ne vient pas de l'Opéra-Comique, et qui ferait mauvaise figure sur une lithographie de romance; mais Vélasquez le saluerait d'un petit clignement d'oeil amical, et Goya lui demanderait du feu pour allumer son papelito.— Comme il braille . . . en râclant le jambon! — Il nous semble l'entendre. . . . Il y a beaucoup de talent dans cette figure de grandeur naturelle, peinte en pleine pâte, d'une brosse vaillante et d'une couleur très-vraie"). Gautier 1861, p. 1017.

57. Describing in 1860 the first of the "universal" exhibitions—the Great Exhibition held in London in 1851—Charles Blanc enumerates the displays that each country devoted to its most technically advanced or useful national products. In the Spanish section, barrels of tobacco, piles of oranges, and crates of merino wool surrounded a pedestal on which was placed "an object one would never

Fig. 9.23 (cat. 172) Édouard Manet, *Polichinelle Presents "Eaux-fortes par Édouard Manet" (Second Frontispiece Project)*, 1862. Etching; third state, 12⅞ x 9½ in. (32.7 x 24 cm) platemark. S. P. Avery Collection, Print Collection, Miriam and Ira D. Wallach Division of Art, Prints, and Photographs, The New York Public Library, Astor, Lenox, and Tilden Foundations

Fig. 9.24 (cat. 173) Édouard Manet, *"Eaux-fortes par Édouard Manet"— Spanish Hat and Guitar (Frontispiece)*, 1862–63. Etching; first state, 2nd plate, 17 x 11¾ in. (44.1 x 29.8 cm) platemark. S. P. Avery Collection, Print Collection, Miriam and Ira D. Wallach Division of Art, Prints, and Photographs, The New York Public Library, Astor, Lenox, and Tilden Foundations

Fig. 9.25 (cat. 163) Édouard Manet, *The Spanish Singer (The "Guitarero")*, 1861–62. Etching, drypoint, and aquatint; second state, 11⅞ x 9¾ in. (30.2 x 24.7 cm) platemark. The Metropolitan Museum of Art, New York, The Elisha Whittelsey Collection, The Elisha Whittelsey Fund, 1952 (52.608.2)

ever dream of . . . a guitar!" ("un objet qu'on ne devinerait pas en mille . . . une guitare!"). Blanc 1860, p. 93.

58. Manet admitted to Proust that he got things wrong: his left-handed guitarist—clearly no guitarist at all—was pretending to play on an instrument strung for a right-handed player. Proust 1897, p. 170; 1988/1996, p. 28; 1913, pp. 40–41.

59. "un groupe de jeunes peintres . . . s'arrêta coi devant un tableau, représentant *Un joueur de guitare espagnol*. Cette peinture, qui faisait s'ouvrir grands tant

looked at each other in amazement, racking their brains and asking themselves . . . where could M. Manet have come from? The Spanish musician was painted in a certain strange, new way, to which the amazed young painters believed only they knew the secret, a style of painting that is a cross between the so-called Realist and so-called Romantic." The group decided to call on the painter. "Manet welcomed a deputation that they sent. . . . That was the first of many visits. The painters even brought a poet and several art critics to visit Manet."[59]

The importance of *The Spanish Singer*—so clear to Manet's young colleagues—has perhaps been overshadowed in our own time by the more sophisticated works that followed it. The painting combines lessons that Manet learned from Murillo's *Beggar Boy* and from the *Gathering of Gentlemen*. It has a remarkable clarity and vigor, setting well-defined forms and clean, clear colors against a relatively traditional sfumato background. Like the Murillo, the picture brings viewers into direct contact with familiar still-life objects placed almost within their grasp, at the limit of the picture space. Originally hung high up on a wall at the Salon, the painting was so successful that it was brought down to eye level. It earned Manet an honorable mention, the only official recognition that he received before 1881, when his portrait of Henri Rochefort was accorded a second-class medal.

In addition to exhibiting at the Salon, young artists often built their reputations by publishing prints. Manet had undoubtedly been stimulated by his study of Goya's etchings, including the copies after Velázquez (figs. 9.16, 9.59, 9.60), but he rarely used etching or lithography to produce original prints. More

Fig. 9.26 (cat. 164) Édouard Manet, *The Little Cavaliers, Copy after Velázquez*, 1861–62. Etching; fourth state, 9⁷⁄₁₆ x 14¹¹⁄₁₆ in. (24.8 x 38.5 cm). S. P. Avery Collection, Print Collection, Miriam and Ira D. Wallach Division of Art, Prints, and Photographs, The New York Public Library, Astor, Lenox, and Tilden Foundations

Fig. 9.27 (cat. 165) Édouard Manet, *Philip IV, Copy after Velázquez*, 1862. Etching, drypoint, and aquatint; sixth state, 14 x 9⅜ in. (35.4 x 23.8 cm) platemark. S. P. Avery Collection, Print Collection, Miriam and Ira D. Wallach Division of Art, Prints, and Photographs, The New York Public Library, Astor, Lenox, and Tilden Foundations

Fig. 9.28 (cat. 166) Édouard Manet, *The Espada* or *Mlle Victorine in the Costume of an Espada*, 1862. Etching, lavis, and aquatint; second state, 13¼ x 11 in. (33.5 x 27.8 cm) platemark. The Metropolitan Museum of Art, New York, Rogers Fund, 1969 (69.550)

Fig. 9.29 (cat. 167) Édouard Manet, *The Absinthe Drinker*, 1861–62. Etching; second state, 11¼ x 6¼ in. (28.7 x 15.9 cm). National Gallery of Art, Washington, D.C., Rosenwald Collection, 1943

often, he employed these media to present or reinterpret his own paintings, working closely with Cadart and his print studio. In 1862 Cadart organized the Société des Aquafortistes, with Manet as a charter member. The Société published members' etchings in monthly installments. Manet's *The Gypsies* (fig. 9.18) figured in the very first, published on September 1, 1862; his *Lola de Valence* (fig. 9.42) appeared in the October 1, 1863, issue. Cadart also published special albums of prints, among them *Huit gravures à l'eau-forte par Édouard Manet (Eight Etchings by Édouard Manet)* in 1862 (figs. 9.23, 9.24). These included prints after his paintings *The Spanish Singer, The Little Cavaliers, Philip IV, Mlle V . . . in the Costume of an Espada, The Absinthe Drinker, The Urchin,* and *The Little Girl* (figs. 9.26–9.31).

d'yeux et tant de bouches de peintres, était signée d'un nom nouveau, *Manet.* MM. Legros, Fantin, Karolus Durand [*sic*] et autres, se regardèrent avec étonnement, interrogéant leurs souvenirs et se demandant . . . d'où pouvait sortir M. Manet? Le musicien espagnol était peint d'une certaine façon, étrange, nouvelle, dont les jeunes peintres étonnés croyaient avoir seuls le secret, peinture qui tient le milieu entre celle dite réaliste et celle dite romantique"; "M. Manet reçut très-bien la députation. . . . On ne

Fig. 9.30 (cat. 168) Édouard Manet, *The Urchin*, 1861–62. Etching; second state, 8¼ x 5⅞ in. (20.9 x 14.8 cm) platemark. The Metropolitan Museum of Art, New York, Rogers Fund, 1921 (21.76.7)

Fig. 9.31 Édouard Manet, *The Little Girl*, 1862. Etching; second state, 8⅛ x 4⅛ in. (20.6 x 11.8 cm). The Metropolitan Museum of Art, New York, Rogers Fund, 1921 (21.76.9)

OLD ART INTO NEW (1862–65)

s'en tint pas à cette première visite. Les peintres même amenèrent un poète et plusieurs critiques d'art à M. Manet." Desnoyers 1863, pp. 40–41.

60. London 1990–91, pp. 112–19, no. 1. See Wilson-Bareau 1991. Manet shared a studio with de Balleroy between 1856 and 1858.

Eighteen sixty-two was Manet's "Spanish year" par excellence, and it was also the year in which he moved decisively to modern subject matter. *Music in the Tuileries* (fig. 9.32), signed and dated that year, reflects the tensions that had been animating the artist's development for the past several years. The subject matter is unmistakably contemporary and Parisian, while the structure is discreetly but clearly based on *The Little Cavaliers*. Manet here substitutes likenesses of himself and his painter friend Albert de Balleroy for the "portraits" of Velázquez and Murillo that the two figures at the left edge of the Louvre's canvas were thought to represent.[60]

Between 1862 and 1865, Manet continued to transform old art into new. The figure in *The Spanish Singer* was clearly a model dressed and posed to "look Spanish." But starting in 1862, Manet presents his models—Victorine Meurent and Gustave Manet, Lola Melea and Mariano Camprubi—as distinct individuals. Yet they are all performers in one way or another. The Spanish dancers are performers in real life. Victorine is a professional artist's model. In the *Déjeuner sur l'herbe* (1863, Musée d'Orsay, Paris), she is portrayed as a model posing for Manet, while Manet's brothers and brother-in-law, who modeled in turn for the males, are more or less recognizably themselves in spite of the references both to contemporary (and outrageous) student mores and to classic earlier art. Manet's *Olympia* (1863, Musée d'Orsay) is not a picture of a prostitute posed like a Titian *Venus* but a picture of Victorine portraying the prostitute—and being quite amused by the whole thing.

The jury for the 1863 Salon rejected all three of Manet's submissions—*Déjeuner sur l'herbe* and the two single-figure paintings discussed below—as it did the works offered by a substantial number of other artists. Some of the latter had exhibited at earlier Salons and even won medals. The rejected artists and a complicit Paris press raised a hue and cry over the jury's severity. In a characteristically media-conscious move, Emperor Louis-Napoleon Bonaparte decreed that the public should be the judge. The rejected pictures would be

Fig. 9.32 Édouard Manet, *Music in the Tuileries*, 1862. Oil on canvas, 29⅞ x 46½ in. (76 x 118 cm). National Gallery, London

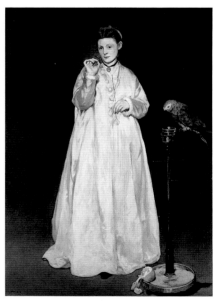

Fig. 9.33 Édouard Manet, *Young Lady in 1866 (Woman with a Parrot)*, 1866. Oil on canvas, 72⅞ x 50⅛ in. (185.1 x 128.6 cm). The Metropolitan Museum of Art, New York, Gift of Erwin Davis, 1889 (89.21.3)

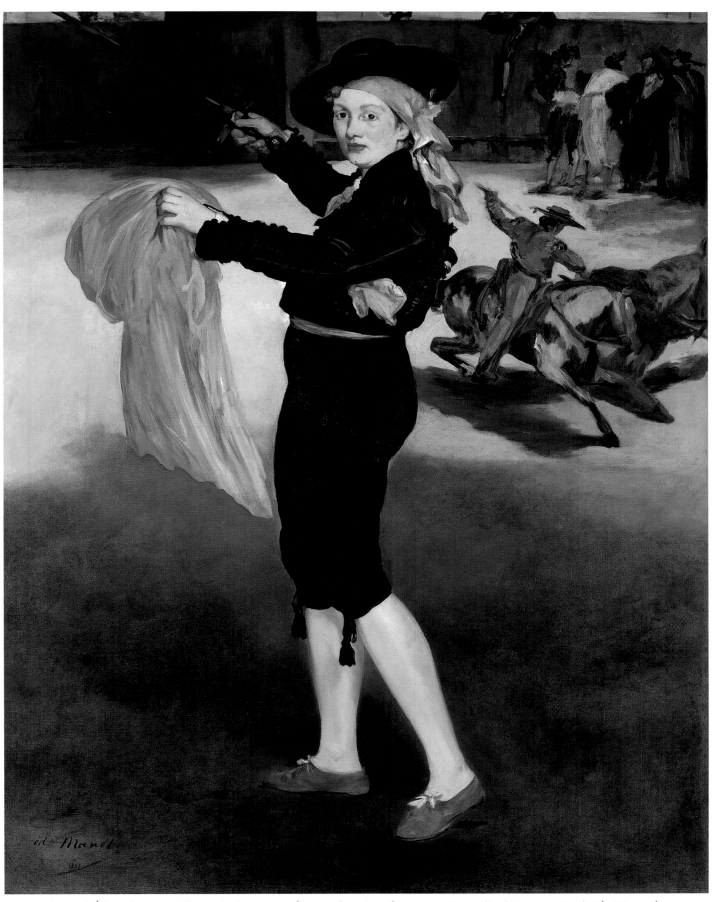

Fig. 9.34 (cat. 139) Édouard Manet, *Mlle V. . . in the Costume of an Espada*, 1862. Oil on canvas, 65 x 50¼ in. (165.1 x 127.6 cm). The Metropolitan Museum of Art, New York, H. O. Havemeyer Collection, Bequest of Mrs. H. O. Havemeyer, 1929 (29.100.53)

Fig. 9.35 (cat. 38) Francisco de Goya y Lucientes, *La Tauromaquia (The Art of Bullfighting)*, *No. 5: El animoso moro Gazul es el primero que lanceó toros en regla (The Courageous Moor Gazul Was the First Who Speared Bulls According to Rules)*, 1815–16. Etching and aquatint with drypoint, 9⅞ x 14⅛ in. (25 x 35.8 cm). The Metropolitan Museum of Art, New York, Rogers Fund, 1921 (21.19.5)

Fig. 9.36 (cat. 39) Francisco de Goya y Lucientes, *La Tauromaquia (The Art of Bullfighting)*, *No. 19: Otra locura suya en la misma plaza (Another Madness of His in the Same Bullring)*, 1815–16. Etching, aquatint, drypoint, and burin, 9¼ x 14 in. (24.7 x 35.5 cm). The Metropolitan Museum of Art, New York, Rogers Fund, 1921 (21.19.19)

61. Farwell 1969, pp. 202–4; Farwell 1981, pp. 163–65, 419, fig. 134; Fried 1996, pp. 145–46; Mauner in Paris–Baltimore 2000–2001, pp. 30–31. For other sources, see Paris–New York 1983, p. 113, no. 33.
62. McCauley 1985, pp. 181, 185, figs. 179, 180.

shown after all—in a space separated from the official Salon only by a turnstile. While this separate-but-equal exhibition, the Salon des Refusés, attracted less press than the official exhibition, it was for many *the* art event of 1863.

The earlier of the two single-figure works Manet exhibited at the Salon des Refusés featured Victorine Meurent, who became the artist's favorite model, replacing Suzanne Leenhoff, the companion whom he was soon to marry and who had posed for many of his "old master" nudes of the 1850s. Victorine posed for a number of Manet's contemporary figures, including *The Street Singer* (ca. 1862, Museum of Fine Arts, Boston) and the *Young Lady in 1866 (Woman with a Parrot)* (fig. 9.33). *Mademoiselle V. in the Costume of an Espada*, the title that Manet gave the work in the 1863 Salon catalogue (it became *Mlle V.* . . for his 1867 one-man show), is one of the strangest pictures that he ever painted (fig. 9.34). In observing the convention to which society portrait painters hewed—they reduced their sometimes very recognizable subject's last name to an initial letter: *Portrait de Monsieur X . . .* , *Portrait de Madame Y****—Manet suggests that Mademoiselle V. is a real and conventionally private person, a particular young lady whose identity he discreetly conceals. But he then garbs her as an espada, or matador, and places her in a bullring, apparently about to kill a bull. There are further problems. Although Victorine brandishes her sword as if the bull were about to charge, she stares not at the animal but at the viewer. Moreover, the scene depicted behind her—the bull, in a strange, dislocated space, charges a mounted picador as a group of toreros watches—belongs to the early stages of the combat, not the final kill. The combat is thus clearly a fiction. The whole thing—figures and setting—is in fact a patchwork of motifs from etchings in Goya's *Tauromaquia* (*The Art of Bullfighting*, figs. 9.35, 9.36). In addition, the Spanish costume and context have been superimposed on an identifiable Raphaelesque source: Marcantonio Raimondi's engravings after a set of Virtues (Mlle V. is a conflation of Temperance and Justice).[61] The presentation of Mlle V. as a female bullfighter also draws on photographs of contemporary opera and ballet stars.[62] Far from revealing Manet as an artist short on inspiration, the picture shows him manipulating a great variety of sources with wit and flair. In this intriguing piece of picture making, Manet rivals Goya as a master of fantasy and caprice.

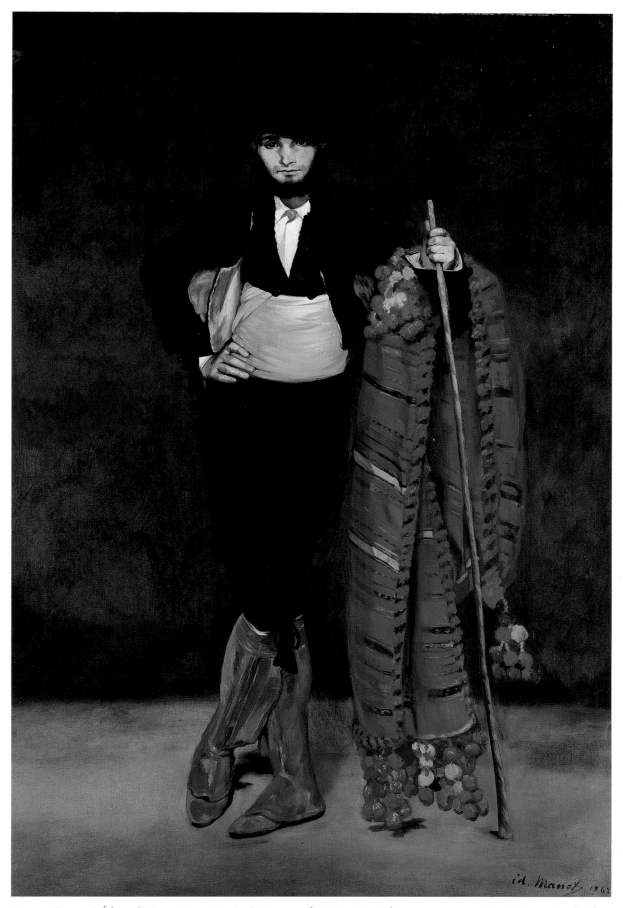

Fig. 9.37 (cat. 140) Édouard Manet, *Young Man in the Costume of a Majo*, 1863. Oil on canvas, 74 x 49⅛ in. (188 x 124.8 cm). The
Metropolitan Museum of Art, New York, H. O. Havemeyer Collection, Bequest of Mrs. H. O. Havemeyer, 1929 (29.100.54)

63. "the man of the people . . . has still kept
. . . the red or yellow sash, the breeches
furnished with filigrane buttons, or with
small coins, soldered to a shank, with the
leather gaiters open up the side to let the
leg be seen . . . It is considered highly
fashionable to carry a cane (*vara*) or
white stick, four feet long. . . . Two
handkerchiefs, with their ends hanging
out of the jacket pockets, a long *navaja*
[knife] stuck in the sash, not in front, but
in the middle of the back, constitute the
height of elegance for these coxcombs of
the people" ("le peuple . . . a gardé . . .
la ceinture rouge ou jaune; le pantalon à
revers retenu par des boutons de filigrane
ou de pièces à la colonne, soudées à un
crochet; les guêtres de cuir ouvertes sur
le côté et laissant voir la jambe. . . . Le
grand genre est de porter à la main une
canne (*vara*) ou bâton blanc, haut de
quatre pieds. . . . Deux foulards dont les

The *Young Man in the Costume of a Majo* (fig. 9.37) accompanied *Mlle V.* to the Salon des Refusés. The model was the youngest of the three Manet brothers, Gustave. His costume, which the painter again assembled from props in his studio, differs little from that of a *majo* described by Gautier in the texts he wrote after his first trip to Spain.[63] Manet signed and dated this painting shortly before sending it to the Salon. It is therefore possible that it was executed as a pendant to the figure of Victorine, with the intention that the two canvases should hang on either side of the *Déjeuner sur l'herbe*—Hispanic wings for an Italian High Renaissance altarpiece.[64] Just as it has been recognized that Victorine's pose reflects that of Raphael's Temperance engraved by Raimondi, so has a classical source for this model's relaxed and confident pose been proposed: the celebrated *Flute-Playing Faun* in the Louvre.[65]

In such works, Manet was playing a double game: he was both pastiching the past and engaging it.[66] And in relation to specifically "Spanish" subject matter, he was both Hispanicizing French subjects and addressing real-life Spanish persons and themes. From August 12 through November 2, 1862, a troupe of Spanish dancers from Madrid performed

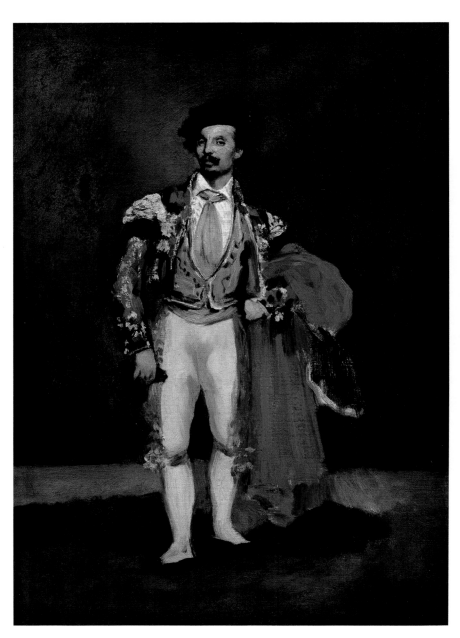

Fig. 9.38 (cat. 137) Édouard Manet, *The Dancer Mariano Camprubi*, 1862–63. Oil on canvas, 18½ x 13 in. (47 x 33 cm). Private collection, United States

Fig. 9.39 (cat. 175) Édouard Manet, *Don Mariano Camprubi (Le Bailarin)*, 1862–63. Etching, 13⅜ x 8¹¹⁄₁₆ in. (23.8 x 16.1 cm). National Gallery of Art, Washington, D.C., Rosenwald Collection, 1945

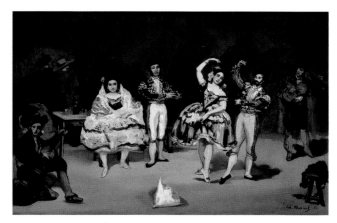

Fig. 9.40 Édouard Manet, *The Spanish Ballet*, 1862–63. Graphite, brush, and India ink, watercolor and gouache, pen and ink, on tracing paper, 9⅛ x 16⅜ in. (23.2 x 41.5 cm). Szépmüvészeti Múzeum, Budapest

Fig. 9.41 (cat. 136) Édouard Manet, *The Spanish Ballet*, 1862. Oil on canvas, 24 x 35⅝ in. (60.9 x 90.5 cm). The Phillips Collection, Washington, D.C.

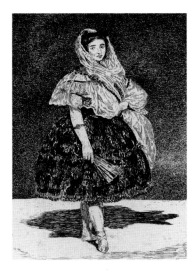

Fig. 9.42 (cat. 181) Édouard Manet, *Lola de Valence*, 1863. Etching and aquatint; third state, 10½ x 7⁷⁄₁₆ in. (26.6 x 18.5 cm) platemark. The Metropolitan Museum of Art, New York, Rogers Fund, 1918 (18.88.28)

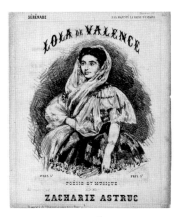

Fig. 9.43 (cat. 180) Édouard Manet, *Lola de Valence—Serenade*, 1863. Lithograph, 13 x 9¼ in. (33 x 24 cm), with lettering. S. P. Avery Collection, Print Collection, Miriam and Ira D. Wallach Division of Art, Prints, and Photographs, The New York Public Library, Astor, Lenox, and Tilden Foundations

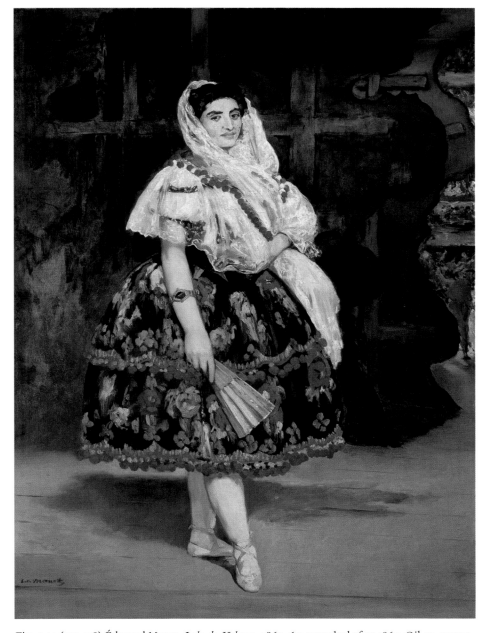

Fig. 9.44 (cat. 138) Édouard Manet, *Lola de Valence*, 1862–63; reworked after 1867. Oil on canvas, 48⅜ x 36¼ in. (123 x 92 cm). Musée d'Orsay, Paris

Fig. 9.45 (cat. 176) Édouard Manet, *The Tavern (La Posada)* or *Before the Corrida*, 1862–63. Etching, 11⅛ x 17¼ in. (29.6 x 44 cm) platemark. S. P. Avery Collection, Print Collection, Miriam and Ira D. Wallach Division of Art, Prints, and Photographs, The New York Public Library, Astor, Lenox, and Tilden Foundations

Fig. 9.46 Édouard Manet, *The Tavern (La Posada)*, 1866. Oil on canvas, 20½ x 35 in. (52 x 89 cm). Hill-Stead Museum, Farmington, Conn., Alfred Atmore Pope Collection

bouts pendent hors des poches de la veste, une longue *navaja* passée dans la ceinture, non par devant, mais au milieu du dos, sont le comble de l'élégance pour ces fats populaires"). Gautier 1853b, p. 169; see also pp. 274, 211–12.

64. In an unpublished caricature by Fabritzius (private collection) that purports to show the Salon des Refusés of 1863, Manet's *Déjeuner sur l'herbe* (titled *Le Bain* in the catalogue) is seen high up on the end wall of a large gallery. It is indeed flanked by the two paintings: the *Young Man in the Costume of a Majo* on the left and *Mlle V. . . in the Costume of an Espada* on the right.

65. Meller 2002, p. 81 n. 67; Haskell and Penney 1981, p. 212, no. 32, fig. 110.

66. Peter Meller will address these issues, as well as Manet's complex relationship with Couture, in a forthcoming publication developing his study of Manet's early drawings. The current essay has benefited greatly from his generous discussion of many topics related to his concerns.

67. McCauley 1985, pp. 173–81, figs. 167, 171–73, 176.

at the Hippodrome in Paris. Mariano Camprubi was the principal male dancer (fig. 9.38), but Lola Melea, whose stage name was Lola de Valence, was the star of the show. Manet and his friends were enthralled; Baudelaire and the artist, writer, and composer Zacharie Astruc both created works celebrating Lola's seductive energy (figs. 9.42, 9.43). Manet is said to have persuaded the whole troupe to pose for him in the studio of the Belgian artist Alfred Stevens, which was much larger than his own. He evoked their ballet *The Flower of Seville* in a painting and in a study for a print (figs. 9.40, 9.41) and replicated his brilliant small canvas of Camprubi in a superbly vigorous etching (fig. 9.39) that evokes contemporary theatrical posters and souvenir photographs.

One writer has recently argued that Manet relied as much on commercial carte-de-visite photographs of his subjects as he did on direct observation in creating his images of the Spanish troupe and his less-than-lifesize portrait of Lola de Valence (fig. 9.44). In support of that argument is the fact that Manet's etching of Lola (fig. 9.42) originally had a neutral background.[67] In addition, the table, bench, and stool in *The Spanish Ballet* (fig. 9.41) are props from Manet's studio, while the shadowy background figures derive from Goya's *Tauromaquia*. The depiction of the Spanish dance troupe is therefore a fiction. In a curious pendant image, incorrectly called *La Posada (The Tavern)* (figs. 9.45, 9.46), bullfighters lounge on the same studio furniture in what is clearly a small chapel—one torero salutes the image of the Virgin—as they await the corrida. In the early 1860s Manet is still wedding reality to unreality—a characteristic of *Incident at a Bullfight*, the large work that he sent to

Fig. 9.47 Édouard Manet, *The Bullfight*, 1864. Oil on canvas, 18⅞ x 42¼ in. (48 x 108 cm). The Frick Collection, New York

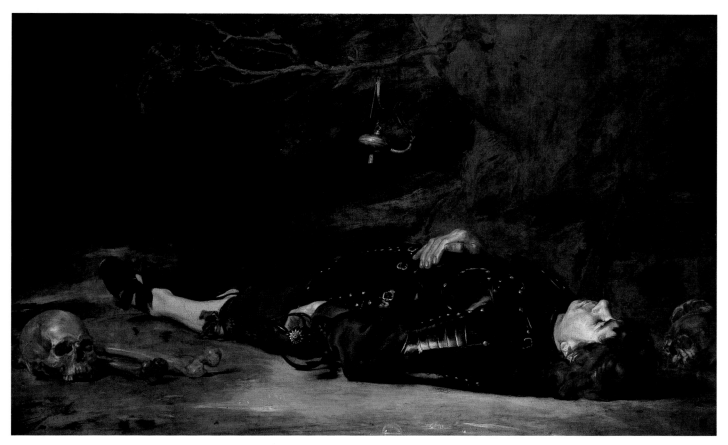

Fig. 9.48 (cat. 81) Formerly Diego Rodríguez de Silva y Velázquez, now Italian, 17th century, *Dead Soldier*. Oil on canvas, 41¼ x 65¼ in. (104.8 x 167 cm). The National Gallery, London

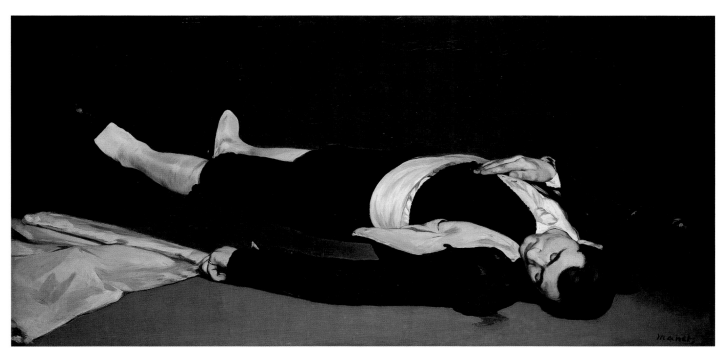

Fig. 9.49 (cat. 141) Édouard Manet, *Dead Toreador*, 1863–64. Oil on canvas, 29⅞ x 60⅛ in. (75.9 x 153.3 cm). National Gallery of Art, Washington, D.C., Widener Collection

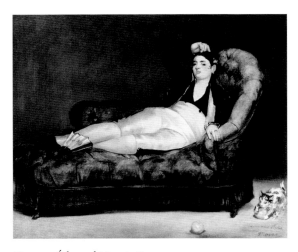

Fig. 9.50 Édouard Manet, *Young Woman Reclining in a Spanish Costume*, 1862–63. Oil on canvas, 37⅛ x 44¾ in. (94.7 x 113.7 cm). Yale University Art Gallery, Bequest of Stephen Carlton Clark, B.A. 1903

68. Gautier 1961, pp. 77–94, 288–99, reported on the bullfights that he saw on his first trip to Spain in 1840 and later on those that he observed in Paris (1849), Brussels (1853), and Saint Esprit (1853 and 1856). One of the earliest French representations of the "typical" bullfight was supplied by Baron Taylor's *Voyage pittoresque en Espagne, en Portugal et sur la côte d'Afrique, de Tanger à Tétouan* (Paris, 1826–32), which devoted fifteen plates to the subject. Each plate was accompanied by a page of explanatory text. Closer to Manet's own time, the illustrated weeklies published a number of images related to bullfights. See Madrid 1989 for discussions and reproductions of contemporary Spanish and French bullfighting prints. Photographers in France and Spain also documented the principal bullrings and celebrities of the bullfighting world. The catalogues of J. Laurent listed portraits of bullfighters from 1863 onward.

69. X-radiography has revealed the very complex development of Manet's composition and enabled tentative reconstructions to be made. See Washington 1982–83, p. 214, no. 77, and the reconstructions by Ann Hoenigswald and Malcolm Park in New York 1999.

70. In his column of June 15, Thoré described the figure in Manet's painting as "boldly copied from a masterpiece in the Pourtalès collection (no. 103 in the catalogue), the work of Velazquez"

the 1864 Salon together with *The Angels at the Tomb of Christ* or, as he later titled it, *The Dead Christ and Angels* (fig. 9.51).

We do not know when Manet began work on the *Incident*. He did not see his first bullfight until he went to Spain in 1865, and bullfighting was not permitted in Paris under the Second Empire. Written accounts were commonplace, however, and there was an abundance of documentary imagery available.[68] Manet created the picture for the 1864 Salon from his imagination, his aim evidently to make something grand and heroic of the trivial, brutal, even absurd aspects of such events. The painting exhibited at the Salon is known from three contemporary caricatures. It pleased no one, including the artist, and he cut the work apart. Two portions are still extant: the one he always called *L'Homme mort* (*The Dead Man*, now generally known as *Dead Toreador*) (fig. 9.49) and a small fragment in the Frick Collection (fig. 9.47).[69] There has been considerable debate about Manet's sources for the striking *Dead Toreador*. The contemporary critic Théophile Thoré observed of the original Salon painting that Manet had copied the figure of the dead man from the *Dead Soldier* (fig. 9.48), also called *Roland mort (The Dead Roland)*, then considered a masterpiece by Velázquez, which was in the private collection of James-Alexandre Pourtalès-Gorgier.[70] Baudelaire heatedly denied in a letter to Thoré that Manet had ever seen the Pourtalès collection, although it was open to visitors.[71] And, indeed, the foreshortened pose that offers the most striking similarity with the pseudo-Velázquez has been widely used to depict the figure of a fallen warrior.[72] In any case, this reworked fragment of the *Incident at a Bullfight* is now recognized as one of Manet's supreme masterpieces—a work of far greater weight and worth than the pseudo-Velázquez that was or was not its model.

The genesis of Manet's *Olympia*, which he certainly worked on in tandem with the *Déjeuner sur l'herbe*,[73] can be traced back to his early contact with Italian Renaissance art. Manet signed the painting in 1863 but did not send it to the Salon until 1865. Baudelaire, who left Paris for Brussels in April 1864, may not have seen the picture in its final form, and he expressed surprise when he heard that a cat appeared in it.[74] He would undoubtedly have approved the final metamorphosis of an image conceived in the High Renaissance tradition into one that—probably to Manet's surprise—the public perceived to be shockingly "low." Baudelaire had seen copies of Goya's two *Majas* (figs. 14.21, 14.22) at a dealer's gallery in 1859. He described them in a letter to the photographer Nadar as pictures of *"the Duchess of Alba, by Goya (real Goya, hyperauthentic Goya). The copies (same size) are in Spain, where Gautier saw them. In one, the Duchess wears Spanish dress. In the other, she is naked, in the same pose—flat on her back."*[75] Baudelaire begged Nadar to photograph the paintings and, if possible, to buy them.[76] It will probably never be known whether Manet saw the copies, but he painted and later dedicated to Nadar a *Young Woman Reclining in a Spanish Costume* (fig. 9.50) that parallels, if it does not imitate, Goya's *Clothed Maja*.[77]

MANET IN SPAIN

The two ambitious works that Manet sent to the 1865 Salon were both accepted.[78] The problematic *Jesus Mocked by the Soldiers* (1864–65, Art Institute of Chicago) was immediately linked to *The Dead Christ and Angels* (fig. 9.51), which Manet had exhibited the year before,

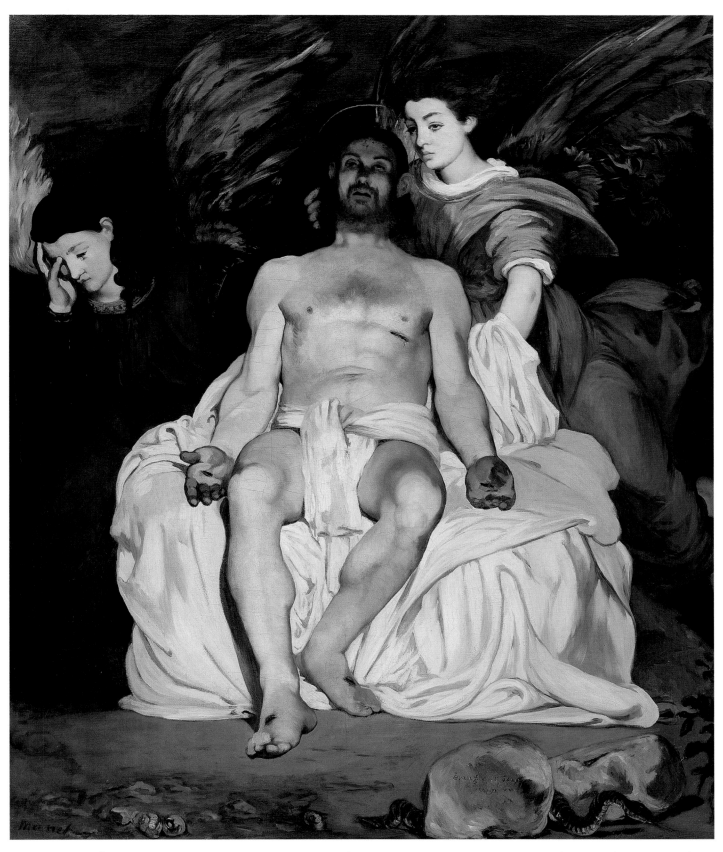

Fig. 9.51 (cat. 142) Édouard Manet, *The Dead Christ and Angels*, 1864. Oil on canvas, 70⅝ x 59 in. (179.4 x 149.9 cm). The Metropolitan Museum of Art, New York, H. O. Havemeyer Collection, Bequest of Mrs. H. O. Havemeyer, 1929 (29.100.51)

("audacieusement copiée d'après un chef-d'oeuvre de la galerie Pourtalès [n° 103 du catalogue], peint par Velazquez tout simplement"). Bürger 1864b, p. 2.

71. In his column of June 26, Thoré acknowledges receipt of Baudelaire's letter: "The apparent similarity between two artists is sometimes only the result of 'mysterious coincidences.' So writes Charles Baudelaire, who assures me that his friend Edouard Manet is not imitating Goya or Greco because he has never seen a Goya or a Greco, and that 'similarities like these are not unknown in nature'" ("la similitude apparente de deux artistes peut n'être que le résultat de 'mystérieuses coïncidences.' C'est ce que vient de m'écrire Charles Baudelaire, assurant que son ami, M. Edouard Manet, ne pastiche point Goya ni le Greco, puisqu'il n'a jamais vu de Goya ni de Greco, et que 'ces étonnants parallélismes peuvent se présenter dans la nature'"). Ibid., p. 2. For the complete text of Baudelaire's letter, see Baudelaire 1973, vol. 2, pp. 386–87. For the accessibility of the Pourtalès collection, see Joanne 1863, "Les collections particulières," pp. 701–2: "The gallery can be visited on Wednesdays, on presentation of an entrance card which may be obtained by a written request" ("La galerie est accessible, le mercredi, au moyen d'une carte d'entrée que l'on obtient sur une demande écrite").

72. The pose appears in nineteenth-century pictures ranging from grand historical Salon paintings to popular battle scenes. It is encountered as early as the sixteenth century, in Johannes Stradanus's engraving of a bullfight (*Venationes ferarum*, pl. 3), a work that Manet is, however, not likely to have seen (Madrid 1989, p. 11, pl. 1).

73. London 1986, pp. 42–47.

74. Baudelaire heard from a visitor that "the picture showing a naked woman, with the black woman and the cat (is it really a cat?), was much better than the religious painting" ("le tableau représentant la femme nue, avec la négresse, et le chat [est-ce un chat décidément?], était très supérieur au tableau religieux"). Baudelaire 1973, vol. 2, pp. 496–97.

75. "*La Duchesse d'Albe*, de Goya (archi-Goya, archi-authentique). Les doubles (grandeur naturelle) sont en Espagne, où Gautier les a vus. Dans l'un des cadres, la Duchesse est en costume national, dans le pendant, elle est nue et dans la même posture, couchée à plat sur le dos." Ibid., vol. 1, p. 574. The model for the *Majas* was thought at the time to have been the duchess of Alba. A reduced copy of the *Clothed Maja*

and reviewers rejected both pictures out of hand.[79] But the critical and popular response concentrated on Manet's other entry, *Olympia*. Fortunately for Salon-goers unwilling to face the artistic issues that this painting raised, Manet had provided an easy way out: they could focus their indignation and ire on the black cat at the foot of the model's bed.[80]

An aggrieved Manet sought solace from Baudelaire: "I wish you were here, my dear Baudelaire," he wrote early in May. "The insults pour down like hailstones. It has never been quite this bad. . . . I wish you were here to tell me what you think of my pictures. Your judgment is good, and the racket is quite annoying, and it's plain that someone is wrong."[81] Baudelaire, who had received his fair share of critical knocks—not always, it bears noting, without provocation—had little patience for his young friend's turmoil: *"People are making fun of you. The jokes are quite annoying. No one is doing you justice. And so on and so forth. Do you really believe you're the first man who has ever been in such a position? Do you have more genius than Chateaubriand or Wagner? People mocked them. And it didn't kill them."*[82]

There are no records as to how Manet spent June, July, and August or where he spent them—because he nurtured hopes of selling *Olympia*, he presumably remained in Paris until the Salon closed—but plans for a serious trip of some sort seemed to be taking shape, and they eventually focused on Spain. In August, Manet addressed a request for advice (now lost) to his Hispanophile friend Zacharie Astruc. Astruc's long and effusive reply from his retreat in Fontainebleau gives Manet a detailed itinerary. Manet thanked him in a letter dated *Mercredi*: "Your itinerary seems excellent; I'll follow it precisely. . . ."[83] The same letter reveals that others—most notably one of the Stevens brothers, probably Alfred, and the critic Champfleury—had been thinking of accompanying Manet. But they could not make up their minds, while Manet was ready to go: "I'm tempted to leave immediately, the day after tomorrow perhaps, I simply can't wait to see all those wonderful things and go to *maître* Velasquez for advice."[84]

By 1865 every alert young artist who was drawn to Velázquez understood that the only place to really see his work was Madrid. Mérimée made the point in 1831 when he described the "musée de Madrid" to stay-at-homes: "That is the only place where I have seen a good number of Velasquezes. . . . It has to be said that works by this master are rare even in Spain."[85] The point was a staple of guidebooks,[86] and the inescapable Charles Blanc—founder and editor of the ambitious *Histoire des peintres de toutes les écoles*, founder of the *Gazette des Beaux-Arts*, organizer of Salons (1848, 1872), and proponent of "high art"—repeated it in 1863. He wrote of his trip to Madrid with the author Paul de Saint-Victor in September 1862, "Vélasquez was the principal reason for our visit, because we are familiar with the other Spanish painters."[87]

It is not known for certain when Manet left Paris. Suzanne and Eugénie Manet retired to a property in west central France belonging to one of Eugénie's relatives, and Suzanne wrote from there on Tuesday, September 5, to inform Baudelaire in Brussels that her husband had left Paris "a week ago."[88] If Suzanne meant the expression to be taken literally, Édouard would have left Paris on Thursday, August 29. The rail trip from Paris via Bordeaux and Bayonne to the border at Irún took a minimum of seventeen hours, while the run from Irún to Madrid via Burgos and Valladolid took another twenty-two hours. Manet later told Astruc that he had "admired" Burgos and Valladolid, which could mean simply that he had taken a good look at them from the train on the way to or from Madrid. But since he also criticizes a

painting by El Greco in the Burgos Cathedral, he must have disembarked there. He also wrote that he spent seven days in Madrid and had visited Toledo.[89] The only record of Manet's presence in Madrid is afforded by the Prado visitors' book, which reveals that he visited the museum with Théodore Duret[90] soon after it opened on Friday, September 1 (fig. 14.65).

Manet's letter of September 3 to Fantin-Latour shows where Manet placed his priorities: "Vélasquez, who all by himself makes the journey worthwhile; the artists of all the other schools around him in the museum at Madrid, who are extremely well represented, all look like shams. He is the supreme artist; he didn't surprise me, he enchanted me."[91] One long, breathless sentence conveys the passion, focus, and intensity with which Manet undertook his lightning visit far better than any paraphrase could do:

> The most extraordinary piece in this splendid oeuvre and possibly the most extraordinary piece of painting that has ever been done is the picture described in the catalogue as a portrait of a famous actor at the time of Philip IV [fig. 9.57]; the background disappears, there's nothing but air surrounding the fellow, who is all in black and appears alive; and the spinners, the fine portrait of Alonso Cano; las Meninas (the dwarfs) [sic], another extraordinary picture; the philosophers, both amazing pieces; all the dwarfs, one in particular seen sitting full face with his hands on his hips, a choice picture for a true connoisseur; his magnificent portraits—one would have to go through them all, they are all masterpieces; a portrait of Charles V by Titian, which is highly regarded and which I'm sure I would have admired anywhere else, seems wooden to me here.[92]

Manet addressed a considerably more composed letter to Baudelaire after his return to France: "At last, my dear Baudelaire, I've really come to know Vélasquez and I tell you he's the greatest artist there has ever been; I saw 30 or 40 of his canvases in Madrid, portraits and other things, all masterpieces; he's greater than his reputation and compensates all by himself for the fatigue and problems that are inevitable on a journey in Spain."[93]

The names of two other painters—El Greco and Goya—turn up in letters that Manet wrote immediately after his trip to Spain. Domenikos Theotokopoulos impressed Manet sufficiently to figure in the review of his trip that he addressed to Astruc on September 17. Manet characterizes El Greco's work as "bizarre"—the word seems harmless enough today, but its negative connotations were doubtless far more powerful in 1865. Certain portraits by Greco are "very fine," but Manet was not at all pleased by "his Christ at Burgos."[94]

Manet was considerably more impressed by Goya, describing him to Fantin-Latour as "the most original next to the master whom he imitated too closely in the most servile sense of imitation. But still he's tremendously spirited. The museum has two fine equestrian portraits by him, done in the manner of Vélasquez, though much inferior. What I've seen by Goya so far hasn't greatly appealed to me; in a day or so I'm to see a splendid collection of his work at the Duque de Ossuna's."[95] Two weeks later, Manet tells Astruc, "I must have asked a dozen times or more at the Café Suisse for the artist Garcia Martinez; he was not in Madrid, so I didn't manage to see the Ossuna Gallery."[96] Thus, the Goyas that Manet inspected were those in public institutions in Madrid and Toledo. His interest in and respect for

(22⅛ x 33½ in. [57 x 85 cm]), now in the Museum Boijmans Van Beuningen, Rotterdam (inv. 2578), belonged to the author Paul de Saint-Victor (see Saint-Victor 1882, lot 31, attributed to Goya). It is said to have come from Javier Goya or his grandson Mariano via Valentín Carderera (Desparmet Fitz-Gerald 1928–50, vol. 1, p. 25, vol. 2, p. 106, note under no. 388).

76. No photographs by Nadar are known, nor has any further allusion to the pictures been found.

77. Paris–New York 1983, no. 29. Manet exhibited the Young Woman at Martinet's gallery in 1863, where it was cruelly caricatured in a drawing by the artist's "admirer" (see n. 45, above).

78. "The jury did well to accept Olympia—not on the first try, but in the end it did. So Manet's handful of admirers cannot cry foul. Moreover, the show's organizers did well to hang her at eye level, because it forces the artist to take a good look at his work. Who knows? He might in the end think it's a bit less comical than we do" ("Le jury a bien fait de recevoir l'Olympia; il s'y est repris à deux fois, mais enfin il l'a reçue, et les trois fanatiques de M. Manet ne pourront pas crier au martyre. De son côté l'administration a eu raison de la placer sur la cymaise; elle a mis ainsi le nez de l'artiste dans sa peinture, et, qui sait ? peut-être lui paraîtra-t-elle moins drôle qu'à nous"). Leroy 1865, p. 2.

Fig. 9.52 Auguste Muriel, *Bullfight in Madrid*. Published in *La Critique Illustrée*, June 25, 1865. Photo courtesy the author

79. The *Jesus Mocked* led Gautier to revive the silly story about Goya that he had dredged up in 1838: "The painter's performance reminds one of Goya's mad sketches, though it lacks their wit. Goya liked to throw buckets of paint at his canvas" ("L'exécution rappelle, moins l'esprit, les plus folles ébauches de Goya, lorsqu'il s'amusait à peindre en jetant des baquets de couleurs contre sa toile"). *Le Moniteur Universel*, July 24, 1865. Gautier was evidently "recalling" an influential 1834 article on Goya whose anonymous author had written of Goya's country house: "he painted murals on all the walls. He sometimes dumped all his pigments into the same big pot, then hurled them at a blank wall. He amused himself by turning the resulting mess of colorful splatters into impressive scenes from contemporary history. That's how . . . he came to paint the massacre of French soldiers by the inhabitants of Madrid that we all remember too well: he used a spoon as a brush" ("il en avait peint lui-même toutes les murailles. Quelquefois il jetait dans une chaudière des couleurs mêlées, et les lançait avec violence contre un vaste mur blanchi; il se plaisait à faire sortir de ce chaos d'éclaboussures des scènes imposantes de l'histoire contemporaine. C'est ainsi [qu'il] a représenté avec une cuillère, en guise de brosse, le massacre trop célèbre de nos soldats par les habitants de Madrid"). Anon. 1834c, p. 324.

80. Bertall managed to work Manet's cat into seven of his caricatures: "Le Salon, par Bertall," *L'Illustration* (June 3, 1865), p. 341; "Le Salon de 1865, par Bertall," *L'Illustration* (June 17, 1865), p. 389.

81. "Je voudrais bien vous avoir ici, mon cher Baudelaire, les injures pleuvent sur moi comme grêle, je ne m'étais pas encore trouvé à pareille fête. . . . J'aurais voulu avoir votre jugement sain sur mes tableaux car tous ces cris agacent et il est evident qu'il y a quelqu'un qui se trompe." Letter from Manet (Paris) to Baudelaire (Brussels), undated (early May 1865), in Pichois 1973, pp. 233–34; Manet 1991, p. 33.

82. "*On se moque de vous.* Les *plaisanteries* vous agacent; on ne sait pas vous rendre justice, etc., etc. Croyez-vous que vous soyez le premier homme placé dans ce cas? Avez-vous plus de génie que Chateaubriand et que Wagner? On s'est bien moqué d'eux cependant? Ils n'en sont pas morts." Letter from Baudelaire (Brussels) to Manet (Paris), May 11, 1865, in Baudelaire 1973, vol. 2, p. 496.

83. "Votre itinéraire me semble excellent; je le suivrai de point en point." The whereabouts of Manet's letter are unknown. See Lassaigne 1945, p. 1, for a transcription,

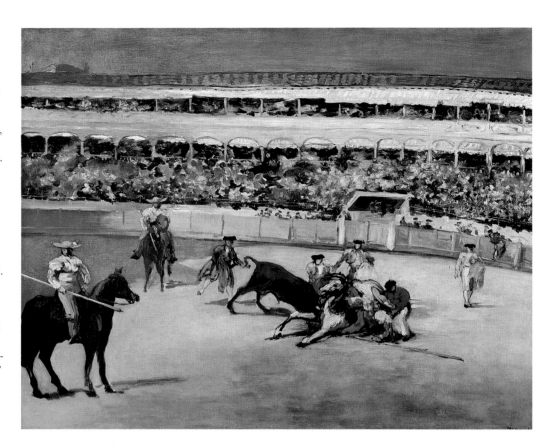

Fig. 9.53 (cat. 147) Édouard Manet, *The Bullring in Madrid*, 1865. Oil on canvas, 35⅜ x 43¼ in. (90 x 110 cm). Musée d'Orsay, Paris

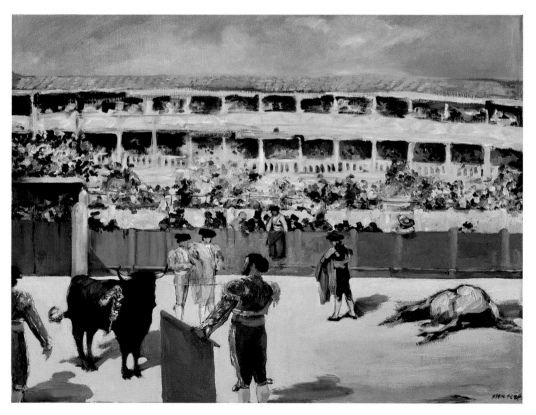

Fig. 9.54 (cat. 148) Édouard Manet, *The Bullfight*, 1865–67. Oil on canvas, 18⅞ x 23¾ in. (48 x 60.4 cm). Art Institute of Chicago, Mr. and Mrs. Martin A. Ryerson Collection

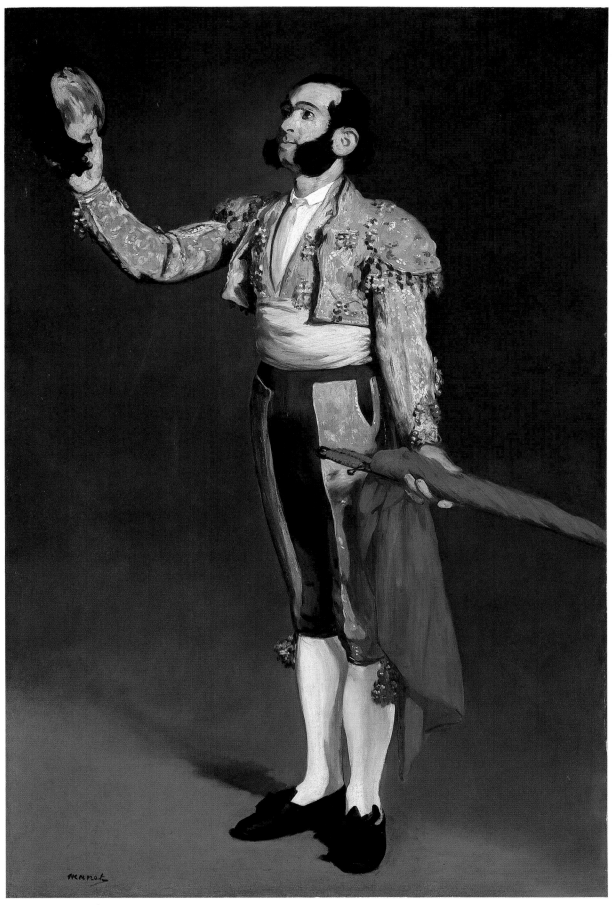

Fig. 9.55 (cat. 149) Édouard Manet, *A Matador (The Saluting Torero)*, 1866–67. Oil on canvas, 67⅛ x 44½ in. (171.1 x 113 cm).
The Metropolitan Museum of Art, New York, H. O. Havemeyer Collection, Bequest of Mrs. H. O. Havemeyer, 1929 (29.100.52)

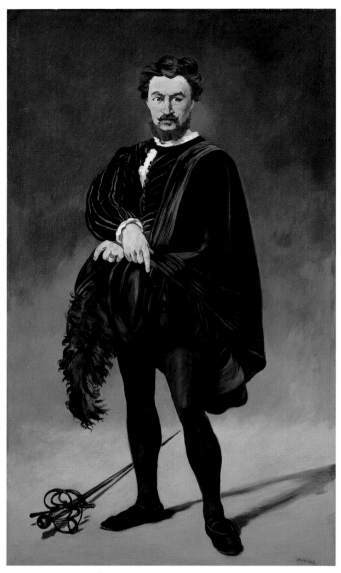

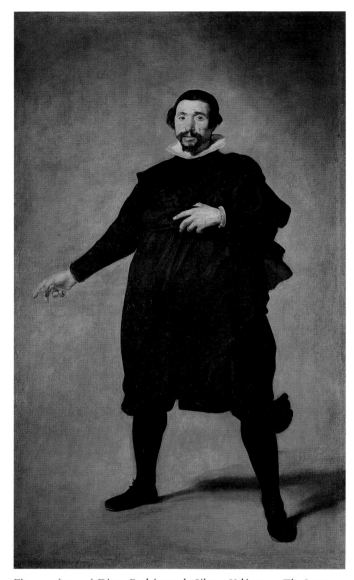

Fig. 9.56 (cat. 150) Édouard Manet, *The Tragic Actor (Rouvière as Hamlet)*, 1865–66. Oil on canvas, 73¾ x 42⅛ in. (187.2 x 108.1 cm). National Gallery of Art, Washington, D.C., Gift of Edith Stuyvesant Gerry

Fig. 9.57 (cat. 73) Diego Rodríguez de Silva y Velázquez, *The Jester Pablo de Valladolid*, ca. 1632–35. Oil on canvas, 84 x 49¼ in. (213.5 x 125 cm). Museo Nacional del Prado, Madrid

reproduced in Manet 1988, pp. 41–42; see also Manet 1991, p. 34.

84. "j'ai presque envie de partir tout de suite, après-demain peut-être; je suis extrêmement pressé de voir tant de belles choses et d'aller demander conseil à maître Velasquez." Manet 1988, pp. 41–42.

85. "C'est là seulement que j'ai vu une collection de Velasquez. . . . Il faut remarquer que les ouvrages de ce maître sont rares, même en Espagne." Mérimée 1831c, p. 74.

86. "Madrid is the only home of the mighty Andalucian, for here is almost his entire work." Ford 1845 (1966 ed.), vol. 3, p. 1115.

87. "c'était Vélasquez qui nous attirait là presque à lui seul, car les autres peintres

Goya centered on one of these works: "an incredibly charming portrait of the Duchess of Alba dressed as a *majo*," he tells Baudelaire. To Astruc he writes of Goya "whose masterpiece seems to me to be in the Academy (*The Duchess of Alba* [fig. 14.22], what a stunning invention)."[97]

It is impossible to read Manet's letters about his trip to Spain without reaching two conclusions. First, his primary reason for going there was to see a great many authentic works by Velázquez. Yes, Astruc and Baudelaire had mentioned other painters to him—foremost among them Goya. And, prudent, cost-conscious traveler that he was, Manet made an effort to see their works and at least some of the other sights that Astruc had spelled out. But his main goal had been to see Velázquez, and he accomplished it with signal success. Second, exhausting as the trip had been, Manet was enormously refreshed and revivified by the experience: "I discovered in his work the fulfillment of my own ideals in painting, and the sight of those masterpieces gave me enormous hope and courage."[98] By October, he was back in Paris hard at work on new paintings directly inspired by his pilgrimage.

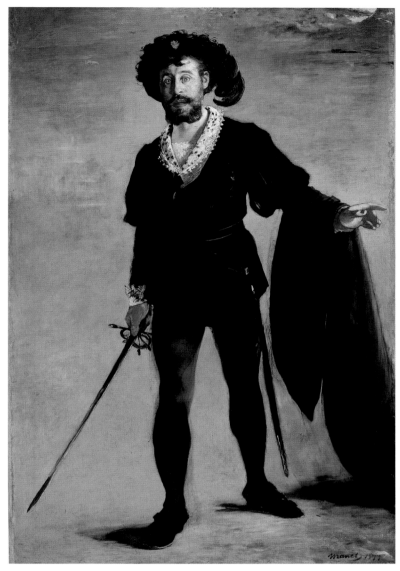

Fig. 9.58 (cat. 159) Édouard Manet, *Faure in the Role of Hamlet*, 1876–77. Oil on canvas, 76⅜ x 51¼ in. (194 x 131.5 cm). Museum Folkwang Essen

Manet after Spain

Four days after his return to France, Manet told Astruc: "I stayed a week in Madrid and had plenty of time to see everything, the Prado with all those mantillas was absolutely delightful, but the outstanding sight is the bullfight. I saw a magnificent one, and when I get back to Paris I plan to put a quick impression on canvas: the colorful crowd, and the dramatic aspect as well, the picador and horse overturned, with the bull's horns ploughing into them and the horde of *chulos* trying to draw the furious beast away."[99] Less than a month later, he wrote to his new friend Théodore Duret that he was back in Paris: "I have . . . already painted *the bullring in Madrid* since my return."[100] He was referring to the largest of his bullfight scenes (fig. 9.53), which was no doubt based on quick pencil sketches made on the spot at the bullfight Manet attended on Sunday, September 3.[101] X-radiography has revealed that the melee of men and animals as well as other passages of the vigorously brushed and thickly painted *Bullfight* were altered in the course of work; a photograph that Manet could have seen before he went to Spain (fig. 9.52) probably served as an aide-mémoire and model for

espagnols nous étaient suffisamment connus." Blanc 1863, p. 65.

88. "il y a huit jours." Pichois 1973, p. 235; Manet 1988, p. 46.

89. Letter from Manet (château de Vassé, near Sillé-le-Guillaume [Sarthe]) to Astruc (Fontainebleau), Sunday, September 17, 1865, in Manet 1988, p. 50; Manet 1991, p. 37. In 1867 the 90-kilometer trip from Madrid to Toledo took three hours, and there were two trains a day. If the same conditions prevailed in 1865, a side trip to Toledo would have taken the better part of two days. The letter that Manet addressed from Vassé to Baudelaire in Brussels on Thursday, September 14, begins: "I arrived from Madrid only yesterday" ("j'arrive hier seulement de Madrid"). Pichois 1973, p. 236; Manet 1988, p. 47; Manet 1991, p. 36. If taken literally, Manet's statement indicates that he reached Vassé on September 13. His stop in Burgos, and his hypothetical stop in Valladolid, may have been part of his return trip to France.

90. All visitors to the Real Museo who were not residents of Madrid were required to write their name, nationality, profession, and place of residence in the register. Manet's signature is the fourth on the register for September 1. He was preceded by two Spaniards from Valladolid and by a French citizen who signed himself "Th. Duret." (Duret does not give his profession or place of residence.) Manet signs himself "E. Manet" and for occupation writes "artiste." Manet made the acquaintance of Théodore Duret on his first day in Madrid: "The day I arrived in Madrid I met a Frenchman who is interested in art and who knew me. So I am not alone" ("J'ai trouvé à Madrid, le jour de mon arrivée, un Français qui s'occupe d'art et qui me connaissait. Je ne suis donc pas seul"). Letter from Manet (Madrid) to Henri Fantin-Latour, Sunday, September 3, 1865, in Manet 1988, p. 50; Manet 1991, p. 35.

91. "Vélasquez qui à lui tout seul vaut le voyage; les peintres de toutes les écoles qui l'entourent au musée de Madrid et qui y sont très bien représentés semblent tous des chiqueurs. C'est le peintre des peintres; il ne m'a pas étonné mais m'a ravi." Manet 1988, p. 43; Manet 1991, p. 34. Manet realized on the spot that the Louvre's *Philip IV* (fig. 9.20) was not an autograph work: "The full-length portrait in the Louvre is not his work. The *infanta* is the only thing that cannot be challenged" ("Le portrait en pied que nous avons au Louvre n'est pas de lui. L'infante seule ne peut être contestée"). The *Infanta Margarita* (fig. 1.2) is now considered to be a studio work.

92. "Le morceau le plus étonnant de cet oeuvre splendide et peut-être le plus étonnant morceau de peinture que l'on ait jamais fait est le tableau indiqué au catalogue, portrait d'un acteur célèbre au temps de Philippe IV; le fond disparaît, c'est de l'air qui entoure ce bonhomme tout habillé de noir et vivant; et les *fileuses*, le beau portrait d'Alonzo Cano, *las Meninas* (les nains), tableau extraordinaire aussi, ses philosophes, étonnants morceaux — tous les nains, un surtout assis de face les poings sur les hanches, peinture de choix pour un vrai connaisseur, ses magnifiques portraits, il faudrait tout énumérer, il n'y a que des chefs-d'oeuvre; un portrait de Charles-Quint par Titien, qui a une grande réputation qui doit être méritée et qui m'aurait certainement je crois paru bien autre part, me semble ici être de bois." Manet 1988, p. 44; Manet 1991, pp. 34–35. The works to which Manet refers are identified in Manet 1988, pp. 62–63. His translation of *Meninas* as *nains* (dwarfs) is incorrect; the word means "ladies in waiting."

93. "Enfin mon cher, je connais Vélasquez et vous déclare que c'est le plus grand peintre qu'il y ait jamais eu; j'ai vu à Madrid 30 à 40 toiles de lui, portraits ou tableaux, qui sont tous des chefs-d'oeuvre, il vaut plus que sa réputation et à lui seul vaut la fatigue et les déboires impossibles à éviter dans un voyage en Espagne." Letter from Manet to Baudelaire, September 14, 1865, in Pichois 1973, pp. 236–37; Manet 1988, pp. 47–48; Manet 1991, p. 36.

94. Letter from Manet to Astruc, September 17, 1865, in Manet 1988, p. 49; Manet 1991, pp. 36–37. Manet could have seen eight portraits by El Greco in the Real Museo. As for the *Christ*, Gautier mentions "in the large sacristy, next to the little one . . . a *Crucifixion* by Domenico Theotocopuli, known as *el Greco*, a strange, extravagant artist" ("dans la grande sacristie, voisine de la petite . . . un *Christ en croix*, du Domenico Theotocopuli, dit *el Greco*, peintre extravagant et singulier"). Manet 1988, p. 66. The picture in question cannot now be identified.

95. "le plus curieux après le maître, qu'il a trop imité dans le sens le plus servile d'imitation. Une grande verve cependant. Il y a de lui au musée deux beaux portraits équestres dans la manière de Vélasquez, bien inférieurs toutefois. Ce que j'ai vu de lui jusqu'ici ne m'a pas plus énormément; je dois en voir ces jours-ci une magnifique collection chez le duc d'Ossuna [sic]." Letter from Manet to Fantin-Latour, September 3,

the bullring setting. In Madrid, he would have been able to purchase photographs of the bullring and portraits of the star picadors, banderilleros, and espadas who took part in the corrida that he saw. This contemporary scene in the bullring at Madrid—a record of Manet's intense experience of Spain's quintessential fiesta—has a vivid, even awkward immediacy that is uncharacteristic of the artist. A second canvas (fig. 9.54) offers a closer view and more structured composition. Recollected in tranquillity, that luminous painting depicts the moment of stillness when man and bull confront each other for the kill, and it accords with Manet's preference for "things that are clear and motifs that do not move."[102]

A Matador (fig. 9.55),[103] which was probably one of the first of the lifesize figures that Manet painted on his return from Spain, clearly has a direct connection with the bullfight canvases. The figure may be saluting the president—the individual who presides over the corrida—in his box or dedicating the bull that he will kill to a lady. A very particularized Andalusian, with sideburns and jutting lower lip, he looks every inch a professional and contrasts sharply with Manet's pictures of Victorine Meurent as an espada (fig. 9.34) and of his brother as a *majo* (fig. 9.37).

Although Manet's debt to Velázquez is evident in *A Matador*, it is even more pronounced in his posthumous portrait of the actor Philibert Rouvière, which he titled *The Tragic Actor* (fig. 9.56). The painting in the Prado that most impressed Manet was Velázquez's depiction of a man in black, described in contemporary catalogues as a famous actor at the court of Philip IV but since identified as the court jester Pablo de Valladolid (fig. 9.57). Rouvière died on October 19, 1865, barely a week after Manet wrote Duret that he had completed his first bullfight canvas. The artist seized on the chance to emulate Velázquez's great "actor" portrait. Using photographs of Rouvière and his own friends as models, Manet created a vivid image of the actor as Hamlet, his most famous role. On March 27, 1866, he wrote Baudelaire to say that he had sent to the Salon "a portrait of *Rouvière* in the role of *Hamlet*, which I call the Tragic Actor to escape criticism from people who may not find it a good likeness."[104] The jury rejected the picture, and the public did not see this tribute to Rouvière and Velázquez until Manet's solo exhibition the following year. Manet painted the character of Hamlet again a decade later, this time as the hero of Ambroise Thomas's opera and as portrayed by the celebrated baritone Jean-Baptiste Faure, a famous collector and Manet's most important patron from 1873 on (fig. 9.58). Whereas Rouvière's pose suggests fierce inward passions, Faure, sword in hand, moves toward the viewer's space to confront the ghost of his father. When Manet showed this rather alarming image, which lacks the decorum of Velázquez, at the 1877 Salon, the picture was mocked.

Manet's visits to the Prado evidently led him to respond quickly and quite directly to Velázquez's paired images of Aesop and Menippus (figs. 9.11, 9.12). These had already contributed, probably through Goya's prints (figs. 9.59, 9.60), to *The Absinthe Drinker* (fig. 9.10). Calling his beggars *Philosophers* (figs. 9.61–9.63), Manet included them in his 1867 solo exhibition together with the reworked *Absinthe Drinker*. Of the fifty-three works in the show, Randon found all three of the "philosophers" striking enough to caricature (figs. 9.64–9.66).[105] A little later, Manet painted yet another such figure. Known as *The Rag-picker* (fig. 9.67), it marks a stylistic move away from imitation of Velázquez's manner and anticipates the relaxed realism of later figures such as *The Artist* (fig. 9.92).[106]

Manet quickly learned to adapt the lessons of Velázquez to his own needs. In an audaciously contemporary mode, he painted a lively study of a young "fifer in the Light Infantry

Fig. 9.59 (cat. 19) Francisco de Goya y Lucientes, *Aesop, Copy after Velázquez*, by July 1778. Etching, 11⅞ x 8½ in. (30 x 21.5 cm). The Metropolitan Museum of Art, New York, Rogers Fund, 1931 (31.31.16)

Fig. 9.60 (cat. 20) Francisco de Goya y Lucientes, *Menippus, Copy after Velázquez*, by July 1778. Etching, 11⅞ x 8⅛ in. (30 x 22 cm). The Metropolitan Museum of Art, New York, Rogers Fund, 1931 (31.31.17)

Guard" (fig. 9.68).[107] *The Fifer* was also rejected by the 1866 Salon jury, perhaps because the figure's incisive outline and flat patches of color suggested a popular print. Despite the apparent flatness, one can apply to Manet's *Fifer* his own remark apropos of Velázquez's *Pablo de Valladolid:* "there's nothing but air surrounding the fellow."[108]

The great majority of the paintings just mentioned were included in Manet's solo exhibition of 1867, which was held in a pavilion near the grounds of the Exposition Universelle.[109] Almost half of the fifty-three works exhibited were of Spanish or Spanish-related subjects.[110] Referring to *The Fifer* and *The Tragic Actor,* one critic described Manet as a *"Velasquez of the boulevards* or a Spaniard of Paris."[111] Another deplored his "detestable *Rouvière as Hamlet*" and described *The Fifer* as "imperfect," but admired unreservedly *The Spanish Singer* and *Boy with a Sword*.[112] Although the exhibition was hardly a success, it marked the turn of the tide for Manet and his critics. One of these, Eugène Spuller, commented on the effect of the many pictures "all quite brightly colored but hung so that individual works complement one another and balance each other out[;] every painting [is] clearly the work of the same strong personality. . . . Under these conditions, it is difficult for the viewer not to be surprised and dazzled at first glance and to be struck by the power and unity" of Manet's work.[113] The artist could no longer be taken lightly. At the same time, Manet now moved decisively away from overt dependence on Spanish models. He had found his own voice.

On June 19, 1867, while the Exposition Universelle and Manet's modest parallel exhibition were in full swing in Paris, Maximilian, emperor of Mexico, was executed by a firing squad on a hill outside Queretaro. Louis-Napoleon, emperor of the French, had virtually appointed Maximilian to the throne of that former republic and for a time guaranteed Maximilian's position with the support of French troops. But by 1865, facing mounting opposition at home and doubtless realizing that his grand design for Mexico was unraveling, he

1865, in Manet 1988, pp. 43, 44; Manet 1991, p. 35. Manet mentions the equestrian portraits of Charles IV and Queen María Luisa (Museo del Prado, Madrid).

96. "J'ai demandé vingt fois le peintre Garcia Martinez aux échos du Café suisse; il était absent de Madrid; je n'ai donc pas vu la Galerie d'Ossuna [*sic*]." Letter from Manet to Astruc, September 17, 1865, in Manet 1988, p. 50; Manet 1991, p. 37. This was undoubtedly a reference to the many paintings by Goya at the "Alameda des ducs d'Ossuna [*sic*]. (Environs de Madrid)," as Yriarte 1867, pp. 141–45, described the collection of twenty-two paintings. Paul Lefort, "Francisco Jose Goya y Lucientes," in Blanc et al. 1869, nos. 494–95 (Goya issues), pp. 6–8, 12, put the number of Goyas in the Alameda at twenty-seven and was enchanted by these works, all painted before 1800, which evoked Watteau or Fragonard. If Manet had seen them, his view of Goya would certainly have been altered.

97. "un portrait de la duchesse d'Albe en costume de majo [*sic*] d'un charme inouï." Letter from Manet to Baudelaire, September 14, 1865, in Pichois 1973, p. 236; Manet 1988, p. 48; Manet 1991, p. 36. "Le chef-d'oeuvre se trouve, selon moi, à l'Académie (*La Duchesse d'Albe,* quelle saisissante fantaisie)." Letter from Manet to Astruc, September 17, 1865, in

Manet 1988, p. 50; Manet 1991, p. 37.
The "Academy" is the Real Academia de
Bellas Artes de San Fernando. For Goyas
at the Academia, a typical French guide-
book notes "A *Maja*, a portrait full of
charm and energy" ("Une *Maja*, por-
trait plein de grâce et de vigueur"), the
Clothed Maja, believed to represent
the duchess of Alba, and "four small
pendants, *Auto-da-fé*, *Good Friday
Procession*, *Bullfight*, and *Madhouse*.
Charming, witty, lively inventions"
("quatre petits pendants, *Auto-da-fè*,
Procession du Vendredi-Saint, *Course de
taureaux*, *Maison de fous*. Fantaisies char-
mantes, spirituelles et animées"). Ger-
mond de Lavigne 1866, p. 82. Although
the catalogue of the Real Museo de
Pinturas, also known as the Museo
del Prado, listed only three works by
Goya—his lifesize equestrian portraits
of Charles IV and Queen María Luisa
and a small painting of a picador—his
large canvases *The Second of May 1808*
and *The Third of May 1808* were also dis-
played. Other royal portraits by Goya,
notably the great *Family of Charles IV*,
were in the Salón de Descanso, reserved
for visiting royalty, but anyone could
see them who made arrangements with
the head porter. Astruc had urged Manet
to ask the guardian-concierge at the
entrance about seeing all the rooms
(Manet 1988, p. 37).

98. "j'ai trouvé chez lui la réalisation de mon
idéal en peinture; la vue de ces chefs-
d'oeuvre m'a donné grand espoir et
pleine confiance." Letter from Manet to
Astruc, September 17, 1865, in Manet
1988, p. 49; Manet 1991, p. 36.

99. "Je suis resté sept jours à Madrid et j'ai
eu bien le temps de tout y voir, le Prado
avec toutes ses mantilles m'a plu énor-
mément, mais le spectacle unique c'est
la course de taureaux. J'en ai vu une
superbe et compte bien à mon retour à
Paris mettre sur la toile l'aspect rapide de
cet assemblage de monde tout bariolé,
sans oublier la partie dramatique, pica-
dor et cheval renversés et labourés par
les cornes du taureau et l'armée de chu-
los cherchant à écarter l'animal furieux."
Letter from Manet to Astruc, Septem-
ber 17, 1865, in Manet 1988, p. 50; Manet
1991, p. 36.

100. "J'ai . . . fait déjà depuis mon retour *la
plaza de toros de Madrid*." Letter from
Manet to Duret, October 13, 1865, in
Manet 1988, p. 56; Manet 1991, p. 37.
Duret had returned to Cognac and had
already contributed a number of articles
on Spain to *L'Indépendant de Saintes*.

101. Only one such sketch, an abbreviated
notation of the head and torso of a
picador (Rouart and Wildenstein 1975,
vol. 2, D286), on a detached page from

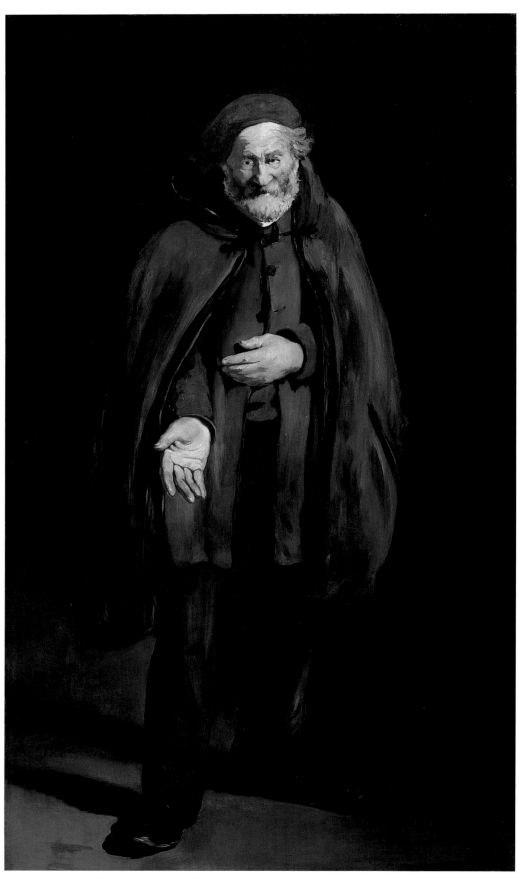

Fig. 9.61 (cat. 146) Édouard Manet, *A Philosopher (Beggar in a Cloak)*, ca. 1864–67. Oil on canvas, 73⅞ x
43¼ in. (187.7 x 109.9 cm). Art Institute of Chicago, A. A. Munger Collection

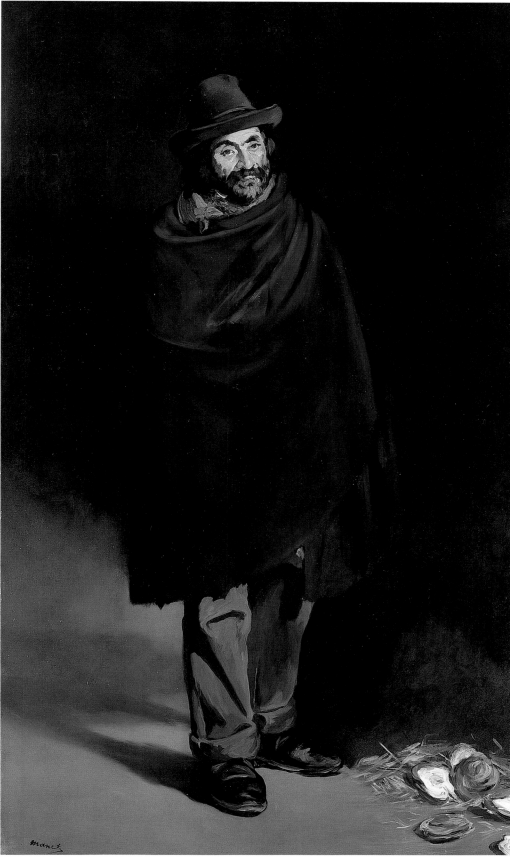

Fig. 9.62 (cat. 145) Édouard Manet, *A Philosopher (Beggar with Oysters)*, ca. 1864–67. Oil on canvas, 73⅝ x 43¼ in. (187 x 110.5 cm). Art Institute of Chicago, Arthur Jerome Eddy Memorial Collection

a sketchbook of unknown date, appears to have survived; it could have been made in Spain. A watercolor initialed *EM* is usually cited as Manet's direct record of the corrida that he saw (ibid., vol. 2, D530), but it appears to lack any of the known characteristics of Manet's drawing style and has no early provenance. The bullfight that the artist attended is documented in Manet 1988, p. 20.

102. "les choses claires et les sujets tranquilles [*sic*]." Proust 1897, p. 129; 1988/1996, p. 16; 1913, p. 24. A third bullfight scene (Rouart and Wildenstein 1975, vol. 1, no. 109), apparently painted with a much more vibrant, Impressionist touch, has not been studied in recent years.

103. The title in the catalogue for Manet's 1867 solo exhibition substitutes the incorrect but popular term "matador" for "espada."

104. "un portrait de *Rouvière* dans le rôle d'*Hamlet*, que j'appelle l'acteur tragique pour éviter la critique des gens qui ne le trouveraient pas ressemblant." Letter from Manet to Baudelaire, March 27, 1866, in Pichois 1973, pp. 238–39; Manet 1991, p. 38.

105. Randon 1867, pp. 6–8.

106. Rouart and Wildenstein 1975, vol. 1, no. 137; Pasadena 1989, pp. 122–23, colorpl.

107. "fifre des voltigeurs de la garde." Letter from Manet to Baudelaire, March 27, 1866, in Pichois 1973, pp. 238–39; Manet 1991, p. 38.

108. "c'est de l'air qui entoure ce bonhomme." Manet 1988, p. 44; Manet 1991, p. 34.

109. The temporary building, erected at Manet's expense, provided a "reception room, very attractively arranged" ("salon, très coquettement arrangé"). Leroy 1867, p. 2. In this "square reception room, illuminated from above, the walls covered in a warm red material" ("salon carré, éclairé par en haut, et tendu d'une étoffe rougeâtre") (Spuller 1867, p. 4), the fifty-three pictures listed in the catalogue (Paris 1867) must have had a stunning effect.

110. The three etchings in the exhibition, *The Gypsies*, *The Little Cavaliers*, and *Philip IV* (figs. 9.18, 9.26, 9.27), were all of Spanish subjects.

111. "C'est un *Velasquez boulevardier*, soit, un Espagnol de Paris." Claretie 1867, p. 2.

112. "détestable *Rouvière en Hamlet*"; "mauvais." Leroy 1867, p. 2.

113. "tous très-montés en couleur, mais disposés de manière à se faire valoir les uns les autres et à se faire équilibre, tous marqués au coin de la même personnalité. . . . Dans de telles conditions, il est bien difficile que le spectateur en arrivant, surpris, ébloui, échappe à une première

Fig. 9.63 (cat. 183) Édouard Manet, *Philosopher*, ca. 1865–67. Etching and drypoint, 12⅝ x 9⁷⁄₁₆ in. (32 x 23.9 cm) platemark. The Metropolitan Museum of Art, New York, Rogers Fund, 1921 (21.76.18)

Fig. 9.64 G. Randon, Caricature published in *Le Journal Amusant*, June 29, 1867. Woodcut. Bibliothèque Nationale de France, Paris. Photo courtesy the author

Fig. 9.65 G. Randon, Caricature published in *Le Journal Amusant*, June 29, 1867. Woodcut. Bibliothèque Nationale de France, Paris. Photo courtesy the author

Fig. 9.66 G. Randon, Caricature published in *Le Journal Amusant*, June 29, 1867. Woodcut. Bibliothèque Nationale de France, Paris. Photo courtesy the author

impression de force et d'unité." Spuller 1867, p. 4.

114. Douglas Johnson, "The French Intervention in Mexico: A Historical Background," in London 1992, pp. 15–33.

115. Druick and Zegers 1983; Juliet Wilson-Bareau, "The Balloon," in Paris–New York 1983, pp. 133–36, no. 44.

116. I have suggested that Manet may have chosen the subjects of his 1864 Salon submissions (*Incident* and *The Dead Christ*) as a personal response to the shedding of French blood in Mexico (London 1992, pp. 41–44).

began to withdraw French support as circumspectly as possible and in effect left Maximilian to his own fate.[114] Manet and his brothers seem to have been strongly anti-Bonapartist, but the degree to which the artist expressed political sentiments in his art is still unclear. An unpublished lithograph of 1862 (fig. 9.69) that was made soon after the start of the French campaign in Mexico has been viewed as Manet's critical comment on Louis-Napoleon's position.[115] It is clear, however, that the major paintings of these years—*Incident at a Bullfight*, reworked as the *Dead Toreador* (fig. 9.49), *The Dead Christ and Angels* (fig. 9.51), *Jesus Mocked by the Soldiers*—reflect Manet's concern with suffering and death.[116] His impressive painting *Monk at Prayer* (fig. 9.70) is a meditation on mortality.

In 1867 the artist who despised "history painting" decided to turn the hapless Maximilian's execution into a major Salon picture. Goya's *Third of May 1808* (fig. 1.18) provided a

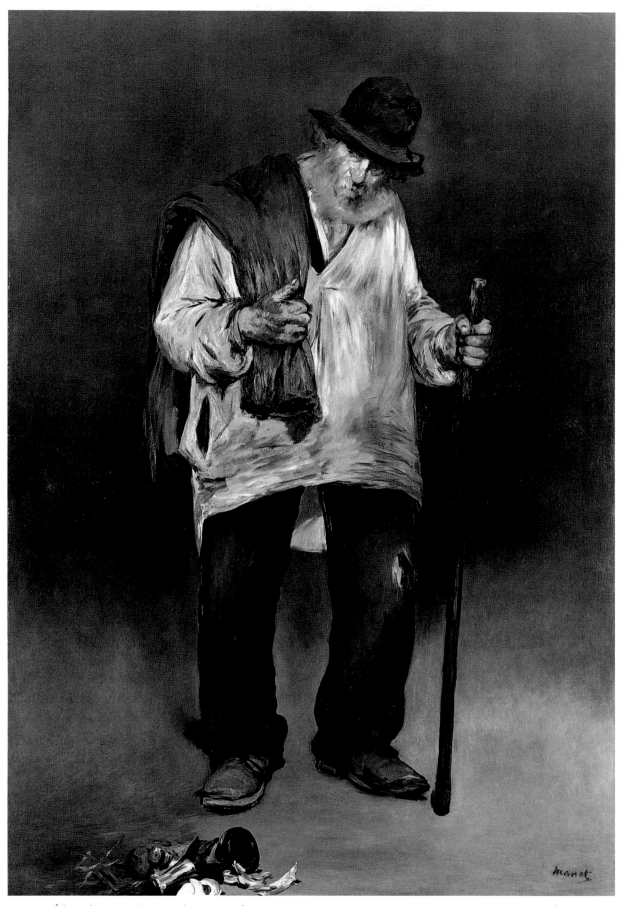

Fig. 9.67 Édouard Manet, *The Ragpicker*, 1869. Oil on canvas, 76¾ x 51¼ in. (195 x 130 cm). Norton Simon Museum, The Norton Simon Foundation, Pasadena, Calif.

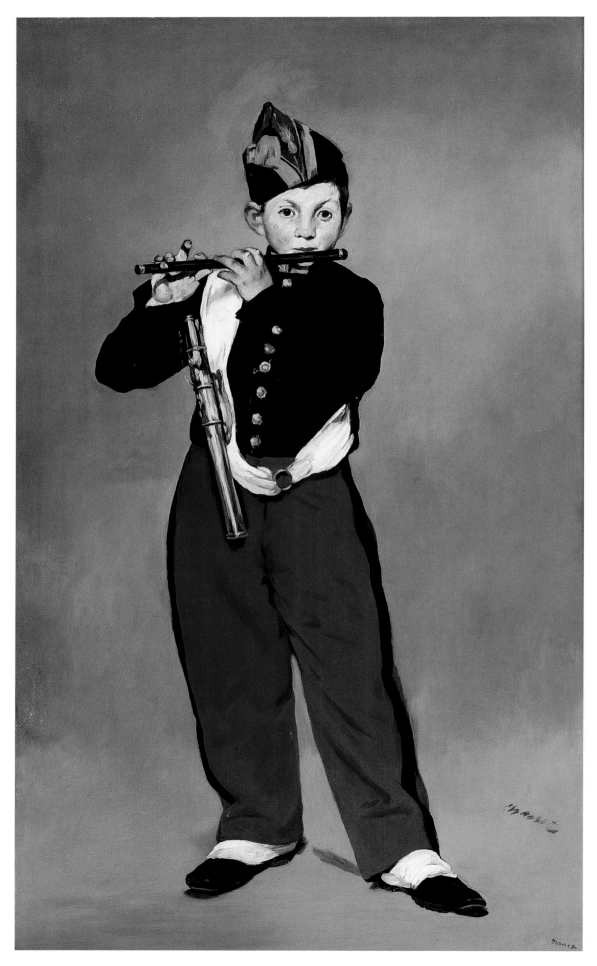

Fig. 9.68 (cat. 151)
Édouard Manet, *The Fifer*, 1866. Oil on canvas, 63 x 38⅝ in. (160 x 98 cm). Musée d'Orsay, Paris, Bequest of Count Isaac de Camondo, 1911

Fig. 9.69 Édouard Manet, *The Balloon*, 1862. Lithograph, 15⅞ x 20¼ in. (40.3 x 51.5 cm). S. P. Avery Collection, Print Collection, Miriam and Ira D. Wallach Division of Art, Prints, and Photographs, The New York Public Library, Astor, Lenox, and Tilden Foundations

Fig. 9.70 (cat. 143) Édouard Manet, *Monk at Prayer*, ca. 1864–65. Oil on canvas, 57⅛ x 45¼ in. (146.4 x 115 cm). Museum of Fine Arts, Boston, Anna Mitchell Richards Fund

Fig. 9.71 (cat. 152) Édouard Manet, *The Execution of Emperor Maximilian*, July–September 1867. Oil on canvas, 6 ft. 5⅛ in. x 8 ft. 6¼ in. (196 x 259.8 cm). Museum of Fine Arts, Boston, Gift of Mr. and Mrs. Frank Gair Macomber

Fig. 9.72 Édouard Manet, *The Execution of Emperor Maximilian*, 1867–68. Oil on canvas, 99¼ x 120 cm (252 x 305 cm). Städtische Kunsthalle Mannheim

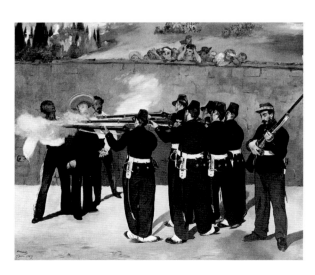

basic framework for the composition. Manet had seen this work as well as Goya's *Second of May 1808* on his visits to the Prado, and Charles Yriarte's monograph on the artist, published in 1867, reproduced it (fig. 9.76).[117] For his early, large-scale draft of a very Mexican-looking scene (fig. 9.71), Manet infused his memories of Goya with the visual and nominally factual material supplied by popular prints and press reports. As more news and photographs reached Paris, Manet twice recast his composition, each time on a new canvas. The revelation that the firing squad had worn French-style uniforms enabled Manet to suggest that France was responsible for this Goyaesque "disaster." The final version (fig. 9.72), which borrows motifs both from Goya's bullfight prints and from his *Disasters of War* (figs. 9.73, 9.74), was completed in time for the 1869 Salon, but Manet was warned not to submit it. As for his lithograph of the scene (fig. 9.75), censorship prevented its publication.[118] Manet was thus unable to make a clear public statement on contemporary events under the Second Empire. His projects to

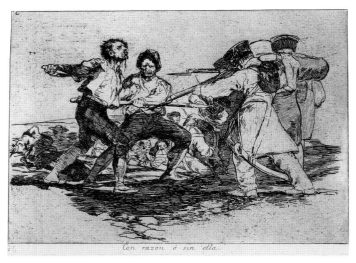

Fig. 9.73 (cat. 33) Francisco de Goya y Lucientes, *The Disasters of War, No. 2: Con razon ó sin ella (Rightly or Wrongly)*, ca. 1812–14. Etching, lavis, and drypoint, 5⅞ x 8¼ in. (15 x 20.9 cm). The Metropolitan Museum of Art, New York, Purchase, Rogers Fund and Jacob H. Schiff Bequest, 1922 (22.60.25 [2])

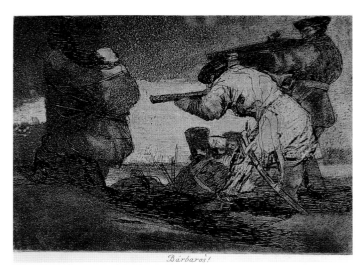

Fig. 9.74 (cat. 36) Francisco de Goya y Lucientes, *The Disasters of War, No. 38: Bárbaros! (Barbarians!)*, ca. 1812–14. Etching, burnished aquatint, and burin, 6⅜₆ x 8⅜₆ in. (15.8 x 20.8 cm). The Metropolitan Museum of Art, New York, Purchase, Rogers Fund and Jacob H. Schiff Bequest, 1922 (22.60.25 [38])

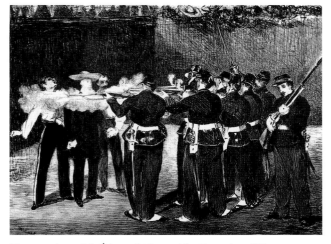

Fig. 9.75 (cat. 186) Édouard Manet, *The Execution of Emperor Maximilian*, 1868. Lithograph, 13⅛ x 17 in. (33.3 x 43.3 cm) image. The Metropolitan Museum of Art, New York, Rogers Fund, 1921 (21.48)

Fig. 9.76 *Le Deux Mai* [sic], published in Charles Yriarte, *Goya, sa biographie, les fresques, les eaux-fortes et le catalogue de l'oeuvre*, 1867

record the execution of Communards in 1871 were also abortive. Only in 1874 was his powerful but essentially apolitical lithograph *Civil War* (fig. 9.77) published—and on that occasion it was paired with one of the most appealing of his Spanish subjects, *The Urchin* (fig. 9.78).[119]

All during the 1860s writers and scholars had been expanding their understanding of Spanish art by visiting Spain and exploring its collections. The publication of Yriarte's lavishly illustrated monograph on Goya was a major step toward a full and informed view of the artist's work. Yriarte ended the monograph with a substantial catalogue of works in Spanish and French collections. He described the works he had seen, such as the murals (now known as the Black Paintings) that at the time were still on the walls of Goya's country house and the pictures in the "Alameda of the dukes of Ossuna," which Manet had failed to

117. Yriarte 1867, repr. facing p. 86 (erroneously titled "Le Deux Mai") from a drawing by Étienne-Gabriel Bocourt. The copyists' register in the Museo del Prado (Registro de Copiantes, 1864–73, Biblioteca L-36) records the visit of Carlos Yriarte, M. Tabar, and M. Bocourt on August 22, 1866.

118. Manet's intention to present the second canvas (National Gallery, London) at the 1868 Salon was either thwarted or aborted (Montifaud 1868, p. 253). The final canvas was shown in New York and Boston in the winter of 1879–80. The complex history of the three monumental canvases is investigated in Providence 1981 and London 1992.

Fig. 9.77 (cat. 187) Édouard Manet, *Civil War*, ca. 1871–73.
Lithograph, 15⅝ x 20 in. (39.6 x 50.8 cm). The Metropolitan
Museum of Art, New York, Rogers Fund, 1922 (22.60.18)

Fig. 9.78 (cat. 188) Édouard Manet, *The Urchin*, ca. 1871–74.
Lithograph, 11⅟₁₆ x 8¹¹⁄₁₆ in. (28.7 x 22.7 cm) border line.
The Metropolitan Museum of Art, New York, Rogers Fund,
1922 (22.60.19)

Fig. 9.79 *Les Manolas au Balcon*, published in Charles
Yriarte, *Goya, sa biographie, les fresques, les eaux-fortes
et le catalogue de l'oeuvre*, 1867

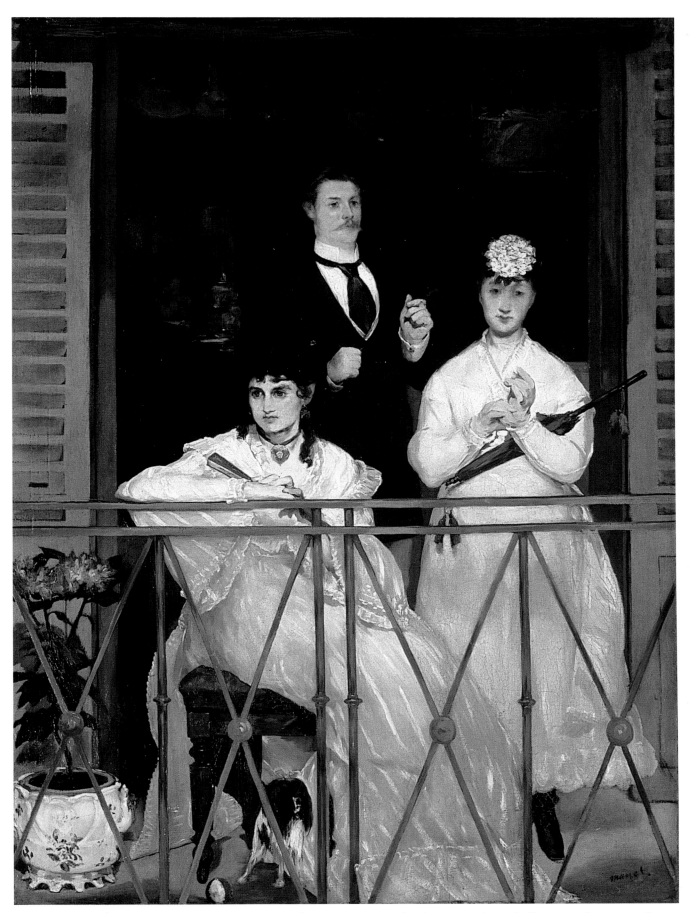

Fig. 9.80 (cat. 155) Édouard Manet, *The Balcony*, 1868–69. Oil on canvas, 66½ x 49¼ in. (169 x 125 cm). Musée d'Orsay, Paris, Bequest of Gustave Caillebotte, 1894

Fig. 9.81 (cat. 124) Constantin Guys, *Two Spanish Women on a Balcony*, ca. 1845? or 1847. Pencil, pen, metallographic ink, and wash, 8⅞ x 6⅞ in. (22.6 x 17.4 cm). Musée des Arts Décoratifs, Paris

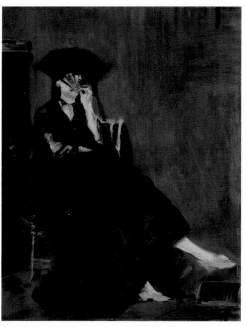

Fig. 9.82 (cat. 157) Édouard Manet, *Berthe Morisot with a Fan*, 1872. Oil on canvas, 23⅛ x 17¼ in. (60 x 45 cm). Musée d'Orsay, Paris

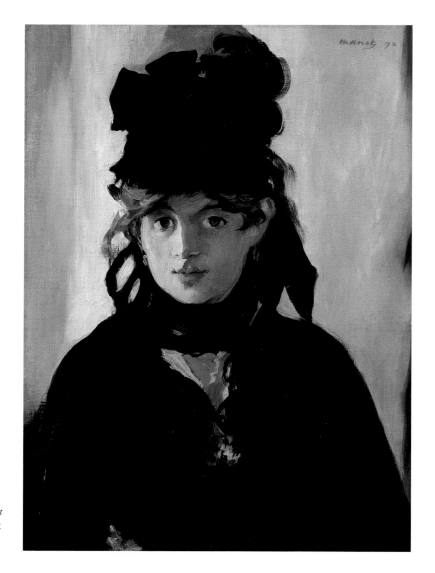

Fig. 9.83 (cat. 156) Édouard Manet, *Berthe Morisot with a Bunch of Violets*, 1872. Oil on canvas, 21⅝ x 15 in. (55 x 38 cm). Musée d'Orsay, Paris

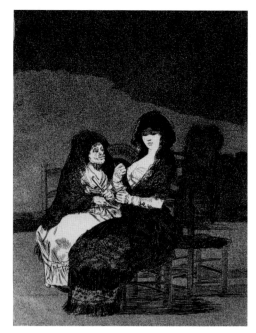

Fig. 9.84 (cat. 28) Francisco de Goya y Lucientes, *Los Caprichos, No. 15: Bellos consejos (Fine Advice)*, 1799. Etching, aquatint, drypoint, and burin, 8⅝ x 6 in. (21.8 x 15.3 cm). The Metropolitan Museum of Art, New York, Gift of M. Knoedler & Co., 1918 (18.64.15)

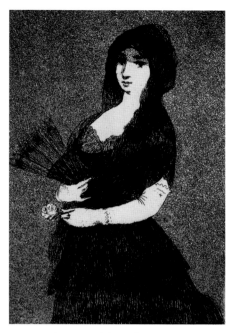

Fig. 9.85 (cat. 185) Édouard Manet, *Exotic Flower (Woman in a Mantilla)*, 1868. Etching and aquatint; second state, 6¼ x 4⅛ in. (15.9 x 10.5 cm). The Metropolitan Museum of Art, New York, Gift of Mrs. B. S. Oppenheimer in memory of Dr. B. S. Oppenheimer, 1964 (64.649.1)

see.[120] The many engravings in the book included not only Goya's *Third of May 1808* (fig. 9.76) but also a handsome reproduction of the prime version of Goya's *Majas on a Balcony* (fig. 9.79), which the duc de Montpensier had purchased at the Louis-Philippe sale in 1853 for his collection in Seville.[121] In June 1867, two months after the publication of Yriarte's book, a version of this striking composition appeared at the Paris auction of José de Salamanca's collection.[122] Manet would no doubt have seen both the engraving and the painting, and Goya's composition is combined with other sources in *The Balcony*, one of his major canvases of the later 1860s.

The Balcony (fig. 9.80) is said to have been inspired by a sight that Manet glimpsed on the family's summer holiday at Boulogne in 1868, and the composition does indeed have the naïveté of a holiday caricature.[123] The view is banal yet full of resonance: Goya's *Majas*, echoed in Constantin Guys's drawings for engravings in the popular *Illustrated London News* (fig. 9.81), throw into relief the high- and low-art aspects of the theme. Manet represents the artist Berthe Morisot as a darkly fascinating femme fatale, as she herself described it.[124] In other, later paintings, Manet depicts her as a flirtatious Goyaesque *maja* dressed in black and holding a fan (fig. 9.82) or in a luminously atmospheric setting (fig. 9.83). In the year in which he began work on *The Balcony*, during the summer of 1868, Manet agreed to make an etching for an illustrated book. He produced what is virtually a pastiche of one of Goya's most beautiful etched and aquatinted plates from the *Caprichos* (figs. 9.84, 9.85), which was presented in the very French context of a *livre de bibliophile*, a luxury collector's item that paired etchings with poems for enhanced aesthetic effect.

By the late 1860s the fashion for Spanish culture, formerly stimulated by Empress Eugénie's links with Spain, had ceased to be characteristic of the regime. It was gradually absorbed into Parisian social life, as it was in varying guises into Manet's art. The Catalan

119. *Civil War* recycles the *Dead Toreador* (fig. 9.49), which Manet cut from his bullfight composition. After the Commune, Manet reused the composition of *The Execution of Emperor Maximilian* for a large gouache (ca. 1871, Szépmüvészeti Múzeum, Budapest) and a lithograph of executions in the streets of Paris. *The Barricade*, which was overtly political, remained unpublished until after his death. See London 1992, pp. 70–75.

120. Yriarte 1867, pp. 127–51, "Catalogue des peintures de Goya." The attribution of many of the pictures listed is doubted by Yriarte, who cites "Alemsa" (Leonardo Alenza) as the possible author of several. This suspicion reflects the judgment expressed by Pedro de Madrazo, brother of the Prado's director and author of the first scholarly catalogue of the musem's collection (1872), in his letter of January 10, 1863, to Thoré about Alenza and Lucas (Eugenio Lucas Velázquez) as "famous forgers" ("fameux falsificateurs") of both Goya and Velázquez. Yriarte was perhaps too polite to express any doubts concerning the pictures that Federico de Madrazo, first court painter and director of the Prado, had acquired from Goya's son (or grandson); some if not all were of unsound attribution. Most of them were sold by Madrazo to the comte de Chaudordy, French ambassador to the court of Madrid, and are now in the Musée d'Agen. On Alenza and the problem of attributions to Goya, see Glendinning 1994; Wilson-Bareau 1996b, pp. 98–100; Wilson-Bareau 1996a. The "unidentified" Alenza referred to in Glendinning's article (p. 104 n. 20) is in Budapest; see Bilbao 1996–97, pp. 137–39, colorpl.

121. Like the portrait of Asensi in Yriarte's publication, the reproduction of *Les Manolas au balcon* (fig. 9.79) was based on a photograph by J. Laurent. Drawn by Janet and engraved on wood by Verdeil (see Yriarte 1867, p. 156), the image succeeds in capturing much of the energy and intensity of Goya's original.

122. Salamanca 1867, lot 176: *Portraits de femmes;* the catalogue description of this painting enables it to be identified with a work (private collection), possibly by Asensio Juliá, that is a variant on the version of the *Majas on a Balcony* owned by the Infante Don Sebastián (fig. 1.32). Unsold in the 1867 sale, the work reappeared in the Salamanca sale of January 25–26, 1875, lot 12.

123. See, for example, Anon. 1864, p. 349.

124. Morisot 1950, p. 27.

Fig. 9.86 (cat. 184) Édouard Manet, *Moorish Lament*, 1866. Lithograph; second state without music on verso, 11⅝ x 9½ in. (29.5 x 24 cm). S. P. Avery Collection, Print Collection, Miriam and Ira D. Wallach Division of Art, Prints, and Photographs, The New York Public Library, Astor, Lenox, and Tilden Foundations

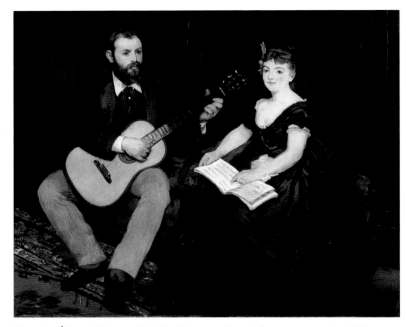

Fig. 9.87 Édouard Manet, *The Music Lesson*, 1870. Oil on canvas, 55½ x 68⅛ in. (141 x 173.1 cm). Museum of Fine Arts, Boston, Anonymous Centennial gift in memory of Charles Deering

125. Duret had evidently requested a small and inexpensive portrait. See cat. 154 for the circumstances under which the portrait was painted.

126. Manet's formal portrait of Eva, sent to the Salon of 1870, recalls French rather than Spanish precedents (Rouart and Wildenstein 1975, vol. 1, no. 154).

127. This work, *The Tavern (La Posada)* (Rouart and Wildenstein 1975, vol. 1, no. 110), is a pendant to *The Spanish Ballet* (fig. 9.41). It belongs to an institution that does not lend (Hill-Stead Museum, Farmington, Conn.), and it has been little studied.

guitarists Jaime Bosch and Lorenzo Pagans regularly played at receptions in the Paris salons, and in 1866 Manet designed a music cover for a "Plainte Moresque" (Moorish Lament) by Bosch (fig. 9.86). Both Victorine Meurent and Astruc posed with their guitars for Manet in settings that have nothing to do with Spanish folklore, and the painting of Astruc with a lady singer that Manet sent to the 1870 Salon contrasts markedly with his costumed *Guitarero* of a decade earlier (figs. 9.87, 9.1). No longer an exotic accessory, the guitar had become part of civilized, cultured life (fig. 9.88). In the same way, reflections of Spain were absorbed and adapted into a French milieu.

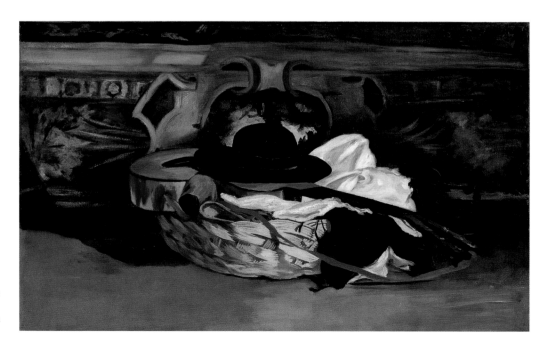

Fig. 9.88 (cat. 132) Édouard Manet, *Still Life with Spanish Hat and Guitar*, 1862. Oil on canvas, 30⅜ x 47⅝ in. (77 x 121 cm). Musée Calvet, Avignon

The distance between Manet's references to Spanish art increased as his style and artistic personality developed. His depiction of Théodore Duret (fig. 9.89) has been likened to portraits by Goya, but the link with Velázquez, wittily concealed, is far stronger. The "budget" small-format canvas for the full-length portrait shows a self-consciously elegant Duret.[125] Poised beside a boldly casual still-life assemblage, the figure evokes Velázquez's portraits of court dwarfs and jesters. Although entirely different and at first sight far removed from Velázquez, Manet's *Émile Zola* (fig. 9.91) is not unrelated to the portrait of Don Diego de Acedo, known as "El Primo" (fig. 9.90), the diminutive palace official who holds a large open book, as does Zola. Above the literary paraphernalia on the table, which echo the foreground objects in *El Primo*, there is a direct reference to Velázquez: a print, perhaps by Goya, after Velázquez's *Los Borrachos* (fig. 9.16), overlapped by a photograph of *Olympia* and a Japanese woodcut. The portrait was posed in Manet's studio. In another view within his studio, Manet sketched Eva Gonzalès, a dark beauty of Spanish descent who became his pupil (fig. 9.93).[126] Beside her, a young man, perhaps Léon Leenhoff, perches on a table in Spanish costume, in a pose lifted straight from an earlier composition (fig. 9.46).[127] Here Manet quotes not from Velázquez but from himself: in the background a framed portrait of his

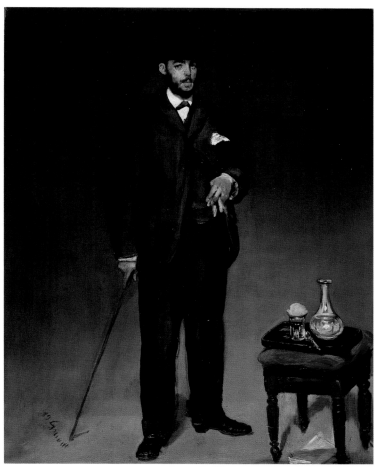

Fig. 9.89 (cat. 154) Édouard Manet, *Théodore Duret*, June–July 1868. Oil on canvas, 16⅞ x 13¾ in. (43 x 35 cm). Petit Palais, Musée des Beaux-Arts de la Ville de Paris

Lola de Valence confirms the connection with his Spanish paintings of 1862. Of all Manet's later pictures, the one that comes closest to emulating Velázquez is *The Artist* (fig. 9.92), for which his friend the bohemian painter and engraver Marcellin Desboutin poses like one of the master's philosophers (figs. 9.11, 9.12).[128]

In his final years, Manet returned to specifically Spanish themes for occasional works: a Goyaesque tambourine for one of the lighthearted exhibitions held at La Vie Moderne (fig. 9.94), bullfight motifs on a fan,[129] and the accessories that complemented his stunning portrait *Émilie Ambre as Carmen* (fig. 9.95).[130] Two late works, above all, sum up the relationship between Manet and Velázquez. The *Self-Portrait* (fig. 9.96) of about 1879 refers unmistakably to the one that Velázquez inserted into his last masterpiece, *Las Meninas* (fig. 4.13),[131] while Manet's final masterpiece, *A Bar at the Folies-Bergère* (fig. 9.97), rivals in its visual complexity and miraculous handling of paint the example set by the Spanish master. The similarities between the barmaid and the gentle blond infanta with her floral corsage, the mirrors, and the play of space and light suggest what Baudelaire would have judged a profound affinity between Manet and Velázquez, between the two artists and their two greatest works.

128. Manet sent the picture to the 1876 Salon, but it was rejected by the jury.
129. Rouart and Wildenstein 1975, vol. 2, no. 529; Berne 1994, no. 81, color repr.
130. The diva had taken Manet's *Execution of Emperor Maximilian* (fig. 9.72) to the United States and arranged to show the work first in New York, then in Boston.
131. For a drawing thought to be of Manet's studio that connects him and *Las Meninas*, see Diers 1998. Malcolm Park kindly provided me with an overlay of the *Meninas* composition onto Manet's drawing; the overlay confirmed Diers's proposal for the source. For the Manet drawing, see Manet 1991, p. 163, pl. 118.

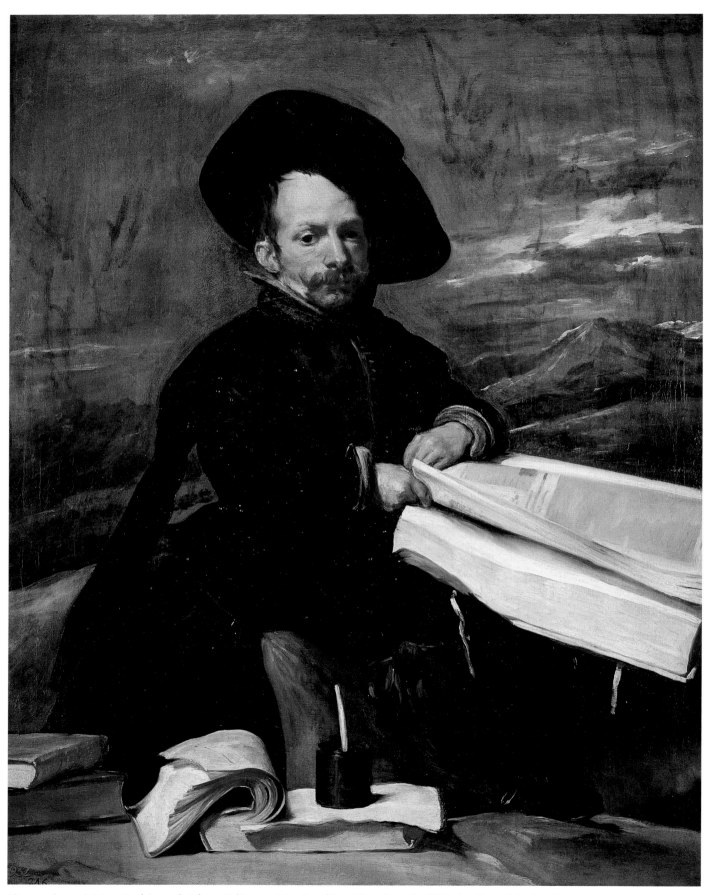

Fig. 9.90 (cat. 74) Diego Rodríguez de Silva y Velázquez, *The Dwarf Don Diego de Acedo,* *"El Primo,"* ca. 1636–38. Oil on canvas, 42⅛ x 32¼ in. (107 x 82 cm). Museo Nacional del Prado, Madrid

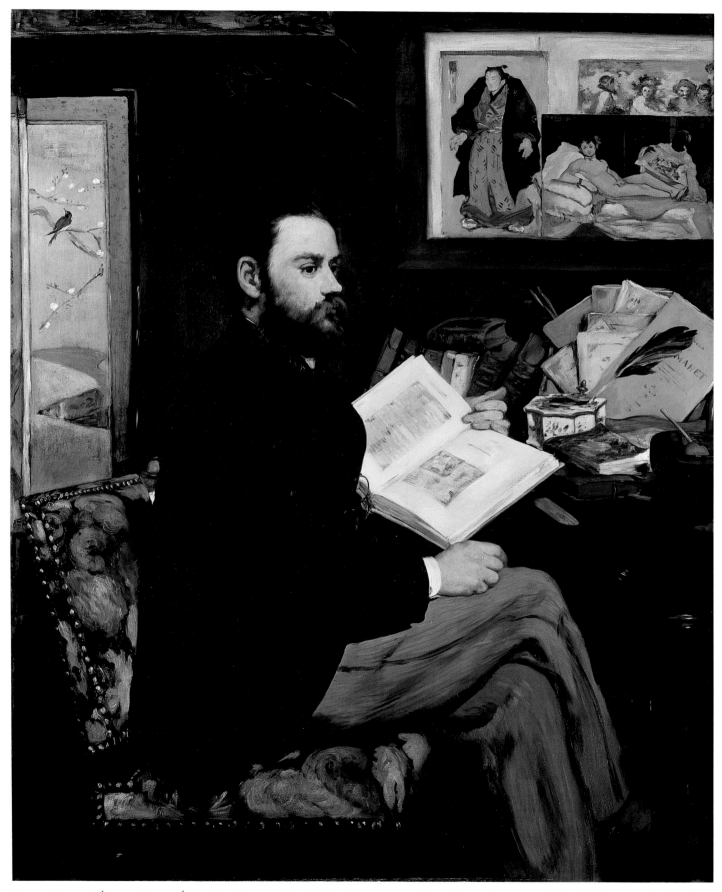

Fig. 9.91 (cat. 153) Édouard Manet, *Émile Zola*, February–March 1868. Oil on canvas, 57⅛ x 44⅞ in. (146.5 x 114 cm). Musée d'Orsay, Paris, Gift of Madame Zola, 1918

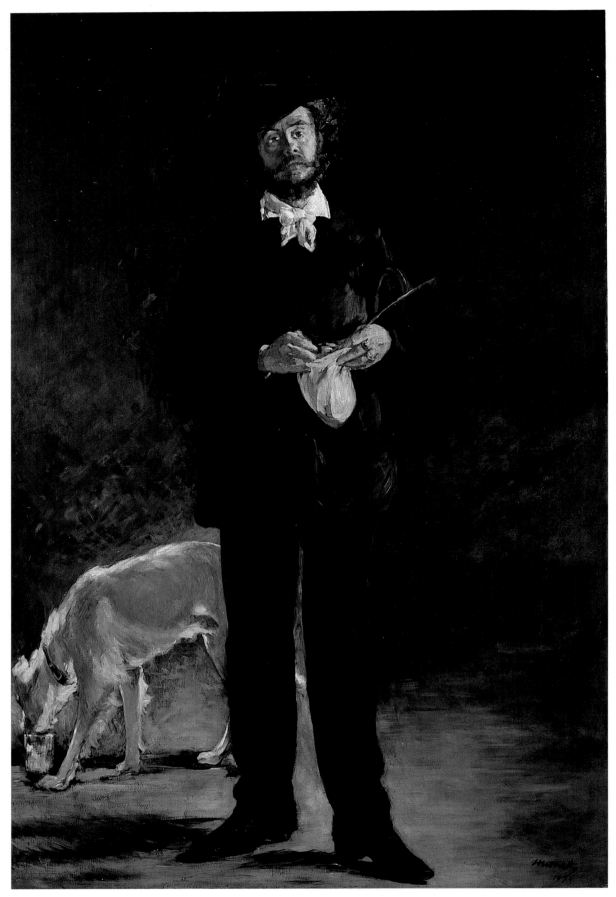

Fig. 9.92 (cat. 158) Édouard Manet, *The Artist (Marcellin Desboutin)*, 1875. Oil on canvas, 75⅛ x 50⅛ in. (192 x 128 cm). Collection Museu de Arte de São Paulo Assis Chateaubriand, São Paulo, Brazil

Fig. 9.93 Édouard Manet, *Eva Gonzalès Painting in Manet's Studio*, 1870. Oil on canvas, 21⅞ x 17⅞ in. (56 x 46 cm). Private collection. Photo courtesy Institute Wildenstein

Fig. 9.94 (cat. 161) Édouard Manet, *Dancer and Majo*, 1879. Basque tambourine; oil on parchment, diam. 7¼ in. (18.5 cm). Private collection, Paris

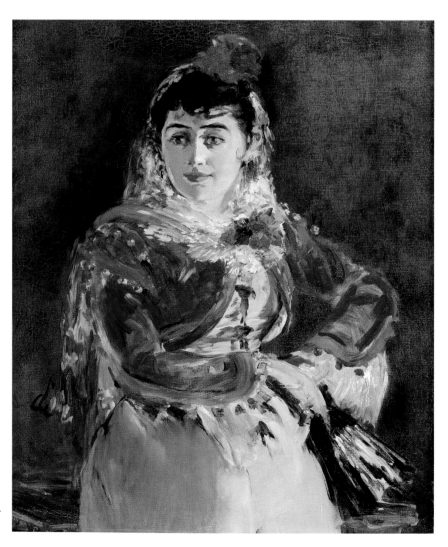

Fig. 9.95 (cat. 162) Édouard Manet, *Émilie Ambre as Carmen*, 1880. Oil on canvas, 36⅜ x 29 in. (92.4 x 73.5 cm). Philadelphia Museum of Art, Gift of Edgar Scott, 1964

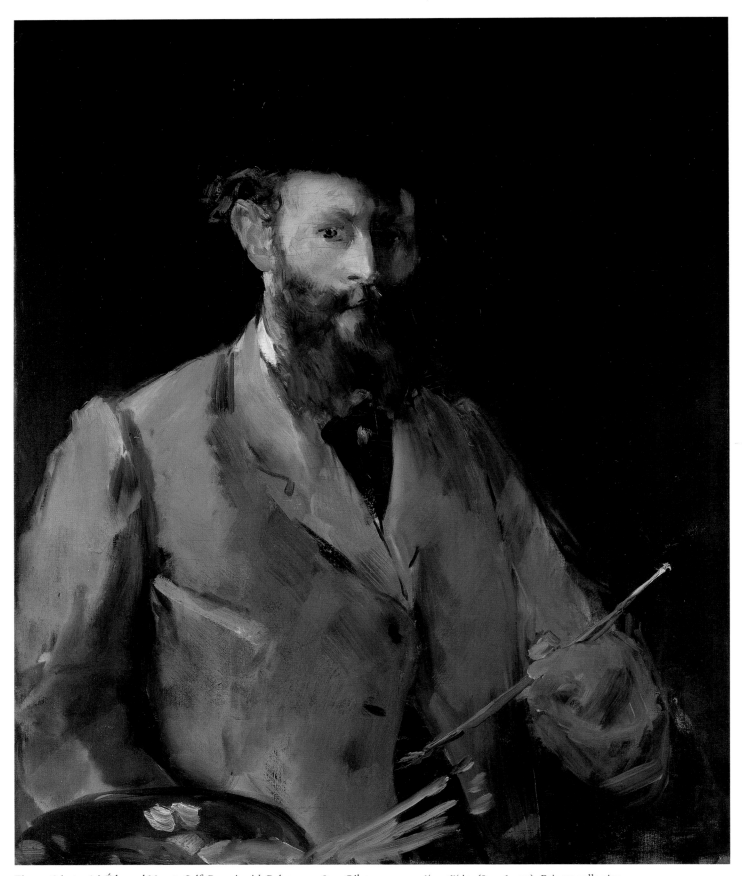

Fig. 9.96 (cat. 160) Édouard Manet, *Self-Portrait with Palette*, ca. 1879. Oil on canvas, 32⅛ x 26⅜ in. (83 x 67 cm). Private collection

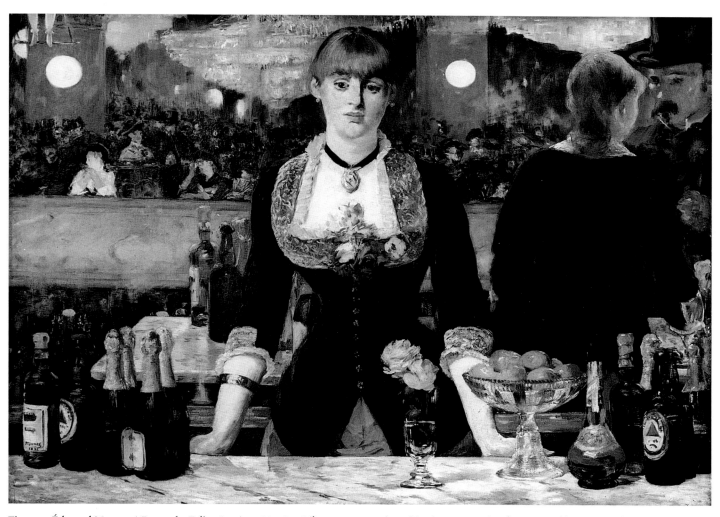

Fig. 9.97 Édouard Manet, *A Bar at the Folies-Bergère*, 1881–82. Oil on canvas, 37¼ x 51⅛ in. (96 x 130 cm). The Courtauld Institute of Art Galleries, London

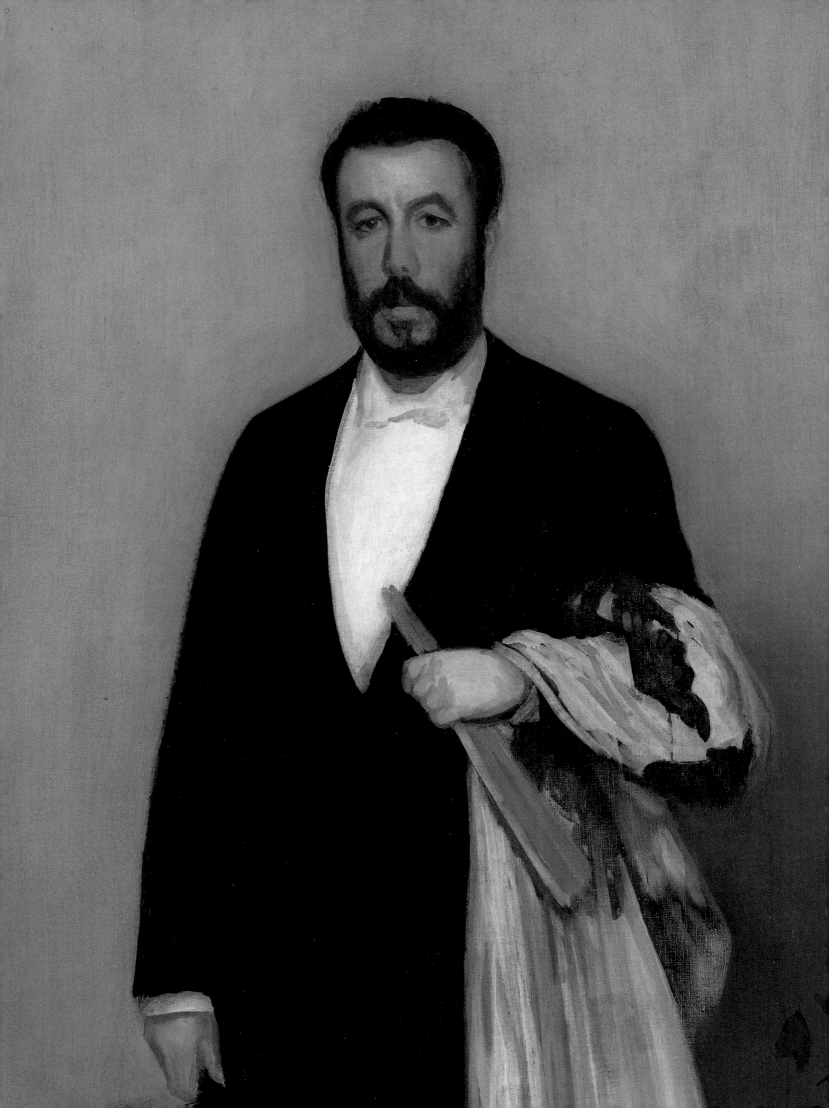

American Artists' Taste for Spanish Painting

H. Barbara Weinberg

American painting, sculpture, and architecture between the Civil War and World War I reflected a keen appreciation and avid absorption of contemporary French styles. Henry James described the state of affairs in 1887: "It sounds like a paradox, but it is a very simple truth, that when to-day we look for 'American art' we find it mainly in Paris. When we find it out of Paris, we at least find a great deal of Paris in it."[1] As there was a great deal of Spain in the art of Paris, Spain appeared in American art as well.

The French, the Americans, and artists of other nationalities realized that Spanish art, above all that of the Golden Age master Diego Rodríguez de Silva y Velázquez, could support their efforts as painters of modern life.[2] American William Merritt Chase recounted his epiphany, which occurred in 1881. He had, he told painter Walter Pach years later, traveled widely, copied works by Frans Hals, Velázquez, Rembrandt, and others, and tried to emulate their principles. When contemporary Belgian artist Alfred Stevens saw Chase's *The Smoker* (1881, location unknown) at the 1881 Salon, he counseled him, "Don't try to make your pictures look as if they had been done by the old masters." Taking Stevens's advice that "modern conditions and trends of thought demand modern art for their expression," Chase came to believe that Velázquez's "sublime example" would help him mediate between past and present. Chase observed to Pach, "One reason he [Velázquez] seems so near to us is that he, like ourselves, journeyed to a country where great art of the past was to be seen, and studied and copied there. But what was important to me just at this time was that Velasquez—with all his acquirement from the masters who had gone before him—felt the need of choosing new forms and arrangements, new schemes of color and methods of painting, to fit the time and place he was called on to depict."[3] In the late 1890s French artist Léon Bonnat described Velázquez's virtues similarly: "What the Spanish master seeks above all are character and truth. He is a realist. . . . He paints nature as he sees her and as she is. The air that he breathes is our own, his sky is that under which we live. His portraits impress us with the same feeling we have when in the presence of living beings."[4]

Four major artists—James McNeill Whistler, Thomas Eakins, Chase, and John Singer Sargent—epitomize the American enthusiasm for and appropriation of Spanish styles, largely under French influence, between 1860 and 1915. In these painters' works we see the profound and durable effects of the art of Velázquez and, to a lesser extent, his contemporaries Jusepe de Ribera and Bartolomé Esteban Murillo; the Romantic Francisco de Goya y Lucientes; and the then-active Raimundo Madrazo Garreta and Mariano Fortuny y Marsal.[5] The four Americans discussed here in the order of their birth—as well as two of their

1. The author acknowledges with gratitude the aid of Dana Pilson, Research Assistant, Department of American Paintings and Sculpture, and Deborah Roldán, Research Assistant, Department of European Paintings, The Metropolitan Museum of Art. James 1887, reprinted in James 1956, p. 216. For the phenomenon in general, see Weinberg 1991. The international impact of contemporary French artistic standards in the period is summarized in Dayton–Philadelphia–Los Angeles 1976–77, pp. 13–45.

2. The diversity of Velázquez's appeal is noted in Simpson 1998, p. 3, which offers "a simple alphabetical roster" of Velázquez's admirers: Léon Bonnat, Mary Cassatt, William Merritt Chase, Thomas Eakins, Henri Fantin-Latour, Mariano Fortuny, G. P. A. Healy, John Everett Millais, Pablo Picasso, Henri Regnault, and Anders Zorn. Robert Alan Mowbray Stevenson, critic, first cousin of the famous Scottish writer, and a former student of Carolus-Duran, stated: "To see the Prado is to modify one's opinion of the novelty of recent art. . . . Whether directly or indirectly, whether consciously or unconsciously, artists have decided after a century of exploration to follow the path of Velasquez. . . . The sight of Velasquez at Madrid does not make us look upon the works of Regnault, Courbet, Manet, Carolus-Duran, Monet, Henner, Whistler, Degas, Sargent and the rest as plagiary. It rather gives the man of our century confidence that he is following a path not unlike that trod to such good purpose by the great Spaniard." Stevenson 1895, revised in Stevenson 1962, pp. 142, 150.

3. Chase 1910a, p. 442, quoted in Bolger 1974, p. 6. The author wishes to thank Fred Baker for information about Chase's *The Smoker*.

4. "Ce que le maître espagnol cherche avant tout, c'est le caractère et la vérité.

Fig. 10.1 (cat. 224) James McNeill Whistler, *Arrangement in Flesh Color and Black: Théodore Duret* (detail of fig. 10.11)

Il est réaliste. . . . Il peint la nature comme il la voit et comme elle est. L'air qu'il respire est le nôtre, son ciel celui sous lequel nous vivons. On éprouve en face de ses personnages l'impression que l'on ressent devant des êtres vivants." Bonnat 1898, p. 177. Bonnat's article also appeared as the preface to Beruete 1898, which Beruete, the director of the Museo del Prado, dedicated to Bonnat.

5. As this essay focuses on style rather than theme, it deals only cursorily with American painters' pursuit of picturesque subjects during their Iberian travels. For that subject and the political implications of American interest in Spain, see Boone 1996, which was supervised by the present author, and New York–New Britain 1998–99.

6. Nicolai Cikovsky Jr.'s introduction in Washington–Boston 1992, pp. 13–19, is a helpful summary of international Hispanism. See also New York 1993a.

7. Duret 1917, p. 16, notes that Whistler spoke and read French fluently, "as a second mother's tongue."

8. Claude Monet, Frédéric Bazille, Alfred Sisley, and Pierre-Auguste Renoir would study under Gleyre in the early 1860s.

9. Fried 1994 comments on analogies among Manet, Whistler, Fantin-Latour, and Legros, whom he characterizes as "the generation of 1863."

10. Margaret F. MacDonald, in London–Paris–Washington 1994–95, p. 307, gives July–August 1861 as the date of the first meeting between Whistler and Manet. For an insightful discussion of the relationship between the two artists and their analogous works, see Robin Spencer, "Whistler, Manet, and the Tradition of the Avant-Garde," in Fine 1987, pp. 47–64.

11. Duret 1917, p. 22. See also Duret 1902 and Duret 1937. Both artists painted images of the writer; see Édouard Manet, *Théodore Duret* (fig. 9.89); James McNeill Whistler, *Arrangement in Flesh Color and Black: Portrait of Théodore Duret* (fig. 10.11). Spassky et al. 1985, pp. 385–92, discusses Whistler's portrait of Duret and compares it with Manet's. Whistler apparently met Duret through Claude Monet in 1880.

associates, Mary Cassatt and Robert Henri, briefly considered with Chase and Eakins, respectively—were colleagues, students, or admirers of leading French painters who had absorbed Spanish traditions. They responded to French versions of Spanish works, to each others' translations of them, and to Spanish originals and contributed to the intense Hispanism, or fascination with Spain, that engaged international artists and writers during the period.[6]

James McNeill Whistler (1834–1903), Manet's American Counterpart

Why drag in Valesquez?
Whistler to "a newly introduced acquaintance," before 1890

James McNeill Whistler participated in the complex artistic ferment in Paris in the late 1850s and 1860s and in the invention of the "new painting." As he had helped to initiate the Western appreciation of Japanese prints and artifacts that invigorated the art of his generation, so too was he among the creators of the cult of Velázquez.

Arriving in Paris in November 1855, already fluent in French from his childhood years in Russia,[7] Whistler enrolled in the École Impériale et Spéciale de Dessin (the "petite École") to study art. In June 1856 he entered Charles Gleyre's independent teaching atelier, where instruction followed Beaux-Arts traditions and where he met Henri Martin, George Du Maurier, and others.[8]

Whistler's artistic development, however, owed less to his formal lessons than to influences outside the academic world. He invented a unique style inflected by inspiration from Dutch and Spanish Baroque masters, especially Rembrandt, Johannes Vermeer, Pieter de Hooch, Gabriel Metsu, and Velázquez, and from contemporary progressive French painters who admired the same traditions, notably Gustave Courbet, Henri Fantin-Latour, and Alphonse Legros. In 1858 Fantin-Latour, Legros, and Whistler proclaimed their allied interests by organizing themselves as the Société des Trois, through which they reinforced ties with the French and British avant-garde.[9] Whistler became friendly as well with Carolus-Duran, Zacharie Astruc, and Félix Bracquemond and was attracted to the innovations of Édouard Manet, two years his senior, whom he met in the summer of 1861.[10] Whistler also valued the writings of Charles Baudelaire and Théophile Thoré (who wrote under the pseudonym W. Bürger), which lauded Eugène Delacroix, Hals, and Velázquez and stressed the importance of harmonious picture surfaces; Eastern, principally Japanese, aesthetics; and the narrative and decorative art of the English Pre-Raphaelites Dante Gabriel Rossetti and John Everett Millais.

The decision to settle in London in May 1859 and thus work at a distance from his French colleagues may reflect Whistler's wish to distinguish himself from them, although he shared their ideas and taste. His continuing association with the Parisian avant-garde is signaled by his appearance in the foreground of Fantin-Latour's *Homage to Delacroix* (fig. 10.2). In Fantin's large canvas, Whistler and Manet bracket the portrait of the just-deceased Romantic painter and are accompanied by Fantin, Legros, Bracquemond, Baudelaire, Champfleury, and other like-minded contemporaries. Théodore Duret, who befriended these men and later wrote monographs on Whistler and Manet, perceived the group portrayed to represent "originality and the future at Paris."[11]

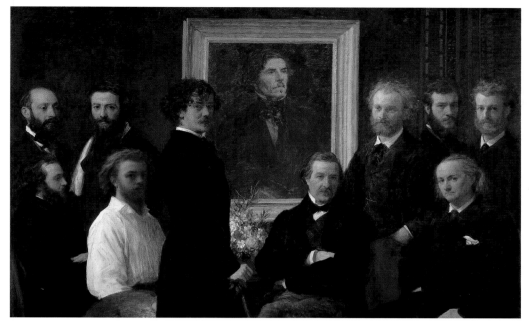

Fig. 10.2 Henri Fantin-Latour, *Homage to Delacroix*, 1864. Oil on canvas, 63 x 98⅜ in. (160 x 250 cm). Musée d'Orsay, Paris

While it is difficult to dissect and discuss a single element from among the many that nourished Whistler's art, Spanish painting appears to have affected him early, deeply, and consistently. The visual analogies between his works and those of Velázquez in particular have been noted by almost all writers. Most stress the influence of Velázquez upon Whistler, their case supported by the enthusiasm for Spanish painting that prevailed in the American's Parisian circle; a few writers prefer to suggest that the similar artistic temperaments of Velázquez and Whistler yielded comparable works.[12]

The first edition of Whistler's volume *The Gentle Art of Making Enemies* (1890) announces the relationship his contemporaries perceived between him and the Spanish master and his reaction to it: "'I only know of two painters in the world,' said a newly introduced acquaintance to Mr. Whistler— 'yourself and Velasquez.' 'Why,' answered Whistler in dulcet tones, 'why drag in Valesquez?'"[13] Commentators on Whistler would always "drag in" Velázquez, despite the American's oft-quoted protest.

In his 1895 monograph on Velázquez, Scottish critic Robert Alan Mowbray Stevenson wrote of Whistler that "Truth is the introducer that bids these two men shake hands across the centuries."[14] American painter Chase echoed in 1897, "If Velasquez lived he would grasp Whistler by the hand."[15] Chase also recalled in 1910 that while he was visiting Madrid in 1884 he noticed that "every Velasquez seemed to suggest Whistler," a discovery that strengthened his resolve to introduce himself to his compatriot the following year.[16] American painter and critic Kenyon Cox commented in 1904, "If any Western artist exercised anything like a permanent influence on Whistler it was the great Spaniard, but it seems to me more just to say that Whistler's talent resembled one side of that of Velasquez than that there was anything like imitation."[17] American critic Carl Sadakichi Hartmann, enumerating in 1910 the portraits by Whistler that "were painted under the ban of Velasquez," pronounced, "In Whistler's paintings Velasquez's art was revived and rejuvenated."[18] Condensing such observations in graphic terms in an

12. The most insistent advocate of parallel development rather than influence is Fleming 1978, pp. 203–4.
13. Whistler 1890a, p. 250. The Ford edition preceded Whistler's own London edition (1890b) and was suppressed by Whistler; see typewritten note in the New York Public Library's copy of the Ford edition. Seitz 1913, p. 27, repeats the tale, characterizing the acquaintance as "a newly introduced feminine enthusiast," and adding: "'Mr. [William Merritt] Chase once asked him if he really said this seriously. 'No, of course not,' he replied. 'You don't suppose I couple myself with Velasquez, do you? I simply wanted to take her down.'"
14. Stevenson 1895, revised in Stevenson 1962, p. 89. When Sutton 1964, p. 72, quoted Stevenson's remark, he added "Velasquez's shadow stands behind many of Whistler's portraits."
15. Chase 1897, p. 68, quoted in Seattle– New York 1983–84, p. 77.
16. Chase 1910b, p. 219. The article gives the date of Chase's revelation in Madrid as 1885, a typographical error. The two Americans met for the first time in London in 1885.
17. Cox 1904, p. 475.
18. Hartmann 1910, p. 124.

Fig. 10.3 A. J. Clayton ("Kyd") Clarke, *Jimmy*, undated. Watercolor, 24⅛ x 19½ in. (61.3 x 49.5 cm). Trustees of the Victoria and Albert Museum, London

Fig. 10.4 James McNeill Whistler, *At the Piano*, 1858–59. Oil on canvas, 26⅜ x 36⅛ in. (67 x 91.6 cm). Taft Museum of Art, Cincinnati, Bequest of Louise Taft Semple

19. See Washington 1995, p. 59, fig. 2:9.
20. Pennell 1919, p. 16. Fleming 1978, p. 51, notes that there were twenty paintings by Murillo and six by Velázquez in the Hermitage when Whistler was in St. Petersburg. For the identity of the paintings, see Kagané 1997, *passim*.
21. Pennell 1919, p. 47.
22. Spencer in Fine 1987, p. 52.
23. "j'espère pouvoir te décrire les *Fileuses* et la *Prise de Bréda*!!!" Bénédite 1905, p. 502, translated in Fleming 1978, p. 176.
24. "Tu dois attendre avec impatience mon voyage en Espagne. . . . je serai le premier qui puisse regarder les Velazquez pour toi. Je t'en rendrai compte, je te causerai de tout! . . . Aussi, si'il y a des photographies à avoir, j'en rapporterai. Pour des esquisses je n'ose presque pas en hasarder! Si je m'enhardis, je verrai. Tu sais, ça doit être de cette glorieuse peinture qui ne se laisse pas copier . . . Ah! mon cher . . . comme il a dû travailler!" Bénédite 1905, p. 502, translated in Fleming 1978, pp. 176–77.

undated watercolor entitled *Jimmy* (fig. 10.3), British caricaturist A. J. Clayton ("Kyd") Clarke showed Whistler in the guise of a portrait by Velázquez admiring a framed portrait meant to be a Velázquez.[19]

Whistler had little contact with Velázquez's major canvases. Exploring Whistler's childhood years in Russia from about 1843 to 1848, his principal biographers, Elizabeth and Joseph Pennell, noted, "Curiously, in his mother's diary there is no mention of the Hermitage, nor in his talks with us did he ever refer to it and to the pictures there by Velasquez, the artist he later grew to admire so enormously."[20] The Pennells observed that, as "there are only a few pictures by Velasquez in the Louvre, . . . Whistler's early appreciation of him has been a puzzle to some, who, to account for it, have credited him with a journey when a student in Madrid. But that journey was not made in the fifties or ever, though he planned it more than once."[21]

Perhaps motivated by his wish "to be the first of his French friends to see the work of Velázquez," as scholar Robin Spencer has suggested, Whistler did set out to visit Madrid in the fall of 1862.[22] The artist documented some details of that failed journey in letters to Fantin-Latour, many of which were published by critic Léonce Bénédite in 1905. Accompanied by his mistress Jo Hiffernan, Whistler left London in October 1862, aiming to visit the Prado. "When I see you again," he enthused to Fantin, "I hope to be able to describe the *Fileuses* and *Prise de Bréda*!!!"[23] Just before departing, he wrote to Fantin, "You must be anxiously waiting for my trip to Spain. . . . I will be the first one who can look at Velazquez for you. I will tell you all about it, I'll tell you everything. . . . Also if there are photographs to be had, I will bring some back—as for sketches, I hardly dare attempt it. If I have the nerve, I may try. You know, that glorious painting cannot be copied—it must carry you off—oh, mon cher, how he must have worked!"[24]

Whistler traveled to Southampton, crossed the Channel, went on to Biarritz, and spent one day visiting picturesque Fontarabia (Fuenterrabía) over the border in Spain. But he was unaccountably deterred by language difficulties from going further south. Rejoicing in the colorful scene and people in the Pyrenees town—"The Spaniards of Opéra-Comique in the street"—he nonetheless fulminated, "No one understands a single word of French, and they don't give a damn."[25]

According to Bénédite, Whistler anticipated going to Madrid again in the spring of 1863, hoping this time to have Fantin join him on what he deemed "a holy pilgrimage for us,"[26] but again the plan failed. Just as he had distanced himself from his French colleagues, perhaps fearing the power of their influence, he may have recognized his susceptibility to Velázquez and avoided too extensive a contact with his works.

Whistler's apparent debt to Velázquez, coupled with the fact that he never entered the Prado, prompted the Pennells and other writers to emphasize the impact of paintings he had seen at the Manchester Art Treasures Exhibition in September 1857.[27] This massive display, organized to promote national art, included some seven hundred British works. Yet the two huge picture galleries in the main exhibition hall were also filled with about one thousand paintings by the old masters of Italy, the Netherlands, Germany, and Spain.[28] Canvases by Murillo and Velázquez were prominent, with the latter represented by fourteen paintings either by or attributed to him, including *Lady with a Fan* (fig. 1.14) and *The Toilet of Venus* ("The Rokeby Venus," 1647–51, National Gallery, London). In the late 1850s, probably after his visit to Manchester, Whistler made a copy (location unknown) in the Louvre after the *Gathering of Gentlemen*, a canvas acquired in 1851 as a work by Velázquez (now reattributed to his workshop) and which Manet copied about 1860 (fig. 9.6).[29]

Throughout his career Whistler nurtured his appreciation of Velázquez by viewing the artist's few canvases in French and English collections and exhibitions.[30] He also studied contemporary art that embodied the Spaniard's principles and referred to photographs, of which he owned nine prints after eight paintings by Velázquez, six of which he never saw in the original.[31]

Although Whistler's knowledge of most of Velázquez's works was secondhand, it was passionate. The Pennells recounted a disagreement in 1896 between Whistler and American critic John C. Van Dyke: "The subject was *Las Meniñas* [*sic*], which he [Whistler] had never seen, which everyone else had seen. Velasquez painted the picture just as you see it, he maintained; no one agreed. . . . Whistler was forced to yield slowly. . . . Though Whistler had never been to Madrid, it seemed as if he had seen the pictures, so familiar was he with them, and though he was at times not right about them, his interest was endless. . . . Whistler could get more from a glance at a photograph than most painters from six months' copying."[32]

Whistler's first ambitious picture, *At the Piano* (fig. 10.4), executed after the Manchester exhibition, echoed canvases by his artistic heroes—Courbet, Vermeer, and Velázquez—and announced the characteristic balance that he would strike between realist and formalist elements in his singular style, which matured in the 1870s. Seeing *At the Piano* in Whistler's debut at the Royal Academy, a critic for *The Times* remarked, "In colour and handling, this picture reminds one irresistibly of Velasquez."[33]

In *Harmony in Green and Rose: The Music Room* (fig. 10.5), an interior scene of 1860–61,

25. Letter from James McNeill Whistler to Fantin-Latour, Biarritz, [late 1862], translated in Fleming 1978, p. 177.

26. "un pèlerinage sacré pour nous." Bénédite 1905, p. 502.

27. Pennell 1919, p. 47.

28. Cooper 2001 provides a brief overview.

29. A. Young et al. 1980, vol. 1, no. 19. Nahum 1993, pp. 330–44, offers a list of "Nineteenth-Century Copies after Paintings by Velázquez" but omits sources for the information and current locations of most of the copies.

30. Fleming 1978, p. 203, notes, for example, that in May 1864, concurrent with the Royal Academy exhibition, the British Institution displayed a group of old-master works that included three portraits by Velázquez—Philip IV of Spain, his wife Isabella, and his minister, the count-duke of Olivares—and a sketch for *Las Meninas*.

31. Nigel Thorp, "Studies in Black and White: Whistler's Photographs in Glasgow University Library," in Fine 1987, p. 89. The eight paintings by Velázquez of which Whistler owned photographs are: *Philip IV*, detail of *Las Meninas*, *The Jester Pablo de Valladolid*, *Infante Don Carlos*, *Villa Medici* (all five in the Museo del Prado); *Philip IV* (collection of the duke of Hamilton, conveyed to the National Gallery, London, in 1882); *Self-Portrait* (Florence); and *Self-Portrait* (Valencia). Thorp adds that Whistler's print of the Florence *Self-Portrait*, which bears the stamp of the Paris publisher Giraudon, could date from the early 1860s and may have inspired the pose of Étienne Carjat's photograph of Whistler (ca. 1864; illustrated in ibid., p. 86), which Fantin-Latour may have simply reversed and reclothed for the image of Whistler in his *Homage to Delacroix* (fig. 10.2).

32. Pennell 1919, pp. 339–40. According to the Pennells (pp. 254–55), "the great pictures for him were Velasquez's *Meniñas* [*sic*], Franz Hals' *Family*, Tintoretto's *Milky Way:* the greatest subject pictures in the world."

33. Quoted in Fleming 1978, p. 165.

Fig. 10.5 James McNeill Whistler, *Harmony in Green and Rose: The Music Room*, 1860–61. Oil on canvas, 37⅛ x 27⅞ in. (95.5 x 70.8 cm). Freer Gallery of Art, Smithsonian Institution, Washington, D.C.

Fig. 10.6 Photograph of left side of Velázquez's *Las Meninas*, Glasgow University Library, Department of Special Collections (see fig. 1.57)

34. The analogy with *Las Meninas* was noted by Richard Dorment in London–Paris–Washington 1994–95, p. 14.

35. See Thorp in Fine 1987, p. 88.

36. Eric Denker, in Washington 1995, pp. 56, 58, analyzes Whistler's *The Artist's Studio* in relation to *Las Meninas*.

37. Fleming 1978, p. 204: "Velasquez's influence on Whistler . . . was indefinite, tenuous, and cumulative, manifesting itself most strongly later in his career."

Whistler included a reference to *Las Meninas* (fig. 1.57) by showing reflected in a mirror an enigmatic figure who is outside the room.[34] Whistler owned a photograph (fig. 10.6) of the left side of Velázquez's masterpiece that includes the mirror and the figures of Velázquez, the attendant in the foreground, and the Infanta Margarita.[35] Although the date at which he acquired the photograph is unknown, he appears to have referred to its composition for two oil sketches, *The Artist's Studio* (1865, Hugh Lane Municipal Gallery of Modern Art, Dublin) and *The Artist in His Studio* (fig. 10.7). Whistler intended to use these sketches to help him paint a huge studio interior in response to *Las Meninas*,[36] Courbet's *The Artist in His Studio* (fig. 1.44), and Fantin's large group portraits, including *Homage to Delacroix*.

Even writers who claim that the visual analogies between Velázquez's and Whistler's paintings arise from parallel development rather than direct influence concede that by the 1870s Whistler was keenly responsive to the Spaniard's works.[37] Velázquez's court portraits in particular moved Whistler to explore in analogous single-figure images strong silhouettes and elegant contours; to calibrate the placement of the figure in relation to the edges of the canvas and to set it well within the frame; to investigate delicate variations on a single subdued hue or a dyad of neighboring or contrasting hues; to abandon positive color in favor of grays and blacks; and, most important, to create visual dialogues between descriptive volumetric illusion and beautiful surface pattern. In comparable portraits,

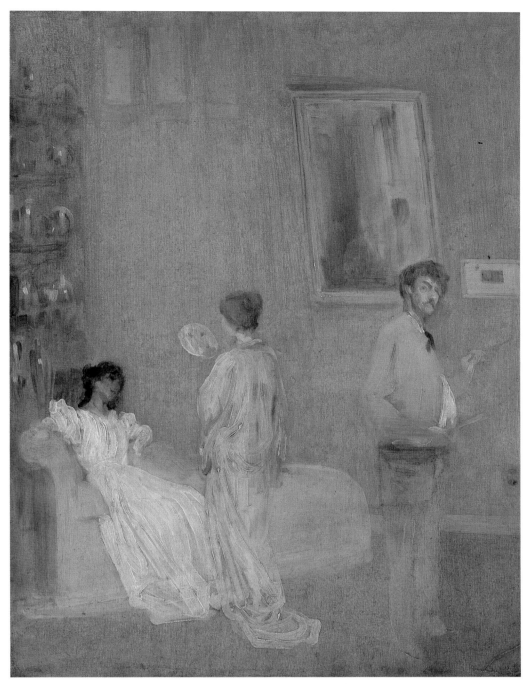

Fig. 10.7 James McNeill Whistler, *The Artist in His Studio*, 1865–66. Oil on paper, mounted on panel, 24¼ x 18¼ in. (62.9 x 46.4 cm). Art Institute of Chicago, Friends of American Art Collection

however, Velázquez almost always tipped the balance in favor of likeness, Whistler in favor of decorative arrangement.

Harmony in Gray and Green: Miss Cicely Alexander (fig. 10.8), a canonical display of Whistler's mature portrait style and his manner of enlisting inspiration from Velázquez, recalls the Infanta Margarita as she is seen in the detail photograph of *Las Meninas* that Whistler owned. In 1874 Otto Scholderer, a German follower of Courbet, told Fantin-Latour that the portrait of Cicely Alexander was "a portrait of a girl a little like a Velásquez, but with unparalleled finesse in each reference."[38] Scholar Michael Quick reviewed the keynotes of Whistler's approach as seen in the portrait: "The figure of the

38. "un tableau d'une petite fille un peu comme un Velásquez mais d'une finesse en chaque rapport sans pareille." Letter from Otto Scholderer to Fantin-Latour, Surrey, June 26, 1874, quoted by Spencer in Fine 1987, p. 58.

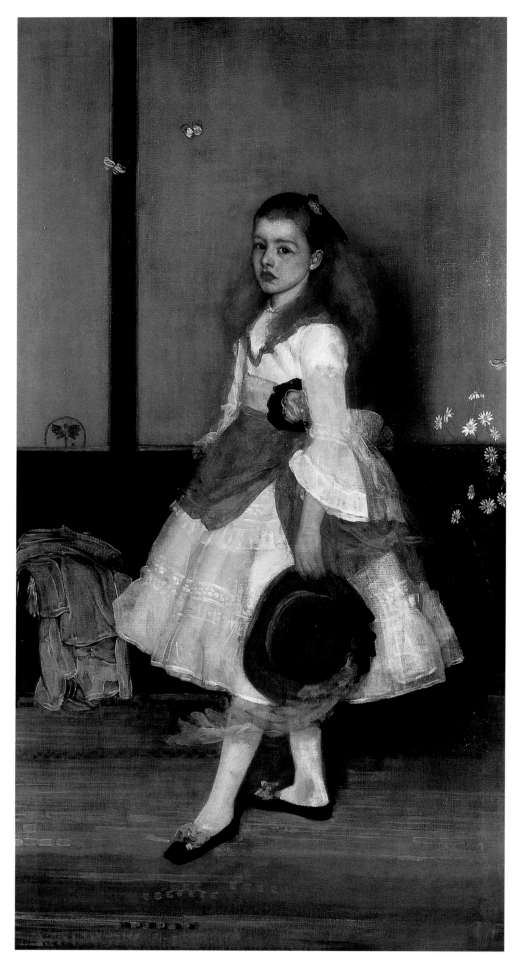

Fig. 10.8 (cat. 222) James McNeill
Whistler, *Harmony in Gray and
Green: Miss Cicely Alexander,*
1872–74. Oil on canvas, 74⅞ x
38½ in. (190.2 x 97.8 cm). Tate,
London, Bequeathed by W. C.
Alexander, 1932

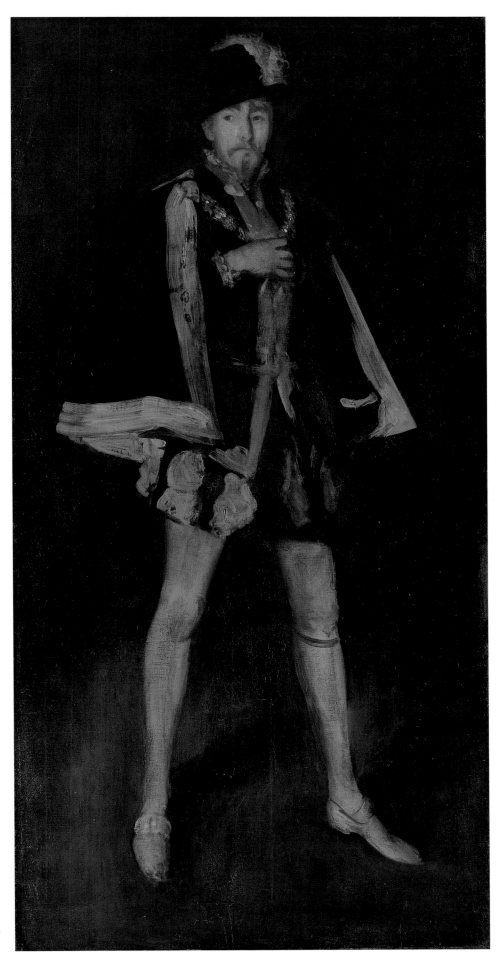

Fig. 10.9 (cat. 223) James McNeill
Whistler, *Arrangement in Black,
No. 3: Sir Henry Irving as Philip II
of Spain*, 1876; revised 1885. Oil
on canvas, 84¼ x 42¼ in. (215.3 x
108.6 cm). The Metropolitan
Museum of Art, New York, Rogers
Fund, 1910 (10.86)

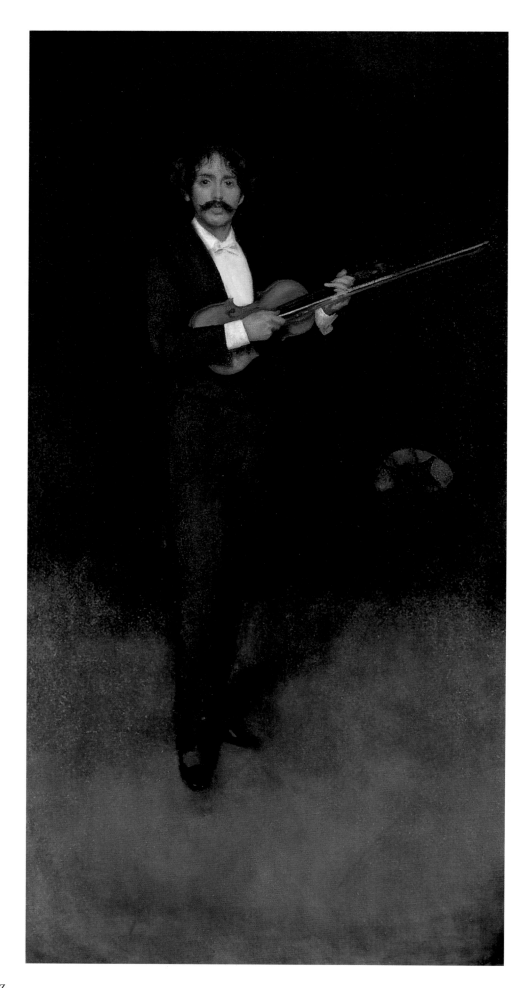

Fig. 10.10 (cat. 225) James McNeill
Whistler, *Arrangement in Black:
Pablo de Sarasate*, 1884. Oil on canvas,
90 x 48 in. (228.6 x 121.9 cm).
Carnegie Museum of Art, Pittsburgh,
Purchase, 1896

young girl is beautifully drawn, but care is taken that she does not seem to be a solid form standing in space. Insistent banding elements and patterning in the nominal background pull to the surface of the canvas, as does the large, distinct, decorative brushwork in the figure itself. With her crisp skirt, the subject presents an elegant silhouette that is carefully placed in relation to the four edges of the canvas, so that the surrounding negative spaces also form taut shapes that read as surface pattern."[39] And art historian Richard Dorment, acknowledging Whistler's enduring reliance on Velázquez (and on Hals), observed that in *Harmony in Gray and Green: Miss Cicely Alexander,* Whistler "took the most sentimentalized Victorian subjects, motherhood and childhood, and created works in which painterly values took precedence over narrative content."[40]

Among Whistler's most challenging explorations of "painterly values" were full-length portraits dominated by finely modulated shades of black, a paradigm of which is *Arrangement in Black, No. 3: Sir Henry Irving as Philip II of Spain* (fig. 10.9). Painted in 1876 and revised in the summer of 1885,[41] the work was impelled by what Whistler had just achieved in his monochromatic likeness of the Spanish violinist, *Arrangement in Black: Pablo de Sarasate* (fig. 10.10). In the final version of Irving's image, Whistler placed the figure against a neutral gray background, well within the frame and surrounded by considered dark shapes that fill the surface to the edges of the canvas. The format, pose, and restricted palette of black, white, silvery grays, and golden ochers owe much to such court portraits by Velázquez as *The Jester Pablo de Valladolid* (fig. 1.49), of which Whistler owned a photograph, and *The Jester "Don Juan de Austria"* (fig. 4.19).

Whistler may have especially wished to invoke Velázquez—perhaps the portrait *Philip IV of Spain in Brown and Silver* (ca. 1631–32, National Gallery, London)—in the likeness of Irving. He had been impressed by the great Victorian actor's 1876 appearance as Philip II, the grandfather of Philip IV (Velázquez's patron), in Alfred Lord Tennyson's verse play *Queen Mary Tudor.* Discussing Whistler's canvas in 1907, the actress Ellen Terry suggested the associations with Velázquez that the actor and the artist might have had in mind. She observed that Irving, "in his dress without much colour (from the common point of view), his long grey legs, and his Velasquez-like attitudes, looked like the kind of thing which Whistler loved to paint. Velasquez had painted a real Philip of the same race; Whistler would paint the actor who created the Philip of the stage."[42] Velázquez was on Whistler's mind just before he repainted Irving's portrait. In the Ten O'Clock Lecture, delivered on February 20, 1885, he praised great artists' ability to find "the beautiful in all conditions and in all times. . . . As did, at the Court of Philip, Velasquez, whose Infantas, clad in inaesthetic hoops, are, as works of Art, of the same quality as the Elgin Marbles."[43]

From the moment of its debut at the newly opened Grosvenor Gallery in 1877, Whistler's portrait of Irving provoked comparisons—not always favorable—with works by the Spanish master. Henry James wrote of the nocturnes, arrangements, harmonies, and impressions on display at the Grosvenor, "The mildest judgment I have heard pronounced upon them is that they are like 'ghosts of Velazquezes.'"[44] Two years later, critic Frederick Wedmore complained, "'Mr. Irving, as Philip of Spain,' was a murky caricature of Velasquez—an effort in which the sketchiness of the master remained, but the decisiveness of the master was wanting."[45] Julius Meier-Graefe observed in his 1908 survey of modern art that "[Whistler] treated [Velázquez] as Turner had treated Claude, and as

39. Michael Quick in Los Angeles–Washington 1981–82, p. 67.
40. Dorment in London–Paris–Washington 1994–95, p. 140.
41. The portrait before repainting is reproduced in Spassky et al. 1985, p. 380.
42. Terry 1907, pp. 135–36. For this and the following quotations from Henry James and Frederick Wedmore, the author is indebted to Spassky et al. 1985, pp. 379–83 *passim.*
43. "Mr. Whistler's 'Ten O'Clock,'" in Whistler 1890b, pp. 136–37.
44. James 1877, p. 156.
45. Wedmore 1879, p. 338, quoted in Spassky et al. 1985, p. 381.

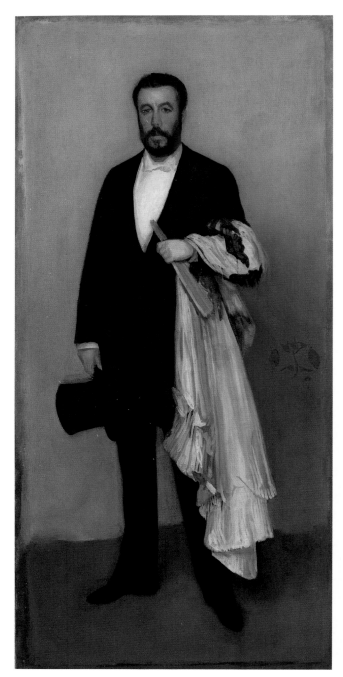

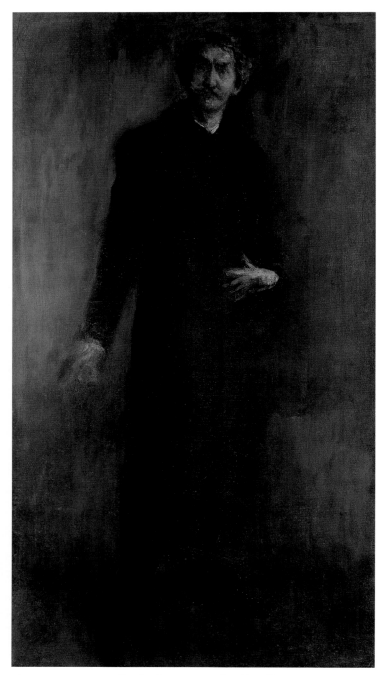

Fig. 10.11 (cat. 224) James McNeill Whistler, *Arrangement in Flesh Color and Black: Théodore Duret*, 1883–84. Oil on canvas, 76⅛ x 35¼ in. (193.4 x 90.8 cm). The Metropolitan Museum of Art, New York, Catharine Lorillard Wolfe Collection, Wolfe Fund, 1913 (13.20)

Fig. 10.12 James McNeill Whistler, *Brown and Gold: Self-Portrait*, ca. 1896. Oil on canvas, 37¾ x 20¼ in. (95.8 x 51.5 cm). Hunterian Art Gallery, University of Glasgow, Birnie Philip Bequest

46. Meier-Graefe 1908, vol. 2, p. 222.
47. Hartmann 1910, p. 124.

Reynolds had treated Rembrandt" and grumbled, "He concealed his Spanish inspiration as discreetly as Manet proclaimed it openly, veiling it under decorative arts, under masquerades, under the culture of a European aesthete."[46] Listing the portrait of Irving with others based on Velázquez, Sadakichi Hartmann commented more kindly in 1910 that "[Whistler] repeats the same inspirations but in an etherealized, modernized and individualized manner."[47]

Whistler's portrait of Irving invites mention of the relationship between works by Whistler and those by Manet that Velázquez also inspired. For example, Whistler knew

Manet's portrait of Philibert Rouvière, *The Tragic Actor* (fig. 1.50), and may have seen Manet's *Faure in the Role of Hamlet* (fig. 1.51) in the 1877 Salon, according to Dorment, who correctly concluded, "in both cases Manet's handling of his figure has a vivid solidity very different from Whistler's much more decorative treatment of Irving."[48] The same differences are apparent when Manet's portrait of Théodore Duret (fig. 9.89) is compared with Whistler's *Arrangement in Flesh Color and Black: Théodore Duret* (fig. 10.11). Meier-Graefe observed, "The one [the Manet] creates life, the other an artistic illusion. . . . We note the bones and flesh in the Manet. Whistler's *Duret* stands on trousers."[49]

Some of Whistler's portraits recall Manet's full-length images of figures in Spanish costumes that adapt the heritage of Velázquez for modern realist subjects. The important distinction is that instead of depicting costumed models, Whistler painted portraits that helped to serve a flourishing international market and revitalize the Anglo-American grand-manner portrait tradition, even though his focus on design discouraged some patrons. Ultimately, French critic Marcel Roland's 1886 prophecy was correct: Whistler's proper place was in the Louvre between Veronese and Velázquez, rather than within the British school.[50]

Brown and Gold (fig. 10.12), Whistler's last full-length self-portrait, offers one of the artist's most explicit and profound tributes to Velázquez. For it he borrowed the pose of a favorite portrait, *The Jester Pablo de Valladolid* (fig. 1.49).[51] Begun during his wife's final illness, worked and reworked during a fretful period of failing health, *Brown and Gold* affirmed Whistler's devotion to his Spanish mentor and announced his own old age and frailty, merging tradition with wrenching modern candor.

THOMAS EAKINS (1844–1916), BONNAT'S STUDENT

I have seen big painting here.
Thomas Eakins to his father, Madrid, December 2, 1869

Thomas Eakins's greatest works conjoin intellect with eloquence, lucid composition and meticulous detail with suggestive tone and color. These dualities reflect his studies in Paris under Jean-Léon Gérôme, arbiter of modern academic naturalism, and Léon Bonnat, advocate of Spanish Baroque expressiveness, as well as his six-month visit to Spain before his return home.[52]

Philadelphia-born Eakins pioneered American painters' pursuit of French art training after the end of the Civil War in 1865. He went to Paris well before hundreds of his compatriots crowded into the studios in the École des Beaux-Arts and private schools such as the Académie Julian or sought instruction under independent teachers. Eakins sailed from New York on September 22, 1866, and arrived in Paris on October 3. Except for a visit home, from mid-December 1868 to March 6, 1869, he studied and traveled in Europe until June 15, 1870. He was admitted to Gérôme's painting atelier in the recently reorganized École des Beaux-Arts on October 25, 1866, as the second American pupil.[53]

Eakins's many long letters home record his despair over difficulties in mastering color and his determination to support himself as an artist upon his return. On June 24, 1869,

48. Dorment in London–Paris–Washington 1994–95, p. 150.
49. Meier-Graefe 1908, vol. 2, pp. 223–24.
50. Marcel Roland, quoted in Pennell 1919, p. 261: "l'oeuvre de Whistler ne quittera son atelier que pour aller tout droit s'ennuyer à jamais sur les murs des grandes salles du Louvre. La place est marquée entre Paul Véronèse et Vélasquez."
51. Spencer in Fine 1987, p. 50, notes that Velázquez's *The Jester Pablo de Valladolid* "had long haunted Manet," who saw it in 1865 and described it as "all in black, so alive, surrounded by air"; Spencer cites Courthion and Cailler 1960, p. 15. Denker in Washington 1995, pp. 69–70, notes that Sir Leslie Ward ("Spy"), *A Symphony* (lithograph, 1878), a caricature of Whistler, was based on the pose of *The Jester Pablo de Valladolid.*
52. For a fuller examination of Eakins's European training, see H. Barbara Weinberg in Philadelphia–Paris–New York 2001–2, pp. 47–60.
53. During Gérôme's absence from Paris to attend the opening of the Suez Canal in early 1868, Eakins enrolled (on March 5, 1868) for three months in the atelier supervised in the École by the respected sculptor Augustin-Alexandre Dumont.

54. Letter from Thomas Eakins to Benjamin Eakins, Paris, June 24, 1869, Bregler Collection. The author is indebted to William Innes Homer for compiling and making available copies of all of Eakins's extant letters.

55. The École emphasized naturalism and held school-wide competitions in rendering "expressive heads," but did not teach portraiture.

56. Foster 1997, p. 240 n. 2, indicates that Eakins's "Spanish sketchbook" (see n. 71, below), p. 8, Bregler Collection, includes between entries made on July 26 and August 12 the words "mois a l'atelier Bonnat 25.00" and "Bienvenue 10.00," referring to the month's tuition, paid in advance, and the collation paid for by new students.

57. "Bonnat is now gone to the country & I will stop his studio at the end of this week probably & work only on my own for in 3 weeks from then our own school is open." Letter from Thomas Eakins to Caroline Cowperthwait Eakins, Paris, August 30, 1869, Bregler Collection.

58. Eakins's often expressed esteem for the painterly manner of *juste-milieu* artist Thomas Couture also anticipated his seeking out Bonnat. Eakins linked Couture with "the greatest men in the world" (letter from Thomas Eakins to unknown recipient, Paris, October 15, 1867, Goodrich Papers); read Couture's *Méthode et entretiens d'atelier* (Conversations on art methods, 1867) "as soon as it came out," called it "curious and interesting," and bought a copy for William Sartain (letter from Thomas Eakins to Benjamin Eakins, Paris, Monday night, February 1868, Bregler Collection); and lamented Couture's absence from the 1868 Salon (letter from Thomas Eakins to Benjamin Eakins and Caroline Eakins, Paris, May 9, 1868, Collection of Mr. and Mrs. Daniel W. Dietrich II).

59. "J'ai été élèvé dans le culte de Velasquez." Bonnat 1898, p. 177.

60. For a comprehensive discussion of Bonnat, see Luxenberg 1990.

61. Heaton 1923, p. 5, referring to the portrait of Levi Morton, banker, minister to France, and later (1889–93), vice-president of the United States, completed in 1883.

62. Blashfield 1896, pp. 48–49, and Blashfield in interview with DeWitt McClellan Lockman, July 1927, Lockman Papers. Blashfield studied with Bonnat in 1867–70 and 1874–80. For information on Bonnat and his American students, see Weinberg 1991, pp. 155–86.

63. Quoted in Sherwood 1928, p. 20.

64. Letter from Thomas Eakins to Benjamin Eakins, September 8, 1869, Goodrich Papers.

after two and a half years of study with Gérôme, Eakins assured his skeptical father of his progress: "One terrible anxiety is off my mind. I will never have to give up painting, for even now I could paint heads good enough to make a living anywhere in America, I hope not to be a drag on you a great while longer."[54]

Since study in the École would not improve his ability to "paint heads,"[55] Eakins enrolled during summer recess in late July or early August 1869 in Bonnat's independent class in Montmartre, where his Philadelphia friend and Paris studio-mate William Sartain had begun working in June.[56] He remained there until early September.[57] Gérôme, who had little interest in portraiture, may have urged Eakins to study with his friend Bonnat, a portraitist since his student years. The fact that Bonnat's current reputation was that of a rising Realist, not the fashionable portraitist he would become in the 1870s, may have increased his appeal to Eakins.[58]

Born in 1833 in the town of Bayonne in the Pyrenees and raised in Spain, Bonnat learned his earliest lessons at the Prado. "I was raised in the cult of Velasquez," Bonnat later asserted.[59] He acquired academic precepts first in Madrid at the Real Academia de Bellas Artes de San Fernando and in the studios of Paris-trained José de Madrazo and his son, Federico, and later in Paris under Léon Cogniet and at the École des Beaux-Arts.[60] Bonnat became a frequent exhibitor at the Salons, earning a reputation for serious canvases executed with energetic brushwork and a strong, dark "Spanish" palette. These pictures included orientalist genre scenes, some of which he executed in 1868 when he accompanied Gérôme to the opening of the Suez Canal and visited the Near East; historical subjects depicted with an almost repulsive realism in the manner of Ribera; and probing portraits that involved as many as eighty sittings.[61]

By 1865, when a group of young artists asked Bonnat to teach them, he was admired as a painter who mediated between academic and realist tendencies. The diverse pupils in Bonnat's independent atelier, which existed until 1883, included many Americans. Edwin H. Blashfield later recalled, "Here we had Bonnat, a novelty, a young man with lots of paint, a forceful fist, fiery enthusiasm for Velasquez and almost as much for Ribera."[62] Truth to nature was paramount. American artist H. Siddons Mowbray, a student from 1878 to 1881, remembered, "At Bonnat's, stern realism was the law. A view of the output of crude torsos, legs, feet and heads suggested a butcher's shop. No one did a thing without the model. It was pure still life."[63]

Eakins's mature works and teaching methods suggest that he found much more inspiration from Bonnat than might have been expected from his brief encounter with him or from the neutral summary of his experience that he provided to his father in a letter of September 8, 1869: "I am very glad to have gone to Bonnat & to have had his criticisms, but I like Gerome best I think. . . . He [Bonnat] is the most timid man I ever saw in my life & has trouble to join three words together."[64] The taciturn Bonnat's dicta were not recorded by his American pupils, but his profound admiration of Velázquez must have pervaded the atelier.

Returning to Gérôme's studio in the fall of 1869, Eakins soon realized that dark, chilly, damp Paris undermined his spirit and his health and decided to conclude his studies. That he did so by making a six-month journey to Spain suggests Bonnat's influence. As early as January 1867 Eakins had been thinking of going to Spain during the coming summer but had contented himself with taking Spanish lessons; in March of that year he

remarked on the ease with which he was learning the language.[65] Eakins must have seen some Spanish paintings in Paris. In addition to works in the Louvre, canvases were on view at auction; several sales of Spanish private collections, for example, were held at the Hôtel Drouot between 1867 and 1869. The many works that Manet showed in his private exhibition outside the gates of the 1867 Exposition Universelle may have captured Eakins's attention. French paintings created under Spanish influence had also begun to appear in the Salons, including Carolus-Duran's *Woman with a Glove* (see fig. 10.39), shown in 1869.

Sartain claimed credit for prompting the trip in late 1869, and Henri Regnault, Mariano Fortuny, and other contemporary painters whom Eakins appreciated may have been influential.[66] Gérôme himself admired Velázquez and would travel in Spain in 1873 and 1883.[67] However, it was Bonnat's passion for Velázquez and Ribera that energized Eakins's plan. As Eakins had led the way for American painters by seeking instruction in Paris, he also set an example for them by visiting Spain at the end of his academic studies, immersing himself in the treasures of the Prado and spending time in picturesque cities such as Seville, the birthplace of both Murillo and Velázquez.

Eakins left Paris by train on the night of November 29, 1869, arrived in Madrid the following evening, and spent the next three days sightseeing and looking at paintings. After weeks of dismal weather in Paris, he was rejuvenated by the bright sunlight and impressed by the clean city and attractive people. He was also overwhelmed by the Prado and wrote home with far more excitement than he had ever expressed for the Louvre.[68] He enthused to his father on December 2, "I have seen big painting here. When I had looked at all the paintings by all the masters I had known I could not help saying to myself all the time, its very pretty but its not all yet. It ought to be better, but now I have seen what I always thought ought to have been done & what did not seem to me impossible. O what a satisfaction it gave me to see the good Spanish work so good so strong so reasonable so free from every affectation. It stands out like nature itself." The next day he added, "I have been going all the time since I have been here and I know Madrid now better than I know Versailles or Germantown and tonight I leave for Seville. I have seen the big work every day and I will never forget it. It has given me more courage than anything else ever could."[69]

After spending a few days in Madrid, Eakins journeyed to Seville, arriving on the evening of December 4, 1869. He visited the Museo de Bellas Artes, the cathedral, and the Alcázar, residence of the Moorish kings, but found himself more interested in the city's lively streets. In January, Sartain and Harry Moore joined him. Eakins's principal project while in Seville was a large multifigured painting, *A Street Scene in Seville* (fig. 10.13), which refers to the stagelike arrangement of Gérôme's *Pifferari* (fig. 10.14)—of which Eakins had obtained a photograph in Paris—but which displays the freer brushwork of Bonnat and Velázquez. Eakins struggled with the daunting task of working in sunlight on an ambitious composition. "Picture making is new to me," he fretted to this father at the end of March; "there is the sun & gay colors & a hundred things you never see in a studio light & ever so many botherations that no one out of the trade would ever guess at."[70]

The travelers parted company following a stay in atmospheric Ronda: Moore continued on to Granada while Sartain and Eakins returned to Madrid for a few days before heading back to Paris. In his "Spanish sketchbook," Eakins made notes on works in the Prado. Although his comments focus on technique and surface effects, he was thrilled by

65. Letter from Thomas Eakins to Benjamin Eakins, Paris, January 21, 1867, Bregler Collection: "Our vacation lasts through the months of August and September and it will no doubt be cheaper living out of Paris than in it, but travelling will cost more I think than either. Much as I would like to visit Spain I fear that Mr. [John] Sartain [artist and father of Eakins's friend William] will have left it before our holydays. However it will do no harm for me to learn enough Spanish to say I am hungry or ask my way back to Paris and I have a chance to practice for I often hear Spanish spoken in our studio now." Letter from Thomas Eakins to Benjamin Eakins, March 12, 1867, Goodrich Papers: "I am studying Spanish which may be of use to me some time, or if of no use otherwise, as a benefit to my mind. . . . I have found a good teacher, who will for a month give me three lessons a week. . . . The grammar is very simple and the verbs analogous with the Italian ones. After the month is up I will take one lesson a week for some time."

66. Foster 1972, p. 77; Milroy 1986, pp. 282–83; and Boone 1996, pp. 82–84. Foster 1982, pp. 193–262, discusses Fortuny's influence on Eakins's watercolor technique.

67. For Gérôme's admiration for Velázquez, see Ackerman 1986, p. 92, citing Théophile Poilpot, who traveled with Gérôme through Spain in 1873 and whose recollections were recorded in Moreau-Vauthier 1906, p. 269.

68. "The first thing a traveler does on reaching Paris is to visit the Louvre," Eakins wrote to his sister Fanny just after his arrival in 1866, using the jesting tone that typifies his letters to her. Of the paintings galleries, he observed: "There must have been half a mile of them, and I walked all the way from one end to the other, and I never in my life saw such funny old pictures." Letter from Thomas Eakins to Frances Eakins, Paris, October 30, 1866, Bregler Collection.

69. Letter from Thomas Eakins to Benjamin Eakins, Madrid, December 2, 1869, Bregler Collection.

70. Letter from Thomas Eakins to Benjamin Eakins, Seville, March 29, 1870, Goodrich Papers. The following letters and preserved portions of letters from Seville, Goodrich Papers, also recount Eakins's difficulties with *A Street Scene in Seville:* Thomas Eakins to Benjamin Eakins, January 26, 1870; Thomas Eakins to unknown recipient, March 14, 1870; Thomas Eakins to unknown recipient, April 28, 1870. His "Spanish sketchbook" (see n. 71), Bregler Collection, contains a note about *A Street Scene in Seville.* Boone 1996, pp. 88–93, discusses the painting.

Fig. 10.13 Thomas Eakins, *A Street Scene in Seville*, 1869. Oil on canvas, 62¼ x 42 in. (159.4 x 106.7 cm). Collection Mr. and Mrs. Erving Wolf

Fig. 10.14 Jean-Léon Gérôme, *Pifferari*, 1859. Photogravure of oil on canvas. From Strahan 1881, vol.1, pl. xii. Photo courtesy the author

71. The "Spanish sketchbook," Bregler Collection, is one of three surviving pocket sketchbooks that Eakins kept in Europe. He began using it in late 1868 to record his accounts and added other notes to it during his visit to Spain and after his return to Philadelphia. Another sketchbook in the Bregler Collection contains studies made in Seville. A sketchbook in the Philadelphia Museum of Art contains accounts and addresses from 1867 to 1868.

72. Quick in Los Angeles–Washington 1981–82, p. 64.

73. On April 2, 1874, Eakins wrote to critic friend Earl Shinn, a former student of Gérôme: "Did you think to ask any picture men about that Femme Fellah de Bonnat [*An Egyptian Peasant Woman and Her Child* (1870, Metropolitan Museum)]. . . . I would like to go with you to see that picture." Bonnat, he said, had told him it was in New York, but Eakins could not remember the owner's name. Planning to go to New York in January 1875 to show his pictures to several dealers, he reminded Shinn, "I want to see that Bonnat." Letter from Thomas

the expressive power of Velázquez and Ribera. Calling "the tapestry weaver" (*The Fable of Arachne* or *The Spinners*, fig. 4.11) by Velázquez "the finest piece of painting I have ever seen," he analyzed the artist's method of defining the mass of the main figure before indicating her features, and added, "I think Ribera and Rembrandt proceeded in the same way, the only [method] in my opinion, that can give both delicacy and strength at the same time." He deduced a personal method: "As soon as my things [i.e., preliminary arrangements] are in place, I shall aggressively seek to achieve my broad effect from the very beginning." His aim was to recombine the best aspects of the French academic and Spanish Baroque traditions, to unite composition and "broad effect," careful structure and tactile surface, much as Bonnat had done: "I must resolve never to paint in the manner of my master [Gérôme]. . . . One can hardly expect to be stronger than he, and he is far from painting like the Ribera or the Velasquez works, although he is as strong as any painter of polished surfaces. . . . The Weaver of Velasquez, although having much impasto, has no roughness at all to catch the light. . . . So, paint as heavily as I like, but never leave any roughness. The things of Velasquez are almost made to slide on. . . . Velasquez does a lot of glazing with quite transparent color in the shaded areas, but it is very solidly painted underneath."[71]

Eakins came home to Philadelphia in the summer of 1870. His accomplishments as an artist and teacher would always reflect what he had learned in Paris and Spain, often

Fig. 10.15 Thomas Eakins, *The Gross Clinic*, 1875. Oil on canvas, 96 x 78 in. (243.8 x 198.1 cm). Jefferson Medical College, Thomas Jefferson University, Philadelphia

Fig. 10.16 Léon Bonnat, *Crucifixion*, 1874. Oil on canvas, 90⅛ x 63 in. (229 x 160 cm). Musée du Petit Palais, Paris

in powerful combination. His greatest painting, *The Gross Clinic* (fig. 10.15), for example, relied for its composition upon a classical pyramid of complex inter-locking forms culminating in the head of Dr. Samuel David Gross. Yet as scholar Michael Quick suggested, in "its lighted foreground figures in a large, shadowed interior containing onlookers" the canvas also included references to *Las Meninas* (fig. 1.57), and in its "harsh rawness" to "the brutal Caravaggism of Ribera, as transmitted through the religious subjects of Bonnat, Théodule Ribot, and other French realists of the 1860s."[72]

Although Eakins did not maintain a personal relationship with Bonnat as he did with Gérôme after his return home, he remained curious about Bonnat's works and sought them out.[73] Through Gérôme, with whom Eakins corresponded in 1874, or Sartain, who returned from Paris in 1876, he may have learned how Bonnat had crucified a cadaver to paint for the Paris law courts a *Crucifixion* (fig. 10.16) that stressed agony in the manner of Ribera, or he may have heard about the

Fig. 10.17 Thomas Eakins, *Crucifixion*, 1880. Oil on canvas, 96 x 54 in. (243.8 x 137.2 cm). Philadelphia Museum of Art, Gift of Mrs. Thomas Eakins and Miss Adeline Williams

Fig. 10.18 Thomas Eakins, *Archbishop William Henry Elder*, 1903. Oil on canvas, 66⅛ x 45⅛ in. (168 x 114.6). Cincinnati Art Museum, Museum Purchase, Louise Belmont Family in memory of William F. Halstrick, Bequest of Farny R. Wurlitzer, Edward Foote Hinkle Collection, and Bequest of Frieda Hauck, by exchange

Fig. 10.19 Léon Bonnat, *John Taylor Johnston*, 1880. Oil on canvas, 52½ x 44 in. (133.4 x 111.8 cm). The Metropolitan Museum of Art, New York, Gift of the Trustees, 1880 (80.8)

Eakins to Earl Shinn, Philadelphia, January 30, [1875], Cadbury Papers.

74. See Milroy 1989.

75. Memorandum from Bryson Burroughs, May 15, 1910, Archives, Metropolitan Museum, folder P1663. It reads: "Mr Eakins wished to call the Museum's attention to a picture of Ribera—He will ask the owner to send it here to be inspected—He also wished to offer (for sale) a large painting by himself 'The Crucifixion.'"

76. Gerdts 1979, p. 157.

canvas when it was shown in the 1874 Salon. Eakins would strap his student John Laurie Wallace to a cross to paint his own *Crucifixion* (fig. 10.17), a painting motivated, as was Bonnat's, by an interest in anatomy, not devotion.[74] Progenitors of Bonnat's image, and possibly Eakins's, include Velázquez's *Christ on the Cross* (fig. 4.10) and Ribera's *The Martyrdom of Saint Philip* (1639, Museo del Prado, Madrid). Eakins's association of his own work with Ribera's is apparent in his recommendation in 1910 that The Metropolitan Museum of Art purchase not only his own *Crucifixion* but also a certain painting by Ribera owned by an unknown collector; the museum made neither acquisition.[75]

Many of Eakins's late portraits, including that of Episcopal Archbishop William Henry Elder (fig. 10.18), recall in their heavy figures, candid poses, and neutral backdrops Bonnat's best-known portrait of an American sitter, *John Taylor Johnston* (fig. 10.19), as well as Velázquez's *Pope Innocent X* (see fig. 2.3),[76] the widely admired and reproduced portrait that Bonnat would have seen during his student years in Rome and that Eakins might have viewed during his three-day visit there in August 1868.

Portraits such as *The Thinker: Portrait of Louis N. Kenton* (fig. 10.20), which rivals, not just recalls, works by the greatest masters, are supreme examples of Eakins's ability to meld the Spanish Baroque and the Beaux-Arts. One of Eakins's late series of lifesize images of standing men, *The Thinker* reveals in its restraint and its restricted palette the durable residue of his admiration of Velázquez. In particular, the legacy of paintings like *Aesop* (fig. 9.11) and *The Jester Pablo de Valladolid* (fig. 1.49) can be seen in the figure's

Fig. 10.20 (cat. 208) Thomas Eakins,
The Thinker: Portrait of Louis N. Kenton,
1900. Oil on canvas, 82 x 42 in. (208.3 x
106.7 cm). The Metropolitan Museum of
Art, New York, John Stewart Kennedy
Fund, 1917 (17.172)

Fig. 10.21 Thomas Anshutz, *A Rose*, 1907. Oil on canvas, 58 x 43⅞ in. (147.3 x 111.4 cm). The Metropolitan Museum of Art, New York, Marguerite and Frank A. Cosgrove Jr. Fund, 1993 (1993.324)

eloquent silhouette against a neutral background and the merest shadow cast to his right to imply his location in space. Most of Eakins's contemporaries found in Velázquez's paintings inspiration for free, facile rendering of flat, simplified forms. Eakins, by contrast, remained devoted to volumetric accounts of anatomy and precise records of costume. Close examination of *The Thinker* reveals his long process of adjusting, perfecting, and laboriously reworking in pursuit of correct contours as well as his care in describing the mundane details of shirt collar, watch chain, and shoes. Kenton does not stand on his trousers! Eakins learned much from Velázquez, but he tempered his admiration for Spanish virtuosity with an allegiance to French academic specificity. Such canvases as *The Thinker* proclaim his assimilation of these diverse traditions, his distinctive responses to American thematic resources, and his singular eloquence and originality.

Eakins had no financial success as a portraitist and little criti- cal recognition during his lifetime; his considerable reputation is posthumous. His relentless realism deterred potential patrons, and even some acquaintances who sat for him as a favor refused to take their portraits as gifts. The harsh criticism that greeted *The Gross Clinic* at the Philadelphia Centennial was an augury of his failed intention to make his living by painting portraits. From the mid-1870s through the 1890s, Eakins supplemented a small income from his father's investments by teaching, first at the Pennsylvania Academy and, after losing his position as director of the school in 1886, as a lecturer at other institutions in Philadelphia and New York. Eakins's appreciation for the Spanish tradition and his emphasis on painting rather than draw- ing created a lasting legacy for his students.

Eakins's pupil Thomas Anshutz, like his teacher, repeatedly sought academic instruction, yet revealed his own assimilation of Velázquez's painterly manner. Anshutz's blend of the two tradi- tions is apparent in works such as *A Rose* (fig. 10.21). As a promi- nent teacher at the Pennsylvania Academy, he passed on Eakins's lessons and preferences to younger students, among them Robert Henri. Following both Eakins and Anshutz, Henri simultane- ously pursued academic studies and investigated painterly tradi- tions at home and abroad. He saw Velázquez's works in London in 1888 and in Paris in 1895–96, and he began to admire Courbet's and Manet's paintings as well. In 1900 Henri spent six weeks in Madrid, where he made five full-scale copies after Velázquez and saw a large exhibition of works by Goya. In June 1906 he sailed for Spain with nineteen of his students, advised their studies at the Prado, and painted portraits, figures, and cityscapes whose vigorous brushwork announced his debt to the Spanish tradition.[77]

Henri and the other New York Realists known as the "Ashcan School" relied on Velázquez's (and Hals's) vitality and low-keyed palette as they rejected the American Impressionists' genteel subjects and pastel hues to respond to the actualities of modern urban life.[78] Henri's full-length portraits, including *George Luks* (fig. 10.22), a likeness of his friend and associate, reveal his appreciation of Velázquez's favored format, candid characterization, fluent brushwork, and muted har- monies. Colleague and then rival of William Merritt Chase as the leading art instructor in New York, Henri advocated to his own students the virtues of Velázquez, praising him for the liveliness and great humanity of his portraits. Through his works, teaching, and writings on art,[79] Henri turned the attention of George Bellows, Edward Hopper, Rockwell Kent, William Gropper, and numerous other students and readers to the Spanish tradition.

Fig. 10.22 Robert Henri, *George Luks*, 1904. Oil on canvas, 77⅛ x 38⅛ in. (196 x 96.8 cm). National Gallery of Canada, Ottawa, purchased 1961

77. Homer 1969, pp. 97, 122–25.
78. For the continuities and differences between the two American artist groups, see New York et al. 1994–95.
79. Henri 1984, pp. 165, 240–42, 280–81.

80. Lauderbach 1917, p. 434.

81. William Merritt Chase, talk given at The Metropolitan Museum of Art, New York, January 15, 1916, quoted in Milgrome 1969, p. 116.

82. Anon. 1917, quoted in Seattle–New York 1983–84, p. 25.

83. "Ishmael" 1891, p. 618, quoted in Bryant 1991, p. 22.

84. Bryant 1991, p. 27, records Chase's initial indifference to the old masters in Munich's galleries and his growing desire to "study or copy the masterworks." Bryant relies on Chase 1906.

85. Lindsay 1973, p. 237, noted that Courbet left Paris for Munich on September 20–21 for celebrations beginning on October 1, 1869. Brooklyn–Minneapolis 1988–89, p. 193, indicates that Courbet visited Munich in the summer of 1869. Munich 1958, pp. 37–38, 50, lists seven works by Courbet and two by Manet: *Boy with a Sword* (fig. 9.21) and *Man Reading* (Saint Louis Art Museum). See also Hamburg–Frankfurt 1978–79, p. 49, for Courbet's exhibition of seven works in Munich.

86. Marggraff 1869 and Marggraff 1878. Both catalogues, which bracket Chase's studies in Munich, list the following works then attributed to Velázquez: "The artist's portrait with a pointed beard and mustaches dressed in black with a starched collar"; "a man's portrait"; "bust of Cardinal Giulio Rospigliosi who lived 1600–1669"; and "portrait of Mary Anne, Infanta of Spain, as a child of five or six years." Count Adolf Friedrich von Schack (1815–1894) played an important role in bringing Spanish literature and painting to the German public, publishing several books about Spanish art and literature and commissioning German painters to make copies after works by such Spanish painters as Murillo and Velázquez. See Rosemary Hoffmann in New York 1993a, pp. 51–52.

87. See, for example, *The Artist Eduard Grützner* (ca. 1875, private collection); illustrated in Cincinnati–Milwaukee–Sacramento 1978, p. 97.

88. Boone 1996, p. 225 n. 3. Boone also suggests the possible influence of paintings by contemporary Spaniard Eduardo Zamacois y Zabala.

William Merritt Chase (1849–1916), Consummate Eclectic

Velasquez lives again!

Two Spanish gentlemen watching Chase copying in the Prado, 1896

William Merritt Chase was an unabashed eclectic. He told his students, "Be in an absorbent frame of mind. Take the best from everything."[80] He proclaimed, "Originality is found in the greatest composite which you can bring together."[81] Chase's eclecticism merely amplified his generation's wish to craft, with pride and pleasure, an American art from the best that the world had to offer. Spanish paintings, notably Velázquez's works as experienced at firsthand and as mediated by his contemporaries, were crucial to Chase's formation.

Indiana-born Chase received some art instruction in Indianapolis and, from 1869 to 1871, at New York's National Academy of Design. Asked by a group of St. Louis businessmen in 1872 if he would like to study in Europe with their support, he is said to have replied, "My God, I'd rather go to Europe than go to heaven"[82]—a sentiment shared by most aspiring American artists of his era. Chase chose to work in Munich rather than in the French capital, where the great majority of his compatriots sought instruction. "I had no great esteem for German art," he stated in 1891. "I knew it was inferior to French art; but I felt, and still feel, that there is plenty to be learnt in any school, and I was anxious to avoid the distractions of Paris."[83]

Enrolled in the Royal Academy in Munich from 1872 to 1877, Chase worked mainly under Karl von Piloty, a history painter and after 1874 director of the academy, and he visited the Alte Pinakothek.[84] At least as important to his formation was Wilhelm Leibl, a Realist painter only five years his senior. Leibl was friendly with Courbet, who had visited Munich in 1869, and admired the works that Courbet and Manet showed in that year at the city's First International Exhibition.[85] Under Leibl's influence, Chase developed a lively style featuring commonplace models, flashy brushwork, dark palette, and dramatic chiaroscuro, traits inspired by contemporary French Realists and certain old masters. Works by the artists whom Leibl preferred could be seen in the Alte Pinakothek, which owned many great canvases by Rubens, Hals, Rembrandt, and other northern Baroque masters, as well as four paintings by Velázquez (plus a few of questionable attribution), and several canvases each by Murillo, Ribera, and Zurbarán.[86]

Chase's informal half-length portraits of his Munich friends suggest Spanish Baroque influence in their dramatic tonal contrasts and expressive hand gestures.[87] The subject of *Keying Up—The Court Jester* (fig. 10.23) implies that Chase was familiar with Velázquez's images of the dwarfs in the Spanish court,[88] and its lush, rosy hues invoke his clerical portraits such as *Pope Innocent X* (see fig. 2.3). Chase's *Ready for the Ride* (fig. 10.24) recalls Velázquez as well as Rembrandt in its fanciful costume and dark palette. The canvas was purchased in Munich by the influential American art dealer Samuel P. Avery; it was shown at the inaugural exhibition of the avant-garde Society of American Artists in New York and helped to identify Chase—then still a student—as a leader of the younger generation.

Chase returned to New York in 1878 to paint and to teach at the Art Students League. He would reinforce his appreciation of Spanish art during his frequent trips to Europe, often taken in the company of friends after the close of the annual spring exhibitions.

Fig. 10.23 William Merritt Chase, *Keying Up—The Court Jester*, 1875. Oil on canvas, 39¾ x 25 in. (101 x 63.5 cm). Pennsylvania Academy of the Fine Arts, Philadelphia, Gift of the Chapellier Galleries

Fig. 10.24 William Merritt Chase, *Ready for the Ride*, 1877. Oil on canvas, 54 x 34 in. (137.2 x 86.4 cm). Union League Club, New York. Photo courtesy Frick Art Reference Library

J. Carroll Beckwith, a student of Carolus-Duran and Bonnat between 1873 and 1875, visited Madrid in 1880 and shared with Chase his enthusiasm for the Prado's collection. In June 1881 Chase accompanied Beckwith and several other painters to Europe, intending to go on to Spain himself. During a two-week stop in Paris, Beckwith introduced Chase to Carolus-Duran and Sargent, and J. Alden Weir introduced him to Cassatt.[89] Since all these painters had already visited Spain, they could have advised Chase about what to expect.

Although Cassatt's Spanish experience provoked an appreciation of the picturesque more than an absorption of stylistic fundamentals, her development warrants a digression. Having gone to France to study in 1865, Cassatt returned home in July 1870 after the outbreak of the Franco-Prussian War. She was eager to get back to Europe. Stimulated by what she had heard about Spain from William Sartain, Eakins's travel companion and brother of Cassatt's artist friend Emily, Cassatt was determined to see the country with her own eyes. In a letter of May 22, 1871, to Emily Sartain, Cassatt lamented that they had not already set out for Spain: "I have been abandoning myself to despair & homesickness,

89. Ibid., pp. 201–2, relying on Beckwith Diary, June 23 and 29, 1881, and letter from William Merritt Chase to Dora Wheeler, Madrid, July 24, 1881, Archives, Cincinnati Art Museum, Gift of Miss Candace Stimson.

90. Letter from Mary Cassatt to Emily Sartain, Hollidaysburg, Pa., May 22, [1871], transcribed in Mathews 1984, p. 70.

91. *During Carnival* is illustrated in Chicago–Boston–Washington 1998–99, p. 229.

92. Letter from Mary Cassatt to Emily Sartain, [Madrid], Saturday, October 5, [1872], transcribed in Mathews 1984, pp. 102–4. Ibid., p. 104 n. 1, identifies the "Academie Museo" as the Prado, which was referred to as the "Real Museo," rather than the Academia Reale, which housed contemporary Spanish art.

93. Letter from Mary Cassatt to Emily Sartain, [Madrid], Sunday, October 5, [1872], transcribed in Mathews 1984, pp. 107–8. Boone 1996, p. 242, indicates that Cassatt is listed on October 5, 1872, the day of her arrival in Madrid, in the *Libro de registro de los señores copiantes* (March 18, 1864–October 18, 1873, box L-36), Archives, Museo del Prado, Madrid. Letter from Mary Cassatt to Emily Sartain, Seville, Wednesday, October 27, [1872], mentions "a sketch of the little prince Balthasar Charles (Velasquez) that I made in the gallery in Madrid." The letter is transcribed in Mathews 1984, pp. 109–10.

94. Letter from Mary Cassatt to Emily Sartain, Seville, Wednesday, October 27, [1872], transcribed in Mathews 1984, pp. 109–10.

95. Boone 1996, p. 133, speculates on Cassatt's contact in 1872–73 with the version of the painting owned by Don Sebastián de Borbón, which she encouraged Louisine and H. O. Havemeyer to purchase in 1904. The painting was bequeathed by Mrs. Havemeyer to The Metropolitan Museum of Art in 1929.

for I really feel as if it was intended I should be a Spaniard & quite a mistake that I was born in America, as the German poet says 'Spanien ist mein heimats land [Spain is my motherland].'"[90]

Cassatt and Emily Sartain left for Europe in early December 1871. They went first to Parma, Italy, where Cassatt fulfilled a commission to copy two paintings by Correggio and began work on *During Carnival* (1872, private collection), a scene of two women throwing flowers, possibly from a balcony.[91] Sartain went back to Paris in May 1871 to continue her studies, and Cassatt traveled to Spain alone, arriving in Madrid on the morning of October 5, 1872. She could not contain her excitement, as she wrote that day to Sartain, "I got here this morning at 10 o'clock at 12 I had had a bath was dressed and on my way to the Academie Museo or whatever they call it." Cassatt continued, "Velasquez oh! my but you knew how to paint! Mr. Antonio Mor or Moro, whom you were introduced to at Parma has a word or two to say to you Emily," then praised Titian and Van Dyck as well. She added to the letter the next day, "I don't hesitate to tell you that although I think now that Correggio is perhaps the greatest painter that ever lived, these Spaniards make a much greater impression *at first*. The men and women have a reality about them which exceed anything I ever supposed possible, Velasquez Spinners, good heavens, why you can walk into the picture. Such freedom of touch, to be sure he left plenty of things unfinished, as for Murillo he is a baby alongside of him, still the Conception is lovely most lovely. But Antonio Mor! And then Rubens! I won't go on."[92]

Cassatt wrote to Sartain on October 13, again urging her to come south: "I am making a sketch from the Velasquez at the gallery, and I am quite if not more enthusiastic than before. I sincerely think it is the most wonderful painting that ever was seen, this of the Spanish school. Murillo has risen immensely in my opinion since I have seen his St. Elizabeth, it is a most tender beautiful thing. . . . I have found a few French artists copying here, and all with one accord agree with me; I think that one learns *how to paint* here, Velasquez manner is so fine and so simple."[93]

After three weeks in Madrid, Cassatt left for Seville, hoping to meet Fortuny there and to capture on canvas, as he did, charming vignettes of Spanish life. Still trying to persuade Sartain to join her, Cassatt wrote on October 27, 1872, signaling her enchantment with the possibilities, "I see the immense capital that can be drawn from Spain, it has not been 'exploited' yet as it might be, and it is suggestive of pictures on all sides."[94]

The four paintings that Cassatt executed during her five months in Seville were efforts to "exploit" the picturesque. Much more resolved than Eakins's *A Street Scene in Seville*, these canvases offer a stylistic nod to works by Correggio, the hero of her studies in Parma, to Murillo and Goya, and to Manet. Despite her stated admiration for Velázquez, and her copying one of his works, he influenced her style then and thereafter hardly at all.

Cassatt's anecdotal *On the Balcony* (fig. 10.25), for example, continues the investigation of women, shown at half length and dressed in colorful and exotic costumes, that the artist had explored in Parma. The painting also pays homage to such popular Spanish images as Goya's *Majas on a Balcony* (fig. 1.32), a version of which (ca. 1827–35, The Metropolitan Museum of Art, New York) Cassatt might have viewed in Madrid in the collection of Infante Don Sebastián María Gabriel de Borbón y Braganza, who admitted the public to his private gallery every afternoon.[95] *On the Balcony* refers as well to Murillo's *Two Women at a Window* (ca. 1655–60, National Gallery of Art, Washington, D.C.), which Cassatt might

Fig. 10.25 (cat. 200) Mary Cassatt, *On the Balcony*, 1872. Oil on canvas, 39¾ x 32½ in. (101 x 82.5 cm). Philadelphia Museum of Art, W. P. Wilstach Collection

Fig. 10.26 (cat. 201) Mary Cassatt, *Offering the Panal to the Bullfighter*, 1872–73. Oil on canvas, 39¾ x 33½ in. (101 x 85 cm). Sterling and Francine Clark Art Institute, Williamstown, Mass.

have known through copies or engravings, and to Manet's *The Balcony* (fig. 9.80)—itself a response to Goya's *Majas on a Balcony*—which she may have seen in the 1869 Salon.[96]

The magnificently attired toreadors of Cassatt's *Offering the Panal to the Bullfighter* (fig. 10.26) and *After the Bullfight* (1872–73, Art Institute of Chicago) also suggest influence from Manet's costume pieces. His picture *A Matador* (fig. 9.55), for example, was among the fourteen Spanish subjects that he showed in Paris in 1867. Cassatt's relatively vigorous brushwork in her toreador paintings further implies inspiration from Manet and indicates more of Velázquez's painterly authority than is usually visible in her works.[97]

Ultimately, Cassatt's Spanish images relate most closely to the international fad for images of Spanish life that affected many artists of her generation. Participants in this trend included the popular Spaniards Fortuny, Madrazo, Eduardo Zamacois y Zabala, and Martín Rico y Ortega, whose works, along with many by French painters of Spanish genre scenes, she could have seen in the Paris collection of American expatriate William Hood Stewart.[98]

Briefed on Spain by his Parisian friends and acquaintances, Chase journeyed on alone to Madrid on July 2, 1881.[99] He spent most of July and August examining Velázquez's works, delighted to find in them more pure color than his studies in Munich had led him to expect.[100] He enthused to his student Dora Wheeler, "The Old Gallery of pictures is simply magnificent. Velazquez is the greatest painter that ever lived. How you would enjoy the pictures by him here. I am sure you would be inspired and encouraged; Velazquez is not like many of the great painters he never discourages one—but on the contrary—

96. Ibid., pp. 134–35.
97. Cassatt would encourage Mr. and Mrs. H. O. Havemeyer to acquire Manet's *A Matador* in 1898.
98. Boone 1996, pp. 142–43. For Cassatt and Spain, see also Boone 1995; Andrew J. Walker in Chicago–Boston–Washington 1998–99, pp. 32–39.
99. Beckwith Diary, Saturday, July 2, 1881: "Chase left for Madrid tonight and I saw him through the preliminaries."
100. Bryant 1991, pp. 86–88. Bryant relies on Beckwith Diary, June 4–July 1, 1881, and Roof 1917, pp. 93–94, 96–97.

Fig. 10.27 William Merritt Chase, *Alice in the Shinnecock Studio*, ca. 1901. Oil on canvas, 38⅛ x 42¼ in. (96.8 x 108.6 cm). Parrish Art Museum, Southampton, N.Y., Littlejohn Collection, 1961.5.6

101. Letter from William Merritt Chase to Dora Wheeler, Madrid, July 24, 1881, Archives, Cincinnati Art Museum, Gift of Miss Candace Stimson, quoted in Boone 1996, p. 202.

102. Boone 1996, p. 202.

103. For example, letter from William Merritt Chase to his wife, Alice Gerson, Munich, June 24, 1903: "This has been a fine day. Three of my former pupils and I went out to Schleisheim [sic] and spent the day. It is a most beautiful place and there are a few good pictures in the Palace, one *capital Velasquez*." Letter from William Merritt Chase to his wife, Vienna, June 26, 1903: "I have been to see both of the galleries here and have enjoyed a rare treat. The pictures by Velasquez and Hals are *very* fine." Letter from William Merritt Chase to his wife, Berlin, June 28, 1903: "The Velasquez and Hals pictures—also the Rembrandts are *fine* here, especially the big fat man by Velasquez." Chase Papers.

104. Southampton–New York 1997, pp. 105–29, illustrates many paintings and photographs of the studio.

makes you feel that everything is possible for one to accomplish. . . . I am copying at the Gallery, have finished one large full length figure by Velazquez and have begun another." Notwithstanding Chase's surprise at Velázquez's palette, he had been well prepared by Leibl to emulate the Spaniard's virtuoso technique. He continued in the same letter to Wheeler, "I understand that my way of going to work has created considerable talk here among the painters. It seems that they are not accustomed to see a brush and paint used as freely as I find it necessary in order to get the character Velazquez got in his work."[101] The Prado's copyist records are incomplete for this period, but contemporary sale catalogues and articles indicate that in the early 1880s Chase made at least two copies of Velázquez's portraits of Philip IV, as well as copies of *Menippus, Aesop* (figs. 9.11, 9.12), and *The Fable of Arachne* or *The Spinners* (fig. 4.11).[102]

Chase would visit Spain again in 1882, 1883, 1884, 1896, and 1905 to refresh his contact with works in the Prado, copy masterpieces, gather bric-a-brac, and paint landscapes on the outskirts of Madrid, in Toledo, and in other cities. Even on travels outside of Spain, he would often pay particular attention to works by Velázquez that he encountered.[103] His richly decorated atelier in New York's Tenth Street Studio Building, which he and his pupils depicted, contained copies from the old masters, including Velázquez, as did his summer studio at Shinnecock on Long Island (figs. 10.27, 10.28).[104] (Chase's New York studio was also the site of the 1890 performances by the dancer Carmencita, who was portrayed by Chase and Sargent [figs. 10.29, 10.30].) Chase would never cease to admire the Spanish

Fig. 10.28 Anonymous, *William Merritt Chase in His Tenth Street Studio, NYC, with Copies after Hals, Velázquez, and Other Old Masters on the Wall*, ca. 1895. Albumen print, 4¼ x 7⅝ in. (11.4 x 19.4 cm). William Merritt Chase Archives, Parrish Art Museum, Southampton, N.Y.

105. Chase 1896, p. 4.
106. Chase 1906.

master. In a speech on Velázquez delivered in 1896 before the American Art Association of Paris, he described the duality of accessible and ineffable qualities in Velázquez's works: "In approaching my subject, I may be permitted to say that Velasquez is, of all artists, the most easy, and, at the same time, the most difficult to treat of; the former being the case, in point of view of his extreme modernism (for of all the old masters he is the most modern), and of the fact that this work appeals for that reason directly to us; the latter being equally true, because, despite those qualities that charm our modern taste, there is something so elusive and subtle about his work that it sets at defiance our power to rightly describe it."[105]

Lecturing to his students in 1906, Chase emphasized the virtue of studying old-master paintings in European museums and lamented the lack of great examples in the Metropolitan: "At the time of the trouble between the States, Spain and Cuba, I was there and fell in with a Spaniard I had known for years. I said to him 'There will be serious trouble, and I think I will ask the President to appoint me a committee of one and box up at least six of your pictures by Velasquez, and ship them to New York.' He said 'That is impossible.' Singularly enough, some one else had the same idea, and I had not expressed it to any one but read an article in the Sun on the same subject."[106]

The heritage of Velázquez can be discerned in several of Chase's multifigured interior scenes. His large pastel *Hall at Shinnecock* (fig. 10.31), quotes from *Las Meninas* a young girl at center (Chase's daughter Cosy) who gazes at the viewer; a mirror (on the right-hand

Fig. 10.29 (cat. 206) William Merritt Chase, *Carmencita*, 1890. Oil on canvas, 69⅞ x 40⅞ in. (177.5 x 103.8 cm). The Metropolitan Museum of Art, New York, Gift of Sir William Van Horne, 1906 (06.969)

Fig. 10.30 (cat. 219)
John Singer Sargent,
Carmencita, 1890.
Oil on canvas, 91⅛ x
55⅞ in. (232 x 142 cm).
Musée d'Orsay, Paris

door of the armoire); a self-portrait (Chase at work reflected in the mirror); a picture-lined back wall;[107] and implied layers of space within, beyond, and in front of the pictorial space. In *Ring Toss* (fig. 10.32), an oil that portrays three of Chase's daughters at play in one of his studios, the artist refers to *Las Meninas* by including the back of a large canvas at the right and by "representing" himself with a framed canvas on an easel at the left, in

the place of Velázquez's self-portrait. The asymmetrical arrangement of *Ring Toss* brings to mind Sargent's *Daughters of Edward Darley Boit* (fig. 10.45), which likewise was inspired by and updated *Las Meninas*.

The consummate eclectic, Chase valued Spanish traditions that were echoed in works by contemporary international painters, among them Manet, Whistler, Sargent, Madrazo, and Fortuny. He was particularly attracted to Manet. Returning to Paris from Spain in September 1881, Chase met up with Beckwith, lunched with Sargent, and found that their friend J. Alden Weir, a former student of Gérôme, was on his second buying trip to Paris, helping American silver-mine owner Erwin W. Davis assemble a collection of paintings that would include works by Velázquez, Sir Joshua Reynolds, Thomas Gainsborough, Courbet, and Jules Bastien-Lepage. Accompanied by Chase in Paris, and perhaps at his urging, Weir purchased for Davis two paintings by Manet: *Boy with a Sword* (fig. 9.21) and *Young Lady in 1866 (Woman with a Parrot)* (fig. 9.33).[108] When Davis gave these two canvases to The Metropolitan Museum of Art in 1889, they were the first works by Manet to enter an American public collection.

Chase may have first learned of Manet's works through Leibl and may have seen *The Execution of Emperor Maximilian* (fig. 9.72) when it was exhibited in New York in the winter of 1879–80.[109] His enthusiasm may have also been reinforced by Alfred Stevens, the Belgian painter who admired Manet's works and who advised Chase in 1881 to abandon old-master inspiration and adopt a more modern style. Chase seems to have favored Manet when he served on the organizing committee for New York's December 1883 Pedestal Fund Art Loan Exhibition, whose purpose was to assist the national campaign to pay for the pedestal for Frédéric-Auguste Bartholdi's monumental statue *Liberty Enlightening the World* (1886). The exhibition emphasized contemporary French artists: the Barbizon painters, Courbet, James Tissot, Degas, and Manet, and included Davis's two Manet oils. As a member of the hanging committee, Chase also managed to pay tribute to Manet, who had died seven months earlier, by installing Davis's oils prominently on the south wall of the main gallery.[110]

When the Parisian dealer Durand-Ruel opened a huge exhibition of 289 works of the French Impressionists at the American Art Galleries, New York, in April 1886, Chase had an opportunity for further contact with works by Manet and his circle. The exhibition proved so controversial—and popular—that it was expanded to 310 works and reopened at the National Academy of Design in May 1886.[111] A review of the Durand-Ruel exhibition by Roger Riordan specifically mentioned similarities between paintings by Manet and Chase: "Manet, who was represented by a number of striking examples, large and small, is absurdly overrated, when compared, as he has been, with Velasquez. He is more like our own Wm. M. Chase, minus his barbaric splendor of color, and plus a touch of Goya's savage imagination."[112] Manet remained a paragon of quality for Chase, who conferred the highest praise upon a portrait study by his pupil Joseph Stella when he said in 1901, "Manet couldn't have done it any better."[113]

By the mid-1880s, Chase had developed a keen appreciation of Whistler. Having become aware of the artist during his student years, Chase would have followed with interest Whistler's notorious 1878 libel suit against critic John Ruskin. Chase got to know more of Whistler's paintings in American exhibitions and in the Paris Salons that he visited in 1882, 1883, and 1884. Whistler's *Arrangement in Gray and Black, No. 1: The Artist's Mother* (fig. 10.33), for example, which had been shown at the annual exhibition of the Pennsylvania Academy of the Fine Arts in 1881 and at the Society of American Artists' annual display in New York in 1882,[114] may have inspired the pose that Chase used for his grand portrait of Miss Dora Wheeler (fig. 10.34). However, Chase added to that compositional foundation brilliant pigments and applied them in a scintillating veneer, choices that suggest the additional influence of Fortuny and Madrazo.[115]

Having admired Whistler's *Harmony in Gray and Green: Miss Cicely Alexander* (fig. 10.8) in London in 1884, Chase went on to Madrid, where, as has been noted, he observed that "every Velasquez seemed to suggest Whistler."[116] As Chase made his way to Spain again in 1885 by way of London, he decided to introduce himself to Whistler. The two artists spent time together, Chase yearning to proceed to Madrid, Whistler urging him not to hurry but to remain in London so that they could paint portraits of each other.[117] For his full-length depiction of Whistler (fig. 10.35), Chase renounced the chromatic vivacity he had applied to an earlier Whistlerian armature for his portrait of Dora Wheeler and instead emulated Whistler's more recent works. That is, he adopted the elongated figure, the austere,

107. These analogies in *Hall at Shinnecock* are noted in Gallati 1995, p. 59.
108. Chase's and Weir's biographers provide slightly different accounts of the episode. Roof 1917, p. 94, credits Chase with initiating the acquisition: "As soon as Chase heard his friend's errand he exclaimed: 'Come with me right away to Durand-Ruel's. They have two wonderful Manets there. You *must* have them.'" D. Young 1960, p. 145, notes that Weir "recalls how he was prowling about Paris with Chase when 'we came across the two pictures that now hang in the Metropolitan Museum, by Manet . . . two splendid canvases which I purchased for a friend.'"
109. The painting was shown at the Clarendon Hotel, 757 Broadway, New York (December 1879–January 1880), and at the Studio Building Gallery, Ipswich Street, Boston (January 1880).
110. Maureen C. O'Brien in Southampton–New York 1986, pp. 160–62. O'Brien also indicates that the three Manets shown were no. 152, *Boy with Sword;* no. 182, *Portrait of a Lady;* no. 191, *Toreador,* which she identifies as the sketch *Mlle V. . . in the Costume of an Espada* (Museum of Art, Rhode Island School of Design, Providence).
111. See New York 1886. Huth 1946, pp. 239–40, mentions the inclusion of about 23 works by Degas; 17 Manets; 48 Monets; 38 Renoirs; 3 Seurats; 15 Sisleys; as well as works by Boudin, Caillebotte, Forain, Cassatt, Guillaumin, and Morisot.
112. Riordan 1886, p. 4, quoted by Barbara Dayer Gallati in Brooklyn–Chicago–Houston 2000–2001, p. 41. Gallati claims that Riordan was implying that the paintings of Velázquez "stood at the foundation of art for both men [Manet and Chase]." While that may be true, Riordan was saying only that Manet is more like Chase than he is like Velázquez.
113. Bryant 1991, p. 190.
114. Seattle–New York 1983–84, p. 191 n. 1.
115. For Chase's portrait in general, see Marling 1978. In his 1896 talk on Velázquez before the American Art Association of Paris, Chase said of Whistler's canvas: "Of all the art work that I have seen in France, there is no modern picture which would not suffer by comparison, were it hung among the canvases of Velázquez—with a single exception . . . that splendid painting in the Luxembourg, the portrait of his mother, by James McNeill Whistler." Chase 1896, p. 5.
116. See p. 261 above.
117. Chase 1910b, pp. 219–20.

Fig. 10.33 James McNeill Whistler, *Arrangement in Gray and Black, No. 1: The Artist's Mother*, 1871. Oil on canvas, 56⅞ x 64 in. (144.3 x 162.5 cm). Musée d'Orsay, Paris

Fig. 10.34 William Merritt Chase, *Miss Dora Wheeler*, 1883. Oil on canvas, 71⅛ x 74¼ in. (180.6 x 188.6 cm). Cleveland Museum of Art, Gift of Mrs. Boudinot Keith in memory of Mr. and Mrs. J. H. Wade, 1921.1239

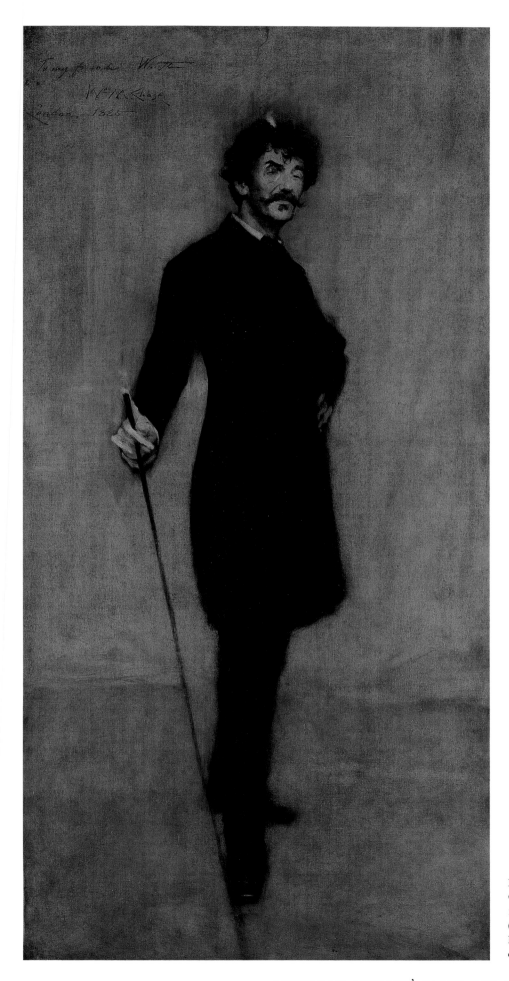

Fig. 10.35 (cat. 203) William Merritt
Chase, *James Abbott McNeill Whistler*,
1885. Oil on canvas, 74⅛ x 36¼ in.
(188.3 x 92.1 cm). The Metropolitan
Museum of Art, New York, Bequest
of William H. Walker, 1918 (18.22.2)

Fig. 10.36 William Merritt Chase, *Lady in Pink: Mrs. Leslie Cotton*, ca. 1888–89. Oil on canvas, 70 x 40 in. (177.8 x 101.6 cm). Museum of Art, Rhode Island School of Design, Gift of Isaac C. Bates

Fig. 10.37 (cat. 205) William Merritt Chase, *Lady in Black*, 1888. Oil on canvas, 74¼ x 36¼ in. (188.6 x 92.2 cm). The Metropolitan Museum of Art, New York, Gift of William Merritt Chase, 1891 (91.11)

118. Whistler in "a letter to a friend" published in the *New York Tribune*, October 12, 1886, p. 1, quoted in Bolger 1980, p. 83; Bolger's catalogue entry contains an excellent summary of the creation of Chase's portrait. A fuller consideration of the stormy friendship between Chase and Whistler appears in Seattle–New York 1983–84, pp. 77–82.

low-key palette, the free brushwork, and the ambiguous space of portraits that Whistler had painted in response to Velázquez. Chase's portrait, certainly intended as an homage to Whistler and his style, provoked Whistler's wrath; he called it a "monstrous lampoon" and may have retaliated by destroying his portrait of Chase.[118]

Despite the rift that developed between the two painters during the summer of 1885, Chase remained affected by Whistler's style. During the mid- and late 1880s, he painted several portraits, based on permutations of a single color, that balance the volumetric appearance of the sitter with harmonious surface design. For two such portraits, Chase enlisted as a model his student Marietta Benedict Cotton. *Lady in Pink: Mrs. Leslie Cotton* (fig. 10.36) paraphrases the pose from Whistler's portrait of his mother. *Lady in Black*

(fig. 10.37) portrays Cotton, garbed in a black dinner dress, resting her right hand on a Chippendale-style table on which rests a pink rose. The rose serves the same function as the pink domino in Whistler's *Arrangement in Flesh Color and Black: Théodore Duret* (fig. 10.11), echoing the flesh tones and relieving the otherwise austere black and gray palette. By including a table at the left in *Lady in Black*, Chase also referred to Sargent's *Madame X (Madame Pierre Gautreau)* (fig. 10.47). The common debt of Chase, Whistler, and Sargent to Velázquez is obvious in all these portraits, as is the influence the three Americans had on each other. Also redolent of Velázquez's spirit, especially as reconsidered by Whistler, Manet, and Sargent, is Chase's *Ready for a Walk: Beatrice Clough Bachmann* (fig. 10.38). Chase may have chosen the title, which invokes his earlier *Ready for the Ride,* to underscore the evolution of his art since 1877 under the influence of his great Spanish precursor and his American colleagues.[119]

Chase's enduring devotion to Spanish painting is signaled by his decision in 1896 to shift his teaching activity to Madrid from New York City, where he had taught since 1878 at the Art Students League, and from Shinnecock, where he had offered summer classes since 1891. With his wife, two of his daughters—including Helen Velázquez, born in 1894—and several students, he left for Madrid in January 1896, intending to spend four months each year teaching there. The pupils, Americans and Europeans, would occupy half a day copying in the Prado and the other half painting from models. One day, probably in 1896, while Chase was copying from *Las Meninas* in the Prado, two Spanish gentlemen approached, looked at the copy, and exclaimed, "Velasquez lives again!"[120]

Fig. 10.38 William Merritt Chase, *Ready for a Walk: Beatrice Clough Bachmann,* ca. 1885. Oil on canvas, 84 x 48 in. (213.4 x 121.9 cm). Terra Foundation for the Arts, Chicago, Daniel J. Terra Collection

The plan to offer instruction only in Madrid collapsed in the face of the increased teaching responsibilities that Chase took on in New York and Philadelphia. When he resumed giving summer classes abroad in 1903, he held them in various locales. In 1905 Chase brought a class to Madrid for the last time, finding in the city verification of the connections that he had perceived between Velázquez's art and modern life.[121] "In the late afternoon and evening," Chase's biographer noted, "he liked to watch the pageant of the streets from a seat at a sidewalk café or from one of the pay-benches along the [Paseo del] Prado. There he delighted in picking out the Velasquez types in the crowd, finding now a dwarf, then a beggar, next an Andalusian horse, quite as if they had stepped out of a Velasquez canvas."[122]

119. Gallati 1995, p. 100, discusses the sources for the Bachmann portrait and illustrates it (p. 102).

120. Bryant 1991, pp. 172–73, relying on Roof 1917, pp. 168–69, and other contemporary sources. *Libro de registro de los señores copiantes* (January 2, 1896–December 31, 1897, box L-2), Archives, Museo del Prado, Madrid, cited in Boone 1996, pp. 249–50, notes that Chase registered to copy Velázquez's *Maria Teresa* on February 25, 1896, and *Las Meninas* on February 29, 1896. Both permits expired on September 22, 1898.

121. See Chase 1910a, p. 442, quoted p. 285 above.

122. Roof 1917, p. 220, quoted in Boone 1999, p. 127.

123. An excellent account of the critical response to Sargent's works in relation to Velázquez's is Simpson 1998.

124. Ormond and Kilmurray 1998, p. xii. The author acknowledges with gratitude the collaboration of Stephanie L. Herdrich, Research Associate, her co-author of *American Drawings in The Metropolitan Museum of Art: John Singer Sargent* (Herdrich and Weinberg 2000).

125. "Every One says that Paris will be the best place to find such advantages as we wd like to give him. . . . If we can get him into the Atelier of some first rate painter we flatter ourselves (perhaps it is a parental delusion) that he will make something out of himself more than common." Letter from Fitzwilliam Sargent to George Bemis, April 23, [1874], Bemis Papers.

126. Olson 1986, p. 33. Olson cites Palmer's diary, May 20, 1874 ("Went to talk to Sargent about studios . . ."), and thanks Maybelle Mann for the information.

127. "An artistic friend with whom I had sketched last winter in Florence . . . told me that he was himself in the atelier of M. Carolus Durand whom he prefers to any other artist in Paris, both as a teacher and as a painter. . . . I dare say I shall go to that atelier rather than to Geromes or Cabanel's. . . . Besides I admired Durand's pictures immensely in the salon, and he is considered one of the greatest french artists." Typewritten transcription of Sargent's autograph letter, signed, to Heath Wilson, [Paris], May 23, 1874; the original letter, now destroyed, was in the possession of William H. Allen, Bookseller, Philadelphia, who kindly made the transcription available. Edited excerpts from this and from a subsequent letter, cited below, are quoted without citations in Leeds–London–Detroit 1979, p. 18.

128. Low 1935, pp. 55–56. See also Low 1910, p. 89, and J. Carroll Beckwith in Coffin 1896, p. 172. For a fuller examination of Sargent's studies in Paris, see H. Barbara Weinberg in Williamstown 1997, pp. 4–29. Williamstown 1997 also includes transcriptions of critics' comments on paintings that Sargent exhibited through 1889.

129. Typewritten transcription of Sargent's autograph letter, signed, to Heath Wilson, Paris, June 12, 1874. The original, now destroyed, was in the possession of William H. Allen, who kindly made the transcription available (see n. 127, above).

130. Sargent matriculated in the École in fall 1874, spring 1875, and spring 1877, when he was ranked second among the 179

John Singer Sargent (1856–1925), Carolus-Duran's Most Celebrated Student

He is Velasquez come to life again.
William C. Brownell, 1884

Prodigiously gifted, only slightly affected by academic precepts, and indoctrinated into the cult of Velázquez by Carolus-Duran, John Singer Sargent was the great Spaniard's most apt and consistent American disciple.[123] Seventeen-year-old Sargent enrolled for his first documented formal art training during the winter of 1873–74 at the Accademia delle Belle Arti in Florence.[124] By the spring of 1874, Sargent's father, Fitzwilliam, was convinced that his young son had exhausted Florentine instructional resources. He decided to move his family to the French capital so that their prodigy could nourish his talent.[125]

The Sargents reached Paris on May 16, 1874, and the young artist promptly decided on his course of study. At the suggestion of the American friend Walter Launt Palmer, who had been working under Carolus-Duran since November 1873,[126] and impressed by Carolus's works in the Salon—especially by comparison with Gérôme's—Sargent chose Carolus as his teacher.[127] On May 26, accompanied by his father, Sargent visited Carolus-Duran's atelier on the boulevard Montparnasse, where he created a vivid impression. American art student Will H. Low later recalled,

> He made his appearance in the Atelier Carolus-Duran almost bashfully, bringing a great roll of canvases and papers, which unrolled displayed to the eyes of Carolus and his pupils gathered about him sketches and studies in various mediums, seeming the work of many years; (and John Singer Sargent was only seventeen) . . . an amazement to the class, and to the youth [Low] in particular a sensation that he has never forgotten. . . .
>
> Having a foundation in drawing which none among his new comrades could equal, this genius—surely the correct word—quickly acquired the methods then prevalent in the studio, and then proceeded to act as a stimulating force which far exceeded the benefits of instruction given by Carolus himself.[128]

Sargent recorded his impressions in a letter to his painter friend Charles Heath Wilson on June 12, 1874: "Carolus-Duran [is] a young and rising artist whose reputation is continuously increasing. He is chiefly a portrait painter and has a very broad, powerful and realistic style."[129] As Sargent did not investigate the range of Parisian schools and teachers before deciding to study with Carolus-Duran, it was the happiest coincidence that he chose a master so well suited to guide him. He would attend Carolus-Duran's atelier until 1878–79, for several semesters concurrently studying drawing at the École des Beaux-Arts.[130]

In 1874 Carolus-Duran's studio was newer and less tested than Bonnat's atelier and more opposed to academic methods. In the fall of 1872 Robert Hinckley, an American student of Bonnat, had asked Carolus-Duran to criticize his work. Refusing, Carolus-Duran suggested instead that Hinckley organize a studio for him in which he would offer regular instruction. Within a year, twelve students had joined Carolus's atelier, including the Americans Low and Beckwith. The studio would be distinguished by the youth of its *patron*—Carolus-Duran was thirty-four years old in 1872, while Bonnat was thirty-nine and Gérôme was forty-eight—as well as its small size, the predominance of Anglo-American

students, and, most important, its emphasis on painting rather than on drawing.[131]

Charles-Émile-Auguste Durand, born in Lille in northern France, had little academic training.[132] His exposure to the greatest French provincial collection in Lille's Musée des Beaux-Arts excited his appreciation of the old masters, from which he would derive all of his subsequent "instruction." Settling in Paris in 1859, Carolus-Duran—as he had begun to call himself—copied in the Louvre, worked from life at the Académie Suisse, and eschewed formal study. Friendly with Fantin-Latour at Suisse's studio, and with the art critic Astruc, another Lille native, Carolus-Duran met Courbet and entered the avant-garde circle of Fantin-Latour, Legros, Bracquemond, and Manet.[133] He shared their interest in Realism and the painterly tradition, which he nourished by travel and study in Italy from 1862 to 1866. Visiting Rome and Venice, Carolus was struck by Velázquez's *Pope Innocent X* (see fig. 2.3) and fascinated by Venetian painting. Success in the Salons and in sales allowed him to spend the years from 1866 to 1868 in Spain, copying works by Murillo and Velázquez in the Prado. Subsequent trips to England exposed him to English Baroque portraiture.

Carolus-Duran's first important portrait summarized his taste and presaged the renown he would gain. *Woman with a Glove* (fig. 10.39), a lifesize image of his new wife, the pastelist and miniaturist Pauline-Marie-Charlotte Croizette, alludes to Titian's *Man with the Glove* (ca. 1520,

Fig. 10.39 Carolus-Duran, *Woman with a Glove*, 1869. Oil on canvas, 9 x 6 ½ in. (22.8 x 16.4 cm). Musée d'Orsay, Paris

Musée du Louvre, Paris) in its title, to Velázquez in its shallow space and monochromatic palette, and to English portraits in its elegant pose. It also echoes Manet's *The Balcony* (fig. 9.80), in which the woman at the right pulls on a glove. *Woman with a Glove* received a second-class medal at the 1869 Salon, where *The Balcony* appeared as well, and was purchased by the French government for the Musée Luxembourg in 1875, an event that gratified Carolus's students.

Although he renounced his early interest in Realist subjects to court portrait patrons and please critics, Carolus remained radical as a teacher. Will Low, a former student of Gérôme, recounted Carolus's repudiation of the Beaux-Arts emphasis on drawing in favor of an *alla prima* technique: "We were all, no matter what our previous lack of familiarity with colour had been, given a model, a palette and brushes, and told to render what we saw."[134] Carolus-Duran also paid more attention to portraiture than to history painting and espoused the Baroque tradition rather than the classical, stressing above all the virtues of Velázquez. "Velasquez, Velasquez, Velasquez, ceaselessly study Velasquez," he exhorted his students.[135] Carolus's identification with Velázquez and his own egotism—almost as great as Whistler's—are reflected in this reply to praise of his work: "Myself, God, and Velasquez!"[136]

competitors, the highest place achieved by any American of the period. *Procès-verbaux originaux des jugements des concours des sections de peinture et de sculpture, 23 octobre 1874–22 octobre 1883* (AJ52: 78), Archives, École Nationale Supérieure des Beaux-Arts, Archives Nationales, Paris.

131. The studio, which would flourish until Carolus closed it in 1888, attracted ninety Americans, of whom Sargent was the sixth to enroll.

132. The most accessible source of biographical information on Carolus-Duran is Gabriel P. Weisberg in Cleveland et al. 1980–82, p. 280.

133. For some of the connections within this circle, see Miura 1994.

134. Low 1910, p. 185.

135. "Velasquez, Velasquez, Velasquez, étudiez sans relâche Velasquez." Charteris 1927, p. 28.

136. "Moi, Dieu et Velasquez!" Carolus's remark was reported in *Art Age* 2, no. 23 (June 1885), p. 168, quoted in Simpson 1998, p. 4. Simpson added, p. 10 n. 12:

"This response did, at least, allow space for the Spaniard, unlike that of Whistler who, when told that he and Velázquez were the only two painters in the world, is reported as saying 'Why drag in Valesquez?'"

137. Letter from Fitzwilliam Sargent to George Bemis, Gibraltar, April 11, 1868, Bemis Papers, mentions the family's itinerary, which included Barcelona, Valencia, Granada, Cordova, Seville, and Cadiz.

138. Several writers have noted that in the fall of 1874 Sargent studied in the evenings in Bonnat's atelier, working in the company of Walter Gay and other Americans. See Charteris 1927, p. 36; Gary A. Reynolds in New York 1980b, p. 22. Reynolds cites Gay 1930, p. 11, and New York 1980a, n.p.

139. Olson 1986, p. 45. Letter from J. Alden Weir to his mother, Susan Martha Bayard Weir, Paris, October 4, 1874: "He speaks as well in French, German, Italian as he does English." Quoted in D. Young 1960, p. 50.

140. Blashfield 1925, pp. 641–42. See also Blashfield 1927.

141. Mount 1963 suggests many analogies between particular works by Sargent and his teacher.

Sargent's commitment to a career as a portraitist is not documented before he enrolled under Carolus-Duran, although his juvenilia display an interest in physiognomy and gesture. Lacking substantial financial resources, he may have preferred to work on commission and realized that painting portraits suited him. Among leading Parisian teachers, only Carolus and Bonnat focused on portraiture. Their common debt to the Spanish Baroque probably struck a responsive chord in Sargent, who had toured Spain with his parents in April and May 1868.[137] Sargent surely would have preferred the outgoing and stylish, voluble and communicative Carolus-Duran to the dour Bonnat.[138]

Sargent, fluent in French and several other languages as a result of his earlier "*Baedeker* education,"[139] quickly moved close to Carolus, and news of his talent spread among American art students in Paris. Edwin Blashfield, who studied in Bonnat's Montmartre atelier in 1874, recalled, "Now and then some momentary visitor from the Rive Gauche . . . would tell us of their wonderful fellow pupil under Carolus-Duran, a Boston boy named Sargent, a painter who was the envy of the whole studio and perhaps a bit the envy of Carolus, himself. . . . We watched his growth and wondered whether Carolus were teaching him or he were stimulating Carolus."[140] Eventually, Carolus-Duran and Sargent would compete for commissions from affluent and prominent international patrons.

There is almost no painting by Sargent—from his atelier studies to his most ambitious portraits and outdoor genre scenes—that does not reveal a debt to the manner and method of Carolus-Duran[141] and, fundamentally, to the art of Velázquez. Sargent's commendations of Velázquez and the other masters he admired echo what is visible in his works. In 1884 he wrote to his friend the art critic Vernon Lee, "Some day you must assert that the only painters were Velasquez, Franz Hals, Rembrandt and Van der Meer of Delft, a tremendous man."[142] He later suggested to a student that Velázquez was the supreme mentor, advising him, "Begin with Franz Hals, copy and study Franz Hals, after that go to Madrid and copy Velasquez, leave Velasquez till you have got all you can out of Franz Hals."[143]

Sargent's portrait of Carolus-Duran (fig. 10.40), which was shown to great acclaim in the Salon of 1879, the third year in which Sargent participated, clearly recalls Velázquez.[144] The origins of the portrait may be traced to the fall of 1877, when Sargent began his fourth full year of study and was enlisted with several studio mates in helping Carolus-Duran paint *Gloria Mariae Medicis* for a ceiling in the Palais du Luxembourg. Sargent added Carolus-Duran's portrait to the mural; the likeness, according to one authority, "so pleased the sitter that he decided to sit to his pupil for a formal easel portrait."[145]

In the easel portrait begun about July 1878 and completed in the spring of 1879, Sargent exploited

Fig. 10.40 John Singer Sargent, *Carolus-Duran*, 1879. Oil on canvas, 46 x 37¾ in. (116.9 x 96 cm). Sterling and Francine Clark Art Institute, Williamstown, Mass.

Fig. 10.41 (cat. 210) John Singer Sargent, *Robert de Cévrieux*, 1879. Oil on canvas, 33¼ x 18⅞ in. (84.5 x 47.9 cm). Museum of Fine Arts, Boston, The Hayden Collection, Charles Henry Hayden Fund

Fig. 10.42 Carolus-Duran, *The Artist's Daughter, Marie-Anne*, 1874. Oil on canvas, 51 ¼ x 33 ½ in. (130.2 x 85.1 cm). Fine Arts Museums of San Francisco, Mildred Anna Williams Collection

the fluent paint handling, monochromatic palette, and ambiguous space that Carolus-Duran preferred. What graduation piece could better display Sargent's mastery of his teacher's technique than an image of the teacher himself? Certainly there could be no more appropriate parting gift than the portrait, which Sargent inscribed "à mon cher maître M. Carolus-Duran, son élève affectionné/John S. Sargent. 1879" (to my dear master Mr. Carolus-Duran, his affectionate student/John S. Sargent. 1879), and it would be difficult to imagine a more flattering image than that of Carolus, whose intent gaze and distinctive mustache recalled "the types of Vélazquez," as one critic noted, especially Velázquez's self-portrait in *Las Meninas*.[146] Indeed, what canvas could provide not just a valedictory but a gauntlet thrown down to announce Sargent's rivalry with Carolus-Duran? Commissions from French patrons resulted in similar works, such as *Robert de Cévrieux* (fig. 10.41) which invokes Carolus-Duran's *The Artist's Daughter, Marie-Anne* (fig. 10.42) and, in turn, the legacy of youthful subjects painted by Velázquez and Goya.

142. Letter from John Singer Sargent to Vernon Lee (pseudonym of Violet Paget), [1884], quoted in Simpson 1998, p. 3.

143. Letter from John Singer Sargent to Julie Heyneman, quoted in Charteris 1927, p. 51. Simpson 1998, p. 10, who quoted the remark from Charteris, observed that Sargent had himself reversed the order, visiting Spain in 1879 and Haarlem in 1880.

144. For a discussion of the portrait, see Conrads 1990, pp. 166–72.

145. Ormond 1970a, p. 18. The ceiling decoration is discussed in Mount 1963, pp. 386–87.

146. Sargent 1880, p. 42, quoted in Simpson 1998, p. 4, which notes the resemblance of Carolus-Duran to "les types de Vélazquez." Nahum 1993, p. 196,

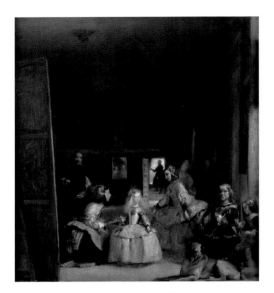

Fig. 10.43 (cat. 211) John Singer Sargent, *Las Meninas, Copy after Velázquez*, 1879. Oil on canvas, 43⅓ x 38½ in. (110.4 x 97.7 cm). Private collection

Finished with his studies under Carolus-Duran and certainly encouraged by him, Sargent began a period of extensive travel in the autumn of 1879, starting with about a month in Madrid.[147] At the Prado, where he signed the copyist register on October 14, Sargent made more than two dozen oil copies, of which thirteen were after Velázquez's works, including *Las Meninas* (fig. 10.43) and *The Fable of Arachne* or *The Spinners* (1879, Alfred Beit Collection, Russborough, Ireland).[148] A scrapbook compiled by Sargent between about 1873 and 1882 contains a large number of Jean Laurent photographs after works by Velázquez, which Sargent may have acquired at Laurent's shop in Madrid in 1879.[149] Sargent appears also to have visited nearby Toledo and the Escorial, which he would later recommend as destinations to his friend Vernon Lee.[150]

Having nourished his curiosity about Spanish art in Madrid and its vicinity, Sargent indulged his long-standing passion for the picturesque by going on to Ronda, Granada, and Seville in Andalusia. Frustrated by poor weather, he crossed the Strait of Gibraltar to Morocco, where he spent January and February 1880 living in Tangier. His Mediterranean travels and experience in Andalusia in particular yielded drawings and paintings of exotic figures, among them Spanish dancers. Back in Paris, Sargent would refer to these works to create his first great subject picture, the monumental, theatrical

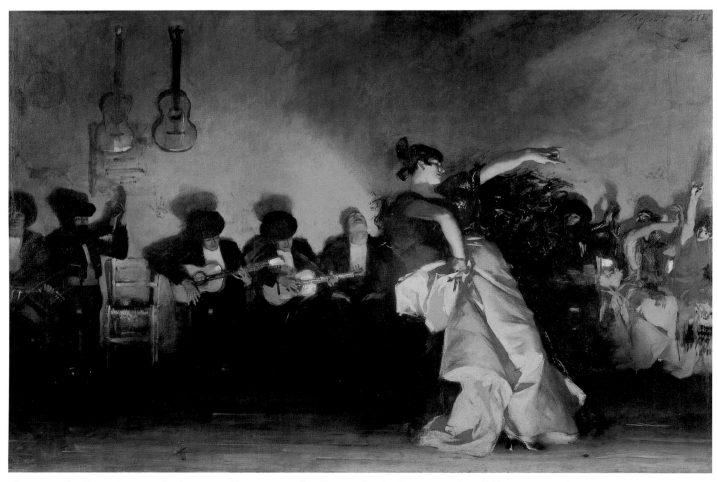

Fig. 10.44 John Singer Sargent, *El Jaleo*, 1882. Oil on canvas, 7 ft. 7½ in. x 11 ft. 8 in. (232 x 348 cm). Isabella Stewart Gardner Museum, Boston

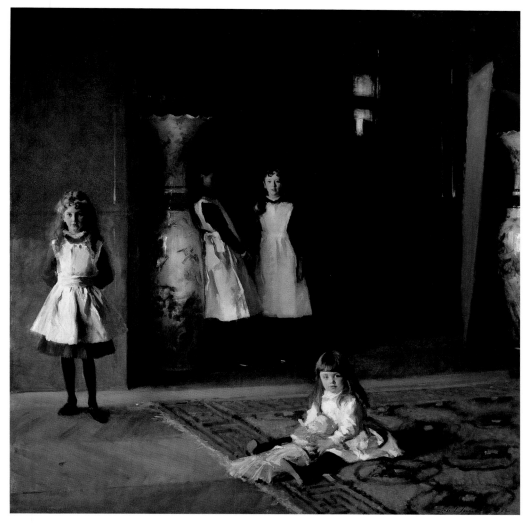

Fig. 10.45 (cat. 216) John Singer Sargent, *The Daughters of Edward Darley Boit*, 1882. Oil on canvas, 87⅛ x 87⅛ in. (221.9 x 222.6 cm). Museum of Fine Arts, Boston, Gift of Mary Louisa Boit, Julia Overing Boit, Jane Hubbard Boit, and Florence D. Boit in memory of their father, Edward Darley Boit, 1919

image of a flamenco performance, *El Jaleo* (fig. 10.44), whose dramatic theme, daring composition, and virtuoso brushwork attracted critics' enthusiasm in the Salon of 1882. The painting generated ample commentary on Sargent's debt to Spanish art and would become the best-known image of Spain ever painted by an American.[151] Armand Silvestre, in *La Vie Moderne*, pointed out the traditions to which Sargent responded and recognized his ability to transform them: "The Gypsy Dance, of Mr. Sargent, gives an impression of Velasquez when one focuses on the principal figure and an impression of Goya when one looks at the background. Does it follow that the work is without originality? Assuredly not."[152]

Paying homage to and updating Velázquez continued to be Sargent's pattern in his portraits. *The Daughters of Edward Darley Boit* (fig. 10.45), for example, appears to be an intentional commentary on *Las Meninas,* as critics always noticed. Seeing the large canvas in the Salon of 1883, American William C. Brownell observed, "It is clear that, although it may be said of Sargent . . . that he is Velasquez come to life again, he owes only to his recent study of that master what there is of general truth and general point of view in his art. . . .

suggests analogies with the artist's self-portrait in *Las Meninas,* and with Velázquez's *Mars* and *A Dwarf Sitting on the Floor,* sometimes known as *Sebastián de Morra* (mid-1840s, Museo del Prado, Madrid).

147. Sargent traveled in the company of two French students of Alexandre Cabanel, Charles-Edmond Daux and Armand-Eugène Bach, whom he had met in Capri during the summer of 1878. Boone 1996, p. 161.

148. Ibid., pp. 161–62, 188 nn. 15, 16, states that Sargent signed the copyist register at the Prado on October 14, 1879, and cites "more than twenty-four copies that are dated 1879." She relies on *Libro de registro de los señores copiantes* (October 27, 1873–April 30, 1881, box L-34), Archives, Museo del Prado, Madrid; Luna 1988; and material from the Sargent catalogue raisonné being compiled by Richard

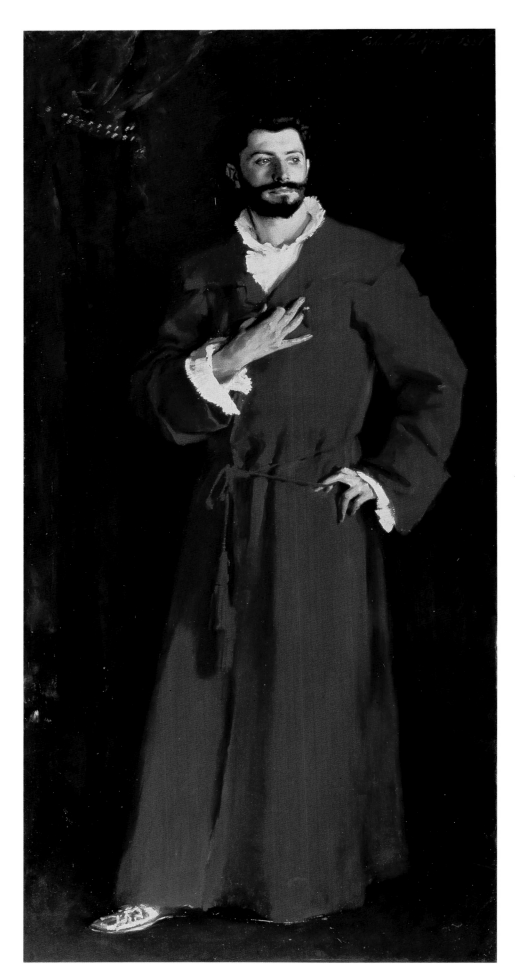

Fig. 10.46 (cat. 214) John Singer
Sargent, *Dr. Pozzi at Home*, 1881.
Oil on canvas, 80½ x 43⅞ in.
(204.5 x 111.4 cm). Armand
Hammer Collection, UCLA
Hammer Museum, Los Angeles

Fig. 10.47 (cat. 218) John Singer
Sargent, *Madame X (Madame Pierre
Gautreau)*, 1883–84. Oil on canvas,
82½ x 43¼ in. (208.6 x 109.9 cm).
The Metropolitan Museum of Art,
New York, Arthur Hoppock Hearn
Fund, 1916 (16.53)

Fig. 10.48 (cat. 215) John
Singer Sargent, *Lady with
the Rose (Charlotte Louise
Burckhardt)*, 1882. Oil on
canvas, 84 x 44⅜ in. (213.4 x
113.7 cm). The Metropolitan
Museum of Art, New York,
Bequest of Mrs. Valerie B.
Hadden, 1932 (32.154)

Fig. 10.49 (cat. 71) Diego Rodríguez de Silva y Velázquez, *The Jester Calabazas*, ca. 1630. Oil on canvas, 69⅛ x 42 in. (175.5 x 106.7 cm). Cleveland Museum of Art, 2001, Leonard C. Hanna, Jr., Fund

Fig. 10.50 Carolus-Duran, *Helena Modjeska Chlapowski*, 1878. Oil on canvas, 75 x 41¾ in. (190.5 x 106 cm). Formerly Pennsylvania Academy of the Fine Arts, Philadelphia, Gift of Paris Haldeman

Fig. 10.51 John Singer Sargent, *Mr. and Mrs. Isaac Newton Phelps Stokes*, 1897. Oil on canvas, 85¼ x 39¾ in. (214 x 101 cm). The Metropolitan Museum of Art, New York, Bequest of Edith Minturn Phelps Stokes (Mrs. I. N.), 1938 (38.104)

Ormond, Elaine Kilmurray, and Warren Adelson. Sargent 1925 includes seven copies after Velázquez (lots 229–35): *A Dwarf, Las Hilanderas, Head of Prince Balthazar Carlos* (two copies), *Portrait of a Buffoon of Philip IV, Head of Aesop, The Infanta Margarita.*

149. See "John Singer Sargent Scrapbook, ca. 1873–82," The Metropolitan Museum of Art, Gift of Mrs. Francis Ormond (50.130.154). Boone 1996, p. 162, mentions the scrapbook; indicates (p. 189 n. 19) that

[In *The Daughters of Edward Darley Boit*], in the way in which the subject is approached and in the way in which it is handled, . . . there is clearly a reminiscence of Velasquez; one even thinks of the special masterpiece in the Madrid Gallery. . . . But it is only because Mr. Sargent has applied the same manner, at once large and sympathetic, to the illustration of his own subject."[153]

For his depiction of the renowned Parisian surgeon, *Dr. Pozzi at Home* (fig. 10.46), Sargent again seems to have relied on inspiration from Velázquez (and Anthony Van Dyck). *Dr. Pozzi*, Sargent's first lifesize, full-length portrait of a man, emulates the dazzling

red-on-red color scheme that Velázquez used for *Pope Innocent X* (see fig. 2.3), which Sargent knew from his early travels in Italy.

Sargent would often undertake experiments in monochrome in the manner of Velázquez. He used black-against-black for *Lady with the Rose (Charlotte Louise Burckhardt)* (fig. 10.48), the formal portrait that he sent to the 1882 Salon along with *El Jaleo*. The economy of palette, direct gaze, and graceful pose in *Lady with the Rose* refer to Velázquez's *The Jester Calabazas* (fig. 10.49), then in a Parisian collection, as well as to a likely intermediary influence, Carolus-Duran's *Helena Modjeska Chlapowski* (fig. 10.50)[154] Other impressive experiments in monochrome include the black-against-black of *Madame X (Madame Pierre Gautreau)* (fig. 10.47); the lush, rosy magenta in *Mrs. Hugh Hammersley* (1892, Metropolitan Museum); and the white-gray-black triad of *Mr. and Mrs. Isaac Newton Phelps Stokes* (fig. 10.51).

By the 1890s Sargent was so often—and so appropriately—compared to Velázquez that critic Clarence Cook borrowed from Whistler's sarcastic riposte to "a newly introduced acquaintance"[155] to defend him in an article he entitled "Why Drag in Velasquez?" "This perpetual dragging-in of the name of Velasquez whenever Mr. Sargent's work is discussed," Cook lamented, "is most damaging to his reputation as an artist of first rank. An artist of first rank can never resemble another so strongly as to call up his name with every fresh picture he paints. Mr. Sargent recalls Velasquez; but whom does Velasquez recall?"[156]

Fig. 10.52. John Singer Sargent, *The Daughters of Edward Darley Boit* (detail of fig. 10.45)

Laurent also marketed his prints in France and England, where Sargent also could have purchased them at any time; but notes that the likely date of the scrapbook suggests early acquisition.

150. Ibid., p. 163, relying on a letter from John Singer Sargent to Vernon Lee, London, ca. 1889, Sargent Papers. Lee's published remarks on Velázquez probably reflected Sargent's taste. See Lee 1884, vol. 2, pp. 40–45. Sargent returned to Spain in August 1892; July or August 1895; spring 1902; June–August 1903; June and September–October 1908; and September–November 1912. See Herdrich and Weinberg 2000, pp. 364–73. His usual aim was to enjoy holidays and paint picturesque subjects in the company of family and friends. However, Boone 1996, p. 188 n. 16, remarks that Sargent signed the *Libro de registro de los señores copiantes,* Archives, Museo del Prado, Madrid, on July 26 and 30, 1895, to copy El Greco, Titian, and Tintoretto, and on June 12, 1903, to copy Velázquez.

151. The painting, which measures 8 x 11½ feet, is the subject of Washington–Boston 1992. On the painting in relation to actual flamenco performance, see also Heller 2000.

152. A. Silvestre 1882, p. 342, quoted in Simpson 1998, pp. 4, 10 n. 18. Simpson quotes many other critics' comments on the painting.

153. Brownell 1883, pp. 498–99, quoted in Simpson 1998, p. 6.

154. For critics' comparisons of *Lady with the Rose* to works by Velázquez, see Nahum 1993, pp. 211–17, and Simpson 1998, p. 4.

155. See p. 261 above.

156. Cook 1891, p. 234, quoted in Boone 1996, p. 170.

A Legacy of Spanish Art for America: Archer M. Huntington and The Hispanic Society of America

Mitchell A. Codding

From the 1890s through the 1920s, Archer M. Huntington (1870–1955) dedicated his life and considerable family resources to forming one of the world's great collections of Spanish art (fig. 11.2). (Born Archer Milton Worsham in New York City in 1870, at the age of fourteen he adopted the Huntington name when his mother, Arabella Duval Yarrington Worsham [1850–1924], married Collis Potter Huntington [1821–1900], founder of the Central Pacific Railroad and the Newport News Shipbuilding and Drydock Company.)[1] In spite of his remarkable accomplishments, Huntington's name today remains less familiar to museum audiences than those of his friends and contemporary collectors, among them J. Pierpont Morgan, Henry Clay Frick, Isabella Stewart Gardner, Henry Walters, Joseph Widener, Benjamin Altman, and Harry and Louisine Havemeyer. Huntington's anonymity, however, was by his own design, for during his lifetime he never permitted any of the institutions that he founded to bear his name, including his most treasured creation, The Hispanic Society of America—the "Spanish Museum" that he founded in 1904 and opened to the public in 1908 on Audubon Terrace in upper Manhattan at Broadway between 155th and 156th Streets.[2]

A truly unique figure in the history of American collecting and museums, Archer Huntington developed his singular focus on the arts of Spain at a phenomenally early age. Unlike other prominent Americans of the Gilded Age, Huntington did not collect as an avocation but as a vocation, working from the beginning with the goal of an all-encompassing museum of Hispanic arts and letters that would provide a legacy of Spanish art for America. Having developed early on an academic approach to Spanish art, he made his selections with an eye toward comprehensiveness rather than contemporary taste or fashion. Huntington's holdings evolved in accordance with his plans, beginning at the age of twelve with coins and medals, then books, the decorative arts, and, finally, after almost twenty years of study, paintings.

Huntington's surviving diaries and correspondence allow us to trace his early fascination with Spain, his subsequent studies, the inception and formation of his collections, and the evolution of his concept of a "Spanish Museum."[3] As a child of privilege, the young Archer attended the best private schools, benefited from private tutors, and enjoyed the experiences and education afforded by foreign travel. In school he was taught the customary Greek and Latin as well as English history and literature, but at home he took up readings on French history

1. For more detailed biographical information, see Proske 1963 and Codding 2002.
2. For additional information on the history and the collections of the Hispanic Society, see Lenaghan et al. 2000.
3. Beginning at the age of twelve, Huntington kept diaries to record his thoughts and daily activities. Unfortunately, later in life he chose to discard most of the diaries from his most formative years. He did preserve what he perceived to be the most significant passages from the diaries in an autobiographical narrative, prepared in 1920 at the request of his mother on the occasion of her seventieth birthday. The resulting Huntington "Diaries" not only reveal his contemporary appraisal of

Fig. 11.2 Photograph of Archer Huntington, ca. 1900. Courtesy The Hispanic Society of America

Fig. 11.1 (cat. 68) Diego Rodríguez de Silva y Velázquez, *Gaspar de Guzmán, Count-Duke of Olivares*, ca. 1625–26. Oil on canvas, 87⅜ x 54¼ in. (222 x 137.8 cm). The Hispanic Society of America, New York

4. Archer M. Huntington, June 20, 1882, Papers, The Hispanic Society of America Library, New York.

5. A. M. Huntington, July 12, 1882, Papers.

6. A. M. Huntington, August 10, 1882, Papers.

7. A. M. Huntington, November 8, 1890, Papers.

events but offer the unique perspective of the fifty-year-old Hispanist reexamining his life and accomplishments.

with his mother, who was well versed in French art and literature. Like many American writers, artists, and collectors of his era, Huntington experienced on his first trip to Europe, in the summer of 1882, a series of cultural and intellectual awakenings that were to have a profound impact upon his life. The remarkable difference in the case of Archer Huntington is that this occurred at the precocious age of twelve.

His stays in London and Paris witnessed the birth of the collector, Hispanist, and museum builder. In London on June 20, 1882, he recorded in his diary that he purchased some rare coins, upon which he commented in retrospect, "Little did I know that a collector had been born in me, and that with 2 shillings, resulting in 7 small pieces of copper, I had entered the pathway which those demented souls who collect follow so assiduously."[4] Still in London, two weeks later the chance purchase of George Borrow's *The Zincali; or, An Account of the Gypsies in Spain* kindled his lifelong passion for Spain. A trip to the National Gallery on July 12 effectively predestined the career of the budding Hispanophile, as he innocently remarked, "Never saw anything like it. Could spend a month here. After lunch I came back until it closed. I never knew there were such pictures. My feet gave out and I went home. Read the catalogue until I could not see anymore and went to bed. I think a museum is the grandest thing in the world. I should like to live in one."[5] After a visit to the great temple of art in Paris a month later, his fate was sealed. Quoting from his original diary, Huntington reminisced, "'I went to the Louvre this morning.' It seems a statement simple enough, but even today, as I look back at this experience, I know that it was a very vital one. Those miles of pictures! I left Quinlan, the courier, and walked and wondered. After a while I could not see more pictures. I felt stupid and ill, and I sat down and rested. And then of a sudden 'my illness passed away and I wasn't tired any more, and I wanted to sing.' There was something about all of these mysterious objects that stirred and excited me. It was like a rapid visit to many countries, and meeting strange persons, and walking in new landscapes. I knew nothing about pictures, but I knew instinctively that I was in a new world."[6] Two years later in New York his first museum took shape with art clipped from newspapers and magazines, which he displayed in seven wooden boxes made into seven galleries.

At fourteen Huntington began the formal study of Spanish, tutored by a young woman from Valladolid, while independently reading all that he could find on Spanish literature, history, art, and architecture. Returning to London and Paris with his parents in the summer of 1887, he took the opportunity to expand his library and to amass four trunks filled with photographs to further his study of Spanish art. Once at home in New York he began an apprenticeship in his father's office, though his focus remained fixed on Spain and dreams of his own museum. By January 1889 Huntington had already concluded that he had no real affection for the world of business, especially since it afforded him little creative opportunity. His first real encounter with Hispanic culture came on a trip to Mexico with his parents in March 1889. Mexico proved to be a revelation that assured Archer that the path that he had chosen was the right one. In January 1890 he made the inevitable decision to reject his father's offer to manage the Newport News shipyards and set about cataloguing his library, which at that time numbered some two thousand volumes. By the end of that year he had initiated plans for a museum, musing in his diary, "I would like to know how much wall space is wasted in U.S.A. museums by windows. The windows of an art museum should be pictures."[7]

Huntington spent most of 1891 preparing for his first journey to Spain, though he still found time to write out plans for a museum and make a short trip to Cuba. Typical of his systematic approach to all endeavors, Huntington developed a thematic strategy for his initial visits to Spain: "The first trip must be cities, the country and the people. Then book collecting and Library work and last History and Archaeology. They will overlap of course but it is best to go with a plan to cover several trips."[8] After ten years of anticipation, study, and planning, he at last arrived in Spain in July 1892. The adventures, experiences, and impressions of this stay were captured in a series of letters to his mother, which he edited and published in 1898 as *A Note-Book in Northern Spain*. Huntington rarely recorded his thoughts on Spanish art, perhaps because he felt incapable of adequately expressing such an extremely personal experience. An exception was his first encounter with the works of Velázquez in the Prado, which he struggled to describe in his diary: "We walked over later to the gallery where I had my first real vision of Velázquez. Stunning, amazing, a discovery, and cannot be talked about."[9]

The many new Spanish friends and contacts Huntington made proved extremely advantageous to his collections, resulting in a flood of offers and many new acquisitions. Commenting on the formation of his library and art collection in those years, he observed, "As to myself, I doubt the certainty which others possess. I have been rather reckless in buying and while many have led me to a work of art I bought only on my own feeling. The collection of the Society to be, which was gradually taking form in some detail, must express my faults and mistakes in no small degree. I had to rely on the long preparation. In the years immediately following 1894, I believe I could have told at once where almost any famous painting of Spanish origin could be found in Europe or the peninsula. I had seen most of them. This was helpful at a later time when I began to buy seriously. My notes and lists were full and there were photographs and books. Painting, of course, is the simplest and the most difficult of the arts."[10]

Huntington married his cousin Helen Manchester Gates Criss in London in the summer of 1895, and in October of the following year his father purchased for the newlyweds a modest estate called Pleasance, at Throggs Neck on Long Island Sound. Another gift from his father in 1896 brought Huntington his first major painting acquisition, *The Duke of Alba* (1549) by Antonis Mor (fig. 11.3), which was accompanied by portraits of Philip IV and Isabella de Bourbon attributed to Claudio Coello. Mor's brilliant portrait of Fernando Álvarez de Toledo, third duke of Alba, had probably been purchased by Archer's father in Paris during the family visit in the summer of 1887,[11] most likely as an anticipated gift for his son. Collis's tastes were more inclined toward the dramatic landscapes of Albert Bierstadt, whose *Canyon of the Middle Feather,* which he had commissioned, hung in the entrance hall of the family's Fifth Avenue mansion,[12] or to works of the French anecdotal genre, which included his favorite, Jehan-Georges Vibert's *The Missionary's Adventures* (fig. 11.4).[13]

In the Huntington household, Archer had grown up surrounded by his father's, or more accurately stated, his mother's collection of paintings, for Arabella was in fact the true connoisseur. The catalogue of Collis's holdings, privately printed in 1896 for distribution among family, friends, and business associates, illustrates 145 paintings, the majority by nineteenth-century European and North American artists, with a preponderance of Barbizon school and Paris Salon painters.[14] While the selection typifies the tastes of American collectors of the period, it also presages Arabella's future interests, demonstrated by the works

8. A. M. Huntington, March 1, 1892, Papers.
9. A. M. Huntington, September 1892, Papers.
10. A. M. Huntington, 1894, Papers.
11. The portrait at that time belonged to the Paris art dealer Stephan Bourgeois and had been reproduced only months earlier in *Le Monde Illustré*, February 5, 1887.
12. A. M. Huntington, January 1, 1889, Papers.
13. O. Lewis 1938, p. 233.
14. C. Huntington 1896.

Fig. 11.3 Antonis Mor, *The Duke of Alba*, 1549. Oil on wood, 42½ x 32⅞ in. (108 x 83.5 cm). The Hispanic Society of America, New York

of such eighteenth-century English painters as Gainsborough, Lawrence, Raeburn, and Reynolds as well as paintings by seventeenth-century Dutch and Flemish masters, most notably Hals, Vermeer, and Van Dyck. Though overall a respectable assemblage for its day, by today's standards the real star was unquestionably Vermeer's *Woman with a Lute* (early 1660s, Metropolitan Museum). Both Arabella's and Archer's most notable acquisitions were yet to come, to be made possible by their inheritance from Collis's estate.

When Huntington revisited Spain in the spring of 1896, he kept to his master plan, searching for books, which now poured in from friends and strangers alike, in no small part due to his growing reputation as an American collector with deep pockets. On his return in 1898 he headed straight for Seville, with his eyes set on the library of the marqués de Jerez de los Caballeros

Fig. 11.4 Jehan-Georges Vibert, *The Missionary's Adventures*, 1883. Oil on wood, 39 x 53 in. (99.1 x 134.6 cm). The Metropolitan Museum of Art, New York, Bequest of Collis P. Huntington, 1900 (25.100.140)

(which he successfully purchased four years later) and on excavations at the nearby site of the ancient Roman city of Italica. Still in the process of defining the concept for his museum, Huntington wrote to his mother, "My collecting has always had for a background—*you know*—a museum. The museum which must touch widely on arts, crafts, letters. It must condense the soul of Spain into meanings, through works of the hand and spirit."[15] Huntington at this time was beginning to think seriously about collecting paintings, but not in Spain, because of a self-imposed rule to acquire the works of Spain's old masters only outside the peninsula: "Of pictures on this trip I shall have nothing to say, nor even time to look at them. . . . They are for another day. Moreover, as you know, I buy no pictures in Spain, having that foolish sentimental feeling against disturbing such birds of paradise upon their perches. Let us leave these beloved inspiration builders where they were born or dwelt, for to Spain I do not go as a plunderer. I will get my pictures, *outside*. There are plenty to be had."[16] Huntington adhered to this practice throughout his life, at times to the detriment of his collection and to the benefit of rivals. In the end his policy did not place him at such a disadvantage, since many of the paintings acquired in Spain by American collectors around the turn of the twentieth century ultimately proved to be either misattributions, copies, or outright forgeries, as evidenced by a number of the Goyas in the Havemeyer collection.[17]

The basis for Huntington's reluctance to begin acquiring paintings up to this point appears to have been threefold. Even though his father had been exceedingly generous in funding his book purchases and travel, Huntington still lacked the necessary resources to assemble an important collection of Spanish old-master paintings. Secondly, he trusted his knowledge of books more than his connoisseurship of art, despite more than a decade of study and research. Writing from Seville in 1898, Huntington expressed dismay over the time he had spent researching Spanish paintings: "I have filled so many note books with futile words about pictures that I am almost ashamed at the time wasted. I say wasted because as long as I live I think I shall never write about pictures. You recall the long lines of

15. Letter from A. M. Huntington to Arabella Huntington, 1898, Papers.
16. Ibid.
17. Gary Tinterow, "The Havemeyer Pictures," in New York 1993b, pp. 13–17.

Fig. 11.5 Diego Rodríguez de Silva y Velázquez, *Portrait of a Little Girl*, ca. 1638–44. Oil on canvas, 20¼ x 16⅛ in. (51.5 x 41 cm). The Hispanic Society of America, New York

critical books on the painters and their art in my library."[18] Perhaps the most significant reason for his hesitance came from having observed his mother's relations with art advisers and dealers, whose friendship was based on profit. Arabella had already fallen under the spell of the London dealer Joseph Duveen, who served as the principal agent for her most celebrated acquisitions, just as he did for other notable American collectors, including Altman, Frick, Mellon, and Morgan. Huntington's wariness of the pitfalls of the art market received immediate confirmation by way of an ill-fated purchase from the Paris dealer Jacques Seligmann, on which he remarked, "[S]ince my dispute with S. [Seligmann] about his picture—the one I returned—I have had more decent treatment from new dealers. But it is hard to make a

18. Letter from A. M. Huntington to Arabella Huntington, 1898, Papers.

dealer look on an American as anything but a gilded victim, ready for slaughter, and the boiling of his skin to extract the gold. Sometimes it is tiresome. There is a certain gentleman (whose name you well know) here who buys as he is told and has spent half a million on the most terrible rubbish. The trouble is that once in a while he gets away, all unconsciously, with a good bit, and it is unrecoverable! Fortunately the dealers are a trifle shy as he does not pay on the nail."[19] Not surprisingly, he came to possess an inherent mistrust of all would-be advisers and dealers, in particular Duveen, whose wiles he profiled in his diary: "The smooth immaculate Duveen, that weaver of promised distinction for wistful collectors, is the chief charmer of the picture business. His well oiled courage knows no defeat. Few can resist him. . . . The Duveen approach is masterly. The slightly waving head suggests the serpent charming the tremulous bird; the subtlety of manner, the friendly perfume of the protruding handkerchief, the wave of the manicured fingers, the subdued appeal to intuitions, the hinted desire for approval even at the expense of all thought of gain. . . . Duveen wants to sell me Spanish pictures, but I did not wish to start him on that quest just now!"[20] Unlike his mother, Huntington did manage to resist Duveen's charms and acquired only one painting from him, *Portrait of a Little Girl* (fig. 11.5) by Velázquez, a joint purchase made with Arabella in 1909.[21]

Following Collis's death in 1900, Archer became one of the wealthiest men in America as the beneficiary of one-third of his father's estate, an inheritance then estimated at 150 million dollars. With the resources to fulfill his dream, he accelerated plans for the Spanish museum, which also meant that the time had at last arrived to actively collect paintings. Huntington had found little competition in his search for Spanish books and manuscripts, but in the art market there were serious rivals when it came to purchasing the works of Murillo, Velázquez, Goya, and El Greco, particularly in America. By the mid-nineteenth century Murillo already had become a favorite with Americans, even though his paintings were known mostly through copies until after 1900.[22] By the end of the nineteenth century Velázquez too had gained favor with American collectors, his works popularized by such prominent American painters as Thomas Eakins, Mary Cassatt, and John Singer Sargent, who traveled to Spain to study and imitate the techniques of the master. To Huntington's further disadvantage, the Havemeyers' avid pursuit of paintings by Goya and El Greco, encouraged by their adviser Mary Cassatt, was rapidly establishing a fashion for these artists in America.[23]

Huntington's outline for a comprehensive collection of Spanish art called for representative examples from the principal periods, schools, and artists. With books and coins it had proven both economical and efficient to purchase entire collections, but, as he soon would learn, the same method could not be applied to paintings. He clearly was not intent on acquiring at any cost all available works by the Spanish masters, nor did he have a list of categories for each artist that he was determined to fill, as was the case for Mrs. Havemeyer with her Goyas.[24] For the purposes of his museum, he would be content with one authentic and characteristic work by any given artist, which at times proved to be the situation, as he described in his diary while on a buying trip to Paris in 1904: "I collected always with the view to the definite limitations of the material to be had, always bearing in mind the necessity of presenting a broad outline without duplication. These limitations greatly aided me by the reduction of the number of pieces adequate to present a comprehensive whole, and I often astonished my dealer friends by refusing an object which most collectors would have seized upon with enthusiasm."[25] Above all, he eschewed the critical opinion of dealers,

19. Ibid.
20. A. M. Huntington, 1898, Papers.
21. Marcus B. Burke, "Velázquez and New York," in New York 1999–2000, p. 16.
22. For a thorough appraisal of Murillo's popularity among American collectors, see Suzanne L. Stratton-Pruitt, "Murillo in America," in Fort Worth–Los Angeles 2002, pp. 91–109. For further discussion of American artists influenced by Spanish masters at this time, see H. Barbara Weinberg's essay in this publication.
23. Tinterow in New York 1993b, p. 17.
24. Ibid., p. 14.
25. A. M. Huntington, 1904, Papers.

Fig. 11.6 Diego Rodríguez de Silva y Velázquez, *Camillo Astalli*, ca. 1650–51. Oil on canvas, 24 x 19⅛ in. (61 x 48.5 cm). The Hispanic Society of America, New York

preferring instead to act upon his own knowledge and instincts.

The years of study had prepared him well for the task at hand, perhaps better than anyone else, but it did not spare him from the mistakes common to novice collectors. At that time art history was still an emerging discipline, and there were few true experts on Spanish paintings, though this did not deter his artist and art historian friends from eagerly volunteering their services as advisers. The first to step forward was Francis Lathrop, a prominent English mural painter, portraitist, and family friend, who along with Elihu Vedder, Edwin H. Blashfield, and H. Siddons Mowbray had executed the murals for Arabella's Fifth Avenue palace in 1894. Huntington's friendship with Lathrop dated back to at least 1897, when he described in his diary an evening spent discussing art and living painters: "Lathrop was very entertaining as he told many stories of B[urne] Jones, and Whistler and Swinbourne [*sic*] and of Madox Brown his master under whom he had worked for a long time. . . . He told us about Morris and Rosetti [*sic*] and Mrs. Morris, at which I was much interested."[26] Apparently at Huntington's request, Lathrop traveled to Madrid in 1901 to make copies for him of Velázquez's *Fable of Arachne* or *The Spinners* (fig. 4.11) and *Las Meninas* (fig. 1.57). On his return through London, Lathrop acted as Huntington's agent in the purchase from the earl of Carlisle of Velázquez's *Juan de Pareja*, now considered a copy. At some point prior to 1904, two fifteenth-century Castilian panels, *Saint Martin Ordained Bishop* and *The Mass of Saint Martin*, also were acquired from Lathrop. In 1903 Lathrop sold him a portrait of Eleanor of Toledo attributed to Bronzino, followed in 1904 by a group of ten paintings that included Velázquez's portrait *Camillo Astalli*, acquired by Lathrop in 1902 from the Trotti gallery in Paris (fig. 11.6); two seventeenth-century portraits of nobles ascribed to Pareja; and five anonymous seventeenth-century portraits of the princess of Eboli, Mary Queen of Hungary, the Infante Don Fernando of Spain, Philip III, and an unknown man. Upon the founding of The Hispanic Society of America, Huntington named Lathrop as a trustee and appointed him artistic director, positions that he held until his resignation in 1908. Lathrop sold him three more works between 1904 and 1907: a Goya sketch, presumed to be for the *Third of May 1808*, now attributed to Eugenio Lucas Velázquez; a dramatic *Via Crucis* (1661) by Juan de Valdés Leal; and an oil sketch by Mariano Fortuny y Marsal. In 1907 Lathrop was paid to hang the paintings in the

26. A. M. Huntington, January 3, July 4, 1897, Papers.

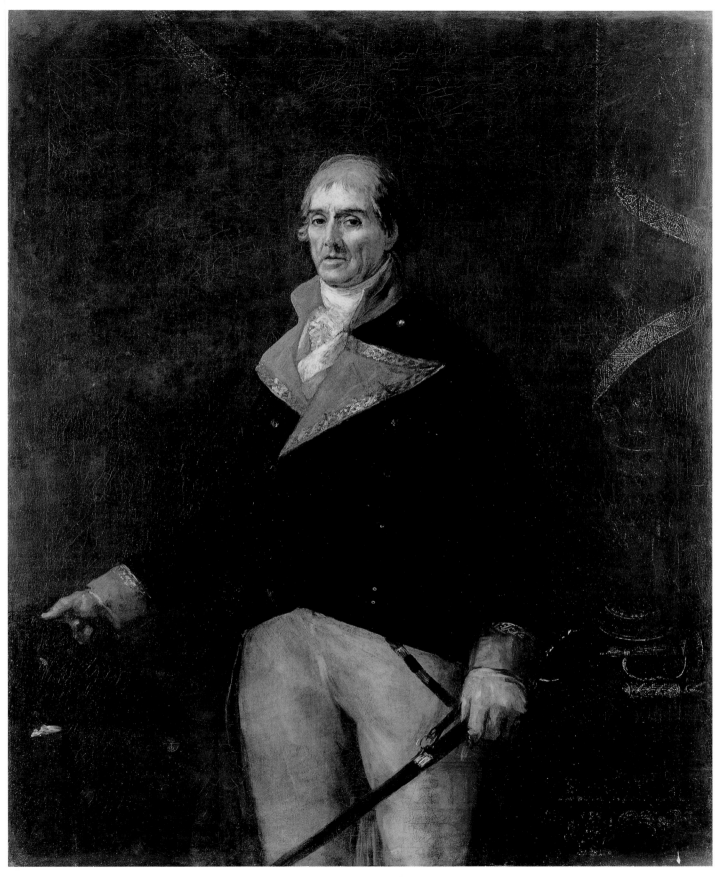

Fig. 11.7 Francisco de Goya y Lucientes, *Brigadier General Alberto Foraster,* 1804. Oil on canvas, 54½ x 43⅛ in. (138.5 x 109.5 cm). The Hispanic Society of America, New York

27. A. M. Huntington, June 13, 1907, Papers.
28. A. M. Huntington, 1904, Papers.
29. Baticle and Marinas 1981, pp. 88–89.
30. Gary Tinterow in New York 1993b, p. 17.

completed main gallery of the Hispanic Society, after which he offered his services as a consultant on commission for art purchases. Huntington declined the offer, noting that "I find it much better to consult no one so that the responsibility may rest on me alone. Moreover as I am collecting with a fixed plan no one would agree with me."[27]

At the time of the founding of the Hispanic Society in 1904, Huntington's fledgling collection held only twenty-three paintings, the majority having been acquired through Lathrop. Fifteen were portraits from the sixteenth and seventeenth centuries with attributions to Bronzino, Coello, Mor, Pareja, Ribera, and Velázquez, along with the two fifteenth-century panels, a picture of an "emaciated" saint by Ribera, "a small painting of one figure" by El Greco, the Valdés Leal *Via Crucis*, Lathrop's two copies after Velázquez, and a portrait of Lathrop by J. Alden Weir.[28] Of the Spanish works, only the Mor, the Valdés Leal, and the Velázquez *Camillo Astalli* remain unquestioned; the rest lost their attributions long ago. By the time the Hispanic Society opened to the public in 1908, Huntington had almost doubled the collection, primarily through a single purchase of fourteen paintings in 1906 from the gallery of Charles Sedelmeyer, a Paris dealer used for many years by Arabella. This group included five paintings by Goya, three by Zurbarán, one by Juan Pantoja de la Cruz, four by Murillo, and one by Juan Carreño de Miranda. In his rush to fill the walls of the new museum, Huntington made the critical error of trusting a dealer's attributions and provenances rather than his own knowledge and instincts. Only two superior works ultimately emerged from the fiasco, Goya's *Brigadier General Alberto Foraster* (fig. 11.7) and Carreño's *Virgin of the Immaculate Conception* (1670). With the exception of one of the Murillos, *Christ the Good Shepherd*, now considered a work from his circle, the remaining eleven are without merit. About the same time Huntington also bought three El Greco's from Sedelmeyer that have fared only slightly better with the passage of time: *Saint James the Great*, probably the "small painting of one figure" described in his collection in 1904, is a product of the artist's workshop; *Supper in the House of Simon* (ca. 1607) is in fact a rare documented work by El Greco's son Jorge Manuel Theotokopoulos; and the third, *Virgin with the Crystal Dish*, is a modern forgery.

Huntington fared no better when following the advice of professional art historians. On the same day that Sedelmeyer prepared the invoice for the fourteen paintings, Huntington purchased sight unseen Velázquez's *A Spanish Wine Dresser* from Colnaghi and Company in London, based primarily upon the recommendation of Dr. Wilhelm Bode, director of the Royal Portrait Gallery in Berlin and an authority on Dutch and Italian paintings. When the painting arrived months later Huntington felt deceived, astonished that anyone could have considered it the work of Velázquez, but under the circumstances he felt obliged to keep it, relegating it to permanent storage.

After this series of false starts, Huntington made one of his most brilliant and expensive acquisitions in November 1906, Goya's *Duchess of Alba* (fig. 11.8), which he purchased for 35,000 dollars from E. Gimpel and Wildenstein in Paris. Here there could be no question of quality or authenticity, for the portrait had a provenance back to the artist's own collection, as well as to Louis-Philippe's Galerie Espagnole.[29] Ironically, the Havemeyers, who were responsible for establishing the fashion for Goya among American collectors, had been offered but declined the portrait of the duchess of Alba;[30] it was Huntington, with his singular mission to educate American audiences on all facets of Spanish art and culture, who succeeded in bringing one of Goya's most important portraits to America. Rather grudgingly,

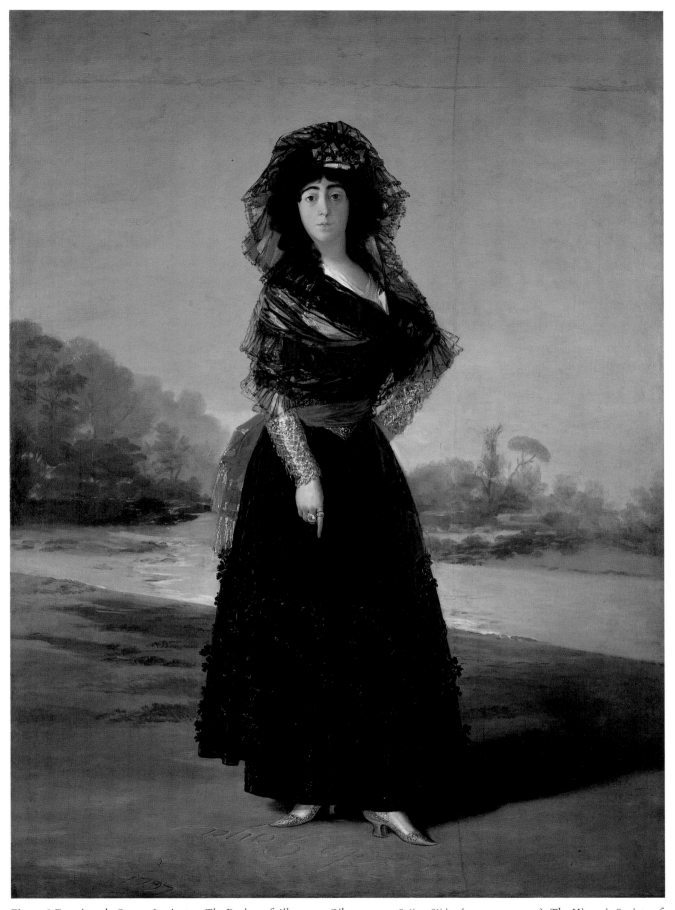

Fig. 11.8 Francisco de Goya y Lucientes, *The Duchess of Alba*, 1797. Oil on canvas, 82¾ x 58¾ in. (210.2 x 149.2 cm). The Hispanic Society of America, New York

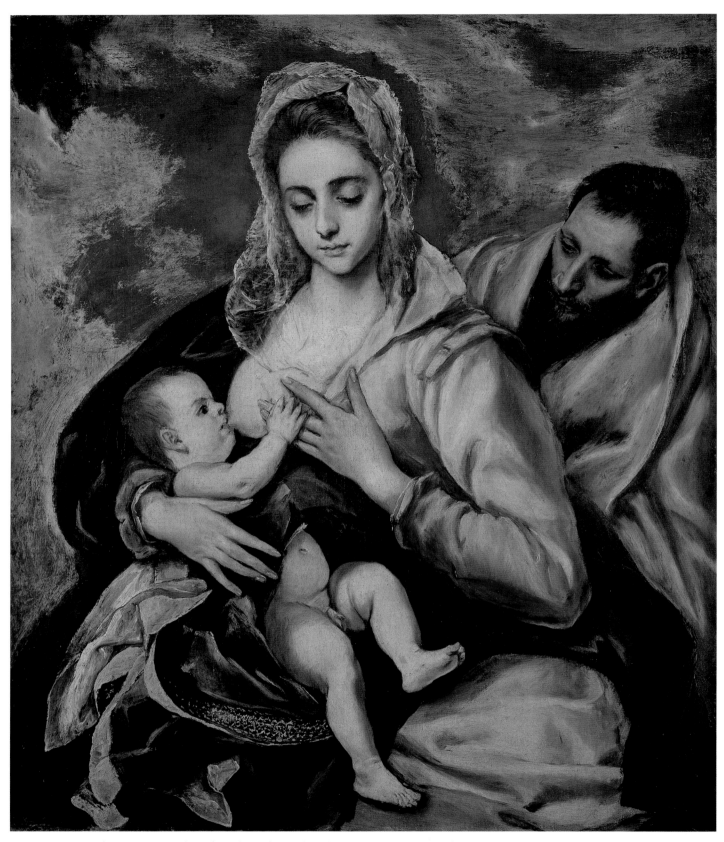

Fig. 11.9 (cat. 65) El Greco (Domenikos Theotokopoulos), *The Holy Family*, ca. 1580–85. Oil on canvas, 41¾ x 34½ in. (106 x 87.5 cm).
The Hispanic Society of America, New York

Huntington seems to have learned the lesson from his mother that significant pictures rarely come cheap. She already had embarked on a spending spree with Duveen, somewhat to her son's dismay, that peaked in 1907 with numerous purchases from the Rodolphe Kann collection in Paris, including Rembrandt's *Aristotle with a Bust of Homer* (1653), now in The Metropolitan Museum of Art. Two of Huntington's most important acquisitions for the Hispanic Society were the result of his mother's mediation, and both naturally came from Duveen. Arabella apparently thought that her son should buy from Duveen the Kann Velázquez, *Portrait of a Little Girl* (fig. 11.5), one of the artist's most intimate works, on which she made a payment of 50,000 dollars. When Duveen reduced his asking price from 125,000 to 100,000 dollars, Huntington acquiesced, though he complained to his mother, "I bought the picture and paid more than he should have asked," adding, "I know you are doubtful of my opinion of him."[31] When Velázquez's *Gaspar de Guzmán, Count-Duke of Olivares* (fig. 11.1) became available in 1910, Arabella knew that Huntington would never agree to Duveen's unprecedented price of 650,000 dollars, so she presented it as a gift to the Hispanic Society in memory of Collis P. Huntington.[32] The famed art historian Bernard Berenson, a friend of the Huntingtons through Duveen, wrote Archer to congratulate him on the acquisition, observing: "I always have and still do regard it as the finest work we have of Velasquez's earlier although not earliest manner. And besides it has more psychological interest than almost any other of Velasquez's portraits."[33] Were it not for the great foresight and enormous generosity of a devoted mother, neither of these critical works by Velázquez would have entered the collection.

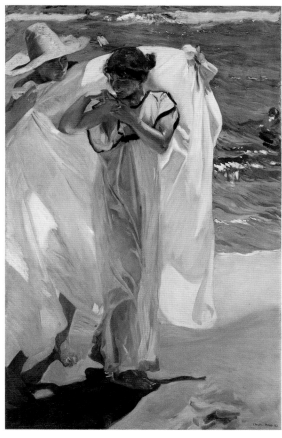

Fig. 11.10 Joaquín Sorolla y Bastida, *After the Bath*, 1908. Oil on canvas, 69¼ x 43⅞ in. (176 x 111.5 cm). The Hispanic Society of America, New York

Raimundo Madrazo Garreta, a third-generation member of the Madrazo family dynasty of painters that spanned the nineteenth century, was the next of Huntington's artist friends to serve as adviser and art dealer. His brother, Ricardo de Madrazo y Garreta, also an artist, served until his death in 1917 as an agent and art dealer for the Havemeyers' purchases in Spain. Despite the potential for conflict, these relationships failed to produce any serious rivalry between Huntington, the Madrazos, and the Havemeyers, primarily because Huntington would not buy paintings in Spain. Increasingly cautious in his dealings with friends and dealers alike, Huntington made numerous significant purchases up to World War I from Raimundo, who maintained a residence in Paris. The first major acquisition from Madrazo occurred in 1906, with Goya's portrait of his friend Pedro Mocarte (ca. 1805–6). The picture had passed directly from Goya's son to José de Madrazo, then to his son Luis, who in turn sold it in Paris, only to later reacquire it and then sell it again, this time to Raimundo.[34] One of Huntington's favorites, the portrait hung for many years in his Fifth Avenue residence; he loaned it on only two occasions, in 1908 and 1910 to The Metropolitan Museum of Art, before presenting it to the Hispanic Society in 1925. Madrazo's next sale also came out of the family collection; about 1908 Huntington purchased El Greco's *The Holy Family* (fig. 11.9) in Paris for 25,000 dollars. The painting had descended in the family from José de Madrazo to his grandson Raimundo, and as Huntington noted in Hispanic Society museum records, "This had been for many years in the hands of Madrazo and hung

31. A. M. Huntington, February 2, 1908, Papers.
32. Burke in New York 1999–2000, p. 16.
33. Letter from Bernard Berenson to A. M. Huntington, October 28, 1909, A. M. Huntington, Papers.
34. Madrid–Bilbao–Seville 2000–2001, p. 38.

Fig. 11.11 Ignacio Zuloaga y Zabaleta, *Lucienne Bréval as Carmen*, 1908. Oil on canvas, 81⅛ x 75⅛ in. (206 x 192 cm). The Hispanic Society of America, New York

over their bed. He painted a copy of it before sending it, which was very good and I have seen it in the Paris house." Between 1911 and 1913 Huntington acquired a substantial number of important works from Madrazo, including a dozen Goya drawings, along with sketches and paintings by Raimundo, his father, Federico de Madrazo y Küntz, his grandfather José de Madrazo, and Mariano Fortuny y Marsal, the brilliant but short-lived Catalonian painter who had been Raimundo's brother-in-law.[35] Madrazo undeniably provided Huntington with many of the Hispanic Society's finest nineteenth-century paintings and drawings: the prodigious portrait *Jean-Auguste-Dominique Ingres* (1833) by the eighteen-year-old Federico de Madrazo; Fortuny's *Arabs Ascending a Hill* (ca. 1862–63), his masterful *Copy of the Portrait of Pedro Mocarte by Goya* (1867), and *Portico, Church of San Ginés* (1868); as well as Raimundo's portrait *María Cristina, Queen Regent of Spain* (1887), a gift to the society from the artist in 1913.

With his collection of old masters well under way, Huntington began to focus on the works of contemporary artists to complete his outline of Spanish art. The doors of the Hispanic Society had been open to the public for only a few months in 1908 when Huntington again set off for Europe. In Paris he met with Ignacio Zuloaga y Zabaleta, the internationally recognized Basque painter whose work presented a unique vision of a "dark," tradition-laden Spain, and invited him to present an exhibition during the next year in New York. While in London, Huntington discovered the sunlit canvases of Joaquín Sorolla y Bastida, Spain's painter of light, on exhibition at the Grafton Gallery. He was unquestionably captivated by Sorolla's work, as he immediately initiated plans through agents in London to arrange for an exhibition at the Hispanic Society the following year. Since the two artists offered disparate and perhaps incompatible visions of Spain, and Sorolla proposed sending a disproportionate number of works, Huntington chose to present the artists in separate exhibitions, with Sorolla taking the lead. The Sorolla exhibition was an immediate sensation, attracting nearly 160,000 visitors from February 4 through March 8, 1909. As an added benefit, Huntington seized the opportunity to secure a number of Sorolla's best works for the Hispanic Society, including the emblematic *After the Bath* (fig. 11.10). In a letter to his mother, Huntington expressed unabashed pride in his accomplishments: "I will not bore you any more about the Sorolla Exhibition. It came upon New York rather stealthily as I had planned. How much it had cost me in time, labor, patience! It was called a triumph. The artists looked upon it as an invasion. The collectors welcomed it as an opportunity to burnish brazen names more highly by association. The dealers secretly snarled & wrote me enthusiastic messages. One said: 'Spain sank low in our defeat of her, she has replied with the lightnings of art.'"[36] Sorolla became a favorite of American audiences, and of Huntington as well. In 1911 he was commissioned to paint for the Hispanic Society a series of monumental canvases, three to three and a half meters high and a total of seventy meters in length, that would capture the essence of contemporary traditions, customs, and costumes of the varied provinces of Spain. Not completed

35. Ibid., p. 40.
36. Letter from A. M. Huntington to Arabella Huntington, 1909, Papers.

Fig. 11.12 (cat. 64) Luca Giordano (formerly attributed to Jusepe de Ribera), *The Ecstasy of Saint Mary Magdalen*, ca. 1660–65. Oil on canvas, 100¼ x 76 in. (256 x 193 cm). The Hispanic Society of America, New York

Fig. 11.13 (cat. 66) El Greco (Domenikos Theotokopoulos) and Workshop, *The Penitent Saint Jerome*, ca. 1600–1610. Oil on canvas, 31⅛ x 25⅝ in. (80 x 65 cm). The Hispanic Society of America, New York

Fig. 11.14 (cat. 48) Luis de Morales, called El Divino, *Ecce Homo*, 1560–70. Oil on panel, 29¼ x 22½ in. (75 x 57 cm). The Hispanic Society of America, New York

until 1919, Sorolla's Vision of Spain occupied all of the remaining productive years of the artist's career. Crippled by a stroke in 1920, Sorolla unfortunately did not live to see the canvases installed at the Hispanic Society in the room that bears his name.

Zuloaga's 1909 exhibition, much smaller in scope than Sorolla's, received enthusiastic reviews and attendance but lacked the popular appeal of the preceding show. Huntington purchased several of Zuloaga's most celebrated paintings for the museum, including *The Family of the Gypsy Bullfighter* (1903) and *Lucienne Bréval as Carmen* (fig. 11.11), a work that had received universal acclaim in Paris at the 1908 Salon. A lasting friendship between Huntington and Zuloaga developed as a result of the 1909 exhibition, just as it had with Sorolla. Huntington continued to acquire the work of both artists through purchases and gifts, maintained regular correspondence with them, and visited them when in Paris, Biarritz, or Madrid.

Until the outbreak of World War I Huntington purchased paintings by sixteenth- and seventeenth-century masters at a rapid pace. In 1910, from the Galleria Simonetti in Rome, he obtained Luca Giordano's *The Ecstasy of Saint Mary Magdalen* (fig. 11.12). Originally attributed to Jusepe de Ribera, this superb painting was bought upon the recommendation of Huntington's friend Roger Fry, art critic, painter, and a member of the Bloomsbury group, as he noted in Hispanic Society museum records: "Roger Fry brought this to my attention and I purchased it from the photograph. Sorolla saw it and was delighted with it."

The purchase of four El Grecos from Ehrich Galleries in 1910 marked the beginning of Huntington's relationship with the New York gallery, one that would last into the 1920s. As with most of his subsequent acquisitions from Ehrich, this proved a mixed blessing, yielding a *Mary Magdalen* and a *Saint Dominic* of questionable attribution, as well as two pictures of unmistakable quality: an exceptional *Pietà* (ca. 1575) from El Greco's years in Rome and *The Penitent Saint Jerome* (fig. 11.13), a late autograph work. That same year the gallery also sold him two paintings with provenances from Louis-Philippe's collection, Morales's *Ecce Homo* (fig. 11.14) and Ribera's more naturalistic *Saint Paul* (1632).[37] Huntington bought at least seven paintings from Ehrich in 1911, only two of which were of true merit, and they ironically proved to be by Italian painters: a masterly "painting of a Dominican monk" by Zurbarán, today definitively given to Luigi Miradori, and a "Lady with Rooster" attributed to Esteban March, now known to be a work by Massimo Stanzione.

These acquisitions clearly illustrate the problems inherent in the attribution of Spanish paintings in Huntington's day. Few scholarly or well-illustrated monographs then existed on Spanish artists. The often unreliable information that was available on works by a specific painter, such as Alonso Sánchez Coello, for example, encouraged attributions to almost any anonymous sixteenth-century portrait that looked even remotely similar. Accurate comparisons of paintings were impossible without the

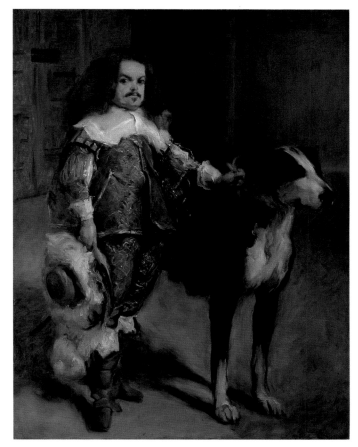

Fig. 11.15 (cat. 213) John Singer Sargent, *Dwarf with a Mastiff, Copy after Velázquez,* 1879–80. Oil on canvas, 55⅞ x 42 in. (142 x 106.5 cm). The Hispanic Society of America, New York

superior color illustrations or photographs that are now common, leaving dealers, experts, and collectors alike to rely on their visual memory. Another major disadvantage was that added signatures and fraudulent restorations were not easily detected without today's scientific methods of analysis. Consequently, as the demand grew for Spanish paintings, the absence of an authentic signature and/or a flawless provenance allowed dealers, knowingly or unknowingly, to attribute works by lesser-known artists, imitators, or even copyists to the Spanish masters. This largely explains how so many knowledgeable collectors—among them Huntington and the Havemeyers—could have been deceived by so many dubious Goyas, to name but one artist.

Still unable to resist the temptation of another fine El Greco, while in Paris in 1911 Huntington purchased from a private owner the rare autograph *Miniature of a Man* (ca. 1578–80), executed shortly after El Greco's arrival in Toledo in 1577. The next year, through Trotti, he bought Carreño's portrait of the afflicted Charles II dressed in armor (ca. 1680), formerly in the collection of the duke of Parma. In his effort to present a comprehensive outline of Spanish art, Huntington also sought out works by seventeenth-century painters virtually unknown outside of Spain. Included among them are *The Virgin of the Immaculate Conception* (ca. 1660–65), purchased from Ehrich in 1912 as the work of Juan Antonio de Frías Escalante, though now attributed to Mateo Cerezo the Younger, followed in 1913 by the exceptional *Marie Louise of Orléans, Queen of Spain, Lying in State* (1689–90) by

37. Baticle and Marinas 1981, pp. 107, 154–55.

38. Jonathan Brown, "The Paintings of the Hispanic Society, 1550–1800," in Lenaghan et al. 2000, p. 71.

39. Letter from A. M. Huntington to Arabella Huntington, August 19, 1919, Papers.

40. For a thorough discussion of the formation of Huntington's collection of contemporary Spanish art, see Priscilla E. Muller, "La España amada de Huntington en América," in Madrid–Bilbao–Seville 2000–2001, pp. 13–25.

Sebastián Muñoz, commissioned by the nuns of the Real Convento de la Encarnación in Madrid. The eminent art historian Jonathan Brown has observed that the Hispanic Society's "concentration of Madrid masters of the seventeenth century is surpassed only by the Hermitage and equaled but by few other museums outside of Spain."[38] About this time Huntington also bought from Ehrich an elegant *Saint Rufina* (ca. 1635) by Zurbarán, which was perhaps his last major acquisition before the onset of World War I.

Huntington ceased collecting during the war years, and even afterward, in 1919, remarked to his mother, "I am about through at last."[39] With a change of mind he slowly resumed, starting in 1920 with a remarkable pair of *Trompe l'oeils* (ca. 1675–1700), the only known paintings by Marcos Fernández Correa, bought at auction from Anderson Galleries in New York. Returning to Ehrich Galleries in 1921, he acquired Zurbarán's *Saint Lucy* (ca. 1630) and Antonio de Pereda's *Saint Anthony of Padua and the Christ Child* (1655), followed in 1922 by his last Goya, the sizable portrait *Manuel de la Peña, Marqués de Bondad Real* (1799). Having largely completed his outline of early works, Huntington turned his attention again to contemporary artists, both his favorites and those wanting in the collection.[40] After Sorolla's death in 1923, Huntington was able to finalize the purchase of the monumental *Provinces of Spain* (1911–19) from the artist's estate, along with an extensive series of portraits of illustrious Spaniards, all of which were installed in the Hispanic Society in 1926. Through the 1920s he augmented the Hispanic Society's holdings with works by American artists in Spain, which included numerous small landscapes by Max Kuehne; two landscapes by Childe Hassam; and John Singer Sargent's *The Spanish Dance* (ca. 1880?), a painting that prefigures his famous *El Jaleo* (fig. 10.44), plus Sargent's copy after a work thought to be by Velázquez, *Dwarf with a Mastiff* (fig. 11.15).

The last of Huntington's artist friends to serve as an adviser was José María López Mezquita, who assisted him up to 1930 in rounding out the museum's survey of contemporary realist painters, including large numbers of his own works. Notably absent were canvases by some of the most prominent Barcelona artists, which Huntington had ignored. This was remedied in part through the purchase in 1928 of several exceptional paintings: Santiago Rusiñol Prats's *Calvary at Sagunto* (1901), Ramon Casas i Carbó's *La Santera* (1915–16?), and Joaquín Mir Trinxet's *Lantern of Tarragona Cathedral* (1928). After 1930 Huntington stopped acquiring works through purchase, allowing instead the holdings of the Hispanic Society to grow through donations from his many friends and associates. Since Huntington's death in 1955, the museum has endeavored to expand the collection and whenever possible to add significant contributions by artists who are not properly represented, as with Murillo's *The Prodigal Son among the Swine* (fig. 11.16).

Formed predominantly by one individual, the Hispanic Society clearly reflects Huntington's personal taste and unique vision. Because his passion for Spain was founded in its people, he sought out works that best expressed Spain's enormously rich cultural heritage, unlike other prominent American collectors, who limited themselves to Spain's greatest painters. Ultimately, he combined the best of both worlds. In the course of thirty years of active acquisitions, Huntington succeeded in assembling not only a comprehensive survey of Spanish painting spanning more than six centuries but a museum collection of international stature filled with some of the finest examples by old and modern masters to be found outside of Spain.

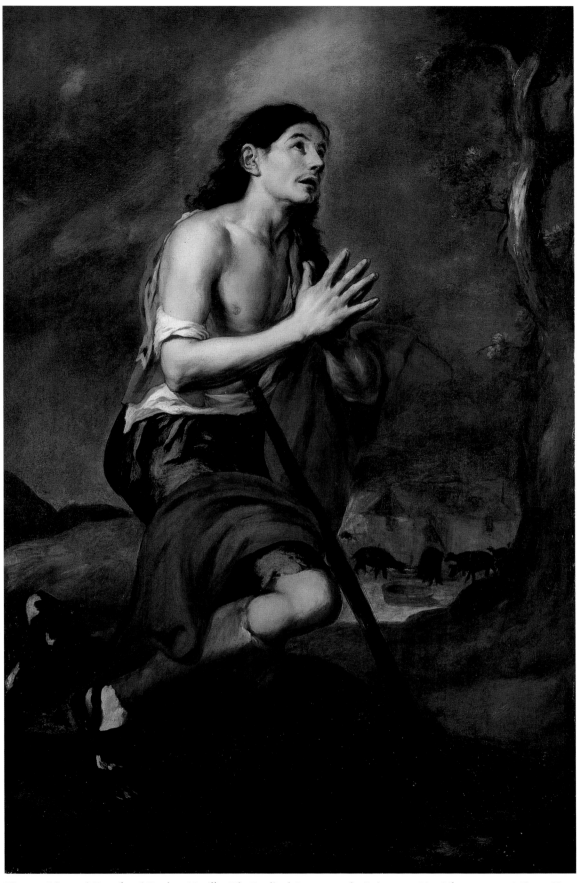

Fig. 11.16 (cat. 51) Bartolomé Esteban Murillo, *The Prodigal Son among the Swine*, ca. 1665. Oil on canvas, 63⅝ x 41⅛ in. (161.5 x 104.5 cm). The Hispanic Society of America, New York

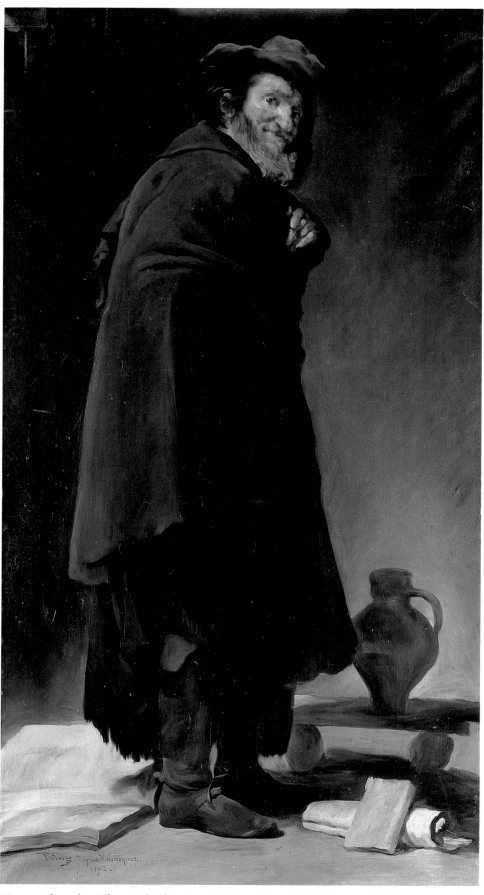

Fig. 12.1 Alexandre-Céleste-Gabriel Prévost, *Menippus, Copy after Velázquez*, n.d. Oil on canvas, 55⅞ x 42⅛ in. (142 x 107 cm). Musée des Beaux-Arts et d'Archéologie, Besançon

Nineteenth-Century French Copies after Spanish Old Masters

Dominique Lobstein

Between January 26, 1841, and October 15, 1880, the directors of the Département des Beaux-Arts of the Ministère de l'Instruction Publique et des Beaux-Arts in France acquired or commissioned 534 copies of paintings from the Spanish Golden Age, which were produced by 366 artists (188 men and 178 women). An exhaustive analysis of dossiers F/21/12 to F/21/261 in the Archives Nationales makes it possible to report in chronological order which artists and works were copied and where the copies were ultimately sent. Related research has revealed who the copyists were and also has supplied material that helps in evaluating what influence their copies may have had on the pictures created in the period 1840–80.

In arriving at the conclusions in this essay, I owe a great debt to those who helped me in analyzing the files in the Archives Nationales. It is also a pleasure to extend warmest thanks to Florence Restoueix and Dominique Vaglio.

THE COPYISTS

Of the 366 copyists, only 169 (106 men and 63 women) have as yet been identified with certainty in published artists' dictionaries. Since these dictionaries were usually based on analysis of the Salon catalogues, they did not record the journeyman painters who survived only by means of public commissions. In addition, the public servants who oversaw the files on commissions often made mistakes: in 1876, for example, one could write "Alchimouiez" for Hyacinthe Alchimowicz (1841–?). It may therefore be necessary in certain cases to qualify the result and to question the value of the data analyzed. Thus, a Pauline Langlois, who does not appear in the dictionaries, produced a copy in 1847; the next year, a Pauline Caron-Langlois appeared as a copyist, and her listing says simply that she exhibited at the Salon in 1848. Do we have one person for our statistics or two, and are copyists or artists referenced?

In any case, it is clear that a few of these copyists who began their careers in the service of the state later found patrons and art lovers for the original subjects they submitted to the Parisian and provincial Salons. Among these fortunate elect—who do not necessarily hold a major place in nineteenth-century art, but who experienced a certain success in their own time—are Albert Besnard, twenty-one years old in 1870; Marie Bracquemond, twenty-nine the same year; Théodore Valério, twenty-three years old in 1842; and Adolphe Yvon, twenty-eight in 1845. One characteristic of such painters, who were later ardently defended by critics at the Salons and universal expositions, is that their names appear among the recipients of public largesse only very rarely and within a fairly short period of time. When success came, they no longer needed to undertake works considered minor to ensure their economic independence.

For most of the other copyists, whose names appear only rarely in the Salon catalogues and booklets, copying appears to have been a fundamental financial resource throughout their lives. Alfred de Geniole (1813–1871), for instance, executed commissions of Spanish paintings from 1849 to 1870; Virginie-Eugénie Hautier (1822–1909), from 1848 to 1869. But the files of the Archives Nationales also reveal that these two artists were at other times engaged in reproducing imperial portraits or copies after Simon Vouet, Anthony Van Dyck, Philippe de Champaigne, or Pierre-Paul Prud'hon, to mention only the most famous and the most frequently reproduced. When artists in this category appear in the dictionaries, a number of different vocations are often given for them. Hence, in 1869, Hautier, who was producing a *Christ on the Cross*, after Velázquez, was known as a painter of still lifes; Claude Maugey (1824–1870), who was also copying the same painting, was considered a portraitist; Léon Olivié (1833–1901), who was painting an *Immaculate Conception*, after Murillo, was called "a painter of human figures and portraits"; and finally, Sainte Marie de Quilleboeuf (active 1845–69, at which date he was also executing a *Christ on the Cross*, after Velázquez) presented himself as a painter of animals. A fairly large number of painters on porcelain also engaged in copying on canvas, for example, a Mlle de Ollendon (active 1865–81), who in 1876 painted a *Virgin of the Rosary*, after Murillo. There were also miniaturists such as Armande Pin (active 1863–79), to whom we are indebted for two copies after Murillo, painted in 1872 and 1879.

To these artists badly in need of revenue, the administration—the invisible face of the state—offered two possibilities: an outright purchase of a completed copy or a commission. On the question of purchases (which were rare until 1870 but became the almost exclusive practice in the last decade considered here), the files of the Archives Nationales have little to say. Their content is often limited to a letter or two from the artist asking the minister for authorization to present the copy, a report from the inspecteur des beaux-arts, and invoices following the purchase when it took place.

For those who wished to obtain a commission, the path was more difficult, as reflected in the numerous documents contained in every F/21 file. Each commission began with a letter of application, in which the artist set out the reasons why the Ministère de l'Instruction Publique et des Beaux-Arts ought to entrust work to him or her. The reasons cited could be personal—such are those most often advanced by women painters, whose letters often mention that they are widows, with or without children, or daughters of disabled soldiers or ruined aristocrats—but they could also be professional, enumerating the applicant's education, art studies, and exhibitions. The acquisition of a previous commission for a copy and the acceptance of the completed work are often recalled, for an initial success seems to have boded well for regular commissions in the future.

It was also most effective to add to the letters a supplementary document signed by an influential person. The files are replete with laudatory comments submitted by members of the Académie Française and by painters of renown (often former teachers of the applicant). There are also recommendations by representatives of the political world—who often submit not a simple note but a letter in which they recall all that the nation owes to themselves—and by members of the administration, prefects, and high officials. Finally, in a few ecclesiastical forays, an archbishop, bishop, abbot, or priest steps forward to praise one of his parishioners, citing his or her potential (if the cleric is a realist) or genius (if an idealist).

The completed file, in which the candidate volunteered to produce a copy without specifying which one, was then sent to the Sous-Secrétariat des Beaux-Arts. (To simplify references to departments, whose names often varied, I have opted for the Third Republic denominations.) Once the proposal was accepted, an order signed by the minister informed the correspondent of the administrative agreement, which did not yet stipulate the subject of the copy but specified that it was to be "a painting of holiness, about which you will be kind enough to let me know the subject agreed upon," and set the fee to be allocated. The phrase "painting of holiness" signifies that all the copies must have been inspired by religious paintings; after 1870, the Franco-Prussian War, and the Commune, this expression disappeared as the government began to favor purchases of finished works with various themes over commissions.

A few letters were then exchanged for the purpose of establishing the subject to be treated—a decision that could, in fact, evolve over time: one proposed copy could be replaced, without any great explanation, by another. A copy of a Spanish painting could be superseded by one of the same origin, as when, in 1849, Jacques-Joseph-Léopold Loustau asked to substitute *The Virgin*, after Murillo, for the same artist's *Heavenly Father and the Holy Spirit*, which had previously been assigned to him. The change could involve a shift from Spain to France; hence, in 1852, Henriette Franquebalme (active 1842–52) was authorized to exchange a *Conception of the Virgin*, after Murillo, for a *Last Supper*, after Philippe de Champaigne. A Spanish work could also be substituted for a painting from another European country, as seen in the case of Henri-Jean Saint-Ange Chasselat (1813–1880), who changed his commission for *Christ in the Tomb*, after Raphael, into one for an *Immaculate Conception*, after Murillo.

Quickly and easily, or slowly and with great effort, the copyist then went on to produce the work, and the crucial moment arrived when it had to be submitted to the inspecteur des beaux-arts. After viewing the work, this official composed a report for his superiors. Sadly, very few works were showered with praise, and it was unusual for the copy to be immediately accepted. Much more often, the files contain catalogues of recriminations, such as this letter from Roger Ballu, inspecteur adjoint des beaux-arts, dated November 29, 1880, following a visit to the studio of Jean-Baptiste Duffaud (1853–1927), who, on December 30, 1879, had been commissioned to paint an *Assumption of the Virgin*, after Murillo:

Mr. Undersecretary,

I have carefully examined the copy of The Assumption of the Virgin *by Murillo, commissioned from M. Duffaud.*

In it I observed shortcomings in the draftsmanship, which (as I want to believe in the painter's talent) are only regrettable cases of negligence. The figure is sloppily done, circumscribed by vague and blurry silhouettes. The appearance of some of the children's faces makes one think of caricature; in one case, a cheek looks as if it is swollen by an inflammation. In addition, M. Duffaud has understood nothing of the harmony of the original painting. In Murillo's canvas, the Virgin is rising in a glowing aureole, whose brilliance is intensified by the choice of dark colors at the left of the composition. The copyist has, as it were, dulled that effect and that contrast; nothing is left but a work without character in a false and pinkish tone.

I would respectfully like to propose that M. Duffaud be invited to revise his copy in detail, to recommence the drawing, and to render the color effects more faithfully.

With respectful devotion, Roger Ballu.[1]

1. "Monsieur le Sous-Secrétaire d'État,
"J'ai examiné avec attention la copie de l'Assomption de la Vierge de Murillo commandée à M. Duffaud.

"J'y ai constaté dans le dessin des défaillances qui (je veux le croire pour le talent du peintre) ne sont que des négligences regrettables. La forme est lâchée, circonscrite dans des silhouettes vagues et indécises. Certains visages d'enfants ont une ressemblance qui fait penser à la caricature, il en est un, entre autres, dont la joue semble gonflée par une fluxion. M. Duffaud, en outre, n'a rien compris à l'harmonie du tableau originel. Dans la toile de Murillo, la Vierge s'élève dans une gloire ardente dont l'éclat est exalté par un parti de colorations sombres qui se voit à gauche de la composition. Le copiste a comme affadi cet effet et ce contraste, il ne reste plus qu'une oeuvre sans caractère, d'un ton faux et rosâtre.

"J'ai l'honneur de vous proposer de faire inviter M. Duffaud à revoir en détail sa copie, à en reprendre le dessin, et à rendre plus fidèlement les effets de couleurs.

"Veuillez agréer, Monsieur le Sous-Secrétaire d'État, l'hommage de mon respectueux dévouement. Roger Ballu." Archives Nationales, Paris, dossier F/21/212.

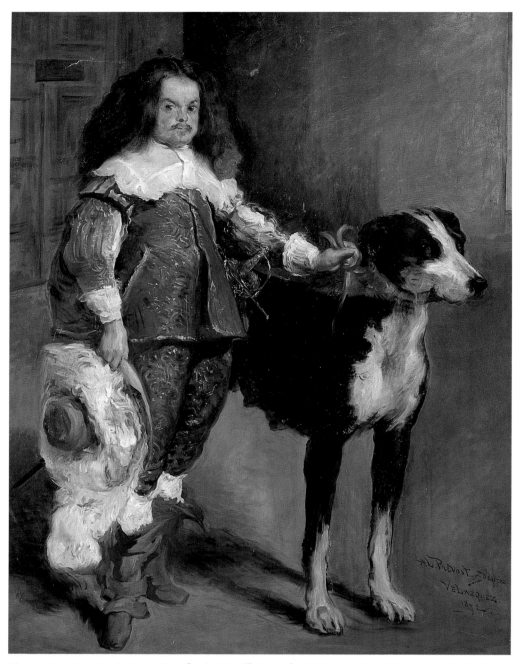

Fig. 12.2 Jean-Baptiste Guignet, *Dwarf and a Mastiff, Copy after Velázquez*, 1865. Oil on canvas. Musée de Grenoble

After several more viewings and reports, the copy was finally accepted, the entire fee or the balance due for the commission was paid (in the vast majority of cases, the fee was between 800 and 1,000 francs), and the canvas was placed in the state warehouse until it was assigned to a museum, public institution, or religious building. In certain cases, the inspectors were aware that they could get nothing more from a copyist and, with some cynicism, accepted the work upon the condition that it be exhibited, if at all, only far from the capital.

The petitioners who lived in close proximity to the authorities often had the greatest success in obtaining commissions. The vast majority of the copyists listed in the Archives Nationales, though originally from the provinces and sometimes from abroad, were residing

Fig. 12.3 (cat. 80) Imitator of Diego Rodríguez de Silva y Velázquez, *Dwarf with a Mastiff*, ca. 1640. Oil on canvas, 55⅞ x 42⅛ in. (142 x 107 cm). Museo Nacional del Prado, Madrid

in Paris or its immediate suburbs, including Adèle d'Argents (dates uncertain) and Adolphe Baune (dates uncertain) in Neuilly and Juliette de Ribeiro, née Bourgeois de Garencière (active 1834–74) in Pantin. Only a few gave addresses in the provinces: for example, Emma Chaussat (1840–?), who lived in Beuzon, a small village near Lamotte-Beuvron, and a Mme Mallet (dates uncertain) whose file bears simply the address "Nantes."

Analysis of the Archives reveals the existence of a few specialized copyists. These were most numerous between 1852 and 1870, when certain artists frequently reproduced portraits of the imperial couple, first after Franz Xaver Winterhalter, then after Hippolyte Flandrin, and finally after Winterhalter's later portrait based on a copy by Charles-Édouard Boutibonne.

Nevertheless, it is not possible to identify any copyists who specialized in the reproduction of Spanish paintings. A large majority of the 366 artists listed (266 to be exact) made only one such copy, 53 made two, and 33 made three. Only nine went so far as to execute four copies, three made five (Palmyre Hurtel [dates uncertain], between 1857 and 1876; Lucie Levol [dates uncertain], between 1844 and 1849; and Sophie Van den Haute [dates uncertain], between 1865 and 1873), and finally, two made six copies. Certain files, identified solely by the name "Marzocchi de Belluci" (six commissions between 1841 and 1870), may correspond to commissions given either to the father, Tito (1800–1871), or the son, Numa, who exhibited at the Paris Salons from 1878 to 1922, or to both of them.

THE COPIES

The 534 copies listed are based on originals by thirteen Spanish painters, who were born between 1558/60 (Juan de Roelas) and 1746 (Francisco de Goya y Lucientes), but all the artists are not equally represented. Only one copy of a Juan Carreño de Miranda is listed, purchased in 1873 from Adolphe Brune (1802–1875), as is one "Juan Coella" (dates uncertain, but the name is clearly an attempt to cover up an error made by the civil servant who recorded the commission), by an artist named Despagne (dates uncertain) in 1843. Also appearing only once are copies after Francisco Collantes, by Joséphine Calbris (dates uncertain) in 1848; Jerónimo Jacinto Espinosa, by Perron (dates uncertain) in 1843; Goya, by Alexandre-Céleste-Gabriel Prévost (active 1850–86) in 1874; and Juan de Roelas, by Henri Poublan (1822–?) in 1843. A work by José Antolínez was copied only on two occasions, in 1842 and 1850, when Jean-Pascal-Adolphe Papin (1800–1880) and Mlle Fabret d'Olivet (dates uncertain), respectively, reproduced *The Baptism of Christ by Saint John*. Jusepe Leonardo (José Chabacier) also had a painting copied twice: his *Saint John the Baptist Preaching in the Desert* was reproduced by Paul Boulat (dates uncertain) in 1843 and by Victor Guerry (dates uncertain) in 1848.

Of the ten copies mentioned, eight were made between 1841 and 1850, and six of those definitely reproduce paintings that appeared in the Galerie Espagnole of Louis-Philippe, which opened in January 1838. The works gathered there offered artists the opportunity to view a diverse group of subjects borrowed from Spanish painting, an opportunity that would gradually diminish during the following decades. Similarly, copies inspired by the canvases of Alonso Cano appear nine times in the decade 1841–50, once in the following decade, and never again afterward. All the Cano copies were produced before the dispersion of the Galerie Espagnole in 1853, and almost every one was probably executed from works in that extraordinary collection. Nevertheless, the capricious titles given the copies make it impossible to clearly link them to the paintings and thus to gather accurate statistical data.

As for Zurbarán, copies of his works appear nine times between 1841 and 1850, once between 1851 and 1860, once between 1861 and 1870, and three times between 1871 and 1880. Again, the vast majority of the ten paintings listed between 1841 and 1860 are copies of works that were in the Galerie Espagnole. The 1867 copy by François Vaesen (dates uncertain) entitled *Saint Francis of Assisi* may have been a copy of a copy, as is also the case for two of the three works painted the following decade: *Monk at Prayer* by Anatole de Beaulieu (1819–1884) and *Saint Francis of Assisi* by Esther Joly (dates uncertain). But the copies, which are unlocated, would have to be examined in order to ascertain what these paintings

with overly imprecise titles actually represented. For example, it is very likely that *Monk at Prayer* was a reproduction of *Saint Francis in Meditation* (fig. 2.13), a painting currently in the National Gallery in London. The last of the copies made between 1871 and 1880, *Saint Peter Nolasco's Vision,* clearly designated in the Archives file, was produced by Jeanne Saint-Aubin Ricador (dates uncertain) during a stay in Madrid.

The surprising presence, in the descriptions cited above, of purchases of copies of Carreño de Miranda in 1873 and of Goya in 1874—the only mentions in our survey of these two artists—deserves some discussion as well. The Galerie Espagnole included two works entitled *Portrait of Charles II of Spain,* which are now attributed to Carreño de Miranda and which both remained in England after the 1853 sale. The purchase by the French state of Brune's copy of one of these paintings (which, given its subject, could not have been destined for a church) was a generous gesture toward an aged painter—he was seventy-one years old at the time. The government concealed the charitable nature of its purchase by acquiring a copy that Brune had produced while the painting was still exhibited in Paris among the collections of Louis-Philippe. Everything leads us to believe that this copy was of good quality, since, before being sent to the museum in Laon, it was exhibited in Paris in the Musée Européen.[2]

Details regarding the Goya copy can be easily deduced from the information appearing on the cover of the file in the Archives Nationales. Prévost, the recipient of the commission, had on several occasions after his return from Madrid offered the copies he had painted there, and the works were eventually acquired for sums much larger than the usual fees. Thus, on November 14, 1871, the undersecretary of fine arts purchased from Prévost a reproduction of *The Family of Philip IV,* after Velázquez, for 8,000 francs; on December 20, 1872, he delivered, again after Velázquez, the *Count-Duke of Olivares on Horseback, Dwarf with a Mastiff, Menippus* (fig. 12.1), and *Aesop* for 10,000 francs; the following January 19 (barely a month later), he handed over the *Philip IV on Horseback,* again after Velázquez, for 7,000 francs; finally, on September 25, 1874, he delivered a copy of Murillo's *Saint Elizabeth Nursing the Sick* for 8,000 francs and, for 3,000 francs, *Majas on a Balcony,* after Goya, which was the only copy of a work by that artist the French state would purchase between 1851 and 1880.

Ribera, Velázquez, and Murillo were the artists most often copied during the period under discussion. A breakdown by decade of works acquired by the French state reveals how the interest in Spanish painting and in each of these artists fluctuated:

	1841–50	1851–60	1861–70	1871–80	Total
Number of Spanish copies acquired	204	72	165	93	534
Murillo	155	61	108	55	379
Velázquez	4	6	44	8	62
Ribera	19	3	12	25	59

A comparison between these results and the records of copies located in the Louvre archives under number LL 26, for the period 1851–59 (no record existed before that time), indicates that the state acquired only a very small share of the copies produced in the halls of the Louvre. There were no fewer than 597 copies made at the Louvre after Murillo alone (fig. 12.5), including 167 after *The Immaculate Conception* from the collection of Marshal Jean de Dieu Soult (fig. 1.20), and 123 after *The Holy Family,* whereas only 61 copies after

2. The Musée Européen is fully discussed in Duro 1985.

Fig. 12.4 Charles Porion, *Count-Duke of Olivares on Horseback*, *Copy after Velázquez*, before 1856. Oil on canvas. Musée du Vieux-Château, Laval

Murillo were acquired by the state during that period. In addition, there were 124 copies after the *Beggar Boy* (fig. 1.4) by Murillo, which, because it was not a religious painting, was never the object of purchases by the administration. Of the 97 Louvre copies after Velázquez, only 8 remain in the breakdown of the acquisitions by the Division des Beaux-Arts.

Another archival source must be mentioned, distinct from those previously discussed: the Louis-Philippe inventory, located in the Département des Peintures at the Louvre. Between 1835 and 1848, the self-proclaimed "King of the French" possessed a civil list that allowed him to acquire or commission original works of art and copies. In her discussion of the French discovery of the Spanish school in her essay in this publication, Geneviève Lacambre identifies in the inventory sixty-one commissions for copies, produced by forty-six artists—among them the landscape artist Antoine Chintreuil (1816–1873) and the future

animalier Rosa Bonheur (1822–1899); seventeen of these artists appear among the beneficiaries of public commissions during the same period or shortly thereafter. The subjects copied are the same as those previously mentioned, with reproductions after Murillo's *Virgin of the Rosary* and *Immaculate Conception* being most common. All these paintings (except for a few that were completed in early 1848 and were lost during the days of revolution or that never left the Louvre) were sent to various religious establishments in metropolitan France.

The fact that close to half the copies of Spanish paintings were made between 1841 and 1853 clearly demonstrates the fundamental role played by the Galerie Espagnole. It is important, however, to keep in mind the relationship between these copies and the acquisitions of the state as a whole. Such paintings represented close to 10 percent of the entire output in the decade 1841–50 but barely 3.5 percent in 1851–60, 5 percent in 1861–70, and finally, no more than 3.5 percent in 1871–80.

The first abrupt drop in copies of Spanish paintings, even as purchases and commissions were continuing to grow at an increasing rate, must be imputed to the disappearance of the models that had previously been so easily accessible. Later, as relations between the French Empire and Spain were normalized and several important works, such as Murillo's *The Birth of the Virgin* and *The Angels' Kitchen*, were acquired, these paintings were once again endowed with a certain aura. Hence, in the Archives Nationales, we find twenty listings of a *Birth of the Virgin* by Murillo, followed by a notation "from the Louvre Museum," among the copies made in the decade 1861–70. Three of the copyists of that canvas even produced two versions of it: Ernestine Froidure de Pelleport (dates uncertain) in 1864 and 1868, Justine de Janvry (dates uncertain) in 1864 and 1866, and Marie-Augustine Erat-Oudet (active 1850–77) in 1863 and 1869.

It is noteworthy that more than 65 percent of the copies produced between 1861 and 1880 were derived from the works of Murillo, and, of those, three paintings represented 90 percent of the total. The title *The Immaculate Conception*, which appears so often, refers to the canvas acquired in the early 1850s from the Soult heirs (now in the Museo del Prado, Madrid) for a price that was a major topic of conversation. For certain canvases, such as *The Virgin of the Rosary*, which did not appear in the Galerie Espagnole, a first copy, which we have been unable to identify, probably served as a model for numerous reproductions or variations.

The exceptional number of Velázquez copies during the decade 1861–70 can be attributed, in forty-three of the forty-four cases, to copies of one work, *Christ on the Cross*. These fruitless attempts to dethrone the long-standing popularity of copies of Prud'hon's painting of the same subject can be explained only by the availability of a copy, commissioned in 1853 from Charles Porion (1814–after 1868), of the original painting in Madrid. The reliance on Porion's copy seems to be confirmed by a commission from Juliette Gambano (dates uncertain), which specifies a copy of *Christ on the Cross, after Velázquez, in the Museum of Madrid* for only 800 francs—that is, the price for a work copied in Paris rather than abroad.

The indirect reference to Porion's work reveals a few unusual elements relating to the copies identified. On several occasions, the Division des Beaux-Arts (the Sous-Secrétariat under the Republic) agreed to pay large sums for special copies, often produced far from Paris. Most of these were no longer destined to adorn churches but were to be part of official buildings or museums—including one in Paris devoted to copies—and provincial museums, where they compensated for the lack of original works. Twelve

artists benefited from this extraordinary largesse, and their commissions are detailed in the following paragraphs.

De Geniole was commissioned on May 7, 1879, to make an enigmatic *Theology of Painting*, after Velázquez, whose destination is unknown, for 15,000 francs; then, on January 21, 1852, for 3,000 francs, he was asked to copy two paintings, whose assigned location is also not known, including Velázquez's *Baltasar Carlos as a Hunter*. Finally, an unspecified price, but certainly one higher than that for an ordinary commission, was probably paid him for the 1870 commission of *The Family of Philip IV*, after Velázquez, which was delivered to the city hall of Saint-Pol-de-Léon on October 14, 1890.

Porion, residing primarily in Madrid, was given the following commissions: on October 10, 1849, for 3,500 francs, the picture of *The Lances*, after Velázquez, sent to the museum of Angoulême; on August 1, 1850, for 1,000 francs, *Los Borrachos*, after Velázquez, sent to the museum of Privas; on February 5, 1853, for 5,000 francs, *Count-Duke of Olivares on Horseback*, after Velázquez (fig. 12.4), destined for the museum of Laval, and *The Forge of Vulcan*, after Velázquez, for the museum of Dijon; on July 28 of the same year, he was promised 2,500 francs for a copy of Velázquez's *Christ on the Cross*, the fate of which is unknown but which was to remain in Paris long enough to be a model for many artists.

A. Colin (dates uncertain) was commissioned on May 14, 1860, for 3,000 francs, to produce *The Spinners*, after Velázquez, for the École Parisienne des Beaux-Arts.

Jean-Baptiste Guignet (1810–1857), in response to a commission of 4,000 francs on June 6, 1856, copied several portraits after Velázquez; the only other information regarding these is found in an 1888 note appearing in the file, which speaks of the search for "four paintings of dwarfs" (figs. 12.2, 12.3). In addition, on December 20, 1871, for 4,000 francs, Guignet delivered, through his intermediary Irma Cruchon (dates uncertain), a *Philip IV as a Hunter*, after Velázquez, and a *Baltasar Carlos as a Hunter*, after Velázquez, with no indication of location assigned.

On November 15, 1871, for 8,000 francs, Ernest-Paul Brigot (1836–after 1872) sold *Los Borrachos*, after Velázquez, which was sent to the Musée Européen in Paris before becoming part of the museum of Laon (the same path as that taken by the previously mentioned *Charles II*, after Carreño de Miranda, by Brune). On December 15, 1872, for 1,500 francs, Brigot sold his *Baltasar Carlos as a Hunter*, after Velázquez; however, there is no indication of its destination.

On July 12, 1872, Hippolyte Lazergues (1817–1887) handed over his *Saint Elizabeth Nursing the Sick*, after Murillo, for 8,000 francs, destined for the Musée Européen.

On November 8, 1873, a certain Lefort (dates uncertain) sold to the state *The Virgin in an Aureole Surrounded by Angels*, after Murillo, for 5,000 francs; the painting was intended for the museum of Bourges.

Between 1871 and 1874, Prévost received 33,000 francs' worth of commissions and purchases and delivered *The Family of Philip IV*, after Velázquez, to the museum of Grenoble; *Count-Duke of Olivares*, after Velázquez (location unknown); *Dwarf with a Mastiff*, after Velázquez, to the museum of Grenoble; *Menippus*, after Velázquez, to the museum of Besançon; *Aesop*, after Velázquez (location unknown); *Philip IV on Horseback*, after Velázquez, to the Musée Européen; *Majas on a Balcony*, after Goya, for the Ministère de l'Intérieur; and finally, *Saint Elizabeth Nursing the Sick*, after Murillo, for the French embassy in Constantinople.

Fig. 12.5 Louis Beroud, *At the Louvre—Copying Murillo*, 1912. Oil on canvas, 51½ x 63½ in. (130.8 x 161.3 cm). Private collection, New York

On December 4, 1871, a Mme Tourny (dates uncertain) delivered, for 6,000 francs, a *Baltasar Carlos on Horseback*, after Velázquez, destined for the museum of La Flèche.

In addition to the preceding copies, all of which were produced on Spanish soil, there was one made in Italy by François Lafon (active 1872–90), which was purchased on December 12, 1872, for 2,500 francs: a *Saint Stanislas and the Christ Child, after the Painting by Ribera in the Borghese Gallery*, destined for the Musée Européen.

Two of the artists did not have time to complete their commissions or to see them arrive at their destinations. On March 19, 1851, Alfred Orgebin (1817–1851) was commissioned for 1,000 francs to "copy a painting of Murillo or Velázquez located in Seville," but the artist died two days later. Then there was Sébastien Cornu (dates uncertain), whose widow sold a *Woman with Glove*, after Velázquez, for 800 francs on July 10, 1872, that was immediately sent to the Musée Européen.

THE DESTINATIONS OF THE COPIES

The files of the Archives Nationales have little to say about the manner in which the works acquired by the state were assigned. A few meager exchanges suggest that they were often sent after requests from municipalities or from local clergy seeking to redecorate churches that had been emptied of their paintings during the Revolution and its aftermath or to adorn new or renovated religious buildings.

Every acquisition, stored for a certain length of time in the state's warehouses of artworks (including the famous one on the Île-aux-Cygnes), was destined to find a home one day.

The period of time between the work's entry into the warehouse and its delivery was sometimes long enough that the administration forgot to report this last item of information. As a result, ninety-two files contain no information regarding the destinations of the works; fifty-two of these are from the period 1861–70, during which there may have been a plethora of works, a lack of requests, or a particularly careless staff. One special case is that of *The Virgin of the Rosary*, after Murillo, by Jeanne Saint-Aubin Ricadat (dates uncertain), commissioned on March 2, 1870, which was to be sent to decorate the Church of Bragny-en-Charollais (Saône-et-Loire) but which, according to file F/21/179, was "destroyed in the warehouse by the explosions in 1871."

The totals of copies by decade, classified by their destinations in metropolitan France (table 1), confirm the conclusions previously mentioned—that is, the major importance of Louis-Philippe's Galerie Espagnole for the period 1841–50 and of acquisitions from the Soult collection in 1852 and 1858. After the dispersion of the works that had belonged to Louis-Philippe, the numbers were little changed by the few copies occasionally sent by the Empire to its embassies and to what would become the overseas territories, nor by those sent by the Third Republic to Algeria. Between 1871 and 1880 Algeria received no fewer than six copies of Spanish paintings, destined for the churches there. Algiers received *The Entombment*, after Ribera, by Alphonse Dargent (active 1874–82) for the Church of Notre-Dame des Victoires, and, for the Church of Saint Augustine, a copy of the same Ribera painting by Pierre Léon Tessier (active 1856–81). Oran was the recipient of *The Nativity of the Virgin*, after Murillo, by an artist named Bayer (dates uncertain) for the Church of Saint Lucien. More modest towns were also sent works, for example, *The Immaculate Conception*, after Murillo, by Ternus (dates uncertain) for the Church of Aïn Smara.

Although the files of the Archives Nationales show that there was a massive distribution of copies of religious paintings to all the departments and colonies, without exception, they also indicate that certain departments (Ariège and Loire, for example) received no copies of Spanish paintings between 1841 and 1880. For the other departments, the number of such copies varies between one and seventeen, but only fourteen administrative districts received at least one copy per decade. Except in two instances, no satisfying explanation can be advanced to clarify why certain places received most of the copies of Spanish paintings. The first instance concerns the Aquitaine region, which was always closely connected to the Spanish world—Goya died in Bordeaux in 1828, after all—and which explicitly asked the central government in Paris for works inspired by art from Spain. Across its four departments (Dordogne, Gironde, Landes, and Basses-Pyrénées), it received a total of thirty-three copies, that is, 7.7 percent of those sent out, for an area comprising only 4.5 percent of the nation. The second exception is the Paris region, for two reasons. First, it was a major market for religious works, whether copies or originals. In fact, as the region most affected by the Revolutionary desire for de-Christianization, and hence by vandalism, it was the first to benefit from the rebuilding of religious institutions and commissions for decorations. Second, and this was especially significant in the decade 1871–80, the establishment of the Musée Européen in Paris led to the commissioning of several copies of famous Spanish paintings destined for the edification of the public and the instruction of artists.

Finally, it is worthwhile to examine how the commission and purchase of Spanish paintings may have influenced the creation of artworks from 1841 to 1880. Of the artists mentioned here (most virtually unknown today), those who escaped anonymity do not seem to

have felt such an influence. In fact, they chose to reproduce Spanish subjects only because the originals could be seen in Paris and could be copied under comfortable conditions. However, since more copies were made in the halls of the Louvre than were actually purchased, it seems logical to conclude that the acquisitions by the state reveal only a small share of the taste of artists and the public for Spanish paintings.

3. For a full discussion of prints after Spanish old masters, see Lobstein 2002.

Several of the artists identified in the Archives did go to Spain and, during their lifetimes, sold copies of Spanish paintings that were not exclusively religious subjects (or their heirs did so after their deaths). A distinction must therefore be made between a massive output of paintings reproduced without reflection and destined to adorn churches (paintings that would thus be little seen by artists) and true pictorial work associated with the art of seventeenth-century Spain (which would be displayed at exhibitions and then in many museums).

A better knowledge of the output of artists such as De Geniole, Porion, and Prévost would effectively show a direct connection between seventeenth-century Spanish art and the works of the most important French painters of the second half of the nineteenth century. Some of the later marks of that influence could establish a link between Delacroix or Chassériau and painting after 1850. In fact, beginning in the 1840s, a number of leading artists were well acquainted with Spain and put to use their knowledge of the country, at least in the themes they treated. Examples include works submitted by De Geniole to the Salon of 1842 (no. 762, *A Street in Granada*) and by Porion to the Salon of 1844 (no. 1470, *A Dance—Memory of Spain*, for which he won third prize).

Despite the number of copies listed in table 1, Spanish subjects never dethroned those of Italian and French artworks of either the seventeenth century (Champaigne, Le Sueur) or the eighteenth (Prud'hon), nor did they uproot the taste for Flemish and Netherlandish art.

For those who were unable to take the trip to Spain, the Salons could serve as a substitute: their engraving and lithography sections made available graphic interpretations of the most renowned Spanish masterpieces. Until the early 1850s engravings after the works in the Galerie Espagnole were predominant, but later a number of interpretations after originals in Spain or Italy were produced. Hence, at the Salon of 1857, Victor-Jean-Baptiste Loutrel (1821–1908) presented *Mars* and *An Idiot Dwarf*, after the Velázquezes in the Prado, and Gustave-Nicolas Bertinot (1822–1888) exhibited *Portrait of Pope Clement IX* "after the painting by Velázquez in the Gallery of Saint Luke in Rome," as the catalogue explained.[3]

Just as the influence of Spanish technique affected only a small portion of French artists in the second half of the nineteenth century, so too did it concern only a small number of copyists. Yet the art authorities did not hesitate to promote it, and by sending the copies to museums, they provided models for the instruction of all.

Table 1

Copies of Spanish Paintings Acquired by the State and Dispersed throughout France, 1841–80*

Department	1841–1851	1851–1860	1861–1870	1871–1880	Total
Ain	0	1	2	1	4
Aisne	3	2	1	0	6
Allier	0	1	0	2	3
Basses-Alpes	1	1	0	1	3
Hautes-Alpes	1	0	1	2	4
Ardèche	3	1	2	1	7
Ardennes	0	0	0	1	1
Aube	1	0	0	0	1
Aude	6	0	1	0	7
Aveyron	9	0	1	0	10
Bouches-du-Rhône	0	0	1	1	2
Cantal	3	0	0	0	3
Charente-Inférieure	4	3	1	1	9
Chartente-Maritime	4	0	0	0	4
Cher	0	0	0	2	2
Corrèze	0	0	1	0	1
Corse	1	3	1	0	5
Côte d'Or	2	1	1	0	4
Côtes du Nord	1	2	3	1	7
Creuse	3	0	3	0	6
Dordogne	3	6	4	4	17
Doubs	2	1	0	2	5
Drôme	2	1	0	1	4
Eure	5	3	5	2	15
Eure-et-Loir	2	0	1	0	3
Finistère	5	1	1	0	7
Gard	3	0	1	0	4
Haute-Garonne	1	1	0	1	3
Gers	0	1	3	1	5
Gironde	4	1	0	1	6
Hérault	2	0	1	0	3
Ille et Vilaine	1	0	0	1	2
Indre	6	2	4	0	12
Indre et Loire	2	0	5	0	7
Isère	5	0	3	4	12
Jura	1	0	0	0	1
Landes	2	0	1	1	4
Loir et Cher	4	1	1	0	6
Haute-Loire	4	0	1	2	7
Loire Inférieure	0	1	0	1	2
Loiret	4	1	2	3	10
Lot	1	0	0	0	1
Lot et Garonne	4	1	0	1	6

Department	1841–1851	1851–1860	1861–1870	1871–1880	Total
Lozère	2	0	1	0	3
Maine et Loire	1	0	1	0	2
Manche	1	4	2	2	9
Marne	1	0	0	0	1
Haute-Marne	2	0	0	1	3
Mayenne	2	1	1	0	4
Meurthe	1	0	0	0	1
Meuse	1	0	0	1	2
Morbihan	5	1	1	2	9
Moselle	2	1	1	0	4
Nièvre	2	0	0	1	3
Nord	5	1	2	1	9
Oise	4	0	3	0	7
Orne	3	0	5	5	13
Pas-de-Calais	6	0	2	1	9
Puy de Dôme	4	2	3	1	10
Basses Pyrénées	5	0	1	0	6
Hautes Pyrénées	1	0	1	0	2
Pyrénées Orientales	1	0	0	0	1
Bas-Rhin	3	1	0	0	4
Haut-Rhin	0	0	1	0	1
Saône-et-Loire	0	0	4	1	5
Sarthe	1	0	1	2	4
Savoie	0	0	1	0	1
Paris	2	2	1	10	15
Seine-et-Marne	3	1	4	1	9
Seine-et-Oise	3	3	3	3	12
Deux-Sèvres	0	0	1	0	1
Somme	4	0	2	0	6
Tarn	4	0	1	0	5
Tarn-et-Garonne	3	1	0	1	5
Var	1	2	1	0	4
Vaucluse	0	0	1	0	1
Vendée	0	1	0	0	1
Vienne	1	1	2	1	5
Haute-Vienne	6	0	3	2	11
Vosges	2	0	1	0	3
Yonne	3	3	1	0	7
Territoire de Belfort	0	0	0	2	2
Total	190	61	104	76	431

*Departments appear as they are traditionally grouped in France, and their names are spelled as they were during the period analyzed.

Fig. 13.1 (cat. 83) Francisco de Zurbarán, *Saint Bonaventure Inspired by an Angel Regarding the Election of the Future Pope Gregory X*, also called *Saint Bonaventure Praying*, 1629. Oil on canvas, 94 x 87 in. (239 x 222 cm). Gemäldegalerie Alte Meister, Staatliche Kunstsammlungen, Dresden

The Dresden Remains of the Galerie Espagnole: A Fresh Look (at the) Back

Matthias Weniger

When the paintings from the Galerie Espagnole brought together by Baron Isidore-Justin-Séverin Taylor for King Louis-Philippe of France were offered for sale in London in 1853, the Dresden Gemäldegalerie sought to secure for Germany some of the finest pieces from among the hundreds of works of rather uneven quality. This massive purchase marked the only serious effort in German museum history to build up a Spanish collection—even if time has shown that not all of the acquired pieces were actually Spanish. Immediately reframed by a Dresden artisan, Gustav Kretzschmar,[1] fifteen out of the sixteen paintings that had come to Dresden in 1853 were apparently already on public view at the inauguration in September 1855 of the new building for the Gemäldegalerie erected by Gottfried Semper.[2] In an attempt to display as large a Spanish collection as possible, the newly acquired pieces were joined with paintings brought in from storage as well as with a large group of Riberas that in earlier times had been catalogued with the Italian school. The resulting combination totaled almost forty paintings. Judging from only slightly later sources, the Spanish works received a special place of honor: in the arrangement recorded for 1862, twenty-three of the paintings then considered Spanish were, together with Genoese and Neapolitan works, presented in one of the six large gallery rooms (today devoted to Rubens), the first gallery to the south from the central pavilion. Twelve more were in a spacious adjacent room, currently reserved primarily for Van Dyck. This arrangement was still essentially in place when Karl Louis Preusser depicted life in the Gemäldegalerie in 1881, showing on the walls several Spanish paintings that are now confined to the storeroom (fig. 13.2).

Of the fifteen Galerie Espagnole paintings exhibited in the nineteenth century, only twelve are listed in the important catalogue published by Jeannine Baticle and Cristina Marinas in 1981.[3] These paintings included works by Cano (*Saint Paul*), Carducho (*Three Saints*), Correa (*Crucifixion*), Espinosa (*Saint Francis*), Murillo (*Saint Roderick*, fig. 13.3), Valdés Leal (*Saint Vasco*), and Zurbarán (*Saint Bonaventure*, fig. 13.1), as well as doubtful or plainly erroneous attributions to Espinosa (*Carrying of the Cross*, now attributed to a follower of Jan van den Hoecke), Orrente (*Jacob at the Well*, the work of a follower), Ribalta (*Mass of Saint Gregory*, possibly done by a seventeenth-century French master), Roelas (*Immaculate Conception*, now given to a follower of the Cavalier d'Arpino), and Pedro Romana (*Christ at the Column with Saint Peter*).[4] The three unlisted works were not acquisitioned directly for Louis-Philippe but were among those presented to him by the British collector Frank Hall Standish in 1842 to form a subdivision of the Galerie Espagnole, the

1. According to the Dresden directories, the company seems to have ceased to exist in this form in 1858. In addition to nine frames for Galerie Espagnole paintings, the Dresden restorer Christoph Schölzel and the author managed to find a Kretzschmar label also on a *Venus and Aeneas* by Christian Wilhelm Dietrich that was first put on view in 1855 (Gal. 2127). For the construction of these frames, see Schölzel 2002, pp. 104–29 esp. p. 112. Due to the Dresden custom of reframing all works on arrival, it might never be possible to establish whether the paintings had come within their frames, what the frames they had in Paris may have looked like, or what frames from Spain had been brought to France.

2. On October 27, 1853, barely five months after the auctions, a ministerial document states that all sixteen paintings had safely arrived in Dresden and were almost fit for public display ("wohlerhalten angelangt und auch theilweise bereits für die Ausstellung in der Gallerie in Stand gesetzt"; archives of the Staatliche Kunstsammlungen Dresden, Königliche Gemälde-Galerie Nr. 4, Bd. 1). They might even have been shown in the old building, since all fifteen were included in an addition to the 1853 edition of the *Katalog der Königlichen Gemälde-Galerie zu Dresden*.

3. Baticle and Marinas 1981.

4. Gal. 702, 681, 679, 700, 704, 707, 696, 1047A, 677, 695, 676, and 678, respectively; Baticle and Marinas 1981, nos. 23, 440, 84, 94, 180, 92, 192, 222, 255, and 81.

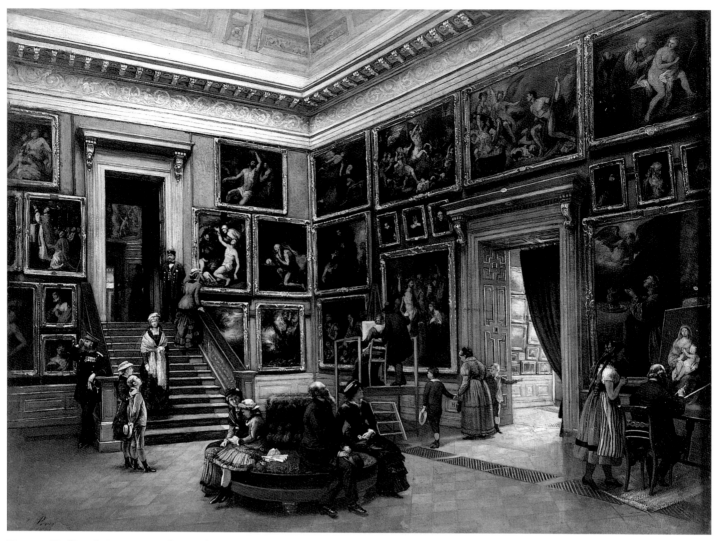

Fig. 13.2 Karl Louis Preusser, *In the Dresden Gemäldegalerie*, 1881. Oil on canvas, 26¾ x 34¼ in. (68 x 87 cm). Staatliche Kunstsammlungen, Dresden

Fig. 13.3 Bartolomé Esteban Murillo, *Saint Roderick*, ca. 1646–55. Oil on canvas, 81¼ x 48⅞ in. (206.5 x 124 cm). Staatliche Kunstsammlungen, Dresden

Fig. 13.4 Reverse of fig. 13.3, showing stretcher. Photo courtesy the author

Fig. 13.5 Reverse of Vicente Carducho, *Saints Francis, Gonzalo, and Bernardino of Sienna*, 1630, showing stretcher. Oil on canvas, 86⅝ x 64⅝ in. (220 x 164 cm). Staatliche Kunstsammlungen, Dresden. Photo Estel/Klut

Musée Standish. These paintings were treated separately in the Christie and Manson sales of 1853, being auctioned one week later, on May 27 and 28 (Dresden acquired lots 60, 96, and 148, corresponding to numbers 103, 144, and 91 in the 1842 catalogue of the Musée Standish:[5] a *Saint Matthew* [Gal. 680] sometimes wrongly attributed to Luis Tristán and at the time considered a *Saint Peter Reading* by Herrera the Elder, a *Last Communion of Saint Onuphrius* by Vasco Pereyra [Gal. 675], and the *Death of the Virgin* by Nicolás Borràs from the Bocairente altarpiece by Vicente Maçip Comes [Gal. 674]).[6] A sixteenth painting brought to Dresden from the Galerie Espagnole passed unnoticed until recently: a *Flagellation*, the sole (attribution to) Navarrete el Mudo contained in the Galerie Espagnole. Considered unworthy of exhibition, the work was included in the 1859–61 sales of several hundred Dresden paintings previously kept in storage.[7] The *Crucifixion* by Correa was destroyed during the bombing of Dresden in February 1945. Even after these losses, the Dresden ensemble most likely forms the largest extant group worldwide of works from the Galerie Espagnole, followed by the Stirling-Maxwell collection at Pollok House, Glasgow; the holdings of the Hispanic Society of America, in New York; and the English royal collection, dispersed in palaces throughout Great Britain.

Remarkably, Louis-Philippe's paintings in Dresden have hardly been touched since their acquisition in 1853. On nine of the remaining eleven paintings from the original Galerie Espagnole, there survives fascinating evidence of their prior history: traces of the

5. Standish 1842.
6. See Louis-Philippe 1853 and Standish 1853. Baticle and Marinas 1981 erroneously thought the *Saint Matthew* to be part of an apostolate by a disciple of Luis Tristán that Baron Taylor bought on March 22, 1836, from Gabriel Bermúdez in Toledo (Baticle and Marinas 1981, annex 3-14; unaccounted).

 According to the annotations in the copy of the sales catalogue in the Christie archives kindly provided by the auctioneers, all three Standish pictures were bought through Ludwig Gruner, who was later to become head of the Dresden Kupferstichkabinett, as were all but four of the remaining Galerie Espagnole paintings. For the role Gruner played in the London sales, see also Marx 1982, pp. 42–55.
7. Baticle and Marinas 1981, no. 191, unidentified. *Verzeichniss der aus den Vorräthen der Kgl. Gemälde-Galerie zu Dresden den 13. Mai 1861 u. folg. Tage . . . zu Dresden . . . zu versteigernden Oelgemälde*, by Carl Gotthelf Bautzmann, no. 62. Although in the printed catalogue listed simply as Spanish

Fig. 13.6 Reverse of Alonso Cano, *Saint Paul*, 1645–50. Oil on canvas, 83¼ x 43¾ in. (212 x 111 cm). Staatliche Kunstsammlungen, Dresden. Photo courtesy the author

Louvre inventory numbers of 1838, the numbers corresponding to the catalogue of the Galerie Espagnole issued in its inaugural year;[8] the lot numbers of the London sale in 1853; plus a tiny stencil of the letter "B," and/or French inscriptions, usually comprising a number, an abbreviated title of the work (sometimes erroneous: "St Etienne" for Murillo's *Saint Roderick*, "Un Card[enal]" for *Saint Vasco* by Valdés Leal), and its dimensions. The works on canvas are all mounted on a similar type of stretcher (one frequently found in French and also English nineteenth-century collections; figs. 13.4, 13.5) and have been identically relined (normally 11 x 9–10 threads).[9] Works on wood, which include two of the Standish paintings, have remained largely untouched; two out of three retain the usual vegetal-fiber coating on the back. On the Standish *Death of the Virgin*, the 1853 lot number 148 is still legible, which is particularly helpful as the sales catalogue gives no hint of the material and misleadingly spells the artist's name "BONAS (Le père Nicholas)" (*sic*, for Nicolás Borràs). On the other Standish panel painting, the *Saint Onuphrius* by Pereyra, a small bar inserted to support the original panel bears the stenciled "B."

The Louvre numbers (still on seven out of the eleven paintings remaining from the 1838 group) are normally applied in black paint on the stretchers, often on all bars; sometimes the painted number is also on the canvas; sometimes the number recurs in white chalk. The Galerie Espagnole numbers (again on seven paintings) occur just once, always on the stretchers, in black chalk. The sale numbers (on at least eight paintings) appear in white chalk written directly on the canvas or wood. They are usually preceded by another number, which seems to stand for the day of the individual sale. Evidently, the sale was originally planned to be carried out in fewer days, as one reads 1–86 on the follower of Cavalier d'Arpino, 2–206 on the Zurbarán, and 2–237 on the Valdés Leal, while in the printed catalogue the second day actually started with lot 84, and the third with lot 169. The persistent presence of a Louvre number without the usual stamp that one finds on the Louis-Philippe paintings that did not come from the Galerie Espagnole (the letters "LP" surmounted by a closed crown)[10] underlines the fact that in its time the Galerie Espagnole was, despite the later decision to return its contents to the deposed king, considered an integral part of the Louvre and not the private property of the monarch.

The French inscriptions in black chalk definitely predate the 1838 inauguration of the Galerie Espagnole, as they generally appear underneath the 1838 inventory numbers. Indeed, the indication of measurements suggests that these inscriptions were conceived as guidelines in the process of relining and building new stretchers. In at least one instance, they vary considerably from the actual measurements: Cano's *Saint Paul* has been cut down on the top and bottom and enlarged on both sides; the inscriptions on it read

school and although the dimensions noted in Dresden differ slightly from those stated in the Paris catalogues, the identity of the painting is confirmed by the fact that it is quoted as Navarrete in the handwritten list of October 27, 1853. It also appears as no. 429 of a "Verzeichniß der Vorrathsbilder der Königlichen Gemälde-Galerie," revised for deacquisitioning on July 12, 1858 (Staatliche Kunstsammlungen Dresden, Königliche Gemälde Galerie Nr. 6, Bd. 1, f. 20ss.).

8. Paris 1838.

9. The two other "original" paintings, the *Saint Francis* by Espinosa and the *Carrying of the Cross* formerly attributed to that same artist, were relined in Dresden and put on new stretchers.

10. Sotheby's, Monaco, "Tableaux, Mobilier et Livres Appartenant à Mgr le Comte de Paris," July 3–4, 1993, postponed to December 14–15, 1996, pp. 8–9.

"1,60 x 2,48 m" (fig. 13.6), while the original canvas has a width of 67 cm (26⅜ in.) and, judging from the deformations along the edges, its height must have measured more than 250 cm (98½ in.). In all the other examples, the measurements written on the stretchers almost exactly match the present-day ones (follower of Cavalier d'Arpino, Carducho, Espinosa, Murillo, Orrente, Valdés Leal, and Zurbarán).

Another surprise to be found on the reverse of the *Saint Paul* by Cano was evidence that this painting, in addition to Murillo's *Saint Roderick*, had belonged to the heirs of the famous collector Francisco Pereira of Seville, whose holdings, according to Félix González de León, comprised approximately two hundred paintings.[11] Both the Cano and the Murillo bear a paper that declares, "Soy del canónigo D. Francisco Pereira" (I belong to the collection of Don Francisco Pereira), followed by a number starting with "9" in the case of the Cano and by one ending with "3" in the case of the Murillo.

The most troubling consequence of these findings is trying to decide whether the stretchers and the relinings were done prior to the departure of the paintings from Spain or even in Paris. It is clear from the evidence of the Dresden paintings that the work was conceived and realized in a brief, uniform process. The stencil "B" that appears on the Standish Pereyra would not argue against an execution in Spain, as Standish spent many years in Seville and was in close contact there with the painter Adrien Dauzats, who worked for Taylor, as well as with the baron himself, who later did so much to secure Standish's collection for France.[12] It is tempting to link the mark to José Bueno (1797–1849), the painter and restorer who was paid by Taylor for stretchers and relinings as well as for the restoration of several Galerie Espagnole paintings.[13] A close collaborator of Prado director José de Madrazo, Bueno was not only the first restorer of the Real Museo de Pinturas (from 1828) but also restorer to the court (from 1831).[14] In addition, he helped Taylor with the acquisition of no fewer than thirty-four works.[15] His applications to the Academia de Bellas Artes de San Fernando confirm that he was keen to lend his skills to other institutions as well.[16] However, other Spanish restorers also assisted in the French project,[17] and receipts alone account for the restoration of a mere twenty-one paintings, a tiny fraction of the overall endeavor. Accordingly, the sums Taylor paid for the restorations of paintings were infinitesimally small in relation to those he paid for the paintings themselves.[18] Furthermore, the unified type of stretchers and relinings suggests that a restoration campaign might just as well have been carried out in France rather than Spain. Stretchers have been replaced so repeatedly at some places and periods that it would not be entirely inconceivable that works relined in Spain in 1836 would have been relined again in Paris in 1837. In that case, the "B" might simply stand for the supplier of the stretcher bars to the Musée Royal.

Louvre archives show that from June, the month a large portion of the paintings entered France, through December 1837, when the documentation ends, there was indeed a concerted effort by the Musée Royal to treat the new arrivals. As with the restorations carried out in Dresden in 1853, however, this might have consisted mainly in preparing the works for exhibition, since the time spent on the individual works would seem rather too limited to allow for substantial intervention. Often some eight or more works were treated by only one restorer in the course of a single month. In October 1837, for example, the restorer Pierre-Julien Gaudefroy worked on twelve Galerie Espagnole paintings, while in August of the same year Jacques-Noël-Marie Frémy claimed to have treated twenty-five works, in addition to restoring the borders of the frames of thirty paintings, to restoring and

11. González de León 1844, vol. 1, p. 254.

12. See Guinard 1967, pp. 233, 241, 242, and passim. For Taylor's efforts, see his correspondence in the Archives des Musées Nationaux, Cote 029.29 Baron Taylor, as well as a letter to Dauzats published in Spadafore 1984, pp. 76–77.

13. See his receipts of April 11, July 18, and August 5, 1836, Archives Nationales, Paris, Maison du Roi et Liste Civile, dossier o⁴ 1725, Dépenses de la mission Taylor.

14. There exists a copious file on Bueno in Archivo General de Palacio, Madrid, Sección Personal, Fondo Expedientes Personales, Caja 16694. I am much indebted to Leticia Ruiz, who so generously shared her extensive documentation on the restorer. For additional information, I would like to thank Mercedes González de Amezúa from the Museo de la Real Academia de Bellas Artes de San Fernando, Madrid.

15. Sales of thirteen paintings to Taylor, Madrid, February 25, 1836; of nineteen more on March 7 of that year (three separate receipts); as well as of individual works by Tristán on April 7 and by Greco on August 17, 1836. Archives Nationales, dossier o⁴ 1725, Dépenses de la mission Taylor. Bueno also helped transport and pack a number of paintings; see the receipts by José Calcerrada and Ramón Llamera of July 16 and 17, 1836 (ibid.).

16. See Navarrete Martínez 1999, pp. 394–95, 399. To credit him with that "B" it would be essential to find the stencil on paintings for which his intervention is documented, as is the case with some works in the Escorial or with the head of St. John the Baptist attributed to Ribera in the Academia de Bellas Artes de San Fernando, Madrid (ibid., pp. 394–95).

17. See the receipts from Ceferino Araujo, Madrid, July 15, 1836; Pedro Bueno, who worked with (his brother?) José Bueno, at the Museo de Pinturas, Madrid, July 18, 1836; and Joseph Escazena, Seville, January 31, 1837. Compare also the apportionment of materials by Fulgencio Emperador (Madrid, August 19, 1836) and José Freyne (probably Seville, October 1836).

18. Altogether Taylor paid 1,159,658.40 francs for (what he considered to be) Spanish paintings, but only 4,116.85 francs for painting conservation (as compared to 3,972.39 francs for transport). Archives Nationales, dossier o⁴ 1725, Dépenses de la mission Taylor.

Fig. 13.8 List of paintings restored by Pierre-Antoine Marchais, August 1837. The second item refers to Carducho's *Saints Francis, Gonzalo, and Bernardino of Sienna*, now in Dresden (see fig. 13.5). Archives des Musées Nationaux, Paris

varnishing twenty-two other pictures destined for the palace of Compiègne, and to doing some work for the Grand Salon. Some bills even speak of work done in (not for) the Galerie Espagnole.[19] Moreover, in several instances the documents mention objects that had already been dealt with in Spain. In one instance, on June 18, 1836, Serafino García de la Huerta in Madrid charged 674 reales for the stretcher, relining, cleaning, and fills of the Dresden Carducho (bought three months earlier from a convent in Madrid; figs. 13.5, 13.7); it was "cleaned and restored" again by Pierre-Antoine Marchais in August 1837 (fig. 13.8). Other Dresden paintings for which treatment in Paris is documented are the *Saint Paul* by Cano, billed by Frémy in August 1837, and *Jacob at the Well* by a follower of Orrente, done by François Gallier that same month.

Unfortunately, observations on the paintings themselves in this context are as inconclusive as the Spanish and Parisian documents. Often the 1838 Louvre number is written on all of the stretcher bars, suggesting that the stretcher itself had at some stage been dismembered. In the case of the Murillo (figs. 13.4, 13.9), an exchange of the two central horizontal bars proves that its stretcher was indeed disassembled after the French inscription had been written on it (some of the Louvre numbers are also upside down). Yet the canvas bears the 1838 number as well. The most logical supposition for a glue relining of the kind employed for the Murillo would be that it was done on the present stretcher

Fig. 13.9 Detail of fig. 13.4, showing part of the Louvre inventory number and the French inscription "Etienne 2 m 06." Photo courtesy the author

itself, but in this example that is difficult to reconcile with the remaining evidence. To add to the confusion, the Pereyra labels predating the Taylor mission have been glued down to the present relining, but are hidden to the eye under the central bar of the stretcher. Even a small "Bartolomé" written on the Murillo stretcher does not necessarily push the balance in favor of Madrid, since it may just be an abbreviation of the artist's name.[20] What at least becomes crystal clear from a bill submitted by Jean-Baptiste Gillet in Madrid, dated September 13, 1836, which provides intriguing insight into the details of the wrapping,[21] as well as from the notes of Dauzats in May 1837, is the fact that the paintings were transported from Spain to France rolled up with stretchers and frames packed separately.[22] If they were shipped in that manner from Paris to London, the papers covering all edges of the canvases would necessarily have been added in England (they remain unopened on a number of the Dresden paintings). These paper protections cannot postdate the London sales, as they also reappear on works from the Galerie Espagnole that did not end up in Saxony (see below). The Dresden canvases thus definitely traveled on their stretchers from London to Dresden.

The importance of all these highly technical matters lies in the fact that the pieces bought for Dresden represent a haphazard choice made from the seven hundred paintings of the Galerie Espagnole and the Musée Standish, combining works with very different provenances and circumstances of acquisition. The consistency of the information they provide makes it highly probable that all of the more than four hundred paintings of the Galerie Espagnole, and to a certain extent those from the Musée Standish, had been treated in a very similar manner. This hypothesis is supported by the numbers that form part of the pre-1838 French inscriptions and suggest a sequence that leads at least to the number 154: "26" on the Orrente, "30" on the Espinosa, "57" on the Carducho, "77" on the Cavalier d'Arpino, "97" on the Murillo, and "154" on the Valdés Leal. The original list to which these numbers belong has yet to be discovered, perhaps somewhere among Baron Taylor's papers.

It is hoped that this fragmentary evidence can and will be of great help in identifying additional paintings from the collection of the Galerie Espagnole, the majority of which

19. See Gaudefroy's bill of August 1837; for this and all bills mentioned in this context, see Archives des Musées Nationaux, Cote MM 1837, Carton II.

20. Still to explain are the large old numbers "5" and "31" written on the Carducho and Orrente canvases, respectively, as well as the large painted letters and numbers cut at the edges on the Cano and Valdés Leal stretchers.

21. Archives Nationales, dossier o⁴ 1725, Dépenses de la mission Taylor. It contains the costs of making the cases for a substantial number of rolled canvases and lists the packing of seventy-five more paintings; wooden panels; frames and the wrapping of frames; stretchers; and removing canvases from the stretchers.

22. See Guinard 1967, pp. 262, 263, 240. Taylor was obsessed to know whether the cases were stored in dry places, ibid., pp. 166, 169, 181.

23. I would like to thank Martha Wolff and Frank Zuccari in Chicago, Aidan Weston-Lewis in Edinburgh, Arnauld Brejon de Lavergnée in Lille, and Fuensanta de la Paz and Mercedes Vega Toro in Seville for their very welcome cooperation.

24. According to technical assistants at the museum, the Prado's *Saint Jerome* from the same series (no. 2593) retains an analogous stretcher but no old inscriptions.

25. The inscription also notes a height of 97 cm (38¼ in.), which surpasses markedly the present one of the painting and is more in line with that of the other Louis-Philippe version of the theme, a work in the Musées Royaux des Beaux-Arts, Brussels (Baticle and Marinas 1981, no. 66).

remains unaccounted for; other institutions, unfortunately, have been less keen to preserve the paintings' original structures. In fact, the large (and still not securely attributed) *Adoration of the Shepherds* acquired by the National Gallery in London in 1853 (no. 232; Baticle and Marinas 292) was relined only two months after the Christie sale, while the National Gallery's *Saint Francis* by Zurbarán (no. 230; Baticle and Marinas 356; fig. 2.13) has been relined no fewer than three times since then, suggesting that these early relinings did not necessarily improve the stability of the paintings. As a matter of record, all of the Louis-Philippe relinings in Dresden were done with a high degree of perfection and remain admirably stable.

In Britain there has been a tendency to preserve at least the old stretchers, whereas until well into the 1960s in American museums there was a preference to remove them, often not for the first time. Paintings offered for sale over decades have suffered even more alterations. Looking at Galerie Espagnole paintings outside Dresden, therefore, often leads to disappointments. The *Balaam and His Ass* by Luca Giordano in Berlin (Gemäldegalerie, cat. 404B; Baticle and Marinas 11) seems to have been relined and put onto a new stretcher about 1900; two paintings in the Brussels museum (portraits of Mary of Austria and Marguerite of Parma attributed to Antonis Mor and Alonso Sánchez Coello, respectively, inv. nos. 1296, 1297; Baticle and Marinas 68, 69) received the same treatment at a slightly earlier date. Both the *Lamentation of Christ* by Jaime Huguet and the *Crucifixion* by El Greco, sole reminders at the Louvre of that glorious past (inv. 8562bis, RF 1713; Baticle and Marinas annex 33, 262), do not retain their original backs. No traces seem to be left on paintings in Chicago (Murillo, *Christ and John the Baptist*, and an anonymous *Job*; Baticle and Marinas 162, 331); Edinburgh (Zurbarán, *Immaculate Conception*; Baticle and Marinas 342); Lille (Goya, *Young Women [The Letter]* and *Old Women [Time]*; Baticle and Marinas 104, annex 24); and Seville (El Greco, *Portrait of His Son*; Baticle and Marinas 269).[23]

However, my search for other remnants of the material history of the Galerie Espagnole has not been entirely in vain. The stretcher, relining canvas, canvas seams, and paper coating on the borders of a *Dominican Martyr* by Valdés Leal in the Museo del Prado, Madrid (no. 2582; Baticle and Marinas 284), are exactly like those we find in Dresden. The Louvre inventory number (310) appears on all bars in the usual black paint and is repeated on the central vertical bar in white chalk. The Galerie Espagnole number (274) appears in black chalk on a crossbar, and the sale number (455) is given in white chalk on the canvas itself. The "B" stencils and the French inscription with the dimensions are evident as well. The sole obstacle is a modern label.[24]

The *Saint Peter* by Alonso Cano in the Chapel of Lancing College, West Sussex, England (Baticle and Marinas 22) has been relined but still has its Louis-Philippe stretcher, which means that the painting also preserves the added strips on the sides, analogous to those in its Dresden counterpart. In addition to a handful of "B" marks, the stretcher bears the Galerie Espagnole number. First given as "23," it was changed to "22"; the Dresden counterpart's number was corrected accordingly, from "22" to "23." Both the Archduke Rudolph and the Juana de Austria portraits by Coello at Hampton Court (inv. 405798, 407223; Baticle and Marinas 71, 67) have been relined, but on the stretcher of Juana's likeness one still finds a "B," the "66" of the 1838 Galerie Espagnole catalogue, and, even more welcome, a French inscription analogous to those in Dresden, enlarging the list to be reconstructed to number "186."[25] On the *Ecce Homo* by Morales in the Hispanic Society of

America, New York (Baticle and Marinas 144), the "252" from the 1853 London sale still exists. And, according to the files on its acquisition, a *Saint Francis* by Zurbarán formerly in the Metropolitan Museum (Baticle and Marinas 355) carried the numbers "381" and "345," quite obviously relating to the Louvre and the Galerie Espagnole classifications. Unfortunately, when this painting was deaccessioned over ten years ago, the sales catalogue made no mention of those numbers.[26] Finally, a standard type of stretcher with the 1842 catalogue number on top of it used for Murillo's *Two Trinities* in Stockholm (NM 4229) underlines once again how similar in treatment the Standish paintings were to those from the original Galerie Espagnole inaugurated in 1838.[27]

How useful this information can be is illustrated by the Murillesque *Saint Joseph with the Christ Child* (Baticle and Marinas 156), which, according to another recent sales catalogue,[28] retains the "152" from the Galerie Espagnole. However, the number is not properly identified in the catalogue, and the Galerie Espagnole provenance is not explicitly stated in the list of previous owners. The stencil "Y" mentioned in the Sotheby's catalogue might refer to a misread (and sometimes misstamped) "B."

Knowledge of the Dresden findings could also be productive in regard to paintings for which a Galerie Espagnole provenance remains hypothetical. Among such cases are the *Martyrdom of Saint Bartholomew* in the Museo Nacional d'Art de Catalunya in Barcelona (Baticle and Marinas 244?), whose stretcher is rather old but of a different type, or the Riberesque *Saint Peter* in Lyon (since 1873; inv. no. x-807b), which Valérie Lavergne-Durey proposes to link to Baticle and Marinas 234.[29] It has since been relined and put on a new stretcher, but a photograph of the previous state shows a stretcher that looks very much like those in Dresden; a large painted "156" on it also strongly recalls the Louvre numbers. The Lyon painting was given to the Louvre in 1869, but unfortunately the number does not match that of the 1838 inventory and must refer to another classification. The *Annunciation* by Pedro Romana, bequeathed by the Reverend Alexander Dyce in 1869 to the Victoria and Albert Museum, London, illustrates both the benefits of these findings and some possible outlines for future research. Although it has been named as a possible candidate for the Galerie Espagnole by Baticle and Marinas,[30] and has indeed got the "B" stencils on the bars of its cradle, its numbers simply do not match either those for the Galerie Espagnole or those for the Musée Standish. As such, this painting becomes an ideal candidate for continued exploration of what this stencil really means.[31]

26. Sotheby's, New York, "Old Master Paintings," June 2, 1989, lot 4.
27. I am deeply indebted to John Rothlind for checking the backs of the Stockholm paintings. Unfortunately, no old traces seem to be visible on the backs of the Nationalmuseum's Zurbarán (NM 5382) and Collantes (NM 6140); for the paintings themselves, see Maurer 2001, nos. 18, 30, 3.
28. Sotheby's, New York, "Important Old Master Paintings," January 25, 2001, lot 174.
29. Lavergne-Durey 1993.
30. Baticle and Marinas 1981, p. 73 n. 3. See also Kauffmann 1973, pp. 243–44.
31. The Murillo exhibition in Fort Worth–Los Angeles 2002 contained a whole series of Galerie Espagnole paintings, for which such information could be very useful.

Fig. 14.1 (cat. 193) Henri Regnault, *Juan Prim, October 8, 1868*, 1869. Oil on canvas, 124 x 101½ in. (315 x 258 cm). Musée d'Orsay, Paris

Chronology

Deborah L. Roldán

I am indebted to Catherine Donnellier, Kathryn Calley Galitz, Lucía Martínez, and Elizabeth Pergam for their research assistance, to Gina Guerra for her help with illustrations, and to Geneviève Lacambre and Gary Tinterow for their advice.

1779
October In Spain, Minister Floridablanca issues decree, sanctioned by King Charles III, that formally forbids the exportation of Spanish works of art. "It had been brought to the king's attention that foreigners in Seville were buying all the Murillos they could acquire, 'openly or surreptitiously,' and it was decided thereupon that 'from this day hence' exportation of paintings by 'authors no longer living' would be forbidden."

See Lipschutz 1972, p. 7. Guillaumie-Reicher 1936, p. 409.

Charles-Claude Flahaut, comte de la Billarderie d'Angiviller (1730–1809), director-general of royal buildings under Louis XVI and creator of the future Musée du Louvre, expresses interest in adding Spanish art to the royal collections in a letter to Charles-François de La Traverse, an aide to the French ambassador in Madrid: "I know there must be paintings by the great masters lost and forgotten in the attics of Spain, which the dealers have yet to explore. It occurred to me that one ought to be able to find inexpensive Titians, Velasquets, Murillos, etc., which would enhance the king's magnificent collection at little cost. Please let me know if you foresee being able to find . . . any paintings or other curiosities."

"Je sais qu'il y a des tableaux des grands maîtres perdus et oubliés dans les greniers en Espagne, je sais que les marchands n'y ont pas encore penetré. J'avois pensé qu'on avrait pu trouver à bon marcher des Titiens, des Velasquets, des Murillos, etc., et qu'on pourroit augmenter facilement et fortifier la magnifique collection du Roi le tout à bon marché; marquez moi je vous prie si vous prévoyés pouvoir trouver dans des maisons particulières dans des gardemeubles des tableaux ou autres curiosités." Archives Nationales, O1 1915 (79), f. 155, quoted in McClellan 1994, p. 63 n. 64.

1785
Murillo's *Beggar Boy* (A 390), *Christ on the Mount of Olives* (A 242), and *Saint Peter before Christ at the Column* (A 244) exhibited in the Louvre's Pavillon Neuf. The *Beggar Boy* was purchased from the 1782 Radix de Sainte-Foy sale, and the latter two from the 1784 comte de Vaudreuil sale. All three were bought by the dealer Lebrun (see 1807), who then sold them to Louis XVI.

Meslay 2001, p. 78.

1788
Jean-François de Bourgoing (French, 1748–1811), after an eight-year residence in Spain (1777–85) during which he served as secretary to the ambassador and then as acting ambassador, publishes his extremely successful study, *Nouveau voyage en Espagne, ou Tableau de l'état actuel de cette monarchie*. An extensive section on Spanish painting lists works he saw there; it is among the first published mentions of Goya.

Bourgoing 1788, vol. 1, p. 248.

1789
Spring Outbreak of the French Revolution; Bastille stormed on July 14.

November 16 In Madrid, Charles IV authorizes the creation of the Compañía para el Grabado de los Cuadros de los Reales Palacios to produce engravings after various masterworks in the royal collection, with an emphasis on Spanish paintings; it will eventually produce some fifty different engravings (among them, fourteen after Velázquez, eight after Ribera, five after Murillo, and one each after works by Zurbarán and Cano), twenty-four of which are published. The Compañía produces engravings between 1791 and 1796 but, plagued by economic difficulties, ceases operation altogether in 1807.

Carrete Parrondo et al. 1987; Carrete Parrondo 1979.

Spain and England declare war on the French Republic.

1790
Goya's eleven engravings after the paintings of Velázquez (G-W 88–117), along with his etchings *El Agarrotado* (G-W 122) and *San Francisco de Paula* (G-W 55), enter the Real Calcografía, Madrid.

José Manuel Matilla, "Gabinete Francisco de Goya," in Madrid 1994b, p. 194.

1793
January 21 Louis XVI (1754–1793), cousin to Spanish king Charles IV, executed in France.

March 7 France declares war on Spain.

August 10 Muséum Français, Paris (predecessor of Musée du Louvre) (fig. 14.2), opens as a public institution on the one-year anniversary of the insurrection at the Tuileries. The collection lists ten Spanish paintings. The four works by Ribera (L'Espagnolet) are no longer attributed to him (nos. 3, 9, 310, 317).

 3. L'Espagnolet, *Saint Paul* (location unknown)
 9. L'Espagnolet, *Saint Pierre* (perhaps Mola's *Saint Pierre en prière*, Musée du Louvre, Paris)
 90. Murillo, *La Vierge, l'enfant Jesus, Ste. Anne, St. Jean; au-dessus le Père Eternel dans sa gloire* (*Holy Family* [*La Sainte Famille*], purchased 1786, [A 184]) (fig. 14.3)
 118. Murillo, *Une femme avec un enfant tenant un chapelet* (*Virgin of the Rosary* [*Vierge au chapelet*], purchased 1784, now Musée Goya, Castres [A 166])
 123. Murillo, *Le Christ attaché a la colonne; s. Pierre à ses pieds* (*Saint Peter before Christ at the Column* [*Le Christ à la colonne*], purchased 1784 [A 244])
 129. Murillo, *Jésus au jardin des Olives* (*Christ in the Olive Grove* [*Le Christ au jardin des oliviers*], purchased 1784 [A 242])

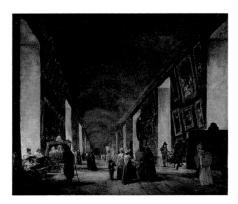

Fig. 14.2 Hubert Robert, *The Grande Galerie of the Louvre between 1794 and 1796*, 1794–96. Oil on canvas. Musée du Louvre, Paris

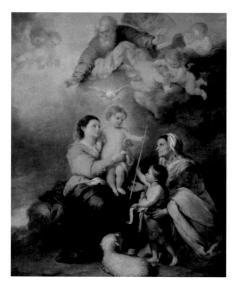

Fig. 14.3 Bartolomé Esteban Murillo, *The Holy Family*, ca. 1670. Oil on canvas. Musée du Louvre, Paris

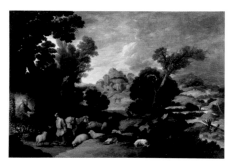

Fig. 14.4 Francisco Collantes, *The Burning Bush*, 2nd quarter 17th century. Oil on canvas. Musée du Louvre, Paris

258. Dominique Féti [Domenico Fetti], *Le buisson ardent* (actually Collantes's *The Burning Bush*, documented in 1679) (fig. 14.4)

310. Joseph Ribera, dit L'Espagnol, *Un buveur* (*A Drinker*, now attributed to Cesare Fracanzano, Compiègne)

317. L'Espagnolet, *Un soldat appuyé sur sa lance* (*Soldier Leaning on His Lance*, now attributed to Cesare Fracanzano, Compiègne)

356. Murillo, *Un enfant assis au soleil* (*Young Beggar Boy* [*Le jeune mendiant*], purchased 1782 [A 390])

Paris 1793.

Also in the French royal collection at this time are an anonymous *View of the Escorial* (in Louis XIV's collection by 1709) and the Velázquez workshop portrait of the Infanta Margarita (fig. 1.2).

The *Infanta Margarita* is one of nineteen or twenty portraits of the Habsburg royal family by the workshop of Velázquez sent to the French court of Louis XIV by the Spanish monarch

Philip IV. Commissioned by Anne of Austria, mother of Louis XIV and eldest sister of Philip IV, in March and September 1654, they were placed in her Louvre apartments (some were lost due to neglect, others were sold at the Nesle sales on July 24, 1797, and January 12, 1798, while yet others were sent to Versailles, where at least eight portraits remain).

See J. Brown 1986, p. 217; Lebrun 1809, vol. 2, p. 22.

Fourth, and final, volume of Antonio Ponz's *Viaje de España* published in Spain (first volume printed in 1772). It includes a letter from Anton Raphael Mengs, court painter to Charles III, that recommends the formation, in the royal palace of Madrid, of a "gallery . . . for the purpose of creating understanding of the differences among [the painters]." It is not realized.

"galería . . . con el fin de hacer comprender la diferencia esencial que hay entre [los pintores]." Quoted in Antigüedad 1987b, p. 68.

Several engravings after Spanish masters are issued by the Compañia del Grabado in Madrid: Carmona's engraving after Velázquez's *Los Borrachos* (edition of 700, 400 sold by 1807), Ametller's engraving after Velázquez's *Waterseller of Seville* (edition of 700, 323 sold by 1807), P. Audoin's engraving after Velázquez's *Las Meninas* (not published), and Selma's engraving after a Murillo (edition of 1,100; 412 sold by 1807).

Carrete Parrondo 1979.

1795

July 22 Manuel Godoy (Spanish, 1767–1851), Charles IV's prime minister (1792–1808), signs the Peace of Basel treaty to end the war with France. Spain cedes to France the eastern half of the island of Santo Domingo (Hispaniola). Charles IV bestows upon Godoy the title of Principe de la Paz (Prince of Peace).

1796

Ca. August 18 French-Spanish alliance formed with the signing of the Treaty of San Ildefonso. In October, war is declared on Britain to protest the seizure of Spanish ships carrying goods from America.

In London, Matthew Gregory Lewis's (1775–1818) novel *The Monk*, a frightening thriller set in a Spanish monastery, creates a sensation soon after its publication. It will be published in French in 1796 (as *Le Jacobin espagnol*) and 1799 (as *Le Moine*). The text eventually serves as the subject of several drawings by Vivant Denon, which are stylistically inspired by Goya's *Los Caprichos*, a set of which Denon owned by 1809 (see 1809, 1826).

1797

Jean-Jacques de Boissieu (French, 1736–1810) carries out the engraving *Les Pères du désert (Desert Monks)*, a pastiche featuring Zurbarán's *Saint Francis* (fig. 1.8), then in Boissieu's possession (purchased from the Convent of the Colinettes in Lyon). The painting will eventually be purchased from him by the Musée des Beaux-Arts, Lyon, in 1807 (see 1807).

The artist Anicet-Charles-Gabriel Lemonnier (French, 1743–1824) purchases Velázquez's *Democritus* (then attributed to Ribera [fig. 1.7]). It will enter Rouen's Musée des Beaux-Arts in 1822.

Bourgoing (see 1788) publishes *Tableau de l'Espagne moderne*, a revised edition of his *Nouveau voyage en Espagne*; it reflects his second trip to Spain (1792–93).

1798

July 3 Ferdinand Guillemardet (French, 1765–1809) appointed the National Convention's French ambassador to Spain (1798–99) on May 20, arrives in Madrid and immediately commissions his portrait from Goya, official painter to the Spanish court. Guillemardet's portrait (Musée du Louvre, Paris [G-W 677]) is finished later in the year and exhibited in Madrid in 1799 (see 1799).

Mariano Luis de Urquijo, Charles IV's first interim secretary of state (1798–1800), proposes to transfer to Madrid the painting cycle by Murillo and Valdés Leal at the Hospital de la Caridad, Seville; his goal is to follow the European model and "to form at the court schools and museums that can not be supported in the provinces." Copies would remain in the Caridad.

Though the project is never realized, Urquijo, as secretary of state in Joseph Bonaparte's occupation government, will oversee Joseph's plans for a national museum in Madrid (see December 1809).

"formar en la corte escuelas y museos que no se pueden mantener en las provincias." Quoted in Antigüedad 1987b, p. 68.

1799

January–February First printing of Goya's eighty-plate series *Los Caprichos* (fig. 5.6). In February they are sold for 320 reales in a shop in the artist's apartment building. Twenty-seven sets are purchased in two days before they are removed from sale (the duque and duquesa de Osuna buy four sets on January 19; Ferdinand Guillemardet most likely acquires, or is given, a volume as well).

April 7 (18 germinal an VII) Musée Central des Arts, Paris, partially reopens its Grande

Galerie with works of the French and Northern schools (the second half of the gallery, composed of the Italian school, will reopen on Bastille Day [July 14], 1801).

July Goya's portrait of Guillemardet (G-W 677) exhibited at the Real Academia de Bellas Artes de San Fernando, Madrid, along with a series of six witchcraft scenes painted for the duque and duquesa de Osuna (G-W 659–664).

November 30 Charles-Jean-Marie Alquier (French, 1752–1826) named ambassador to Spain, where he serves until 1800. Like his predecessor, Alquier will acquire at least one work by Goya, an oil sketch for his tapestry *Autumn,* or *The Grape Harvest* (fig. 5.3), between 1808 and 1813. It will remain in the collection of his heirs, in Nantes, until 1939.

Lille–Philadelphia 1998–99, p. 142 (Lille ed.)

December 12 Napoleon Bonaparte (1769–1821) elected first consul of France (following the coup d'état of November 9, 1799 [18 brumaire an VIII], in which he overthrew the Directory).

1800

March Guillemardet, former French ambassador to Spain, returns to Paris from Madrid, accused of inactivity and an inability to understand the Spanish people and culture. He has with him his portrait by Goya along with another small Goya portrait, *Woman in Spanish Costume* (fig. 2.23). Also in his collection is a volume of *Los Caprichos.* These are works that Delacroix will see sometime during 1818–19 (see 1818), at the height of his friendship with the ambassador's sons Félix and Louis (Guillemardet also was a colleague of Delacroix's father and a witness at the registration of Delacroix's birth in 1798).

October 1 Second Treaty of San Ildefonso signed by France and Spain; Spain agrees to be France's ally in all wars (see 1796).

November 8 (17 brumaire an IX) Lucien Bonaparte (French, 1775–1840) (fig. 14.5), Napoleon's younger brother, leaves for Madrid to begin his tenure as "Ambassador of the Republic to Madrid." He arrives in Madrid on December 6 and will serve until June 28, the date he submits his resignation in a letter to Napoleon. Accompanying him is the painter Guillaume Guillon Lethière (French, 1760–1832), who will serve as Lucien's art adviser and buyer. Also joining Bonaparte, as his embassy attaché, is the writer Alexandre-Louis-Joseph de Laborde (French, 1773–1842), whose five-year journey through Spain (1800–1805) will culminate in his *Voyage pittoresque et historique de l'Espagne* (published between 1806 and 1820; see 1806).

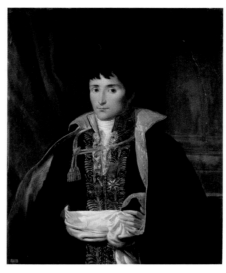

Fig. 14.5 Robert Lefèvre, *Lucien Bonaparte,* 19th century. Oil on canvas. Musée National des Châteaux de Malmaison et de Bois-Préau, Rueil

Juan Agustín Ceán Bermúdez's six-volume *Diccionario histórico de los más ilustres profesores de las bellas artes en España* published in Madrid. This seminal work on the Spanish school will serve as a guidebook for Napoleon's troops looting in Spain (see 1810). The other Spanish reference source of note is Antonio Palomino's *Museo pictórico* (Madrid, 1715–24), published in French in 1749.

1801

March 21 Lucien Bonaparte and Manuel Godoy sign the Treaty of Aranjuez. In gratitude, Charles IV gives Lucien twenty canvases from the Palacio del Buen Retiro and 100,000 ecus of diamonds, which forms the foundation of his fortune.

Edelein-Badie 1997, p. 330.

After submitting his resignation on June 28, Lucien departs Madrid on November 12. Among the artworks with which he returns is Velázquez's *Lady with a Fan* (Wallace Collection, London [LR 79]) and a portrait of Charles IV by Goya, a gift from the king (location unknown). His collection will be engraved for a catalogue in 1812 (see 1812), and the works will eventually be sold in a series of auctions in London and Paris (see 1816).

March 27 Spain allies itself with Napoleon and declares war against Portugal, initiating the War of the Oranges.

April 1 In Madrid, Bernardo de Iriarte (Spanish, 1735–1814), vice-protector of the Real Academia de San Fernando as of 1792, writes to the secretary of state Pedro Ceballos about the covert art buying of the new ambassador Lucien Bonaparte: "Shortly after the arrival of Lucien Bonaparte to Madrid, I understood, through one of his retinue,

that he proposed to acquire them [the paintings] for France, which I regarded as the looting of fine art relics in Spain by the [French] Republic during peacetime, as they also sacked Flanders, Holland, and later Italy while at war. I see that Lucien confirms and carries out his plan."

"Poco después de la llegada de Luciano Bonaparte a Madrid comprehendí, por uno de los de su séquito, se proponía adquirir para enviarlas a Francia, lo cual se me figuró una especie de saqueo de las reliquias de las Bellas Artes que la República se proponía hacer en España en santa paz, al uso del executado en guerra abierta primero en Flandes y Holanda y luego en Italia. Veo que Luciano comprueba y efectúa de hecho su programa." Sánchez Cantón 1937a, pp. 165–66.

July 14 (Bastille Day) (25 messidor an IX) Musée Central des Arts displays in the Grande Galerie its paintings of the Lombard and Bolognese schools. Listed in the catalogue, among the Italian school, are two small oils by Murillo: no. 925, *Christ on the Mount of Olives (Le Christ au Jardin des Olives),* and no. 926, *Saint Peter before Christ at the Column (La Flagellation),* Musée du Louvre, Paris (A 242, 244). The pair had entered the collection of Louis XVI in 1784.

Paris 1801, cited in Paris 1999–2000, p. 163, no. 171.

1802

Early 1802 David's equestrian portrait *Napoleon Crossing the Alps* (Château de Malmaison) (fig. 1.15) exhibited in the Palacio Real, Madrid; it was commissioned by Charles IV, sometime between September 1799 and August 1800, in honor of the first Treaty of San Ildefonso (see 1796). Charles IV also commissioned two equestrian portraits from Goya, in late 1799, of himself and his wife (G-W 776, 777), intended for Napoleon but never sent to Paris.

The David painting may have hung in the same room of the palace with the equestrian portraits of *Charles V at Mühlberg* by Titian and Velázquez's *Count-Duke of Olivares on Horseback* (LR 66) (fig. 1.16).

Gerard-Powell 1998, pp. 407–9.

March 25 Peace of Amiens between Britain and France.

August 2 Napoleon made first consul for life.

November 19 (28 brumaire an X) Napoleon names Dominique-Vivant Denon (French, 1747–1825) (fig. 14.6) to the new position of director-general of the Musée Central des Arts, soon to be the Musée Napoléon, with an annual salary of 12,000 francs. As director (serves 1802–14), Denon, in the wake of Napoleon's conquests in Europe, undertakes five voyages to recover works of art seized from conquered countries, traveling to Italy (1805–6, 1811), Germany

Fig. 14.6 Jean-Baptiste Mauzaisse, after René Berthon, *Baron Vivant Denon in His Office*, ca. 1813. Engraving. Musée du Louvre, Paris

(1806–7), Spain (November 1808–January 1809), and Austria and Germany, where he learns lithography (1809).

1803

January Denon's first exhibition as director opens at the Musée Central des Arts, featuring works by Raphael that had entered the museum as a result of recent conquests.

Paris 1999–2000, p. 226.

January Léon Dufourny (French, 1754–1818), architect and former administrator of the Musée Central des Arts (January 1797–October 1800), in Italy as of May 1801 to recover works seized during the Napoleonic campaigns in Rome and Naples, returns to Paris. Among the paintings he brings back is Ribera's *Adoration of the Shepherds* (Musée du Louvre, Paris [PS-S 201]) (fig. 2.11), which is a gift—presented in 1802—from Ferdinand IV (1751–1825), king of Naples, to the French government as recompense for works of art removed by Neapolitan troops from the Church of San Luigi dei Francesci in Rome.

July 7 Goya writes to the secretary of state offering the copperplates of *Los Caprichos*, as well as 240 unsold sets of the prints (Goya retained several for himself), to Charles IV in exchange for an annual royal pension of 12,000 reales so that his son can study art abroad. The proposition is agreed to in a letter of October 6, and the plates eventually are deposited in the Real Calcografía, Madrid.

July 22 Musée Central des Arts is renamed the Musée Napoléon at the suggestion of Denon: "There is a frieze over the door awaiting an inscription: I think that 'Musée Napoléon' is the only one that suits it."

"Il y a une frise sur la porte qui attend une inscription: je crois que musée Napoléon est la seule qui y convienne." Letter from Denon to Napoleon, Paris, July 14, 1803, cited in Paris 1999–2000, pp. 140, 145, no. 126, and Denon 1999, vol. 2, p. 1248, no. AN 10.

August 15 On Napoleon's thirty-fourth birthday, Denon inaugurates the first exhibition of old-master paintings in the Grand Salon of the Musée Napoléon. Included in the exhibition are works seized in Venice, Florence, Turin, and Bologna, as well as three works from Naples, among them Ribera's *Adoration of the Shepherds* (Musée du Louvre, Paris) (fig. 2.11). Among the paintings from the French royal collections that Denon includes in the exhibition are two Murillos, *Holy Family* (Musée du Louvre, Paris, [A 184]) (fig. 14.3) and *Beggar Boy* (Musée du Louvre, Paris, [A 390]) (fig. 2.32).

Paris 1803, no. 474; see also Paris 1999–2000, p. 164, no. 173.

Third edition of Bourgoing's *Tableau de l'Espagne moderne* published in Paris and Strasbourg.

Taking advantage of the panic induced by Napoleon's southern advance, British residents in Spain begin to buy Spanish paintings from convents, monasteries, and churches.

France and Britain renew war. Spain declares war on Britain.

Louisiana Purchase: United States buys the Louisiana Territory from France.

1804

May 18 Napoleon named emperor by the French Senate.

May 19 Napoleon appoints Jean de Dieu Soult (1769–1851) (fig. 14.9) marshal of France and colonel-general of the Imperial Guard. In 1808, after his victory at Königsberg (1807), he becomes duc de Dalmatie and heads the Second Army Corps in Spain. He and his troops will occupy Seville for four years (1808–12); in the process, Soult will acquire the largest private collection of Spanish painting of his time.

Willesme 1987, p. 106.

December 2 Napoleon crowns himself emperor of France at the Cathedral of Notre-Dame de Paris (fig. 14.10).

First three volumes of Joseph Lavallée's eleven-volume *Galerie du Musée Napoléon* published. Of the numerous works of art listed, each accompanied by an extensive description and an engraving, only four Spanish paintings are included: Murillo's *Christ on the Mount of Olives* (A 242) and *Beggar Boy* (A 390) (fig. 14.7), and Ribera's

Fig. 14.7 After Bartolomé Esteban Murillo, *Le Petit Mendiant (Young Beggar Boy)*, 1804. Engraving. From Lavallée 1804–28, vol. 3, pl. 155

Fig. 14.8 After L'Espagnolet (Ribera), *L'Adoration des Bergers (Adoration of the Shepherds)*, 1804. Engraving. From Lavallée 1804–28, vol. 3, pl. 163

Fig. 14.9 Anonymous, *Marshal Soult* (detail), 19th century. Engraving. Musée National des Châteaux de Malmaison et de Bois-Préau, Rueil

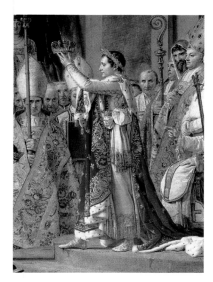

Fig. 14.10 Jacques-Louis David, *The Coronation of Napoleon in Notre-Dame* (detail), 1806–7. Oil on canvas. Musée du Louvre, Paris

Adoration of the Shepherds (PS-S 201) (fig. 14.8). Murillo's *Immaculate Conception* (A 41) (fig. 1.20), acquired in 1817 from the Soult collection, appears in the final volume in 1828. All are listed among the Italian school.

Christ on the Mount of Olives appears in volume 1, Beggar Boy and Adoration of the Shepherds in volume 3. The remaining volumes will be published in 1807, 1814, and 1828, though the catalogue is retitled Galerie du Musée de France *with the fifth volume in 1814.*

First of two enormous art auctions held in Paris "to turn superfluous articles into money for military purposes" (second sale held in 1811).

Quynn 1945, p. 445.

1805

October 21 Admiral Horatio Nelson's British fleet destroys the combined naval fleets of France and Spain off Cape Trafalgar, Spain.

Pennsylvania Academy of the Fine Arts founded in Philadelphia. In 1811 it begins annual art exhibitions (to continue until 1969). The museum building opens in 1876.

1806

First volume of Laborde's *Voyage pittoresque et historique de l'Espagne* published in Paris (1806–20). The comprehensive, oversize guidebook through Spain includes engravings of artistic, architectural, and geographical monuments. The remaining three volumes are published in 1811, 1812, and 1820; it is translated into Spanish (1807) and German (1809–11). Engravings after nine Spanish paintings appear in the 1820 volume (see 1820).

Laborde was the son of a banker of Spanish origin. In 1800 he traveled to Spain as the embassy attaché of Lucien Bonaparte. From 1800 to 1805 he traveled throughout the peninsula with sketch artists compiling materials for *Voyage pittoresque et historique de l'Espagne*; it was an expensive book financed through subscription by the Spanish court (Charles IV of Spain ordered fifty sets) as well as by other Europeans. The War of Independence brought a stop to the publication; to complete it, Laborde put up his fortune.

See García-Romeral Pérez 1999.

Laborde's *Itinéraire descriptif de l'Espagne et tableau élémentaire des différentes branches de l'administration et de l'industrie de ce royaume* will be published in 1808 in Paris (2nd ed., 1809).

1807

August–October Jean-Baptiste-Pierre Lebrun (French, 1748–1813), picture dealer, collector, writer, and painter (and husband of the painter Élisabeth Vigée-Lebrun), is in Spain to purchase pictures. Lebrun's commercial trip through Europe (1806–8) will result in the purchase of more than 600 works of art, a portion of which will be sold in a five-day auction in Paris in March 1810 (see 1810). A portion of the collection, 179 works, will be engraved for his catalogue *Recueil des gravures . . . d'après un choix de tableaux . . .* , which will be published in 1809 (see 1809).

Bailey 1984, p. 36.

"Spain," he writes, "is a mine of riches in works of art, formed from all the schools of painting. My admiration of many of their most celebrated masters, which are perfectly unknown out of Spain itself, excited in me a desire of carrying off examples of their works; but great obstacles opposed themselves to my projects."

"L'Espagne est une mine de richesse de l'art, formée de toutes les écoles. Mon admiration me donna bientôt le désire d'arracher à l'oubli plusiers maîtres célèbres qui sont inconnus de tout ce qui n'est pas l'Espagne; mais de grands obstacles s'opposaient à mes projets." Lebrun 1809, vol. 1, p. v; English translation in Buchanan 1824, vol. 2, p. 252.

Among the Spanish paintings he purchases are works by Murillo, Velázquez, Ribera, Coello, and Cano. Acting as his adviser and translator is Frédéric Quilliet, a Frenchman residing in Seville who will assume a prominent position of power under the reign of Joseph Bonaparte (see 1809–10).

To circumvent the ban on exporting art, Lebrun has himself qualified as a professor at the Real Academia de San Carlos in Valencia, which gives him the right to acquire paintings for export. Despite this, royal guards remove some crates from his residence in Spain, but all are returned to him after the French ambassador Beauharnais intercedes on his behalf. Of this exportation ban, observes Lebrun, "Is it not a great evil for an artist, after having arrived at a perfection in art which would render him worthy of the admiration of all Europe, to find his works confined to a country the least enlightened of the present period? What riches does not a government deprive itself of which follows so blind a policy? Is not the glory of the immortal Poussin known to the world? Are not the superlative talents of a Raphael, and a Titian, acknowledged by all? And yet the inquisitorial government of Spain would stifle the renown of its greatest masters, their first and best reward! It is to the free entry and exit of monuments of art that France owes the riches and learning that so notably distinguish it."

"N'est-ce point un malheur pour un artiste, après avoir acquis des talens dignes de l'admiration de l'Europe, de voir ses ouvrages, et avec eux sa gloire concentrés dans le pays souvent le moins éclairé pour les arts? De quelles richesses un gouvernement ne se prive-t-il pas en interdisant un échange mutuel et commercial! La gloire immortelle du Poussin n'est-elle pas dans tout l'univers? Celle des Raphael, des Titiens, etc., est connue partout. Mais il convenait à un régime inquisiteur de faire des lois qui pussent étouffer la renommée des artistes, leur première et plus noble récompense. C'est à la libre entrée et sortie des monumens des arts que l'on doit les richesses et les connaissances qui distinguent si éminemment la France." Lebrun 1809, vol. 1, pp. v, vi; Buchanan 1824, vol. 2, pp. 252–53.

October 18 French troops, under the leadership of General Andoche Junot, duc d'Abrantès (French, 1771–1813), enter Spain en route to Portugal. The Treaty of Fontainebleau, signed by France and Spain (October 27), will allow Napoleon to place French troops in Spain using as pretext a joint French-Spanish war against Portugal. Junot enters Lisbon on November 30; the Portuguese royal family flees to Brazil.

Zurbarán's *Saint Francis* (fig. 1.8), the only work by the artist documented in France in the eighteenth century, is purchased from the artist Boissieu by the Musée des Beaux-Arts in Lyon as a work by Ribera (see 1797).

Fourth edition of Bourgoing's *Tableau de l'Espagne moderne* published. The text is used as a guide by Napoleon's armies in Spain. The new edition notes that "Goya also excels at portraiture."

"Goya excelle aussi dans le portrait." Bourgoing 1788 (1807 ed.), vol. 1, p. 293, quoted in Lipschutz 1972, p. 19.

1808

Napoleon's war in Spain. He names his older brother Joseph Bonaparte (1768–1844) king of Spain, after forcing Charles IV to abdicate. The French occupation will last for more than five years (until 1814). French troops eventually

number 300,000 strong; plundering is rampant and is decried by many in contemporary accounts. Napoleon's generals—Soult, Murat, Mathieu de Faviers, Merlin, Sébastiani, Dupont de l'Étang, and Junot among them—assemble private art collections.

January 1 Dated inventory by Frédéric Quilliet of the collection of Manuel Godoy, Prince of Peace, lists some 1,100 works of art. Despite some controversy, Quilliet's extensive knowledge of Spanish painting will result in his appointments (by December 1809) as administrator of national goods, commissioner of fine arts, museum director, and artistic attaché of the Andalusian armies (this last as of January 10, 1810) in Joseph Bonaparte's occupation government.

Saltillo 1933, p. 11; Antigüedad 1987b, p. 72.

February 23 Napoleon names his brother-in-law Joachim Murat (French, 1767–1815) lieutenant-general of the emperor in Spain. Murat will later become marshal of France and will replace Joseph Bonaparte as king of Naples on June 6.

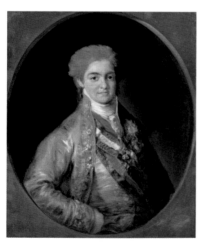

Fig. 14.11 Francisco de Goya y Lucientes and Workshop, *Ferdinand VII, When Prince of Asturias*, 1800. Oil on canvas. Metropolitan Museum, New York (51.70)

March 18–19 *Motín de la Granja:* Charles IV abdicates, Manuel Godoy is arrested, and Ferdinand VII (fig. 14.11) succeeds to the Spanish throne.

March 20 A dated royal decree orders the confiscation of Manuel Godoy's art collection. The French invasion prevents the works from being inventoried.

March 23 Murat enters Madrid.

March 24 Ferdinand VII enters Madrid as king of Spain.

April 10 Ferdinand VII leaves Madrid to meet Napoleon at Bayonne, followed by his father and

mother, Charles IV and María Luisa, and Manuel Godoy; all arrive at Bayonne on April 30.

April–May Antoine-René-Charles-Mathurin, comte de La Forest (French, 1756–1846), replaces François de Beauharnais (French, 1756–1846) as the French ambassador to Spain (1808–13).

La Forest will figure prominently in the efforts to obtain Spanish paintings for the Musée Napoléon.

Lovett 1965, p. 122 n. 38.

May 2 Spain's War of Independence (Peninsular War) commences with Madrid's rebellion against Murat's occupying forces. The event and its bloody reprisals inspire Goya's *Second of May 1808* and *Third of May 1808*, both painted in 1814 (Museo del Prado, Madrid [G-W 982, 984]).

May 6 At Bayonne, Napoleon forces Ferdinand VII to return the crown to his father, Charles IV, who had already ceded it to Napoleon on May 5.

June 6 Joseph Bonaparte named king of Spain (r. 1808–13) by imperial decree.

July 20 Joseph enters Madrid.

July 25 In Madrid, Joseph is officially proclaimed king. He will be known as the *rey intruso* and given the derogatory nickname "Pepe Botella," among others.

July 31 Joseph abandons Madrid after devastating defeat of the French army at Bailén on July 22 (date on which the Treaty of Capitulation of Bailén was signed). French troops retreat from the capital.

September 25 English artist G. A. Wallis, in Madrid as an agent for the picture dealer William Buchanan, writes him for money: "The present moment is still more favourable . . . on account of the great expenses of the present war; besides which the government will sell all the property of the noblemen who have taken the French party. . . . Of the Spanish school we have no idea whatever in England. If they could see the two or three best Murillos of the St. Iago family, and some of the fine pictures of Velasquez, Alonzo Canno, Pereda, Zuberan, Caregni, and del Greco, really first-rate men, whose works are quite unknown out of Spain, some estimate of the high excellence of this school might then be formed. This school is rich beyond idea, and its painters are all great colourists: some of their colossal works are surprising. If you had time and could bear the horrors of travelling in Spain it would be worth while to visit this country. After all, I must own I have, as an artist, learnt a great deal from this admirable school. . . . Do not

therefore lose any time in sending me credits on several Spanish houses . . . indeed, nothing is understood here at present but the *peso duro*."

Buchanan enters into a financial partnership with William Coesvelt, in Madrid as of 1801 as an agent of the banking house of Messrs. Hopes, Amsterdam. Coesvelt provides Wallis with funds for purchasing works of art (and holds a half interest in the purchased works). Coesvelt begins to acquire his own collection of Spanish paintings (see July 1814).

Buchanan 1824, vol. 2, pp. 229–30.

November 5 Napoleon arrives at Vitoria, where Joseph has settled his court. Throughout the month, surrounded by his best commanders and at the head of more than 200,000 troops, Napoleon retakes Spain in a series of decisive battles. He will remain in Spain until January 1809.

November 21 Denon writes to Louis-Nicolas-Philippe-Auguste, comte de Forbin (French, 1777–1841), *chambellan officier d'état-major* of the army in Portugal, and a Salon painter, with an encouraging word: "I hope, Sir, that at the next Salon you will be able to exhibit some of the beautiful sites that you have already visited and are going to see again. For landscape painters and architects Spain is a rich mine to exploit, and I am persuaded in advance of your successes, if your military duties allow you sufficient leisure."

"J'espère, Monsieur, qu'au Salon prochain vous pourez exposer quelques-uns des beaux sites que vous avez déjà parcourus et que vous allez voir de nouveau, l'Espagne est pour les peintres de paysage et les architectes une mine féconde à exploiter et je suis persuadé d'avance de vos succès si vos fonctions militaires vois laissent le loisir de vous occuper." Denon 1999, vol. 1, no. 1543, pp. 552–53.

Fig. 14.12 Charles Monnet, *Surrender of Madrid*, 19th century. Pen and ink. Musée National des Châteaux de Malmaison et de Bois-Préau, Rueil

November–March 1813 Marshal Soult is in Spain. He and his troops settle in Seville in March 1810.

December 4 Madrid surrenders to Napoleon (fig. 14.12).

December 26 Denon arrives in Madrid to obtain twenty Spanish paintings for the Musée Napoléon (see January 18, 1809).

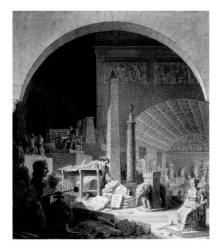

Fig. 14.13 Benjamin Zix, *Imaginary View of Vivant Denon at Work*, 1811. Musée du Louvre, Paris

December 31–January 5, 1809 Denon has access to the art collections of Spain's noble families; in a letter of January 6, 1809, to Major-General Berthier, he lists several works he has seen and chosen for the Musée Napoléon (fig. 14.13).

Denon 1999, vol. 2, no. AN 78, p. 1351 n. 2 (AMN Z4 1809, January 6). See also Wormser 1955, pp. 25–27.

1809
January 14 Joseph reenters Madrid.

In Paris, Cirque Olympique inaugurated with Jean Cuvelier de Trie's "La belle Espagnole, ou l'entrée triomphale des Français à Madrid" (The Spanish belle, or the triumphal entry of the French into Madrid), complete with equestrian display.

Hoffmann 1961, p. 168.

January 15 Napoleon writes to Joseph regarding the artworks sought for his museum: "Denon would like to take some paintings. I would prefer that you take all those you find in the seized houses and suppressed convents and make me a gift of about fifty masterpieces that the Paris museum lacks. In the proper time and place, I'll give you others. Call Denon in and tell him about this. He can give you suggestions. You're well aware that there must be only good things, and

the general opinion is that you are immensely wealthy in this regard."

"Denon voudrait prendre quelques tableaux. Je préférerais que vous prissiez tous ceux que se trouvent dans les maisons confisquées, et dans les couvents supprimés et que vous me fissiez présent d'une cinquantaine de chefs d'oeuvre que manquent au Muséum de Paris. En temps et lieu, je vous en donnerai d'autres. Faites venir Denon et parles lui dans ce sens. Il peut vous faire les propositions. Vous sentez bien qu'il ne faut que de bonnes choses, et l'opinion est que vous êtes immensément riches en ce genre." Lelièvre 1969, p. 367: Correspondance de Napoléon, no. 14716, January 15, 1809.

January 18 Denon writes Napoleon from Valladolid complaining of the lack of assistance from the emperor's brother Joseph in acquiring works of art: "If any prince but the brother of your majesty were occupying the throne of Madrid I should have begged for orders to add to the collection of the museum twenty pictures for the Spanish school which it lacks altogether and which would have been an eternal trophy of the present campaign."

"Si tout autre prince que le frère de Votre Majesté eût occupé le trône d'Espagne, je les aurais sollicités pour ajouter à la collection du musée vingt tableaux de l'école espagnole dont elle manque absolument et qui auraient été à perpétuité un trophée de cette dernière campagne." Denon 1999, vol. 2, no. AN 78, p. 1351.

Denon appears to have acquired some Spanish paintings for himself during this trip, as six works of the Spanish school are included in his posthumous sale of 1826 (see 1826). More influential, however, is the volume of Goya's *Caprichos* that he obtains in Spain (it will enter the Bibliothèque Impériale, Paris, after his death in 1826 [see 1826]).

January 23 Napoleon arrives in Paris, having left Spain upon learning that Austrian troops are mobilizing.

February 14 Denon is back in Paris.

March 11 Théâtre du Vaudeville, Paris, presents a new one-act comedy, *Le peintre français en Espagne, ou Le dernier soupir de l'Inquisition* (The French painter in Spain, or the last sigh of the Inquisition), written by Pierre Barré, Jean Baptiste Radet, and François de Fouques (Desfontaines).

May 4 Ferdinand Guillemardet dies in Paris. His son Louis will bequeath the two Goyas in his collection to the Louvre in 1865 (see 1865).

August 18 or 20 All religious orders in Spain suppressed by decree, issued by Joseph Bonaparte's secretary Mariano Luis de Urquijo (see 1798). In Madrid, the Dominican convent of El Rosario is chosen to warehouse the paintings

removed from these institutions. Consideration is given to converting the structure into a museum, but its poor condition prevents this (see August 22, 1810).

Antigüedad 1987b, p. 73.

December 20 In Joseph Bonaparte's name, Urquijo issues a decree stating his intention to establish a national museum of painting in Madrid: "Wanting, for the benefit of the fine arts, to make available the multitude of pictures that, separated from the view of connoisseurs, were found up to now locked away in the cloisters; that these displays of the most perfect of the old works serve first as models and guide the talents; that the merit of the celebrated Spanish painters, little known by neighboring nations, shines, procuring for them at the proper time the immortal glory that so justly deserve the names of Velazquez, Ribera, Murillo, Rivalta, Navarrete, Juan San Vicente, and others." The works will be drawn from "all public establishments and even from our palaces," notably from the suppressed religious institutions.

Article 2 of the decree mandates the formation of "a general collection of the celebrated painters of the Spanish school, which we will offer to our august brother the Emperor of the French, . . . [which] will serve as a pledge of the most sincere union of the two nations."

"Queriendo, en beneficio de las bellas artes, disponer de la multitud de quadros, que separados de la vista de los conocedores, se hallaban hasta aquí encerrados en los cláustros; que estas muestras de las obras antiguas mas perfectas sirvan como de primeros modelos y guia á los talentos; que brille el mérito de los célebres pintores españoles, poco conocidos de las naciones vecinas, procurándoles al propio tiempo la gloria inmortal que merecen tan justamente los nombres de Velazquez, Ribera, Murillo, Rivalta, Navarrete, Juan San Vicente y otros." "Se formará una colección general de los pintores célebres de la escuela española, la que ofreceremos á nuestro augusto hermano el Emperador de los franceses, manifestándole al proprio tiempo nuestros deseos de verla colocada en una de las salas del Museo Napoleón, en donde siendo un monumento de la gloria de los artistas españolas, servirá como prenda de la unión más sincera de las dos naciones." Beroqui 1932, p. 93.

Comte de La Forest, the French ambassador, writes of the decree to the French foreign minister Champagny, duc de Cadore, and attaches a list of forty-six paintings chosen for the emperor, accompanied by commentaries (most likely by Quilliet):

École de Madrid

Blas del Prado	Sainte Famille (Curieux.)
Coxein	Descente de Croix (Brillant effet.)
Navarette el Mudo	Nativité (Le plus beau du maître.)
Navarette el Mudo	Sainte Famille
Louis de Carvajal	S. Eugène, S. Ildefonse (Très beau.)

Louis de Carvajal	S. Isidore, S. Léandro (Idem.)
Alonzo Coëllo	S. Étienne, S. Laurent (Précieux.)
Alonzo Coëllo	Fiançailles de Ste. Catherine (Idem.)
Pantoja	Nativité (Curieux.)
Pantoja	Nativité de la Vierge (Idem.)
Carducho	La Cène (Riche de couleur.)
Eugenio Caxes	Sainte Famille (Rare.)
Le Greco	Couronnement de la Vierge (Le plus beau du maître.)
Le Greco	S. Pierre
Carducho	S. Jean au désert (Très beau.)
Carducho	Annonciation (Idem.)
Ant. Pereda	Christ (Superbe.)
Ant. Pereda	Ste. Herménégilde (Idem.)
Collantès	S. Jérôme au désert (Célébre.)
Collantès	Mission d'Ézéchiel (Idem.)
Velasquez	Les fils de Jacob (Capital.)
Velasquez	Chasse au Prado (Charmant.)
Martinez del Maso	Vue de Saragosse (Vérité admirable.)
Carreño	Annonciation (Extrême facilité.)
Carreño	Ste. Catherine (Idem.)
Sébast. de Herrera	S. Barnabé (Aussi beau que le Guerchin.)
Claude Coëllo	Adorations des Rois (Très beau.)
Claude Coëllo	Ste. Catherine
Cabazalero	Calvaire (Couleur.)
Cabazalero	La voie des douleurs (Idem.)
Mateo Cerezo	S. Jérôme (Excellente manière.)

École de Séville

Antoine del Rincon	Isabelle (Magnifique.)
Morales	Ecce homo (Grand essor.)
Zurbarán	Un moine (Vérité admirable.)
Zurbarán	Jésus monte au Calvaire (Vérité admirable.)
Alonzo Cano	La vierge de Monserrate (La douceur de l'Albane.)
Alonzo Cano	Christ a l'ange
Murillo	S. Ildefonse (Belle simplicité.)
Murillo	S. Bernard (Couleur brillante.)
Nunez Villavicencio	Jeux d'enfants (Très bon.)

École de Valence

Gelarte	Naissance de la Vierge (Très curieux.)
Gelarte	Adorations des Rois
Joannès	La Cène (Très beau; capital.)
Orrente	Jacob (Curieux.)
Ribalta	La Cène (Magnifique.)
Ribera	Sainte Famille (Le plus grand du maître.)

Beroqui 1932, pp. 94–95.

Louis-Philippe, duc d'Orléans (French, 1773–1850), an heir to the French Bourbon throne, marries Marie-Amélie de Bourbon (1782–1866), niece of Charles IV of Spain and cousin of Ferdinand VII.

Jean-Baptiste-Pierre Lebrun, *Recueil des gravures . . . d'après un choix de tableaux recueillis en Espagne*, published in two volumes in Paris (see 1807). It is perhaps the first mention of the engravings by Goya after Velázquez's paintings in the royal collection.

"Goya, peintre vivant, a gravé, à l'eau forte, une suite de divers tableaux du palais de Madrid." Lebrun 1809, vol. 2, p. 22.

Fig. 14.14 After Alonso Cano, *Saint Anthony Receiving the Virgin and Child*, 1809. Engraving. From Lebrun, 1809, vol. 2, pl. 141

1810

January Lebrun displays in his gallery more than 200 paintings, a portion of the 600 paintings acquired during his art-buying trip through Europe in 1806–8. As the Louvre is closed in preparation for the wedding of Napoleon and Marie-Louise of Austria (1791–1847), the exhibition elicits much attention. In addition to the paintings, Lebrun also places on view all of the engravings commissioned for his *Recueil* (including several not published in his text).

Bailey 1984, p. 40.

January–February French forces conquer Andalusia.

Late January Marshal Soult, commander in chief of the Second Army Corps, having spent November fighting alongside Napoleon, is given a choice of taking Cadiz or Seville, and chooses the latter. He and his troops are settled there by March, and he begins to acquire an impressive collection of Spanish painting, primarily appropriated from local monasteries, convents, and churches and gathered at the Alcázar (see February 11). His holdings will eventually include more than 100 paintings, the largest private assemblage of Spanish paintings to date.

Sources disagree on the exact number of works in his collection. It may have contained as many as 180 Spanish paintings, as noted in García Felguera 1991, p. 54. His sale of 1852 will include 110 lots of Spanish paintings.

Céan Bermúdez's *Diccionario* (see 1800) serves as Soult's guide to plunder. As noted by Richard Ford in his *Hand-book for Travellers in Spain*, the *Diccionario* "forms a complete dictionary of all the leading artists of Spain, with their biographies, lists of their principal works, and where they are or *were* to be seen; for this book in the hands of the Soults and Ci. proved a catalogue which indicated what and where was the most valuable artistical plunder."

Ford 1845 (1855 ed.), vol. 1, p. 72, quoted in Lipschutz 1972, p. 33.

During the French retreat, Soult's collection will be transported to Paris and installed at his *hôtel* on the rue de l'Université. The majority of the paintings remain with him until his death in 1852 (though he will eventually sell some works privately [see 1823, 1830, 1835]; estate sales take place in Paris on May 19, 21–22, 1852, and April 17, 1867).

February 3 Denon writes to Quilliet of his exasperation with the lack of cooperation he faced during his trip to Seville (1808–9) to recover works of art for the Musée Napoléon and cites instances of the pains taken by Spain's clergy to hide works: "The cathedral has removed its four Murillos . . . and placed them, along with other treasures, aboard a ship with orders to raise anchor upon entry of French troops. The Capuchins rolled up their seventeen Murillos and they have either buried them (the barbarians) or placed them in private homes. St. Albert has removed these days its Cano and Zurbaran. St. Francis, initially closed, has refused for fifteen days to take 60,000 *piastres fortes* for the seven Murillos that still adorn their church. La Merced sold all but three of its Murillos, two remained in the church, one in the Chapel of Atonement. The Shod Carmelites have sold their Murillo *Virgin of the Rosary* (the ignorants) for 250 *piastres*."

"La cathédrale a retiré ses quatre Murillos . . . et les a mis avec tous ses bijoux dans une barque qui, a cinq lieues d'ici, avait l'ordre de lever l'ancre à l'entrée des troupes. / Les Capucins ont roulé leurs dix-sept Murillo et les ont ou enterrés (les barbares) ou mis dans des maisons particulières. / St. Albert a retiré ces jours-ci del Cano et des Zurbaran. / St. François, fermé en principe, a refusé il y a quinze jours 60,000 piastres fortes de les sept Murillos, qui ornent encore son Eglise. / La Merced a tout vendu moins trois Murillo qui sont deux dans l'Eglise et un dans la Chapelle de l'Expiation. / Les Carmes chaussés ont vendu leur Vierge du Rosaire de Murillo (les ignorans) 250 piastres." Saltillo 1933, pp. 16–17, quoted in Lipschutz 1972, p. 44.

February 11 By royal decree in Seville the Alcázar is chosen as the site "to unite in the same place all the monuments of the fine arts existing in this City." Don Eusebio de Herrera, army field marshal, is named governor of the Alcázar.

Among the commission from the Academia de Bellas Artes appointed to gather these works are Antonio Aboza and Miguel Alea, general archivist of the crown. Quilliet oversees the project.

"Queriendo reunir en un mismo sitio todos los monumentos de las bellas artes existentes en esta Ciudad." Gómez Ímaz 1896, p. 37.

Eight of Murillo's series of paintings from the Hospital de la Caridad, including *Saint Elizabeth of Hungary Nursing the Sick* (A 86), are taken to the Alcázar to be inventoried. The *Saint Elizabeth* eventually is confiscated by Marshal Soult.

March 20–24 Sale of the Lebrun collection, Paris (Lugt 7787), including a portion of the 600 works purchased during his art-buying trip of 1806–8. Of the 261 lots, 151 are paintings (13 of which are Spanish). Among the buyers is Joséphine Bonaparte, Napoleon's first wife, who purchases Alonso Cano's *Saint Anthony Receiving the Virgin and Child* (*Vision of Saint Anthony of Padua*, Alte Pinakothek, Munich).

Bailey 1984, p. 37.

April 2 Napoleon marries Marie-Louise of Austria. The ceremony takes place in the Salon Carré (Grand Gallery) of the Musée Napoléon.

Lanzac de Laborie 1912, pp. 635–36.

April 30 Joseph regains Madrid.

June 2 Dated inventory, signed by Aboza and Alea, of works deposited in the Alcázar, Seville, lists 999 paintings. They are dispersed among 39 numbered galleries. Pride of place is given to the eight Murillos taken from the Hospital de la Caridad, all of which are displayed together in the first gallery; the first painting on the inventory is Murillo's *Saint Elizabeth of Hungary Nursing the Sick* (A 86). Among the works are 82 by Zurbarán, 74 by Valdés Leal, 43 by Murillo, and 40 by Alonso Cano.

Gómez Ímaz 1917.

Beginning of July Quilliet, rumored to be dealing illegally in the sale of confiscated art, comes under investigation. He and the painters Manuel Nápoli and Jean Maignan (Juan Miñán, in Spanish) are accused of selling works to the British. Quilliet is relieved of service on July 21, his curatorial duties assumed by Nápoli.

Antigüedad 1987b, pp. 72, 79.

July 14 Imperial decree invests Marshal Soult with command of the province of Andalusia.

Gotteri 1993, p. 46.

August 1 Joseph issues a decree that "renews the prohibition [of October 1779] on exporting pictures and paintings, under penalty of confiscation and a fine equal to the value of the objects."

"Se renueva la prohibición de exportar quadros y pinturas, baxo la pena de confiscación, y de una multa igual al valor de los objetos." Beroqui 1932, p. 95.

Mid-August Marshal Soult, despite the export ban, applies for and receives a license to remove six paintings, among them a Navarrete and a Ribera. General Sebastiani also applies for and receives licenses. Soult will export an additional fifteen paintings he had purchased, disguising their value by registering them as copies.

García Felguera 1991, p. 52 n. 31.

August 18 Soult receives a reply from Juan de Pradas, president of the chapter of Seville Cathedral, to his letter of July 2 requesting the donation of two Murillos from the chapter's collection, *Birth of the Virgin* (Musée du Louvre, Paris [A 130]) and *Death of Abel* (now attributed to Cano, location unknown). Pradas responds favorably and, in addition to the two requested works, donates another three "as a token of gratitude and recognition that is due to Your Excellency for favors and protection."

"en señal de gratitud y reconocimiento a los fabores y a la proteccion que merece a V.E." Gotteri 1993, p. 44.

August 22 Joseph names the Palacio de la Buenavista, Madrid, as the site of the future Museo de Pinturas, "which will gather all the pictures of the suppressed convents that are worthy of being offered for study or to exhibit before the view of the public." The establishment of the museum was announced on December 20, 1809.

"el museo de pintura reunirá todos los quadros de los conventos suprimidos, que sean dignos de ofrecerse al estudio, o de exponerse a la vista del público." Beroqui 1932, p. 93.

September Fifty Spanish paintings are selected —probably overseen by Quilliet—and readied for shipment to Paris for the Musée Napoléon; they are stored in the Church of San Francisco el Grande. They will not leave Madrid until 1813.

Antigüedad 1987b, p. 80.

September 6 La Forest writes in a letter to Paris that he "had hoped to be able to announce the departure of the pictures but that the packing was not yet finished." On the 26th, La Forest again writes to Paris warning of another delay in the departure of the pictures; many of the paintings are hanging in Joseph Bonaparte's apartments, and he does not wish to part with them. To avoid an incident, Joseph appoints his

own group of three consultants from the Real Academia de Bellas Artes de San Fernando in Madrid to devise another list of works to send to Paris, which excludes those in his possession (see October 25).

Gould 1965, p. 98.

October Monsieur de Crochart, paymaster general of the French army in Spain, obtains permission to export 111 Spanish and Flemish paintings from Spain.

Buchanan 1824, vol. 2, pp. 263ff.; see also García Felguera 1991, p. 52.

October 25 A newly selected committee of professors from the Real Academia, including Manuel Nápoli, Mariano Salvador de Maella, and Goya, examines more than 600 paintings and compiles another list of fifty pictures for the Musée Napoléon. Despite the committee's expertise, Joseph and La Forest revise the list, excluding works that Joseph deems too important to leave Spain or that he wishes to keep for himself. Yet another list will be drawn up.

Gould 1965, p. 99; see also Lipschutz 1972, p. 50.

November 24 La Forest reports that of the fifty pictures selected for the Musée Napoléon, only twenty-seven are of sufficient quality to be sent to Paris as representative of the Spanish school. He notes also that "Joseph had permitted the royal palaces of Seville and Cordoba to be drawn on if necessary, but that his palace at Madrid and the Madrid Academy were not to be touched except in case of absolute necessity." The shipment will not arrive in Paris until July 1813.

Gould 1965, pp. 98–99; see also Lipschutz 1972, p. 50.

Notice des tableaux exposés dans la galerie Napoléon (Paris, 1810) lists eight Spanish paintings in the collection, all included among the Italian school:

930. Ribera, *Adoration of the Shepherds* (Musée du Louvre, Paris) (fig. 2.11)
931. Ribera, *Mother of Sorrow* (Gemäldegalerie, Kassel)
1055. Murillo, *Holy Family* (Musée du Louvre, Paris) (fig. 14.3)
1056. Murillo, *Virgin of the Rosary* (Musée Goya, Castres) (fig. 2.5)
1057. Murillo, *Christ on the Mount of Olives* (Musée du Louvre, Paris) (fig. 2.6)
1058. Murillo, *Saint Peter before Christ at the Column* (Musée du Louvre, Paris) (fig. 2.7)
1059. Murillo, *Beggar Boy* (Musée du Louvre, Paris) (fig. 2.32)
1213. Velázquez, *The Family of Velázquez* (now *Family of the Artist*, by Mazo, Kunsthistorisches Museum, Vienna) (fig. 2.8)

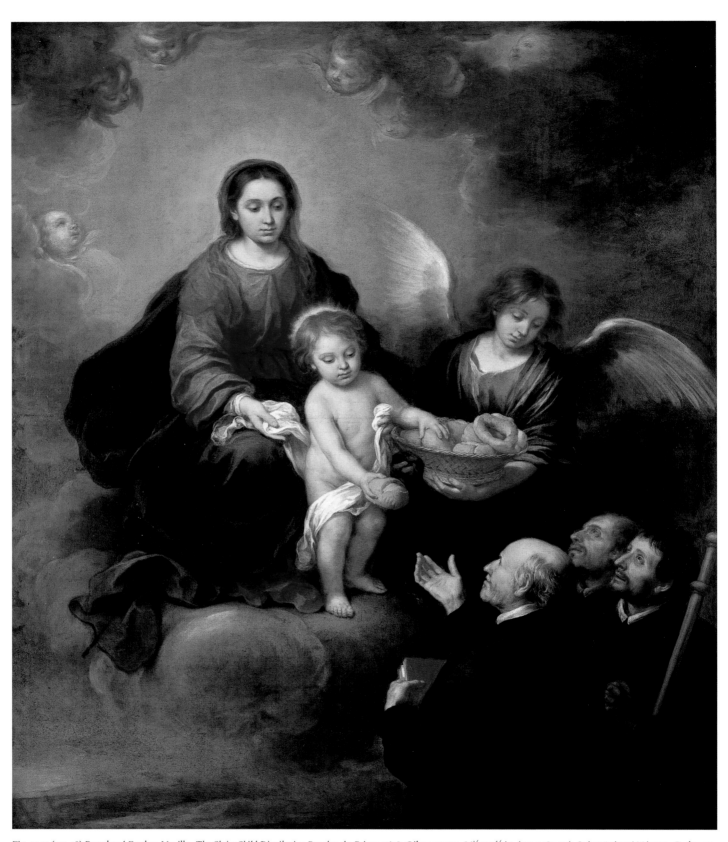

Fig. 14.15 (cat. 58) Bartolomé Esteban Murillo, *The Christ Child Distributing Bread to the Priests*, 1678. Oil on canvas, 86¼ x 71⅝ in. (219 x 182 cm). Szépmüvészeti Múzeum, Budapest

The Ribera (no. 931) and the Velázquez (no. 1213) had been removed from their museums and taken to the Louvre in 1806 and 1809, respectively; both will be returned in 1815, in accordance with the restitution act signed by Louis XVIII on May 8, 1814 (see 1814).

1811

March 11 Joseph confers upon Goya the Royal Order of Spain.

March 19 Commissioned by Joseph Bonaparte, a dated inventory of artworks on the *étage noble* of the Palacio Real in Madrid lists more than 1,000 paintings and over 200 sculptures. Among them are paintings that Joseph will take with him in 1813 when he flees Spain; they will be captured by Arthur Wellesley, the future duke of Wellington, at Vitoria (see 1813).

Gerard-Powell 1998, p. 407.

June 16 A nine-year-old Victor Hugo (French, 1802–1885) arrives in Madrid in the company of his mother, Sophie Hugo, and two brothers, Abel and Eugène, to join his father, General Léopold Sigisbert Hugo. The family takes up residence in the Palacio Masserano. They will return to Paris on March 3, 1812.

November 11 Noting the lack of canvases by painters from Seville (particularly Murillo) in Madrid, the conde de Mélito, superintendent of the royal house, asks the superintendent of the alcázars of Seville to send to Madrid the list of works destined for the national museum. The paintings themselves eventually join those gathered at El Rosario. Among them are eight of Murillo's paintings from the Hospital de la Caridad and other religious institutions, including *The Christ Child Distributing Bread to the Priests* (fig. 14.15).

Antigüedad 1987b, p. 78.

Notice des tableaux exposés dans la galerie Napoléon (Paris, 1811) lists seven Spanish paintings among the Italian school. The works are the same as those in the catalogue of 1810, except that the Murillo *Beggar Boy* is not itemized.

Second of two enormous art auctions held in Paris "to turn superfluous articles into money for military purposes." The first was held in 1804.

Quynn 1945, p. 445.

Second volume of Laborde's *Voyage pittoresque et historique de l'Espagne* published.

Philipp Joseph von Rehfues's *L'Espagne en 1808* published in French from a German manuscript. Rehfues is among the earliest writers on Spain to distinguish Spanish painting as a school separate from that of Italy: "Murillo and Velázquez have a special character, and do not appear to be the fruit of a sweet and profound sensibility, like those of the Italian schools." Instead, they "belong to a great national school distinct from the others."

García Felguera 1991, p. 21.

François-Auguste-René de Chateaubriand (French, 1768–1848) publishes his three-volume travel diary, *Itinéraire de Paris à Jérusalem et revenant par l'Égypte, la Barbarie et l'Espagne* in Paris. The book recounts his travels of 1806–7; though Spain figures in the title, he devotes very few words to it.

1812

July 22 Joseph abandons Madrid as British troops advance. His court follows on August 25.

August 12 Following his victories against Napoleon's forces at Fuentes de Oñoro and Albuera in 1811, Arthur Wellesley (1769–1852), future duke of Wellington, enters Madrid. Joseph flees to Valencia. Wellington leaves the city on September 1.

September 29 Convoy of Spanish paintings destined for the Musée Napoléon is in Bayonne by this date. In a letter to the minister of the interior, Denon writes: "Sir, there has been for some time the matter of a selection of pictures of painters of the Spanish school that His Majesty the king of Spain was to send to His Majesty the Emperor. I do not know if this intention of the king of Spain has received its execution, but I am informed that there is in the storerooms of the army or of customs at Bayonne several crates of pictures that remain deposited there without a final destination. I dare to beg you, Your Excellency, to write so as to have information about these pictures and, if they are property of the State, to instruct that they be directed to Paris, so as to prevent the moisture that they may contract in the storerooms where they are to be found from damaging them."

"Monseigneur, il a été longtemps question d'un choix de tableaux des peintres de l'école espagnole que Sa Majesté le roi d'Espagne devait envoyer à Sa Majesté l'Empereur. J'ignore si cette intention du roi d'Espagne a reçu son exécution, mais je suis informé qu'il y dans les magasins de l'armée ou des douanes à Bayonne plusieurs caisses de tableaux qui y sont restées déposées sans direction ultérieure.

"Oserai-je prier Votre Excellence d'écrire pour avoir des renseignemens sur ces tableaux et, s'ils sont propriété de l'État, d'ordonner qu'ils soient dirigés vers Paris, afin d'éviter que l'humidité qu'ils pouraient contracter dans les magasins où ils se trouvent ne les détériore." Denon 1999, vol. 2, p. 902, no. 2593 (September 29, 1812), quoted in Lelièvre 1969, p. 367.

December 3 Joseph returns to Madrid. He is followed, at year's end, by imperial troops.

Catalogue of Lucien Bonaparte's paintings collection published in London: *Choix de gravures à l'eau forte, d'après les peintures originales et les marbres de la galerie de Lucien Bonaparte—cent quarante deux gravures.* Seven of the 142 engravings illustrate his Spanish paintings:

Murillo, *Saint in Prayer* (location unknown)
Murillo, *Saint Augustine*, stanza IV, no. 35 (Musée Ingres, Montauban [A 1720])
Murillo, *Rest on the Flight into Egypt*, stanza XII, no. 109 (City Art Gallery, Glasgow [see A 232])
Murillo, *Portrait of a Woman*, stanza VII, no. 73 (Wildenstein, New York [A 2943])
Ribera, *Archimedes*, stanza XIV, no. 119 (Worcester Art Museum, Mass. [PS-S 125])
Ribera, *Saint Jerome*, stanza VI, no. 51 (location unknown)
Velázquez, *Portrait of a Woman*, stanza IV, no. 36 (Wallace Collection, London [LR 79]) (fig. 1.14)

Third volume of Laborde's *Voyage pittoresque et historique de l'Espagne* published.

French version of Friedrich Bouterwek's *Histoire de la littérature espagnole* published in Paris.

1813

January Following the disaster in Russia, Napoleon recalls a portion of his troops from Spain.

February 2–4, 9–11 Sale of the J.-B.-P. Lebrun collection, Paris (Lugt 8291). Among the 357 lots are 13 Spanish paintings, including Zurbarán's *Christ Carrying the Cross* (G-G 297), which is bought in and eventually donated to the Church of Saint-Pierre-du-Martroi in Orléans, before being transferred to Orléans Cathedral.

March 17 Joseph departs Spain for the final time.

April 20–May 19 Denon and Marshal Soult exchange letters regarding Soult's offer to donate paintings to the Musée Napoléon. The proffered works are Zurbarán's *Saint Thomas avec les docteurs de l'Église* (*Apotheosis of Saint Thomas Aquinas*, Museo de Bellas Artes, Seville [G-G 78]), Cano's *Death of Abel* (formerly Carvalho Collection, Villandry [W, p. 187, as school of Valdés Leal]), Herrera the Elder's *Saint Anthony Giving Communion* (location unknown), and Murillo's *Soul of Saint Philip Ascending to Heaven* (A 8) and *Saint James Kneeling before a Magsitrate* (A 7). Denon, stating that "as your [Soult's] intention is not to offer the Museum anything but first-rate morsels," rejects all but the Zurbarán and asks, instead, for three other Murillos: *Dream of the*

Patrician (A 39) (fig. 1.22), *The Patrician John and His Wife before Pope Liberius (The Foundation of Santa Maria Maggiore in Rome)* (A 40) (fig. 1.23), and the coveted *Saint Elizabeth of Hungary Nursing the Sick* (A 86) (fig. 3.13). These four works will be exhibited in the Louvre in September.

"comme son intention est de n'offrir au musée que des morceaux du premier mérite." Denon 1999, vol. 2, no. 2796; see also nos. 2809², 2825.

May 21 Fifty Spanish paintings intended for the Musée Napoléon leave Spain as part of a small convoy led by General Mancune.

Beroqui 1931; see also Lipschutz 1972, pp. 50–51.

May 26/27 French army leaves Madrid for the last time, followed by an immense caravan of looted goods, including works intended for the Musée Napoléon. Led by General Hugo, the caravan passes through Valladolid.

Lipschutz 1972, p. 50; see also "Hugo" entry in Tulard 1987.

June 21 Wellesley, future duke of Wellington, defeats the French at the Battle of Vitoria, Spain. Most of the looted works in Hugo's convoy are confiscated by Wellesley. After the defeat, 12,000 families of *afrancesados*—Spaniards who had shown loyalty to Joseph—flee to France.

Carr 1982, p. 105.

Among these emigrants is Quilliet, who will settle in Paris.

Rouchès 1930b, p. 43.

July 27 Denon (fig. 14.6) acknowledges in a letter to the comte de Fermont, French minister of state, the arrival in Paris of twenty-three crates of paintings from Spain: "I received the letter that you did me the honor of sending to announce the arrival in Paris of 23 crates containing pictures and prints coming from the galleries of the buildings belonging to the extraordinary property of the Crown at Madrid and by which you inform me that the intention of His Majesty is that these pictures be placed in the Musée Napoléon."

"J'ai reçu la lettre que vous m'avez fait l'honneur de m'adresser pour m'annoncer l'arrivée à Paris de 23 caisses contenant des tableaux et estampes provenant des galeries des hôtels appartenant au domaine extraordinaire de la Couronne à Madrid et par laquelle vous m'informez que l'intention de Sa Majesté est que ces tableaux soient déposés au musée Napoléon." Denon 1999, vol. 2, no. 2890 (July 27, 1813).

August 13 In another letter to Fermont, Denon writes of his disappointment with the shipment

of paintings from Spain: "This collection . . . contains few pictures of the first order." The letter reveals that not all of the paintings were of the Spanish school, as he cites Rubens's *Garden of Love* as the one masterpiece among them.

"Cette collection, Monsieur le Comte, renferme peu de tableaux de premier ordre." Denon 1999, vol. 2, no. 2923 (August 13, 1813).

August 16 Dated inventory of Manuel Godoy's collection numbers 381 works, a far cry from the 1,100 works inventoried by Quilliet in 1808 (see January 1, 1808). The depletion of the collection is attributed to looting and pillaging. Quilliet, mindful of the losses, had sought in July 1810 to save what then remained by asking that the king decide upon a destination for the collection.

Antigüedad 1987b, pp. 78, 82–83.

September 3 Denon, in a letter to the foreign minister Champagny, writes of the overall quality of the shipment of 300 pictures from Spain (50 are works of the Spanish school from the Spanish royal collection; 250 have been collected by the Imperial Commission for Sequestrations and Indemnities from the private collections of Spain's noble families). Denon deems only 6 of the group of 50 worthy of entering the Musée Napoléon, while only 2 of the 250 paintings are "of the first order," with "150 others that would be advantageously placed in His Majesty's palace." He ends the letter by noting that he will enter 280 of the paintings into the museum's inventory.

A selection of the works will be exhibited in Denon's 1814 exhibition of "écoles primitives," where they are praised for their amazing compositions and quality (see July 25, 1814).

"du premier ordre"; "150 autres qui seront très avantageusement placés dans les palais de Sa Majesté." Denon 1999, vol. 2, no. 2931 (September 3, 1813); Paris 1999, p. 241 n. 102.

Inventory of Spanish paintings in the Louvre (after 1810) lists seventy-two works, of which all but two are described as destined for the Musée Napoléon.

Archives des Musées Nationaux–Musée du Louvre, Paris (1 DD 16), Inventaire Napoléon—peintures.

1814

March 1 Joseph Bonaparte abdicates the Spanish throne; Ferdinand VII assumes the crown. Ferdinand will enter Madrid on May 7; later he will abolish the Spanish Constitution and reinstate the Inquisition.

April 6 Napoleon abdicates at Fontainebleau. He is banished to Elba on April 11.

April 14–May 2 The comte d'Artois heads a provisional government until Louis XVIII, his brother, returns from England.

Quynn 1945, p. 445.

May 3 Louis XVIII (1755–1824) enters Paris and assumes the throne as the king of France (r. 1814–24).

Fig. 14.16. Anonymous, *The French Artist Crying over the Return of Artworks in 1815*, 19th century. Engraving. Bibliothèque Nationale, Paris

May 8 Upon restoration, Louis XVIII signs a decree ordering restitution to the former owners of art taken from the German states and the Spanish nobles. On May 15 restitution is ordered for those works removed from the homes of Spanish nobles. By September 1815, 223 of 230 paintings will be returned to their Spanish owners. The remaining 7 works will be returned between 1815 and 1825 (fig. 14.16).

Archives des Musées Nationaux, 1 DD 53, pp. 3–7.

May 30 Austria, Britain, Russia, Switzerland, and Portugal sign a peace treaty with France.

June 4 Louis XVIII announces the Constitutional Charter.

July 2 Emperor Alexander I of Russia visits the Amsterdam gallery of Spanish and Italian paintings belonging to William Coesvelt (see September 1808). Enamored of the collection of Spanish paintings, he purchases them from Coesvelt. A total of eighty-four works will eventually be shipped to St. Petersburg and incorporated into the Hermitage in 1814–15.

Kagané 1997, pp. 11, 12.

July 20 Spain signs a peace treaty with France.

July 21 Spanish Inquisition reinstated.

July 25 Opening of the first major exhibition at the newly named Musée Royal, Paris, under Denon's directorship. "L'exposition des 'écoles primitives'" presents 123 works. The exhibition catalogue, *Notice des tableaux des écoles primitives de l'Italie, de l'Allemagne et de plusieurs autres tableaux de différentes écoles, exposés dans le grand salon du Musée Royal, ouvert le 25 juillet 1814,* lists seventeen Spanish works:

30. Carreño de Miranda, *La Madeleine pénitente,* 1654 (Academia de Bellas Artes de San Fernando, Madrid) (fig. 14.17)
34. Eugenio Caxes, *L'Étreinte à la porte Dorée* (Academia de San Fernando, Madrid)
36. Francisco Collantes, *La Vision d'Ézéchiel,* 1630 (Museo del Prado, Madrid) (fig. 14.19)
37. Francisco Collantes, *Paysage,* 1634 (Academia de San Fernando, Madrid)
38. Francisco Collantes, *Le Buisson ardent* (Musée du Louvre, Paris)
49. Ribera, *Magdalena Ventura avec son époux, dite La Femme à barbe* (Palacio Lerma, Toledo [PS-S 49])
78. Luis de Morales, *Le Christ devant Pilate* (Academia de San Fernando, Madrid)

Fig. 14.17 Juan Carreño de Miranda, *The Penitent Magdalen,* 1654. Oil on canvas. Academia de Bellas Artes de San Fernando, Madrid

Fig. 14.18 Antonio de Pereda, *Dream of the Gentleman,* ca. 1650. Oil on canvas. Academia de Bellas Artes de San Fernando, Madrid

Fig. 14.19 Francisco Collantes, *Vision of Ezekiel,* 1630. Oil on canvas. Museo Nacional del Prado, Madrid

Fig. 14.20 Bartolomé Esteban Murillo, *Adoration of the Shepherds,* 1645–60. Oil on canvas. Museo Nacional del Prado, Madrid

80. Sebastian Muños, *Le Martyre de saint Sébastien* (location unknown)
81. Navarrete, el Mudo, *Le Martyre de saint Jacques,* 1571 (El Escorial)
82. Murillo, *L'Adoration des bergers* (Museo del Prado, Madrid) (fig. 14.20)
83. Murillo, *La Fondation de Sainte-Marie-Majeure à Rome: le songe du Patricien* (Museo del Prado, Madrid [A 39]) (fig. 1.22)
84. Murillo, *La Fondation de Sainte-Marie-Majeure à Rome: l'explication du songe au pape Libère* (Museo del Prado, Madrid [A 40]) (fig. 1.23)
85. Murillo, *Sainte Élisabeth soignant les teigneux* (Hospital de la Caridad, Seville [A 86]) (fig. 3.13)
90. Antonio de Pereda, *Le Songe du gentil-homme* (Academia de San Fernando, Madrid) (fig. 14.18)
114. Zurbarán, *Apothéose de saint Thomas d'Aquin* (Museo de Bellas Artes, Seville [G-G 78]) (fig. 3.9)
115. Zurbarán, *L'Adoration des Mages* (Musée des Beaux-Arts, Grenoble [G-G 125]) (fig. 7.12)
116. Zurbarán, *La Circoncision* (Musée des Beaux-Arts, Grenoble [G-G 124]) (fig. 7.13)

Paris 1999, pp. 508–10. See Paris 1815b for another edition of the exhibition catalogue.

The *Mercure de France* (August, pp. 258–259) and *Journal des Débats* (August 14, pp. 1–2) single out many works in the exhibition for their astonishing subject matter and quality.

August 1 Denon, in a letter to the prince of Bavaria, writes of the private sale of Joséphine Bonaparte's collection, at Malmaison. Among the Flemish and Italian masterworks is Cano's *Saint Anthony Receiving the Virgin and Child,* purchased by Joséphine in 1810 (see 1810).

Denon 1999, vol. 2, no. 3169² (August 1, 1814).

Notice des tableaux exposés dans la Galerie Napoléon (Paris, 1814) lists the same eight Spanish paintings that appeared in its catalogue of 1810.

1815

February 6 Sale of Lucien Bonaparte's collection, New Gallery, London (not in Lugt). First of four sales featuring Spanish paintings (the remaining sales take place on May 14–16, 1816, in London (Lugt 8892); December 25, 1823–January 10, 1824, in Paris (not in Lugt); and January 13–16, 1840, in Paris (Lugt 15622). All six of the Spanish paintings go unsold and are offered again in 1816 (see 1816): Velázquez, *Portrait of a Lady* (Wallace Collection, London, LR 79 [lot 141 (1816)]); Murillo(?), *Rest on the Flight into Egypt* (City Art Gallery, Glasgow, see A 232 [lot 117 (1816), lot 47 (1823–24), lot 155 (1840)]); Murillo (after?), *Saint Augustine* (Musée Ingres, Montauban, A 1720 [lot 55 (1816), lot 46 (1823)]); Spagnoletto, *Archimedes* (Worcester Art Museum, Mass. [lot 27 (1816)]); Spagnoletto, *Saint Jerome* (location unknown [lot 83 (1816), lot 48 (1823)]); Murillo, *Portrait of a Young Woman* (Wildenstein, New York, A 2943 [lot 87 (1816)]).

March 16 Goya appears before the Inquisition, reinstated on July 21, 1814, on obscenity charges for having painted the *Naked Maja* (G-W 743) and the *Clothed Maja* (G-W 744) (figs. 14.22, 14.21). The Inquisition had confiscated the paintings in 1813.

March–June The Hundred Days: Napoleon escapes from Elba and attempts to reestablish the Empire. Louis XVIII flees to London. Napoleon defeated at the Battle of Waterloo (June 18) and exiled to Saint Helena.

July Jesuits return to Spain; their order had been reinstated by Pope Pius VII in 1814.

August Dated inscription by one John Graham of England, in a bound volume of three French summary catalogues of 1815, states: "This book contains the catalogues of the statues and pictures amassed in the galleries of the Louvre during Napoleon's reign and seen by me . . . before they were again dispersed and sent to the various

Fig. 14.21 Francisco de Goya y Lucientes, *Clothed Maja*, 1798–1805. Oil on canvas. Museo Nacional del Prado, Madrid

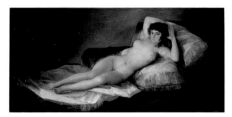

Fig. 14.22 Francisco de Goya y Lucientes, *Naked Maja*, 1798–1805. Oil on canvas. Museo Nacional del Prado, Madrid

parts of Europe from whence they were taken— which happened shortly afterwards."

Bound volume in The Metropolitan Museum of Art consisting of the following catalogues: Notice des tableaux exposés dans la galerie Napoléon (Paris, 1815), Notice des tableaux des écoles primitives de l'Italie, de l'Allemagne et de plusieurs autres tableaux de différentes écoles, exposés dans le grand salon du Musée Napoléon (Paris, April 1815), Notice des statues, bustes et bas-reliefs, de la galerie des antiques du Musée, ouverte pour la première fois le 18 Brumaire an 9 (Paris, 1815), and supplements.

Notice des tableaux exposés dans la galerie Napoléon (Paris, 1815), lists the same eight Spanish paintings that appeared in its catalogue of 1810.

September 22–24 Denon and the conde de Alava, minister of the king of Spain, exchange correspondence regarding the works in the Musée Napoléon that are to be restituted to Spain by royal decree (see May 8, 1814). Denon resists the return of the Spanish works donated by Marshal Soult in 1813 (see April 20–May 19, 1813), in particular Murillo's masterpiece *Saint Elizabeth of Hungary Nursing the Sick* (A 86) (fig. 3.13), which Denon states was given to Soult by the city of Seville. Alava famously replies: "The city of Seville could not give to Marshal Soult that which does not belong to her, that which never belonged to her."

"La ville de Séville ne pouvait pas donner à M. le maréchal Soult ce qui ne lui appartenait pas, ce qui ne lui a jamais appartenu." Letter from Alava to Denon, September 24, 1815, in Denon 1999, vol. 2, no. 3543. See letters nos. 3537–3541 for entire correspondence.

All four paintings (see April 20–May 19, 1813) are returned to Spain. Soult later noted: "Unfortunately, those four superb paintings were seized and carried off by the allied armies, along

with so many other masterpieces during the occupation of Paris in 1814."

"Malheureusement ces quatre superbes tableaux furent saisis et emportés par les armées alliées, avec tant d'autres chefs d'oeuvre, lors de l'occupation de Paris en 1814." Willesme 1987, p. 112.

October 3 Denon submits his resignation to Louis XVIII. The comte de Forbin is named director of the national museums.

Denon 1999, vol. 2, no. 3561 (October 3, 1815).

December Soult is exiled from France until 1819 for his loyalty to Napoleon during the Hundred Days.

Willesme 1987, p. 107.

At the fall of the Empire, Joseph Bonaparte departs France for the United States. He takes with him paintings obtained during his Spanish rule, notably works by Murillo and Velázquez. Settling in Bordentown, New Jersey, he lives under the name of the comte de Survilliers. Ten years later (between 1825 and 1828) he will lend paintings, among them a Ribera, for an exhibition at the American Academy of Fine Arts in New York. In January 1830 a portion of his collection is destroyed, and in 1833 he sells a number of pictures in London. After his death in 1844, sales of his collection are held in the mansion at Bordentown on September 17–18, 1845, and June 25, 1847.

Benisovich 1956, pp. 296–97.

Pennsylvania Academy of the Fine Arts commences annual exhibition of Murillo's painting *Caritas Romana* (A 425), which it acquired from Richard Worsam Meade, a Philadelphia merchant who resided in Spain during the Napoleonic occupation (in 1845 the painting is destroyed in a fire). Meade also owned paintings by Sánchez Cotán, Ribera, Murillo, and Velázquez, displayed occasionally at the Academy before 1860.

M. Elizabeth Boone, "Sol y Sombra: American Artists Explore the Sunlight and Shadows of Spain," in New York–New Britain 1998–99, p. 22.

1816
February 20 Rossini's opera *Il Barbiere di Siviglia* (The Barber of Seville) premieres in Rome. It is based on the 1775 comedy of the same title by the French author Pierre Beaumarchais (1732–1799). Earlier, Beaumarchais's *Le Mariage de Figaro* (1784) had served as the basis for Mozart's *Le Nozze di Figaro*, which premiered in Vienna on May 1, 1786.

May 14–16 Sale of Lucien Bonaparte collection, Stanley, London [Lugt 8892]. All six of the

Spanish paintings offered in 1815 are included, three of which sell: Spagnoletto, *Archimedes* (Worcester Art Museum, Mass. [PS-S 125]); Murillo, *Portrait of a Young Woman* (Wildenstein, New York [A 2943]); Velázquez, *Portrait of a Lady* (Wallace Collection, London [LR 79]) (see 1823).

October 28 First advertisement for *La Tauromaquia* (G-W 1149–1243), Goya's thirty-three-plate print series on the bullfight, appears in the *Diario de Madrid*.

October Frédéric Quilliet publishes his *Dictionnaire des peintres espagnols* in Paris, the first French text devoted to the Spanish school. The book, which includes no living artists, is a compilation of articles written on "Les beaux-arts en Espagne" for the *Mercure de France* between December 1815 and July 1816. Scattered throughout the entries, which borrow heavily from Ceán Bermúdez's *Diccionario* (1800), are comments by Quilliet on his various activities in Spain.

Wellington offers to return to Spain all 165 paintings confiscated by him from General Hugo's convoy at the Battle of Vitoria (see June 21, 1813). Instead, he is granted ownership of the works by the Spanish ambassador to England on behalf of King Ferdinand VII, grateful for Wellington's help in reestablishing his throne.

Notice des tableaux exposés dans la galerie du Musée Royal (Paris, 1816) lists eight Spanish works. Replacing Ribera's *Mother of Sorrow* and Velázquez's *Family of the Artist* in the 1815 catalogue is Collantes's *The Burning Bush* and Velázquez's *Infanta Margarita* (see also 1810).

Henry Milton writes of the Musée Royal, noting the presence of "a very few pictures by Spanish masters, which were classed with [the Italians]." He sees only one Velázquez but ecstatically describes Murillo's *Dream of the Patrician and His Wife* (A 39) and the *Patrician John and His Wife before Pope Liberius* (*The Foundation of Santa Maria Maggiore in Rome*) (A 40), a pair that "eclipses all the rest; and yields in powerful effect to very few in the collection. . . . This painting

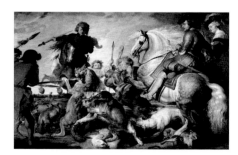

Fig. 14.23 Peter Paul Rubens and Workshop, *Wolf and Fox Hunt*, ca. 1615–21. Oil on canvas. Metropolitan Museum, New York (10.73)

and its companion are placed one on each side of the picture of *Hunting the Wolf* [by Rubens (fig. 14.23; now Rubens and workshop, *Wolf and Fox Hunt*)], all the three are of large dimensions, occupying together nearly the whole length of the room [the Salon Carré]. The animation, the flash and burning day-light of Rubens, form an admirable contrast to the tranquility and grave tone of Murillo." *Hunting the Wolf* had been appropriated from the collection of the conde de Altamira, Madrid, and taken to Paris; eventually returned to Altamira, it will be sold in 1824.

Milton 1816, pp. 25, 36, 40, respectively.

1817

April 14 First of four sales of Lapeyrière collection, Paris (Lugt 9098). Lapeyrière, tax collector general in Napoleon's army, had sold many of his Dutch and Flemish paintings in order to buy Spanish ones. This sale includes Velázquez's *Philip IV as a Hunter,* later purchased by the Louvre in 1857 (now Velázquez workshop, on deposit at Musée Goya, Castres).

Murillo's *The Apparition of the Immaculate Conception* (*L'Apparition de l'Immaculée Conception à six personnages,* [A 41]) (fig. 14.24), from the Soult collection, purchased for 6,000 francs from a Monsieur Lom for Louis XVIII's collection.

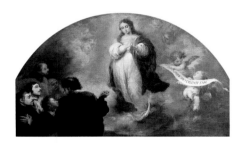

Fig. 14.24 Bartolomé Esteban Murillo, *The Apparition of the Immaculate Conception,* ca. 1665. Oil on canvas. Musée du Louvre, Paris

Mercure de France publishes an article on Goya by "Bachelier de Salamanque" (pseudonym of José Gallardo Blanco).

1818

March Juan de Villanueva's building on the Paseo del Prado, originally intended for the museum of natural history, is assigned to house the new Real Museo in Madrid. In preparation, inventories of the royal palaces and houses are undertaken.

May 4 Collection of Field Marshal Junot, duc d'Abrantès, sold at Christie's, London (Lugt 9368); included are two Spanish paintings: Ribera's *Saint Jerome Seated* ("from a Convent at Zaragoza") taken from the Manuel Godoy

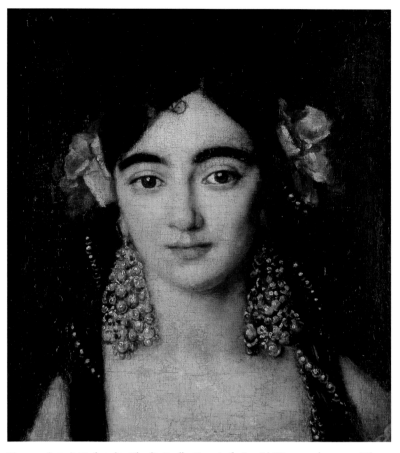

Fig. 14.25 (cat. 2) Attributed to Claudio Coello, *Portrait of a Spanish Woman,* 17th century. Oil on canvas, 15 x 13⅜ in. (38 x 34 cm). Musée Ingres, Montauban

collection (fig. 8.5) and Murillo's *The Miracle of Saint Francis Xavier* ("when brought to France from Spain, was ascribed to Guercino"). The paintings had gone unsold at the Junot auction on June 7, 1817 (Lugt 9155).

Junot Sale 1818, lots 55 and 57, respectively.

The Calcografía Nacional, Madrid, acquires the fifty plates produced by the Compañía para el Grabado (see 1789).

Delacroix first exposed to the work of Goya at the home of his friends Félix and Louis Guillemardet, whose father, Ferdinand Guillemardet, had brought prints and paintings back with him

Fig. 14.26 (cat. 115) Eugène Delacroix, *After Goya, Studies of "Los Caprichos,"* Nos. 24, 28, 33, 60, 61, ca. 1824. Pen and brown ink. Musée du Louvre, Paris

after his tenure as ambassador to Spain (see 1800) (fig. 14.26).

Jean-Auguste-Dominique Ingres, residing in Rome, has in his possession *Portrait of a Spanish Woman* (now attributed to Claudio Coello) (fig. 14.25).

1819

January 2 and 19 Death of Maria Luisa and Charles IV in Rome.

November 19 Real Museo del Prado opens its doors to the public under the direction of the marqués de Santa Cruz. The *Catálogo de los cuadros de escuela española que existen en el Real Museo del Prado* lists 311 canvases, including Goya's equestrian portraits of Charles IV and Maria Luisa (Museo del Prado, Madrid [G-W 776, 777]). Luis Eusebi, editor of the catalogue, had been appointed curator on April 21.

Madrid 1819.

Edward Davies's *The Life of Bartolomé E. Murillo, compiled from the Writings of Various Authors* translates passages from numerous texts, among them Bourgoing's *Nouveau voyage en Espagne* (1788), A.-J. Dézallier d'Argenville's *Abrégé de la vie des*

plus fameux peintres (1745–52), Palomino's *Museo Pictórico* (1724), Ponz's *Viaje de España* (1776–94), and Ceán Bermúdez's *Diccionario* (1800).

As noted in Curtis 1883, pp. 360–61.

1820

January 1 Revolution of 1820 in Cadiz overthrows the government of Ferdinand VII.

March 9 Ferdinand VII forced to accept the Constitution of 1812, which diminishes his powers as an absolute monarch.

August 6 Italian galleries open at the Real Museo, Madrid, under a new director, Pedro Téllez-Girón, prince of Anglona (appointed April 9).

November 20 Marshal Soult, in exile in Germany since December 1815, returns to Paris (he had received authorization to return to France on May 31, 1819). All of his titles and honors will be restored, and he will serve in Louis-Philippe's government.

Isidore-Justin-Séverin Taylor (French, 1789–1879) makes his first trip to Spain and, in Murcia, meets the infamous bandit Jaime Alfonso, "el rey de la Sierra" (the king of the Sierra), whose exploits were followed in both France and Spain.

Plażaola 1989, p. 52.

Notice des tableaux exposés dans la galerie du Musée Royal (Paris, 1820) lists ten Spanish works in the collection:

862. Collantes, *Le Seigneur apparaît à Moïse sur le mont Horeb, dans une flamme de feu qui sort du milieu d'un buisson . . .*, thought by some to be by Fetti (*The Burning Bush*, Musée du Louvre, Paris)

Fig. 14.27 After Diego de Rodríguez de Silva y Velázquez, *Fernand Cortes*, 1812. Engraving. From Laborde 1806–20, vol. 2, pl. 64

901. Ribera, *L'Adoration des Bergers* (*Adoration of the Shepherds*, Musée du Louvre, Paris)
1014. Murillo, *Le Mystère de la Conception de la Vierge Marie* (*Immaculate Conception*, Musée du Louvre, Paris); purchased in 1817
1015. Murillo, *Jésus assis sur les genoux de sa mère, joue avec un chapelet*, engraved by Henriquez (*Virgin of the Rosary*, Castres)
1016. Murillo, *Le Père Éternel et l'Esprit-Saint contemplent l'Enfant-Jésus . . .* (*Holy Family*, Musée du Louvre, Paris)
1017. Murillo, *Sur la montagne des Oliviers, un Ange présente à Jésus le Calice et la Croix* (*Christ on the Mount of Olives*, Musée du Louvre, Paris)
1818. Murillo, *Saint-Pierre à genoux demande*
[sic] *pardon de son parjure à Jésus qui est attaché à la colonne et flagellé* (*Saint Peter before Christ at the Column*, Musée du Louvre, Paris)
1019. Murillo, *Saint-Jean-Baptiste encore enfant, tient une croix de jonc, et pose le bras sur un agneau* (location unknown)
1020. Murillo, *Un jeune mendiant . . .* (*Beggar Boy*, Musée du Louvre, Paris)
1152. Velázquez, *Portrait de l'Infante Marguerite Thérèse*, thought to be a study for *Las Meninas* (Velázquez workshop, *Infanta Margarita*, Musée du Louvre, Paris)

Second half of the second volume of Laborde's *Voyage pittoresque et historique de l'Espagne* published in Paris. It includes nine engravings after Spanish paintings:

Coello, *Miracle of Saint Peter of Alcantara* (Alte Pinacothek, Munich [Sullivan P82]); Laborde notes it was brought into France by Lebrun
Murillo, *Saint Francis of Assisi* (Museo de Bellas Artes, Seville [A 72])
Murillo, *Assumption* (location unknown)
Murillo, *Dream of the Patrician* (Museo del Prado, Madrid [A 39])
Ribera, *Adoration of the Shepherds* (Musée du Louvre, Paris [PS-S 201])
Velázquez, *Portrait of Fernand Cortes* (*The Jester "Don Juan de Austria,"* Museo del Prado, Madrid [LR 65]) (fig. 14.27)
Velázquez, *Waterseller* (Wellington Museum, Apsley House, London [LR 16])
Velázquez, *Adoration of the Shepherds* (now, Italian, seventeenth century, National Gallery, London [C 8])
Zurbarán, *Saint in Spanish Apparel* (*Saint Margaret*, last documented in Royal Palace, Madrid [S 57; see G-G 180])

1821

Napoleon dies on Saint Helena at the age of fifty-two.

Eusebi edits a new *Catálogo de los cuadros que existen colocados en el Real Museo del Prado*; it includes 512 works of the Spanish and Italian schools. Among the new works installed is Goya's *Picador* (fig. 2.12).

1822

Chefs-d'oeuvre des théâtres étrangers traduits en français, twenty-five volumes published in Paris between 1822 and 1827, devotes five volumes to Spanish plays.

1823

April 7 Cent Mille Fils de Saint Louis (One Hundred Thousand Sons of Saint Louis) enter Spain from France. The military expedition, led by the duc d'Angoulême, is composed of French soldiers sent by Louis XVIII to help restore Ferdinand VII to absolute power. They enter a welcoming Madrid on May 23.

Accompanying Angoulême is Louis Viardot (French, 1800–1883), whose interest in Spain and Spanish art will inspire an article, published in December 1834, proposing the creation of a gallery of Spanish painting in France (his later texts, *Notice sur les principaux peintres de l'Espagne* [Paris, 1839] and *Les musées d'Espagne, d'Angleterre et de Belgique* [Paris, 1843], will become important mid-nineteenth-century references on Spanish painting).

Also joining the mission is Isidore-Justin-Séverin Taylor. In Spain until October, Taylor returns to Paris with some of the sketches that will illustrate his *Voyage pittoresque en Espagne, en Portugal et sur la côte d'Afrique, de Tanger à Tétouan* (see 1826).

Plażaola 1989, p. 87.

May 26 Curator Luis Eusebi edits and prints 1,000 copies of a new French catalogue, *Notice des tableaux exposés jusqu'à présent dans le Musée Royal de peinture au Prado*, to accommodate the French forces. On December 28 a new joint directorship of the museum is formed by José Idiáquez Carvajal, marqués de Ariza, and the painter Vicente López (Spanish, 1772–1850).

Beroqui 1931, pp. 200–204; also cited in Lipschutż 1972, p. 56.

September 30 The duc d'Angoulême obtains the release of Ferdinand VII, who immediately resumes his rule as absolute monarch of Spain; he reenters Madrid on October 13.

December 25–January 10, 1824 Sale of Lucien Bonaparte's collection, in Paris (not in Lugt). Included are three of the Spanish paintings offered in 1816, two of which find buyers: Murillo (after?), *Saint Augustine* (Musée Ingres, Montauban [A 1720]); Spagnoletto, *Saint Jerome* (location unknown) (see 1840).

In Paris, Marshal Soult attempts to find buyers for his paintings, particularly his Murillos. Pursuing English collectors, he begins negotiations with the London art dealer William Buchanan. In Paris, the comte de Forbin, director of the Louvre, also begins negotiations—ultimately unsuccessful—with Soult for the purchase of seven paintings, assigning them the following values:

Murillo, *La Conception de la Vierge* (A 110) (fig. 1.20), 250,000 francs
Murillo, *L'Enfant prodigue* (A 83) (fig. 11.16), 250,000 francs
Murillo, *Le Paralytique* (A 82) (fig. 14.42), 250,000 francs
Morales, *L'Enlèvement du Christ mort*, 50,000 francs
Zurbarán, *Moines devant un Crucifix* (*Saint Bonaventure and Saint Thomas Aquinas before the Crucifix*, Kaiser Friedrich Museum, Berlin, destroyed in April 1945 [G-G 16]), 50,000 francs
Zurbarán, *Les Docteurs de l'Église* (*Apotheosis of Saint Thomas Aquinas*, Museo de Bellas Artes, Seville [G-G 78]) (fig. 3.9), 50,000 francs
Piombo, *Le Christ portant la Croix*, 80,000 francs

Curtis 1883, pp. 116ff.; Gotteri 1993, p. 48.

Notice des tableaux exposés dans la galerie du Musée Royal (Paris, 1823) lists ten Spanish paintings in the collection (the same works listed in the catalogue of 1820).

1824

March–May Various entries in Delacroix's journal refer to Velázquez, Goya, and the Soult collection. On Friday, March 19, Delacroix writes of a good day spent at the Louvre: "The Poussins! The Rubenses! . . . Velasquez. Afterward, saw the Goyas, in my studio, with Édouard [Bertin, a landscape painter]."

Fig. 14.28 Juan Carreño de Miranda, *Charles II*, 1671–73. Oil on canvas. Museo Nacional del Prado, Madrid

Fig. 14.29 (cat. 108) Eugène Delacroix, *Self-Portrait (Ravenswood)*, ca. 1821. Oil on canvas, 16⅛ x 13 in. (41 x 33 cm). Musée Eugène Delacroix, on deposit from Musée du Louvre, Paris

"Les Poussin! Les Rubens! . . . Velasquez. Après, vu les Goya, à mon atelier, avec Édouard." Delacroix 1960, vol. 1, p. 62, "Vendredi 19 mars."

On Thursday, March 25, Delacroix sees paintings in the gallery of the duc d'Orléans at the Palais-Royal: "Went with [Frédéric] Leblond to see pictures . . . , and an admirable Velasquez [actually, a Carreño de Miranda of Charles II (fig. 14.28)], which filled my mind."

"Été avec Leblond voir tableaux . . . et un Velasquez admirable, qui occupe tout mon esprit." Delacroix 1960, vol. 1, pp. 63–64, "Jeudi 25 mars."

Delacroix writes of Goya's prints on Wednesday, April 7: "Worked on a small *Don Quixote*.—In the evening Leblond, and tried lithography. Splendid plans on this account. *Takeoffs in the style of Goya*." (Delacroix will undertake his illustrations for *Macbeth* in the following year and those for *Faust* in 1828.)

"Travaillé au petit Don Quichotte.—Le soir, Leblond, et essayé de la lithographie. Projets superbe à ce sujet. Charges dans le genre de Goya." Delacroix 1960, vol. 1, p. 69, "Mercredi 7 avril."

In an extensive journal entry on Sunday, April 11, Delacroix notes a Velázquez (the Carreño mentioned above) that he is copying (private collection, Paris [J 21]). The portrait of Charles II appears to have influenced Delacroix's own *Self-Portrait (Ravenswood)* (fig. 14.29). Delacroix is, at this time, finishing his *Massacres at*

Chios (Musée du Louvre, Paris [J 105]), exhibited at the Salon of 1824, and beginning *The Agony in the Garden* (Church of Saint-Paul-Saint-Louis, Paris [J 154]), exhibited at the Salon of 1827. This same day he also attends a viewing of Géricault's studio in preparation for the artist's sale (which does not take place until November [Lugt 10747]): "What a piece of luck it would be to have one or two copies after the master in his sale! His family picture after Velasquez, etc." This copy after Velázquez is the painting from the Kunsthistorisches Museum, Vienna, now attributed to Mazo, that had been on display at the Louvre from 1809–10 until 1815, when it was returned to Vienna (see 1810).

"Quel bonheur ce serait d'avoir à sa vente une ou deux copies d'après les maîtres! Son tableau de famille d'après Velasquez, etc." Delacroix 1960, vol. 1, p. 75, "Dimanche 11 avril."

On Monday, May 3, Delacroix refers to the famous Soult collection for the first time: "Saw Marshal Soult's pictures.—In doing my angels for the prefect [*Agony in the Garden*], think of those beautiful, mystical figures of women, one of them bearing her breasts on a dish" (Zurbarán's *Saint Agatha* and *Saint Casilda* (figs. 14.30, 14.31).

"Vu les tableaux du maréchal Soult.—Penser, en faisant mes anges por le préfet, à ces belles et mystiques figures de femmes, une, entre autres, qui porte ses tétons dans un plat." Delacroix 1960, vol. 1, p. 91, "Lundi 3 mai."

April National Gallery, London, founded with the purchase by the House of Commons of the collection of John Julius Angerstein. The collection is housed in Angerstein's home until a new museum building is constructed. It will open to the public in 1838.

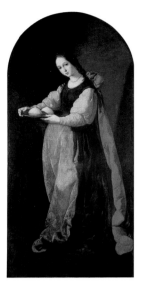

Fig. 14.30 Francisco de Zurbarán, *Saint Agatha,* before 1634. Oil on canvas. Musée Fabre, Montpellier

May 30 Goya, after petitioning on May 1 for a six-month leave of absence, is granted his departure from Madrid. Intending to seek a permanent home in France, he had signed his house, the Quinta del Sordo (fig. 14.32), over to his grandson Mariano on September 17, 1823, leaving behind the frescoed cycle known as the *Pinturas negras,* or Black Paintings, as well as the copperplates of his print series, *Los Desastres de la Guerra* and *Los Disparates* (Academia de San Fernando, Madrid, 194).

On June 24, Goya stops in Bordeaux, en route to Paris, to see his friend Moratín.

Goya arrives at the home of Vicente González Arnao in Paris on June 30. Arnao arranges for him to stay at the Hotel Favart, 5, rue Marivaux. While in Paris, Goya is commissioned for portraits of Joaquín María Ferrer (G-W 1659) and his wife, Manuela Alvárez Coiñas de Ferrer (collection of the marquesa de la Gándara, Rome [G-W 1660]), as well as a bullfight scene (J. Paul Getty Museum, Los Angeles, formerly Gándara collection [G-W 1672]).

During his stay Goya may have visited the Salon, which opened in August, where he would have seen Delacroix's *Massacres at Chios* (J 105), Prud'hon's *Christ on the Cross* (1822–23, Musée du Louvre, Paris) (fig. 2.34), and Constable's *The Haywain* (National Gallery, London).

On September 1, Goya leaves Paris for Bordeaux, staying at a hotel on the rue Esprit des Lois. By October 13 Goya settles in a house at 10, chemin de la Croix-Blanche, in Bordeaux.

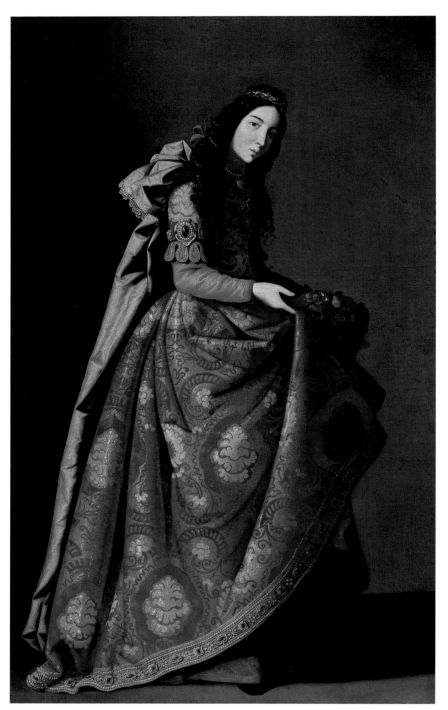

Fig. 14.31 (cat. 84) Francisco de Zurbarán, *Saint Casilda,* 1630–35. Oil on canvas, 67⅞ x 42⅛ in. (171 x 107 cm). Museo Thyssen-Bornemisza, Madrid

September 16 Comte d'Artois (1757–1836), grandson of Louis XV, succeeds his brother Louis XVIII as Charles X, last Bourbon king of France (r. 1824–30). In Bordeaux, Goya moves into a house at 24, cours de Tourny.

French catalogue of the Real Museo, Madrid, published in 1823, is translated into Spanish and published in Madrid: *Catálogo de los cuadros que existen colocados en el Real Museo de pinturas del Prado.*

1825
January Charles Motte publishes *Caricatures espagnoles,* a book of ten lithographs after Goya's *Los Caprichos* (reproducing plates 10, 14, 15, 18, 23, 32, 40, 43, 52, and 55) (fig. 5.27). Motte will also publish Delacroix's lithographs.

Summer French artist Pharamond Blanchard (1805–1873) accepts an offer of work from José de Madrazo (Spanish, 1781–1859), painter to Ferdinand VII and former pupil of David, who

Fig. 14.32 Saint-Elme Gautier, *Quinta del Sordo (Goya's House)*, 1867. Pen drawing. From Yriarte 1867

is in France to recruit lithographers to reproduce works of art in the Real Museo, Madrid.

In March, Madrazo and Ramon Castilla had obtained permission from Ferdinand VII to create the Real Establecimiento Litográfico, with exclusive rights, for ten years, to reproduce paintings from the royal collections. Their catalogue will be published in 1826 (see 1826).

Guinard 1967b, p. 85.

November 17, 29, and December 23 In Bordeaux, the printer Gaulon registers the publication of 100 sets of Goya's four lithographs, the *Bulls of Bordeaux* (figs. 5.22–5.25).

December 20 From Bordeaux, Goya writes to his friend Ferrer in Paris of having painted, during the previous winter, forty miniatures on ivory (G-W 1676–1697), which he describes as looking "more like the brushwork of Velázquez than of Mengs."

Gassier and Wilson 1971, p. 362.

Prosper Mérimée (French, 1803–1870), even though he was not to visit Spain until 1830, publishes as his first book *Théâtre de Clara Gazul*, a series of light Spanish comedies narrated by a fictitious Spanish actress.

Frédéric Quilliet publishes *Les arts italiens en Espagne* (Rome, 1825), the result of his intimate knowledge of the painting collections of Spain.

1826
March 8 First of twenty-two bimonthly *livraisons* (installments) of engravings for the first volume of Baron Taylor's *Voyage pittoresque en Espagne, en Portugal et sur la côte d'Afrique, de Tanger à Tétouan* announced in *Bibliographie de la France*. Seven will be published by November 1830, seventeen by August 1835. By 1845 all twenty-two *livraisons* of the first volume, and ten of the second volume (consisting of twenty *livraisons*), will be published. The third volume, consisting of the text, will be published sometime after 1848. It will follow the example of the renowned *Voyages pittoresques et romantiques dans*

l'ancienne France (1820–78) by Taylor, Charles Nodier, and Alphonse de Cailleux.

Guinard 1967b, p. 109; Plazaola 1989, p. 145.

March 30 First portfolio of sixteen lithographs constituting the *Colección lithográphica de cuadros del Rey de España el Señor Don Fernando VII que se conservan en sus reales palacios, Museo y Academia de San Fernando, con inclusion de los del real monasterio del Escorial* published under the direction of José de Madrazo, with text by Ceán Bermúdez (Madrid, 1826–32). Eventually bound into three volumes, it will include 198 lithographs after paintings in the royal collections.

Alcolea Blanch 1996, p. 35; see also Curtis 1883, p. 467.

March 31 Real Museo, Madrid, closed for alterations by order of the king. It will reopen in March 1828.

May 1–19 Sale of Dominique-Vivant Denon's collection (Lugt 11164), Paris, includes 987 lots, the majority drawings. Six works are listed as Spanish school, but only one can be identified today: lot 53, a Velázquez *Holy Family*, now

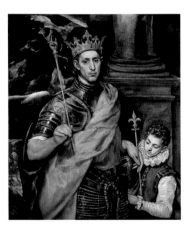

Fig. 14.33 El Greco (Domenikos Theotokopoulos), *Saint Louis of France and a Page*, 4th quarter 16th century. Oil on canvas. Musée du Louvre, Paris

assigned to Pieter-Fransz. de Grebber (Musée des Beaux-Arts, Besançon). It is possible that a Veronese *Portrait of Saint Louis* may be El Greco's *Saint Louis of France and a Page* (Musée du Louvre, Paris) (fig. 14.33).

As proposed by Marie-Anne Dupuy in Paris 1999–2000, pp. 438–39.

Denon's volume of *Los Caprichos* acquired by the Bibliothèque Impériale, Paris. Also among the lots is a series of eighteen drawings by Denon that may have been intended to illustrate the fourth French edition of Matthew Gregory Lewis's thriller novel *The Monk*, printed in Paris as *Le Moine* (4th ed., 1819). Seven drawings from

the series are produced as lithographs by René Berthon (1776–1859) and evoke Goya's *Caprichos*, a copy of which Denon had by 1809 (see 1809).

Paris 1999–2000, p. 102, no. 71: lot 894: "dix-huit dessins terminés à la plume et au lavis, offrant des sujets tirés du roman du Moine. Cette collection intéressante n'a pas été gravée."

Notice des tableaux exposés dans la galerie du Musée Royal (Paris, 1826) includes eleven Spanish paintings in the collection. The works are the same as those listed in the catalogue of 1823, with the addition of a painting by Luis Morales, *Christ Carrying the Cross* (no. 1098), acquired in 1824 (now Spanish?, early seventeenth century, Musée du Louvre, Paris).

1827
April 5 Thirty-five paintings from the reserved galleries of Madrid's Academia de San Fernando —including the infamous gallery of nudes—are transferred to the Real Museo; several of these works will be placed on display in 1828.

Alcolea Blanch 1996, p. 39.

April 17–21 Sale of chevalier Féréol Bonnemaison's collection (Lugt 11401), Paris, includes 148 paintings, among them 7 Spanish works. Bonnemaison served as gallery director for the Dauphine and curator of the gallery of the duchesse de Berry and the duc de Bordeaux as well as director of painting conservation of the Musée Royal.

Bonnemaison 1827.

June 1 Sale of the conde de Altamira's collection, Stanley, London (Lugt 11468). Among the seventy-five paintings offered are twenty-eight Spanish works. Altamira's family was one of the ten noble Spanish houses forced to contribute works to the Musée Napoléon (see 1809) and to whom restitution was made following the decree of May 1814.

Salon (November 4) Desiring to increase subscriptions for his travelogue *Voyage pittoresque en Espagne, en Portugal et sur la côte d'Afrique, de Tanger à Tétouan* (see 1826), Taylor exhibits eight engravings of views of Seville, Gibraltar, Barcelona, Tolosa, and Portugal at the Salon.

1828
March 17 *Gaceta de Madrid* announces the reopening of the Real Museo on March 19 and lists its hours: "every week on Wednesdays and Saturdays: from May 1 until the end of August at eight in the morning, and from September 1 until the end of April at nine, and all year round until two in the afternoon." It also advertises the new catalogue of the collection, *Noticias de los cuadros que se hallan colocados en la galería del Museo del Rey, Nuestro Señor, sito en el Prado de esta Córte.*

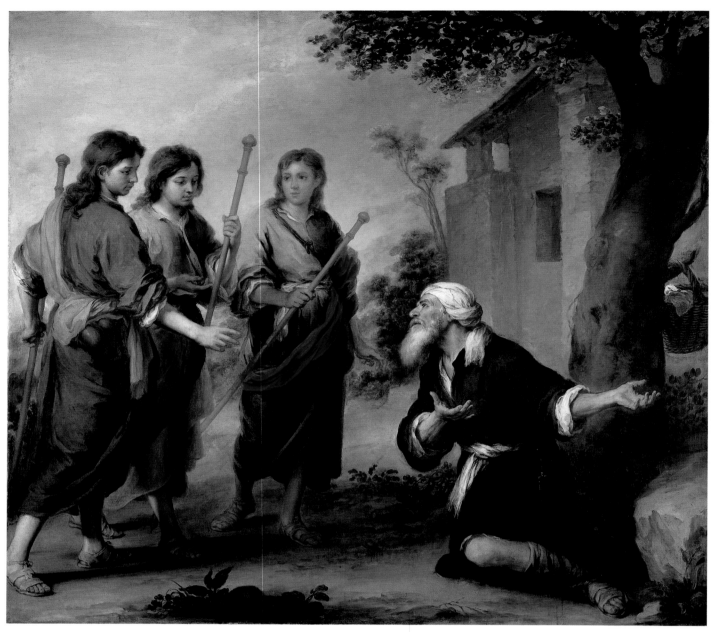

Fig. 14.34 (cat. 54) Bartolomé Esteban Murillo, *Abraham and the Three Angels*, 1667. Oil on canvas, 93 x 103 in. (236 x 261 cm). National Gallery of Canada, Ottawa

The new installation includes Goya's *Second of May 1808* and *Third of May 1808* (G-W 982, 984).

Beroqui 1931, p. 272; also quoted in Alcolea Blanch 1996, p. 39.

April Victor Hugo's "Fantômes," a group of five poems devoted to Spanish subjects, is published.

April 16 Goya dies in Bordeaux.

Delacroix's illustrations for Goethe's *Faust* (Paris, 1828) (fig. 6.11) are indebted to Goya's *Caprichos,* as are Louis Boulanger's illustrations for Victor Hugo's poem "La Ronde du Sabbat" (in *Odes et ballades,* Paris, 1828).

Publication of the first volumes of Achille Réveil's *Musée de peinture et de sculpture avec des notices descriptives, critiques et historique par J. Duchesne aîné.* The copiously illustrated catalogue includes thirty-six engravings after Spanish masters (one Herrera, one Claudio Coello, two Alonso Canos, three Zurbaráns, six Velázquezes, seven Riberas, sixteen Murillos).

Lipschutz 1972, p. 87.

1829
December 9 Ferdinand VII marries his fourth wife, María Cristina of Naples (1806–1878). Under her influence, Ferdinand will publish, in March 1830, the Pragmatic Sanction, which will

exclude his brother Don Carlos (1788–1855) from the Spanish throne even if the queen gives birth to a daughter.

Mérimée's comedy *Le Carrosse du Saint-Sacrement* is published in the *Revue de Paris* and the *Revue Française.* For the only time in his writings, Mérimée mentions a Spanish painter, Murillo.

Lipschutz 1972, p. 110.

Washington Irving's extremely popular *Chronicle of the Conquest of Granada* is published simultaneously in England and America. His inspiration for the book had come while conducting research in Spain for *A History of the*

Life and Voyages of Christopher Columbus, published in 1828.

1830

February 25 Victor Hugo's *Hernani, ou L'honneur castillan* (fig. 14.35) opens with much fanfare at the Théâtre Français, Paris, with Mademoiselle Mars playing the role of Doña Sol. Baron Taylor, named royal commissioner of the Théâtre

Fig. 14.35 Albert Besnard, *La Première d'Hernani*, 19th century. Musée Victor Hugo, Paris

Français in 1825 and upon whose recommendation the play is staged, is on the cusp of his famous expedition to Egypt but delays his trip for a month owing to the play's premiere; he does not leave until he has seen it twelve times.

Guinard 1967b, p. 52 n. 11.

April 30 Flemish and Dutch galleries, as well as part of the sculpture gallery, open at the Real Museo, Madrid.

May 15 Victor Hugo mentions Goya and plate 64 of *Los Caprichos*, *Buen viage*, in his poem number 28 from *Les feuilles d'automne*, which he wrote at the same time as *The Hunchback of Notre Dame*.

Lipschutz 1972, p. 114.

June–December Mérimée visits Spain for the first time and befriends the noble family of the conde de Montijo. He submits a number of articles from Spain in the form of letters ("Lettres d'Espagne"), which are published in the *Revue de Paris* between 1830 and 1833. His first is addressed to Victor Hugo and dated Sunday, June 6, 1830. His chronicles bear titles such as "Les combats de taureaux" (Bullfights, January 1831); "Une exécution" and "Musée de Madrid" (An execution; Museum of Madrid, March 1831); "Les voleurs en Espagne" (The thieves in Spain, August 1832); "Les sorcières espagnoles" (The Spanish sorcerers, December 1833). The articles are eventually compiled for a book (see 1833).

July Following the July Revolution, Charles X abdicates the French throne and Louis-Philippe

(1773–1850) (fig. 14.36), eldest son of the duc d'Orléans, becomes king of France, initiating the July Monarchy.

October 10 Birth of Ferdinand's heir, the future Isabella II of Spain.

Richard Ford is in Spain (until 1833). His travels will serve as the source for his pivotal *Hand-book for Travellers in Spain and Readers at Home* (London, 1845).

Future English statesman Benjamin Disraeli (1804–1881) writes to Austen: "Run my dear fellow, run to Seville and for the first time in your life know what a great artist is, Murillo, Murillo, Murillo!"

Quoted in García Felguera 1989b, p. 9.

Disraeli also posts a letter to his father from Cadiz on July 14, describing the collection of Mr. Brackenbury, British consul in Cadiz, as a palace wallpapered with paintings.

Tromans 1998, p. 68.

Among the works in Brackenbury's collection is Murillo's *Don Andrés de Andrade y la Cal* (fig. 1.31), which he lends to an exhibition at the British Institution in 1836.

Soult comes close to selling four Spanish paintings from his collection to Louis-Philippe for 500,000 francs, but he is unsuccessful: Murillo, *Immaculate Conception* (fig. 1.20); Murillo, *Abraham and the Three Angels* (fig. 14.34); Murillo, *Return of the Prodigal Son* (fig. 14.43); and Velázquez, *Saint Francis Borgia* (location unknown). He will later sell

Fig. 14.36 F.-H.-E. Philippoteaux, *Louis-Philippe*, 1830–48. Graphite with gouache. Musée National des Châteaux de Malmaison et de Bois-Préau, Rueil

three of them to the duke of Sutherland for the same sum (see 1835).

Curtis 1883, p. 117.

Mérimée's *La Perle de Tolède*, a romantic tale of a Moor's love for a Christian beauty, published in Paris.

Alfred de Musset writes a series of poems published as *Contes d'Espagne et d'Italie* (Paris, 1830). Several of the poems devoted to Spain are inspired by Goya's *Caprichos*, plates of which Musset had copied. The young women depicted in his copies—nos. 15, *Bellos consejos* (fig. 9.84) and no. 31, *Ruega por ella* (fig. 6.18)—are evoked in his poems "Madame la marquise" and "L'Andalouse."

Lipschutz 1972, p. 156.

1831

March Mérimée's article "Le Musée de Madrid," published in the first issue of *L'Artiste*. He notes that the museum is open two days per week to the public, though foreigners can visit on any day, save Sunday, upon showing their passport, and laments that the Italian paintings are illuminated to the detriment of the Spanish and Flemish schools. His favorite work is Murillo's *Vision of Saint Bernard* (A 287) (fig. 4.25), as he cannot imagine a Madonna more capable of making a devout but young monk sin than this beauty. "Read Lewis's *The Monk*," he advises his readers (see 1796).

"Lisez le Moine de Lewis." Mérimée 1831c, p. 75.

May Adélaïde de Montgolfier (as Ad.M.) publishes an article on Goya in the *Revue Encyclopédique*.

September–November At the Arsenal in Paris, Antoine Fontaney shows a volume of *Los Caprichos* (acquired during a trip to Madrid in the first half of 1831) to friends and the writers Madame Belloc (Louise Swanton) and Adélaïde de Montgolfier.

Lipschutz 1972, pp. 90–91.

November The Hermitage receives the shipment of thirty-three paintings purchased from Manuel Godoy in Paris. Among the most important of these works is Murillo's *Death of the Inquisitor Pedro de Arbués* (A 366) and Ribera's *Saint Jerome Listening to the Sound of the Heavenly Trumpet* (fig. 8.5).

Kagané 1997, p. 13.

Victor Hugo's *Notre-Dame de Paris* (*The Hunchback of Notre Dame*) published in France. Henri de Latouche's *La reine d'Espagne* staged at the Comédie-Française; it does poorly.

Guinard 1967b, p. 110 n. 3.

Notice des tableaux exposés dans le Musée Royal (Paris, 1831) includes twelve works by five Spanish artists in the permanent collection, all listed under the Italian school. The works are the same as those listed in 1823, with the addition of Murillo's *Un saint personnage inspiré du ciel*, no. 1129 (this is Murillo's *Saint Augustine*, which entered the collection under Charles X and was previously in the collection of Lucien Bonaparte [see 1812]. It was considered to be an old copy, and in 1872 it was sent to the Musée Ingres, Montauban).

As noted by Geneviève Lacambre.

1832

January–June Delacroix, who left Paris in late December 1831, travels to Spain and North Africa as a member of the diplomatic mission led by the comte de Mornay, who was appointed ambassador extraordinary to the sultan of Morocco by Louis-Philippe. Delacroix is asked to produce a visual record of the journey and returns with seven albums of sketches (three are extant: one in Chantilly, two in the Musée du Louvre, Paris).

January 24 (Algeciras) Sailing along the eastern coast of Spain, Delacroix catches glimpses of Minorca, Majorca, and Malaga, as well as Granada, Gibraltar, and Algeciras. En route to Tangiers, his ship is briefly quarantined in the port of Algeciras, and he is able to go ashore with the crew for provisions. He writes to his friend Pierret that "I have seen the grave Spaniards, with costumes à la Figaro. . . . One of my most happy sensations has been seeing myself . . . transported . . . to this picturesque country; to see its houses, the capes worn by the ragged elderly, including the children of the beggars, etc. All of Goya palpitates around me."

"J'ai vu les graves Espagnols en costume à la Figaro. . . . Ça été une des sensations de plaisir les plus vives que celle de me trouver . . . transporter . . . dans ce pays pittoresque; de voir leurs maisons, leurs manteaux que portent les plus grand gueux et jusqu'aux enfants des mendiants, etc. Tout Goya palpitait autour de moi." Delacroix 1936–38, vol. 1, p. 305.

May 16–20 (Cadiz) Returning from Tangiers, Delacroix arrives in Cadiz on May 16, after a seven-day quarantine. He writes in his journal: "obtained entry to Cadiz; extreme joy." During his trip he visits several churches and convents. May 19: He notes a visit to the convent of the Capuchins, where he sees "Murillo's Virgin: the cheeks perfectly painted and the eyes celestial." May 20: He visits the convent of the Dominicans and the cathedral; a cursory "the bull" may refer to a visit to the bullfight.

"obtenu l'entrée à Cadix; joie extrême"; "La Vierge de Murillo: les joues parfaitement peintes et les yeux

célestes"; "Le taureau." Delacroix 1960, vol. 1, pp. 152, "le 16 mai," 154, "Samedi 19 mai."

May 21–28 (Seville) (figs. 14.37, 14.38) On May 21, Delacroix departs for Seville, arriving May 22. He visits the cathedral on May 25, climbing its bell tower, La Giralda (see fig. 14.40). He visits the monastery of La Cartuja, where he sees a "beautiful Zurbaran in the sacristy" (either

Fig. 14.37 (cat. 118) Eugène Delacroix, *A Picador*, 1832. Watercolor with graphite. Musée du Louvre, Paris

Fig. 14.38 Eugène Delacroix, *Plaza San Lorenzo in Seville: May 1832*, 1832. Watercolor with graphite. Musée du Louvre, Paris

Saint Hugo in the Refectory [G-G 299; fig. 3.14], *Virgin of Mercy of Las Cuevas* [G-G 298], or *Pope Urban II and Saint Bruno* [G-G 300], all Museo de Bellas Artes, Seville). During a visit to the Capuchins he writes of "beautiful Murillos; among others the saint with the miter and the black robe giving alms" (*Saint Thomas of Villanueva*, Museo de Bellas Artes, Seville [A 76]). He recalls "The morning, in the sacristy of the cathedral, two saints of Goya" (*Saint Justa and Rufina*, Seville Cathedral [G-W 1569]). On May 26, he visits the Alcázar, then writes also of "the famous Romero, matador and professor of bullfighting." The following day he records that "I have wandered in the streets a lover of Spain." On May 28, his last day in Seville, he visits the Casa de Pilatos and departs via ship.

"Beau Zurbaran dans la sacristie"; "Beaux Murillos; entre autres le saint avec la mitre et la robe noire donnant

l'aumône"; "Le matin, dans la sacristie de la cathédrale, deux saintes de Goya"; "le fameux Romero, matador et professeur de tauromachie"; "j'avais erré dans les rues en amant espagnol." Delacroix 1960, vol. 1, pp. 155–56, "Vendredi 25 mai" and "Samedi 26," p. 157, "Dimanche 27."

June In a letter to Pierret on June 5, Delacroix states: "I return from Spain, where I have spent several weeks: I have lived twenty times more than in several months in Paris. I am so happy at having been able to get an idea of this country. . . . I have found in Spain all that I had left behind in Morocco. Nothing has changed, save the religion; the fanaticism otherwise is the same. I have seen the beautiful Spanish women who do not refute their fame. There is nothing more graceful in the world than the mantilla. Monks of every color, Andalusian costumes, etc. Churches and an entire civilization as it was 300 years ago."

"Je reviens de l'Espagne, où j'ai passé quelques semaines: . . . j'ai vécu vingt fois plus qu'en quelques mois à Paris. Je suis bien content d'avoir pu me faire une idée de ce pays. . . . J'ai retrouvé en Espagne tous ce que j'avais laissé chez les Maures. Rien n'y est changé que la religion: le fanatisme, du reste, y est le même. J'ai vu les belles Espagnoles qui ne sont pas au-dessous de leur réputation. La mantille est ce qu'il y a au monde de plus gracieux. Des moines de toute couleur, des costumes andalous, etc. Des églises et toute une civilisation comme elle était il y a trois cents ans." Delacroix 1936–38, vol. 1, pp. 331–32.

The poem "Albertus, ou l'âme et le péché" (1832) by Théophile Gautier (French, 1811–1872) cites Goya: "In the shadows, at the foot of the bed, swarm strange forms / Of incubi, nightmares, specters, heavy and misshapen, / An entire collection by Goya and Callot!"

Dans l'ombre, au pied du lit, grouillaient d'étranges formes / Incubes, cauchemars, spectres, lourds et difformes, / Un recueil de Callot et de Goya complet! See Lipschutz 1972, pp. 118–19.

Fig. 14.39 Mateo Cerezo, *Saint Thomas of Villanueva Distributing Alms*, mid-17th century. Oil on canvas. Musée du Louvre, Paris (formerly Soult collection)

Washington Irving's *The Alhambra*, a collection of romantic tales about the Moors in Spain, published in London.

1833

July 3–30 Baron Taylor is in Spain with the painter Adrien Dauzats (French, 1804–1868) (fig. 14.40), who had also accompanied Taylor to Egypt, Syria, Palestine, and Turkey in 1829. In Madrid they encounter the engraver Pharamond Blanchard (see 1825), who introduces Taylor and Dauzats to the prominent artistic family of José de Madrazo. Taylor's stay in Madrid and visit to Toledo are reported in several issues of *La Revista Española*.

July 23 and August 2, 1833, as well as the following two issues; as noted in Guinard 1967b, p. 111 n. 7.

Fig. 14.40 Adrien Dauzats, *"La Giralda," Seville Cathedral*, ca. 1839. Oil on canvas. Musée du Louvre, Paris

Upon his return to Paris, Taylor plays host in mid-August to Madrazo's son Federico (Spanish, 1815–1894), who ultimately paints his portrait (Versailles). The work does not meet with his father's approval, and Madrazo writes to Federico, "I am sorry that your portrait of Baron Taylor includes the uniform, because the head loses much of its effect thereby. . . . I would have preferred it in the style of Velázquez."

"Je regrette que ton portrait du Baron Taylor comporte l'uniforme, parce que l'effet de la tête y perdra beaucoup . . . je l'aurais préféré dans le style de Velázquez." Letter from José de Madrazo to his son Federico, September 30, 1833, quoted in Guinard 1967b, p. 124.

September 29 Death of Ferdinand VII. María Cristina becomes queen regent (r. 1833–40). Outbreak of the Carlist Wars in Spain, which pits the *cristinos* (the forces of the infant queen Isabella II, daughter of Ferdinand VII) against the *carlistas* (supporters of her uncle Don Carlos,

who seeks the throne for himself). The conflict will continue, in the form of sporadic battles, until 1868. The first Carlist War extends from October 3, 1833, to August 31, 1839.

Delacroix writes to his patron Baron Schwiters: "Moreover, he told me that you are taking him on Thursday to Marshal Soult's [fig. 14.39]. Is it an indiscretion to ask you if you can take me as well?"

"De plus il m'a dit que vous mèneriez jeudi chez le maréchal Soult. Y a-t-il de l'indiscrétion à vous demander si vous pouvez m'y mener par-dessus le marché?" Delacroix 1936–38, vol. 1, p. 362.

Delacroix's lithograph *A Blacksmith (Le Forgeron* [D 19]) (fig. 5.32) issued.

Mérimée's *Lettres sur l'Espagne* published in Paris; subsequent editions appear in 1842, 1881, 1888, and 1896.

1834

February 6 *Le Charivari* publishes *Un Cauchemar*, an anonymous lithograph that caricatures Goya's *The Sleep of Reason Produces Monsters* (plate 43 of *Los Caprichos*) (fig. 6.4).

Salon (March 1) Delacroix exhibits *Dominican Convent in Madrid* (Philadelphia Museum of Art [J 146]) (fig. 14.41). The subject is derived from the romantic novel *Melmoth the Wanderer* (1821) by Charles Robert Maturin (1780–1824)

April 22 England engineers the Quadruple Alliance with France, Spain, and Portugal in support of the Spanish crown.

July 15 Spanish Inquisition abolished.

September 29 Dauzats, in a letter to Federico de Madrazo, asks "a small favor . . . I am doing a piece on the life and works of Goya. It is a homage that we want to render to one of the most celebrated modern painters of Spain." Madrazo, responding the following April, regrets that he cannot comply as he is unable to obtain

Fig. 14.41 Eugène Delacroix, *Dominican Convent in Madrid*, 1831. Oil on canvas. Philadelphia Museum of Art

the information from Goya's son, who is currently not in Madrid.

"un petite grâce . . . je m'occupe d'une notice sur la vie et les ouvrages de Goya. C'est un hommage que nous voulons rendre à l'un des peintres modernes les plus célèbres de l'Espagne." Quoted in Guinard 1967b, p. 126. Guinard proposes that it is perhaps Dauzats who is the anonymous writer of the Goya article in the Magasin Pittoresque *(see below).*

November 24 Delacroix is in possession of a volume of Goya's *Caprichos*, most likely the edition from the Guillemardet collection. George Sand notes in her *Journal intime* that "this morning . . . Lacroix showed me the collection by Goya . . . he spoke to me of Alfred [Musset] and told me that he would have made a great painter had he wished."

"ce matin . . . Lacroix, m'a montré le recueil de Goya . . . il m'a parlé d'Alfred [Musset] à propos de cela et m'a dit qu'il aurait fait un grand peintre s'il eût voulu." Quoted in Floorisone 1952, pp. 142–43, and Huyghe 1963, p. 108.

December Louis Viardot publishes an article in the *Revue Républicaine* in which he proposes the idea of "a scientific and artistic mission" to Spain that would culminate in the opening of a French museum of Spanish art.

L'Artiste publishes an article on Murillo by Théophile Thoré (French, 1807–1869) as well as a lithograph of Goya's tapestry cartoon *Un Mariage burlesque* by the painter Jean-Louis Gintrac (French, 1808–1886).

Thoré 1834; Gintrac 1834. Gintrac had seen the cartoon in Madrid.

The *Magasin Pittoresque* publishes a series of anonymous articles devoted to the following Spanish painters: Murillo, with a reproduction of *Beggar Boy*; Goya, with illustrations of plates 1, 39, and 51 of *Los Caprichos*; and Ribera, with a reproduction of *Adoration of the Shepherds*. Additional articles are published in 1838 (see 1838).

Anon. 1834b, no. 27; Anon. 1834c, no. 41; Anon. 1834a, no. 45.

1835

January 4 In Madrid, Federico de Madrazo and his brother-in-law Eugenio de Ochoa (Spanish, 1815–1872) found the art journal *El Artista*, which publishes its first issue. Blanchard contributes several etchings. A biography of Goya will be published in issue 2.

April 13 Louis-Philippe's agent purchases three Spanish paintings from Soult for 500,000 francs; they are briefly stored at the Louvre before the deal is canceled by Soult on May 23: Murillo, *Immaculate Conception* (Museo del Prado, Madrid [A 110]); Murillo, *Christ Healing the Paralytic*

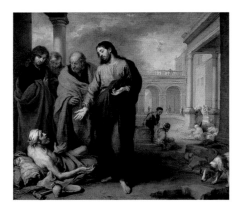

Fig. 14.42 Bartolomé Esteban Murillo, *Christ Healing the Paralytic*, 1667–70. Oil on canvas. National Gallery, London

(National Gallery, London [A 82]) (fig. 14.42); Murillo, *Liberation of Saint Peter*, then attributed to Ribera (Hermitage, St. Petersburg [A 85]).

Archives des Musées Nationaux, P5, 23 mai 1835. See also Anon. 1835b, p. 195.

Soult sells three works to the duke of Sutherland for 500,000 francs (he had tried to sell these same paintings to Louis-Philippe in 1830): Murillo, *Abraham and the Three Angels* (fig. 14.34); Murillo, *Return of the Prodigal Son* (National Gallery, Washington, D.C. [A 83]) (fig. 14.43); Velázquez, *Saint Francis Borgia* (location unknown).

Curtis 1883, p. 117.

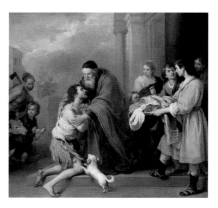

Fig. 14.43 Bartolomé Esteban Murillo, *Return of the Prodigal Son*, 1667–70. Oil on canvas. National Gallery of Art, Washington, D.C.

May Louis Viardot's *Études sur l'histoire des institutions, de la littérature, du théâtre et des beaux-arts en Espagne* published in Paris. In his study of the fine arts he writes, "Instead of doing the history of painting in Spain, I am going to give a description of the museum in Madrid. It will be the same thing."

"Au lieu de faire l'histoire de la peinture en Espagne, je vais donner la description du musée de Madrid. Ce sera la même chose." Viardot 1835, p. 383.

July 4 In Spain, the Jesuit order (reestablished in Europe by Pius VII in 1814) is abolished by decree. During July, monasteries of fewer than twelve persons are abolished and those remaining are forbidden to recruit novices. On October 11, all teaching and nursing institutions will be suppressed.

August 21 Baron Taylor, in a letter to Dauzats asking him to accompany the Spanish expedition, adds the following postscript: "All the Spanish provinces are declaring themselves independent. Folly, fever, and rage. They cry: Death to the monks, war on the castles and the rich, long live liberty! It is as if they were saying: Long live tyranny!"

"Toutes les provinces d'Espagne se déclarent indépen-dantes. Folie, fièvre et rage. Ils crient: mort aux moines, guerre aux châteaux et aux riches, vive la liberté! C'est comme s'ils disaient: vive la tyrannie!" Quoted in Guinard 1967b, p. 140.

October 19 Prior to departing for Spain, Baron Taylor attends the premiere of *Don Juan d'Autriche* by Casimir Delavigne at the Comédie-Française.

Guinard 1967b, p. 136.

November–April 1837 Baron Taylor begins his "scientific and archeological mission" to Spain, ordered by Louis-Philippe. His task is to acquire works for a Galerie Espagnole to be opened at the Louvre in Paris, thus rectifying the lack of Spanish painting in France. The expedition is particularly well timed to take advantage of the instability wrought by the skirmishes of the Carlist War and the large number of paintings that flood the market after the *ex-claustraciónes* (secularizations) of 1834–35. Joining the mission are Dauzats and Blanchard (see July 1833).

The group enters Spain quietly via Portugal and heads south to Andalusia. The travelers do not wish to alert the Spanish government and possibly impede the export of any works pur-chased, nor do they want picture sellers to raise their prices. The French particularly do not want the British, possible competitors, to know of their mission. The official pretext for the trip is said to be research for Taylor's *Voyage pittoresque en Espagne, en Portugal et sur la côte d'Afrique, de Tanger à Tétouan* (see 1826). The latter is confirmed by Federico de Madrazo's item in *El Artista* regarding Taylor's visit: "MM. Taylor and Dauzats will spend a short time in Madrid, where we hope that the government will offer them every means to gather the greatest possible number of facts for their important work."

"Los Sres. Taylor y Dauzats pasarán una breve temporada en Madrid, donde esperamos que el Gobierno les facilite todos los medios para reunir el mayor número posible de datos para su importante obra." F. Madrazo 1836, n.p., quoted in Plazaola 1989, p. 126.

Taylor's concerns are increased by an article, "Conventos españoles: Tesoros artísticos encerra-dos en ellos," written by his acquaintance the Spanish author Mariano José de Larra and pub-lished in *La Revista Española* on August 3, 1835; however, no alarm is raised.

Taylor eventually returns to Paris with more than 500 paintings from different schools as well as works on paper, sculptures and plaster casts of architectural elements from the Alhambra, furni-ture, glass, porcelain, and ceramics. Among the paintings are 455 Spanish works by eighty differ-ent artists, 412 of which will be exhibited in the Galerie Espagnole in 1838.

Marinas 1983, p. 135.

Revue de Paris publishes two articles by Thoré on the Spanish paintings in the Soult collection. He admires the works by Murillo: "There is cer-tainly no gallery in the world (except for Seville and Madrid) where we can study as fully as at Marshal Soult's this fine artist's life as a whole, with every transition of talent, every develop-ment of his genius."

Of particular interest is Thoré's assessment of the prints of Spanish paintings available in the Bibliothèque Nationale, among them Velázquez's *Waterseller of Seville*, *Forge of Vulcan*, and a *Dwarf of Philip IV* by Goya. "There are a great many other reproductions of Velasquez . . . but the directors of the Bibliothèque Royale are apparently little interested in the print collection, for it includes only four Spaniards, Ribera, Murillo, Velasquez, and the comic work of the old Goya."

"il n'y a certainement pas une gallerie au monde (excep-tions Séville et Madrid), où l'on puisse étudier aussi com-plètement que chez le maréchal Soult, toute cette belle vie d'artiste, toutes les transitions de son talent, tout le dével-oppement de son génie." "Il existe beaucoup d'autres reproductions de Velasquez . . . mais les directeurs de la bibliothèque royale s'inquiètent apparemment fort peu de la collection d'estampes, car elle ne comprend que quatre Espagnols, Ribera, Murillo, Velasquez, et l'oeuvre comique du vieux Goya." Thoré 1835a and 1835b; for quotations, see pp. 44 and 57, respectively.

Brackenbury, the British consul in Cadiz who had acquired an important collection of paintings during his residence in Spain, offers to donate several Murillos from his collection to the National Gallery, London; the offer is rejected. He will sell several works in 1836–37.

Tromans 1998, p. 68.

In Cherbourg, Thomas Henry donates his col-lection to the city. The Musée Thomas Henry (predecessor of the Musée Cherbourg) includes seven Spanish works: Coello's *Penitent Magdalen* (fig. 2.37); Herrera the Elder's *David Praying to God* and *Saint*; Murillo's *Christ at Calvary*;

Palomino's *Saint Sebastian*; and Ribera's *Philosopher* and *Astronomer*.

A young Jean-François Millet (1814–1875), who received his early artistic training in Cherbourg, undoubtedly views the collection before leaving for Paris in January 1837.

Laure Junot, duchesse d'Abrantès (French, 1784–1838), wife of General Andoche Junot, Napoleon's governor of Portugal, publishes *Memorie contemporane sulla Spagna e sul Porto-gallo* in Milan. Her various books on life in Spain prove popular.

1836

January 13 In Spain, a royal decree calls for the collection of art from the suppressed religious institutions; they are to be taken to the former convent of La Trinidad in Madrid. The Museo Nacional de la Trinidad will open in July 1838.

June 9 Sale of the Richard Ford collection, London (Lugt 14389).

August 30 Xavier Goya signs a receipt for the sale of eight of his father's paintings to Baron Taylor, purchased for 15,000 reales (approximately 4,000 francs):

A Burial (*Un enterrement*, location unknown [G-W Appendix II, no. 21])
Last Prayer of a Condemned Man (*Dernière prière d'un condamné. Reo en capilla*, location unknown [G-W Appendix II, no. 17])
Majas on a Balcony (*Femmes de Madrid*, private collection [G-W 959])
Young Women (*The Letter*) (fig. 7.18)
Old Women (*Time*) (*Les vieilles*, Musée des Beaux-Arts, Lille [G-W 961])
The Forge (*La Forge*, Frick Collection, New York [G-W 965])
Lazarillo de Tormes (private collection [G-W 957])
Asensio Juliá (fig. 5.8)

September 29 An indignant Taylor writes to Dauzats from Seville expressing his anger at the news of Soult's sale to the duke of Sutherland (see 1835), of which Taylor had learned through a British newspaper in Seville: "So, a marshal of France, famous for the services he has rendered to his country, rich from his victories and the spoils of his victories, great man of war and who must have been a great citizen, sells his flags, fruit of our victories, sells his trophies, our trophies, my God! My God!"

"Ainsi, un maréchal de France, illustre par les services qu'il a rendus à son pays, riche de ses victoires et des dépouilles de ses victoires, grand homme de guerre et qui devrait être grand Citoyen, vend les drapeaux fruits de nos victoires, vend ses trophées, les nôtres, mon Dieu! mon Dieu!" Quoted in Plazaola 1989, p. 128, and Tromans 1998, p. 68.

December 27 Dauzats visits the Academia at Cadiz and executes a series of sketches in ink of the Zurbarán cycle of paintings from the monastery of Nuestra Señora de la Defensión, Jerez de la Frontera. The twelve paintings had been sent to the Academia after the supression of religious institutions in 1834 (three of the paintings—*Adoration of the Magi*, *The Circumcision* [G-G 125, 124, respectively; both Musée de Grenoble], and *The Battle between Christians and Moors at El Sotillo* [fig. 3.12]—had actually been appropriated for the Musée Napoleon but were returned in 1815). Taylor ultimately buys six of the canvases; the other six remain at the Academia and become property of the new museum of Cadiz, where they go on display in 1847.

Baticle 1998, p. 103.

Describing the masterpieces of the Soult collection in *L'Artiste*, an anonymous writer laments, "In traversing the vast salons of Marshal Soult, I confess that my admiration for so many fine works was assailed by two sad reflections: first, that it was possible in the nineteenth century of modern civilization to subject works of art to the barbarous rights of conquest; second, that all these masterpieces were shut up in obscurity and sterility in a private residence, accessible only to the commonplace curiosity of some connoisseurs, without any profit for art."

"En parcourant ces vastes salons de M. Soult, j'avoue que mon admiration pour tant de belles oeuvres était combattue par deux tristes préoccupations: la première, c'est qu'il avait été possible, dans le dix-neuvième siècle de la civilisation moderne, de faire peser les droits sauvages de la conquête sur des objets d'art; et la seconde, c'est que tous ces chefs-d'oeuvre étaient obscurcis et stérilement renfermés dans une demeure particulière, livrés seulement à la curiosité banale de quelques amateurs, sans profit pour l'art." S.-C. 1836, pp. 38–42; quoted in Lipschutz 1972, p. 36.

Notice des tableaux exposés dans le Musée Royal (Paris, 1836) lists twelve Spanish works (the same as those listed in the 1831 catalogue).

Louis Viardot's new translation of Cervantes' novel *Don Quixote*, illustrated with 765 woodcut prints by Tony Johannot (1803–1852), published in Paris. The second volume will appear in 1840, and another edition issued in 1845. Viardot's translation remains in use today (see also 1869).

Manuel Godoy's memoirs are translated and first published in French (*Mémoires du Prince de la Paix, Don Manuel Godoy* [Paris, 1836–37]), and then in Spanish (*Cuenta dada de su vida política por Don Manuel Godoy, Príncipe de la Paz* [Madrid, 1836–42]).

Charles Didier (Swiss, 1805–1864) publishes *De 1830 á 1836, ó La España de Fernando VII hasta Mendizábal* in Madrid. His article "L'Espagne en

1835" appears in *Revue des Deux Mondes*. Didier traveled through Spain between 1835 and 1839. Several articles about his travels are published in *Revue des Deux Mondes* and *Revue de Paris* throughout 1836–38 and in 1845. His travel diary, *Une année en Espagne*, will appear in 1837 (see 1837, 1838, 1845).

Laure Junot, duchesse d'Abrantès, publishes her two-volume *Scènes de la vie espagnole* in Paris and Brussels.

1837

February 24 In his article on Delacroix for *Le Siècle*, Thoré writes of the artist's monumental *Agony in the Garden* (Church of Saint-Paul-Saint-Louis, Paris [J 154]): "When he has to paint *Jesus Christ in the Garden of Olives* and beautiful angels parting the clouds, it is Murillo who prevails."

"Quand il faut faire Jésus-Christ au jardin des oliviers et de beaux anges qui entrouvent les nuages c'est Murillo qui domine." Thoré 1837.

April 4 "Baron Taylor, on the trip he has just made to Spain, has acquired for the government 300 pictures by the leading masters for the sum of about 700,000 francs."

"Le baron Taylor, dans le voyage qu'il vient de faire en Espagne, a acquis pour le gouvernement 300 tableaux des premiers maîtres au prix de 700,000 fr. environ." Anon. 1837a, p. 29.

April 11 Sale of the collection of Baron Mathieu de Faviers, quartermaster-general of the army and peer of France, Paris (Lugt 14657); among forty-six paintings are eight Murillos.

May 28 Alexandre Dumas, in an article published in *La Presse*, recounts Baron Taylor's adventures in Spain. As Dumas observes, Taylor's art-buying trip is for "an entire gallery of Spanish paintings, the masters of which we know well but their works hardly at all, since our museum, so rich in Italians and Flemings, owns only Murillo's *Beggar*, Ribera's *Adoration of the Shepherds*, and the *Little Infanta* by Velasquez."

"Amidst all these ravages, rescuing them more than once by one door while those bent on destruction were breaking down the other, he collected twenty Murillos, twelve Riberas, fifteen Velasquezes, fifty Zurbarans, eighteen Alonzo Canos; then works by Joan de Joanes, Ribalta, Espinosa, El Greco, Vilegas, Careno, Carducho, Sanchez Coello, Juan of Toledo, Moralez, Esteban, Melindez, Vergasa, Yanes, Aguila, Castillo, Valdez, Correa, Orente, Blas of Prado, Gonca, in short, a whole history of art, written with the brush from Galegos to Goya. . . . In the end, as an artist and out of devotion to art, he has flung his life into the heart of revolutions, fought with the demon of war for the masterpieces of the genius of peace, endowed France with a treasure

that was about to be lost to the world, and brought back for 800,000 francs four hundred pictures that are worth three million."

"une galerie complète de peintures espagnoles, dont nous connaissions bien les maîtres, mais à peine les oeuvres, puisque notre musée, si riche d'Italiens et de Flamands, ne possédait que le Pauvre de Murillo, l'Adoration des Bergers de Ribera, et la Petite Infante de Velasquez."

"Au milieu de tous ces ravages, les sauvant plus d'une fois par une porte, tandis que les devasteurs enfoncent l'autre, il recueille vingt Murillo, douze Ribera, quinze Velasquez, cinquante Zurbaran, dix-huit Alonzo Cano; puis des Joan de Joanes, des Ribalta, des Espinosa, des Greco, des Vilegas, des Careno, des Carducho, des Sanchez Coello, des Juan de Tolède, des Moralez, des Esteban, des Melindez, des Vergasa, des Yanes, des Aguila, des Castillo, des Valdez, des Correa, des Orente, des Blas de Prado, des Gonca une histoire de l'art toute entière enfin, écrite au pinceau depuis Galegos jusqu'à Goya.... En fin, comme artiste, il a, par dévotion pour l'art, jeté sa vie au milieu des révolutions, disputé les chefs-d'oeuvre du génie de la paix au démon de la guerre, doté la France d'un trésor qui allait être perdu pour le monde, et rapporté pour 800,000 francs, quatre cents tableaux qui valent trois millions." Dumas 1837, pp. 1–2.

June 10 Louis-Philippe inaugurates the Musée de l'Histoire de France at Versailles.

June 20 Series of six Zurbarán paintings from Jerez, purchased by Taylor at the Academia in Cadiz, are exported on a French ship amid the protests of the Academia de San Fernando in Madrid.

Baticle 1998, p. 103.

August–September Baron Taylor is in London in search of Spanish paintings, arriving prior to August 12 (date of his first receipt of purchase in London). Among the collectors he seeks out is Brackenbury, whom he had met in Andalusia the previous year. Brackenbury's sale of several Spanish paintings from his collection may have been a motivating factor in Taylor's trip to London, as he purchases Murillo's *Don Andrés de Andrade y la Cal* (fig. 1.31) from him for 1,025 pounds sterling, making the portrait one of the most expensive works in the Galerie Espagnole. Taylor also purchases the following Spanish paintings (locations unknown): Cano's *Head of an Old Man*, Murillo's *Servant of Murillo*, Pereda's *Saint John the Evangelist*, and Ribera's *Saint Peter*. During his visit, Taylor announces in *The Spectator* the creation of the Galerie Espagnole.

The Spectator 10 (1837), pp. 763–64; Tromans 1998, p. 66.

Though the Galerie Espagnole will not officially open until January 1, 1838, the many reviews that are published in the period between Baron Taylor's return and the public opening make it evident that the art critics of Paris are given access to the works well in advance,

though Gautier mentions that the paintings were not yet on stretchers when he saw them in September, "still lying unrolled on the floor."

"déroulées gisaient encore à terre." Gautier 1837. Among the reviews published in 1837 are the following: Anon. 1837d; Blaze de Bury 1837; Anon. 1837b; Gautier 1837; Raphaël 1837; Césena 1837; Gozlan 1837; and Jubinal 1837. Listed by Lipschutz 1972, pp. 400–401, and Plazaola 1989, p. 138.

September 24 Théophile Gautier's review of the Galerie Espagnole in *La Presse* asks, "Does a Spanish school really exist?"

"Existe-t-il réelement une école espagnole?" Gautier 1837.

Collection of the Spanish infante Sebastián Gabriel de Borbón y Braganza (1811–1875), rich in seventeenth-century Spanish painting, is confiscated for political reasons in Madrid; it is placed on display in the Museo de la Trinidad, along with pictures acquired from the suppression of the religious orders. Returned to the infante shortly before his death in 1875, the collection is sold in a series of auctions in 1876, 1890, and 1902.

Laure Junot, duchesse d'Abrantès, publishes her two-volume *Souvenirs d'une ambassade et d'un séjour en Espagne et en Portugal, de 1808 à 1811* in Paris and Brussels.

Charles Didier publishes *Une année en Espagne* in Paris (2rd ed. 1840/41), and the two-part "Souvenirs d'Espagne" in *Revue de Paris*.

1838

January 7 The Galerie Espagnole opens to the public in five galleries of the east wing, the Colonnade, of the Musée Royal au Louvre, Paris. In December, the French royal family led a dramatic nocturnal inauguration with torches. Although the Galerie Espagnole is devoted exclusively to paintings, Spanish sculptures and plaster casts are exhibited on the ground floor of the Louvre; 923 ceramic and glass objects are sent to the Musée de la Manufacture de Sèvres. The collection was almost entirely acquired in Spain by Baron Taylor over a period of eighteen months for a sum of 1,327,000 francs.

The first of four editions of the catalogue of the paintings collection, *Notice des tableaux de la Galerie Espagnole exposés dans les salles du Musée Royal au Louvre*, written by Baron Taylor, lists 412 paintings by eighty artists.

The Galerie Espagnole will remain open until January 1, 1849.

Guinard 1967b, p. 291. Debeaux-Fournier 1946, p. 51. Plazaola 1989, p. 501. Among modern-day accounts there is great variation in the actual number of paintings exhibited. The leading authority, Jeannine Baticle, lists 440 paintings with 30 left unexhibited; see her essay in this

catalogue, and Baticle and Marinas 1981. Lipschutz 1972, p. 160, notes that there were 446 paintings. Debeaux-Fournier 1946, p. 51, lists 412 with 15 from the Northern school and 26 by Italian masters (453 paintings in all). Among the reviews of the Galerie Espagnole published in 1838 are Benoist de Matougues 1838; Anon. 1838f; F. P. 1838; Huard 1838; Delécluze 1838; anonymous letter to Louis-Philippe, Correo Nacional (Madrid, June 25, 1838). Listed in Lipschutz 1972, pp. 400–401, and Plazaola 1989, p. 138.

As a souvenir of the opening of the Galerie Espagnole, the journal *Paris-Illustrations* publishes engravings after Velázquez's *Coronation of the Virgin* (Museo del Prado, Madrid [LR 23]) and Murillo's *Saint Elizabeth of Hungary Nursing the Sick* (A 86).

Lipschutz 1972, pp. 80–81. Oddly, neither work is among those in the Galerie Espagnole: the Velázquez never left Spain, and the Murillo, taken by Soult from Seville, was presented by him to Napoleon, inventoried in the Musée Royal, Paris, and included in Denon's inaugural exhibition at the Musée Royal (1814). However, it was ultimately returned to Spain in 1815, where it remained.

January Installments of Étienne Huard's two-volume *Vie complète des peintres espagnols et histoire de la peinture espagnole* (Paris, 1839–41) begin to appear in *Journal des Artistes*.

The *Magasin Pittoresque* continues its series on Spanish artists (see 1834) with articles on "Juan de Joanès.—Velasquez de Silva.—Esteban Murillo" and "François Zurbarán."

Anon. 1838c, 1838d.

Salon (March 1) Delacroix's *Medea about to Murder Her Children* (Musée des Beaux-Arts, Lille [J 261]) (fig. 14.44) is shown to great acclaim.

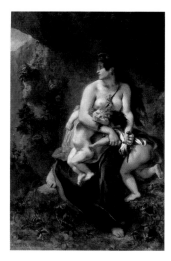

Fig. 14.44 Eugène Delacroix, *Medea about to Murder Her Children*, 1838. Oil on canvas. Musée des Beaux-Arts, Lille

July 5 Théophile Gautier's article "Les Caprices de Goya," published in *La Presse*,

appears inspired by two bad pictures at the Galerie Espagnole attributed to Goya that, for Gautier, do not detract from a true appreciation of this "artist of the first order." The prints, he writes poetically, "are of dark nights in which some sudden ray of light outlines pale silhouettes and strange phantoms."

"Les compositions de Goya sont des nuits profondes où quelque brusque rayon de lumière ébauche de pâles silhouettes et d'étrangers fantômes." Gautier 1838a.

July 21 Millet writes to a friend in Cherbourg describing "the opening of a gallery [Galerie Espagnole] filled with the greatest Spanish masters, in which there are things impossible to describe. . . . Oh! it seems to me that if Lemarquand, who was so entranced on seeing the *Spartacus* (which is a fine thing, it's true, but still pretty debatable as to its merits), found himself in front of two Riberas, one representing a saint being flayed and the other Cato opening his breast [fig. 14.45], I imagine that he would feel yet other impressions. An ignoble-looking executioner, with that cold-bloodedness which is the inevitable sign of cruelty, cuts off the old man's withered skin, holding a piece of it in one hand and with the other striking with his fist as butchers do. One can almost hear the crackling of the skin as it parts from the flesh. In Cato's open chest his bleeding entrails are visible, and one can almost feel their warmth; the expression on his face is unspeakably dreadful! He utters cries, but not the ordinary cries of a person in pain: cries torn from the depths of his entrails, heart-rending, unbearable cries that overwhelm the viewer's spirit. . . . Several monks by Zurbaran and Murillo are the most incredible one can imagine as an expression of sanctity; their gaze is no longer of this earth; it is the burning love of the seraphim."

"l'ouverture d'une galerie remplie des plus grands maîtres espagnols, où il se trouve des choses impossibles à décrire. . . . Oh! il me semble que si Lemarquand, qui a été si ravi en voyant le Spartacus (qui est une belle chose, il est vrai, mais d'un mérite encore bien contesté), se trouvait devant deux Ribera, l'un représentant un saint qu'on écorche, et l'autre Caton s'ouvrant la poitrine, je m'imagine qu'il sentirait d'autres impressions encore. Un bourreau à tête ignoble, et avec ce sang-froid qui n'annonce que de la cruauté, décolle la peau flétrie du vieillard en tenant le morceau d'une main et de l'autre frappant avec le poing, comme font les bouchers. On croirait entendre le craquement de la peau se détachant d'avec la chair. On voit dans la poitrine ouverte de Caton ses entrailles saignantes, dont on croit sentir la chaleur; l'expression de sa tête est d'une atrocité indicible! Il pousse des cris, mais pas de ces cris comme en pousse ordinairement quelqu'un qui souffre; mais des cris arrachés du fond des entrailles, déchirants, et qui accablent l'âme du spectateur, et qui sont insoutenables. . . . Plusieurs moines de Zurbaran et de Murillo sont ce qu'on peut imaginer de plus incroyable comme expression de sainteté; leur regard n'a plus rien de terrestre; c'est l'amour brûlant des séraphins." Moreau-Nélaton 1921, vol. 1, pp. 29–30.

July 24 Museo Nacional de la Trinidad opens in Madrid, though it will soon close for renovation. It will reopen in May 1842.

August 20 José de Madrazo named director of the Real Museo, Madrid. In the autumn, concerned about the dangers posed by the ongoing civil war, he initiates a temporary transfer of paintings from the Escorial. In October he obtains royal approval to integrate the works, which will arrive through April 1839, into the permanent collection.

Alcolea Blanch 1996, p. 50.

Charles Didier's article "Saragosse" published in *Revue de Paris.*

During 1838, Louis-Philippe hires the painter and engraver Alphonse Masson (French, 1814–1898) to engrave works in the Galerie Espagnole.

Baticle and Marinas 1981, p. 227.

1839

April 27 Newly installed galleries of the Real Museo in Madrid open to the public.

Alcolea Blanch 1996, p. 52.

June 14 Sale of Comte Christophe-Antoine de Merlin's collection, Paris (Lugt 15488). There are only fifteen lots, but seven are of Spanish paintings. Of those seven, all but a Velázquez, *Portrait of an Infanta of Spain* (lot unknown) are bought in and will reappear at the sale of the count's wife, Mercedes Jaruco, on May 28, 1852 (see 1852). Merlin had been a lieutenant-general in Napoleon's army and was stationed in Spain until 1813.

Étienne Huard's *Vie complète des peintres espagnols et histoire de la peinture espagnole* published in Paris (1839–41) (see January 1838).

Galerie Aguado, choix des principaux tableaux de la galerie de M. le marquis de las Marismas del Guadalquivir, by Charles Gavard and Louis Viardot, catalogues the important collection assembled by Alejandro María López Aguado, marqués de las Marismas (Spanish, 1784–1842), a banker of Sevillian origin who served as an aide-de-camp to Soult during the occupation. He settled in Paris in 1815 but maintained ties with Spain, eventually returning there and serving as an aide to Ferdinand VII, who granted him the title of marqués de las Marismas (of the swamps) for having engineered the draining of the swamps at the mouth of the Guadalquivir River.

Some thirty-seven engravings illustrate the Aguado collection catalogue, twenty of them after the 240 Spanish paintings in his collection;

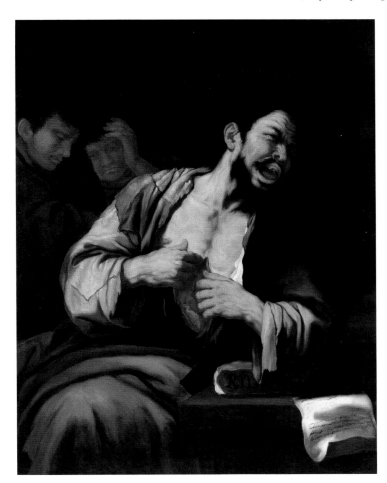

Fig. 14.45 (cat. 63) Formerly Jusepe de Ribera, now Luca Giordano, *Cato Tearing Out His Entrails,* ca. 1660. Oil on canvas, 49 x 38¼ in. (124.5 x 97.2 cm). Art Gallery of Hamilton

Fig. 14.46 Célestin Nanteuil, *Petrus Borel, Copy after Louis Boulanger,* 1839. Engraving. From Janin 1839, p. 253

it was originally intended to include prints of all of the works. The accompanying text contains essays by Viardot on Velázquez, Murillo, Ribera, Cano, Zurbarán, Juanes, Morales, Navarrete, El Greco, Sanchez Coello, and Pacheco, all of which are reprinted in Viardot's *Notice sur les principaux peintres de l'Espagne,* also published in Paris this year. The essays are indebted to Palomino, Ponz, and Céan Bermúdez.

The collection will be dispersed in a series of sales (1841–91).

The Aguado catalogue was "intended to comprise 240 prints, but only 36 [sic] were published. The plates were subsequently sold, and probably fell into the hands of Virtue & Co. of London. Several of them were used in W. B. Scott, Murillo, London, 1873." Curtis 1883, pp. 10, 353.

Célestin Nanteuil's engraving (fig. 14.46) after Louis Boulanger's portrait of the poet Petrus Borel published in *L'Artiste.* Boulanger's painting (location unknown), exhibited at the Salon of 1839, was modeled after Velázquez's *Philip IV as a Hunter* (fig. 9.20), then in a private collection.

Janin 1839, opp. p. 300, repr.

1840
January 13–16 Sale of Lucien Bonaparte's collection, in Paris (Lugt 15622). Included is the one Spanish painting that did not sell in 1823, Murillo?, *Rest on the Flight into Egypt* (City Art Gallery, Glasgow [see A 232]).

May 5–October 1 Gautier travels to Spain with Eugenio Piot, an art and antiquities specialist (and founder of *Le Cabinet de l'Amateur*). The purpose of the trip is to purchase inexpensive works of art. Bargains are no longer to be found, however, as Gautier writes: "Persons who go to Spain for the sake of purchasing curiosities will be greatly disappointed; they will not find a

single valuable weapon, a rare book or a manuscript. Such objects are never to be met with."

Gautier had made arrangements to submit articles *en voyage* to *La Presse,* and they appear in serial form in nine chapters published between May 27 and September 3. An additional six chapters will appear in *Revue de Paris* and then *Revue des Deux Mondes* in 1841 and 1842, respectively. From these fifteen chapters will emerge *Tra los montes* (Paris, 1843), as well as a separate book of poems, odes to Spain, that will be published in 1845 as *España.* Gautier's texts on Spain are among the most widely read of the second half of the nineteenth century.

Gautier 1853, pp. 51–52.

June London art dealer William Buchanan arranges an exhibition of paintings from the Soult collection at 49 Pall Mall, London, with a catalogue.

Brigstocke 1982, p. 474.

August–October Mérimée returns to Spain and publishes articles on his travels.

December 2 Donizetti's opera *La Favorita,* set in fourteenth-century Spain, premieres at the Paris Opéra. On December 26, 1841, his *Maria Padilla,* which also takes place in fourteenth-century Spain, will premiere at La Scala in Milan.

In Paris, French painter Jean-François Gigoux (1806–1894) purchases a series of four small works on tin by Goya: *The Victim, Joseph's Tunic, Woman Reading,* and *The Fight* (now assigned to Lucas Velázquez [G-W 1657a–d]) (figs. 2.39, 2.40). He will bequeath them to the Musée des Beaux-Arts in Besançon in 1894.

1841
Salon (March 15) Delacroix exhibits *Shipwreck of Don Juan* (Musée du Louvre, Paris [J 276]).

April 22 First of six sales of the collection of Alejandro Aguado, marqués de las Marismas, in Paris (see 1839). The sale consists of pictures and marbles from his Paris residence, the Château Petit Bourg.

Baron Taylor travels to London to retrieve the collection of Frank Hall Standish (British, 1799–1840) of Duxbury Hall, Lincolnshire, which has been bequeathed to Louis-Philippe for his Galerie Espagnole (see 1842). Taylor met Standish in Seville during his Spanish expedition (1835–37). The collection consists of paintings, drawings, books, and manuscripts.

Tromans 1998, p. 66.

Jean-Joseph-Stanislas-Albert Damas Hinard translates the works of Calderón de la Barca

and Lope de Vega in *Chefs-d'oeuvre du théâtre espagnol* (Paris, 1841–43). Subsequent editions published in 1861, 1869, 1881, and 1891.

1842
Musée Standish opens in the Louvre. The collection—formed by Standish during his lengthy residence in Seville—consists of 244 paintings (of which 145 are identified as Spanish) by thirty-one artists and 214 drawings by forty-five Spanish artists.

Curtis 1883, no. 8, notes that there were 656 Spanish works in the Galerie Espagnole, 140 more than in the Prado; Lipschutz 1972, pp. 225–28, states that the holdings of the Galerie Espagnole now numbered 712 paintings and 214 drawings by Spanish artists. See also Thoré 1842.

In an article on Goya in *Le Cabinet de l'Amateur,* Gautier, benefiting from his travels through Spain in 1840, highlights the artist's important paintings: the equestrian portraits of Charles IV and María Luisa (G-W 776, 777), a *Picador* (fig. 2.12), the *Second of May 1808,* and the *Third of May 1808,* of which he writes, "With a spoon by way of a brush, he executed a scene of the *Dos de Maio* [sic] in which the French are to be seen shooting down the Spanish. It is a work of incredible energy and rage. This curious painting is unceremoniously relegated to the anteroom of the Madrid museum." The *Clothed Maja* (or duchess of Alba) (fig. 14.21) at the Academia de San Fernando is "of exquisite elegance and charming in color." Gautier also writes of works in the collection of the duque de Osuna; the cupola of San Antonio de la Florida; the *Taking of Christ* (G-W 736) at the Cathedral of Toledo; and the *Saints Justa and Rufina* (G-W 1569) at the Cathedral of Seville.

A catalogue raisonné of Goya's prints accompanies the article. Gautier remarks that "Goya's work is entirely lacking in the Bibliothèque Royale, which owns only the volume of the *Caprichos.*" And, on the *Caprichos* and *Tauromaquia,* he writes, "In appearance these lithographs, strange to relate, very much recall the style of Eugène Delacroix in the illustrations of Faust."

"Il exécuta, avec une cuiller en guise de brosse, une scène du Dos de Maio *[sic] où l'on voit des Français qui fusillent des Espagnols. C'est une oeuvre d'une verve et d'une furie incroyables. Cette curieuse peinture est reléguée sans honneur dans l'antichambre du musée de Madrid." "d'une élégance exquise et d'une couleur charmante." "L'oeuvre de Goya manque entièrement à la Bibliothèque royale que ne possède que le recueil les Caprices." "L'aspect de ces lithographies rappelle beaucoup, chose curieuse! la manière d'Eugène Delacroix dans les illustrations de Faust." Gautier 1842, pp. 539, 545.*

French painter Adolphe Leleux (1812–1891) travels to Spain and subsequently incorporates Spanish subjects in his work; his brother, supported

by Ingres, will be given a grant by the French state to travel to Spain in 1846 (see 1846).

Cleveland et al. 1980–82, pp. 300, 315.

1843

February Following the publication of the last chapter of his serial on Spain in *Revue des Deux Mondes* on January 1, Gautier issues his travel diary, *Tra los montes*; it is the first edition of what will be reissued as *Voyage en Espagne*. In September, Gautier will present a vaudeville show of the same title at the Théâtre des Variétés.

In his diary, Gautier comments on Spanish painters and on the French artists, most notably Delacroix and Decamps, whose work recalls Spain. On El Greco he writes, "the fine works of his second style greatly resemble Eugène Delacroix's romantic pictures." The paintings he sees in Madrid's residences are "smoke-laden, blackish pictures, representing some beheading or disemboweling of a martyr, favorite subjects of the Spanish painters." Velázquez, Ribera, and Zurbarán are mentioned in passing; he will devote texts to each at a later date.

While Gautier appreciates the beauty of Murillo's paintings, he seems exasperated with their ubiquity, commenting that "the honor and also the plague of Seville is Murillo." However, he does single out three "admirable" Murillos at the Academia in Madrid, *Saint Elizabeth of Hungary Nursing the Sick* (A 86), the *Dream of the Patrician* (A 39), and the *Patrician John and His Wife before Pope Liberius (The Foundation of Santa Maria Maggiore)* (A 40), each of which had been taken to Paris during the Napoleonic occupation. He has much to say about Goya, with whose prints he is very familiar, and whom he regards as "the national painter par excellence" and "the still-recognizable grandson of Velázquez."

Jean-Claude Berchet, "Introduction," in Gautier 1981, p. 12. "Les bon ouvrages de sa seconde manière ressemblent beaucoup aux tableaux romantiques d'Eugène Delacroix." "tableaux enfumés et noirâtres, représentant quelque décollation ou quelque éventrement de martyr, sujets favoris des peintres espagnols"; "l'honneur et aussi la plaie de Séville est Murillo"; "le peintre national par excellence"; "le petit-fils encore reconnaissable de Vélasquez." Gautier 1981, pp. 96–97, 156, 357.

March 20–28 Second, and largest, sale of the Aguado collection, Paris (Lugt 16911). Of the 395 pictures put up for sale, 240 are Spanish. A third sale takes place April 18–22 (Lugt 16975).

In an 1839 inventory (compiled for insurance purposes), Aguado's collection had been estimated at 3,330,950 francs. However, in the March sale the collection sells for a total of only 501,644 francs.

Curtis 1883, p. 9.

Charles Baudelaire (French, 1821–1867) pays several visits to the Galerie Espagnole.

Baudelaire 1973, vol. 1, p. 880 n. 1.

In a letter written between 1843 and 1846, British collector William Coningham describes Louis-Philippe's Galerie Espagnole to his artist friend John Linnell: "The new Spanish Gallery are [*sic*] infamous, not a single picture worth picking up except one Murillo portrait, really Isaacs in Regent Street has nothing so bad."

Quoted in Haskell 1991, p. 677.

Catalogue of the Real Museo in Madrid lists 1,833 paintings.

Alcolea Blanch 1996, p. 52.

Louis Viardot's *Les musées d'Espagne, d'Angleterre et de Belgique* published in Paris.

1844

March 9 Verdi's *Ernani*, set in Aragon in 1519, and based on Hugo's play (see 1830), premieres in Venice.

Louis-Philippe commissions the Spanish critic and poet Eugenio de Ochoa (see 1835), then living

Fig. 14.47 (cat. 46) Francisco de Herrera the Elder, *The Temptation of Job*, 1636. Oil on canvas, 84⅛ x 59½ in. (215 x 151 cm). Musée des Beaux-Arts, Rouen

in Paris, to carry out the catalogue raisonné of the Spanish manuscripts in the Bibliothèque Royale. During his seven-year residence in Paris, Ochoa also translates into French a number of Spanish literary classics.

Guinard 1967b, p. 127 n. 11.

Musée des Beaux-Arts, Rouen, purchases Herrera the Elder's *Temptation of Job* (fig. 14.47).

Damas Hinard's *Romancero général, ou Recueil des chants populaires de l'Espagne, romances historiques, chevaleresques et moresques* published in Paris.

1845
Salon (March 15) Courbet's *Le Guitarrero* (private collection, New York) is accepted, though four other works by the artist are rejected.

May 9 William Stirling-Maxwell (Scottish, 1818–1878) is in Paris to view the Galerie Espagnole, to which he will refer in his seminal work, *Annals of the Artists of Spain*, in 1848.

August 1 Didier's article on "L'Apuxarra" published in *Revue des Deux Mondes* (the second half of the article appears on September 1).

October 1 Mérimée's *Carmen* published in *Revue des Deux-Mondes*. On August 21, 1844, he had written to his friend Édouard Grasset that "over a few days" he had dedicated himself "to the study of the gypsy jargon."

Ramón Buenaventura, "Introducción," in Mérimée 1846 (1986 ed.), p. 6.

December 19–20 Fourth sale of the Aguado collection, Paris (Lugt 17961).

French journalist and illustrator Constantin Guys (1805–1892) submits several "Sketches in Spain" to the *Illustrated London News*, launched in 1842. They include "Priests in Madrid" and "Balcony Scene, at Andalusia" (October 4, 1845); "Costumes of the Prado" and "The Royal Palace at Madrid—The Armeria" (December 13, 1845).

Richard Ford's *Hand-book for Travellers in Spain* published in London. A substantially revised edition will appear in 1855.

Gautier's *España* published in Paris. This collection of forty-three poems, some of which appeared individually in various journals, was inspired by his trip to Spain in 1840. Among the poems are "Deux tableaux de Valdès Léal," devoted to the artist's paintings at the Hospital de la Caridad, *In Ictu Oculi* and *Finis Gloriae Mundi*; "À Zurbarán," first published in *Revue de Paris* (January 12, 1844); and "Ribeira." Also issued this year is a revised edition of Gautier's *Tra los montes*, now titled

Voyage en Espagne, which will be published in numerous editions (1856, 1858, 1859, 1862, 1865, 1869[?], 1870, 1873, 1875), and translated into English (1853), German (published in serial form in 1842 and 1843), and Spanish (1920).

Marius Petipa (French, 1819–1910), the father of classical ballet, travels to Spain after a tour of North America in 1839. In Madrid he works at the king's theater, where he studies Spanish dance and choreographs.

1846
January 20 A commission to copy a Velázquez is awarded to the painter Armand Leleux (French, 1818–1885), who was recommended by Ingres to Cavé, director of fine arts: "He is going to Spain and he would like to be charged with painting a copy for the Government. There are such fine Velázquez canvases there—an admirable painter, and so little known in France—that I do not hesitate . . . to recommend this young man to you." Due to illness, Leleux delivered only one copy, after Murillo's *Saint John the Baptist and the Christ Child*, in January 1847. He will exhibit several Spanish genre scenes at the Salons between 1847 and 1853.

"Il va en Espagne et il désirerait y peindre une copie pour le gouvernement, il y a là de si beaux Velasquez—peintre admirable et si peu connu en France—que je n'hésite pas . . . à vous recommander ce jeune homme." Quoted in Boime 1971 (1986 rpt.), pp. 31, 617 n. 55.

Salon (March 16) Courbet's *Portrait of M. X**** (*Man with the Leather Belt* [fig. 1.42]) is accepted, though seven other works by the artist are rejected.

September Outbreak of the second Carlist War, which continues until 1849.

September 27 Baron Taylor's article "Quelques détails sur Murillo et ses oeuvres" published in the *Moniteur des Arts*.

Plazaola 1989, p. 501.

October 5–late November Alexandre Dumas *père* (French, 1802/3–1870), travels through Spain accompanied by his son, Dumas *fils*; the painter Louis Boulanger; and Dumas's collaborator, Auguste Maquet. The romantic painter Adolphe Desbarolles (1801–1886) and engraver Eugène Giraud (1806–1881), whom Dumas meets in Madrid on October 10, join the party in Spain (fig. 14.48). The trip is documented in Dumas *père*'s lengthy travelogue *Impressions de voyage: De Paris à Cadix* of 1847 (see 1847).

October 10 Double royal weddings take place in Madrid: Isabella II, daughter of Ferdinand VII, marries her cousin Francisco de Asis, and her sister Luisa Fernanda (1832–1897) marries Antoine d'Orléans (1824–1890), duc de Montpensier (youngest son of Louis-Philippe).

Fig. 14.48 Eugène Giraud, *Souvenir de Voyage de Cadix à Seville*, 1851. Oil on canvas. Musée Carnavalet, Paris

Gautier returns to Spain to report on the weddings; his article "Les fêtes de Madrid" appears in *La Presse* and the *Musée des Familles* in 1846 and 1847 and will be reprinted as "En Espagne" in *Loin de Paris* in 1865. During this trip he encounters Dumas's traveling party (see above).

Gautier acquires a greater appreciation for Velázquez during this trip, writing, "One painter who cannot be appreciated but in Spain is Velasquez, the greatest colorist in the world after Vecelli [Titian]. We place him, for our part, well above Murillo, despite all of the tenderness and softness of this Sevillian Correggio. Don Diego Velasco de Sylva is truly the painter of feudal and chivalrous Spain. His art is brother to that of Calderon. . . . His painting is romantic in all senses of the word."

See Dumas 1959, p. 35; Gautier 1929. "Un peintre, qu'on ne peut apprécier qu'en Espagne, c'est Velasquez, le plus grand coloriste du monde après Vecelli. Nous le mettons, pour notre part, bien au-dessus de Murillo, malgré toute la tendresse et la suavité de ce Corrège sévillan. Don Diégo Velasco de Sylva est vraiment le peintre de l'Espagne féodale et chevaleresque. Son art est frère de celui de Calderon, et ne relève en rien de l'antiquité. Sa peinture est romantique dans toute l'acception du mot." Gautier 1847a.

October 17 Constantin Guys is also in Spain for the royal weddings. His illustration *The Spanish Marriages—Madrid, The Puerta del Sol*, runs in the *Illustrated London News*.

October 28 Dumas *père* writes from Granada, "We were going first to the Generalife, but at the angle of the two paths we paused to listen to the singing and the sound of castanets, watching the shadows of the leaves playing over the white walls, and the long cluster of red pimientos hanging from one of the windows like some fantasy by [Alexandre Gabriel] Decamps [1803–1860]."

Dumas 1959, p. 123.

Murillo's *Christ Healing the Paralytic* (fig. 14.42), in the Soult collection, purchased by London art dealer William Buchanan and sold to George Tomline in 1846/47 for 160,000 francs. It remains in the collection of Tomline's descendants until 1933. Soult had originally attempted to sell this work, along with two others, to Louis-Philippe in 1835 (see 1835).

Maclaren 1970, p. 69.

French painter Léon Bonnat (1833–1922), from Bayonne, joins his family in Madrid; they will return to Bayonne in 1853.

Cleveland et al. 1980–82, pp. 315–16.

Edgar Quinet's *Mes vacances en Espagne* published in Paris.

1847

Dumas *père*'s five-volume *Impressions de voyage: De Paris à Cadix* published in Paris (1847–48); German and Spanish editions also appear this year.

The protagonist of Gautier's novel *Militona* is a young *madrileño* (native of Madrid) of good name who is enamored of the *plaza de toros* (bullring).

Constantin Guys, in Spain, submits sketches to newspapers, including the *Illustrated London News*.

Damas Hinard's translation of *Don Quixote* published. Another edition appears in 1869.

1848

February 22–25 Revolution of 1848 forces French king Louis-Philippe into exile in London. The Second Republic is proclaimed in Paris. From London, Louis-Philippe submits a claim of ownership to the French state demanding all of

Fig. 14.49 Léon Bonnat, *Study after "Baltasar Carlos on Horseback" by Velázquez*, 1848–53. Oil on canvas. Musée Bonnat, Bayonne

the works in the Galerie Espagnole. His request granted, the works will be returned to his heirs over a period of nine months (October 1850–July 1851).

Debeaux-Fournier 1946, p. 51.

February Bonnat, enrolled at the Real Academia de Bellas Artes de San Fernando, Madrid, studies history painting under Federico de Madrazo (fig. 14.49).

William Stirling-Maxwell's *Annals of the Artists of Spain* published in London. This seminal work is also the first art-history book to include photographs—Talbotypes—of etchings after the paintings and prints illustrated.

November 15 Mérimée's article "Sur la peinture espagnole," a review of William Stirling-Maxwell's *Annals of the Artists of Spain*, published in *Revue des Deux Mondes*.

December 10 Louis-Napoleon Bonaparte (1808–1873), Napoleon's nephew, elected president of the French Republic for a period of four years.

The galleries of the Louvre are reorganized chronologically and by school.

Dumas *père*'s four-volume *L'Espagne, le Maroc et l'Algérie* published in Paris (1848–49).

1849

January 1 Galerie Espagnole closes its doors to the public.

Debeaux-Fournier 1946, p. 51.

June 12–13 Sale of the collection of the marquis de Forbin-Janson, Paris (Lugt 19410). Among the items offered is *Gathering of Gentlemen* (then attributed to Velázquez). It is purchased by Ferdinand Laneuville, who will sell it to the Louvre in 1851.

August 1 French painter Alfred Dehodencq (1822–1882) is commissioned by the French state to execute a painting for the sum of 2,000 francs. He departs for Madrid on August 27; there he is befriended by José and Federico de Madrazo, who give him access to a studio.

The Louvre acquires *Portrait à mi-corps de Don Pedro Moscoso de Altamira, Doyen de la Chapelle Royale de Tolède, depuis Cardinal*, also known as *Portrait of a Monk*, then considered a work by Velázquez (fig. 2.17; now Spanish, seventeenth century). It will be copied by numerous French artists, among them Édouard Manet.

Roger de Beauvoir's poem "À Goya" appears in *L'Artiste*.

1850

January 29 An eighteen-year-old Manet registers to copy at the Louvre.

August 26 Louis-Philippe, former king of France (r. 1830–48), dies in England.

August 27–28 Gautier devotes an article to the Galerie Espagnole in *La Presse*.

September Dehodencq exhibits the painting commissioned by the French state, *Bullfight in Spain (Los Novillos de la Corrida)* (fig. 14.50), at the salon of the Real Academia de Bellas Artes de San Fernando, Madrid. The influence of Velázquez is noted by critics. The painting will be exhibited at the Paris Salon of 1850–51 under the title *Course de taureaux en Espagne* (no. 766). It will enter the collection of the Musée du Luxembourg before 1852.

J. L. 1850; Anon. 1850; cited in Luxenberg 1990, pp. 62–63.

October–July 1851 Louis-Philippe's request for the paintings in the Galerie Espagnole granted, all of the pictures that made up the collections of the Galerie and the Musée Standish are packed and sent to Christie, Manson and Woods, London, to be sold. More than 1,600 items are sent: 505 paintings, 126 sculptures and casts, 13 drawings and engravings, and 956 pieces of furniture, pottery, porcelain, and glass.

Debeaux-Fournier 1946, p. 51.

December 22 Dehodencq writes about Velázquez to a friend: "My dear friend, what a painter! Nothing can give you an idea. It is nature done on the spot. The finest observation, the truest types, delicious color harmonies; everything is there, thrown in profusion on the canvas. His manner, lively and facile, his way of treating costume from the point of view of the shape and character, leaving all the details out, the hands barely indicated, demonstrates a continual preoccupation with the ensemble, with the general effect. And this is what really hits you and knocks you to the ground when you see his works."

"Quel peinture, mon cher ami! Rien n'en donne une idée. C'est la nature prise sur le fait. L'observation la plus fine, les types les plus vrais, des harmonies de ton délicieuses, tout est là, jeté à profusion sur la toile. Sa manière vive et facile, sa façon de traiter le costume au point de vue de la tournure et du caractère, laissant de côté tous les détails, ces mains à peine indiquées quelquefois, témoignent d'une préoccupation continuelle de l'ensemble, de l'effet général; et c'est réellement ce qui vous empoigne et vous arrache de terre à la vue de ses oeuvres." Séailles 1910, p. 32.

Salon (December 30) Courbet's *Burial at Ornans* (fig. 1.43) exhibited. Champfleury writes of it: "Without knowing the admirable canvases of Velasquez, he finds himself in agreement with

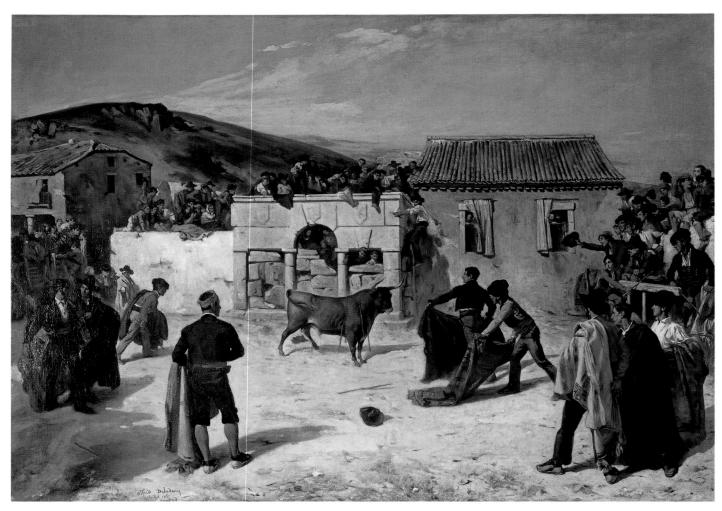

Fig. 14.50 (cat. 107) Alfred Dehodencq, *Bullfight in Spain (Los Novillos de la Corrida)*, 1850. Oil on canvas, 58⅛ x 81⅛ in. (149 x 206 cm). Musée des Beaux-Arts, Pau

the illustrious master. . . . Whoever does not have the intelligence to understand Velasquez cannot understand Courbet. If the Parisians had better known the works of Velasquez, they would have been less upset by the *Burial at Ornans*."

"Sans connaître les admirables toiles de Velasquez, il se trouve d'accord avec l'illustre maître. . . . Qui n'a pas l'intelligence de Velasquez ne saurait comprendre Courbet. Si les Parisiens connaissaient davantage les oeuvres de Velasquez, ils se seraient sans doute moins fâchés contre l'Enterrement à Ornans." Champfleury, "Courbet en 1860" (1861), in Champfleury 1973, p. 182.

1851
June 17 Manet registers at the Louvre to copy *The Monk*, acquired in 1849 and then attributed to Velázquez (inv. 942). This year the Louvre acquires the *Réunion de treize personnages (Gathering of Gentlemen)*, at the time attributed to Veláz-quez, which Manet will also copy (fig. 2.19).

September 24 Courbet's portrait of the Span-ish dancer Adela Guerrero (fig. 14.51), painted in Brussels, is presented by the artist to Leopold I of Belgium.

November 24–28 Sale of Marshal Sébastiani's collection, Paris (Lugt 20536). Among the lots are seven hundred bottles of Spanish wine and eleven Spanish paintings.

November 26 Death of Marshal Soult.

December 2 Coup d'état by Louis-Napoleon (1808–1873) in Paris. He will proclaim himself Emperor Napoleon III in November 1852.

J. Vallent contributes an entry on Goya to the *Encyclopédie du XIXᵉ siècle*.

Two French Artists in Spain, by Adolphe Desba-rolles (French, 1801–1886) and Eugène Giraud (French, 1806–1881), published in London. The travelogue documents their trip through Spain in 1846, which appeared as a serial in *L'Assemblée Nationale*. The French book edition will appear in 1855.

1852
February 2 Assassination attempt made on Isabella II in Madrid.

February 7 Hermitage Museum, St. Petersburg, opens to the public.

February 16 The collection of Manuel Godoy, Prince of Peace, sold in Paris (Lugt 20634).

May 19, 21, and 22 Sale of Marshal Soult's collection, Paris (initially scheduled for May 24–26); (Lugt 20857). Of the 163 lots, 110 are listed as Spanish school in the catalogue. The sale brings in a total of 1,477,830 francs.

The Louvre acquires Murillo's *Immaculate Conception* (fig. 1.20), Soult's most highly prized painting, for 586,000 francs (615,300 with taxes), at that time the highest price ever paid for a paint-ing at auction. By May 21, the Louvre receives 30 requests from copyists; within five years some 167 requests to copy the work will be processed. In 1940, the *Immaculate Conception* will be returned to Spain in an exchange of artworks.

Among the other bidders at the sale are the Musée de Montpellier, which acquires Zurbarán's *Saint Agatha* (G-G 220) (fig. 14.30); Fiodor Bruni, director of the Hermitage, who unsuc-cessfully bids for the *Immaculate Conception* but ultimately acquires four paintings; the National

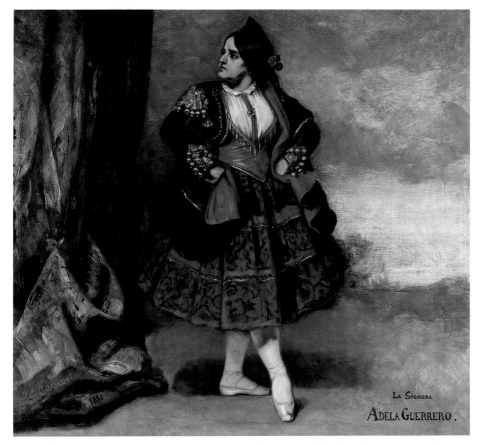

Fig. 14.51 (cat. 101) Gustave Courbet, *Adela Guerrero*, 1851. Oil on canvas, 62¼ x 62¼ in. (158 x 158 cm). Musées Royaux des Beaux-Arts de Belgique, Brussels

Gallery, London, which purchases three works; and the Gemäldegalerie, Dresden, which acquires no fewer than sixteen Spanish paintings.

May 28 Sale of the collection of Comtesse Merlin (Mercedes Jaruco of Cuba), wife of Comte Christophe-Antoine de Merlin, former lieutenant-general in Napoleon's army (initially scheduled for May 18; Lugt 208429/20869). Of the forty painting lots there are twenty-two Spanish works, most of which were supposedly acquired during her travels in Spain in 1845. The sale includes six Spanish paintings (lots 1, 3, 5, 6, 7, 8) that had gone unsold at the sale of Comte Merlin's collection on June 14, 1839 (see 1839).

June 19 French painter François Bonvin (1817–1887) writes to his patron, Laperlier: "Seeing the Spanish paintings belonging to Marshal Soult awoke an ardor in me which I intend to use to the fullest; this is why I have a number of things I am working on which, I hope, will not displease you."

Paris–Pittsburgh 1998–99, no. 31.

November 21 Louis-Napoleon elected emperor of France under the name Napoleon III (fig. 14.52).

Louis Viardot publishes *Les musées d'Espagne* in Paris.

1853

January 19 Verdi's opera *Il Trovatore* (The troubador), set in fifteenth-century Spain, premieres in Rome. It is based on the Spanish romantic drama *El Trovador* (1856) by Antonio García Guitiérrez (1813–1884).

January 29 Emperor Napoleon III marries the Spanish noblewoman Eugenia de Montijo de

Fig. 14.52 Hippolyte Flandrin, *Napoleon III*, 1862. Oil on canvas. Musée National du Château de Versailles et de Trianon

Guzmán (1826–1920), condesa de Teba, who thus becomes the empress Eugénie of France (fig. 14.53).

May 6–7, 13–14, and 20–21 Sale of Louis-Philippe's collection at Christie & Manson London (Lugt 21383); 501 lots bring 27,812.16.6 pounds sterling (1,260,000 francs). Lots sold as follows: May 6: lots 1–83; May 7: lots 84–168; May 13: lots 169–252; May 14: lots 253–330; May 20: lots 331–417; May 21: lots 418–501.

Sale total given in Louis Réau, "Velázquez et son influence sur la peinture française du XIXe siècle," in Paris 1963c, p. 98.

May 14, 21, and 28; June 4 and 11 Richard Ford's articles on the Louis-Philippe and Standish sales appear in the *Athenaeum*, London.

May 28–30 Sale of the Standish collection, Christie & Manson London (Lugt 21422). Included are the 244 pictures that Standish bequeathed to Louis-Philippe in 1842; of those, 89 are identified as Spanish. The auction brings in 9,859 pounds sterling (446,654 francs).

A previous sale at Christie & Manson on December 6–30, 1852 (Lugt 21071), offered 368 drawings and books from the collection.

September–December Mérimée is in Spain.

November 30 Delacroix records in his journal a conversation with the painter Delaroche: "I was speaking to him one day about Marshal Soult's admirable Murillos, which he was willing to let me admire; only, he said, *that is not serious painting.*"

"Je lui parlais un jour des admirables Murillo du maréchal Soult, qu'il voulait bien me laisser admirer; seulement, disait-il, ce n'est pas de la peinture sérieuse." Delacroix 1960, vol. 2, p. 125, "Mercredi 30 novembre."

Fig. 14.53 Studio of Franz Xaver Winterhalter, *Empress Eugénie*, 1855. Oil on canvas. Musée National du Château de Versailles et de Trianon

Baron Taylor's *L'Alhambra* published in Paris, with drawings and lithographs by Asselineau.

1854

November 23 Henri Fantin-Latour (French, 1836–1904) registers at the Louvre to copy Velázquez's *Infanta Margarita.*

Amornpichetkul 1989, p. 363.

Bonnat, after the death of his father in 1853, leaves Madrid to continue his education in Paris. He will make his debut at the Salon of 1857.

Inventory of the Museo Nacional de la Trinidad, Madrid, lists 1,733 paintings.

First part of Marshal Soult's memoirs, *Histoire des guerres de la Révolution,* published in Paris.

1855

March 29 Posthumous sale of the collection of Collot, former tax collector general and director of the mint, in Paris (Lugt 22330), includes four Spanish paintings: Murillo's *La Partie de cartes* (lot 17), Velázquez's *Martyre de saint Agathe* (lot 19) and *Portrait of Philip IV* (listed as a Rubens), and Zurbarán's *Saint Joachim et la jeune Marie* (lot 18). Charles Perrier notes disappointing sales: "What this shows is how little is known of the Spanish School abroad; and if this happens in Paris, what would happen in Rome, Vienna and Northern Europe?"

Collot, who collected works by Delacroix, Corot, and Millet, had commissioned from the last the *Notre-Dame-de-Lorette* (fig. 1.37).

Charles Perrier in an article in the Revue des Beaux-Arts, *recounted in its sister publication in Spain, the* Revista de

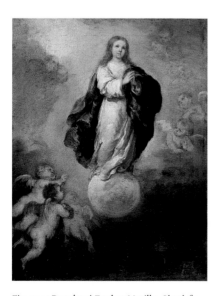

Fig. 14.54 Bartolomé Esteban Murillo, *Sketch for "The Immaculate Conception,"* 1st half 17th century. Oil on canvas. Musée du Louvre, Paris

Bellas Artes, *Valencia, no. 16 (April 1855), pp. 169–70. See also Collot 1855.*

May 15 Exposition Universelle des Beaux-Arts opens at the Palais des Beaux-Arts, Paris; it unites, for the first time in France, the fine arts and products of industry. The art of Spain is represented by thirty-five painters, five sculptors, one engraver, and sixteen architects: the quality of the work, however, is lamented: "Like Italy, she is in the midst of a complete artistic decadence: the noble land of Murillo, Velasquez, Zurbaran, and Ribera is nothing more than a temple without priests. There is not a vestige of this old school, which is the sister and the rival of that of Venice. Religious painting and pure art have had their day in Spain."

"Comme l'Italie, elle est dans une décadence artistique complète: la noble terre des Murillo, des Velasquez, des Zurbaran et des Ribera, n'est plus qu'un temple sans pontifes. Aucun vestige de cette vieille école, qui est la soeur et la rivale de celle de Venise. La peinture religieuse et l'art pur ont fait leur temps en Espagne." Paris 1856, p. 96.

December 21 Baudelaire, in a letter to a friend, writes, "I am looking everywhere for a booklet on the *royal museums* in the time of *Louis-Philippe,* which covers the *Spanish* and *Standish* museums. I assumed that you would have one."

"Je cherche partout un livret des musées royaux *au temps de* Louis-Philippe, *et qui contienne les musées* Espagnol *et* Standish. *J'ai présumé que vous en pourriez avoir un." Baudelaire 1973, vol. 1, p. 331.*

Napoleon III donates Murillo's oil sketch of his *Immaculate Conception* (A 116) (fig. 14.54) to the Louvre.

The Calcografía Nacional, Madrid, reissues editions of Goya's *Tauromaquia* and *Los Caprichos.*

William Stirling-Maxwell's *Velázquez and His Works* published in London. The book reproduces all of the Velázquez prints published in Stirling-Maxwell's seminal *Annals of the Artists of Spain* (1848). A French translation will appear in 1865.

Antoine de Latour (1808–1901), who traveled to Spain for the royal weddings (see 1848) as part of the duc de Montpensier's retinue, publishes the notes of his travels as *Études sur l'Espagne: Séville et l'Andalousie.* It is the first of several books on Spain that he will write.

1856

January 24 Delacroix writes to Louis Guillemardet, asking if he would grant Laurent Matheron access to his Goyas: "[the] portrait of your father . . . and that of a lady (a small fulllength portrait) . . . that you also own."

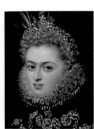

Fig. 14.55 Alonso Sánchez Coello, *Four Bust-Length Miniatures,* 2nd half 16th century. Oil on panel. Musée du Louvre, Paris

Matheron's biography of Goya, dedicated to Delacroix, will appear in 1858 (see 1857, 1858).

"du portrait de ton père . . . et de celui d'une dame (petite portrait en pied) . . . que tu possèdes également." Delacroix 1936–38, vol. 5, p. 200.

January Reviews in London and Paris newspapers and journals glowingly describe a recently discovered painting by Murillo, *Saint Peter, Weeping,* on display in the new Paris studio of the French painter Henri DurandBrager (1814–1879).

Notices 1856.

April 15 Murillo's *Holy Family* (A 184) is removed from the Grande Galerie of the Louvre by order of the emperor and installed in the salon of the empress at the Palais SaintCloud (fig. 14.56). The painting is returned to the Louvre on August 23, 1870.

July In Madrid, Jaime Machén offers to sell the plates of Goya's print series *Los Desastres de la*

Fig. 14.56 J. B. Fortuné de Fournier, *The Salon of the Empress at Saint-Cloud,* 19th century. Watercolor. Château de Compiègne

Fig. 14.57 (cat. 125) Constantin Guys, *Two Women with an Officer*, 1856. Pen and ink, watercolor, 10 x 7¼ in. (25.3 x 18.3 cm). Musée des Arts Décoratifs, Paris

Guerra and *Los Disparates* to the Spanish state; his offer is rejected. The plates had come into Machén's possession after being sold by Goya's grandson Mariano, who had inherited them upon the death of his father, Javier, in 1854. Machén will eventually sell them to the Academia de San Fernando in 1862.

Matilla in Madrid 1994b, p. 194.

August 2 Constantin Guys is again in Spain; two of his Madrid sketches are published in the *Illustrated London News* (fig. 14.57).

November 20 The Bibliothèque Impériale (predecessor of the Bibliothèque Nationale), Paris, acquires the working proofs of Goya's *Los Desastres de la Guerra*.

Cabinet des Estampes of the Bibliothèque Impériale acquires an aquatint impression of Goya's *Infante Don Fernando, Copy after Velázquez* (G-W 97).

Paris–New York 1983, p. 119.

Bequest of Charles Savageot to the Louvre includes five bust-length miniatures of the Spanish school (now all assigned to Alonso Sánchez Coello, inv. M.I. 800, 807–10) (fig. 14.55).

1857
March 27 Sale of M. X*** (Louis Viardot), Hôtel Drouot, Paris, includes nine Spanish paintings, among them a series by Antoliñez, a work by Coello, a *Saint Paul* by Ribera, and *Infanta María Teresa* by Velázquez (LR-1963 389). Valued at 7,000 francs, Velázquez's painting goes unsold.

May 5 The Art Treasures Exhibition opens in Manchester, England (fig. 14.58). Among the hundreds of paintings of the Italian, German,

Fig. 14.58 Philip Delamotte, Photograph of the Art Treasures Exhibition, 1857. Manchester Central Public Library

Dutch, and Flemish schools are ninety-seven Spanish paintings, including thirty-one Murillos, twenty-four Velázquezes (among them fourteen portraits), and eight Zurbaráns. Many of the works are lent by British collectors, who had purchased them at the Louis-Philippe sale in London in 1853.

Charles Blanc (French, 1813–1882), in his *Les trésors de l'art à Manchester* (Paris, 1857), regretfully notes, "What has become of our Spanish museum? we often say in Paris.—It is in England in its entirety."

"Qu'est devenu notre musée espagnol? disons-nous souvent à Paris.—Il est tout entier en Angleterre." Blanc 1857, p. 63.

September 11 James McNeill Whistler (American, 1834–1903), in the company of his colleague, the painter Henri Martin (French, 1860–1943), visits the Art Treasures Exhibition in Manchester, England, where he sees paintings of the Spanish school, including works by or attributed to Velázquez, which greatly impress him. Whistler returned from Paris especially to view the exhibition.

New York 1995–96, p. 161.

November 27 Delacroix writes to Matheron, gratefully acknowledging receipt of his book on Goya and expressing his own opinion of the artist: "It is doubly pleasing to me in that it is about a great artist whose compositions and energy have so often inspired me. I am also infinitely grateful to you for informing me, like the rest of the world, of so many interesting details, as much about his singular life as about his works. I have no doubt that long and patient research was needed to obtain them; but especially praiseworthy is the way in which you have presented them so as to enhance the interest of the subject. Let the Spanish forget the bones of Goya in the Chartreuse [cemetery in Bordeaux]. . . . The Chartreuse is of its kind the most majestic and worthiest of its purpose: and as for the abandonment of this tomb doubly abandoned by his compatriots, it is a conse-

quence of that necessity that causes those who for a time were able to remember us to disappear in their turn."

"Il m'est doublement agréable que ce soit à propos d'un grand artiste dont les compositions et la verve m'ont inspiré si souvent. Je vous sais aussi un gré infini de m'apprendre comme à tout le monde tant de détails intéressants, aussi bien sur sa vie si originale que sur ses ouvrages. Je ne doute pas qu'il ne vous ait fallu de longues et patientes recherches pour vous les procurer: mais il faut vous louer surtout de la manière dont vous les avez mis en oeuvre pour augmenter l'intérêt du sujet. Laissez les Espagnols oublier les os de Goya dans la Chartreuse. . . . La Chartreuse est le lieu de son espèce le plus majestueux et le plus digne de son objet: et quant à l'abandon de ce tombeau doublement abandonée par ses compatriotes, c'est une suite de cette nécessité qui fait disparaître après nous ceux qui ont pu quelque temps garder notre souvenir." Delacroix 2000, pp. 84–85, no. 65. Thank you to Catherine Donnellier for bringing this letter to my attention.

1858
July 15 "Quelques jours en Espagne," by John-Émile Lemoinne (French, 1815–1892), published in *Revue des Deux Mondes*, Paris.

September At the behest of the minister of state, the French government accepts five paintings from the Soult collection in payment of a tax debt of 300,000 francs. This arrangement

Fig. 14.59 Bartolomé Esteban Murillo, *Birth of the Virgin*, 3rd quarter 17th century. Oil on canvas. Musée du Louvre, Paris

was sought by the Soult family after the death of Soult's heir, his son Napoléon-Hector Soult, the duc de Dalmatia, in July. Baron Seillière, among the first to take advantage of this private sale, acquired Murillo's *The Boys* (*Los niños* [A 2630]) for 25,000 francs (at the 1852 sale it had reached only 9,000 francs). The paintings accepted by the state are:

Murillo, *Birth of the Virgin* (A 130) (fig. 14.59), valued at 150,000 francs
Murillo, *Miracle of Saint James (Angels' Kitchen* [A 11]) (fig. 14.60), valued at 80,000 francs
Herrera the Elder, *Saint Basil Dictating His Doctrine* (MR P.74) (fig. 14.61), valued at 20,000 francs
Zurbarán, *Saint Peter Nolasco* (G-G 18), valued at 25,000 francs
Zurbarán, *Funeral of a Bishop* (G-G 19), valued at 25,000 francs

Fig. 14.60 Bartolomé Esteban Murillo, *The Angels' Kitchen*, begun 1646. Oil on canvas. Musée du Louvre, Paris

Reported in Revue des Beaux-Arts *(Paris) by Théodore Lejeune and translated in* Las Bellas Artes *1 (Valencia, September 15, 1858), p. 159 (though he incorrectly states that the French state had purchased the paintings for this amount). See also Curtis 1883.*

November 26 Manet's name first appears in the register of the Bibliothèque Impériale, Paris.

Whistler and the French painters Alphonse Legros (1837–1911) and Fantin-Latour form the Société des Trois to foster their mutual regard for, among other things, Dutch and Spanish painting.

Laurent Matheron's biography *Goya* published in Paris. It is dedicated to Delacroix.

Damas Hinard's translation of the *Poème du Cid* published in Paris.

1859
January The five Spanish paintings bequeathed to the French state from the collection of Soult's heirs (see 1858) are placed on display in the Grand Gallery of the Louvre.

Salon (April 15) Édouard Manet (French, 1832–1883) submits *The Absinthe Drinker* (fig. 9.10); it is rejected.

April 30 Gautier, in his review of the Salon, recalls Zurbarán in writing of Paul Baudry's submission *The Penitent Magdalen* (Musée des Beaux-Arts, Nantes): "She is not very austere, but who dreams of complaining about that and preferring the wild sinners of Zurbarán, with

Fig. 14.61 Francisco de Herrera the Elder, *Saint Basil Dictating His Doctrine*, 1654? Oil on canvas. Musée du Louvre, Paris

their sunken eyes, furrowed cheeks, withered throat, bony arms, and skin as yellow as the skull they roll between their scrawny hands?"

"Elle n'est pas bien sévère, mais qui songe à s'en plaindre et à lui préférer les farouches pécheresses de Zurbarán, aux yeux caves, aux joues ravinées, à la gorge flétrie, aux bras osseux, au teint jaune comme le crâne qu'elles roulent entre leurs maigres mains?" Gautier 1992, p. 18.

Baudelaire's review of the Salon also refers to a Spanish painter, in this case Velázquez, with regard to Baudry: "Although his painting is not always sufficiently solid, M. Baudry is more naturally an artist. In his works one detects sound and loving Italian studies, and that figure of a little girl called, I think, *Guillemette*, had the honor of reminding more than one critic of the witty, lively portraits of Velázquez."

"Bien que sa peinture ne soit pas toujours suffisamment solide, est plus naturellement artiste. Dans ses ouvrages on devine les bonnes et amoureuses études italiennes, et cette figure de petite fille, qui s'appelle, je crois, Guillemette, a eu l'honneur de faire penser plus d'un critique aux spirituels et vivants portraits de Velasquez." Baudelaire 1975–76, vol. 2, p. 647.

In a later article (July 20, 1859), Gautier cites Boulanger's *Don Quichotte avec les chevriers* and *Rencontre de Gil Blas et de don Melchior Zapata*, in which "M. Louis Boulanger has combined his personal feelings for Spain, which he knows at first hand [see 1846], with an imitation of the style and coloring of Goya."

"M. Louis Boulanger a mêlé à son sentiment personnel sur l'Espagne, qu'il connaît de visu, une imitation du faire et de la couleur de Goya." Gautier 1859, p. 137.

April Bonvin holds a Salon des Refusés of approximately eight works in his studio at 189, rue Saint-Jacques: Fantin-Latour, Legros, Théodule Ribot (1823–1891), Whistler, and possibly Antoine Vollon (1833–1900) exhibit. They hold in common an admiration for the Dutch and Spanish old masters.

Denney 1993, pp. 100–101.

May 14 Baudelaire writes to Nadar advising him to go see, and photograph, two paintings of Goya's duchess of Alba ("archi-Goya, archi-authentic") currently with a picture dealer named Moreau. They are reductions of the

Clothed Maja and *Naked Maja* at the Prado. (The small *Clothed Maja* may be the one in the Museum Boijmans Van Beuningen, Rotterdam, as communicated by Juliet Wilson-Bareau.)

"archi-Goya, archi-authentique." Baudelaire 1973, vol. 1, p. 574.

In 1862, Manet will paint *Baudelaire's Mistress* (Szépmüvészeti Múzeum, Budapest [R-W I 48]) and *Young Woman Reclining, in Spanish Costume* (Yale University Art Gallery, New Haven [R-W I 59]), the latter commonly accepted as a portrait of Nadar's mistress. Both works are indebted to Goya's reclining *majas*.

July 1 Manet registers as a copyist at the Louvre. Though there is no record of what he copied, it undoubtedly includes Velázquez's *Gathering of Gentlemen* (fig. 2.19) and the Spanish master's *Infanta Margarita* (fig. 1.53). Also dating to this year is Manet's homage to Velázquez, *Spanish Cavaliers* (fig. 9.7), inspired by the *Gathering of Gentlemen* and *Spanish Studio Scene* (private collection [R-W I 25]).

Fig. 14.62 Félix Bracquemond, *Don Quixote, Copy after Goya*, 1860. Published in *Gazette des Beaux-Arts* (1860), vol. 7, no. 4

Victor Hugo's poetry collection, *La Légende des siècles* published in Brussels and Paris. Among the poems is "La rose de l'Infante," devoted to Velázquez's *Infanta Margarita* in the Louvre.

1860
August 15 Valentín Carderera's extensive article on Goya, "François Goya, sa vie, ses dessins et ses eaux-fortes," published in *Gazette des Beaux-Arts*. The second half, devoted to Goya's prints, will be published in 1863. Among the illustrations is an etching by Bracquemond after Goya's album drawing *Don Quixote* (G-W 1475) (fig. 14.62), then circulating in Paris (it will be acquired by the British Museum in 1862).

Manet signs and dates *The Spanish Singer* (fig. 1.45) and *The Salamanca Students* (private collection [R-W I 28]).

The preface of the *Guide Joanne* for Spain and Portugal observes that "In popular opinion, Spain is still a country that one can visit without having made one's will beforehand."

"Dans l'opinion vulgaire, l'Espagne est encore l'un des pays que l'on peut visiter sans au préalable avoir fait son testament." Quoted in Manet 1988, p. 15.

1861

Salon (May) Manet exhibits *The Spanish Singer* (fig. 1.45), as well as the portrait of his parents, *M. and Mme Auguste Manet* (Musée d'Orsay, Paris [R-W I 30]), to high praise. Gautier famously writes of the former, "*Caramba!* Here is a *Guitarrero* who does not come from the Opéra-Comique, and who would look out of place in a romantic lithograph; but Vélasquez would salute him with a friendly wink, and Goya would have asked him for a light for his *papelito*."

"Caramba! voilà un Guitarrero qui ne vient pas de l'Opéra-Comique, et qui ferait mauvaise figure sur une lithographie de romance; mais Vélasquez le saluerait d'une petit clignement d'oeil amical, et Goya lui demanderait du feu pour allumer son papelito." Gautier 1861, quoted in Paris–New York 1983, p. 63.

The Spanish Singer inspires a group of young painters and writers—Fantin-Latour, Legros, Carolus-Duran, Bracquemond, Baudelaire, Champfleury, and Duranty—to visit Manet's studio to express their admiration for it.

July 1 Ernest Beulé's "Velasquez au Musée de Madrid" appears in *Revue des Deux Mondes*, Paris. In October he will publish a second article, "Murillo et l'Andalousie," in the same journal.

October 1–15 Manet exhibits *The Spanish Singer* (fig. 1.45) at Galerie Martinet, Paris, though it is not for sale.

Paris–New York 1983, p. 507.

Justin-Édouard-Mathieu Cénac-Moncaut (French, 1814–1871) publishes *L'Espagne inconnue: Voyage dans les Pyrénées, de Barcelone à Tolosa* in Paris (2nd ed., 1870).

1862

May The Louvre acquires Velázquez's *Philip IV as a Hunter* (fig. 9.20; now, Velázquez workshop). An engraving of the work accompanies an article by Charles Blanc in *Gazette des Beaux-Arts*, July 1863.

On May 31, the Société des Aquafortistes is founded by Alfred Cadart and Félix Chevalier. Among the initial members are Manet, Bracquemond, Fantin-Latour, Jongkind, Legros, and Ribot.

August 12–November 2 Dance troupe from the Real Teatro, Madrid, performs the ballet

La Flor de Sevilla (The Flower of Seville) in its second season at the Hippodrome, Paris. The troupe and its principal dancers, Lola Meléa (known by her stage name, Lola de Valence) and Mariano Camprubi, serve as subjects for Manet.

September Charles Blanc travels to Spain with Paul de Saint Victor to "see the only great museum in Europe that we had not yet seen, the Musée de Madrid. To tell the truth, it was Vélasquez who attracted us." The trip is perhaps motivated by the Louvre's acquisition of the Velázquez in May, as Blanc writes an article about the Spanish master for the *Gazette des Beaux-Arts* the following year (see 1863).

"pour y voir le seul grand musée de l'Europe que nous n'eussions pas encore vu, le Musée de Madrid. A vrai dire, c'était Vélasquez qui nous attirait." Blanc 1863, p. 65.

September–October On September 1, Manet's etching *The Gypsies* (G 21), printed by Cadart, is reproduced in the first issue of *Eaux-fortes modernes*, the publication of the newly formed Société des Aquafortistes.

In October, Manet's portfolio *Huit gravures à l'eau-forte* is published by Cadart. Of the nine engravings (two printed on one sheet), the majority are after his "Spanish" paintings:

1. *The Spanish Singer* (G 16) (fig. 9.25)
2. *The Little Cavaliers* (G 8) (fig. 9.26)
3. *Philip IV* (G 7) (fig. 9.27)
4. *"L'Espada"* (G 32) (fig. 9.28)
5. *The Absinthe Drinker* (G 9) (fig. 9.29)
6. *The Toilette* (G 26)
7. *The Boy with a Dog* (G 17)
8. *The Urchin* (G 27) (fig. 9.30) and *The Little Girl* (G 25), printed together on one sheet

Also printed at this time is *Boy with a Sword Turned Left* (G 13) (fig. 14.63).

During this year, Manet signs and dates his paintings, *Mlle V. . . as an Espada* (fig. 9.34), *Lola de Valence* (fig. 9.44), *Mariano Camprubi* (fig. 9.38), *The Spanish Ballet* (fig. 9.41), and *Still Life with Spanish Hat and Guitar* (fig. 9.88). His reclining women, *Baudelaire's Mistress* (R-W I 48) and *Young Woman Reclining in a Spanish Costume* (R-W I 59; see 1867), are also dated to this year.

Manet first encounters Edgar Degas (French, 1834–1917) while visiting the Louvre. Degas, much to Manet's expressed dismay, is attempting to copy Velázquez's *Infanta Margarita* directly onto a copperplate.

October James McNeill Whistler (American, 1834–1903) leaves London on a trip to Spain,

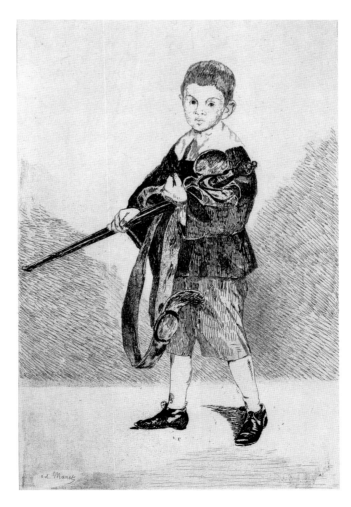

Fig. 14.63 (cat. 174) Édouard Manet, *Boy with a Sword Turned Left III*, 1862–63. 12⅛ x 9⅜ in. (32 x 23.8 cm) platemark. 3rd state, etching, drypoint, and aquatint. Metropolitan Museum (1980.1077.1)

specifically to see the Prado in Madrid, but he is thwarted in his efforts to communicate and turns back upon reaching the border.

November Real Academia de San Fernando, Madrid, purchases the eighty plates of Goya's series *Los Desastres de la Guerra* and eighteen plates of *Los Disparates* from Jaime Machén for 28,000 reales. The plates enter the Calcografía National, Madrid, which will issue the first prints of both series in 1864. Paul Lefort will donate plates 81 and 82 of the *Desastres* in 1870.

Matilla in Madrid 1994b, p. 194.

November 10 Verdi's *La Forza del Destino* (The force of destiny) premieres in St. Petersburg (a revised version will premiere on February 20, 1869, in Milan). Set in 1850 Spain and Italy, it is based on the Spanish drama *Don Álvaro* (1835) by Angel de Saavedra (1791–1865).

Carolus-Duran (Charles-Émile-Auguste Durand, 1837–1917), having won the Wicar prize in his native city of Lille, undertakes a lengthy residence (1862–66) in Italy. It is most likely in Rome that he is first inspired by Velázquez, whose masterpiece *Pope Innocent X* is at the Galleria Doria-Pamphilj.

Madrid 1997, p. 124, no. 29.

Charles Davillier (French, 1823–1883) and Gustave Doré (French, 1832–1883) publish, under the title of "Voyage en Espagne," a lengthy series of articles that document their journeys through Spain. Written by Davillier and illustrated by Doré, they appear over eleven years (1862–73) in *Le Tour de Monde*, one of the most important travel magazines published in Europe in the second half of the nineteenth century. The articles will be compiled for a book that will be published in 1874 (see 1874).

1863
March 1 Manet exhibits fourteen paintings at the Galerie Martinet, Paris, eleven of which can be identified. The majority of the works reveal the artist's fascination with Spanish subject matter:

Mme Brunet (private collection, New York [R-W I 31])
Boy with a Dog (private collection, Paris [R-W I 47])
Boy with a Sword (fig. 1.1)
Young Woman Reclining in a Spanish Costume (Yale University Art Gallery, New Haven [R-W I 59])
The Street Singer (Museum of Fine Arts, Boston [R-W I 50])
Lola de Valence (fig. 9.44)
The Gypsies (remaining sections: private collection, Paris [R-W I 44]; Art Institute

of Chicago [R-W I 43]; private collection [R-W I 42])
The Old Musician (National Gallery of Art, Washington, D.C. [R-W I 52])
The Spanish Ballet (fig. 9.41)
The Gypsies, etching (fig. 9.18)

Paris–New York 1983, p. 507.

March 7 Manet's lithograph of *Lola de Valence* (fig. 9.43) is printed as the cover of sheet music by Zacharie Astruc. The serenade is dedicated to the queen of Spain. On October 1, Manet's etching after his portrait of Lola de Valence, printed by Cadart, is reproduced in the second issue of *Eaux-fortes modernes*.

Also issued during this year, *Eaux-fortes par Édouard Manet*, an album of fourteen prints with frontispiece containing all of those in the portfolio of 1862 (see 1862) as well as *Spanish Hat and Guitar, The Candle Seller* (G 19), *Mariano Camprubi (Le Bailarin)* (fig. 9.39), *Boy with a Sword* (fig. 14.63), *The Gypsies* (fig. 9.18), and *Lola de Valence*.

April 1 Sale of Louis Viardot's collection, Paris (Lugt 27228). A total of forty-eight lots are put up for sale, among them forty-two paintings. Two Spanish paintings are offered, both of which

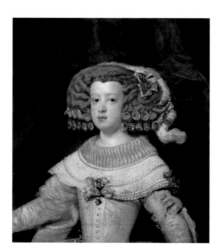

Fig. 14.64 Diego Rodríguez de Silva y Velázquez, *Infanta María Teresa* (detail), ca. 1652. Oil on canvas. Musée du Louvre, Paris

went unsold at his sale of 1857 (see 1857): a Ribera (lot 26) and Velázquez's *Infanta María Teresa* (lot 37) (fig. 14.64), whose entry reveals an interesting history—"This portrait was in the palace in Madrid. During the retreat of the French in 1814, an officer of King Joseph cut out the head and torso from the original picture, and, rolled around a baton, bore off this fragment, which passed into the collection of M. Didot. Fortunately, even thus mutilated, it forms a complete and excellent portrait."

"Ce portrait était au palais de Madrid. Lors de la retraite des Français, en 1814, un officier du roi Joseph coupa la tête et le buste dans le tableau original, et rapporta, roulé autour d'un bâton, ce fragment, qui passa dans la collection de M. Didot. Heureusement que, même ainsi mutilé, il forme un portrait complet et excellent." Viardot 1863, p. 32.

Salon (May) Jehan Georges Vibert (French, 1840–1902) exhibits his first Spanish works. Manet's paintings *Déjeuner sur l'herbe, Mlle V . . . in the Costume of an Espada* (fig. 9.34), and *Young Man in the Costume of a Majo* (fig. 9.37) are all rejected.

Salon des Refusés (May 15) Of the six works exhibited by Manet, five are of Spanish subjects, including an engraving after the Louvre's Velázquez portrait of Philip IV:

Le Déjeuner sur l'herbe (Musée d'Orsay, Paris [R-W I 67])
Young Man in the Costume of a Majo (fig. 9.37)
Mlle V . . . in the Costume of an Espada (fig. 9.34)
Philip IV, after Velázquez, etching (fig. 9.27)
Little Cavaliers, etching (fig. 9.26)
Lola de Valence, etching (fig. 9.42)

The etching of Lola de Valence, which will be published by the Société des Aquafortistes in October, is accompanied by Baudelaire's verse:

Among all the beauties that are to be seen
I understand, friends, Desire chooses with pain;
But one may see sparkling in Lola of Spain
The unforeseen charm of black-rose opaline.

*Entre tant de beautés que partout on peut voir
Je comprends bien, amis, que le Désir balance;
Mais on voit scintiller dans Lola de Valence
Le charme inattendu d'un bijou rose et noir.
Paris–New York 1983, pp. 507, 148.*

July 1 Charles Blanc's article "Vélasquez à Madrid" published in *Gazette des Beaux-Arts*. Blanc relates his trip to Spain in 1862 (see September 1862) to see the works of Velázquez in the Prado and expresses his regret at having written, in 1851, an essay on Velázquez for his *Histoire des peintres* without fully appreciating him. However, he had seen the Velázquez paintings in the Brussels collection of the prince of Orange, at the National Gallery, London, and in the collection of Lord Ashburton, as well as those in the Galerie Espagnole, Paris. Moreover, he notes that it was only through lithographs that he was familiar with the artist's great works: the equestrian portraits of Philip IV and the count-duke of Olivares, *The Surrender at Breda, The Spinners*, and *Las Meninas*. In addition, Blanc mentions Goya's etchings after the works of Velázquez. Accompanying the article is an engraving, by William Haussoullier, of the Louvre's newly acquired Velázquez, *Philip IV as a Hunter* (see 1862).

July 4 The Louvre exhibits Spanish works selected by the Académie des Beaux-Arts from the Campana collection in July 1862. The paintings include two works attributed to the school of Murillo (no longer considered Spanish school) and *Les Hommes Illustres*, a series of fourteen panel paintings attributed to Pedro Berruguete.

Paris 1863a.

August Manet exhibits *Boy with a Sword* (R-W I 37) at the Brussels Salon.

September 1 Part 2 of Carderera's article on Goya published in *Gazette des Beaux-Arts* (see 1860).

The Calcografía Nacional, Madrid, issues the first edition of Goya's eighty-two-plate series *Los Desastres de la Guerra* (G-W 993–1148).

Degas, perhaps in the following year, acquires a volume of the *Desastres* that will remain in his collection until his death.

Indeed, the volume remains in the collection of his family. Paris–Ottawa–New York 1988–89, p. 106.

Charles Gueullette's *Les peintres espagnols* published in Paris.

Francisco Zapater y Gómez's *Apuntes histórico-biográficos acerca de la escuela aragonesa de pintura* published in Madrid.

1864

February 17–29 Posthumous sale of the contents of Delacroix's studio, Paris (Lugt 27692). Included are sketches by the artist after Goya's prints, over one hundred studies of Spanish subjects, seven sketchbooks of his trip to Spain and Morocco (January–June 1832), and several prints by Goya, among them *Los Caprichos* (lot 826) as well as two Géricault copies after Spanish works (acquired by Delacroix at the Géricault studio sale in November 1824).

Among the buyers, Millet, "with the help of P. Burty, Sensier and other friends, . . . acquires many drawings by Delacroix during and after the studio sale."

Paris–London 1975–76, p. 27.

April 25 M. R. Zarco del Valle, in the *Chronique des Arts*, writes of the reopening of the Prado to the public after "une longue closure" (a lengthy closing) during which the new director, Federico de Madrazo, reinstalled the permanent collection chronologically within schools, in well-lit galleries: "This arrangement permits one to enjoy, to study advantageously and to appreciate the beauty of the pictures of Velázquez, Murillo, and other masters now placed in the very best light."

"Cet arrangement permet de jouir, d'étudier avantageusement et d'aprécier la beauté des tableaux de Vélasquez, de Murillo et autres maîtres placés maintenant sous la plus belle lumière." Zarco del Valle 1864, p. 180.

Salon (May) Manet exhibits *The Dead Christ with Angels* (fig. 9.51) and *Incident at a Bullfight* to vicious criticism. He subsequently cuts the latter canvas into pieces and out of the fragments creates *The Dead Toreador* (fig. 9.49) and *The Bullfight* (Frick Collection, New York [R-W I 73]) (fig. 9.54).

In June, Baudelaire writes to Théophile Thoré, reproaching him for the Salon review in which he accused Manet of creating a pastiche of Velázquez, Goya, and El Greco with the *Incident at a Bullfight*: "The word *pastiche* is unjust. M. Manet has never seen a *Goya*. M. Manet has never seen an *El Greco*. M. Manet has never seen the Pourtalès gallery. That may seem incredible to you, but it is true. . . . At the time when we were reveling in that marvelous Spanish museum that the stupid French Republic, in its excessive regard for property rights, delivered up to the princes of Orleans, M. Manet was a child and was serving on board a ship. So much has been said to him about his pastiches of Goya that he is now trying to see some Goyas. It is true that he has seen some works by Velázquez, where I do not know."

"Le mot pastiche n'est juste. M. Manet n'a jamais vu de Goya, M. Manet n'a jamais vu de Gréco. M. Manet n'a jamais vu la galerie Pourtalès. Cela vous parait incroyable, mais cela est vrai. . . . M. Manet, à l'époque où nous jouissions de ce merveilleux musée espagnol que la stupide république française, dans son respect abusif de la propriété, a rendu aux princes d'Orléans, M. Manet était un enfant et servait à bord d'un navire. On lui a tant parlé de ses pastiches de Goya que maintenant il cherche à voir des Goya. Il est vrai qu'il a vu des Vélasquez, je ne sais où." Baudelaire 1973, vol. 2, p. 386.

August 15 The Irún–Madrid railroad line is inaugurated in San Sebastián, Spain. Gautier, as a guest of the railroad, writes a series of articles chronicling his trip from Paris to Madrid and back for the *Moniteur Universel*; they are published between August 18 and October 19. It is Gautier's third trip to Spain. An article on his return to Madrid's Real Museo (the Prado) is published on September 24; in it he rhapsodizes about Velázquez: "[the Prado's] special glory, its singular wealth, is to contain Velázquez in his entirety."

"Sa [Prado's] gloire particulière, sa richesse originale, c'est de contenir Velasquez tout entier." Thank you to David Degener for providing this information.

The Calcografía Nacional, Madrid, issues the first edition of Goya's eighteen-plate series *Los Disparates* (published under the title *Los Proverbios* [G-W 1571–1613]). Four additional plates in the series (G-W 1601–1604), separated from the others, will first be published in the French journal *L'Art* in 1877.

The tenth edition of Francisco de P. Mellado's *Guía del viajero en España* cites the population of Spain and Madrid at 15,673,481 and approximately 300,000, respectively. He relates that although the museum of paintings (the Prado), with close to 2,000 paintings, is open to the public only on Sundays, foreigners can obtain permission from the director to visit on other days.

Théophile Thoré (under the pseudonym W. Bürger) writes of the extraordinary art collection of the brothers Émile and Isaac Pereire in Paris, filled with works by Velázquez, Murillo, Zurbarán, Ribera, El Greco, and Goya, among others.

Bürger 1864a, pp. 1–18.

1865

February 1 Paul Mantz's final article in a four-part series on "La Galerie Pourtalès" for the *Gazette des Beaux-Arts* is devoted to "Spanish, German, Dutch, Flemish and French paintings." Among the illustrations is an engraving, by the artist Flameng, of the famous painting *Roland mort*, then attributed to Velázquez (fig. 9.48, now Italian, seventeenth century, *Dead Soldier*, National Gallery, London). Mantz writes, "The *Orlando* has all the qualities of strength and harmony that one admires in Vélasquez, and this picture will have the plaudits even of those who have seen the master in his triumph, in his great works in the museum in Madrid." Mantz counts this work, and Murillo's *Triumph of the Eucharist* (A 42), as among "the true pearls of the gallery."

"Les peintures espagnoles, allemandes, hollandaises, flamandes et françaises." "L'Orlando a toutes les qualités de force et d'harmonie qu'on admire chez Vélasquez, et ce tableau aura l'applaudissement de ceux-là même qui ont vu le maître en son triomphe, dans ses grandes oeuvres du musée, à Madrid"; "les vraies perles de la galerie." Mantz 1865, pp. 99, 116.

March 27–April 4 Sale of the collection of James Alexandre, comte de Pourtalès-Gorgier (1776–1855), Paris; among the 383 works offered are 14 Spanish paintings by Ribera, Murillo, Navarrete, Ribalta, Velázquez, and Zurbarán. The *Roland mort*, then attributed to Velázquez (fig. 9.48), is included in the sale.

March 27 Sale of "Un Tableaux par Ribera" (A Picture by Ribera), Paris (Lugt 28407).

April 10 Sale of eight Spanish pictures from the Aguado collection, Paris (Lugt 28443). *Chronique des Arts* notes that of the paintings, "only one, . . . the Murillo, has real interest." The Murillo in question is the *Death of Saint Clare* (Gemäldegalerie, Dresden [A 10]), which had been taken from Seville by General Faviers.

"dont un seul, le Murillo, offrait un réel intérêt." Anon. 1865b, p. 137.

April 14 The Bibliothèque Impériale, Paris, acquires the trial proofs of Goya's *Los Desastres de la Guerra* and *Los Proverbios*.

Salon (May) Manet exhibits *Olympia* (Musée d'Orsay, Paris [R-W I 69]) and *Jesus Mocked by the Soldiers* (Art Institute of Chicago [R-W I 102]), to a torrent of negative criticism.

May 31–June 12 Sale of the collection of Charles-Auguste-Louis-Joseph, duc de Morny (1811–1865, half brother of Napoleon III), Paris (Lugt 28564). The sale includes five Spanish paintings (three works by Murillo, two by Velázquez).

August Manet writes to Zacharie Astruc from Paris, requesting advice on his impending trip to Spain: "I simply can't wait to see all those wonderful things and go to master Vélasquez for advice."

"je suis extrêmement pressé de voir tant de belles choses et d'aller demander conseil à maître Vélasquez." Manet 1988, p. 41; Manet 1991 (English ed.), p. 34.

Late August Manet leaves for Spain for a monthlong trip but returns within two weeks, complaining about the horrible food ("sale cuisine"). He visits Burgos, Valladolid, and Toledo and spends seven days in Madrid, where he meets the art writer and Hispanophile Théodore Duret (French, 1838–1927), whose portrait he will paint in 1868 (fig. 9.89).

September 1 Manet and Duret sign the visitor's book at the Prado (fig. 14.65); Manet lists his profession as "artiste." Manet writes to Fantin-Latour from Madrid: "How happy it would have made you to see Vélasquez who all by himself makes the journey worthwhile. . . . He is the supreme artist; he didn't surprise me, he enchanted me. The full-length portrait that we have at the Louvre [*Philip IV*, fig. 9.20] is not by him. Only the infanta cannot be contested. Here there is an enormous picture filled with small figures [*View of Saragossa*, now by Mazo] like those that are found in the Louvre's picture titled the cavaliers [fig. 2.18] but figures of women and men perhaps superior and, above all, perfectly free of restoration. The background, the landscape, is by a student of Vélasquez. The most extraordinary piece in this splendid *oeuvre* and possibly the most extraordinary piece of painting that has ever been done is the picture described in the catalogue as a portrait of a famous actor at the time of Philip IV [*Pablo de Valladolid*, fig. 9.57]; the background disappears, there's nothing but air surrounding the fellow, who is all in black and appears alive; and the *Spinners*, the fine portrait of Alonzo Cano; *las Meninas* (the dwarfs) [*sic*], another extraordinary picture; the philosophers, both amazing pieces; all the

Fig. 14.65 Prado visitor's book with signatures of Manet and Duret, September 1, 1865

dwarfs, one in particular seen sitting full face with his hands on his hips [*Don Sebastian de Morra*, Museo del Prado, Madrid (LR 103) (fig. 14.66)], a choice picture for a true connoisseur; his magnificent portraits—one would have to go through them all, they are all masterpieces. . . . Then there's Goya, the most original next to the master whom he imitated too closely in the most servile sense of imitation. But still he's tremendously spirited. The museum has two fine equestrian portraits by him, done in the manner of Vélasquez, though much inferior. What I've seen by Goya so far hasn't greatly appealed to me; in a day or so I'm to see a splendid collection of his work at the Duke of Osuna's. . . . Tomorrow I am going on an excursion to Toledo where I'm told I shall see both Greco and Goya very well represented."

"Mon cher ami, que je vous regrette ici et quelle joie c'eût pour vous de voir ce Vélasquez qui à lui tout seul vaut le voyage. . . . C'est le peintre des peintres; il ne m'a pas étonné mais m'a ravi. Le portrait en pied que nous avons au Louvre n'est pas de lui. L'infante seule ne peut être contestée. Il y a ici un tableau énorme rempli de petits figures comme celles qui se trouvent dans le tableau du Louvre intitulée les cavaliers, mais figures de femmes et

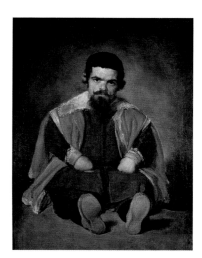

Fig. 14.66 Diego Rodríguez de Silva y Velázquez, *Don Sebastián de Morra*, ca. 1645. Oil on canvas. Museo Nacional del Prado, Madrid

d'hommes, supérieures peut-être et surtout parfaitement pures de restauration. Le fond, le paysage est d'un élève de Vélasquez. Le morceau le plus étonnant de cet oeuvre splendide et peut-être le plus étonnant morceau de peinture que l'on ait jamais fait est le tableau indiqué au catalogue, portrait d'un acteur célèbre au temps de Philippe IV; le fond disparaît, c'est de l'air qui entoure ce bonhomme tout habillé de noir et vivant; et les fileuses, le beau portrait d'Alonzo Cano; las Meninas (les nains), tableau extraordinaire aussi, ses philosophes, étonnants morceaux—tous les nains, un surtout assis de face les poings sur les hanches, peinture de choix pour un vrai connaisseur, ses magnifiques portraits, il faudrait tous énumérer, il n'y a que des chefs-d'oeuvre. . . . Et Goya, le plus curieux après le maitre, qu'il a trop imité dans le sens le plus servile d'imitation. Une grande verve cependant. Il y a de lui au musée deux beaux portraits équestres dans la manière de Vélasquez, bien inférieurs toutefois. Ce que j'ai vu de lui jusqu'ici ne m'a pas plu énormément; je dois en voir ces jours-ci une magnifique collection chez le duc d'Ossuna. . . . Je vais demain faire une excursion à Tolède. Là je verrai Gréco et Goya très représentés, m'a-t-on dit." Manet 1988, pp. 43–44; Manet 1991 (English ed.), pp. 34-35.

September 14 Manet writes to Baudelaire from the Château de Vassé: "I saw some interesting things by Goya, some of them very fine, including an incredibly charming portrait of the Duchess of Alba dressed as a *majo* [*sic*]. One of the most beautiful, most curious and most terrifying sights to be seen is a bullfight. When I get back I hope to put on canvas the brilliant, glittering effect and also the drama of the *corrida* I saw."

"J'ai vu de Goya des choses très intéressantes, quelques fort belles entre autres un portrait de la duchesse d'Albe en costume de majo d'un charme inouï. Une des plus beaux, des plus curieux et des plus terribles spectacles que l'on puisse voir, c'est une course de taureaux. J'espère à mon retour mettre sur la toile l'aspect brillant, papillotant et en même temps dramatique de la corrida à laquelle j'ai assisté." Manet 1988, p. 48; Manet 1991 (English ed.), p. 36.

September 17 Manet writes to Astruc from the Château de Vassé: "I was not at all impressed by Ribera and Murillo. They are definitely second-rate artists. Compared to Velazquez's portrait of the *Duke of Olivares* [*on Horseback* (LR 66)], Titian's *Charles V* looks like a dummy on a rocking horse. There are only two painters, apart from the Master, who attracted me: Greco whose work is bizarre, but includes some very fine portraits (I didn't like his *Christ* at Burgos at all) and Goya whose masterpiece seems to me to be in the Academy (*The Duchess of Alba* [in fact the *Clothed Maja* (G-W 744) (fig. 14.21)], what a stunning creation). I must have asked four dozen times or more at the Café Suisse for the artist García Martínez; he was not in Madrid, so I didn't manage to see the Osuna Gallery [at La Alameda]. Like you I admired Toledo, Valladolid and San Pablo, Burgos and its cathedral. But what horrible food in that country . . . ! It's a great pity. I stayed a week in Madrid and had plenty of time to see everything, the Prado with all those

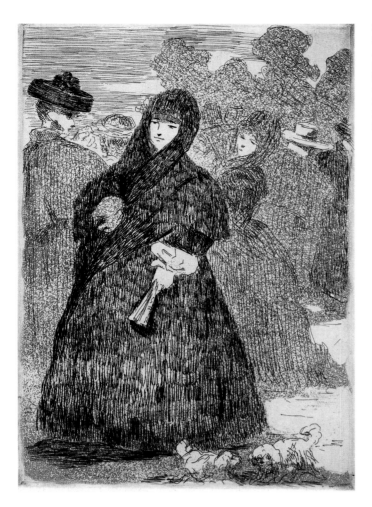

Fig. 14.67 (cat. 178) Édouard Manet, *On the Prado II*, 1863. 1st state, etching and aquatint, image 8¾ x 6¼ in. (22.1 x 15.8 cm). New York Public Library, Astor, Lenox, and Tilden Foundations

mantillas was absolutely delightful (fig. 14.67), but the outstanding sight is the bullfight. I saw a magnificent one, and when I get back to Paris I plan to put a quick impression on canvas: the colorful crowd, and the dramatic aspect as well, the picador and horse overturned, with the bull's horns ploughing into them and the horde of *chulos* trying to draw the furious beast away."

*"Je n'ai nullement été satisfait de Ribera et de Murillo. C'est des peintres de second ordre décidément. Le portrait de Charles-Quint par Titien a l'air, à côté de celui du duc d'Olivarès, d'un mannequin sur un cheval de bois. Deux hommes seulement, après le Maître, m'ont séduit là-bas : Greco dont l'oeuvre est bizarre, des portraits fort beaux cependant (je n'ai pas été content du tout de son Christ de Burgos) et Goya dont le chef-d'oeuvre se trouve, selon moi, à l'Académie (*La Duchesse d'Albe, *quelle saisissante fantaisie). J'ai demandé vingt fois le peintre Garcia Martinez aux échos du Café suisse; il était absent de Madrid; je n'ai donc pas vu la Galerie d'Ossuna. J'ai admiré, comme vous, Tolède, Valladolid et [San Pablo?], Burgos et sa cathédrale. Mais quelle sale cuisine on mange dans ce pays . . . ! C'est vraiment fâcheux. Je suis resté sept jours à Madrid et j'ai eu bien le temps de tout y voir, le Prado avec toutes ses mantilles m'a plu énormément, mais le spectacle unique c'est la course de taureaux. J'en ai vu une superbe et compte bien à mon retour à Paris mettre sur la toile l'aspect rapide de cet assemblage de monde tout bariolé, sans oublier la partie dramatique, picador et cheval renversés et labourés par les cornes du taureau et l'armée de*

chulos cherchant à écarter l'animal furieux." Manet 1988, pp. 49–50; Manet 1991 (English ed.), pp. 36–37.

October 13 Manet writes to Duret: "I would have written to you earlier to say how interesting I found your articles on Spain [published in *L'Indépendant*, Saintes], but I was not yet back in Paris when your packet reached me. . . . I have, however, already painted *The Bullring in Madrid* [fig. 9.53] since my return; I would love to have your dauntingly frank opinion of it on your next trip to Paris. I must say that I very much hope there will be a follow-up to your articles and that you will go on to talk about Spain from the artistic and political points of view, with special emphasis on Vélasquez, Goya, and Greco! So make sure you send me the texts. It will be nice to see you again and have a chat about our adventures in Spain, but I warn you in advance, you will never get me to agree that we ate a decent lunch in Toledo."

*"Je vous aurais déjà écrit pour vous dire tout l'intérêt que j'ai pris à lire vos articles sur l'Espagne, mais j'étais encore absent de Paris quand votre envoi m'est arrivé. . . . J'ai cependant fait déjà depuis mon retour *la Plaza de toros de Madrid; *à votre prochain voyage à Paris ne manquez pas de venir me voir, je serai bien aise d'avoir votre terrible et positif jugement. Ah mais j'espère bien que vos articles vont avoir une suite et que vous allez parler de l'Espagne*

au point de vue artistique et politique, Vélasquez, Goya, Greco à la rescousse! Me les envoyer bien entendu. J'aurai grand plaisir à vous revoir et à causer un peu de nos aventures d'Espagne mais je ne vous accorderai jamais, je vous en avertis d'avance, que nous ayons bien déjeuné à Tolède." Manet 1988, p. 56; Manet 1991 (English ed.), p. 37.

Among the works that Manet executes upon his return are three paintings of the bullfight, all 1865–66: *The Bullring in Madrid* (fig. 9.53) and two titled *Bullfight* (fig. 9.54; private collection, Tokyo [R-W I 109]).

The Louvre acquires Goya's portraits *Ferdinand Guillemardet* (G-W 677) and *Woman in Spanish Costume* (fig. 2.23) by bequest of Louis Guillemardet, Ferdinand's son. They are the first paintings by Goya to enter the museum.

Gustave Brunet's *Étude sur Francisco Goya: Sa vie et ses travaux* published. Also appearing this year is Brunet's translation of Stirling-Maxwell's *Velazquez and His Works*, under the title *Velasquez et ses oeuvres*, with notes by W. Bürger (pseudonym of Théophile Thoré).

*Brunet may have been an acquaintance of Manet, and it may be his wife who is the subject of Manet's *Portrait of Mme Brunet, *1860–67 (private collection, New York [R-W I 31]).*

Henry O'Shea's *Guide to Spain* published in London.

Bonnat begins teaching. Among his students will be Thomas Eakins (American, 1844–1917) (see 1869), who will first enroll in Gérôme's classes in October 1866.

1866
Carolus-Duran, encouraged by his friends Zacharie Astruc and Manet, who had traveled to Spain in 1864 and 1865, respectively, undertakes a lengthy trip to Spain with the proceeds from the sale of his painting *L'Assassiné,* which received a medal at the Salon of 1866 and was purchased by the French state for 5,000 francs. He remains in Spain for more than two years, returning to Paris in 1868.

Castres 1999, p. 102.

Salon (May 1) Manet's *The Fifer* (fig. 9.68) and *The Tragic Actor* (fig. 9.56) rejected. In July, after visiting Manet's studio, Thoré mentions in an article the "large portrait of a man in black, reminiscent of the portraits of Velázquez, and which the jury has rejected."

L'Indépendance Belge (July 5), quoted in Paris–New York 1983, p. 509.

September 15 Manet's lithograph *Moorish Lament* (G 70) printed as the cover for sheet

music by the Paris-based Catalan composer Jaime Bosch.

November 2 Carolus-Duran registers as a copyist at the Prado. On December 10–15 and 17–19, he carries out a copy of *The Dwarf, El Primo, after Velázquez* (Sénat, Paris).

"Durando, Carlos, [calle] Carmen, Hotel de Francia." He lists Casado as his sponsor. Registro de copistas (L-36), 18 marzo 1864–18 octubre 1873, n.p. [10]. Castres 1999, pp. 101–2, no. 33, ill.

Eugène Crépet describes Baudelaire's room: "The chief ornaments on the walls were two canvases by Manet, one a copy of Goya's portrait of the duchess of Alba [*Clothed Maja*], which he so much admired."

Baudelaire 1887, p. 95, quoted in Paris–New York 1983, p. 102.

Jules Salles's *L'Andalousie, l'art arabe et le peintre Murillo, frágment d'un voyage en Espagne* published in Nîmes.

1867
March 11 Verdi's opera *Don Carlos* premieres in Paris. Set in sixteenth-century Spain, it is based on the play *Don Carlos, Infant von Spanien* (1787) by Friedrich von Schiller (German, 1759–1805).

April 17 Sale of the Soult collection, Hôtel Drouot, Paris (Lugt 29730). Of the sixteen paintings offered, fourteen are by Spanish artists. The Louvre purchases Zurbarán's *Saint Apollonia*, lot 5 (S119) (fig. 14.68) for 7,000 francs.

Fig. 14.68 Francisco de Zurbarán, *Saint Apollonia*, ca. 1636. Oil on canvas. Musée du Louvre, Paris

May 21 Sale of Murillo's painting series *Life of the Virgin*, Hôtel Drouot, Paris (Lugt 29826).

The series fetches a total of 47,100 francs (today the works are regarded as copies and their location is unknown).

May 22 or 24 Manet opens his one-man exhibition in a specially constructed pavilion at the Pont d'Alma, outside the grounds of the Exposition Universelle, which opened in Paris this month. Courbet also mounts an exhibition in his own pavilion, which opens one week later.

Manet exhibits fifty paintings and three etchings; almost half of the works are his "Spanish" or Spanish-influenced paintings. The exhibition marks the apogee of Manet's "Spanish" period. One critic describes Manet as a "Velázquez of the boulevards . . . or a Spaniard of Paris":

Portrait of Mme Brunet (private collection, New York [R-W I 31])
Boy with a Dog (private collection, Paris [R-W I 47])
The Spanish Singer (fig. 1.45)
Boy with a Sword (fig. 1.1)
Young Woman Reclining in a Spanish Costume (Yale University Art Gallery, New Haven [R-W I 59])
The Street Singer (Museum of Fine Arts, Boston [R-W I 50])
Mlle V. . . in the Costume of an Espada (fig. 9.34)
Philip IV, after Velázquez, etching (fig. 9.27)
Little Cavaliers, after Velázquez, etching (fig. 9.26)
The Gypsies, etching (fig. 9.18)
Lola de Valence (fig. 9.44)
Young Man in the Costume of a Majo (fig. 9.37)
The Dead Toreador (fig. 9.49)
The Dead Christ and the Angels (fig. 9.51)
Jesus Mocked by the Soldiers (Art Institute of Chicago [R-W I 102])
The Tragic Actor (fig. 9.56)
Philosopher (fig. 9.62)
Philosopher with Cap (fig. 9.61)
Absinthe Drinker (fig. 9.10)
A Matador (fig. 9.55)
The Fifer (fig. 9.68)

Claretie 1867.

June 3–6 Sale of the famed collection of the marquis de Salamanca, Hôtel Drouot, Paris (Lugt 29861) (see cat. 15).

June 19 Emperor Maximilian executed in Mexico.

July Manet's etching of *The Spanish Singer* (fig. 9.25) inserted in *L'Artiste*, July 15–30.

A Spanish dance troupe performs at the Exposition Universelle in Paris.

Paris–New York 1983, p. 240.

Charles Yriarte's monograph *Goya: Sa biographie, les fresques, les toiles, les tapisseries, les eaux-fortes et le catalogue de l'oeuvre* published in Paris. The *Third of May 1808* (G-W 984), *Asensio Juliá* (fig. 5.8), and *Majas on a Balcony* (private collection, Zurich [G-W 959]) are illustrated with engravings.

In Toledo, where he resides for almost six months, Carolus-Duran paints one of two portraits of his friend the Madrid painter Matías Moreno (fig. 14.69), which is inspired by Velázquez's self-portrait in *Las Meninas*.

Augé in Madrid 1977, p. 124.

In Paris, Gigoux buys a pair of small works on panel by Goya, both titled *Martyrdom* (G-W 922–923). They join a series of four works on tin purchased in 1840 (see 1840). He will bequeath all of them to the Musée des Beaux-Arts, Besançon, in 1894.

1868
April 1 Alphonse Hirsch's etching after Goya's *Caprichos* no. 10 published in the *Gazette des Beaux-Arts*.

April–May John Singer Sargent (American, 1856–1925) and his family tour Spain, visiting Barcelona, Valencia, Granada, Cordova, Seville, and Cadiz.

May 27 Painter and printmaker Jean-Louis Forain (French, 1852–1931) registers at the Louvre to copy the etchings of Rembrandt and Goya.

July Manet exhibits *The Dead Toreador* (fig. 9.49) at Le Havre.

August Painter Alexandre-Georges-Henri Regnault (French, 1843–1871), who won the Prix de Rome in 1866, asks to transfer his scholarship from Rome to Madrid to aid in his recuperation from a horse-riding accident. He arrives in Spain via the Basque lands and travels through Bilbao, Burgos, and Ávila before settling in Madrid. In the months prior to his move to Madrid, Regnault visited the Rome studio of the Spanish painter Mariano Fortuny (1838–1874), which inspired him to travel to southern Spain.

Brey Mariño 1949, p. 15.

September 4 Courbet signs the register of copyists at the Prado (though there is no record of what he copied). This little-known visit to Madrid, unmentioned in the artist's extensive correspondence, occurs sometime between August 21 and September 10.

Luxenberg 2001, p. 690.

Fig. 14.69 (cat. 94) Carolus-Duran, *Matías Moreno*, 1867. Oil on canvas, 31⅞ x 24¼ in. (81 x 61.5 cm). Museo Nacional del Prado, Madrid

September 12 Regnault, along with fellow students Jules-Georges-Victor Clairin (1843–1919) and Roger-Joseph Jourdain (1845–1918), each of whom lists his address as Alcalá 16 in Madrid, register as copyists at the Prado (nos. 370, 368, 369, respectively). They list as their sponsor Federico de Madrazo, director of the Real Museo (Prado).

Registro de copistas (L-36), 18 marzo 1864–18 octubre 1873, n.p. [15].

September Revolution In Madrid, General Juan Prim (1814–1870) leads a revolt against the Spanish monarchy. Isabella II is deposed and flees to France.

October–February 1869 Regnault undertakes and completes the equestrian portrait of General Juan Prim (fig. 14.1), leader of the Revolution of September 29 and future minister of war (January). The portrait commission was arranged by the count and countess de Barck (a Swedish official in Madrid and his French wife). In November, Regnault also undertakes a small portrait of the countess de Barck (fig. 2.24).

Brey Mariño 1949, p. 54.

December 1 Hoping to attract buyers, Manet exhibits *The Spanish Singer* and *Boy with a Sword* (figs. 1.45, 1.1) at the Société Artistique des Bouches-du-Rhône in Marseilles. Also in

December, Manet's etching *Exotic Flower* (fig. 9.85) is printed in Philippe Burty's *Sonnets et eaux-fortes*.

Napoleon III donates Ribera's *Deposition of Christ* (*La Déposition du Christ* [PS-S 38]) to the Louvre.

French painter Paul Baudry (1828–1886) visits Spain.

Brey Mariño 1949, p. 25.

The Calcografía Nacional, Madrid, reissues Goya's *Los Caprichos*.

Francisco Zapater y Gómez's *Goya, noticias biográficas* published in Saragossa.

1869

January *Catalogue de la collection de dessins anciens des maîtres espagnols, flamands, français, hollandais et italiens. Pièces rares de l'œuvre de Goya, cette vente aura lieu . . . Janvier 1869*, by Paul Lefort (1829–1904), published in Paris.

February 1–4 Atelier sale of painter Adrien Dauzats, Hôtel Drouot, Paris (Lugt 30942). His collection includes numerous sketches, studies, watercolors, and figure compositions of Spanish subjects done during his travels through Spain with Baron Taylor (1835–37). One old-master Spanish painting, *La Vierge noire*, is listed among his possessions, and his library contains editions of *Don Quixote* and *Don Juan*, as well as Spanish travel books.

April 16–17 Sale of the collection of Alphonse Oudry, Paris (Lugt 31191). Millet acquires El Greco's *Saint Ildefonso*, lot 139 (now, El Greco workshop [X-361]). After Millet's death in 1875, it will be kept by his wife and eventually purchased by Degas at her posthumous sale (see 1894).

Salon (May 1) Regnault exhibits his equestrian portrait *General Prim* (fig. 14.1), which is awarded a medal, and his portrait *Countess de Barck* (fig. 2.24). Carolus-Duran shows *Woman with a Glove* (fig. 10.39), which reflects his new "Spanish-influenced" style.

Manet exhibits his paintings *The Balcony* (fig. 9.80) and *The Luncheon* (Munich [R-W I 135]) as well as five etchings, among them the *Little Cavaliers* (fig. 9.26) and *Portrait of Baudelaire* (G 38). Having received word that *The Execution of Maximilian* will be rejected, Manet does not submit it to the jury.

Eakins spends the latter half of the summer studying with Bonnat.

November–June 1870 Eakins travels through Spain, visiting Madrid, Seville, and Ronda. He writes to his father in December of his frequent visits to the Prado. He spends a week in Madrid and then leaves for Seville.

December The Bolshoi Ballet, Moscow, premieres the ballet *Don Quichotte*, with a *livret* by Marius Petipa.

The Louvre and provincial museums are bequeathed 582 paintings from the collection of Dr. Louis La Caze. Among the 272 destined for the Louvre, 13 are Spanish works, including Ribera's *The Beggar (The Clubfoot)* (*Le Pied-Bot*) (fig. 2.25); Velázquez's *Infanta María*

Fig. 14.70 Anonymous, *B. Esteban Murillo*, 1869. Engraving. From Blanc et al. 1869, p. 1

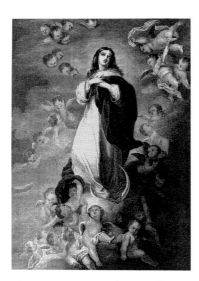

Fig. 14.71 Anonymous, *The Immaculate Conception*, 1869. Engraving. From Blanc et al. 1869, p. 11

Teresa (fig. 14.64), acquired at the Viardot auction of 1863 (lot 37) [LR 1963 389]); and Mateo Cerezo's *Saint Thomas of Villanueva Distributing Alms* (fig. 14.39), acquired at the Soult sale of 1852 (lot 89).

La Caze's collection was known to many artists, including his good friend the painter François Bonvin, as a result of the doctor's Sunday salons.

Béguin 1969, cited by Chu 1974, p. 3.

Charles Blanc's volume on the Spanish school, from his comprehensive series *Histoire des peintures*, published. The first installment on a Spanish painter had appeared in 1849. The essays are written by Blanc, Paul Lefort, Paul Mantz, Théophile Thoré (under the pseudonym W. Bürger), and Louis Viardot (figs. 14.70, 14.71).

A new edition of Louis Viardot's translation of Cervantes's *Don Quixote*, with 370 illustrations by Gustave Doré, published.

Anacharsis Combes's *Histoire anecdotique de Jean-de-Dieu Soult* published in Castres.

1870
February 18 Manet exhibits the *Philosopher* (fig. 9.62) and the watercolor of *The Dead Christ and the Angels* (Musée du Louvre, Paris [R-W II 130]) at the Cercle de l'Union Artistique on the place Vendôme.

Salon (May) Ribot exhibits *The Samaritan* (fig. 2.27), to moderate success. It will be purchased by the state in the following year.

June 25 Isabella II of Spain abdicates in favor of her son, Alfonso XII (1857–1885). He will become

king in 1874 (r. 1874–85). Her abdication leads the Hohenzollern dynasty of Prussia to stake a claim for the throne. Napoleon III disputes their claim and declares war on Prussia, initiating the Franco-Prussian War (July 1870–71). French forces are ultimately defeated, and Napoleon III capitulates. Prussia initiates the siege of Paris in September.

Paul Lefort donates plates 81 and 82 of Goya's *Los Desastres de la Guerra* to the Academia de San Fernando, Madrid.

Matilla in Madrid 1994b, p. 194.

Gregorio Cruzada Villaamil's *Los tapices de Goya* published in Madrid.

Marguerite Tollemache's *Spanish Towns and Spanish Pictures: A Guide to the Galleries of Spain* published in London.

1871
October 26 Charles Blanc, director of fine arts and founder of the *Gazette des Beaux-Arts*, submits an official report to the minister of fine arts

Fig. 14.72 Auguste Renoir, *Still Life with Bouquet*, 1871. Oil on canvas. Museum of Fine Arts, Houston

of his plan to open a museum of reproductions, the Musée des Copies. Its aim is to house reproductions of important works of art from foreign museums, commissioned from young French artists. Blanc's plan is approved by December 1871; it will open in April 1873.

Boime 1964.

Renoir's *Still Life with Bouquet* (fig. 14.72) pays homage to both Velázquez and Manet by including the latter's print *The Little Cavaliers* (fig. 9.26).

Davillier and Doré make a second trip to Spain together in search of materials for a history of glass that Davillier is writing (never realized).

1872
January 11–12 Art dealer Paul Durand-Ruel (1831–1922) purchases twenty-four of Manet's paintings for 35,000 francs. He will exhibit fourteen of them during the course of the year at exhibitions of the Society of French Artists in London. Among the works exhibited are:

Boy with a Dog (R-W I 47)
The Spanish Singer (fig. 1.45)
The Dead Christ and Angels (fig. 9.51)
Philosopher (fig. 9.62)
The Fifer (fig. 9.68)

March 22 The Museo Nacional de la Trinidad is officially closed by royal decree and a portion of its holdings is transferred to the Museo del Prado. The remainder of the collection is disposed throughout Spain.

Alcolea Blanch 1996, p. 64.

Spring Davillier attends the Feria de Sevilla (Seville Fair) in the company of Spanish artists.

Summer Zacharie Astruc escorts Berthe Morisot (French, 1841–1895) and her sister Yves through Madrid. In a letter to her sister Edma Pontillon, Morisot reports: "I have written to Manet asking him for the address of Astruc. . . . He will be of great help to me, since he speaks Spanish and knows Madrid thoroughly. . . . We should give ourselves plenty of time to admire the Velasquez and the Goyas. That is for me about the only interest in going."

Morisot 1950, p. 88, no. 71; see also Alisa Luxenberg, "Over the Pyrenees and through the Looking-Glass," in New York 1993a, p. 26.

October 5 Mary Cassatt (American, 1844–1926) arrives in Madrid for a three-week stay. She visits the Prado that morning and registers as a copyist.

"Mary S. Casstt. [sic], extranjera," no. 416, Registro de copistas (L-36), 18 marzo 1864–18 octubre 1873.

Cassatt then takes up residence in Seville, where she carries out a number of Spanish genre scenes, among them *Offering the Panal to the Bullfighter* (fig. 10.26) and *On the Balcony* (fig. 10.25). She will return to Paris in April 1873.

Mathews 1987, pp. 24–26.

Manet's etching *The Gypsies* (fig. 9.18) is included in *Cent eaux-fortes par cent artistes*, printed by Cadart.

After being awarded the Legion of Honor, Carolus-Duran opens a teaching studio that

attracts a large number of American painters, among them Sargent (see 1874).

Cleveland et al. 1980–82, p. 320.

Frédéric Villot's *Notice des tableaux exposés dans les galleries du Musée Impérial du Louvre* lists twenty-four Spanish paintings.

Astruc founds the magazine *L'Espagne Nouvelle* in Madrid.

1873

February 21 Sale of the collection of Lord Dalling and Bulwer, Christie's, London (Lugt 33696), which includes four works by Goya that, as the catalogue states, came from the Louis-Philippe collection.

April–December Blanc's short-lived Musée des Copies (see October 1871), also called the Musée Européen, opens to the public in the Palace of the Champs-Elysées (Palais de l'Industrie), though critics and students had been given access since November 1872. The catalogue of the collection, published by the *Journal des Débats* on December 30 (and reprinted by *Chronique des Arts* on January 3 as well as February 7 and 14 of 1874), lists 157 paintings, including 18 copies after Spanish paintings, 14 after Velázquez. In total, 199 works—among them 31 copies after Spanish works—were commissioned (although not all were realized), with Velázquez second only to Raphael in number. Though the bulk of the paintings remain at the École des Beaux-Arts, Paris, the cities of Besançon, Dijon, La Flèche, Grenoble, Laon, Lyon, and Orleáns all receive Spanish copies for their museums. The 31 Spanish works commissioned are:

Carreño de Miranda, *Portrait de Charles [II] d'Espagne*—A. Brune (1802–1875)
*Goya, *Les femmes au balcon*—
A.-C.-G. Prévost (1832–?)
*Murillo, *Sainte Élisabeth soignant les malades* (Museo del Prado, Madrid)—
A.-C.-G. Prévost
*Murillo, *Sainte Élisabeth soignant les malades* (Prado)—J.-R.-H. Lazerges (1817–1887)
[Lazerges refuses the commission due to the political troubles in Spain.]
Murillo, *La Trinité* (National Gallery, London)—
H. D. Holfeld (1804–1872), not exhibited
Ribera, *La Déposition de croix* (San Martino, Naples)—G.-G. Lethière (1760–1832)
Ribera, *Saint Stanislas et l'Enfant Jésus* (Museo Galleria Borghese, Rome)—F. Lafon
Ribera, *Martyre de Saint Barthélémy* (Prado)—
J.-F.-S. Layraud (1833–1913), not exhibited
Velázquez, *Portrait en pied de don Fernando* (Prado)—J.-B. Guignet (1810–1857)
Velázquez, *Portrait en pied de Philippe IV* (Prado)—J.-B. Guignet

Velázquez, *Nain el Primo* (Prado)—J.-B. Guignet
Velázquez, *L'Idiot de Coria* (el Bobo) (Prado)—
J.-B. Guignet
Velázquez, *L'Infant Don Carlos* (Prado)—
J.-B. Guignet
*Velázquez, *Portrait du nain Francisco Lezcano, dit L'Enfant de Vallecas* (Prado)—J.-B. Guignet
*Velázquez, *Nain barbu (El Enano barbado)* (Prado)—J.-B. Guignet
Velázquez, *Les Fileuses* (Prado)—A.-M. Colin (1798–1873)
Velázquez, *Ménippe* (Prado)—A.-C.-G. Prévost
Velázquez, *Esope* (Prado)—A.-C.-G. Prévost
Velázquez, *Famille de Philippe IV* (Prado)—
A.-C.-G. Prévost
Velázquez, *Portrait équestre du duc d'Olivares* (Prado)—A.-C.-G. Prévost
Velázquez, *Portrait équestre de Philippe IV* (Prado)—A.-C.-G. Prévost
Velázquez, *Nain au chien* (Prado)—
A.-C.-G. Prévost
Velázquez, *Les filles d'honneur* (Prado)—
A.-C.-G. Prévost
Velázquez, *Les Buveurs* (Prado)—E.-P. Brigot (1836–?) [Brigot also made a copy of Velázquez's *Baltasar Carlos as a Hunter* that Blanc purchased in 1872 but felt was not of sufficient quality to exhibit.]
Velázquez, *Le Christ en croix* (Prado)—
L.-E.-C. Porion (1814–?)
Velázquez, *Les forges de Vulcain* (Prado)—
L.-E.-C. Porion
Velázquez, *La Dame aux gants* (formerly Galerie Aguado)—S.-M. Cornu (1804–1870)
Velázquez, *Les Lances ou La Rendition de Breda* (Prado)—H.-A.-G. Regnault (1843–1871)
Velázquez, *Portrait de Léon X [sic]* (Pitti Palace, Florence)—Steuben (1788–1856)
Velázquez, *L'Enfant Balthazar Carlos à cheval* (Prado)—Mme E. Tourny
Zurbarán, *Saint François en prière* (formerly Galerie Espagnole, at the Louvre)—
A.-H. de Beaulieu (1819–1884)
[* NEVER EXECUTED]

Boime 1964; see also Duro 1985 and Auvray 1873.

After Blanc's dismissal from his post in mid-December 1873, his successor, the marquis de Chennevières, begins plans for dismantling the Musée des Copies. The majority of the works are sent to the École des Beaux-Arts; transfer of the paintings begins in late January 1874.

Gérôme visits Spain. He will make another trip there in 1883.

1874

February 20 Manet's lithographs *Boy with a Dog* (G 27) and *Civil War* (G 76) printed by Lemercier. This year Cadart issues *Édouard Manet. Eaux-fortes*, an album of nine etchings:

Hat and Guitar (frontispiece; G 62)
The Urchin (G 27)
The Infanta Margarita (G 6)
The Dead Toreador (G 33)
The Spanish Singer (G 16)
La Toilette (G 26)
The Little Cavaliers (G 8)
The Gypsies (G 21)
Lola de Valence (G 23)

Spring The "Exposition en faveur de l'oeuvre des Alsaciens et Lorrains" (Exhibition to benefit the work of the Alsatians and Lorrainers) held at the Palais Bourbon, Paris. It includes works by El Greco, Coello, Murillo, Ribera, Velázquez, and Goya.

May Sargent and his family, living in Florence, cancel their plans to summer in Venice and travel to Paris to look for ateliers where Sargent can study. They visit Carolus-Duran's studio on May 26, and he is placed there by May 30.

Ormond and Kilmurray 1998, p. 43.

Though sold in London at the Louis-Philippe sale in 1853, Goya's paintings *Young Women (The Letter)* and *Old Women (Time)* (G-W 962, 961) are purchased, by subscription, for 7,000 francs for the Musée des Beaux-Arts, Lille.

Both works were purchased for the Galerie Espagnole by Baron Taylor in 1838, but only Young Women (The Letter) was exhibited in the museum.

Compilation of Davillier's articles, which appeared in *Le Tour de Monde* between 1862 and 1873, is published in Paris as *L'Espagne* and illustrated with 309 woodcut engravings by Doré. It is translated into Italian (1874), English (1876), and Danish (1878).

1875

January 25–26 Sale of the marquis de Salamanca's collection, Hôtel Drouot, Paris (Lugt 35303).

March 3 Bizet's *Carmen*, after the novel by Prosper Mérimée, premieres at the Opéra-Comique (Salle Favart) in Paris. Despite public outcry and reviews about its scandalous subject matter, it runs for forty-five performances in this year, with an additional three performances in 1876. The opera attains additional notoriety when Bizet dies on the evening of its thirty-third performance, June 3, 1875.

An exhibition of paintings from the collection of the duc de Montpensier opens at the Museum of Fine Arts, Boston. Among the works are seventeen Spanish paintings, most of which had been retained by Montpensier in 1853 at the London sale of his father, Louis-Philippe. Exhibited are major works by Zurbarán, Murillo, Velázquez,

Fig. 14.73 (cat. 8) Francisco de Goya y Lucientes, *Still Life with Golden Bream*, ca. 1808–12. Oil on canvas, 17⅛ x 24¼ in. (44.1 x 61.6 cm). Museum of Fine Arts, Houston

Ribera, Valdés Leal, Herrera the Elder, Ribalta, Morales, and Orrente.

The Louvre acquires Ribera's *Saint Paul the Hermit* (PS-S 209A) (fig. 2.28) at the sale of the marquess de Gouvello.

P.-L. Imbert's *L'Espagne, splendeurs et misères: Voyage artistique et pittoresque. Illustrations d'Alexandre Prevost* published in Paris. Imbert writes of his visit to Goya's house, the Quinta del Sordo, where he saw the Black Paintings.

1876
March 6–9 Sale of Camille Marcille's collection, Hôtel Drouot, Paris (Lugt 36232). Four Spanish paintings are offered; the Musée de Chartres acquires Zurbarán's *Saint Lucy* (fig. 2.22) for 510 francs.

April 10 Sale of the Alphonse Oudry collection, Hôtel Drouot, Paris (Lugt 36390). Oudry, a bridge and road engineer, was an amateur collector of old masters; his collection consisted of sixty-three works by Italian, Spanish, and Flemish painters. Among the selection are thirteen Spanish paintings.

Salon (May) Manet's *The Artist* (fig. 9.92) and *The Laundry* (R-W I 237) rejected. Manet opens his studio (April 15–May 1) to exhibit the rejected paintings, among other works.

The Calcografía Nacional, Madrid, reissues Goya's *La Tauromaquia*.

1877
Salon (May) Manet exhibits *Faure in the Role of Hamlet* (fig. 9.58).

Whistler's *Arrangement in Black, No. 3: Sir Henry Irving as Philip II of Spain* (fig. 10.9) exhibited at the Grosvenor Gallery, London. It elicits numerous comparisons with the portraits of Velázquez.

L'Art magazine, Paris, publishes four plates from Goya's print series *Los Disparates*. The first edition of the series, consisting of eighteen prints, was issued in Madrid in 1864 (see 1864).

Francisco Goya: Étude biographique et critique, suivie de l'essai d'un catalogue raisonné de son oeuvre gravé et lithographié by Paul Lefort (1829–1904) published in Paris.

1878
April 11–12 Sale of Zacharie Astruc's collection, Hôtel Drouot, Paris (Lugt 38255). Included are works by Cano, Goya, El Greco, Murillo, and Velázquez. Among the offerings is Goya's *Still Life with Golden Bream*, lot 22 (fig. 14.73).

Goya's Black Paintings (G-W 1615–1627) (fig. 14.74) from his residence outside Madrid, the Quinta del Sordo, are exhibited at the Exposition Universelle, Paris. Badly placed in a hallway leading from the Spanish pavilion to the Scandinavian ethnographic exhibition, the paintings nonetheless elicit attention. A guide to the exposition notes: "These canvases, painted with astonishing boldness, raise a good deal of criticism and are the subject of a good deal of discussion. Without any doubt they please the impressionist painters, but they should remind them that Goya, who did these works at the end of the last century and beginning of this one, had forestalled them and had no fear of greatly exaggerating the method of painting that he was trying to make us accept."

"Ces toiles, peintes avec une audace étonnante, soulèvent bien des critiques et sont l'objet de bien des discussions. Elles plaisent sans nuls doute aux peintres impressionistes, mais elles doivent leur rappeler que Goya, qui a fait ces oeuvres à la fin du siècle dernier et au commencement du siècle actuel, les avait devancés, et n'avait pas craint d'exagérer de beaucoup le système de peinture qu'il cherchait à nous faire accepter." Bréban 1878, p. 126.

1879
October–December Sargent is in Spain. He registers as a copyist at the Prado on October 14, giving his address as Salud 13. He will carry out more than two dozen copies, thirteen after works by Velázquez, among them *The Jester Calabazas* (fig. 14.78), *Las Meninas* (fig. 10.43), *The Spinners* (The Alfred Beit Collection, Russborough, Ireland), *Dwarf with a Mastiff* (fig. 11.15), and *Aesop* (fig. 14.79). He also paints a copy of El Greco's *Holy Trinity* (fig. 4.8). Traveling south, Sargent visits Ronda, Seville, and Granada and crosses into Morocco in late December. Upon his return to Paris, Sargent carries out several works that reveal the impact of Spain and Spanish painting (fig. 14.83).

During one of his trips to Spain, Sargent comes into possession of El Greco's *Saint Martin and the Beggar* (John and Mable Ringling Museum of Art, Sarasota, now attributed to Jorge Manuel [W X-404]).

Libro de registro de los señores copiantes, October 27, 1873–April 30, 1881, cited in Luna 1988, p. 102. Ormond and Kilmurray 1998, p. xiii.

Fig. 14.74 Francisco de Goya y Lucientes, *El Aquelarre (Asmodea)*, ca. 1820–23. Oil on canvas. Museo Nacional del Prado, Madrid

December 1879–January 1880 Manet's *Execution of Emperor Maximilian* (Städtische Kunsthalle, Mannheim [R-W I 127]) shown in New York at the Clarendon Hotel and in Boston at the Studio Building Gallery. The exhibition is organized by the French singer Émilie Ambre, a friend of Manet, who is in New York and Boston on an opera tour. Upon Ambre's return home, Manet executes a portrait of her in the role of *Carmen* (fig. 9.95).

Also in December, *La Vie Moderne* sponsors an exhibition in Paris of painted tambourines to which Manet contributes.

At his "Exposition Générale de ses oeuvres" in Paris, Théodule Ribot (French, 1823–1891) exhibits his *Lazarillo de Tormes and His Blind Master* (fig. 14.80). It is inspired by Goya's *Lazarillo de Tormes* (private collection), which Ribot undoubtedly saw at the Galerie Espagnole (1838–48).

Fig. 14.77 El Greco (Domenikos Theotokopoulos), *Saint Francis*, ca. 1590. Oil on canvas. Musée des Beaux-Arts, Lille

The Louvre acquires Luis Tristan's *The Vision of Saint Francis of Assisi* (fig. 14.75). The painting is a donation from the collection of Isaac Pereire, who had acquired it from the Aguado collection.

Musée des Beaux-Arts, Lille, acquires, via donation and purchase, two paintings by El Greco: *Christ in the Garden of Olives* (P10 [W X-14]) (fig. 14.76) and *Saint Francis* (P51 [W X-298]) (fig. 14.77).

1881

July 2 William Merritt Chase (American, 1849–1915) leaves Paris for Madrid. It is the first of several trips to Spain (in 1882, 1883, 1884, 1896, and 1905). Upon visiting the Prado, he writes, "Velázquez is the greatest painter that ever lived."

Quoted in Boone 1996, p. 202.

Fig. 14.75 Luis Tristan, *The Vision of Saint Francis of Assisi*, 1st quarter 17th century. Oil on canvas. Musée du Louvre, Paris

Fig. 14.76 El Greco (Domenikos Theotokopoulos), *Christ in the Garden of Olives*, 1600–1610. Oil on canvas. Musée des Beaux-Arts, Lille

Fig. 14.78 John Singer Sargent, *The Jester Calabazas, Copy after Velázquez*, 1879. Oil on canvas. Agnew's Gallery, London

Fig. 14.79 (cat. 212) John Singer Sargent, *Head of Aesop, Copy after Velázquez*, 1879. Oil on canvas, 18¼ x 14⅝ in. (46.4 x 37.2 cm). Ackland Art Museum, University of North Carolina at Chapel Hill

Among the copies he undertakes are *Menippus*, *Aesop*, and *The Spinners*. His high regard for Velázquez and Spain will be long-standing, even manifesting itself in portraits of his family (figs. 14.81, 14.82).

December 20 Goya's Black Paintings (G-W 1615–1627) are accepted into the Prado by royal decree. They will be listed in the museum's 1889 catalogue.

1882
Gautier's *Guide de l'amateur au Musée du Louvre*, published in Paris, includes a description of the paintings of the Spanish school.

Léon de Rosny (French, 1837–1914) and A. Lesouëf, *Souvenirs du voyage en Espagne et en Portugal* is printed in Paris by Rosny in an edition of one hundred numbered copies.

1883
Gérôme takes his second trip to Spain. He carries out numerous studies of the Alhambra in Granada, which will appear as backgrounds in several paintings. He also paints a bullfight scene (location unknown).

Summer Jean-Jacques Henner is in Spain, traveling to Madrid and Burgos.

1884
February 4–5 Manet sale, Hôtel Drouot, Paris (Lugt 43575). Sargent purchases an oil study for *The Balcony* (*Portrait of Fanny Claus* [R-W I 133]) for 580 francs and a watercolor of irises (R-W I 664) (both now in private collections).

March 26 Among the five lithographs printed by Lemercier for Manet's widow, Suzanne, are Manet's *Execution of Maximilian* (G 73) and, perhaps, *The Barricade* (G 76).

Chase is in Madrid.

1885
November 30 Massenet's opera *Le Cid* premieres in Paris. It is based on the play of 1637 by Pierre Corneille (French, 1606–1684).

Fig. 14.80 (cat. 198) Théodule-Augustin Ribot, *Lazarillo de Tormes and His Blind Master*, before 1880. Oil on fabric, 36 x 29 in. (91.5 x 73.7 cm). Cleveland Museum of Art

Fig. 14.82 (cat. 207) William Merritt Chase, *An Infanta, A Souvenir of Velázquez*, 1899. Oil on canvas, 30½ x 24⅛ in. (77.5 x 61.3 cm). Mr. and Mrs. Joel R. Strote

Fig. 14.81 (cat. 204) William Merritt Chase, *A Tambourine Player (Mrs. Chase as a Spanish Dancer)*, 1885–86. Oil on canvas, 65 x 30 in. (165.1 x 76.2 cm). Montclair Art Museum

Fig. 14.83 (cat. 217) John Singer Sargent, *Albert de Belleroche*, ca. 1882. Oil on canvas, 27¾ x 19½ in. (70.5 x 49.5 cm). Colorado Springs Fine Arts Center

Odilon Redon publishes his album of lithographs *Homage à Goya*, in Paris.

Ambroise Tardieu (French, b. 1840) publishes *Un mois en Espagne: Voyage artistique à Madrid, l'Escorial, Tolède, Cordoue, Grenade, Séville, Cadix, Barcelone, etc.* in Herment (Puy-de-Dôme).

1887

April Alma Strettell's book *Spanish & Italian Folk-Songs* published with illustrations by Sargent.

Lucien Solvay's *L'art espagnol, précédé d'une introduction sur l'Espagne et les espagnols* published in Paris.

F. Hopkinson Smith's *Well-Worn Roads of Spain, Holland, and Italy: Traveled by a Painter in Search of the Picturesque* published in Boston.

1889

June 16 Theo van Gogh writes to his brother Vincent about his recently painted portrait, *L'Arlésienne: Madame Ginoux* (the version at the Musée d'Orsay, Paris [H 1625] (fig. 14.84), or the one at The Metropolitan Museum of Art [H 1624]): "I had a visit from a certain Polack,

Fig. 14.84 Vincent van Gogh, *L'Arlésienne: Madame Ginoux*, 1888. Oil on canvas. Musée d'Orsay, Paris

who knows Spain and the pictures there well. He said it was as fine as one of the great Spaniards." Van Gogh responded two days later: "I am also glad to hear that someone else has turned up who actually saw something in the woman's figure in black and yellow. That does not surprise me, though I think that the merit is in the model and not in my painting."

New York 1984, p. 207.

September 8 Degas arrives in Madrid early in the morning, with the Italian painter Giovanni Boldini (1842–1931), who had proposed the trip. They stay at the Hôtel de Paris. Degas is at the

Prado by 9:00 A.M. They attend a bullfight while in Madrid, then ultimately leave for Andalusia. By September 18 they are in Tangiers, and Degas writes of his plan to return to Paris via Cadiz and Granada.

Paris–Ottawa–New York 1988–89, p. 392.

Léon de Rosny's two-volume *Taureaux et mantilles: Souvenirs d'un voyage en Espagne et en Portugal* published in Paris. The first volume is a reprint of Rosny's 1882 *Souvenirs du voyage* (see 1882).

Gustave Clausse, member of the Société Centrale des Architectes, publishes *Espagne, Portugal: Notes historiques et artistiques sur les villes principales de la péninsule ibérique* in Paris.

1890

A major edition of Manet's prints, issued by his wife, comprises twenty-three etchings, more than half of which had previously appeared in the portfolios of 1862, 1863, and 1874.

1891

L'art en Espagne, by Paul Flat (French, 1865–1918), published in Paris.

1893

Duret donates El Greco's *Saint Francis of Assisi and Brother Leo Meditating on Death*, now after El Greco [W X-328]) (fig. 14.85), to the Louvre.

Fig. 14.85 Anonymous, after El Greco (Domenikos Theotokopoulos), *Saint Francis of Assisi and Brother Leo Meditating on Death*, 1st quarter 17th century. Oil on canvas. Musée du Louvre, Paris

Henri de Toulouse-Lautrec (French, 1864–1901) executes designs for the covers of bound sets of Goya's *Los Desastres de la Guerra* (in 1893) and *La Tauromaquia* (in 1894). The latter is exhibited in Nancy in 1894 and reproduced in an exhibition review by Jules Ruis in *Revue Encyclopédique*

Fig. 14.86 El Greco (Domenikos Theotokopoulos), *Saint Dominic*, ca. 1605. Oil on canvas. Museum of Fine Arts, Boston

(October 1, 1894). Toulouse-Lautrec will visit Spain in September 1894.

London–Paris 1991–92, no. 124.

Paul Lefort's *La peinture espagnole* published in Paris.

1894

April 24–25 Sale of the collection of Mme Millet (the painter's widow), Hôtel Drouot, Paris (Lugt 52524). Degas (through Durand-Ruel) purchases El Greco's *Saint Ildefonso* (see 1869), lot 261, for 2,000 francs.

Maurice Barrès (French, 1862–1923) publishes *Du sang, de la volupté et de la mort: Un amateur d'âmes. Voyage en Espagne. Voyage en Italie, etc.* in Paris.

June 20 Massenet's opera *La Navarraise* (The woman of Navarre) premieres in London (it will premiere in Paris on October 3, 1895). It is based on Jules Claretie's short story *La Cigarette* (1890).

Charles Clerc's *Campagne du maréchal Soult dans les Pyrénées occidentales en 1813–1814* published in Paris.

1895

July Sargent is in Madrid and registers as a copyist at the Prado.

Emilia Pardo Bazán (Spanish, 1852–1920) publishes *Por la España pintoresca: Viajes* in Barcelona.

R. A. M. Stevenson's monograph on Velázquez is published.

From 1895 to 1898, Whistler, in the last decade of his life, undertakes four self-portraits, including *Gold and Brown* (fig. 14.87). In color and composition they are indebted to Velázquez, for whom Whistler held a lifelong admiration.

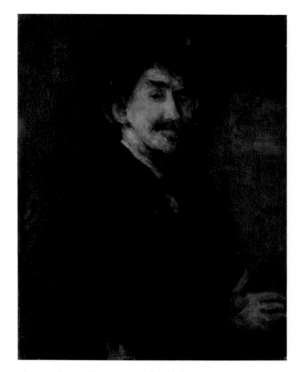

Fig. 14.87 (cat. 226) James McNeill Whistler, *Gold and Brown: Self-Portrait*, 1896–98. Oil on canvas, 24½ x 18¼ in. (62.4 x 46.5 cm). National Gallery of Art, Washington, D.C.

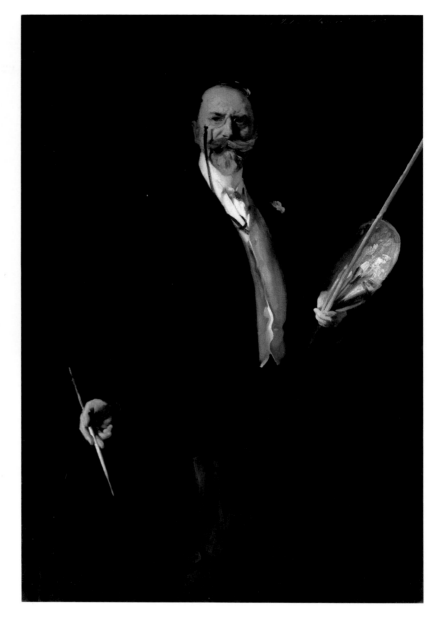

Fig. 14.88 (cat. 221) John Singer Sargent, *William M. Chase*, 1902. Oil on canvas, 62¼ x 41⅜ in. (158.8 x 105.1 cm). Metropolitan Museum, New York (05.33)

1896
February 29 Chase registers at the Prado to copy *Las Meninas*.

September Degas acquires El Greco's *Saint Dominic* (W 205) (fig. 14.86) from Zacharie Astruc for 3,000 francs.

New York 1997–98, no. 600, p. 67.

Small exhibition of five of Manet's works held at Durand-Ruel, Paris. Displayed are:

> *Portrait of an Old Man* (location unknown)
> *Mlle V . . . in the Costume of an Espada*
> (fig. 9.34)
> *Young Man in the Costume of a Majo* (fig. 9.37)
> *The Street Singer* (Philadelphia Museum of
> Art [R-W I 50])
> *Virgin of the Rabbit, Copy after Titian*
> (R-W I 5)

1898
March Bonnat's article on Velázquez is published in the *Gazette des Beaux-Arts*.

Spanish–American War.

Archer Huntington's *A Note-Book in Northern Spain* published. It is a compilation of letters to his mother recounting his first trip to Spain in 1892.

1901
Exhibition of Spanish old-master paintings, Guildhall, London.

1902
November Sargent's portrait of Chase (fig. 14.88), commissioned in this year by Chase's students, is exhibited in New York. Inspired by Velázquez's self-portrait in *Las Meninas* (fig. 4.13), Sargent depicted Chase in a similar pose.

1903
Eakins completes *An Actress (Portrait of Suzanne Santje)* (fig. 14.89), which, in composition and palette, evokes Velázquez's *Pope Innocent X* (Galleria Doria Pamphilj, Rome) (see fig. 2.3).

1904
October 14 Claude Monet (French, 1840–1926), his wife Alice, and son Michel arrive in Madrid and are met by Paul Durand-Ruel. "There they visited museums, churches and art academies. Monet was moved to tears by the paintings of Velázquez. An excursion to Toledo reminded him of his time in Algeria as a young man; the El Grecos astounded him."

Wildenstein 1996, vol. 1, p. 369.

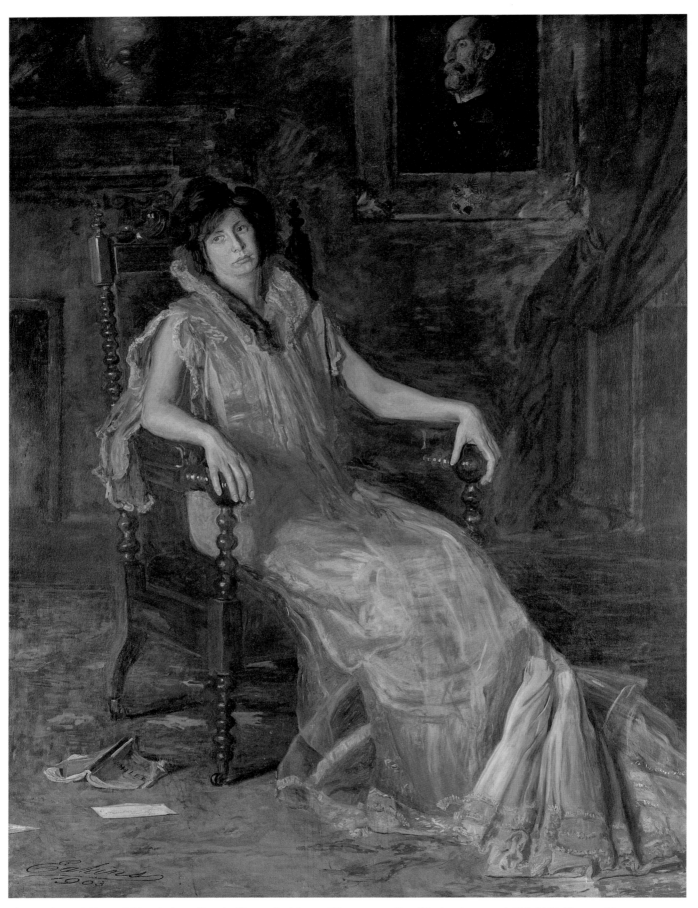

Fig. 14.89 (cat. 209) Thomas Eakins, *An Actress (Portrait of Suzanne Santje)*, 1903. Oil on canvas, 79¼ x 59⅞ in. (202.6 x 152.1 cm). Philadelphia Museum of Art

CATALOGUE

CLAUDIO COELLO

Madrid, 1642–Madrid, 1693

Born in Madrid, Coello was trained in the High Baroque style by the royal painter Francisco Rizi, from whom he also learned fresco painting. Though little of his fresco work survives, Coello's numerous commissions for religious institutions reveal him to be one of the finest Late Baroque painters of the seventeenth century, his style reflecting the influence of contemporary Italian and Flemish painting as well as that of Renaissance Venice. His talents did not go unnoticed, and he was appointed royal painter *(pintor del rey)* in 1683; in 1686 he replaced Juan Carreño de Miranda as court painter *(pintor de cámara)* to Charles II, the last Habsburg king of Spain. In the nineteenth century, Coello's work was appreciated as an ideal union of the styles of Velázquez, Murillo, and Cano, and Juan Agustín Ceán Bermúdez's mistaken belief that Coello had studied with Raphael was repeated by French Hispanists. One painting by Coello was included in the Galerie Espagnole. DLR

I.
Fig. 2.37

Claudio Coello

The Penitent Magdalen

Ca. 1665–70
Oil on canvas
23 ⅞ x 20 ⅜ in. (60.5 x 51.8 cm)
Musée d'Art Thomas Henry, Cherbourg-Octeville
835.32

CATALOGUE RAISONNÉ: Sullivan 1986, no. P14

PROVENANCE: Thomas Henry, Cherbourg, until 1835; his bequest to the city of Cherbourg, 1835

REFERENCES
19th century: Cherbourg 1835, p. 16, no. 32; Cherbourg 1870, p. 14, no. 32

20th century (selected references): Cherbourg 1912, p. 9; E. Harris 1963, p. 322; Paris 1963b, pp. 135–36, no. 44; Baticle 1964, no. 58, p. 296

Coello's *Penitent Magdalen* was one of seven Spanish paintings in the collection of the French artist Thomas Henry. A painter who exhibited in the Salons between 1798 and 1801, Henry had traveled throughout Europe, sharpening his eye as an artist as well as a picture dealer and collector. His talents resulted in his being named acquisitions commissioner of the Musée Royal, Paris, in 1816. In 1835 Henry donated his collection of 163 paintings to found the first museum in Cherbourg, his native city. He served as the curator of the Musée de Cherbourg from its opening on July 29 until his death the following year.

An 1898 description of the Cherbourg collection in a regional newspaper reveals how Henry acquired at least one of his Spanish paintings: "One day the baron James de Rothschild commissioned him to find an authentic Murillo for his gallery. Henry left for Spain and had the good fortune to lay his hands on two pictures. The baron kept one and offered his agent the other. This is how Cherbourg owns a Christ falling beneath the cross with figures of great beauty."[1]

The Penitent Magdalen was one of the first works by Coello in France. The art dealer Jean-Baptiste-Pierre Lebrun had acquired the artist's *Miracle of Saint Peter of Alcantara* (Bayerische Staatsgemäldesammlungen, Munich), originally from the Church of San Hermenegildo in Madrid, during his travels through Europe in 1807–8, and eventually sold the work to Josephine Bonaparte.[2] In his *Recueil de gravures* (1809)—which included an engraving of the Coello—Lebrun noted, "I have never seen works [by this painter] in France."[3]

By mid-century, however, Coello's work was more familiar. Charles Blanc's *Histoire des peintres de toutes les écoles: École espagnole* (1869) noted that "Coellos are not rare. There were Coellos in the Musée Espagnol of the Louvre, in the Soult and Aguado galleries, in the Salamanca gallery, etc."[4] Théophile Thoré, in his essay on Coello in the same volume, wrote, "Cean Bermudez states: 'the *professors* and (intelligent) *connoisseurs* considered him one of our best *naturalists*.'. . . In Spain Coello had combined the drawing of Alonso Cano with the coloring of Murillo and the *execution* of Velasquez."[5] In an earlier article, Thoré had mistakenly attributed Coello's somewhat Italianate style to Raphael: "We are well aware that Coello was a student of Raphael."[6]

Coello's Magdalen, her loose hair tumbling onto her shoulders, perhaps owes more to Van Dyck, whose work Coello knew and copied in the Spanish royal collections. Nonetheless, such naturalistic saints and madonnas, which populated seventeenth-century Spanish paintings, bewitched French audiences.[7] The realism of these models, so obviously posed from life, resonated among the French Realists and naturalists. Prosper Mérimée wrote of a Virgin Mary in Murillo's *Vision of Saint Bernard* (fig. 4.25) that she was "most capable of making a devout—if young—monk sin."[8]

The Coello was surely known by the young Jean-François Millet, who was studying art in Cherbourg, his birthplace, when Henry's museum opened (he was to leave for Paris in January 1837); in fact, he was sent there by his teacher to make copies.[9] Millet was undoubtedly taken with the Riberas in the museum, for he would write with fascination a year later about the macabre subjects—in particular Ribera's martyrs—that he had seen in the Galerie Espagnole in Paris and would note that "Several monks by Zurbaran and Murillo are the most incredible one can imagine as an expression of sanctity."[10]

DLR

1. "Un jour le baron James de Rothschild, le chargea de lui trouver un Murillo authentique pour sa galerie; Henry partit pour l'Espagne, et eut la chance de mettre la main sur deux tableaux. Le baron garda l'un et offrit l'autre à son mandataire. C'est ainsi que Cherbourg possède un Christ fléchissant sous la Croix avec des figures de toute beauté." Seignac 1898, n.p. For the Murillo in question, see Angulo Íñiguez 1981, vol. 2, no. 260. I am grateful to Jean-Luc Dufresne, director, and his assistant Benjamin Simon, of the Musée d'Art Thomas Henry for generously sharing this information.
2. See Sullivan 1986, no. P82.
3. "Jamais je n'avais vu des ouvrages en France." Lebrun 1809, vol. 2, p. 32.
4. "les Coello ne sont pas rares. Il y avait des Coello du Musée Espagnol du Louvre, dans les galeries Soult et Aguado, dans la galerie Salamanca, etc." Blanc et al. 1869 (Coello issue), p. 4.
5. "Dit Cean Bermudez, les *professeurs* et les *connaisseurs* (*inteligentes*) l'estimaient comme un de nos meilleurs *naturalistes.* . . . Coello, en Espagne, avait réuni le dessin d'Alonso Cano au coloris de Murillo et à l'*effet* de Velasquez." Ibid., p. 1.
6. "Nous savons bien que Coello fut élève de Raphael." Thoré 1834, p. 165.
7. See Lipschutz 1984.
8. "capable de faire pécher un moine dévot, mais jeune." Mérimée 1831c, p. 75. For the Murillo painting, see Angulo Íñiguez 1981, vol. 2, no. 287.
9. Moreau-Nélaton 1921, vol. 1, p. 17.
10. "plusieurs moines de Zurbaran et de Murillo sont ce qu'on peut imaginer de plus incroyable comme expression de sainteté." Ibid., p. 30.

2. *(New York only)*
Fig. 14.25

Attributed to Claudio Coello

Portrait of a Spanish Woman

17th century
Oil on canvas
15 x 13 ⅜ in. (38 x 34 cm)
Musée Ingres, Montauban 867.165

CATALOGUE RAISONNÉ: Sullivan 1986, no. PQ9

PROVENANCE: Acquired by Jean-Auguste-Dominique Ingres (1780–1867), as a work by Velázquez, prior to 1818; his collection; his bequest to the Musée Ingres, Montauban, 1867

EXHIBITION: Castres 1999, no. 12, p. 47

REFERENCES
19th century: Cambon 1881, p. 274 (as by Velázquez); Cambon 1885, no. 4 (as by Velázquez); Momméja 1891, p. 561 (as by Velázquez); Momméja 1893, p. 55 (as by Velázquez)

20th century (selected references): Gonse 1900, p. 197 ("pas Velázquez, plus récent d'après le costume"); Laurens 1901, p. 247 (as by Velázquez); Bredius 1904, p. 93 (as by Velázquez); Boyer d'Agen 1909,

p. 324 (as by Velázquez); Durand-Gréville 1925, p. 235; Bouisset 1926, p. 50, repr. (as by El Maso [sic] or Ferabosco[?]); Lécuyer 1939, p. 285 (as by Ferabosco), repr.; Mayer 1947, p. 480 (as by Carreño de Miranda); Benisovich 1948, p. 59; Lécuyer 1949, p. 66 (as by Ferabosco), repr.; Montauban 1953, p. 60 (as by Mazo); Gaya Nuño 1958, p. 99, no. 69 (as by Carreño de Miranda); Ternois 1959, p. 12 (as by Carreño de Miranda), repr.; Ternois 1962, p. 208 and n. 4, repr. (attributed to Carreño de Miranda); Ternois 1965, no. 1 (attributed to Coello); Angrand 1966, no. 19, p. 7; Ternois 1966, no. 19, pp. 13–14 (as by Coello, ca. 1690); Salas 1968–99, pp. 25–26, repr; Barousse 1973, p. 17 (as by Coello); Coural 1981, no. 53 (as by Coello); Viguier 1993, no. 23 (attributed to Coello), repr.

This lovely young woman's portrait—considered a work by Velázquez for most of the nineteenth century—found its way into the Rome studio of the young Ingres, who had remained in the city after his tenure as a student at the French Academy in 1810. The dramatic story of its acquisition was recounted by the painter Alfred Stevens: "One beautiful morning, a dealer had arrived at his studio with this canvas and offered it to him for a reasonable price; the sale was thus concluded. Upon departing, this individual recounted that this head came from a large portrait from which it had been cut.—'Upon hearing this,' Ingres told me, 'I took the man by the collar and threw him down the stairs, which were very steep and straight. He fell, his forehead bloody . . . but he really had deserved it,' he concluded, with the expression of a firmly convinced man."[1]

Ingres hung the work in his studio on the via Gregoriana, where it appears in the painting *Ingres's Studio* (1818, Musée Ingres, Montauban) by Jean Alaux.

Like others, Ingres had benefited from an art market flooded with Spanish paintings following the French occupation of Spain (1808–14). The secularization decree of August 1809 had emptied many of Spain's religious institutions of untold artworks, and looting continued until the French withdrawal. In the auction catalogue for his sale of April 1, 1863, the Hispanophile and art writer Louis Viardot noted a history similar to that of Ingres's Coello for his *Infanta María Teresa* by Velázquez (Musée du Louvre, Paris), which "was at the palace of Madrid. During the French retreat in 1814, an officer of

King Joseph cut the head and shoulders from the original picture and took the fragment, wrapped around a baton."[2]

Despite Ingres's obvious appreciation of this attractive portrait, Alfred Stevens did not share his opinion: "Ingres owns a head by Velázquez. Just between us, it was a bad painting; I didn't say it in front of others, but among artists we can freely admit it."[3]

Nevertheless, Ingres kept the work all his life.

DLR

1. "je pris l'homme au collet et le précipitai de haut en bas de mon escalier qui était tout droit et raide. Il tomba, le front en sang . . . mais il l'avait bien mérité,' conclut-il avec l'expression d'un homme profondément convaincu." Durand-Gréville 1925, p. 235. I am grateful to Geneviève Lacambre for bringing this reference to my attention.
2. "était au palais de Madrid. Lors de la retraite des français, en 1814, un officier du roi Joseph coupa la tête et le buste dans le tableau original, et rapporta, roulé autour d'un batôn, ce fragment. . . ."
3. "Ingres possédait une tête de Velázquez. Entre nous, c'était une croûte; je ne le dis pas devant tout le monde, mais entre artistes on peut bien l'avouer." Durand-Gréville 1925, p. 235.

FRANCISCO DE GOYA Y LUCIENTES

Fuendetodos, 1746–Bordeaux, 1828

Goya, the son of a master gilder from Saragossa and, beginning at age thirteen, a student of the Aragonese painter José Luzán, traveled through Italy in 1770–71. In 1773 he married Josefa Bayeu, whose brother Francisco Bayeu, court painter to the king, was at first a powerful rival. Goya nevertheless became painter to the king in 1786, court painter to the king in 1789, after the advent of Charles IV, and first court painter in 1799, a post that brought him a high salary. The court commissions lasted until 1802. Although Goya was not remunerated during the five years of Joseph Bonaparte's reign, he did not retire until 1826.

Following a serious illness in 1792–93, Goya became deaf. When his wife died in 1812, an inventory was made of Goya's works to be given to their son Xavier (later Javier); the son subsequently sold some of these to Baron Taylor for Louis-Philippe's Galerie Espagnole.

In 1819 Goya purchased a house known as the Quinta del Sordo (the Deaf Man's House) near Madrid. In the 1820s he executed the series known as the Black Paintings on the walls of two rooms there. Later removed and displayed at the Paris Exposition Universelle in 1878, they are now in the Museo del Prado. Goya gave the Quinta to his grandson, Mariano, in 1823, before settling in Bordeaux in 1824. Both a painter and an engraver, Goya engraved Velázquez's paintings from the Spanish royal collections in 1778. A few years after his death, the *Magasin Pittoresque* (1834, p. 324) noted that he "had perhaps hoped to revive Velázquez."

GL

3. *(New York only)* *Fig. 5.3*

Francisco de Goya y Lucientes
Autumn or *The Grape Harvest*

1786
Oil on canvas
13 ⅜ x 9 ½ in. (34 x 24 cm)
Sterling and Francine Clark Art Institute,
Williamstown, Mass. 1955.749

CATALOGUES RAISONNÉS: Gudiol 1970, no. 218 [1980, no. 206]; Gassier and Wilson 1971, no. 258; De Angelis 1974, no. 198

PROVENANCE: Duque and duquesa de Osuna, La Alameda, 1798 (purchased from the artist); Baron Charles Jean-Marie Alquier, Madrid (nominated as French ambassador November 1799, replaced November 1800), then France; heirs of Baron Alquier, Nantes; M. Knoedler and Co., New York, by 1939; R. Sterling Clark, Upperville, Va., March 1939; given by him to Sterling and Francine Clark Art Institute, Williamstown, Mass., 1955

EXHIBITIONS: Madrid–London–Chicago 1993–94, no. 21; Lille–Philadelphia 1998–99, no. 12 (Lille ed.), p. 21 (Philadelphia ed.); Madrid–Washington 2001–2, no. 15

REFERENCES
19th century: Yriarte 1867, n. p. 143 (as with Goupil)

20th century (selected references): Watt 1939, p. 28, repr.; McVan 1945; Sambricio 1946, p. 252, no. 42a (based on Yriarte); Gaya Nuño 1958, p. 159, no. 894; Arnáiz 1987, pp. 288–89, no. 46 [B-1], [B.2]; Gil 1990, pp. 71, 108, no. 45; Madrid–London–Chicago 1993–94, p. 164 (Madrid ed.)

In the summer of 1866, the writer and journalist Charles Yriarte visited La Alameda de Osuna, not far from Madrid, where the descendants of Goya's early and most committed patrons, the duque and duquesa de Osuna, retained in situ the works commissioned or purchased by their forebears. Yriarte was preparing a major monograph on Goya and wished to catalogue as many works as possible at first hand. When listing the artworks in the library at La Alameda, he saw that a set of small paintings of the four seasons was incomplete: *Autumn* was lacking. A note in his catalogue indicates that "by a curious coincidence, the picture that is missing from the

series or at least one that could be the pendant work, is currently for sale at Messrs. Goupil."[1]

The small paintings were, in fact, sketches for tapestry cartoons, the *modelli* for proposed designs that Goya presented to the royal family for approval before starting on the full-scale cartoons.[2] Such preparatory sketches remained his own property, to be given or sold to friends and patrons. In 1798, Goya invoiced the duque de Osuna for a group of seven paintings that included sketches from two of his finest sets of tapestry designs, commissioned in 1786 and 1788, respectively. The duke's order for payment, dated April 1799,[3] included "la Pradera de San Ysidro" (cat. 4) and "four seasons of the year," so the sketch for *Autumn* was certainly among the works delivered to La Alameda. However, this small picture may have remained in the Osuna collection only briefly. Its next owner was the French diplomat Baron Charles Jean-Marie Alquier (1752–1826). Alquier replaced Ferdinand Guillemardet (fig. 5.1) as French ambassador to Spain. Nominated in November 1799, he did not arrive in Spain until late February 1800; replaced in his turn by the sudden appointment of Lucien Bonaparte in November, Alquier appears to have left Madrid on December 25, 1800, never to return.[4] According to the condesa de Yebes, Alquier was a friend of the Osuna family, no doubt as a result of the duke's presence in Paris in 1798–99. It seems that he transported his baggage to Spain in a wagon that belonged to the Osunas and had been left behind by them, loaded with trunks, perhaps with this intention.[5] Alquier's correspondence with Talleyrand suggests a perhaps uncomfortably close relationship with the duke. On March 5, he wrote: "The duke of Osuna . . . greeted my arrival with pressing demonstrations of his good will; but I refused to see him before my formal presentation, alleging diplomatic protocol as my excuse. . . . However, I can no longer defer a meeting with him, and I will see him tomorrow."[6] It is possible that the small painting by the recently nominated first court painter, just one of the many works by Goya owned by the Osuna family at that date, was a gift made to Alquier in gratitude for his good offices over the safe passage of their baggage, and in the hope of support for the duke's political aims.[7]

When the picture was sold to R. Sterling Clark in 1939, it was said to have been "mentioned in the inventory of [Alquier's] effects" and to have remained in the family collection until its rediscovery in 1939.[8] All that we know at present is that the picture remained with Alquier's heirs, presumably those descended in the only male line from his two sons, that of Jules. As to Yriarte's reference to a version of *Autumn* that was for sale at the Goupil gallery in Paris in the mid-1860s, it is quite possible that this was the Alquier picture, offered for sale but subsequently returned to the family from whom, years later, it was acquired and sold by Knoedler to the American collector.[9]

While the picture's provenance has proved puzzling, doubts have also been expressed concerning its authenticity.[10] However, its examination and presentation with all the other sketches in the series for an exhibition in 1993–94[11] established it as a characteristic example of Goya's style and handling

at this period, marked by lively underdrawing in graphite and spontaneous brushwork with many traces of pentimenti. The development of the iconography from sketch to finished cartoon reveals the artist's determination to give traditional, allegorical subjects a thoroughly contemporary look, and the final tapestry cartoon is one of Goya's masterpieces.[12]

JW-B

1. "par une particularité curieuse, la toile qui décomplète la collection ou du moins celle qui pourrait former un pendant, est actuellement en vente chez MM. Goupil." Yriarte 1867, p. 143n.

2. The four seasons were designed to decorate a room in the palace of El Pardo; see Gassier and Wilson 1971, nos. 256–71; Madrid–London–Chicago 1993–94, pp. 172–83, 350–52, nos. 19–24. For the projected hang of the tapestries, as reconstructed by José Luis Sancho, see Madrid 1996c, pp. 163–65; see also Madrid–London–Chicago 1993–94, pp. 158–59 (Madrid ed.).

3. Documents listed in Gassier and Wilson 1971, Appendix 5, pp. 383 (May 6, 1798, regarding the invoice) and 384 (April 26, 1799, regarding the payment). On La Alameda and the subsequent fate of the Osuna collection, see McVan 1945.

4. See Perrin de Boussac 1983, pp. 106–41. Alquier has erroneously been said to have held the post of ambassador to the court of Joseph Bonaparte (as in Madrid–London–Chicago 1993–94, p. 351, no. 21 [Madrid ed.]). I am grateful to David Degener for providing detailed information concerning Alquier's career.

5. Yebes 1955, p. 207. This biography of the duquesa de Osuna is based on family archives and, in respect of the Osunas' relationship with Alquier, on the correspondence of Queen María Luisa and Manuel Godoy. Jeannine Baticle kindly drew my attention to Alquier's connection with the Osuna family.

6. "Le duc d'Osuna . . . m'a fait témoigner infiniment d'empressement et d'obligeance à mon arrivée; mais j'ai refusé de le voir avant ma présentation, et me suis retranché sur l'usage. . . . Cependant, je ne peux pas différer plus longtemps de chercher le duc, et je le verrai demain." Perrin de Boussac 1983, p. 121.

7. The duque de Osuna was said to be the leader of a cabal that sought to remove the current prime minister, Mariano Luis de Urquijo, from office.

8. Documents in the curatorial files at the Sterling and Francine Clark Art Institute, Williamstown, Mass. I am indebted to Kathryn Price for much information about the acquisition of the work and its previous history. The *inventaire après décès* of Baron Alquier (d. 1826) and later family inventories remain to be examined for evidence of the picture's history. A sale of part of Alquier's collection in 1825 included only three Spanish pictures: two attributed to Murillo and one to the "Spanish school" (Alquier 1825, lots 70–72). Until we have proof that Baron Alquier himself acquired the painting by Goya, an alternative and very different hypothesis concerns the ambassador's younger son, Jules. Jules Alquier (b. 1787) joined Napoleon's army in Spain in 1808 and played an active part in the siege of Saragossa and the campaigns in Aragon and Catalonia under marshals Suchet and Soult (see Perrin de Boussac 1983, p. 293). During the war, the Osuna home at La Alameda was taken over by the French, and it became the headquarters of General Béliard in 1812. The Osunas had retreated to Cadiz and there received reports of thefts and damage committed by the French troops (McVan 1945, p. 128).

9. Not too much should be made of the apparent discrepancy between the painting in Williamstown and the description of the work seen by Yriarte in Paris (see n. 1); such descriptions are often inaccurate.

10. Arnáiz 1987, pp. 288–89, expressed strong reservations, citing the negative opinion of Martin Soria.

11. See Madrid–London–Chicago 1993–94.

12. For discussion of the iconography and for earlier references, see Tomlinson 1989, pp. 159–63; Lille–Philadelphia 1998–99, no. 12 (Lille ed.); Madrid–Washington 2001–2, no. 15.

4.

Fig. 5.2

Francisco de Goya y Lucientes
The Meadow of San Isidro

May–June 1788
Oil on canvas
16½ x 35¾ in. (42 x 90 cm)
Museo Nacional del Prado, Madrid P 750

CATALOGUES RAISONNÉS: Gudiol 1970, no. 252 [1980, no. 245]; Gassier and Wilson 1971, no. 272; De Angelis 1974, no. 231

PROVENANCE: Duque and duquesa de Osuna, La Alameda, 1798 (purchased from the artist); Osuna sale, Palacio de la Industria y de las Artes, Madrid, May 11 (and following days), 1896, no. 66 (as "La romería de San Isidro"); acquired for the Museo del Prado, Madrid

EXHIBITIONS: Madrid 1896, no. 66; Madrid–London–Chicago 1993–94, no. 26 (citing earlier references); Madrid 1996c, no. 49; Saragossa 1996, no. 28; Lille–Philadelphia 1998–99, no. 20 (Lille ed.), p. 22, repr. (Philadelphia ed.); Madrid–Washington 2001–2, no. 17; Paris 2002–3, no. 2

REFERENCES
19th century: Yriarte 1867, repr. facing p. 79 (as *La Romeria de San-Isidro*, incorrectly located [*Musée de Madrid*]), pp. 85, 143 (catalogue), 156 (*Table des gravures*)

20th–21st century (selected references): Madrid–London–Chicago 1993–94, pp. 172–78 (Madrid ed.); Moreno de las Heras 1997, pp. 159–63, no. 53 (citing earlier references); Madrid–Washington 2001–2, pp. 135–37

This detailed scene, with its miraculously atmospheric view of the city of Madrid from across the River Manzanares, is one of Goya's most celebrated masterpieces. It was made as a sketch for a tapestry cartoon, part of a new series that had been ordered at the beginning of 1788 to decorate the Bedchamber of the Infantas (the infantas were, in this case, the granddaughters of Charles III) in the palace of El Pardo. By the end of May, Goya had not yet completed his sketches for the five tapestries required. He wrote to his friend Martín Zapater in Saragossa that he had to have them ready for the arrival of the

king and the royal princes, the parents of the infantas, who were to see and approve the designs. But time was short, "and besides, the subjects are so difficult and give so much work, for example the Meadow of San Isidro, on the saint's day, with all the excitement and goings-on that are customary here in Madrid. . . ."[1]

The Feast of San Isidro, the patron saint of Madrid, falls on May 15. Perhaps Goya's delay in completing work on the sketches was partly due to a wish to visit the site and take in the view over the meadow, particularly since all five scenes depict aspects of this great annual fiesta.[2] The tradition, still current, sends the people of Madrid across the river to wend their way up to the hermitage of San Isidro, and there to stand in line for water from the holy spring beside the chapel (a scene depicted in another of the sketches). Goya's painting offers a brilliant combination of a topographical mapping of the Madrid skyline with an imaginative and poetic evocation of the city caught in the late afternoon sun, its historic heart cradled between the royal palace and the great dome of San Francisco el Grande. The view takes in the principal bridge, the Puente de Segovia, to the left, and the area around the Puerta de Toledo far to the right. It is a view that many travelers would have had as they arrived at the city from the south and west or cast a backward glance as they left it to travel toward Andalusia.

Goya completed his sketches and one tapestry cartoon, but the series was abandoned on the death of the old king. In 1798, the artist sold these and other early sketches (cat. 3), as well as a recent set of witchcraft pictures, to his faithful and enlightened patrons, the duque and duquesa de Osuna. Destined for their country home, where seven large decorative paintings had been installed in 1787, the collection offered perhaps the largest and most varied group of works by Goya that nineteenth-century visitors to Spain could see, until its dispersal by public auction in 1896.[3] Charles Yriarte, whose monograph on Goya was published in 1867, devoted part of the chapter "Goya peintre de genre" (on Goya's genre paintings) to the collection at La Alameda. He described the property, known as "*el Capricho*, situated nine kilometers from Madrid, between Barajas and Castillejos," and likened it to "our Grand Trianon at Versailles."[4] Of the Goyas, he commented that "this group of works offers a fresh surprise for those who seek to understand the painter. They show the formidable artist who etched the *Disasters of War* and painted the Quinta [del Sordo] in an unexpected light. He turns gentle and tender, precious and refined, and the detailed, finicky, almost loving handling is not unlike that of Fragonard. His choice of subjects recalls those of Watteau, Lancret, and the painters of 'gallant' themes from the previous century."[5] Yriarte quoted from Goya's letter to his friend Zapater, already mentioned,[6] and described the present painting as "the most astonishing work in this whole collection . . . the most remarkable of all his paintings."[7]

When Yriarte arrived in Spain with his artist colleagues Léopold Tabar and Étienne Bocourt, it was Tabar who copied *The Meadow of San Isidro* for reproduction in his book. Yriarte hoped that the full-page wood engraving would evoke something of "the *effect* of the picture, its sense of movement and of the innumerable throngs that . . . disport themselves on the banks of the Manzanares."[8] Manet, who failed to visit La Alameda on his trip to Madrid in 1865, would later have seen this magical work in the greatly reduced reproduction that nevertheless succeeds in giving a hint of the brilliance and atmospheric subtlety of Goya's original painting. JW-B

1. ". . . [A] mas de esto, ser los asumptos tan dificiles y de tanto que hacer, como la Pradera de San Ysidro, en el mismo dia del Santo, con todo el bullicio que en esta Corte, acostumbra haver. . . ." Letter dated May 31, 1788, in Goya 1982, p. 182, no. 104. I am grateful to Sarah Symmons, editor of a forthcoming edition of Goya's letters in a translation by Philip Troutman, for her help with this and other translations.
2. For this series, see Gassier and Wilson 1971, nos. 272–76; Madrid–London–Chicago 1993–94, pp. 172–83, 352–54, nos. 25–29. For the projected hang of the tapestries, see the reconstruction by José Luis Sancho in Madrid 1996c, pp. 163, 172–73.
3. Yriarte 1867, pp. 139, 141–45, listed twenty-two genre paintings at La Alameda as well as five portraits in the Osuna palace in Madrid; the Osuna sale (nos. 63–91) included all these works together with one incorrectly attributed portrait and a painting in the style of Goya. For the other Alameda pictures, see Gassier and Wilson 1971, nos. 248–54 (large decorative paintings), nos. 659–64; Madrid–London–Chicago 1993–94, pp. 211–25, 358–59, nos. 44–49 (witchcraft subjects).
4. "*el Capricho*, propriété située à neuf kilomètres de Madrid, entre Barajas et Castillejos"; "notre grand Trianon de Versailles." Yriarte 1867, p. 83.
5. "La collection de ces oeuvres réserve une nouvelle surprise à ceux qui veulent suivre le peintre. Elle montre le terrible artiste qui a pu graver les *Désastres de la guerre* et peindre la Quinta sous un aspect inattendu. Il devient doux et tendre, précieux et raffiné, et son exécution serrée, léchée, presque amoureuse, rappelle un peu celle de Fragonard. Le choix des sujets fait songer à Watteau, à Lancret et à tous les gallants peintres du siècle dernier." Ibid., p. 84.
6. For Goya's letter, see n. 1 above. Yriarte (1867, p. 85) referred mistakenly to the letter as "kindly communicated by his son" ("obligeamment communiquée par son fils"). Martín Zapater died a childless bachelor in 1803; in 1868 his nephew published an abridged version of Goya's letters to Zapater, together with a biography that sought to redress the romanticized image of the artist as a freethinker and womanizer. See Zapater y Gómez 1868.
7. "L'oeuvre la plus étonnante de toute cette collection . . . la plus curieuse de toute l'oeuvre peinte." Yriarte 1867, p. 85.
8. "la *sensation* du tableau par ce mouvement et cette foule innombrable qui vient . . . s'ébattre au bord du Manzanarès." Ibid. Tabar's drawn or painted interpretation of the picture (unlocated) was copied onto a woodblock by Edmond Morin (1824–1882) and engraved by Henry Linton (1815–1899).

5.

Francisco de Goya y Lucientes
(with later rework)
A Picador

Ca. 1792(?); reworked ca. 1808
Oil on canvas

Fig. 2.12

22 x 18½ in. (57 x 47 cm)
Museo Nacional del Prado, Madrid P 744

CATALOGUES RAISONNÉS: Gudiol 1970, no. 252 [1980, no. 245]; Gassier and Wilson 1971, no. 255; De Angelis 1974, no. 312

PROVENANCE: Palacio Real, Madrid, before 1819; deposited in the Museo del Prado, August 1819

EXHIBITIONS: Madrid–London–Chicago 1993–94, no. 60 (Madrid ed.); Madrid 1996b, no. 79 (citing earlier references); Paris 2002–3, no. 3

REFERENCES
19th century: Yriarte 1867, p. 130 (as *Un Picador à cheval*)

20th century (selected references): M. Madrazo 1945, p. 251, no. 75; Mercedes Águeda, "Los retratos ecuestres de Goya," in García de la Rasilla and Calvo Serraller 1987, pp. 45–48; Alfonso E. Pérez Sanchez, "Goya en el Prado," in ibid., p. 308; Madrid–London–Chicago 1993–94, pp. 251–52 (Madrid ed.); Moreno de las Heras 1997, p. 174

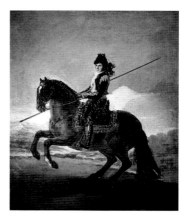

When the Real Museo del Prado was inaugurated in 1819, the catalogue listed twenty-one works in the gallery devoted to contemporary artists. Among them were Goya's splendid lifesize equestrian portraits—much influenced by Velázquez—of Charles IV and Queen María Luisa, the parents of the reigning monarch, Ferdinand VII. In 1821, this small painting of a picador joined them in the gallery, and until 1872, these three pictures were the only works by Goya listed in the Prado catalogues. Other works were nevertheless to be seen. From 1834, *The Family of Charles IV* (fig. 1.55), Goya's response to Velázquez's *Las Meninas* (fig. 4.13), hung in a private royal salon (to which visitors could obtain access), and by the 1860s, the great history paintings *The Second of May 1808* and *The Third of May 1808* (figs. 1.17, 1.18) were displayed, at first in the corridors and then with the modern collection at the entrance to the grand central gallery.

It seems, at first sight, very surprising that *A Picador*, a small and unpretentious image, should have entered the museum from the royal collections at such an early date. However, radiography has recently solved the mystery.[1] Beneath the picador lies an equestrian portrait of the young Don Manuel Godoy, the queen's favorite, who also captured the

affections of King Charles IV and became the most powerful person in the land. The little painting could have been a *modello* for a lifesize portrait, perhaps commissioned by the queen,[2] who would have kept the small canvas for her personal enjoyment or received it as a gift from Godoy. In 1808, when Napoleon Bonaparte intervened in Spain's affairs, Godoy was almost lynched in a popular uprising, the notorious revolt known as the Motín de Aranjuez. A large portrait may have been destroyed at this time, along with other images of the hated favorite. This small sketch or replica would have been overpainted—the work is clumsily done and is certainly not by Goya's hand—to transform the portrait of Godoy into an inoffensive picador and thus save it from destruction.

Contemporary critics must have been perplexed by the informal aspect of the little picture. Charles Yriarte suggested that it was a sketch for one of the decorative paintings[3] that adorned the home of the Osunas, who acquired many works by Goya for their country property, La Alameda, which was not far from Madrid. By a strange twist of circumstance, *A Picador*—one of the earliest Goyas to enter the Prado—turns out to be, perhaps, the first deliberate "fake" Goya in existence. It is a remarkable historic item that throws light on Goya's relationship with his times and with the history of the Museo del Prado itself.[4]

JW-B

1. Águeda in García de la Rasilla ad Calvo Serraller 1987, pp. 45–48. The X-ray is also reproduced in Madrid–London–Chicago 1993–94, p. 252, and in Rose-De Viejo et al. 2001, p. 136.

2. Another canvas of similar dimensions shows Godoy on horseback, facing in the opposite direction (Gassier and Wilson 1971, no. 344; Madrid–London–Chicago 1993–94, pp. 254–55, 363, no. 61).

3. *Apartado de toros (Sorting the Bulls);* Gassier and Wilson 1971, no. 254 (this large canvas disappeared during World War II). Yriarte 1867, p. 130, described *A Picador* as a "pretty sketch of one of the figures of the *Arroyo*, which can be seen at the Alameda" ("jolie esquisse d'une des figures de l'*Arroyo*, qui se voit à l'Alameda").

4. At the time of the Madrid–London–Chicago 1993–94 exhibition, there was discussion as to whether an attempt should be made to recover Goya's original portrait. Since the work in its present form has been part of the Prado from its earliest years, it was decided to leave the picture untouched.

6.

Fig. 5.8

Francisco de Goya y Lucientes
*Presumed Portrait of Asensio Juliá
(Su Amigo Asensi)*

Ca. 1798
Oil on canvas
21½ x 16⅛ in. (54.5 x 41 cm)
Signed and dedicated lower left: *Goya a su /Amigo Asensi*
Museo Thyssen-Bornemisza, Madrid 1971.1

CATALOGUES RAISONNÉS: Gudiol 1970, no. 378 [1980, no. 359]; Gassier and Wilson 1971, no. 682; De Angelis 1974, no. 345

PROVENANCE: Queen María Cristina, Carabanchel (Madrid), Old Palace of Vista Alegre, before 1846; Isabel II and the Infanta Luisa Fernanda, Vista Alegre, 1846 (by gift); duc and duchesse de Montpensier, Vista Alegre, 1858, then Seville, Palace of San Telmo, 1859–92, then duchesse de Montpensier, 1892–97; Prince Antoine d'Orléans, Sanlúcar de Barrameda, 1897–1911; Durand-Ruel, Paris, purchased January 27, 1911; Durand-Ruel, New York, purchased October 17, 1912; Arthur Sachs, Paris, purchased April 6, 1923; sale, Sotheby's, London, March 24, 1971, no. 17, sold for 170,000 pounds to Ovsievski; Villa Favorita, Lugano, Collection Thyssen-Bornemisza; Museo Thyssen-Bornemisza, Madrid, 1992

EXHIBITIONS: Madrid–London–Chicago 1993–94, no. 66 (with earlier references); Indianapolis–New York 1996–97, no. 51 (not exhibited); Lille–Philadelphia 1998–99, no. 30 (Lille ed.), repr. p. 47 (Philadelphia ed.); Paris 2002–3, no. 9

REFERENCES
19th century: Montpensier 1866, no. 263 (as *Retrato de Asensi*); Yriarte 1867, pp. 77 (reproduced *hors texte*), 146

20th century (selected references): Gaya Nuño 1958, p. 166, no. 960; Baticle and Marinas 1981, pp. 89–90, no. 108; Matilla Tascón 1982, pp. 283–348; Gil 1986; Gil 1990, pp. 61–63, 117, Appendix 1; Madrid–London–Chicago 1993–94, pp. 264–65 (Madrid ed.); Rivas Ramírez 1999

This small canvas made its first known appearance in April 1846 in an inventory drawn up by Vicente López of pictures in the Old Palace on the royal domain known as Vista Alegre, at Carabanchel near Madrid.[1] The property had been acquired in 1832 by Queen María Cristina, who set about to embellish it and fill its various palaces and houses with works of art. In 1846 the queen gave the property to her two daughters, and in 1858 Vista Alegre became the exclusive property of the younger sister, the Infanta Luisa Fernanda, and her husband, Prince Antoine d'Orléans, the duc and duchesse de Montpensier. The following year, Vista Alegre was sold to the businessman Don José de Salamanca, and the Montpensiers took themselves and their art collection to the Palace of San Telmo in Seville. Goya's painting appears in the catalogue of the San Telmo

picture gallery that was published in 1866. One year later, it was described by Charles Yriarte in his major monograph on Goya and illustrated by a full-page wood engraving, based on a drawing made "from a photograph that His Highness the duc de Montpensier was kind enough to have made for the purpose."[2] In the text and in Yriarte's catalogue at the end of the volume, the picture is entitled *Portrait of Asensi*. Yriarte said of it that it was "possibly the only [work] the origin of which is unknown; the Asensi to whom Goya dedicated the work is unidentified." The reference in the catalogue ends with this note: "N.B. The last two canvases [this portrait and *Manolas on a Balcony*] . . . come from the gallery of the late king Louis-Philippe."[3]

If, as indicated by Yriarte and repeated in all subsequent catalogues, this picture formed part of the Galerie Espagnole in the Louvre, it can only have been the work catalogued as no. 108, *Le portrait de Goya*.[4] In the catalogue of the Louis-Philippe sale at Christie & Manson in 1853, the same work appeared as lot 446 with the title *GOYA. Portrait of himself*. While the picture *Manolas* [or *Majas*] *on a Balcony* was acquired on behalf of the duc de Montpensier or sold to him soon afterward by Colnaghi, it was Durlacher who acquired the portrait, together with four other pictures in the sale.[5] It had escaped notice until now that these five works passed into the collection of Sir Henry Bulwer, the future Lord Dalling and Bulwer, and reappeared in the sale of his estate in 1873.[6] In the Dalling and Bulwer sale, lot 51 is a "Portrait of the artist. *From the Collection of King Louis Philippe.*" This must be identical with *Le portrait de Goya* from the Galerie Espagnole that was sold at Christie & Manson in 1853. Since this self-portrait—which has still to be identified—was in the Bulwer collection from 1853 or shortly afterward, it cannot be the portrait of Asensi that was at Vista Alegre and then in Seville between 1846 and 1866.[7]

It is the erroneous note in Yriarte's catalogue that has led to so much confusion.[8] In his description of the painting, the critic speculated on the identity of the figure and indulged his romantic theories: "Who might this Asensi be, whom the artist shows in working garb in a vast studio, perhaps a cathedral or a chapel in which scaffolding has been erected for the painting of frescoes? At the figure's feet are brushes and a bowl of colors; . . . this is a portrait of an artist; the fine head and abundant, carelessly tended locks that reveal an intelligent brow proclaim a man given over to artistic concepts; even the originality of his dress supports this idea; finally . . . the model is wounded, his left hand lies in some sort of apparatus that is held by a ribbon around his neck."[9] Having speculated on the significance of the scaffolding, Yriarte wondered whether one should conclude that "a fall at work had forced the artist to remain idle, and that Goya took advantage of this to paint him *on site*, as they say in architectural parlance."[10] The reproduction follows Yriarte's hypothesis by showing Asensi's hand as if bandaged and supported by a ribbon that is, in fact, nothing more than the blue satin border of the robe he is wearing. The scaffolding has led to the belief that the site is the hermitage of San Antonio de la Florida and that

Asensio Juliá assisted Goya with his fresco decorations there in the summer of 1798.

After further inconclusive musings concerning the possible identification with Asensio Juliá or even Goya himself, Yriarte turned with relief to the quality of the work: "It is one of Goya's finest achievements. The canvas is exquisitely delicate and, in spite of its small format, is as broadly painted as his large-scale works."[11] Asensio Juliá died in October 1832 and if this little canvas does indeed represent him, it is possible that it was acquired by Vicente López for Queen María Cristina[12] between 1832 and 1840, when the rise of Baldomero Espartero led to her departure for France. While the later history of this small portrait is now clear, its origin and the identity of the sitter,[13] as well as the identification of the portrait that formed part of the Galerie Espagnole, remain an enigma.

JW-B

1. In the inventory of 1846, the picture was located in Room 34 of the Old Palace—"De las escribanías" (offices)—and identified as "*Goya: Retrato de Asensi, en cuerpo entero* (6.000 rs.)." See Matilla Tascón 1982, p. 320. The amended provenance of this picture owes much to Gudrun Maurer, who kindly checked many inventory and catalogue references in Madrid.

2. "d'après une photographie que S.A. le duc de Montpensier a bien voulu faire exécuter pour notre usage." Yriarte 1867, p. 77. The photograph was probably the same as the one that appears with those of other works in the Montpensier picture gallery in the catalogues of photographs published by J. Laurent from 1872. No print has yet been made in modern times from the original glass negative (Archivo Ruiz Vernacci–J. Laurent, Instituto del Patrimonio Histórico Español, Madrid; former inventory no. A-1017, current no. 8131). Ana María Gutiérrez, curator of the Ruiz Vernacci archive, kindly provided information about this and other works by Goya reproduced in Laurent's photographs.

3. "peut-être la seule dont nous ne connaissons pas l'origine; nous ignorons jusqu'à la personnalité de cet Asensi, auquel Goya dédie cette œuvre." Yriarte 1867, p. 77. The note in the catalogue reads: "N.B. Ces deux dernières toiles [this portrait and *Les Manolas au balcon*] . . . proviennent de la galerie du feu roi Louis-Philippe."

4. Paris 1838, 4th ed., no. 108 (1st to 3d eds., no. 104). See Baticle and Marinas 1981, pp. 89–90, no. 108.

5. Purchased by Durlacher at the Louis-Philippe sale, 1853: nos. 169, "Old Women" (*Old Women [Time]*, fig. 1.33); 353, "Women of Madrid dressed as Majas" (private collection; see cat. 14); 375, "An Interment" (possibly Musée de Grenoble, as Eugenio Lucas Velázquez; see Gerard-Powell 2000, pp. 76–77, no. 7); 445, "Portrait of Charles III" (to be identified among several versions cited in Baticle and Marinas 1981, p. 273; see Gassier and Wilson 1971, no. 230n.). I am grateful to Francis Russell and Jeremy Rex-Parkes for their generous help in consulting the annotated catalogues of the sales cited here and at n. 6 in the Christie's archives.

6. Dalling-Bulwer 1873 (see cat. 11). While the Dalling and Bulwer provenance for the Goyas escaped notice in Baticle and Marinas 1981, the sale catalogue is cited (p. 127) for no. 176, the "Murillo" of Saint Bonaventure (lot 65, not 75 as indicated; Yale University Art Gallery, New Haven). For biographical information regarding Bullwer, see cat. 11, n. 2.

7. The "Portrait of the artist" in the Dalling and Bulwer sale was bought by Polak for ten guineas. Its subsequent history and present location are unknown.

8. The catalogue of the Montpensier collection, published in 1866, the year before Yriarte's monograph, notes a provenance from the Galerie Espagnole only for Goya's *Manolas*

asomadas á un balcon, p. 58, no. 255 (Gassier and Wilson 1971, no. 959).

9. "Qui pouvait être cet Asensi que l'artiste a représenté en tenue de travail dans un vaste atelier, peut-être une cathédrale ou une chapelle dans laquelle on a dressé des échafaudages pour l'exécution des fresques? Au pied du personnage on voit des pinceaux et une jatte de couleurs; . . . c'est un portrait d'artiste; la tête fine et le ton négligé de ces grands cheveux qui découvrent un front intelligent caractérisent un homme voué aux conceptions artistiques; le costume lui-même est assez original pour nous confirmer dans cette idée; enfin . . . le modèle est blessé, sa main gauche repose dans un appareil que retient un ruban passé autour du cou." Yriarte 1867, p. 77.

10. "une chute faite pendant le travail a condamné l'artiste au repos, et que Goya en a profité pour le peindre *sur le tas*, comme on dit en architecture." Ibid.

11. "Goya a rarement fait mieux. La toile est d'une finesse exquise, et, malgré sa petite dimension, aussi largement peinte que les grandes oeuvres de l'artiste." Ibid.

12. For Vicente López's early role in the formation of the queen regent's collection at Vista Alegre, see Rivas Ramírez 1999, p. 53.

13. For an outline of the personality and oeuvre of Asensi Julià, the Valencian form of the artist's name (1767–1832), see Gil 1990.

7. *Fig. 2.38*

Francisco de Goya y Lucientes
The Cannibals

Ca. 1800–1808
Oil on panel
12⅞ x 18½ in. (32.7 x 47 cm)
Musée des Beaux-Arts et d'Archéologie, Besançon
896.1.177

CATALOGUES RAISONNÉS: Gudiol 1970, no. 476 [1980, no. 592]; Gassier and Wilson 1971, no. 923; De Angelis 1974, no. 409

PROVENANCE: Jean Gigoux, Paris, by 1867; his bequest to the Musée des Beaux-Arts et d'Archéologie, Besançon, 1896

EXHIBITIONS: Madrid– London–Chicago 1993–94, no. 83; Lille–Philadelphia 1998–99, no. 39 (Lille ed., citing earlier references), p. 55 (Philadelphia ed.); Paris 2002–3, no. 16

REFERENCES
19th century: Yriarte 1867, p. 151

20th century (selected references): Gaya Nuño 1958, p. 178, no. 1084; Madrid–London–Chicago 1993–94, pp. 288–89 (Madrid ed.); Lille–Philadelphia 1998–99, pp. 202–3 (Lille ed.)

In the catalogue that completes Charles Yriarte's 1867 monograph on Goya, four works are listed in the collection of Jean Gigoux in Paris. Two are identifiable as the panel under discussion and its pendant; the other two belong to a group of four small paintings on tinplate (see cats. 17, 18). All six works were bequeathed by Gigoux to the museum in Besançon. The origin of the titles for the two panels in Yriarte's catalogue—*L'Archevêque de Québec* (The Archbishop of Quebec) for the disemboweling of a murdered victim, and *J'en ai mangé* (I have eaten some of it) for this picture of cannibals displaying human body parts—is unknown.

On the basis of Yriarte's titles, attempts have been made to establish a real-life context: first by identifying the archbishop in question (an attempt that failed because of the dates and the death by natural causes of the suggested candidate), and then by focusing on the equally historic but much more distant deaths of two French missionaries at the hands of Iroquois Indians in the seventeenth century.[1] Nowadays, this pair of images is seen as an allegory in the same vein as the prints in Goya's *Caprichos* or *Disasters of War* series. In them, the artist appears to stigmatize violence and primitive superstitions. At the same time, these paintings, perhaps produced at a time of political unrest and civil disorder, provide food for thought: they lead the spectator to wonder whether these savages, involved in their customary, savage practices, are not—as Goya puts it in the title of one of his drawings—"Less savage than some," with reference to those who commit atrocities in so-called civilized society.[2]

The date of execution of these works remains difficult to determine. The delicacy and generally light tonality of the paint and the slim build and supple movements of the figures suggest a time not far removed from that of the *Caprichos* prints. In the series of drawings that Goya titled *Dreams*, on which many of the witchcraft scenes in *Los Caprichos* are based (cat. 31), *Dream 7*, the basis for plate 69 (cat. 32), shows an infernal "kitchen" in which all appetites will be satisfied, and in *Dream 25*, a human head is brought in on a platter to be served up to greedy monks who feed on their fellow men.[3] At the same time, the subjects anticipate some of the most horrific scenes in *The Disasters of War*, in which men mutilate their victims and display their dismembered corpses (plates 31 to 39; see cats. 35, 36).

Nothing is known about the origin of the pictures owned by Jean Gigoux (1806–1894). He was a painter and lithographer who exhibited at the Salon from 1831. At the 1833 Salon, he showed a lithograph, no. 2877, titled *Portraits of Messrs. Delaroche and Delacroix*, which situates him in the circle of Delacroix and thus of those who were interested in Goya's work.[4] Gigoux probably acquired his six pictures—two masterpieces and four pastiches—thanks to the close connections between French artists and collectors and such Spanish counterparts as Valentín Carderera and Federico de Madrazo, who succeeded his father, José de Madrazo, as director of the Museo del Prado. The correspondence of the young Federico with his father reveals that he had dealings with Gigoux in Paris in 1838–39.[5] Later on, both the younger Madrazo and his colleague

Carderera were involved in marketing works from Mariano Goya's very mixed and partly spurious "inheritance," following the death of his father, Javier, in 1854. These strange scenes of cannibalism in an artist's collection in Paris would have reinforced the notion of Goya's supposed fascination with horror, but their light touch and technical mastery would have belied the popular vision of his manner of painting, as propagated by Théophile Gautier and by anecdotes in the Goya literature.

JW-B

1. Paris 1963b,, no. 121.
2. Album C, p. 2, *Salvage menos q.e otros:* Gassier and Wilson 1971, no. 1245; Gassier 1973, pp. 230, 355, no. 152.
3. *7. Sueño de Brujas consumadas* (No. 7. Dream of consummate witches) and *25. Sueño. De unos hombres q.ᵉ se nos comian* (No. 25. Dream. Of some men that they were eating us): Gassier and Wilson 1971, nos. 477, 590; Gassier 1975, p. 83, no. 46, p. 94, no. 57.
4. I am grateful to Ghislaine Courtet for information on Gigoux's paintings at Besançon, and to Geneviève Lacambre for drawing my attention to the connection with Delacroix.
5. Gigoux's name appears several times in Federico's letters to his father in 1838 and 1839, as someone who had given advice to the young artist on his Salon pictures and made recommendations for wood engravers. See F. Madrazo 1994, vol. 1, letters 31, 68, 71, 73.

8. *(New York only)* *Fig. 14.73*

Francisco de Goya y Lucientes
Still Life with Golden Bream

Ca. 1808–12
Oil on canvas
17⅜ x 24¼ in. (44.1 x 61.6 cm)
Signed, almost vertically, across lower right foreground: *Goya;* inscribed with 1812 inventory mark, in white paint, at lower right: *X.11*
Museum of Fine Arts, Houston, Museum purchase with funds provided by the Alice Pratt Brown Museum Fund and the Brown Foundation Accession Endowment Fund 94.245

CATALOGUES RAISONNÉS: Gudiol 1970, no. 592 [1980, no. 545]; Gassier and Wilson 1971, no. 907; De Angelis 1974, no. 519

PROVENANCE: Javier de Goya y Bayeu, Madrid, 1812 (by inheritance shared with the artist); Francisco Javier de Mariátegui, Madrid, before 1845; María de la Concepción Mariátegui, 1845 (by inheritance), and her husband, Mariano Goya, Madrid; Francisco Antonio Narváez y Bordese, conde de Yumuri, Carabanchel Alto (Madrid),

August 1, 1851 (by forfeiture against a loan); Francisco Antonio Narváez y Larrinaga, conde de Yumuri, Carabanchel Alto (Madrid), 1865 (by inheritance, as *vesugos* ["golden bream"] in the inventory); Zacharie Astruc, Paris, by 1878 (bought in Madrid, 1875?); his sale, Hôtel Drouot, Paris, April 11–12, 1878, no. 35, bought for 165 francs by A. Thévenot; Mme Thévenot, Paris; bought via Hector Brame by David David-Weill, Paris, April 16, 1926; private collection, Paris, 1975 (by descent); bought by the Museum of Fine Arts, Houston, 1994

EXHIBITIONS: The Hague–Paris 1970, no. 36; London 1995, no. 66; Lille–Philadelphia 1998–99, no. 47 (Lille ed., citing earlier references)

SELECTED REFERENCES: Gaya Nuño 1958, p. 182, no. 1130; Rose-De Viejo 1997, p. 406; Vischer 1997, pp. 121–23; Bodo Vischer, "Les natures mortes de Goya: Histoire d'un ensemble," in Lille–Philadelphia 1998–99, pp. 76–82, 212–24 (Lille ed.)

Goya seems to have engaged only once with the painting of *bodegones,* as the genre of still life is known in Spain. His early biographer Laurent Matheron spun a romantic tale of such works being painted in Bordeaux from items selected by the elderly artist in the marketplace and sketched in a trice, between two cigarettes.[1] However, it is now clear that the only securely attributable works of this kind belong to a single set of twelve canvases, of which ten are extant. First mentioned in an inventory dated October 26, 1812, these were no doubt executed during the period of the war of independence, between 1808 and the death of Goya's wife in June 1812.[2] The identification of these paintings, which are widely scattered and cover a surprising range of artistic styles, has been facilitated by three factors: their uniform technical characteristics, the presence or traces on two canvases of the 1812 inventory number (X.11), and a later inventory of September 22, 1865, that describes their subject matter.[3]

The pictures range from a traditional display of fruit, bottles, a barrel, and other items on a tabletop, treated with straightforward, unforced naturalism, to the dramatic presentation of three raw salmon steaks against a dark background (both works are in the Oskar Reinhart Collection, "Am Römerholz," Winterthur). Several of the paintings have Goya's signature worked into the composition in a fanciful way: inscribed vertically on the label of a bottle in the composition in Winterthur, almost invisibly placed over a little pool of blood beneath the sheep's head in another (Musée du Louvre, Paris), or added in broad, brushy "writing" that is softly integrated into the foreground or background in works such as this pile of *besugos* (golden bream, so named in the 1865 inventory), where Goya's signature seems almost to emerge from the mouth of one of the fish.

The dramatic nature of this painting suggests that it was one of the last in the series. The dead or dying creatures lie as if flung on the shore by a great wave, as the diagonal streak of white across the dark background has been construed. The pile of fish resembles the piles of corpses in Goya's *Disasters of War,* particularly in the earlier etchings, some of them dated 1810, or the famine scenes of 1811–12.

The progression in intensity of expression from one image to the next in Goya's still-life paintings suggests that they took on symbolic meaning for him as he worked. Probably conceived as a decorative series for a dining room, the series became a meditation on life and death, on innocent victims and the brutal hand of man, set against the background of the grim events of the time.

The twelve paintings passed from one collection to another but remained together until a final inventory records them all for the last time in Spain in 1866.[4] After that date, they were gradually dispersed among various owners and all trace was lost of two of them. Eight found their way to Paris, no doubt as a single group. Of four that passed through sales of the collection of the comte de Terbecq in 1877 and again in 1882, one finally reached the Louvre in 1937.[5] The present work was acquired by Manet's friend and colleague Zacharie Astruc and appeared in the sale of part of his collection in Paris in 1878.[6] It is an impressive example of a genre that Goya appears to have practiced only once but which he transformed through the power of his invention. Drawing on the profoundly Spanish tradition seen in the *bodegones* of Sánchez Cotán and Zurbarán, in which the mystical element plays a large role, Goya anticipates the still-life paintings of such artists as Delacroix, Courbet, and Ribot, whose realism is often tinged with a strong sense of allegory.

JW-B

1. Matheron 1996, pp. 256, 258.
2. See Gassier and Wilson 1971, p. 381, Appendix I, no. 11.
3. The paintings are all on the same type and size of linen canvas, prepared with a light orange-beige ground left uncovered around the edges. See Vischer in Lille–Philadelphia 1998–99, pp. 76–82 (Lille ed.). For the later inventory, see also Glendinning 1994, p. 107.
4. Their last mention in the Yumuri inventory, completed July 30, 1866 (see Vischer in Lille–Philadelphia 1998–99, pp. 76–82 [Lille ed.]).
5. See Rose-De Viejo 1997, p. 406; Vischer in Lille–Philadelphia 1998–99, p. 81 (Lille ed.).
6. The Astruc sale also included, as lots 32–34, versions of two of the small pictures of "children's games" attributed to Goya, *Enfants jouant au moine* and *Enfants jouant au soldat* (see Gassier and Wilson 1971, nos. 154, 155), and a very far-fetched *Petite-fille de l'auteur* ("The artist's granddaughter"—Goya's only grandchild was a boy, Mariano). Astruc's correspondence indicates that, like many artists, he served as an agent for dealers and collectors, and was in Madrid in Sepember 1875, hoping to make profitable business deals. I am indebted to Bodo Vischer, who has generously shared much unpublished information concerning Goya's still-life paintings.

9. *(New York only)* *Fig. 5.10*

Francisco de Goya y Lucientes
General Nicolas Guye

March–September 1810
Oil on canvas
41¼ x 33⅜ in. (106 x 84.7 cm)
Inscribed on verso (before relining): *Sʳ Dʳ Nicolas Guye, Marquis de Rio-Milanos, Général Aide de Camp de S. M. Catholique. Membre de la Légion d'Honneur de l'Empire Français, Commandeur de*

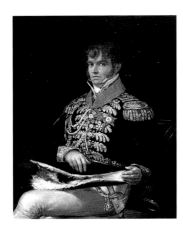

l'Ordre des Deux-Siciles et Commandeur de l'Ordre Royal d'Espagne, etc. Né à Lons-le-Saunier (Jura) le 1er mai 1773. Donné à Vincent Guye, son frère. A Madrid, le 1er octobre 1810 [and] *Pintado por Goya* (see Beruete 1913)
Virginia Museum of Fine Arts, Richmond, Gift of John Lee Pratt 71.26

CATALOGUES RAISONNÉS: Gudiol 1970, no. 553 [1980, no. 518]; Gassier and Wilson 1971, no. 883; De Angelis 1974, no. 510

PROVENANCE: Vincent Guye, Madrid, then France (Jura); Guye family, Saint Dié; Trotti & Cie, Paris, by 1913; M. Knoedler & Co., Paris, London, New York, by 1915; bought for 36,000 dollars (with *Victor Guye,* see cat. 10) by Mr. and Mrs. J. Horace Harding, New York, 1916; sold by Mrs. J. Horace Harding (after her husband's death in 1929); Mr. and Mrs. Marshall Field, New York; bought by Heinemann, and Knoedler; E. V. Thaw, New York, 1970; bought for 1,200,000 dollars by John Lee Pratt, New York, 1971; his gift to the Virginia Museum of Fine Arts, Richmond, 1971

EXHIBITIONS: New York 1915, no. 24; New York 1955, no. 185 (Marshall Field coll.)

REFERENCES
19th century: Bardy 1898–99

20th century (selected references): Beruete 1913, pp. [1]–4, repr.; Hosotte 1927; Desparmet Fitz-Gerald 1928–50, vol. 2, no. 550s; Gaya Nuño 1958, p. 175, no. 1060; Trapier 1964, pp. 35–37; Muller 1971, pp. 29, 51, repr.; Lipschutz 1972, p. 12; Gassier 1981, p. 249, fig. 4; J. Brown and Mann 1990, pp. 19–21, repr. (citing earlier references); Ceballos-Escalera y Gila 1997, p. 82

Goya's portraits from 1805 to 1810 reflect a troubled period in Spain's history and the artist's response to the consequent challenges to his career. From 1805 to 1807 Goya painted a series of family portraits, as well as a variety of aristocratic and bourgeois patrons, including the *Marquesa de Santa Cruz* (Museo del Prado, Madrid) as a reclining muse in 1805 and *Tadeo Bravo de Rivero* (Brooklyn Museum of Art), a portrait of his liberal Peruvian friend, the following year. In March 1808, shortly after the overthrow of Godoy and the abdication of Charles IV, the Real Academia de Bellas Artes de San Fernando

commissioned Goya to paint an equestrian portrait of the new king, Ferdinand VII, for which the artist was granted two brief sittings. Ferdinand soon retired to France, where the crown of Spain was handed to Napoleon, who installed his brother Joseph on the throne. Bravo de Rivero, an *afrancesado* (pro-French) supporter of Joseph and from 1809 a municipal councilor, commissioned for the town hall of Madrid the large allegorical painting by Goya that originally included a likeness, based on an engraving, of the intruder King Joseph (Museo Municipal, Madrid). Goya refused to draw his salary as court painter under Joseph but continued to work privately as a portraitist, painting with equal professional commitment members of his own family; *afrancesados* like Bravo de Rivero; Juan Antonio Llorente, the historian of the Inquisition; José Manuel Romero, minister of justice and of the interior under Joseph; and the French general Nicolas Philippe Guye.[1]

Nicolas Guye was born at Lons-le-Saunier in the Jura region of France on May 1, 1773, and enlisted as a soldier in 1792. As a military man with a distinguished career in the service of Napoleon, he arrived in Spain as adjutant to King Joseph with the rank of lieutenant colonel. On January 20, 1809, he was made a Commander of the Royal Order of Spain, an order—mockingly referred to by Spanish patriots as *la berenjena* (the eggplant)—recently instituted by Joseph. The decoration hangs from the broad red ribbon around Guye's neck, and another, larger one is pinned on his chest;[2] the blue decoration and its pendant are those of Commander of the Royal Order of the Two Sicilies (the kingdom of Naples), also one of Joseph's orders, bestowed on Guye in 1808. In 1810, the year of this portrait, Nicolas Guye was appointed field marshal and chevalier of the Legion of Honor (the white-and-gold decoration on his chest); by royal decree dated February 10 he was created marqués de Río Milanos. It was no doubt between the latter date and October 1, when the gift of the portrait to his brother Vincent was recorded on the back of the canvas, that Marshal Guye sat for Goya wearing full regalia, with both hands prominently displayed—an indication of a prestigious and expensive portrait. A year later, Nicolas Guye replaced General Léopold Hugo, his exact contemporary and the father of Victor Hugo, as commander of the French troops fighting the Spanish guerrilla forces led by Juan Martín Díaz, nicknamed El Empecinado (the Unyielding), in the provinces to the north of Madrid.[3]

Goya's portrayal of Guye combines the paraphernalia of rank and honors with a lively response to the personality of the sitter. Although the artist was probably already working on his etchings of "the fatal consequences of the bloody war in Spain against Bonaparte" (cats. 33–37) at the time of this commission, the French military commander—who in 1811 determined to become a Spanish citizen—was rewarded in this commission and that of his young nephew (cat. 10) by a sympathetic response from Goya.[4]

JW-B

1. See the portraits catalogued under Gassier and Wilson 1971, nos. 881–87.

2. Along with other palace officials who were obliged to swear allegiance to Joseph in March 1811, Goya was awarded the Royal Order of Spain but never wore it.

3. A portrait of El Empecinado (featuring inaccurately depicted military uniform) has been attributed to Goya by various authors.

4. Apart from the references cited, thanks are due to Malcolm Cormack, at the Virginia Museum of Fine Arts, and to Jesús María Alía Plana, at the Museo Naval, Madrid, for information concerning the painting and the sitter. The latter kindly provided material from his doctoral thesis, "Imágenes y textos para el estudio de la iconografía del uniforme militar español en el Arte de la Ilustración," Universidad Nacional de Educación a Distancia, 1995.

Copies of both Guye portraits, probably those mentioned by Hosotte (1927), but not known to Muller (1971, p. 51), have come to light recently from two different sources.

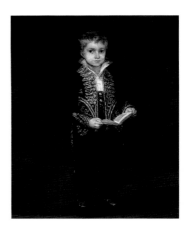

10. *(New York only)* *Fig. 5.11*

Francisco de Goya y Lucientes
Victor Guye

1810(?)
Oil on canvas
40¾ x 33¼ in. (103.5 x 84.5 cm)
Inscribed on verso (before relining): *Ce Portrait de mon Fils a été peint par Goya pour faire le pendant de celui de mon Frère le Général. V Guye.* (This portrait of my son was painted by Goya as a pendant to that of my brother the General. V Guye.)
National Gallery of Art, Washington, D.C., Gift of William Nelson Cromwell 1956.11.1

CATALOGUES RAISONNÉS: Gudiol 1970, no. 554 [1980, no. 519]; Gassier and Wilson 1971, no. 884; De Angelis 1974, no. 511

PROVENANCE: Vincent Guye, Madrid, then France (Jura); Guye family, Saint Dié; Trotti & Cie, Paris, by 1913; M. Knoedler & Co., Paris, London, New York, by 1915; bought for 50,000 dollars (with *General Nicolas Guye,* see cat. 9) by Mr. and Mrs. J. Horace Harding, New York, 1916; Mrs. J. Horace Harding, 1929–41; Harding estate sale, Parke-Bernet, New York, March 1, 1941, 36, no. 59, to Charles B. Harding, Catherine Tailer, and Laura Harding; purchased for the National Gallery of Art, Washington, D.C., 1957 (with funds from the bequest of William Nelson Cromwell)

EXHIBITIONS: New York 1915, no. 25; New York 1928, no. 16; [see J. Brown and Mann 1990, pp. 19–20, for further exhibitions]

REFERENCES

19th century: Bardy 1898–99, p. 132

20th century (selected references): Beruete 1913; Hosotte 1927, p. 67; Desparmet Fitz-Gerald 1928–50, vol. 2, no. 551s; Gaya Nuño 1958, p. 178, no. 1059; Muller 1971, pp. 29, 51; Lipschutz 1972, p. 12; Gassier 1981, p. 249; J. Brown and Mann 1990, pp. 18–21 (citing earlier references)

According to the inscription formerly visible on the back of the canvas, this portrait of young Victor Guye was painted as a pendant to that of his uncle, General Nicolas Guye (cat. 9). The general had presented his own likeness to his brother Vincent, the boy's father, as recorded by a similar inscription dated Madrid, October 1, 1810. When Beruete published the two portraits in 1913, his account was evidently based on information gathered from the Guye family. Yet the role of Vincent Guye, and the reason for his presence with his family in Madrid, appear to be unknown. Young Victor Guye was said by Beruete to have been four or five years older than a brother born in 1808. He would therefore have been six or seven in 1810, and a little older if there was a lapse of time between the two works.

The child wears the uniform of the Order of Pages to Joseph Bonaparte, king of Spain. It has been suggested that he would have been too young, in 1810, to be a member of this order. However, Nicolas Guye was a friend and contemporary of General Léopold Hugo, whose estranged wife arrived in Madrid in June 1811 with their three sons, Abel, Eugène, and Victor, aged thirteen, eleven, and nine, respectively. All three boys were sent by their father to the exclusive College of Nobles, but Abel left to join the Order of Pages.[1] It is possible that the friendship between the two families and their close relationship to the king enabled the younger Victor Guye to gain early entrance to the order, although this portrait could have been painted at any time between October 1810 and the departure of the family—at the latest in 1813, when the defeated Napoleonic armies withdrew from Spain.

The apparently simple yet masterfully orchestrated presentation creates one of Goya's most successful child portraits: the open book in the boy's hands is echoed by the shape of the tall collar, and the boy's wide eyes, direct gaze, and mobile expression are vividly rendered. The blue-black costume, encrusted with gold embroidery, is set off by the dark ground, with only a shadow—as in the sparest of Velázquez's portraits—to suggest the space in which the child stands alive and attentive before the artist.

JW-B

1. See Gassier 1981 for information on the Hugo family. Details concerning the Guye and Hugo families remain unclear, in particular whether Victor Guye attended the College of Nobles, as implied by Lipschutz (1972, p. 12), and when he became a page. Further research into the circumstances of Vincent Guye's presence in Madrid might also help to determine the precise date of the child's portrait.

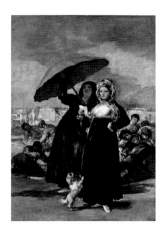

11. *Fig. 7.18*

Francisco de Goya y Lucientes

Young Women (The Letter)

After 1812
Oil on canvas
71¼ x 49¼ in. (181 x 125 cm)
Inscribed lower left: *C 103*
Musée des Beaux-Arts, Lille 9

CATALOGUES RAISONNÉS: Gudiol 1970, no. 583 [1980, no. 552]; Gassier and Wilson 1971, no. 962; De Angelis 1974, no. 551

PROVENANCE: Javier Goya(?), Madrid; unidentified collection "C" (no. 103); acquired by Baron Taylor, August 30, 1836 (in a group of eight pictures); King Louis-Philippe, Paris (Musée du Louvre, Galerie Espagnole), 1838–48; Louis-Philippe sale, Christie & Manson, London, May 20, 1853, no. 353, to Durlacher, London; Lord Dalling and Bulwer, London; Lord Dalling and Bulwer sale, Christie's, London, February 21, 1873, no. 63, to Warneck, Paris; acquired by the Musée des Beaux-Arts, Lille, 1874

EXHIBITIONS: Paris, Galerie Espagnole, Musée du Louvre, 1838–48, nos. 100/104; Lille–Philadelphia 1998–99, no. 53 (Lille ed., citing earlier references), p. 65 (Philadelphia ed.); Madrid–Washington 2001–2, no. 60; Paris 2002–3, no. 18

SELECTED REFERENCES: Gaya Nuño 1958, p. 176, no. 1073; Baticle and Marinas 1981, p. 85, no. 104; Arnaud Brejon de Lavergnée, "Fortune critique des *Jeunes* et des *Vieilles* du musée du Lille," in Lille–Philadelphia 1998–99, pp. 97–98, 236 (Lille ed.)

Femmes de Madrid en costume de Majas (Women of Madrid Dressed as Majas): this was the title, in its French and English versions, given to the present picture in the catalogue of the Galerie Espagnole in 1838 and then in the sale of Louis-Philippe's collection in London in 1853. On August 30, 1836, Javier Goya, the artist's son, had signed the receipt for a group of eight paintings, sold to Baron Taylor for the overall sum of 15,500 reales.[1] The group of works presumably belonged to him as a result either of the division of property between him and his father in 1812 or of the death in 1828 of the artist, whose sole heir was Javier.

This picture, now known as *Young Women*, has the same dimensions and characteristics as *The Forge* (fig. 7.19), as well as what appears to be an identical inventory mark: *C 103* on *Young Women*, *C 104* on *The Forge*. At the Louis-Philippe sale, *Young Women* was acquired by a dealer and passed to the collection of Sir Henry Bulwer, the future Lord Dalling and Bulwer,[2] where it remained (with other works from the same source) until his death in 1871. *The Forge* took a different route and was bought by another collector.[3] This sequence of events following the 1853 sale suggests that the *C* mark must have been added to the pair of pictures before their purchase by Baron Taylor in 1836. In that case, both paintings would have been marked with a hitherto unknown inventory number when they were in Javier Goya's collection; alternatively, one may hypothesize that Javier included in the group of works sold to Baron Taylor pictures from another source. What is certain is that the two works do not appear in the 1812 inventory and must have been painted at a later date.

There has been much discussion of the supposed influence exercised by the "admirable paintings by Goya" noted by Baudelaire in the Galerie Espagnole but "unfortunately relegated to obscure corners."[4] In fact, the attractive *Young Women* appears to have evoked no contemporary commentary at all. It is a difficult work to date, since its composition draws on elements that are found in Goya's work of various periods, from motifs and gestures in the early tapestry cartoons to the Black Paintings for the strange figures that crowd the middle ground to the right. The young woman reading a letter suggests but does not clearly portray a *maja*—she lies somewhere between the figures of the *Caprichos* etchings (1797–99) and that of Leocadia in the Quinta mural (1820–23). Goya's albums of drawings, with their washerwomen and their groups of figures, also provide relevant points of comparison.[5] The most striking comparison, however, must be with the portrait of Gumersinda Goya y Goicoechea (private collection), the artist's daughter-in-law, whom he painted in 1805. In the portrait, the young woman coolly faces the viewer, apparently oblivious to the little dog jumping up at her skirts; in *Young Women*, the dog is a curious creature of undefined pedigree, a roughly painted reprise of Gumersinda's very smart little lapdog.[6] As is now well known, the two paintings in Lille were not painted as pendants: the very different, somewhat smaller picture *Old Women (Time)* (fig. 1.33), an arrestingly original work with the *X.23* mark of the 1812 inventory, was purchased with the present work at the Louis-Philippe sale. The two remained together and were subsequently made into a pair through the enlargement of *Old Women* to the same size as the other canvas. In spite of some loss of dramatic intensity due to the enlargement of Goya's cruel allegory, titled *Time (El Tiempo)* in the 1812 inventory, the two pictures afford a striking contrast in style and handling. The true pendant of *Old Women* is the 1812 inventory version of *Majas on a Balcony*, Goya's salute to youth and beauty, of which the second version (cat. 14) and the present work appear as distant echoes.

JW-B

1. The individual works were not specified. See Baticle and Marinas 1981, p. 84.

2. William Henry Lytton Bulwer (1801–1872), brother of the author Edward Bulwer Lytton, was ambassador in Madrid from November 1843 until his expulsion by Spain as a result of the events provoked by the Revolution of 1848. Sir Henry Bulwer was granted the title of Baron Dalling and Bulwer of Wood Dalling in 1871. See *Encyclopaedia Britannica*, 9th ed. (Edinburgh, 1875–89), vol. 6, pp. 780–83. For the sale at Christie's, see cat. 6, n. 6.

3. The painting of blacksmiths known as *The Forge* was purchased at the sale by the dealer Farrer and acquired by Henry Labouchère, the future Lord Taunton, of Stoke, near Windsor; it was inherited by his grandson, E.A.V. Stanley, of Bridgewater, Somerset. See Baticle and Marinas 1981, p. 86, no. 105.

4. "précieuses peintures de Goya"; "reléguées malheureusement dans les coins obscurs." Baudelaire 1975–76, vol. 1, "Quelques caricaturistes français," p. 570.

5. See the "Black Border" album (called album E), nos. 28, 37 (washerwomen), and album F, in which page 51 was the model for *The Forge*. See Gassier and Wilson 1971, nos. 1398, 1406, 1472; Gassier 1973, nos. 126, 132, 317.

6. Gassier and Wilson 1971, no. 851; see Madrid–Washington 2001–2, p. 35, fig. 4.

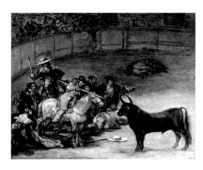

12. *(New York only)* *Fig. 5.18*

Francisco de Goya y Lucientes
Bullfight: Suerte de vara

1824
Oil on canvas
19⅛ x 24 in. (50 x 61 cm)
The J. Paul Getty Museum, Los Angeles 93.PA.1

CATALOGUES RAISONNÉS: Gudiol 1970, no. 734 [1980, no. 704]; Gassier and Wilson 1971, no. 1672; De Angelis 1974, no. 660

PROVENANCE: Joaquín María Ferrer, Paris, 1824–33, then Madrid 1833–67; marqués de Baroja, Madrid, by 1900 (by descent); marquesa de la Gándara, Rome, by 1970 (by descent); private collection, Switzerland, by 1992 (by descent); Sotheby's, London, December 9, 1992, no. 84, bought by the J. Paul Getty Museum, Los Angeles

EXHIBITIONS: Madrid 1900, no. 119; Bordeaux 1951, no. 59; Arles–Madrid 1990, no. 48; Madrid–London–Chicago 1993–94, no. 112; Madrid 1996, no. 167

SELECTED REFERENCES: Salas 1964a, pp. 37–38, fig. 30; Madrid–London–Chicago 1993–94, p. 330 (Madrid ed.); Jeannine Baticle, "L'oeuvre peint de Goya à Paris et à Bordeaux," in Bordeaux 1998, pp. 81–90; Álvaro Martínez Novillo, "Les *Taureaux*

de Bordeaux," in ibid., pp. 119–20; Jesusa Vega, "Goya 1900: La Exposición," in Glendinning et al. 2002, vol. 2, pp. 234–35, repr. (photo Moreno)

The best-known works of Goya's old age, executed during his voluntary "exile" in France, are the four magnificent lithographs known as *The Bulls of Bordeaux* (cats. 42–45), published in 1825 when he was almost eighty years old. The lithographs, which play on memories of his *Tauromaquia* etchings of a decade earlier (cats. 38–41), were preceded by this remarkable painting of a picador performing the *suerte de vara*, challenging the bull to return to the attack although the picador's horse has been badly gored. In 1964, an article by Xavier de Salas linked this picture with several others believed to be by Goya, in spite of very wide discrepancies in the style and quality of the works. Rather than enter this difficult terrain, where questions of attribution rely to a large extent on unverifiable evidence,[1] it is more useful to evaluate the painting and its context.

On the strength of an inscription, formerly visible on the back of the canvas, that read *Pintado en Paris en Julio de 1824. / Por / D.ⁿ Fran.ᶜᵒ Goya. / JMF* (Painted in Paris in July 1824 by Don Francisco Goya. J[oaquín] M[aría] F[errer]),[2] it has been assumed that the work was offered by Goya to his Spanish friend during the artist's visit to Paris in July and August 1824. Joaquín María Ferrer y Cafranga (1777–1867) had been a liberal deputy in Guipúzcoa during the period of Constitutional rule in Spain (1821–23) and was obliged to emigrate when Ferdinand VII was restored to absolute power. During the same two months in Paris, the artist painted two lively portraits of Ferrer and his wife: that of Ferrer is signed *Goya* and located and dated *Paris 1824*.[3] On his return to Bordeaux, where he was to live until his death four years later, Goya spent the winter months painting miniatures on ivory and then embarked on an ambitious project to publish his set of large lithographs of bullfighting subjects. It was to Ferrer that Goya sent proofs of his bullfight lithographs, asking for advice about marketing them. It seems ironic, given the gift of this particular painting to his friend, that Ferrer's response was evidently discouraging about Parisian interest in such prints.

Like many of Goya's late inventions, the painting alludes to earlier work by the artist. The most striking comparison is with the *Bullfight in a Village*, one of the set of four celebrated panels in the Real Academia de Bellas Artes de San Fernando. In that work, a mounted picador confronts a charging bull that is watched intently by his white horse, still only slightly gored. Other comparisons can be made with etchings from the *Tauromaquia*: plate 7 shows a Moor preparing to throw a banderilla at a bull that is almost an exact model for the one in the painting, and in plate 27 a celebrated picador challenges the bull from his blindfolded horse, providing a reversed image close to the early state of the painting—in which the horse was also blindfolded. Given the lack of exactly contemporary works of this kind painted by Goya in France, it is difficult to find precedents or comparisons for its painterly style, in which strongly impastoed areas contrast

with the thinly washed background. The work made the first of its rare public appearances in the Madrid exhibition of 1900, when it was photographed by Moreno.[4] JW-B

1. Salas 1964a cited an inventory once thought to be from 1828 but probably of a later date (see Wilson-Bareau 1996a, p. 166), and the "Memorias tradicionales de D. F. Goya" of a Carthusian monk who visited the home of Goya's son (see Viñaza 1887, p. 463), but the bullfight pictures mentioned in these two sources cannot convincingly be connected with those discussed by Salas (see Arles–Madrid 1990, pp. 118–23, nos. 49–51).

2. The original inscription with Ferrer's initials and his rubric, presumably added on his instructions, was reproduced by Salas 1964a, p. 36, fig. 30; lost when the canvas was relined in 1959, it was copied onto the relining canvas (see Arles–Madrid 1990, p. 116, repr.).

3. These portraits are still owned by a descendant of the sitters. Virtually unknown, they are on a par with the finest portraits painted by the aged artist in France. See Gassier and Wilson 1971, nos. 1659–63; Baticle in Bordeaux 1998, p. 84, figs. 2, 3.

4. See Madrid 1900, and the reproduction in Glendinning et al. 2002, vol. 2, pp. 234–35.

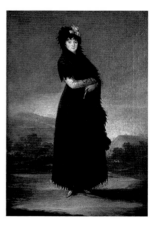

13. *Fig. 2.23*

Francisco de Goya y Lucientes and/or Studio
Woman in Spanish Costume, Presumed Portrait of María de Quero y Valenzuela, Marquesa de la Merced (Also Called de las Mercedes), or of Maria Anna Waldstein, Ninth Marquesa de Santa Cruz

Ca. 1797–99(?)
Oil on canvas
20½ x 13⅜ in. (52 x 34 cm)
Inscribed on reverse of canvas: *Goya 1799*
Musée du Louvre, Paris, Bequest of Louis Guillemardet, 1865 MI 698

CATALOGUES RAISONNÉS: Gassier and Wilson 1971, no. 678n.; De Angelis 1974, no. 336n.

PROVENANCE: Ferdinand Guillemardet, Madrid (1799?–March 1800?), Paris (1800–1809?); Louis Guillemardet, Paris, 1809, by inheritance; bequeathed to the Musée du Louvre, Paris, 1865

EXHIBITIONS: Madrid 1928a, no. 67; Paris 1935b, no. 346 (as "preparatory sketch"); Paris 1938, no. 8 (as "reduced replica"); Paris 2002–3, no. 10 (attribution uncertain)

REFERENCES
19th century: Ségoïllot 1866, pp. 222–23; Massarani 1880, vol. 2, p. 254

20th–21st century (selected references): Madrid 1928b, pp. 46–47, no. 44; Desparmet Fitz-Gerald 1928–50, vol. 2, p. 103, under no. 385 (as *étude sur nature*); Sterling 1938, p. 3 n. 2 (as *copie réduite*); Gaya Nuño 1958, p. 166, no. 967; Held 1964, p. 189; Baticle 1977, p. 153 (as *petite réplique non autographe*); Louvre 1981, p. 116 (as *Copie* of RF 1976-69, Louvre); Louvre 2002, pp. 307–8, repr. (*Portrait de Marie-Anne Waldstein*, as by "Entourage de Goya")

In 1878, the Italian senator Tullo Massarani, who was president of the Fine Arts section of the Paris Exposition Universelle, wrote about various aspects of the exhibition, including the display of Goya's so-called Black Paintings in the Trocadéro building.[1] Providing answers for the visitor who found himself confronted with terrifying scenes that seemed to have emerged from the sick mind of a demoniac, Massarani explained, "They were made by Goya. But if by chance, on another day, you went to relax your frazzled nerves amid the pleasant wonders of the Louvre, you might come upon a seductive *mañola* [*sic*], a pretty little grisette with a red ribbon bow above her ear, a black mantilla, and a plump arm whose perfect curves can be perfectly well made out under the pink silk of a coquettish little basque embroidered in silver. What paintbrush brought this charmingly fashionable little demon to life? Goya's paintbrush?"[2]

The little picture of a lady as a *manola* or *maja* was one of just two paintings by Goya in the Louvre at that time. A far cry from such monumental works as Goya's Black Paintings, it belongs to the late-eighteenth-century, proto-Romantic world of portraits like those of the duchess of Alba (fig. 11.8) and the marquesa de la Solana (ca. 1794–95, Musée du Louvre, Paris). The small figure's arms and the way in which she holds the fan are similar to those of the marquesa, although reversed, and there is also a clear connection with the *majas* in Goya's *Caprichos* prints (cats. 27, 28), which were published in 1799, the date inscribed on the back of the canvas.

The picture was bequeathed to the Louvre in 1865 by Louis Guillemardet, together with Goya's portrait of his father (fig. 5.1), painted during the eighteen months that Ferdinand Guillemardet spent as French ambassador to Spain under the Directory. It has always been assumed that both pictures were brought to France after Guillemardet was replaced in November 1799 by Baron Alquier (see cat. 3).[3] The earliest known reference to the small work in France comes from a letter addressed by Delacroix to Louis Guillemardet on January 24, 1856. Delacroix writes that he has mentioned the "portrait of your father . . . and one of a lady (a small full-length portrait) . . . that you also own" to the author of a forthcoming biography and catalogue of Goya's works, Laurent Matheron.[4] The ex-ambassador had died in 1809, and on the death of his son Louis in 1865, both works entered the Louvre. They were greeted with an article in *L'Artiste* by someone close to the Guillemardet family,[5] and the little canvas later enchanted Senator Massarani on his visits to the Louvre.

The picture, freshly cleaned, makes its appearance here after a long eclipse. Its status has varied over the years.[6] Once considered to be a small portrait, it was later seen as the sketch for a larger and more spectacular work, now also in the Louvre, after which assessment the small picture lost its status as an original creation and slipped out of sight and into the reserves.[7] The large portrait had come from the collection of the marqués de la Remisa in Madrid. In an inventory of 1846, this work was identified as a portrait of the marquesa de las Mercedes, María de Quero y Valenzuela; her title has since been shown to have been a variant of the official title of marquesa de la Merced.[8] This same portrait has since been given a new and quite different identity, that of the ninth marquesa de Santa Cruz, Maria Anna Waldstein. While there are arguments for each of the proposals, there is as yet no concrete evidence that would support one rather than the other identification. Similarly, it has proved impossible for the present to define the relationship between the two works and to determine whether one precedes the other. It has even been suggested that they do not represent the same person. For the moment, the most interesting question remains the attribution of the present painting.

The small work is most closely allied in its composition, tonality, and air of quiet confidence with Goya's portraits of the late 1790s, mentioned above. The tranquil, graceful figure stands firmly on her small feet; the rose-pink preparation is expertly used for the shadows on the pink satin sleeve and for the hand; the embroidery on the sleeve and slippers is conveyed by skillfully applied touches of paint. Yet there is something amiss in the elongation of the figure and a certain lack of vitality in the silhouette and in the treatment of the skirt. The landscape is swiftly and freely handled, with a fine perspective effect, and bears comparison with Goya's sketches for tapestry cartoons (cats. 3, 4) and small paintings. As for the young woman's face, finely and vigorously painted with an intelligent, compelling gaze, it seems to anticipate the miniatures on copper painted by Goya in 1805.[9] A few years earlier, in 1794, Goya had written about the newly discovered talents of his assistant, Agustín Esteve, as a miniature painter.[10] But Esteve was never able to paint with the freedom and assurance of the master.

While the authorship of this small canvas remains an open question, it is certain that Delacroix knew it at least from the mid-1850s and possibly much earlier[11] and that other artists would have seen it before its arrival at the Louvre in 1865.

JW-B

1. Goya's Black Paintings had been removed from the walls of the Quinta del Sordo after its purchase by Baron d'Erlanger in 1873. They were transferred to canvas and taken to Paris, where rumors concerning their imminent sale by auction were recorded (Yriarte 1877, p. 10). In 1878, they were hung in a corridor near the official Spanish display in the historical and ethnographic section of the Paris Exposition, before their return to Spain and donation to the Museo del Prado. See the Chronology: 1878.

2. "Elles étaient de Goya. Mais si par hasard, un autre jour, vous alliez détendre vos nerfs fatigués au milieu des suaves merveilles du Louvre, vous vous rencontriez avec une séduisante *mañola* [*sic*], la jolie grisette au noeud de ruban rouge à l'oreille, à la noire *mantilla*, au bras dodu dont les courbes parfaites se laissent parfaitement deviner sous la soie rose d'une coquette petite basquine à broderies d'argent. De quel pinceau était-il éclos, ce charmant petit démon mondain? Du pinceau de Goya." Massarani 1880, vol. 2, p. 254. Massarani's reports were written in Italian for the *Annali del Ministero d'Agricoltura, Industria e Commercio* and published in a French translation.

3. Guillemardet probably did not leave Madrid until the arrival of Alquier at the end of February 1800 (Perrin de Boussac 1983, p. 110).

4. "je lui ai parlé du portrait de ton père . . . et de celui d'une dame (petit portrait en pied) . . . que tu possèdes également." Delacroix 1936–38, vol. 5, pp. 199–200. Matheron's very summary *essai de catalogue* mentions only the "Portrait de M. Guillemardet, ambassadeur de la République (1798)," with no reference to its location (Matheron 1858, p. [112]; Matheron 1996, p. 280).

5. Ségoïllot 1866. Almudena Ros Barbero kindly brought to my attention this article, cited in Louvre 2002, p. 308.

6. With reference to the bequest, Louis Guillemardet's nephew described the work as "another little picture by the same artist Goya, a very delicately handled work, representing a lady in rich and elegant Spanish costume" ("un autre petit tableau de ce même artiste Goya, oeuvre très délicatement touchée, représentant une dame en riche et élégant costume espagnol") (see Louvre 2002, p. 308). It was registered and later catalogued as *Jeune femme espagnole*, although Hadrian Ségoïllot (see n. 5) had hinted mysteriously at a precise identification, stating that this other portrait was that of "a lady at court who was very much in favor with the Queen, *Mme la marquise de* . . ." ("une dame de la cour qui était très en faveur auprès de la reine"). Ségoïllot 1866, cited in Louvre 2002, p. 308.

7. Following the appearance in the David-Weill collection in Paris of the almost identical, two-thirds-lifesize portrait (from the Remisa collection, Madrid; now Louvre, RF 1976.9), French critical opinion questioned, then rejected, the attribution of the small work to Goya. See Sterling 1938, p. 3 n. 2: "Comparison [of the large and small paintings] highlights the poor technique and application of the latter example: it is only a reduced copy" ("Le rapprochement a mis en évidence la facture mesquine et appliquée du dernier exemplaire: ce n'est qu'une copie réduite"). The larger work, initially known as the *Marquesa de las Mercedes*, was subsequently identified by Jeannine Baticle as a portrait of Maria Anna Waldstein, ninth marquesa de Santa Cruz (Baticle 1977, p. 153). Both works are discussed in Louvre 2002, pp. 307–8.

8. The painting, which bears a collection mark and number, is listed in an unpublished inventory of the Remisa collection that was signed and dated by Ceferino de Araujo on March 5, 1846: "107 Retrato de la marquesa de las Mercedes" (information kindly provided by Manuela B. Mena Marqués). The questions raised by this identification were addressed by Enrique Lafuente in Madrid 1928a, no. 67, and Madrid 1928b, pp. 46–47, no. 44: the title of marqués de la Merced (the correct form) was transformed at this period and appears as las Mercedes in the dedication of a poem written by Nicasio Álvarez de Cienfuegos (1764–1809) on the death of the marquesa, Doña María de Quero y Valenzuela, whose name Quero is evoked in the poem itself, published in 1798 (a date that sets a terminus ante quem for any portrait, unless painted as a posthumous memorial).

9. Madrid–London–Chicago 1993–94, pp. 266–69, nos. 67–73.

10. Goya 1981, p. 317, no. 192; Goya 1982, p. 218, letter 129.

11. Although the assumption is traditional and long-standing, there is as yet no documentary proof that this canvas was acquired by Ferdinand Guillemardet in Spain and brought by him to France. One may note that Louis Guillemardet was a collector who acquired and gave to Delacroix some pastiche oil paintings from a set based on the eighty prints of *Los Caprichos* (see Delacroix 1936–38, vol. 4, p. 249; Ségoïllot 1866, p. 224 n. 5; Louvre 2002, under Lucas Velázquez [attributed], RF 2542 [not one of those owned by Delacroix]). In the absence of any concrete evidence, it is conceivable that the small canvas attributed to Goya was acquired by Louis Guillemardet in France. This possibility may help to clarify the puzzling relationship between the large and small pictures.

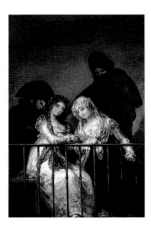

14.

Fig. 1.32

Attributed to Francisco de Goya y Lucientes

Majas on a Balcony

Ca. 1812–35
Oil on canvas
76¾ x 49½ in. (194.9 x 125.7 cm)
The Metropolitan Museum of Art, New York,
H. O. Havemeyer Collection, Bequest of Mrs.
H. O. Havemeyer, 1929 29.100.10

CATALOGUES RAISONNÉS: Gudiol 1970, no. 576 [1980, no. 555]; Gassier and Wilson 1971, no. 960; De Angelis 1976, no. 87.472

PROVENANCE: Javier Goya, Madrid; the Infante Don Sebastián Gabriel de Borbón y Braganza, Madrid, before 1835; Museo Nacional de la Trinidad, Madrid, under state sequestration, 1835–60; restored to the Infante Don Sebastián, 1860 (Madrid 1860–68, Pau 1868–75); estate of the Infante Don Sebastián (d. February 14, 1875), Pau (collection returned to Madrid, 1881–83); Don Francisco de Borbón y Borbón, duque de Marchena, 1887, by inheritance (d. 1904); Durand-Ruel, Paris, purchased November 9, 1904 (stock no. 7813); Mr. and Mrs. H. O. Havemeyer, New York, purchased November 1904; bequeathed by Mrs. H. O. Havemeyer to The Metropolitan Museum of Art, New York, 1929

EXHIBITIONS: Madrid 1900, no. 112 (repr. in Glendinning et al. 2002, vol. 2, p. 221); New York

1955, no. 184; New York 1993b, p. 344, no. 296 (as "attributed to Goya"); New York 1995, pp. 65, 68; Madrid–Washington 2001–2, no. 61; Paris 2002–3, no. 17

REFERENCES

19th century: O'Shea 1865, p. 300 (as in "Gallery of Infante Don Sebastian")

20th–21st century (selected references): Gaya Nuño 1958, p. 162, no. 931; Águeda 1982, no. 48, p. 107 (inventory July 31, 1835); Baratech Zalama 1989, no. 247 (inventories June 19, 1875, and June 1885); Prado 1990–91, vol. 2, no. 123 (inventory 1854); Gary Tinterow, "The Havemeyer Pictures," in New York 1993b, pp. 15–17, pl. 13; Susan Alyson Stein, "A History of the Collection," in New York 1995, p. 47; Manuela B. Mena Marqués, "Goya, la question n'est pas résolue," in Lille–Philadelphia 1998–99, p. 31 (Lille ed.); Madrid–Washington 2001–2, pp. 247–49; Nigel Glendinning, "El problema de las atribuciones desde la exposición Goya de 1900," in Glendinning et al. 2002, vol. 1, pp. 16, 26–28; Jesusa Vega, "Goya 1900: La Exposición," in ibid., vol. 1, p. 110 (vol. 2, pp. 220–22)

"Two paintings of young women on a balcony with the number twenty-four": this is the brief description in the 1812 inventory of two masterpieces by Goya that still bear the original inventory mark and number, *X.24*, in the lower left corner of each canvas.[1] In one of them, a young blonde leans on a balcony rail, displaying her charms for the delectation of passersby. Beside her, an old *celestina*, the traditional Spanish procuress, points knowingly to her charge, inviting customers to step up.[2] In the other picture, two vivacious, pink-cheeked young women are seated on a similar balcony; they lean toward each other as they observe what is going on down below, in the spectator's space. A *majo* with a cigarette replaces the *celestina* to the left, and to the right the somewhat menacing silhouette of a companion, his face barely visible between cape and bicorne hat, looms over the girls. Of this celebrated painting there is, exceptionally, a second version—shown here—that was accepted until quite recently as an autograph work by the master.[3]

Following the discovery of a connection between the inventory of 1812 and the *X* mark that appears with a number on a good many paintings,[4] it was assumed that pictures not attributed in the inventory to other artists—Tiepolo and, in one case, possibly Velázquez[5]—must be original works by Goya. Yet where portraits were concerned, we have known for a long time that replicas or copies were made in Goya's studio by his assistants, and more recently it has been shown that the "original" version of such a commissioned work may have been executed under the control of, but with the more or less direct participation by, the artist (for example, in the case of the 1814 portraits of Ferdinand VII, who posed only once, and then briefly, for Goya in 1808). However, no one imagined that genre paintings—works of artistic imagination—might have been adapted or even initiated by artists other than Goya himself. When doubts began to emerge concerning the

authenticity of certain works with inventory numbers, one possible candidate in the immediate vicinity of the artist was the person behind the *X* mark: Xavier Goya (who later spelled his name Javier), the son whose career as an artist Goya had sought to advance, who declared himself a painter on his marriage certificate, and whose own son, Mariano, later affirmed that his father had painted one of the works that decorated the Quinta del Sordo.[6]

In the case of the present canvas, technical and aesthetic characteristics have raised serious doubts about its attribution to Goya.[7] This version of *Majas on a Balcony* lacks the "attack," the rhythms and dramatic vitality, that are present in the inventory original and are features of the artist's composition and handling in all his indisputably authentic works. This large painting was acquired by the Infante Don Sebastián, at a time and in circumstances that remain unclear.[8] It was inventoried in July 1835 in the infante's palace in Madrid, then sent to the Museo Nacional de la Trinidad together with other works sequestered in 1837 as a result of the infante's support for Don Carlos, the pretender to the throne of Spain; years later, when the infante returned to Madrid from exile and publicly recognized the legitimacy of Queen Isabella II, his collection was returned to him and the picture was hung in his gallery. Charles Blanc saw it there on a visit with Paul de Saint-Victor in 1862 and declared it to be a "masterpiece by Goya" ("chef-d'oeuvre de Goya").[9] The gallery was open to the public and was mentioned in guidebooks by Lannau-Rolland in 1864 and Germond de Lavigne in 1866; in 1865, Henry O'Shea published a brief catalogue of the gallery and described the Goya as "two Majos and two Majas looking out of a Balcony. . . . A charming composition."[10] When the revolution of 1868 ousted Queen Isabella II from the throne of Spain, the Infante Don Sebastián immigrated to France, where he settled at Pau until his death in 1875. *Majas on a Balcony* did not appear in the catalogue of the exhibition held at Pau in 1876, but the picture appears with five other works attributed to Goya in an inventory made in Madrid in 1885.[11] In the 1890 auction catalogue of the collection of the Infante Don Sebastián's eldest son, the duc de Durcal, some notes "from the family Archives" indicate the provenance of the "Goyas" from collections formed by or on the advice of José de Madrazo, director of the Museo del Prado at the time, whose entire collection was acquired by the infante.[12] JW-B

1. Gassier and Wilson 1971, p. 381, nos. 958, 959, Appendix 1: "Dos quadros de unas jovenes al balcon con el nº veinte y quatro." Both paintings are in private collections.

2. See Lille–Philadelphia 1998–99, no. 51 (Lille ed.), p. 63 (Philadelphia ed.).

3. In the case of some paintings the authenticity of which is in doubt—such as the panels in the X.9 series and *The Greasy Pole* (Gassier and Wilson 1971, nos. 930, 931, 951)—replicas or copies are known. On the present picture, see Janis Tomlinson's résumé of various opinions in Madrid–Washington 2001–2, pp. 247–49.

4. See Salas 1964b.

5. 1812 inventory, no. 10, "Dos de Tiepolo," and no. 17, "El retrato de Velázquez y su Compañero," which could refer to copies painted by Goya.

6. When Goya made a "gift" of the copperplates of *Los
 Caprichos* to the king in 1803, he requested in compensation
 a stipend that would enable his son to travel in order to
 further his career as an artist; later, Goya had to fight
 for the payments to be continued. See Sambricio 1946,
 "Documentos," pp. cxlii–cxliii, nos. 219–21; Goya 1981,
 p. 360, nos. 223, 224, pp. 477, 479, nos. CVIII, CXII. For
 the marriage certificate, see Goya 1981, p. 478, no. CIX.
 For the painting in the Quinta, see Gassier and Wilson 1971,
 p. 384, Appendix 6, no. 7a (the work—"Deux sorcières"
 according to the so-called Brugada inventory—has not
 been identified).

7. The present author agrees with this judgment, following the
 direct confrontation of the two works in 1995; see New
 York 1995, pp. 64–65.

8. For various hypotheses concerning the date of the picture's
 acquisition, see Glendinning in Glendinning et al. 2002,
 pp. 26–27.

9. On the infante's gallery in 1835, see Águeda 1982, pp.
 102–17. Louis Viardot (1843, p. 157) commented on the new
 museum, inaugurated on May 2, 1842: "If it were not for
 the confiscated gallery of the infante Don Sebastián, the
 national Museum . . . would hardly be worth visiting, let
 alone remembering" ("Sans la galerie confisquée de l'infant
 don Sébastien, le Musée national . . . ne méritait guère la
 peine qu'on allât le voir et qu'on s'en souvint"). Viardot
 cited the single picture by Goya in the collection as "a *Box
 in a bullring*" ("une *Loge au cirque des taureaux*"), interpret-
 ing *Majas on a Balcony* not as a street scene but as a scene at
 a bullfight (ibid., p. 167). On the infante's gallery in 1862,
 see the introduction by Charles Blanc to Bourbon 1863,
 p. 176.

10. Lannau-Rolland 1864, p. 82; O'Shea 1865, p. 300; Germond
 de Lavigne 1866, p. 82. The infante was obliged to leave
 the property of the calle de Alcalá in 1865. A variant on the
 infante's picture, possibly by Asensio Juliá (d. 1832), was
 included in the sale of the Salamanca collection in 1867 as lot
 176 (see cat. 15): *Portraits de femmes* (private collection, Paris).

11. Borbón y Braganza 1876. The inventory and a valuation of
 the picture gallery, made by Salvador Martínez Cubells in
 June 1885, included the following works: Gassier and
 Wilson 1971, nos. 672, 936, 939, 960, 1668, 1669 (the
 authenticity of all these works appears untenable in the
 present state of this author's investigations); see Baratech
 Zalama 1989.

12. Borbón y Braganza 1890, pp. iv–vii.

15. *Fig. 5.34*

Style of Francisco de Goya y Lucientes (Eugenio Lucas Velázquez?)

Bullfight in a Divided Ring

After 1828(?)
Oil on canvas
38¼ x 49¼ in. (98.4 x 126.4 cm)
The Metropolitan Museum of Art, New York,
Catharine Lorillard Wolfe Collection, Wolfe Fund,
1922 22.181

CATALOGUES RAISONNÉS: Gudiol 1970, no. 615
[1980, no. 566]; Gassier and Wilson 1971, no. 953;
De Angelis 1974, no. 535

PROVENANCE: Javier Goya, Madrid; "vente Goya,"
place and date unknown; José de Salamanca y Mayol,
Madrid, then marquis de Salamanca, Paris; Salamanca
sale, 50, rue de la Victoire, Paris, June 3–6, 1867, no.
178 (bought in at 3,000 francs); Salamanca sale, Hôtel
Drouot, Paris, January 25–26, 1875, no. 13, sold for

7,500 francs to A. Dreyfus, Paris; Dreyfus sale,
Hôtel Drouot, Paris, May 27, 1889, no. 103, repr.
(bought in at 6,100 francs); Dreyfus de Gonzalez
sale, Hôtel Drouot, Paris, June 8, 1896, no. 2,
repr., sold for 4,100 francs to Veil Picard, Paris;
Wildenstein and Co., Paris and New York; pur-
chased by The Metropolitan Museum of Art, New
York, 1922

EXHIBITIONS: New York 1955, no. 186; New York
1995, p. 68 (as "Style of Goya"); Paris 2002–3,
no. 21 (as "Imitator of Goya")

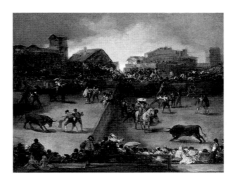

SELECTED REFERENCES: Lafond 1902, pp. 27,
repr., 107, no. 27; Oertel 1907, p. 148; Gaya Nuño
1958, pp. 175–76, no. 1065; Susan Alyson Stein,
"A History of the Collection," in New York 1995,
p. 42, fig. 26, pp. 46, 62 n. 52; Wilson-Bareau 1996a,
pp. 168–70, fig. 11; Wilson-Bareau 1996b, pp. 100–
101; Manuela B. Mena Marqués, "Goya, la question
n'est pas résolue," in Lille–Philadelphia 1998–99,
p. 31 (Lille ed.)

In 1867, Paris was the focus of the world's attention
thanks to its hosting of the great Exposition
Universelle. A wealthy banker of Spanish origin,
Don José de Salamanca, recently ennobled by
Isabella II and known in France as the marquis de
Salamanca, chose this moment to organize an auc-
tion in his private residence on the rue de la Victoire.
He offered for sale his collection of paintings, which
included eight pictures attributed to Goya, among
them this bullfight scene.[1] In Madrid, an English
guide published in 1865 had praised the Salamanca
collection after extolling the merits of the Infante
Don Sebastián's picture gallery (see cat. 14); both
collections were open to visitors.[2] According to the
guide, the Salamanca collection had been "formed in
a few years by this enterprising capitalist, aided
principally by Sr. D. Val[entín] Carderera, one of
the best authorities on subjects of art in Spain."
Listing works by Velázquez, Murillo, Zurbarán,
Dürer, Titian, and Rembrandt, the guidebook entry
referred to "several other remarkable and authentic
pictures by G. Don [*sic*, for Dou], Goya, &c."

José de Salamanca, who had purchased the royal
domain of Vista Alegre from the duc and duchesse
de Montpensier (see cat. 6), acquired almost en bloc
the extensive art collection formed by the late Don
José de Madrazo, former first court painter and
director of the Museo del Prado. This transaction
was effected in 1861 with Federico de Madrazo, who

succeeded to his father's posts and became the most
notable artistic personality in Spain. When Goya's
son died in 1854 and the artist's inheritance passed to
his grandson Mariano, Madrazo, in close collabora-
tion with Carderera, played a major role in the dis-
persal of the collection, and several paintings and a
very large number of drawings were acquired by the
two friends.[3] According to the catalogue of the
Salamanca sale, this *Bullfight* and its pendant, a
Procession in Valencia (Foundation E. G. Bührle,
Zurich), had come from the "Goya sale."[4] *Procession*
and another canvas from this series still show the
mark of Goya's son Javier, or Xavier, the *X.1* of the
inventory of 1812.[5]

While deploring his own "succinct and rapid
description" of the works due to lack of time, the
"expert" responsible for the sale affirmed at the out-
set that "M. le marquis de Salamanca's picture
gallery is widely regarded as a museum. It enjoys a
reputation based on unanimous admiration."[6] One
contemporary commentator begged to disagree.
Théophile Silvestre visited "the gallery of the
Spanish marquis and financier. Gallery is hardly the
right word. It is a depot, a warehouse full of can-
vases . . . attributed to the greatest of the old masters
with breathtaking assurance, to say the least." He
denigrated "the highly vaunted Goyas" that, accord-
ing to him, were "second-rate, formless sketches of
interest only to practicing artists."[7]

The large, undeniably spectacular paintings of
the X.1 group lack the qualities of Goya's indis-
putably authentic pictures.[8] As a pendant to one of
the marked inventory pictures, *Bullfight* would have
been painted before 1812. Yet its composition is
unfocused and excessively busy, and the work is
characterized by weak and clumsy drawing and by
such absurdities as the ill-defined crowd surging in
sometimes disembodied waves across the back-
ground and into the far distance, against all the laws
of perspective. Above all, the work is marked by the
absence of compositional coherence and of any real
sense of tension or drama. It is a pastiche based on
one of Goya's four masterpieces that entered the
Real Academia de San Fernando in Madrid in
1836—*Bullfight in a Village*, from which it appro-
priates several figures—and on the *Tauromaquia*
prints that were published in Madrid in 1816 (cats.
38–41). The work even appears to take inspiration
from a late lithograph, *The Divided Ring*, executed
by Goya in Bordeaux in 1825 (cat. 45). This *Bullfight*
and its companion, *Procession*, were bought in at
3,000 and 2,500 francs, respectively, in the Sala-
manca sale; they reappeared in the second sale in
1875 and there confirmed the judgment passed by
Pierre Dax on the first sale: "Spanish painting . . .
from Murillo to Goya was present, but the new
school was overwhelmed by the old one. Murillo
will probably never decline in value, but Goya will
rise one day."[9]

 JW-B

1. See Salamanca 1867.
2. O'Shea 1865, p. 302.
3. On the activities of Carderera and Madrazo, see Wilson-
 Bareau in London 2001, pp. 24–25; for their picture col-
 lections, see O'Shea 1865, p. 302 ("Gallery of Señor

Carderera"), other contemporary guides, and the catalogue in Yriarte 1867, pp. 136 (for Carderera) and 137 (for Federico and Luis de Madrazo).

4. Salamanca 1867, lots 178, 179. The reference to a "Goya sale" suggests a public dispersal (although no documentary trace of such an event is known) of works that had belonged to Javier Goya (see Gassier and Wilson 1971, nos. 852, 952, and 953, no. 951 being the other work that shows the inventory mark); lot 176, *Portraits de femmes* (private collection, Paris), is a variant of the *Majas on a Balcony* already classified as a pastiche of the inventory picture (cat. 14). As for the "Galerie de Goya" also cited in the catalogue, this could refer to works that were acquired directly from Mariano Goya (see Gassier and Wilson 1971, nos. 837, 890).

5. For the inventory, see Gassier and Wilson 1971, p. 381, Appendix 1, no. 1: "four similar pictures with the number 1." In a later inventory (incorrectly said to date from 1828), three pictures from the X.1 series of 1812 reappear (the fourth remains to be identified). See ibid., pp. 381–82, Appendix 2, nos. 19, 29, 30.

6. "La galerie de tableaux de M. le marquis de Salamanca est généralement considérée comme un musée. Un sentiment unanime d'admiration a consacré sa réputation." Étienne Le Roy, introduction to Salamanca 1867, pp. v, xiv–xv.

7. "la galerie du marquis et financier espagnol. Galerie est un mot impropre. C'est entrepôt qu'il faut dire, entrepôt de toiles . . . attribuées aux plus grands maîtres avec une assurance superlative, pour ne pas parler plus carrément. . . . Les Goya, si prônés [sont] d'un intérêt secondaire, des ébauches informes qui n'ont de valeur que pour des practiciens." T. Silvestre 1867, p. 3.

8. See Stein in New York 1995 and Wilson-Bareau 1996a.

9. Salamanca 1875, nos. 13, 14. "Ainsi la peinture espagnole . . . allait de Murillo à Goya, mais la jeune école a été écrasée par l'ancienne. Murillo ne baissera probablement jamais, mais Goya se relèvera quelque jour." Dax 1867, p. 158.

16. *(New York only)* *Fig. 5.33*

Style of Francisco de Goya y Lucientes (Eugenio Lucas Velázquez?)

City on a Rock

19th century
Oil on canvas
33 x 41 in. (83.8 x 104.1 cm)
The Metropolitan Museum of Art, New York,
H. O. Havemeyer Collection, Bequest of Mrs.
H. O. Havemeyer, 1929 29.100.12

CATALOGUES RAISONNÉS: Gudiol 1970, no. 674 [1980, no. 702]; Gassier and Wilson 1971, no. 955; De Angelis 1974, no. 570

PROVENANCE: James S. Inglis, New York, purchased in Spain between 1882 and 1887, until his death in 1908; his estate, 1908–12; sold to Cottier and Co., New York, November 14, 1912; bought for 8,000 dollars by Mrs. H. O. Havemeyer, New York, November 18, 1912; bequeathed to The Metropolitan Museum of Art, New York, 1929

EXHIBITIONS: New York 1993b, no. 300; New York 1995, no. 188

SELECTED REFERENCES: Gaya Nuño 1958, p. 178, no. 1095; Arnáiz 1981, pp. 116, 117 color repr., 522–23, no. 422; New York 1993b, no. 300 (citing earlier references); Susan Alyson Stein, "A History of the Collection," in New York 1995, p. 54;

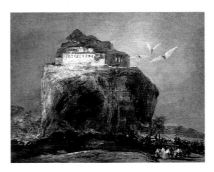

Manuela B. Mena Marqués, "Goya, la question n'est pas résolue," in Lille–Philadelphia 1998–99, p. 31 (Lille ed.)

This painting, long accepted as a Goya, was one of the first works the authenticity of which began to be challenged in the 1960s. Of unknown early provenance, it surfaced in Spain in the 1880s. Strongly questioned in the Gassier-Wilson catalogue raisonné, the painting was included by José Manuel Arnáiz in his tentative catalogue of the works of Eugenio Lucas Velázquez (1817–1870). Arnáiz drew telling comparisons between this picture and two works with a well-known provenance: *The Balloon* and a *Capricho* were among six paintings catalogued as Goyas by Yriarte in 1867 in the collection of Federico de Madrazo, five of which were sold by Madrazo to the comte de Chaudordy, the French ambassador in Madrid in 1874. Chaudordy then bequeathed them to the Musée des Beaux-Arts, Agen. In a note to Yriarte's catalogue, all were said to have come from the collection of Goya's son Javier, no doubt when the grandson, Mariano, began selling off the estate after his father's death in 1854.[1] The authenticity of all six works has been challenged.[2] Arnáiz linked the two works mentioned above with others that were excluded by Gassier-Wilson, but he did not connect them with the *X.1* pictures or *Bullfight in a Divided Ring* (cat. 15), although they have many technical features in common, notably the extensive use of a palette knife in distant features of the composition.

The style of Lucas's painting changed considerably over the years and evolved even in his identifiable imitations of Goya's work. His dated works of the 1840s and early 1850s already reveal him as an artist with a wide vocabulary of styles and as an accomplished pasticheur of Goya's paintings, drawings, and prints. Apart from paintings sold by Javier Goya to the Infante Don Sebastián (cat. 14) and to Baron Taylor (cat. 11) in the 1830s—some of them painted with assistance from, if not entirely by, one or more hands other than the artist's—it seems that relatively few works left the family collection before Javier's death in 1854. The questions that remain to be resolved are the dates and circumstances of the production of fraudulent Goyas "from the artist's collection" and the extent to which this activity may have involved Eugenio Lucas, whom the Madrazo family classed with Leonardo Alenza (1807–1845) as a formidable imitator of the works of Velázquez and Goya.[3] In the present picture, motifs from the Black Paintings and the *Disparates*, or *Proverbios*, prints—the flying men

suggest a close connection with Lucas, who owned four copperplates from that series[4]—are juxtaposed to create the kind of wild, romantic imagery that is only now being recognized and gradually removed from Goya's oeuvre. Whether this painting can be securely ascribed to Lucas is a matter to be settled in the future. What is certain is that a spurious and misleading imitation can now be reevaluated as a response to the demand for Goyas by the nineteenth-century art market.

JW-B

1. Yriarte 1867, p. 137; Arnáiz 1981, pp. 116–23; Wilson-Bareau 1996a, p. 166.

2. The works in question are Gassier and Wilson 1971, nos. 201, 876, 902, 956, 975, and the *Capricho* at no. 956.

3. See Théophile Thoré, "Nous avons eu dans les dernières années deux fameux falsificateurs de Velázquez et Goya: Alenza et Lucas" (Paris, Bibliothèque de l'Arsenal, Thoré Archive), cited in Castres 1999, p. 59; see also Wilson-Bareau 1996b, pp. 100–101.

4. The airborne figures were lifted from plate 13 of the *Proverbios*, first published by the Real Academia in 1864, but available earlier, in a small printing made ca. 1848. See Clifford Ackley, "The Disparates," in Boston–Ottawa 1974–75, p. 251.

17. *Fig. 2.39*

Formerly Francisco de Goya y Lucientes, now Eugenio Lucas Velázquez

The Fight

After 1840(?)
Oil on tinplate
8⅝ x 12¾ in. (22 x 32.5 cm)
Musée des Beaux-Arts et d'Archéologie,
Besançon 896.1.331

CATALOGUES RAISONNÉS: Gudiol 1970, no. 686 [1980, no. 656]; Gassier and Wilson 1971, no. 1657c; De Angelis 1974, no. 646

PROVENANCE: Jean Gigoux, Paris; his bequest to the Musée des Beaux-Arts et d'Archéologie, Besançon, 1894

EXHIBITION: Paris 2002–3, no. 23

REFERENCES
19th century: Yriarte 1867, p. 151 ("Sujet tiré de la Bible"[?], as by Goya)

20th century (selected references): Lafond 1902, p. 111, no. 84 (as by Goya); Lapret 1902, pp. 23–24, no. 183 (one of three sketches, as by Goya); Desparmet Fitz-Gerald 1928–50, vol. 2, n. p. 275 (as by Lucas)

18.

Fig. 2.40

**Formerly Francisco de Goya y Lucientes,
now Eugenio Lucas Velázquez**

The Victim

After 1840(?)

Oil on tinplate

8⅝ x 12⅝ in. (22 x 32 cm)

Musée des Beaux-Arts et d'Archéologie,
Besançon 896.1.343

CATALOGUES RAISONNÉS: Gudiol 1970, no. 687
[1980, no. 657]; Gassier and Wilson 1971, no. 1657d;
De Angelis 1974, no. 645

PROVENANCE: Jean Gigoux, Paris; his bequest
to the Musée des Beaux-Arts et d'Archéologie,
Besançon, 1894

EXHIBITION: Paris 2002–3, no. 24

REFERENCES

19th century: Yriarte 1867, p. 151 (undescribed)

20th century (selected references): Lafond 1902 (unde-
scribed); Lapret 1902, pp. 23–24, no. 183 (one of
three sketches, as by Goya); Desparmet Fitz-Gerald
1928–50, vol. 2, n. p. 275 (as by Lucas)

The Fight, The Victim, and two other small paint-
ings on tinplate form a series that belonged to the
artist Jean Gigoux (1806–1894). Gigoux also owned
the two panels of *Cannibals* (cat. 7), masterpieces of
Goya's maturity that are finely and delicately han-
dled in spite of their terrible subject. The four tin-
plate pictures are very different. These romantic,
almost expressionistic works are close in style to
Goya's Black Paintings and may have been painted
by Eugenio Lucas Velázquez (1817–1870).[1] The
inventory of Gigoux's collection was made by Paul
Lapret, his pupil, executor, and sole heir, who attrib-
uted all six works to Goya, no doubt on the basis of
notes made by the collector.[2] The attribution of
these works has varied according to the ideas that
various specialists have formed concerning the oeu-
vre of Goya and that of Lucas.[3] One of the paint-
ings is an interpretation (in reverse, and therefore
with a possibly fraudulent intention) of Goya's lith-
ograph *A Woman Reading,* executed about 1819.[4]
In Lapret's catalogue, one of the works is connected
with the biblical story of Joseph and his brothers,
but in fact these dark and violent scenes may never
have had a particular significance.

The oils are rhythmically and broadly brushed
over a dark ground in a way that accentuates the
drama of the small compositions. Although gestural
and powerful in their intensity, the paintings display
none of the meaningless violence or the hysterical
stares and gestures that so often characterize the
works of Lucas Velázquez.[5] They nevertheless
appear stylistically compatible with a number of
paintings by Lucas.[6] Their subjects imply an inti-
mate knowledge of Goya's work: one picture is
based on a rare lithograph, already mentioned; oth-
ers are related to the Black Paintings in the Quinta
del Sordo; and they recall above all Goya's private
albums of drawings and the prints of *The Disasters
of War,* in which figures fight or collapse and die,
and of the *Proverbs,* in which gestures and actions
are often both passionate and incomprehensible.
Those print series were not published until 1863 and
1864, respectively, and Lucas himself owned four
copperplates from the *Disparates* or *Proverbs* series
that were first printed in Paris in 1877.[7]

The date of Gigoux's acquisition of these works
and their origin are unknown (see cat. 7). The artist,
evidently a compulsive collector, is mentioned in the
Guide Joanne to Paris in 1863, in the section devoted
to "Private collections": "M. Gigoux, rue Beaujon,
17.—Large collection of drawings by masters of all
schools; many paintings, many prints."[8] It comes as
no surprise that such manifestly authentic works as
the pair of *Cannibals* (cat. 7) should have entered the
collection of a French artist, alongside some good,
Goyaesque pastiches, by the date of Yriarte's 1867
catalogue. JW-B

1. These works are not included as by Lucas in Trapier 1940,
 or in Arnáiz 1981, in which the corpus—an "Intento de
 catalogación"—is nevertheless deliberately all-embracing.
 Paris 2002–3, fig. 153 (p. 258), erroneously reproduces, in
 place of *The Fight,* the work whose subject is usually
 identified as *Jacob's Sons Bringing Joseph's Bloody Tunic to
 Their Father* (Gassier and Wilson 1971, no. 1657b).
2. The inventory is preserved in the Bibliothèque Municipale
 at Besançon. Ghislaine Courtet kindly provided information
 concerning Gigoux, Paul Lapret, and the collection. See
 Gudiol 1970, no. 687 (where it is noted that Gigoux appears
 to have acquired his collection in the 1840s), and Morales y
 Marín 1994, pp. 346–47, nos. 493–96 (this publication,
 closely based on those of Gudiol, contains material errors
 that precluded its use in the present catalogue).
3. Since the works had not been examined at first hand, the
 Gassier-Wilson catalogue abstained from any commentary
 for or against an attribution to Goya. The attribution to
 Goya was unquestioned by Barghahn 1993.
4. Gudiol 1970, no. 684 [1980, no. 654]; Gassier and Wilson
 1971, no. 1657a; De Angelis 1974, no. 643. For the litho-
 graph, see T. Harris 1964, vol. 2, no. 276; Gassier and
 Wilson 1971, no. 1699 (erroneously as in the Bordeaux
 period); Madrid 1990a, p. 57, repr.
5. Research by Arnáiz 1981 and Baticle 1972 has dispelled the
 confusion concerning the names and dates of Eugenio
 Lucas Velázquez (1817–1870) and of his son Eugenio Lucas
 Villaamil (1858–1918).
6. See Arnáiz 1981, pp. 446–47, no. 297.
7. Original prints from the four plates, which had remained
 apart from the eighteen published by the Real Academia de
 San Fernando, Madrid, appeared in Yriarte 1877, facing
 pp. 6, 40, 56, 82. See T. Harris 1964, vol. 2, nos. 266–69;
 Gassier and Wilson 1971, nos. 1601–4.
8. "Nombreuse collection de dessins par des maîtres de toutes
 les écoles; beaucoup de tableaux, beaucoup d'estampes."
 Joanne 1863, "Les collections particulières," p. 709. At the
 time of his death, Gigoux's collection included 3,000 drawings
 and 460 paintings, many of them Spanish. See the introduc-
 tion to Pinette and Soulier-François 1992.

19–24.
COPIES AFTER VELÁZQUEZ

On July 28, 1778, an announcement appeared on the
back page of the *Gaceta de Madrid* for "nine prints
drawn and etched by the Painter *Don Francisco
Goya,* after the lifesize originals in oils by *D. Diego
Velázquez* in the collection at the Royal Palace in
Madrid."[1] The advertisement listed five equestrian
portraits—of Philip III and Philip IV, their respec-
tive queens, and the conde-duque de Olivares—and
"standing figures of *Menippus* and *Aesop* and two
seated dwarfs" (cats. 20, 19).[2] It also gave the names
and addresses of the two bookshops where the prints
could be purchased, as well as their prices.

The background of this project is not entirely
clear. Goya had been summoned to Madrid from
Saragossa three years earlier in order to paint tapes-
try cartoons for the Spanish court. His enterprise
and originality had been remarked upon by Anton
Raphael Mengs, the chief court painter, and by
Antonio Ponz, the secretary of the Real Academia
de Bellas Artes de San Fernando. Both men were
acutely aware of the importance of Spain's art treas-
ures and anxious that they should become much
more widely known, particularly abroad. Along
with current projects to make professional copper-
plate engravings of such works, and perhaps as part
of that initiative,[3] young painters at the Real Fábrica
de Tapices (royal tapestry factory) began to use the
etching technique, a much swifter, less laborious
process, to copy paintings in the royal collections.
Goya chose to copy the works of Velázquez.

The nine prints published in July 1778 were
evidently part of a more ambitious program. Two
further prints—of the equestrian portrait of Baltasar
Carlos (cat. 21) and the painting known as *Los
Borrachos* (cat. 22)[4]—were announced in the *Gaceta*
five months later, on December 22, 1778. In 1792,
two more copperplates, etched and aquatinted with
copies after Velázquez's portraits of the Infante Don
Fernando (cat. 23) and the jester known as
Barbarroja, were acquired and published by the Real
Calcografía.[5] Rare or unique proofs of an additional
four aquatinted prints, including Goya's valiant
attempt to reproduce Velázquez's great masterpiece
Las Meninas (cat. 24), have also survived, as well as
four preparatory drawings. It has been suggested
that all the aquatinted prints belong to a later
group, perhaps made in 1785. The new technique of
aquatint was developed in France, and Goya's early
attempts to use it were frequently unsuccessful.
However, his copies after Velázquez in pure etching,
first presented in the Academia de San Fernando in
1778, were acclaimed in Spain and found their way
abroad as soon as they appeared.[6] They were col-
lected by William Stirling-Maxwell and catalogued
in *Velázquez and His Works* (London, 1855),[7] and
were reprinted at intervals throughout the nine-
teenth century in Madrid.[8] In 1856, as part of its
major purchase of eighty-nine prints by Goya, the
Bibliothèque Impériale in Paris acquired "thirteen
etchings after Vélasquez": first-edition impressions
of all the published prints.[9]

JW-B

1. For the original Spanish text and English translations, see Boston–Ottawa 1974–75, p. 19; Vega 1995, p. 145. The latter, along with Jesusa Vega, "Pinturas de Velázquez grabadas por Francisco de Goya, pintor," in Vega et al. 2000, pp. 47–94, provides the fullest account to date of Goya's project and its context. See T. Harris 1964, vol. 2, nos. 4–19; Gassier and Wilson 1971, nos. 88–117; Wilson-Bareau 1981, pp. 18–22; Frankfurt 1991–92; Juliet Wilson-Bareau, "Goya, pintor y grabado," in Madrid 1996e, pp. 41–42 (nos. 79–104); Enriqueta Harris, "Velázquez and His Works, by William Stirling," in Stirling-Maxwell 1855 (1999 ed.), pp. 36ff.; Juan Carrete Parrondo, "Catalogue of Prints after Works of Velázquez by Stirling in 1855," in ibid., pp. 356ff.

2. Prado inv. 1176–1179, 1181, 1201, 1202, 1206, 1207; López-Rey 1996, vol. 2, nos. 66, 68–71, 92, 93, 102, 103.

3. See Rose 1981.

4. Prado inv. 1180 and 1170; López-Rey 1996, vol. 2, pp. 41, 72.

5. Prado inv. 1186 and 1199; López-Rey 1996, vol. 2, pp. 64, 84.

6. See "Rapport sur les progrès littéraires pour ce dernier semestre," dated October 21, 1778, by Pietro Paolo Giusti, addressed (in French) to the Austrian grand chancellor Prince Wenzel Anton Kaunitz in Vienna: in Velázquez 1963, document 206, p. 176; and in Juretschke 1970–, vol. 13, no. 12, pp. 79–81. The authors quote from two different documents in the Österreichisches Nationalbibliothek (Austrian National Library) in Vienna, and I am grateful to Dr. Andreas Fingernagel for providing copies of a third manuscript, Cod. 13969, f. 9–11 (mentioned by Juretschke under no. 12); English trans. (from Velázquez's text) in Glendinning 1977, p. 35. Gudrun Maurer in Madrid and Marietta Mautner in Vienna offered unstinting help with the complexities of the Giusti report. For Lord Grantham's enthusiasm, see Glendinning et al. 1999, p. 601.

7. Stirling-Maxwell 1855 (1999 ed.), pp. 367–417, nos. 25, 39, 45, 47, 49, 56, 58, 70, 76, 94, 101, 150, 153, 154.

8. Glendinning 1989b, pp. 394–403.

9. Documents in the Département des Estampes, Bibliothèque Nationale de France, Paris, relating to the acquisition: A1930, registered on November 20, 1856 (Rés. Ye-88-Pet. fol., 1856, no. 1930); see also the register of "Demandes d'autorisation d'acquisition" (Rés. Ye-88a-Pet. fol., f° 258).

19. (New York only) Fig. 9.59

Francisco de Goya y Lucientes

Aesop, Copy after Velázquez

By July 1778
Etching
11⅞ x 8½ in. (30 x 21.5 cm)
Etched inscription upper right: *ÆSOPVS;* first edition, July 1778, with letters/engraved inscription in lower margin: *Sacada y gravada del Quadro original*

de D. Diego Velázquez que existe en el R. Palacio de Madrid, por D. Fran.co Goya Pintor, /año de 1778. Representa á Esopo el Fabulador de la estatura natural.
The Metropolitan Museum of Art, New York, Rogers Fund, 1931 31.31.16

CATALOGUES RAISONNÉS: Delteil 1922, no. 16; T. Harris 1964, vol. 2, no. 13.III.1; Gassier and Wilson 1971, no. 101

RELATED WORK: The painting by Velázquez (cat. 75)

20. (New York only) Fig. 9.60

Francisco de Goya y Lucientes

Menippus, Copy after Velázquez

By July 1778
Etching
11⅞ x 8½ in. (30 x 21.5 cm)
Etched inscription upper left: *MOENIPPVS;* first edition, July 1778, with letters/engraved inscription in lower margin: *Sacada y gravada del Quadro original de D. Diego Velázquez que existe en el R.l Palacio de Madrid, por D. Fran.co Goya Pintor, /año de 1778. Representa á Menipo Filosofo de la estatura natural.*
The Metropolitan Museum of Art, New York, Rogers Fund, 1931 31.31.17

CATALOGUES RAISONNÉS: Delteil 1922, no. 17; T. Harris 1964, vol. 2, no. 14.III.1; Gassier and Wilson 1971, no. 103

RELATED WORK: The painting by Velázquez (cat. 76)

21. (New York only) Fig. 4.16

Francisco de Goya y Lucientes

Baltasar Carlos, Prince of Spain and Son of Philip IV, Copy after Velázquez

By December 1778
Etching and drypoint
13¼ x 8⅛ in. (35 x 22 cm)
First edition, December 1778, with letters/engraved inscription in lower margin: D. BALTASAR CARLOS

PRINCIPE DE ESPAÑA. HIJO DEL REY D. FELIPE IV. / *Pintura de D. Diego Velázquez del tamaño natural, dibujada y grabada por D. Francisco Goya, Pintor. 1778.*
The Metropolitan Museum of Art, New York, Bequest of Grace M. Pugh, 1985 1986.1180.899

CATALOGUES RAISONNÉS: Delteil 1922, no. 10; T. Harris 1964, vol. 2, no. 9.III.1; Gassier and Wilson 1971, no. 95

RELATED WORK: The painting by Velázquez (fig. 4.15)

22. (New York only) Fig. 9.16

Francisco de Goya y Lucientes

Los Borrachos (The Drunkards), Copy after Velázquez

By December 1778
Etching
12⅛ x 16⅞ in. (31.5 x 43 cm)
First edition, December 1778, with letters/engraved inscription in lower margin: *Pintura de Don Diego Velázquez con figuras del tamaño natural en el Real Palacio de Madrid, que representa un BACO fingido coronando algunos /borrachos: dibujada y grabada por D. Francisco Goya, Pintor Año de 1778.*
The Metropolitan Museum of Art, New York, Harris Brisbane Dick Fund, 1924 24.97.1

CATALOGUES RAISONNÉS: Delteil 1922, no. 10; T. Harris 1964, vol. 2, no. 9.III.1; Gassier and Wilson 1971, no. 95

RELATED WORK: The painting by Velázquez (1628–29, Museo del Prado, Madrid, inv. 1170)

23. *(New York only)* *Fig. 5.5*

Francisco de Goya y Lucientes

Infante Don Fernando, Copy after Velázquez

Ca. 1785(?)
Etching, aquatint, drypoint or burin, roulette, and burnisher
11 x 6¾ in. (28 x 17 cm)
First edition, 1792, with letters/engraved inscription in lower margin: UN INFANTE DE ESPAÑA. *Pintura de Velázquez del tamaño natur.ˡ en el R.ˡ Palacio de Madrid. Dibux.ᵒ y grabado p.ʳ Fran.ᶜᵒ Goya Pintor.*
Bibliothèque Nationale de France, Département des Estampes, Paris, 1856 Bf 4j rés.

CATALOGUES RAISONNÉS: Delteil 1922, no. 12; T. Harris 1964, vol. 2, no. 11.III.1; Gassier and Wilson 1971, no. 97

PROVENANCE: M. Aznarez, Paris, 1856 (from Mariano Goya via Valentín Carderera?)

RELATED WORK: The painting by Velázquez (ca. 1634, Museo del Prado, Madrid, inv. 1186)

24. *(New York only)* *Fig. 4.14*

Francisco de Goya y Lucientes

Las Meninas, Copy after Velázquez

Ca. 1785(?)
Etching, with drypoint, before roulette and aquatint, retouched with black crayon
16 x 12¾ in. (40.5 x 32.5 cm)

One of two working proofs in the second state; one of seven or eight known sheets printed with a total of ten or twelve proofs
Biblioteca Nacional de España, Madrid 45537

CATALOGUES RAISONNÉS: Delteil 1922, no. 5; T. Harris 1964, vol. 2, no. 17.I.2; Gassier and Wilson 1971, no. 107

PROVENANCE: Valentín Carderera, Madrid; bequest to the Biblioteca Nacional, 1880

SELECTED REFERENCES: Colta Ives, "The Artist and His Works," in New York 1995, pp. 12–14, fig. 3 (recto); Madrid 1996e, p. 50, no. 60

RELATED WORK: The painting by Velázquez (fig. 4.13)

25–32.

Francisco de Goya y Lucientes

Los Caprichos

1797–99
Prints from a set of eighty; first edition, 1799
NY: The Metropolitan Museum of Art, New York, Gift of M. Knoedler and Co., 1918 18.64.1–80
P: Bibliothèque Nationale de France, Département des Estampes, Paris

PROVENANCE: Paul J. Sachs

SELECTED REFERENCES: Wilson-Bareau 1981, pp. 23–41; Eleanor A. Sayre, "Introduction to the Prints and Drawing Series," in Madrid–Boston–New York 1988–89, pp. xcviii–civ; Goya 1999; Paris 2002–3, nos. 4–8

Goya's eighty etched and aquatinted prints were probably all made in 1797 and 1798 and were advertised for sale in the *Diario de Madrid* on February 6, 1799.[1] The prints were issued as a complete set. There was no title page, only a "frontispiece" self-portrait (cat. 25), and no list of prints or explanation of the plates beyond the captions engraved below each image. From the start, the book of prints was known simply as *Caprichos de Goya*, the title that appears on the spine of many contemporary bindings.

Goya's *Caprichos* grew out of a series of preparatory drawings that he entitled *Dreams (Sueños)*.[2] Under cover of the fashionable theme of witchcraft and its absurdities, he launched an attack against the follies, errors, and vices of the society of his day, and in particular against those evils he identified with the Church. The celebrated image *The Sleep of Reason Produces Monsters* was designed as a frontispiece to *Dreams*, as initially conceived; in the set of prints as finally completed, it took its place as plate 43 (cat. 30), where it introduces the witchcraft prints that Goya grouped mainly in the second half of the book. Among the prints that originated as part of the *Dreams* sequence, plate 66 (cat. 31) was based on *Dream 5*, one of the earliest witchcraft drawings. Several comically devilish, allegorical *Dreams* drawings were followed by others with directly social themes: for example, the comedy of

deceit in *Dream 21*, etched as plate 7 of *Los Caprichos* (cat. 27). The prints based on *Dream* drawings are the earliest that Goya made for this new series and are characterized by fine etched lines and a timid, rather tentative use of aquatint. In the final arrangement and numbering of the plates, they were mixed with later prints, made when Goya had completely mastered both the etching and the aquatint techniques. Plates 3 and 15 (cats. 26, 28) are examples of his ability to use these techniques to make powerful aesthetic and moral statements, and these prints were admired and copied by Eugène Delacroix (cats. 112–117) and Alfred de Musset.[3] One of the later and most gruesome of the witchcraft scenes, plate 59, made a profound impression on poets and critics, Baudelaire among them, and was copied and reproduced many times. In a lighter vein, Goya's satire on genealogy and the Spanish obsession with *hidalguía*, the establishment of a pure, untainted lineage, as seen in plate 39 (cat. 29), is one of his most original technical achievements, being worked in pure aquatint, without an etched line.

Goya was evidently obliged to withdraw the prints from sale after just a few days.[4] Less than four years later, he cut his losses by offering the copperplates, together with a large number of unsold sets of the edition, to Charles IV for the Real Calcografía, the royal copperplate printing works, in exchange for a pension for his son. In his letter of July 7, 1803, Goya commented that "foreigners are those most anxious to acquire them."[5] These foreigners included the French ambassador Ferdinand Guillemardet, who arrived in Madrid in July 1798, not long before *Los Caprichos* was published. On his return to Paris eighteen months later, he took with him his portrait painted by Goya (fig. 5.1) and a copy of *Los Caprichos* that was possibly the earliest example to reach France and was later closely studied by Delacroix (cats. 112–117). Several copies had found their way into French private collections by the 1820s, and in 1827, the copy owned by Vivant Denon was purchased at the sale of his collection by the Bibliothèque Royale (now the Bibliothèque Nationale), thereby making the prints more widely available to artists, writers, and connoisseurs.[6] It was above all through the prints of *Los Caprichos* that Goya was known and admired in France in the nineteenth century. JW-B

1. The duque and duquesa de Osuna purchased four copies of *Los Caprichos* from Goya on January 17, 1799, in advance of the press announcement. Goya's receipt of the same date refers to "four books of *caprichos* etched by my own hand" ("cuatro libros de caprichos y grabados à la agua fuerte por mi mano"). See Gassier and Wilson 1971, Appendix 5, p. 384. For documents and contemporary bindings, see T. Harris 1964, vol. 1, p. 103, and Madrid 1996e, pp. 178–79.
2. For this series of drawings, see Gassier 1975, pp. 73–102, nos. 39–65.
3. Musset combined figures from two prints of *Los Caprichos* (see Florisoone 1958, p. 134 n. 2; Lipschutz 1972, p. 152).
4. A second and final advertisement for this edition appeared in another Madrid newspaper on February 19, just thirteen days after the first. See n. 1.
5. T. Harris, vol. 1, pp. 104–6; Goya 1981, pp. 360–61, nos. 223, 224, p. 477, no. CVIII.
6. See Paris 2002–3, nos. 4–8, figs. 52, 53, 64, 66, 68.

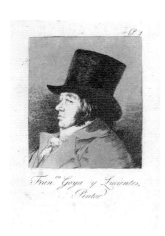

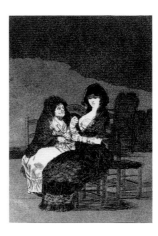

CATALOGUES RAISONNÉS: Delteil 1922, no. 40; T. Harris 1964, vol. 2, no. 48.III.1; Gassier and Wilson 1971, no. 453

Copied in a drawing (cat. 113) and in an etching and aquatint by Delacroix (cat. 119)

CATALOGUES RAISONNÉS: Delteil 1922, no. 52; T. Harris 1964, vol. 2, no. 50.III.1; Gassier and Wilson 1971, no. 481

Copied by Delacroix (Musée du Louvre, RF 10461) and Musset (see Lipschutz 1972, p. 152); reproduced in Goya 1824

25. *(New York only)* Fig. 5.6

Francisco de Goya y Lucientes

Los Caprichos, No. 1: Francisco Goya y Lucientes, Pintor

Etching, aquatint, drypoint, and burin
8⅛ x 6 in. (22 x 15.3 cm)
The Metropolitan Museum of Art, New York, Gift of M. Knoedler & Co., 1918 18.64.1

CATALOGUES RAISONNÉS: Delteil 1922, no. 38; T. Harris 1964, vol. 2, no. 36.III.1; Gassier and Wilson 1971, no. 451

Reproduced in *Magasin Pittoresque*, 1834, no. 41, p. 324; Yriarte 1867, cover and p. 101; Blanc et al. 1869, nos. 494–495 (Goya issues), p. 1

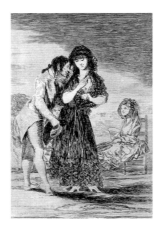

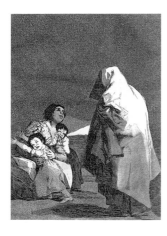

27. *(Paris only)* Fig. 6.5

Francisco de Goya y Lucientes

Los Caprichos, No. 7: Ni asi la distingue (Even Thus He Cannot Make Her Out)

Etching, aquatint, and drypoint
7⅞ x 5⅞ in. (20 x 15 cm)
Signed lower left: *Goya*
P: Bibliothèque Nationale de France, Département des Estampes, Paris (Collection Vivant Denon, A7108)
NY: The Metropolitan Museum of Art, New York, Gift of M. Knoedler & Co., 1918 18.64.7
(not exhibited)

CATALOGUES RAISONNÉS: Delteil 1922, no. 44; T. Harris 1964, vol. 2, no. 42.III.1; Gassier and Wilson 1971, no. 463

Based on *Dream 21;* copied by Delacroix (cat. 112); reproduced in *Gazette des Beaux-Arts*, August 1860, p. 215, and February 1868, p. 169; Yriarte 1867, p. 101

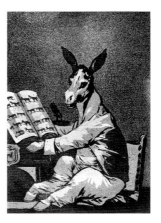

29. *(Paris only)* Fig. 5.26

Francisco de Goya y Lucientes

Los Caprichos, No. 39: Asta su abuelo (As Far Back as His Grandfather)

Etching and aquatint
8⅛ x 6 in. (21.8 x 15.4 cm)
P: Bibliothèque Nationale de France, Département des Estampes, Paris (Collection Vivant Denon, A7108)
NY: The Metropolitan Museum of Art, New York, Gift of M. Knoedler & Co., 1918 18.64.39
(not exhibited)

CATALOGUES RAISONNÉS: Delteil 1922, no. 76; T. Harris 1964, vol. 2, no. 74.III.1; Gassier and Wilson 1971, no. 526

Copied by Delacroix (cat. 116); reproduced in *Magasin Pittoresque*, 1834, p. 325

26. Fig. 5.29

Francisco de Goya y Lucientes

Los Caprichos, No. 3: Que viene el Coco (Here Comes the Bogeyman)

Etching and burnished aquatint
8⅛ x 6 in. (21.9 x 15.4 cm)
NY: The Metropolitan Museum of Art, New York, Gift of M. Knoedler & Co., 1918 18.64.3
P: Bibliothèque Nationale de France, Département des Estampes, Paris (Collection Vivant Denon, A7108)

28. Fig. 9.84

Francisco de Goya y Lucientes

Los Caprichos, No. 15: Bellos consejos (Fine Advice)

Etching, burnished aquatint, and burin
8⅛ x 6 in. (22 x 15.4 cm)
NY: The Metropolitan Museum of Art, New York, Gift of M. Knoedler & Co., 1918 18.64.15
P: Bibliothèque Nationale de France, Département des Estampes, Paris (Collection Vivant Denon, A7108)

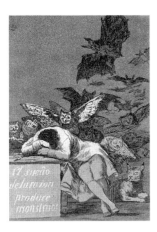

30. *(New York only)* Fig. 6.3

Francisco de Goya y Lucientes

Los Caprichos, No. 43: El sueño de la razón produce monstruos (The Sleep of Reason Produces Monsters)

Etching and aquatint
8½ x 6 in. (21.7 x 15.2 cm)
The Metropolitan Museum of Art, New York, Gift of M. Knoedler & Co., 1918 18.64.43

CATALOGUES RAISONNÉS: Delteil 1922, no. 80; T. Harris 1964, vol. 2, no. 78.III.1; Gassier and Wilson 1971, no. 536

Based on *Dream 1;* reproduced in Goya 1824; pastiched as a caricature in *Le Charivari*, February 6, 1834 (cat. 91)

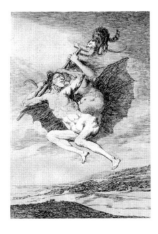

31. Fig. 6.9

Francisco de Goya y Lucientes

Los Caprichos, No. 66: Allá vá eso (There It Goes)

Etching, aquatint, and drypoint
8¼ x 6⅛ in. (21 x 16.7 cm)
NY: The Metropolitan Museum of Art, New York, Gift of M. Knoedler & Co., 1918 18.64.66
P: Bibliothèque Nationale de France, Département des Estampes, Paris (Collection Vivant Denon, A7108)

CATALOGUES RAISONNÉS: Delteil 1922, no. 103; T. Harris 1964, vol. 2, no. 101.III.1; Gassier and Wilson 1971, no. 583

Based on *Dream 5;* copied by Delacroix (cat. 114) and used as a basis for his *Mephistopheles Aloft* (cat. 120)

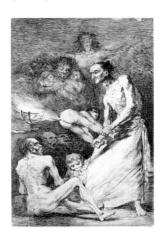

32. *(New York only)* Fig. 6.7

Francisco de Goya y Lucientes

Los Caprichos, No. 69: Sopla (Blow)

Etching, aquatint, drypoint, and burin
8⅛ x 6 in. (21.4 x 15.2 cm)
Signed lower left: *Goya*
The Metropolitan Museum of Art, New York, Gift of M. Knoedler & Co., 1918 18.64.69

CATALOGUES RAISONNÉS: Delteil 1922, no. 106; T. Harris 1964, vol. 2, no. 104.III.1; Gassier and Wilson 1971, no. 589

Based on *Dream 7;* copied by Delacroix (cat. 117)

33–37.

Francisco de Goya y Lucientes

The Disasters of War (Los Desastres de la guerra)

1810–ca. 1819(?)
Prints from the series of eighty etchings with aquatint and/or lavis
Contemporary working proofs before the engraved titles (nos. 15, 38) and first-edition impressions, 1863 (nos. 2, 37, 47)

SELECTED REFERENCES: Wilson-Bareau 1981, pp. 43–60; Eleanor A. Sayre, "Introduction to the Prints and Drawing Series," in Madrid–Boston–New York 1988–89, pp. cix–cxii; Goya 2000

The uprising of the citizens of Madrid against the invading French troops on May 2, 1808, and the harsh reprisals carried out on the following day were events that Goya himself must have witnessed, at least from the sidelines (figs. 1.17, 1.18). He traveled to his native Aragon later that year to see the havoc caused by the first of two sieges of Saragossa by the

French. In 1810 the artist signed and dated the first prints in a new series. Between this date and the end of the war in 1814, and continuing perhaps as late as 1819, Goya etched and aquatinted a series of eighty-two copperplates. More than half of them, in plates 2 to 47, illustrate the guerrilla war waged by Spanish patriots against Napoleon's troops and atrocities committed by both sides (cats. 33–37); these are followed, in plates 48 to 64, by prints showing scenes of the famine that affected Madrid in 1811–12. The series was completed, perhaps speedily, perhaps over a period of years, by a group of new allegorical and satirical *caprichos* (caprices) on copperplates of a uniformly larger size. They include plate 1, a frontispiece to the series, and the allegorical plates 65 to 82.[1]

During the war itself and the ensuing repressive regime of Ferdinand VII, Goya was unable to publish his prints; they remained virtually unknown for many years. From the numerous proofs printed while he was working on the series, possibly with the idea of circulating the prints privately, he made two complete sets, adding manuscript captions to one of them (British Museum, London). This set, bound for his friend Juan Agustín Ceán Bermúdez, has Goya's title inscribed on the front page: *Fatal Consequences of the Bloody War in Spain against Bonaparte, and Other Allegorical Caprichos.*[2] Long after Goya's death, eighty of the eighty-two copperplates were acquired by the Real Academia de Bellas Artes de San Fernando, Madrid. The artist's captions were engraved on the plates, copied from Ceán Bermúdez's set, which by then had passed to Valentín Carderera, but Goya's long title was rejected in favor of *The Disasters of War (Los Desastres de la guerra)*, by which name the series has been known since its publication in 1863.

Goya probably printed the plates of *The Disasters* himself during the war and its aftermath. Although the quality of the proofs is variable, they can be extraordinarily beautiful. The posthumous first edition, published in 1863, did not follow Goya's style but was made in accordance with mid-nineteenth-century taste and printing techniques; a thin film of ink left on the surface of the plate dulled the effect intended by Goya: a clear contrast between the brilliant luminosity of fine handmade rag paper and the areas of shadow (produced by linear hatching or by aquatint or, in this series, by washes of acid known as lavis). Two of the prints exhibited and reproduced here come from a group of Goya's early proofs, while others, from the 1863 edition, serve to demonstrate the difference in printing techniques and to illustrate the prints that were more widely available in France from the 1860s.

The first impressions of *The Disasters of War* to reach a public collection in France were a superb group of thirty-nine working proofs. These "Scenes of the Invasion" were purchased by the Bibliothèque Impériale (now the Bibliothèque Nationale), with other rare Goyas, from a Spaniard in Paris in 1856; the acquisition request for a group of "89 autograph pieces by Goya," signed by Achille Devéria for the curators on October 29 and sanctioned "the same day, as a matter of urgency," was authorized by the minister on November 20.[3] The Goyas were acquired together with a varied collection

of twenty-six Spanish prints. In conjunction with the volume of *Los Caprichos* purchased in 1827,[4] they provided the Bibliothèque with an impressive group of Spanish prints that Manet could have consulted from 1858, when he began to frequent the print room of the Bibliothèque Impériale.

JW-B

1. There has been disagreement about the dating of these larger etchings. Five of them were included among, and relate to, the war scenes (pls. 8, 28, 29, 40, 42), and it is possible that Goya acquired a fresh batch of plates in order to complete his series of war and famine prints at the end of the conflict and before supplies of good-quality, imported plates had become available. See the analysis of various views in Goya 2000, vol. 1, p. 62 n. 99.

2. *Fatales consequencias /de la sangrienta guerra en España /con Buonaparte. / Y otros caprichos enfaticos, /en 85 estampas. / Inventadas, dibuxadas y grabadas, /por el pintor original /D. Francisco de Goya y Lucientes. /En Madrid.* The eighty-five plates include the two plates 81 and 82 that were never printed with the eighty of the normal editions, and three prints of "Prisoners" (T. Harris 1964, vol. 2, nos. 26–28; Gassier and Wilson 1971, nos. 986, 988, 990).

3. The proofs, listed as "Scènes de l'invasion," formed part of a lot of "89 pièces de la main de Goya"; see "Demandes d'autorisation d'acquisition," citing the name and address of "M.ʳ Aznarez, rue S.ᵗ Georges n.° 58" (Rés. Ye-88ᵃ-Pet. fol.: 1848–1857, f⁰ 258). See also the "Registre des acquisitions," November 20, 1856, no. 1930 (Rés. Ye-88-Pet. fol.: 1848–1907, f⁰ 258). Bibliothèque Nationale, Paris, Département des Estampes et de la Photographie. See Paris 2002–3, nos. 11, 12.

4. See Paris 2002–3, nos. 4–8.

33.

Fig. 9.73

Francisco de Goya y Lucientes

The Disasters of War, No. 2: Con raȝon ó sin ella (Rightly or Wrongly)

Ca. 1812–14
Etching, lavis, and drypoint; first edition with letters, 1863
5⅞ x 8¼ in. (15 x 20.9 cm)
NY: The Metropolitan Museum of Art, New York, Purchase, Rogers Fund and Jacob H. Schiff Bequest, 1922 22.60.25 (2)
P: Bibliothèque Nationale de France, Département des Estampes, Paris A1930, 1856

CATALOGUES RAISONNÉS: Delteil 1922, no. 122; T. Harris 1964, vol. 2, no. 123.III.1; Gassier and Wilson 1971, no. 996

This print anticipates Goya's two monumental paintings that record the uprising and executions of May 2 and 3, 1808 (figs. 1.17, 1.18).

34. *(New York only)*

Fig. 5.12

Francisco de Goya y Lucientes

The Disasters of War, No. 15: Y no hai remedio (And It Can't Be Helped)

Ca. 1810–11
Etching, drypoint, and burin; contemporary working proof before numbers; before letters
5⅝ x 6⅝ in. (14.2 x 16.8 cm)
The Metropolitan Museum of Art, New York, Harris Brisbane Dick Fund, 1932 32.62.17

CATALOGUES RAISONNÉS: Delteil 1922, no. 134; T. Harris 1964, vol. 2, no. 135.I.1; Gassier and Wilson 1971, no. 1015

This composition and three others were etched on the backs of two very beautiful landscape plates that Goya, short of materials, sacrificed by cutting each one in two (T. Harris 1964, vol. 2, nos. 23, 24; Gassier and Wilson 1971, nos. 748, 750). The print anticipates aspects of Goya's *The Third of May 1808* (fig. 1.18), painted in 1814, when the war had ended.

35. *(New York only)*

Fig. 5.13

Francisco de Goya y Lucientes

The Disasters of War, No. 37: Esto es peor (This Is Worse)

Ca. 1812–14
Etching, lavis, drypoint, and burin; first edition with letters, 1863

6⅛ x 8⅛ in. (15.7 x 20.8 cm)
The Metropolitan Museum of Art, New York, Purchase, Rogers Fund and Jacob H. Schiff Bequest, 1922 22.60.25 (37)

CATALOGUES RAISONNÉS: Delteil 1922, no. 156; T. Harris 1964, vol. 2, no. 157; Gassier and Wilson 1971, no. 1052

In his records of brutally dismembered bodies, Goya drew inspiration from antique sculpture.

36. *(Paris only)*

Fig. 9.74

Francisco de Goya y Lucientes

The Disasters of War, No. 38: Bárbaros! (Barbarians!)

Ca. 1812–14
Etching, burnished aquatint, and burin; working proof in the 2nd state, with aquatint to the plate edges, before numbers, burin, or borderline
6³⁄₁₆ x 8³⁄₁₆ in. (15.8 x 20.8 cm)
P: Bibliothèque Nationale de France, Département des Estampes, Paris A1930, 1856
NY: The Metropolitan Museum of Art, New York, Purchase, Rogers Fund and Jacob H. Schiff Bequest, 1922 22.60.25 (38) (not exhibited)

CATALOGUES RAISONNÉS: Delteil 1922, no. 157; T. Harris 1964, vol. 2, no. 158.I.2; Gassier and Wilson 1971, no. 1053

37. *(New York only)*

Fig. 5.14

Francisco de Goya y Lucientes

The Disasters of War, No. 47: Así sucedió (This Is How It Happened)

Ca. 1812–14
Etching, drypoint, burin, and lavis; first edition with letters, 1863
6⅛ x 8¼ in. (15.6 x 20.9 cm)
The Metropolitan Museum of Art, New York, Purchase, Rogers Fund and Jacob H. Schiff Bequest, 1922 22.60.25 (47)

CATALOGUES RAISONNÉS: Delteil 1922, no. 166; T. Harris 1964, vol. 2, no. 167.III.1; Gassier and Wilson 1971, no. 1069

A priest kneels crumpled against the altar rail as French soldiers hasten off with their booty: a richly adorned religious image, cross, candlesticks, and a sack of other loot.

38–41.

Francisco de Goya y Lucientes

La Tauromaquia (The Art of Bullfighting)

1815–16
Prints from the series of thirty-three plates with etching and aquatint published in Goya's lifetime (first edition 1816)

SELECTED REFERENCES: T. Harris 1964, vol. 1, pp. 173–76; Boston–Ottawa 1974–75, pp. 197–250; Wilson-Bareau 1981, pp. 61–75; Goya 2001

Goya's set of bullfighting prints, etched and aquatinted in 1815 and 1816, was offered for sale in sheet form, as single prints or complete sets. A list of prints appears on an explanatory page, titled "Treinta y tre estampas que representan diferentes suertes y actitudes del arte de lidiar los Toros, inventadas y grabadas al agua fuerte en Madrid por Don Francisco de Goya y Lucientes" ("Thirty-three prints that represent different maneuvers and actions in the art of bullfighting, invented and etched in Madrid by Don Francisco de Goya y Lucientes." The series was announced in the *Diario de Madrid* of October 28, 1816, but appears not to have met with much success. The originality of Goya's compositions and technique probably found little favor with a public accustomed to the traditional, didactic, and essentially inartistic sets of bullfight prints that were widely available.

The artist began by etching contemporary scenes in the bullring—several of which are signed and dated 1815. He went on to elaborate a visual history of bullfighting, from its supposed primitive origins, through its development by the Moors, who transformed the hunting of bulls into an art with its own rules and customs, its practice by the Catholic kings and the nobility, and its adoption in Goya's own day by men of the people who fought on foot and were idolized for their skill and courage. This progression from contemporary to historical in the making of the prints is demonstrated by the fact that several of the historical subjects are engraved on the backs of plates previously used for contemporary scenes that had been rejected for technical defects or, perhaps, for unsatisfactory compositions.

The first edition was printed with great care on fine paper, in a manner similar to that of *Los Caprichos*. According to Paul Lefort, author of the first detailed catalogue of Goya's prints (1867–68), relatively few sets of the *Tauromaquia* were sold, and the bulk of the first edition remained with the artist's family, to be dispersed only after the death of Goya's son in 1854. The Bibliothèque Impériale in Paris purchased a complete set in 1856, together with the working proofs of *The Disasters of War* (cats. 33–37). A second edition was published in Madrid in 1855, thus making these remarkable compositions available to a wider public. The copperplates found their way to Paris and were printed there in 1876 by Loizelet, who added seven rejected prints from the backs of the plates to the thirty-three already published, bringing the total to forty.

JW-B

38. *Fig. 9.35*

Francisco de Goya y Lucientes

La Tauromaquia (The Art of Bullfighting), No. 5: El animoso moro Gazul es el primero que lanceó toros en regla (The Courageous Moor Gazul Was the First Who Speared Bulls According to Rules)

Etching and aquatint with drypoint
9⅞ x 14⅛ in. (25 x 35.8 cm)
NY: The Metropolitan Museum of Art, New York, Rogers Fund, 1921 21.19.5
P: Bibliothèque Nationale de France, Département des Estampes, Paris A1930, 1856

CATALOGUES RAISONNÉS: Delteil 1922, no. 228; T. Harris 1964, vol. 2, no. 208.III.1; Gassier and Wilson 1971, no. 1157

This print was used by Manet for the picador and bull in *Mlle V . . . in the Costume of an Espada* (cat. 139). The related drawing was acquired by Charles Yriarte and reproduced in Yriarte 1877, p. 79.

39. *(New York only)* *Fig. 9.36*

Francisco de Goya y Lucientes

La Tauromaquia (The Art of Bullfighting), No. 19: [Temeridad de Martincho en la plaza de Zaragoza] Otra locura suya en

la misma plaza ([Boldness of Martincho in the Bullring at Saragossa] Another Madness of His in the Same Bullring)

Etching, aquatint, drypoint, and burin
9¾ x 14 in. (24.7 x 35.5 cm)
Signed and dated lower right: *Goya 1815*
The Metropolitan Museum of Art, New York, Rogers Fund, 1921 21.19.19

CATALOGUES RAISONNÉS: Delteil 1922, no. 242; T. Harris 1964, vol. 2, no. 222.III.1; Gassier and Wilson 1971, no. 1188

The title follows from that of plate 18. Figures from the group at far right were used by Manet in the backgrounds of *Mlle V . . . in the Costume of an Espada* (cat. 139) and *The Spanish Ballet* (cat. 136).

40. *(Paris only)* *Fig. 5.15*

Francisco de Goya y Lucientes

La Tauromaquia (The Art of Bullfighting), No. 28: El esforzado Rendon picando un toro, de cuya suerte murió en la plaza de Madrid (The Forceful Rendon Stabs the Bull with the Pica, From Which Pass He Died in the Ring at Madrid)

Etching, burnished aquatint, and burin
10 x 14 in. (25.5 x 35.6 cm)
Signed lower right: *Goya*
P: Bibliothèque Nationale de France, Département des Estampes, Paris A1930, 1856
NY: The Metropolitan Museum of Art, New York, Rogers Fund, 1921 21.19.28 (not exhibited)

CATALOGUES RAISONNÉS: Delteil 1922, no. 251; T. Harris 1964, vol. 2, no. 231.III.1; Gassier and Wilson 1971, no. 1206

41. Fig. 5.16

Francisco de Goya y Lucientes

*La Tauromaquia (The Art of Bullfighting),
No. 33: La desgraciada muerte de
Pepe Illo en la plaza de Madrid (The
Unfortunate Death of Pepe Illo in the
Bullring at Madrid)*

Etching, aquatint, drypoint, and burin
9¼ x 14 in. (24.9 x 35.5 cm)
NY: The Metropolitan Museum of Art, New York,
Rogers Fund, 1921 21.19.33
P: Bibliothèque Nationale de France, Département
des Estampes, Paris A1930, 1856

CATALOGUES RAISONNÉS: Delteil 1922, no. 256;
T. Harris 1964, vol. 2, no. 236.III.1; Gassier and
Wilson 1971, no. 1217

42–45.

Francisco de Goya y Lucientes
The Bulls of Bordeaux

1825
The set of four crayon lithographs, two with titles,
as published

SELECTED REFERENCES: Sayre 1966; Wilson-
Bareau 1981, pp. 90–95; Madrid 1990a, pp. 60–63

This set of four large lithographs, drawn on stone
by Goya in Bordeaux, was printed by the master
lithographer Cyprien Charles Marie Nicolas Gaulon,
who, on three separate dates—November 17 and 29
and December 23, 1825—registered an edition of
one hundred large-folio prints of *Courses de taureaux
(Bullfights)*.[1] On December 6, Goya wrote to his
friend Joaquín María Ferrer in Paris about this ambi-
tious project: "I sent you a lithographic proof that
shows a fight with young bulls [cat. 44] so that you
and our friend Cardano might see it and if you
thought that some could be disposed of I would
send as many as you like; I put this message with the
print and having had no response I am writing
again, begging you to let me know because I have
now made three more bullfight subjects of the same
size." We know from Goya's next letter, written on
December 20, that Ferrer's reply was unenthusiastic
(he suggested that Goya would do better to reprint
Los Caprichos). The eighty-year-old artist's response
was disarming: referring to the many art connois-
seurs in the capital and the large number of people,

apart from Spaniards, who might be expected to see
the lithographs, he wrote: "I thought it would be
easy to give them to a printseller without mention-
ing my name and for a low price."[2]

Goya's companion and assistant in Bordeaux
was the young Spanish artist Antonio Brugada. He
told Laurent Matheron, Goya's first French biogra-
pher, how the prints were made: "The artist worked
at his lithographs on an easel, the stone placed like a
canvas. He handled his crayons like brushes and
never sharpened them. He remained standing, walk-
ing backwards and forwards every other minute to
judge his effects. . . . You might laugh if I said that
all Goya's lithographs were executed with a magni-
fying glass. It was not in order to do very detailed
work but because his eyesight was failing."[3] As
well as using his crayons, Goya wielded the point
of a knife to carve brilliant highlights out of the
stone, achieving effects that were unparalleled in
their day and have never been surpassed. Delacroix,
who owned a major group of Goya's lithographs
by 1848,[4] had probably seen these prints much
earlier, when he began to work in this technique (see
cat. 120). Years later, Manet's early lithographs
(see cat. 179) reveal his debt to Goya.

JW-B

1. Delteil 1922, vol. 15, n.p., "Les Taureaux, dits de Bordeaux
(Nos. 286–89)"; the manuscript entries in the register of the
Dépôt Légal of the Gironde department are reproduced.
2. "le enviaba a V. un ensayo litográfico q.ᵉ representa una cor-
rida de novillos a fin de q.ᵉ la viese V. y el amigo Cardano y
si la encontraban digna de despachar algunos enviaré los q.ᵉ
V. quisiere; este escrito lo meti en la estampa y no teniendo
noticia, vuelvo a suplicarle a V. me avise p.ʳ q.ᵉ tengo echos
tres mas del mismo tamaño y asunto de toros." "crei q.ᵉ era
facil dandolas a un estampero sin decir mi nombre, y a poco
precio aberse hecho." Sayre 1966, pp. 113–14 (letters II, III);
this author's translation. A set of the lithographs in the
Biblioteca Nacional, Madrid, from the collection of Juan
Agustín Ceán Bermúdez, has numbers and an explanatory
text in Spanish inscribed in pencil on the first print (see
Madrid 1996e, pp. 260–63). That at least one of Goya's
Bulls of Bordeaux reached a provincial, if not a Parisian,
audience is suggested by an entry in the *Bibliographie de la
France*, no. 5 (January 18, 1826), p. 47: under "Gravures et
lithographies" no. 38 appears, among various prints, "El
Famoso Americano Mariano Tabellos [sic]. A Lyon, chez
Brunet." The spelling of the title is so close to that of the
first print in Goya's set of four as to suggest that the
difference is owing to a typographical error.
3. "L'artiste exécutait ses lithographies sur son chevalet, la
pierre posée comme une toile. Il maniait ses crayons comme
des pinceaux, sans jamais les tailler. Il restait debout,
s'éloignant ou se rapprochant à chaque minute pour juger
ses effets. . . . On rirait peut-être si je disais que les lithogra-
phies de Goya ont toutes été exécutées à la loupe. Ce n'était
pas en effet pour faire fin; mais ses yeux s'en allaient."
Matheron 1858, pp. [95–96]; Matheron 1996, pp. 264, 266.
4. Matheron 1858, p. [107] n. 11, records the gift of Goya's
Portrait of Gaulon, together with several other litho-
graphs, to Delacroix "ten years ago." The sale of
Delacroix's collection (Hôtel Drouot, February 17–29,
1864) included two *Bulls of Bordeaux*: lot 829, "Dibersión
de España. Scène de tauromachie," and lot 830, "Autre
scène de tauromachie." These two prints are now in the
Biblioteca Nacional, Madrid, inv. 45715 *(Diversión de
España)* and inv. 45716 *(The Divided Ring)*; see Madrid
1996e, pp. 262–63, nos. 411, 412.

42. *(New York only)* Fig. 5.22

Francisco de Goya y Lucientes

*The Bulls of Bordeaux: El famoso
Americano, Mariano Ceballos (The
Celebrated American, Mariano Ceballos)*

Crayon lithograph with scraping
12¼ x 16 in. (31.2 x 40.5 cm) image
Signed lower left: *Goya*
The Metropolitan Museum of Art, New York,
Bequest of Mrs. Louis H. Porter, 1946 46.103

CATALOGUES RAISONNÉS: Delteil 1922, no. 286;
T. Harris 1964, vol. 2, no. 283 ; Gassier and Wilson
1971, no. 1707

A proof in the Biblioteca Nacional, Madrid (inv.
45704), is lettered in pencil: *I./D. Francisco Goya y
Lucientes, primer pintor de Camara del Rey de España/
y Director de la Real Academia de San Fernando, /
inventó y litografió estas cuatro estampas en Bourdeaux
[sic] el año de 1826 á los 80 de edad*. The image is
based on plate 24 of Goya's earlier *Tauromaquia*
etchings, showing Ceballos "El Indio," a famous
Hispanic bullfighter, mounted on a bull and attack-
ing another bull with short spears.

43. *(New York only)* Fig. 5.23

Francisco de Goya y Lucientes

*The Bulls of Bordeaux: Bravo toro
(A Picador Caught on the Bull's Horns)*

Crayon lithograph with scraping
12¼ x 16¼ in. (31.2 x 41.2 cm) image
Signed lower left: *Goya*
The Metropolitan Museum of Art, New York,
Rogers Fund, 1920 20.60.2

CATALOGUES RAISONNÉS: Delteil 1922, no. 287; T. Harris 1964, vol. 2, no. 284; Gassier and Wilson 1971, no. 1708

A proof in the Biblioteca Nacional, Madrid (inv. 45705), is lettered in pencil: *II*. This is no doubt a variant of one of Goya's earlier etchings showing the death of Pepe Illo (*Tauromaquia* plate F).

44. *Fig. 5.24*

Francisco de Goya y Lucientes

The Bulls of Bordeaux: Dibersión de España (Spanish Entertainment)

Crayon lithograph with scraping
11⅞ x 16⅜ in. (30.2 x 41.5 cm) image
Signed lower left: *Goya*
NY: The Metropolitan Museum of Art, New York, Rogers Fund, 1920 20.60.3
P: Bibliothèque Nationale de France, Département des Estampes, Paris Bf 4l rés.

CATALOGUES RAISONNÉS: Delteil 1922, no. 288; T. Harris 1964, vol. 2, no. 285 ; Gassier and Wilson 1971, no. 1709

This was the print of a *novillada*, a fight with young bulls in which the public participated, that Goya first sent to Ferrer. A proof in the Biblioteca Nacional, Madrid (inv. 45706), is lettered in pencil: *III*. The impression that belonged to Delacroix is now also in the Biblioteca Nacional (inv. 45715).

45. *Fig. 5.25*

Francisco de Goya y Lucientes

The Bulls of Bordeaux: Plaza Partida (The Divided Ring)

Crayon lithograph with scraping
12 x 16⅜ in. (30.6 x 41.6 cm) image
Signed lower edge, toward left: *Goya*
NY: The Metropolitan Museum of Art, New York, Rogers Fund, 1920 20.60.4
P: Bibliothèque Nationale de France, Département des Estampes, Paris Bf 4l rés.

CATALOGUES RAISONNÉS: Delteil 1922, no. 289; T. Harris 1964, vol. 2, no. 286; Gassier and Wilson 1971, no. 1710

A proof in the Biblioteca Nacional, Madrid (inv. 45707), is lettered in pencil: *IV.* The impression that belonged to Delacroix is now also in the Biblioteca Nacional (inv. 45716).

FRANCISCO DE HERRERA THE ELDER

Seville, ca. 1590–Madrid, 1654?

Born in Seville into a family of artists, Herrera was probably trained in painting by his father, a master illuminator and engraver. His earliest known works are etchings that date from 1609, but he was to make his name with the many painting commissions he received from Seville's increasing number of religious institutions. By the 1620s Herrera's work revealed a transition from the Mannerist to the Baroque, reflecting the influence of the naturalism then revolutionizing Sevillian painting. In 1650 he left Seville, which had been decimated by the plague in the spring of 1649, to find work in Madrid, where he died.

 Antonio Palomino noted that Herrera was Velázquez's first teacher and, although this theory remains unproven, it was accepted as truth during the nineteenth century. The Galerie Espagnole exhibited no fewer than thirteen works by Herrera (most of which remain untraced), as well as two paintings by his son Francisco de Herrera the Younger. The Louvre acquired one of the artist's masterworks, *Saint Basil Dictating His Doctrine* (fig. 14.61), from the estate of Marshal Soult in 1858.

 DLR

46. *(Paris only)* *Fig. 14.47*

Francisco de Herrera the Elder

The Temptation of Job

1636
Oil on canvas
84⅛ x 59½ in. (215 x 151 cm)
Signed and dated on stone at lower right: *Franco. de Herrera/faciebat 1636/en Sevilla (Franc[isc]o de Herrera/made this [in] 1636/in Seville)*
Musée des Beaux-Arts, Rouen 844.1

CATALOGUE RAISONNÉ: Martínez Ripoll 1978, no. P.65, fig. 55

PROVENANCE: Purchased from a M. Derbanne by the city of Rouen for the Musée des Beaux-Arts, 1844

SELECTED REFERENCES: Minet 1908, no. 574; Nicolle 1920, p. 7; Thacher 1937, pp. 342, 345, 367–68; Paris 1963b, no. 55, p. 157 (as *Saint Jérôme*); Baticle 1964, pp. 289, 293; Angulo Íñiguez 1966, pp. 194–95; Popovitch 1967, p. 212

The introduction to the 1858 catalogue of the Musée des Beaux-Arts, Rouen, states: "The Museum of Painting of the city of Rouen, originally consisting chiefly of pictures acquired during the Revolution that came from suppressed churches and religious communities, was opened to the public for the first time in 1809."[1] In fact, most of the provincial museums were established in this way under the French Empire and were also the recipients of paintings confiscated during the Napoleonic wars. However, unlike Italian and Flemish seizures, none of the paintings acquired as booty in Spain were sent to provincial capitals.

 Though rich in Italian religious painting, Rouen had only five Spanish canvases in its collection in 1858, all of which came from private collections. The selection included Herrera's *Job*, then titled *Vision of Saint Jerome;* Montero de Rojas's *Death of Abel* (before 1683) and three paintings by Ribera. Of these three, only one, *Saint Zacharias* (ca. 1634), acquired in 1847, is still attributed to Ribera; *The Samaritan* (before 1705), acquired in 1839, is now given to Luca Giordano, and the third was nothing less than Velázquez's *Democritus*, acquired in 1822 and misattributed until 1881 (cat. 70). The religious institution for which Herrera's *Job* was painted is unknown. It is first documented in France in 1844, when it was purchased by the city of Rouen for the Musée des Beaux-Arts from a M. Derbanne. It was, until 1966, considered to be a depiction of Saint Jerome.[2]

 Though Herrera's works were rare in France prior to the opening of the Galerie Espagnole in 1838, information on the artist was not. Nineteenth-century French chroniclers of Spanish painting, among them Frédéric Quilliet, Louis Viardot, and Édouard Laforge, simply translated Juan Agustín Ceán Bermúdez's brief biography of Herrera. In this way French audiences also came to revere the painter as "the first in Andalusia to abandon the timid manner that Spanish painters retained for so

long, soon forming a style for himself that displayed the national genius."[3]

The paintings by Herrera the Elder in the Galerie Espagnole included a *Job on the Dung Heap* (location unknown)[4] that was comparable in size to the Rouen painting, perhaps revealing a common origin. Like that painting, described in the catalogue as "Job, deprived of all his riches, abandoned by his friends, scorned by his wife, humbles himself before the power and justice of God, and awaits his mercy," the present work depicts the beleaguered Job, tormented by the devil, who tries unsuccessfully to tempt him into renouncing God.[5]

By far the most famous work in France by Herrera, however, was the *Saint Basil Dictating His Doctrine* (Musée du Louvre, Paris). Originally from the Soult collection, this painting was termed "a miraculous composition" by Théophile Thoré in his 1835 review of the collection;[6] it entered the Louvre in 1858.

Another of Herrera's masterworks cited in the French sources was *The Last Judgment* (1628–29) painted for the Church of San Bernardo in Seville (in situ), to which the *Job* is indebted.[7] Viardot's comments (again quoting Ceán Bermúdez) on the nudes in that work are equally well applied to Job: "They were unable to make as frequent use of the nude. . . . But when the occasion presented itself, they have always shown a great knowledge of anatomy and imitated nature under its most difficult aspects with a felicity, a sureness that only work and study can confer."[8]

The *Job* is typical of the kind of Spanish Baroque painting that captivated young French artists such as François Bonvin, Alphonse Legros, and Théodule Ribot, all of whom were searching for a manner in which to represent what Thoré had termed in the 1860s "l'art pour l'homme" (art for man).[9] In the harshly realistic figures of Herrera, Ribera, and Zurbarán, nineteenth-century artists found the naturalism that they sought as an antidote to the constrictions of the ideal. DLR

1. "Le Musée de peinture de la ville de Rouen, composé principalement, à son origine, des tableaux recueillis pendant la Révolution, et provenant des églises et des communautés supprimées, fut ouvert au public pour la première fois en 1809." Rouen 1858, p. 5.

2. See Angulo Íñiguez 1966, pp. 194–95.

3. "le premier qui, en Andalousie, laissa la manière timide que long-temps ont gardée les peintres espagnols, en se formant bientôt un style qui manifesta le génie national." Quilliet 1816, p. 155; also paraphrased in Viardot 1839, p. 192, and Laforge 1859, p. 163.

4. See Martínez Ripoll 1978, p. 196.

5. "Job, dépouillé de toutes ses richesses, abandonné de ses amis, méprisé de sa femme, s'humilié devant la puissance et justice de Dieu, et attend tout de sa miséricorde." Paris 1838, no. 106, p. 32 (no. 110 in 4th ed.).

6. "une composition miraculeuse." Thoré 1835a, p. 217.

7. See Martínez Ripoll 1978, p. 49, and Thacher 1937, p. 342.

8. "Ils n'ont pu faire un usage du nu aussi fréquent. . . . Mais, lorsque l'occasion s'en est offerte, ils ont toujours montré une grande connaissance de l'anatomie, et ont imité la nature dans ses plus difficiles aspects, avec un bonheur, une sûreté, que pouvaient seuls donner l'étude et le travail." Viardot 1839, p. 194.

9. Jowell 1977, p. x.

JUAN BAUTISTA MARTÍNEZ DEL MAZO

Cuenca province, ca. 1612–Madrid, 1667

After arriving in Madrid from his native province of Cuenca, Mazo obtained a position in the studio of Velázquez and eventually married the master's daughter Francisca in 1633. With his father-in-law's assistance he obtained positions at court—among them painter to the young prince Baltasar Carlos—while continuing to serve as the principal assistant in Velázquez's workshop. In this role he carried out numerous copies after the master's royal portraits, although he also revealed his own talents in the area of landscape painting. In 1661, after the death of Velázquez, Mazo assumed the post of court painter, a position held until his own death in 1667. In nineteenth-century France, Mazo's work was recognized in contemporary art-historical texts, but many of his best-known paintings were, at that time, attributed to Velázquez. Among these was the well-known *Family of the Artist* (fig. 2.8), which was exhibited at the Louvre from 1809 to 1815 as a work by Velázquez.

 DLR

47. *Fig. 1.56*

Juan Bautista Martínez del Mazo

Infanta María Teresa

1644–45
Oil on canvas
58¼ x 40½ in. (148 x 102.9 cm)
The Metropolitan Museum of Art, New York, Rogers Fund, 1943 43.101

PROVENANCE: Chevalier Féréol Bonnemaison, Paris, by 1827; his estate sale, Paris, April 17–21, 1827, no. 44 (as *Portrait d'une jeune fille* by Velázquez), sold for 1,500 francs; Charles-Auguste-Louis-Joseph, duc de Morny, Paris, by 1863–65; his estate sale, Palais de la Présidence du Corps Législatif, Paris, May 31–June 12, 1865, no. 127 (as *Portrait d'une infante* by Velázquez), sold June 8 for 51,000 francs; Mrs. Lyne Stephens, Lynford Hall, Norfolk, by 1874–95; her estate sale, Christie's, London, May 9–17, 1895, no. 321 (as *A Young Lady called an Infanta* by Velázquez), sold May 11 for

4,515 pounds to dealer Agnew; Tho. Agnew and Sons, London, 1895; J. P. Morgan, London and New York; J. Pierpont Morgan, Jr., New York, by 1896–1943; M. Knoedler and Co., New York, 1943; purchased by the Metropolitan Museum, 1943

EXHIBITIONS: Paris 1874, no. 505 (as by Velázquez; lent by Mrs. Lyne Stephens); London 1891c, no. 112 (as *Portrait of the Infanta Maria Theresa* by Velázquez; lent by Mrs. Lyne Stephens); London 1896b, no. 117 (as *Portrait of an Infanta* by Velázquez; lent by J. Pierpont Morgan); London 1901, no. 131 (as *Portrait of the Infanta María Teresa* by Velázquez; lent by J. Pierpont Morgan)

SELECTED REFERENCES: Lagrange 1863, pp. 387–88, repr. facing p. 388 (engraved by Sotain, in reverse; as by Velázquez); Mantz 1874, pp. 297–98; Curtis 1883, pp. 104–5, no. 268 (as by Velázquez); Justi 1889, pp. 404–5, repr. p. 402 (as by Velázquez and described as "in the style of the fifth decade"); Armstrong 1896, p. 86; Armstrong 1897, p. 86

Throughout the nineteenth century and into the twentieth, this portrait was universally attributed to Velázquez. It is now acknowledged as a work by his chief assistant and son-in-law, Juan Bautista Martínez del Mazo, whose deft adoption of his teacher's style and technique, as well as his many repetitions and variations on original compositions by Velázquez, have often led to erroneous attributions to the master. As its auction prices attest, this work was highly valued by the various owners who regarded it as a painting by Velázquez.

The painting depicts the Infanta María Teresa, the only child of Philip IV of Spain and his first wife, Isabella de Borbón, to reach maturity. In 1660, at the age of twenty-two, the princess married her cousin Louis XIV of France and subsequently came to be known as Marie-Thérèse. The portrait shows her at the age of six or seven. Other supposed Velázquez portraits of María Teresa were owned by the British merchant Frank Hall Standish, whose entire collection was bequeathed to the French monarch Louis-Philippe and placed on view at the Galerie Espagnole in 1842,[1] and the French Hispanophile and art writer Louis Viardot.[2]

Despite such misattributions, Mazo was known and admired in nineteenth-century France, owing to his inclusion in such primary sources as Antonio Palomino (1724), Antonio Ponz (1776–94), and Juan Agustín Ceán Bermúdez (1800), which were dutifully translated in the works of Fréderic Quilliet and Louis Viardot. "The most distinguished disciple of James Velasquez," writes Quilliet in his *Dictionnaire* (1816), while Viardot notes that "Mazo-Martinez was not simply a copyist; like his illustrious master, whose style and methods he adopted, he excelled in the portrait and was no less successful in the painting of a lively landscape."[3] In addition, the Galerie Espagnole had featured a portrait of the young Charles II, said to be by Mazo (location unknown).[4] Nonetheless, Léon Lagrange, in his 1863 description of this work, then in the duc de Morny's collection, reveals the special passion inspired by paintings thought to be by Velázquez: "It is only by the literal reproduction of reality that he has produced a work

of character. What pride there is already in this child of eight! . . . before his eyes he had a live human being, and he has reproduced the life, life in both the material and the moral sense, the child's brilliant coloring, the innate aristocracy of the royal baby."[5] He concludes, "Such is Velasquez, a firm brush in a virile hand, and at the end of this hand a rare artistic temperament; but as for the man—that is to say, his tastes, his mind, his knowledge—nothing."[6] When sold at the duc de Morny sale in 1865, it was one of five Spanish paintings, and its price of 51,000 francs far surpassed that of Murillo's *Saint Anthony of Padua* (Collection Gaillard, Paris),[7] another highlight of the auction, which sold for 13,000 francs.

While in the collection of Mrs. Lyne Stephens of Lynford Hall, Norfolk, the painting was included in the "Exposition en faveur de l'oeuvre des Alsaciens et Lorrains" held at the Palais de la Présidence du Corps Législatif, Paris, in the spring of 1874. This exhibition, comprising works from private collections, included paintings by El Greco, Murillo, Ribera, and Goya. By far the highest praise, however, was reserved for the portrait of the infanta: "The execution is a marvel. The sense of life and the reality in this painting, in which everything seems easy and accomplished at the first attempt, are dazzling"—and for the artist who presumably had executed it, "for everything that belongs to the purely painterly, Velasquez was a worker without equal."[8]

DLR

1. Standish 1853, lot 224: *Portrait en buste de Marie-Anne d'Autriche, reine d'Espagne, née en 1635, morte en 1696* (70 x 51.5 cm) (*Bust-Length Portrait of Maria Anna of Austria, Queen of Spain, Born in 1635, Died in 1696* [27½ x 20¼ in.]), by school of Velázquez, sold for 100 pounds.

2. Louis Viardot sale, Paris, March 27, 1857, lot 49: *Portrait d'Infante Marie-Thérèse d'Autriche, depuis femme de Louis XIV* (69 x 59 cm) (*Portrait of Infanta Maria Teresa of Austria, Later Wife of Louis XIV* [27⅛ x 23¼ in.]), by Velázquez, priced at 7,000 francs. Unsold, it is offered again at Viardot sale, Paris, April 1, 1863, lot 37: *Portrait de Marie-Thérèse d'Autriche (Portrait of Maria Teresa of Austria)*, and is bought for 5,000 francs by Louis La Caze. The painting is now in the Musée du Louvre (MI 898). See Chronology: April 1, 1863, for the painting's history.

3. "Le disciple le plus distingué de Jacques Velasquez." Quilliet 1816, p. 201. "Mazo-Martinez ne fut pas seulement copiste; comme son illustre maître, dont il adopta le style et les procédés, il excella dans le portrait, et n'eut pas moins de succès dans la peinture du paysage animé." Viardot 1839, p. 216.

4. "137. Portrait de Charles II, cité par Palomino dans la vie de Mazo Martinez." Paris 1838, cited in Baticle and Marinas 1981, p. 103.

5. "C'est seulement par la reproduction littérale de la réalité qu'il a produit une oeuvre de caractère. Quelle fierté déjà dans cette enfant de huit ans! . . . il avait aussi sous les yeux un être humain vivant, et il a reproduit la vie, la vie matérielle et la vie morale, la carnation brillante de l'enfant, l'aristocratie native du bébé [*sic*] royal." Lagrange 1863, p. 387.

6. "Tel est Velasquez, le pinceau le plus ferme dans une main virile, au bout de cette main un rare tempérament d'artiste, mais, quant à l'homme, c'est-à-dire le goût, l'esprit, le savoir,—néant." Ibid., p. 388.

7. See Angulo Íñiguez 1981, vol. 2, no. 283.

8. "l'exécution est une merveille. Le sentiment de la vie et de la réalité éclatent dans cette peinture où tout semble facile et venu du premier coup"; "pour toutes ces choses qui tiennent au pur pittoresque, Velasquez a été un ouvrier sans pair." Mantz 1874, p. 298.

LUIS DE MORALES, CALLED EL DIVINO

Badajoz, ca. 1520–Badajoz, 1586

Even before the publication of the decrees of the Council of Trent in 1564, Spanish artists such as Luis de Morales had begun to elaborate the new, reformed iconography that the Catholic Church of the Counter-Reformation would come to demand. Morales, called "El Divino Morales" in Spain because of the intense piety of his images, worked in Badajoz, the remote capital of Extremadura, itself the most impoverished and backward part of Spain (and the region that typically sent *conquistadores* to the New World). In spite of his provincial location, Morales found extraordinary patrons in three reforming bishops of Badajoz, Francisco de Navarra, Cristóbal de Sandoval y Rojas, and Juan de Ribera. Paintings by Morales exhibit certain elements that recall the influence of Leonardo da Vinci and especially Sebastiano del Piombo on the school of Valencia; there may have been some connection, as yet undocumented, between him and the painters of that city. Morales, like the previous generations of Spanish artists, was also influenced by Flemish art.

MBB

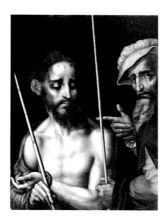

48. *(New York only)* *Fig. 11.14*

Luis de Morales, called El Divino

Ecce Homo

1560–70
Oil on panel
29½ x 22½ in. (75 x 57 cm)
The Hispanic Society of America, New York A79

CATALOGUES RAISONNÉS: Gaya Nuño 1961a, no. 19; Bäcksbacka 1962, no. 24

PROVENANCE: J. Casanova y Hermano, Cadiz [agents(?), before 1838]; Louis-Philippe, king of France, 1838–53 (Galerie Espagnole, Musée du Louvre, Paris, 1838–48, nos. 140/144); his sale, Christie & Manson, London, May 13, 1853, no. 252, acquired by "Graves" [Algernon Graves(?)], as agent for Thomas Baring; Thomas Baring, London, 1853–73; his nephew, Francis George Baring, second earl of Northbrook, London, 1873–after 1889

(no. 225); Ehrich Galleries, New York, by 1910; Archer Milton Huntington, New York, 1910–14; presented by him to The Hispanic Society of America, New York, 1914

EXHIBITION: Paris, Galerie Espagnole, Musée du Louvre, 1838–48, nos. 140/144

REFERENCES
19th century: Archives du Louvre, Paris, 1 DD 122.I.G.E., no. 169, September 20, 1838 (cited in Baticle and Marinas 1981, pp. 107 [incorrectly given as no. 170] and 283 [as 169]); Circourt 1838b, p. 104; Paris 1838, p. 41, no. 140 (cf. 4th ed., no. 144); Louis-Philippe 1853, no. 252; Gower 1885, no. 225; Weale and Richter 1889, p. 170, no. 225 (citing former collections of Thomas Baring and Louis-Philippe)

20th century (selected references): Murdoch 1917, p. 23; Trapier 1929, pp. 8, 9, pl. II; Baticle and Marinas 1981, no. 144, p. 107; Lenaghan et al. 2000, pp. 222–23, repr.

The subject of the painting is found in the Gospel of John (19:5): "Then came Jesus forth, wearing the crown of thorns, and the purple robe. And Pilate saith unto them, Behold the man!" The title is taken from Pilate's comment, rendered in Latin as *Ecce homo*. Morales has removed the crown of thorns, leaving only the marks, but has placed a reed in Christ's hand, as found in the Gospel of Matthew (27:29). The way Morales's image anticipates the reforms of the Council of Trent may be seen in the placement of Christ near the picture plane, with the hand holding the reed pushed illusionistically into the viewer's space, as well as in the way Pilate makes eye contact with the viewer. This intimate encounter with the suffering Christ (the "Man of Sorrows") was what Catholic reformers, such as Saint Ignatius Loyola, sought as they developed the new Christian piety. Catholic theology also equates the mistreated body of Christ in this image with the Body of Christ miraculously present in the Eucharist.

At least seven images of the *Ecce Homo* by Morales are documented in Spain before 1800. Ingjald Bäcksbacka accepts fourteen extant pieces as autograph and lists thirty-one mentions of this subject in the literature,[1] making it one of Morales's most common motifs. However, only three of the extant versions are multifigured: the present panel, a similar image in the parish church at Arroyo de la Luz, Extremadura, and a horizontal image in the Real Academia de Bellas Artes de San Fernando, Madrid.[2]

As is typical with wood panels from Spain, where hardwood was a scarce commodity and the climate suffers wide swings of temperature and humidity, this work manifests condition problems, notably the extreme warping of the panel. Yet, the curved surface effectively augments the three-dimensional illusion of the composition—a serendipitous effect presumably unforeseen by the artist.

The present work has been identified with a panel, said to be of slightly smaller size, exhibited in the Galerie Espagnole of Louis-Philippe. The identification is certain, since the reverse of the panel

bears the numerals "169" and "252," the entries in the Louvre 1838 inventory and the 1853 Louis-Philippe sale, respectively (see also Matthias Weniger's essay in this publication). The work subsequently passed into the Baring collection in England. In spite of the presence of this and other works by the artist in British and French collections, Morales seems not to have exercised a significant influence on nineteenth-century art, although the matter has not been studied adequately.

<div align="right">MBB</div>

1. Bäcksbacka 1962, pp. 207–8.
2. For the version in Extremadura, see ibid., no. 17:14; for that in Madrid, see ibid., no. 52.

BARTOLOMÉ ESTEBAN MURILLO

Seville, 1617–Seville, 1682

Bartolomé Esteban Murillo spent his entire life in Seville. His only stay outside of the Andalusian city was a trip to Madrid in 1658, when his fellow Sevillian Velázquez was at the court of King Philip IV. Murillo studied in the workshop of Juan del Castillo, and his early works reflect the influence of Zurbarán and the young Velázquez (in his Sevillian phase) in the way scenes are illuminated with strong contrasts and in the use of a dense palette in browns and earth tones.

Murillo's Seville had begun to decline from its glory days because of plagues and famines. But Sevillians still spent money on art for religious institutions, and Murillo executed paintings for the city's various orders, for the cathedral, and for churches and hospitals. Additionally, he had a clientele of foreign merchants, most of them from the Low Countries.

Thoroughly immersed in the life of his city, Murillo was the most important painter in Seville during the second half of the seventeenth century. Once he became familiar with Venetian painting, his style evolved from its initial hardness toward greater softness, with a gentler, more glowing illumination and a brush less heavily laden with paint—a manner that was called his "vaporous" style. Through this technique, Murillo brought religious subjects to earth, as though Mary, Jesus, or Saint Anne were commonplace people. This approach has always been at the root of Murillo's success, from his own day to contemporary times.

Most of Murillo's religious paintings remained in Seville. Those of his works that left Spain during his lifetime were of secular subjects and, although fewer in number, were responsible for his great fame in Europe. Thanks to them, Murillo was the first Spanish painter to have his portrait and his biography known outside the country. The key moment for the dissemination of his work outside Spain was the war of independence against the French, beginning in 1808: the churches of Seville were emptied of their contents, and Parisians were able to see (thanks to Marshal Soult and the Galerie Espagnole) an enormous number of Murillo paintings. Some of

his best works, such as *The Immaculate Conception* (cat. 57), the *Saint Elizabeth of Hungary Nursing the Sick* (fig. 3.13), and the paintings from Santa María la Blanca (figs. 1.22, 1.23), were among them. Some of these returned to Spain, others were dispersed throughout the rest of Europe and to America as European collections were sold.

<div align="right">MSGF</div>

49. *(New York only)* Fig. 7.15

Bartolomé Esteban Murillo

Self-Portrait

Ca. 1655–60
Oil on canvas
42⅛ x 30½ in. (107 x 77.5 cm)
Inscribed (after artist's death): VERA EFIGIES BARTHOLOMAEI STEPHANI A MORILLO MAXIMI PICTORIS,/HISPALI NATI ANNO 1618 OBIT ANNO 1682 TERTIA DIE MENSIS APRILIS. [True likeness of Bartolomé Esteban Murillo great painter,/Spanish born in the year 1618 died in the year 1682 on the third of the month of April]
Private collection, New York

CATALOGUES RAISONNÉS: Curtis 1883, p. 295, no. 465; Angulo Íñiguez 1981, vol. 2, no. 413

PROVENANCE: Gaspar Murillo, Seville, 1709; Bernardo Iriarte, Madrid; his sale, Madrid, 1806, bought by Francisco de la Barrera Enguídanos; on his death bought by Julian Williams; Julian Williams, Seville, until 1832; purchased by Baron Taylor for Louis-Philippe, 1836; Galerie Espagnole, Musée du Louvre, Paris, 1838–48, nos. 183/187; Louis-Philippe sale, Christie & Manson, London, May 14, 1853, no. 329, bought by John Nieuwenhuis, London, for 420 pounds; Baron de Seillière, to his daughter Princess Sagan, Paris, 1883; private collection, United States, from Lawrie and Co., 1904

EXHIBITIONS: Paris, Galerie Espagnole, Musée du Louvre, 1838–48, nos. 183/187; Fort Worth–Los Angeles 2002, no. 33

REFERENCES
18th–19th century: Palomino 1724 (1947 ed.), p. 173; Ceán Bermúdez 1806, pp. 103–4; Burckhardt 1837, pp. 481–82; Stirling-Maxwell 1848 (1891 ed.), vol. 3, pp. 1066–67; Ford 1853, p. 623; Bürger 1865, p. 130; Blanc et al. 1869 (Murillo issue), fig. 1; Lefort 1892, p. 94, no. 47

20th–21st century (selected references): Calvert 1907, p. 185; Mayer 1923b, fig. XXXIII; Montoto 1945, p. 319; MacLaren 1970, p. 73 n. 3; Bédat 1973, p. 144; Angulo Íñiguez 1981, vol. 1, p. 169; Baticle and Marinas 1981, no. 187, pp. 133–34; Princeton–Detroit 1982, p. 169; E. Harris 1987, p. 159; Schiff 1988, p. 12; Karin Hellwig, "Vom Reiz des Alltäglichen: Bartolomé Esteban Murillo," in Karge 1991, p. 167; Waldmann 1995, no. 16, p. 213; Claire Barry, "Looking at Murillo's Technique," in Fort Worth–Los Angeles 2002, pp. 77, 80

This portrait must be the one that Antonio Palomino saw in Seville in the collection of Gaspar Murillo, the son of the painter, and which was later seen by Juan Agustín Ceán Bermúdez in the collection of Bernardo Iriarte, the "protector" of the Real Academia de Bellas Artes de San Fernando in Madrid.

Murillo presents himself here in his maturity, as an elegant man in his forties, dressed in a suit of fine black cloth with slashed sleeves and a white *golilla* (collar). He confidently gazes directly at the viewer from the dark background of a portrait set in a chipped oval stone frame. The use of oval frames for portraits was more common in the Low Countries than in Spain, but Murillo had friends from that region who lived in Seville. He knew their art collections, and he painted for them, sometimes employing this format. Thus he portrayed Nicolás Omazur (1672, Museo del Prado, Madrid) and his wife, Isabel Malcampo (copy in Pollok House, Glasgow), and thus he portrayed himself in the best known of his self-portraits (1670–73, National Gallery, London), which would make Murillo's image well known and would influence Hogarth's self-portrait (1745, Tate Britain, London).

In this self-portrait, Murillo also uses an oval format but appears younger than in the London version, with smoother skin and a less fleshy face. He also seems closer to the viewer and presents himself less theatrically, without his hand clutching the frame. He is not yet accompanied by the London version's compasses, drawings, pencils, and palettes—the instruments of an important and intellectual occupation. On the other hand, the portrait's stone frame is significant, as recently demonstrated by William Jordan.[1] Murillo's paintings on marble, jasper, and obsidian, usually on a small scale, were intended for a cultured, refined clientele, who paid high prices for them. Those that are still in their original frames give us an idea of the seventeenth-century valuation of them as "jewels." Like such a jewel, even though the stone is here faked on the canvas (and additionally charged with sentimental value), this self-portrait would be kept in the home, near the cathedral, by the canon Gaspar Esteban, one of the few of Murillo's children to outlive him.

The painting is a double fiction: a portrait painted on a block of stone resting on a table, a "painting within a painting."[2] Murillo, one of the founders of the drawing academy in Seville and painter of *The Origins of Painting* (Romania National Art Museum, Bucharest), was not an "intellectual" painter like Alonso Cano, but he had seen many paintings in Seville and Madrid, had used

many engravings after earlier masters, and was very knowledgeable about their art. And, to judge by his self-portraits, he was proud of demonstrating that knowledge.

The picture is painted in an extremely somber range of colors: blacks for the clothing, in Spanish style, on a dark background of grays and ochers. Murillo used a brush thinly loaded with paint, so that here and there the underlying reddish ground is visible. Light illuminates three-quarters of the face and shines in a few touches of white on the collar and the shirt sleeves that peep out from the black drapery. A couple of red brushstrokes lend a touch of life to the lips, which inspired (perhaps to excess) the erudite Jacob Burckhardt: "Look at these splendid, slightly pouting lips! . . . Happy the woman who has been loved by this man! His mouth has kissed a lot!"[3]

Murillo, who was so busy with religious commissions, executed few portraits, but those works, whether depicting others or himself, reveal his great talent in the genre. His contemporary Fernando de la Torre Farfán, writing about *The Apparition of the Virgin of the Immaculate Conception to Six Persons of Rank*, painted for the Church of Santa María la Blanca (fig. 14.24), noted that "at her feet several portraits *live*."[4] That is indeed the impression Murillo's portraits give: live figures, who look directly at the viewer, whether standing firmly on the ground (see cat. 52), as in portraits by Velázquez, seated as suits their religious rank (*Justino de Neve*, 1665, National Gallery, London), or in an oval frame in the style of the Low Countries (the portrait of Nicolás Omazur or this self-portrait).

The Scottish painter David Wilkie, who was very interested in Murillo, painted himself searching for the Spanish master's remains in the monasteries of Seville *(Wilkie in Search of Murillo)*. Wilkie saw this self-portrait in Seville and made a copy (Baron de Leven, Melville House, Fifeshire), which William Stirling-Maxwell considered excellent.[5] Engravers also copied it: Albuerne and Alegre in Spain, about 1790, and Collin, Sichling, and Blanchard while the work was exhibited at the Galerie Espagnole.[6] Most of these prints were made to illustrate biographies of the artist: H. Adlard engraved it for Stirling-Maxwell, who was always searching for "veras efigies" (true likenesses) of the great Spanish masters for his *Annals* (1848),[7] and Carbonneau engraved it for Charles Blanc's *Histoire des peintres* (1869). In addition, popular books such as those by Ellen Minor (1882) and A. F. Calvert (1907) used engravings of this self-portrait as their frontispieces.

MSGF

1. William B. Jordan, "A Forgotten Legacy: Murillo's Cabinet Pictures on Stone, Metal, and Wood," in Fort Worth–Los Angeles 2002, pp. 63–73.

2. See Gállego 1978.

3. The rest of the text is similarly impassioned: "flashing eyes under the splendid wrathfully arching eyebrows . . . the most beautiful jet-black locks . . . arsenal of passions," and so on. For the complete text, see Fort Worth–Los Angeles 2002, p. 187.

4. "a sus pies [de la Virgen] *viven* algunos retratos." Torre Farfán 1666, fº4.

5. "An excellent copy . . . and now hardly inferior in interest

and value to the original." Stirling-Maxwell 1848 (1891 ed.), vol. 3, p. 1067 n. 2.

6. There is also a lithograph by Mauzaise.

7. "[The Murillo self-portrait] has been engraved, for the third time, for the present work." Stirling-Maxwell 1848 (1891 ed.), vol. 3, p. 1067. He previously mentioned the versions by Blanchard and Sichling.

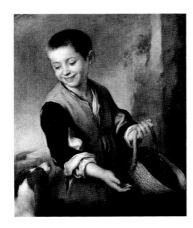

50. Fig. 1.6

Bartolomé Esteban Murillo
Boy with a Dog

Before 1660
Oil on canvas
27½ x 23⅝ in. (70 x 60 cm)
State Hermitage Museum, St. Petersburg 386

CATALOGUES RAISONNÉS: Curtis 1883, no. 413; Gaya Nuño 1978, no. 82, p. 93; Angulo Íñiguez 1981, vol. 2, no. 379

PROVENANCE: Nicolás Omazur, Seville, 1690; duc de Choiseul (Étienne-François Choiseul-Stanville) sale, Paris, 1772, along with *Girl with Fruit and Flowers* (before 1660, Hermitage, St. Petersburg), bought by Prince Galitzin for 4,600 francs as agent for Catherine the Great, who installed it in the Hermitage

EXHIBITIONS: Osaka 1970, no. 200; United States–Mexico–Canada 1975–76, no. 14; Leningrad 1984, no. 16; Belgrade–Ljubljana–Zagreb 1987–88, no. 11; Nara 1990, no. 3; London–Munich 2001, no. 7

REFERENCES

18th–19th century: Choiseul 1772, p. 37, no. 118; Waagen 1864, p. 111; Blanc et al. 1869 (Murillo issue), p. 1, repr.; Clément de Ris 1879, p. 347; Stromer 1879, p. 114; Curtis 1883, pp. 276–77; Alfonso 1886, no. 376, p. 216; Justi 1892, pp. 16–17; Lefort 1892, no. 434, p. 234

20th–21st century (selected references): Réau 1912, p. 393; Mayer 1913b, p. 101; Mayer 1922, p. 342; Zervos 1932, p. 317; Mihan 1944, p. 89; Dacier 1949, pp. 68, 74; Haraszti-Takács 1978, pp. 399–400; J. Brown 1982, pp. 34–35; Haraszti-Takács 1983, no. 77, pp. 119, 157; Paris 1983, pp. 20–21, 54; Kinkead 1986, no. 29, p. 136; Kaganë 1995, p. 74; Kaganë 1997, no. 52; London–Munich 2001, pp. 22, 71–72;

María de los Santos García Felguera, "Niños afortunados," in Madrid 2001, pp. 80, 87

Un Chulito is the title given to this picture in the inventory of the collection of Nicolás Omazur. In the seventeenth century, a "chulo" meant simply a boy whose behavior is amusing, even a bit fresh. The catalogue of the Choiseul sale describes the painting as "a young boy seen to the knees, holding a wicker basket in one hand, and staring and smiling at the dog near him."[1]

The theme is one of Murillo's favorites among secular subjects: a boy "of the baskets," as those encountered in Cervantes's novel *Rinconete y Cortadillo* (1613) are called. Such little boys ran errands throughout the city of Seville, selling food or simply carrying it for shoppers from the market to their homes (see *Beggar Boy [The Flea Picker]*, fig. 2.32). This is a poor boy, as indicated by his clothing, one of many who frequented the streets in the second half of the seventeenth century, trying to earn a little money for small jobs during a time of economic crisis. As is usual in Murillo's paintings of children, the boy is poor but not sad: he smiles while he plays with the dog in a restful moment.

Like the *Beggar Boy*, this is an early work, though not quite so early. The colors employed are few, dense, and sober: a range of browns, to which the artist has added white, gray, green, and blue. The brushstrokes are thick and loaded with paint, but the chiaroscuro is much softened and the contrasts of light and dark are not so abrupt as in the *Beggar Boy*. Louis Clément de Ris said that it was painted "in his dry manner," as opposed to his "velvety manner" and his "warm" style, which the writer preferred.[2] It does not seem so "dry" to us today, although neither does it attain the delicacy of the *Two Boys Eating a Tart* (Alte Pinakothek, Munich), of the 1670s. Physically, this boy with short, dark hair is closer to the child in the *Beggar Boy* than to the more idealized, handsome children with curly blond hair in Munich, who look rather like Murillo's depictions of Christ and Saint John as children.

A simple suggestion of landscape, achieved in a summary manner with little impasto, contrasts with the minute attention paid to the representation of the wicker basket and the pottery jug—an attention to the materiality of objects that Murillo shares with other Spanish painters of the period such as Velázquez, Zurbarán, Alonso Cano, and Ribera. Beginning with this work in St. Petersburg, the open air becomes a natural setting for paintings of these children.

The present work has as its pendant a painting in the same collection, *Girl with Fruit and Flowers*. Murillo created several pairs of such pictures on secular themes with smiling children or youths. One scholar has found erotic meaning in these paintings,[3] but although possible, it does not seem to be a determining aspect of the images. Pleasant, amiable, enjoyable paintings, with nothing problematical about them, they would have been appropriate on the walls of a seventeenth-century house such as that of Nicolás Omazur, Murillo's friend, or in a Rococo palace like that of the duc de Choiseul,

a minister of Louis XV. Those qualities brought them to the attention of women collectors with modern tastes, including Madame de Verruë, who owned another pair, *A Peasant Boy Leaning on a Sill* (1670–80, National Gallery, London) and *Girl Lifting Her Veil* (private collection, London); Isabel de Farnese, the wife of King Philip V of Spain; and Catherine the Great of Russia.[4]

The prestige of such paintings has never wavered. They sold very well in Murillo's lifetime and were the works initially responsible for his fame beyond Seville and Spain. From the eighteenth century they have often been copied and engraved.[5] The present work and its pendant were engraved for the catalogue of the Choiseul sale in 1772 before they left Paris. In Russia in 1793 Yakov Yakimovich copied them for the tapestry factory in St. Petersburg, and several prints were made after them in Russia in 1847 and 1872. But the person truly responsible for spreading their fame was Charles Blanc, who included new engravings of them in his *Histoire des peintres de toutes les écoles: École espagnole* (Paris, 1869). It was this engraving that inspired Manet's *Boy with a Dog* (1860–61, private collection, Paris) and his etching of 1862 (cat. 168).[6]

MSGF

1. "Un jeune garçon vû jusqu'aux genoux, tenant d'une maine un panier de jonc, et fixant en riant un chien qui est prés de lui." Choiseul 1772, p. 37.

2. "dans la manière sec"; "manière veloutée"; "manière chaude." Clément de Ris 1879, p. 347.

3. See J. Brown 1982, nos. 169–71, pp. 35–43.

4. For these eighteenth-century women, the role of Murillo in their collections, and the formation of "modern taste," see García Felguera in Madrid 2001, pp. 79–87.

5. Stirling-Maxwell probably meant this picture when he referred to a "Boy with a basket and a dog" in his section on "Fancy compositions and figures," although the dimensions are not exactly the same (1848, vol. 3, p. 1411).

6. See Paris–New York 1983, nos. 6–9.

51. *(New York only)* *Fig. 11.16*

Bartolomé Esteban Murillo
The Prodigal Son among the Swine

Ca. 1665
Oil on canvas
63 ⅛ x 41 ⅛ in. (161.5 x 104.5 cm)
The Hispanic Society of America, New York
LA1791

CATALOGUES RAISONNÉS: Curtis 1883, no. 191b (citing Louis-Philippe sale, no. 75, and Cave and Drax collections); Angulo Íñiguez 1981, vol. 2, no. 238 (as autograph), vol. 2, no. 1500 (for citation of the "lost" Louis-Philippe work), vol. 3, pls. 325–26

PROVENANCE: Duque de Hijar, Seville; sold by him to Baron Taylor, April 12, 1836, as agent for Louis-Philippe, king of France; Louis-Philippe, 1836–53 (Galerie Espagnole, Musée du Louvre, Paris, 1838–48, nos. 178/182); his sale, Christie & Manson, London, May 6–7, 13–14, 20–21, 1853, no. 75, bought by "Cave" for 110 pounds; W. Cave, Bentley House, near Bristol; his sale, Christie's,

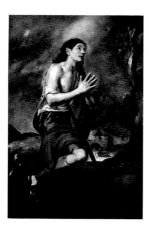

London, June 29, 1854, bought by "Drax" for 105 pounds; J.S.W.S. Erle Drax, Esq., Loantigh Towers, Wye, Kent; his heirs; W.E.S. Erle Drax, Esq., until 1910; his sale, Christie's, London, February 19, 1910 (as "Tobar"), bought by "Sr. de Quinto" (an agent?); Oliver family, Buenos Aires, from 1910; by descent to "Oliver Romero," Buenos Aires, by 1964; by descent to Samuel F. Oliver, Buenos Aires, by 1968; L. Hirschfeld, London, by 1973–after 1981; offered at Sotheby's, London, March 21, 1973 ("the property of a gentleman," bought in); on the art market, London, by 1995–97; acquired for The Hispanic Society of America, New York, by exchange, 1997

EXHIBITIONS: Paris, Galerie Espagnole, Musée du Louvre, 1838–48, nos. 178/182; Barcelona 1910, no. 52; Buenos Aires 1964, no. 83; Fort Worth–Los Angeles 2002, no. 17

REFERENCES
19th century: Archives Nationaux, Paris, O4 1725, April 12, 1836, "Reçu signé du trésorier du duc de Hijar pour deux tableaux de Murillo, dont *L'enfant prodigue*"; Archives du Louvre, Paris, 1 DD 122.I.G.E., no. 189, September 20, 1838 (cited by Baticle and Marinas 1981, p. 131, no. 182); Paris 1838, p. 48, no. 178 (as "L'enfant prodigue. Haut. om. [*sic*] 57 c.—Larg. 1 m. 03 c." [the vertical dimension is probably a typographical error for 157 cm high]); Stirling-Maxwell 1848 (1891 ed.), vol. 4, p. 1622; Ford 1853, p. 594 (unsigned article on the Louis-Philippe sale, presumed to have been written by Richard Ford, citing no. 110 [75], and describing the Hispanic Society picture); Louis-Philippe 1853, no. 75

20th–21st century (selected references): Baticle and Marinas 1981, p. 131, no. 182; Valdivieso 1990, p. 138; Fort Worth–Los Angeles 2002, no. 17, pp. 144–47

Except for a brief trip to Madrid in 1658, Murillo spent his entire career in Seville. His early works follow the same tenebrist-naturalist mode established in that city by Velázquez and Zurbarán, and in Naples by the Spanish expatriate Jusepe de Ribera. By the late 1640s, Murillo had begun to supplant Zurbarán as the principal artist in Seville. After 1656, when Francisco Herrera the Younger returned from Italy with a full-blown High Baroque manner,

Murillo's works combined dynamic compositions, classical figure drawing, beautiful coloristic effects, and lush brushwork. From this point forward, he dominated the local art establishment. Although a founder of the Real Academia de Bellas Artes de Santa Isabel de Hungría, Seville, in 1660, Murillo also produced genre pictures, often for Flemish patrons resident in Andalusia.

This image is taken from the Parable of the Prodigal Son in the Gospel of Luke (15:11–32). The Prodigal Son, having "wasted his substance with riotous living" in the fleshpots of Egypt, is cast out as a beggar and forced to take work as a swineherd, a profession abhorrent to any Jew, given the Torah's proscription of pork. At the nadir of his existence, the son repents and decides to return to his father and ask forgiveness. In Catholic art of the Counter-Reformation, the Prodigal Son, along with Mary Magdalen, Saint Jerome, and the penitent Saint Peter, were considered types of the Sacrament of Penance, points of Catholic theology specifically denied by Protestants.

Along with three series of paintings on the Prodigal Son theme, Murillo also included the scene of the son's return to his father among the images of charity he painted in 1667–70 for the Hospital de la Caridad, Seville. The Hispanic Society canvas seems, however, to have been a stand-alone image emphasizing repentance and may have had some connection to its original owner's membership in a penitential confraternity, still a typical aspect of Sevillian piety today. Its crisp but fluid brushwork and tenebrist lighting reflect Murillo's debt to Ribera and suggest a date before the Caridad commission, while the interest in anatomy and pose locate the picture in the years after Murillo's founding of the Academia de Bellas Artes.

The identity of the original owner is unknown, but since the picture was said to have been sold to Baron Taylor in 1836 by the duque de Hijar, it is possible that an earlier duke commissioned the piece. Suzanne Stratton-Pruitt's research establishes that the Hispanic Society canvas is the same as that exhibited from 1838 in the Galerie Espagnole, where it must have contributed mightily to the vogue for neotenebrist painting documented by Ilse Hempel Lipschutz.[1]

MBB

1. For Stratton-Pruitt, see Fort Worth–Los Angeles 2002, no. 17, pp. 144–47; Lipschutz 1972, pp. 190–212.

52. *(New York only)* *Fig. 1.31*

Bartolomé Esteban Murillo
Don Andrés de Andrade y la Cal

Ca. 1665–72
Oil on canvas
79 x 47 in. (200.7 x 119.4 cm)
Inscription on column at left: *d andre[s] / de Andrade y/la Cal;* upper left, on coat of arms: *ave maria gracia plena* [Hail Mary full of grace]
The Metropolitan Museum of Art, New York, Bequest of Collis P. Huntington, by exchange, 1927
27.219

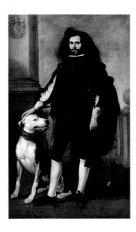

CATALOGUES RAISONNÉS: Curtis 1883, no. 457; Gaya Nuño 1958, no. 1868; Gaya Nuño 1978, no. 68; Angulo Íñiguez 1981, vol. 2, no. 405

PROVENANCE: Andrade family, Seville; Antonio Bravo, Seville, 1828; Sir John M. Brackenbury (British consul to Cadiz), Cadiz, 1836; Baron Taylor, purchase for Louis-Philippe's Galerie Espagnole, Paris, 1837; Galerie Espagnole, Musée du Louvre, 1838–48, nos. 182/186; Louis-Philippe sale, Christie & Manson, London, May 14, 1853, no. 328, bought by Thomas Baring; Captain R. Langton Douglas, purchase from the Baring family, 1927; purchase, bequest of Collis P. Huntington, The Metropolitan Museum of Art, New York, 1927

EXHIBITIONS: London 1836, no. 109; Paris, Galerie Espagnole, Musée du Louvre, 1838–48, nos. 182/186; London 1853, no. 64; London 1870; New York 1928, no. 42; Fort Worth–Los Angeles 2002, no. 34

REFERENCES

19th century: Cunningham 1843, vol. 3, p. 117; Head 1848, p. 178; Stirling-Maxwell 1848, vol. 2, p. 919, vol. 3, p. 1444 [1891 ed., vol. 3, p. 1090, vol. 4, p. 1637]; Ford 1853, p. 623; Waagen 1864, pp. 180–81; Scott 1873, p. 106; Gower 1885, pp. 19–21; Alfonso 1886, pp. 188, 191; Weale and Richter 1889, no. 228, pp. 173–74; Justi 1891, pp. 266–69; Justi 1892, pp. 35–36; Lefort 1892, p. 95 n. 419

20th century (selected references): Mayer 1913b, p. 222; Mayer 1923b, pp. 227, 243; Lipschutz 1972, p. 222; Baticle and Marinas 1981, pp. 132–33; López-Rey 1987, p. 29; Mallory 1991a, p. 221

This "ugly" man—though not as ugly as his mastiff, wrote William Stirling-Maxwell with his characteristic flippancy[1]—was Andrés de Andrade y la Cal, as stated in the inscription that appears on the pedestal of the pilaster. Although not much is known about the family, one of his ancestors, Pedro Fernández de Andrada, published a book about horses in 1580,[2] and a Francisco Andrade appears in a document of 1667 as a member of the confraternity of La Caridad, of which Murillo was also a member. Diego Angulo Íñiguez believed the sitter was the grandfather of a notable seventeenth-century Sevillian, Antonio Andrade Cansino, who was an official at the city hall.[3]

The catalogue of Louis-Philippe's sale of Galerie Espagnole paintings describes Andrés as the "Master of ceremony of the Cathedral of Toledo" ("Maître de céremonie de la Cathédrale de Tolède") and, according to August Mayer, he was the *pertiguero* (verger), the one who carried the *pértiga*, a good-sized staff garnished with silver, when accompanying the priests in various church ceremonies.[4] The position, which today seems minor, must have been of some importance in the seventeenth century. The inscription on the coat of arms must reflect either Andrade's position as *pertiguero* or his noble status; it also appears in the book written by his ancestor.

The position of verger, if that is what Andrade was, is not a religious appointment, although it is connected to the cathedral. Andrade was a layperson and is portrayed as such—well dressed, elegant (note the saucy shoes), all in black, with a *golilla* (collar), hat, and sword. Other elements in the painting, such as the coat of arms, suggest his nobility. The pilaster and balustrade create a palatial ambience, reminiscent of the backdrops used in nineteenth-century photographs. Finally, the presence of the dog enhances the moral status of the sitter, who is shown as important but still attentive to his companion animal, as in Titian's portrait of Emperor Charles V (ca. 1532, Museo del Prado, Madrid), then in the royal collections.

Full-length portraits were normally reserved for important individuals, and Murillo created several of them, almost all of which depict isolated, lifesize figures. In most cases we know the name of the sitters, and some of the portraits include coats of arms, including *Juan de Miranda* (collection of the dukes of Alba, Madrid) and *Justino de Neve* (1665, National Gallery, London). The great majority of the sitters are Sevillian nobles, clergymen, or merchants. They belong to the painter's social circle—his friends, patrons, fellow members of the confraternity of La Caridad.

Along with his *Self-Portrait* (1670–73, National Gallery, London) and the likeness of the businessman *Joshua von Belle* (National Gallery of Ireland, Dublin), the present work is a fine example of Murillo's efforts in the genre. It is closest, both in pose and costume, to the representation of an unknown gentleman whose portrait is today in the Prado, though in the latter painting the dog is replaced by a table, which was also a status symbol in the seventeenth century. Both subjects wear serious expressions, stand with their legs slightly apart, their bodies slightly turned to the left and their heads to the right, toward the spectator. They appear proud of their social position and of the likelihood that posterity will know them by their portraits.

This "superb portrait," as Paul Lefort described it,[5] painted during the 1650s, has a sober air that was considered characteristically Spanish during the nineteenth century. Stirling-Maxwell found in it "a forcible Velazquez-like style," and remarked on the sitter's "prodigious crop of coal-black hair and his bad legs."[6] The Scottish painter David Wilkie, who had seen the painting in Seville, at Antonio Bravo's house, and saw it again in Paris,

recalled it as "the Man with the Dog" and was taken by the expression of the face: "It seems to see you while you look at it."[7]

This painting has had an adventurous life. Sir John M. Brackenbury bought it from the descendants of Andrade for 1,000 pounds, but there was no agreement on the amount owed to the intermediary, who was perhaps Bravo, and the latter demanded the enforcement of the conde de Floridablanca's law to prevent the painting from leaving Spain.[8] Even so, the law was circumvented: a copy was hung in place of the original, and the portrait left the country.[9] The portrait was offered to the National Gallery in London for 500 pounds, but the offer was rejected. Louis-Philippe bought it for double that, and, when the king's collection was sold, Thomas Baring paid 1,020 pounds, even though his agent had been authorized to spend as much as 1,700.

MSGF

1. "The Louvre has a full-length picture, painted in a forcible Velazquez-like style, of a certain Don Andres de Andrade, a personage chiefly remarkable for his prodigious crop of coal-black hair and his bad legs, and attended by a white mastiff yet uglier than himself." Stirling-Maxwell 1848 (1891 ed.), vol. 3, p. 1090.
2. Pedro Fernández de Andrada, *Libro de la gineta de España* (Seville, 1580).
3. See Angulo Íñiguez 1981, vol. 2, no. 458.
4. Baticle and Marinas 1981, no. 186, pp. 132–33; Mayer 1923b, pp. 227, 243.
5. "superbe portrait." Lefort 1892, p. 95.
6. See n. 1, above.
7. Cunningham 1843, vol. 3, p. 117.
8. The edict was issued in 1779, during the reign of Charles III, in an attempt to stop paintings (especially those by Murillo) from leaving Spain. Murillo's name was the only one cited in the text of the edict, an indication of his prestige and of the degree to which foreigners sought his work. See García Felguera 1989b.
9. A copy is preserved in the Real Academia de Bellas Artes de San Fernando, Madrid, signed by the Sevillian painter José Gutiérrez de la Vega, one of the nineteenth-century painters most strongly influenced by Murillo.

53. (New York only) *Fig. 1.30*

Bartolomé Esteban Murillo
The Liberation of Saint Peter

1667
Oil on canvas
7 ft. 9¾ in. x 8 ft. 6⅛ in. (238 x 260 cm)
The State Hermitage Museum, St. Petersburg 342

CATALOGUES RAISONNÉS: Curtis 1883, p. 263; Gaya Nuño 1958, p. 251, no. 1856; Gaya Nuño 1978, p. 108, no. 251; Angulo Íñiguez 1981, vol. 2, no. 85

PROVENANCE: Church of the Hospital de la Caridad, Seville, 1667; inventoried in the Alcázar of Seville, 1810, no. 4 (attributed to Ribera); taken to Paris by Marshal Soult, 1812; Musée du Louvre, Paris (on deposit though not exhibited), April 13– May 23, 1835; Soult collection, Paris; his sale, Paris, May 19, 21, 22, 1852, no. 64, bought for 151,000 francs by Fiodor Bruni, through the dealer N. Moreau, for the Hermitage Museum, St. Petersburg

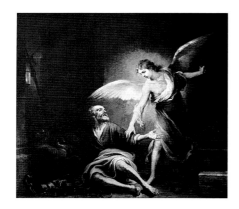

EXHIBITION: Leningrad 1984, no. 25

REFERENCES

17th–19th century: Ortiz de Zúñiga 1677, p. 1661; Ponz 1776–94, vol. 9, letter V, p. 149; Ceán Bermúdez 1800, vol. 2, p. 61; Ceán Bermúdez 1806, p. 87; Réveil 1828–34, vol. 3, p. 178 (attributed to Ribera); Thoré 1835a, pp. 52–53; Ford 1845, vol. 1, pp. 180, 190; Stirling-Maxwell 1848 (1891 ed.), vol. 3, pp. 1030–34; *L'Illustration*, May 31, 1852 (attributed to Ribera); Waagen 1864, p. 109; Blanc et al. 1869 (Murillo issue), p. 16; Clément de Ris 1879, p. 374; Gestoso y Pérez 1889, vol. 3, pp. 330–31; Viñaza 1889–94, vol. 3, p. 130; Justi 1892, p. 63

20th century (selected references): Gómez Ímaz 1910, no. 4 (in Lipschutz 1972, p. 303); Mayer 1913a, vol. 2, pp. 125, 287; Beroqui 1932, p. 96; Saltillo 1933, p. 24; Malitskaia 1947, p. 180; Angulo Íñiguez 1961, p. 31; J. Brown 1970, pp. 269, 276; Lipschutz 1972, p. 37; J. Brown 1978, pp. 135, 139; Angulo Íñiguez 1981, vol. 1, pp. 392–93; Paris 1983, p. 57; Kagané 1997, no. 60

The scene depicted here is inspired by the Acts of the Apostles 12:6–9.[1] Herod, the king of the Jews, had Peter, one of Christ's disciples, imprisoned and tied with chains. The night before Herod was to present Peter to the people, while the saint slept between two soldiers, "the angel of the Lord came upon him, and a light shined in the prison." The angel awoke Peter, and the chains that bound his hands miraculously loosened; Peter left the cell believing it was all a vision. Murillo, like nearly all the artists who painted this subject, departed from the biblical text in eliminating the soldiers who guarded the gate to the cell and nearly eliminating those who slept at the saint's side.[2] The painter concentrates his attention, and the viewer's, on the two protagonists: Saint Peter and the angel.

The apostle's liberation was a common subject in Christian art, at least after Raphael painted it in the Stanza of Heliodorus in the Vatican in Rome (1513–14). Probably because of its religious message—that one can be confident of divine help in the worst of times—it was frequently depicted by seventeenth-century artists, both Italian (Annibale Carracci, Domenichino, Giovanni Lanfranco, and Mattia Preti) and Spanish (Ribera, José María de Pereda, Juan de Roelas, and José Antolínez). The subject of a celestial vision in the middle of the night enabled artists to showcase their ability to paint the effects of golden light in the darkness of a prison, and all of them, from Raphael to Ribera, took advantage of that opportunity.

Murillo's composition is very similar to a drawing dated 1640 in Claude Lorrain's *Liber veritatis* ("Book of Truth," British Museum, London) as well as to an engraving of 1657 by Hendrik Bary after a painting by Gisbert van der Kuyl.[3] Thus, there might be an earlier model that inspired Murillo and others. There is also a sketch for this painting in the Národní Galerie in Prague.

The Liberation of Saint Peter was part of one of Murillo's most important commissions, the series that decorated the church of the Hospital de la Caridad in Seville (see also cat. 54). The commission was given to Murillo by the founder of the hospital, Miguel de Mañara, a friend and a powerful Sevillian who had led the confraternity of La Caridad since 1664. Murillo himself was a "brother" of the confraternity from 1665. As such, he participated in its activities, including the distribution of bread on various occasions. The hospital was intended for the needy, and the confraternity's mission was to exercise charity and to put into practice the "acts of mercy" described in Matthew 25:35–36, the subject of the decorative program of the church: feeding the hungry, giving drink to the thirsty, giving refuge to the pilgrim, clothing the naked, visiting the sick, and visiting the prisoner. *The Liberation of Saint Peter* illustrates the last of these.

The angel descends toward the saint to miraculously free him from the prison. The composition follows a diagonal that moves downward to the left, along the head and right arm of the angel to Saint Peter. The light emphasizes that diagonal, illuminating the right half of the body of the angel and the figure of Saint Peter, which receives the light emanating from the angel. The rest of the scene is in a penumbra that conceals everything but the chains, a sleeping soldier to one side, and the left arm of the angel, pointing the way out. The gazes of both figures cross, emphasizing the diagonal, as does the placement of their arms. Murillo has contrasted the idealized beauty and youth of the angel with the more realistic features and greater age of the saint.

The painting was finished in June 1667 and installed in the church along with *Abraham and the Three Angels* (cat. 54). Murillo was paid 8,000 reales for it. He had achieved a command of his art that allowed him to manipulate light and shadows without the hardness found in his early work. In 1879 Louis Clément de Ris expressed pleasure that the Hermitage had acquired the painting and said that it had been "executed in [Murillo's] velvety manner."[4]

Even in the early nineteenth century, the paintings in the Hospital de la Caridad were highly valued in Spain. During the reign of Charles IV, when the minister Mariano de Urquijo undertook the creation of a royal museum in Madrid, the government issued an order in 1800 to bring Murillo's paintings to the capital. They were to be replaced at the hospital with copies begun by the Sevillian painter Joaquín Cortés; three years later, when the order was revoked, Cortés had made copies of this and two other canvases. A few years later Marshal Soult recognized the quality of the paintings and emptied the hospital church of them. He also took other pictures dating from the 1660s and 1670s, the painter's best period, when he worked for the Church of Santa María la Blanca, the Venerables, the cathedral, and the Capuchin order. Warehoused along with the others in the Alcázar of Seville and destined for the Musée Napoléon, *The Liberation* found its way into Soult's private collection instead. He tried to sell the painting to Louis-Philippe in 1835 for 500,000 francs, as a work by Ribera, along with *The Immaculate Conception* (cat. 57) and *Christ Healing the Paralytic at the Pool of Bethesda* (fig. 14.42). The sale, and the presence of the works at the Louvre (though they were not exhibited), was short-lived: from April 13 to May 23, when the arrangement was annulled and the paintings were returned to Soult's home; the price, he felt, was too low.

The fortunes of the pictures varied. Some, like *Saint Elizabeth of Hungary Nursing the Sick* (fig. 3.13), eventually returned to Seville, and others, like the present work, lived bumpier lives and are now marked by substantial repainting and old restorations.

While the painting was still in Paris, engravings of it appeared in the *Musée de peinture* of Achille Réveil (1828–34) and in *L'Illustration* (1852); in both instances it was attributed to Ribera. This is not surprising since Ribera had painted the same subject in a similar composition (1639, Museo del Prado, Madrid); in that work, however, the saint has fallen, the angel is leaning more to the right (toward the exit), and the two figures are shown in a more open arrangement. Ribera's painting entered the royal collections through the auspices of Isabel de Farnese (the wife of Philip V), who bought it. In the 1746 inventory of the palace of La Granja, it was said to look like a Murillo ("parece de Murillo"), *Jacob's Dream* (1639, Museo del Prado, Madrid), at that time clearly attributed to him.

This work undoubtedly had an influence on the young Delacroix, who visited the Soult collection in 1824. On May 3, he wrote in his journal, "Saw Marshal Soult's pictures. In doing my angels for the prefect, think of those beautiful, mystical figures of women."[5] Though Delacroix was referring specifically to the nearly dozen Zurbarán paintings of virgin-martyrs in Soult's collection, it is hardly a coincidence that he began work on his monumental *Agony in the Garden* (fig. 1.29) in the same year. Théophile Thoré was well aware of that painting's inspiration when he wrote in 1837: "When he has to paint Jesus Christ in the Garden of Olives and beautiful angels parting the clouds, it is Murillo who prevails."[6]

MSGF

1. "And when Herod would have brought him forth, the same night Peter was sleeping between two soldiers, bound with two chains: and the keepers before the door kept the prison. And, behold, the angel of the Lord came upon him, and a light shined in the prison: and he smote Peter on the side, and raised him up, saying, Arise up quickly. And his chains fell off from his hands. And the angel said unto him, Gird thyself, and bind on thy sandals. And so he did. And he saith unto him, Cast thy garment about thee, and follow me. And he went out, and followed him; and wist not that it was true which was done by the angel; but thought he saw a vision."

2. The artist who stayed closest to the text was Raphael, by

including many soldiers in his fresco in the Stanza of Heliodorus at the Vatican (1513–14).

3. F. W. H. Hollstein, *Dutch and Flemish Etchings, Engravings and Woodcuts* (Amsterdam, 1949), vol. 1, p. 104, cited in Kagané 1997, no. 60.

4. "execuṭe dans la manière veloutée." Clément de Ris 1879, p. 347.

5. "Vu les tableaux du maréchal Soult.—Penser, en faisant mes anges por le préfet, à ces belles et mystiques figures de femmes." Delacroix 1960, vol. 1, p. 91.

6. "Quand il faut faire Jésus-Christ au jardin des oliviers et de beaux anges qui entrouvent les nuages c'est Murillo qui domine." Thoré 1837, cited in Johnson 1981–89, vol. 1, p. 166.

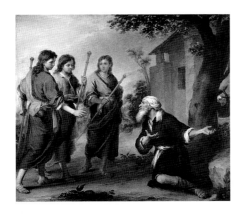

54. *(New York only)* *Fig. 14.34*

Bartolomé Esteban Murillo
Abraham and the Three Angels

1667
Oil on canvas
93 x 103 in. (236 x 261 cm)
National Gallery of Canada, Ottawa, Purchased
1948 4900

CATALOGUES RAISONNÉS: Curtis 1883, pp. 115–17; Gaya Nuño 1958, no. 1959; Gaya Nuño 1978, no. 254; Angulo Íñiguez 1981, vol. 2, no. 84

PROVENANCE: Commissioned for the church of the Hospital de la Caridad, Seville, 1667; inventoried in the Alcázar of Seville, no. 2, 1810; taken by Marshal Soult to Paris, 1812; unsuccessful effort by Soult to sell it to Louis-Philippe, 1830; purchased by George Grandville, second duke of Sutherland, London, 1835; Agnew, London, 1947; sold by Agnew to the National Gallery of Canada, Ottawa, 1948

EXHIBITIONS: London 1836, no. 10; London 1938, no. 221; Ottawa, National Gallery of Canada, 1967, "Religion in Art"; Ottawa, National Gallery of Canada, 1975–76, "Murillo and Some 17th-Century Prints and Drawings"

REFERENCES
18th–19th century: Twiss 1775, pp. 309–10; Ponz 1776–94, vol. 9, letter V, p. 148; Ortiz de Zúñiga 1795–96, vol. 5, p. 300; Ceán Bermúdez 1800, vol. 2, pp. 60–61; Ceán Bermúdez 1806, p. 80; Buchanan 1824, vol. 1, pp. 347–48; Réveil 1828–34, vol. 3, p. 271; Thoré 1835a, pp. 49, 51, 53; S.-C. [Alexandre de Saint-Chéron?] 1836, p. 40; Jameson 1844,

pp. 168, 191–92; Ford 1845, vol. 1, pp. 395–96; Stirling-Maxwell 1848 (1891 ed.), vol. 3, pp. 1019, 1028–29; Waagen 1854, vol. 2, p. 68; Tubino 1864, pp. 98, 191–95; Curtis 1883, p. 217; Lefort 1892, p. 39; Gómez Ímaz 1896, no. 2 (in Lipschutz 1972, p. 303)

20th century (selected references): Justi 1904, p. 63; Mayer 1913b, no. 333; Mayer 1938, no. 15; Hubbard 1949, pp. 98, 103–4; J. Brown 1970, pp. 265–77; J. Brown 1978, pp. 135, 139, 140; Angulo Íñiguez 1981, vol. 1, pp. 391–92; London 1981, no. 51; Calvo Castellón 1982, pp. 236–37; E. Harris 1982–83, p. 13; Laskin and Pantazzi 1987, pp. 201–2, no. 4900

The scene is found in Genesis 18:1–5: "And the Lord appeared unto him [Abraham] in the plains of Mamre: and he sat in the tent door in the heat of the day; and he lifted up his eyes and looked, and, lo, three men stood by him: and when he saw them, he ran to meet them from the tent door, and bowed himself toward the ground, and said . . . let a little water . . . be fetched, and wash your feet, and rest yourselves under the tree: and I will fetch a morsel of bread, and comfort ye your hearts. . . ." Murillo shows the patriarch Abraham kneeling, respectfully "bowed . . . toward the ground" and gesturing with his hands in an invitation to the visitors to take shelter in the shade of the tree. The painter has substituted the tent of the biblical text with a house that seemed to Stirling-Maxwell "a ruinous Spanish *venta* [roadside inn]."[1]

The painting was hung in the church of the Hospital de la Caridad in Seville along with *The Return of the Prodigal Son* (1667–70, now in the National Gallery of Art, Washington, D.C.) and represented one of the acts of mercy—giving refuge to the pilgrim, exemplified here by the three angels. When the inhabitants of the hospital, or even members of the faithful who came to attend religious ceremonies, saw this painting, they would behold a model of conduct and an example of the charity that the institution itself practiced. In order to make the scene more accessible to a seventeenth-century audience, Murillo eliminated all heavenly allusions. The angels do not descend from the clouds, nor do they have wings: they are simply young men who have arrived on foot, with their walking sticks in hand.

This theme, which had received a new impulse from the Council of Trent, was frequently depicted in seventeenth-century paintings, including some by Rembrandt. Murillo also had access to models for the scene, among them one painted by Juan Fernández de Navarrete (called el Mudo) in 1576 for the Monastery of El Escorial (now National Gallery of Ireland, Dublin), which was placed at the entrance to welcome visitors. Surely Murillo would have seen this painting when he visited the court in Madrid. He did not use it as his model, however, for the painting is instead closer to Raphael's version of the subject in the Vatican Stanze.[2] Although Murillo surely never saw the Vatican painting, he knew its composition from engravings, and his image is thus the reverse of Raphael's.

This is a large, complex painting, with four figures in a landscape, similar to *The Return of the Prodigal Son*, previously mentioned, and *Christ*

Healing the Paralytic at the Pool of Bethesda (1667–70, National Gallery, London), which was in the same church. The four figures create a semicircular space that opens toward the viewer, and their staffs draw a descending fanlike line from left to right and downward from above. This line continues through Abraham's head and his left hand, pointing to the oak under whose shadow the angels are invited to rest. The composition is ordered by the verticals created by the figures and the walls of the house, while the trunk of the tree inclines to the right, following the gesture of Abraham's hands.

The painter creates his usual skilled play of gazes: the two angels on the left look at the patriarch and their gazes cross on a diagonal, while the central figure turns toward one of his companions. Murillo contrasts the aged features of Abraham with those of the youthful angels, whose idealized faces are more conventional and even very alike. Something about the painting elicited a somewhat negative response from Juan Agustín Ceán Bermúdez and Alexandre de Saint-Chéron;[3] William Stirling-Maxwell concurred: "His [Abraham's] turbaned head, and his figure clothed in dark drapery, are grave and venerable; but the angels are deficient in dignity and grace, as is justly remarked by Ceán Bermúdez, who likewise objects to the want of that family likeness in their faces, which he commends in El Mudo's picture on the same subject at the Escorial."[4]

Recent studies of the painting have enabled us to examine Murillo's painting technique here: he applied two preparatory grounds, a thin one with a white lead base and over that another, thicker one of gray-brown.

The painting was finished by June 1667, when it was installed in the church, along with *The Liberation of Saint Peter* (cat. 53). Murillo was paid 8,000 reales for each of them.[5]

MSGF

1. Stirling-Maxwell 1848 (1891 ed.), vol. 3, p. 1028.

2. Raphael, in turn, was inspired by a fifth-century mosaic in Santa Maria Maggiore in Rome.

3. "In the Abraham adoring the three Angels, I like above all the head and pose of the patriarch, the simple and noble manner of the angels; but their heads are not sufficiently elevated in style." (Dans l'Abraham adorant les trois Anges, j'aime surtout la tête et la pose du patriarche, l'attitude simple et noble des anges; mais leurs têtes n'ont pas assez d'elevation de style.") S.-C. 1836, p. 40. Saint-Chéron must have read Ceán Bermúdez, as did Stirling-Maxwell (see n. 4 below).

4. Stirling-Maxwell 1848 (1891 ed.), vol. 3, p. 1028–29.

5. The masons who hung them on the wall received 64 reales. Archivo del Hospital de la Caridad, Seville *Libro de quentas y visitas*, 1657–1701, fol. 69 vo (in Angulo Íñiguez 1981, vol. 2, p. 87).

55. *(New York only)* *Fig. 7.17*

Bartolomé Esteban Murillo
Saint Joseph and the Christ Child

Ca. 1670–75
Oil on canvas
42¼ x 33¾ in. (108 x 84 cm)

Bequest of John Ringling, Collection of The John and Mable Ringling Museum of Art, Sarasota, Florida SN349

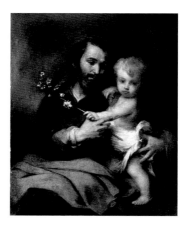

CATALOGUES RAISONNÉS: Curtis 1883, no. 344; Gaya Nuño 1958, no. 1987; Gaya Nuño 1978, no. 232; Angulo Íñiguez 1981, vol. 2, no. 328

PROVENANCE: Serafino García de la Huerta; sold by her to Baron Taylor, Madrid, 1837; Galerie Espagnole, Musée du Louvre, Paris, 1838–48, nos. 154/157; Louis-Philippe sale, Christie & Manson, London, May 7, 1853, no. 1687, bought by Rutley for 440 pounds; Lyne Stephens, Lynford Hall; Stephens sale, London, May 11, 1895, no. 335; purchased by Agnew

EXHIBITIONS: Paris, Galerie Espagnole, Musée du Louvre, 1838–48, nos. 154/57; Paris 1874, no. 359; Jacksonville, Florida, Cummer Gallery of Art, 1962, "Loans from the Collection of the Ringling Museum of Art"; Bradenton, South Florida Museum, 1971; Fort Worth–Los Angeles 2002, no. 24

REFERENCES
19th century: Ford 1853, p. 594

20th century (selected references): Mayer 1913b, no. 279; Mayer 1923b, no. 185; Suida 1949, no. 349; Baticle and Marinas 1981, no. 157; Paris 1983, no. 61

Of the three paintings on this subject that hung in the Galerie Espagnole, only the present work is today attributed to Murillo: the other two are considered, respectively, a shop piece (private collection, London) and a work by a follower (Musée Condé, Chantilly). However, Diego Angulo Íñiguez did not exclude the possibility that even the Ringling painting is a copy created in Murillo's workshop.

This is probably the painting that the astute Baron Taylor bought in 1837 in Madrid from García de la Huerta for the Galerie Espagnole. However, the secure dates in the provenance begin with the 1853 Louis-Philippe sale at Christie & Manson in London.

Joseph attending Jesus, in the place more usually occupied by Mary, appears with some frequency in the work of Murillo, from a drawing (collection of Yvette Baer) to *The Holy Family with a Bird* [fig. 4.24]). In this painting, unlike the other works,

the attention is focused on the seriousness of the subject, not on play. Murillo knew youngsters well, for he came from a family with many siblings and was himself the father of many children. Some have suggested that several of the models for these paintings (such as the one in the Alte Pinakothek, Munich) could be his own children or perhaps another child in the household, the daughter of a servant, for example.

Among Murillo's subjects, *Saint Joseph and the Christ Child* is one of the most frequently copied, because the theme touches on an important aspect of Sevillian religiosity: the closeness between celestial and earthly beings. The saints (in this case, Saint Joseph) seem to experience the same sentiments as the viewers who contemplate them. Joseph, the "official" father of Jesus, expresses tenderness toward his "son," gazing at him affectionately and gently helping him to stand. The boy also holds Joseph's flowering rod, the symbol of his being chosen as Mary's husband. In spite of his tender age, the Christ Child wears a serious expression as he gazes directly out at the faithful.

This painting, like so much of Murillo's production, was intended for a specific audience—faithful members of the Catholic Church, who would contemplate the work in a public or private setting. Laypersons often commissioned paintings of this type (with subjects such as the Ecce Homo and the Sorrowful Virgin) for their homes as devotional works that would arouse them to prayer and intensify their religious experience. This personal response is far from our modern contemplation in the galleries of museums, where such works are offered along with Egyptian scarabs and twenty-first-century "installations."

Saint Joseph is a minor figure in the New Testament. According to Matthew (1:19) he was a "just man," who took Mary and the Christ Child to Egypt to escape Herod's persecution, and from there to Galilee. Nevertheless, he is a constant figure in art from the Middle Ages on, pictured in scenes of the Adoration of the Shepherds or of the Magi and in paintings of the Flight into Egypt. The cult of Saint Joseph expanded considerably in seventeenth-century Spain, primarily because of the Franciscans and the Council of Trent; from 1621 on, he had his own feast day. Saint Ignatius of Loyola, among other writers,[1] emphasized the important role Joseph played during Christ's childhood, and Saint Teresa of Avila dedicated more than half of the convents she founded throughout Spain to him.

The figure type that Murillo used throughout his oeuvre to represent the saint is that of a mature, not old, man—strong, affectionate, a responsible father and family man. Perhaps Joseph's elevation to sainthood explains the positive reception this painting had in Seville, as well as the many copies by Murillo's workshop and followers that were created while the painting was still in that city.[2] Murillo probably used a model showing Saint Joseph full length, for this and other paintings on the same subject. Possibilities include the little oil on panel belonging to the Newhouse Gallery, New York, which may be a sketch for the subject, or the copy in the Pérez Asencio collection, Jerez de la Frontera.

The subject of Saint Joseph with the Christ Child shares affinities with other devotional paintings by Murillo that include male saints, such as Anthony of Padua, Jerome, and Francis of Assisi, depicted as half-length figures in poses expressing their love for the child.

Throughout the nineteenth century, when the painting was in France, the popularity of the painting continued, and more than a dozen different engravings were made after it (by Lemoine, Cottin, Geoffroy, Lasalle, Magi, Prat, Barry, Lavigne, Maurin, Pingot, Laujol, Jannin, and Lafosse), perhaps nearly twenty, according to one writer.[3] The subject and mode of presentation were appropriate for the last quarter of the nineteenth century, when there was a rebirth of conservative, even sentimental, Catholicism. Saint Joseph was taken as a model for the docile craftsman—as opposed to the radicalized laborer of the new industrialized society—and his cult was one of the most widespread. His popularity is reflected in the many churches, monasteries, and religious institutions dedicated to him, as well as in the numerous prints after Murillo's painting.

Richard Ford, who saw the painting in London, considered it "painted in his third and most popular manner, and full of tender sentiment and melting tones."[4] He also noted other important aspects of the painting: its soft, warm coloring, the contours delicately softened with loose brushwork, and the golden light that illuminates the body of the child in his white drapery, as well as the hands, and, above all, the face of his father. The flowers stand out from the dark background with thicker touches of white paint.

Murillo painted this in the 1670s, when he was at the top of his form, the master of what was called his velvety or warm manner.[5]

MSGF

1. See, for example, Jerónimo Gracián de la Madre de Dios, *Grandezas y excelencias del glorioso San José* (Rome 1597).
2. The closest copy is attributed to Alonso Miguel de Tovar and is now in the Glasgow Art Gallery and Museum, Kelvingrove. The painting here especially recalls the one in the Pushkin Museum, Moscow.
3. Curtis (1883) found nineteen engravings after this canvas.
4. Ford 1853, p. 594.
5. "manière veloutée"; "manière chaude." Clément de Ris 1879, p. 347.

56. *(New York only)* *Fig. 7.16*
Bartolomé Esteban Murillo
Ecce Homo

Ca. 1675
Oil on panel
33¼ x 31 in. (85.5 x 79 cm)
Inscribed upper left: A LUIS/FELIPE/DE/ORLEANS/ REY DE LOS/FRANCESES (To Louis/Philippe/de Orléans/King of the/French); upper right: EL CABILDO/DE LA SANTA/METROPOLITANA/PATRIARCAL /YGLESIA/DE/SEVILLA (The Cabildo/of the Holy/ Metropolitan/Patriarchal/Church/of/Seville)
El Paso Museum of Art, Gift of the Kress Foundation 1961.1.54

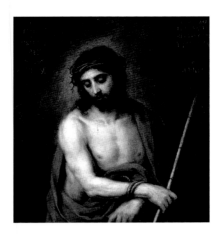

CATALOGUES RAISONNÉS: Curtis 1883, no. 199; Angulo Íñiguez 1981, vol. 2, no. 247

PROVENANCE: Cathedral of Seville, Capilla del Pilar; Cathedral of Seville, Capilla de la Virgen de la Alcobilla; Cathedral of Seville, Sacristy of the Chalices; given by the cabildo of the cathedral to King Louis-Philippe of France through the agency of Baron Taylor, Paris; Galerie Espagnole, Musée du Louvre, Paris, 1838–48, nos. 163/167; Louis-Philippe sale, Christie & Manson, London, May 13, 1853, no. 240, bought for 160 pounds by Norton; John Campbell, fifth earl of Breadalbane, Taymouth Castle, Perthshire; Robert Baillie-Hamilton, Langton House, Scotland, by 1881; sold at Christie's, London, for 441 pounds by Arkwright, July 8, 1927; T. G. Morgan-Granville-Gavin sale, London, June 18, 1954, bought for 1,470 pounds by Koetser Gallery, London; sold to Samuel H. Kress Foundation, New York, 1955; donated to El Paso Museum of Art, 1961

EXHIBITIONS: Paris, Galerie Espagnole, Musée du Louvre, 1838–48, nos. 163/167; London 1881, no. 218; London 1893b, no. 112; Fort Worth–Los Angeles 2002, no. 27

REFERENCES

18th–19th century: Ponz 1776–94, vol. 9, letter I, p. 12; Ceán Bermúdez 1804, p. 72; Standish 1840, p. 194; Amador de los Ríos 1844, p. 183; Stirling-Maxwell 1848, vol. 3, p. 1430; Latour 1855, vol. 1, p. 78; Velázquez y Sánchez 1864, p. 203; Gestoso y Pérez 1889–92, vol. 2, pp. 135, 571; Lefort 1892, no. 197, p. 82

20th century (selected references): Mayer 1926b, p. 251; El Paso 1961, no. 46; Guinard 1967c, p. 292; Eisler 1977, no. K 2108, pp. 219–21; Angulo Íñiguez 1981, vol. 1, p. 216; Baticle and Marinas 1981, no. 167; Plazaola 1989, pp. 134–35

"Ecce homo" ("Behold the man") is the phrase that, according to John 19:5, Pilate pronounced when he brought Jesus before the Jews, after Jesus had been arrested, crowned with thorns, whipped, and subjected to derision: the cane in his hand is a parody of a king's scepter. Thus he appears in Murillo's painting, stripped of his clothing, dressed only in a purple mantle—another mocking prop—with his hands tied and the mark of the cords on his wrists.

Wounded, aching, his gaze lowered, he presents an image of suffering that would awaken compassion among those who saw him, as well as repentance among those who responded with the words "Crucify him, crucify him."

For this reason, such representations are known as the Man of Sorrows and often form a pendant to images of Mary as the Mater Dolorosa (Sorrowful Mother), who also suffers on seeing what has been done to her son. Murillo painted various of these pairs, some of them now in the Museo del Prado, Madrid; the paired subjects also are found in Andalusian sculpture of the period.[1]

Works of this type are devotional paintings that were hung in churches or in private oratories in homes. By the seventeenth century, such images had long been traditional, having been painted by Early Netherlandish artists, but they convey a different feeling beginning with Titian's *Ecce Homo* (1548, Prado), painted for Charles V.[2] In Spain these subjects were frequently depicted, and were painted by almost all the great masters of the sixteenth and seventeenth centuries. The notable exception was Velázquez, who, as painter in the service of Philip IV, had other obligations.

Murillo executed this *Ecce Homo* on a wood panel, a support, like stone (see figs. 2.6, 2.7), that he occasionally used for such devotional paintings.[3] The line where two pieces of wood have been joined is visible across the middle of Christ's torso. The painting recalls Titian's version of the subject, although the figure is reversed in Murillo's work, perhaps because he was basing it on an engraving. The figure of Jesus is more slender than in Titian's painting, and the red of the mantle is more intense in Murillo's work.

In the upper two corners, the painting bears an inscription written on two rectangles that appear to have been added about 1839, after the painting had arrived in France. That is to say, the panel was a different shape—rectangular but narrower at the top—when it crowned the altarpiece in the Capilla del Pilar, where it was first installed. When the painting left the Cathedral of Seville and took up an artistic rather than devotional function in the Galerie Espagnole, the two pieces were added to regularize its shape so that it would be more suitable as a museum piece. A similar alteration took place on two canvases that Murillo painted for the Church of Santa María la Blanca, *The Dream of the Patrician* and *The Patrician John and His Wife before Pope Liberius* (figs. 1.22, 1.23), both also taken from Seville to France. In Paris, the paintings had curved triangles added to the upper edges, converting them from lunettes into rectangles.[4]

This *Ecce Homo* has had an active history. Even when it was in Seville, it was moved around to various places in the cathedral. Antonio Ponz (1776–94) saw it in the Capilla del Pilar, Juan Agustín Ceán Bermúdez (1804) in the chapel dedicated to the Virgen de la Alcobilla, and José Amador de los Ríos (1844) in the Sacristy of the Chalices. From there the painting went to France, England, and the United States and never stopped changing hands and locations until 1961. Its travels are a reflection of changes in taste: although Baron Taylor, Louis-Philippe's agent in Spain, wanted to acquire it for the Galerie Espagnole at any cost, it was not considered an attractive adornment for the home in the second half of the nineteenth century and the first half of the twentieth.

The "gift" of this painting to the French king by the cabildo of Seville Cathedral was influenced by many factors: the debility spreading throughout Spain at the time, the neediness of the cabildo, the power of Taylor's friends in Spain, and the intervention of Manuel López Cepero in Seville and the Madrazo family in Madrid. In exchange for the *Ecce Homo*, the cathedral received some "trifles" (*pequeñeces*):[5] a medal of the French royal family, a portrait of Christopher Columbus (painted by Émile Lasalle) for the library, some musical scores, a copy of Taylor's *Voyage pittoresque*, and some art books. The dean of the cabildo, Manuel López Cepero, was given illustrated editions of Molière.

MSGF

1. This painting was the subject of a comprehensive entry by Suzanne Stratton-Pruitt in Fort Worth–Los Angeles 2002, pp. 172–73, to which I am indebted.
2. The king had it in his bedroom when he retired to Yuste.
3. Titian's painting of the subject in the Prado is on slate.
4. These gilded triangles, added by the architect Charles Percier, bore plans and elevations of the basilica of Santa Maria Maggiore in Rome; those decorations were retained after the restoration by Ferdinando Fuga. They remained in place after the paintings were returned to Spain and are still there today.
5. The comte de Bondy wrote to the cabildo on April 29, 1839, thanking them in the name of the king. See Guinard 1967c. The archives of the López Cepero family contain documents related to the gifts.

57.

Bartolomé Esteban Murillo
The Immaculate Conception

Fig. 1.20

Ca. 1678
Oil on canvas
9 ft. 1⅞ in. x 6 ft. 2¼ in. (274 x 190 cm)
Museo Nacional del Prado, Madrid P 2809

CATALOGUES RAISONNÉS: Curtis 1883, no. 29; Gaya Nuño 1978, no. 311; Angulo Íñiguez 1981, vol. 2, no. 110

PROVENANCE: Hospital de los Venerables Sacerdotes, Seville, until 1813; requisition of Marshal Soult, Paris, until his death in 1852; Soult sale, Paris, May 19, 21, 22, 1852, no. 57, bought for 615,300 francs by the Musée du Louvre, Paris; Museo del Prado, Madrid, 1941, through exchange of works of art with the French government

EXHIBITIONS: Madrid–London 1982–83, no. 75; Seville 1991–92, no. 46

REFERENCES

18th–19th century: Palomino 1724 (1947 ed.), vol. 3, p. 1033; Ponz 1776–94 (1947 ed.), vol. 9, p. 794; Ceán Bermúdez 1800, vol. 2, pp. 53–54, 60; Ceán Bermúdez 1806, p. 93; Quilliet 1816 (Saltillo 1933),

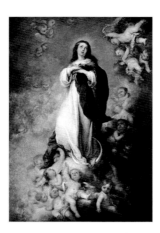

pp. 100–101; Soult 1852a, no. 57; Blanc et al. 1869, nos. 102–3 (Murillo issue), repr.; Gruyer 1891, p. 277

20th–21st century (selected references): Mayer 1913b, no. 166; Mayer 1923b, p. 293; Michel Nicolle, "École espagnole," in Guiffrey 1929, vol. 2, pp. 28–32; Mâle 1931, p. 56; Sánchez Cantón 1940; Sánchez Cantón 1942, no. 2809; Pantorba 1947, p. 34; Gaya Nuño 1958, p. 27; Lipschutz 1972, p. 120; Angulo Íñiguez 1976a, p. 43; Haraszti 1977, no. 23; Angulo Íñiguez 1981, vol. 1, p. 414; Madrid–London 1982–83, no. 75, p. 54 (Madrid ed.); Portús Pérez 2001, pp. 192–98

According to Juan Agustín Céan Bermúdez, Justino de Neve, a canon of Seville Cathedral whose portrait was painted by Murillo in 1665 (National Gallery, London), commissioned this painting in 1678 for an altar in the Venerables Sacerdotes, the church of the home for retired priests that Neve had recently founded (see cat. 58).[1] The Hospital de los Venerables, as it is known in Seville, is still one of the most characteristic Baroque buildings in the entire city and particularly in the neighborhood of Santa Cruz. Neve, who was also responsible for Murillo's commission to paint the lunettes for the Church of Santa María la Blanca, had eighteen of the artist's paintings in his collection. Along with the Fleming Nicolás Omazur, he was the most important private collector of the painter's work.

This enormous painting served as an altarpiece and as an exaltation of Mary, the mother of Jesus Christ. Two concepts are united in it: Mary's corporeal ascent into heaven (the Assumption) and her conception without the physical union of her parents (the Immaculate Conception). The second concept, which the official church did not formalize as dogma until the nineteenth century, had become a standard for some religious orders, for the city of Seville, for some theologians, and for Spain, beginning in the sixteenth century. The iconography was fixed by the end of that century, but it was mostly diffused during the seventeenth century thanks to Murillo, who codified the canonical representation of the subject and painted more than twenty versions depicting it.

For people in the seventeenth century, the image of the Virgin of the Immaculate Conception represented their devotion to Mary as intercessor on behalf of humanity before God. But the image was also a sign of identity, a symbol that made them feel united and proud. These ideas and sentiments were expressed by Murillo better than anyone in his images of Mary. His beautiful and serene young woman rises heavenward, supported by a crescent moon and surrounded by charming putti, without the various attributes (allusions to the litanies or to landscapes) that accompany her in paintings by other artists such as Zurbarán (cat. 89) or Velázquez.

Céan Bermúdez considered this Immaculate Conception "the best of all those by his [Murillo's] hand that there are in Seville, as much because of the beauty of the color as because of the effect and contrast of the chiaroscuro."[2] It is a work of Murillo's maturity, in which the air, clouds, and angels take up more space than is usual with this subject. There is also a more dramatic contrast between the golden light, falling on a nearly vertical diagonal, that illuminates the figure and the two lateral triangles that are thus left in shadow. The angels, free of symbols, painted in Murillo's "vaporous" manner, move playfully, in a line that leads to the Rococo and, in one case, derives from Titian.[3]

The Immaculate Conception is the most important of Murillo's versions of the subject and also the best known, thanks to its stay in France for nearly a hundred years. In fact, the life of the painting has been more exciting than that of the artist, who apparently never left Spain. The picture was taken by Marshal Soult when he occupied Seville with his troops during the war of independence (1808–14), along with other Murillo works of the first rank, including the *Saint Elizabeth of Hungary Nursing the Sick* (fig. 3.13) from the Hospital de la Caridad in Seville.[4] Soult tried to sell the painting twice, for very high prices: 250,000 francs in 1823, in London through the dealer William Buchanan, and 500,000 francs in 1835, to King Louis-Philippe for his Galerie Espagnole, in a lot that included two other paintings from the Hospital de la Caridad.[5] The latter deal was closed on April 13, and the painting, though in the Louvre for more than a month, apparently was not exhibited. The sale was canceled on May 23 and the painting was again in Soult's hands.

Finally, the Louvre obtained *The Immaculate Conception* in 1852, when the marshal's paintings were put up for auction in Paris. The price paid—615,000 francs, the highest price ever for a picture to that date—shows the prestige of the work in France, as well as throughout Europe. Besides the Louvre, the czar of Russia bid for the painting, as did Queen Isabella II of Spain, and the National Gallery in London was prepared to pay up to 5,000 pounds sterling for it.

The prestige of *The Immaculate Conception* was made particularly clear by its installation in a place of honor at the Louvre—in the Salon Carré, on a wall with Italian paintings by Veronese, Raphael, and Leonardo, facing works by Rubens and Van Dyck (fig. 1.48). Artists, especially women, came from everywhere to copy the painting during the second half of the nineteenth century and the opening years of the twentieth (fig. 12.5), until the avant-garde shrank Murillo's fame.

Thanks especially to writers (as Lipschutz has shown),[6] in France the painting became the proto-type of feminine beauty, not just of the Virgin Mary but also of flesh-and-blood Andalusian women. For Rafael, the protagonist of Balzac's *Peau de chagrin* (1831), contemplation of this *Immaculate Conception* (along with Rossini's music, a certain landscape, and other picturesque matters) brought sweet memories of his first love.[7] The painting is a place in which beauty on one hand and a well-known image on the other meet as a point of reference that the reader can share with Rafael.[8]

The return of the painting to Spain was formalized in 1940 on December 8, the day on which the Immaculate Conception of the Virgin is celebrated, and it was solemnly delivered to the Prado on June 27, 1941. This event, closely following the end of the Spanish Civil War, was presented as a triumph of international diplomacy on the part of isolated Spain. The painting, now on view in the Prado, again became a sign of identity during years that bore little resemblance to the sixteenth and seventeenth centuries (as much as those who governed might have felt impelled to resuscitate the "empire"). Murillo's Virgin adorned little religious prints (mementos of first communions, novenas, and religious festivals of all sorts), candy boxes, and even the announcements of military celebrations, in her role as patroness of the Spanish army's infantry.

MSGF

1. Céan Bermúdez 1806, p. 93.
2. "superior a todas las de su mano [de Murillo] que hay en Sevilla, tanto por la belleza del color cuanto por el efecto y contraste del claroscuro." Ibid.
3. Manuela B. Mena Marqués, in Madrid–London 1982–83, no. 75, points to the similarity of one of the angels with a putto in Titian's *Rape of Europa* (ca. 1560, Isabella Stewart Gardner Museum, Boston), a painting Murillo could have known when it was in the Spanish royal collection.
4. Lipschutz 1972, pp. 35–37.
5. *Christ Healing the Paralytic at the Pool of Bethesda* (fig. 14.42) and *The Liberation of Saint Peter* (cat. 53), the latter offered as by Ribera but now attributed to Murillo. Ibid., p. 37.
6. Ibid., p. 160.
7. "The sight of the lake of Bienne, some themes of Rossini, the Murillo Madonna owned by Marshal Soult, the letters of La Lescombat, a word here and there in collections of anecdotes, but above all the prayers of the ecstatics and some passages of our *fabliaux*—on their own these have had the power to transport me into the heavenly regions of my first love." ("La vue du lac de Bienne, quelques motifs de Rossini, la Madone de Murillo que possède Maréchal Soult, les lettres de la Lescombat, certain mot épars dans les recueils d'anecdotes, mais surtout les prières des extatiques et quelques passages de nos fabliaux, ont pu seuls me transporter dans les divines régions de mon premier amour.") Balzac, *La peau de chagrin* (Paris 1831), p. 120.
8. Émile Zola also mentions the painting in *L'Assommoir*, published in 1877.

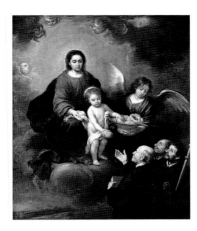

58. *(New York only)* *Fig. 14.15*

Bartolomé Esteban Murillo

*The Christ Child Distributing Bread
to the Priests*

1678
Oil on canvas
86¼ x 71⅛ in. (219 x 182 cm)
Szépmüvészeti Múzeum, Budapest 777

CATALOGUE RAISONNÉ: Angulo Íñiguez 1981,
vol. 2, no. 145

PROVENANCE: Commissioned by Justino de Neve
(canon of the Cathedral of Seville) for the refectory
of the Hospital de los Venerables Sacerdotes,
Seville, 1678; deposited in the Alcázar of Seville
with the other paintings destined for France, 1810;
taken by Marshal Soult to Paris, 1810; sold by him to
Prince Esterházy of Vienna, 1822; purchased by the
Hungarian crown for 1,300,000 florins, 1870

REFERENCES

18th–19th century: Ponz 1776–94, vol. 9, letter IV,
p. 124; Townsend 1791, vol. 3, p. 279; Ceán Bermúdez
1800, vol. 2, p. 60; Ceán Bermúdez 1806, p. 94;
Stirling-Maxwell 1848 (1891 ed.), vol. 3, pp. 1050–51;
Gómez Ímaz 1896, no. 290 (in Lipschutz 1972, p. 309)

20th century (selected references): Mayer 1923b,
p. 292; Montoto 1923, p. 14; Térey 1923, p. 773;
Saltillo 1933, pp. 27–28; Pigler 1967, vol. 1, p. 471;
Haraszti-Takács 1968, p. 12; Angulo Íñiguez 1976a,
pp. 70, 84, 95; Angulo Íñiguez 1981, vol. 1, p. 433;
Haraszti-Takács 1982, no. 24; Nyerges 1996, p. 108

The British traveler Joseph Townsend, who was in
Spain in 1786–87, saw this painting in Seville and
deemed it "the most charming of all the works of
Murillo."[1] Townsend, who admired the Sevillian
painter, was one of those who best understood
Murillo's talent for bringing religious scenes to the
common man and for turning sacred figures into
amiable persons of flesh and blood, accessible to the
faithful. This aspect of Murillo's art is reflected in
the title that Manuel Gómez Ímaz gave this painting
in 1896: *The Virgin and Child Distributing Some
Cookies.*[2]

In the Seville of the second half of the seven-
teenth century, a city devastated by plague and
hunger, the charity of religious and privately estab-
lished institutions was responsible for easing need
and helping to cover the basic necessities of the pop-
ulace. The confraternity of La Caridad (to which
Murillo belonged from 1665) and the monasteries
took on the distribution of bread to the poor.
Murillo himself participated in these distributions,
and he painted the subject on several occasions, with
children as the protagonists in more than one of
these works.

The scene in this painting would have been
familiar to the priests of the Hospital de los
Venerables Sacerdotes, who contemplated it in the
refectory while they were eating; perhaps in their
minds they exchanged the celestial figures for the
earthly ones who performed the acts of charity in
their names. The old and sick but "venerable" (wor-
thy of veneration) priests and pilgrims such as the
figure on the right spent the last years of their
lives in this hospital thanks to the generosity of
Justino de Neve (1625–1685). Neve, who belonged
to a powerful family of Flemish merchants, was a
canon of the Cathedral of Seville and the founder
of the hospital.

In the painting, the old priests line up to receive
the bread given to them by the Christ Child, assisted
by his mother and served by an angel. The men
respond gratefully and worshipfully. Murillo, who
so often painted playful and amusing children, chil-
dren he knew well because of his own family, also
understood how to paint them in a serious mood in
which they are conscious of their acts. The Child
here, in a gesture that also symbolizes the sacrament
of the Eucharist, exemplifies that mode, as does the
somewhat older boy Thomas of Villanueva in *Saint
Thomas of Villanueva Dividing His Clothes among
Beggar Boys* (ca. 1667, Cincinnati Art Museum).
The Virgin, an attentive mother, holds the Christ
Child, and the angel fulfills its task as a servant, with
the same seriousness.

The gazes of the three heavenly figures are
directed downward, while those of the priests rise to
meet them. The composition follows a diagonal line
that rises from the lower right, through the head and
hand of the oldest priest, to the hand of the child
holding bread, and finally to Mary's head. Another
small opposing diagonal moves through the boy's
hand, the basket of bread, and the angel, making an
inverted triangle with the figure of the Virgin. The
vertical lines created by the figures of Mary and
Jesus and the heads of an old man and the angel give
the composition stability. Light plays a composi-
tional role, with the child most brilliantly lit by a
halo shining behind his head. The overall tonalities
are warm: the red of Mary's gown, the orange light
of the background, and the golden loaves of bread.

The use of half-length figures attending a heav-
enly apparition is also employed by Murillo in other
paintings such as those he created for Santa María
la Blanca: *Apparition of the Virgin of the Immacu-
late Conception to Six Persons of Rank* (fig. 14.24)
and *Triumph of the Eucharist* (Faringdon Collection,
Buscot Park, England).[3] The two works are organ-
ized similarly to this one, with a group of figures at
the lower right turned toward a seated woman. The
employment of half-length figures was frequent in
sixteenth-century painting and was revived in the
seventeenth. Alonso Cano, among others, used them
in scenes of the Virgin with saints.

As in the paintings for Santa María la Blanca, the
earthly figures in the Budapest picture are painted in
detail and with a high degree of realism; they can thus
also be thought of as portraits. The images of Mary,
Jesus, and the angel are more idealized. It has been
suggested that the oldest priest, the one holding a
book in his hand and wearing an elegant black suit
with velvet trim, could be Neve, whose portrait
Murillo had painted in 1665 (National Gallery,
London) when Neve was forty years old. However, it
seems unlikely that the canon would have changed so
much in thirteen years, nor is there sufficient physical
similarity to make such an identification plausible.[4]

Murillo's characteristic attention to the physical
qualities of objects is seen here in the little woven
wicker basket, the loaves of bread, the book held by
the priest, and the pilgrim's cane. Those "fine
wheaten loaves" that were baked in Alcalá de
Guadaira convinced William Stirling-Maxwell that
nothing much had changed between Murillo's time
and his own.[5]

Murillo's receipts for payments indicate that the
artist painted this work in 1678, during the produc-
tive period of personal triumph comprising the
decades of the 1660s and 1670s. Those were the
years when he painted for Santa María la Blanca, the
Hospital de la Caridad, and the Cathedral of Seville,
all the while undertaking private commissions, por-
traits, and genre paintings. For the Hospital de los
Venerables, Murillo also painted *The Immaculate
Conception* (cat. 57) and *The Penitent Saint Peter*
(Townsend, Newick, Lewes).

This work, like *The Immaculate Conception*, fell
into the hands of Napoleon's marshal, who person-
ally transported it from Seville to Paris. It remained
in Soult's well-known collection until 1822, when he
sold it to Prince Esterházy of Vienna.

MSGF

1. Townsend 1791, vol. 3, p. 279.
2. "la Virgen y el niño repartiendo unas rosquitas." Gómez
 Ímaz 1896.
3. These paintings were also commissioned by Justino de
 Neve, and they too left Seville in the baggage of French
 soldiers.
4. The portrait of Justino de Neve was hung in the "antere-
 fectory" of the hospital, where Ponz saw it (Ponz 1776–94,
 vol. 9, letter IV, p. 124).
5. "In the Museum of Cadiz may be seen an indifferent copy,
 which is sufficient to give some idea of the graces of the
 original, and to show that the fine wheaten loaves of Seville
 and Alcalá have not undergone any change in shape since
 the days of Murillo." Stirling-Maxwell 1848 (1891 ed.),
 vol. 3, pp. 1050–51.

JUSEPE DE RIBERA

Játiva, 1591–Naples, 1652

Though born in the Spanish city of Játiva, in the province of Valencia, Ribera spent his entire life in Italy, where he acquired the sobriquet Lo Spagnoletto. He took up residence in Parma (where he is recorded in 1611) and Rome (1613–16), where he studied at the Accademia di San Luca, and carried out important religious commissions in both cities before eventually settling in Naples in 1616. His early works reveal a knowledge of northern Italian painting, in particular the work of Caravaggio. Despite his residence in Naples, Ribera's art became known and revered in Spain through the promotion of Spanish officials in Italy, among them the Spanish ambassador to Rome and the viceroys who ruled Naples (then a territory of Spain). Canvases by Ribera were commissioned by no fewer than four viceroys, who, after completing their terms in office, returned to Spain with the works. It was in this way that Ribera's paintings entered the royal collection of Spain, where they were seen by Velázquez and Zurbarán, among others. Ribera also inspired Murillo's renowned representations of the Immaculate Conception of the Virgin Mary.

Ribera's works were also disseminated through a series of eighteen etchings. These prints, known throughout Europe, were recorded in Paris collections by the eighteenth century and, as Théophile Thoré noted in an article in the *Revue de Paris* in 1835 (vol. 22, p. 57), could be seen as well in the collection of the Bibliothèque Nationale.

Records indicate that copies after Ribera's works were carried out during the artist's lifetime. Moreover, the majority of Riberas recorded in France in the early nineteenth century have since been reattributed, in certain cases to other noted artists. Such was the case with the *Democritus* by Velázquez (cat. 70) and the *Saint Francis* by Zurbarán (cat. 90). Napoleon's generals sought out Ribera's paintings, which are documented in the collections of the Marshals Soult and Andoche Junot, comte de Merlin, and the baron Mathieu de Faviers. Napoleon's brothers, Lucien and Joseph Bonaparte, also acquired paintings by the Spanish master during their residence in Spain. In 1802 the Louvre was to receive as a gift one of his most important late works, *The Adoration of the Shepherds* (fig. 2.11), and in July 1814 his extraordinary *Bearded Woman (Magdalena Ventura with Husband and Child*, 1631, Palacio Lerma, Fundación Casa Ducal de Medinaceli, Toledo) was a highlight of Vivant Denon's "L'exposition des 'écoles primitives,'" at the Louvre.

Though Ribera's pictures of violently tortured martyrs inspired emotionally wrought poems and prose, by the mid-nineteenth century his works were appreciated as exceptional examples of naturalism and served as inspiration for the Realist school.

DLR

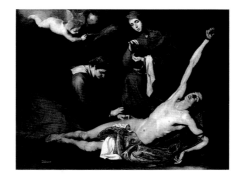

59. *Fig. 1.19*

Jusepe de Ribera

Saint Sebastian Tended by the Devout Women

1621(?)
Oil on canvas
71 x 91⅛ in. (180.3 x 231.6 cm)
Signed and dated on stone in right foreground: *Jusepe de Ribera, de Spagnolet F. 1621* (?), [almost illegible]
Museo de Bellas Artes, Bilbao 69/206

CATALOGUES RAISONNÉS: Felton 1971, no. X-208; Pérez Sánchez and Spinosa 1978, no. 78

PROVENANCE: Diego Felipe de Guzmán, marqués de Leganés, Madrid, d. 1655; Philip IV, by ca. 1657; sent by him to the monastery of the Escorial at the suggestion of Velázquez, ca. 1657; requisitioned by Frédéric Quilliet, Administrador de Bienes Nacionales, and brought to Madrid; included in a list of works taken from the Escorial (crate no. 65) signed by Quilliet on December 3, 1809; one of six works given to Marshal Soult as "national recompense" by royal decree of December 27, 1809, and retrieved by Soult's agent M. Barrillon on August 17; Barrillon applies for an export license on the following day for these six works as well as another fifteen in Soult's possession, thirteen of which are listed as workshop copies; Marshal Soult, Paris, 1809–51; his sale, Paris, May 19, 21, 22, 1852, no. 16, bought in at 3,100 francs; his sale, Paris, April 17, 1867, no. 7, bought in at 13,600 francs; purchased by Museo de Bellas Artes, Bilbao, from marquesa de Balleroy (great-granddaughter of Soult), 1924

REFERENCES

17th–19th century: Santos 1667, pp. 79–80; Santos 1681, p. 66; Santos 1698, p. 81; Ximénez 1764, p. 99; Ponz 1776–94 (1947 ed.), p. 184; Ceán Bermúdez 1800, vol. 4, p. 190; Réveil 1828–34, vol. 2, pl. 133, repr. (as *Saint Sebastian*)

20th century (selected references): Saltillo 1933, pp. 32, 85, no. 65; Pérez Sánchez in Naples–Madrid–New York 1992, p. 142, no. 18, repr. (Naples ed.), p. 194, no. 17, repr. (Madrid ed.); Bilbao 1999, p. 102

This important early work by Ribera was in the collection of the marqués de Leganés (d. 1655), and from there it entered the collection of Philip IV. About 1657 the painting was sent to the Escorial as part of a large shipment of forty-one paintings.

This undertaking was overseen by Velázquez, who organized the works upon their arrival. The *Saint Sebastian* was documented in the Escorial in the 1667 edition of Padre Francisco de los Santos's *Descripción breve del Monasterio de S. Lorenzo el Real del Escorial*.[1] Antonio Ponz and Juan Agustín Ceán Bermúdez noted its presence in the Escorial in 1745 and 1800, respectively.

Having acted as guide to the picture dealer Jean-Baptiste-Pierre Lebrun during his art-buying trip through Spain in 1807–8, the art connoisseur Frédéric Quilliet was already familiar with the Escorial's vast collections. He thus eagerly availed himself of its treasures when he was charged with assembling artworks from the royal collections for Joseph Bonaparte's proposed national museum of painting. Requisitioned by Quilliet, this painting was instead sent to Madrid, where, by royal decree of December 27, 1809, it was presented as "national recompense" to Marshal Soult, head of French forces in Andalusia.[2] Following Soult's death in 1851, the painting was offered at the auction of his collection in 1852, where it failed to sell, and—again unsuccessfully— at the auction of 1867. It remained in the collection of his heirs until 1924, when it was purchased by the Museo de Bellas Artes, Bilbao, from Soult's great-granddaughter, the marquesa de Balleroy.

In Ribera's *Saint Sebastian*, the martyr is tended to by Saint Irene and a companion after having been tied to a tree and shot with arrows upon being discovered as a Christian. This work figured among Soult's extraordinary collection of more than one hundred Spanish paintings, which was housed in his mansion on the rue de l'Université and was accessible to visitors by appointment. Prior to the opening of the Galerie Espagnole in 1838, and after its closing in 1849, Soult's collection constituted the most important display of Spanish painting in France. Delacroix himself sought the aid of a friend in obtaining entrance to Soult's home in 1833, as, undoubtedly, did countless other artists and amateurs.[3] The painting would also have been known through an etching published in Achille Reveil's *Musée de peinture* (1828).

Ribera's extraordinary paintings of tortured martyrs fascinated French viewers in the Galerie Espagnole, where twenty-six of his paintings were exhibited from 1838 to 1848. For some, they were a confirmation of a violent Spanish Catholicism. For others, revulsion was offset by high regard for the talents of this *naturaliste*. "Among these naturalist painters," wrote Louis Viardot, "Ribera must occupy the first rank."[4] Charles Blanc wrote of this "strange painter": "if the viewer approaches a canvas by Ribera, he suddenly has before his eyes figures that are full of life, some scene taken from the tragedies enacted in the public square, plebeian masques, skin so realistically rendered that it seems palpable."[5] Théophile Gautier, who had also seen Ribera's paintings during his Spanish voyage in 1840, devoted an entire poem to him in 1845, a stanza of which could be applied to this work: "As another seeks the beautiful, you look for what shocks: / Martyrs, executioners, gypsies, beggars / Displaying an open sore beside a rag."[6]

DLR

1. For this history see Pérez Sánchez in Naples–Madrid–New York 1992, pp. 39–40 (New York ed.)

2. Saltillo 1933, p. 32.

3. Letter to Baron Schwiter, ca. 1833, in Delacroix 1936–38, vol. 1, p. 362.

4. "Parmi ces peintres naturalistes, Ribera doit occuper le premier rang." Viardot 1839, p. 61.

5. "étrange peintre"; "si le spectateur s'approche de la toile de Ribera, il a tout à coup devant les yeux des figures pleines de vie, quelque scène empruntée aux tragédies de la place publique, des masques vulgaires, des carnations palpables à force de vérité." Blanc et al. 1869 (Ribera issue), p. 6. This article was written earlier, most likely in the 1840s, as it refers to the twenty-six Riberas in the Galerie Espagnole, which was closed in 1848.

6. "Comme un autre le beau, tu cherches ce qui choque:/Les martyrs, les bourreaux, les gitanos, les gueux/Étalant un ulcère à côté d'une loque." "Ribeira" (1845), in Gautier 1890, vol. 2, p. 115.

60. (New York only) Fig. 8.5

Jusepe de Ribera

Saint Jerome Listening to the Sound of the Heavenly Trumpet

1626
Oil on canvas
72⅞ x 52⅜ in. (185 x 133 cm)
Signed and dated lower right: *Joseph a Ribera/ Valentinus et/academicus Roman/faciebat 1626*
State Hermitage Museum, St. Petersburg 311

CATALOGUES RAISONNÉS: Felton 1971, no. A-10; Pérez Sánchez and Spinosa 1978, no. 29

PROVENANCE: Manuel Godoy, Prince of Peace, Madrid, by 1800, until 1808; Marshal Andoche Junot, duc d'Abrantès, Paris; his sale, Christie's, London, June 7, 1817, no. 32, unsold; his sale, Christie's, London, May 4, 1818, no. 55 (as "from a Convent at Saragossa"); Manuel Godoy, Villa Mattei, Rome, until 1831; among a group of thirty-three paintings purchased from Godoy for the Hermitage Museum, St. Petersburg, arriving there in November 1831

EXHIBITIONS: Toledo 1941, p. 84; Naples–Madrid–New York 1992, no. 22 (Naples ed.), no. 19 (Madrid ed.), no. 15 (New York ed.)

REFERENCES
19th century: Junot 1817, p. 6, no. 32; Junot 1818,

no. 55; Hermitage 1838, p. 312; Cunningham 1843, vol. 2, pp. 253, 257–58; Viardot 1844, p. 462; Somov 1859, p. 65; Viardot 1860a, p. 341; Waagen 1864, p. 104; Somov 1869–71, vol. 1, p. 118, no. 333; Bode 1882, p. 13, no. 17

20th century (selected references): Pérez de Guzmán 1900, p. 120, no. 786; Somov 1901–3, vol. 1, p. 181, no. 333; Lafond 1909, p. 69; Mayer 1913a, vol. 2, p. 16; Loga 1923, p. 208; Mayer 1923a, pp. 15, 38, 197; Malitskaia 1947, p. 75; Trapier 1952, pp. 35, 59, fig. 17; Réau 1955–59, vol. 3, p. 743; Znamerovskaia 1955, pp. 76–77; Bazin 1958, pp. 90, 229 n. 136; Gaya Nuño 1958, pp. 59, 276, no. 2269; Hermitage 1958, vol. 1, pp. 246–48, no. 311, repr. no. 165; Chenault 1969, p. 561; Angulo Íñiguez 1971, p. 106; Princeton–Cambridge 1973–74, pp. 26–28; Felton 1976, pp. 38–39; Hermitage 1976, pp. 174–75; Kagané 1977, p. 53; Pardo Canalís 1979, p. 306; Fort Worth 1982–83, fig. 24, p. 117; Camón Aznar 1983, p. 106; Rose Wagner 1983, vol. 2, p. 370, no. 472; Kagané 1997, pp. 192–93, no. 94

"One might be surprised . . . to find there [the Hermitage] up to one hundred and ten pictures of the Spanish school, which flourished at the other end of Europe, and which remained, one might say, unknown to other foreign nations until the present century. It is a rare, curious, and distinguished collection that could rival a certain other, larger collection whose first mistake was to have been announced in our country with too much pomp and ostentation."[1] When the Hispanophile Louis Viardot first wrote these words in 1844, the Galerie Espagnole—to which he refers somewhat disdainfully—was still on display in the Louvre, and the Hermitage's collection of Spanish painting had recently been enriched by a number of Spanish pictures acquired in the 1830s. Among them was the present work, one of thirty-three paintings purchased from Manuel Godoy in Paris in 1830–31.[2]

Godoy, the former minister of Charles IV of Spain, had settled in Rome after his exile from Spain in March 1808. Prior to his exile, Godoy had asked Frédéric Quilliet to inventory his collection, which numbered some 1,100 works, among them no less than forty-five by Ribera; Quilliet regarded the *Saint Jerome* as among the most important.[3] After Godoy's exile, his artworks fell prey to the French occupying forces. The *Saint Jerome* came into the possession of General Andoche Junot, duc d'Abrantès, who during the Empire served as governor of both Paris and Portugal. At the Junot sale of 1818, this work was described on the cover of the auction catalogue as "an unusually clear and brilliant Picture." Godoy reacquired it sometime after Junot's death.

Saint Jerome proved to be a popular subject for Ribera, who executed numerous depictions of the saint. French collectors were among those who favored the theme, and Ribera's paintings of the saint are listed in the Galerie Espagnole as well as in the collections of Comte Alexandre de Pourtalès-Gorgier and Alejandro María López Aguado, the marquis de las Marismas. The present image, in which Jerome, who translated the Bible into Latin, is interrupted in his writings by an angel blowing a

trumpet—a scene variously interpreted as a warning of the Last Judgment or an admonition against idolatry—was also known in France through a celebrated version in Naples.

DLR

1. "On peut éprouver une surprise . . . en y trouvant jusqu'à cent dix tableaux de l'école espagnole, qui a fleuri à l'autre bout d'Europe, et qui restée, on peut le dire, inconnue à toutes les nations étrangères jusqu'à siècle présent. C'est une collection rare, curieuse, distinguée, qui peut rivaliser avec une certaine autre collection plus nombreuse, et don't le premier tort fut d'être annoncée dans notre pays avec trop de pompe et de fracas." Viardot 1860a, p. 338.

2. For an extensive discussion of the Hermitage painting, see Kagané 1997, pp. 192–93.

3. For Godoy as a collector, see Rose Wagner 1983.

61. Fig. 2.25

Jusepe de Ribera

The Beggar (The Clubfoot)

1642
Oil on canvas
64½ x 37 in. (164 x 93.5 cm)
Signed and dated: *Jusepe de Ribera Español/F. 1642*
Musée du Louvre, Paris, Bequest of Louis La Caze, 1869 MI 893

CATALOGUES RAISONNÉS: Felton 1971, no. A-96; Pérez Sánchez and Spinosa 1978, no. 174

PROVENANCE: Don Ramiro Felipe de Guzmán, duque de Medina de las Torres, viceroy of Naples, 1637–64, Naples; princes of Stigliano, Naples, until 1830?; bought for 300 francs by Dr. Louis La Caze, Paris, before 1849; his bequest to the Musée du Louvre, Paris, 1869

EXHIBITION: Paris, 1849, "Exposition du bazar Bonne-Nouvelle" (La Caze collection), no. 36

REFERENCES
19th century: Horsin-Déon 1861, pp. 245–46; Mantz 1870, p. 406; Reiset 1871, p. 13, no. 32, repr.; Lefort 1882b, pp. 40–43, repr.; Charcot and Richer 1889, pp. 42–44

20th–21st century (selected references): Lafond 1909, pp. 72–73; Naples–Madrid–New York 1992, no. 60 (New York ed.); Louvre 2002, pp. 228–31, repr. (for further exhibitions and references)

This celebrated work most likely entered France in the early nineteenth century following the upheavals of the Napoleonic invasions. Prior to that it had been in Naples since being painted in 1642 for Ramiro Felipe de Guzmán, duque de Medina de las Torres, who served as viceroy of Naples from 1637 to 1644. An inscription on the frame makes reference to the princes of Stigliano of Naples, its subsequent owners. It was purchased by Dr. Louis La Caze sometime in the nineteenth century and formed part of his bequest to the Musée du Louvre in 1869.[1]

Ribera's beggars, whether in the guise of philosophers, saints, or simply genre figures, both charmed and repulsed nineteenth-century viewers, and the present work perfectly embodies these disparate viewpoints. The figure fills the canvas, and the low horizon, revealing a vast sky, emphasizes the boy's deformity. His crutch is slung over his left shoulder, and the sheet of paper in his left hand asks for alms.[2] Nevertheless, Ribera's portrayal does not evoke pity for the boy's condition but rather shared delight in his youthful optimism. This humanizing aspect of Ribera's work was expressed in Léon Horsin-Déon's description of the work, included in an 1861 review of La Caze's extensive collection that singled out this painting: "of Ribera, M. La Caze owns some remarkable works. We admired . . . an individual who, though less gracious, was no less interesting from the point of view of art; we refer to a dwarf who is quite deformed as to his legs but admirably executed in terms of modeling and energy. This figure is alive and full of expression; he laughs and invites us to laugh."[3]

The Beggar was one of six Riberas owned by La Caze and one of thirteen Spanish works in his substantial collection of 582 paintings, all of which were bequeathed to the Louvre in 1869. While small, La Caze's collection of Spanish paintings nonetheless seemed to contain all the requisite artists: Ribera, Velázquez, and Murillo (though all but two have been deattributed). Although La Caze was a doctor by profession, his family fortune allowed him to indulge a passion for art. He counted among his friends the painters Géricault, Girodet, Guérin, and Bonvin, and shared with the last a passion for seventeenth-century Dutch and Spanish paintings. Bonvin surely helped these and other artists gain access to La Caze's collection.[4]

The Beggar was only the second authentic work by Ribera to enter the Louvre, but the public was already familiar with his work. At mid-century there were numerous private collections containing works purportedly by the Spanish master, most notably that of Marshal Soult, which was dispersed in 1852. In addition, the twenty-six Ribera paintings exhibited in the Galerie Espagnole (1838–48) had exposed the French to the most tortured and bloodied figures of Ribera's oeuvre. Moreover, by the 1860s, trips to Spain had become de rigueur for artists and writers, and there they saw, particularly in the Prado, numerous works by Ribera.

The influence of Ribera's naturalism and coarse realism was evident in the works of artists such as Théodule Ribot, Alphonse Legros, Henri Regnault, and Alfred Dehodencq, all of whom were exhibiting "Spanish" pictures in the Salons of the 1850s and 1860s. This influence was affirmed by contemporary critics. Théophile Gautier, writing about the work of Bonvin, Breton, and Millet at the Salon of 1859, stated that "Ribera is regarded as the leader of the naturalist school."[5] Jules Castagnary, however, found fault with Ribot's use of black: "Undoubtedly, if Ribera had painted these heads of *Philosophers*, as he was quite capable of doing, his picture, having darkened over time, would today be as black as M. Ribot's; but three hundred years would have passed over it, and three hundred years is an excuse that M. Ribot, who painted his picture yesterday, cannot invoke."[6]

For Paul Mantz, *The Beggar*, "which was not done to please lovers of elegant, rose-colored painting, is naturalistic and full of contrast"; nevertheless, "the figure of the little cripple is discreetly shrouded, and its rendering is lovingly finished."[7] Paul Lefort identified the painting as one of Ribera's "realist representations."[8] The painting would fascinate artists throughout the nineteenth century. The painter Charles Maurin executed a half-length copy that he donated in 1876 to the Musée Crozatier in Le Puy, and even Henri Matisse would find inspiration in this charming child, producing a copy in 1893 (location unknown).

DLR

1. For additional information on the painting, see Naples–Madrid–New York 1992, no. 60 (New York ed.). For more information on Ribera in the nineteenth century, see Pierre Rosenberg, "De Ribera à Ribot," in ibid., pp. 147–63 (Madrid ed.).
2. The Latin note reads, "DA MIHI ELIMO SINAM PROPTER AMOREM DEI" (Give me alms for the love of God).
3. "de Ribera, M. La Caze possède des ouvrages fort remarquables. Nous avons admiré . . . un personnage qui, quoique moins gracieux, n'en n'est pas moins intéressant au point de vue de l'art; nous voulons parler d'un nain tout bancroche, mais dont l'exécution est admirable de modelé et de vigueur. Cette figure est vivante et pleine d'expression; elle rit et invite à rire." Horsin-Déon 1861, pp. 245–46.
4. See Denney 1993, pp. 100–101.
5. "Ribera se regardait comme le chef de l'école des naturalistes." Gautier 1992, p. 115.
6. "Assurement, si Ribera avait peint ces têtes de *Philosophes*, ce dont il eût été fort capable, son tableau, ayant poussé, serait aujourd'hui aussi noir que celui de M. Ribot; mais trois cents ans auraient passé dessus, et trois cents ans c'est une excuse que M. Ribot ne peut pas invoquer, lui qui a peint son tableau hier." Castagnary 1892, pp. 376–77.
7. "qui n'est pas fait pour plaire aux amoureux de la peinture rose et galante, est d'un naturalisme plein de relief"; "la figure du petit boiteux est discrètement enveloppée, et le modelé en est caressé avec amour." Mantz 1870, p. 406.
8. "représentations réalistes." Lefort 1882b, p. 41.

62. *(New York only)* *Fig. 1.5*

Jusepe de Ribera

The Holy Family with Saints Anne and Catherine of Alexandria

1648
Oil on canvas
82¼ x 60¼ in. (209.6 x 154.3 cm)
Signed and dated lower right: *Jusepe de Ribera español/accademico R.o.^{no}/F. 1648*

The Metropolitan Museum of Art, New York, Samuel D. Lee Fund, 1934 34.73

CATALOGUES RAISONNÉS: Felton 1971, no. A-109; Pérez Sánchez and Spinosa 1978, no. 194

PROVENANCE: Private collection, Genoa, until 1807–8; Jean-Baptiste-Pierre Lebrun, Paris, 1807/8–after 1810; Sir Thomas Baring, second bart., Sutton Park, Southampton, Hampshire, by 1824–48; Thomas Baring, M.P. for Huntingdon, 1848–73; Thomas George Baring, first earl of Northbrook, Stratton Park, 1873–1904 (cat. 1889, no. 237); Francis George Baring, second earl of Northbrook, Stratton Park, 1904–19; sale of Baring collection, Christie's, London, December 12, 1919, no. 134, sold for 546 pounds to Colnaghi; Colnaghi, London, 1919–21; Henry Georges Charles Lascelles, Viscount Lascelles, later sixth earl of Harewood, London, 1921–34; Arnold Seligmann Rey & Co., Paris and New York, 1934; purchased by The Metropolitan Museum of Art, New York, 1934

EXHIBITIONS: Paris, Collection Lebrun, January 1810; London 1828, no. 51 (lent by Sir T. Baring); London 1872a, no. 97 (lent by Thomas Baring, Esq.); London 1895–96, no. 61 (lent by the Earl of Northbrook); London 1925; New York 1940, no. 115; New York 1952–53, no. 125; Boston 1970; New York 1971, no. 1; Fort Worth 1982–83, no. 36; Naples–Madrid–New York 1992, no. 95 (Naples ed.), no. 120 (Madrid ed.), no. 66 (New York ed.)

REFERENCES
19th century: Lebrun 1809, vol. 2, pp. 18ff., pl. 128; Buchanan 1824, vol. 2, p. 255; Waagen 1838, vol. 3, p. 39; Waagen 1854, vol. 2, p. 180; Justi 1889, p. 343; Weale and Richter 1889, no. 237, pp. 182ff., repr.; Carl Justi, review of Weale and Richter 1889 in *Kunstchronik* 1 (1890), p. 320; Woermann 1890, p. 179

20th century (selected references): Mayer 1908, pp. 117–19; Lafond 1909, p. 69; Mayer 1913a, p. 20; London 1919, no. 134, p. 26; Mayer 1922, p. 274; Mayer 1923a, pp. 118ff., 198, 202; Wehle 1934, pp. 119–22; Darby 1946, pp. 160, 163, 167, 168–70, 172; Trapier 1952, pp. 179, 205; Gaya Nuño 1958, no. 2396; Kubler and Soria 1959, p. 242; Gállego 1962, p. 107; Waterhouse 1962, p. 180; Angulo Íñiguez 1971, p. 109; Fahy 1971, p. 457; Washington–Saint Louis 1972, p. 70; Haskell 1976, p. 20

In 1807, Jean-Baptiste-Pierre Lebrun, an enterprising art dealer and connoisseur who also happened to be married to Élisabeth Vigée-Lebrun, painter to Marie-Antoinette, undertook an extensive trip through France, Italy, and Spain in search of paintings to sell in Paris. He sought to take advantage of the turmoil caused by Napoleon's campaigns and thus purchase works at minimal prices from owners fleeing the country and desperate for cash. Lebrun eventually acquired some six hundred paintings, among them numerous works by Spanish painters, including Murillo, Morales, Valdés Leal, and Ribera.[1]

Ribera's *Holy Family*, a masterpiece of his late period, was among the treasures Lebrun acquired. Despite his three-month residence in Spain (August–October 1807), where he bought other works by the artist, the *Holy Family* was actually purchased in Italy. As Lebrun himself wrote, the painting had come from "one of the most beautiful galleries in Genoa,"[2] and while it entered France as part of his acquisitions, it was to remain in the country for a relatively brief period.

Depicted is the vision of Saint Catherine of Alexandria, who dreamed that she was wed to the Christ Child. In this "Mystic Marriage of Saint Catherine," in the presence of the Virgin and Child and Saints Anne and Joseph, the young saint leans forward in submission to kiss the hand of the Christ Child.

Lebrun revealed his appreciation of the painting's extraordinary composition and the beauty of its figures when he included it as one of the 179 paintings he had engraved for his *Recueil de gravures* (Selection of engravings; Paris, 1809). His praise is effusive: "The richness of the luminous and brilliant color, the admirable choice of heads, the beautiful shape and grace of the hands, the beauty of the draperies, the projection, and the vigor, lead us to regard this canvas as one of this great painter's first masterpieces."[3]

DLR

1. For an extensive article on Lebrun and his activities, see Bailey 1984.
2. "l'une des plus belles galeries de Gênes." Lebrun 1809, vol. 2, p. 19.
3. "la richesse de la couleur lumineuse et brillante, le choix admirable des têtes, les belles formes et la grace des mains, la beauté des draperies, de la saillie et de la vigeur, nous font regarder ce tableau comme un des premiers chefs-d'oeuvre de ce maître." Ibid, pp. 18–19. Lebrun's *Recueil de gravures* was a highly effective sales tool, as it provided potential buyers not only with an illustration but also with a brief biography of the artist and Lebrun's own well-respected opinion of the work.

63. (New York only) Fig. 14.45

Formerly Jusepe de Ribera, now Luca Giordano

Cato Tearing Out His Entrails

Ca. 1660
Oil on canvas
49 x 38¼ in. (124.5 x 97.2 cm)
Art Gallery of Hamilton, Ontario, Gift of Jenifer-Lyn Tanenbaum from the Joey and Toby Tanenbaum Collection, 2000 2000.34.2

PROVENANCE: Possibly collection of duc de Hijar, Madrid; inventory of Galerie Espagnole, Paris, September 20, 1838, no. 274; Galerie Espagnole, Musée du Louvre, Paris, 1838–48, nos. 241/249; sale of Louis-Philippe collection, Christie & Manson, London, May 14, 1853, no. 315 (with the mention "acquis du duc de Hijar" [acquired from the duc de Hijar]), sold for 11 pounds to Colnaghi for the duc de Montpensier; the duc de Montpensier, Palace of San Telmo, Paris, 1866; Galerie Heim, London, 1975; sale, Sotheby's, London, July 7, 1995, no. 108 (as *The Suicide of Cato* by Luca Giordano) (possibly the work in the Galerie Espagnole); sale, Sotheby's, New York, January 28, 1999, no. 523 (as The *Death of Cato* by Luca Giordano) possibly the work in the Galerie Espangnole), bought in; Joey and Toby Tanenbaum, Canada; given by them to the Art Gallery of Hamilton, Ontario, 2000

EXHIBITIONS: Paris, Galerie Espagnole, Musée du Louvre, 1838–48, nos. 241/249; Boston 1875, no. 11

SELECTED REFERENCES: Blanc et al. 1869 (Ribera issue), repr. p. 1; Stirling-Maxwell 1848 (1891 ed.), vol. 3, p. 902

This painting, or a version of it, was among the most infamous works in the Galerie Espagnole (1838–48). For Stirling-Maxwell, who visited the Galerie in May 1845, it was "a [masterpiece] of horror, too frightful to be remembered without a shudder."[1] The young Millet was enthralled, writing of it in a letter to a friend back in Cherbourg: "In Cato's open chest we see his bleeding entrails and believe we can feel their warmth; the expression on his face is unspeakably dreadful! He is screaming, but it is not one of those screams that a suffering person ordinarily emits; rather, these are screams ripped from the depths of his entrails, heartrending, which overwhelm the beholder's soul and are unbearable."[2]

The subject of the painting is the death of Cato of Utica (93–46 B.C.) by his own hand. A Roman statesman revered for his honesty and morality, Cato opposed the rule of Julius Caesar and sided against him with his former ally Pompey. After Pompey was killed and after being defeated at the battle of Thapsus, Cato chose to take his own life by stabbing himself with a sword. In the background of the painting can be seen his horrified servants.

Ribera's tortured subjects became notorious, as did the painter whom many regarded as a tortured soul himself. Charles Blanc begins his article on Ribera: "It is amazing that all painters with a strong style had a tormented, melodramatic life, filled with tempests, tragedy, and misfortune. . . . Ribera's life in particular was a long series of contrasts between splendor and misery, dark shadow and dazzling light, like his paintings."[3]

Numerous works once thought to be by Ribera have been reattributed to Luca Giordano (see cat. 64). These errors are not surprising given that Giordano was a pupil of Ribera and worked with him on several late commissions.

DLR

1. Stirling-Maxwell 1848 (1891 ed.), vol. 3, p. 902.
2. "On voit dans la poitrine ouverte de Caton ses entrailles saignantes, dont on croit sentir la chaleur; l'expression de sa tête est d'une atrocité indicible! Il pousse des cris, mais pas de ces cris comme en pousse ordinairement quelqu'un qui souffre; mais des cris arrachés du fond des entrailles, déchirants, et qui accablent l'âme du spectateur, et qui sont insoutenables." Letter of July 21, 1838, in Moreau-Nélaton 1921, vol. 1, pp. 29–30.
3. "Il est remarquable que tous les peintres de la manière forte eurent une vie tourmentée, romanesque, remplie d'orages, de drames et de malheurs. . . . L'existence de Ribera, surtout, fut un long contraste de splendeur et de misère, d'ombre noir et de lumière éclatante, comme sa peinture." Blanc et al. 1869 (Ribera issue), n.p.

64. (New York only) Fig. 11.12

Formerly Jusepe de Ribera, now Luca Giordano

The Ecstasy of Saint Mary Magdalen

Ca. 1660–65
Oil on canvas
100¼ x 76 in. (256 x 193 cm)
The Hispanic Society of America, New York A76

CATALOGUES RAISONNÉS: [all attributing the work to Giordano] Mayer 1908, fig. 57; Mayer 1923a, fig. 66; Ferrari and Scavizzi 1966, vol. 1, p. 61, vol. 2, p. 70, vol. 3, fig. 120; [1992, vol. 1, pp. 51, 281, 564, vol. 2, fig. 269]; Felton 1971, no. x-49; Pérez Sánchez and Spinosa 1978, no. 96a

PROVENANCE: Possibly Louis-Philippe, king of France, 1838–53 (Galerie Espagnole, 1838–48,

Musée du Louvre, Paris, nos. 224/229); possibly his sale, Christie & Manson, London, May 13, 1853, no. 463, acquired by "Pearce"; Prince Giuseppe de Sangro di Fondi, Naples (no. 324, attributed to Murillo); said to have been sold at auction to Sangiorgi, Rome; Galleria Simonetti, Rome, by 1906–10; purchased in 1910 by Roger Fry, agent for Archer Milton Huntington, New York; presented by Huntington to The Hispanic Society of America, New York, 1911

EXHIBITION: Paris, Galerie Espagnole, Musée du Louvre, 1838–48, nos. 224/229

REFERENCES

19th century: [possible mention, attributing the work to Ribera] Paris 1838, nos. 224/229

20th–21st century (selected references): [attributing the work to Ribera] Freund 1926, p. 18; Hispanic Society 1926, pp. 9–14, repr.; Trapier 1929, pp. 146–48, pl. 39; Hispanic Society 1938, p. 19; Darby 1942; Darby 1946, p. 157; Trapier 1952, pp. 117–23, frontis. and figs. 69, 71, 73; Trapier 1966, pp. 165–69, repr.; Baticle and Marinas 1981, p. 51, no. 182; Haskins 1993, p. 462 n. 91 (describing iconography); [attributing the work to Giordano] Naples–Madrid–New York 1992, p. 109 (New York ed.; cf. Naples ed., p. 204, and Madrid ed., p. 290); Lenaghan et al. 2000, pp. 308–9, repr.; Alicia Lubowski, manuscript article, archives of the Museum Department, The Hispanic Society of America, 2001

This large canvas is one of three versions of *The Ecstasy of Saint Mary Magdalen* once attributed to Jusepe de Ribera (1591–1652). Another of the canvases is signed by Ribera and dated 1636; now in the Real Academia de Bellas Artes de San Fernando, Madrid, it is thought to have come into Spain sometime before 1680 and was inventoried at the Escorial in 1700–1701. The last version, formerly in the collection of Dr. G. Martius in Bonn, was destroyed in 1942. Either the New York or the Bonn version was formerly in the Galerie Espagnole of Louis-Philippe. While the Madrid version is universally accepted as one of Ribera's most important compositions, scholars have differed on the attributions of the other two versions, with the New York canvas being assigned alternately to Ribera and to the Italian Baroque painter Luca Giordano (1634–1705).

The iconography of the New York and Madrid versions is related to apocryphal legends of the Magdalen, elaborated in France during the eleventh century and codified in the *Legenda aurea* of Jacobus de Voragine (ca. 1230–1298). These claimed that Mary Magdalen miraculously drifted in a boat to Provence, subsequently evangelized the region, and spent the last years of her life there as a hermit. Voragine also reported that the saint was lifted into the air by angels seven times a day, at the canonical hours. The elevation of the Magdalen over the Bay of Marseille (seen in the background at the lower right) is the subject of both the Madrid and New York pictures.

Nevertheless, as Alicia Lubowski has demonstrated, these two pictures differ significantly in their presentation of the Magdalen.[1] In the Madrid version, she wears a hair shirt, and the most prominent of the attributes carried by the putti below her are the skull, dramatically silhouetted at the right, and the scourge, unfurled by the putto at the bottom right as though ready to strike. In the New York image, the Magdalen, while still in an attitude of contrition and prayer, is no longer wearing a hair shirt. Furthermore, the skull has switched positions with the jar of ointment, and the scourge is reversed in the putto's hand, so that the handle extends out to the right and the strands hang loosely down. The New York Magdalen, gazing resolutely up to heaven, does not seem inclined to take the putto's offer of the scourge. Lubowski notes that this change in emphasis from penitence to spiritual triumph and love of Christ is typical of the development from Early to High Baroque art and, one might add, from the grimmer piety of the earlier Counter-Reformation to the more relaxed yet triumphalist devotion of the Catholic Church after the end of the Thirty Years' War (1648).

While autograph replicas are not unknown in Ribera's oeuvre, the New York canvas presents some unusual challenges to attribution. It is a picture of surpassing quality, extremely effective in its dynamic, Baroque spirituality, and clearly the work of a master. Yet, its High Baroque qualities seem to be from a later era than the much more restrained, Early Baroque elements in the 1636 Madrid composition. Already in 1908, August Mayer questioned the attribution of the New York canvas to Ribera and suggested Luca Giordano as the author, just as in 1892, Carl Justi had attributed the Bonn version to Giordano.

Although rejected by Elizabeth du Gué Trapier, Mayer's arguments have found favor with most other scholars since World War II, and the New York canvas was included in Oreste Ferrari and Giuseppe Scavizzi's catalogue of Giordano's works. While the painting is unlike most of Giordano's early pictures imitating Ribera—principally because it copies, with variations, a known Ribera composition—comparison with Giordano's works of the late 1650s and 1660s suggests many stylistic points in common. Chief among these are the treatment of the draperies, which mirror the scythelike patterns of Giordano's images, the play of light, and the representation of the putti. Lubowski's analysis of the iconography, which would imply a date after Ribera's death in 1652, also accords well with the dates of works by Giordano most closely related to the New York canvas.

Putting Giordano and the Madrid canvas in the same place at the same time still remains a problem, however. Little is known about the original location of the Madrid picture, except that it was probably in Italy and not in the Escorial before 1657, when Padre Santos published the first edition of his *Descripción breve del monasterio de S. Lorenzo el Real del Escorial*. It seems to have been in Spain by 1680, when it influenced a painting by Claudio Coello of the same subject for the main altar of the church at Ciempozuelos, Spain. Since the New York picture was in Italy prior to its acquisition by the Hispanic Society, one possible scenario for Giordano's intervention has him making a copy in Italy to replace the Madrid canvas at the time it was sent to Spain, presumably about 1660–65. This is pure speculation as to motive but not as to date, since the alternative hypothesis—that Giordano copied the picture during his stay in Spain from 1692 to 1702—seems not to conform with his much different style at the end of his career. Nevertheless, since it is known that Giordano did imitate works of art in the Spanish royal collection, including those of the Netherlandish schools (for example, his *Preaching of John the Baptist*, 1692–1702, Los Angeles County Museum of Art), during his tenure at Madrid and the Escorial, his having made the New York picture in Spain cannot be ruled out.

While on view at the Galerie Espagnole, Paris (1838–48), the composition was to influence one artist in particular, Jean-François Millet (1814–1875), whose *Assumption of Saint Barbara* (cat. 189) is indebted to this work.

MBB

1. See her article (2001) in the archives of the Museum Department, The Hispanic Society of America. We are indebted to Ms. Lubowski for sharing her research on this painting.

EL GRECO (DOMENIKOS THEOTOKOPOULOS)
Candia, Crete, 1541–Toledo, 1614

Domenikos Theotokopoulos, called El Greco in Spain, was born in 1541 on Crete, then a possession of the Venetian empire. Trained there in the local late Byzantine style, and subsequently in Venice and Rome, El Greco came to Spain about 1576–77. Although he failed to secure the patronage of King Philip II at the Escorial, he found an enthusiastic group of supporters in the theological circles gathered around the Toledo Cathedral in the wake of the reforms of the Council of Trent. Strongly influenced by Michelangelo and Tintoretto, El Greco's style and artistic theory reflect the then-dominant Mannerist movement, although his works often have surprisingly naturalistic touches. He was among the first artists to develop the new Tridentine (or Counter-Reformation) imagery demanded by the reformed Catholic Church.

MBB

65. *(New York only)* *Fig. 11.9*
El Greco (Domenikos Theotokopoulos)
The Holy Family

Ca. 1580–85
Oil on canvas
41 1/4 x 34 1/2 in. (106 x 87.5 cm)
The Hispanic Society of America, New York A74

CATALOGUES RAISONNÉS: Cossío 1908, vol. 2, pls. 54, 54a; Mayer 1926a, no. 25; Rutter 1930, no. 71; Wethey 1962, vol. 2, no. 84; Camón Aznar 1970, vol. 2, no. 245; Gudiol 1971, no. 69; Cossío and

Cossío de Jiménez 1972, no. 31; Baccheschi 1980, no. 42, repr.; Álvarez Lopera 1993, no. 77

PROVENANCE: Probably Don Pedro Laso de la Vega, conde de Arcos (inventory, 1632); by descent to Don Diego Isidro de Guzmán, twenty-second conde de Valencia de Don Juan and duque de Nájera, 1849; his heirs; the marqués de Salamanca(?); sold to José de Madrazo y Agudo, Madrid, 1856; by descent to his grandson, Raimundo de Madrazo y Garreta, Paris; sold to Archer Milton Huntington, ca. 1908; presented by him to The Hispanic Society of America, New York, 1909

EXHIBITIONS: London, The New Gallery, 1894–95; Los Angeles, The J. Paul Getty Museum, 2000–2001

SELECTED REFERENCES: Calvert and Hartley 1909, p. 129 (as collection of Don Raimundo de Madrazo); Loga 1913, p. 124; Mayer 1916, fig. 4; Trapier 1925, frontis.; Starkweather 1926, p. 35; Hispanic Society 1927, n.p., repr.; Trapier 1929, pp. 78–80, pl. XIX; Mayer 1931a, pp. 82, 100, fig. 67; Mâle 1932, pp. 309–25 (for iconography); Legendre and Hartmann 1937, p. 151; Goldscheider 1938, fig. 99; Hispanic Society 1938, p. 13; Pantorba 1953, pp. 35–36, repr.; Trapier 1958, pp. 15–16, 30–31, fig. 22 and frontis. (detail); Martínez Caviro 1985; Lenaghan et al. 2000, pp. 250–51, repr.

All the elements that came to play a role in El Greco's early development may be seen in the Hispanic Society's *Holy Family*. The emphasis on Mary as Mother of God, nursing the incarnate Christ, is typical of Spanish piety. Joseph, the patron saint of the newly invigorated Roman Catholic Church, is no longer the doddering, almost comic figure of medieval art but rather a vigorously mature parent, protecting his divine wards as he joins in the viewer's devout contemplation of the holy child. Recent conservation has revealed the magnificent play of space around the hands and shoulders of the figures, along with subtleties such as the contrast of color between the blue cloak of the Madonna and the green cloth of honor under the baby Jesus.

The Holy Family was one of a group of pictures by El Greco that belonged, according to the Spanish scholar Balbina Martínez Caviro, to the aristocrat Don Pedro Laso de la Vega, conde de Arcos, whose collection was inventoried in 1632. Four of

these works—the present example, another at the Hispanic Society thought to represent Saint Luke (ca. 1590), and two at the Metropolitan Museum, the famous *View of Toledo* (ca. 1610) and the *Portrait of the Cardinal (Don Fernando Niño de Guevara?)* (ca. 1600)—passed from Pedro Laso's nineteenth-century descendants into the American collections of Archer Milton Huntington and Louisine Havemeyer (Huntington's went to the Hispanic Society of America, the Havemeyers' to the Metropolitan Museum). The four canvases were consequently among the first works by El Greco known to American audiences, and indeed to Spanish audiences, when the present example was sold in 1856 to José de Madrazo of the well-known Spanish artistic family.

Manuel Cossío (1972) identifies this work as being in the renowned collection of the marqués de Salamanca, Paris. Sold in 1867, the collection was acclaimed as a veritable museum of Spanish art and, "with the exception of the sale of Marshal Soult's gallery [in 1852]," the Salamanca sale was acknowledged as "the first and perhaps the last time in this century that such an event is presented by the art world."[1] MBB

1. "À l'exception de la vente de la galerie du maréchal Soult, c'est la premiere et peut-être la derniere fois de ce siècle qu'un pareil événement se présentera pour le monde des arts." Salamanca 1867, pp. v–vi.

66. *(New York only)* *Fig. 11.13*

El Greco (Domenikos Theotokopoulos) and Workshop

The Penitent Saint Jerome

Ca. 1600–1610
Oil on canvas
31½ x 25⅝ in. (80 x 65 cm)
The Hispanic Society of America, New York A73

CATALOGUES RAISONNÉS: Cossío 1908, vol. 2, pl. 72; Mayer 1926a, no. 284b; Wethey 1962, vol. 2, no. 245; Camón Aznar 1970, vol. 2, no. 516; Cossío and Cossío de Jiménez 1972, no. 265; Álvarez Lopera 1993, no. 237

PROVENANCE: Jacob-Émile and Isaac Pereire, Paris, before 1867–68; their sale, Paris, January 29,

1868, no. 32; F. Bamberg, Messina; Convent of Sainte-Gudule, Brussels; its sale, July 12–13, 1905, no. 121; [Dr. Bambery, Nice(?)]; Paul Mersh, Paris; Ehrich Galleries, New York, by 1907(?)–1910; bought by Archer Milton Huntington, New York, for The Hispanic Society of America, December 24, 1910

SELECTED REFERENCES: Calvert and Hartley 1909, p. 153 (as at "Erich [Ehrich Galleries], New York"); Loga 1913, p. 124; Trapier 1925, pp. 88–89, pl. XXII; Starkweather 1926, p. 35; Hispanic Society 1927, n.p., repr.; Trapier 1929, pp. 84–86, pl. XXII; Legendre and Hartmann 1937, p. 439; Hispanic Society 1938, p. 14; Beryes 1948, n.p., repr. (as at "L. R. Erich [Ehrich Galleries]"); Vallentin 1955, p. 188; Lenaghan et al. 2000, pp. 252–53, repr.

Saint Jerome (ca. 347–419/420) was one of the most important early Christian fathers, one of the four principal Doctors of the Roman Catholic Church. Traditionally understood to have been a cardinal, he was also the translator of the Vulgate, the Latin version of the Bible used by Catholics, and an early model of the penitential life. Since all of these elements—the traditions of the Church fathers, the College of Cardinals, the use of the Bible in Latin (as opposed to the vernacular), and the Sacrament of Penance—were opposed by most Protestants, Jerome became one of the most popular saints of the Counter-Reformation and a symbol of all that was Catholic. In Spain, his popularity was further increased by commissions from the Hieronymite order, which followed his teachings and was under royal patronage at locations such as the Monastery of Guadalupe Extremadura and the Escorial.

As one of the first great artists of the Counter-Reformation, El Greco was in the forefront of iconographic innovation. This is particularly true of his images of Saint Jerome, which include half-length figures of the saint, in cardinal's robes and with a long beard, interrupted as he peruses the Vulgate (Frick Collection, New York, and The Robert Lehman Collection, The Metropolitan Museum of Art, New York) as well as full- and half-length representations of Jerome doing penance in the wilderness that allowed the artist to show his skill in rendering the human figure.

Numerous versions of the present image—the penitent saint shown at half-length and set in a landscape—are known from El Greco and his school. However, the scholar Harold Wethey accepted only four as wholly or partially autograph: a work in the National Gallery of Scotland, Edinburgh; another in the possession of the Communidad de Madrid, exhibited at the Museo del Prado; another in a private collection in Madrid; and this example. To these may be added other versions discovered since the publication of Wethey's text, such as a canvas recently donated to the Real Academia de Bellas Artes de San Fernando in Madrid. Wethey assigned the Hispanic Society version to El Greco and his workshop, and the picture does indeed show the intervention of assistants in its rather schematic background. But the masterful anatomy of the aged saint, the vivid way the rapt devotion on his face is

expressed, and the play of space in the foreground, not to mention the signature, all argue persuasively for El Greco's having completed much of the composition himself.

Like *The Holy Family* (cat. 65), this canvas was among the first works by El Greco to be in circulation outside of Spain. It is first documented in the celebrated collection of the Pereire brothers in Paris. Théophile Thoré, in an extensive article on the Pereire collection, noted that among the works by Velázquez, Murillo, Zurbarán, Valdés Leal, Cano, and others were some dozen pictures by El Greco.[1]

MBB

1. Bürger [pseud. Thoré] 1864a.

JUAN DE VALDÉS LEAL

Seville, 1622–Seville, 1690

Born in Seville, Valdés Leal received his artistic training in Córdoba but ultimately settled in his native city in 1656. After his contemporary Murillo, he was the most important painter in Seville during the second half of the seventeenth century. Though his works differed markedly from those of Murillo in style and composition, Valdés Leal was widely admired in his own day. He also distinguished himself as a draftsman, sculptor, and gilder. In 1663 he was elected president of the recently formed Real Academia de Bellas Artes de Santa Isabel de Hungría in Seville. He worked continuously into the 1680s, at times with the help of his son Lucas de Valdés (1661–1725), and died at the age of sixty-eight. Frédéric Quilliet, in his *Dictionnaire des peintres espagnols* (1816), noted that "after his death, there was no other painter in Seville who was his equal in creative inventiveness, in drawing, and above all in color."[1]

Valdés Leal carried out numerous important religious commissions in Seville, among them the series for the Monasterio de San Gerónimo de Buenavista, which accounted for seven of the ten works by the artist exhibited in Louis-Philippe's Galerie Espagnole in Paris (1838–48). By far the most celebrated of Valdés Leal's canvases, which were also well known in France, were his pendants for the Hospital de la Caridad in Seville—*In Ictu Oculi* and *Finis Gloriae Mundi* (1672)—works that Antonio Palomino, Antonio Ponz, and Juan Agustín Ceán Bermúdez all referenced (and were therefore cited in all the French sources as well). The paintings inspired Théophile Gautier's poem "Deux Tableaux de Valdès Léal" (1845), and an etching of *Finis Gloriae Mundi* was included in Paul Lefort's chapter on Valdés Leal in Blanc's *Histoire des peintres de toutes les écoles: École espagnole* (1869).

DLR

1. "depuis sa mort, il n'y eut à Séville aucun peintre qui l'ait égalé dans la fécondité de l'invention, dans le dessin, et surtout dans la couleur." Quilliet 1816, p. 356.

67. *(New York only)* *Fig. 7.22*

Juan de Valdés Leal

Brother Alonso de Ocaña

Ca. 1656–58
Oil on canvas
98⅜ x 51⅛ in. (250 x 131 cm)
Inscribed on scroll in foreground: *El V. herm.°*
fr. Alonso de Ocaña
Musée de Grenoble MG 1327

CATALOGUE RAISONNÉ: Kinkead 1978, no. 53, pp. 373–75, pl. 51

PROVENANCE: Sacristy of the Monasterio de San Gerónimo de Buenavista, Seville, 1657–1808; inventoried in the Alcázar, Seville, no. 23, as a group of eight works of Hieronymite saints, 1810; returned to the Monasterio de San Gerónimo de Buenavista, Seville, 1823–35; deposited in the Hospital de la Sangre, Seville, 1835–January 1837; purchased by Baron Taylor; inventory of Galerie Espagnole, Paris, September 20, 1838, no. 309; Galerie Espagnole, Musée du Louvre, Paris, 1838–48, nos. 273/283 (in both as *Dominicain allant officier*); stored in Louvre after close of Galerie Espagnole, 1849–50; returned to the exiled heirs of Louis-Philippe, England, 1850–May 1853; sale of Louis-Philippe collection, Christie & Manson, London, May 21, 1853, no. 454, sold for 10.15 pounds to Charles Harding; Viscount Charles Stewart Harding, London or Penthurst, 1853; Duc de Dino, Paris; Gustave Rothan, Paris, ca. 1874–90; Rothan heir to Jules Feral, 1890; sale at Feral's, Paris, May 14, 1901; purchased at Feral's by Colonel Beylié; sent to Musée de Grenoble, June 27, 1901

EXHIBITIONS: Galerie Espagnole, Musée du Louvre, Paris, 1838–48, nos. 273/283; Paris 1935a, no. 63; Paris 1963b, no. 80 (as *Frère Antanasio de Ocaña*); Seville–Madrid 1991, no. 27

REFERENCES
18th–19th century: Ponz 1776–94 (1947 ed.), no. 18, p. 801; Ceán Bermúdez 1800, vol. 5, p. 114; González de León 1844, vol. 2, p. 245; Gómez Ímaz 1896, p. 62

20th century (selected references): Beylié 1909, p. 25, repr. (as by Murillo); *Catalogue*, Musée du Grenoble (1911), no. 555, p. 159 (as by Murillo); Gestoso y Pérez 1916, pp. 48–49; Mayer 1922, p. 352; Loga 1923, p. 273; Mayer 1935, p. 16; Mayer 1947, p. 372–73; Sancho-Corbacho 1949, p. 225; Gaya Nuño 1958, no. 2747, p. 312; Trapier 1960, p. 14; Paris 1963b, pp. 209, 213; Sobral 1976, no. 46; Baticle and Marinas 1981, no. 283, pp. 185–86; Valdivieso 1986, p. 265; Valdivieso 1988, pp. 85, 236; E. Young 1988, p. 165

In his *Diccionario* (1800), Juan Agustín Ceán Bermúdez writes that Valdés Leal executed a series of paintings for the Monasterio de San Gerónimo de Buenavista in Seville: "Six or eight paintings of the life of Saint Jerome and others that represent venerable figures of that religion with lifesize figures: all in the sacristy, and among the best he painted."[1] Félix González de León notes that, during the occupation of Seville by Napoleon's troops, a total of sixteen paintings by Valdés Leal were taken from the monastery.[2] Thirteen of the canvases, including this work, were inventoried in the Alcázar in Seville in 1810.[3]

Despite these appropriations, this painting, along with others from the series, did not leave Seville until they were purchased decades later by Baron Taylor, during his art-buying trip through Spain in 1835–37 on behalf of the French king Louis-Philippe. At least seven works from the series were exhibited in the Galerie Espagnole at the Louvre (1838–48, nos. 268–74/278–84): *Saint Jerome* and *Martyr of the Hieronymite Order* (both Museo del Prado, Madrid), *Brother Vasco de Portugal* (Gemäldegalerie Alte Meister, Staatliche Kunstsammlungen, Dresden), *Hieronymite Holy Nun* (Bowes Museum, County Durham, England), *An Abbess* (Musée Le Mans), the present work, and *Saint Jerome Disputing with the Heretics* (Gisela Marx-Cremer, Wiesloch).[4]

Brother Alonso de Ocaña was purchased by Colonel Beylié in 1901 and donated to the Musée de Grenoble. Beylié also donated four Zurbarán paintings to the museum in 1904.[5]

DLR

1. "Seis ú ocho quadros de la vida del santo fundador, y otros que representan venerables de esta religion con figuras del tamaño del natural: todos en la sacristía, y son de lo que mejor pintó." Ceán Bermúdez 1800, vol. 5, p. 114.
2. González de León 1844, vol. 2, p. 397.
3. Gómez Ímaz 1896, nos. 23, 87, 88, 89; see also no. 382.
4. For an extensive discussion of the present work and the others in the series, see Gerard-Powell 2000, pp. 22–34.
5. The Zurbarán paintings were part of the artist's decorative cycle for the Monasterio de Nuestra Señora de la Defensión, Jerez de la Frontera, and had been exhibited at the Galerie Espagnole, Paris (see cat. 87).

DIEGO RODRÍGUEZ DE SILVA Y VELÁZQUEZ

Seville, 1599–Madrid, 1660

Velázquez's career took place in three fundamental locations: Seville, where he learned his art from the master Francisco Pacheco; Madrid, where he worked in the service of Philip IV from 1623 until his death in 1660; and Italy, where he traveled in 1629 and 1649. In each of these places he remained open to all sorts of artistic influences, which he then used in the creation of a uniquely personal style, one that resulted from reflections on sixteenth-century Venetian painting, Caravaggesque naturalism, and the work of contemporary painters such as Rubens and the classicizing artists working in Rome about 1630. Velázquez's style is expressed primarily through court portraits, although his oeuvre also includes genre scenes, religious subjects, and various mythological fables. JPP

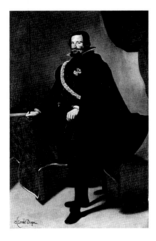

68. *(New York only)* *Fig. 11.1*

Diego Rodríguez de Silva y Velázquez

Gaspar de Guzmán, Count-Duke of Olivares

Ca. 1625–26
Oil on canvas
87⅛ x 54¼ in. (222 x 137.8 cm)
The Hispanic Society of America, New York, Gift of Arabella Duval Huntington, in memory of Collis Potter Huntington A104

CATALOGUES RAISONNÉS: Curtis 1883, no. 171; Gensel 1905, p. 12; Loga 1921, p. 37, repr.; Mayer 1936, no. 318; López-Rey 1963, no. 507; Gudiol 1974, no. 41; López-Rey 1979, no. 32

PROVENANCE: Conde de Altamira, Spain(?); Col. Hugh Baillie, London, by 1824; his sale, May 15, 1858 ("believed to be from the Altamira Gallery"); Charles Scarisbrick, Lancastershire, England, to 1861; his sale, May 10, 1861; Captain Robert S. Holford, Dorchester House, London; his heir, Sir G. L. Holford, to 1909; Duveen Brothers, London; purchased by Mrs. C. P. Huntington (née Arabella Duval Yarrington) and presented to The

Hispanic Society of America, New York, 1910

EXHIBITIONS: London 1855; London 1887; London 1901; New York 1999–2000

REFERENCES

19th century: Justi 1889, pp. 117–18 (as in Dorchester House, citing earlier provenance)

20th–21st century (selected references): Beruete 1906, pp. 68–69, pl. 47 (as at Dorchester House); Loga 1913, p. [130]; Cortissoz 1928, nos. 372–75, repr. pp. 36–37; Trapier 1929, pp. 156–58, pl. XLI; Hispanic Society 1938, p. 22; Trapier 1948, pp. 102–6, figs. 61, 64–65, and frontis.; Gerstenberg 1957, pp. 43–46, figs. 36–38; Camón Aznar 1964, vol. 1, pp. 296–300 (as "attributed" to Velázquez), repr. (Hispanic Society version [?]); E. Harris 1982, pp. 58–60, fig. 48; J. Brown 1986, p. 50, fig. 55; Martínez Ripoll 1990, fig. 1; Seville–Madrid 1996–97, p. 34, repr.; Marías 1999, pp. 60–66, fig. 39; New York 1999–2000, pp. 9, 16, 20–21, repr.; Lenaghan et al. 2000, pp. 266–67, repr.

After beginning his career about 1617 in his native Seville, Velázquez moved in 1623 to Madrid, remaining thereafter at the court, except for brief trips and two longer sojourns in Italy, in 1629–31 and 1649–51. Indeed, the same change of regime that had brought the sitter, the count-duke of Olivares, to power in 1621 also made it possible for his fellow Sevillian, Velázquez, to join the intellectuals, writers, and artists assembled around the new government.

Gaspar de Guzmán, count of Olivares and duke of Sanlúcar la Mayor (hence the double title "count-duke," or *conde-duque* in Spanish), was born in Rome in 1587 and died in Toro, Spain, in 1645. Socially and politically ambitious but also highly intelligent and hardworking, Olivares sought to reform the corruption that he felt had characterized the government of the previous king, Philip III (r. 1598–1621), and his favorite, the duque de Lerma. Reform, however, was extremely complicated in an age when the office of prime minister as such did not exist. Instead, the new king, Philip IV (r. 1621–65), like his predecessor, chose a confidant or favorite— variously called a *valido* or *privado* in Spanish—to organize the government and manage day-to-day affairs. This favorite was Olivares.

This painting is typical of Velázquez's court portraiture of the 1620s, in which Caravaggesque lighting is combined with Baroque touches and careful attention to details, several of which give us important information about Olivares's career. The new *valido* made sure he would remain in power by monopolizing the young king's person, both inside the palace as *sumiller de corps* (Master of the King's Bedchamber) and outside as *caballerizo mayor* (Master of the King's Horse). Velázquez has indicated both these offices by tucking a golden key, the symbol of the *sumiller*, discreetly into Olivares's belt and having him ostentatiously hold a riding crop, the symbol of the *caballerizo mayor*.

Olivares has placed his hand on the hilt of his sword, pushing up his black cloak, adorned with the green cross-fleury of the knightly order of

Alcántara. The right angle formed by the riding crop and the sword give some sense of the rectitude and determination of this reformer. Even the plate-like collar, or *golilla*, that Olivares wears calls attention to the reforms of the new regime, since its design resulted from sumptuary laws promulgated in the early 1620s.

Two versions of the present composition were known outside of Spain in the nineteenth century: this canvas, which came to England in the 1820s and was often on the art market before entering the Holford collection at Dorchester House in the 1860s, and a replica, the autograph status of which is debated by scholars, formerly in Louis-Philippe's Galerie Espagnole and now in the Varez-Fisa collection, Madrid. As early as 1835, for example, the French artist Eloi-Firmin Féron painted a half-length version of the composition for a decorative ensemble at Versailles.[1] The image was therefore well known to artists and connoisseurs throughout the nineteenth century and was an important element in forming opinions about Velázquez's art.

MBB

1. See Castres 1999, p. 114.

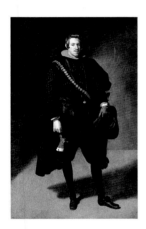

69. *(New York only)* *Fig. 4.20*

Diego Rodríguez de Silva y Velázquez

Infante Don Carlos

Ca. 1626
Oil on canvas
82⅛ x 49⅛ in. (210 x 126 cm)
Museo Nacional del Prado, Madrid P 1188

CATALOGUES RAISONNÉS: Curtis 1883, no. 144; Mayer 1936, no. 294; López-Rey 1963, no. 326; Gudiol 1973, no. 44; López-Rey 1996, vol. 2, no. 37

PROVENANCE: Royal collections; saved from the fire in the Alcázar, Madrid, 1734; Palacio Real Nuevo, Madrid, until 1816; Real Academia de Bellas Artes de San Fernando, Madrid, 1816; Museo del Prado, Madrid, 1827

EXHIBITIONS: Geneva 1939, no. 80; London 1976, no. 45; Paris 1976, no. 58; Madrid 1981–82a, no. 66; Madrid 1990b, no. 17

REFERENCES

19th century: Cruzada Villaamil 1885, p. 314; Beruete 1898, p. 20

20th century (selected references): Pantorba 1955, no. 31; E. Harris 1982, p. 64; J. Brown 1986, p. 52; Garrido Pérez 1992, pp. 127–35; Marías 1999, p. 57

From the beginning to the end of his career, Velázquez cast a personal and intelligent gaze on his surroundings and on pictorial tradition; this enabled him to constantly re-create various genres and themes. Among the traditions the artist revised was the court portrait, to which Velázquez dedicated a very important part of his professional efforts from his definitive move to Madrid in 1623. At the court there was already an outstanding tradition of court portraiture, thanks to the works that artists such as Titian, Antonio Moro, Alonso Sánchez Coello, and Juan Pantoja de la Cruz had created for the Spanish monarchs. Velázquez took up this tradition and, from the beginning, subjected it to a process of purification, with his ability as a portraitist, his love for the essential, and his sense of elegance all coming into play. During a period in which European court portraiture moved toward a flashier palette and rhetorical overload, the painter from Seville vindicated sobriety, truth of expression, and elegance.

There is no greater proof of those qualities than this portrait of the infante Don Carlos. The subject's resemblance to his brother Philip IV is close enough that the painting was for some time thought to represent the king himself. Carlos's short life (1605–1632) might be quite overlooked if not for this splendid portrait. One of the highlights of Velázquez's art during his first years at court, it can be dated to about 1626.

The composition generally follows the traditional model established by Sánchez Coello.[1] The sitter appears full length, standing, dressed in black, gazing toward the viewer, with his feet placed at nearly right angles to each other. Much of the effectiveness of the image is in the relationship of the figure to the surrounding space. Deleting elements such as chairs, tables, and curtains, Velázquez has preferred to confront the viewer directly with the physical reality of the infante, placing him in an indeterminate environment. Nevertheless, he has not ignored the spatial references that give the figure volume and corporeality, which he achieves masterfully through subtle tonal gradations and the careful projection of Don Carlos's shadow. This kind of space will appear again in later works by Velázquez, most notably in *The Jester Pablo de Valladolid* (cat. 73).

At this point in his career, Velázquez was interested in exploiting the infinite possibilities offered by a range of blacks and grays (earlier in his career, in Seville, he had brilliantly mastered earth tones). The turn to black was not a personal choice but a condition imposed by the predominance of dark colors in Spanish court dress. Instead of playing with the contrasts between these costumes and more colorful objects in the interiors in which the sitters pose, the artist surrounds the figures with a similar chromatic ambience, as had earlier Spanish court portraitists.

It is astounding how Velázquez is able to create an image that offers both sumptuousness and a chromatic and textural variety. To do that, he plays with light and luster, distributing a series of "sparkles" over the surface of the canvas, and creates bright areas that give body and volume to the figure, such as the golden chain, with the emblem of the Order of the Golden Fleece, the *golilla* (collar), the cuffs of the sleeves, and the gray braid on the costume. Within this extraordinarily elegant ensemble, some details stand out that indicate how original an artist Velázquez was, sure of himself and fond of leaving proof of his singularity. One example here is the right hand, which lightly holds a marvelous glove, a detail that inspired some famous lines by the poet Manuel Machado, writing in the early twentieth century: "And, instead of a royal scepter, he barely holds / with gallant unconsciousness, a suede glove / the white hand with bluish veins."[2]

This type of portrait, so reduced to its essence, in which Velázquez was able to magisterially resolve the problem of the relationship between the model and space, offers a formula that could be universally applied. It was especially useful for artists interested in ridding their work of any rhetoric beyond the physical reality and psychology of the sitter. It is therefore not surprising that Velázquez's example was so successful in the nineteenth century. The influence of this kind of painting can be seen in the portraits of many artists, from Manet, of course, to Eduardo Rosales (in his portrait of the duque de Fernán Núñez [1865, private collection, Madrid]) to Sargent and Whistler.

JPP

1. See Mulcahy 1996.

2. "Y, en vez de cetro real, sostiene apenas / con desmayo galán un guante de ante / la blanca mano de azuladas venas." "Felipe IV (A un retrato de Felipe IV pintado por Velázquez" (1901), in Machado 2000.

70.

Fig. 1.7

Diego Rodríguez de Silva y Velázquez
Democritus

Ca. 1629
Oil on canvas
38⅛ x 31⅞ in. (98 x 81 cm)
Musée des Beaux-Arts, Rouen 822.1.16

CATALOGUES RAISONNÉS: Mayer 1936, nos. 67, 448; López-Rey 1963, no. 76; Gudiol 1973, no. 51; López-Rey 1996, vol. 2, no. 40

PROVENANCE: Marqués del Carpio sale, Madrid, 1692, no. 214; given or sold to Pedro Rodríguez, gardener to Carpio, as payment for back wages; Bureau des Finances, Rouen, by 1789; deposited at the Abbey of Saint-Ouen, 1790; Préfecture de la Seine-Inférieure, Rouen; sold to the painter Lemonnier, 1797; acquired from Lemonnier as a work by Ribera by the Musée des Beaux-Arts, Rouen, 1822

EXHIBITIONS: Bordeaux 1955, no. 62; Stockholm 1959–60, no. 94; Madrid 1960–61, no. 44; Paris 1963b, no. 84; Madrid 1990b, no. 13; Castres 1999, no. 1

REFERENCES

19th century: Le Breton 1881, p. 10

20th century (selected references): Weisbach 1928; Pita Andrade 1952, p. 236; Pantorba 1955, no. 33; Jeannine Baticle, "Recherches sur la connaissance de Velázquez en France de 1650 à 1830," in *Varia Velazqueña* 1960, vol. 2, p. 543; Angulo Íñiguez 1963; Chroniques 1964; J. Brown 1986, p. 57; Bergot et al. 1992, p. 130; Jean-Louis Augé, "Velázquez et la France," in Castres 1999, pp. 22, 24–26

Like the painting *Saint Thomas the Apostle* (1618–20, Musée des Beaux-Arts, Orléans), this work was recognized quite late as by Velázquez: it was previously believed to be by Jusepe de Ribera because of its similarities to some of that artist's "philosophers." In 1881 Gustave Le Breton recognized the parallels between this figure and one in *Los Borrachos* (see fig. 9.16) and judged the painting to be by Velázquez. Most specialists have accepted that attribution.[1] Thus, one of the few paintings by Velázquez actually in French collections was not attributed to him until late in the nineteenth century. This exemplifies the great critical confusion concerning Velázquez during the century in which he was "discovered" by Europe.

This may be the painting described in the 1692 inventory of the collection of the marqués del Carpio in Madrid and purchased from him by one Pedro Rodríguez. The dimensions and description match: "A portrait, one vara in size of a laughing philosopher with a globe, original by Diego Velázquez."[2] By 1789 the painting was definitely in the Bureau des Finances of Rouen and after three more moves entered the Rouen museum in 1822. The same model appears in two other paintings, which are considered copies or workshop pieces; in both, a figure holds up a glass of wine in his left hand (Toledo [Ohio] Museum of Art; Museo Zorn, Mora, Sweden).

The neck and head of the figure are stylistically very different from the rest of the painting. The much looser technique of the head suggests a later retouching, which has been confirmed by radiographic analysis.[3] The remainder of the figure reveals a taste for defining contours and volumes that imply a date before the painter's first visit to Italy, that is, not later than 1629.

As in many of his other paintings, Velázquez here tightens the relationship between fiction and reality and offers few clues as to the identity of the figure. What the viewer sees is an individual dressed in dignified fashion, looking directly out at him or her. Next to him is a globe of the Earth, supported on a table on which there are also two books. His smiling expression has prompted critics to identify him as Democritus, the philosopher traditionally shown thus in western European painting. The index finger of his left hand is pointed at the globe, but it is not clear whether he is showing the globe to the spectator or turning it, or both. In either case, his expression, together with the geographical reference, clearly proposes to the viewer a skeptical and distanced reflection on reality and the world. In this respect, it is useful to recall that a terrestrial globe often appears in Vanitas paintings and other similar images.

Although this figure has sometimes been described as a geographer, it seems more correct to retain his identification as a philosopher, for that type was often painted in the period, by Velázquez himself, by Ribera, and by Rubens. The same was not true of geographers or other anonymous members of professions (although paintings of geographers do exist, especially in Dutch art). Equally relevant is the fact that the author of Carpio's inventory expressed no doubt in describing the subject as a philosopher.

Discussions concerning the true subject of this work have always emphasized the markedly portrait-like appearance of this character. Velázquez has described a specific face, which some have sought to identify among the palace jesters, just as, a few years later, he would do with the painting of Mars (Museo del Prado, Madrid). That is precisely what is most disquieting. Ribera, for example, used a supposedly realistic manner, but in the faces of his saints and philosophers, no concrete individual can be easily discerned. Velázquez does not work in a "realistic manner": rather, he creates a tension between fiction and reality by disguising living beings. This interaction between what is represented and who is represented would be greatly appreciated by the nineteenth-century artists who were drawn to his painting.

This painting was very probably the finest original by Velázquez that could be seen in France throughout the nineteenth century. JPP

1. There are some exceptions, such as Angulo Íñiguez 1963.

2. "Un retrato de una bara de un filósofo estándose riendo con un globo original de Diego Velázquez." Pita Andrade 1952, p. 236.

3. See Chroniques 1964.

71. *(New York only)* *Fig. 10.49*

Diego Rodríguez de Silva y Velázquez

The Jester Calabazas

Ca. 1630
Oil on canvas
69⅛ x 42 in. (175.5 x 106.7 cm)
The Cleveland Museum of Art, Leonard C. Hanna, Jr., Fund 1965.15

CATALOGUES RAISONNÉS: Curtis 1883, no. 75; Mayer 1936, no. 445; López-Rey 1963, no. 423; Gudiol 1973, no. 95; López-Rey 1996, vol. 2, no. 39

PROVENANCE: Palacio Real del Buen Retiro, Madrid, 1701–1808; the duc de Persigny, Paris, by 1867; his sale, Paris, April 4, 1872, bought for 1,600 francs; Château Congé, Paris, at the time of the death of its then owner, Maurice Cottier, 1881; George Donaldson, London, 1906; Sir Herbert Cook, Bart, Richmond, by the 1910s; Sir Francis Cook, Le Coin, La Haute, Jersey Island, by 1956; his sale, Christie's, London, March 19, 1965, no. 104, bought by Agnew & Sons for 170,000 guineas (ca. 499,800 dollars); bequeathed by Leonard Hanna, Jr. to The Cleveland Museum of Art, 1965

EXHIBITIONS: Paris 1867; London 1920–21; New York 1989–90, no. 26; Madrid 1990b, no. 20; Rome 2001, p. 196

REFERENCES
18th century: Ponz 1776–94, vol. 1, p. 133

20th century (selected references): Allende-Salazar 1925, p. 30; Trapier 1948, p. 115; Pantorba 1955, no. 32; Francis 1965; Steinberg 1965, p. 283; Moffitt 1982; J. Brown 1986, p. 101

It was Velázquez's numerous portraits of court jesters, called *hombres de placer* (entertainers), that most attracted European attention during the nineteenth century. Characters like these were found in many of the courts of Europe, and they were occasionally painted, but no important artist ever depicted them as often as Velázquez, who portrayed them in an absolutely singular way. He transformed them into a powerful figurative theme, and they offered him material with which he could freely address many challenges of pictorial representation. While these works were all greatly appreciated and form a substantial part of the artist's historical identity, they also pose many problems regarding their origins and intentions.

The French painters' discovery of Velázquez's jesters took place mainly in Madrid, because the most important collection of them was in the Prado. In some paintings, the jesters are the sole protagonists, in others, such as *Las Meninas* (fig. 4.13), they appear in a group of figures. A few of these works

were to be found abroad, including *Baltasar Carlos with a Dwarf* (1632, Museum of Fine Arts, Boston), which was documented in England from the mid-eighteenth century, and the present work, which most historians identify as the one cited as being in the Palacio Real del Buen Retiro, Madrid, throughout the eighteenth century. It is described in a 1789 inventory as "Another [painting] by Velázquez. Portrait of Velazquillo the jester, which the old inventory says is of Calabacillas holding a portrait and a pinwheel in his hands."[1] It was probably removed from the palace for its safety during the war of independence and taken to France, where it is documented until at least 1881.

Despite the allusions to Velazquillo, the painting actually represents Juan de Calabazas, known as Calabacillas, who was a jester at the Spanish court. Between 1630 and 1632 he was in the service of Cardinal Infante Ferdinand of Austria, and between 1632 and his death in 1639 he served Ferdinand's brother King Philip IV. Another portrait of Calabazas by Velázquez is in the Museo del Prado (1205). The physiognomy is the same, and the squint seen in the Madrid painting was also visible in the Cleveland painting before it was restored.

The style of the painting, especially its stylistic relationship with *Los Borrachos* (see fig. 9.16), caused José López-Rey to date it about 1628–29, just before Velázquez's first trip to Italy. Other critics propose similar dates. In any case, it should be considered, along with the Rouen *Democritus* (cat. 70), as the earliest of the paintings of jesters clearly by Velázquez's hand. This work differs in many ways from other such portraits by the artist. It is in a much more draftsmanlike style; the painter seems determined to clearly mark contours, in a manner very different from that of later canvases. The space is also a bit rigid and formulaic, created without the marvelous casualness found in the later portraits, and the way in which the figure is placed within it seems somewhat forced. These characteristics have sometimes raised doubts about whether the painting is a completely autograph work by Velázquez. Nevertheless, the painting exhibits qualities that prevent it from being attributable to anyone but the master.

As in Velázquez's other paintings of jesters, there is an interesting tension between form and meaning. So strongly individualized are the features of this jester that no one has ever seriously doubted that the subject of this painting is a specific person. Yet many questions remain regarding the artist's meaning. Basically, the painting represents a jester dressed in black. The shape of his body is emphasized through the comparison with the chair at his side. He holds a paper pinwheel in his left hand and a miniature portrait of a woman in his right. The pinwheel clearly symbolizes the wind, because it works only when driven by movement of air, which was at the time an explicit reference to inconstancy. Miniature paintings were essentially intimate objects, bearing portraits of loved ones. They are often seen in Vanitas paintings, along with objects such as hourglasses, jewels, terrestrial globes, weapons, and crowns. There the miniature has an erotic dimension and generally represents women;

thus, the one held here by Calabacillas has a clear meaning. This painting has sometimes been called an allegory of madness, which Cesare Ripa's *Iconologia* (1st ed., 1593) characterized as a man climbing a reed and carrying a paper pinwheel. In any case, the most important reference in the painting is the miniature. Although the jester simply holds the pinwheel in one hand, he ostentatiously offers the portrait of the woman with the other. Probably the meaning of the painting should be related to the madness, instability, and inconstancy associated with love.

Like all the works by Velázquez that were in French collections during the nineteenth century, this one influenced certain French artists. Indeed, it is sometimes possible to find a direct reference to it, as in Sargent's *Lady with the Rose* (cat. 215).

JPP

1. "Otra de Velázquez. Retrato de Velazquillo el Bufón, y el inventario antiguo dice ser de Calabacillas con un retrato en la mano y un reguilete." Inventory of the Palacio Real, September 7, 1789, compiled by Don Pedro Gil de Barnabé, no. 178. Quoted in López-Rey 1996, p. 94.

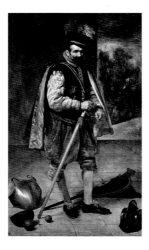

72. *Fig. 4.19*

Diego Rodríguez de Silva y Velázquez
The Jester "Don Juan de Austria"

Ca. 1632
Oil on canvas
82⅛ x 48⅛ in. (210 x 123 cm)
Museo Nacional del Prado, Madrid P 1200

CATALOGUES RAISONNÉS: Curtis 1883, no. 72; Mayer 1936, no. 453; López-Rey 1963, no. 422; Gudiol 1973, no. 112; López-Rey 1996, vol. 2, no. 65

PROVENANCE: Palacio Real del Buen Retiro, Madrid, 1700; Palacio Real Nuevo, Madrid, 1772; Real Academia de Bellas Artes de San Fernando, Madrid, 1816; Museo del Prado, Madrid, 1827

EXHIBITIONS: Florence 1986, no. 66; Madrid 1986, no. 21; New York 1989–90, no. 25; Madrid 1990b, no. 58

REFERENCES
19th century: P. Madrazo 1872; Cruzada Villaamil 1885, p. 328; Justi 1889, p. 440; Beruete 1898, p. 208

20th century (selected references): Moreno Villa 1939, pp. 67–72; Pantorba 1955, no. 96; J. Brown 1986, p. 97; E. Harris 1991, p. 108

There are strikingly great differences between how Velázquez's career was regarded in the nineteenth century and in the twentieth, and these involve matters of content, the attribution of works, and the description of his stylistic evolution. This painting has a direct relevance to the changing characterization of the artist's style. Today art historians are in agreement in dating this work to about 1632, when, documents inform us, the model received a suit like the one in the painting. That is to say, this work was executed relatively early in Velázquez's career, just after the strongly classical moment that followed his first trip to Italy. Nonetheless, it was long thought to date to a much later period. Critics of the stature of Carl Justi and Aureliano de Beruete dated it to the last decade of Velázquez's career on stylistic grounds. Beruete, for example, called attention to the extraordinarily summary technique, which he supposed to be the culmination of a career that could be described as a journey toward the dissolution of forms into color.[1] Actually, this attitude had long prevailed in the history of Velázquez criticism and was also applied to other great painters in the Western tradition. During the nineteenth century, many described Velázquez's career in terms of "evolution," as a journey throughout which the artist placed less and less importance on the value of drawing. The appearance of new documents about Velázquez's life and work and the radical reduction of his oeuvre have substantially modfied this vision of his work today. It is no longer adequate to describe his career in terms of evolution, for, although stylistic differences can be seen throughout his career, a common style marks all his paintings from the early 1630s to the end of his life. In fact, the differences between his pictures are largely unconnected to their chronology and relate more to the different expressive needs required by different subjects.

During the nineteenth century there were various theories about the identification of the subject of this painting. Louis Viardot, following a long tradition, believed it to be a portrait of the marqués de Pescara,[2] and it was thought to represent a professional soldier until 1872. In that year Pedro de Madrazo discovered that the real identity of the figure was given in the 1700 inventory of the Palacio del Buen Retiro: the jester Don Juan de Austria, who had been nicknamed after the hero of the Battle of Lepanto and who worked at the court from 1624 to 1645. Here, as in many of his paintings throughout his career, Velázquez confronts the narrative paradox, at which he was a true master. He presents us with a jester dressed like the hero after whom he was named, emphasizing the contrast between his frightened, evasive expression and his militaristic setting—the military costume, the baton of command, and the arms, ammunition, and armor scattered on the floor. In the background, a naval battle unequivocally refers to Lepanto. As when Velázquez represents Mars as a tired and melancholy warrior, in this painting, through paradox, he offers the spectator a

subtle and intelligent maneuvering of the limits between reality and fiction, between individual identity and historical or social identity.

This portrait and others in this exhibition that have jesters and *hombres de placer* (entertainers) as their subjects raise the question of the attitude of the nineteenth-century public toward pictures with unusual iconography. Fernand Petit had such an aversion to these figures that, although he recognized Velázquez's self-portrait in *Las Meninas* (fig. 4.13) as "an incomparable masterpiece," he felt the painting did not remotely merit such praise, because the presence of the jesters María Bárbola and Nicolasito Pertusato defaced the whole.[3] For the traveler Frances Elliot, who could not hide her distaste for the jester, *Las Meninas* seemed a portrait of a family of monsters.[4] Such cases reflected an aversion to the models, who were considered unworthy of the artist's brush. Some criticized the artist himself: Frederick Seymour was enchanted by the simplicity, kindness, and love of humanity in Murillo's paintings of the subject but thought Velázquez's were meant to caricature the meek.[5] Others, such as the Reverend Richard Roberts, saw in these paintings an artist who understood throughout his life the innate dignity of humans, a dignity that derives not from social status but from one's condition as a child of God.[6] Yet, numerous critics, such as Richard Ford, admired the jesters for their artistic merit and did not bother themselves with questions of human dignity.[7]

The fact is that these paintings attracted the public, the critics, and the artists of the nineteenth century more than any others by Velázquez. Many of the artists, according to Elliot, gathered before these paintings in order to copy them—so many that tourists were kept from seeing them. In reality, the attitudes described in the nineteenth century are similar to those of today, when writers still approach these paintings as a profound reflection on human dignity. This is the case, for example, in a lovely essay by John Berger.[8] However, there is also no lack of critics who propose a less passionate, more contextualized reading of these works.

JPP

1. Beruete 1906, pp. 94–95.
2. Viardot 1852 (1860 ed.), pp. 126–27.
3. Petit 1877, pp. 28–29.
4. Elliot 1884, vol. 1, p. 90.
5. Seymour 1906, pp. 89–115.
6. R. Roberts 1860, pp. 106–7.
7. Ford 1845 (1981 ed.), vol. 1, p. 78.
8. J. Berger 1994, p. 379.

73. *Fig. 1.49*

Diego Rodríguez de Silva y Velázquez
The Jester Pablo de Valladolid

Ca. 1632–35
Oil on canvas
84 x 49¼ in. (213.5 x 125 cm)
Museo Nacional del Prado, Madrid P 1198

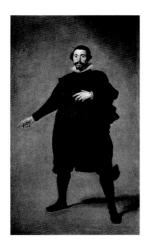

CATALOGUES RAISONNÉS: Curtis 1883, no. 71; Mayer 1936, no. 449; López-Rey 1963, no. 433; Gudiol 1973, no. 107; López-Rey 1996, vol. 2, no. 82

PROVENANCE: Palacio del Buen Retiro, Madrid, 1701; Palacio Real Nuevo, Madrid, 1772–1814; Real Academia de Bellas Artes de San Fernando, Madrid, in 1816; Museo del Prado, Madrid, 1827

EXHIBITIONS: Geneva 1939, no. 89; Madrid 1981–82a, no. 67; Madrid 1986, no. 23; Madrid 1990b, no. 57

REFERENCES
19th century: Cruzada Villaamil 1885, p. 108; Beruete 1898, p. 106

20th century (selected references): Pantorba 1955, no. 53; Solkin 1975; J. Brown 1986, p. 104; Garrido Pérez 1992, pp. 420–26; Varela de Vega 1993

Along with *Aesop* and *Menippus* (cats. 75, 76), this was one of the paintings by Velázquez in the Prado that was most esteemed and praised by artists during the second half of the nineteenth century. Many painters made copies of the three works while others were inspired by them to create their own compositions. These were the paintings that caused Velázquez to be called the "painter of truth" and that were used by many who subscribed to the different nineteenth-century "realisms" to vindicate aesthetic alternatives free of rigid classicist and academic restraints.

The subject of this portrait was born in 1587 in Vallecas, a town near Madrid, and died in Madrid in 1648. From 1632 he was among the many dwarfs, jesters, and *hombres de placer* (entertainers) on the court payroll. Since his presence at the court was probably because of his comic and theatrical ability, he appears in this painting (which was known for a long time as *The Actor*) in a declamatory pose. His legs are extended, and he gestures with his hand at some verbal allusion within his speech.

The apparent age of the model and the style of the painting itself suggest a date immediately following the sitter's entry into service at the court, that is, between 1632 and 1635. It is thus very interesting to compare this work with the *Infante Don Carlos* (cat. 69), painted several years earlier. *Pablo de Valladolid* is much more radical in its shedding

of rhetoric and breaking with classicist conventions. In *Don Carlos*, a subtle horizontal line in the background and the contrast between a light surface and a dark area at the left serve to define a three-dimensional space with two walls and a floor. In *Pablo de Valladolid*, the figure is situated in an absolutely indeterminate space, indicated only by the faint shadow cast by his legs; this space does not exist independent of the model but is created by him. The painter thus confronts the viewer in a much more radical way with the physical and psychological reality of the person, concentrating attention on his lively gaze, the gestures of his hands, and the expressiveness that emanates from the way he is posed. In this search for the essential, Velázquez once again limits his palette, reducing it to the earth tones of the background, against which the body is resolved primarily in grays and blacks. He adds highlights of light and color in the areas of the human body that are most expressive: the head and the hands.

The artistic and critical influence of this painting has been immense. Among the principal painters to have been inspired by it are Goya, whose portrait of Cabarrús (1788, Banco de España, Madrid) is an almost direct transposition;[1] Whistler, whose *Harmony in Blue and Gold: The Little Blue Girl* (1894, Freer Gallery of Art, Washington, D.C.) and *Brown and Gold: Self-Portrait* (fig. 10.12) were inspired by a photograph of the picture; and Manet, who used it for *The Fifer*, *The Tragic Actor*, and *Faure in the Role of Hamlet* (cats. 151, 150, 159). In his self-portrait (Newberry Library, Chicago), the American painter George P. Healy included a reproduction of Velázquez's painting on the wall.[2] Besides these pictorial homages, Manet occasionally praised the painting in words, as when he stated in a letter to Henri Fantin-Latour that it was "possibly the most extraordinary piece of painting that has ever been done."[3] One of Manet's colleagues, the Dutch painter Josef Israëls, wrote after he saw this painting that "Velázquez is the painter closest to the model of a painter that one imagines when one is young."[4]

Many of those who wrote about Velázquez or the Prado during the second half of the nineteenth century mentioned this painting enthusiastically. For example, the critic Jules Claretie stated in 1870, "What [is] more striking than this person dressed in black from head to toe: an actor reciting his lines? He starts, he proceeds, he falls quiet."[5] For Lucien Solvay, a historian of Spanish painting, the work served to encapsulate Velázquez's ability to achieve great effects with a prodigious economy of means: "Modesty is the very background of his art, which he offers just as it is, chivalrously, without sleight of hand, chest bared and visor raised. The black stain of a figure—Pablillos de Valladolid, buffoon of Philip IV—posed against a gray background, cut only by the white of his collar, is enough for him: and the effect thus obtained is enormous."[6]

JPP

1. Madrid–Boston–New York 1988–89, no. 15, p. 34.
2. Carol M. Osborne, "Yankee Painters at the Prado," in New York 1993a, p. 67.
3. "peut-être le plus étonnant morceau de peinture que l'on ait jamais fait." Letter of September 3, 1865, in Manet 1988, p. 43.

4. Israëls 1900, p. 42.
5. "Quoi de plus frappant que ce personnage vêtu de noir de sa tête aux pieds: un comédien récitant son role? Il parle, il agit, il se meut." Claretie 1870, p. 210.
6. "L'honnêteté fait le fond même de son art, qui s'offre comme il est, chevaleresque, sans détour, sans escamotages, poitrine découverte et visière levée. La tache noir d'un personnage,—Pablillos de Valladolid, bouffon de Philippe IV—posée sur un fond gris, où tranche seulement le blanc d'une collerette, lui suffit: et l'effet ainsi obtenu est énorme." Solvay 1887, p. 173.

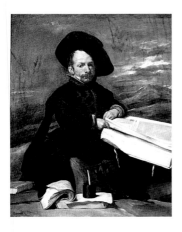

74. *Fig. 9.90*

Diego Rodríguez de Silva y Velázquez
The Dwarf Don Diego de Acedo, "El Primo"

Ca. 1636–38
Oil on canvas
42 1/8 x 32 1/4 in. (107 x 82 cm)
Museo Nacional del Prado, Madrid P 1201

CATALOGUES RAISONNÉS: Curtis 1883, no. 69; Mayer 1936, no. 452; López-Rey 1963, no. 420; Gudiol 1973, no. 105; López-Rey 1996, vol. 2, no. 102

PROVENANCE: Torre de la Parada, 1701; Palacio de El Pardo, 1714; Palacio Real Nuevo, Madrid, 1772; Museo del Prado, Madrid, 1819

EXHIBITIONS: Geneva 1939, no. 101; Madrid 1986, no. 24; Paris 1987–88, no. 30; Madrid 1990b, no. 55; Amsterdam 1998–99, no. 161

REFERENCES
19th century: P. Madrazo 1872, no. 30; Cruzada Villaamil 1885, p. 328

20th century (selected references): Pantorba 1955, no. 85; Martín González 1960, p. 251; J. Brown 1986, p. 148; Garrido Pérez 1992; David Davies, "El Primo," in Alpers et al. 1999, pp. 169–96; Mena Marqués 2000, pp. 110–14

Don Diego de Acedo, the supposed model for this painting, was a jester documented in the service of the king between 1635 and 1660. His duties at the palace took him beyond the simple entertainment of the court, for he worked in the *estampilla*, the office in charge of the facsimile of the royal signature. It is known that during his years in the Alcázar he had a

servant and in 1643 was involved in a passionate affair that led to a crime. He traveled with the king to Aragon the following year, at which time Velázquez painted his portrait. Several hypotheses have been offered regarding how he got the nickname "El Primo" (which can mean either cousin or dolt). Because the figure shown here is surrounded by books and writing materials, and because he is dressed in black (a gift to Acedo of a suit like this one is documented), historians have identified him as this jester,[1] even though the facts are not absolutely conclusive.

Some believe that this portrait is the one painted in 1644 and that it is the same work that appears in the Alcázar inventories of 1666, 1668, and 1700 as a portrait of "El Primo." Nevertheless, a portrait described as similar to this one was mentioned as being in the royal hunting pavilion, the Torre de la Parada, in 1701; it reappeared in the Pardo palace in 1714 among the paintings moved there from the Torre. It is most likely that the painting cited in the Alcázar was lost and that the present work was expressly created for the Torre de la Parada between 1636 and 1638 as a pendant to another similar painting, such as *The Dwarf Francisco Lezcano* (ca. 1636–38, Museo del Prado, Madrid). This is suggested not only by the information cited here but also by the placement of the figure in a landscape featuring the Maliciosa, one of the most distinctive mountains in the Sierra de Guadarrama, in the background. It is the same scenery that appears, for example, in *Baltasar Carlos as a Hunter* (1635–36, Prado) and the *Cardinal Infante Don Fernando as a Hunter* (ca. 1634, Prado), which also were painted for the Torre.

The iconographic program of the Torre de la Parada included numerous series of mythological paintings, four images of philosophers, various royal portraits, views of royal palaces, hunting scenes, and animal paintings. For that reason, certain scholars have thought that its four paintings of jesters must have some meaning. Xavier de Salas suggested that they represented the temperaments, and recently Manuela Mena Marqués has tried to read the present painting as a comic allusion to philosophical knowledge.[2] Whether or not these figures "interpret" something, their features have a forcefully portraitlike quality, and there is no reason to doubt that the subjects are real court jesters. Anyway, this would not be the first time that Velázquez combined a depiction of an actual person with an allegorical meaning, as in *The Jester "Don Juan de Austria"* (cat. 72) and *Democritus* (cat. 70).

The reactions that these paintings provoked in the nineteenth century were quite varied, as they are today, although in both periods they were unanimously considered to be among Velázquez's most original works, the ones that best exemplify his aesthetic ideology. In the nineteenth century, the paintings affirmed the artist's fame as a "painter of truth," who was able to confront his pictorial subject without any artifice and who was capable of capturing an image with absolute veracity and directness. The English writer Richard Ford described *Don Sebastián de Morra* (fig. 14.66) as a "dwarf, seated just as Velázquez saw him, and as no one else would

have dared paint him,"[3] while Manet regarded the same work as "a choice picture for a true connoisseur."[4] As Juliet Wilson-Bareau notes in her essay in this publication, Manet may even have been inspired by the dignity of "El Primo" to use him as a model for the portrait of his dear friend Émile Zola (cat. 153).

These paintings of jesters perfectly exemplified the artist's capacity for creating a painting at the margins, it would seem, of the conventional. In addition, some of them, such as this one, clearly demonstrated Velázquez's ability to represent still-life objects (the inkwell and book in the foreground) and landscape (the mountain in the background). All this inspired the acutely observant critic Aureliano de Beruete to write that, in this picture, Velázquez "never displayed his genius to better advantage than by executing from such an unpromising model one of his most admirable masterpieces."[5]

JPP

1. P. Madrazo 1872, no. 30.
2. Salas 1977, n.p.; Mena Marqués 2000, pp. 112–13.
3. Ford 1845, vol. 1, p. 789.
4. "peinture de choix pour un vrai connaisseur." Manet 1988, p. 43; Manet 1991, p. 34.
5. Beruete 1906, p. 91.

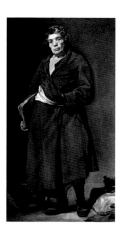

75. *(New York only)* *Fig. 9.11*

Diego Rodríguez de Silva y Velázquez
Aesop

Ca. 1638
Oil on canvas
70⅞ x 37 in. (179.5 x 94 cm)
Inscribed upper right: *ÆSOPVS*
Museo Nacional del Prado, Madrid P 1206

CATALOGUES RAISONNÉS: Curtis 1883, no. 30; Mayer 1936, no. 65; López-Rey 1963, no. 73; Gudiol 1973, no. 109; López-Rey 1996, vol. 2, no. 92

PROVENANCE: Torre de la Parada, 1703; Palacio de El Pardo, 1714; Palacio Real Nuevo, Madrid, 1772 and 1794; Museo del Prado, Madrid, 1819

EXHIBITIONS: Geneva 1939, no. 97; Paris 1987–88, no. 29; New York 1989–90, no. 25; Madrid 1990b, no. 49

SELECTED REFERENCES: Pantorba 1955, no. 79; Palm 1967; E. Harris 1982, p. 132; J. Brown 1986, p. 163; J. Berger 1991; Francisco Rico, "Los filósofos de Velázquez o el Gran Teatro del Mundo," in Pérez Sánchez et al. 1991, pp. 345–47; Garrido Pérez 1992, pp. 459–65; Tromans 1996; José Manuel Cruz Valdovinos, "Menipo y Esopo en la Torre de la Parada," in Alpers et al. 1999, pp. 141–47; Mena Marqués 2000

Aesop and *Menippus* (cat. 76) are first mentioned in the 1703 inventory of the Torre de la Parada, a hunting pavilion in the El Pardo forest outside Madrid. There they were accompanied by, among others, an extensive cycle of mythological paintings by Rubens and his workshop, various portraits of jesters by Velázquez (cats. 72, 73), some Velázquez portraits of members of the royal family dressed as hunters, and another pair of philosophers, Heraclitus and Democritus, painted by Rubens (ca. 1636–38, Museo del Prado, Madrid). Though somewhat narrower in width, the last two are very similar in size to the philosophers executed by Velázquez. It has been supposed that the four canvases formed a series and that they were painted around the same period, although the question arises as to why the very prolific Flemish painter was not commissioned to paint all of them.

In any case, the comparison between the philosophers by Rubens and those by Velázquez sheds light on the personality of the Spanish master—especially in view of the fact that the Fleming was the most formidable Baroque inheritor of the classicist tradition. Rubens's splendid figures are shown dressed in antique garb and seated before a rocky landscape, a setting frequently used for the pictorial description of hermits and penitents. Their feet are bare; one laughs and the other cries. Their bodies are absolutely Rubenesque, robust and well muscled, and their gestures are adapted to firmly established expressive codes. Velázquez, on the other hand, places his figures in interiors, although vague ones; their shoes and clothing are those that would be worn by any beggar in any Spanish city; and a will to achieve realism is apparent in their features. They are situated in space in a manner similar to many other subjects of Velázquez's portraits. Although there are a number of objects that encourage a symbolic reading of the two images, the painter again experiments with the limits between portraiture and fiction.

There have been a variety of efforts to identify the meaning of these figures in the context of the Torre de la Parada. Some possible connections are obvious, such as the relationship between Aesop and the many paintings depicting fables in the building. Other, more complicated interpretations assume an interest in extremely recondite narrative on the part of the painter and a great interpretive subtlety on the part of his public. Both Aesop and Menippus were well known to cultured Spaniards and were associated with certain concrete meanings.[1] Additionally, the association between philosophy and poverty had become a figurative topos

in Baroque Europe, probably as a result of the popularity of Stoic ideas at that time.

Aesop, who appears holding a book (probably his fables), is surrounded by objects alluding to the circumstances of his life. His poor clothing refers to his origins as a slave and to his humble existence. The bucket of water symbolizes the ingenious answer he gave to a riddle posed by his master, who then rewarded him with his freedom. The baggage on the right could refer to the circumstances surrounding his violent death. When he criticized the inflated reputation of the city of Delphos, its inhabitants hid a cup in his baggage, accused him of robbery, and hurled him off a cliff.

Although the meaning of paintings such as this one is interesting to contemporary scholars, *Aesop* attracted the attention of many artists and writers during the second half of the nineteenth century for other reasons. The first, and principal, is rooted in the pictorial values of the painting: few works so clearly show the artist's mastery of brushwork and tonal range, as well as his ability to create a truthful, realistic image with great economy of means—a goal European and American painters of the nineteenth century sought to achieve.[2] The appreciation of the image was also based on its narrative content. Initial surprise at seeing an ancient writer dressed in rags was succeeded by astonishment at how well the artist had brought the philosopher to life. Although scraggly, tired, and worn out, Aesop approaches the viewer with a proud gaze and does not shy away. This aspect was noted by the Danish writer Hans Christian Andersen (who undoubtedly, because of literary affinities, would have had great sympathy for Aesop), who wrote, "one cannot imagine the fabler with any other face."[3]

The list of artists who copied this painting or were inspired by it is very long. There are copies by painters such as Mariano Fortuny, Joaquín Sorolla, William Merritt Chase, and Sargent, all of whom were primarily interested in the face.[4] Among the works inspired by it, several by Manet stand out, including his two portraits of philosophers in the Art Institute of Chicago (cats. 145, 146) and his *Absinthe Drinker* (cat. 128). Manet's friend and biographer Antonin Proust wrote that the latter work was of "a Parisian type, studied in Paris, executed with the economy of means that [Manet] found in the paintings of Velázquez."[5]

JPP

1. See Rico in Pérez Sánchez et al. 1991, pp. 345–57, for the most important study of the meaning of both philosophers during the Golden Age in Spain.
2. Lucien Solvay, for example, wrote, "The figures baptized with conventional names, Menippus, Aesop, are wonderful portraits, of a very Spanish type, certainly possessing nothing of the Greek." ("Les figures baptisées de noms conventionnels, Ménippe, Esope, sont d'admirables portraits, aux types très espagnols, n'ayant rien de grec assurément.") Solvay 1887, p. 190.
3. Andersen 1988, p. 207.
4. The Fortuny is in the Museo del Prado, Madrid; the Sorolla is cited in Florencio de Santa Ana, "La perdurabilidad de Velázquez en la pintura española del siglo XIX: Sorolla," in Jornadas 1991, p. 439 (private collection); the Chase copy appears in a photograph of the artist's studio in New York

(see Gallati 1995, p. 52); the Sargent is in the Ackland Art Museum, Chapel Hill, North Carolina (cat. 212). See also New York 1993a, no. 41.
5. Cited in García Felguera 1991, p. 138.

76. *(Paris only)* *Fig. 9.12*

Diego Rodríguez de Silva y Velázquez
Menippus

Ca. 1638
Oil on canvas
70½ x 37 in. (179 x 94 cm)
Inscribed upper left: *MOENIPPVS*
Museo Nacional del Prado, Madrid P 1207

CATALOGUES RAISONNÉS: Curtis 1883, no. 32; Mayer 1936, no. 66; López-Rey 1963, no. 78; Gudiol 1973, no. 110; López-Rey 1996, vol. 2, no. 93

PROVENANCE: Torre de la Parada, 1703; Palacio de El Pardo, 1714; Palacio Real Nuevo, Madrid, 1772 and 1794; Museo del Prado, Madrid, 1819

EXHIBITION: Madrid 1990b, no. 50

SELECTED REFERENCES: Pantorba 1955, no. 80; Palm 1967; E. Harris 1982, p. 129; J. Brown 1986, p. 163; J. Berger 1991; Francisco Rico, "Los filósofos de Velázquez o el Gran Teatro del Mundo," in Pérez Sánchez et al. 1991, pp. 345–47; Garrido Pérez 1992, pp. 467–70; Tromans 1996; José Manuel Cruz Valdovinos, "Menipo y Esopo en la Torre de la Parada," in Alpers et al. 1999, pp. 141–47; Mena Marqués 2000

Like Aesop (see cat. 75), Menippus was one of the "simple" philosophers, who were born into slavery and became outspoken social critics. The elements that identify him are the books, symbols of his intellectual activity; his poor clothing, an allusion to his humble origins and life and to his lack of interest in worldly goods; his smile, the equivalent of a distanced, intelligent gaze upon reality; and a pitcher on a board barely held up by two round stones, a clear allusion to the instability of life and the relativity of things, the subjects of his discourses. Two lateral additions to the painting must have been added after the application of the inscription, which, it has

been said, was needed because there was no iconographic tradition that would enable viewers to identify Menippus.

Even more than *Aesop*, its companion piece, *Menippus* amazes the viewer with its extraordinary freedom of execution, a freedom unsurpassed by any other contemporaneous painter. The brushstrokes are exactly those needed to create an absolutely truthful image of the philosopher. In works such as this, Velázquez offered a new way of looking at reality and re-creating it on canvas, skirting classicist conventions. Although the painting is not without rhetorical devices, the composition is imposed with enough force to suppress any element of a narrative character. It is not surprising that *Aesop* and *Menippus* were among those paintings most admired during the second half of the nineteenth century by artists and critics, who learned some very important lessons from them. For example, details of Menippus's lower body—the shoes, pants, and hem of the cape—clearly anticipate the pictorial language of Manet, who knew how to borrow from Velázquez's paintings elements that would decisively influence not only his own work but the evolution of later Western painting. We have only to compare *Menippus*, for example, with the figure wearing a top hat in Manet's *The Old Musician* (fig. 9.15). Other painters, such as Mariano Fortuny, Joaquín Sorolla, Degas, and Sargent, were moved by this painting and copied it.[1]

JPP

1. Fortuny's copy belongs to the Museo del Prado, Madrid; see Carol M. Osborne, "Yankee Painters at the Prado," in New York 1993a, p. 68. Sorolla's copy is in the Museo Sorolla, Madrid; see Florencio de Santa Ana, "La perdurabilidad de Velázquez en la pintura española des siglo XIX: Sorolla," in Jornadas 1991, p. 438. Degas's is cited in the sale of the contents of his studio; see Crombie 1963, p. 128.

77. *(New York only)* *Fig. 9.20*

Workshop of Diego Rodríguez de Silva y Velázquez
Philip IV as a Hunter

Ca. 1632
Oil on canvas
78¼ x 47¼ in. (200 x 120 cm)
Musée Goya, Castres, on deposit from the Musée du Louvre, Paris MI 292

CATALOGUES RAISONNÉS: Curtis 1883, no. 109; Mayer 1936, no. 223; López-Rey 1963, no. 251

PROVENANCE: Laneuville sale, Paris, 1819, no. 116; Lapeyrière sale, Paris, 1825; Philip Delahante sale, Paris, 1828, bought by Otto Mündler; acquired from Mündler by the Musée du Louvre, Paris, 1862

EXHIBITIONS: Madrid 1960–61, no. 90, pl. LVIII; Paris 1963b, no. 85, repr.; Castres 1999, no. 2, repr.

REFERENCES
19th century: Blanc et al. 1869, nos. 68–69 (Velázquez issue), p. 16; Vilno. 1872, p. 341

20th–21st century (selected references): Beruete 1906,
p. 57; Manrique de Lara 1921, p. 183; Hautecoeur
1926, p. 165; Bardi 1977, no. 61; J. Brown 1986,
p. 132; Lipschutz 1988, pp. 205–7; Louvre 2002,
pp. 360–62, repr.

While consolidating his position as a court por-
traitist, Velázquez was also forming an increasingly
active workshop that let him meet the growing
demand for portraits of the king and his family.
Thus, most of the original portraits of the royal
family by Velázquez also exist in one or more repli-
cas made by his collaborators and destined primarily
for other European courts, especially Vienna, or for
members of the court in Madrid.

These portrait replicas were frequently painted
shortly after the originals, since one of their func-
tions was to show what the sitter looked like at a cer-
tain age. This was very probably the case with the
present portrait of Philip IV, as can be ascertained
by comparing it with the autograph painting in the
Prado. The original was one of three royal portraits
created by Velázquez for the Torre de la Parada, a
hunting pavilion in the forest of El Pardo outside
Madrid. These depicted the king, his brother
Ferdinand, and the king's son Baltasar Carlos
dressed in hunting attire, carrying firearms, and
accompanied by dogs. Each stands next to a tree in a
landscape that resembles the region north of Madrid.
The portrait of Philip IV can be dated to about 1632
on both stylistic and historical grounds. (The por-
trait of his brother must have been done before
Ferdinand's departure for Antwerp in 1635.)

One of the most notable aspects of the original
in the Prado is the obvious pentimento that runs
along the lower profile of the body, from waist to
feet. In an earlier phase of the execution, this part of
the anatomy was placed farther to the right; in addi-
tion, the harquebus played a more important role.
To know what this earlier state looked like, one need
not rely on this evidence or on radiographs but on
the version in Castres, which was doubtless painted
before Velázquez made these last changes in his
original. At first, as the Castres painting demon-
strates, Philip IV was pictured with his head bare
and holding his cap in his left hand. It is not known
why or when Velázquez made these changes, but they
were presumably done before the execution of the
two companion pieces, whose models both wear caps.

In any case, the Castres painting is a valuable
source of information about Velázquez's working
methods and about the dynamics of his workshop.
Although it has sometimes been said that the origi-
nal painting of Philip IV was copied while it was
being created, the general understanding is that a
painting is copied when it is completed. Therefore,
the pentimento in the original probably does not
betray an intermediate state but rather the appear-
ance of the work when Velázquez first considered it
finished. Later, perhaps when he undertook the
other two works, he decided to modify the first.

The Castres painting is very close to its model,
both compositionally and in its pictorial construc-
tion, but it lacks the sureness and aplomb that make
the original one of the most important portraits of
this phase of Velázquez's career. However, its qual-
ity is sufficiently high to have prompted some critics,
such as Aureliano de Beruete,[1] to attribute it to Juan
Bautista Martínez del Mazo, Velázquez's son-in-law
and chief workshop assistant.

There is no proof that this painting is the one
that appears in the inventories of the Madrid Alcázar
from 1686 and 1700, as has occasionally been stated.
It is more likely that it was in the collection of the
counts of Altamira in Madrid. From there it went to
France, where it was successively in the Laneuville
and Lapeyrière collections before entering the
Louvre in 1862.

Ilse Hempel Lipschutz has noted that this
painting left an interesting imprint on French
Romanticism:[2] it was the basis for Louis Boulanger's
1839 portrait of the poet Petrus Borel (location
unknown), which is recorded in a print by Céléstin
Nanteuil (fig. 14.46). Borel appears standing, posed
before a landscape, with his right hand resting on the
head of a dog that is seated very like the one here.
The artist was able to capture perfectly the elegance
of Velázquez's figure and has transposed it onto his
own model. Théophile Gautier called attention to
the Castilian gravity that "always seems to emerge
from a painting by Velasquez."[3] Another French
painter interested in this work was, unsurprisingly,
Manet, who did both a drawing and a print after it
(cat. 165).[4]

<div align="right">JPP</div>

1. Beruete 1906, p. 57.
2. Lipschutz 1988, pp. 205–7.
3. "paraissait toujours sortir d'un cadre de Velasquez."
 Quoted in Lipschutz 1972, p. 172.
4. Crombie 1963, p. 127.

78. *Fig. 1.2*

Workshop of Diego Rodríguez de Silva y Velázquez
Infanta Margarita

Ca. 1653
Oil on canvas
27½ x 23 in. (70 x 58 cm)
Musée du Louvre, Paris 941

CATALOGUES RAISONNÉS: Curtis 1883, no. 255;
Mayer 1936, no. 527; López-Rey 1963, no. 398;
Gudiol 1973, no. 255

PROVENANCE: Cabinet des Bains, Palais du
Louvre, Paris, 1654–1709; Palais des Tuileries,
Paris, before 1780; Musée Napoléon, Paris, 1810

EXHIBITIONS: Madrid 1960–61, no. 79, pl.
LXXXII; Paris 1963b, no. 87, repr.; Tokyo 1991,
no. 71, repr.; Mexico City 1994b, no. 19, repr. p. 30

REFERENCES
19th century: Stirling-Maxwell 1848, vol. 2, pp.
653–54; Viardot 1860b, p. 97; Solvay 1887, p. 186;
Justi 1888 (1999 ed.), pp. 611–12; Wyzewa 1891, p. 64

20th–21st century (selected references): Bréal 1919,
p. 84; Manrique de Lara 1921, pp. 195ff.; Pantorba
1955, no. 112; Jeannine Baticle, "Recherches sur la
connaissance de Velázquez en France de 1650 à
1830," in *Varia Velazqueña* 1960, vol. 2, pp. 534ff.;
Lipschutz 1988, pp. 138ff.; Jean-Louis Augé,
"Velázquez et la France," in Castres 1999, p. 15;
Louvre 2002, pp. 247–51, repr.

Among the paintings in French public collections
attributed to Velázquez, this portrait of Infanta
Margarita has probably been the best known and
most praised. Although Carl Justi thought that
Velázquez was lending a hand to Mazo in this paint-
ing, and Manuel Manrique de Lara doubted its
authenticity in 1921,[1] until 1963 it was considered an
autograph work in the critical catalogues and mono-
graphs published about the artist. That year, in his
catalogue raisonné, José López-Rey called attention
to the apparent difference between the age of the
face and that of the body and to the many problems
of pictorial construction in the picture.[2] Since then,
it has generally been considered a workshop piece.

This is one of many royal portraits by Velázquez
and his workshop painted during the 1650s to be sent
to various European courts. These works were cre-
ated within the context of the matrimonial politics
that so preoccupied the Spanish royal family at that
time. In 1654 the present painting was sent to
France, where it was hung in the Cabinet des Bains
in the Palais du Louvre. It remained there, one of a
gallery of twenty-four portraits of Habsburgs, until
at least 1709.

Several factors account for the great popularity
of this painting in nineteenth-century France. In the
first place, its high quality accurately reflects
Velázquez's style during his last decade, when his

brushwork reached a peak of looseness and brilliance. But the success of the painting was also due to the attractive way in which this model of childlike grace is presented. No other artist or school in the history of European painting had been able to achieve such a unique mix of lovely color, magisterial execution, and delightful choice of subject. As a result, throughout the nineteenth century, Velázquez's portraits of infantas and princesses constituted a fundamental pillar of his critical fortunes as a creator of iconic images.

Many references testify to the popularity of this painting in France among historians and critics, novelists and artists of the nineteenth century. Renoir referred to the infanta's pink sash when he said, "All of painting is in it."[4] He painted a homage to this portrait in his famous *La Loge* (1874, Courtauld Institute Galleries, London) and undoubtedly recalled the *Infanta* when he portrayed Romaine Lacaux (cat. 194).[5] Many others were seduced by its attractions. Prosper Mérimée tried to copy it in 1831 but declared himself incapable of finishing the task because of the chromatic complexity of the painting.[6] Like him, many professionals and amateurs planted their easels before this work. According to William Stirling-Maxwell, it was "one of the most popular pictures in the gallery, and a bone of contention for the copyist."[7] Among the most important of the copyists were Manet and Degas, and Millet, Sargent, and Jean-Jacques Henner (cat. 126) were only a few of those who were inspired by it. The attraction of its palette to the nineteenth-century public was underlined by Lucien Solvay, who referred to "its adorable symphony of blacks, blonds, and pinks" and to its refinement, which many contemporary artists tried to achieve but could not surpass.[8]

But the critical impact of the *Infanta Margarita* was not felt only by art historians and artists. It also influenced literature, as in Victor Hugo's *La rose de l'infante* (1870), which takes this painting as its point of reference and re-creates the canvas in each of its details.[9]

These qualities brought the *Infanta Margarita* to the Salon Carré of the Musée du Louvre, where the masterpieces of the collection were shown. There, according to the exaggerated enthusiasm of Teodor de Wyzewa, the rest of the paintings paled in comparison.[10]

In a way, the critical fortunes of this work are comparable to those of the *Dwarf with a Mastiff* in the Prado (cat. 80). Both were immensely popular during the nineteenth century (though the former was more so); both were frequently reproduced in monographs about Velázquez and in studies of Spanish painting; and both were attributed to Velázquez until well into the twentieth century. The two share not only a history of appreciation but also certain formal and stylistic qualities that made Velázquez one of the most admired artists by the public and the painters of the second half of the nineteenth century as well.

JPP

1. Justi 1888 (1999 ed.), pp. 611–12; Manrique de Lara 1921, pp. 195ff.
2. López-Rey 1963, no. 398.

3. Baticle in *Varia Velazqueña* 1960, vol. 2, pp. 534ff.
4. "Toute la peinture est là dedans." Quoted in García Felguera 1991, p. 143.
5. Ibid.
6. Lipschutz 1988, pp. 138–39.
7. Stirling-Maxwell 1855 (1999 ed.), p. 278.
8. "son adorable symphonie de noirs, de blonds et de rose." Solvay 1887, p. 186.
9. Lipschutz 1988, p. 104.
10. Wyzewa 1891, p. 64.

79. *Fig. 2.18*

Workshop of Diego Rodríguez de Silva y Velázquez
Gathering of Gentlemen

Oil on canvas
18⅝ x 30⅝ in. (47.2 x 77.9 cm)
Musée du Louvre, Paris 943

CATALOGUES RAISONNÉS: Curtis 1883, no. 25; Mayer 1936, no. 145; López-Rey 1963, no. 135

PROVENANCE: Infante Don Gabriel de Borbón, 1752–88; given by him to the duchess of Alba; sold upon the death of the duchess, Madrid, 1802; acquired by the marquis de Forbin-Janson, Paris, 1827; his sale, Paris, May 2–4, 1842, bought in; his sale, Paris, June 12–13, 1849, bought by Ferdinand Laneuville; sold by him to the Musée du Louvre, Paris, 1851

EXHIBITION: Montauban 1942, no. 29 (as "school of Velázquez")

REFERENCES
19th century: Stirling-Maxwell 1855 (1999 ed.), p. 383; Viardot 1860b, p. 97; Blanc et al. 1869 (Velázquez issue), n.p.; Villot 1872, p. 342; Justi 1888 (1999 ed.), pp. 490–92

20th–21st century (selected references): Gensel 1905, p. 70; Beruete 1906, p. 61; Geffroy 192?, repr. p. 140; Hautecoeur 1926, p. 166; Jeannine Baticle, "Recherches sur la connaissance de Velázquez en France de 1650 à 1830," in *Varia Velazqueña* 1960, vol. 2, p. 550; Louvre, 2002, pp. 185–87 (as *Réunion de quatorze personnages*, attributed to Mazo)

An extraordinary number of Spanish paintings circulated in France during the nineteenth century, but few were autograph works by Velázquez. His oeuvre was small, and the fact that most of his paintings were executed for the king restricted their

dissemination outside Spain. In France most of the paintings attributed to Velázquez were painted by his pupils or members of his workshop, so that his work was known primarily at second hand. Nevertheless, those few paintings came to exercise considerable influence on the critics and artists of the time.

The most important example of such works is this *Gathering of Gentlemen*, which has belonged to the Louvre since 1851. From the time it entered the museum, the painting was often reproduced and studied. The year after it was acquired, it appeared in a wood engraving in the *Art Journal* and in Charles Blanc's *Histoire des peintres de toutes les écoles* (1869). From then on it was usually found in monographs about Velázquez and books about Spanish painting in general. A significant moment in its critical history occurred when Manet copied it onto canvas and made an etching of it about 1860 (cats. 129, 164).[1] The painting conformed to the image of Velázquez's art that Manet had formed before his trip to Spain in 1865, and it fascinated and exercised a strong influence on him. Curiously, his etching was reproduced in Renoir's *Still Life with Bouquet* (fig. 14.72), which offers a triple homage to Manet, Velázquez, and Japanese art.[2]

The painting pleased because of its intrinsic artistic qualities and its direct and forthright formula for approaching reality. However, it was also interesting because it fit the expectations of artists and the general public, who were fond of historical anecdotes; moreover, it reflected the image of the Madrid court that was spreading throughout Europe. The possibility was even suggested that it represented a "meeting of artists," an interpretation that made the narrative element of the painting even more attractive, with Velázquez identified as the figure at the far left and Murillo as the man peering at him.[3]

The viewers who most admired this painting were those who had not seen original works by Velázquez. On the other hand, those who had been to Madrid and who knew the Prado, such as the author Louis Viardot, were keenly aware that its quality did not compare well with that of the painter's masterpieces.[4] Manet himself realized this when he traveled to Spain. Nevertheless, for nearly the entire second half of the nineteenth century, Velázquez specialists considered it an autograph work, and the first doubts about it were not expressed until Aureliano de Beruete's 1898 monograph. Its weak drawing and technique suggested that Mazo might have been responsible for it. Although some writers of that period, such as Walther Gensel and Gustave Geffroy, did not exclude it from the catalogue of Velázquez's works, Beruete's opinion has been generally accepted.

The painting can be easily connected with various large paintings and some fragments of paintings created during the 1630s and 1640s. Some of these, such as *Philip IV Hunting Wild Boar* (*La Tela Real*) (ca. 1632–37, National Gallery, London), are generally attributed to Velázquez, while others are the work of Mazo. Among the latter are various compositions describing the entrance of Philip IV into Pamplona; *The Stag Hunt at Aranjuez* (ca. 1640, Museo del Prado, Madrid), which Mazo inventoried

as his own work in 1666; and the magnificent *View of Saragossa* (1646–47, Museo del Prado, Madrid). In the foreground of the latter are a varied collection of figural types posed along the shores of the Ebro River. The *Gathering of Gentlemen* is very probably a fragment of a much larger, panoramic picture on a subject related to the public life of the Spanish court.[5] Distributed in several groups, some of them are placed in space in a manner similar to those in the Prado painting. Manet also saw these similarities when he visited the Prado in 1865 and recalled the Louvre's *Gathering of Gentlemen*: "Here there is an enormous picture filled with little figures like those in the Louvre's picture titled the cavaliers, but figures of women and men perhaps superior and, above all, perfectly free of restoration. The background, the landscape, is by a student of Vélasquez."[6]

JPP

1. Fantin-Latour said that Whistler also made a copy of this painting. See Crombie 1963, p. 128.
2. See London 1971, no. 212.
3. These identifications are echoed in Curtis 1883, no. 25.
4. Viardot 1860b, pp. 97–98. Of all the supposed works by Velázquez in the Louvre, Viardot admired only the *Infanta Margarita* (cat. 78).
5. A recent restoration revealed a fragment of another figure in the right border of the painting.
6. "Il y a ici un tableau énorme rempli de petit[e]s figures comme celles qui se trouvent dans le tableau du Louvre intitulé les cavaliers, mais figures de femmes et d'hommes, supérieures peut-être et surtout parfaitement pures de restauration. Le fond, le paysage est d'un élève de Vélasquez." Manet 1988, p. 43.

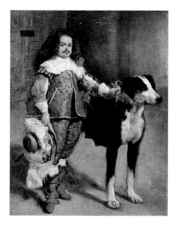

80. *(New York only)* *Fig. 12.3*

Imitator of Diego Rodríguez de Silva y Velázquez

Dwarf with a Mastiff

Ca. 1640
Oil on canvas
55⅞ x 42⅛ in. (142 x 107 cm)
Museo Nacional del Prado, Madrid P 1203

CATALOGUES RAISONNÉS: Curtis 1883, no. 73; Mayer 1936, no. 454; López-Rey 1963, no. 437

PROVENANCE: Palacio Real Nuevo, Madrid, 1772 and 1794; Museo del Prado, Madrid, 1819

EXHIBITIONS: Geneva 1939, no. 109; Buenos Aires 1980, p. 72; Tokyo 1980, no. 15; Belgrade 1981; Madrid 1986, no. 29; Geneva 1989, no. 37; Sofia 1989, no. 27; Mexico City 1991; Rome 1991–92, no. 19; Madrid 1994c, no. 25; Bologna 1998, no. 69; Rio de Janeiro 2000, p. 214

REFERENCES

19th century: P. Madrazo 1872, no. 1097; Cruzada Villaamil 1885, no. 186; Lefort 1888, pp. 77–78; Beruete 1898, p. 93

20th century (selected references): Mayer 1924, p. 454; Allende-Salazar 1925, p. 285; Moreno Villa 1939, p. 85; Lafuente Ferrari 1944, pp. 46–50; Trapier 1948, p. 226; López-Rey 1950; Gerstenberg 1957, p. 207; Pérez Sánchez 1985, pp. 81–82; García Felguera 1991, p. 147; Mallory 1991b, p. 267; Carol M. Osborne, "Yankee Painters at the Prado," in New York 1993a, pp. 74, 77; Carmen Bernis, "La moda en los retratos de Velázquez," in Portús Pérez 1994b, pp. 292–93

The growing critical and historiographical interest in Velázquez since the nineteenth century has resulted in a radical reduction in the number of works attributed to him. A good example of this process is afforded by the collection of his works in the Museo del Prado: the 1843 catalogue attributes sixty-one paintings to Velázquez, of which more than fifteen are now considered shop works or paintings by other artists. Among these is the present work, described as a "full-length portrait of a dwarf . . . holding the collar of a handsome mastiff at his side."[1] Of the works no longer attributed to Velázquez, this painting has had one of the most interesting critical fortunes, for it not only reflects the great differences among scholars but also helps to clarify the various opinions about Velázquez's work held at different times.

During the nineteenth century, this painting interested not only critics and historians but important painters as well. It was copied by various artists who spent time in the Prado, including Lizzie Boott, Annie Dixwell, and Sargent, who hung his version (cat. 213) on a wall of his studio.[2] It also inspired French painters such as Thomas Couture, whose *Dwarf with Dog* (Musée Goya, Castres) refers to this kind of painting.

Until the early decades of the twentieth century, historians, with the sole exception of Juan Allende-Salazar, considered this painting an autograph work by Velázquez, of the same quality as the rest of his paintings of court jesters. It is thus one of the paintings that was most often reproduced in monographs about the artist, as well as in general histories of Spanish painting. Appearing in books by Gregorio Cruzada Villaamil (1885), Lucien Solvay (1887), Paul Lefort (1893), Edwin Stowe (1894), Walter Armstrong (1896), Hermann Knackfuss (1896), Aureliano de Beruete (1898), Walther Gensel (1905), and many others, it became quite a popular picture.

In 1925 Allende-Salazar called attention to the significant differences in spatial construction and

pictorial treatment between this work and the other jesters by Velázquez.[3] He proposed as the painter Juan Carreño de Miranda, who was court portraitist following Velázquez's death and whose style has certain similarities with that of the older master. Recently, Alfonso E. Pérez Sánchez has again suggested Carreño, on the basis of both the style of the painting and the fashion of the costume worn by the figure.[4] In 1957 Kurt Gerstenberg thought the work might be by Mazo.[5] José López-Rey rejected both possibilities, alleging that the presence of numerous awkward passages in the work was not usual for those skilled painters and suggesting instead that the work was by a mediocre imitator.[6]

The painting itself offers certain information that helps to place it in an exact chronological and artistic context; this includes the identity of the figure, the style of his dress, and the identity of the dog that accompanies him. In 1872 Pedro de Madrazo, in the Prado catalogue, identified the figure as the jester Don Antonio, known as El Inglés (The Englishman). The work was given that title until 1939, when José Moreno Villa pointed out that Don Antonio, who was given to Philip III by the duke of Windsor, died in 1617 and thus could not be the subject of the painting. However, Moreno Villa thought that the face of the model indicated a foreign origin, and he theorized that the subject might be the Fleming Nicholas Hodson or the Italian Antonio Mascareli.[7] Both men were documented at the Spanish court after Velázquez's death, which would require that an artist other than Velázquez be sought, as Allende-Salazar had done in suggesting Carreño. Nevertheless, Carmen Bernis has called attention to the fact that the figure is dressed in the French style that marked the reign of Louis XIII, which ended in 1643.[8]

Another fact argues for dating the work to approximately the late 1630s or early 1640s. This is the presence of the same dog in a painting by Mazo entitled *The Stag Hunt at Aranjuez* (ca. 1640, Museo del Prado, Madrid), which can be dated to that period. In the Mazo work the dog appears at the right, next to another dwarf, and, curiously, only the front part of its body—that is, exactly what one sees in the *Dwarf with a Mastiff*—is visible. This servile dependence, as well as the style of the costume, implies that the present work was executed by an imitator of Velázquez in about 1640.

Although visually attractive, the *Dwarf with a Mastiff* has its limitations, as López-Rey indicated. The space is inconsistent, and the figures are unconvincingly placed within it; the shadows are formulaic; and many details, such as the transition between the animal's collar and the dwarf's hand, are poorly accomplished. The freedom of brushwork that, in Velázquez's hands, translates into structural solidity and visual credibility is here converted into a mere amalgam of color. The popularity of the painting was probably due to its flashy overall impact and the fact that it carries to extreme, and even caricature, the freedom of brushwork then considered the principal hallmark of the painter from Seville.

JPP

1. P. Madrazo 1843, p. 58.

2. For the Dixwell copy, see Osborne in New York 1993a, p. 74. The Sargent copy can be seen in a photograph that shows the artist in his studio. See García Felguera 1991, p. 147.

3. Allende-Salazar 1925, p. 285.

4. Pérez Sánchez 1985, pp. 81–82.

5. Gerstenberg 1957, p. 207. The attribution to Mazo has recently been proposed as well in Mallory 1991b, p. 267.

6. López-Rey 1950.

7. Moreno Villa 1939, p. 85.

8. Bernis in Portús Pérez 1994b, pp. 292–93.

81. *Fig. 9.48*

Formerly Diego Rodríguez de Silva y Velázquez, now Italian, 17th century
Dead Soldier

Oil on canvas
41¼ x 65 ¾ in. (104.8 x 167 cm)
The National Gallery, London NG741

PROVENANCE: In Sweden and Berlin, where it was purchased from a Mr. Andriel, before 1818; offered to the Musée du Louvre by Mme Desmoland, 1818; Paris, anonymous sale [Duparc de la Rue and Veuve Laforest], August 20, 1821, as by Velázquez; M. de Saint-Rémy sale, Paris, 1841; cited in the Pourtalès-Gorgier collection, Paris, 1841; Pourtalès-Gorgier sale, Paris, March 27, 1865, no. 205, bought by The National Gallery, London

REFERENCES
19th century: Mantz 1865, pp. 98–99; Sanjuanena y Nadal 1866; Curtis 1883, no. 26; Justi 1888 (1999 ed.), pp. 472–73

20th century (selected references): Beruete 1906, pp. 11–12; Orozco Díaz 1949; Jeannine Baticle, "Recherches sur la connaissance de Velázquez en France de 1650 à 1830," in *Varia Velazqueña* 1960, vol. 2, p. 550; Zampetti 1967, pp. 13–14; Levey 1971, pp. 148–49; E. Young 1976; Caturla 1982, pp. 28–29

A good portion of the works attributed to Velázquez in the nineteenth century are today considered to be by his workshop or circle; others of these paintings have encountered serious doubts regarding their provenance. One of these is the *Dead Soldier*, a painting with a troubled, still unresolved history. Nothing was known about it until 1818, when a Mme Desmoland offered it to the Louvre. The museum subsequently learned that the painting was not by an artist of the Spanish school and that it had been in Sweden and in Berlin, where it was purchased from a Mr. Andriel. In 1821 it appeared at the Duparc sale in Paris as a work by Velázquez. Twenty years later

it entered the Pourtalès-Gorgier collection, one of the most important in Paris, and in 1865 it was purchased by the National Gallery in London.[1]

The composition of the work, showing the body of a soldier arranged horizontally on the ground, is impressive. Next to the body are a skull and two bones, which make this discourse about death even more explicit. On the body, an oil lamp without a flame offers a clear and simple symbol of an extinguished life. The theme of the painting can easily be related to the long tradition of Vanitas paintings, images meant to encourage reflection on death and the brevity of life, although this subject is quite different from the iconography common in seventeenth-century European art.[2]

Because of its presence in the Pourtalès-Gorgier collection and the National Gallery, the painting has drawn the attention of many writers. Of course, its unusual composition and its subject have also accounted for some of the attention. For decades, it was taken as a certainty that the painting was by Velázquez. Both William Stirling-Maxwell and Charles Blanc attributed it to the master. So did Paul Mantz, who published a four-part series of articles about the Pourtalès-Gorgier collection in the *Gazette des Beaux-Arts* (1864–65). These contain much interesting information as well as an etching by François Flameng after the painting that figured prominently in spreading its fame.[3]

However, greater acquaintance with the painting began to raise doubts concerning its style in comparison with what was expected in works by Velázquez. In 1866 Ramón Sanjuanena seriously questioned the attribution.[4] In 1883 Charles Curtis wrote in his monograph that although he considered the painting an admirable work, he doubted its attribution to Velázquez.[5] A few years later, Carl Justi (who reported having seen an eighteenth-century print after the painting, which he reproduced) considered it a work close to the Neapolitan school.[6] Aureliano de Beruete also did not think it was painted by a Spanish artist.[7] These opinions, which came to be accepted, were expressed even as other critics and historians still held to the old attribution. Among them was Gustave Geffroy, who at the beginning of the twentieth century referred to "that quality of white, cold flesh in the somber air of the sepulchre—this is the secret of the genius of the painter."[8]

Since then various scholars have tried to find an artist for the painting who was active in Velázquez's circle. In 1949 Emilio Orozco Díaz, in an article that unequivocally framed the subject of the painting within the Baroque taste for the Vanitas, proposed its attribution to José Antolínez (1635–1675). Some years later, Eric Young saw a stylistic relationship between the painting and a series of works that he related to the anonymous painter of *The Knife Grinder* in the State Hermitage Museum, St. Petersburg.[9] María Luisa Caturla, who attributed *The Knife Grinder* to the Galician artist Antonio de Puga (by whom there are few surely attributed works), attributed the *Dead Soldier* to Puga as well.[10]

Other scholars have, nonetheless, preferred to seek the artist among Italian painters of the seventeenth century. Pietro Zampetti thought of Bernardo

Cavallino,[11] which did not convince Michael Levey, who did not find clear stylistic affinities with any other known painter. Levey catalogued the work, with reservations, as seventeenth-century Italian.[12] In any case, this is a singular painting of notable quality, which has always surprised those who have seen it and whose style belongs to the southern European schools of the seventeenth century. Among the artists impressed by it were Gérôme and, above all, Manet, who made a print after it and was inspired by it for his *Dead Toreador* (cat. 141).

Like other paintings no longer attributed to Velázquez, the *Dead Soldier* is of interest in that it projects the image the nineteenth century had of this artist and of the Spanish school in general, an image that can be compared with the one held today. The inclusion of this painting in early catalogues of Velázquez's work probably resulted from its general quality, and particularly from the mastery demonstrated by its taking full advantage of a limited range of colors. But the theme must also have influenced the attribution: it fit perfectly the repertoire of subjects that was being formed around the personality of Spanish Golden Age painting. In its powerful invasion of pictorial space by a corpse, for instance, this painting finds a parallel in the *Finis Gloriae Mundi* by Juan de Valdés Leal (1671–72, Hospital de la Caridad, Seville).

JPP

1. Baticle in *Varia Velazqueña* 1960, vol. 2, p. 550.

2. Orozco Díaz 1949.

3. Mantz 1865, p. 99.

4. Sanjuanena y Nadal 1866, pp. 49–53.

5. Curtis 1883, no. 26.

6. Justi 1888 (1999 ed.), pp. 475–76.

7. Beruete 1906, pp. 11–12.

8. "cette qualité de chair blanche et froide dans l'air sombre du sépulchre, voilà le secret du génie du peintre." Geffroy 190?, pp. 143–44.

9. E. Young 1976. The Hermitage now attributes the work to Puga.

10. Caturla 1982, p. 29.

11. Zampetti 1966, pp. 13–14.

12. Levey 1971, pp. 148–49.

82. *(Paris only)* *Fig. 2.17*

Formerly Diego Rodríguez de Silva y Velázquez, now anonymous
Portrait of a Monk

1633
Oil on canvas
36⅜ x 28⅞ in. (92.5 x 73.5 cm)
Inscribed upper left: AET 54 DN [last two letters intertwined]; upper right: *1633*
Musée du Louvre, Paris 942

CATALOGUE RAISONNÉ: Curtis 1883, no. 65

PROVENANCE: Archbishop of Toledo; marquis of Guardia Real, from an undetermined date until 1846; Couturier collection, Paris, 1846; Callery collection, 1849; from the Callery collection to the Musée du Louvre, Paris, 1850

EXHIBITION: Paris 1963b, no. 111, repr.

REFERENCES

19th century: Cottini 1851, pp. 97–98; Villot 1852, no. 556; Villot 1872, p. 341; Both de Tauzia 1883, no. 553; Justi 1888 (1999 ed.), p. 471; Mesonero Romanos 1899, p. 159

20th–21st century (selected references): Manrique de Lara 1921, p. 190; Hautecoeur 1926, p. 126; Louvre 1981, p. 127, repr.; Louvre 2002, pp. 282–83, repr.

The study of works sometimes attributed to Velázquez in the nineteenth century is both interesting and surprising—interesting because it helps to define the parameters of the style considered to be Velázquez's, and surprising because of the variety of forms and styles that were grouped together under the master's name. One such painting is this portrait of a monk, who was identified in the nineteenth century as Pedro Moscoso de Altamira, dean of the Royal Chapel of the Cathedral of Toledo. While the portrait is remarkably lively and immediate, its style is quite linear, far from the art of Velázquez and especially far from his manner of about 1630, when the Louvre had dated it. The early catalogues of the Louvre note the presence of an inscription (*AET 54*) that indicates the model was fifty-four years old when the portrait was painted. The same sources indicate that, at the end of the seventeenth century, the painting was given by the archbishop of Toledo to the marquis of Guardia Real.[1]

Although the catalogues of the Louvre continued to cite the painting as by Velázquez throughout the second half of the nineteenth century, scholars began to express doubts about its attribution. This is no surprise given the many differences in style between this painting and other Velázquez works. William Stirling-Maxwell wrote in 1855 that it was a work of doubtful authenticity.[2] Fourteen years later, Charles Blanc, although he recognized the painting as a work of high quality, did not consider it a Velázquez.[3] Charles Curtis, for his part, affirmed in 1883 that the style of the painting was too "tame" to be Velázquez's. He rejected Carreño de Miranda (who was only nineteen years old in 1633) as the artist and also did not accept the identification of the sitter with any known historical figure.[4] Some years later Carl Justi, in denying the painting was by Velázquez, noted that such attributions were sometimes based solely on the supposedly Spanish features of the model.[5] Since then, the attribution to

Velázquez has been made only sporadically.[6] Some scholars have attempted to name the artist responsible for the work: Paul Lefort, for example, suggested Angelo Nardi, an Italian painter active at the Madrid court.

The painting's arrival in the Louvre in 1850 was met with great interest among artists. As Geneviève Lacambre and Juliet Wilson-Bareau have discovered (see their essays in this volume), between June 30, 1851, and July 8, 1856, the work elicited thirty-seven copy requests. Among those who registered was Manet, although it is not known if he ever executed the copy. JPP

1. Villot 1872, pp. 341–42.
2. Stirling-Maxwell 1855 (1999 ed.), p. 341.
3. Blanc et al. 1869, nos. 68–69 (Velázquez issue), n.p.
4. Curtis 1883, no. 165.
5. Justi 1888 (1999 ed.), p. 471.
6. One such case is Louis Hautecoeur (1926), who identifies it merely as "attributed to."

FRANCISCO DE ZURBARÁN

Fuente de Cantos, Badajoz, 1598–Madrid, 1664

Among the Spanish artists, Zurbarán was one of the most gifted at interpreting naturalism in a personal and interesting way. Although he spent most of his career in Seville, he also worked in other regions of the country, such as Extremadura and Madrid. This fact, along with the production of his prolific workshop, caused his works to be widely disseminated throughout Spain. Most of his paintings are of religious subjects, although he also painted several portraits, some splendid still lifes, a series of mythological themes, and several works on historical subjects. JPP

83. *(New York only)* *Fig. 7.14*
Francisco de Zurbarán
Saint Bonaventure Inspired by an Angel Regarding the Election of the Future Pope Gregory X, also called *Saint Bonaventure Praying*

1629
Oil on canvas
94 x 87 in. (239 x 222 cm)
Gemäldegalerie Alte Meister, Staatliche Kunstsammlungen, Dresden 696

CATALOGUES RAISONNÉS: Posse 1929, pp. 342ff.; Soria 1953, no. 24; Frati 1973, no. 26; Gállego and Gudiol 1977, no. 17

PROVENANCE: Colegio de San Buenaventura, Seville, from 1629; removed by order of Joseph Bonaparte, 1810; on deposit in the Alcázar, no. 70, 1810; returned to the college, 1814; bought by Baron Taylor from Julian B. Williams for the Galerie Espagnole, Musée du Louvre, Paris, January 10, 1836; Galerie Espagnole, 1838–48, nos. 348/358; Louis-Philippe sale, Christie & Manson, London, May 1853, no. 206; bought by Grüner for the Gemäldegalerie, Dresden, 1852

EXHIBITION: Seville 1998, no. 6

SELECTED REFERENCES: Gaya Nuño 1948, no. 19; Guinard 1960, no. 379; Torres Martín 1963, no. 33; Baticle and Marinas 1981, no. 358; New York–Paris 1987–88, pp. 80–93; Caturla 1994, pp. 65–71

The religious fervor and austere, somber character of Spanish art, already noted when it was exhibited at the Galerie Espagnole, did not accord with the smooth forms and graceful subjects preferred since the eighteenth century by the Gemäldegalerie in Dresden. However, a new political and intellectual climate and pride over having acquired a valuable share of the Galerie Espagnole paintings led to the works being prominently displayed in the 1850s (see Appendix B in this publication). As late as about 1900, photographs and paintings still show the present work exhibited in a central location, as one of the first pictures visitors would encounter (fig. 13.2).

From 1838 to 1848 the *Saint Bonaventure* had been a highlight of the much-acclaimed group of Zurbarán paintings at the Galerie Espagnole. The work belongs to a series of eight canvases—four by Herrera the Elder, four by Zurbarán—portraying subjects from the saint's life that were commissioned from the Colegio de San Buenaventura in Seville. After the defeat of Napoleon this particular canvas was returned to its original site, but the other three by Zurbarán were taken by Marshal Soult (see Ignacio Cano Rivero's essay in this publication). Two of these are now in the Louvre; the third, signed and dated 1629, is one of the large-scale paintings that has been missing from Berlin's Gemäldegalerie since 1945 and believed to have been destroyed during the war.

The series is probably the most important to exist on the life of this great thirteenth-century Franciscan theologian. Executed at a peak early in the artist's career, the four works—and particularly the Berlin and Dresden pictures—are among the best that Zurbarán ever painted. The sobriety of the Dresden image and its theatrical mise-en-scène follow a scheme dear to the artist. The large figures in the foreground are brought close to the picture plane and arranged in front of a simple black architectonic screen. As in the prints of the Flemish

engraver Philips Galle, to whom Zurbarán owes so much, the buildings in the background resemble a stage set more than real architecture, and the sequence of planes in which the saint, the three lay spectators,[1] and the group of cardinals act is far from logical. Yet, all the deficiencies of design and foreshortening are overcome by the powerful, almost classical image of the kneeling saint, by the delicacy of the heavenly messenger, by the smoothness of the surfaces, and above all by the concentration on a few limited colors. Restored in 1991–92 by Gerthilde Sacher, these powerful accents still enhance the almost abstract qualities of Zurbarán's design, which make his oeuvre so attractive to a contemporary audience.[2]

Like most of the Galerie Espagnole paintings in Dresden (see Appendix B), the present work has a French inscription on its stretcher. In this case it contains the notation "N° 155 = S' François [?] h[auteur] 2 ᵐ 38 L[argeur] 2 ᵐ 22 ="[3] as well as a few "B" stencils, the Louvre number (385) in white chalk and in black paint, and the number in the first edition of the Galerie Espagnole catalogue ("348"). The relining canvases are sewn together and coated with thick paint, as is customary. On the back of the canvas are the lot number "2-206" and, also in white chalk, a repetition of the Louvre number. Despite these markings, it is clear that the stretcher was tampered with in Dresden: the Louvre numbers were repainted there (probably by someone who mistook them for Dresden ones) in a way familiar from Dresden paintings that do not come from the Galerie Espagnole. MW

1. Their faces are the only important feature of the painting that is in very poor condition.
2. Paradoxically, the design is at the same time weaker and much more impressive than in the print that has been identified as a prototype by Martin Soria (1953, no. 24).
3. While the receipt by Julian B. Williams quotes the painting as a "San Buenaventura de Zurbarran" (Archives Nationales, Paris, dossier o⁴ 1725), the Galerie Espagnole catalogue (Paris 1838, no. 348) describes it as a "Saint François en méditation."

84. *(New York only)* *Fig. 14.31*

Francisco de Zurbarán

Saint Casilda

1630–35
Oil on canvas
67⅛ x 42⅛ in. (171 x 107 cm)
Museo Thyssen-Bornemisza, Madrid 1979.26

CATALOGUES RAISONNÉS: Soria 1953, no. 179; Frati 1973, no. 349; Gállego and Gudiol 1977, no. 445 (as *Saint Elizabeth of Portugal*)

PROVENANCE: Taken from Seville to Paris by Marshal Soult; Soult sale, Paris, May 19, 21, 22, 1852, no. 35, bought for 3,200 francs by Comte Duchatel, Paris; Ehrich Galleries, New York, before 1913; William Van Horne, Montreal, 1913; Baron Thyssen-Bornemisza, 1978

EXHIBITIONS: Montreal 1933, no. 23; Paris 1982, no. 59; New York–Paris 1987–88, no. 45

SELECTED REFERENCES: Kehrer 1918, p. 147; Soria 1944, pp. 130–31; Guinard 1960, no. 260; J. Brown 1974, p. 163; Caturla 1994, p. 188

The identity of this figure has been much debated, because there are two saints traditionally depicted in this way: Saint Casilda and Saint Elizabeth of Portugal, both of whom hold baskets of flowers in the folds of their skirts. Both were highborn ladies who performed charitable works in secret. When they were discovered, the food or alms they carried hidden in their skirts were transformed into flowers, permitting them to escape punishment and so to continue their good works. Zurbarán represented this type with great frequency and success, for it allowed him to sumptuously display the folds of the garment and to add an attractive floral detail as well.

This kind of legend, extremely popular in sixteenth- and seventeenth-century Spain, sometimes had masculine protagonists, such as the Franciscan Diego de Alcalá, one of the best-loved saints of that period, who was also painted by Zurbarán. Arguing for the possibility that the present work represents Elizabeth of Portugal rather than Casilda is the fact that there was less devotion to the latter and it was largely confined to Burgos and the surrounding region.[1]

Whatever its specific subject, the image not only stimulated charity on the part of the viewer but also offered many plastic possibilities to the artist, as Zurbarán demonstrates here, in one of his finest representations of single figures of saints. She is solidly planted in space through Zurbarán's skillful modeling of the forms via the use of direct light, which also serves to emphasize the rich quality and texture of the fabrics. The young woman's gently questioning gaze and the delicate gesture with which she holds the basket serve to emphasize the charm of the image.

Some of these paintings involve an expressive play on the strong relationship between religion and daily life felt at the time. These *retratos a lo divino* use sacred iconography to "disguise" a portrait. Their frequent mention in literary works, especially poetry, demonstrate that the practice was a relatively common one.[2] Some of Zurbarán's saints, such as the *Saint Elizabeth of Portugal* in the Prado, belong to this type, which is distinguished by strongly individualized features. In others, like the present example,

it is more difficult to detect signs of a particular face, for the features are both delicate and stereotyped.

These images have been favorites of the public from the time they were painted up to the present day. Nevertheless, the enthusiastic response has occasionally been muted, and the same arguments raised against them during the sixteenth and seventeenth centuries were brought up again in the 1800s. The main problem had to do with decorum: various writers protested against this kind of image, arguing that the richness of the clothing and the detailed painting technique captured the whole attention of the viewer and conflicted with the required "modesty" that ought to govern sacred images.[3] An article published in *Le Charivari* in January 1838 also called negative attention to the worldly nature of these works, using arguments similar to those of the theologians of the Baroque era: "As for the female saints, since he is unlikely to have had an entry into convents of women, he was forced to choose his models in the Prado, at the theater, and in the amphitheater. This is what gives Zurbaran's holy women such a strangely wordly air; we know of nothing more provocative and less evangelic than their figures curved like a drawn bow, their extravagant hips, their winding arms, their eyes that look behind them to see if they are being followed. These are out-and-out Spanish women, very charming, very alluring; if they really dwell in Paradise, it is our belief that the blessed are subjected to severer temptations than men [on earth]. . . . Zurbaran gives the impression of being a rank libertine."[4] Nevertheless, for Delacroix, who saw the works in Soult's collection in 1824, they were "beautiful and mystical figures of women" who served as inspiration for the angels in his *Agony in the Garden* (fig. 1.29).[5] JPP

1. Regarding the differing opinions on the identity of the subject of this painting, see New York–Paris 1987–88, no. 45.
2. The subject is studied in depth in Orozco Díaz 1977.
3. See Ceballos 1989.
4. "Quant aux saintes, comme il n'est pas probable qu'il eut ses entrées dans les couvents des femmes, il était bien forcé de choisir ses originaux au Prado, au théatre, à l'amphithéâtre. C'est ce qui fait que les bienheureuses de Zurbaran ont un air si étrangement mondain; nous ne connaissons rien de plus agaçant et de moins évangelique que leurs tailles cambrées comme un arc tendu, leurs hanches démesurées, leurs bras que se tordent, leurs yeux qui regardent derrière elles pour voir si personne ne les suit. Ce sont de franches espagnoles, très charmantes et très appétissantes; si elles habitaient réellement le paradis, nos croyons que les bienheureux sont soumis à de plus rudes tentations que les hommes. . . . Zurbaran fait l'effet d'un fieffé libertin." Anon. 1838f, cited in Lipschutz 1988, p. 233.
5. "belles et mystiques figures de femmes." Delacroix 1960, vol. 1, p. 91: May 3, 1824.

85. *Fig. 2.13*

Francisco de Zurbarán

Saint Francis in Meditation

Ca. 1635–40
Oil on canvas
60 x 39 in. (152 x 99 cm)
The National Gallery, London NG230

CATALOGUES RAISONNÉS: Soria 1953, no. 166;
Frati 1973, no. 169; Gállego and Gudiol 1977, no. 258

PROVENANCE: Louis-Philippe, king of France,
1837–53 (Galerie Espagnole, Musée du Louvre,
Paris, 1838–48, nos. 346/356); his sale, Christie &
Manson, London, May 6, 1853, no. 50, bought for
265 pounds by Uwins for The National Gallery,
London

EXHIBITIONS: London 1981, no. 33; New York–
Paris 1987–88, no. 53; Madrid 1988c, no. 103

REFERENCES
19th century: L'Artiste 16 (1837), p. 368, repr.; Anon.
1838c, p. 66; Stirling-Maxwell 1848, vol. 2, p. 775
[1891 ed., vol. 3, p. 927]; Ford 1853, pp. 593–94;
London Times (May 10, 1853), p. 8; ibid. (May 12,
1853), p. 3; ibid. (July 9, 1853), p. 8; Gueullette 1863,
pp. 38–39; Blanc et al. 1869 (Zurbarán issue), n.p.

20th century (selected references): Guinard 1960,
no. 354; MacLaren 1970, pp. 137–38; Baticle and
Marinas 1981, no. 356; Caturla 1994, p. 225

One of Zurbarán's masterpieces on Franciscan
themes, this painting depicts Saint Francis kneeling
at a perfect right angle, with his joined hands hold-
ing a skull. His imploring gaze is directed toward
heaven, his mouth half open, and his face partially
hidden by the cowl of his habit. The saint is placed
in a bare corner of a cell, removed from ambient
distractions, so that the viewer can concentrate
exclusively on his body and expression, which are
treated with the same descriptive deliberateness and
compositional rigor as any of the artist's still lifes.
Zurbarán uses a very direct light, ultimately derived
from tenebrism, as a principal instrument for the
definition of space and volume.

As in many of his other works, Zurbarán
shows here his ability to play with a narrow range
of colors, extracting all their potential. A sym-
phony of browns and grays is handled with such
mastery and subtlety that an authentic sensation of
volume and reality is created. As in his still-life
paintings, there is an illusionistic will that aspires
to provoke in the unsuspecting viewer a confusion
between image and reality.

This is a typically devotional painting, suitable
for an intimate space, in which the values of history
painting have been replaced by those of expression.

Light and composition are employed not to unveil
narrative elements but to describe surfaces with a
strong emotive value: the interlaced fingers, the anx-
ious expression of the mouth, and the coarse texture
of the habit. The painting tells us nothing, not even
a story from the life of the saint. It simply transmits
a profoundly devotional attitude in a truthful and
sincere manner. In this sense, it is directly bound to
the Catholic Church's interest, following the Coun-
cil of Trent, in intensifying the use of images by
heightening their emotive value.

The early provenance of the painting remains
unknown. Although its formal characteristics suit it
to either a public or a private context, no documents
concerning its commission or early locations have
appeared. Its style and affinity with other works of
the period suggest a date of about 1635 to 1640, the
period of Zurbarán's full maturity as a painter.

In 1837 this painting already belonged to Louis-
Philippe of Orléans, and between 1838 and 1848 it
was in his Galerie Espagnole at the Louvre.
Although that exhibition included about eighty
paintings by Zurbarán, none was as famous as this
one, which propelled the hitherto unknown painter
into a leading position among the masters of the
Spanish school. For decades, this was the image
most closely associated with the artist's memory, to
the point that, as Francis Haskell has noted, the
image of the artist himself was somewhat distorted.[1]
The fame of the painting was spread through prints
such as the splendid etching by Alphonse Masson,
published in Charles Blanc's *Histoire des peintres de
toutes les écoles. École espagnole* (1869), that served as
a model for its illustration in a number of important
publications about Spanish painting, including the
monograph by Lucien Solvay (1887).

It was rare for a European writing about the
Galerie Espagnole, about Zurbarán, or even about
Spanish painting in general not to mention this
painting, and the mentions were almost always in
the most laudatory terms. In 1853, when the possi-
bility arose of acquiring the painting for the
National Gallery in London, a brief argument about
whether to do so occurred in the *Times*. Some
British voices most knowledgeable about Spanish
painting favored the purchase, among them Richard
Ford.[2] In general, admiration of *Saint Francis in
Meditation* during the nineteenth century was
unconditional, although some judgments were
projected onto the work from an other than purely
art-historical point of view. Two examples from
England and France reflect the kind of commentary
that the painting elicited. In 1848 William Stirling-
Maxwell wrote: "Of his gloomy monastic studies,
that in the Louvre of a kneeling Franciscan holding
a skull, is one of the ablest; the face dimly seen
beneath the brown hood, is turned to heaven; no
trace of earthly expression is left on its pale features,
but the wild eyes seem fixed on some dismal vision;
and a single glance at the canvas imprints the figure
on the memory for ever."[3] Twenty-one years later,
the French critic Charles Blanc repeated similar
opinions, in an equally literary tone. When the
Galerie Espagnole was opened, he wrote, what
attracted attention was not Murillo or Velázquez, "it
was a certain *Monk in Prayer* by Zurbaran, one of

those paintings that, once seen, is impossible to for-
get. On his knees, in his gray woolen habit torn here
and there and patched, his face lost in the shadow of
his hood, a monk implores the mercy of the
Christian God, a God gentle and fierce. In his pale,
emaciated hands he holds a skull, and with his eyes
raised to heaven, he seems to be saying: 'De pro-
fundis clamavi ad te, Domine, Domine [Out of the
depths I have cried to thee, O Lord, Lord].' . . . All
of Spain is epitomized in this passionate, devout,
and somber painting, at once mystical and harsh."[4]

This work also had an impact on contemporary
painters such as Manet, who used it as the inspira-
tion for his *Monk at Prayer* (cat. 143).

JPP

1. Haskell 1976, p. 163.

2. See García Felguera 1991.

3. Stirling-Maxwell 1848, vol. 2, p. 775.

4. "ce fut un certain *Moine en prière* de Zurbaran, une de ces
peintures qu'il n'est pas possible d'oublier, ne les eut-on
vues qu'une fois. A genoux, sous sa robe de laine grise
déchirée çà et là et rapiécée, le visage perdu dans l'ombre de
son capuchon, un moine implore la miséricorde du Dieu des
chrétiens, du Dieu doux et terrible. De ses mains pâles et
décharnées il tient une tête de mort, et les yeux levés au ciel,
il semble dire: 'de profundis clamavi ad te, Domine,
Domine.' . . . L'Espagne toute entière était résumées dans
cette peinture passionnée, dévote et sombre, mystique et
brutale toute ensemble." Blanc et al. 1869, no. 122
(Zurbarán issue), n.p.

86. *Fig. 2.22*

Francisco de Zurbarán
Saint Lucy

Ca. 1636
Oil on canvas
45¼ x 26¼ in. (115 x 68 cm)
Musée des Beaux-Arts, Chartres 3807

CATALOGUES RAISONNÉS: Soria 1953, no. 120;
Frati 1973, no. 182; Gállego and Gudiol 1977, no. 244

PROVENANCE: Main altarpiece of the monastery of
the Merced Descalza, Seville; Alcázar, Seville, 1810,
no. 321; Marshal Soult, Paris; Soult sale, Paris,
May 19, 21, 22, 1852, no. 31, bought for 485 francs

by Camille Marcille; Camille Marcille, Paris, 1852–76; Marcille sale, Hôtel Drouot, Paris, March 6–9, 1876, bought for 510 francs by the Musée des Beaux-Arts, Chartres

EXHIBITIONS: Paris 1925, no. 120; Granada 1953, no. 53; Bordeaux 1955, no. 76; Paris 1963b, no. 96; Madrid 1981b, no. 9; New York–Paris 1987–88, no. 22; Madrid 1988c, no. 31

REFERENCES
18th–19th century: Ponz 1776–94 (1947 ed.), vol. 9, p. 790; Blanc et al. 1869 (Zurbarán issue), n.p.

20th century (selected references): Kehrer 1918, p. 106; Guinard 1946–49, pp. 178–79; Soria 1948, pp. 249–50; Gaya Nuño 1958, no. 3032; Guinard 1960, no. 270

Among the many qualities that made Zurbarán attractive to the French during the nineteenth century was what, to their eyes, seemed his unique treatment of religious images. In this exhibition, for example, one can see Zurbarán's artistic personality when he depicts Saint Francis (cat. 85) or when he chooses a form in which he undertakes to represent the Immaculate Conception (cat. 89). Another theme that the artist treated in an extraordinarily attractive manner is the representation of female saints isolated against a homogeneous background, carrying the attributes by which they are traditionally identified, and clothed in elaborate costumes that were already a bit old-fashioned at the time they were painted. Zurbarán painted many works of this type throughout his career, responding to the expectations of a large segment of the public of his time.

Such depictions of female saints were very versatile paintings not only because they addressed the public's expectations but also because of the ways in which they were used. In some cases their original sites in churches and convents are documented. Even today, some of these paintings, whether directly or indirectly linked to Zurbarán, can be found in church buildings such as the Cathedral of Seville and the convent of Santa Clara in Carmona. But it is also possible that others were created for the patron's private devotion. The origin and use of these paintings have been related to processions, such as those of Corpus Christi,[1] in which certain participants were costumed as saints. Nevertheless, although the profile view of many of these figures recalls the image of a participant as seen by the spectator of a procession, it is also true that the use of the profile can be understood merely as a strategy of pictorial representation. In any case, there is at least a general connection between these paintings of saints and the Corpus Christi procession, in that both are manifestations of a Church on friendly terms with the means used to draw people close to it.

Saint Lucy is a pendant to the *Saint Apollonia* (ca. 1636) in the Musée du Louvre.[2] The pair has been identified as the "two saints" that Antonio Ponz mentioned in the eighteenth century as parts of the main altarpiece in the church of the monastery of San José, which belonged to the order of the Discalced Mercederians in Seville;[3] most of Zurbarán's work on this altarpiece took place about 1636. He painted other notable works for the same

convent, such as *Saint Anthony Abbot* (private collection, Barcelona), *Saint Joseph and the Christ Child* (Church of Saint-Médard, Paris), and *Saint Lawrence* (State Hermitage Museum, St. Petersburg). It has been noted that the quality of the *Apollonia* is somewhat better that that of the *Lucy.*[4]

Lucy was one of the most popular saints in Spain at the end of the Middle Ages and in the first centuries of the modern era, because her story was colored by novelistic elements and devotion to her had a much appreciated utilitarian dimension. She was one of those female saints of early Christian times who suffered martyrdom because of her determination to defend her faith and protect her virginity: she decided to pluck out her eyes so that no one would make an attempt on her honor. Although this story was relegated to the realm of legend by purists, what is certain is that—whether because of the story itself or the associations between her name and light—Lucy became the saint most useful to call upon in case of vision problems. This earned her many devotees, and images of her multiplied, invariably representing her with a plate bearing a pair of eyes. By 1636 representations of this saint were not as popular as in the past, but she continued to be much loved and appreciated, and no one looking at this painting would doubt the identity of the figure. It is therefore strange that the saint's name is inscribed on the lower part of the painting. However, such an inscription also appears on the *Saint Apollonia*, a personage equally popular because of her ability to solve medical problems related to the mouth.

The European public of the nineteenth century found in these paintings a beautiful conjunction among the delicate models, the detail with which the artist represented the fabrics, and the refinement of his pictorial technique. The effect was enhanced by the placement of the figure against a neutral background, so that nothing distracted the viewer, and by the use of light to powerfully model the forms.

JPP

1. See Caturla 1994.
2. Guinard 1946–49, pp. 178–79.
3. Ponz 1776–94 (1947 ed.), vol. 9, p. 790.
4. Caturla 1994, p. 92.

87. *(New York only)* *Fig. 3.12*
Francisco de Zurbarán
The Battle between Christians and Moors at El Sotillo

Ca. 1638
Oil on canvas
131⅞ x 75¼ in. (335 x 191.1 cm)
The Metropolitan Museum of Art, New York, Kretschmar Fund, 1920 20.104

CATALOGUES RAISONNÉS: Frati 1975, no. 251; Gállego and Gudiol 1977, no. 126

PROVENANCE: Monastery of Nuestra Señora de la Defensión, Jerez de la Frontera; Musée Napoléon, Paris, no. 349, 1813; Real Academia de Bellas Artes

de San Fernando, Madrid, 1818; returned to monastery, documented in 1835; sold by José Cuesta of Seville for 40,000 reales to Baron Taylor through Antonio Mesas at Cadiz, dated receipt of June 26, 1837, royal order authorizing the sale issued July 9, 1837; Louis-Philippe, king of France, 1838–53 (Galerie Espagnole, Musée du Louvre, Paris, 1838–48, nos. 355/365); Louis-Philippe sale, Christie & Manson, London, May 20, 1853, no. 405 ("the picture of the day"), sold for 160 pounds to Farrer for Henry Labouchère (later Baron Taunton), Stoke, near Windsor, 1853–69; Mary Dorothy Labouchère (later Mrs. Edward James Stanley), Quantock Lodge, Bridgwater, Somerset, 1869; Captain R. Langton Douglas, London, 1920; acquired by The Metropolitan Museum of Art, New York, 1920

EXHIBITIONS: Madrid 1964–65, pp. 70–75; New York–Paris 1987–88, no. 30; Madrid 1988c, no. 50

SELECTED REFERENCES: Tormo y Monzó 1909, p. 33; Kehrer 1918, pp. 71ff.; Pemán 1950; Guinard 1961c, p. 369; Pemán 1961, pp. 284–85; Lipschutz 1972, pp. 125, 133, 225, 310; Baticle and Marinas 1981, no. 365; Liedtke 1988; Caturla 1994, pp. 152–53

Although the *Saint Francis in Meditation* now in the National Gallery, London (cat. 85), was the work by Zurbarán that won the greatest popular and critical success during the years the Galerie Espagnole was in existence, there were certainly other paintings that were of no less importance in demonstrating his artistic achievement. Among them the most outstanding are the six large paintings from the church of the Carthusian monastery of Nuestra Señora de la Defensión in Jerez de la Frontera. Four of them (with scenes from the Gospels) are today in the collection of the Musée de Grenoble (figs. 7.10–7.13); one, *The Virgin of the Rosary with Carthusians*, is in the Muzeum Narodowe, Poznań; and the sixth is the present work. The ensemble, dated to the second half of the 1630s, represents a moment of splendid creative maturity in Zurbarán's art. The paintings remained in situ until the outbreak of the war of independence in 1808, but then they changed locations frequently. In 1813 they were taken to Paris to form part of the Musée Napoléon. Two years later they were returned to Spain and deposited in the

Real Academia de Bellas Artes de San Fernando in Madrid. It is not known exactly when they were sent to Cadiz, where they were sold in 1837 to Baron Taylor, who was gathering pictures for the Galerie Espagnole.[1] When that collection was dissolved, the paintings were dispersed.

The Battle between Christians and Moors at El Sotillo was at the center of the altarpiece. Giving it the principal place within the narrative ensemble was appropriate,[2] for its subject is the battle in which the site of the monastery, El Sotillo, was won from Muslim troops by Christians. Early historians do not agree on when this occurred, some dating the battle to 1248, others to 1368. The chapel built on the site was later replaced during the sixteenth century by the large monastic complex.

The main protagonist of the battle was not the Christian troops but rather the Virgin Mary, to whose intercession the military success was attributed. Thus, she appears in the upper part of the painting in a burst of glory, surrounded by putti and holding her son. All these figures are attentive to the developments in the battle below, which takes place in an area that occupies three-quarters of the canvas. The presence of such a warlike subject so prominently located at the center of an altarpiece must have been very striking. Indeed, far from emphasizing the importance of the Virgin Mary, Zurbarán made the battle the main subject of the picture. In this sense, it is one of the few occasions in which he decidedly chose to depict a historical narrative of a secular character. It is not known whether this emphasis on the battle scene derives in some way from the fresco that, according to early sources, was painted in the old hermitage.

Zurbarán has laid out the composition in two clearly delimited planes. In the near plane appear four soldiers of colossal scale, one of them turning to his right and gesturing toward the battle that takes place beyond. This division of a battle scene into planes has close precedents in Spanish art. Specifically, it was the compositional strategy used by almost all the artists who participated in the decoration of the Hall of Realms in the Palacio del Buen Retiro, Madrid, including Jusepe Leonardo, Vicente Carducho, Eugenio Cajés, and Félix Castello. Zurbarán knew these works very well, for he himself had contributed some paintings to that decorative ensemble.[3] He also used prints for the composition of this painting, as he often did. In fact, some of the details of the equestrian battle are directly based on compositions by Antonio Tempesta.[4]

Within the altarpiece, this painting would have attracted attention not only because of the place it occupied but also because of the deep spatial development of the composition. The other scenes that accompanied it on the altarpiece, especially the ones in Grenoble, all concentrate the main figures on the first plane of the picture, which makes the construction of space less important. Since an accurate use of perspective and complex spatial constructions was not among Zurbarán's main strengths, *The Battle between Christians and Moors at El Sotillo*, although splendid, is less convincing and accomplished than the masterpieces that surrounded it.

JPP

1. In Cadiz the ensemble of paintings was seen and sketched by the French painter Adrien Dauzats. See Baticle 1998, pp. 101ff.
2. For hypothetical reconstructions of the altarpiece, see Liedtke 1988, pp. 153ff., in which the author proposes a convincing one of his own.
3. For the debt this painting owes to paintings Zurbarán may have seen in Madrid, see Pérez Sánchez 1993, p. 78.
4. Navarrete Prieto 1998, pp. 281–83.

88. *(New York only)* Fig. 7.21

Francisco de Zurbarán

The Martyrdom of Saint James

Ca. 1639
Oil on canvas
99¼ x 73¼ in. (252 x 186 cm)
Signed lower right: *Frnco de Zurbaran*
Museo Nacional del Prado, Madrid P 7421

CATALOGUES RAISONNÉS: Frati 1973, no. 213; Gállego and Gudiol 1977, no. 325

PROVENANCE: Louis-Philippe, king of France, 1838–53 (Galerie Espagnole, Musée du Louvre, Paris, 1838–48, nos. 351/361); his sale, Christie & Manson, London, May 6, 1853, no. 68, bought for 70 pounds by Sharpe; Julia Martínez Ibáñez collection, Madrid; Plandiura collection, Barcelona, 1939; Museo del Prado, Madrid, 1987

EXHIBITIONS: Galerie Espagnole, Musée du Louvre, Paris, 1838–48, nos. 351/361; Madrid 1964–65, no. 71; New York–Paris 1987–88, no. 34; Madrid 1988c, no. 65; Madrid 1995, pp. 31–33; Bonn 1999–2000, no. 49

SELECTED REFERENCES: Guinard 1960, no. 188; Baticle and Marinas 1981, no. 361; Caturla 1994, p. 135; Delenda and Garraín Villa 1995, p. 24

It has been suggested that this painting was part of the altarpiece that Zurbarán contracted to work on together with Jerónimo Velázquez for the Church of Nuestra Señora de la Granada in Llerena, in the Extremadura region.[1] They agreed to finish the work in two and a half years, but it is not known whether they ever completed the project. Zurbarán's exact contribution is unknown, although he surely also painted *The Resurrection, The Crucifixion,* and

the *Virgin in Glory* that were still in the church until only a few decades ago. Recently added to the paintings determined to have been made for Llerena is *The Virgin of the Immaculate Conception,* now in a private collection in New York.[2] The suggested provenance for *The Martyrdom of Saint James* is based on its style, which accords with works Zurbarán executed in the late 1630s; on the iconography, because the church at Llerena depended on the order of Santiago (Saint James); and on the fact that the 1853 sale catalogue of the paintings from the Galerie Espagnole said that this work came from a monastery in Extremadura. Nevertheless, a difference in quality between this painting and the others by Zurbarán that remained in Llerena led Juan Miguel Serrera to doubt that it came from that particular town.[3]

Created during Zurbarán's most masterful years, this painting depicts the moment in which James, the patron saint of Spain, is decapitated by order of Herod Agrippa (the turbaned figure behind the apostle). The composition, which was inspired by engravings of the life of Saint Catherine by Anton Wiericx, also includes details based on Dürer prints (such as the splendid head of the dog, or the man seen in profile at the far left). These sources are translated, however, into the painter's finest style, revealing his extraordinary gift for textures and skillful use of shadow to create volumes. Rejecting a dramatic vision of the martyrdom, Zurbarán has preferred to construct a painting that, despite its subject, is serene and meditative. The monumental scale of the composition relates this work to some of the canvases Zurbarán created for the main altarpiece of the Carthusian monastery of Jerez de la Frontera.

The Martyrdom of Saint James is one of the few paintings now in the Museo del Prado that once belonged to the collection of Louis-Philippe.

JPP

1. Guinard 1960, no. 188.
2. Delenda and Garraín Villa 1995, p. 24.
3. See Madrid 1995, no. 6.

89. Fig. 7.20

Francisco de Zurbarán

The Virgin of the Immaculate Conception with Saints Anne and Joachim

Ca. 1640
Oil on canvas
88¾ in. x 69⅛ in. (225.5 x 177 cm)
National Gallery of Scotland, Edinburgh NG340

CATALOGUES RAISONNÉS: Soria 1953, no. 143; Frati 1973, no. 272; Gállego and Gudiol 1977, no. 144

PROVENANCE: Louis-Philippe, king of France, 1838–53 (Galerie Espagnole, Musée du Louvre, Paris, 1838–48, nos. 332/342); his sale, Christie & Manson, London, May 7, 1853, no. 143, bought for 90 pounds by Hickman; Lord Elcho collection; acquired by the National Gallery of Scotland, Edinburgh, 1859

EXHIBITIONS: Galerie Espagnole, Musée du Louvre, Paris, 1838–48, nos. 332/342; Manchester 1857, no. 793; Edinburgh 1951, no. 41; New York–Paris 1987–88, no. 33; Seville 1998, no. 48

SELECTED REFERENCES: Pemán 1950, p. 218; Soria 1953, no. 143; Gaya Nuño 1958, no. 3050; Guinard 1960, no. 11; Baticle and Marinas 1981, no. 342; Brigstocke 1993, pp. 207–9; Caturla 1994, p. 169; Stratton 1994, p. 76

The massive shipment of Spanish paintings to France during the nineteenth century put the rest of Europe in touch with certain Spanish artists and stylistic options practically unknown until then. It also introduced a thematic repertoire that, while sharing the general characteristics of the art of Catholic Europe, included some images rare outside of Spain. Among the most singular of these were paintings of the Immaculate Conception, which quickly became popular because of works by Murillo.

Until the Immaculate Conception was proclaimed as dogma in the mid-nineteenth century, devotion to the doctrine had a fundamentally Spanish cast. Its extraordinarily widespread dissemination throughout the lands belonging to the Spanish monarchy can be explained not only by purely religious reasons but also by political and social motives. Eventually becoming an authentic sign of collective identity, the theme had great power to unify people. Some of the most important Spanish celebrations of the early modern age were intended to glorify this sacred mystery—that the Virgin Mary was conceived without the stain of original sin—and an extraordinary part of the literary and artistic production of those centuries was dedicated to its exaltation.

Among the painters who treated the subject with the greatest frequency and originality was Zurbarán, who painted a dozen versions. He usually depicts the Virgin Mary as a girl, lifted against the golden light of the sky and surrounded by symbols mentioned in her litanies, which sometimes include a city with Sevillian references. Occasionally, he introduces other elements.[1] For example, in a painting in the National Gallery of Dublin, the Virgin is accompanied by personifications of Faith and Hope; in another at the Museu Nacional d'Art de Catalunya,

Barcelona, two young men in religious habits are pictured below her image.

The Edinburgh picture is exceptional among Zurbarán's paintings of the subject for several reasons. In the first place, the iconography is different: the presence of Saints Anne and Joachim (the Virgin's parents) is an archaizing feature, more often found in sixteenth-century depictions of the Immaculate Conception than in Baroque ones. In addition, the painting is noteworthy on account of its scale. The rest of Zurbarán's paintings of the subject are mid-size works, appropriate for both religious and private spaces. This, in contrast, is a work of monumental scale, which could only have been commissioned for a religious institution. And in fact, the iconography itself, with its decidedly historical and dogmatic aspect, is much closer to the realm of public rather than private devotion.

The origins of this painting have been much discussed. It was first recorded in 1838, in the catalogue of Louis-Philippe's Galerie Espagnole. Also in the Galerie were other paintings by Zurbarán of equally monumental scale, such as the six large canvases from the Carthusian monastery at Jerez de la Frontera that are now distributed among the Musée de Grenoble, the Muzeum Narodowe, Poznań, and the Metropolitan Museum, New York (cat. 87). This circumstance, as well as stylistic analysis, induced César Pemán to hypothesize that the Edinburgh painting originated at the Jerez monastery, and his idea has been accepted by other art historians.[2] Nonetheless, as Hugh Brigstocke has pointed out, the evidence for that theory is entirely circumstantial.[3] The Edinburgh painting is noticeably smaller than *The Virgin of the Rosary with Carthusians* in the Poznań museum, which Pemán considered its pendant. Besides, none of the sources that cite the other six paintings (Antonio Ponz, in the eighteenth century, or the sales documentation) refer to this one. Nor does it appear among the drawings by the French painter Adrien Dauzats of the paintings from the Jerez monastery when they were in Cadiz.[4] The dimensions and format of the Edinburgh painting suggest that it was probably a principal part of an important altarpiece.

The painting is an excellent example of the style developed by Zurbarán about 1640, when he was at mid-career. The Virgin is of an elongated figure type found in other similar images by Zurbarán, including that of *The Immaculate Conception* in the Museo Cerralbo, Madrid, but differs in her more ecstatic expression. The sky in glory that surrounds her demonstrates how, with the passing of years, Zurbarán developed an ability to create space through the play of a chromatic range. Below her, the figures of Saints Joachim and Anne are sharply and powerfully outlined against the background, most notably in the angles of Joachim's face. Similar contours occur in some of the figures of *The Martyrdom of Saint James* (cat. 88), which is also dated to the end of the 1630s and the beginning of the following decade.

The work undoubtedly had an impact on Jean-François Millet, a frequent visitor to the Galerie Espagnole, whose *Virgin of Loreto* (cat. 190) it recalls.

JPP

1. Stratton 1994, p. 76.
2. Pemán 1950, pp. 218ff.
3. Brigstocke 1993, pp. 207–9.
4. See Baticle 1998.

90.

Fig. 2.2

Francisco de Zurbarán

Saint Francis

Ca. 1650–60
Oil on canvas
82¼ x 43¼ in. (209 x 110 cm)
Musée des Beaux-Arts, Lyon A-115

CATALOGUES RAISONNÉS: Soria 1953, no. 183; Frati 1973, no. 369; Gállego and Gudiol 1977, no. 234

PROVENANCE: Convent of the Colinettes, Lyon; purchased by J. S. Morand, Lyon, ca. 1791; J. A. Morand, 1794; acquired by Jean-Jacques de Boissieu, Lyon, ca. 1794; sold to the Musée des Beaux-Arts, Lyon, 1807

EXHIBITIONS: Bordeaux 1955, no. 82; Paris 1963b, no. 103; New York–Paris 1987–88, no. 69

SELECTED REFERENCES: Kehrer 1918, pp. 121–23; Demerson 1953; Guinard 1960, no. 373; Ternois 1975, p. 228; Baticle 1977, p. 177

Although paintings from Spain's Golden Age were generally unknown in France until the early decades of the nineteenth century, there were some exceptions. Certain paintings by Murillo were in choice collections, as was a portrait attributed to Velázquez. Another exception is this *Saint Francis*, which was probably already in France by the end of the seventeenth century, when it is believed to have been the property of the Franciscan convent of the Colinettes in Lyon.[1] A century later, about 1791, it was purchased by J. S. Morand, and after his death in 1794, it belonged to J. A. Morand. In turn, after the latter Morand's death in 1794, it was acquired by a local painter, Jean-Jacques de Boissieu. He used the image to compose an etching entitled *Desert Monks* (1797, National Gallery of Art, Washington, D.C.)

that depicts Saint Francis standing in the foreground in a wooded landscape. While the image is copied literally from the painting, the transfer of the print from plate to paper caused the image to be reversed, the saint's rope belt now being on the right. The painting was not in Boissieu's hands for long: in 1807 he sold it to the Musée des Beaux-Arts, Lyon.

For a long time, this painting was attributed to Jusepe de Ribera, which is unsurprising because Zurbarán was completely unknown outside of Spain for the first 150 years after his death. On the other hand, Ribera, considered a master of the Neapolitan school, was famous and esteemed thanks to the diffusion of works by him and his followers throughout Europe and to the interest aroused by his prints. It was only with the opening of Louis-Philippe's Galerie Espagnole that Zurbarán's work became familiar—a familiarity reflected in the critical fortunes of this painting, which was catalogued as being by him from 1847 onward.

When Boissieu created his print, he undoubtedly thought the painting represented an ecstatic vision of Saint Francis, so there seemed no reason not to move the image outdoors. However, Zurbarán was actually describing what Pope Nicholas V found when he visited the saint's tomb in Assisi. As Odile Delenda has shown, the painter based his image directly on the account of that visit included in the famous *Flos sanctorum* (1624) by the Spanish Jesuit Pedro de Ribadeneyra: "He was standing upright. . . . He had his eyes open, like a living person, and calmly raised to heaven. The whole and entire body was without corruption. . . . His hands were covered with the sleeves of the habit and in front of his chest."[2]

This theme had all the ingredients necessary to make it popular in Spain: it featured one of Catholicism's most beloved saints; it asserted the illusionistic potential of painting; and it played effectively with the parameters of prayer, mystical ecstasy, and death. Zurbarán painted this subject on at least two other occasions, and it is also the theme of one of the most important works of seventeenth-century Spanish sculpture, Pedro de Mena's *Saint Francis* in the Cathedral of Toledo (1663).

The qualities that made this sort of image popular in Spain in the seventeenth century also made it attractive in the eyes of the French public two hundred years later. The standing saint, isolated in front of a dark background, on which he projects a shadow that emphasizes his volume; his simultaneously mystical, anxious, and yearning expression; the consummate mastery that the painter demonstrates by limiting his palette to brown and yet achieving an astonishing variety of tonalities; the search for the essential, without extraneous elements; the intense emotional climax—all were qualities then frequently attributed to some of the greatest representatives of Spanish painting. The facture of this painting accords with Zurbarán's oeuvre of the 1650s, when his modeling of figures gradually softened. JPP

1. It has been suggested that the painting was donated to the convent by Mariana of Austria, wife of Philip IV. See New York–Paris 1987–88, p. 308.
2. Ibid., p. 306.

91. *(New York only)* Fig. 6.4

Anonymous

A Nightmare

February 1834
Plate 146 of the "Série politique," published in
Le Charivari, no. 37 (February 6, 1834)
Crayon lithograph
8⅛ x 7¼ in. (20.5 x 18.5 cm) image
Signed (with reversed initial *E*) lower left corner:
EM or *ME*; lettered below center with the title, lower
left: *Chez Aubert, galerie véro dodat*; lower right: *L. de
Becquet, rue Furstemberg 6*
Bibliothèque Nationale de France, Département de
Philosophe, Histoire, Sciences de l'homme, Paris
Fol. Lc2 1328 M 735

SELECTED REFERENCES: Lipschutz 1972, pp. 75, 76,
repr.; Villa 1979, p. 368, no. 12.361

This remarkable caricature of Louis-Philippe—a pas-
tiche of Goya's celebrated *Sleep of Reason Produces
Monsters* (cat. 30)—appeared just a few years after the
artist's death in 1828. Nicole Villa (1979) describes
Louis-Philippe as sleeping on bags full of gold that a
devil is about to steal. The unidentified caricaturist
turns the creatures of the night in Goya's print
into winged devils—caricaturists—parading all the
visual elements (pear-shaped head, Tuileries, cockaded
hat) that in just a few years had come to signify the
"citizen-king." A devil crushes Louis-Philippe's crown,
while an animated newspaper, the *Tribune*, looks on.
Imploring arms and a long-nosed head emerging from
a steaming cooking pot in the foreground are those of
the comte d'Argout, a politician. *Le Charivari* published
the lithograph facing an unsigned text that described
Louis-Philippe with evident irony as "Le plus honnête
homme de SON royaume!" (The most regular citizen
in *his* kingdom!). For those who still did not get the
joke, the text identifies the source for its sarcastic char-
acterization as the *Journal des Judas* (parodying the
official *Journal des Débats*) and capitalizes the possessive
adjective. That a print from Goya's *Caprichos* could
become the basis for a French caricature as early as 1834
suggests that readers of *Le Charivari* were conscious of
Goya's work four years before Louis-Philippe's Galerie
Espagnole opened in the Louvre. JW-B

LÉON BONNAT

Bayonne, 1833–Monchy-Saint-Éloi, 1922

Living in Madrid with his family from December
1846 until 1853, Bonnat was a pupil of José and
Federico de Madrazo at the Real Academia de Bellas
Artes de San Fernando. The works of Velázquez and
Ribera, which he studied at the Prado, had the great-
est influence on him as an artist, engendering his
taste for naturalism and his interest in chiaroscuro.
On his return to France, he won a scholarship from
his home city of Bayonne and entered Léon
Cogniet's studio at the École des Beaux-Arts, Paris.
Though he achieved only second place in the 1857
Prix de Rome, the grant enabled him to travel to
Italy, where he formed friendships with Jean-
Jacques Henner, Jules-Elie Delaunay, and Gustave
Moreau. In a letter to Moreau dated March 16, 1860,
Delaunay refers to Bonnat as "the young Spaniard."[1]

Returning in 1860 to Paris, he began a brilliant
career as a portraitist and teacher. He formed a col-
lection rich in masterpieces—including Spanish
works, particularly by Goya, El Greco, and Ribera—
which he bequeathed to his native city, with a clause
forbidding its loan. The Musée Bonnat in Bayonne
possesses various Bonnat copies, among them five
after Spanish artists (fig. 14.49). These include a
copy of Velázquez's *Pope Innocent X* (1650–51,
Rome, Galleria Doria Pamphilj) and Ribera's
Martyrdom of Saint Bartholomew (Museo del Prado,
Madrid). The latter bears an obvious relationship to
The Martyrdom of Saint Andrew (Musée Bonnat),
which Bonnat exhibited at the 1863 Salon. GL

1. "jeune Espagnol." Archives of the Musée Gustave-Moreau,
Paris, Correspondance Delaunay.

92. Fig. 2.29

Léon Bonnat

Job

1880
Oil on canvas
63¾ x 51⅛ in. (162 x 130 cm)
Signed bottom left: *Ln Bonnat*
Musée Bonnat, Bayonne, on deposit from the Musée
d'Orsay, Paris 2679 (RF 487)

PROVENANCE: Gift of the artist to the Musée du
Luxembourg, Paris, 1886; deposited with the Musée
Bonnat, Bayonne, 1932

EXHIBITIONS: Paris, Salon of 1880, no. 395; Paris,
Exposition Nationale, 1883, no. 85

SELECTED REFERENCES: Bénédite 1912, no. 53,
repr.; Bénédite 1923, no. 50, repr.; Ducourau 1988,
repr. p. 83; Pierre Rosenberg, "De Ribera a Ribot,"
in Naples–Madrid–New York 1992, p. 160, repr. fig.
28 (Madrid ed.); Perutz 1993, repr. fig. 78

Job, put to the test by God, lost everything, and was
reduced to living on a dunghill. He continued never-
theless to praise the Almighty, who was satisfied

with his submission and returned his possessions.
This biblical subject is treated here with a realistic
sense of destitution that is completely Spanish in
nature. The painting has a clear link with the
harshly lit nudes of Ribera, particularly *Saint Paul
the Hermit*, acquired by the Louvre in 1875. A study
by Bonnat of that work is currently in the Musée
Bonnat, Bayonne.[1] GL

1. Inv. 1169; 9½ x 7½ in. (24 x 19 cm).

FRANÇOIS BONVIN

Vaugirard, 1817–Saint-Germain-en-Laye, 1887

Bonvin, who had little money, began by taking
classes at the school of design on the rue de l'École
de Médecine in Paris. Later he trained himself by
studying the paintings exhibited at the Louvre, valu-
ing Chardin and the Le Nain brothers as much as the
Flemish and Dutch painters and the works in the
Galerie Espagnole. He then took the free classes
offered by the Gobelins studio and, after becoming a
public employee, for a time attended the Académie
Suisse. It was there, about 1843, that he first met the
painter François-Marius Granet, who would long
exert a strong influence on his style. After exhibiting
watercolors at the Institut Français, Bonvin had one
of his portraits accepted by the Salon of 1847;
beginning in 1849, his increasingly intimist genre
scenes were also displayed at the Salons. To certain
journalists, these works reflected the influence of
Murillo in the choice of theme and that of Velázquez
or Ribera in the choice of color. Such paintings
would henceforth assure Bonvin success with the
critics and the respect of many collectors. DL

93. Fig. 2.33

François Bonvin

The Little Chimney-Sweep

1845
Oil on canvas
8¼ x 10⅛ in. (21 x 27 cm)
Signed and dated upper left: *F Bonvin 1845*
Château-Musée, Boulogne-sur-Mer

PROVENANCE: M. A. Bellino sale, Galerie Georges Petit, Paris, May 20, 1892; Josiah Bradlee sale, American Art Galleries, New York, February 20–21, 1924; Gallery Brame, Paris, 1924; Galerie Tempelaere, Paris; Marmottan collection, Paris, 1925; gift of Marmottan to Musée des Beaux-Arts et d'Archéologie, Boulogne-sur-Mer, 1935

EXHIBITION: Paris, Galerie D. Rothschild, May 10–31, 1866, "Exposition de tableaux et dessins par F. Bonvin," unnumbered

SELECTED REFERENCES: Moreau-Nélaton 1927, p. 25 and fig. 6; Weisberg 1978; Weisberg 1979a, pp. 28, 163, no. 3; Cleveland et al. 1980–82, no. 1; Chartres 1983–84, no. 96

The first description of this little painting, executed early in Bonvin's career, appears in Étienne Moreau-Nélaton's book devoted to the artist in 1927: "You see a little boy, who seems to be one of those chimney-sweeps accustomed from an early age to roaming the highways. His feet are encased in wooden shoes, waiting until they can put on the big shoes destined for them. The child, lying on the ground near a sack he carries in his travels, is counting the pennies that make up his meager fortune."[1] The image of the little chimney-sweep, like that of the youthful Italian *pifferari* (pipers) who left for the city to ply their trade as chimney-sweeps or musicians, is a leitmotif of nineteenth-century painting. Some critics saw it as a discreet and ambiguous denunciation of the exodus of a portion of the population, obliged to cut itself off from its roots to survive. Yet the aim of paintings that illustrate this theme, such as the present one, is not to criticize contemporary society but rather to evoke an intentionally touching moment in a lonely and impoverished childhood.

This canvas recalls a number of earlier and modest models, such as Corot's *Young Italian Seated in the Artist's Room in Rome* (ca. 1825–27, Musée des Beaux-Arts, Reims) and Octave Tassaert's apprentice in *Studio Corner* (1849, Musée du Louvre, Paris). Through its palette and deep shadows, however, it also alludes to many figures painted by Murillo, including the *Beggar Boy* (fig. 2.32). The child in Murillo's painting is depicted in a very similar manner: lit from the side, leaning against a wall, his face lowered, he contemplates with great concentration his meager belongings. Nearby, one of his little riches—an apple—is escaping from his sack.

DL

1. "On y voit un petit gamin, qui paraît être un de ces Savoyards, habitués dès le jeune âge à courir les grands chemins, dont les pieds reposent dans des sabots en attendant de rechausser les gros souliers qui les attendent. L'enfant, allongé par terre auprès du sac qu'il porte dans ses voyages, est en train de compter les sous dont se compose sa maigre fortune." Moreau-Nélaton 1927, p. 25.

Charles-Émile-Auguste Durand, called
CAROLUS-DURAN
Lille, 1838–Paris, 1917

Born in Lille to a humble family with distant Spanish ancestry, Duran began his artistic education in that city at the age of eleven. He moved to Paris in 1853, and about 1859, the year of his first Salon acceptance, he met Henri Fantin-Latour. Through Fantin and Zacharie Astruc, whom he had known in Lille, Duran made the acquaintance of Manet and other artists in the emerging Realist camp. Unlike them, however, he spent much of the 1860s traveling outside France: in Italy from 1862 to 1866, and, more important, in Spain from 1866 to 1868. His Salon successes of that decade—*The Kiss* (1868, Musée des Beaux-Arts, Lille) and *Woman with a Glove* (1869, Musée d'Orsay, Paris)—show his assimilation of Spanish art in general, Velázquez in particular, but also Goya.

Returning from Brussels to Paris after the Commune, Duran opened an atelier that was especially popular with American students. The most brilliant of these, John Singer Sargent, arrived in 1874.[1] Duran transmitted to him his profound respect for Spanish painting as well as some technical practices he had observed while in Spain. Duran developed an extremely successful career in portraiture while climbing the ladder of official recognition. At the end of his life he was made a member of the Académie and the director of the Académie de France in Rome.

GT

1. See especially H. Barbara Weinberg, "Sargent and Carolus-Duran," in Williamstown 1997, pp. 5–29.

94.
Carolus-Duran
Matías Moreno

Fig. 14.69

1867
Oil on canvas
31 7/8 x 24 1/4 in. (81 x 61.5 cm)
Inscribed at lower right: *A mi queridísimo amigo/M. Moreno/Carolus Duran/Toledo 67* (To my very dear friend/M. Moreno/Carolus Duran/Toledo 67)
Museo Nacional del Prado, Madrid P 5842

PROVENANCE: Given by the artist to Matías Moreno, 1867; acquired by royal order and destined for the Museo de Arte Moderno, Madrid, August 8, 1918; deposited in the Museo Provincial, Lugo, February 7, 1933; Museo del Prado, Madrid, 1988

SELECTED REFERENCES: Madrid 1997, pp. 124–27, no. 29; Castres 1999, p. 102

"Velasquez, Velasquez, Velasquez, ceaselessly study Velasquez,"[1] Carolus-Duran always reminded his students, and this is what he himself did during his nearly three-year stay in Spain. Based in Madrid (though with a lengthy sojourn in Toledo), he spent many long hours at the Prado. His mature technique, using a half-tint (*demi-teinte*) to lay in his figures, followed by the judicious application of lights, is based on his observation of Velázquez: "That was always my goal: to express the maximum with the minimum of means."[2] He passed this technique, and the admiration of Spanish Baroque painting, to his many students, of whom the American John Singer Sargent was unquestionably the greatest.

While in Toledo, Carolus-Duran painted this portrait for his friend Matías Moreno (1840–1906), a genre painter who had studied with Federico de Madrazo. Long considered Moreno, the sitter was identified in 1999 as Carolus-Duran.[3] Either identification is conceivable since the two artists resembled one another in the 1860s. Another portrait of Moreno by Carolus-Duran is at Lille (Palais des Beaux-Arts).

GT

1. Quoted in Charteris 1927, p. 2, and cited by H. Barbara Weinberg in Williamstown 1997, p. 19.
2. "Mon but a été toujours celui-là: exprimer le maximum au moyen du minimum." Quoted in Alexandre 1903, p. 20.
3. See Jean-Louis Augé in Madrid 1997, pp. 124–27, no. 29 (as a self-portrait), and Castres 1999, p. 102 (as a self-portrait).

THÉODORE CHASSÉRIAU
El Limón, near Samaná, present-day Dominican Republic, 1819–Paris, 1856

As Chassériau defined himself, he was "born at Samana (Spanish America), of French parents, student of M. Ingres."[1] His father was a French diplomat, his mother a Creole. Chassériau was always self-conscious about the dark complexion that betrayed his roots in the Caribbean, although he moved with great ease in the highest intellectual and artistic circles of Rome and Paris. A precocious

draftsman, he became a pupil of Ingres at the age of eleven and exhibited his first painting at the Salon in 1836. He remained attached to Ingres's ideal of elegant style until the mid-1840s, when he developed a more individual painterly manner rooted in Delacroix's colorism; in 1846 he followed in Delacroix's steps to North Africa.

Chassériau received many important state commissions and found success at most of the Salons until his premature death at the age of thirty-seven. A principal figure of French Romanticism, he was much admired by writers and critics of the era, especially Théophile Gautier, the great Hispanophile. He was also good friends with Prosper Mérimée, Adrien Dauzats, and Prosper Marilhat, all of whom held a special interest in Spanish art. (See also Stéphane Guégan's essay in this publication.)

GT

1. "né à Samana (Amérique espagnole), de parents français, élève de M. Ingres." Quoted in Paris–Strasbourg–New York 2002–3, no. 168.

95. *(New York only)* *Fig. 8.1*

Théodore Chassériau

Copy after a Portrait of a Spanish Princess

Ca. 1838
Oil on canvas
31½ x 23⅝ in. (80 x 60 cm)
Private collection

CATALOGUE RAISONNÉ: Sandoz 1974, no. 6, pl. IV

PROVENANCE: Alice Ozy, Paris; the painter's studio until his death; Chassériau sale, Hôtel Drouot, Paris, March 16–17, 1857, no. 28 ("Ébauches et études diverses" ["Drafts and various studies"]), sold to his cousin Frédéric; Baron Arthur Chassériau; given by him to Alice Ozy, Paris; bequeathed by her to Baron Arthur Chassériau; Baron Arthur Chassériau, until 1934; by descent; sale, Christie's, London, June 16, 1995, no. 121, bought in; acquired by the present owner

EXHIBITION: Paris–Strasbourg–New York 2002–3, no. 5, pp. 72–74

REFERENCES
19th century: Bouvenne 1887, pp. 162–63; Chevillard 1893, pp. 168–73

20th–21st century (selected references): Vaillat 1907, p. 177; Vaudoyer 1930, pp. 67–69, 106–7; Bénédite 1931, vol. 2, pp. 390–92, repr. p. 382; La Tourette 1931; Paris 1933b, pp. 27–28; Boyé 1946, pp. 240–41; Sandoz 1967–68, p. 80; Sandoz 1974, no. 6, pp. 100, 101, pl. 4; Baticle and Marinas 1981, no. 268, pp. 173–74 (the El Greco painting); Sandoz 1982, p. 27, fig. 12; Randall 1995, pp. 48–49; Peltre 2001, p. 23, repr. p. 19, p. 231 nn. 28–30

In the catalogue of the recent Chassériau retrospective, Vincent Pomarède ably recounted the various myths that surround this handsome picture.[1] As early as 1884 it was called a copy after an unidentified painting by El Greco in the Galerie Espagnole. Since then, it has been suggested that the El Greco in question was the *Lady in a Fur Wrap*, the so-called portrait of the artist's daughter formerly in the Galerie Espagnole and now at Pollok House, Glasgow; it has recently been reattributed to Sofonisba Anguissola. That painting, however, could not have been the model for this Chassériau: the pose and the costume are entirely different. Nevertheless, it is possible that both the *Lady in a Fur Wrap* and the work that Chassériau copied portray the same young woman, either Infanta Catalina Micaela of Austria (1567–1597), or Infanta Isabella Clara Eugenia (1566–1633), the daughters of Philip II of Spain by his third wife, Isabelle of Valois.

Existing portraits of Catalina Micaela (now in St. Petersburg, Munich, and Madrid) closely resemble the woman depicted by Chassériau. All show the same impassive, heavily lidded eyes and the same pouting lips. The sitter appears to be in her mid-teens, which would correspond to the mid-1580s, before the princess left Spain for Turin to marry the duke of Savoy in 1585. Alonso Sánchez Coello was Philip II's court portraitist at this time, and Chassériau's princess resembles the Sánchez Coello portrait of Catalina Micaela now in Munich. But it is impossible to determine exactly which painting Chassériau copied. The catalogue of the Galerie Espagnole lists a "Portrait d'une dame de la cour de Philippe III" (43 x 33 cm) (*Portrait of a Lady of the Court of Philip III* [16⅞ x 13 in.]), attributed to Juan Pantoja de la Cruz, that can no longer be identified. Pantoja's work and that of Sánchez Coello were often, and still are, confused. Pantoja, a student of Sánchez Coello, succeeded him at court, but his earliest portraits date from the early 1590s. There is a *Portrait of an Unknown Woman* now at the Prado (1029) attributed to Pantoja that resembles the young lady in Chassériau's picture, only slightly older. This woman wears similar sleeves of rich fabric; another unknown woman, also by Pantoja, has a similar ornament in her hair (Prado, 1035, on deposit at the Museo Balaguer de Villanueva y Geltrú, Barcelona). It is therefore tempting to believe that Chassériau copied a Pantoja portrait of the 1590s, perhaps the one given in the catalogue of the Galerie Espagnole. If that is the case, then the princess is probably not Catalina Micaela, who left Madrid in 1585, but it could be her sister Isabella Clara Eugenia.

It does seem likely that Chassériau copied a painting at the Galerie Espagnole: family lore

records an incident during which his lover, Alice Ozy, slashed a painting of his that she thought was a copy after an El Greco in the Galerie. The present canvas bears witness to that violent attack.[2]

GT

1. Paris–Strasbourg–New York, 2002–3, no. 5, pp. 72–74.
2. Ibid.

96. *Fig. 2.31*

Théodore Chassériau

Christ Carrying the Cross,
Copy after Luis de Morales

Ca. 1838
Oil on canvas
30⅛ x 18¾ in. (76.5 x 47.5 cm)
Musée des Beaux-Arts, La Rochelle, on deposit from the Musée du Louvre, Paris 353 (RF 3858)

CATALOGUE RAISONNÉ: Sandoz 1974, no. 251, pl. CCXVII (incorrect illustration)

PROVENANCE: Baron Arthur Chassériau; his bequest to the Musée du Louvre, Paris, 1934; entered Musée du Louvre, by 1936; deposited at the Musée des Beaux-Arts, La Rochelle, by 1937

SELECTED REFERENCES: Sandoz 1982, p. 31; Stéphane Guégan, "Entre Paris et Alger: Un croyant obstiné?" in Paris–Strasbourg–New York 2002–3, p. 33, fig. 2, p. 72

Like Courbet and Jules Ziegler, Chassériau came of age in the 1830s, when the new interest in Spanish painting was beginning to be strongly felt. Evidence of his affinity for Spanish painters emerged early. An album put together by Arthur Chassériau, the artist's nephew (Musée du Louvre, Paris, RF 26431), includes small sketches after several Spanish paintings; they would appear to date to 1832, when the artist was only thirteen and still quite inexpert. Although L.-A. Prat believes these drawings to have been made by some other artist, Marc Sandoz (and Arthur Chassériau) accepted them;[1] at the very least, they show a marked interest in Spanish art on the part of a very young artist. It is remarkable that these sketches were made long before the Galerie Espagnole opened in 1838. They include a drawing

of a Velázquez portrait of María Teresa (fig. 14.64) that in 1832 was in the collection of Louis Viardot, who was among the Cent Mille Fils de Saint Louis when the force invaded Spain in 1823. (It was Viardot who proposed in 1834 that the French government put together a collection of Spanish painting, an effort that culminated in Baron Taylor's mission and the Galerie Espagnole.) It is also noteworthy that the young artist chose to reproduce works by artists, such as Juan Pantoja de la Cruz, who were not yet represented at the Louvre; the Pantoja in this album may well be a copy of the "Portrait de femme" (*Portrait of a Woman*) that was in the Salamanca collection (no. 193; 42⅓ x 34⅛ in. [108 x 88 cm]).[2] Sometime about 1838, Chassériau made a fine copy in oils after a portrait either by Pantoja or his master, Alonso Sánchez Coello (cat. 95).

Chassériau's copy after *Christ Carrying the Cross*, then attributed to Luis de Morales,[3] is further evidence that he preferred the painters of the reign of Philip II to those of Philip IV. His early Hispanism inclined toward the Mannerism of late sixteenth-century painting rather than toward the naturalism of Velázquez and Ribera. This coincides with the truly mannered style of his master, Ingres, whose works were often closer to Bronzino than to Raphael; it also accords with the temperament of writers like Théophile Gautier, who emphasized the feverishly spiritual, intensely Catholic aspect of Spanish art. However, once the Galerie Espagnole opened and he was afforded the opportunity to study Spanish painting at length, Chassériau was strongly impressed by artists of the Golden Age such as Zurbarán.[4] His early masterpiece, *The Reverend Father Dominique Lacordaire* (Louvre), is in effect an essay in Zurbaranismo. GT

1. See Prat 1988, vol. 2, p. 987, and Sandoz 1982.
2. Salamanca 1867, no. 143, p. 148.
3. The painting copied by Chassériau had been acquired by the Louvre as a Morales in 1824 (inv. 926). It is now attributed to the Spanish school (?), early seventeenth century.
4. See the list of Chassériau's comments on Spanish artists inscribed in a notebook reprinted in Sandoz 1982, pp. 30–31. I thank Bruno Chenique for his help on Chassériau and Spanish art.

CAMILLE COROT

Paris, 1796–Paris, 1875

Corot's mother was a successful milliner in Paris; his father ran the shop. When he was twenty-six, his parents allowed him to study painting and financed his efforts with money set aside for a sister who had just died. This financial independence structured his career, for he was not obliged to enter the Académie or win commissions, and he always remained aloof from art politics. He studied briefly with the landscapists Achille Michallon and Jean-Victor Bertin before going to Italy from 1825 to 1828, the first of three long trips. An inveterate traveler, Corot visited all of France, Italy, and Switzerland, and once crossed the Channel to London. His only experience

of Spain, however, was the Basque countryside, reached in 1872 from Biarritz.

In 1845 Baudelaire deemed Corot "at the head of the modern landscape school."[1] He retained that place, which he shared with Théodore Rousseau, until displaced by Courbet sometime before 1867. Although esteemed as a naturalist and famous for his plein-air studies, Corot invariably organized his compositions along classical principles. He nevertheless remained a seminal figure for a generation of Impressionists—Monet, Pissarro, Degas, and Morisot—even after his death in 1875. At the end of his life, he was a much-honored master whose work was in high demand on both sides of the Atlantic. GT

1. "à la tête de l'école moderne du paysage." Baudelaire 1992, p. 44.

97. *(Paris only)* *Fig. 1.39*
Camille Corot
Saint Francis (Franciscan Kneeling in Prayer)

Ca. 1840–45; retouched ca. 1870
Oil on canvas
18⅞ x 13⅜ in. (48 x 34 cm)
Signed lower right: *Corot*
Musée du Louvre, Paris RF 1980.194

CATALOGUE RAISONNÉ: Robaut 1905, vol. 2, no. 1043

PROVENANCE: Collection Robert, by 1905; anonymous donation to the Musée du Louvre, Paris, 1980

SELECTED REFERENCES: Louvre 1983, p. 57; Louvre 1986, p. 160

Corot's biographers, Alfred Robaut and Étienne Moreau-Nélaton, believed that the artist never copied works in the Louvre. Although a frequent visitor, he was known instead to sketch the copyists themselves or other visitors. Corot's student *carte de copyiste* has recently come to light, however,[1] and the catalogue of the 1996 Corot retrospective in Paris, Ottawa, and New York stressed the artist's awareness of the work of previous masters and of his contemporaries.

Corot was intrigued by the motif of a monk in a landscape and went so far as to order Franciscan and Capuchin habits from a friend in Rome in January 1856; he had a model wear them in several paintings of the late 1850s and the 1860s. But the present work was clearly inspired by a trip to the Galerie Espagnole, where Zurbarán's stunning *Saint Francis in Meditation* (cat. 85) hung from 1838 through 1848. Corot's painting also depicts Francis of Assisi, the founder of the mendicant order. The saint's face conforms to the classic description: "slightly elongated . . . average eyes, brown and simple . . . thin lips, black beard but sparse . . . extremely thin, his clothing coarse."[2] The Franciscans and their reformed order, the Capuchins, were so influential in Spain, and especially in Madrid, that there were seven paintings representing Saint Francis in the Galerie Espagnole. Corot's *Saint Francis*, like the Zurbarán now in London, wears the patched habit and pointed hood of the Discalced Friars.

Zurbarán also painted a kneeling Saint Francis in a landscape (1659, now in the collection of Plácido Arango, Madrid), but technical examination suggests that Corot executed his figure on a uniform background, probably in the mid-1840s. Later, perhaps around 1870, Corot painted the landscape now visible. GT

1. See Wallens 2001.
2. Tommaso da Celano, quoted in New York–Paris 1987–88, p. 271.

98. *(New York only)* *Fig. 1.38*
Camille Corot
Man in Armor

Ca. 1868–70
Oil on canvas
28¾ x 23¼ in. (73 x 59 cm)
Signed lower left: *Corot*
Musée du Louvre, Paris RF 2669

CATALOGUE RAISONNÉ: Robaut 1905, vol. 3, no. 1509

PROVENANCE: M. de Kryff; Sourigues sale, Paris, February 28, 1881, bought for 4,005 francs by M. Brame; Édouard Martell, 1888; his bequest to the Musée du Louvre, Paris, 1929

EXHIBITION: Paris, École des Beaux-Arts, 1875, no. 142

SELECTED REFERENCE: Sterling and Adhémar 1958–61, vol. 1, no. 448

Although no anecdotal or documentary evidence supports the assertion, there is clearly more than a hint of Velázquez in two series of pictures painted by Corot in the late 1860s. One is the set called *L'Atelier de l'Artiste*,[1] in which models are shown posing in the studio in a manner evocative of *Las Meninas* (fig. 4.13). The rich costumes, often with the Spanish master's signature touch of salmon pink, the easel, the works of art lining the walls, the sense of interrupted activity, the muddy palette, all bear the stamp of the "idea" of Velázquez. The second set, to which this painting belongs, is a group of studio pieces that show male models wearing armor.[2] Other references—to Italian Renaissance painting, for example—may be dominant, but the impress of Spanish seventeenth-century painting is undeniable (e.g., Velázquez's *The Jester "Don Juan de Austria"* [cat. 72], which Corot could have known through photographs). In Corot's case, however, the Hispanism is indirect, having already been filtered through works exhibited by Courbet and Manet, and also through those of close friends such as Alexandre-Gabriel Decamps. GT

1. See Paris–Ottawa–New York 1996–97, nos. 134–39.
2. The others are Robaut 1905, no. 1510 (Musée du Louvre, Paris) and 1511 (private collection).

GUSTAVE COURBET

Ornans, 1819–La Tour-de-Peilz, Switzerland, 1877

Courbet was born in the Franche-Comté to a family of prosperous farmers. He arrived in Paris by the time he was twenty, but did not enter the official system of art education. Instead he studied at the informal Académie Suisse, and for the rest of his life he cultivated a reputation as a countryman-painter (*paysan-peintre*) and as an antiestablishmentarian, a martyr to artistic liberty. His early work, generally refused by the Salons of the 1840s, was Romantic in sentiment and colorfully decorative in appearance. After a long trip to Holland and Belgium in 1847, he decided on a dark, tenebrist style founded on the conventions of Baroque painting. Huge canvases such as *After Dinner at Ornans* (1849, Musée des Beaux-Arts, Lille), *Burial at Ornans* (1849–50, Musée d'Orsay, Paris), and *The Artist in His Studio* (1855, Musée d'Orsay, Paris) reveal Courbet's assimilation, respectively, of Caravaggio, Zurbarán, and (for *The Artist in His Studio*) Rembrandt and Velázquez.

Courbet won a medal at the open, revolutionary Salon of 1848 and soon thereafter was championed by Champfleury and Baudelaire as the apostle of Realism. He flouted the government of Napoleon III by constructing his own Pavillon du Réalisme across from the Exposition Universelle of 1855. Although the Pavillon was a critical and popular

success, a similar venture in 1867 showed that the public had tired of Courbet's confrontational stance. His role in the toppling of the Vendôme column in 1871 resulted in his bankruptcy, imprisonment, and exile in Switzerland.

Courbet's monumental, Realist genre painting was a primary inspiration for Manet, Monet, and Renoir, and his art made a fundamental contribution to the growing appreciation for Spanish art and the acceptance of a nonclassical paradigm of painting. As Champfleury wrote in 1861, speaking of the *Burial*, "Without knowing the admirable paintings of Velasquez, he found himself in accord with the illustrious master, who posed[?] individuals next to each other, without being disturbed by the rules set down by pedantic and mediocre spirits."[1] Courbet made a brief but little-known trip to Madrid in 1868.[2] GT

1. "Sans connaître les admirables toiles de Velasquez, il se trouve d'accord avec l'illustre maître, qui a placé des personnages les uns à côté des autres, et n'est pas inquiété des lois posées par des esprits pédants et médiocres." Champfleury, "Grands figures d'hier et aujourd'hui" (1861), in Champfleury 1990, p. 182.
2. As revealed in Luxenberg 2001.

99. *(Paris only)* *Fig. 1.42*
Gustave Courbet
Man with the Leather Belt
(Portrait of the Artist)

1845–46(?)
Oil on canvas
39⅜ x 32¼ in. (100 x 82 cm)
Signed lower left: *Gustave Courbet*
Musée d'Orsay, Paris RF 339

CATALOGUES RAISONNÉS: Fernier 1977–78, vol. 1, no. 93; Courthion 1987, no. 68

PROVENANCE: Juliette Courbet, 1846(?)–81; the artist's studio sale, Hôtel Drouot, Paris, December 9, 1881, no. 5; acquired by the French government for 26,100 francs; Musée du Luxembourg, Paris, 1882–87; Musée du Louvre, Paris 1888–1986; Musée d'Orsay, Paris, as of 1986

EXHIBITIONS: Paris, Salon of 1849, no. 450; Paris, Rond-Point de l'Alma, 1855, no. 25; possibly at Paris, Rond-Point de l'Alma, 1867; Paris 1882a, no. 36; Paris 1973, no. 1, cover

REFERENCES
19th century: Astruc 1859, p. 214; Bruno 1872, p. 208; Le Hir, *Journal des Amateurs* (1881), p. 181; Jules-Antoine Castagnary, preface to Paris 1882a, pp. 28, 30; Eudel 1882, pp. 384–85; Luxembourg 1884, pl. 25 ("lithographie ridicule de E. Pirodaus"); Jouin 1888, p. 38; Estignard 1896, pp. 20, 70, 150

20th century (selected references): Geffroy 1906, repr. p. 262; Riat 1906, p. 65, repr.; Bénédite 1911, pp. 25, 26, pl. V; Léger 1920; Clark 1973, p. 41; Paris 1977–78, no. 13

In 1854 Courbet wrote in a letter to the collector Alfred Bruyas, "I have done a good many self-portraits in my life, as my attitude gradually changed. One could say that I have written my autobiography."[1] Indeed, Courbet painted some ten self-portraits during the 1840s, in which he tried on various Romantic guises: diffident philosopher, dueling lover, desperate individual on the margin of society. This, one of the greatest, is ultimately the most mysterious. It shows the artist, his chalk laid aside, deep in thought, holding his belt with one hand and caressing his flowing hair with the other. It is a projection of one aspect of the Romantic sensibility—the pensive, troubled artist.

At the Salon of 1846, the painting was shown under the title *Portrait de M. X****. In 1855 Courbet exhibited it under the title *Portrait de l'auteur (étude des Vénitiens) (Portrait of the Artist [A Study of the Venetians])* and the false date of 1849. Beginning in the 1920s, several art historians made the connection between this portrait and that title and further extrapolated a relationship to Titian's famous *Man with a Glove* (ca. 1520–22) at the Louvre. Radiographs published in 1973 revealed that Courbet painted this picture on top of a copy that he had made of the same Titian, confirming the historians' intuition. Nevertheless, Courbet himself said of this picture, "It's super-Vélasquez."[2] Doubtless Courbet wished to associate his art with the prestige of Spanish painting, which had been glorified by the popularity of the Galerie Espagnole. But there is in fact something specifically Spanish about this work. The modern historian T. J. Clark articulated it well: "The portrait is melodrama, but this time without bathos; Romanticism with a new kind of conviction. And this, exactly, was what Courbet borrowed from the Spanish paintings in Louis-Philippe's Musée Espagnol [*sic*], not so much their formal qualities, though he sometimes copied these, as their sheer brutality, the unembarrassed emotion of the paintings, and of the painters' own legendary lives."[3]

GT

1. "J'ai fait dans ma vie bien des portraits de moi [au] fur et [à] mesure que je changeais de situation d'esprit; j'ai écrit ma vie, en un mot." Ornans, May 3, 1854, in Courbet 1996, p. 114.
2. "C'est du sur-Vélazquez." Cited in Paris 1973, no. 1.
3. Clark 1973, p. 41.

100. *Fig. 1.41*

Gustave Courbet
The Cellist (Self-Portrait)

1847
Oil on canvas
46⅛ x 35½ in. (117 x 89 cm)
Signed lower left: *G.C.*
Nationalmuseum, Stockholm NM 3105

CATALOGUE RAISONNÉ: Fernier 1977–78, vol. 1,
no. 74

PROVENANCE: Gustave Arosa; his sale, Hôtel
Drouot, Paris, February 25, 1878, no. 20, repr.;
M. Mathey, 1912; Colon and C. E. S. Wood, United
States; Ivar Krenger, Stockholm; his sale,
September 14 and 16, 1932, no. 41, repr.; given to
the Nationalmuseum, Stockholm, by the National
Musei Vänner, 1936

EXHIBITIONS: Paris, rejected for Salon of 1847
(Souvenir de Consuelo); Paris, Salon of 1848, no.
1015; Brussels, Cercle Artistique et Littéraire, 1851
(Le Bassiste); Paris, Rond-Point de l'Alma, 1855, no.
10 (with the date 1845); Bordeaux, 1855, "Exposition
de la Société des artistes vivants," no. 146; Paris,
Rond-Point de l'Alma, 1867, no. 82; Brussels,
Cercle Artistique et Littéraire, 1878

REFERENCES
19th century: Haussard 1848; Champfleury, "Revue
des Beaux-Arts" (1848), in Champfleury 1973;
caricature by Quillenbois, *L'Illustration,* July 21,
1855; Champfleury, "Du réalisme" (1855), in
Champfleury 1990, pp. 172–73; Astruc 1859, p. 214;
Champfleury, *Grandes figures d'hier et d'aujourd'hui:
Balzac, Gérard de Nerval, Wagner, Courbet* (1861), in
ibid., pp. 182–83; Lemonnier 1868, pp. 70–71;
Ideville 1878, p. 46; Lemonnier 1888, pp. 48–49;
Estignard 1896, p. 153

20th century (selected references): Riat 1906, pp. 45,
49, 133, 254; Duret 1918, pp. 11–13, 49, repr. pl. IV;
New York 1919, no. 1, repr.; Léger 1920, pp. 30, 67;
Gauffin 1923; Mack 1951, pp. 45, 82; Philadelphia–
Boston 1959–60, no. 11, repr.; Fermigier 1971, p. 21;
Clark 1973, pp. 42–43, 50; Paris 1973, pp. 32–33;
Faunce 1993, p. 15; Guégan and Haddad 1996, p. 13

In this celebrated painting, Courbet shows himself
as the sensitive, expressive artist in the guise of a

musician. When he exhibited this painting in 1867,
Courbet noted in the catalogue that it had been
refused at the Salon of 1847 but accepted in that of
1848, where it was noticed by several critics, includ-
ing Courbet's apostle, Champfleury. However, no
self-portrait or musician by Courbet was listed
among the entries of the 1848 Salon. Hélène
Toussaint subsequently associated this painting with
a work given as *"Souvenir de Consuelo"* in the 1847
Salon handbook. This title refers to *Consuelo* (1842–
44), a novel by George Sand, who was herself close
to Champfleury, in which the writer tells the story of
a young singer devoted to her art.

Champfleury often evoked Spanish painting in
his discussion of Courbet's work: "Courbet . . .
favored by the revolution, since the academic jury
[of the previous regime] would have refused every-
thing, sent some very remarkable and diverse paint-
ings, of which I will speak of the first. Nourished by
Rembrandt and Ribeira, this young man has taken
such solid qualities that he is exaggerating his ances-
tors a bit. One could put his portrait *The Cellist* in
the Galerie Espagnole, where it would remain,
proud and easy, without fearing the Velasquezes and
the Murillos."[1] On the other hand, the critic Prosper
Haussard saw other sources: "His Cellist has the
stuff of style and [good] manner, a way of handling
the lights and shadows that recommends itself with
strength; it's like a Caravaggio and a Rembrandt."[2]
Hence, although the dominant impression was
Baroque tenebrism, the precise source was disputed.
But as Spanish painting assumed prominence over
the next twenty years, Courbet himself often pro-
claimed that his art was analogous to that of the
great Spanish masters.

Courbet made another version of this composi-
tion, with sheet music at the right (1847, Portland
Art Museum, Oregon). GT

1. "Courbet . . . a la faveur de la révolution, car le jury
 académique aurait tout refusé, envoyait des peintures très
 remarquables et diverses, dont je parle le premier. Nourri de
 Rembrandt et de Ribeira [*sic*], ce garçon avait pris de telles
 qualités solides, qu'il exagérait un peu ces ancêtres. On met-
 trait dans le musée espagnol son portrait d'*Homme à la basse*
 qu'il resterait fier et tranquille, sans craindre les Velasquez et
 les Murillo." Champfleury 1848, in Champfleury 1973, p. 154.
 When Champfleury reprinted this review in his *Souvenirs et
 portraits de jeunesse* (1872), he cut the favorable comparisons
 to Rubens and the Spanish painters (see Champfleury 1973,
 p. 153 n. 1).
2. "Son violoncelliste a une étoffe de style et de manière, une
 manoeuvre de toucher de clair-obscur qui se recommandent
 avec éclat; c'est comme un ressouvenir de Caravage et de
 Rembrandt." Haussard 1848.

101. *Fig. 14.51*

Gustave Courbet
Adela Guerrero

1851
Oil on canvas
62¼ x 62¼ in. (158 x 158 cm)
Signed and dated lower left: *G. Courbet* [in red]
Bruxelles, 1851 [in black]; inscribed lower right:

LA SIGNORA ADELA GUERRERO
Musées Royaux des Beaux-Arts de Belgique,
Brussels 6416

CATALOGUES RAISONNÉS: Fernier 1977–78, vol. 1,
no. 125; Courthion 1987, no. 118

PROVENANCE: Painted for a fête organized by the
Cercle Artistique et Littéraire de Bruxelles in honor
of King Leopold I of Belgium on September 24,
1851

EXHIBITIONS: Brussels, Cercle Artistique et
Littéraire, 1851; Paris 1955, no. 16, pl. 19; Berlin
1965, no. 35, repr. pl. 83; Paris 1968–69, no. 225;
Rome 1969–70, no. 9, repr.; Paris–New York
1994–95, no. 38 (Paris ed.)

REFERENCES
19th century: T. Silvestre 1856, p. 278; Estignard
1896, p. 182

20th century (selected references): Léger 1920;
Léger 1948, p. 46; Rostrup 1967, p. 35; Brooklyn–
Minneapolis 1988–89, no. 15

Invited to Brussels in 1851 by the Cercle Artistique
et Littéraire for a celebration honoring King
Leopold I, Courbet responded with a typically
grandiose and maladroit gesture: he offered this
painting to the king. The object of the gift was no
less curious than the choice of subject, for Courbet
was an antimonarchist. (Indeed, in 1870 he refused
the Légion d'Honneur for this very reason.)

Adela Guerrero—one in a long line of Spanish
dancers who became famous through performances
in European capitals—danced in Brussels during
Courbet's visit. In portraying her, the artist adopted
imagery known through handbills, popular illustra-
tions, and sheet music. The pose has been likened to
that of Goya's *Duchess of Alba* (fig. 11.8), which
hung in the Galerie Espagnole from 1838 through
1848, but otherwise the resemblance is scant. That
Manet would show Lola de Valence in a similar pose
in 1862 (cat. 138), without ever having seen this
work, is proof that both artists were working from
convention. Both pictures are, however, deeply
imbued with a Spanish sensibility. GT

EDGAR DEGAS

Paris, 1834–Paris, 1917

Degas was the firstborn son of an affluent couple in Paris. His father, a banker, had an extensive family in Naples; his mother, who was born in New Orleans, died when he was thirteen. Encouraged by his father in his art studies, Degas entered the atelier of Louis Lamothe, a former student of Ingres, in 1854; two years later he made the first of many study trips to Italy. For the rest of his life he would integrate his observation of the works of old masters with his contemporary practice. Degas became aware of Manet's work in the early 1860s, and by the end of that decade he was committed to Realism and subjects taken from modern life. Along with Pissarro he was a principal organizer of the Impressionist exhibitions held from 1874 to 1886. He traveled to Spain only once, in 1889, in the company of the Italian painter Giovanni Boldini. In the 1890s he bought, among many important works by Ingres, Delacroix, and his own contemporaries, two works by El Greco, one from the collection of the painter Millet, the other from the writer Zacharie Astruc.

GT

102. *Fig. 1.58*

Edgar Degas

Variation on Velázquez's "Las Meninas"

1857–58
Oil on canvas
12¼ x 9⅞ in. (31.2 x 25.1 cm)
Bayerische Staatsgemäldesammlungen, Munich
12760

Catalogue raisonné: Lemoisne 1984, suppl., no. 12

Provenance: The artist's niece, Jeanne Fèvre, Nice; Hector Brame and then his son Paul Brame, Paris; private collection, Basel; acquired by the Bayerische Staatsgemäldesammlungen, Munich, 1958

Selected references: Cabanne 1958, p. 75; Reff 1964b, pp. 250–59; Reff 1976b, vol. 1, p. 14, pl. 44, and Notebook 11, pp. 26, 28–30, 32; Pinakothek 1982, pp. 73–74; McMullen 1984, pp. 98, 222–23,

382, 456; Douglas Druick and Peter Zegers, "Degas and the Printed Image, 1856–1914," in Boston–Philadelphia–London 1984–85, pp. xix, xxvi; Sutton 1986, pp. 42, 288, 290, 298–99; Brainerd 1988, pp. 31–37; Éric Darragon, "Degas sans Manet," in Colloque Degas 1989, pp. 93–94; "Lettres de Degas provenant des archives Durand-Ruel," in ibid., p. 506; Theodore Reff, "Les vies des maîtres anciens dans les oeuvres de jeunesse de Degas," in ibid., pp. 190–95, 200; Loyrette 1991, pp. 101, 184–85, 583

On the basis of related drawings in the artist's notebook, Theodore Reff has rightly ascribed this work to Degas's stay in Rome in 1857–58; he has also rightly placed it in a small group of pictures illustrating events in the lives of great painters—Giotto, Tintoretto, Velázquez, and Bernard Palissy.[1] Degas never realized these compositions beyond sketches, drawings, and *ébauches*, the present work belonging in the last category. Nevertheless, the number of surviving works and the quality of several drawings suggest that Degas was preoccupied with the project for several months. Among the drawings for this picture, which are found in Notebook 11, is one after an engraving of the so-called *Self-Portrait* of Velázquez, now attributed to the master's workshop (High Museum of Art, Atlanta).[2]

Reff has noted the peculiarity of Degas's working on a picture about Velázquez in Rome, where there was only a single, but very famous, work by the Spanish master, *Pope Innocent X* (1650–51), in the Doria Pamphilj collection. However, the series that Degas envisioned conforms to typical Romantic hagiography, and it is now apparent that the choice of Velázquez reflects the new stature given to Spanish painting in France in the 1850s and 1860s. Since Degas was only fourteen when the Galerie Espagnole closed, his appreciation of Velázquez would have come through books and newly available reproductive photographs of celebrated paintings. (In another notebook, used in Italy and Paris from 1858 to 1860, there are drawings after the Louvre's *Infanta Margarita* [cat. 78] and the Velázquez *Lady with a Fan* [fig. 1.14], then in the Hertford Collection in Paris, now at the Wallace Collection, London.)[3]

Reff recognized that this work, a variation on the *Meninas*, does not represent a known episode in the life of the Spanish master but is instead a fictive homage. It corresponds in date to Manet's small *Spanish Studio Scene* (fig. 9.8), though Manet and Degas had not yet met. Both pictures may derive their spirit from the Louvre's *Gathering of Gentlemen* (cat. 79), but it is interesting that Degas should insist here on the respect given to Velázquez. It was well known that the Spanish master sought to be ennobled, wanting greater status for his profession and for himself personally, and finally succeeded in both.

GT

1. Reff 1964b, p. 252. See also Reff in Colloque Degas 1989.
2. Notebook 11, Dc 327 réserve, Carnet 28, Bibliothèque Nationale, Paris; see fols. 26, 28, 29, 30, 32.
3. Notebook 13, Dc 327d réserve, Carnet 16, Bibliothèque Nationale, Paris, fols. 84, 112.

103. *(New York only)* *Fig. 1.52*

Edgar Degas

Infanta Margarita, Copy after Velázquez

1861–62
Etching and drypoint, 1st state
5¼ x 4¼ in. (13.2 x 10.8 cm)
Bibliothèque Nationale de France, Département des Estampes, Paris Dc327d rés., boîte 2

Catalogues raisonnés: Delteil 1919, no. 12; Adhémar and Cachin 1973, no. 16; Boston–Philadelphia–London 1984–85, no. 16

Provenance: Alexis Rouart, Paris; purchased from Marcel Guiot, Paris, July 5, 1935

Selected references: Reff 1976b, vol. 1, p. 81, no. 112, vol. 2, Nb. 13, p. 112

Loys Delteil, a meticulous historian, recorded in 1919 that Degas and Manet first met while copying Velázquez's portrait of the Infanta Margarita (cat. 78) at the Louvre: Manet reputedly expressed astonishment that Degas was working directly on his copperplate.[1] The date of this encounter can be fairly narrowly defined—Degas registered to make copies in September 1861 and January 1862[2]—and the results are almost certainly this etching and that by Manet (cat. 182).

That Degas and Manet would simultaneously think to make etchings after Velázquez is testimony both to the new esteem for the Spanish master and to the rising interest in etching, manifested by the founding in 1862 of the Société des Aquafortistes. Degas's etching is a careful, artful rendition, in which he sought in the first state (known only in this unique example) to capture Velázquez's shimmering light with thin parallel lines of etching and stronger accents of drypoint. At some later point he burnished the plate, obliterating much of the detail, and pulled a unique second impression, now at The Metropolitan Museum of Art (1997.240). Degas's etching reverses the composition of the painting, a fact that corroborates the story that Manet found Degas drawing directly on the plate; Manet's etching, which is in the same direction as the painting, depended on an intermediate watercolor. A sketch

of the same painting in one of Degas's notebooks of the late 1850s does not seem to be related to this etching.[3] GT

1. "This small plate, etched directly on the copper[plate] in front of the painting belonging to the Musée du Louvre, was the starting point of Degas' relationship with Manet; the latter, who did not know Degas, seeing him work, tapped him on the shoulder as he exclaimed: 'You have the audacity to etch that way, without any preliminary drawing, I would not dare to do the same!'" ("Cette petite planche, gravée directement sur le cuivre devant le tableau appartenant au Musée du Louvre, fut le point de départ des relations de Degas avec Manet; celui-ci qui ne connaissait pas Degas, le voyant travailler, lui tapa sur l'épaule en accompagnant son geste de cette exclamation: 'Vous avez de l'audace de graver ainsi, sans aucun dessin préalable, je n'oserais en faire autant!'") Delteil 1919, no. 12. Also recounted in Moreau-Nélaton 1926, vol. 1, p. 36, and Tabarant 1947, p. 37.
2. Reff 1963, pp. 241–51; Reff 1964b, pp. 250–59.
3. Reff 1976b, vol. 2, Nb. 13, p. 112.

104. *Fig. 1.61*

Edgar Degas

Thérèse De Gas

Ca. 1862–63
Oil on canvas
35 x 26⅛ in. (89 x 67 cm)
Musée d'Orsay, Paris RF 2650

CATALOGUES RAISONNÉS: Minervino 1974, no. 156; Lemoisne 1984, vol. 2, no. 109

PROVENANCE: The artist's studio; René De Gas, the artist's brother, Paris; his estate sale, Hôtel Drouot, Paris, November 10, 1927, no. 70, repr.; acquired by the Musée du Louvre, Paris, for 181,000 francs; Musée du Jeu de Paume, Paris, 1947; Musée d'Orsay, Paris, 1986

EXHIBITIONS: Paris 1931, no. 28; Paris 1969, no. 10; Rome 1984–85, no. 78; Paris–New York 1994–95, no. 54 (Paris ed.)

SELECTED REFERENCES: Jamot 1928, pp. 175–76; Boggs 1962, pp. 17–18; Reff 1976a, pp. 111–12; Loyrette 1989, pp. 21–23; Loyrette 1991, pp. 176–77; Paris–New York 1994–95, no. 54

Very little is known about this handsome portrait of the artist's younger sister (1840–1897). It is thought to date from late 1862 or early 1863 because it is associated with Thérèse's marriage to her first cousin Edmondo Morbilli, which took place in Paris at the Church of La Madeleine on April 16, 1863. Presumably, Degas shows his sister as a fiancée, not as a bride, although through the window there is a view of Naples, the city where she will live with her husband. She wears a black *mantilla à l'espagnole*, a fashionable nod to the nationality of Empress Eugénie.

Degas's composition is perfectly conventional, falling within the prototype promulgated by Ingres and followed by Degas's master, Louis Lamothe, yet the facture is anything but traditional. Even though the canvas is patently unfinished, it is obvious that in certain passages Degas was striving for a loose, painterly technique and a blurred effect. The painting was probably made in the year following Degas's encounter with Manet in front of Velázquez's *Infanta Margarita* at the Louvre (cat. 78), and this technique may suggest the "soft smudges of Velásquez" that Degas admired and mentioned to the Goncourt brothers in 1874.[1]

Degas kept this painting, which he never finished, in his studio throughout his life; on his death it passed to his younger brother René. GT

1. "boueux tendre de Velasquez." Quoted in Goncourt 1956–58, vol. 2, p. 570: February 13, 1874.

105. *(New York only)* *Fig. 1.59*

Edgar Degas

James Tissot

1867–68
Oil on canvas
59½ x 44⅛ in. (151 x 112 cm)
Signed lower right: *Degas*
The Metropolitan Museum of Art, New York, Rogers Fund, 1939 1939.39.161

CATALOGUES RAISONNÉS: Lemoisne 1946–49, vol. 2, no. 175; Minervino 1974, no. 240

PROVENANCE: The artist's studio; posthumous sale of the "Atelier Edgar Degas," Galerie Georges

Petit, Paris, May 6–8, 1918, no. 37 (*Portrait d'homme dans un atelier de peintre*); bought for 25,700 francs by Jos Hessel, Paris; deposited by him at Durand-Ruel, Paris, March 14, 1921; acquired by Durand-Ruel, New York, April 28, 1921; bought for 1,400 dollars by Adolph Lewisohn, New York, April 6, 1922; Adolph Lewisohn, until his death in 1938; Jacques Seligmann, New York, 1939; acquired by The Metropolitan Museum of Art, New York, 1939

EXHIBITIONS: Cambridge 1931, no. 3; New York 1937, no. 2, repr.; New York 1960, no. 14; New York 1977, no. 6; Paris–Ottawa–New York 1988–89, no. 75; Paris–New York 1994–95, no. 62; Baltimore–Houston–Cleveland 1999–2000, no. 25; Atlanta–Minneapolis 2001, no. 22

SELECTED REFERENCES: Lapauze 1918, p. 146; Lafond 1918–19, vol. 2, p. 15; Bourgeois 1928, pp. 98ff., repr.; Burroughs 1941, repr. cover; Boggs 1962, pp. 23, 32, 54, 57, 59, 106, 131, pl. 46; Sterling and Salinger 1967, pp. 62–64; Reff 1968, pp. 133–40; Reff 1976a, pp. 28, 90, 101–10, 138, 144, 145, 223, 224, pl. 68; Dunlop 1979, pp. 55–57ff.; Moffett 1979, pp. 7–8, pl. 9; K. Roberts 1982, pl. 7 (n.p.); Wentworth 1984, pp. xv, 49, 59, pl. 37; Michael Wentworth, "James Tissot: 'cet être complexe,'" in London–Manchester 1984–85, pp. 12–17ff.; Moffett 1985, pp. 56, 59; Paris 1985, pp. 43–44; Manchester–Cambridge 1987, pp. 26–27, repr.; "Degas-Tissot Correspondence," in Colloque Degas 1989, pp. 357–66; Jean Sutherland Boggs, "Degas as a Portraitist," in Zurich–Tübingen 1994–95, p. 24; George Maurer, "Portraits as Pictures: Degas between Taking a Likeness and Making a Work of Art," in ibid., pp. 100–107; Barbara Stern Shapiro, "Degas's Printed Portraits," in ibid., pp. 141–42; Marianne Karabelnik, "Au milieu des artistes et des hommes de lettres," in ibid., pp. 255, 258; Colta Ives, "Degas, Japanese Prints, and Japonisme," in New York 1997–98, pp. 248ff.; Linda Nochlin, "Impressionist Portraits and the Construction of Modern Identity," in Ottawa–Chicago–Fort Worth 1997–98, pp. 60ff.

Until recently, the setting for this swagger portrait of Degas's friend the fashionable painter James Jacques Tissot (1836–1902) was said to represent a room that belonged to neither painter and that was not even a studio.[1] However, the large canvas at the top of the composition and the one on the easel have since been identified as works by Tissot; we can therefore presume that the copy after Cranach also represents a work by Tissot and that the setting is, just as one would suspect, an evocation of the chic studio that Tissot no doubt enjoyed. This canvas, the largest Degas devoted to an individual in the 1860s (only *The Bellelli Family* is larger), is one of a series of seemingly casual portraits of artists caught in characteristic moments of repose. Here, Tissot has doffed his satin-lined cape and top hat to sit for his friend. But lurking behind the studied asymmetry and chance encounter is a memory of Velázquez's *Las Meninas* (fig. 4.13). Though it was known to Degas at this time only through reproduction—Jean

Laurent's photographs of the paintings of the Prado had just been made available in Paris[2]—Velázquez's composition is palpably present, in the placement of pictures on the back wall, in the use of a curtain and an easel to frame the view, and in the conceit of the principal subject's pausing for a moment at center stage. GT

1. Paris–Ottawa–New York 1988–89, pp. 130–32; Paris–New York 1994–95, pp. 374–75.
2. See J. Laurent 1863.

106. *(New York only)* *Fig. 1.46*

Edgar Degas

Lorenzo Pagans and Auguste De Gas

Ca. 1871–72
Oil on canvas
21½ x 15¾ in. (54.5 x 40 cm)
Musée d'Orsay, Paris, Gift of the Society of the Friends of the Louvre, 1933, with the participation of Mr. David-Weill RF 3736

CATALOGUES RAISONNÉS: Minervino 1974, no. 255; Lemoisne 1984, vol. 2, no. 256

PROVENANCE: The artist's studio; René De Gas, the artist's brother, Paris, 1918–21; his daughter, Mme Nepveu-Degas, Paris; bought by the Société des Amis du Louvre with the assistance of D. David-Weill, 1933; Jeu de Paume, Paris, 1947; Musée d'Orsay, Paris, 1986

EXHIBITIONS: Paris 1933a, no. 76; Paris 1937a, no. 16, pl. II; Belgrade, Prince Paul Museum, 1939, "La peinture française ou XIXe siècle," no. 39, repr.; Paris 1946, no. 133; Paris 1947, no. 61, repr.; Paris 1953, no. 39; Paris, Musée du Louvre, 1958, "Impressionistes," no. 69; Paris 1969, no. 17

SELECTED REFERENCES: Lafond 1918–19, vol. 1, p. 115, repr.; Guérin 1933, pp. 33–34; Degas 1945, pp. 70 n. 2, 233–34; Boggs 1962, pp. 22, 27–28, 127, pl. 58; Louvre 1986, p. 197, repr.; Loyrette 1989; Loyrette 1991, pp. 269–70

As Henri Loyrette has insisted, this painting is a portrait of Pagans rather than a double portrait: it is a question of emphasis. Yet this work does fit into the series of double portraits that Degas made throughout the 1860s and 1870s, as well as into his series of portraits of musicians and artists from the same period. Late in life, Degas considered it very highly. A friend, Paul Poujaud, remembered, "I am certain that he did not show me the Pagans as a souvenir of his father, whom I never knew, of whom Degas never spoke, but as one of his [highly] finished works that he esteemed above all others. My impression was very strong in front of this exceptional piece."[1]

Degas depicts here one of the musical soirées regularly held on Monday evenings in his father's apartment on the rue de Mondovi; a large grand piano by Sebastian Érard is visible behind the two figures. Many of Degas's friends attended these events, including Manet and his wife. Pagans (1838–1883) was a talented Spanish tenor who sang at the Paris Opera and later in fashionable homes. The Goncourts remembered him singing Rameau one night and an Arabic melody the next.[2] They also recorded seeing, shortly after his death, his belongings in a basket at the Hôtel Drouot: "a tambourine, some guitars, sketches of painters, baskets of underwear and flannel waistcoats [were being sold]. A handwritten notice stuck on the door said that it was a sale of the belongings of one M. P. . . . This Monsieur P . . . was poor Pagans, whose guitars and tambourine have for so many years produced such brilliant and entrancing music."[3]

To create this work, Degas alternated between his highly precise mode of description and a much looser, painterly style. The depth of field determines which is used: the important details—faces, hands, guitar—are rendered with precision; all else is only summarily indicated. Such a shift in observation was often associated with Velázquez's work, by Pierre-Jean Mariette in the eighteenth century, but especially by Prosper Mérimée and Louis Viardot in the 1830s and 1840s. While painting this picture, Degas most certainly had in mind Manet's *Spanish Singer* (cat. 131), painted ten years before. Although Degas did not emulate Manet's technique here, he did do so in a slightly later, and more distinctively composed, version of this picture, now in the Museum of Fine Arts, Boston. GT

1. "Je suis sûr qu'il ne me montra pas le Pagans comme un souvenir de son père que je n'avais pas connu, dont il ne m'avait jamais parlé, mais comme une de ses oeuvres achevées, qu'il estimés entre toutes. Mon impression fut très forte devant cette pièce exceptionnelle." Excerpted in Degas 1945, pp. 233–34.
2. Goncourt 1956–58, vol. 3, pp. 808, 848: December 7, 1878, and November 20, 1879.
3. "un tambourin, des guitares, des esquisses de peintres, des paniers de linge de corps et de gilets de flanelle. Une affiche manuscrite collées à la porte dit que c'est la vente d'un M. P***. M. P***. est ce pauvre Pagans, dont les guitares et ce tambourin ont apporté, toutes ces années, de si vives ou rêveuses musiques." Ibid., p. 1063: April 14, 1884.

ALFRED DEHODENCQ

Paris, 1822–Paris, 1882

A pupil of Léon Cogniet at the École des Beaux-Arts, Dehodencq first exhibited at the 1844 Salon and obtained a third-class medal in 1846. During the summer of 1849, he left Paris to take a cure at Barèges in the Pyrenees and took the opportunity to cross into Spain to fulfill a boyhood ambition. He arrived in Madrid the evening of August 27, 1849. There the painters José and Federico de Madrazo soon placed a studio at his disposal, and he visited the Prado, where he admired the work of Velázquez. He left Madrid in September 1850 to join the duc de Montpensier (a son of Louis-Philippe) in Seville, remaining with him until 1853.

During 1854 Dehodencq visited Tangier, and in 1855 he was back in France. In December of the same year, he set out again, settling this time in Cadiz; there he married and remained until his permanent return to France in 1864. As a result of his long absence from France, he had begun to slip from public notice, despite having exhibited in the Paris Salons, winning medals in 1853 and 1865. His cause was championed by Manet's friend, Zacharie Astruc, for whom he was "le révélateur pictural de l'Espagne"—the artist who revealed Spain to the French. GL

107. *Fig. 14.50*

Alfred Dehodencq

Bullfight in Spain (Los Novillos de la Corrida)

1850
Oil on canvas
58⅝ x 81⅛ in. (146 x 206 cm)
Signed and dated at lower left: *Alfred Dehodencq, juillet 1850 Madrid*
Musée des Beaux-Arts, Pau, on deposit from the Musée d'Orsay, Paris 886.3.1 (RF 384)

PROVENANCE: Musée du Luxembourg, Paris, 1852; Musée du Louvre, Paris 1883; deposited with the Musée des Beaux-Arts, Pau, 1885

EXHIBITIONS: Madrid 1850; Paris, Salon of 1850–51, no. 766; Paris 1974, no. 65, repr.; Castres 1997, no. 32, repr.

REFERENCES
19th century: Séailles 1885, pp. 39–41, 54, 240

20th century (selected references): Séailles 1910, pp. 29–46, p. 191, no. 31, repr. p. 43; C. Georgel 1998, pp. 184, 227

Shortly after his arrival in Madrid in late August 1849, Dehodencq visited El Escorial, where, in a village square, he witnessed a bullfight of young bulls (*novillos*) that was on a smaller scale but more colorful than any he had seen in the capital. According to Gabriel Séailles, "He spent the evening drawing a bullfight."[1] Doubtless this was the sketch of September 4, 1849, now in the Musée Bonnat, Bayonne. Dehodencq used this drawing to fulfill an official commission for a painting whose subject matter had not been specified.

Prior to his journey to Madrid, Dehodencq had traveled to Barèges, in the Pyrenees, for his health. In a communication of August 1, 1849, the director of the Beaux-Arts forwarded the artist's request to go to Barèges, adding: "He received a very serious wound to the left arm in [the] 1848 [Revolution] during an attack on a barricade in the Faubourg St. Denis, and is on the point of leaving to take the waters at Barèges, which have been expressly recommended by his physician as being likely to afford him a complete cure. In my opinion, Minister, M. Dehodencq displayed sufficient resourcefulness and courage during the events of June to deserve the favor he is requesting."[2]

This painting, on a scale large enough to satisfy the administrative demands of his commission, was exhibited in Madrid with a high degree of success, attracting the attention of the duc de Montpensier. To finance his trip to Seville, Dehodencq offered a smaller version—*Fight of the Novillos at the Escorial*[3]—as a lottery prize in September 1850.

Some months later, after the larger painting's presentation at the Salon, it was selected for the Musée du Luxembourg, which in those days of the Second Republic was on the lookout for Realist subjects. This accomplishment was the crowning glory for the artist, who now could be admired by the younger generation, including Fantin-Latour, Carolus-Duran, Legros, and Zacharie Astruc.[4] In his *souvenirs* (memories) of Manet published in the *Revue Blanche* in 1897, Antonin Proust further asserted that this painting played a decisive part in the decision of his childhood friend to travel to Spain in 1865.[5]

GL

1. "il passe la soirée à composer un tableau des courses." Séailles 1885, p. 39.
2. "[il] a reçu une blessure très grave au bras droit en juin 1848 à l'attaque d'une barricade du Faubourg St Denis et qu'il est sur le point de partir pour les eaux de Barèges qui lui ont été expressément recommandées par son médecin pour son entière guérison. Je pense, Monsieur le Ministre, que M. Dehodencq est digne, par son talent et par le courage dont il a fait preuve lors des événements de juin, de la faveur qu'il sollicite." Archives Nationales de France 21/24.
3. 28⅞ x 40½ in. (73 x 102.9 cm); private collection. See Castres 1999, no. 41, repr.
4. Séailles 1910, p. 45. Séailles also quotes Valéry-Varnier, who is not listed in dictionaries of artists.
5. Proust 1988/1996, p. 27. He adds (p. 26), in connection with the Galerie Espagnole, "This gallery had often been visited by Manet as a boy. He was sorry to see it disappear" ("Cette galerie avait été souvent visitée par Manet dans son enfance. Il en regrettait la disparition").

EUGÈNE DELACROIX

Charenton-Saint-Maurice, 1798–Paris, 1863

Delacroix's first links with Spain date from his childhood. Ferdinand Guillemardet, whose signature appears as witness on the birth certificate of the future master, was shortly afterward appointed ambassador to Spain in Madrid, where he made the acquaintance of Goya. In due course, Delacroix became a close friend of Guillemardet's children, Félix and Louis, who frequently entertained him at their home. There he saw the Goyas brought back from Spain in 1800, including in all probability a copy of *Los Caprichos*.

Delacroix visited the Louvre when he was still a schoolboy, before the restoration of the Spanish paintings in 1815, and he may well have seen the *Family of the Artist*, now attributed to Juan Martínez del Mazo (fig. 2.8). He acquired a copy of this work by Géricault (private collection) for 100 francs at the sale of the latter's studio on November 2, 1824.[1]

Delacroix's correspondence informs us that, from 1819, he was already reading about the dramatic events of sixteenth-century Spanish history,[2] and his journal entries for 1824 are littered with references to Goya and Velázquez (see Chronology: 1824). During the course of his travels to Morocco and Algeria in 1832, he made a rapid visit to Spain (in May), bringing away from Cadiz and Seville generalized views of convents he had visited and sketches of contemporary costumes.[3]

Théophile Thoré praises Delacroix's work in *Le Salon de 1847*, adding: "The painter he approaches most closely is, perhaps, Velázquez (see Chronology: 1824). He has the same rather untamed style, silvery tones, the brusque touch, the same superb effects; but he is no more Spanish than Venetian or Flemish."[4]

GL

1. Géricault 1824, lot 21. See Grunchec 1976, pp. 406, 418. In the *Cahier Héliotrope*—ca. 1833–34—Delacroix indicates that he is lending this copy to Hippolyte Poterlet (Delacroix 1996, p. 830).
2. Letter to Félix Guillemardet, September 23, 1819, in Delacroix 1954, p. 81.
3. See Sérullaz 1984, vol. 2, nos. 1687–1720.
4. "Le peintre dont il se rapproche le plus, c'est peut-être Velázquez. Il en a le style un peu sauvage, les tons argentés, la brusquerie de touche, les effets superbes; mais il n'est pas plus Espagnol que Vénitien ou Flamand." Thoré 1868, p. 451.

108. *Fig. 14.29*

Eugène Delacroix

Self-Portrait (Ravenswood)

Ca. 1821
Oil on canvas
16⅛ x 13 in. (41 x 33 cm)
Inscribed on stretcher: *Ravenswood*
Musée Eugène Delacroix, Paris, on deposit from the Musée du Louvre, Paris RF 1953.38

CATALOGUES RAISONNÉS: Robaut 1885, no. 40; Rossi Bortolatto 1984, no. 35, repr.; Johnson 1987, vol. 1, no. 64, repr.

PROVENANCE: Gift of the artist to the miniaturist Joseph Auguste Carrier; sold posthumously on behalf of J. Auguste Carrier, Paris, May 5, 1875; Alfred Robaut Collection; P. A. Chéramy sale, May 5, 1908, no. 165; Chéramy heirs, April 15, 1913, no. 26; Paul Jamot Collection; given by Paul Jamot to the Société des Amis de Delacroix, 1939; acquired by the Musée du Louvre, Paris, 1953; deposited with the Musée Eugène Delacroix, Paris, 1994

EXHIBITION: Paris 1998, no. 13, repr.

SELECTED REFERENCE: Jobert 1997, p. 116, repr. fig. 1

There has been much discussion concerning the meaning of the inscription, "Ravenswood," on the reverse of this self-portrait. Lord Ravenswood is Lucy's lover in Walter Scott's *Bride of Lammermoor*, translated into French in 1819. Does the inscription signify Delacroix's self-identification with the fictional young hero, or is it a dedication to, and nickname for, his friend Joseph Auguste Carrier, to whom the artist gave this work as a gift? What concerns us most here, however, is the artist's seventeenth-century Spanish costume and pose in the style of that period. This self-portrait was executed well before 1824, when he made a copy of a portrait of Charles II that he believed to be by Velázquez in the gallery of the duc d'Orléans; in fact the latter work's provenance was unknown at the time, and the painting was attributed some years later to Carreño de Miranda (ca. 1680, Museo del Prado, Madrid). The gallant pose of the standing figure and the somber tones exhibit some affinity with Goya's small portrait of a woman (cat. 13), which Delacroix might have seen in the home of his friends the Guillemardets.

GL

109. *(Paris only)* *Fig. 6.21*

Eugène Delacroix

Orphan Girl in a Cemetery

1823–24
Oil on canvas
25¾ x 21⅜ in. (65.5 x 54.3 cm)
Musée du Louvre, Paris, Étienne Moreau-Nélaton Bequest RF 1652

CATALOGUES RAISONNÉS: Robaut 1885, no. 66; Rossi Bortolatto 1984, no. 88, repr.; Johnson 1987, vol. 1, no. 78, repr.

PROVENANCE: Collection of Frédéric Leblond, boyhood friend of Delacroix, later of his widow; sale of Dr. Gebaüer, their nephew, Cléry, May 31–June 1, 1904, no. 12; Étienne Moreau-Nélaton Collection, 1904; given by Étienne Moreau-Nélaton to Musées Nationaux, 1906; Musée des Arts Décoratifs, Paris, 1907; Musée du Louvre, Paris, 1934

EXHIBITIONS: Paris, Salon of 1824, part of no. 451 ("Studies, *same number*"); Paris 1864, no. 103, lent by Leblond; Paris 1885, no. 87 (lent by Gebaüer); Paris 1991, no. 13, repr.

REFERENCES
19th century: Moreau 1873, p. 168

20th century (selected references): Florisoone 1963, repr. p. 201; Sérullaz 1963, no. 55, repr.

This celebrated canvas is related to the artist's *Massacres at Chios* (Musée du Louvre, Paris), a large painting exhibited at the Salon of 1824 that was inspired by a particularly dramatic episode in the Greeks' fight for independence from the Turks. The attitude of the weeping girl is mirrored by that of the young man on the left. Delacroix alluded to the present work—which he considered worthy to hang in the Salon with the *Head of an Old Woman* (cat. 110)—when he recorded in his journal (February 17, 1824) a payment to the "beggar girl who posed for my study in the cemetery,"[1] allowing us to date it to about late 1823 or early 1824.

The handling of the figure, which recalls that of Goya in his portrait of Guillemardet (fig. 5.1), also bears resemblances to Murillo's technique, which Delacroix glimpsed in 1815 at the Louvre and perhaps observed again in one of the masterpieces in Marshal Soult's residence. GL

1. "la mendiante qui m'avait posé l'étude dans le cimetière." Delacroix 1996, p. 51.

110. *(New York only)* *Fig. 6.20*
Eugène Delacroix
Study for "The Massacres at Chios":
Head of an Old Woman

1824
Oil on canvas
17¾ x 13⅛ in. (45.1 x 33.3 cm)
Musée des Beaux-Arts, Orléans 96.2.1

CATALOGUES RAISONNÉS: Moreau 1873, p. 168; Robaut 1885, no. 95; Rossi Bortolatto 1984, no. 91, repr.; Johnson 1987, vol. 1, no. 77, vol. 2, pl. 68

PROVENANCE: Frédéric Leblond, childhood friend of the artist; Leblond's widow; their nephew Dr. Gebaüer, sale, Cléry (Loiret), May 31–June 1, 1904, no. 15; Mme Albert Esnault-Pelterie, Paris, 1930; Mme Jacques Meunié, Paris, 1963; private collection; acquired by the Musée de Beaux-Arts, Orléans, with the aid of the Fonds du Patrimoine, the Fonds Régional d'Acquisition pour les Musées, and the Société des Amis des Musées d'Orléans, 1996

EXHIBITIONS: Paris, Salon of 1824, part of no. 451 ("Studies, *same number*"); Paris 1864, no. 102 (lent by Leblond); Paris 1885, no. 88 (lent by Gebaüer)

SELECTED REFERENCES: Sérullaz 1963, no. 54, repr.; Florisoone 1963, p. 202; Delacroix 1996, p. 832; Moinet 1996, p. 21, repr.; Orléans 1997–98, no. 203, repr.

The weeping old woman in this study is replicated exactly in *The Massacres at Chios* (Musée du Louvre, Paris), Delacroix's large composition for the Salon of 1824: she is found seated toward the right, next to the dead woman in the foreground. The *Massacres* is clearly influenced by Spanish painting, which the artist was able to study not only at the home of his friends the Guillemardets, who owned works by Goya, but also in major private collections in Paris, as his journal attests. However, he may also have recalled the paintings exhibited at the Louvre in 1814–15, particularly the kneeling old woman in *Saint Elizabeth of Hungary Nursing the Sick*, Murillo's regrettably lost masterpiece (fig. 3.13). This study should be seen less as an expressive figure—though certainly more in the tradition of Géricault than Lebrun—and more as a memory of the ecstatic looks of the female saints or Virgins in Spanish art (compare, for example, the eyes of Coello's *Penitent Magdalen* [cat. 1]). Delacroix reports a few comments by Léon Cogniet, who came to the studio on Wednesday, May 12, 1824, to see *The Massacres at Chios*, and remarked: "How

poor Géricault would love this painting! The old woman, without a gaping mouth or any exaggeration in the eyes."[1]

Like the *Orphan Girl in a Cemetery* (cat. 109), this study from a living model was part of the collection of Delacroix's friend Frédéric Leblond. They are cited together on a list of paintings and sketches, probably composed about 1843 and found in the *Cahier Héliotrope:*[2] "*The 2 studies* he has of mine, *the old woman and the young girl.*"[3] Does this mean the works were simply lent to Leblond at the time? He is cited in the journal on June 21, 1856, along with Mme de Rubempré for *Saint Catalina* (cat. 111), on a list that seems to be the draft of a will. In any case, it was Leblond who lent the two works to the posthumous exhibition of 1864. GL

1. "Et puis combien ce pauvre Géricault aimerait cette peinture! La vieille, sans bouche grande ouverte, ni exagération dans les yeux." Delacroix 1996, p. 80.
2. Published following the journal, in ibid., p. 832.
3. "*Les 2 études* qu'il a à moi, *la vieille et la jeune fille.*" Ibid., p. 586.

111. *Fig. 1.24*
Eugène Delacroix
Saint Catalina, Copy after Alonso Cano

1824–27
Oil on canvas
32⅛ x 25⅛ in. (81.5 x 65 cm)
Inscribed on stretcher: *Eugène Delacroix à la baronne de Rubempré*
Musée des Beaux-Arts, Béziers 896.1.9

CATALOGUES RAISONNÉS: Rossi Bortolatto 1984, no. 860, repr.; Johnson 1987, vol. 1, no. 22, vol. 2, pl. 19

PROVENANCE: Bequeathed by the artist to Alberthe de Rubempré, his second cousin; Adalbert de Faniez legacy to the town of Béziers, 1896

EXHIBITIONS: Bordeaux 1963, no. 66; Nice 1986, no. 32, repr.

SELECTED REFERENCES: Florisoone 1963, p. 200; Johnson 1963, p. 302, repr. fig. 8; Delacroix 1996, p. 586; Delenda 2002, repr. p. 7

Delacroix notes in his journal for June 21, 1856, among a list of friends and relations to whom he

intended to bequeath his pictures, "Rubempré, Portrait of Saint."[1] The reference must be to this work, which he eventually left to his second cousin, Alberthe de Rubempré (1804–1879).

The artist's initial visit to the Soult collection took place in 1824, but we do not know the exact date when he made this copy there. It corresponds to number 40 in the Soult sale of May 19–22, 1852, where it appears under the name of Zurbarán, whereas the posthumous Delacroix inventory attributes it to Alonso Cano. The recent restoration of the original confirms the attribution to Cano.[2]

After Delacroix visited Marshal Soult's collection on May 3, 1824, he cited Zurbarán's *Saint Agatha* (fig. 14.30) as among the "beautiful and mystical figures of women" that he was "contemplating"[3] for the angels of *The Agony in the Garden*, his entry for the 1827 Salon (fig. 1.29). Without a journal entry for the following years, it is difficult to date this copy precisely, though it almost certainly belongs to the period between 1824 and 1827.

GL

1. Delacroix 1996, p. 586.
2. Delenda 2002, p. 6, repr. p. 5.
3. "belles et mystiques figures de femmes"; "penser." Delacroix 1996, p. 75.

112–117.
Eugène Delacroix
After Goya, Studies of "Los Caprichos"

112. *(Paris only)* *Fig. 6.6*

After Goya, Studies of "Los Caprichos,"
No. 7

Ca. 1824
Pen and brown ink, graphite
7 x 4¼ in. (17.7 x 10.7 cm)
Musée du Louvre, Département des Arts
Graphiques, Paris RF 10177

PROVENANCE: Étienne Moreau-Nélaton bequest to the Musée du Louvre, Paris, 1927

SELECTED REFERENCE: Sérullaz 1984, vol. 2, no. 1314, repr.

113. *(Paris only)* *Fig. 5.30*

After Goya, Studies of "Los Caprichos,"
Nos. 3, 5

Ca. 1824
Pen and brown ink
7 x 4¼ in. (17.7 x 10.7 cm)
Musée du Louvre, Département des Arts
Graphiques, Paris RF 10178

PROVENANCE: Étienne Moreau-Nélaton bequest to the Musée du Louvre, Paris, 1927

SELECTED REFERENCE: Sérullaz 1984, vol. 2, no. 1316, repr.

114. *(Paris only)* *Fig. 6.10*

After Goya, Studies of "Los Caprichos,"
Nos. 11, 31, 33, 66

Ca. 1824–26
Pen and brown ink
12½ x 8⅛ in. (31.8 x 20.7 cm)
Musée du Louvre, Département des Arts
Graphiques, Paris RF 10460

PROVENANCE: Étienne Moreau-Nélaton bequest to the Musée du Louvre, Paris, 1927

SELECTED REFERENCE: Sérullaz 1984, vol. 2, no. 1321, repr.

115. *(New York only)* *Fig. 14.26*

After Goya, Studies of "Los Caprichos,"
Nos. 24, 28, 33, 60, 61

Ca. 1824
Pen and brown ink
4⅞ x 8 in. (12.5 x 20.3 cm)
Musée du Louvre, Département des Arts
Graphiques, Paris RF 31217

PROVENANCE: The artist's studio; studio sale, Paris, 1864, part of no. 640 (11 sheets), bought for 35 francs by Philippe Burty; acquired by the Musée du Louvre, Paris, 1960

SELECTED REFERENCE: Sérullaz 1984, vol. 2, no. 1322, repr.

116. *(Paris only)* *Fig. 5.28*

After Goya, Studies of "Los Caprichos,"
No. 39

Ca. 1824
Pen and brown ink
7⅞ x 6 in. (20 x 15.3 cm)
Inscribed in pencil by unknown hand: *After Goya*
Musée du Louvre, Département des Arts
Graphiques, Paris RF 10384

PROVENANCE: Étienne Moreau-Nélaton bequest to the Musée du Louvre, Paris, 1927

SELECTED REFERENCE: Sérullaz 1984, vol. 2, no. 1326, repr.

117. *(New York only)* *Fig. 6.8*

After Goya, Studies of "Los Caprichos,"
Nos. 26, 27, 29, 35, 69

Ca. 1824
Pen and brown ink on off-white laid paper, laid down
8¾ x 7⅛ in. (22.1 x 18 cm)
Fogg Art Museum, Harvard University Art
Museums, Bequest of Frances L. Hofer 1979.110

PROVENANCE: Léon Voillemont (L. Suppl. 789d);
Louis Dimier (L. Suppl. 1721c); Strölin, Paris; bequest
of Frances L. Hofer to the Fogg Art Museum, 1979

SELECTED REFERENCE: Mongan 1996, no. 104, repr.

The posthumous sale of Delacroix's work in 1864 included eleven drawings made after Goya's *Caprichos*,[1] only one of which, after passing through the Philippe Burty collection, is now in the Louvre.[2] The 1927 Moreau-Nélaton bequest to the Louvre included sixteen others,[3] and some are still in private hands. The artist must have had access to a complete set of the *Caprichos*, no doubt through the Guillemardet family, since in 1799 Ferdinand Guillemardet had lent some assistance to Goya in creating the series.

Delacroix was fascinated by characters or gestures from various parts of the series, often combining them on a single sheet and sometimes interspersing them with sketches for his major paintings, such as the *Death of Sardanapalus* (1827; see cat. 114). The group of children clutching at their mother to protect themselves from the bogeyman (cat. 113), depicted by Goya in *Capricho no. 3*, was copied by Delacroix in his print *Interior Scene* (cat. 119) and also may have inspired the pose for Medea and her children in the painting for the Salon of 1838 (fig. 14.44). His journal reveals that his interest in Goya began as early as 1824; the entry for March 19 of that year records that he "saw the Goyas, in my studio, with Edouard [the landscapist Édouard Bertin]."[4] This notation allows a tentative dating for the drawings presented here, to about 1824–26. GL

1. Delacroix 1864, no. 640.
2. RF 31217 (Sérullaz 1984, vol. 2, no. 1322, repr.).
3. Sérullaz 1984, vol. 1, no. 13, vol. 2, nos. 1312–21, 1323–27, repr. See also Lipschutz 1988, pp. 121, 128.
4. "vu les Goya, à mon atelier, avec Edouard." Delacroix 1996, p. 57.

118. *(New York only)* *Fig. 14.37*

Eugène Delacroix
A Picador

1832
Watercolor with traces of graphite
5 x 3¾ in. (12.6 x 9.6 cm)
Musée du Louvre, Départment des Arts
Graphiques, Paris RF 36804

PROVENANCE: The artist's studio; his studio sale, Paris, 1864, part of no. 585; Roger-Marx, Paris; Mme Asselain, his daughter, Paris; given by her to the Musée du Louvre, Paris, in memory of her father, 1978

SELECTED REFERENCE: Sérullaz 1984, vol. 2, no. 1696

Delacroix arrived in Cadiz on May 16, 1832, at the end of a lengthy trip to North Africa as part of a diplomatic mission led by the comte de Mornay, for which Delacroix had kept a visual record. After several days in Cadiz he left for Seville, where he spent a week, recording in his own journal and sketchbook the sights that he beheld. In addition to the paintings by Zurbarán, Murillo, and Goya that he saw and described, he also made note, on May 26, of a bullfight he attended at which "the famous matador Romero" impressed the audience with his skills.[1] This watercolor undoubtedly marks that event. DLR

1. "le fameux Romero matador." Delacroix 1960, vol. 1, p. 156, "Samedi 26."

119. *(New York only)* *Fig. 5.31*

Eugène Delacroix
Interior Scene

1820–24
Aquatint; retouched with pen and ink
7⅛ x 5⅛ in. (18.9 x 13.1 cm)
Bibliothèque Nationale de France, Départment des Estampes, Paris Dc183n rés., fol.t.1–RCA 39 457

PROVENANCE: Purchased from Loys Delteil, May 14, 1913

CATALOGUES RAISONNÉS: Robaut 1885, no. 23; Delteil 1997, no. 7

120. *Fig. 6.11*

Eugène Delacroix
Mephistopheles Aloft, from *Faust* (Paris, 1828)

1820–24
Lithograph
10¾ x 9½ in. (27.3 x 24 cm)
Inscribed bottom left: *Delacroix Invt. et Lithog.;* bottom right: *Lith. de Villain* [Printed by Villain]; quotation, bottom: *De temps en temps j'aime à voir le vieux Père /Et je me garde bien de lui rompre en visière* (From time to time I like to see the old Father/And I'm careful not to quarrel with him openly)
NY: The Metropolitan Museum of Art, New York, Rogers Fund, 1917 17.12 (2nd state, with lettering)
P: Musée Gustave-Moreau, Paris 11912-95 (3rd state)

CATALOGUES RAISONNÉS: Robaut 1885, no. 233; Delteil 1997, no. 58

SELECTED REFERENCE: Lipschutz 1988, pp. 128–30

This illustration for Albert Stapfer's French translation of Goethe's *Faust*, published by Charles Motte in 1828, corresponds to an episode from the prologue (quoted at the bottom of the lithograph) in which Mephistopheles has just visited God in heaven to wager that he will win the soul of Faust. Now he flies above Wittenberg, about to return to Earth and begin his struggle.[1] The third state, printed by Villain, was actually distributed separately.

The flying figure, with left leg drawn up beneath the body, is clearly inspired by the witch in number 66 of Goya's *Caprichos* (cat. 31), of which Delacroix had made a sketch (cat. 114). GL

1. See Paris 1998, no. 58.

121. *Fig. 5.32*
Eugène Delacroix
A Blacksmith

1833
Aquatint and drypoint, 2nd state
6¼ x 3¾ in. (15.9 x 9.5 cm); leaf 9 x 6½ in. (22.7 x 16.7 cm)
NY: The Metropolitan Museum of Art, New York, Purchase, Rogers Fund and Jacob H. Schiff Bequest, 1922 22.60.13
P: Bibliothèque Nationale de France, Paris, Département des Estampes

CATALOGUES RAISONNÉS: Robaut 1885, no. 459; Johnson 1987, vol. 3, no. LII5; Delteil 1997, p. 44, no. 19, repr. p. 45

The subject of this print, sketched earlier by Delacroix (ca. 1821), doubtless owes much to Géricault, whom Delacroix greatly admired, and to his engravings on Realist themes. The technique itself, however, with its "chiaroscuro effects in the manner of Goya"—to quote Théophile Gautier in the preface to *Mademoiselle de Maupin* (1834)[1]—demonstrates that Delacroix's fascination with Goya remained undiminished at this time, particularly with regard to *Capricho* no. 35. GL

1. See Gautier 1946.

BARON FRANÇOIS GÉRARD
Rome, 1770–Paris, 1837

A historical painter, portraitist, and lithographer, Gérard enjoyed immense success under successive political regimes. From 1814, thanks to Talleyrand, he entered the service of the Restoration and became a member of the royalist circles of Mme Récamier and Chateaubriand. Noteworthy among his entries for the 1824 Salon were a *Philip V* (Château de Chambord) and *Marshal Soult, duc de Dalmatie*. GL

122. *Fig. 1.26*
Baron François Gérard
Saint Teresa

1828
Oil on canvas
107⅛ x 37¾ in. (272 x 96 cm)
Maison Marie-Thérèse, Paris

PROVENANCE: Executed for the chapel of the Infirmerie Marie-Thérèse, Paris, and given by the artist to Mme de Chateaubriand; placed on the high altar at the end of April 1828 and inaugurated June 3, 1828; remained in situ when the infirmary was ceded to the Archdiocese of Paris in 1838

EXHIBITION: Paris, Salon of 1827–28 (unlisted)

SELECTED REFERENCES: Paris 1974–75, no 70; Foucart 1987, pp. 41–42; Nantes–Paris 1995–96, no. 96

Founded in the rue d'Enfer by Mme de Chateaubriand in 1819 as a refuge for aged clergy and distressed gentlewomen, the Infirmerie Marie-Thérèse was dedicated to the surviving daughter of Louis XVI, Marie-Thérèse, duchesse d'Angoulême, who had played an important role in the restoration of the monarchy in 1815. Her husband, the duc d'Angoulême, son of the comte d'Artois (the future Charles X), was entrusted with the command of the royal army, which set out to rescue Ferdinand VII; he distinguished himself at the capture of the Trocadero, near Cadiz, on August 31, 1823. It now appears that in 1823 Gérard began working on this painting of the Spanish Carmelite Saint Teresa, which he would later offer to the infirmary chapel at the instigation of a friend of Chateaubriand, Mme Récamier. Chateaubriand and his wife installed themselves in a house next to the infirmary in 1826.

The painting was finished in virtual secrecy in 1828 and revealed on the final days of the Salon. The public and the press acclaimed it deliriously. It was, to quote Bruno Foucart, "the perfect example of Romanticism," inspiring copies and imitations.[1] The very subject matter, the representation of ecstasy, and the chiaroscuro effects not usually associated with Gérard evince a familiarity with Spanish art, although it is not possible to pin down this influence to a particular artist among the many whose works were found in private Parisian collections. It is unlikely that Gérard had the opportunity to study a work from the collection of the duquesa del Infantado, *The Ecstasy of Saint Teresa*, which had been accepted into the Louvre in 1813 under the guise of anonymity and sent back to Spain the following year as a Murillo, without ever having been exhibited.[2] GL

1. "romantique de plein droit." Foucart 1987, pp. 41–42. A small-format copy, signed Brisset (?) and dated 1845, is preserved in Mexico at the Museu Nacional de San Carlos.
2. No. 227 in the inventory of the Musée Napoléon (archives, Musées Nationaux, Paris).

EVA GONZALÈS
Paris, 1849–Paris, 1883

Gonzalès's father, Emmanuel, was a successful writer who was born in Spain but became a French citizen. Her mother, a fine musician, was Belgian. The Gonzalès household was frequented by literary and musical circles, and Eva was educated in a worldly environment. She studied with the elegant portraitist Charles Chaplin before becoming Manet's pupil in February 1869, at the age of twenty. Obviously struck by Gonzalès, Manet sent an impressive portrait of her to the Salon of 1870 (National Gallery, London). For her part, Gonzalès submitted *Soldier Boy* (Musée Gaston Rapin, Villeneuve-sur-Lot) to the same Salon, and critics immediately detected the effect of Manet's instruction. Manet seemed to delight in playing his new pupil against his former (though informal) student, Berthe Morisot, who wrote: "Manet encourages me and holds up that eternal Mlle Gonzalès as an example; she has poise, perseverance, she is able to carry something to a successful completion, whereas I am capable of nothing."[1]

Like Manet, Gonzalès eschewed the Impressionist exhibitions in favor of the Salons. In 1879 she married the artist Henri Guérard; after her death in childbirth in 1883, he married her sister Jeanne, who was also a painter. GT

1. "Manet me fait de la morale, et m'offre cette éternelle Mlle Gonzalès comme modèle; elle a de la tenue, de la persévérance, elle sait mener une chose bien, tandis que moi, je ne suis capable de rien." Berthe Morisot to Edme Pontillon, August 13, 1869, in Morisot 1950, p. 33.

123. *Fig. 1.62*
Eva Gonzalès
A Box at the Théâtre des Italiens

1874
Oil on canvas
38⅝ x 51⅛ in. (98 x 130 cm)

Signed lower left: *Eva Gonzalès*
Musée d'Orsay, Paris, Gift of Jean Guérard, the
artist's son, 1927 RF 2643

CATALOGUE RAISONNÉ: Sainsaulieu and Mons
1990, no. 61

PROVENANCE: The artist; inventory after her death,
July 14, 1883, no. 53 ("un tableau par Madame
Guérard [loge aux italiens] estimé cinq cents francs");
the artist's posthumous sale, Hôtel Drouot, Paris,
February 20, 1885, no. 47; bought by Henri Guérard
for 1,150 francs; Henri Guérard, Paris; inventory after
his death, May 24, 1897 ("Un grand tableau 'La loge'
par Eva Gonzalès"); Jeanne Guérard-Gonzalès, Paris,
1897; Jean-Raymond Guérard, Paris, 1924; his gift to
the Musée du Louvre, Paris, 1927; Musée d'Orsay,
Paris, since 1986

EXHIBITIONS: Paris, refused at Salon of 1874;
Paris, 11, place Breda, May 1874, studio of Eva
Gonzalès; Ghent, Exposition Triennale, 1874, no.
592; Paris, Salon of 1879, no. 1405; Paris, Palais des
Champs-Elysées, Salon, 1885, no. 1405; Paris, salons
of *La Vie Moderne*, 1885, "Eva Gonzalès," no. 68

REFERENCES
19th century: Deraismes 1874, n.p.; Anon. 1879, p. 2;
Véron 1879, p. 175; Wolff 1879, p. 2; Huysmans
1883, p. 53; Anon. 1885, p. 2; Edmond Bazire, pref-
ace to Gonzalès 1885, p. 11; Burty 1885, p. 3; Claretie
1885, p. 2; Javel 1885, p. 3; Katow 1885, p. 3; Masque
1885, p. 1; Eudel 1886, pp. 245–46

20th century (selected references): Paris, Exposition
Universelle, 1900, no. 329; Genet 1914; Roger-Marx
1950; Louvre 1986, p. 284; Boime 1994–95

Although this painting immediately inscribes itself
in the sequence of scenes from modern life painted
and exhibited by Manet and Degas in the 1860s and
1870s, it is equally indebted to Goya's *Majas on a
Balcony*. Goya's primary version (1808–12, private
collection) was exhibited at the Galerie Espagnole at
the Louvre from 1838 to 1848; another (cat. 14) was
visible in Madrid at mid-century and reproduced in
contemporary publications in France. Being the
source of inspiration for *The Balcony* by Manet (cat.
155), Goya's composition could also not have been
far from Gonzalès's mind. Nevertheless, like Cassatt
just a few years later, she could see Goya only
through Manet's eyes.

Gonzalès's sister Jeanne and Henri Guérard, the
future husband of them both, posed for the picture.
Manet may have had a hand in its conception, for he

sketched but did not finish a version in pastel; the
woman's bouquet is an obvious reminder of the one
offered in Manet's *Olympia* (Musée d'Orsay, Paris).
After being rejected at the Salon of 1874, this paint-
ing was instead shown in Gonzalès's studio, where it
provoked commentary in the press. Alexandre
Dumas, a friend of Gonzalès's parents, reputedly
remarked: "There are the underpinnings of
Velasquez."[1] The painting was acclaimed at the
Salon of 1879 and had become very well known by
the time it was shown in Gonzalès's memorial exhi-
bition. GT

1. "Il y a là les dessous de Velasquez." Quoted by Roger-Marx
1950, n.p.

CONSTANTIN GUYS

Flushing, The Netherlands, 1802–Paris, 1892

Guys was an illustrator and traveler *par excellence*
who found employment with the *Illustrated London
News* (established 1842), remaining one of its
accredited journalists until 1860. He also worked for
Le Monde Illustré (founded 1857). His work as a
reporter took him all over Europe, and included
several trips to Spain. A drawing made at Seville and
dated 1847 (Museum Boijmans Van Beuningen,
Rotterdam), and two on Spanish subjects, published
July 26 and August 2, 1856, in the *Illustrated London
News*, are but a few of the incomplete landmarks of
his many trips through the Iberian Peninsula. In
Paris, he made the acquaintance of Nadar, Paul
Gavarni, and, at the end of 1859, Baudelaire. The
poet immortalized him as "The Painter of Modern
Life" in an article that appeared in serial form in *Le
Figaro* (November– December 1863), with a follow-
up in *L'Art Romantique*. The Goncourts, who met
him in 1858, Théophile Gautier, Manet, and many
others came to cultivate and esteem this solitary
artist, whose life ended in unhappy circumstances.
GL

124. *(Paris only)* *Fig. 9.81*
Constantin Guys
Two Spanish Women on a Balcony

Ca. 1845 (?) or 1847
Pencil, pen, and metallographic ink; wash
8⅞ x 6⅞ in. (22.6 x 17.4 cm)
Musée des Arts Décoratifs, Paris 34710

PROVENANCE: Dorville bequest, 1942

SELECTED REFERENCES: Duflo 1988, repr. p. 95 D;
Dufilho 1997, no. 8 (2), p. 74

Two drawings by Guys of very similar composition[1]
represent two Spanish women on a balcony. This
one, with its vigorous hatching, can be likened in
technique to the drawing in the Museum Boijmans
Van Beuningen, Rotterdam, dated 1847 and featur-
ing a street scene in Seville. Jérôme Dufilho believes
these drawings may have been used by the *Illustrated*

London News for one of the woodcuts that appeared
on October 4, 1845, in an article titled "Sketches in
Spain" (as *Balcony Scene, Andalusia*). If he is cor-
rect, then the magazine did not hesitate to alter
details of its reporter's sketches, since in the print,
the balcony is viewed side on, in a precise architec-
tural setting, and the young women are by no means
looking in the same direction (as they are in the
drawings).

The composition of these drawings is reminis-
cent of Goya's in his *Majas on a Balcony*. Guys may
indeed have seen the version of Goya's work
acquired by Baron Taylor, which had been exhibited
in the Galerie Espagnole at the Louvre before 1848,
as well as the version in the collection of the Infante
Don Sebastián (cat. 14), which had hung in a public
gallery in Madrid since 1842. Unlike Goya and
Manet, Guys depicts the two women alone.
GL

1. Musée des Arts Décoratifs, Paris (34712), repr. in Rome
1980, no. 34, and Dufilho 1997, no. 8 (1), p. 73.

125. *(Paris only)* *Fig. 14.57*
Constantin Guys
Two Women with an Officer

1856
Pencil, pen, and metallographic ink, ink and water-
color wash
10 x 7¼ in. (25.3 x 18.3 cm)
Musée des Arts Décoratifs, Paris 34727

PROVENANCE: Dorville bequest, 1942

SELECTED REFERENCE: Dufilho 1997, p. 339, no. 86

This brilliant colored sketch shows two Spanish women in mantillas, accompanied by an officer, on the Paseo del Prado in Madrid. It was reproduced fairly faithfully as the central part of an engraving in the *Illustrated London News* of July 26, 1856, under the title *Street Scene in Madrid*.[1] Apart from the different lighting, the principal adaptations involve the officer: the plume of his hat has vanished, the position of his sword has changed (turned toward the rear), and the hem of his jacket has been lengthened. Jérôme Dufilho proposes a date of about July 15, 1856. The virtuosity in Guys's allusive use of watercolor and his ability to "freeze" the attitudes and gestures of people as he glimpsed them on the streets would captivate Baudelaire.

GL

1. Repr. by Jamar-Rolin 1956, p. 81, fig. 11.

JEAN-JACQUES HENNER

Bernwiller, Alsace, 1829–Paris, 1905

After winning the 1858 Grand Prix de Rome for historical painting, Henner spent six years in Italy. During this stay he admired Velázquez's *Pope Innocent X* at the Galleria Doria Pamphilj, Rome, as he recalled in his later conversations with Émile Durand-Gréville, in the course of which the name of Velázquez occurred at least a score of times. At the Louvre he also enjoyed the *Infanta Margarita* and *Philip IV as a Hunter* (cats. 78, 77).

He made a brief trip to Spain in 1883 with Faugère-Dubourg, and his visit to the Prado appears to have taught him little new about Velázquez's technique; he was already drawing inspiration from his hero, adopting his silvery tones and eliminating the yellows from his treatment of flesh.

In 1885 Faugère-Dubourg sent him (from Nérac, where he may have discovered it) the "complete series of Goya's bullfight etchings," which "you wished you could have brought back from Madrid."[1]

GL

1. "la série complète des eaux-fortes de Goya sur la tauromachie"; "vous regrettiez de n'avoir pu rapporter de Madrid." Faugère-Dubourg to Henner, August 9, 1885, Archives of the Musée National Jean-Jacques-Henner, Paris (which also houses Goya's etchings). Faugère-Dubourg adds in his letter, "I'm very much afraid that Goya will not reconcile you to bullfighting; he only saw the spectacular and bloodthirsty side of it. Never mind, study these etchings; they contain everything Spanish we glimpsed at Burgos" ("J'ai bien peur que Goya ne vous réconcilie pas avec les courses de taureaux dont il n'a vu que le côté pittoresque et bestial. C'est égal, regardez bien ces eaux-fortes, il y a là toute l'Espagne que nous avons entrevue à Burgos").

126. *(Paris only)* Fig. 2.9

Jean-Jacques Henner

Henriette Germain

1874
Oil on canvas
15¾ x 12¼ in. (40 x 32 cm)
Signed top left: *J. J. HENNER*
Musée National Jean-Jacques-Henner, Paris
JJHP 356

PROVENANCE: The artist's studio, Paris, then Bernwiller; collection of Jules Henner, the artist's nephew, 1905; donated to the state by Mme Jules Henner, 1923

SELECTED REFERENCES: Lannoy 1986, no. 343, repr.; Lannoy 1990, no. 402, repr.

Henner is particularly admired for his portraits of children. From his diary for 1874, we know that he painted this portrait of Henriette Germain, age four, in two sittings (January 8 and 12) and decided to keep it. He then worked on a second version for the family, in the same format, between January 16 and 28. Little Henriette, whom he painted full face with her blond hair falling over her shoulders, was the daughter of Henri Germain, a founder of Crédit Lyonnais. There is no doubt that the artist was satisfied with his spirited first version, with its echoes of Velázquez's *Infanta Margarita* in the Louvre (cat. 78), which he often mentioned in his (slightly later) conversations with Émile Durand-Gréville. On December 17, 1879, for instance, he declared it "extremely beautiful," explaining, on March 6, 1882," His *Infanta* in the Louvre is one of the most beautiful things in the world: the nose and mouth are not quite so accomplished, but the upper parts of the hair, the forehead, and the temples are masterpieces of contouring and simplicity of tone." Again, on November 18, 1882, he remarked: "Look at Velasquez's *Infanta*. That's what I call modeling!" Finally, on July 21, 1883, having just returned from Spain, he again praised the painting: "The little *Infanta* in the Louvre is as beautiful as anything you could dream of, believe me. She might have been sculpted by Phidias."[1]

GL

1. "très beau"; "Son *Infante* du Louvre est une des plus belles choses qu'il y ait au monde: le nez et la bouche sont moins bien, mais le dessus des cheveux, le front et la tempe sont des chefs-d'oeuvre de modelé et de ton simple"; "Regardez l'*Infante* de Velasquez. Voilà qui est modelé!"; "La *Petite Infante* du Louvre est ce qu'on peut rêver de plus beau, croyez-moi. C'est modelé comme Phidias." Durand-Gréville 1925, pp. 73, 155, 161, 165.

ALPHONSE LEGROS

Dijon, 1837–Watford, 1911

A pupil of Lecoq de Boisbaudran and a member of Courbet's Realist circle, Legros first exhibited at the Salon in 1857. He was both a painter and an engraver, with links to Fantin-Latour and Whistler. His etching *Spanish Singers* (Salon of 1861) recalls those of Manet. From 1863, he lived mainly in London, where he taught while continuing to exhibit regularly at the Paris Salon. In 1880 he became a British citizen.

GL

127. Fig. 2.21

Alphonse Legros

Making Amends

1868
Oil on canvas
70½ x 68⅞ in. (179 x 175 cm)
Signed lower right: *A. Legros*
Musée d'Orsay, Paris RF 2771

PROVENANCE: Acquired by the state, 1868; Musée du Luxembourg, Paris, 1871; state deposit, 1926; Musée du Louvre, Paris, 1929; Musée de Cambrai, 1931; Tribunal de Commerce de Niort, 1938; Musée d'Orsay, Paris, 1982

EXHIBITIONS: Paris, Salon of 1868, no. 1524; Vienna, Universal Exhibition, 1873, no. 429; Paris 1974, no. 154, repr.

SELECTED REFERENCES: Bénédite 1900, pp. 12, 15, 32; Bénédite 1912, no. 304, repr.; Bénédite 1923, no. 343, repr.

An enthusiastic visitor to the Louvre and an admirer of Holbein, Legros also revered Zurbarán, in partic-

ular the two works by the artist that entered the Louvre in 1858 from the Soult collection, especially the large, square painting *Saint Bonaventure at the Council of Lyon* (fig. 2.20).[1] He adopted the overall composition of these works, with figures filling the frame and looking toward the left, in both *Ex-Voto*[2] for the 1861 Salon and *The Calling of Saint Francis*,[3] shown the same year at Galerie Martinet. He returned to the same square format for his *Stoning of Saint Stephen* (Salon of 1867), known from a photograph by Michelez. That year he also exhibited *Scene from the Inquisition*, a subject that had already been treated by Joseph-Nicolas Robert-Fleury for the Salon of 1814.[4]

Making Amends, which earned a medal, was a breathtaking revival of Zurbarán, with its Spanish theme, its placement of figures, and its very style.[5] At the time, Zurbarán's painting was known, wrongly, as *Saint Peter Nolasco and Saint Raymond of Peñafort*—its title in the catalogue of the Soult sale. It was thought to depict the Chapter of Barcelona, from which Legros was able to make the transition to an ecclesiastical court.

GL

1. 98½ x 88⅛ in. (250 x 225 cm). See Paris 1988, no. 3, repr.
2. Musée des Beaux-Arts, Dijon.
3. Musée d'Alençon.
4. Reproduced in *Magasin Pittoresque* (1841, p. 201), to introduce an article on the history of the Inquisition in Europe and particularly in Spain, where it was abolished by Napoleon in 1808 and reintroduced from 1815 to 1820.
5. The restoration undertaken in 2002 revealed underlying traces of an earlier work. Did Legros reuse a canvas for economy's sake or did he perhaps alter some similar subject intended for the 1867 Salon, now lost to art history?

ÉDOUARD MANET

Paris, 1832–Paris, 1883

Born into a well-to-do bourgeois family, Manet declined to take up the career of his magistrate father. He apprenticed with Thomas Couture and found inspiration in the art of the Italian masters before discovering Velázquez, whom he considered "the painters' painter." Manet's independence manifested itself very early, and his works shocked the public, who were accustomed to the hackneyed classicism and smooth surfaces then in vogue. His bright tones, his refusal to depict objects in relief, and the flatness of his paintings led people to believe that he did not know how to paint or that he was making fun of them; they were scandalized by what they perceived as the "triviality" of his subject matter. Manet persisted in trying his luck at the Salon, although he was often rejected by its juries, and never wanted to exhibit with his Impressionist friends. Zola, then Mallarmé, proved to be passionate defenders of his art.

JW-B

128. *Fig. 9.10*

Édouard Manet

The Absinthe Drinker (A Philosopher)

1858–59; reworked ca. 1868–72
Oil on canvas
71 x 41⅛ in. (180.5 x 105.6 cm)
Signed on wall at right: *Manet*
Ny Carlsberg Glyptotek, Copenhagen MIN 1778

CATALOGUES RAISONNÉS: Tabarant 1931, no. 27; Orienti 1967, no. 16; Rouart and Wildenstein 1975, vol. 1, no. 19

PROVENANCE: The artist's studio, rue Guyot, Paris 1859–70/72 (one of four *Philosophes*, valued at 6,000 francs, or 1,500 francs each); bought for 1,000 francs by Durand-Ruel, Paris, January 1872 (*Le buveur d'absinthe*, Paris stock 950); bought for 5,750 francs by Jean-Baptiste Faure, Paris, November 10, 1882 (with two other *Philosophes*, Paris stock 1170); deposited by Faure with Durand-Ruel, Paris, February 20, 1906; bought by Ny Carlsberg Foundation, Copenhagen, 1914 (at the "Exposition d'art français," 1914, q.v.); gift of the Foundation to Ny Carlsberg Glyptotek, Copenhagen, 1917

EXHIBITIONS: Paris 1867, no. 29 *(Le Buveur d'absinthe)*; Paris 1884, no. 5 (Faure coll.); Berlin 1906, no. 4; London 1906, no. 6 (priced at 2,000 pounds); Paris 1906, no. 6; Stuttgart 1906, no. 3; Munich 1907, no. 5; Mannheim 1909, no. 52 (priced at 64,000 marks); Vienna 1910, no. 2; Copenhagen 1914, no. 127; [see Rouart and Wildenstein 1975 for further early exhibitions]; Copenhagen 1989, no. 2; Paris 1995–96, no. 8; Copenhagen 2000a, no. 40; Paris 2002–3, no. 69

REFERENCES

19th century: Randon 1867, p. 8 (*Le Buveur d'absinthe*, cut at mid-calf; caricature); Zola 1867a, p. 13; Claretie 1872; Godet 1872, no. 6 (*Mendiant à l'absinthe*, photograph); Bazire 1884, p. 15; Proust 1897, pp. 134–35, 168 [1913, pp. 32–36; 1988/1996, pp. 23–25]

20th–21st century (selected references): Proust 1901, p. 72 [1988/1996, pp. 89–90]; J. Faure 1902, no. 28; [see Rouart and Wildenstein 1975 for further early references]; Callen 1974, pp. 157,

169, 173 nn. 1, 76; Fonsmark 1985; Fonsmark 1987; Munk 1993, pp. 46–47, no. 18 (citing other references); Meller 2002, p. 110

Since Manet reworked it more than once, this impressively somber painting presents a mixture of styles. It was the first painting that Manet submitted to the Paris Salon, in 1859. It had already outraged his former teacher, Thomas Couture, and was now rejected by the Salon jury. The twenty-seven-year-old artist had taken as his model a ragpicker named Colardet and depicted him realistically, as the low-class urban type that he was, adding a bottle that rolled suggestively at his feet. At that date, there was no glass of absinthe beside the figure, on the low wall, as is clear from Manet's reproductive etching of 1861–62 (cat. 167). When the painting appeared in his retrospective exhibition in 1867, its lower part was missing,[1] and the glass still had not been added. The work was listed in the catalogue of that exhibition as *The Absinthe Drinker*, for which the artist was chided in a caricature by Randon: "Now then, Monsieur Manet, how can we tell that this individual is partial to absinthe . . .? It would not have cost you much to offer him a glass. . . ."[2] Manet later unfolded the canvas in its entirety and repainted the picture extensively, adding the fatal glass.

In this introduction of his work to the public, Manet chose to tackle a resolutely modern theme, using methods learned in Couture's studio and looking to the old masters for inspiration. His drunken ragpicker wrapped in a shabby cloak plays on images of ancient philosophers as represented by Velázquez (cats. 75, 76) and probably seen by Manet in Goya's etchings (cats. 19, 20). These are among the high-art sources that underlie Manet's Baudelairean image, one from a world both too modern and too banal for the taste of the jury and the public of 1859.

JW-B

1. The canvas, doubled up behind a new stretcher, was restored to its original length when Manet reworked the picture, adding it to the group of four *Philosophers* that he sold to Durand-Ruel in 1872. The complex story of its development is told in Fonsmark 1987.
2. "Voyons, monsieur Manet, à quoi pouvons-nous reconnaître que cet individu aime l'absinthe . . . ? Il vous en coûtait si peu de lui en offrir un verre. . . ." Randon 1867, p. 8.

129. *Fig. 9.6*

Édouard Manet

The Little Cavaliers, Copy after Velázquez

1859–60(?)
Oil on canvas
18 x 29¾ in. (47 x 78 cm)
Signed lower right: *Manet d'après Vélasquez*
Chrysler Museum of Art, Norfolk, Virginia, Gift of Walter P. Chrysler, Jr. 71.679

CATALOGUES RAISONNÉS: Tabarant 1931, no. 6; Orienti 1967, no. 5; Rouart and Wildenstein 1975, vol. 1, no. 21

PROVENANCE: The artist's studios, 1860–78; bought for 2,600 francs by Jean-Baptiste Faure,

Paris, 1878 (with the *Déjeuner sur l'herbe* and *Filippo Lippi*, Manet's account book); Durand-Ruel, Paris, February 20, 1906 (Paris deposit 10928); bought by Durand-Ruel, Paris, March 13, 1907 (Paris stock 8431); bought by the comtesse de Béarn, Paris, August 31, 1908; Tryggve Sagen, Oslo, 1922; Paul Guillaume, Paris; Bignou Gallery, New York, 1943–48; sale, Parke-Bernet, New York, January 15, 1949, no. 62; Reid and Lefèvre, London; D. W. Cargill, 1949; private collection, Philadelphia; sale, Parke-Bernet, New York, April 22, 1954, no. 81; Walter P. Chrysler, Jr., New York, before 1961; gift to The Chrysler Museum, Norfolk, Virginia, 1971

EXHIBITIONS: Paris 1867, p. 16 *(COPIES/[no. 3] Les Petits Cavaliers, d'après Vélasquez)*; Berlin 1906, no. 3 *(Die Edelleute)*; London 1906, no. 5 (priced at 800 pounds); Paris 1906, no. 5; Stuttgart 1906, no. 2; Munich 1907, no. 4; [see Rouart and Wildenstein 1975 for further early exhibitions]; Durham–Birmingham 1986–87, no. 31; New York 1993a, no. 30

REFERENCES
19th century: Henri de La Madelène, in Desnoyers 1863, p. 41; Proust 1897, pp. 129, 174 [1913, pp. 23–24, 49; 1988/1996, pp. 14, 16, 34]

20th century (selected references): J. Faure 1902, no. 48 *(Réunion de portraits)*; Reff 1964a, p. 556; Callen 1974, pp. 167, 172; [see Rouart and Wildenstein 1975 for further early references]; Harrison 1991, no. 85 (citing earlier references); Rudd 1994, pp. 747–49, fig. 11

In 1851 the Louvre acquired a painting attributed to Velázquez that immediately gained wide popularity, particularly with artists (cat. 79). Recent restoration has shown it to be a fragment, and it was recognized at the time that it had been extensively retouched. Yet for Manet the picture proved to be a revelation, one that set his art on a new course. In spite of damage and repainting of the canvas, Manet responded to the lively attitudes of the figures (numerous pentimenti show that they were original inventions, individually and in their groupings), to their disposition across an open, undefined landscape, to their active engagement with each other without the fiction of a "story" to tell, and no doubt to the fact that the figures were identified as portraits of contemporary artists, with Velázquez himself and Murillo at the left. All these aspects, together with the light tonality of the picture and the relatively bright coloring of the costumes, provided Manet with the means to advance on territory already conquered by Courbet in his search for modern themes but expressed by him in tones that Manet judged too dark. The cavaliers have an elegance and an almost

Parisian "chic" that Manet translated and enhanced in his brilliant, swiftly brushed, and richly colored copy of the pseudo-Velázquez.

Although there is no record of Manet's copy in the incomplete registers in the Louvre (see Juliet Wilson-Bareau's essay "Manet and Spain" in this publication), comparison of the original with the copy suggests that the latter was almost certainly executed directly from the former. Enchanted by this model, Manet used it as a basis for other works: one or more pastiches on canvas (cat. 130) and an etching that he regarded highly and published repeatedly (cat. 164). The most striking instance of the major impact of the Spanish picture on Manet's work is the celebrated *Music in the Tuileries* (fig. 9.32). In that painting the Parisian public, largely composed of the artist's friends, is distributed across the canvas in the manner of the Spanish cavaliers; the two figures of Velázquez and Murillo have been replaced by portraits of Manet himself and his aristocratic friend and artistic colleague Count Albert de Balleroy. JW-B

130. *Fig. 9.7*
Édouard Manet
Spanish Cavaliers

Ca. 1859–60
Oil on canvas
17⅞ x 10⅜ in. (45.5 x 26.5 cm)
Initial at lower left: *M*
Musée des Beaux-Arts, Lyon B.1153b

CATALOGUES RAISONNÉS: Tabarant 1931, no. 37; Orienti 1967, no. 25; Rouart and Wildenstein 1975, vol. 1, no. 26

PROVENANCE: Paul Chéramy, Paris, then Munich; his sale, Galerie Georges Petit, Paris, May 5–7, 1908, no. 219, bought by Dr. Raymond Tripier, Lyon; bequeathed to the Musée des Beaux-Arts, Lyon, 1917

EXHIBITIONS: Paris, Salon d'Automne, 1905, "Oeuvres d'Edouard Manet," no. 28; Marseille 1961, no. 7; Paris–New York 1983, no. 2; Martigny 1996, no. 11; Castres 1999, no. 46; Paris–Baltimore 2000–2001, p. 170, pl. 13; Paris 2002–3, no. 71

SELECTED REFERENCES: [see Rouart and Wildenstein 1975 for early references]; Farwell 1981, p. 58; Rudd 1994, pp. 747–49; George Mauner, "Manet and the Life of *Nature morte*," in Paris–Baltimore 2000–2001, pp. 16, 34, 66; Meller 2002, pp. 72, 75, 92, fig. 20

Despite the lack of documentary records, the first owner of this picture appears to have been Paul Chéramy, the Manet family's lawyer.[1] The picture belongs with works inspired by Manet's encounter with *Gathering of Gentlemen* (cat. 79), a painting attributed to Velázquez of which Manet made a close but freely brushed copy (cat. 129). In a brilliant little fantasy sketch, *Spanish Studio Scene* (fig. 9.8), Manet took two of the cavaliers and placed them in front of the figure of Velázquez himself, seated at his easel while studying the models for his painting. The artist confronts and studies the figure seen from the rear at the right edge of *Gathering of Gentlemen*, while the other cavalier has adopted the pose of the foreground figure on the left but is presented from the artist's viewpoint and, therefore, from the spectator's point of view, in reverse. In 1981 Beatrice Farwell noted that both *Spanish Cavaliers* and *Spanish Studio Scene* appeared to have been cut down and suggested that Manet may have been working toward a larger composition. More recently, Peter Rudd (1994) has proposed a reconstruction, based on these two works, in which the hypothetical picture is seen as a variation on Velázquez's *Las Meninas* (fig. 4.13).

To date, only the Lyon picture has been X-rayed, and, until a similar examination of the other canvas can take place, it is impossible to ascertain whether the two pictures were cut from the same painted canvas.[2] The X-ray of the present work shows that the canvas has indeed been unevenly cut along all four sides. Surprisingly, there are almost no signs of pentimenti, and the X-ray reveals very little beyond what appears on the surface of the picture, although with noticeably less definition in the figures.[3] Along with the three cavaliers, the figure of a boy has been introduced in the foreground. This figure recalls the image of Léon Leenhoff in *Boy with a Sword* (cat. 133) and is also very closely related to the watercolor and etching of *Boy with a Tray*,[4] a motif that Manet created from a combination of Spanish and Italian sources, as noted by Peter Meller (2002), and that reappears years later in the background of *The Balcony* (cat. 155). Whether or not this picture and the *Spanish Studio Scene* were cut from the same canvas (Rudd's reconstruction would measure approximately 19¾ x 29½ inches [50 x 75 cm], allowing for slight loss at the edges), an intriguing reference to a lost painting was made by the painter Jacques-Émile Blanche. He was once the owner of the *Spanish Studio Scene*, a picture he referred to as an "elaborate 'sketch'" of a larger work. According to a letter he wrote in 1940, "'The Velasquez in his studio, with two Cavalier-visitors' [was] the original scheme of a bigger canvas I saw at Manet's studio when I was a boy. This canvas remained unfinished—so far as I can remember: perhaps destroyed."[5] For the time being, the mystery surrounding these works endures. JW-B

1. See Paris–New York 1983, p. 48, "Provenance." The work was not listed in the inventory of Manet's estate or in the inventory of his studio compiled by Léon Leenhoff.

2. I am grateful to D. Brachlianoff for arranging for me to examine the X-ray made of the canvas. It arrived as the French version of this catalogue was going to press, and one hopes that an X-ray of the other canvas will one day be forthcoming. If the hypothesis of the cut canvas turns out to be correct, then the deed was finalized already in Manet's lifetime: "Scène d'atelier espagnol" (*Spanish Studio Scene*) was listed in the estate inventory among the "Tableaux et études" and in Leenhoff's studio inventory as a framed painting. It was bought by J.-E. Blanche at the studio sale, February 4–5, 1884, lot 46 (see Bodelsen 1968, p. 342, *procès verbal* no. 74).

3. Reproductions of the *Spanish Studio Scene* (Rouart and Wildenstein 1975, vol. 1, no. 25; see Manet 1991, p. 151, pl. 109) reveal pentimenti and scraping of the painted surface. The picture is no doubt more or less contemporary with *The Little Cavaliers*, rather than dating from the late 1860s as suggested in the 1991 publication. It is much to be regretted that it could not be included in the current exhibition.

4. See Guérin 1944, no. 15; J. Harris 1970/1990, no. 28.

5. The letter came to light at the Boston Museum of Fine Arts in the curatorial file on Manet's painting of *Monk at Prayer* (cat. 143). Dated April 17, [19]40, it refers to the provenance of the *Monk* (also previously owned by Blanche), and then to the painting Blanche had seen many years earlier. I am grateful to Alexandra Ames Lawrence for bringing this to my attention. In auction catalogues describing Blanche's canvas of the *Spanish Studio Scene*, the provenance has been partially confused with that of the Lyon picture (Christie's, London, July 2, 1974, no. 63; Christie's, New York, November 13, 1984, no. 102).

131.

Fig. 9.1

Édouard Manet

The Spanish Singer (The "Guitarero")

1860
Oil on canvas
58 x 45 in. (147.3 x 114.3 cm)
Signed and dated on bench at right: *éd. Manet 1860*
The Metropolitan Museum of Art, New York,
Gift of William Church Osborn, 1949 49.58.2

CATALOGUES RAISONNÉS: Tabarant 1931, no. 34; Orienti 1967, no. 33; Rouart and Wildenstein 1975, vol. 1, no. 32

PROVENANCE: The artist's studio, rue Guyot, Paris, 1861–70; on deposit with Théodore Duret, Paris, September 1870–71; the artist's studio, rue Guyot, 1871–72 (Joueur de guitare, valued at 3,000 francs); bought for 3,000 francs by Durand-Ruel, Paris, January 1872 (*L'homme à la guitare*, Paris stock 934); bought for 7,000 francs by Jean-Baptiste Faure, Paris, January 3, 1873; bought for 20,000 francs by Durand-Ruel, Paris, April 17, 1906 (Paris stock 8136); bought for 150,000 francs by William Church Osborn, New York, May 2, 1907; gift to The Metropolitan Museum of Art, New York, 1949

EXHIBITIONS: Paris, Salon of 1861, no. 2098 (*Espagnol jouant de la guitare*); Paris, Galerie Martinet, 1861 (*Le joueur de guitare*); Paris 1867, no. 3 (*Le Chanteur espagnol*); Marseille, Société Artistique des Bouches-du-Rhône, 1868–69;

Munich 1869; London 1872b, no. 38 (*The Guitar Player*); Paris 1884, no. 8 (Faure coll.); Berlin 1906, no. 6; London 1906, no. 7 (priced at 480 pounds); Paris 1906, no. 7; Stuttgart 1906, no. 5; Munich 1907, no. 7; [see Rouart and Wildenstein 1975 for further early exhibitions]; Paris–New York 1983, no. 10; Paris 2002–3, no. 72

REFERENCES

19th century: Louis Martinet in *Le Courrier Artistique*, October 15, 1861; [see Rouart and Wildenstein 1975 for contemporary criticism]; Godet 1872, no. 19 (*Espagnol jouant de la guitare*, photograph); Durand-Ruel 1873, vol. 1, pl. XIX (*Le guitariste*, etched by Ch. Courtry); Armand Silvestre in ibid., vol. 1, p. 24; Proust 1897, pp. 170, 174 [1913, pp. 40–42, 49; 1988/1996, pp. 28, 34]

20th–21st century (selected references): J. Faure 1902, no. 29; [see Rouart and Wildenstein 1975 and Paris–New York 1983 for further early references]; Callen 1974, pp. 162, 172–73; Colette Becker, "Lettres de Manet à Zola," in Paris–New York 1983, p. 522, letter no. 13 (Paris ed.); Flint 1984, p. 357; Meller 2002, p. 102

Two years after the rejection of *The Absinthe Drinker* (cat. 128), a depiction of Parisian poverty too realistic and unpalatable for the Salon jury, this entirely different painting was accepted for the next Salon, in 1861, thereby marking Manet's arrival on the artistic scene in Paris. Widely recognized as a work of real quality, it was moved to a better position on the Salon walls and received the accolade of an honorable mention. *The Absinthe Drinker* was painted in the later 1850s after a lengthy stay in Italy and while Manet was still under the strong influence of his former teacher, Thomas Couture. *The Spanish Singer* (or *The Guitarero* in Manet's informal title) represents a breakthrough and reinforces the impression that a major change occurred in the artist's work in 1860, the year he dated this picture. Here and in other significant pictures of this time— *The Salamanca Students* (fig. 9.9), also dated 1860, and perhaps *Fishing* (1861–63, Metropolitan Museum of Art, New York)—Manet found a way of marrying fantasy and realism, genre subjects and a new sense of atmosphere, if not of plein air, using free yet smooth and evenly detailed brushwork, and rich, clear colors.

After the disappointment suffered in 1859, and very probably as a result of studying and copying the Velázquez *Gathering of Gentlemen* (cat. 79), Manet determined to find success at the Salon. Years later, Antonin Proust reported him, perhaps not entirely accurately, as saying after the rejection of his *Absinthe Drinker*: "I painted . . . a Paris character, whom I studied in Paris, and executed with the kind of naive painterly technique that I found in the picture by Velasquez. People don't understand. Perhaps they will understand better if I do a Spanish character."[1] The more or less Spanish costume sported by the model (Théophile Gautier identified the vest as from Marseille and raised an eyebrow at the pants and espadrilles)[2] was put together from disparate elements among Manet's studio props; these appear piled in a basket in a later painting and later prints (cats. 132, 172, 173).

The artist so arranged his subject matter that it provided him with a singular harmony of black and white, green and gray, enlivened by the red ribbon on the guitar, the yellow-brown soundboard of the instrument, and the warm brown of the earthenware jar. In another passage quoted by Proust, Manet commented, "In painting the figure, I had in mind the Madrid masters and also Hals," adding that it occurred to him that Hals might well have been "of Spanish origin" and that it would not be surprising since he came from Malines.[3] The effect of the painting, strong, clean, and bold, is as invigorating as that of Hals's finest portraits and figures, and its impact on the Salon walls, even when skied, was evidently strong enough to outshine all the works around it. Manet was proud to have painted the head in a single session and cared nothing for the fact that the guitar was incorrectly strung for a left-handed player.[4] This first official success confirmed him in his choice of masters: Velázquez and Murillo, contemplated or copied in the Louvre, had inspired a new kind of painting, direct and sincere, and would carry forward a new generation of artists with Manet at their head. JW-B

1. "J'ai fait, dit-il, un type de Paris, étudié pà Paris, en mettant dans l'exécution la naïveté du métier que j'ai retrouvée dans le tableau de Velasquez. On ne comprend pas. On comprendra peut-être mieux si je fais un type espagnol." Proust 1901, p. 71; 1988/1996, p. 89. According to Proust, the Velázquez mentioned was *Los Borrachos*, which Manet could have known from reproductions (cat. 22), but it could equally well be the *Gathering of Gentlemen*.

2. Gautier 1861, p. 265; Tabarant 1931, p. 59.

3. "En peignant cette figure, je pensais aux maîtres de Madrid et aussi à Hals"; "de race espagnole." Proust 1897, p. 170; 1988/1996, p. 28 (this passage was omitted in Proust 1913). Hals was almost certainly born in Antwerp, a year or two after the Northern Netherlands assemblies had renounced the authority of Philip II of Spain in 1581.

4. "My Guitarero plays with his left hand a guitar meant to be played with the right hand. What do you say about that? Can you imagine—I painted the head in one go. After two hours of work I looked in my small black mirror, that holds together. I did not touch it again." ("Mon Guitarero joue de la main gauche une guitare accordée pour être jouée de la main droite. Qu'en dis-tu ? Figure-toi que la tête, je l'ai peinte du premier coup. Après deux heures de travail j'ai regardé dans ma petite glace noire, ça se tenait. Je n'y ai pas donné un coup de brosse de plus.") Ibid., and Proust 1913, pp. 40–41.

132. *(New York only)* Fig. 9.88

Édouard Manet

Still Life with Spanish Hat and Guitar

1862
Oil on canvas
30⅛ x 47⅛ in. (77 x 121 cm)
Musée Calvet, Avignon 22.273

CATALOGUES RAISONNÉS: Tabarant 1931, no. 49;
Orienti 1967, no. 54; Rouart and Wildenstein 1975,
vol. 1, no. 60

PROVENANCE: The artist's studios, 1862–83;
Léon Leenhoff's studio register, 1883, no. 31
(Dessus de porte—Chapeau espagnol et guitare);
the artist's estate inventory, 1883 ("Tableaux et
études," no. 22: *Dessus de porte, nature morte,*
valued at 100 francs); the artist's estate sale, Hôtel
Drouot, Paris, February 4–5, 1884, no. 93 *(Guitare
et chapeau, dessus de porte),* bought by Leenhoff
for 120 francs *(procès verbal no. 153);* his gift to
Raoul Fournier, Paris; sale D***, Hôtel Drouot,
Paris, May 1923, bought by J. Rignault for 42 francs
(recorded in Tabarant 1931); Joseph Rignault,
Paris and Saint-Cirq-Lapopie; gift to the Musée
Calvet, Avignon, 1947

EXHIBITIONS: Paris 1884, no. 17 *(Guitare et
chapeau, dessus de porte);* [see Rouart and
Wildenstein 1975 for further early exhibitions];
Marseille 1979, no. 119 (according to a label on
verso); Tokyo–Fukuoka–Osaka 1986, no. 5;
Paris–New York 1994–95, no. 85; Paris–Baltimore
2000–2001, p. 170, repr. p. 55

SELECTED REFERENCES: [see Rouart and
Wildenstein 1975 for early references]; Reff 1962;
Bodelsen 1968, p. 344 *(procès verbal no. 153);* Henri
Loyrette, in Paris–New York 1994–95, p. 395;
George Mauner, "Manet and the Life of *Nature
morte,*" in Paris–Baltimore 2000–2001,
pp. 43–44, 54–56

When Léon Leenhoff made the inventory of the
contents of Manet's studio during the weeks follow-
ing the artist's death, he entered all the works in a
small register with ruled pages numbered 1 to 327.
He began with the most celebrated works that hung,
framed, on the studio walls: *Olympia, Chez le père
Lathuile, A Bar at the Folies-Bergère.* Number 14 was
a framed "dessus de porte" (decorative overdoor)
depicting the young son of his collector friend
Ernest Hoschedé in a garden setting (1876, National
Museum of Western Art, Tokyo).[1] The present
work, number 31 among the early works described
in the register, was unframed but was also described

as a "dessus de porte." It was either pinned up over
one of the studio doors or was a work that Leenhoff
recalled as having served as an overdoor in one of
Manet's previous studios. He later noted on the
same page that it had been given to Raoul Fournier,
one of Manet's cousins, and that it had been
engraved more than once as a frontispiece to sets of
etchings (cats. 172, 173). The register also records
that it was photographed and sent to the picture
framer Jacob.[2] The painting was exhibited in the
1884 retrospective exhibition of Manet's works at
the École des Beaux-Arts before it was given to
Fournier.

In spite of an early error in Adolphe Tabarant's
description of the background as "an architectural
decoration,"[3] it is clear from Manet's second trial for
an etched title page (cat. 172) and from the painting
itself that the background to the still life is the lower
part of a large stage curtain, slightly parted at the
left edge. A still unanswered question is whether this
canvas is a fragment of a much larger work, given
that virtually all Manet's early etchings are faithful
copies of his paintings.[4] If this proves to be the case,
then the still-life elements in the picture would also
have included the great sword and sword belt that
are carried by the child in *Boy with a Sword* (cat.
133), as well as other motifs from the upper area of
the composition seen in the print.

The painting in its present form illustrates Émile
Zola's reference to the Spanish props and costumes
that Manet acquired long before his brief visit to
Spain and that first appear in *The Spanish Singer*
(cat. 131) of 1860: "If Édouard Manet has painted
espadas and *majos,* it is because he kept Spanish cos-
tumes in his studio and liked their colors."[5] The
broad-brimmed sombrero, guitar, bolero, and pale
pink satin cummerbund were used by Manet to dress
up his models in major paintings between 1860 and
1863, including *The Spanish Singer, Mlle V . . .* (cat.
139), and *Young Man in the Costume of a Majo* (cat.
140). The basket of props and costumes holds items
that were necessary to Manet's creation of a fictional
Spain; he discarded these after his journey there in
1865. The basket appeared in its final, isolated form
as a vignette adorning the wrapper for a set of prints
offered by the artist to his closest friends.

JW-B

1. Rouart and Wildenstein 1975, vol. 1, no. 247.
2. The picture was photographed, along with almost all the
 works in the studio, by Fernand Lochard. Rouart and
 Wildenstein 1975, vol. 1, p. 60, indicates that the painting
 was retouched, but this has never been investigated.
3. "un ornement architectural." Tabarant 1931, no. 49. This
 interpretation was followed in Paris–New York 1994–95.
4. The possibility of a cut canvas was raised by this author
 (Tokyo–Fukuoka–Osaka 1986, p. 152, no. 5). The left edge
 of the present canvas is substantially cropped with respect
 to the corresponding area on the right—in reverse—of the
 print. Only technical examination and X-ray will substanti-
 ate this hypothesis.
5. "si Édouard Manet a peint des *espada* et des *majo,* c'est qu'il
 avait dans son atelier des costumes espagnols et qu'il les
 trouvait beaux de couleur." Zola 1867a, p. 27; 1867b, p. 53;
 1959, p. 93.

133. Fig. 9.21

Édouard Manet

Boy with a Sword

1860–61
Oil on canvas
51⅛ x 36¾ in. (131.1 x 93.4 cm)
Signed lower left: *Manet*
The Metropolitan Museum of Art, New York, Gift
of Erwin Davis, 1889 89.21.2

CATALOGUES RAISONNÉS: Tabarant 1931, no. 42;
Orienti 1967, no. 37; Rouart and Wildenstein 1975,
vol. 1, no. 37

PROVENANCE: The artist's studios, rue de Douai,
1860?, and rue Guyot, Paris, 1861–70; on deposit
with Théodore Duret, September 1870–71; the
artist's studio, rue Guyot, 1871; bought for 1,200
francs by Alexis-Joseph Febvre, Paris, before
January 1872 (the artist's tabbed notebook);
bought from Febvre for 1,500 francs by Durand-
Ruel, Paris, January 8, 1872 (Paris stock 930; on
deposit with Alfred Edwards against a loan to
Durand-Ruel); anonymous sale (Edwards),
Hôtel Drouot, Paris, February 24, 1881, no. 39,
repr. (etching by Bracquemond), bought for 9,100
francs by Jules Feder; Durand-Ruel, Paris,
February 25, 1881 (Paris deposit 3080), bought from
Feder, June 28, 1881 (Paris stock 1880–84: 1135);
bought for 10,000 francs by J. Alden Weir, Paris,
June 27, 1881, as agent for Erwin Davis; Erwin
Davis, New York; his sale, Ortgies & Co.,
Chickering Hall, New York, March 19–20, 1889,
no. 141, bought in at 6,700 dollars; Davis's gift to
The Metropolitan Museum of Art, New York, 1889
(see Weitzenhoffer 1981, p. 127)

EXHIBITIONS: Bordeaux 1862, no. 438 *(Enfant
portant une épée);* Brussels 1863, no. 755; Paris
1863, no. 134; Paris 1867, no. 4; Marseille, Société
Artistique des Bouches-du-Rhône, 1868–69; New
York 1883a, no. 153 (Davis coll.); New York 1886,
no. 303 (Davis coll.); [see Rouart and Wildenstein
1975 for further early exhibitions]; Paris–New York
1983, no. 14; Stockholm 1985, no. 59; Paris 2002–3,
no. 73

REFERENCES
19th century: Chesneau 1863, pp. 148–49; Maire
1869, p. 2; Godet 1872, no. 16 *(Enfant à l'épée,*

photograph); Durand-Ruel 1873, vol. 1, pl. LVI (*Enfant à l'épée*, etched by Bracquemond); Armand Silvestre in ibid., p. 24; Wolff 1886, p. 220[1]

20th–21st century (selected references): [see Rouart and Wildenstein 1975 for further references]; Weitzenhoffer 1981; Colette Becker, "Lettres de Manet à Zola," in Paris–New York 1983, p. 522, letter 13 (Paris ed.); Manet 1991, pp. 29, 49; George Mauner, "Manet and the Life of *Nature morte*," in Paris–Baltimore 2000–2001, p. 21; Meller 2002, p. 92

The critics who railed against the excesses of Manet's painting—the patches of uniform color, the absence of modeling, the lack of "finish"—invariably returned to *Boy with a Sword* as an example of what this talented but exasperatingly nonconformist painter was capable of. Manet himself held the work in high esteem and used it as the subject matter for his first experiments in etching (cat. 174). The model, young Léon Leenhoff, son of his model and future wife Suzanne, grasps a large sword—a studio prop that reappears in another of Manet's early etchings (cat. 172). Léon's short pants are similar to those of the boy portrayed in *The Young Lange* (cat. 134), but his costume also suggests seventeenth-century Dutch or Spanish precedents, while the pose recalls that of the tray-bearing boy in a Zurbarán that had graced the Galerie Espagnole (fig. 7.13). However, it has also recently been suggested that the model's pose owes as much, if not more, to an Italian work that Manet studied and drew on his visit to Italy in 1857.[2]

Manet might have presented this painting at the Salon if it had been an annual event in the early 1860s. He evidently pinned his hopes on selling it and showed it at least five times between 1862 and 1871 or early 1872,[3] when it was acquired by the dealer Alexis-Joseph Febvre. Although overshadowed by many striking new works when it was included in the 1863 exhibition at Galerie Martinet, it was described by the critic Ernest Chesneau as "a very fine painting, of unusual sincerity and feeling."[4] But Paul Mantz, who preferred to discuss Manet as "a Parisian Spaniard mysteriously related to the school of Goya," was more interested in such works as *The Spanish Singer*, *The Spanish Ballet*, and *Lola de Valence* (cats. 131, 136, 138).[5]

JW-B

1. Albert Wolff, in 1886, referred to an exhibition of *Boy with a Sword* at the Cercle de l'Union Artistique, rue de Choiseul, implying that this occurred after Manet's visit to Madrid, yet before 1863. Antonin Proust (1897) also misdated the visit to Spain to the early 1860s. Wolff's reference, which led Rouart-Wildenstein (1975) to posit an exhibition of about 1861–62, may indicate the existence of a later, unidentified showing of the work. I am grateful to the Wildenstein Institute and Sophie Pietri for information on exhibitions, particularly those in 1862 in Bordeaux and in 1868–69 in Marseille and their related references.

2. See Juliet Wilson-Bareau's essay "Manet and Spain" in this publication and Meller 2002, p. 92. Compare the motif of the boy with a tray in *Spanish Cavaliers* (cat. 130).

3. See n. 1 above. In an undated letter to Louis Martinet (perhaps of 1863, perhaps recording an earlier showing of the picture), Manet advised the gallery owner that he "would like *one thousand* francs for it," but would let it go for eight

hundred ("J'en désirerais *mille* francs, cependant je laisserais à votre *juste* appréciation de le laisser à huit cents francs"). Manet 1991, p. 29. In an annotated copy of the 1862 Bordeaux exhibition catalogue, the picture is priced at 1,500 francs.

4. "une très-bonne et d'un sentiment de couleur et de sincérité fort rare." Chesneau 1863, p. 149. See Hamilton 1986, pp. 38–39.

5. "un espagnol de Paris, et qu'une parenté mystérieuse rattache à la tradition de Goya." Mantz 1863, p. 383. See Hamilton 1986, pp. 39–40.

134. *(New York only)* *Fig. 9.22*

Édouard Manet
The Young Lange

Ca. 1861
Oil on canvas
46⅛ x 28 in. (117 x 71 cm)
Signed and inscribed lower right: *à M^me h. Lange / Ed. Manet*
Staatliche Kunsthalle Karlsruhe 2482

CATALOGUES RAISONNÉS: Tabarant 1931, no. 59; Orienti 1967, no. 57; Rouart and Wildenstein 1975, vol. 1, no. 61

PROVENANCE: Lange family, Paris; Bernheim-Jeune, Paris, September 1911; Dr. von Frey, Paris, November 1911; Thannhauser Gallery, Munich, 1913; P. von Bleichert, Leipzig; Müller, Soleure (Switzerland); Howard Young, New York, 1930; Mrs. Louis C. Coburn, Chicago; sale, Parke-Bernet, New York, March 2, 1944, no. 57; Ralph C. Colin, New York; Wilhelm Grosshenning, Düsseldorf, 1962; bought for the Staatliche Kunsthalle Karlsruhe, 1962

EXHIBITIONS: [see Rouart and Wildenstein 1975 for exhibitions, 1948–63]

SELECTED REFERENCES: [see Rouart and Wildenstein 1975 for references to 1970]

This striking portrait, little known and rarely exhibited, has never been fully investigated in the context of Manet's paintings of the early 1860s; even the identity of the child, known as "le jeune Lange" (the Lange boy), remained unverified for many years. Manet dedicated the picture in a corner of the can-

vas "to Mme h. Lange" (the lower-case *h* sometimes read as *n*), who was assumed to be the child's mother. The name Lange appears in Léon Leenhoff's notes of the ladies who attended the Manet family's *mardis*, the Tuesday salons hosted from 1864 by Manet's widowed mother and his wife.[1] The corresponding list of males who attended the Manets' Thursday salons does not include a M. Lange. However, his name appears beneath a carte-de-visite portrait in the Manet family photograph album: a seated gentleman identified by a penciled inscription as "Lange." The next photograph shows a nameless child.[2] Although the penciled "1861" on the back of that card accords with the date proposed for Manet's portrait, the photograph appears to portray a girl, and any identification with the child in the painting is unlikely or at most hypothetical.[3]

The identity of Manet's young model is confirmed and given a context by a letter from Théodore Duret to the Danish collector Wilhelm Hansen, who was considering the purchase of the picture. On October 4, 1916, Duret wrote, "Dear Sir, The Manet in the photograph you have sent me is the portrait of the young Lange boy. His father M. Lange was one of M. de Lesseps's collaborators at the time of the construction of the Suez Canal. The person who owned the portrait before the war was asking 80 thousand francs for it, but I think you should now be able to get it for between 30 and 50 thousand francs."[4]

The portrait, like so many of Manet's works, was probably painted on a previously used canvas. Forms and colors that have nothing to do with the boy or his immediate context are visible in many places, particularly where the child is most boldly and summarily sketched, and there are traces of extensive scraping in the background areas. Whether the underlying painting, or fragment of a painting, can be identified remains to be seen. The image of this engaging child is unique in Manet's early work and provokes speculation concerning the circumstances of its creation. Further research into the identity of the child's father may add to our understanding of the context and dating of this splendid early example of Manet's work.

JW-B

1. Leenhoff's manuscript notes were compiled for an article published in *Journal des Curieux*, no. 27 (March 10, 1907), at a time when he was seeking to sell the portrait *Madame Manet mère* (Rouart and Wildenstein 1975, vol. 1, no. 62). Titled "Portrait de la mère de l'artiste," the manuscript is in the Tabarant archive, Pierpont Morgan Library, New York (see p. 5 for Mme Lange). The ladies' names are not reproduced in the article; the men's names in the manuscript were evidently drawn from lists of various dates.

2. The photographs are identified as pages 21d and 22a in the *Album de photographies ayant appartenu à Manet* (Bibliothèque Nationale de France, Paris, Département des Estampes et de la Photographie, Na 115 in-4°, microfilm T.038513 and T.038514). The first, of M. Lange, is by Dagron, 66, rue Neuve des Petits-Champs; the second, of the child, is by Ad. Anjoux, 270, rue St.-Honoré, with the manuscript date 1861 on the verso.

3. Little boys were often clothed in dresslike garments at that time, and the round face, full cheeks, and prominent ear in this image are not unlike those of the child in Manet's portrait. However, the fashionably trimmed dress and a

coiffure that suggests a chignon or a plait support the view that the child is a girl. I am grateful to Sylvie Aubenas for providing information concerning the two carte-de-visite photographs in the album, and for her opinion concerning the child's dress.

4. "Cher Monsieur/ Le Manet dont vous m'envoyez la photo est le portrait du jeune Lange. Son père M. Lange, à l'époque de la création du Canal de Suez, était un des collaborateurs de M. de Lesseps. La personne qui possédait ce portrait, avant la guerre, en demandait 80 mille francs, mais il me semble que vous devriez l'avoir présentement entre 30 et 50 mille francs." The text of Duret's letter (Ordrupgaard Archives, box 2, acc. no. 1978/156, letter 2) and details of its original publication were kindly provided by Thomas Lederballe. See Rostrup 1981, p. 72 (extracted in Rostrup 1982, p. 104). I am indebted to Sophie Pietri, of the Wildenstein Institute in Paris, for drawing my attention to Rostrup's article and for informing me that a M. Daniel Adolphus Lange was part of the International Commission for the creation of the Suez Canal (work began in April 1859 and the canal was inaugurated by Empress Eugénie ten years later).

135. *Fig. 9.17*
Édouard Manet
The Water Drinker (The "Régalade")

1861–62 *(The Gypsies)*; canvas cut, fragment reworked ca. 1868–72
Oil on canvas
24⅜ x 21⅜ in. (61.8 x 54.3 cm)
Signed lower right: *Manet*
The Art Institute of Chicago, Bequest of Katharine Dexter McCormick 1968.303

CATALOGUES RAISONNÉS: Tabarant 1931, no. 45; Orienti 1967, no. 46; Rouart and Wildenstein 1975, vol. 1, no. 43

PROVENANCE: The artist's studios, rue Guyot, 1862 [uncut canvas]–1868–70 [cut canvas?]/1872 (inventory: *La régalade,* valued at 600 francs), and 4, rue de Saint-Pétersbourg, July 1872–75; bought for 1,500 francs by Hubert Debrousse, Paris, September 1875 (*Le buveur d'eau,* the artist's account book); Durand-Ruel, Paris (Paris stock 2780, label on stretcher); [unconfirmed collections: see Rouart-Wildenstein 1975, vol. 1, no. 43]; Charles Ephrussi, Paris (?); Dreyfus-Gonzalès, Paris, 1912?–31 (Tabarant 1931, no. 45); Paul Rosenberg (Tabarant 1947, p. 50); Bernheim-Jeune, rue Lafitte,

Paris (label on stretcher); Mr. and Mrs. Stanley McCormick, Chicago, by 1932; Mrs. Stanley McCormick, Chicago, 1947; her bequest to The Art Institute of Chicago, 1968

EXHIBITIONS: [Paris 1863 (*Les Gitanos,* uncut canvas)]; [Paris 1867, no. 9 (*Les Gitanos,* uncut canvas)]; Paris 1884, no. 27 (*Le Buveur d'eau,* lent by Hubert Debrousse); [see Rouart and Wildenstein 1975 for further early exhibitions]; Tokyo–Fukuoka–Osaka 1986, no. 4; Paris 2002–3, no. 74

REFERENCES
19th century: Salon 1865, p. 87, repr. (of a drawing by Manet; Rouart and Wildenstein 1975, vol. 2, D371, detail of the uncut canvas); Randon 1867, p. 7 (*Les Gitanos,* uncut; caricature)

20th century (selected references): [see Rouart and Wildenstein 1975 for further references]; Hanson 1970; Stuckey 1983, pp. 161–62; Wilson-Bareau 1989, pp. 31, 34, fig. 9 (Manet's account book); Manet 1991, p. 170 (letter to Duret)

In 1862 Manet painted a large, ambitious picture depicting a family of gypsies in the countryside. Apparently discouraged by its effect, he cut the canvas into several pieces after only two public showings, one in 1863, the other in his retrospective exhibition of 1867. After completing the painting, he had published a handsome reproductive etching (cat. 169) that, as so often with Manet's prints, presents the picture in reverse. In a caricature made by Randon at the time of the 1867 exhibition (fig. 9.19), the entire painting is seen for the last time but as an object of mockery. Manet's original composition was a bold patchwork of motifs drawn from a variety of old-master sources, chief among them Murillo's *Beggar Boy* (fig. 2.32) and Velázquez's *Philip IV as a Hunter* (cat. 77), a studio replica that had just been acquired as an original by the Louvre. Manet had immediately drawn and etched the Louvre's new "Velázquez," absorbing its lessons for his art (cat. 165). Today, the only fragment that is known of *The Gypsies* is the motif of the boy drinking Spanish style (*à la régalade*) from the pitcher. X-radiography has determined that this painting was undoubtedly part of the lost canvas: it reveals the head of the gypsy woman beneath the boy's repainted shirt, and the dark ground obscures the blue sky full of clouds in the original composition. The unified ground throws the figure into relief, highlighting the boy's sensitively brushed head. His vigorous gesture may have been inspired as much by Ribera's *Beggar* (cat. 61) as by Murillo's *Beggar Boy.*

The transformation of this fragment reveals how skillful Manet was in reworking his canvases. The picture remained in his studio in spite of efforts to sell it, as recorded in Manet's letters to Duret. However, having valued the work at 600 francs in 1872, the artist sold it for almost three times that price in 1875, when it was purchased by the collector Hubert Debrousse. The transaction was noted on a page that became detached from the book in which Manet kept his accounts and has emerged only in recent years to complete the history of the work.

JW-B

136. *Fig. 9.41*
Édouard Manet
The Spanish Ballet

1862
Oil on canvas
24 x 35⅞ in. (60.9 x 90.5 cm)
Signed and dated lower right: *éd. Manet 62*
The Phillips Collection, Washington, D.C. 1250

CATALOGUES RAISONNÉS: Tabarant 1931, no. 50; Orienti 1967, no. 46; Rouart and Wildenstein 1975, vol. 1, no. 55

PROVENANCE: The artist's studio, rue Guyot, Paris, 1862–70; on deposit with Théodore Duret, Paris, September 1870–71; the artist's studio, rue Guyot, 1871–72 (tabbed notebook: *le ballet espagnol,* valued at 3,000 francs); bought for 2,000 francs by Durand-Ruel, Paris, January 1872 (Paris stock 964); bought for 110,000 dollars by Duncan Phillips, Washington, D.C., December 1928

EXHIBITIONS: Paris 1863; Paris 1867, no. 28; Reims 1874, no. 715 (lent by Durand-Ruel); London 1883, no. 41; Paris 1884, no. 12 (lent by Durand-Ruel); New York 1895a, no. 18; Vienna Secession, 1903, "Entwicklung des Impressionismus in Malerei und Plastik," no. 33 (*Spanische Tänzer*); London 1905c, no. 85 (*Spanish Dancers*); Paris 1912b, no. 85; [see Rouart and Wildenstein 1975 for further early exhibitions]; Washington 1982–83, no. 32; Paris–New York 1994–95, no. 86; Paris 2002–3, no. 79

REFERENCES
19th century: Salon 1865, p. 87, repr. (detail of a drawing; Rouart and Wildenstein 1975, vol. 2, D371); [see Rouart and Wildenstein 1975 for further early references]

20th century (selected references): Flint 1984, p. 361; McCauley 1985, pp. 173–79

In 1862, the Parisian public could once again enjoy a popular spectacle: a troupe of Spanish dancers directed by "don Mariano Camprubi, primer bailarin del teatro royal de Madrid," according to the caption on the print after Manet's painting (cat. 175). The dancers had presented their ballet *Flor di Sevilla* (Flower of Seville) at the Odéon theater in April, but Manet, Zacharie Astruc, Baudelaire, and their friends probably saw the performances at the Hippodrome between August and November, since the works produced as a result of Manet's involvement with the troupe all came to fruition the following

year.[1] Although the canvases of *The Spanish Ballet*, *Lola de Valence* (cat. 138), and *The Dancer Mariano Camprubi* (cat. 137) were painted and in two cases dated in 1862, two if not all three made their first appearance at Galerie Martinet in March 1863. On March 7, Manet's lithograph based on Lola appeared as a sheet-music cover (cat. 180); in May, his etching after Lola (cat. 181) was displayed in the Salon des Refusés, together with two prints "after Velázquez": *The Little Cavaliers* and *Philip IV* (cats. 164, 165). Finally, the etching of Lola de Valence was issued privately, together with that of Mariano Camprubi, in a collection of Manet's prints, and was also published by the Société des Aquafortistes in the October 1863 issue of *Eaux-fortes modernes*.

The Spanish Ballet is structured very much along the lines of *The Little Cavaliers*. Dancers and musicians are spaced across the canvas without any indication of a defined space or setting. There is a story that Manet arranged for the troupe to pose for him in the large studio that belonged to his friend Alfred Stevens.[2] However, the fragmentary nature of the composition, a surviving pencil sketch possibly made at the Hippodrome, and the existence of carte-de-visite photographs of some of the dancers[3] suggest that the picture was essentially created by the artist in his rue Guyot studio. The dancers are flanked by two guitarists, one seated, the other standing. Lola Melea sits on a chair in front of a table set with a bottle and glasses, while a male dancer stands beside her.[4] Anita Montés and Mariano Camprubi are dancing the bolero to the accompaniment of their castanets, their figures modeled with exquisite precision, down to the gleaming highlight that descends the ballerina's silk-stockinged leg ending in two touches of impasto on her foot. In the background to the left, two cloaked and hatted figures, derived from one of Goya's *Tauromaquia* etchings (cat. 39), look on, while a bouquet wrapped in paper and tossed as if onto a stage and the green stool on which Manet had posed his *Spanish Singer* (cat. 131), placed at lower right, serve to underline the mélange of fiction and reality in the scene.

The deliberate unreality of the picture is further established by the fact that Manet painted an entirely fictional pendant to his ballet scene in *The Tavern* (*La Posada*) (fig. 9.46),[5] a work in which the same props of table and bench reappear, but where all the figures are bullfighters rather than dancers. The title, probably invented when Léon Leenhoff catalogued the picture in 1883, suggests that its subject was not recognized two decades after its execution: it shows a group of bullfighters before the corrida, one of them on the left doffing his hat to an image of the Virgin flanked by lighted candles.[6] One bullfighter sits on the studio bench, while another lights a cigarette, half-seated on the table—a motif that reappears several years later in a small painting of Manet's studio (fig. 9.8).

The propriety of pairing these pictures is borne out by the fact that Manet made tracings of both, perhaps from photographs, as preparations for etchings. Both drawings are executed in graphite on tracing paper (now yellowed), with the additions of

ink wash, watercolor, and gouache (fig. 9.40).[7] Both were incised for transfer to a copperplate, but only the etching of *The Tavern* is known, and that in a unique impression (cat. 176).

JW-B

1. The dates of the autumn performance have been variously reported. According to Tabarant 1947, p. 52, the dancers performed from August 12 and were featured on posters for the Hippodrome until its annual closure on November 2. Henri Loyrette, in Paris–New York 1994–95, p. 395 n. 1, quoted from a contemporary journal, *L'Entracte* of August 12, 1862, announcing the start of the troupe's performance and an "exceptional daily performance until next Sunday" ("représentation extraordinaire tous les jours jusqu'à dimanche prochain"). However, after its launch on a Tuesday, the ballet was, no doubt, interspersed with other acts and repeated less frequently over time.

2. The story was told, as so often is the case, by Tabarant, whose sources of information were the Manet family and surviving friends of the artist. There is no corroboration from contemporary sources in the 1860s.

3. A single pencil sketch, out of many that probably were made at the time (Rouart and Wildenstein 1975, vol. 2, D531), has survived, perhaps because Manet used it as the basis for a brush-and-wash drawing reproduced in Salon 1865, p. 87 (see Paris 1978, no. 10). For the carte-de-visite photographs, see McCauley 1985, figs. 171–73, 176.

4. Manet took these two figures as one of the motifs for his drawing; see n. 3.

5. Rouart and Wildenstein 1975, vol. 1, no. 110 (misdated to 1865–66, as part of the group of bullfight scenes painted on Manet's return from Spain). The catalogue cites the dimensions given in Léon Leenhoff's register of works in Manet's studio: 20⅝ x 35 in. (52 x 89 cm), where the picture was listed as belonging to Alfred Stevens, who lent it to the 1884 retrospective exhibition of Manet's work.

6. The painting, in the Hillstead Museum, Farmington, Connecticut, can never be lent and has escaped close study. See the comments of Bois 1994, p. 134. The subject of the bullring chapel ("La chambre de la vierge") is one of the scenes in an engraving entitled *Les Combats de taureaux, au Havre*, in *Le Monde Illustré* (May 30, 1868), p. 340.

7. For the drawing of *The Tavern* (*La Posada*) (private collection), see Rouart and Wildenstein 1975, vol. 2, D534; Tokyo–Fukuoka–Osaka 1986, no. 38, repr. p. 74; Bois 1994, pp. 136–37, repr. (enlarged).

137. *(New York only)* Fig. 9.38

Édouard Manet

The Dancer Mariano Camprubi

1862–63
Oil on canvas
18½ x 13 in. (47 x 33 cm)
Signed and dated lower right: *éd. Manet 62*
Private collection, United States

CATALOGUES RAISONNÉS: Tabarant 1931, no. 52; Orienti 1967, no. 48; Rouart and Wildenstein 1975, vol. 1, no. 54

PROVENANCE: Camentron, Paris, before 1913; Carl O. Nielson, Oslo, by 1922; Knoedler, New York; Henry R. Ickelheimer, New York; Mr. and Mrs. Donald S. Stralem, New York; private collection

EXHIBITIONS: Paris 1863; Paris 1912a, no. 66; Stockholm 1922; [see Rouart and Wildenstein 1975

for further early exhibitions]; Philadelphia–Chicago 1966–67, no. 42; Washington 1982–83, no. 33

SELECTED REFERENCES: [see Rouart and Wildenstein 1975 for early references]; Washington 1982–83, p. 110; McCauley 1985, pp. 173, 179–81; Bois 1994, pp. 98–101; Henri Loyrette in Paris–New York 1994–95, p. 395

The caption to Manet's etching *Don Mariano Camprubi* (cat. 175) describes him as *primer bailarin*—the male equivalent of prima ballerina—at the Teatro Royal in Madrid. This small painting must have been signed and dated by the artist on or soon after its completion (the form of the inscription is restricted to these early years), possibly for its exhibition at Galerie Martinet in March 1863, and it may have been sold or given away by Manet during the 1860s.[1] Boldly brushed in brilliant colors, Camprubi cuts a dashing figure, yet his face with its tranquil, pensive expression is no longer that of a young man. At more than sixty years of age, he was the most senior member of the ballet troupe and had performed on the Paris stage as early as 1834.[2] The presentation of the figure in the painting and its caption in the print recall the conventions of theater prints and carte-de-visite photographs.[3] However, it is hard to believe that Manet did not come face to face with Camprubi, brush in hand, in order to construct this swiftly sketched, vividly colorful image.

The small size of the single-figure painting is unusual, and tracings of scraping and disturbance in the background suggest that it may originally have been part of a larger, multifigure canvas, perhaps an early alternative version of *The Spanish Ballet* (cat. 136). This image of Camprubi—which is comparable in scale with Goya's portrait *Asensio Juliá* (cat. 6) and with the *Woman in Spanish Costume* that entered the Louvre in 1865 (cat. 13)—was reproduced by Manet in the above-mentioned etching of 1863 and copied as a three-quarter-length figure in a drawing.[4] In these two works the chin strap that holds Camprubi's hat in place is a prominent feature, while in the painting the strap that follows the line of the jaw has disappeared and the head appears to sit straighter on the neck. The finely detailed painting of the dancer's features contrasts with the very summary treatment of the rest of the canvas, reinforcing the impression that a sketch of the

dancer may have been transformed by Manet into a more finished portrait of the aging star.[5]

JW-B

1. The early history of the picture is unknown. The signature and date suggest that this may have been one of the three as yet unidentified works out of the fourteen that Manet showed at Galerie Martinet in 1863. It does not appear in the photographs taken by Godet, the artist's customary photographer from at least the early 1870s, nor was it among the works photographed by Fernand Lochard in Manet's studio or in accessible collections soon after the artist's death in 1883.

2. See reproductions of a lithograph of that date in Washington 1982–83, fig. 58, and Bois 1994, p. 98.

3. McCauley 1985 suggests several specific sources in photographs by Weyler.

4. The brush-and-India-ink drawing (Rouart and Wildenstein 1975, vol. 2, D461) may have been made slightly later for reproductive purposes; it is stylistically similar to the drawing, including Spanish ballet motifs that was reproduced in Salon 1865, p. 87 (Rouart and Wildenstein 1975, vol. 2, D371).

5. The handling of the figure of Camprubi may be compared with that of Manet's small plein-air sketch portrait of Ambroise Adam, painted in July 1861 (see Wilson-Bareau 1984, fig. 10). If the face was reworked, the Weyler photograph or similar ones of Camprubi (which do not show the chin strap) may have served as an *aide-mémoire*.

138. *(Paris only)* Fig. 9.44

Édouard Manet

Lola de Valence

1862–63; reworked after 1867
Oil on canvas
48⅜ x 36¼ in. (123 x 92 cm)
Signed lower left: *éd. Manet*
Musée d'Orsay, Paris RF 1991

CATALOGUES RAISONNÉS: Tabarant 1931, no. 51; Orienti 1967, no. 47; Rouart and Wildenstein 1975, vol. 1, no. 53

PROVENANCE: The artist's studio, rue Guyot, Paris, 1863–70; on deposit with Théodore Duret, Paris, September 1870–71; the artist's studio, rue Guyot, 1871–72 (inventory: valued at 5,000 francs), and 4, rue de Saint-Pétersbourg, July 1872–73; bought for 2,500 francs by Jean-Baptiste Faure,

Paris, November 18, 1873 (*Danseuse*, Manet's account book); Camentron and Père Martin, Paris; bought for 15,000 francs by Comte Isaac de Camondo, Paris, July 1893–1911; bequeathed to Musée du Louvre, Paris, 1914; Musée du Jeu de Paume, Paris, 1947; Musée d'Orsay, Paris, 1986

EXHIBITIONS: Paris 1863, no. 129 (plain background); Paris 1867, no. 17 (plain background); Paris 1884, no. 14 (Faure coll.); [see Rouart and Wildenstein 1975 for further early exhibitions]; Washington 1982–83, no. 32; Paris–New York 1983, no. 50; Paris–New York 1994–95, no. 87 (citing recent references)

REFERENCES

19th century: Salon 1865, p. 87, repr. (from a drawing by Manet, Rouart and Wildenstein 1975, vol. 2, D371, bust detail); Randon 1867, p. 6 (*Lola de Valence*, caricature); [see Rouart and Wildenstein 1975 for further early references]

20th century (selected references): Callen 1974, pp. 162–63, 171; [see Rouart and Wildenstein 1975 for further references]; McCauley 1985, p. 181; Darragon 1989, pp. 77–79; Henri Loyrette in Paris–New York 1994–95, pp. 396–97

Lola Melea, the star of a Spanish ballet troupe from Madrid, was portrayed by Manet as a formidably solid and muscular figure, not unlike Courbet's image of Adela Guerrero (cat. 101). The canvas, exhibited at Galerie Martinet in 1863, was accompanied by Baudelaire's famously suggestive lines evoking "le charme inattendu d'un bijou rose et noir"—the unexpected charm of a rose-pink and black jewel.[1] Even allowing for poetic license, there is a mismatch between Baudelaire's intimate evocation and the flamboyant combination of red, yellow, and green against the heavy black bell of the dancer's skirt. However, his words find a literal echo, and perhaps their source, in another image of Lola: the small painting *The Spanish Ballet* (cat. 136), in which the seated dancer's pink skirt, its flounces edged with black, parallels the erotic harmony of the poet's verse.

After 1867 Manet enlarged and transformed this canvas, adding the theater decor and the glimpse of the stage and house in the background.[2] In its original state, known from the artist's contemporary prints and drawings and from caricatures, the dancer was set against a neutral ground, like the figures in the majority of such paintings by Manet. In that form, the picture must have appeared strikingly spare and modern compared with Courbet's dancer, who was flanked by a heavy curtain and set against a "Romantic" backdrop. Goya's *Duchess of Alba* (fig. 11.8), once part of the display in the Galerie Espagnole, has been cited as a possible source but it is a distant and tenuous one. Manet's *Lola de Valence* no doubt owes more to the tradition of popular theater portraiture than to high-art portrait conventions of the Spanish school. Elizabeth McCauley (1985) has explored its relationship with contemporary carte-de-visite photography and a photographic image of the real Lola Melea. The addition of stage scenery behind Lola and a glimpse of the interior of

a theater—a far cry from the circus environment of the Hippodrome, where the Spanish ballet actually performed—may have been a concession to the picture's first owner, the opera singer Jean-Baptiste Faure, who acquired the work in 1873.

The framed painting of *Lola de Valence* is seen in Manet's studio in a small oil sketch of about 1869–70. The image is too summarily brushed to show whether the background of the painting had already been reworked, but the presence of a "quotation" from one of Manet's earlier Spanish pictures—the toreador perched on a table in the painting known as *The Tavern (La Posada)* (fig. 9.46)—suggests that Manet was reconnecting with his Spanish past while painting what may be a version of *The Balcony* (cat. 155), seen on the easel.[3] The work is contemplated by Eva Gonzalès, the Franco-Spanish beauty who was his pupil at this time and of whom Manet painted a formal portrait as an artist (1870, National Gallery, London), as in 1862 he had portrayed Lola Melea in her role as dancer.

JW-B

1. Baudelaire 1975–76, vol. 1, p. 168.

2. It is possible that the present signature, very softly and freely brushed, was added after the canvas was reworked and that it has obliterated the original signature and even a date; the canvas of the principal male dancer Mariano Camprubi (cat. 137) and that of *The Spanish Ballet* (cat. 136), are both signed and dated 1862.

3. On the basis of the instrument lying in the foreground of the studio sketch, the picture on the easel has also previously been identified as *The Bugler*, shown by Eva Gonzalès at the Salon of 1870. See Manet 1991, pp. 150, 309, pl. 108; for *The Bugler*, see London 1992, p. 70.

139. Fig. 9.34

Édouard Manet

Mlle V . . . in the Costume of an Espada

1862
Oil on canvas
65 x 50¼ in. (165.1 x 127.6 cm)
Signed and dated lower left: *éd. Manet 1862*
The Metropolitan Museum of Art, New York, H. O. Havemeyer Collection, Bequest of Mrs. H. O. Havemeyer, 1929 29.100.53

CATALOGUES RAISONNÉS: Tabarant 1931, no. 54; Orienti 1967, no. 51; Rouart and Wildenstein 1975, vol. 1, no. 58

PROVENANCE: The artist's studio, rue Guyot, Paris, 1862–70/72 (*une f*[emme] *en cost*[ume] *de majo/toréador*, valued at 4,000 francs); bought for 3,000 francs by Durand-Ruel, Paris, January 1872 (*le Toréador*, Paris stock 954); bought for 5,000 francs by Jean-Baptiste Faure, Paris, February 16, 1874; deposited by Faure with Durand-Ruel, Paris, November 11, 1896–January 9, 1897 (*Femme torero*, Paris deposit 9021); on deposit with Durand-Ruel, September 11, 1897–August 30, 1898 (*Toréador*, Paris deposit 9182); bought for 45,000 francs by Durand-Ruel, Paris, December 22, 1898 (*Femme toréador*, Paris stock 4906); Durand-Ruel, New York, December 28, 1898, Paris (stock book), or January 21, 1899, New York (New York stock 2095); bought for 15,000 dollars by Mr. and Mrs. H. O. Havemeyer, New York, December 31, 1898; Mrs. H. O. Havemeyer, New York, 1907–29; her bequest to The Metropolitan Museum of Art, New York, 1929

EXHIBITIONS: Paris, Salon des Refusés, 1863, no. 365 (*Mademoiselle V. en costume d'espada*); Paris 1867, no. 12 (*Mlle V. . . en costume d'espada*); Paris 1884, no. 15 (lent by Faure); [see Rouart and Wildenstein 1975 for further early exhibitions]; Paris–New York 1983, no. 33; New York 1993b, no. A 344; Paris–New York, 1994–95, pp. 396–97, no. 90; Paris 2002–3, no. 78

REFERENCES
19th century: Godet 1872, no. 12 (*Jeune Toréador*, photograph); [see Rouart and Wildenstein 1975 for further early references]

20th–21st century (selected references): Farwell 1969; Callen 1974, p. 163; Farwell 1981, pp. 164–65; McCauley 1985, pp. 181, 185; George Mauner, "Manet and the Life of *Nature morte*," in Paris–Baltimore 2000–2001, p. 14; Meller 2002, p. 81 n. 67

In 1862, Manet met the professional model who was to assume such a major role in his paintings. Victorine Meurent, a redhead with milk-white skin, was at once elegant and amusing and could play the guitar as well as pose. She replaced the buxom Suzanne as nymph or Venus in the ambitious paintings still in progress in the studio. Indeed, the contours of one of these two models lie hidden beneath the figure of the female toreador; X-radiography shows a large study of a nude whose forms are half-glimpsed under the pink cape. Manet turned the canvas he had sketched out upside down in order to develop the curious composition of our toreador.

The model's pose is based on engravings of grave and graceful allegorical figures of the Virtues by Marcantonio Raimondi, after Raphael. In this instance, the image is a conflation of Temperance, traditionally shown holding bridle and reins, and Justice brandishing her sword. Yet these Italian sources have also been transformed and given a Spanish twist. Indeed, Manet has combined his orig-

inal sources in a highly sophisticated way. Some critics have even detected the influence of Japanese prints in the dislocated spatial arrangement within the picture, in which the motifs of picador and bull in the middle distance and of toreros in the background were plucked from several different prints of Goya's *Tauromaquia* (cats. 38–41).[1] Manet's signed and dated picture was completed by September 1862, when his etching after it (cat. 166) was included in the set of prints published by Alfred Cadart. In May, the Louvre had acquired a very significant "Velázquez," the full-length portrait of Philip IV in hunting dress (cat. 77), of which Manet's vigorous etching was also included in his set of prints (cat. 165). The new work by the Spanish master acted as a powerful stimulus on Manet's art, and the piling-up of motifs and flattening of space in the right-hand area of his painting was probably a direct response to Velázquez's landscape background. In what Manet later realized was a studio copy, the magical effects of recession and aerial perspective in the original in the Prado have been reduced to a series of tonal bands that lie flat on the picture plane. But this misinterpretation of Velázquez's original by a studio assistant enabled Manet to reinvent, here and in such works as *The Gypsies* (cat. 169), the relationship between the picture plane and perspectival illusion. In this endlessly intriguing composition, Manet blended Spanish and Italian old-master references with images of modern Parisian life, drawn from recent ballets at the Paris Opera and recorded in carte-de-visite photographs of star ballerinas costumed and posing as an *espada* or *banderillero*.[2]
JW-B

1. See Farwell 1969.
2. McCauley 1985 reproduces a series of such carte-de-visite photographs by Disdéri. Charles Moffett, in Paris–New York 1983, pp. 110–14, summarized the many opinions that have been expressed concerning this picture.

140. *Fig. 9.37*

Édouard Manet
Young Man in the Costume of a Majo

1863
Oil on canvas
74 x 49⅛ in. (188 x 124.8 cm)
Signed and dated lower right: *éd. Manet 1863*
The Metropolitan Museum of Art, New York, H. O. Havemeyer Collection, Bequest of Mrs. H. O. Havemeyer, 1929 29.100.54

CATALOGUES RAISONNÉS: Tabarant 1931, no. 53; Orienti 1967, no. 49; Rouart and Wildenstein 1975, vol. 1, no. 70

PROVENANCE: The artist's studio, rue Guyot, Paris, 1863–70/72 (*majo*, valued at 1,500 francs, the artist's tabbed notebook); bought for 1,500 francs by Durand-Ruel, Paris, January 1872 (*L'Espagnol*, Paris stock 960); sold and reacquired by 1877(?) (Paris stock 1363); bought for 4,000(?) francs by Ernest Hoschedé, Paris, January 29, 1877 (with twenty-eight other works for 18,500 francs); bought

for 650 francs by Jean-Baptiste Faure at his sale, Hôtel Drouot, Paris, June 6, 1878, no. 43 *(Le Torréador)*; on deposit with Durand-Ruel, Paris, November 11, 1896–January 9, 1897 (Paris deposit 9183); bought for 20,000 francs by Durand-Ruel, Paris, December 31, 1898 (*Portrait de son frère, costume de majo*, Paris stock 4933); bought by Durand-Ruel, New York, January 24 (Paris stock book) or February 9, 1899 (*Le majo*, New York stock 2107); bought for 10,000 dollars by Mr. and Mrs. H. O. Havemeyer, New York, February 24, 1899; Mrs. H. O. Havemeyer, New York, 1907–29; her bequest to The Metropolitan Museum of Art, New York, 1929

EXHIBITIONS: Paris, Salon des Refusés, 1863, no. 364 (*Jeune homme en costume de Majo*); Paris 1867, no. 13; London 1874b, no. 4 (*A Spaniard*); Paris 1884, no. 11 (lent by Faure); [see Rouart and Wildenstein 1975 for further early exhibitions]; Paris–New York 1983, no. 72; New York 1993b, no. 345; Paris 1997–98, no. 23; Paris 2002–3, no. 81

REFERENCES
19th century: Saint-Victor 1863; Bürger 1863; [see Rouart and Wildenstein 1975 for further early references]

20th–21st century (selected references): Callen 1974, pp. 163, 167; Flint 1984, p. 359; McCauley 1985, p. 185; Distel 1990, pp. 77, 83, 104; Havemeyer 1993, pp. 7, 224, 307–8 n. 10, 333 n. 322; Gary Tinterow, "La collection Havemeyer," in Paris 1997–98, pp. 19, 55–56, 105, no. 23; Meller 2002, p. 81 n. 67

This painting is so simple in its presentation—a solitary figure, standing at ease against a dark background—yet so bold and colorful in its effect that one could easily apply to it Paul de Saint-Victor's disparaging remarks about Manet and the exhibition that had taken place at Galerie Martinet: "Imagine Goya transported to Mexico, a Goya gone native in the middle of the pampas, daubing his canvases with crushed cochineal, and there you will have M. Manet, the latest Realist."[1] Gustave Manet, brother of the artist, is dressed as an Andalusian *majo*. With the black hat casting a shadow over the fixed expression of his dark eyes, his black beard, black jacket and breeches, and leather gaiters, he appears as an incarnation of Gautier's robustly romantic image of Spain.[2] Yet here, too, the pose looks back to a classi-

cal past, and Peter Meller (2002) has evoked the statue of the *Flute-Playing Faun* at the Louvre as a source. One could also see in this *majo* a reference to the *Farnese Hercules*, as he nonchalantly leans on his staff in lieu of a club, the lion's skin replaced by the "crushed cochineal" wrap draped over the arm of this young hero of modern life. Manet sent his *majo* to partner Victorine as an *espada* (cat. 139) at the Salon des Refusés. As described by Théophile Thoré, they flanked the *Déjeuner sur l'herbe* "to the left, a Spanish *majo*; to the right a Parisian girl in the costume of an *espada*."[3] The *Young Man in the Costume of a Majo* was painted in early 1863, four years after *The Absinthe Drinker* (cat. 128) and two and a half years before the artist's visit to Spain. Here, Manet's still limited but intuitive understanding of Velázquez, and what Zacharie Astruc called "his passion for all things Spanish"[4] in contemporary life, have fused to create an image that dispenses with any hint of narrative and boldly states its autonomy as a work of art. JW-B

1. "Imaginez Goya passé au Mexique, devenu sauvage au milieu des pampas, et barbouillant des toiles avec de la cochenille écrasée, vous aurez M. Manet, le réaliste de la dernière heure." Saint-Victor 1863.
2. Gautier 1845c, p. 211–12, 220–21; Gautier 1853b, pp. 162, 169.
3. Bürger [pseud. Thoré] 1863, quoted in Hamilton 1969, p. 50.
4. See cat. 147.

141.

Fig. 9.49

Édouard Manet

Dead Toreador

1863–64
Oil on canvas
29⅞ x 60⅜ in. (75.9 x 153.3 cm)
Signed lower right: *Manet*
National Gallery of Art, Washington, D.C.,
Widener Collection 1942.9.40

CATALOGUES RAISONNÉS: Tabarant 1931, no. 73; Orienti 1967, no. 64; Rouart and Wildenstein 1975, vol. 1, no. 72

PROVENANCE: The artist's studio, rue Guyot, Paris, 1863–70/72 (*Homme mort*, valued at 2,000 francs); bought for 2,000 francs by Durand-Ruel, Paris, January 1872 (*le Toréador mort*, Paris stock 935); bought for 3,000 francs by Jean-Baptiste Faure, Paris, February 9, 1874; bought for 16,000 francs by Durand-Ruel, Paris, 1892 (Paris stock 2561); bought for 20,000 or 30,000 francs by James S. Inglis, New York, 1893; Cottier & Co.,

New York; Peter A. B. Widener, Elkins Park, Pennsylvania, 1894; Joseph E. Widener, Philadelphia, 1915; his gift to the National Gallery of Art, Washington, D.C., 1942

EXHIBITIONS: Paris, Salon of 1864, no. 1282 (*Épisode d'une course de taureaux*, uncut canvas); Paris 1865 (*l'Espada mort*)(?); Paris 1867, no. 5 (*l'Homme mort*); Le Havre, Exposition Maritime Internationale, 1868; Paris 1884, no. 24 (*L'Homme mort [fragment du* Combat de taureaux], lent by Faure); Paris, Exposition Universelle, 1889, no. 488; Chicago, World's Columbian Exposition, 1893, no. 3057 (lent by Inglis); [see Rouart and Wildenstein 1975 for further early references]; Washington 1982–83, no. 77; Paris–New York 1983, no. 73; Stockholm 1985, no. 61; Cologne–Zurich–Lyon 1987–88, no. 45; London 1992, pp. 41–44, no. 26; Paris–New York 1994–95, no. 90; New York 1999; Paris 2002–3, no. 84

REFERENCES

19th century: Godet 1872, no. 22 (*Toréador tué,* photograph); Durand-Ruel 1873, vol. 2, pl. CXVII (*Toréador mort,* engraved by Flameng); [see Rouart and Wildenstein 1975 for further early references]

20th century (selected references): Hanson 1970, pp. 158–61; Callen 1974, pp. 163, 171

The perfection of this image of *The Dead Man*, as Manet called it—the sobriety and harmony of its lines and color—belies its difficult birth. At the same time that he sent his *Dead Christ and Angels* (cat. 142) to the 1864 Salon, Manet submitted an "incident at a bullfight" (*Épisode d'une course de taureaux*); it attracted protests and hilarity from both critics and the public. Written descriptions and three caricatures allow us to picture the original composition, which was criticized for its implausible perspective—a too-small bull and too-large toreros in the background. It was obvious that Manet had never seen a bullfight. After the Salon, Manet cut up his canvas and reworked this figure and another fragment. He refers to "the dead Espada" as a title for the figure early in 1865.[1] Theodore Reff's work in 1982 using X-radiography of the two fragments of the canvas—this one and the part showing the three toreros (Frick Collection, New York)—proves that Manet twice transformed his composition even before he sent it to the Salon.[2] Manet undoubtedly used photographs and the illustrated press in his attempt to represent a striking scene of contemporary life through one of the most powerful and dramatic moments of a corrida.[3]

JW-B

1. A note to Louis Martinet, written in February 1865, lists the works that Manet intended to exhibit, including *l'Espada mort*. See Manet 1991, p. 32.
2. See Washington 1982–83.
3. For recent attempts to analyze the original composition of *Incident at a Bullfight* and its development, see Ann Hoenigswald, Malcolm Park, and Juliet Wilson-Bareau in New York 1999, pp. 19–24.

142.

Fig. 9.51

Édouard Manet

The Dead Christ and Angels

1864
Oil on canvas
70⅛ x 59 in. (179.4 x 149.9 cm)
Signed lower left: *Manet*
Inscribed, lower right, on stone: *évang*[ile]. *sel*[on]. *St Jean/chap*[ître]. *XX v.XII*
The Metropolitan Museum of Art, New York,
H. O. Havemeyer Collection, Bequest of Mrs. H. O. Havemeyer, 1929 29.100.51

CATALOGUES RAISONNÉS: Tabarant 1931, no. 72; Orienti 1967, no. 63; Rouart and Wildenstein 1975, vol. 1, no. 74

PROVENANCE: The artist's studio, rue Guyot, Paris, 1864–70/72 (*Christ et les anges,* valued at 4,000 francs); bought for 3,000 francs by Durand-Ruel, Paris, January 1872 (*le Christ,* Paris stock 959); sold and reacquired (Paris stock 1178)(?); unidentified collection; Durand-Ruel, Paris, June 4, 1881 (*le Christ et les anges,* Paris stock 19; Durand-Ruel, New York, February 27, 1895 (New York deposit 5253); bought for 4,050 francs from Durand-Ruel, Paris, November 16, 1900 (stock book), or New York, November 17, 1900 (New York stock 2411); bought for 17,000 dollars by Mr. and Mrs. H. O. Havemeyer, New York, February 7, 1903; on loan to The Metropolitan Museum of Art, New York; Mrs. Havemeyer's bequest to the Museum, 1929

EXHIBITIONS: Paris, Salon of 1864, no. 1281 (*Les Anges au tombeau du Christ*); Paris 1867, no. 7 (*Le Christ mort et les anges*); London 1872c, no. 91 (*Christ in the Sepulchre*); Boston 1883a, no. 1 (*Entombment of Christ*); New York 1895a, no. 8; Pittsburgh 1902–3, no. 94 (*Angels at the Tomb of Christ*); [see Rouart and Wildenstein 1975 for further early exhibitions]; Paris–New York 1983, no. 74; New York 1993b, no. 346; Paris–New York 1994–95, no. 96; Paris 2002–3, no. 85

REFERENCES

19th century: Bürger 1864b; Godet 1872, no. 20 (*Descente de Croix,* photograph); [see Rouart and Wildenstein 1975 for further early references]

20th–21st century (selected references): Flint 1984, p. 357; Meller 2002, pp. 74, 78, fig. 28

In the catalogue for the 1864 Salon, Manet's *Dead Christ and Angels* preceded the *Incident at a Bullfight* (see cat. 141). Both paintings depicted a dead man, one the seeming victim of a divine destiny, the other the genuine victim of the bullring's game of chance and of the bull's brute force. If the *espada*, lying on the ground, is treated with remarkable reticence—there is only the faintest hint of blood on the ground near his shoulder, and his clothing is impeccable—the wounds of Christ are dramatically highlighted, intensifying the confrontation between the spectator and this impressive representation of death.

Having identified a Spanish source for the dead *espada*—the "Velázquez" in the Pourtalès collection—Théophile Thoré maintained, rather inexplicably, that Manet's *Christ* was a pastiche of El Greco's paintings.[1] Various sources have been proposed for this composition, one of which is an engraving after a Francisco de Ribalta painting with two angels, which appeared in an issue of Charles Blanc's *Histoire des peintres*.[2] But the similarity, proposed by Peter Meller (2002), with a fresco by Andrea del Sarto, an artist long studied by Manet in Florence, again suggests that Manet had integrated his Italian experience with his abiding interest in Spanish painting.

JW-B

1. Bürger [pseud. Thoré] 1864b; Thoré 1870, vol. 2, p. 99.

2. It is not certain that the undated issue, no. 477, would have appeared in time for its use as a source.

143.
Fig. 9.70

Édouard Manet
Monk at Prayer

Ca. 1864–65
Oil on canvas
57⅛ x 45¼ in. (146.4 x 115 cm)
Signed lower left: *Manet*
Museum of Fine Arts, Boston, Anna Mitchell Richards Fund 35.67

CATALOGUES RAISONNÉS: Tabarant 1931, no. 100; Orienti 1967, no. 91; Rouart and Wildenstein 1975, vol. 1, no. 104

PROVENANCE: The artist's studios, rue Guyot, Paris, 1864–70/72 (*le Moine*, valued at 3,000 francs),

rue de Saint-Pétersbourg, then rue d'Amsterdam, 1872–82; bought for 6,000 francs by Marcel Bernstein, Paris, 1882 (the artist's account book); exchanged for a Daubigny, Jacques-Émile Blanche, Paris, after 1884; Marie Sterner Galleries, New York, after 1922; bought by the Museum of Fine Arts, Boston, March 7, 1935

EXHIBITIONS: Paris 1867, no. 21 (*Un Moine en prières*); Paris 1884, no. 25 (*Un Moine en prière*, lent by Bernstein); Paris 1922, no. 106 (lent by Blanche); Copenhagen 1989, no. 10; Paris 2002–3, no. 86

SELECTED REFERENCES: Reff 1970b, p. 457; Murphy 1985, no. 35.67

At the 1884 exhibition, this impressive painting was catalogued among the works from 1864, along with *Dead Toreador* (cat. 141) and *The Water Drinker* (cat. 135). A year before his death, when his illness was occasioning great expense, Manet had sold it to Marcel Bernstein. The work belongs in the context of paintings from 1864–65: *Dead Toreador* and *The Dead Christ and Angels* (cat. 142), and *The Mocking of Christ* (1865, Art Institute of Chicago) in the Salon of 1865. The rich, vigorous brushwork in the present painting is also a point in favor of an earlier date, before Manet's decisive encounter with Velázquez.

The source for this work is no doubt Zurbarán's *Saint Francis with Stigmata*, as it was catalogued in the Galerie Espagnole of the Louvre in 1838 (cat. 85). It was acquired by the London National Gallery at the Louis-Philippe sale in 1853, and Manet probably saw it during his visit to London in 1868. However, the inspiration for his own canvas was, in all likelihood, the large etching after Zurbarán that Alphonse Masson exhibited at the Salon of 1855, of which a wood engraving was made for the issue devoted to the painter in Charles Blanc's *Histoire des peintres* in 1854.[1] In the catalogue of the Salon des Refusés, an etching by Masson after a Ribera work follows those by Manet after Velázquez (cats. 164, 165).

JW-B

1. Geneviève Lacambre kindly drew my attention to the etching by Masson.

144.
Fig. 1.60

Édouard Manet
Woman at Her Window,
also called *Angélina*

Ca. 1860–64
Oil on canvas
36¼ x 28¾ in. (92 x 73 cm)
Signed lower right: *Manet*
Musée d'Orsay, Paris, Bequest of Gustave Caillebotte, 1891 RF 3664

CATALOGUES RAISONNÉS: Tabarant 1931, no. 98; Orienti 1967, no. 93; Rouart and Wildenstein 1975, vol. 1, no. 105

PROVENANCE: The artist's studios, Paris, 1864–79(?); bought by Gustave Caillebotte in 1879(?);[1] his bequest to the Musées Nationaux,

1894; Musée du Luxembourg, Paris, 1896; Musée du Louvre, Paris, 1929; Musée du Jeu de Paume, Paris, 1947; Musée d'Orsay, Paris, 1986

EXHIBITIONS: Paris 1867, no. 39 (*Une dame à sa fenêtre [étude]*); Paris 2002–3, no. 87

REFERENCES
19th century: Randon 1867, p. 7 (*Une dame à sa fenêtre*, caricature)

20th century (selected references): Copenhagen 1989, no. 13; Anne Distel, "Essai de récapitulation de Gustave Caillebotte," in Paris–Chicago 1994–95, pp. 42–43, fig. 17 (Paris ed.); Copenhagen 2000a, no. 13

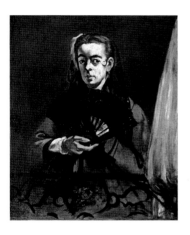

Adolphe Tabarant, cataloguer of Manet's work, was not above embellishing the facts to add to his documentary archives (now preserved at the Pierpont Morgan Library, New York). According to Tabarant, it was Gustave Caillebotte who, having acquired this painting, "gave it the name of the model who had posed, Angélina."[2] If the picture was painted around 1865, and not acquired by Caillebotte until the end of the 1870s, one wonders how he would have known the name of a model who seems to have posed only once for Manet. In his 1867 exhibition catalogue Manet titled her simply *Woman at Her Window*. We do not know when he painted this arresting study. Previously thought to date from after the visit to Spain, it appears more likely to belong to the period before Manet's encounter with Velázquez in the Prado. It may even date from the early 1860s, when Manet painted his striking portraits of the young Lange boy (cat. 134) and of Madame Eugène Brunet (ca. 1860–62, reworked 1867; private collection). The latter, a boldly brushed, distinctly unflattering portrait, was cruelly mocked when Manet showed it at Galerie Martinet in 1863, and was mocked again in Randon's caricature of 1867 (figs. 9.19, 9.64–9.66),[3] as was the present painting: below the drawing of this picture Randon commented: "A window should be open or closed; if it were my choice, I would prefer it closed."[4]

In this work, Manet created a picture that is outspokenly "Spanish" in its realism. It also recalls the dramatic effects of some of the strongly aquatinted prints of the *Caprichos* (cats. 25–32). Yet although the woman's features are so marked and painted

with such violent contrasts of light and shade, she retains that sense of dignity and gravitas to which Manet responded so strongly in Velázquez's art. Given that the unlikely *Portrait of a Monk* in the Louvre (cat. 82) was a Velázquez in his eyes, this Spanish *Woman* makes sense as a relatively early response to what Manet then believed to be characteristic of the master's art.

JW-B

1. According to Manet's account book, one of the works sold by him in 1879 was *Croquet*, at 600 francs, known to have been bought by Caillebotte (Rouart and Wildenstein 1975, vol. 1, no. 173). This entry is closely followed by two others: *Divers* (Various works), at 200 francs, and *Esquisse* (Sketch), at 500 francs. Although no buyer's name appears, it is possible that both entries also refer to purchases by Caillebotte and that the *Esquisse* was the present *Étude*. See Leenhoff Notebook 1, Bibliothèque Nationale de France, Paris, Département des Estampes, Yb-3-2401, 8°, Rés., p. [79].

2. "lui donna le nom du modèle qui l'avait posé, Angélina." Tabarant 1931, p. 138. However, Anne Distel, cited above, has kindly confirmed that the title *Angélina* does not appear until a relatively late date in the documents concerning the Caillebotte bequest.

3. For the portrait of Mme Brunet and caricatures, see Rouart and Wildenstein 1975, vol. 1, no. 31; Paris–New York 1983, no. 5.

4. "Il faut qu'une fenêtre soit ouverte ou fermée; si j'avais le choix, je préférerais qu'elle fût fermée." Randon 1867, p. 7 (cliché no. 25490).

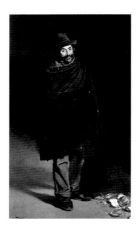

145. *Fig. 9.62*

Édouard Manet

A Philosopher (Beggar with Oysters)

Ca. 1864–67
Oil on canvas
73⅝ x 43½ in. (187 x 110.5 cm)
Signed lower right: *Manet*
The Art Institute of Chicago, Arthur Jerome Eddy Memorial Collection 1931.504

CATALOGUES RAISONNÉS: Tabarant 1931, no. 104; Orienti 1967, no. 94; Rouart and Wildenstein 1975, vol. 1, no. 99

PROVENANCE: The artist's studio, rue Guyot, Paris, ca. 1864–70/72 (one of four *Philosophes*,

valued at 6,000 francs, or 1,500 francs each); bought for 1,000 francs by Durand-Ruel, Paris, January 1872 (*le Philosophe*, Paris stock 952); bought for 5,750 francs by Jean-Baptiste Faure, Paris, November 10, 1882 (as a group of three *Philosophes*); bought for 10,000 francs by Durand-Ruel, Paris, October 16, 1894 (Paris stock 3136); bought for 20,000 francs by Arthur Jerome Eddy, Chicago; Mrs. Eddy and her son Jerome O. Eddy, 1920; gift to The Art Institute of Chicago, 1931

EXHIBITIONS: Paris 1867, no. 32 (*Philosophe*); Paris, Cercle de l'Union Artistique, 1870; London 1872b, no. 15 (*The Philosopher*); Paris 1884, no. 30 (*Un philosophe*, lent by Faure); New York 1886, no. 244; New York 1913, no. 5; [see Rouart and Wildenstein 1975 for further early exhibitions]; Paris–New York 1983, no. 90; Paris 2002–3, no. 90

REFERENCES
19th century: Randon 1867, p. 6 (*Philosophe*, caricature); Godet 1872, no. 5 (*Mendiant aux huitres*, photograph)

20th century (selected references): Callen 1974, pp. 169, 171 nn. 76, 86; Flint 1984, p. 357

In the letter he wrote to Fantin-Latour two days after his arrival in Madrid and his encounter with Velázquez's paintings in the Prado, Manet commented on several pictures, including "a portrait of a famous actor" (cat. 73) and "his philosophers, amazing pieces. . . ."[1] These latter were the lifesized "portraits" of Aesop and Menippus (cats. 75, 76). Manet, who must have already been acquainted with them through copies etched by Goya (cats. 19, 20), was enthralled by the images of these celebrated figures from antiquity that related so strongly to his own *Absinthe Drinker* (cat. 128). It may even have been before the visit to Spain that Manet painted the present work and its pendant, *A Philosopher (Beggar in a Cloak)* (cat. 146), thus creating a pair of "beggar philosophers" after the fashion of the Spanish master. They were shown at Manet's one-man exhibition in 1867, with *The Absinthe Drinker* (cut down and still without the glass). Later, Manet decided to make these impressive figures into a quartet, returning his *Drinker* to its original dimensions and painting *The Ragpicker* (fig. 9.67) to complete the group, which was bought by Durand-Ruel in 1872.[2]

JW-B

1. "portrait d'un acteur célèbre"; "ses philosophes, étonnants morceaux." Manet 1988, pp. 43–44; Manet 1991, p. 34.

2. Recent restoration of this relatively dark painting and its companion has clearly revealed their facture, making it more difficult to see them as works painted after the encounter with Velázquez, on a par with *The Tragic Actor* and *The Fifer* (cats. 150, 151). This assessment is supported by the more luminous aspect and freer handling of *The Ragpicker*, which must have been the final addition to the group and appears much more likely to postdate the visit to Spain. I am grateful to Faye Wrubel, conservator at The Art Institute of Chicago, for her informed discussion of the pendant works in that collection.

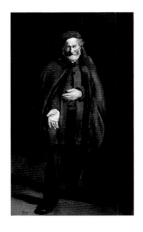

146. *Fig. 9.61*

Édouard Manet

A Philosopher (Beggar in a Cloak)

Ca. 1864–67
Oil on canvas
73⅞ x 43¼ in. (187.7 x 109.9 cm)
The Art Institute of Chicago, A. A. Munger Collection 1910.304

CATALOGUES RAISONNÉS: Tabarant 1931, no. 105; Orienti 1967, no. 95; Rouart and Wildenstein 1975, vol. 1, no. 100

PROVENANCE: The artist's studio, rue Guyot, Paris, ca. 1864–70/72 (one of four *Philosophes*, valued at 6,000 francs, or 1,500 francs each); bought for 1,500 francs by Durand-Ruel, Paris, January 1872 (*le Mendiant*, Paris stock 956); bought for 5,750 francs by Jean-Baptiste Faure, Paris, November 10, 1882 (as a group of three *Philosophes*); Durand-Ruel, Paris, 1898 (Paris stock 4934); acquired by The Art Institute of Chicago, 1910

EXHIBITIONS: Paris 1867, no. 32 (*Philosophe*); Munich 1869; London 1872b, no. 31 (*A Beggar*); Paris 1884, no. 29 (*Un philosophe*, lent by Faure); New York 1886, no. 240; London 1905c, no. 97 (*A Beggar*); [see Rouart and Wildenstein 1975 for further exhibitions]; Paris 2002–3, no. 91

SELECTED REFERENCES: Randon 1867, p. 8 (*Philosophe*, caricature); Godet 1872, no. 7 (*Mendiant au caban*, photograph)

A Philosopher (Beggar with Oysters) (cat. 145) depicts a figure wrapped in a ragged cape or blanket. His posture expresses the fierce independence characteristic of cynic philosophers and for whom Velázquez's *Menippus* (cat. 76) served as a source. In contrast, its pendant, *A Philosopher (Beggar in a Cloak)*, holds out his hand, soliciting alms from the spectator.

A skillful restoration has brought back much of the original richness to this work, long dulled by layers of old varnish. The costume is now seen to consist of a red beret and a golden brown duffle coat with a black border, worn over a blue coat also

bordered in black. A *caban*, or duffle coat, was a garment often used by mariners, and the costume suggests a uniform. The painting was shown, with its pendant, in Manet's exhibition held during the summer of 1867, when five years of French military intervention in Mexico came to an abrupt and catastrophic end. Except in the case of *The Execution of Emperor Maximilian* (cat. 152), Manet's references to contemporary events always remained veiled and ambiguous. His beggar with outstretched hand reveals only his poverty, not its cause.

JW-B

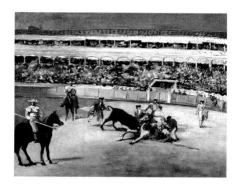

147.

Fig. 9.53

Édouard Manet
The Bullring in Madrid

1865
Oil on canvas
35⅛ x 43¼ in. (90 x 110 cm)
Signed lower right: *Manet*
Musée d'Orsay, Paris RF 1976.8

CATALOGUES RAISONNÉS: Tabarant 1931, no. 114; Orienti 1967, no. 100; Rouart and Wildenstein 1975, vol. 1, no. 107

PROVENANCE: The artist's studios, Paris, 1865–1870/72–ca. 1878(?); bought from the artist(?) by Eugène Pertuiset, Paris, after 1872; P[ertuiset] sale, Hôtel Drouot, Paris, June 6, 1888, no. 2, bought for 1,200 francs by Durand-Ruel, Paris; baronne de Goldschmidt-Rothschild, Berlin, 1928, then Paris; entered the Musées Nationaux as payment for inheritance taxes and with a donation from the Société des Amis du Louvre, 1976; Musée d'Orsay, Paris, 1986

EXHIBITIONS: Paris 1884, no. 36 (*Le Combat de taureaux*, lent by Pertuiset); London 1905c, no. 86; Paris–New York 1983, no. 91; Stockholm 1985, no. 62; Paris 2002–3, no. 88

SELECTED REFERENCES: Rouart and Wildenstein 1975, vol. 2, D286; Flescher 1978b, pp. 38–42, 145; Miura 1988, pp. 73–75; London 1992, pp. 44–45; New York 1999, pp. 8–9, fig. 1

In 1864, during a trip to Spain preceding that of Manet, his friend Zacharie Astruc came across "some very picturesque photographs of bullfighting" and had "the idea of sending them as a present to my favorite painter who is so crazy about Spain and giving him some images which, with his passion for all things Spanish, would send him to seventh heaven."[1] According to Antonin Proust, before Manet's departure for Spain, *Bullfight in Spain* by Alfred Dehodencq (cat. 107) "added the final touch to his enthusiasm."[2] Having arrived in Madrid on September 1, 1865, Manet wrote to Fantin-Latour on September 3 that he had already been to see the Velázquez and Goya works and was hoping to attend a bullfight that evening. As soon as he returned to France, Manet began setting down in paint what he had seen of the "plaza de toros," the bullring in Madrid.[3] We do not know whether Astruc sent his photographs to Manet in 1864, but Atsushi Miura (1988) has revealed the similarities between a photograph (fig. 9.52) that appeared in France in *La Critique Illustré* (June 25, 1865) and the present painting. Moreover, the description that Manet gave Astruc of the bullfight he had seen corresponds on every point with this painting, which was later bought by Eugène Pertuiset, the well-known lion hunter who was a friend of the artist and collector of his work.

JW-B

1. "quelques photographies de combats de taureaux d'un goût fort pittoresque"; "l'idée de les adresser en présent à cet enragé d'Espagnol Manet qui est mon peintre chéri et de lui fournir quelques documents qui mettraient aux anges sa passion espagnole." Astruc, "Fragment du voyage" (1864), Archives du Louvre, Paris, Ms 420 (16/1), fols. 28–29.
2. "avait achevé de l'enthousiasmer." Proust 1897, p. 169; 1988/1996, p. 27. Proust connects the exhibition of Dehodencq's picture at the 1850–51 Salon and then in the Musée du Luxembourg with Manet's visit to Spain, erroneously dated by him to the late 1850s or very early 1860s.
3. For Manet's references to bullfighting in letters to Fantin-Latour, Baudelaire, Astruc, and Duret, see Manet 1988, pp. 44, 48, 50, 56; Manet 1991, pp. 35–37.

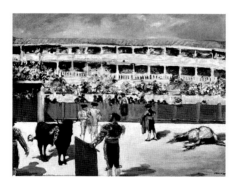

148.

Fig. 9.54

Édouard Manet
The Bullfight

1865–67
Oil on canvas
18⅞ x 23¾ in. (48 x 60.4 cm)
Signed lower right: *Manet*
The Art Institute of Chicago, Mr. and Mrs. Martin A. Ryerson Collection 1937.1019

CATALOGUES RAISONNÉS: Tabarant 1931, no. 115; Orienti 1967, no. 98; Rouart and Wildenstein 1975, vol. 1, no. 108

PROVENANCE: The artist's studio, rue Guyot, Paris, 1865–70/72 (*Combat de taureaux*, valued at 500 francs); bought for 500 francs by Durand-Ruel, Paris, January 1872 (Paris stock 970); James S. Inglis, New York, 1886; H. T. Chapman sale, American Art Association, New York, February 21–23, 1888, no. 147; J. Cook, Jr., New York; Durand-Ruel, New York, 1910; Reinhardt Galleries, Chicago; bought for 16,000 dollars by Martin A. Ryerson, Chicago, 1912; donated to The Art Institute of Chicago, 1937

EXHIBITIONS: London 1872, no. 36 (*A Bull Fight*); London 1883, no. 54 (*Course de taureaux*); Paris 1884, hors cat. (photographed by Godet); New York 1886, no. 190; New York 1895a, no. 19; Vienna Secession, 1903, "Entwicklung des Impressionismus in Malerei und Plastik," no. 28 (lent by Durand-Ruel); Toledo 1912, no. 183; New York 1913, no. 7; [see Rouart and Wildenstein 1975 for further early exhibitions]; Washington 1982–83, no. 81; Copenhagen 1989, no. 14; London 1992, no. 28; Paris 2002–3, no. 89

REFERENCES
19th century: Godet (1884) in Moreau-Nélaton 1926, vol. 2, fig. 341 (*Exposition de 1884*, no. 3, *Course de taureaux*)

20th century (selected references): Flint 1984, pp. 357, 361; London 1992, p. 45

This painting, smaller than the scene of the bullring painted immediately after Manet's return from Spain (cat. 147), is also more structured and more aesthetically satisfying. Where the large painting seeks above all to render what Manet called "the dramatic aspect" of the spectacle,[1] this one places the drama on another register entirely, with *espada* and bull facing each other in that instant of immobility that precedes the final confrontation and sword thrust. In the present, carefully thought out composition, the artist pulls the ringside boxes with their tiled roof, the tiers of seats, and the inner palisade into the plane of the painting, situating his human and animal figures in such a way as to rhythmically punctuate the space of the arena. The play of shadows on the ground is particularly skillful. Disturbances in the layers of paint in the foreground suggest that the artist reworked the area; an X-ray would probably prove revealing. This part of the painting visibly contrasts with that situated behind the palisade, where the color is thin and fluid, the crowd sketched with a delicate confection of impressionistic brushstrokes.

JW-B

1. "la partie dramatique." Manet 1988, p. 50; Manet 1991, p. 37.

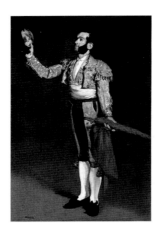

149. *Fig. 9.55*

Édouard Manet

A Matador (The Saluting Torero)

1866–67
Oil on canvas
67⅜ x 44½ in. (171 x 113 cm)
Signed lower left: *Manet*
The Metropolitan Museum of Art, New York,
H. O. Havemeyer Collection, Bequest of
Mrs. H. O. Havemeyer, 1929 29.100.52

CATALOGUES RAISONNÉS: Tabarant 1931, no. 113;
Orienti 1967, no. 101; Rouart and Wildenstein 1975,
vol. 1, no. 111

PROVENANCE: The artist's studio, rue Guyot,
Paris, 1866–70; bought from the artist for 1,200
francs (as *Torero saluant*) by Théodore Duret, Paris,
1870; Duret sale, Galerie Georges Petit, Paris,
March 19, 1894, no. 20, bought for 10,500 francs (as
Torero saluant) by Durand-Ruel, Paris (Paris stock
2965, half-share with Faure); bought by Durand-
Ruel, New York, October 25, 1894 (New York stock
1223); bought back by Durand-Ruel, Paris, August
31, 1895; Durand-Ruel, New York, August 31,
1895–December 31, 1898 (New York deposit 5350);
Faure's half-share bought by Durand-Ruel, Paris,
December 21, 1898; bought for 20,000 francs by
Durand-Ruel, New York, December 21 (Paris stock
book) or December 31, 1898 (New York stock
2073); bought for 8,000 dollars by Mr. and
Mrs. H. O. Havemeyer, New York, December 31,
1898; Mrs. H. O. Havemeyer, New York, 1907–29;
her bequest to The Metropolitan Museum of Art,
New York, 1929

EXHIBITIONS: Paris 1867, no. 16 *(Un Matador de
taureaux)*; Paris 1884, no. 34 *(Le Matador saluant,*
lent by Duret); New York 1895a, no. 24; Buffalo,
N.Y., 1896, "Buffalo Society of Artists Fifth Annual
Exhibition," no. 56; Pittsburgh 1897–98, no. 139;
Boston 1898b (as *Le Torero saluant*), no. 58 (lent by
Durand-Ruel); [see Rouart and Wildenstein 1975
for further early exhibitions]; Paris–New York
1983, no. 92; New York 1993b, p. 353, no. 348; Paris
2002–3, no. 94

SELECTED REFERENCES: Bodelsen 1968, pp. 344–45
(procès verbal no. 14); Callen 1974, p. 171; Manet
1991, p. 54 (sale to Duret); Inaga 1994, fig. 2; [see

Rouart and Wildenstein 1975 and New York 1993b
for further references]

The gesture and the moment that Manet chose for
his model have long given rise to much discussion.
The bullfighter is an *espada,* or matador. His pose
recalls that of the torero seen from the rear in the
earlier painting and the print that show bullfighters
before the fight (cat. 176, fig. 9.46). There the torero
prays before a statue of the Virgin; here, although
the setting is undefined, he is probably to be imag-
ined in the bullring since he holds the sword
wrapped in the red *muleta,* ready for the final
sequence when the bull will be killed. According to
Adolphe Tabarant and Étienne Moreau-Nélaton,
Manet's brother Eugène posed for the painting, but
his features certainly do not match those of the typi-
cally Andalusian model. Théodore Duret, who pur-
chased the canvas from Manet in 1870,[1] thought he
was a Spanish dancer connected to the Exposition
Universelle—but the canvas went on display during
the exposition in Manet's pavilion on the avenue
d'Alma on May 22, 1867.[2] As in the portrait of
Rouvière (cat. 150), it is possible that Eugène or
another model put on the *traje de luces* (splendid
matador's costume) and assumed the pose, and that
the striking head was taken from one of the carte-
de-visite photographs that portrayed famous
bullfighters. The remarkable vigor and assurance of
the work suggest that its most important source was
a memorable moment of the bullfight Manet
attended in Madrid.

 JW-B

1. Duret purchased the picture for a bargain price and Manet
 asked him not to let it be known, saying that he "wouldn't
 let anyone have such a major figure for less than 2,500"
 (Manet 1991, p. 54). Duret acknowledged his ownership
 of the work, named as *Torero saluant,* for which he had
 not yet paid, in a letter of September 16, 1870 (see Manet
 1935, pp. 6–7).
2. Charles Moffett has suggested that the picture was
 painted early in 1867, since it was not mentioned by critics
 who visited Manet's studio in 1866 (Paris–New York
 1983, p. 240).

150. *Fig. 9.56*

Édouard Manet

The Tragic Actor (Rouvière as Hamlet)

1865–66
Oil on canvas
73¾ x 42½ in. (187.2 x 108.1 cm)
Signed lower right: *Manet*
National Gallery of Art, Washington, D.C., Gift of
Edith Stuyvesant Gerry 1959.3.1

CATALOGUES RAISONNÉS: Tabarant 1931, no. 103;
Orienti 1967, no. 90; Rouart and Wildenstein 1975,
vol. 1, no. 106

PROVENANCE: The artist's studio, rue Guyot,
Paris, 1865–70/72 *(Rouvière,* valued at 2,000
francs); bought for 1,000 francs by Durand-Ruel,
Paris, January 1872 *(le portrait de Rouvière,* Paris
stock 953); George Vanderbilt, Asheville, North

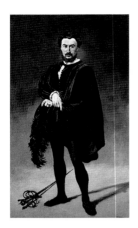

Carolina, 1898; Mrs. Edith Stuyvesant Vanderbilt,
1914 (by inheritance), later Mrs. Vanderbilt Gerry;
her bequest to the National Gallery of Art,
Washington, D.C., 1959

EXHIBITIONS: Paris 1867, no. 18 *(l'Acteur tragique)*;
Boston 1883a; New York 1895a, no. 13; [see Rouart
and Wildenstein 1975 for further early exhibitions];
Washington 1982–83, no. 27; Paris–New York 1983,
no. 89; Paris 2002–3, no. 92

REFERENCES

19th century: Charles Baudelaire, "Philibert
Rouvière," in *Nouvelle galerie des artistes drama-
tiques vivants* (January 1856), reprinted in *L'Artiste*
(December 1, 1859), and "Le comédien Rouvière
[obituary]," *La Petite Revue* (October 28, 1865)
[see Baudelaire 1975–76, vol. 2, pp. 61–65, 241–43];
Godet 1872, no. 14 *(Portrait de Rouvière en costume
de théâtre)*

20th century (selected references): Venturi 1939, vol.
2, p. 190, no. 77; Callen 1974, p. 171 n. 91; McCauley
1985, pp. 187–88

This painting, which was refused by the 1866 Salon
jury, was acquired by Durand-Ruel in January 1872
as one of twenty-three paintings the dealer bought
from Manet. Despite the obvious quality of the
painting, *The Tragic Actor* found a buyer only in
1898, when the gallery sold it to George Vanderbilt.[1]
 The Tragic Actor is Manet's response to the "por-
trait of an actor" by Velázquez (cat. 73), whose
model, Pablo de Valladolid, was court buffoon. That
Manet had managed to keep this work in his mem-
ory while executing his own painting is an indication
of the lasting impact of his brief visits to the Prado
on his sensitive eye. Among the twenty-two works
by Velázquez in the catalogue published by the pho-
tographer J. Laurent in Madrid in 1863, *Las Meninas*
(fig. 4.13) and this "actor" are missing. However, the
sight of these masterpieces sufficed for Manet to
fully grasp the art of painting black on black and of
conveying an overwhelming sense of atmosphere
and space around his painted figures.

 JW-B

1. Adolphe Tabarant was a source of much confusion on this
 subject. In his 1931 catalogue he indicated that the work had
 passed into Faure's possession. The Durand-Ruel version
 given by Venturi (1939)—and later confirmed by Callen
 (1974)—forced Tabarant, in 1947, to admit his error.

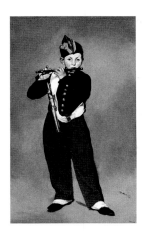

151. *Fig. 9.68*

Édouard Manet
The Fifer

1866
Oil on canvas
63 x 38⅛ in. (160 x 98 cm)
Signed lower right: *Manet*
Musée d'Orsay, Paris, Bequest of Count Isaac de
Camondo, 1911 RF 1992

CATALOGUES RAISONNÉS: Tabarant 1931, no. 117;
Orienti 1967, no. 104; Rouart and Wildenstein 1975,
vol. 1, no. 113

PROVENANCE: The artist's studio, rue Guyot,
Paris, 1866–70/72 (*Fifre*, valued at 1,500 francs);
bought for 1,500 francs by Durand-Ruel, Paris,
January 1872 (*Le fifre*, Paris stock 961); bought for
2,000 francs by Jean-Baptiste Faure, Paris,
November 11, 1873; bought back from Faure for
17,000 francs by Durand-Ruel, Paris, February 6,
1893 (Paris stock 2666); bought for 30,000 francs by
Comte Isaac de Camondo, Paris, January 1894; his
bequest to the Musée du Louvre, Paris, 1911, exhib-
ited in 1914; Musée du Jeu de Paume, Paris, 1947;
Musée d'Orsay, Paris, 1986

EXHIBITIONS: Paris 1867, no. 11 *(Le Fifre)*; Paris
1884, no. 33 (lent by Faure); New York 1886, no. 22;
Paris, Exposition Universelle, 1889, no. 485; [see
Rouart and Wildenstein 1975 for further early exhi-
bitions]; Paris–New York 1983, no. 93; London
1992, no. 29; Paris–New York 1994–95, no. 102;
Paris 2002–3, no. 93

SELECTED REFERENCES: Callen 1974, pp. 163, 171,
178 n. 85; Flint 1984, p. 357

Manet painted this young fifer on his return from
Spain. He wanted to exhibit the canvas at the 1866
Salon, along with *The Tragic Actor* (cat. 150), but,
after the uproar generated the previous year by
Olympia (1863, Musée d'Orsay, Paris) and *The
Mocking of Christ* (1865, Art Institute of Chicago),
the jury rejected both works.

We do not know why the painter chose particu-
lar characters for the series of full-length portraits
he painted under the spell of Velázquez. If Rouvière
in the role of Hamlet, the subject of *The Tragic
Actor*, can be seen as a direct response to *The Jester*

Pablo de Valladolid (cat. 73), the source for the
astonishingly modern *Fifer* is not so obvious.[1] There
is nothing comparable to this sturdy little boy in a
painting by Velázquez, unless it be the young infante
Baltasar Carlos as a Hunter (1635–36, Museo del
Prado, Madrid), or the flat red tints and silhouette of
the jester known as Barbarroja (ca. 1636, Prado).
Manet remarked on Velázquez's portrait of the sup-
posed actor, "There's nothing but air surrounding
this fellow,"[2] and indeed his fifer inhabits purely
abstract, atmospheric space. Manet's reflection
echoes the opinion of Goya and contemporary eigh-
teenth-century commentators that prime qualities of
Velázquez's art were the effects of aerial perspective
and the sense of atmosphere he was able to create in
his paintings.[3]

 JW-B

1. George Mauner has pointed out the striking resemblance
 between Manet's *Fifer* and a nineteenth-century Tarot
 card that represents the Fool (or modern-day Joker), an
 interesting connection, given the relationship of Manet's
 actor to Velázquez's buffoons and court entertainers (see
 Paris–Baltimore 2000–2001, pp. 22–23, repr.). Other often-
 cited sources are the popular, boldly colored "Images
 d'Épinal" and their oriental counterparts, Japanese prints—
 especially of actors—that had begun to appear in Paris and
 of which a striking example is seen in the background of
 Manet's portrait of Émile Zola (cat. 153).
2. "C'est de l'air qui entoure ce bonhomme." Manet 1988,
 p. 44; Manet 1991, p. 34.
3. Anton Raffael Mengs praised Velázquez's remarkable grasp
 of the effects of aerial perspective in an open letter to
 Antonio Ponz; see Ponz 1776–94 (1947 ed.), vol. 6, p. 574.
 Goya's understanding of "the magic . . . of the atmosphere
 of a picture" ("la magia . . . del ambiente de un cuadro")
 was described by his son Javier in a biographical note; see
 Beroqui 1927, p. 100; and Glendinning 1977, p. 68, for
 English translations.

152. *Fig. 9.71*

Édouard Manet
The Execution of Emperor Maximilian

July–September 1867
Oil on canvas
77⅛ x 102¼ in. (196 x 259.8 cm)
Museum of Fine Arts, Boston, Gift of Mr. and Mrs.
Frank Gair Macomber 30.444

CATALOGUES RAISONNÉS: Tabarant 1931, no. 130;
Orienti 1967, no. 115; Rouart and Wildenstein 1975,
vol. 1, no. 124

PROVENANCE: The artist's studios, Paris, 1867–83;
Suzanne Manet, Paris, Gennevilliers, Asnières,
1883–99; Léon Leenhoff, Paris, 1899(?); bought
for 500 or 800 francs by Ambroise Vollard, Paris,
July 1899; bought, through Mary Cassatt, by
Frank Gair Macomber, Boston, 1909; gift of
Mr. and Mrs. Macomber to the Museum of Fine
Arts, Boston, 1930

EXHIBITIONS: [see Rouart and Wildenstein 1975
for early exhibitions]; Providence 1981, no. 29;
Paris–New York 1983, no. 104; London 1992, no. 1;
Mannheim 1992–93, pl. 8; Paris 2002–3, no. 95

SELECTED REFERENCES: [See Rouart and
Wildenstein 1975 and Paris–New York 1983
for references]

Maximilian, emperor of Mexico, was killed by a
firing squad at Querétaro on June 19, 1867. The
news reached Paris on July 1, just as prizes were
being awarded at the Exposition Universelle. Manet,
moved by the tragedy and outraged by this evidence
of Napoleon III's culpability (he was not alone in
objecting to the French monarch's foreign policy
and the disastrous Mexican "adventure" that began
in 1862), decided to make the incident the subject of
a large-format history painting.

In 1865, while at the Prado, Manet would have
seen Goya's depictions of the heroic uprising in
Madrid on May 2, 1808, and the executions of May 3
(figs. 1.17, 1.18).[1] The latter painting served as the
basis for three large compositions by Manet, of
which this is the first. It was sketched out in haste,
perhaps because the artist wished to show it in his
current exhibition. But Manet's quest for verisimili-
tude undermined his initial composition. In the
absence of reliable news accounts, he imagined a
fictive scene, with followers of the revolutionary
Benito Juárez wearing traditional Mexican clothing,
adding as a "true" note the sombrero always worn
by the emperor. After more accurate reports of
events emerged, Manet began to transform his
canvas—changing the soldiers' sombreros into
caps—then abandoned this version altogether and
continued his pursuit of "truth" on a new canvas
(fig. 9.72).

 JW-B

1. In 1865 Goya's two great paintings were probably still hung
 in corridors, away from the main display. O'Shea's English-
 language guide to Spain referred to Goya as "this truly
 national and original genius" whose "Dos de Mayo, and
 Massacre of Frenchmen by Spaniards deserve attention"
 (O'Shea 1865, p. 283), while Germond de Lavigne, in the
 Guide Joanne of 1866, described them as "furious sketches
 in which Goya took pleasure in depicting scenes from
 the war of Independence, in a way that does not suggest
 any great love for the French" ("furieuses ébauches
 où Goya s'est plu à retracer des scènes de la guerre
 de l'Indépendance, d'une façon qui ne prouve pas un
 grand amour pour les Français") (Germond de Lavigne 1866).

153.

Fig. 9.91

Édouard Manet
Émile Zola

February–March 1868
Oil on canvas
57⅛ x 44⅞ in. (146.5 x 114 cm)
"Signed" on pamphlet at right: *MANET*
Musée d'Orsay, Paris, Gift of Madame Zola, 1918
RF 2205

CATALOGUES RAISONNÉS: Tabarant 1931, no. 132;
Orienti 1967, no. 118; Rouart and Wildenstein 1975,
vol. 1, no. 128

PROVENANCE: Gift of the artist to Émile Zola,
Paris, then Médan, 1868; Mme Zola, Médan, 1902;
her gift to the Musée du Louvre, Paris, reserving
life interest, 1918; Musée du Louvre, 1925; Musée
du Jeu de Paume, Paris, 1947; Musée d'Orsay,
Paris, 1986

EXHIBITIONS: Paris, Salon of 1868, no. 1660
(Portrait de M. É Z); Paris 1883, no. 304; Paris 1884,
no. 42 (lent by Zola); [see Rouart and Wildenstein
1975 for further early exhibitions]; Paris–New York
1983, no. 93; Paris–New York 1994–95, no. 108;
Basel 1999, no. 1; Paris 2002–3, no. 96

SELECTED REFERENCES: Katharina Schmidt, "Zu
Edouard Manets 'Porträt Emile Zola,'" in Basel
1999, pp. 21–41, fig. 14 *(Gazette des Beaux-Arts)*;
Paris–Baltimore 2000–2001, fig. 4 (Paris ed.)

Émile Zola's portrait was painted in February and
March 1868 in Manet's studio at 81, rue Guyot. Zola,
here presented as an art critic, sits in a corner of the
studio arranged to suggest a writer's study. The
desk[1] is crowded with books and pamphlets, fore-
most among them the reprint of Zola's January 1
article on Manet. On its blue cover, half hidden by
the writing quill in the inkstand, appear their two
names: ZOLA and MANET.

All the elements are full of significance. Paper
knife at hand, Zola holds open a volume of *Gazette
des Beaux-Arts*. Recently identified,[2] the right-hand
page carries the first of a series of articles on Goya's
prints by Paul Lefort, entitled "Essai d'un catalogue
raisonné," which was published February 1, 1867.
Its first pages evoke the *Copies after Velázquez* (cats.
19–24). In a frame on the wall above the desk are

three emblematic works: a Japanese print, the photo-
graph of *Olympia*, and, half hidden, a print that has
been identified as Goya's etching after the *Bacchus*,
known as *Los Borrachos*, by Velázquez (ca. 1628–
29, Museo del Prado, Madrid). Thus, Goya and
Velázquez find themselves paired with Manet and
Zola in this portrait, which was shown at the 1868
Salon.[3]
JW-B

1. The "desk" is recognizable as the buffet on which Manet
 arranged many of his still-life pictures.
2. See the major study of this portrait in Basel 1999, particu-
 larly Katharina Schmidt, "Zu Edouard Manets 'Porträt
 Emile Zola,'" pp. 21–41, fig. 14 *(Gazette des Beaux-Arts)*.
3. Zola wrote to Théodore Duret on February 29, 1868,
 "Manet is doing my portrait for the Salon and since we
 don't have much time I have to spend every afternoon in his
 studio." ("Manet fait mon portrait pour le Salon, et, comme
 nous avons peu de temps, je me trouve cloué[?] toutes les
 après-midi dans son atelier.") Letter in the Cabinet des
 Dessins, Musée du Louvre, Paris (Bc.b8.L53).

154.

Fig. 9.89

Édouard Manet
Théodore Duret

June–July 1868
Oil on canvas
16⅞ x 13¾ in. (43 x 35 cm)
Signed and dated lower left (upside down): *Manet 68*
Petit Palais, Musée des Beaux-Arts de la Ville de
Paris PPP00485

CATALOGUES RAISONNÉS: Tabarant 1931, no. 133;
Orienti 1967, no. 119; Rouart and Wildenstein 1975,
vol. 1, no. 132

PROVENANCE: Commissioned by Théodore Duret,
Paris, in June 1868, paid for with a case of aged
cognac in September; his gift to the Musée des
Beaux-Arts, Paris, 1908

EXHIBITIONS: Paris 1884, no. 43 (lent by Duret);
Paris, Galerie Bernheim-Jeune, 1907, "Portraits
d'hommes," no. 80; [see Rouart and Wildenstein
1975 for further early exhibitions]; Paris–New York
1983, no. 108; Copenhagen 1989, no. 19; Paris
2002–3, no. 97

SELECTED REFERENCES: [see Rouart and
Wildenstein 1975 for earlier references]; Manet

1988, pp. 17–20, 25–26, 56, letter 8, pp. 69–78;
Manet 1991, pp. 37, 46, 54, 56 (letters to Duret);
Inaga 1994, no. 1, repr.; Paris–Baltimore
2000–2001, p. 172; Loyrette 2002

Manet and Duret met by chance in Madrid in 1865.
They signed the Prado register together and went to
the bullfight one evening. Duret, who worked in the
family business in Cognac, did not become a
Parisian art critic until 1867, but his friendship with
Manet involved business as well. At the end of
February 1868, Émile Zola had invited Duret to
keep him company during the interminable sittings
for his portrait in Manet's studio (cat. 153).[1] This
evidently gave Duret the idea that he would like to
have his own portrait by the artist, though not on the
same scale. In June 1868 Manet wrote him: "My dear
Duret, I think one could do a small full-length por-
trait to the size you want; a head on its own is always
rather dull—as to the rest, it will be whatever you
are able or willing to make it, there should be no
obligations between friends."[2] Duret later irritated
his friend by asking him to efface the signature or to
"sign *invisibly* in the shadows," so that visitors
would not be put off by the sight of his name and
might be tricked into thinking the portrait was by "a
Goya, a Regnault, or a Fortuny."[3] It seems—from
recent investigations—that Manet did not make the
required alteration, nor did he paint the picture in
the way Duret recounted it, with the piece-by-piece
addition of the still-life elements, a story endlessly
repeated until now.[4]

Manet put many of his best canvases in storage
with Duret during the Franco-Prussian War, sold
him *A Matador* (cat. 149) for a low price, and made
him the executor of his estate. Two years after
Manet's death, Whistler painted a lifesize portrait of
the critic which must have fully satisfied his self-
esteem (cat. 224).[5]

JW-B

1. "If you have an afternoon to spare, come and see me in
 Manet's studio, 81 rue Guyot, behind the Parc Monceau. We
 can have a leisurely chat." ("Si vous avez une après-midi à
 perdre, venez me voir à l'atelier de Manet, 81 rue Guyot,
 derrière le Parc Monceau. Nous causerons à l'aise."). Letter
 of February 29, 1868, in the Cabinet des Dessins, Musée du
 Louvre, Paris (Bc.b8.L53).
2. "Mon cher Duret, Je pense qu'on pourrait faire un petit por-
 trait en pied dans les dimensions que vous désirez; une tête
 seule est toujours une chose ennuyeuse, pour le reste ce sera
 ce que vous voudrez ou ce que vous pouvez, entre amis on
 ne doit pas avoir d'exigences." Manet 1991, p. 46.
3. The text of Duret's letter, which suggested to Manet that he
 might "effacer votre signature dans le clair, sauf à ne pas
 signer, ou à signer *invisiblement* dans l'ombre," is quoted in
 full in Tabarant 1947, p. 151. Duret paid for the portrait with
 a case of cognac, announced in a letter dated September 23,
 1868 (Moreau-Nélaton 1926, vol. 1, pp. 101–2).
4. Henry Loyrette has revealed and analyzed the intriguing
 results of a technical examination conducted by Jean-Paul
 Rioux at the Centre de Recherche et de Restauration des
 Musées de France; this strongly suggests that the fore-
 ground still life was a compositional element from the start.
 See Loyrette 2002.
5. Inaga 1994, no. 26, repr.

155. *Fig. 9.80*

Édouard Manet
The Balcony

1868–69
Oil on canvas
66½ x 49¼ in. (169 x 125 cm)
Signed lower right: *Manet*
Musée d'Orsay, Paris, Bequest of Gustave
Caillebotte, 1894 RF 2772

CATALOGUES RAISONNÉS: Tabarant 1931, no. 135;
Orienti 1967, no. 121; Rouart and Wildenstein 1975,
vol. 1, no. 134

PROVENANCE: The artist's studio, rue Guyot,
Paris, 1869–70; on deposit with Théodore Duret,
Paris, September 1870–71; the artist's studio, rue
Guyot, 1871–72 (inventory *Le balcon*, valued at
18,000 francs); the artist's studios, 1872–83; Léon
Leenhoff's studio register, 1883, no. 10; the artist's
estate inventory, 1883 ("Tableaux et études," no. 3,
valued at 1,500 francs); the artist's estate sale, Hôtel
Drouot, Paris, February 4–5, 1884, no. 2, bought for
3,000 francs by Gustave Caillebotte; Gustave
Caillebotte, Paris and Petit Gennevilliers; his
bequest to the Musées Nationaux, 1894; Musée du
Luxembourg, Paris, 1896; Musée du Louvre, Paris,
1929; Musée du Jeu de Paume, Paris, 1947; Musée
d'Orsay, Paris, 1986

EXHIBITIONS: Brussels 1869, no. 754; Paris,
Salon of 1869, no. 1616; London 1873, no. 68
(At a Balcony); Paris 1884, no. 52; Paris–New York
1983, no. 115; Lille–Martigny 2002, no. 159; Paris
2002–3, no. 99

SELECTED REFERENCES: Bodelsen 1968, p. 344
(procès verbal no. 149); Anne Distel, "Essai de
récapitulation de Gustave Caillebotte," in
Paris–Chicago 1994–95, pp. 42–43, fig. 16
(Paris ed.)

In the inventory he undertook of the works in his
studio in 1872, Manet listed *The Balcony* third, after
Olympia and *La Partie carrée* (that is, *Le Déjeuner sur
l'herbe*), valuing it at 18,000 francs. Apart from its
showing at the 1869 Paris and Brussels Salons, and a
brief appearance in one of Durand-Ruel's London
shows (in 1873), the painting embellished the walls
of Manet's various studios until his death. It was

bought for just 3,000 francs at his estate sale by
Gustave Caillebotte, practitioner and collector
extraordinaire of the "new painting." The sources
for this composition are complex. According to
Léon Leenhoff, "The idea came from a hotel bal-
cony at Boulogne sur mer,"[1] where Manet spent the
summer of 1868 with his family. Back in Paris, the
artist's friends, the two painters Berthe Morisot and
Antoine Guillemet, and a violinist, Fanny Claus,
served as models. But for the boy with a ewer in the
background, Manet turned to the motif seen in an
early print and drawing and in *Spanish Cavaliers*
(cat. 130), in which old-master sources are para-
mount. The most striking parallel is with Goya's
Majas on a Balcony, shown at the Galerie Espagnole
in the Louvre when Manet was a teenager and
reproduced the previous year, in 1867, in Charles
Yriarte's monograph on Goya.[2] Besides these ear-
lier sources, such images as those in Constantin
Guys's drawings for the illustrated press (cat. 124),
as well as current and usually ironic views of the
pleasures, problems, and tedium of a bourgeois
"holiday" (a subject broached in several of Manet's
letters), provide additional layers of significance for
one of Manet's most brilliant pieces of painting.

 JW-B

1. Léon Leenhoff's studio register, under no. 10, identifies
 the models for Manet's painting and notes its genesis in
 Boulogne—"L'idée est venue d'un balcon d'un hotel à
 Boulogne sur mer"—and its execution in the rue Guyot
 studio.
2. Yriarte 1867, facing p. 90: engraving after a photograph
 of *"Les Manolas au balcon,"* in the collection of the duc
 de Montpensier.

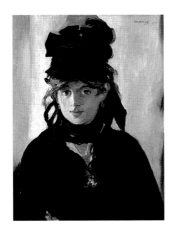

156. *Fig. 9.83*

Édouard Manet
Berthe Morisot with a Bunch of Violets

1872
Oil on canvas
21⅝ x 15 in. (55 x 38 cm)
Signed and dated upper right: *Manet 72*
Musée d'Orsay, Paris RF 1998.30

CATALOGUES RAISONNÉS: Tabarant 1931, no. 176;
Orienti 1967, no. 158; Rouart and Wildenstein 1975,
vol. 1, no. 179

PROVENANCE: Théodore Duret, Paris, date
unknown; his sale, Galerie Georges Petit, Paris,
March 19, 1894, no. 22 *(La Jeune Femme au chapeau
noir)*, bought for 5,100 francs by Durand-Ruel for
Berthe Morisot-Manet, Paris; her daughter, Julie
Manet, Paris, later Mme Ernest Rouart, 1895, by
inheritance; her heirs, Paris, 1967–98; acquired by
the Musée d'Orsay, Paris, with the support of the
Fonds du Patrimoine of the Meyer Foundation and
funding coordinated by the newspaper *Nikkei*, 1998

EXHIBITIONS: Paris, Salon d'Automne, 1905,
"Oeuvres d'Édouard Manet," no. 10; [see Rouart
and Wildenstein 1975 for further early exhibitions];
Paris–New York 1983, no. 130; Copenhagen 1989,
no. 25; Martigny 1996, no. 29; Paris 2000, no. 12;
Paris–Baltimore 2000–2001, no. 31 (Paris ed.);
Lille–Martigny 2002, no. 165; Paris 2002–3, no. 102

SELECTED REFERENCES: Bodelsen 1968, pp. 344–45
(procès verbal no. 28); Inaga 1994, no. 7

This beautiful image of Berthe Morisot reveals how
much Manet had learned from Velázquez by the
beginning of the 1870s: the startlingly direct and
somber qualities of such works as *Woman at Her
Window* (cat. 144), probably datable earlier than has
hitherto been thought, and the clean, clear luminos-
ity of *The Fifer* (cat. 151) in the mid-1860s, after the
visit to Spain, give way to portraiture that is as
informal and atmospheric, as vital and captivating,
as that of Velázquez's little infanta surrounded by
her *meninas*, or maids of honor (fig. 4.13).
 Berthe and her painter sister Edma enchanted
their fellow artists: soon after meeting them in 1868,
Manet joked with Fantin-Latour: "I agree with you,
the young Morisot girls are charming, it's a pity
they're not men, but as women they could still do
something for the cause of painting by each marry-
ing an academician and bringing discord into the
camp of those old dodderers, though that would be
asking for considerable self-sacrifice."[1] The follow-
ing year Edma married a naval officer and moved
away from Paris, and in December 1874, after vari-
ous courtships that came to nothing, Berthe finally
married Édouard Manet's brother Eugène. Berthe
and Manet enjoyed six years of a close artistic rela-
tionship, in which Berthe exerted a beneficially dis-
ruptive influence on Manet. She posed for him
several times in such masterpieces as *The Balcony*
(cat. 155) and *Repose* (1870, Rhode Island School of
Design, Providence) and then, after the privations
of the Siege of Paris and Manet's move to a new stu-
dio in 1872, in a series of informal sketches and por-
traits to which Berthe's marriage put an end.[2] The
present canvas, described in the catalogue of
Duret's 1894 sale simply as *Young Woman in a Black
Hat*, is the most intimate and revealing of all
Manet's portraits of Berthe.[3]

 JW-B

1. "Je suis de votre avis, les demoiselles Morisot sont char-
 mantes, c'est fâcheux qu'elles ne soient pas des homes,
 cependant elles pourraient comme femmes serivir la cause
 de la peinture en épousant chacune un académicien et en
 mettant la discorde dans le camp de ces gâteux, mais c'est
 leur demander bien du dévouement." Manet 1991, p. 49.

2. Berthe Morisot appears in eleven surviving oil paintings by Manet, of which all save the group portrait in *The Balcony* are individual studies. Nine of these works were reunited in a unique exhibition staged within the showing of the 2002 Berthe Morisot retrospective at Lille. Only the "immovable" *Berthe Morisot with a Fan* in the Moreau-Nélaton bequest (cat. 157) and the enchanting sketch in a Japanese collection (Rouart and Wildenstein 1975, vol. 1, no. 177; Martigny 1996, no. 32) were missing. A twelfth oil study, clearly unfinished, is known only from a photograph taken by Fernand Lochard and was not recorded in Leenhoff's 1883 register of works in Manet's studio (Rouart and Wildenstein 1975, vol. 1, no. 210).

3. Although we do not know to whom Manet gave or sold this portrait, if not directly to Duret, its importance for him is suggested by the fact that he reinterpreted it in two lithographs and an etching (J. Harris 1970, nos. 59, 73, 74; Lille–Martigny 2002, nos. 166–68).

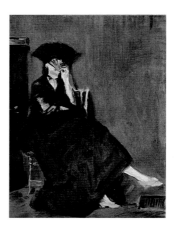

157. *(Paris only)* *Fig. 9.82*

Édouard Manet

Berthe Morisot with a Fan

1872
Oil on canvas
23⅝ x 17¾ in. (60 x 45 cm)
Signed lower left: *Manet 72*
Musée d'Orsay, Paris RF 1671

CATALOGUES RAISONNÉS: Tabarant 1931, no. 175; Orienti 1967, no. 157; Rouart and Wildenstein 1975, vol. 1, no. 181

PROVENANCE: The artist's studio, rue de Saint-Pétersbourg, Paris; bought for 600 francs by Théodore Duret, Paris, November–December 1873 (*Femme à l'éventail*, the artist's account book); Georges de Bellio, Paris, by 1884; M. and Mme Eugène Donop de Monchy, Paris, 1894, by inheritance (inventory no. 63); sale (various owners, including Donop de Monchy), Hôtel Drouot, Paris, May 29, 1897, no. 43, bought for 1,900 francs by Moreau-Nélaton (*procès verbal* no. 57); Étienne Moreau-Nélaton, Paris; his bequest to the Musées Nationaux, 1906; Musée des Arts Décoratifs, Paris, 1907; Musée du Louvre, Paris, 1934; Musée du Jeu de Paume, Paris, 1947; Musée d'Orsay, Paris, 1986

EXHIBITIONS: Paris 1884, no. 65 (*Femme à l'éventail*, lent by de Bellio); [see Rouart and Wildenstein 1975 for further early exhibitions]; Paris 1991,

no. 82; Paris–Washington 1998, no. 23, fig. 134 (Paris ed. only); Paris 1998–99, no. 187; Paris 2002–3, no. 103

SELECTED REFERENCES: Niculescu 1970, p. 61, no. 63; Anne Distel, in Paris 1991, p. 2 n. 7; Paris–Washington 1998, p. 155

In the account book in which Manet noted sales of his paintings, an entry at the end of the list for 1873 reads: "to Duret, woman with a fan 600."[1] This has always been assumed to be the small sketch portrait of Berthe Morisot that later passed to Georges de Bellio, perhaps when Duret acquired the more important and appealing portrait of Berthe with a bunch of violets (cat. 156). Dr. Georges de Bellio, a wealthy Romanian living in Paris, was interested in many aspects of art and science and was a practitioner of homeopathy. He became one of the few staunch supporters of the Impressionists, in particular of Claude Monet, and he acquired several works by Manet.[2] Curiously, he, like Duret, owned two portraits of Berthe Morisot. This one he acquired from Duret and lent to the memorial exhibition in 1884;[3] the second, the striking image known as *Berthe Morisot in Mourning* (1874, private collection), was given to him after Manet's death, no doubt in gratitude for medical or other services.[4]

This is one of Manet's most informal and quirky images of Berthe. Perched on a little gilt chair, she peeps playfully at the artist through the ribs of her fan, while swinging her pink-slippered foot above a hot-air vent that is still to be seen in the artist's former studio on the rue de Saint-Pétersbourg. The intimacy and energy of this little masterpiece mark it out from other small works such as Manet's portrait of Duret (cat. 154) and place it on a par with Goya's brilliant portrait of his artist friend Asensi (cat. 6) as well as the lovely *majas* of Goya's *Caprichos* (cat. 28).

JW-B

1. "à Duret, femme à l'éventail 600." Copy by Léon Leenhoff in Leenhoff Notebook 1, Bibliothèque Nationale de France, Paris, Département des Estampes, Yb-3-2401, 8°, Rés., p. [75].

2. See Niculescu 1970, pp. 43–45, 61, 70, 79–81 (for Manet).

3. The painting was listed as no. 63, titled *Sous l'éventail*, in an inventory of works drawn up after de Bellio's death in 1894 (Musée Marmottan, Paris); the inventory is discussed and transcribed in Niculescu 1970, pp. 56, 61, no. 63. Inherited by de Bellio's daughter and son-in-law, Eugène Donop de Monchy, the work was included in a sale held in 1897. The *procès verbal* document, kindly communicated by Anne Distel, shows that it was acquired directly by Étienne Moreau-Nélaton.

4. Rouart and Wildenstein 1975, vol. 1, no. 228. The portrait of Berthe Morisot in mourning was recorded in Léon Leenhoff's register of works in Manet's studio under no. 256, *Berthe*, and the annotated album page with Lochard's photograph indicates that it was given to de Bellio (Lochard album I, p. 50, Tabarant archive, Pierpont Morgan Library, New York).

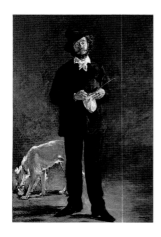

158. *Fig. 9.92*

Édouard Manet

The Artist (Marcellin Desboutin)

1875
Oil on canvas
75⅛ x 50⅛ in. (192 x 128 cm)
Signed and dated lower right: *Manet/1875*
Collection Museu de Arte de São Paulo Assis Chateaubriand, São Paulo 77.1958

CATALOGUES RAISONNÉS: Tabarant 1931, no. 225; Orienti 1967, no. 202; Rouart and Wildenstein 1975, vol. 1, no. 244

PROVENANCE: Bought for 3,500 francs by Henri Debrousse, Paris (*L'Artiste*, the artist's account book); Auguste Pellerin, Paris, before 1899; bought by Durand-Ruel and Bernheim-Jeune, Paris, and Paul Cassirer, Berlin, 1910, each owning one-third interest; bought for 300,000 marks by Eduard Arnhold, Berlin, 1910 (with *The Monet Family in the Garden*); Wildenstein, Paris, 1954; bought by the Museu de Arte, São Paulo, 1954

EXHIBITIONS: Paris, the artist's studio, rue de Saint-Pétersbourg, April 15–May 1, 1876; Paris 1884, no. 78 (lent by Hubert Debrousse); Paris, Exposition Universelle, 1900, "Centennale," no. 446 (lent by Pellerin); Berlin–Munich 1910, no. 1; Paris 1910b, no. 8; [see Rouart and Wildenstein 1975 for further early exhibitions]; Paris–New York 1983, no. 146; Martigny 1996, no. 46; Paris 2002–3, no. 104

SELECTED REFERENCES: [see Rouart and Wildenstein 1975 for references from 1876 to 1972]; Wilson-Bareau 1989, pp. 31, 34, fig. 9 (account book); Martigny 1996, p. 232

In the 1870s Manet's palette lightened, his brushwork became looser, and for a period he experimented with Impressionism, especially in 1874, during the summer in Argenteuil and in Venice in the fall. But his art was marked by the great masters of the past, and thus his entry for the 1875 Salon, the river landscape scene he titled *Argenteuil* (Musée des Beaux-Arts, Tournai), was an impressive, carefully constructed composition.

Two canvases, both rejected by the Salon of 1876, reveal the road he would subsequently follow.

In 1875 he painted *Le Linge* (Barnes Foundation, Merion, Pa.), a plein-air garden scene flooded with light. In *The Artist*, a dark portrait of his friend Marcellin Desboutin, painter and printmaker, Manet returns to the somber tonality and gravitas of the large full-length figures of the early 1860s, although in a newly vibrant manner. The subject, like that of *The Tragic Actor* (cat. 150), is represented in his professional capacity, but the simplicity of the pose links with *The Absinthe Drinker* (cat. 128). While his dog laps from a water glass, Desboutin fills his pipe meditatively, with an expression as alive and haunting as those of Velázquez's philosophers and dwarfs (cats. 74–76). JW-B

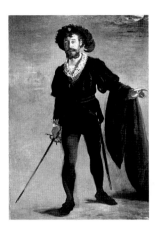

159. *(New York only)* *Fig. 9.58*
Édouard Manet
Faure in the Role of Hamlet

1876–77
Oil on canvas
76⅜ x 51¼ in. (194 x 131.5 cm)
Signed and dated lower right: *Manet 1877*
Museum Folkwang, Essen GIII

CATALOGUES RAISONNÉS: Tabarant 1931, no. 258; Orienti 1967, no. 230C; Rouart and Wildenstein 1975, vol. 1, no. 257

PROVENANCE: The artist's studios, rue de Saint-Pétersbourg and rue d'Amsterdam, Paris, 1877–83; Léon Leenhoff's studio register, 1883, no. 9 *(Hamlet)*; the artist's estate inventory, 1883 ("Tableaux et études," no. 15, *Hamlet*); the artist's estate sale, Hôtel Drouot, Paris, February 4–5, 1884, no. 5 *(procès verbal* no. 51), bought for 3,500 francs by Durand-Ruel, Paris (Paris stock 1880–84: 3194); Durand-Ruel, New York, February 27, 1895 (New York deposit 5254), bought in 1900; bought by Durand-Ruel, Paris, February 14, 1910 (Paris stock 9241); bought by Durand-Ruel, New York, January 1926 (New York stock 4911); bought by Durand-Ruel, Paris, October 14, 1927; Galerie Matthiesen, Berlin, 1927; bought by the Museum Folkwang, Essen, 1927

EXHIBITIONS: Paris, Salon of 1877, no. 1415; New York 1886, no. 1; New York 1895a, no. 7; Copenhagen 1914, no. 128; [see Rouart and

Wildenstein 1975 for further early exhibitions]; Okayama et al. 1996–97, no. 44

SELECTED REFERENCES: [see Rouart and Wildenstein 1975 for early references]; Bodelsen 1968, p. 342 *(procès verbal* no. 51); Callen 1974, pp. 164–66; Washington 1982–83, pp. 100–101; Darragon 1989, pp. 283–89; Wilson-Bareau 1989, p. 31 and n. 22; Darragon 1991, pp. 268–69, fig. 191; Paris–Washington 1998, p. 176

Jean-Baptiste Faure (1830–1914) was a phenomenally successful baritone and a major patron of the arts. His operatic career was launched in the early 1850s. As his fame grew, the singer began to buy art, first works by the Barbizon school, Corot, Courbet, and Delacroix.[1] Faure became closely associated with the dealer Paul Durand-Ruel, and the two waited out the Siege of Paris (1870–71) together in London. In January 1872 Durand-Ruel made his major purchase of works from Manet's studio. On January 3, 1873, Faure acquired his first two paintings by Manet from Durand-Ruel's stock: *The Spanish Singer* (cat. 131) and *Moonlight over Boulogne Harbor* (1868, Musée d'Orsay, Paris). Faure acquired a third Manet painting in March 1873 and a fourth in April.

In early November 1872 or 1873, Manet asked Théodore Duret for Faure's address, because he wanted to send the singer a fine proof of his etching after *The Spanish Singer* (cat. 163).[2] On November 18, 1873, Faure visited Manet's studio on the rue de Saint-Pétersbourg and purchased five major paintings from the artist. They included *Masked Ball at the Opera* (1873, National Gallery of Art, Washington, D.C.), on which Manet was still working, and his *Lola de Valence* (cat. 138), of which Manet may have repainted the background at Faure's request. These two canvases were connected with opera and dance; the others were of genre and marine subjects. Faure went on to purchase many more works by Manet, ranging from *The Fifer* (cat. 151) later in November 1873 to five paintings just weeks before the artist's death, including *Music in the Tuileries* (fig. 9.32). Altogether, Faure acquired a total of sixty-eight works by Manet. Following his decision to part with a substantial number of them, twenty-four were offered for sale in 1906 through Durand-Ruel, who showed them in a series of gallery exhibitions, first in Paris and London, then in Berlin, Stuttgart, and Munich.[3]

A short text intended by Stéphane Mallarmé for the London weekly *Athenaeum* (but never published in that journal) sheds light on this portrait project. Believed to have been written in November 1875, it reports that "M. MANET . . . is working on a standing, lifesize portrait of *Faure* in *Hamlet*" and also alludes to "one of his two pictures for the Salon of 1876 that are already finished: *Le Linge*" (Barnes Collection, Merion, Pa.).[4] Mallarmé's unpublished note suggests that Manet began to paint a portrait of Faure in 1875 and not, as usually assumed, in 1876, thus underscoring the lengthy gestation of this project. Manet depicts Faure as the hero of Ambroise Thomas's opera *Hamlet*. Faure first sang the role in 1868, and it was as Hamlet that he gave his last per-

formance at the Paris Opera on May 13, 1876. Faure himself described the painful progress of the portrait: it was "redone nine times by Manet, who destroyed three canvases because they did not correspond to his preconceived notion of this portrait."[5] One large-scale alternative canvas is known (Hamburger Kunsthalle), and an earlier pastel depicts the scene in which Hamlet confronts his father's ghost on the castle battlements (Wickham-Boynton Collection, Burton Agnes Hall, Bridlington, England).[6]

Whatever Manet's "preconceived notion" may have been, and however many attempts he may have made to realize it, the final version of the portrait was effectively a reworking of the earlier, Velázquez-influenced *Tragic Actor (Rouvière as Hamlet)* (cat. 150) of 1865–66. Abandoning the shimmering atmosphere and luminous colors of the pastel and the Hamburg ébauche, which reflect the artist's brush with Impressionism, Manet produced a much more sober, "official" image of the veteran singer. Anthea Callen (1974) has noted the close resemblance between Manet's painting and a bust-length photograph of Faure by Reutlinger that was probably taken in May 1876. Faure wears the same plumed cap and white lace collar and has the same curl over his forehead in both representations. Beneath the lace collar lies a ribbon—blue in the paintings—from which hangs a medal. An almost identical full-length portrayal of Faure is seen in a drawing by Paul Renouard that was reproduced in the journal *L'Art* in April 1877.[7] Both images may be based on a photograph that is as yet unidentified.

In spite of Faure's refusal to accept the portrait—on the grounds that it did not sufficiently resemble him—Manet sent it to the Salon of 1877 with a note providing information for the catalogue.[8] Although Edmond Duranty and one or two others appreciated the portrait, it was an object of general mockery and criticism. Both the ébauche and the finished portrait remained in Manet's studios. At his death, the finished version was displayed in a fine "antique" frame, flanked by Manet's two self-portraits (see cat. 160);[9] the ébauche remained unframed. Léon Leenhoff's brief comments in his 1883 register of works in the rue d'Amsterdam studio summed up the situation: "Hamlet — Signed and dated 1877. Antique frame. Faure did not consider it a good likeness. Was bought by Durand-Ruel [in the estate sale]. Its frame was lent to the *Gustave in the costume of a Majo*." The last remark alludes to the painting that Faure lent, along with twenty-two others, to the 1884 memorial exhibition (cat. 140). Faure's portrait was not exhibited at that time.[10]

This impressive canvas shows traces of extensive reworking, with pentimenti around the legs and the cloak over Faure's arm; visual evidence also suggests that the background has been altered. The changes bear witness to Manet's hesitations and no doubt to the constraints imposed on him by his patron and model. Yet when the portrait is considered with the related works—from the preparatory pastel to the later ink drawing reproduced in *Gazette des Beaux-Arts* via the astonishing ébauche in Hamburg—it provides a unique insight into Manet's creative processes. JW-B

1. For an account of Faure's career and collecting, based on his autobiographical *Notice sur la collection J.-B. Faure* (Paris, 1902), see Callen 1974.

2. See Manet 1991, p. 164. The letter, dated simply "November 4," could have been written in 1872 (as indicated), exactly two months before Faure's purchase of the painting, or in 1873, shortly before Faure's recorded visit to Manet's studio.

3. For the exhibitions of Faure's collection, see the Bibliography under the relevant place names in 1906 and 1907.

4. "M. MANET . . . prepare un portrait en pied et de grandeur naturelle de *Faure* dans *Hamlet*"; "un de ses deux tableaux du Salon de 1876 déjà achevés." Mallarmé 1962, p. 42. The modern editors of Mallarme's so-called *Gossips* give no reasons for the dating of the text. The dating is, however, supported by a letter written on September 19 in which Manet told Mallarmé that he hoped to complete *Le Linge* by the end of the month (see Manet 1991, p. 175).

5. "repris par Manet neuf fois et trois toiles ont été détruites par le peintre à coups de couteau, parce qu'elles ne correspondaient pas à son idée préconçue de ce portrait." Quoted in Callen 1974, p. 164.

6. The painting in Hamburg is a dazzling impressionistic work that was no doubt rejected by Faure at an early stage (Rouart and Wildenstein 1975, vol. 1, no. 256; see Washington 1982–83, pp. 100–101, and Copenhagen 1989, p. 116). For the pastel (Rouart and Wildenstein 1975, vol. 2, P4), see Paris 1998–99, p. 80, fig. 46, p. 168, no. 71. For a related drawing, see n. 7 below. An oil "study" was catalogued by Tabarant in 1931 (no. 260, not repr.) and 1947 (no. 272, repr.); it was excluded from the oeuvre by Rouart and Wildenstein 1975.

7. See Washington 1982–83, p. 101. The drawing by Renouard appears in an article by Walter Herries Pollock entitled "Le théâtre en Angleterre," *L'Art* 9 (April 1877), p. 53; this is preceded and followed by Charles Yriarte's articles on "Goya aquafortiste," accompanied by the first publication of original prints from Goya's additional plates of the *Proverbios* or *Disparates* (Gassier and Wilson 1971, nos. 1601–4; T. Harris 1964, vol. 2, nos. 266–69).

A drawing usually described as a preparatory study for the painting (Rouart and Wildenstein 1975, vol. 2, D476) is an exact equivalent of Renouard's drawing for *L'Art*. Manet's pen-and-wash sketch after his painting was reproduced in Duranty 1877, p. 67.

8. "Exposition de 1877 / Edouard Manet / 4 rue S¹ Pétersbourg / Portrait de Faure / (role d'Hamlet) / [signed] E. Manet." The note was included in an auction sale, "Lettres et Mss autographes, Documents historiques," Hôtel Drouot, Paris, December 12–13, 1994, lot 369. The following lot was a letter from Manet to the "directeur des Beaux-arts," dated March 24 (no year), regretting that in spite of the additional time allowed him, his portrait—unspecified—would not be ready to send to the Salon. It seems probable that the two documents are connected; in any event, Manet's portrait of Faure finally made the deadline for the exhibition. Thierry Bodin kindly provided information concerning these documents.

9. See Bazire 1884, p. 132.

10. "Hamlet. Signé et daté 1877. / Cadre ancien / Faure n'a pas trouvé ressemblant. / A été acheté par Durand-Ruel / son Cadre prêté au Gustave en costume de Majo." Leenhoff register, Bibliothèque Nationale de France, Paris, Cabinet des Estampes, Rés. Yb¹-4649-4°, no. 9. The frame on the portrait of Faure that was "lent" to the *Young Man in the Costume of a Majo* (cat. 140) is seen in Godet's photograph of the 1884 exhibition (Moreau-Nélaton 1926, vol. 2, fig. 341).

160. *(New York only)* *Fig. 9.96*

Édouard Manet
Self-Portrait with Palette
Ca. 1879
Oil on canvas
32⅛ x 26⅛ in. (83 x 67 cm)
Private collection

CATALOGUES RAISONNÉS: Tabarant 1931, no. 299; Orienti 1967, no. 274; Rouart and Wildenstein 1975, vol. 1, no. 276

PROVENANCE: The artist's studio, rue d'Amsterdam, Paris, ca. 1879–83; Leenhoff studio register, 1883, no. 51 (*Portrait palette*); lent by Suzanne Manet to Ferdinand Leenhoff, Paris, 1883; Suzanne Manet, Asnières; given by her to her sister Martiena Vibert-Leenhoff, February 2, 1899; bought for 1,000 francs from Suzanne Manet by Hermann Paechter, Berlin, 1899; Auguste Pellerin, Paris; marquise de Ganay, Paris, by May 1910; Dr. Jakob Goldschmidt, Berlin, by 1931, then New York, 1936–55; his sale, Sotheby's, London, October 15, 1958, no. 1, bought for 65,000 pounds by J. Summers; John and Frances L. Loeb, New York; their sale, Christie's, New York, May 12, 1997, no. 107, bought for 17,000,000 dollars; Stephen A. Wynn collection; private collection

EXHIBITIONS: Berlin 1910; Paris 1910a, no. 118 (lent by marquise de Ganay); Paris 1910b, no. 16; [see Rouart and Wildenstein 1975 for further early exhibitions]; Washington 1982–83, no. 1; Paris–New York 1983, no. 164

SELECTED REFERENCES: Tabarant 1947, pp. 355–57; [see Rouart and Wildenstein 1975 for further references]

Manet represented himself twice in the early 1860s: first in period costume as Rubens in *Fishing* (1861–63, Metropolitan Museum of Art, New York), then, in homage to Velázquez's alleged self-portrait in *Gathering of Gentlemen* (cat. 79), in modern dress in *Music in the Tuileries* (fig. 9.32).[1] These early self-portraits are playful, allusive, and witty. In sharp contrast to Courbet (cats. 99, 100), Manet did not indulge in the practice of representing himself. Near the end of his relatively short life, however, Manet again scrutinized his own image twice: in a dramatically confrontational full-length pose in a small work (Bridgestone Gallery, Tokyo), and half-length in this portrait, which focuses attention on the artist's head. Both portraits were left unsigned at Manet's death. Years later Suzanne Manet would describe them as "sketches" (*ébauches*). It is not clear whether the artist himself had already hung them in his studio on either side of his great portrait of Faure (cat. 159) or whether, as seems more probable, Léon Leenhoff had them framed in order to present images of Manet as part of a memorial display for those who came to pay their respects.[2]

The two self-portraits are usually considered to be contemporaneous. Adolphe Tabarant, no doubt on information obtained from Manet's family and friends, dated them to the end of 1879. If one seeks a raison d'être for Manet's unusual interrogation of himself—in representations that mingle high levels of self-assertiveness, tension, and anxiety—it may perhaps be found in Léon Leenhoff's reply to a question from Théodore Duret: "In which year did he notice the onset of his illness?"—"1879."[3] The portraits could thus be seen as a response, at once anxious and defiant, to sudden intimations of mortality, which led Manet to seek increasingly drastic remedies over the next three years.

Manet depicts himself here in the yellow vest he habitually wore when he painted. The same garment appears on the young man in his *Chez le père Lathuile* (1879, Musée des Beaux-Arts, Tournai), which he showed at the 1880 Salon.[4] This portrait has long been recognized as a quotation from Velázquez's *Las Meninas* (fig. 4.13), one of the works that left an indelible impression on the artist when he visited the Prado in 1865. The structure of Velázquez's masterpiece has recently been recognized in a small pencil-and-watercolor sketch of a studio, usually assumed to be Manet's own, that shows an artist standing before his easel painting.[5] The date of the drawing is unknown, and the room is not immediately recognizable as the interior of Manet's studio at 4, rue Saint-Pétersbourg.[6] It is possible that the little sketch is more closely related to this later self-portrait à la Velázquez, and it may even represent an idea for a large canvas that illness forced Manet to abandon.

JW-B

1. See Paris–New York 1983, nos. 12, 38.

2. Tabarant 1947, p. 357, cites the deed of gift, dated February 2, 1899, by Suzanne Manet to her sister, which describes each portrait as an *ébauche*. For their presentation in the studio, see Bazire 1884, p. 132. No Lochard photograph exists of either portrait. Neither was shown in the 1884 retrospective exhibition at the École des Beaux-Arts, and there is no contemporary record of their condition or appearance. They were first exhibited in 1910 (half-length) and 1922 (full-length).

3. "Questions de Duret du 25 Juin 1900 demandées par lettre à Mad. Manet à Sarcelles . . . En quelle année a-t-il senti la première atteinte de sa maladie. 1879." Notes written by Leenhoff on the final page, numbered 327, of his manuscript register of works in Manet's studio, 1883 (Bibliothèque Nationale de France, Paris, Cabinet des Estampes, Rés. Yb¹-4649).

4. Although the young man posed at first in his military uniform, Manet gave him his vest to wear when his female model failed to appear and he was obliged to replace her with another. Tabarant 1931, pp. 353–54; Manet 1991, p. 246.

5. The drawing (Rouart and Wildenstein 1975, vol. 2, D355; see Paris–New York 1983, no. 136) is analyzed in Diers 1998. Malcolm Park demonstrated to me the precise and very close relationship of the drawing to part of Velázquez's painting.

6. The pictures in the background of the sketch have been identified as works painted at Berck-sur-Mer in the summer of 1873 and the location as Manet's studio, opened for a public viewing of *Le Linge* (Barnes Foundation, Merion, Pa.) and *The Artist* (cat. 158) in April 1876 (Paris–New York 1983, no. 164); see also Manet 1991, p. 163, fig. 118 (drawing), and Paris–Washington 1998, figs. 121, 131 (studio interior).

161.

Fig. 9.94

Édouard Manet

Dancer and Majo

1879
Oil on parchment (Basque tambourine)
Diam. 7¼ in. (18.5 cm)
Signed on border at right: *Manet*
Private collection, Paris

CATALOGUES RAISONNÉS: Tabarant 1931, no. 315 (group of tambourines); Orienti 1967, no. 303; Rouart and Wildenstein 1975, vol. 1, no. 323

PROVENANCE: Antonin Proust, Paris; Étienne Moreau-Nélaton, Paris; his heirs, 1927; private collection; anonymous sale, Hôtel Drouot, Paris, June 25, 1986, no. 22; private collection

EXHIBITIONS: Paris 1884 (not in catalogue); Paris 1978, no. 17

SELECTED REFERENCE: Moreau-Nélaton 1926, vol. 2, p. 93, fig. 308

In 1879 the publisher Georges Charpentier and the critic Émile Bergerat launched a new illustrated journal, *La Vie Moderne*. A gallery on the premises offered a variety of exhibitions that ranged from one-man shows for both Manet and Monet to topical and essentially frivolous displays: painted ostrich eggs for an Easter 1880 exhibition; decorated tambourines for a Christmas–New Year show in 1879–80.[1] Information about such "minor" works is necessarily sketchy, but two tambourines that belonged to the guitarist Pagans are known to have been shown in Manet's memorial exhibition.[2] Étienne Moreau-Nélaton acquired two others that Manet painted for his friend Antonin Proust. One shows a café-concert scene, with motifs from Manet's recent paintings.[3] In the other, while the dancer with her fan is a modern *maja*, the *majo* enveloped in his cape comes straight out of Goya's *Majas on a Balcony* (see cat. 14), which Manet must have known in one of its two versions, through a print or photograph.

The tambourine has survived intact, with its original ribbons and bells. It is a lighthearted evocation of the Spanish manner and themes that Manet had pursued for two decades in the art of Velázquez and Goya. JW-B

1. A. Silvestre 1879–80, p. 580 (1879), and p. 4, repr. (1880).
2. Photographed by Godet in the exhibition; see Moreau-Nélaton 1926, vol. 2, fig. 351.
3. Ibid., fig. 309; Paris 1978, no. 18.

162. *(New York only)*

Fig. 9.95

Édouard Manet

Emilie Ambre as Carmen

1880
Oil on canvas
36⅜ x 29 in. (92.4 x 73.5 cm)
Philadelphia Museum of Art, Gift of Edgar Scott, 1964 1964.114.1

CATALOGUES RAISONNÉS: Tabarant 1931, no. 304; Orienti 1967, no. 301; Rouart and Wildenstein 1975, vol. 1, no. 334

PROVENANCE: Suzanne Manet, 1883, by inheritance (estate inventory, "Tableaux et études," *Femme andalouse*[?]); Léon Leenhoff's studio register, no. 68 (*Ambre*); purchased from Leenhoff by Mrs. Thomas Alexander Scott, Paris, December 10, 1883 (the artist's account book: *Carmen*, 5,000 francs for three works); Edgar Scott, Philadelphia, by inheritance; his gift to the Philadelphia Museum of Art, 1964

EXHIBITIONS: Philadelphia, Pennsylvania Academy of the Fine Arts and University of Pennsylvania Lecture Association, 1892, loan exhibition of French art (no known catalogue) *(Spanish Woman)*; [see Rouart and Wildenstein 1975 for further early exhibitions]; Shizuoka et al. 1994, no. 15; Baltimore–Houston–Cleveland 1999–2000, no. 39; Stuttgart 2002–3, no. 60

SELECTED REFERENCES: Huth 1946; Tabarant 1947, pp. 364–65; [see Rouart and Wildenstein 1975 for further early references]; Philadelphia 1985, p. 15

Manet's portrait of the opera singer Emilie Ambre was painted in September and October 1880 in Bellevue, which was located on the left bank of the Seine between the river and the town of Meudon.[1] Bellevue had two hydrotherapy establishments, and Manet was then receiving treatment at one of them. The portrait was executed quickly. The head is relatively finished—the contour of Ambre's face is outlined in white, as if viewed in the glare of stage lighting—but the garments are broadly brushed, and the hand holding the fan is only a few summary strokes.

Ambre and Gaston de Beauplan, her lover and possibly her husband, had gone to the United States in September 1879, Ambre as a member of James Henry Mapleson's touring opera troupe.[2] The couple took the final version of Manet's *Execution of Emperor Maximilian* with them and exhibited it in New York and Boston, but it is not known how the artist made their acquaintance or why he entrusted the picture to them.[3]

When Manet painted Ambre's portrait, she was preparing for her second trip to the States, this time as the star of Beauplan's Grand Opera Company.[4] Adolphe Tabarant and writers who rely on him treat the Beauplan company as an ill-conceived lark. The evidence supplied by contemporary newspapers, however, suggests that Beauplan made a serious, well-intentioned effort to mount a showcase for Ambre's talents. The troupe arrived in New York on October 19, 1880, and went straight to New Orleans, where the tour began with a successful four-month repertory season. However, expenditures outstripped receipts in Cincinnati, Chicago, and Philadelphia. The venture collapsed in New York when five principals refused to sing unless paid their back wages.

Manet depicts Ambre here as the heroine of Georges Bizet's opera *Carmen*, which some commentators have assumed was her favorite role. She did ask Manet to urge Antonin Proust to use his influence as a member of the Grévy government's fine-arts commission to pressure Léon Carvalho into reviving *Carmen* for her.[5] Her efforts proved unsuccessful, and she sang the role only once for Mapleson and six times for the Beauplan troupe. A photograph made in New York in the fall of 1879 showing Ambre costumed exactly as Manet represents her has been cited as evidence that the artist was revisiting his "Spanish" past in this portrait.[6] Since opera stars in 1879 and 1880 costumed themselves as they pleased, the photograph reveals only that Ambre's Carmen costume was at least a year old when Manet painted her.

Some scholars believe that the portrait was painted at Ambre's request, others that it was Manet's thanks

for her having taken *Maximilian* to the United States. However, the painting was still in Manet's studio at the time of his death. Ambre could not have seen Manet again before her return to France in May or June 1881 at the earliest. She and Beauplan are recorded in the 1881 census as residing in Bellevue, but Manet seems never to have returned there. After their American mishap, they may have wanted to avoid the limelight.

Mrs. Thomas Alexander Scott, a relative of Mary Cassatt, purchased the painting together with two pastels from Léon Leenhoff seven weeks before the Manet studio sale of February 1884.[7]

JW-B

1. Manet's undated letter to Eva Gonzalès (postmarked September 27, 1880) informs her: "I'm working again. At the moment I'm doing a portrait of Mlle Émilie Ambre, a landowning prima donna neighbor. I go and work on it every day because she's leaving for America on October 8." ("J'ai repris le travail, je fais en ce moment le portrait de Mlle Émilie Ambre, une châtelaine prima donna du voisinage; je vais tous les jours travailler, elle devant partir en Amérique le 8 octobre.") Manet 1991, p. 256. Manet's return address on his letters from the summer of 1880 is for a small house on a much larger property referred to as "Les Montalais." Ambre owned "Les Montalais" between 1877 and 1881. The writer is indebted for this information to Véronique Magnol-Malhache, Archives Départementales des Hauts-de-Seine. There is no documentary support for claims that Manet rented from Ambre or was lent by her the house at 41 route des Gardes in which he and his family spent the months from June to November 1880.

2. Hans Huth's 1946 article, which is often cited for Ambre's first American tour, should be used with caution. Consider, for example, Beauplan's phrase "In Chicago—lard, tallow, pigs. That slaughters 110,000 pigs a day" ("A Chicago, saindoux, suifs, porcs. Voilà la devise de cette ville dans laquelle on abat par jour 110,000 cochons"). Beauplan to Manet, January 9, 1880, Musée du Louvre, Département des Arts Graphiques, *Album (Moreau-Nélaton)*, fol. 23. This becomes in Huth "city of 'lard, Jews and swine'" (p. 227).

3. On the exhibition of the painting in America, see London 1992, pp. 69–70. Adolphe Tabarant's statement that Manet began the portrait in 1879 is based on his misreading of the postmark of the letter cited in n. 1 above.

4. Gaston's grandfather Amédée de Beauplan composed comedies, vaudevilles, operettas, and songs. His father Arthur started life as a journalist and librettist but in the late 1860s became an arts bureaucrat with a speciality in "lyric theater." In June 1871 he became head of theaters in the Third Republic's arts administration, and in January 1877 sous-directeur des Beaux-Arts (undersecretary of fine arts). When Jules Grévy replaced Maurice de MacMahon as president of France on January 30, 1879, Arthur's post was abolished, and he retired from public life in February. Gaston's relationship with Ambre seems to have embarrassed his father. *Le Figaro* (February 4, 1879, p. 4) hotly denied rumors that Gaston and Ambre had married, and a month later the father tried to have the son declared mentally incompetent (*Le Temps*, March 15, 1879, p. 3). Gaston's letters to Manet from the United States are those of a young man responding enthusiastically to a wide-open entrepreneurial environment.

5. Ambre to Manet, undated letter (ca. September 15, 1879), Musée du Louvre, Département des Arts Graphiques, *Album (Moreau-Nélaton)*, fols. 25, 26. *Carmen* premiered at the Opéra-Comique on March 3, 1875. The work was not a smashing success, and there were no performances in Paris between February 15, 1876, and April 21, 1883. Between

those two dates, however, the work was mounted with great success in a number of other European and American cities, often in translation, in versions that turned the spoken French dialogue of the original into sung recitatives. Léon Carvalho ran a succession of opera theaters in Paris. In 1879 a combination of circumstances involving tightened arts budgets and closed buildings made the Opéra-Comique, at the time headed by Carvalho, the only possible venue for a revival of Bizet's work.

6. See Baltimore–Houston–Cleveland 1999–2000, p. 116. The photograph in the Harvard University Theater Collection is undated (see ibid., fig. 39a), but it was probably made in November or December 1879 when the Mora studio photographed Ambre as Aïda (Tabarant Collection, Pierpont Morgan Library, New York).

7. This catalogue entry is based on research carried out and texts provided by David C. Degener.

PRINTS AND DRAWINGS

Manet's early prints have often been classed in the category of reproductions since almost all of them are copies after his own paintings and tend therefore to find themselves denied the status of original works. However, Manet produced his etchings in considerable numbers during the early 1860s. He included them in the publications produced by the print dealer Alfred Cadart for the Société des Aquafortistes (Society of Etchers), which was founded to promote original printmaking, or he issued them through Cadart as sets of prints under his own name. Impressions were often dedicated by Manet to close friends (cat. 163), and he was well aware of the value of a fine print. At the time of his major retrospective exhibition in 1867, he lamented an accident that had affected the copperplate of *The Little Cavaliers* (cat. 164) and urged a prospective patron "to choose one or another of two etchings after pictures that are included in my exhibition, *The Spanish Singer* and *The Urchin* [cats. 163, 168]. Personally I prefer *The Urchin* as an example of printmaking, but do, please, follow your own inclination and let me know your decision so that I can send the plate to Delâtre at 303 rue St Jacques."[1] Some years later, in 1872 or 1873, he wrote to a friend asking for the address of the opera singer Jean-Baptiste Faure, who was to become one of his most important patrons, "so that I can send him a proof of the *Guitarist*" (cat. 163), but with the anxious enquiry: "By the way, does he appreciate etchings and would it give him pleasure? For I don't like giving fine proofs to people who don't appreciate them."[2]

The etching known as *The Spanish Singer (The "Guitarero")* (cat. 163), after the painting of the same name (cat. 131), was one of Manet's most consistently popular prints and the object of the first known reference to his printmaking. The *Chronique des Arts et de la Curiosité*, a gossipy weekly supplement to the venerable *Gazette des Beaux-Arts*, carried this announcement on April 13, 1862: "*A Guitarero.* / He's singing his head off, sitting on a stool, scratching his instrument and beating time with his foot. M. Ed. Manet has just made his own etching, full of energy and a lively feeling for color,

of the picture he showed at the last Salon. This example inspires the hope that M. Manet will etch his other compositions, which are remarkable for their straightforward approach and their attentive study of nature.—This etching, and those of MM. Bonvin and Jongkind, are to be found at the publishers A. Cadar[t] and Chevalier."[3]

Baudelaire (cats. 170, 171) followed, on or after April 15, with his reference to "several experiments in etching" by Philippe-Auguste Jeanron, Théodule Ribot, and Manet, in a brief article that he rewrote in a much fuller form in September of that year.[4] While welcoming these new initiatives, the poet expressed the fear that the freedom exercised in informal "etched studies and sketches" by "men of mature and tested talent" could, when practiced by countless imitators, degenerate into displays of incompetence that would produce public contempt.[5] He praised Manet's paintings rather than his prints and looked forward to his contributions to the next Salon and to pictures "drenched in the most intense Spanish flavor."[6]

Manet, who sketched and painted swiftly, must have found the etching needle a delight to use as it skated over the prepared surface of a copperplate. At Alfred Cadart's print shop and gallery on the rue de Richelieu, at the printing works of Auguste Delâtre, and benefiting from the advice of his friends and colleagues Alphonse Legros and Félix Bracquemond, the novice printmaker could count on expert technical help. Enthusiasm for the new technique and awareness of the advantages of disseminating his own work to a wider public led the artist to spend much time and effort on printmaking over the brief period from 1861 to 1864; afterward, his activity in the medium became sporadic and is mainly remarkable for magnificent but isolated lithographs produced between 1867 and the end of his life.

JW-B

1. Paris–New York 1983, p. 62; Manet 1991, p. 46.

2. Manet 1991, p. 164. On the question of "originality," see Michel Melot, "Introduction à l'oeuvre gravé de Manet," in Ingelheim 1977 (French ed.), pp. 15–20.

3. "*Un Guitarero.* Il chante à plein gosier, assis sur un escabeau, grattant son instrument et battant du pied la mesure. / M. Ed. Manet vient de graver lui-même à l'eau-forte, avec beaucoup d'énergie et un vif sentiment de la couleur, la peinture qu'il avait exposée au Salon dernier. Cette pièce nous fait désirer que M. Manet grave lui-même ses autres compositions, qui se font remarquer par une exécution d'une rare franchise et une étude sincère de la nature. – On trouve cette eau-forte, ainsi que celles de MM. Bonvin et Jongkind, chez A. Cadar[t] et Chevalier, éditeurs." Unsigned announcement under "Bibliographie . . . Estampes," *Chronique des Arts et de la Curiosité*, no. 20 (April 13, 1862), p. [4].

4. "quelques essais d'eau-forte." Unsigned [Baudelaire], "L'eau-forte est à la mode," *Revue Anecdotique* (April [15–30], 1862); see Baudelaire 1975–76, vol. 2, p. 736.

5. "Que des hommes d'un talent mûr et profond . . . fassent au public confidence et leurs esquisses et de leurs croquis gravés, c'est fort bien, ils en ont le droit." Unsigned [Baudelaire], "Peintres et aquafortistes," *Le Boulevard* (September 14, 1862); see Baudelaire 1975–76, vol. 2, p. 739.

6. "empreinte de la saveur espagnole la plus forte." Ibid., p. 738.

Manet's First Print Publication,
Huit gravures à l'eau-forte,
September 1862

The first print seen in public appears to have been Manet's etching after *The Spanish Singer* (cat. 131), the painting that had met with critical acclaim at the Salon of 1861, and of which he presented proofs that show the date *1861* in the copperplate to a number of close friends (cat. 163). Already on view in Cadart's shop window in April 1862, the etching formed part of Manet's first portfolio of prints, which was published later in the year. The proof shown here, in an early state before the edition, is dedicated to the Abbé Hurel, a close friend of the Manet family who became vicar of the Church of La Madeleine in Paris. On the sober title page engraved for the 1862 edition of *Huit gravures à l'eau-forte par Édouard Manet* (Eight Etchings by Édouard Manet), the prints are listed as follows: 1. *le Guitarero* (cat. 163), 2. *les Petits Cavaliers (d'après Vélasquez)* (cat. 164), 3. *Philippe IV (d'après Vélasquez)* (cat. 165), 4. *l'Espada* (cat. 166), 5. *le Buveur d'absinthe* (cat. 167), 6. *la Toilette*, 7. *le Garçon et le Chien*, and 8. *le Gamin* (cat. 168)—*la Petite Fille* (the last two prints, originally on one copperplate that was cut in two, were printed on a single sheet).

Of the nine prints in this publication, probably the latest and certainly one of the freest and most remarkable as an example of etching technique is Manet's copy after Velázquez's portrait of Philip IV in hunting dress (see cat. 77), a work that was not acquired by the Louvre until May 1862 and of which Manet made a graphite copy in preparation for his print.[1] The print went through six different states before it was ready for publication. The large plate of *The Little Cavaliers* also gave Manet much work and is shown here in a unique proof that documents the accident to which Manet referred (see above). The copy after *Mlle V . . . in the Costume of an Espada* (cat. 139), prepared with a traced, incised, and watercolored drawing similar to that made from Manet's painting *The Spanish Ballet* (cat. 136),[2] is distinguished by the use of lavis and aquatint over the shadowed foreground and an etching style that relates directly to Goya's *Tauromaquia* prints (cats. 38–41). *The Absinthe Drinker*, included in the 1862 portfolio, is shown here in a beautiful early proof from the 1863 printing on China paper (cat. 167). Other printings included Cadart's 1874 edition (limited to fifty) on Japan paper from ten of Manet's copperplates, half of which were included in this 1862 portfolio. *The Urchin* (cat. 168) is seen here in a well-printed impression on greenish paper from the 1894 edition of thirty of Manet's original copperplates. These plates were reissued in a final edition (of one hundred impressions) in 1905, after which they were canceled by punching with two holes, top and bottom. Most of them are now preserved in the Département des Estampes of the Bibliothèque Nationale de France.[3] JW-B

1. See Paris 1978, no. 7, repr. For states of the print and a reproductive etching by Haussoullier, published in the *Gazette des Beaux-Arts* (July 1, 1863), see Paris–New York 1983, no. 36.
2. See Paris–New York 1983, no. 34; Bois 1994, pp. 84–85.
3. Where Manet's original copperplates exist, the dimensions given in the catalogue entries are those of the plates. Measurements taken from particular proofs will vary depending on the degree of shrinkage of the paper.

163. *(New York only)* *Fig. 9.25*

Édouard Manet

The Spanish Singer (The "Guitarero")

1861–62
Etching, drypoint, and aquatint (or false biting?), 2nd state
11⅞ x 9¾ in. (30.2 x 24.7 cm) platemark
Signed and dated in plate upper right (2nd state): *éd. Manet/1861*
Impression in the 2nd state, before reduction of the etched image, and before the 1862 publication *Huit gravures à l'eau-forte*, no. 1, *le Guitarero;* inscribed in graphite: *à mon ami l'abbé Hurel/Ed. Manet.* (to my friend Abbé Hurel/Ed. Manet.)
The Metropolitan Museum of Art, New York, The Elisha Whittelsey Collection, The Elisha Whittelsey Fund, 1952 52.608.2

CATALOGUES RAISONNÉS: Guérin 1944, no. 16.ii; J. Harris 1970/1990, no. 12.ii

PROVENANCE: Abbé Hurel, Paris; Loys Delteil, Paris; his sale, Hôtel Drouot, Paris, June 13–15, 1928, no. 310, bought for 17,100 francs by Le Garrec; Henri Thomas, Paris; his sale, Hôtel Drouot, Paris, June 18, 1952, no. 129, bought for 130,000 francs by The Metropolitan Museum of Art, New York, 1952

SELECTED REFERENCES: Bailly-Herzberg 1972, vol. 1, pp. 55, 72, no. 4; Paris–New York 1983, pp. 68–70; Washington 1985–86, pp. 43–44, nos. 11, 12

RELATED WORKS: The painting by Manet (cat. 131); drawings by Manet (Rouart and Wildenstein, vol. 2, D458, D459)

164. *Fig. 9.26*

Édouard Manet

The Little Cavaliers, Copy after Velázquez

1861–62
Etching, aquatint (or false biting?), and drypoint
9⁷⁄₁₆ x 14¹³⁄₁₆ in. (24.8 x 38.5 cm), sheet trimmed within platemark
Unique proof in the 4th state, after the 1862 publication *Huit gravures à l'eau-forte*, no. 2, *le Petits Cavaliers (d'après Vélasquez);* probably 1867 after repair of the copperplate and drypoint retouching; letters partially effaced or not inked
Lettered below (3rd state), left: *Cadart et Chevalier Editeurs*; center: *Imp. Delâtre Paris*; right: *éd. Manet d'après Vélasquez*
NY: S. P. Avery Collection, Print Collection, Miriam and Ira D. Wallach Division of Art, Prints and Photographs, The New York Public Library, Astor, Lenox and Tilden Foundations (4th state)
P: Bibliothèque Nationale de France, Département des Estampes, Paris (3rd state)

CATALOGUES RAISONNÉS: Guérin 1944, no. 8.iv; J. Harris 1970/1990, no. 5.iv

PROVENANCE: [Suzanne Manet, Henri Guérard, Paris?]; George A. Lucas, Paris; Samuel P. Avery, New York; his gift to the New York Public Library, 1900

SELECTED REFERENCES: Paris 1978, no. 23 (see Appendix); Paris–New York 1983, p. 121; Washington 1985–86, p. 37

RELATED WORKS: *Gathering of Gentlemen*, workshop of Velázquez (cat. 79); the painting by Manet after Velázquez (cat. 129); etching proof watercolored by Manet (Paris–New York 1983, no. 37, 1st state)

165. *Fig. 9.27*

Édouard Manet

Philip IV, Copy after Velázquez

1862
Etching, drypoint, and aquatint, 6th state
14 x 9⅜ in. (35.4 x 23.8 cm) platemark
Lettered below, left: *Vélasquez p.'*; right: *éd. Manet sc.*; center: PHILIPPE IV/ROI D'ESPAGNE (PHILIP IV/ KING OF SPAIN), with the names of the publishers Cadart et Chevalier and the printer Delâtre
Impression from the 1862 publication *Huit gravures à l'eau-forte*, no. 3, *Philippe IV (d'après Vélasquez)*

NY: S. P. Avery Collection, Print Collection, Miriam and Ira D. Wallach Division of Art, Prints and Photographs, The New York Public Library, Astor, Lenox and Tilden Foundations
P: Bibliothèque Nationale de France, Département des Estampes, Paris

CATALOGUES RAISONNÉS: Guérin 1944, no. 7.vi; J. Harris 1970, no. 15.v/1990, no. 15.vi

PROVENANCE: Samuel P. Avery, New York; his gift to the New York Public Library, 1900

SELECTED REFERENCE: Washington 1985–86, pp. 45–46

RELATED WORKS: *Philip IV as a Hunter,* workshop of Velázquez (cat. 77); drawing by Manet after workshop of Velázquez (Rouart and Wildenstein 1975, vol. 2, D68; Paris 1978, no. 7)

166. *(New York only)* Fig. 9.28
Édouard Manet
The Espada or *(Mlle Victorine in the Costume of an Espada)*

1862
Etching, lavis, and aquatint, 2nd state
13¼ x 11 in. (33.5 x 27.8 cm) platemark
Signed in plate lower left: *éd. Manet*
Impression from the 1862 publication *Huit gravures à l'eau-forte,* no. 4, *l'Espada*

The Metropolitan Museum of Art, New York, Rogers Fund, 1969 69.550

CATALOGUES RAISONNÉS: Guérin 1944, no. 32.ii; J. Harris 1970, no. 35.ii/1990, no. 35.iii

PROVENANCE: Possibly Roger-Marx, Paris; his sale, Paris, April 27–May 2, 1914, no. 899; Peter Deitrich Fine Arts, New York; purchased by The Metropolitan Museum of Art, 1969

SELECTED REFERENCES: Paris–New York 1983, pp. 116–17; Washington 1985–86, pp. 50–51, no. 19

RELATED WORKS: *Mlle V . . . in the Costume of an Espada* by Manet (cat. 139); drawing for Manet's etching (Rouart and Wildenstein 1975, vol. 2, D372; see Paris–New York 1983, no. 34; Bois 1994, pp. 84–85, repr.)

167. *(New York only)* Fig. 9.29
Édouard Manet
The Absinthe Drinker

1861–62
Etching, 2nd state
11¼ x 6¼ in. (28.7 x 15.9 cm)
Signed in plate upper right: *éd. Manet*
Proof after the 1862 publication *Huit gravures à l'eau-forte,* no. 5, *le Buveur d'absinthe;* probably from the 1863 publication, before the foreground scratches, on China paper
National Gallery of Art, Washington, D.C., Rosenwald Collection, 1943 1943.3.5754

CATALOGUES RAISONNÉS: Guérin 1944, no. 9.ii; Harris 1970/1990, no. 16.ii

PROVENANCE: Sessler Gallery, Philadelphia; Lessing J. Rosenwald, Jenkintown, Pennsylvania, 1930; gift to the National Gallery of Art, Washington, D.C., 1943

EXHIBITION: Washington 1982–83, no. 64

SELECTED REFERENCES: Paris 1978, no. 24; Washington 1982–83, p. 184; Washington 1985–86, pp. 40–41, no. 9

RELATED WORKS: The painting by Manet (cat. 128); preparatory drawing for the print (National

Gallery of Art, Washington, D.C., 1943.3.5753; Rouart and Wildenstein 1975, vol. 2, D451; a second drawing postdates the addition of the glass; ibid., D452)

168. *(New York only)* Fig. 9.30
Édouard Manet
The Urchin

1861–62
Etching, 2nd state
8¼ x 5⅞ in. (20.9 x 14.8 cm) platemark
Signed in plate upper left (2nd state): *éd. Manet*
Impression after the 1862 publication *Huit gravures à l'eau-forte,* no. 8, *le Gamin;* from the limited edition (thirty proofs) published by Dumont in 1894
The Metropolitan Museum of Art, New York, Rogers Fund, 1921 21.76.7

CATALOGUES RAISONNÉS: Guérin 1944, no. 27.ii; J. Harris 1970/1990, no. 31.ii

PROVENANCE: Maurice Gobin, Paris; purchased by The Metropolitan Museum of Art, New York, 1921 (complete set of thirty prints)

SELECTED REFERENCES: Paris–New York 1983, pp. 58–60, no. 7; Washington 1985–86, pp. 34–35

RELATED WORKS: The painting by Manet (Rouart and Wildenstein 1975, vol. 1, no. 47; Paris–New York 1983, no. 6); the lithograph by Manet (cat. 188); for the Murillo source and its copies, see cat. 50

169.
Manet's First Etching for the Société des Aquafortistes, September 1, 1862

A collection of *8 Eaux-fortes* ("8 Etchings") by Manet was announced on the inside front cover of the very first issue, dated September 1, 1862, of *Eaux-fortes modernes,* published by the Société des Aquafortistes.[1] Five prints were to be issued every month, and this first wrapper contained etchings by Félix Bracquemond, Charles-François Daubigny, Alphonse Legros, and Théodule Ribot, as well as Manet. Manet's contribution was his etching *The Gypsies* (cat. 169), after a painting subsequently

destroyed by the artist and known only from fragments (see cat. 135), from this reversed etched image, and from a smaller, very rare print that shows the composition the right way around.[2] The prospectus for *Eaux-fortes modernes* announced a subscription rate, at twice the normal cost, for a "de luxe edition on Holland paper, in an edition of 25 proofs before letters."[3] The print seen here is probably such a proof since it lacks the title and other lettering on the plate. JW-B

1. On the Société des Aquafortistes, see Bailly-Herzberg 1972.
2. See J. Harris 1970/1990, no. 17.
3. "Édition de luxe sur papier de Hollande, tirée à 25 exemplaires avant la lettre." Bailly-Herzberg 1972, vol. 1, p. 49, repr.

169. *(New York only)* Fig. 9.18

Édouard Manet

The Gypsies

1862
Etching, 2nd state
12⁹⁄₁₆ x 9⁹⁄₁₆ in. (31.9 x 23.8 cm) platemark
Signed in plate lower right: *éd. Manet*
Proof on laid paper, 2nd state before letters (?) as engraved for *Eaux-fortes modernes* (published by the Société des Aquafortistes), issue 1, no. 4, LES GITANOS, September 1, 1862
S. P. Avery Collection, Print Collection, Miriam and Ira D. Wallach Division of Art, Prints and Photographs, The New York Public Library, Astor, Lenox and Tilden Foundations

CATALOGUES RAISONNÉS: Guérin 1944, no. 21.ii; J. Harris 1970/1990, no. 18.ii

PROVENANCE: [Suzanne Manet, Henri Guérard, Paris?]; George A. Lucas, Paris; Samuel P. Avery, New York; his gift to the New York Public Library, 1900

SELECTED REFERENCES: Paris–New York 1983, pp. 142–44; Washington 1985–86, pp. 47–48

RELATED WORKS: Fragments of Manet's lost or partially reworked painting (see cat. 135; see Rouart and Wildenstein 1975, vol. 1, nos. 41–44); *The Little Gypsies*, etching by Manet (Guérin 1944, no. 20; J. Harris 1970/1990, no. 17)

170, 171.
Portraits of Baudelaire, 1862–68

The renewed interest in printmaking, encouraged by Cadart and by the founding of the Société des Aquafortistes, was commented on by journalists and critics, among whom Charles Baudelaire was the most distinguished. He had followed Manet's early career, from the disappointment of the Salon jury's rejection of *The Absinthe Drinker* (cat. 128) in 1859 to the success of *The Spanish Singer* (cat. 131) in 1861. In 1862 poet and artist were constant companions as *flâneurs* strolling in the streets and parks of Paris. Inevitably, Manet included Baudelaire among the friends scattered in groups, as he believed Velázquez had done in *Gathering of Gentlemen* (cat. 79), across the picture titled *Music in the Tuileries* (fig. 9.32). From the profile portrait of Baudelaire in the painting, or from a study made for it, Manet extracted an evocative etched "sketch" (cat. 170) that remained unpublished until after the artist's death. Baudelaire left Paris for Belgium in 1864, returning to die in the French capital in 1867. Another version of the profile portrait was used, together with a slightly later full-face likeness (cat. 171), in etchings made and offered by Manet to Charles Asselineau for publication in his posthumous biography of the poet.[1] Manet wrote: "If there is going to be a frontispiece portrait to the *Spleen de Paris*, I have a Baudelaire wearing a hat, as if going for a stroll . . . and I have yet another, more substantial image of him, bare-headed, that would look well in a volume of verse."[2] This latter image, of which Manet made several versions, was based on a photograph of Baudelaire by Nadar.

JW-B

1. Asselineau 1869, facing pp. 79, 99. See Paris–New York 1983, pp. 158–60; Manet 1991, p. 102, pl. 64.
2. "Si l'on met un portrait en tête du *Spleen de Paris* j'ai un Baudelaire en chapeau, en promeneur enfin . . . , j'en ai encore un autre, tête nue, plus important qui figurerait bien dans un livre de poésie." Manet 1991, p. 44.

170. *(New York only)* Fig. 9.13

Édouard Manet

Baudelaire with a Hat, in Profile I

1862 or 1867–68?
Etching, 1st plate

5⅛ x 3 in. (13 x 7.5 cm) platemark
Signed with monogram upper left: *EM*
Impression from the limited edition (thirty proofs) published by Dumont in 1894
The Metropolitan Museum of Art, New York, Rogers Fund, 1921 21.76.23

CATALOGUES RAISONNÉS: Guérin 1944, no. 30; J. Harris 1970/1990, no. 21

PROVENANCE: Maurice Gobin, Paris; bought by The Metropolitan Museum of Art, New York, 1921 (complete set of thirty prints)

SELECTED REFERENCES: Paris–New York 1983, pp. 158–60; Manet 1991, pp. 44, 102, pl. 64

RELATED WORKS: *Music in the Tuileries* by Manet (fig. 9.32); *Baudelaire with a Hat, in Profile II*, etching by Manet (Guérin 1944, no. 31; J. Harris 1970/1990, no. 59)

171. *(New York only)* Fig. 9.14

Édouard Manet

Baudelaire Bare-Headed, Full Face III

Ca. 1867–68
Etching, 3rd state, with banderole
6⅞ x 4⅛ in. (17.5 x 10.6 cm) platemark
Signed in plate lower right: *Manet* [banderole and name *Charles Baudelaire* etched below (3rd state only)]
One of four or five known proofs in the 3rd state, before reduction of the plate, on Japan paper
Bibliothèque Nationale de France, Département des Estampes, Paris Dc 300d rés., fol.

CATALOGUES RAISONNÉS: Guérin 1944, 38.iii; J. Harris 1970/1990, no. 61.iii

PROVENANCE: Étienne Moreau-Nélaton, Paris; his bequest to the Bibliothèque Nationale, Paris, 1927

SELECTED REFERENCES: Paris–New York 1983, pp. 158–60; Manet 1991, pp. 44, 102, pl. 64

RELATED WORKS: *Baudelaire Bare-Headed, Full Face I* and *II*, earlier versions of this etching (Guérin 1944, nos. 36, 37; J. Harris 1970/1990, nos. 46, 60)

172–175.
Manet's Second Collection of Prints,
Eaux-fortes par Édouard Manet,
1863

In 1862 Manet signed and dated an intriguing print (cat. 172) that may have been prepared as a title page for his *Huit gravures à l'eau-forte,* the collection published in September of that year (see discussion above).[1] The head of a Polichinelle (Punchinello), with a long nose and longer mustache, peers through a gap in what seems to be a stage curtain fronting a makeshift fairground theater. A balloon print nailed to a board hangs in front of the curtain, and the great sword in its scabbard, featured in *Boy with a Sword* (cat. 133), is suspended as if by magic, with its long leather sword belt, to the left. On the ground lies the basket of Spanish costumes, crowned by the hat and guitar, that Manet isolated as a painting (cat. 132) and adapted as a vignette in a later version of the title page (cat. 173). In both prints, the title is the same: *Eaux-fortes par Édouard Manet (Etchings by Édouard Manet).* The etched designs were printed on a sheet intended to serve as a wrapper for the set of loose prints. The earlier image, so full of incident that there was no room for individual titles, was printed on blue and, as here, light brown paper, similar to the wrappers normally issued by Cadart.[2] The later one was preceded by a watercolored drawing, hand-lettered with the main title and with the titles of nine prints painstakingly added in mirror-writing as a guide for etching. All the known impressions of this cover design were printed on strong white paper.

The final design is a bold, spare print in which a dark border frames Manet's rather uncertain lettering and the crisply etched and aquatinted vignette below. The prints listed include the nine published by Cadart in 1862 (in *Huit gravures à l'eau-forte*) and five others: *Les Gitanos (The Gypsies),* also published in 1862 (cat. 169); *L'Enfant à l'épée (Boy with a Sword),* which Manet took a long time to bring to completion as a publishable print (cat. 174);[3] a large etching titled *La Marchande de cierges (The Candle Seller);*[4] and two newer prints connected with the Spanish ballet: *Lola de Valence* and *Le Baïlarin* (cats. 181, 175), after Manet's paintings of the two star performers, Lola Melea and Mariano Camprubi (cats. 138, 137).

The circumstances of this publication remain mysterious. The inclusion of prints after Manet's paintings of the Spanish dancers sets the publication date no further back than the end of 1862 or the spring of 1863, when Manet's painting of Lola de Valence was exhibited at Galerie Martinet, the etching (cat. 181) was shown in the Salon des Refusés, and Manet's lithographic song-sheet cover (cat. 180) based on the painting was published. Five of the six known proofs of the *Spanish Hat and Guitar* cover page were dedicated to some of Manet's closest friends. The sheet inscribed "à mon ami Charles Baudelaire" is also marked with Manet's instructions for twenty-eight proofs to be printed, and the project appears to have been of a personal rather than commercial nature. I have suggested that a context for such a publication could have been the artist's

marriage to Suzanne Leenhoff in October 1863 in Holland.

The etchings included in the strong white-paper wrappers were carefully printed in dark umber ink on fine China paper affixed to a support of the same size and weight as the wrapper (although most of the surviving prints have been detached from their backing). *The Absinthe Drinker* (cat. 167)—discussed above in connection with its original publication with the *Huit gravures à l'eau-forte* of 1862—is in fact a beautiful early example of these 1863 proofs, as is the *Don Mariano Camprubi* (cat. 175). The aquatinted etching *Lola de Valence,* for which Baudelaire provided the verse engraved in the lower margin, was part of this exquisite private printing; the plate was then numbered *67,* engraved with the names of publisher and printer, and published as the second of Manet's contributions to the Société des Aquafortistes. It is seen here in an impression from the issue dated October 1, 1863, which included prints by Martial, Ribot, Longueville, and Valentin.[5]

JW-B

1. A first, much more traditional, title page showed an open portfolio of prints on a stand; the design with the figure of Polichinelle is usually known as the "second frontispiece project." See Paris–New York 1983, pp. 136–38; Paris–Baltimore 2000–2001, pp. 58–59, pls. 55, 56.
2. Only one or two folded wrappers have survived. The Punchinello print is seen here in the unique second state, in which a rebiting of the plate to strengthen the etched lines resulted in false biting that speckles the surface and marks a "fingerprint" at upper center.
3. Manet etched four versions of *Boy with a Sword* on four different copperplates, the earliest of which may have been his very first etching, made with the help of Alphonse Legros (see Paris–New York 1983, p. 81). A proof on laid paper has Manet's "bon à tirer" for twenty-five impressions (New York Public Library), and a number of prints are known on laid papers with watermarks used by the Société des Aquafortistes between 1862 and February 1863 (the proof seen here [cat. 174] has the watermark HUDELIST). This printing would therefore predate that of the impressions on China paper made for the folder of fourteen prints in 1863 (see ibid.).
4. *The Candle Seller,* one of Manet's early prints (Guérin 1944, no. 19; J. Harris 1970/1990, no. 8), was based on a small pencil sketch (Rouart and Wildenstein 1975, vol. 2, D364). On more than one of the *Hat and Guitar* cover designs, the title *la m[archan]de* has been struck out, suggesting that it was not included in at least some of the sets.
5. For the connections between the Société des Aquafortistes and Manet, Charles Longueville, Adolphe-Martial Potémont (called Martial), Théodule Ribot, and Henry Valentin, see Bailly-Herzberg 1972, vol. 2, pp. 140–41, 144–48, 163–64, 173.

etched inscription, center: *EAUX-FORTES/Par/ Édouard Manet* (ETCHINGS/By/Édouard Manet)
One of three known proofs, the only one on light brown Canson paper, in a rebitten, 2nd state
S. P. Avery Collection, Print Collection, Miriam and Ira D. Wallach Division of Art, Prints and Photographs, The New York Public Library, Astor, Lenox and Tilden Foundations

CATALOGUES RAISONNÉS: Guérin 1944, no. 29; J. Harris 1970/1990, no. 38

PROVENANCE: [Suzanne Manet, Henri Guérard, Paris?]; George A. Lucas, Paris; Samuel P. Avery, New York; his gift to the New York Public Library, 1900

SELECTED REFERENCES: Reff 1962; Paris 1978, no. 39; Paris–New York 1983, pp. 136–38; Fried 1996, pp. 48–54 (citing earlier references); George Mauner, "Manet and the Life of *Nature morte,*" in Paris–Baltimore 2000–2001, pp. 54–55

RELATED WORKS: *Boy with a Sword* by Manet (cat. 133); *Still Life with Spanish Hat and Guitar* by Manet (cat. 132); *The Balloon* by Manet (cat. 179)

173. *(New York only)* *Fig. 9.24*
Édouard Manet
*"Eaux-fortes par Édouard Manet"—
Spanish Hat and Guitar (Frontispiece)*

Cover design for an album of fourteen etchings 1862–63

172. *(New York only)* *Fig. 9.23*
Édouard Manet
Polichinelle Presents "Eaux-fortes par Édouard Manet" (Second Frontispiece Project)

1862
Etching
12⅞ x 9½ in. (32.7 x 24 cm) platemark
Signed and dated in plate lower right: *62 éd. Manet;*

Etching, drypoint, and aquatint, 1st state/2nd plate
17⅜ x 11¾ in. (44.1 x 29.8 cm) platemark
Etched inscription: *Eaux-fortes /par/Edouard Manet*
(Etchings/by/Edouard Manet); list of print titles
below:

Philippe IV (Velasquez)	*le guitarero*
les petits Cavaliers (di)	*Lola de Valence*
l'enfant à l'épée	*l'espada*
le buveur d'absinthe	*le baïlarin*
le gamin	*les gitanos*
la petite fille	*la toilette*
l'enfant et le chien	*la m^de de cierges*
le gamin [repeated]	

Inscribed in pen and ink upper right:
à P. M[erased]/[erased] témoignage d'amitié/
Edouard Manet (to P. M . . . a mark of friendship/
Edouard Manet); *di* corrected to *id*; the last two
etched titles struck out and *le prado* added
One of six known proofs in the first state, before
reduction of the copperplate (it was reprinted, with
a new engraved title, for Cadart's edition of
Manet's prints published in 1874)
S. P. Avery Collection, Print Collection, Miriam
and Ira D. Wallach Division of Art, Prints and
Photographs, The New York Public Library, Astor,
Lenox and Tilden Foundations

CATALOGUES RAISONNÉS: Guérin 1944, no. 62.i;
J. Harris 1970/1990, no. 39.i

PROVENANCE: P[aul]? Meurice? Montluc?
Montrosier? [name erased] (Manet dedicated a
complete set of the 1862 *Huit gravures à l'eau-forte*
to Paul Montluc; Bibliothèque Nationale de France,
Cabinet des Estampes, Paris); George A. Lucas,
Paris; Samuel P. Avery, New York; his gift to the
New York Public Library, 1900

EXHIBITIONS: Washington 1985–86, no. 29;
Paris–Baltimore 2000–2001, no. 3a (Paris ed.)
(incorrectly described as printed in 1874)

SELECTED REFERENCES: Reff 1962; Paris 1978, no.
68; Paris–New York 1983, pp. 139–41; Washington
1985–86, pp. 64–65; George Mauner, "Manet and
the Life of *Nature morte,*" in Paris–Baltimore
2000–2001, pp. 54–55

RELATED WORKS: *Still Life with Spanish Hat and*
Guitar by Manet (cat. 132); *Polichinelle Presents*
"Eaux-fortes par Édouard Manet" by Manet (cat. 172);
preparatory drawing (Rouart and Wildenstein
1975, vol. 2, D671; Paris–Baltimore 2000–2001,
p. 56, pl. 2)

174. *(New York only)* *Fig. 14.63*
Édouard Manet
Boy with a Sword Turned Left III

1862–63
Etching and aquatint, 3rd state
12⅛ x 9⅜ in. (32 x 23.8 cm) platemark
Signed in plate lower left: *éd. Manet*
Impression in the 3rd state, with a light aquatint;
one of an edition of twenty-five prints on laid
paper, predating the proofs on China paper for the

1863 publication of fourteen etchings (see n. 3 above)
The Metropolitan Museum of Art, New York,
The Elisha Whittelsey Collection, The Elisha
Whittelsey Fund, 1980 1980.1077.1

CATALOGUES RAISONNÉS: Guérin 1944, no. 13.iii;
J. Harris 1970/1990, no. 26.iii

PROVENANCE: Early provenance unknown

SELECTED REFERENCES: Ives 1980, p. 52;
Paris–New York 1983, pp. 80–82; Washington
1985–86, pp. 49–50

RELATED WORKS: *Boy with a Sword* by Manet (cat.
133); traced drawing by Manet (Rouart and
Wildenstein 1975, vol. 2, D456; Paris 1978, no. 6);
other etchings by Manet (Paris–New York 1983,
nos. 15–17)

175. *(New York only)* *Fig. 9.39*
Édouard Manet
Don Mariano Camprubi (Le Bailarin)

1862–63
Etching
13⁹⁄₁₆ x 8¹¹⁄₁₆ in. (23.8 x 16.1 cm)
Signed in plate lower left: *éd. Manet*; with Manet's
etched inscription below: *don Mariano Camprubi/*
primer bailarin del teatro royal de Madrid
Proof on China paper, probably from the publica-
tion of fourteen etchings, *le Baïlarin*
National Gallery of Art, Washington, D.C.,
Rosenwald Collection,1945 1945.5.86

CATALOGUES RAISONNÉS: Guérin 1944, no. 24;
J. Harris 1970/1990, no. 34

PROVENANCE: Lessing J. Rosenwald, Jenkintown,
Pennsylvania; his gift to the National Gallery of
Art, Washington, D.C., 1945

SELECTED REFERENCE: Washington 1985–86, p. 62

RELATED WORKS: *The Dancer Mariano Camprubi*
by Manet (cat. 137); brush and ink drawing by
Manet (Burrell Collection, Glasgow; Rouart and
Wildenstein 1975, vol. 2, D461)

176–178.
Prints and a Drawing Related to the 1863 Publication (cats.)

Two other prints that might have formed part of the
previously discussed publication remained unexe-
cuted or unpublished. Probably after completing his
painting *The Spanish Ballet* (cat. 136), Manet made a
drawing on tracing paper that he appears to have
transferred to a copperplate for etching by incising it
with a stylus (fig. 9.40). However, no print of *The*
Spanish Ballet is known. A very similar drawing was
made from a pendant oil painting known as *The*
Tavern (La Posada) (fig. 9.45). In this case the traced
and watercolored drawing (private collection) was
transferred to a copperplate from which a unique
proof is known on China paper (cat. 176).[1] Manet
must have regretted not being able to complete and
publish what would have been two large and impres-
sive prints.

A pair of small prints is more closely related to
the 1863 project. One has the etched title *au Prado*
(cat. 177). The almost identical composition of the
other print (cat. 178) is more refined and less realis-
tic, its technique more accomplished. The title *le*
Prado [*sic*] appears in reverse on the preparatory
drawing for the *Spanish Hat and Guitar* cover design
(cat. 173), suggesting that at least one print existed at
that stage. The etchings are known in a handful of
rare proofs on China paper, similar to those from
the 1863 publication. The title *au Prado* was not
etched and printed on the 1863 wrapper but was
added by Manet in pen and ink on the proof shown
here (cat. 178). The prints owe much to Goya's etch-
ings of scenes on the *paseo* in *Los Caprichos* (cats. 27,
28),[2] but Manet's modern *majas* and *majos* are also
close to the wood engravings in popular illustrated
journals, such as those after drawings by Constantin
Guys in the *Illustrated London News* (cat. 124).

JW-B

1. Henri Guérard, the young etcher who assisted Manet with
 his prints in later years, confused the relationship between
 the two early paintings when he annotated the proof of *The*
 Tavern: "pièce dite 'le Ballet espagnol.' État. Très rare. . . ."
 ("piece called 'the Spanish Ballet.' State. Very rare. . . .").
2. That *On the Prado II* followed *On the Prado I* is supported
 by the fact that the little dog added in the second state of *On*
 the Prado I turns in the restructured design into a reference
 to the two lap dogs that confront each other in plate 27 of
 Goya's *Caprichos.*

176. *(New York only)* *Fig. 9.45*

Édouard Manet

The Tavern (La Posada) or
Before the Corrida

1862–63
Etching, only state
11⅛ x 17¼ in. (29.6 x 44 cm) platemark
Signed in plate lower left: *éd. Manet*
Unique proof on China paper; annotated in
graphite below: *pièce dite "le Ballet espagnol." État.
Très rare Beraldi 15 H Guérard.*
S. P. Avery Collection, Print Collection, Miriam
and Ira D. Wallach Division of Art, Prints and
Photographs, The New York Public Library, Astor,
Lenox and Tilden Foundations

CATALOGUES RAISONNÉS: Guérin 1944, no. 47;
J. Harris 1970/1990, no. 36

PROVENANCE: [Suzanne Manet, Henri Guérard,
Paris?]; George A. Lucas, Paris; Samuel P. Avery,
New York; his gift to the New York Public Library,
1900

RELATED WORKS: The painting by Manet (fig. 9.46;
Rouart and Wildenstein 1975, vol. 1, no. 110);
preparatory drawing for the print (Rouart and
Wildenstein 1975, vol. 2, D534)

177. *(Paris only)* *Not illustrated*

Édouard Manet

On the Prado I

1863
Etching and aquatint, 1st state
7⅛ x 4¹¹⁄₁₆ in. (18.1 x 11.9 cm) platemark
Initialed in the plate lower left: *M*; etched in the
lower margin: *au Prado*
Unique proof in the 1st state, before rebiting of the
etching and the addition of aquatint; on ivory laid
paper
The Art Institute of Chicago, Clarence Buckingham
Collection 1984.1120

CATALOGUES RAISONNÉS: Guérin 1944, no. 45.i;
J. Harris 1970/1990, no. 44.i

PROVENANCE: Henri Guérard, Paris; private col-
lection, France; private collection, Germany;
bought by The Art Institute of Chicago, 1984

SELECTED REFERENCES: Paris 1978, no. 52;
Washington 1985–86, p. 58

RELATED WORK: *On the Prado II*, etching by Manet
(cat. 178)

178. *Fig. 14.67*

Édouard Manet

On the Prado II

1863
Etching and aquatint, 1st state
8¾ x 6¼ in. (22.1 x 15.8 cm) platemark
One of four or five proofs in the 1st state with a
light, grainy aquatint; before the signature at lower
left and the very strong "lavis" in two tones; with
an effaced annotation by Henri Guérard (?)
NY: S. P. Avery Collection, Print Collection,
Miriam and Ira D. Wallach Division of Art, Prints
and Photographs, The New York Public Library,
Astor, Lenox and Tilden Foundations
P: Bibliothèque Nationale de France, Département
des Estampes, Paris

CATALOGUES RAISONNÉS: Guérin 1944, no. 46.i;
J. Harris 1970/1990, no. 45.i

PROVENANCE: [Suzanne Manet, Henri Guérard,
Paris?]; George A. Lucas, Paris; Samuel P. Avery,
New York; his gift to the New York Public Library,
1900

SELECTED REFERENCES: Paris 1978, no. 53;
Washington 1985–86, p. 63

RELATED WORK: *On the Prado I*, etching by Manet
(cat. 177)

179–188.
Lithographs and Etchings: Spanish or Hispanic Themes, 1862–74

Manet's interest in street scenes and the interactions
among groups and individuals in crowds is clear
from his 1862 painting *Music in the Tuileries* (fig.
9.32). Another striking example appears in a large
print of that year, made in a different print tech-
nique. The innovative publisher Cadart was inter-
ested not only in reviving etching but also in
rescuing lithography as a medium for artists. After
its tentative beginnings in the early 1800s and its
swift development into a magnificent art form by
such artists as Goya (cats. 42–45) and Delacroix (cat.
120), lithography had largely sunk to the status of a
reproductive and commercial technique, although

Daumier continued to exploit its technical capabili-
ties in his caricatures, and Manet first used the
medium for a caricature portrait that appeared in a
satirical journal in 1860.[1] In 1862 Cadart sent three
lithographic stones to each of five artists—
Bracquemond, Fantin-Latour, Legros, Manet, and
Ribot—with instructions to draw whatever they
liked. Manet used only one stone and created the
lithograph known as *The Balloon* (cat. 179). The
print, known in five impressions, remained unpub-
lished, probably on account of its highly unortho-
dox technique and sketchy, unfinished appearance.[2]
The possible political significance of the print is
hinted at by the central figure of the cripple and the
prominent "Hispanic," perhaps more topically
Mexican, waterseller. This has been discussed in the
context of Emperor Napoleon III's military inter-
vention in Mexico. Manet's feelings about the disas-
trous outcome of the emperor's foreign policy were
later expressed in paintings and the lithograph rep-
resenting the execution of Maximilian (see cats. 152,
186). Although Cadart's project failed, Manet's
experiment with lithography as an artistic medium
produced a splendid print in *The Balloon* of 1862.

The following year Manet returned to a more
traditional use of lithography, the illustration of
sheet music. Zacharie Astruc, alternately poet,
painter, composer, sculptor, and critic, and a dedi-
cated Hispanophile, was one of those who fell under
the spell of the Spanish ballet. He composed the
words and music of a *Serenade* to Lola de Valence
and dedicated it "To Her Majesty the Queen of
Spain." Adapted from the figure of Lola in Manet's
painting (cat. 138), the star appears in a lively
vignette (cat. 180) drawn directly on the stone and
therefore reversed, to which the publisher added
such fanciful typography that Manet took care, on a
later occasion, to design the lettering himself (cat.
184). The serenade was published in March 1863,
when a group of Manet's paintings that included the
portrait of Lola was displayed at Galerie Martinet.
The product of an ephemeral fashion, the song
sheet has survived in only a few copies.

Manet's more soberly etched and aquatinted
reproduction of his portrait of Lola (cat. 181) was
engraved with the verse composed by Baudelaire, a
provocative quatrain that was also affixed to the
painting in the Martinet exhibition. The etching was
simultaneously exhibited at the Salon des Refusés,[3]
and later that same year it formed part of the
Société des Aquafortistes' October issue of prints.
Manet's etching documents the painting's original
plain background, to which he later added the
theater decor.

A number of isolated etchings remained unpub-
lished in the 1860s. These included Manet's unsigned,
perhaps unfinished etching after Velázquez's *Infanta
Margarita* (cat. 182), a somewhat schematic interpre-
tation based on a beautiful lost drawing after the
painting. Manet also etched some of his own genre
figures and portraits painted in the manner of
Velázquez. Another unsigned print after one of his
four philosophers, the *Beggar with Oysters* (cats. 183,
145), is etched very much in the style of Goya (cats.
19, 20), with broken outlines and light invading the

forms, particularly around the feet. No contemporary proofs are known, and the etching is seen here in an impression from the posthumous edition of Manet's prints published in 1894.

Once thought to be contemporaneous with the lithograph of *Lola de Valence* (cat. 180), Manet's other cover design for a musical composition is now known to have been published in 1866. The *Moorish Lament* (cat. 184) features the Catalan guitarist Jaime Bosch, who, like Lorenzo Pagans, was much in demand as a singer and guitarist in Parisian salons.[4] Bosch sang and played at many soirées, including those of the Manet family, where Suzanne Manet accompanied him on the piano. The sympathetic portrait, lithographed for the cover of Bosch's solo guitar piece, was certainly based on sketches made from life.

By the later 1860s, the taste for Spain and things Spanish had lost its wilder, more romantic overtones and had become domesticated, integrated into a bourgeois lifestyle. In June 1868, Philippe Burty asked Manet to contribute to a luxury volume of *Sonnets et eaux-fortes* (Sonnets and etchings). The artist responded to his allotted poem, Armand Renaud's "Fleur exotique" (Exotic flower), with an elegant pastiche (cat. 185) that combines two of the most attractive prints from Goya's *Caprichos*: plates 5 and 15 (cat. 28). Manet's technique, a harmonious interplay between etching, aquatint, and the dramatic luminosity of the paper, also came straight from Goya to produce an image as graceful and stylized as a fashion plate.

Cool stylization was a stance that Manet came to adopt in the very different circumstances of his depiction of the execution in Mexico of Emperor Maximilian on June 19, 1867. The first of three great paintings of the execution is full of movement and pathos (cat. 152) and recalls Goya's *Third of May 1808* (fig. 1.18). A second canvas, now much damaged, already offered a simpler and more monumental presentation (National Gallery, London).[5] The third and final canvas (Städtische Kunsthalle, Mannheim) was preceded by an oil sketch (Ny Carlsberg Glyptotek, Copenhagen). Although Manet subsequently reworked this sketch while painting the final picture, its original composition is recorded in an impressive lithograph (cat. 186). He was officially discouraged from presenting his painting at the Salon of 1869, and the printing and publication of his lithograph were banned.

Possibly for similar reasons, it was not until 1874 that Manet published the lithograph titled *Civil War* (cat. 187). The print is signed and dated 1871, but this probably records the historical date of the scene depicted—death and destruction during the Paris Commune—rather than the date at which he made the work. Taking up the motif of his *Dead Toreador* (cat. 141), Manet's lithograph records and commemorates the slaughter of soldiers and civilians who fell together in the fighting that brought the Commune to a close. Realized with velvety black lines and the abstract patterns formed by short sideways jabs of the crayon, the anonymous victims are treated with a tough sobriety that marks the passage of time since Daumier's equally powerful *Rue Transnonain* of 1834 (Metropolitan Museum of Art, New York).

This somber image was published together with a lithograph after one of Manet's most enchanting Spanish pictures. More than a decade earlier, he had included the etching after his painting *The Urchin* in the 1862 portfolio of his prints (cat. 168). In 1872 he reworked the painting and sold it, with many others, to Durand-Ruel. The picture was photographed in its reworked state by Godet, and the photograph served, via a tracing, as the basis for Manet's lithograph (cat. 188). In 1862 painting and print pointed clearly to Murillo and his ragamuffin children as Manet's source (cat. 50); by 1874 the gentle dignity conveyed in the lithographic interpretation of Manet's reworked painting, and its contrast with the earlier etching, served to underline the transformation that had occurred in Manet's art through his experience of Velázquez in Spain.

JW-B

1. The lithographic caricature of Émile Ollivier, of which a unique proof survives, was published as a gillotage reproduction in *Diogène*, no. 6 (April 14, 1860); see Guérin 1944, no. 67; J. Harris 1970/1990, no. 1.
2. This episode and the horrified reaction of Lemercier's lithographers when confronted by the works drawn on stone are recounted in G. Hédiard, "Fantin-Latour," *L'Artiste* (April–June 1892), pp. 15–16, reprinted in Geneva 1980–81, pp. 49–50.
3. Manet sent three prints to the Salon des Refusés: no. 674, *The Little Cavaliers* (cat. 164), no. 675, *Philip IV* (cat. 165), both after Velázquez, and no. 676, *Lola de Valence* (cat. 181).
4. On Pagans, see Paris–Ottawa–New York 1988–89, pp. 169–71, no. 102.
5. Rouart and Wildenstein 1975, vol. 1, no. 126. For all three versions, the oil sketch, and the lithograph, see London 1992, pp. 61–68, 112–13.

179. *(New York only)* Fig. 9.69

Édouard Manet
The Balloon

1862
Crayon lithograph with scraping
15⅞ x 20⅛ in. (40.2 x 51 cm) image; 17 x 21¼ in. (43 x 55.2 cm) sheet
Signed (and dated?) lower right: *éd. Manet* [illegible]
One of five known proofs
S. P. Avery Collection, Print Collection, Miriam and Ira D. Wallach Division of Art, Prints and Photographs, The New York Public Library, Astor, Lenox and Tilden Foundations

CATALOGUES RAISONNÉS: Guérin 1944, no. 68; J. Harris 1970/1990, no. 23

PROVENANCE: [Suzanne Manet, Henri Guérard, Paris?]; George A. Lucas, Paris; Samuel P. Avery, New York; his gift to the New York Public Library, 1900

SELECTED REFERENCES: Druick and Zegers 1983; Paris–New York 1983, pp. 133–36; Washington 1985–86, pp. 54–56

180. *(New York only)* Fig. 9.43

Édouard Manet
Lola de Valence—Serenade

1863
Crayon lithograph with scraping
13 x 9½ in. (33.5 x 22 cm) image and letters (trimmed into the lowest line of lettering); 13¼ x 10½ in. (33.7 x 26.7 cm) sheet
Signed in the stone, vertically at left of image: *éd. Manet*; with the lithographic title and other lettering indicating the author: POÉSIE ET MUSIQUE / DE / ZACHARIE ASTRUC, and the name and address of the printer Lemercier
One of seven known impressions of which only this and one other are complete with the second page (the engraved music bleeds through the sheets); lithograph registered with the Dépôt Legal on March 7, 1863
S. P. Avery Collection, Print Collection, Miriam and Ira D. Wallach Division of Art, Prints and Photographs, The New York Public Library, Astor, Lenox and Tilden Foundations

CATALOGUES RAISONNÉS: Guérin 1944, no. 69; J. Harris 1970/1990, no. 32

PROVENANCE: Samuel Putnam Avery; his bequest to the New York Public Library, 1900

SELECTED REFERENCES: Paris–New York 1983, pp. 154–56; Washington 1985–86, p. 61

RELATED WORKS: The painting by Manet (cat. 138); drawings and an etching by Manet (cat. 181)

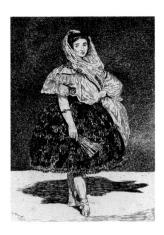

181. *(New York only)* *Fig. 9.42*
Édouard Manet
Lola de Valence

1863
Etching and aquatint, 3rd state
10⅛ x 7⁷⁄₁₆ in. (26.6 x 18.5 cm) platemark
Signed in the plate lower left: *éd. Manet*
Sixth state, with the image reduced and Baudelaire's
quatrain in the lower margin; numbered at upper
right and with the names and addresses of Cadart
and Delâtre, as engraved for *Eaux-fortes modernes*,
published by the Société des Aquafortistes, second
year, issue 2, no. 67, October 1, 1863
The Metropolitan Museum of Art, New York,
Rogers Fund 1918 18.88.28

CATALOGUES RAISONNÉS: Guérin 1944, no. 23;
J. Harris 1970/1990, no. 33.vi

PROVENANCE: E. Weyhe, New York; purchased by
The Metropolitan Museum of Art, 1918

SELECTED REFERENCES: Bailly-Herzberg 1972,
vol. 1, pp. 93, 109, no. 67; Paris 1978, no. 34,
Appendix; Paris–New York 1983, pp. 152–54;
Washington 1985–86, pp. 99–100

RELATED WORKS: The painting by Manet (cat. 138);
drawings by Manet (Rouart and Wildenstein 1975,
vol. 2, D369, D370; Paris–New York 1983, no. 51)

182. *Fig. 9.4*
Édouard Manet
Infanta Margarita, Copy after Velázquez

Ca. 1861–63
Etching, only state
9 x 7½ in. (22.9 x 18.9 cm) platemark
Unsigned
Proof on heavy laid paper, probably printed by
Henri Guérard between 1874 and 1894
NY: The Baltimore Museum of Art, George A.
Lucas Collection BMA 1996.48.5135
P: Bibliothèque Nationale de France, Département
des Estampes, Paris

CATALOGUES RAISONNÉS: Guérin 1944, no. 6;
J. Harris 1970/1990, no. 14

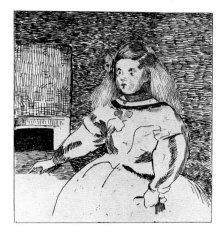

PROVENANCE: George A. Lucas, Paris; Henry
Walters, Baltimore, 1909; the Maryland Institute,
College of Art, 1911; Baltimore Museum of Art by
purchase, 1996

SELECTED REFERENCES: Paris 1978, no. 21;
Boston–Philadelphia–London 1984–85, pp. 43–44;
Washington 1985–86, pp. 65–66

RELATED WORKS: *Infanta Margarita*, workshop
of Velázquez (cat. 78); lost drawing by Manet
(Lochard photograph no. 244; Rouart and
Wildenstein 1975, vol. 2, D69); etching by Degas
(cat. 103)

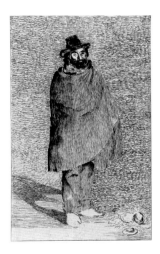

183. *(New York only)* *Fig. 9.63*
Édouard Manet
Philosopher

Ca. 1865–67
Etching and drypoint, only state
12⅛ x 9⁷⁄₁₆ in. (32 x 23.9 cm) platemark
Unsigned
Impression on blue-green laid paper from the
limited edition (thirty proofs) published by
Dumont in 1894
The Metropolitan Museum of Art, New York,
Rogers Fund, 1921 21.76.18

CATALOGUES RAISONNÉS: Guérin 1944, no. 43;
J. Harris 1970/1990, no. 47

PROVENANCE: Maurice Gobin, Paris; purchased by
The Metropolitan Museum of Art, New York, 1921
(complete set of thirty prints)

SELECTED REFERENCE: Washington 1985–86,
pp. 67–68

RELATED WORK: *A Philosopher (Beggar with
Oysters)* by Manet (cat. 145)

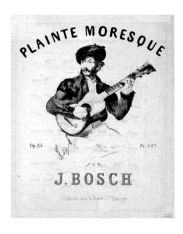

184. *(New York only)* *Fig. 9.86*
Édouard Manet
Moorish Lament

1866
Crayon lithograph with scraping, 2nd state
11 x 9½ in. (29.5 x 24 cm) image with letters; 13¹¹⁄₁₆ x
10⁹⁄₁₆ in. (34.7 x 26.8 cm) folded sheet
Signed in the stone lower left: *Manet*; with the
lithographic title and other lettering indicating the
composer J. BOSCH and with the name and address
of the printer Lemercier
One of four known impressions in the 2nd state
with letters; complete with the second page
(with music offsetting and bleeding through the
paper); annotation in graphite on the verso:
Champfleury n.° 254
S. P. Avery Collection, Print Collection, Miriam
and Ira D. Wallach Division of Art, Prints, and
Photographs, The New York Public Library, Astor,
Lenox and Tilden Foundations

CATALOGUES RAISONNÉS: Guérin 1944, no. 70.ii;
J. Harris 1970/1990, no. 29.ii

PROVENANCE: Champfleury (Jules Husson, called
Fleury), Paris; his sale, Hôtel Drouot, Paris,
January 26, 1891, no. 254 (to George A. Lucas?);
Samuel P. Avery, New York; his gift to the New
York Public Library, 1900

SELECTED REFERENCES: Paris 1978, no. 74;
Paris–New York 1983, no. 95, pp. 252–54

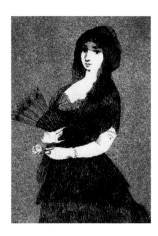

185. *Fig. 9.85*

Édouard Manet

Exotic Flower (Woman in a Mantilla)

1868
Etching and aquatint, 2nd state
6¼ x 4⅛ in. (15.9 x 10.5 cm)
Signed in the plate lower left (2nd state): *Manet*
Impression from the edition on laid paper (limited
to 525) of *Sonnets et eaux-fortes*, by various authors,
edited by Philippe Burty. Achevé d'imprimer:
December 20, 1868; Paris: Alphonse Lemerre, 1869
NY: The Metropolitan Museum of Art, New York,
Gift of Mrs. B. S. Oppenheimer in memory of
Dr. B. S. Oppenheimer, 1964 64.649.1
P: Bibliothèque Nationale de France, Département
des Estampes, Paris

CATALOGUES RAISONNÉS: Guérin 1944, no. 51.ii;
J. Harris 1970/1990, no. 57.ii

PROVENANCE: Given to The Metropolitan Museum
of Art by Mrs. B. S. Oppenheimer, 1964

SELECTED REFERENCE: Washington 1985–86,
pp. 82–84

RELATED WORKS: *Los Caprichos*, plates 5 and 15,
by Goya (cat. 28)

186. *(New York only)* *Fig. 9.75*

Édouard Manet

The Execution of Emperor Maximilian

1868
Crayon lithograph with scraping, 1st state
13⅛ x 17 in. (33.3 x 43.3 cm) image

Signed in the stone lower left: *Manet*
Proof before letters or from the edition of fifty
impressions, published in 1884 (the chine appliqué
paper remounted; no letters visible)
The Metropolitan Museum of Art, New York,
Rogers Fund, 1921 21.48

CATALOGUES RAISONNÉS: Guérin 1944, no. 73;
J. Harris 1970/1990, no. 54

PROVENANCE: Gutekunst-Klipstein, Bern; pur-
chased by The Metropolitan Museum of Art, 1921

SELECTED REFERENCES: Paris 1978, no. 77 (citing
earlier references); Providence 1981, p. 196, no. 33;
Paris–New York 1983, pp. 277–80, and Appendix
II: "Documents Relating to the 'Maximilian
Affair,'" pp. 531–34; Washington 1985–86, pp.
86–87; London 1986, pp. 55–58

RELATED WORKS: Paintings by Manet (cat. 152;
Rouart and Wildenstein 1975, vol. 1, nos. 124
[Museum of Fine Arts, Boston], 125 [Ny Carlsberg
Glyptotek, Copenhagen], 126 [National Gallery,
London], 127 [Städtische Kunsthalle, Mannheim])

187. *Fig. 9.77*

Édouard Manet

Civil War

Ca. 1871–73
Crayon lithograph with scraping, 2nd state
15⁹⁄₁₆ x 20 in. (39.6 x 50.8 cm)
Signed and dated in the stone lower left: *Manet /
1871*; with letters, center: GUERRE CIVILE; left: *Tiré à
cent exemplaires*; right, the address of Lemercier
Impression on violet papier appliqué, from the lim-
ited edition (100 impressions) printed by Lemercier
and registered with the Dépôt Légal on February 20,
1874
NY: The Metropolitan Museum of Art, New York,
Rogers Fund, 1922 22.60.18
P: Bibliothèque Nationale de France, Département
des Estampes, Paris

CATALOGUES RAISONNÉS: Guérin 1944, no. 75;
J. Harris 1970/1990, no. 72.ii

PROVENANCE: Maurice Gobin, Paris; purchased by
The Metropolitan Museum of Art, 1922

SELECTED REFERENCE: Washington 1985–86,
pp. 94–95

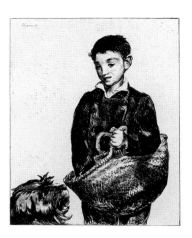

188. *Fig. 9.78*

Édouard Manet

The Urchin

Ca. 1871–73
Crayon lithograph with scraping, 2nd state
11⁵⁄₁₆ x 8¹³⁄₁₆ in. (28.7 x 22.7 cm) border line
Signed in the stone upper left: *Manet*; with letters,
center: LE GAMIN; left: *Tiré à cent exemplaires*;
right, the address of Lemercier
Impression on violet papier appliqué, from the
limited edition (100 impressions) printed by
Lemercier and registered with the Dépôt Légal
on February 20, 1874
NY: The Metropolitan Museum of Art, New York,
Rogers Fund, 1922 22.60.19
P: Bibliothèque Nationale de France, Département
des Estampes, Paris

CATALOGUES RAISONNÉS: Guérin 1944, no. 71;
J. Harris 1970/1990, no. 30.ii

PROVENANCE: Maurice Gobin, Paris; purchased by
The Metropolitan Museum of Art, 1922

SELECTED REFERENCES: Paris–New York 1983,
pp. 59–61; Washington 1985–86, pp. 94–95; London
1986, p. 21

RELATED WORKS: The painting by Manet (Rouart
and Wildenstein 1975, no. 47; Paris–New York
1983, no. 6); 1862 etching by Manet (cat. 168);
photograph in Godet 1872, no. 17

JEAN-FRANÇOIS MILLET

Gruchy, 1814–Barbizon, 1875

From 1835, Millet devoted himself to painting. At
Cherbourg he studied the old masters in the Thomas
Henry collection, recently donated to the town. In
1837 he was in Paris, where he frequented the
Louvre and, as soon as it was opened, the Galerie
Espagnole. Until 1845 he divided his time between
Cherbourg and Paris, and after 1849 he settled at
Barbizon. There he turned to a naturalistic represen-
tation of peasant life, never afraid to portray
poverty and exhaustion, as in *Man with a Hoe*
(1861–62, J. Paul Getty Museum, Los Angeles),
with its powerful sense of realism. GL

189.

Fig. 1.35

Jean-François Millet

The Assumption of Saint Barbara

1841
Oil on canvas
36¼ x 29 in. (92 x 74 cm)
Signed bottom left: *F. MILLET*
Musée des Beaux-Arts, Angers MBA 793

PROVENANCE: Julien Bessonneau bequest to the
Musée des Beaux-Arts, Angers, 1917

EXHIBITIONS: Castres 1997, no. 94, repr.;
Karuizawa 2001, no. 10, pp. 34, 164, repr. p. 35

SELECTED REFERENCE: Pierre Rosenberg, "De
Ribera à Ribot," in Naples–Madrid–New York
1992, fig. 14, p. 155 (Madrid ed.)

During his early career, Millet haunted the galleries.
We know that he was particularly fascinated by the
Galerie Espagnole at the Louvre. There he would
have been able to study a version (possibly the one
now at the Hispanic Society of America, New
York [cat. 64])[1] of Ribera's *Ecstasy of Saint Mary
Magdalen* (Academia de San Fernando, Madrid).
Millet took up the theme, with Saint Barbara ascend-
ing to heaven on a cloud and surrounded by angels,
one of whom (on the right) bears the martyr's palm,
while a landscape is visible below. The catalogue of
the Galerie Espagnole insists that the location in the
Ribera painting is quite identifiable as "the hills of
Provence and Sainte-Baume."[2] Millet portrays in
great detail (bottom left) the ordeal of Saint Barbara
in front of the tower where she was imprisoned. Her
disheveled hair, her gaze turned upward in a gesture
of prayer, the ascension signaled by the great diago-
nal of the drapery—all point to the influence of
Ribera, far more than to two Assumptions preserved
in the Musée d'Art Thomas Henry, Cherbourg—
one by Philippe de Champaigne, with its plump little
angels, and the other, a small-format composition by
Prud'hon without a landscape in the lower section.
GL

1. Baticle and Marinas 1981, no. 229, repr.; 100½ x 69 in. (255 x
175 cm).
2. "les côtes de la Provence et la Sainte-Baume." Paris 1838,
cited in Baticle and Marinas 1981, no. 229.

190.

Fig. 1.37

Jean-François Millet

*The Virgin of Loreto (Notre-Dame-de-
Lorette)*

1851
Oil on canvas, upper portion rounded
91⅜ x 52½ in. (232 x 132.5 cm)
Signed right: *J.-F. Millet*
Musée des Beaux-Arts, Dijon 5036

PROVENANCE: Sale, Hôtel Drouot, Paris, April 18,
1884, no. 40 (*Vierge glorieuse*, 3,700 francs);
acquired for the Musée de Dijon at public sale,
Hôtel Georges-V, Paris, May 10, 1969, no. 86,
through gift of Pierre Lévy

REFERENCES
19th century: Sensier 1881, p. 128

20th century (selected references): Soullié 1900, p. 64;
Moreau-Nélaton 1921, vol. 1, p. 98, fig. 75;
Granville 1975, pp. 344–53, repr. p. 345

"I lived at the Louvre, in the Galerie Espagnole, in
the Standish Museum, among the drawings. . . ."
Millet recalled of his years in Paris.[1] There, he
would certainly have discovered Zurbarán's *Virgin
of the Immaculate Conception* (cat. 89). In *The Virgin
of Loreto* he copied the hieratic attitude of the Virgin
in Zurbarán's work and the solid appearance of her
many-folded garment. With great originality he
combined the traditional iconography of the Virgin
of the Immaculate Conception on her crescent with
that of the Virgin and Child, here a newborn infant
still unable to hold his head up and portrayed with
rare realism. This large canvas, which was restored
to its original rounded format after its acceptance by
the Musée de Dijon, had been used as a sign for a
novelty shop called À Notre-Dame-de-Lorette, at
the corner of the rue Notre-Dame-de-Lorette and
the rue Saint-Lazare in Paris. The owner, Collot,
who collected the work of Delacroix, Corot, and the
Barbizon school, also commissioned his portrait
from Millet in 1851.[2]
In 1858, Millet was asked to produce a very simi-
lar Immaculate Conception for the special railroad
car made for Pope Pius IX.[3]
GL

1. "Je vivais au Louvre, au musée espagnol, au musée
Standish, aux dessins." Sensier 1881, p. 56.
2. Musée de Dijon, on deposit from the Musée d'Orsay, Paris.
3. Oil on canvas; 31⅛ x 17¾ in. (79 x 45 cm); property of
Aikawa Press Industry Co. Ltd., Tsuru, deposited with
Yamanashi Prefectural Museum of Art, Kofu, Japan.

GUSTAVE MOREAU

Paris, 1826–Paris, 1898

A pupil of François-Édouard Picot, Moreau came
under the influence of Théodore Chassériau, his
neighbor in the ateliers of the avenue Frochot,
before moving in 1853 to a house at 14, rue de la
Rochefoucauld. He had the building enlarged, and
after his death it became the Musée Gustave-
Moreau. His library and papers have been pre-
served. Among these are (unbound) installments of
Charles Blanc's *Histoire des peintres de toutes les
écoles* relating to the Spanish artists Ribera,
Velázquez, Murillo, Zurbarán, and Alonso Cano.
Also discovered in his boxes were a few prints after
Velázquez,[1] as well as *The Musician*, an etching by
Charles Jacque, falsely signed Ribera.[2]
During the Exposition Universelle of 1878,
Moreau encountered Goya's Black Paintings from
the Quinta del Sordo,[3] lent by Baron d'Erlanger for
the Historical Exhibition in the Trocadéro. These,
now hanging in the Prado (Madrid), were perhaps
the inspiration for Moreau's *Galatea* (Musée
d'Orsay, Paris), presented at the Salon of 1880.
GL

1. Musée Gustave-Moreau, Paris, *Roland mort* (Pourtalès col-
lection) by François Flameng, plate from *Gazette des Beaux-
Arts*, February 1, 1865 (inv. 16658-29); *Pablo of Valladolid*
by Henri Guérard, plate from *Gazette des Beaux-Arts*,
August 1, 1880 (inv. 11918-9) and *The Spinners by Milius*,
from *L'Art* of 1878 (inv. 11918-10). See Lobstein 2002.
2. Musée Gustave-Moreau, Paris, (inv. 11918-7), from
L'Artiste, January 1, 1865, signed and dated: *A. Ribera, 1621.*
See Sanchez and Seydoux 1998, no. 1865-3.
3. Musée Gustave-Moreau, Paris, Arch. GM 241 ("Notes pour
les choses à revoir à l'Expos. Univ./Trocadéro—fresques de
Goya. . . . ") and Des. 347, repr. in Lacambre 1998, p. 50,
fig. 3, p. 54.

191.

Fig. 2.4

Gustave Moreau

*Philip IV on Horseback, Copy after
Velázquez*

1859
Oil on canvas
34½ x 25 in. (87.5 x 63.5 cm)
Musée Gustave-Moreau, Paris MGM 13619

PROVENANCE: Gustave Moreau bequest to the
state, 1898; accepted 1902

SELECTED REFERENCES: Mathieu 1991, p. 76,
no. 24, repr.; Moreau 2002, pp. 591, 593

This copy of a painting attributed to Velázquez was executed in January 1859[1] during the artist's second stay in Florence. It is smaller than the original (49⅛ x 36⅝ in. [126 x 93 cm]), now in the Palazzo Pitti, Florence, and identical in composition to the monumental 1636 version (Museo del Prado, Madrid). Frédéric Quilliet considered the Pitti version to be the earlier one.

As a preparatory sketch for a commission received by the Florentine Pietro Tacca for a statue of the king "on a curvetting horse," to be placed in the gardens of the Palacio del Buen Retiro, Velázquez "painted, in a small frame, a portrait of the king, unbelievable in its likeness."[2] Although today the attribution of the Pitti version is contested, Moreau believed that he was copying the sketch by Velázquez, and he noted several technical qualities that interested him: "Velasquez: tones muted, though still rich. Controlled brilliance. Splendid coloring. Wonderfully exhilarating golds, superb fullness of brown tones in his horses, costumes, etc., gray-browns of the landscape. Colors in local touches; no excessive variety. Tones solid. Use of earth pigments—exquisite pale or livid effects."[3]

Moreau compared the work to the fairly similar but more "fluid" style of Van Dyck, whose *Equestrian Portrait of Charles V* he copied at the Tribune des Offices. The two always hung as a pair in the study where Moreau kept most of his painted copies and where, on the evidence of Robert de Montesquiou, he received visitors at the end of his life. GL

1. Musée Gustave-Moreau, Arch. GM 335-2.
2. "sur un cheval dan le mouvement de la courbette"; "exécuta dans un petit cadre le portrait du roi, qui se trouva d'une ressemblance inouïe." Quilliet 1816, p. 373.
3. "Velasquez: tons nourris mais sourds. Eclat contenu. Superbes qualités de colorations. Ors magnifiquement fouettés, superbe plénitude de ses tons bruns dans les chevaux, costumes, etc., gris brun de ses terrains. Localité du ton très simple et sans variété outrée. Tons solides. Emploi des terres—pâleurs adorables, lividité de tons." Moreau 2002, p. 585, Appendix 3.

HENRI REGNAULT

Paris, 1843–Buzenval, 1871

Regnault studied under Lamothe and Cabanel, obtaining the Grand Prix de Rome in 1866. After a stay of only two years in Italy, he left for Spain in July 1868 to join his friend Georges Clairin at Burgos. In the Prado in Madrid, he developed a passion for Velázquez. He painted the head of *The Dwarf Francisco Lezcano* in a copy sketched by Clairin, now in the Musée de Louviers (along with five Velázquez copies by another traveling companion, the painter Roger Jourdain). To inaugurate his third year of residency at the Académie de France in Rome, he undertook a lifesize copy of *The Surrender of Breda (The Lances)* (École des Beaux-Arts, Paris), the result of which disappointed him. He moved on to Seville, "where Murillo appeared to him in a wholly new light," and Regnault pronounced him "as great as his own great Velasquez."[1] In 1870 he was in Tangier, but he returned to France upon the outbreak of the Franco-Prussian War. He died in combat during the Siege of Paris. GL

1. "où Murillo lui apparut sous un jour tout nouveau . . . presque aussi grand que son grand Velasquez." Timbal 1881, p. 284.

192. *Fig. 2.24*
Henri Regnault
Countess de Barck

1869
Oil on canvas
23⅝ x 17⅛ in. (60 x 44 cm)
Dedicated, signed, and dated bottom left: *À M. le comte de Barck, souvenir bien affectueux de son ami Henri Regnault [Ma]drid 1869* (To M[onsieur] the comte de Barck, very affectionate souvenir from your friend Henri Regnault [Ma]drid 1869)
Musée d'Orsay, Paris RF 260

PROVENANCE: Sale X (John. W. Wilson), Paris, April 27–28, 1874, no. 115; acquired from Baron de Beurnonville by the Musée du Louvre, Paris, 1879; Musée d'Orsay, Paris, 1981

EXHIBITIONS: Paris, Salon of 1869, no. 2011; Paris 1872, no. 45; Paris, Exposition Universelle, 1878, no. 724

While in Spain, Regnault had been introduced, at the home of the duquesa de Colonna, to the Swedish count Nils Barck. Barck was instrumental in the return of General Prim to Spain from London, accompanying and concealing him. It was through Barck that Regnault had been able to paint his *Juan Prim* (cat. 193). The portrait of the countess de Barck, like that of Prim, was beset with problems: her husband could not afford to buy it. Nonetheless, Regnault reserved it for Barck; as he explained to the dealer Brame, when refusing an offer of purchase, "He [Barck] was counting on some business deals to bring him a fortune; but they fell flat, thanks to the efforts of Señor Prim and this bunch of clowns."[1] The countess is wearing Spanish costume and is portrayed in the manner of Goya.

GL

1. "Il comptait sur des affaires qui devaient lui rapporter une fortune mais qui ont mal tourné, grâce aux bons soins de M. Prim et de cette troupe de saltimbanques." Letter from Tangier, June 1870: copy in archives, Musée d'Orsay, Paris.

193. *Fig. 14.1*
Henri Regnault
Juan Prim, October 8, *1868*

1869
Oil on canvas
124 x 101½ in. (315 x 258 cm)
Signed and dated bottom left: *H. Regnault, Madrid 1869*
Musée d'Orsay, Paris RF 21

PROVENANCE: Acquired by the state from the artist's heirs for the Musée du Luxembourg, Paris, 1872; Musée du Louvre, Paris, 1881; Musée d'Orsay, Paris, 1980

EXHIBITIONS: Paris, Salon of 1869, no. 2010; London, International Exhibition, 1871, no. 551; Paris, Exposition Universelle, 1878, no. 723; Paris, Exposition Universelle, 1889, no. 572; Paris 1974, no. 197, repr.; Saint-Cloud 1991–92, no. 53

SELECTED REFERENCES: Baillière 1872, pp. 49–53; Blanc 1876, p. 356; Timbal 1881, pp. 272–75; Claretie 1882, p. 11; Marx 1886, pp. 43–46, repr. p. 45

Regnault had not been long in Madrid when revolution broke out. We know from his correspondence with his father that he witnessed the triumphal entry of General Prim, who succeeded, after several attempts, in overthrowing Queen Isabella. Two years later, on December 30, 1870, Prim was assassinated.

It was thanks to the count de Barck that the artist secured permission to execute the portrait of the new "strongman." Regnault failed to get Prim to pose and had to work from memory. More a historical canvas than a traditional portrait, the work was refused by the general, who was anxious to be portrayed in a nobler attitude and was shocked at finding himself hatless.

The painting, as monumental as the great royal portraits of the Golden Age of Spain, was finally kept by Regnault, who sent it to the Paris Salon of 1869, where its effect was sensational. Charles Blanc even ventured that "it is etched into our memories like a Goya print."[1]

"Whatever it borrows from Velasquez, Goya, and Delacroix, it is original," Théophile Gautier stated.[2] In his review for *L'Illustration*, he remarks how, in the background, "there is a delirious crowd sketched in the manner of Goya with amazingly unrestrained and furious brushwork," a comment that Henri Baillière reiterated almost word for word in his monograph on Regnault.[3]

If the portrayal of the crowd was inspired by Goya's famous *Second of May 1808* (fig. 1.17), it was the name of Velázquez that constantly recurred in connection with the horse. Blanc, for instance, writing in 1876, found it "quite similar to Vélasquez's heroically lifelike horses,"[4] while in 1882, Jules Claretie described it as "a steed from the princely stable of Velasquez."[5] GL

1. "a mordu sur notre mémoire comme ferait une eau-forte de Goya." Blanc 1876, p. 356.

2. "Quoiqu'il dérive de Velasquez, de Goya et de Delacroix, il est original." Gautier in Paris 1872, p. 11.

3. "s'agit une foule ébauchée à la Goya avec une turbulence et une furie de brosse incroyable." Baillière 1872, p. 51.

4. "assez semblable aux chevaux héroïquement vrais de Vélasquez." Blanc 1876, p. 356.

5. "un cheval pris à l'écurie princière de Velasquez." Claretie 1882, p. 11.

PIERRE-AUGUSTE RENOIR

Limoges, 1841–Cagnes-sur-Mer, 1919

Renoir, the sixth child of a humble tailor and a seamstress, was born in the pottery-making town of Limoges. Early on, he apprenticed with a porcelain decorator and developed an affinity for Rococo art that would continually resurface throughout his career. By 1860 he was studying in Paris. He began to frequent the studio of Charles Gleyre in 1861 and was accepted the following year at the École des Beaux-Arts. He became good friends with Bazille, Sisley, and eventually Monet. A Romantic work, *La Esmeralda* (destroyed), was accepted at the 1862 Salon, but subsequent paintings were refused. Critical success came with *Lise with a Parasol* (1867,

Museum Folkwang, Essen) at the Salon of 1868, but by then the jury had stigmatized Renoir as a rebel, along with Courbet, Manet, and Monet. Joining his colleagues, he exhibited in the Impressionist shows in the 1870s, but returned to the Salon at the end of the decade. By the 1890s Renoir was widely considered a leading artist of his generation; by his death in 1919, his reputation outshone that of Monet and rivaled that of Cézanne. GT

194. *(New York only)* *Fig. 1.64*

Pierre-Auguste Renoir

Romaine Lacaux

1864
Oil on fabric
31⅞ x 25½ in. (81.3 x 65 cm)
Signed and dated lower right: *A. Renoir, 1864*
The Cleveland Museum of Art, Gift of the Hanna Fund 42.1065

CATALOGUES RAISONNÉS: Daulte 1971, no. 12; Fezzi 1985, no. 7

PROVENANCE: Lacaux family, Paris; Edmund Decap, Paris; by descent to Mme Maurice Barret-Decap, Biarritz, until at least 1933; M. Decap, Paris; M. and Mme Maurice Barrand-Decap, Biarritz; sale, Hôtel Drouot, Paris, December 12, 1929, no. 12, repr.; bought for 330,000 francs by Roger Bernheim, Paris; Jacques Seligmann and Co., Inc., New York, by 1941; gift of the Hanna Fund to the Cleveland Museum of Art, 1942

EXHIBITIONS: Paris 1933c, no. 1; Chicago 1973, no. 2; Philadelphia–Detroit–Paris 1978–79, no. 268; London–Paris–Boston 1985–86, no. 1; Paris–New York 1994–95, no. 169; Ottawa–Chicago–Fort Worth 1997–98, no. 3

SELECTED REFERENCES: Francis 1943; Champa 1973, pp. 35–37; McCauley 1985, pp. 200–201

The research of Anne Distel and Colin Bailey has identified Romaine Lacaux (1855–1918) as the second child of Paul-Adolphe Lacaux, a Parisian pottery manufacturer, and Denise-Léonie Guénault,

whose family was in the same business. Renoir presumably met Monsieur Lacaux through his own contacts from his porcelain-decorating days. When she sat for Renoir in 1864, Romaine was nine years old.

Scholars have noted the similarities of this arresting portrait to contemporary cartes de visite; other sources as disparate as portraits by the elderly Ingres and the young Whistler have also been cited. No doubt Renoir, who lived hand to mouth, attempted both to satisfy prevailing taste and to impress his patron. But the controlling reference here is without question Velázquez's famous portrait of the Infanta Margarita at the Louvre (cat. 78)— the one painting there that was certainly by the master, as Manet put it. Manet and Degas met each other at the Louvre while copying this same Velázquez in 1862, and it is known that Renoir copied at the Louvre in the early 1860s. Conscious of the allure of Velázquez for his contemporaries, Renoir attempted in this portrait to emulate the Spanish master's astonishing naturalism as well as his fluid handling of paint.

In works such as *The Clown (James Bollinger Mazutreek)* (1868, Rijksmuseum Kröller-Müller, Otterlo) and *Madame Henriot in Men's Costume* (ca. 1875–77, Columbus Museum of Art), Renoir acknowledged the conventions of Spanish Baroque painting newly popularized by Courbet and Manet. However, his approach was never as aggressive as that of his older colleagues, and his art was always tempered by a sweet nostalgia for the Rococo. One of his last monumental works, a portrait of his son Jean (1910, Los Angeles County Museum of Art), shows the teenager in the pose of Velázquez's *Baltasar Carlos as a Hunter* (1635–36, Museo del Prado, Madrid), but the color and handling are reminiscent of Fragonard at his most vaporous. GT

THÉODULE-AUGUSTIN RIBOT

Saint-Nicolas-d'Attez, 1823–Colombes, 1891

Ribot, a pupil of Glaize, had his entry for the Salon of 1859 refused, and it was subsequently exhibited, with the work of Whistler, Fantin-Latour, and Legros, at the studio of François Bonvin. Like them, Ribot studied the old masters in the Louvre, but he also made frequent visits to the Laperlier and La Caze collections. We know that the collection of Dr. Louis La Caze[1]—before it passed to the Louvre— could be viewed on Sundays in his house at 18, rue du Cherche-Midi, Paris; it included some French paintings, especially still lifes by Chardin, but also a few Spanish masterpieces.

Ribot's interest in Ribera did not escape contemporary critics. Ernest Chesneau wrote of Ribot's *Saint Sebastian* (Musée d'Orsay, Paris) at the 1865 Salon that "it was in the same spirit as Ribeira; as powerful as, if not more powerful than, Ribeira."[2] Ribot's major historical canvases were noteworthy, from that period on, for his use of Spanish chiaroscuro and realism. GL

1. Marx 1886, p. 133.

2. "Dans le même esprit que Ribeira, c'est aussi fort sinon plus fort que Ribeira." *Le Constitutionnel,* May 9, 1865.

195.
Fig. 1.40

Théodule-Augustin Ribot
Still Life with Eggs

Ca. 1865–70
Oil on canvas
20⅛ x 36⅜ in. (52.4 x 92.5 cm)
Signed bottom left: *t. Ribot*
Van Gogh Museum, Amsterdam s463 S/1997

PROVENANCE: The artist's studio; sale by the artist's widow, Hôtel Drouot, Paris, May 30, 1896, no. 23, repr.; Arcade Gallery, London, 1965; private collection, United States; acquired by the Van Gogh Museum, Amsterdam, from Hazlitt, Gooden & Fox, London, 1997

SELECTED REFERENCE: Vergeest 2000, no. 893, repr.

Ribot often painted *oeufs sur le plat* (baked eggs), thus the provenance of this still life, which was reproduced in the catalogue of his posthumous studio sale, cannot be assumed.[1] This and a similar still life in the Musée du Haubergier, Senlis,[2] could both be of relatively late date, even if Ribot seems to have devoted much time to this type of subject, popular among art lovers, as early as 1865–75.

The smaller still life in the Musée du Haubergier is essentially a reversed version of this one, depicting baked eggs in a brown earthenware dish, with the same stone snail on the opposite side. Here, Ribot has added a glazed pot in the background, with a cabbage and a few cherries on the left.

To judge by his realism and his fascination with portraying rough surfaces sharply illuminated from overhead in his garret studio at Colombes,[3] the artist was familiar with the youthful work of Velázquez, especially the textural effects and the play of light on pottery in *The Waterseller of Seville* (fig. 1.21). This masterpiece was removed from the possession of Joseph Bonaparte by Arthur Wellesley, the future duke of Wellington, and remains in his London residence, Apsley House (Wellington Museum). Long known through a print, it was also reproduced by Charles Blanc, as early as 1852, to illustrate the first installment devoted to Velázquez (reprinted many times since) in the *Histoire des peintres de toutes les écoles: École espagnole* (1869). GL

1. In 1892, at the Ribot exhibition (École des Beaux-Arts, Paris), no. 64, *Les Oeufs sur le plat,* belonging to M. Steken, had the same dimensions—20½ x 36⅛ in. (52 x 93 cm)—as the Amsterdam canvas. However, the catalogue of the posthumous sale, which indicates the presence of some works in one or another of the earlier Ribot exhibitions, makes no mention of this painting in connection with the exhibition of 1892.

2. Repr. in Cleveland et al. 1980–82, no. 120 (23¼ x 29⅛ in. [59 x 74 cm]), donated to the museum in 1939; entered Debrousse sale October 4–6, 1900, no. 187 (23⅝ x 28¼ in. [60 x 73 cm]) and possibly linkable to no. 22 of the posthumous sale (23¼ x 28⅜ in. [59 x 72 cm]); entered for the Ribot exhibition at Galerie Bernheim-Jeune, Paris, 1890, no. 168.

3. Sertat 1892, p. 1111, includes a photograph.

196.
Fig. 2.16

Théodule-Augustin Ribot
The Torture of Alonso Cano

1867
Oil on canvas
59 x 82¼ in. (150 x 209 cm)
Signed bottom right: *t. Ribot*
Musée des Beaux-Arts, Rouen 869.4

PROVENANCE: Acquired in 1869 from the artist by the city of Rouen for 4,000 francs

EXHIBITIONS: Paris, Salon of 1867, no. 1281 *(Le Supplice des coins)*; Rouen, 1869, "Exposition Municipale des Beaux-Arts," no. 319 *(Le Supplice d'Alonso Cano)*; Paris 1880 (unnumbered); Paris 1892, no. 42; Philadelphia–Detroit–Paris 1978–79, no. 269, repr. (Paris ed.)

SELECTED REFERENCES: Du Camp 1867, pp. 264–65; Dolent 1888, pp. 21–22

At the 1867 Salon, no one recognized this painting's true subject—a well-known episode in the life of the great painter, sculptor, and architect Alonso Cano (1601–1667)—but it was criticized for its black patina. The caricaturist Cham reproduced a sketch of it (under the title *La Question*), with the caption: "The real question is whether these people have ever taken a bath. I doubt it."[1] Maxime Du Camp referred to the painting as "a slavish copy of a work by L'Espagnolet [Ribera]."[2] He was thinking, perhaps, of Ribera's *Saint Sebastian Tended by the Devout Women* (cat. 59), which had just resurfaced a few days before the opening of the Salon, in the

Soult sale of April 17, 1867. The artist may also have drawn inspiration for the positioning of the figures from the victim's pose in Ribera's *Martyrdom of Saint Sebastian,* a horizontal composition of which several copies exist, including those in the Palazzo Pitti, Florence; the Musée de Grenoble;[3] and the Musée de Lyon.[4] Ribera also painted a vertical version[5] exhibiting many similarities to *The Torture of Alonso Cano;* a version hung in the Galerie Espagnole at the Louvre. Adolphe Masson reproduced it as a large etching for the Salon des Refusés of 1863.[6] Masson was also the author of a portrait of Ribot and of a small etching based on *The Torture of Alonso Cano,* which was shown at the 1881 Salon (the original having been sent to Paris the previous year for an exhibition). Almost certainly the two artists came to know each other well in the 1860s within the Realist circle.

The episode depicted in this painting was related, with variations, by all of Cano's biographers. Charles Blanc has a long discussion of the affair in the 1856 installment of the *Histoire des peintres* devoted to Cano. If Juan Agustín Ceán Bermúdez (1800) considers it apocryphal, Antonio Palomino, in 1724, relates it as the climax of a long period during which the artist lived in concealment, after discovering his wife had been murdered. Don José Pellicer, in the *Annales Manuscritos* passed on to Blanc by M. Delaroca, dated the killing precisely to June 14, 1644. A copyist lodging with Cano stabbed the latter's wife fifteen times with a knife before disappearing. "When the husband arrived, suspicion fell on him. . . . He was arrested, and resisted torture with unwavering resolution, steadfastly denying he had committed any such crime. When the preliminary inquiries were completed, Alonso Cano was exonerated."[7]

According to the legend that grew up around this incident, Philip IV "forbade anyone to harm the artist's right arm, in consideration of the fine things this arm had painted."[8] Ribot therefore deliberately depicted Cano in an impassive pose, which the critics of the time failed to understand; it was no doubt for this reason that the artist explained the subject matter when he dispatched the work to Rouen in 1869. This time it won a gold medal. GL

1. "La véritable question est de savoir si ces gens-là ont jamais pris un bain. J'en doute." In Cham 1867, no. 1281.

2. "d'une copie servile d'une toile de L'Espagnolet." Du Camp 1867, pp. 264–65.

3. Acquired in Paris for the Musée de Grenoble, 1828.

4. Bequeathed in 1863 by Count Sébastien Des Guidi, of Lyon. An inscription on the stretcher beginning "The 1st September 1847, given to Mr. Philippe" ("Le 1er septembre 1847, donné à Mr Philippe") alludes perhaps to a transaction.

5. Baticle and Marinas 1981, no. 244 (77½ x 59½ in. [197 x 151 cm]); the reproduction is of a version in the Museu Nacional d'Art de Catalunya, Barcelona.

6. Bibliothèque Nationale de France, Paris, Département des Estampes (call number AA4).

7. "Quand vint son mari, les soupçons se portèrent sur lui. . . . Il fut arrêté, mais il subit la question avec une fermeté indomptable, niant jusqu'au bout qu'il fût l'auteur d'un tel meurtre, et l'affaire ayant été instruite, Alonso Cano fut

reconnu innocent." Blanc et al. 1869, no. 171 (Cano issue), p. 5.

8. "défendit que l'on touchât au bras droit de l'artiste, en considération des belles choses que ce bras avait peintes." Ibid., p. 4.

imagine these paintings before me are French. One thinks of the Spanish—Ribera, Zurbaran, the masters of black."[2] GL

1. See Paris–Milan 1988–89, no. 81, repr. (painting acquired in 1839 for the Musée de Rouen as a Ribera).

2. "Pas un instant, je ne puis m'imaginer que j'ai devant moi des tableaux français. On pense aux Espagnols, Ribera, Zurbaran, aux maîtres noirs." Rolland 1952, p. 136.

197. *Fig. 2.27*

Théodule-Augustin Ribot

The Samaritan

1870
Oil on canvas
44⅛ x 57⅛ in. (112 x 145 cm)
Signed bottom right: *t. Ribot*
Musée d'Orsay, Paris RF 106

PROVENANCE: Acquired by the state, 1871; Musée du Luxembourg, Paris, 1874; state deposit, Paris, 1926; French Embassy (Department of Commercial Attaché), Warsaw, 1931; transferred by the city of Warsaw to the Muzeum Narodowe, 1938 or 1939; restored to France, February 19, 1998; Musée d'Orsay, Paris, April 28, 1998

EXHIBITIONS: Paris, Salon of 1870, no. 2421; Vienna, Universal Exhibition, 1873, no. 549; Paris, Exposition Universelle, 1878, no. 727; London, Franco-British Exhibition, 1908, no. 399, repr.; San Francisco 1915, no. 71

SELECTED REFERENCES: Bénédite 1912, no. 436, repr.; Bénédite 1923, no. 205, repr.; Paris 1974, no. 200, repr.

To illustrate the parable of the Good Samaritan (Luke 10:30–37), Ribot chose to depict him as a tiny silhouette on horseback on the horizon, leaving center stage to the man he is about to encounter, who has been stripped and abandoned, half dead, by the robbers. The violent chiaroscuro is typical of Ribera, and the body lying on its back in the foreground recalls his tortured nudes of Prometheus or Ixion (Museo del Prado, Madrid). Whereas Ribera's giant figures howl open-mouthed in their agony, Ribot's victim sprawls with face tilted back and scarcely visible, as in a tenebrist *Samaritan* in the Musée de Rouen, acquired in 1839 as a Ribera but now attributed to Luca Giordano.[1]

Romain Rolland's comment of June 2, 1887, on an exhibition devoted to Ribot at the Galerie Bernheim-Jeune succinctly captures the public reaction to the artist's work: "Not for an instant can I

198. *(New York only)* *Fig. 14.80*

Théodule-Augustin Ribot

Lazarillo de Tormes and His Blind Master

1870–79
Oil on fabric
36 x 29 in. (91.5 x 73.7 cm)
Signed lower left: *t. Ribot*
The Cleveland Museum of Art, Bequest of Noah L. Butkin, 1980 1980.282

PROVENANCE: Émile Oppenheim, Paris, 1890; his sale, Hôtel Drouot, Paris, May 11, 1897, no. 22 (*The Blind Man and Don Guzman d'Alfarache*); sale, Hôtel Drouot, Paris, December 4–5, 1918, no. 8, repr. (same title); sale, Hôtel Drouot, Paris, November 7, 1973, no number (same title); Arcade Gallery, London; Mr. and Mrs. Noah L. Butkin, Shaker Heights, Ohio; their bequest to the Cleveland Museum of Art, 1980

EXHIBITIONS: Paris 1890, no. 227 bis (*The Blind Man*, lent by Oppenheim), also cited under "Peintures diverses" (Miscellaneous paintings), p. 19 (*The Blind Man with Green Jug and Child*, lent by Oppenheim, etched engraving by Masson); Paris, Galerie Bernheim-Jeune, 1911, "Exposition Ribot," no. 24 (*The Blind Man*)

SELECTED REFERENCES: Weisberg 1976, pp. 258, 261, repr. p. 260 (figs. 16, 17); Argencourt 1999, vol. 2, no. 192, pp. 546–49, repr.

At the Salon of 1879, under number 5747, Alphonse Masson displayed two engravings after Ribot, the first of them entitled *Guzman d'Alfarache*. This etching appeared the next year in the review *L'Art* with

the title *The Blind Man and Guzman d'Alfarache*.[1] It corresponded in every respect to the painting displayed here. That is the source of the title adopted in 1897; in the 1890 exhibition catalogue, the painting is described simply as *The Blind Man with Green Jug and Child*, or as *The Blind Man*.

Are we to think that the subject was misidentified by Masson, a great lover of Spanish painting? He was very close to Ribot, having engraved several of the artist's works and done a portrait of him. Here, however, he was confusing two classics of sixteenth-century Spanish picaresque literature. "Guzman d'Alfarache" is a reference to the novel by Mateo Aleman, published in 1599, which was very well known in France through the abridged version by Alain-René Lesage, published in 1732 under the title *L'histoire de Guzman d'Alfarache, nouvellement traduite et purgée de moralités superflues* (The story of Guzman d'Alfarache, newly translated and purged of superfluous morals), and reissued by Didot in 1838 as part of Lesage's selected works, along with *Le diable boiteux* (The lame devil), *Gil Blas*, and *Le bachelier de Salamanque* (The student of Salamanca). The latter book would inspire Manet in 1860. *Don Guzman d'Alfarache* was then published by Garnier Frères in 1864. It is possible that Ribot had read this novel when he chose the subject for his painting *The Empty Gourd*, described by Hippolyte Devillers in the 1890 Ribot exhibition catalogue: "*The Empty Gourd* is a frightening thing: a recumbent, grimacing man, his bulging bare torso fully exposed to the light, writhes under the effects of alcohol. This is Ribot dreaming of Spain."[2] The scene is related to an anecdote reported in the first part of *Guzman d'Alfarache* (book 1, chapter 3): a "mountain dweller who was burying his wife" stopped at a cabaret, drank there for a long time, and fell asleep. His friends, returning from the cemetery, "found him stretched out on the ground."

Nevertheless, as Gabriel Weisberg noted in 1976, the subject was actually inspired by the anonymous 1554 picaresque novel *Lazarillo de Tormes*, which recounts the adventures of a child left to fend for himself from the age of eight. Clever and resourceful, Lazarillo plays tricks on his first master, a blind man who is letting him die of hunger and thirst. Thus, among other ruses, the boy decides to discreetly drink the wine from a jug that his master, as a precaution, holds firmly in one hand. He uses a "long rye straw prepared for that purpose," which he slips "into the jug through the neck to suck it dry of wine." This is the precise moment that Ribot depicts, taking pleasure in portraying the young hero's animated face and gleaming eyes. He does not address the old man's revenge, described a few lines later: when the master recognizes the trick, he smashes the jug on the child's face.

Thus reduced to an agreeable genre scene, the painting appeared with a simple descriptive title at the 1890 exhibition, with no reference to picaresque novels. Another painting with a similar subject at the same exhibition, bearing the number 220 and simply titled *Le Grand-père (The Grandfather)*, is described this way: "Mischievously, a child amuses himself by running a paintbrush over the belly of an earthenware jug, held between the half-naked legs of a

seated old man with long beard and white hair, his head wrapped in a light-colored scarf and covered with a wide-brimmed fedora."[3] The head covering, the same as that worn by the figure in Manet's *Spanish Singer* (cat. 131), is also found in the present work.

As always with Ribot, it is difficult to determine the exact date of this painting, but it must have been executed in the 1870s, after the major losses suffered during the Franco-Prussian War.

Goya had already depicted another episode of Lazarillo's adventures in a painting that was part of Louis-Philippe's Galerie Espagnole; in the 1812 inventory, it was called *El Lazarillo de Tormes.*[4] In Goya's much more violent scene, the blind man is seeking to extract a stolen sausage from the child's mouth. While it is difficult to say whether Ribot was thinking of that painting, it is certain that he was familiar with picaresque novels as well as with the bearded old men depicted by Ribera. GL

1. *L'Art* 21 (1880), insert plate facing p. 160.
2. "*La gourde vide* est une chose effrayante, un homme couché, grimaçant, le torse nu bombé en pleine lumière, se tord sous la brûlure de l'alcool, c'est Ribot songeant à l'Espagne." Paris 1890, p. 11.
3. "Espiéglement un enfant s'amuse à promener un pinceau sur la panse d'une cruche en terre que tient entre ses jambes demi-nues un vieillard assis à longue barbe et chevelure blanche, la tête ceinte d'un foulard clair et couverte d'un feutre à larges bords." Paris 1890, no. 220.
4. See Lille–Philadelphia 1998–99, no. 550 (Lille ed.), repr. (private collection); Baticle and Marinas 1981, no. 106, repr.

AMÉDÉE TERNANTE-LEMAIRE

Châtillon-sur-Seine, 1821?–after 1866

Bénézit's dictionary of artists cites only three portraits under the name of this artist: *Full-Length Portrait of Marie de Médicis* in the Louvre, *Portrait of Joan of Austria,* and *Portrait of Marie de Rohan,* both at Versailles. It neglects to note that the first of these was copied from Frans Pourbus the Younger (an 1847 commission), the second from Alonso Sánchez Coello after a painting in the Galerie Espagnole, and the third from Louis Elle, known as the Elder (commissions of 1841 and 1840, respectively). In fact, despite his intermittent presence as a portraitist at the Salons beginning in 1849, Ternante-Lemaire was less a recognized independent artist than one who made his living primarily through public commissions. Little is known about his original works, although the *Village of Pravady (Bulgaria)*, which was auctioned in Paris on December 14, 1994, suggests that he liked to travel. It is his work as a copyist, always recognized as of high quality by the officials in the Département des Beaux-Arts and remunerated at a higher than usual rate, that has earned him his current place in major institutions. DL

199. *Fig. 2.3*
Amédée Ternante-Lemaire
Pope Innocent X, Copy after Velázquez

1846
Oil on canvas
51⅛ x 44⅛ in. (131 x 112 cm)
Musée National des Châteaux de Versailles et de Trianon, on deposit at the French Embassy, Vatican City MV 4248

PROVENANCE: Commissioned for the Château of Versailles, 1846

SELECTED REFERENCE: Constans 1995, vol. 2, p. 852

The portrait of Pope Innocent X by Velázquez, an outstanding work in the collection of the Doria Pamphilj family of Rome ever since it was painted in 1650–51, has always been an object of admiration. Hippolyte Taine, for example, in the first volume of his *Voyage en Italie* (Journey to Italy), wrote of his visit to the family's gallery during a trip in 1864: "The masterpiece among all these portraits is Velázquez's Pope Innocent X: in a red armchair, in front of a red curtain, under a red calotte, above a red mantle is a red face, the face of a poor simpleton, an obsolete pedant; and from that an unforgettable painting has been made! One of my friends, on returning from Madrid, told me that, next to the paintings there by Velázquez, all the others, even the most sincere and the most splendid, seemed dead or academic."[1] The painting also earned a place of honor in Pierre Larousse's *Grand dictionnaire universel du XIXᵉ siècle* (Unabridged universal dictionary of the nineteenth century); the entry devoted to it mentions many autograph or semiautograph replicas, a few existing copies of the painting, and some of the engravings made from it.[2]

When Louis-Philippe decided to devote certain halls at Versailles to historical subjects, Velázquez's portrait of the pope was considered an important addition, both historically and aesthetically. Hence this copy was commissioned from Ternante-Lemaire in 1846. Other copies of Velázquez works were also commissioned, including one by Charles-Alexandre Debacq of the portrait of Gaspar de

Guzmán, conde-duque de Olivares.[3] Executed at the site of the original work and absolutely faithful to its model, this copy is exemplary of the many works commissioned by the Beaux-Arts administration to encourage young artists or to aid older ones.

DL

1. "Le chef-d'oeuvre entre tous les portraits est celui du pape Innocent X par Velázquez: sur un fauteuil rouge, devant une tenture rouge, sous une calotte rouge, au-dessus d'un manteau rouge, une figure rouge, la figure d'un pauvre niais, d'un cuistre usé; faites avec cela un tableau qu'on n'oublie plus! Un de mes amis revenant de Madrid me disait qu'à côté des peintures de Velázquez qui sont là, toutes les autres, les plus sincères, les plus splendides semblaient mortes ou académiques." Taine 1990, vol. 2, p. 225.
2. Vol. 9, p. 703.
3. See Constans 1995, vol. 1, p. 229.

MARY CASSATT

Pittsburgh, 1844–Mesnil-Théribus (Oise), 1926

The daughter of a successful businessman, Cassatt grew up in western Pennsylvania. As a girl she spent four years in Europe (1851–55), where her parents sought medical help for one of their children. The family returned to the United States in 1855, settling near Philadelphia. In 1860 Cassatt began her training at the Pennsylvania Academy of the Fine Arts in Philadelphia, where she enrolled in drawing and painting classes. To continue her education she traveled to Paris in 1865, at the age of twenty-one. Not admitted to the École des Beaux-Arts as a woman, Cassatt fashioned an individual course of study: she attended Charles Chaplin's class for women, arranged to be a private pupil of Jean-Léon Gérôme (a professor at the École), participated in informal evening study groups, and copied works at the Louvre. She spent time in rural communities about thirty miles north of Paris, studying with Paul Constant Soyer, Pierre-Édouard Frère, and Thomas Couture. In 1870 she visited Rome for about six months, working in the studio of French artist Charles Bellay. Her first paintings accepted at the Paris Salon (1868 and 1870) were images of picturesque peasant women.

Returning to Philadelphia in 1870 at the outbreak of the Franco-Prussian War, Cassatt went back to Europe late the following year. In 1872–73 she explored Italy and Spain, re-establishing herself in Paris in 1874. Most of Cassatt's submissions to the Salons from 1872 to 1876 were accepted; in 1877, however, both her entries were rejected. That same year Edgar Degas invited her to participate in the artist-run exhibitions of the Impressionists, with whom she exhibited in 1879, 1880, 1881, and 1886, gaining critical attention on both sides of the Atlantic. In 1879 Degas invited Cassatt and other friends to make etchings in his studio; over the years Cassatt produced innovative and influential works in the medium, notably ten drypoint and aquatint color prints of 1891 that were deeply influenced by Japanese woodcut prints, especially Utamaro's images of women. Cassatt's investigations of the universal themes of mothers and children continued throughout her careeer.

Familial relations were both a source of artistic inspiration and a time-consuming duty. Cassatt's parents and her sister Lydia moved permanently to Paris in 1877; Lydia was a frequent model until her death in 1882. Cassatt never married, and in later years she was closest to her brothers' families and to a few artists and collectors, particularly the New Yorkers Louisine and Horace O. Havemeyer. Thanks to Cassatt, the Havemeyers purchased a number of Spanish pictures by Manet (including *Mlle V . . . in the Costume of an Espada*, *Young Man in the Costume of a Majo*, and *A Matador*, cats. 139, 140, 149) and some seventeen works by or attributed to Goya (most notably *Majas on a Balcony*, cat. no. 14). TF

200. *(New York only)* *Fig. 10.25*

Mary Cassatt

On the Balcony

1872
Oil on canvas
39¼ x 32½ in. (101 x 82.5 cm)
Signed, dated, and inscribed lower left corner:
M.S.C./1872, à Seville
Philadelphia Museum of Art, W. P. Wilstach
Collection w'06.1.7

CATALOGUE RAISONNÉ: Breeskin 1970, no. 18

PROVENANCE: The Wilstach Collection, Philadelphia, by 1906; subsequently incorporated into the Philadelphia Museum of Art

SELECTED EXHIBITIONS: Cincinnati 1873, no. 184; Philadelphia, Bailey and Co., 1873; New York 1874, no. 286; Chicago 1926–27; Chicago–New York 1954, no. 2; Philadelphia Museum of Art, 1953, "Homer, Cassatt, Eakins"; Philadelphia 1985, no. 1; Jacksonville, Fla., Cummer Gallery of Art, 1986, "Transitions in American Impressionism"; Chicago–Boston–Washington 1998–99, no. 3

SELECTED REFERENCES: *Daily Evening Telegraph* (June 16, 1873), quoted in Philadelphia 1985, p. 37; *The Nation* (May 14, 1874), quoted in Chicago–Boston–Washington 1998–99, p. 38; Carey 1908, p. xxxi

Early in the summer of 1871 Cassatt admitted to her friend the artist Emily Sartain that she longed to exchange the mountains of western Pennsylvania for the Sierra Nevada in Spain. She even declared it a "mistake" that she was American: "I really feel as if it was intended I should be a Spaniard."[1] Although she had never visited Spain, her eagerness to do so had probably been heightened by two other Philadelphia artists, William Sartain (her friend Emily's brother) and his friend Thomas Eakins, who upon completion of their studies in Paris visited Madrid and Seville.

Cassatt traveled to Europe late in 1871, accompanied by Emily Sartain. The bishop of Pittsburgh had provided her with a means to fund her trip: Cassatt would go to Parma and paint copies of two famous works by Correggio (*Madonna of Saint Jerome* and *Coronation of the Virgin*), which would adorn Pittsburgh's new cathedral. Cassatt's nine months in Italy in 1872 deepened her appreciation of Renaissance and Baroque art, which in turn inspired a new painting of two Italian women, *During Carnival* (private collection), accepted that year by the Salon. Finally arriving in Spain in the fall of 1872, Cassatt spent six months there alone, three weeks in Madrid followed by an extended stay in Seville.

The Prado's collection jolted Cassatt's assumptions about the supremacy of the Italian school. Writing to Sartain soon after arriving in Madrid, Cassatt was enraptured by the clarity and directness of Velázquez and Murillo: "These Spaniards make a much greater impression *at first*. The men and women have a reality about them which exceed anything I ever supposed possible."[2] A week later, having scrutinized Velázquez's "so fine and so simple" manner, Cassatt remarked, "I think that one learns *how to paint* here."[3] She copied one of Velázquez's portraits of the child prince Baltasar Carlos (location unknown).

In Seville, Cassatt rented a studio in a sixteenth-century palace and worked for about five months on her own Spanish works. *On the Balcony* was the first large exhibition painting that she produced in Spain, as well as her first work featuring a male figure. Attired in costumes that French and American audiences would find picturesquely Spanish, two women with colorful shawls, flowers, jewelry, and fans and a man in a broad-brimmed hat and cape form a lively grouping that reflects Cassatt's recent studies in Italy, as does the twisting, Mannerist-inflected pose of the woman at right.

On the Balcony no doubt demonstrates Cassatt's awareness of well-known pictures by Murillo and Goya in which young women are framed by balconies or windows; *Two Women at a Window* (ca. 1655–60, National Gallery of Art, Washington, D.C.) and *Majas on a Balcony* (cat. 14) were both available to her as nineteenth-century prints and illustrations. Although the scenarios envisioned by those artists have long been read as allusions to prostitution, in part because the women gaze directly at the viewer, Cassatt's presentation seems more innocently admiring of the unrestrained common people it depicts. Working in a country she barely knew, Cassatt hired three models to pose in ways that she, a tourist, assumed to embody the charming essence of local color. It is also likely that Cassatt knew Manet's *The Balcony* (cat. 155), which had its debut at the Salon of 1869, but its influence on this work was superficial at best. Manet's balcony scene alluded to famous Spanish precedents yet struck an arrestingly modern note: the artist treated his oddly pensive French subjects like objects in a still life. Cassatt, on the other hand, posed her smiling Spaniards in a spirited enactment of a conventional flirtation narrative.[4]

Addressing the playfulness of its subjects with an exoticizing yet wholesome delight, the painting masked the condescending initial impressions of the Spanish people that Cassatt expressed in private. She wrote Sartain that she liked "the odd types and the peculiar rich dark coloring of the models"; on a more general note, however, she pronounced that "The Spaniards [are] infinitely inferior in education and breeding to the Italians."[5] What little is known

of the early reception of this work is positive in tone. In 1873 the Philadelphia critic William J. Clark (who was at that time an early champion of Thomas Eakins) praised the close observation and "intense vitality": "There is an ease, an unconstraint, in the attitudes of the figures, a careless grace."[6] In 1874 the critic for *The Nation* responded strongly to its affinities with the old masters: "In one of these balcony groups there is a leaning girl's head, full of somber power, and painted with the best traditions of Murillo."[7] That same year the jury for the annual exhibition at the National Academy of Design, New York, accepted two of Cassatt's Spanish pictures.

TF

1. Letter from Mary Cassatt to Emily Sartain, Hollidaysburg, Pa., May 22, [1871], transcribed in Mathews 1984, p. 70.

2. Letter from Mary Cassatt to Emily Sartain, [Madrid], Saturday, October 5, [1872], transcribed in ibid., p. 103.

3. Letter from Mary Cassatt to Emily Sartain, Madrid, Sunday, October 13, [1872], transcribed in ibid., p. 108.

4. The above-mentioned works by Murillo, Goya, and Manet are discussed as "sources" for *On the Balcony* in Boone 1995.

5. Letter from Mary Cassatt to Emily Sartain, Seville, January 1, 1873, transcribed in Mathews 1984, p. 114.

6. *Daily Evening Telegraph*, June 16, 1873, quoted in Philadelphia 1985, p. 37.

7. *The Nation* (May 14, 1874), quoted in Chicago–Boston–Washington 1998–99, p. 38.

201. (New York only) *Fig. 10.26*

Mary Cassatt

Offering the Panal to the Bullfighter

1872–73
Oil on canvas
39¾ x 33½ in. (101 x 85 cm)
Signed, dated, and inscribed lower right: *Mary S. Cassatt/Seville/1873*
Sterling and Francine Clark Art Institute, Williamstown, Massachusetts 1955.1

CATALOGUE RAISONNÉ: Breeskin 1970, no. 22

PROVENANCE: M. Engrand, Paris, after 1878; M. Parisot; Durand-Ruel, New York, to Carroll Carstairs, New York, to Knoedler and Co., New York, 1947; purchased by R. Sterling Clarke, 1947

SELECTED EXHIBITIONS: Cincinnati 1873, no. 250; Paris, Salon of 1873, no. 1372; New York 1874, no. 280; Philadelphia 1878, no. 192; New York 1993a, no. 12; Chicago–Boston–Washington 1998–99, no. 5

SELECTED REFERENCES: Conrads 1990, pp. 27–31; Pollock 1998, pp. 100–108

Offering the Panal to the Bullfighter showcases Cassatt's growing desire to emulate the painterly effects she admired in Velázquez's works. These colorful contemporary characters from the bullring offered the kind of visual pageantry that Velázquez had painted for the seventeenth-century Spanish royal court; their spectacular outfits inspired Cassatt to experiment with bigger, more fluent strokes and the bravura effects of the Spanish master. In addi-

tion, the subject matter, compositional simplicity, and loose technique of *Offering the Panal to the Bullfighter* profess Cassatt's growing affinity with the art of Manet, especially works such as *A Matador* (cat. 149).

Cassatt achieved a greater severity and immediacy in this painting than in the earlier *On the Balcony* (cat. 200). Limiting herself to two figures set against a flat, dark gray background in strong raking light, she honed the narrative details. The strapping, splendiferous male casts an appraising stare at a woman whose shadowed face is turned from the viewer, a suggestive moment in a routine exchange on the sidelines during a bullfight: the toreador waits while the panal (a sweet, honeycombed confection) absorbs some of the water that is also part of the adoring fan's ritual offering.

Strongly ambitious when she embarked on her Spanish pictures, Cassatt's business acumen surfaced when she wrote to Emily Sartain from Seville that "I see the immense capital that can be drawn from Spain, it has not been 'exploited' yet as it might be, and it is suggestive of pictures on all sides."[1] She may have tried to sell *Offering the Panal* to William Hood Stewart, an American expatriate living in Paris and building a collection of contemporary Spanish paintings. Stewart, who owned works by Mariano Fortuny, José Villegas, and many others, hosted a visit from Cassatt, her mother, and sister a week before this painting had its debut in the Paris Salon of 1873.[2]

Offering the Panal did not readily find a buyer nor did it attract significant attention from Parisian art critics. The same was true when Cassatt sent it to exhibitions in Cincinnati, New York, and Philadelphia between 1873 and 1878. The picture's history is obscure for the remainder of the artist's life, reflecting in large part Cassatt's shift away from traditional narratives and old-master innuendoes after she associated with the Impressionists. Pictures such as this one were crucial steps in her artistic development and illustrate a comment that Cassatt made to her friend the collector Louisine Havemeyer: "To be a great painter, you must be classic as well as modern."[3]

TF

1. Letter from Mary Cassatt to Emily Sartain, Seville, Wednesday, October 27, [1872], quoted in Mathews 1984, p. 109.

2. The Stewart collection is discussed by Andrew J. Walker in Chicago–Boston–Washington 1998–99, pp. 32–33.

3. Quoted in Havemeyer 1993, p. 179.

202. (New York only) *Fig. 1.63*

Mary Cassatt

In the Loge

1877–78
Oil on canvas
32 x 26 in. (81 x 66 cm)
Signed lower left corner: *Mary Cassatt*
Museum of Fine Arts, Boston, The Hayden Collection, Charles Henry Hayden Fund 10.35

CATALOGUE RAISONNÉ: Breeskin 1970, no. 73

PROVENANCE: From the artist to Martin, Camentron, and Co., Paris, ca. 1893; with Durand-Ruel, Paris and New York, ca. 1894–1910; with F. W. Bayley, Boston; purchased by the Museum of Fine Arts, Boston, 1910

SELECTED EXHIBITIONS: Boston 1878, no. 234 (as *At the Français, a Sketch*); Paris 1893, no. 13 (as *La Loge*); New York 1895b, no. 5; New York 1895c, no. 17; Boston 1898a, no. 14; Cincinnati 1900, no. 12; New York 1903b, no. 1; Philadelphia 1907, no. 124; Boston 1909, no. 24; Chicago 1933, no. 437; New York 1964, no. 10; Chicago–Boston–Washington 1998–99, no. 17

SELECTED REFERENCE: Pollock 1988, pp. 75–79

Soon after Degas asked Cassatt to exhibit with the Impressionists in 1877, she began to paint images of people attending Parisian theaters; several works from her new series were included in her first show with "les peintres indépendants" in 1879.[1] An early exploration of the theme, *In the Loge* was the only one to echo the flirtation motif that had interested Cassatt during her Spanish sojourn. Changing the setting of *On the Balcony* (cat. 200) from a modest Spanish balcony to a loge at the glittering Théâtre Français, Cassatt presents a woman as the main character and replaces romantic notions of picturesque peasants with an incisive firsthand account of social life in her adopted city. Moving closer to Manet, Cassatt makes an urbane and provocative nod to Goya's *Majas on a Balcony* (cat. 14).

In the Loge offers a dispassionate "slice of life" of the type initiated by Manet in the late 1860s with *The Balcony* (cat. 155). Inspired by that remarkable picture, the Impressionists Renoir and Eva Gonzalès explored similar social vignettes of

splendidly dressed Parisian couples seated in loges, each artist viewing the theater box from the front and treating the female figure as a fetching center of attention.[2] Cassatt's foray into this field demonstrates an active curiosity about the social boundaries within the theater. The viewer looks at the profiled silhouette of a woman in a black day dress and bonnet from within the loge. Gazing toward the stage, Cassatt's protagonist uses opera glasses to examine something beyond the picture's edge; across the auditorium an animated man seems to scrutinize the woman in black through his own glasses. She is either unaware of his attentions or confident in avoiding them.

The passion of Cassatt's first embrace of modernism is exemplified in this painting. Its snapshot-like image was a novel exploration of a fleeting urban episode whose outcome and meaning could not be predicted at the moment the impression was captured. The lively asymmetrical composition, the rapid brushwork used for the background, and the way in which the richly toned, velvety shade within the loge is contrasted with the more acidic glare in the auditorium space confirm the artist's interest in Impressionist investigation. Cassatt may have turned to Japanese woodcuts for her unorthodox shift from a large foreground figure directly to a distant background view. Most progressive, perhaps, is her choice of subject: all the elements in the picture suggest that the woman in black is a free agent out on the town.

More so than Manet in his studies of customers in brasseries or Degas in his dance-class vignettes, Cassatt in her theater series focused narrowly on the same subject: young women observed in exclusive and costly theater seats. Some appear to be happy and confident, others are quietly reserved. These glamorous women never look at the viewer and are often depicted with their own reflections (captured by the box's mirrored back wall);[3] they are special blooms that enjoy yet transcend the aggressive sparkle of Parisian nightlife.

In 1881 *In the Loge* was illustrated in *Scribner's Monthly* as part of an influential series of essays about new American painters. Characterizing Cassatt's art as "the better sort of 'impressionism,'" the author cautiously praised the "force" and "directness" of her style while noting that certain "prosaic details" of the painting would have seemed like *"gaucheries"* had they not been so "deliberate, intelligent, and well executed."[4] The strength and originality of *In the Loge* would surely have seemed radical to viewers with conventional tastes. TF

1. There were at least four theater paintings on view in Cassatt's room at the Impressionists' exhibition; see Chicago–Boston–Washington 1998–99, pp. 110–11.
2. See, for example, Renoir's *La Loge* (1874, Courtauld Institute Galleries, London) and Gonzalès's *Box at the Théâtre des Italiens* (cat. 123), which was exhibited at the Salon of 1879.
3. See Chicago–Boston–Washington 1998–99, pp. 45–55.
4. Brownell 1881, p. 333.

WILLIAM MERRITT CHASE

Williamsburg [now Ninevah], Indiana, 1849–New York, 1916

Growing up in a modest storekeeper's family in small-town Indiana, Chase later became one of the most visible figures in New York's smartest social and artistic circles. After taking private art classes in Indiana and serving briefly in the U.S. Navy, Chase committed himself to becoming a painter. Studying for two years at the National Academy of Design in New York (1869–71), Chase then sought portrait and still-life commissions in New York and St. Louis to help support himself. Offered a stipend from a group of midwestern businessmen, Chase traveled to Europe and enrolled at the Royal Academy in Munich in 1872, learning from Alexander von Wagner and Karl von Piloty, as well as the German realist Wilhelm Leibl. During his six years abroad, Chase sent his dark-toned figurative paintings to American exhibitions and attracted much attention with his showy "foreign" style indebted to seventeenth-century masters, favoring such picturesque subjects as court jesters, Turkish page boys, and Moorish warriors. Following a sojourn in Venice with Frank Duveneck and John H. Twachtman (two other Americans recently trained in Munich), Chase returned to the United States in 1878, settling in New York.

Chase embarked on a remarkable teaching career. His first appointment was at the newly formed Art Students League (1878–94). In 1891 he established a summer art school in the Long Island village of Shinnecock, where he taught landscape painting through 1902. Early in 1896 he experimented with a four-month "American school" in Spain: his pupils copied pictures in the Prado and worked from models; Chase himself produced several copies of works by Velázquez while in Madrid. Later that year he established the Chase School of Art (renamed New York School of Art in 1898 and today the Parsons School of Design) and was its chief instructor until 1907. He also taught at the Pennsylvania Academy of the Fine Arts in Philadelphia (1896–1909), in addition to shorter assignments in Brooklyn, Chicago, and Carmel, California. From 1903 until the outbreak of World War I Chase took students to summer classes in various European countries, including Holland, England, Spain, and, most often, Italy. As a result of these numerous activities he counted the following artists among his pupils: Arthur B. Carles, Howard Chandler Christy, Charles Demuth, Edward Hopper, Rockwell Kent, Kenneth Hayes Miller, Georgia O'Keeffe, Guy Pène du Bois, Ellen Emmett Rand, Charles Sheeler, Joseph Stella, and Irving Wiles.

Frequently using his family and immediate environs in his art, Chase produced figure studies and summer landscapes featuring his wife and children, as well as a fine series of paintings devoted to the richly appointed interiors of his New York studio and Long Island summer home. Noted for his versatility, Chase mastered a variety of media and capitalized on different genres as tastes changed, among them interior scenes, landscapes, nudes and other figurative pictures, still lifes, and portraits. He was active in the Tile Club, the American Water-Color Society, and the Pastel Society and served as the president of the progressive Society of American Artists (1880, 1885–95). In 1905 Chase joined the Impressionist group Ten American Painters. Having taught the foundations of art for his entire professional career, Chase was disturbed by the showcase of Cubist and other radical modernist works at New York's Armory Show of 1913; in his late public lectures, he spoke as a staunch defender of traditional realism. TF

203. *(New York only)* *Fig. 10.35*

William Merritt Chase

James Abbott McNeill Whistler

1885
Oil on canvas
74⅛ x 36¼ in. (188.3 x 92.1 cm)
Signed, dated, and inscribed upper right: *To my friend Whistler/Wm M. Chase/London 1885*
The Metropolitan Museum of Art, New York, Bequest of William H. Walker, 1918 18.22.2

PROVENANCE: The artist until 1915; William H. Walker, New York and Great Barrington, Massachusetts, 1916–18; his bequest to The Metropolitan Museum of Art, New York, 1918

SELECTED EXHIBITIONS: Boston 1886, no. 6; New York 1887, no. 111; Chicago 1888, no. 75; Paris, Galerie Durand-Ruel, 1891, "Artistes américaines"; St. Louis 1892, no. 33; Philadelphia 1896, no. 55; Indianapolis et al. 1909, no. 24; New York 1910b, no. 93; Worcester [Mass.] Art Museum, 1912, "Annual Exhibition of Paintings," no. 8; San Francisco 1915, no. 3759; Indianapolis 1949, no. 16; Brooklyn–Richmond–San Francisco 1967–68, no. 60; Seattle–New York 1983–84, p. 79; Gallati 1995, p. 96

SELECTED REFERENCES: Letter from Chase to Alice Gerson, August 8, 1885, quoted in Bolger 1980, p. 83; Anon. 1886, p. 179; Cook 1886, p. 21; Whistler 1892 (1967 ed.), pp. 184–85; Chase 1910b, p. 222

Chase and Whistler, though based on opposite sides of the Atlantic, were two unusually ambitious and virtuosic showmen committed to progressive work. It was inevitable, therefore, that their paintings were prominent in the 1878 inaugural exhibition of the Society of American Artists in New York. Chase no doubt grew more intensely aware of his older, Paris-trained colleague at the end of that year, when Whistler engineered a libel action against John Ruskin to gain international press coverage. One of Chase's visits to Madrid made him especially eager to meet his countryman, for, as he later recalled, "Every Velasquez seemed to suggest Whistler."[1]

Chase made summer visits to Europe—including trips to Spain—every year from 1881 to 1885, but he initially had difficulty overcoming his misgivings about Whistler's "sharp, ready tongue" and his reputed "cruelties."[2] He finally introduced himself to Whistler in 1885 and promptly received an insider's tour of fashionable and artistic London. As Chase tried to resume his scheduled trip to Spain, Whistler convinced him to stay in England so that they might paint each other's portrait. Although Whistler was tyrannical about making Chase pose, he never finished his portrayal and probably abandoned it, for it has not been seen since. Chase, on the other hand, worked productively on his *Whistler* and wrote his future wife: "[It] promises to be the best thing I have ever done."[3] With its elegant lines and tonal restraint, the likeness echoed Velázquez's full-length portraits as well as Whistler's recent Velázquez-inflected images of Henry Irving and Théodore Duret (cats. 223, 224). Its rich background color may reflect Whistler's penchant for using yellows in his interior schemes. Chase mimicked Whistler's technique in rendering the body as a rather flat silhouette but used his own lively yet careful manner to depict the dandy's face. When Chase returned home with his painting, he agreed not to exhibit it until Whistler himself arrived in New York for a proposed lecture tour. But the older man remained in Europe, and Chase, after a year's wait, finally shared this portrait with the public. *The Studio* reproduced it as a special print for subscribers in August 1886, and two months later the *New York Herald* published a letter from Whistler denouncing "Chase's monstrous lampoon."[4] They would not meet again.

James Abbott McNeill Whistler debuted in late 1886 at the Boston Art Club, where it was the most discussed picture in Chase's first solo exhibition. As Whistler anticipated, most American viewers assumed that the picture was a caricature because they had never seen the subject in person, and they lacked the experience necessary to comprehend a fifty-one-year-old dandy from Europe. One Boston critic assumed that Chase had accentuated Whistler's "eccentricity of person and bearing" with malicious intent: "He looks like a finical half-decayed old fop, with a good deal of the petit maître of the old school suggesting itself."[5] Ironically, the portrait was a good and well-intentioned likeness of the artificial persona that Whistler assumed as a means to sustain public attention. A profile of Whistler published in an American art magazine in 1886 described precisely those characteristics that

Chase depicted: "The nervous way in which he fixes his glass in one eye, his dark hair with one white lock, the dark complexion and alert, bird-like expression, make Mr. Whistler's personality unforgettable. In his hand he carries a very slender, very long cane like the wands that were once the mode for fine ladies."[6] Despite Whistler's objection to the portrait, it proved to be a memorable and important likeness.[7]

Seven years after Whistler's death Chase wrote an essay for *Century Magazine* in which he described the artist's "two distinct and striking personalities, almost as unlike as the storied Dr. Jekyll and Mr. Hyde."[8] While Chase's portrait depicted the public Whistler, the private Whistler—the toiler in the studio—deserved acknowledgment. The behind-the-scenes Whistler dressed carelessly, had messy hair, wore "an unsightly pair of iron spectacles," and was an "earnest, tireless, somber worker, a very slave to his art, a bitter foe of all pretense and sham, an embodiment of simplicity almost to the point of diffidence, an incarnation of earnestness and sincerity of purpose."[9] TF

1. Chase 1910b, p. 219.
2. Ibid.
3. Letter from William Merritt Chase to Alice Gerson, August 8, 1885, quoted in Bolger 1980, p. 83.
4. The print is described in Cook 1886, p. 21. Whistler's comments about Chase's painting first appeared in a letter to the *World* published on October 13, 1886; he reprinted it (with the title "Nostalgia") in Whistler 1892 (1967 ed.), pp. 184–85.
5. Anon. 1886, p. 179.
6. De Kay 1886, p. 1.
7. Whistler was the single most depicted artist prior to the twentieth century: approximately one hundred artists portrayed him in over four hundred works. See Washington 1995, p. 16.
8. Chase 1910b, p. 222.
9. Ibid.

204. *(New York only)* *Fig. 14.81*

William Merritt Chase

A Tambourine Player (Mrs. Chase as a Spanish Dancer)

1885–86
Oil on canvas
65 x 30 in. (165.1 x 76.2 cm)
Montclair Art Museum, Montclair, New Jersey,
Museum purchase; Acquisition Fund 1962.16

PROVENANCE: With the dealer F. A. Lawlor, New York, by 1938; with James Graham and Sons, New York; purchased by the Montclair Art Museum, 1962

SELECTED EXHIBITIONS: New York 1976; Seattle–New York 1983–84, p. 109; New York–New Britain 1998–99, pp. 56, 58; Montclair 2000–2001

SELECTED REFERENCE: Van Rensselaer 1886

This whimsical picture depicts New Yorker Alice Bremond Gerson (1866–1927), Chase's model from about 1885. Alice and her two sisters lived with their

widowed father, Julius Gerson, who managed the art department at Louis Prang and Company, the prominent lithographic firm. Gerson's daughters expressed a desire to meet Chase because they admired his *Ready for the Ride* (fig. 10.24). For that haunting female portrait, a great success at the first Society of American Artists exhibition in 1878, the artist had revived Dutch seventeenth-century imagery. Chase soon became a regular at the artistic and musical gatherings at the Gersons' apartment in the early 1880s. Seventeen years younger than Chase, Alice was near the end of her first pregnancy when she married him early in 1887.[1]

The compositional format and plain, dark setting of *A Tambourine Player* attest to the artist's interest in Spanish seventeenth-century portraits, and the image conjures up the playful allure of the Mediterranean. The uninhibited, dark-haired tambourine player embodies the sensual appeal that Spanish and Italian culture held for Northern Europeans and Americans. Two of Chase's best artist friends—John Singer Sargent and Robert Blum—had recently featured Spanish and Italian women in some of their most romantic images. *A Tambourine Player*, however, was produced in New York with the help of an American model. Chase may have purchased the red tambourine, yellow shawl, and white dress as souvenirs during one of his recent trips to Spain. Indeed, his student Katherine Roof recalled that in 1882 Chase collected "a vast amount of bric-à-brac, stuffs, curios and pictures in Spain."[2] But it is also possible that he and Alice Gerson improvised the simple costume and props used for this picture. (Other contemporary paintings of his wife that include overtly Spanish details are *Mrs. Chase as a Spanish Girl* [private collection], in which Alice wears a black shawl and mantilla and has flowers in her hair, and *A Spanish Girl* [private collection], in which she holds a fan and sits in front of a wall with a crude drawing of a bull.)[3]

Chase's limited palette and use of only two strong accents, red and yellow, may have been an adaptation of Whistler's practice of composing his figure studies around "notes" of color. During his

visit to London in 1885, Chase attended a Whistler exhibition that included the watercolor of a standing model wearing a white skirt and a bright green shawl, *A Note in Green* (1881–84, Freer Gallery of Art, Washington, D.C.).

In October 1886 *A Tambourine Player* was featured in a landmark publication, *Book of American Figure Painters*, by the New York writer Mariana Griswold Van Rensselaer. The author chose pictures by thirty-five young and mid-career artists (including Eakins, Homer, La Farge, and Vedder), and selected poetry to accompany each image. For Chase's painting she chose two verses by Charles Mackay that describe "youths and maids" leaving their summer bowers to dance and sing in the twilight, accompanied by the "tinkle of the tambourine"; there was no suggestion that *A Tambourine Player* had a Spanish theme. TF

1. See Brooklyn–Chicago–Houston 2000–2001, p. 37.
2. Roof 1917, p. 107.
3. *Mrs. Chase as a Spanish Girl* is reproduced in Indianapolis 1949, no. 18; *A Spanish Girl* is reproduced in Seattle–New York 1983–84, no. 109.

205. *(New York only)* Fig. 10.37
William Merritt Chase
Lady in Black

1888
Oil on canvas
74¼ x 36⅜ in. (188.6 x 92.2 cm)
Signed upper right: *Wᵐ M. Chase*
The Metropolitan Museum of Art, New York, Gift of William Merritt Chase, 1891 91.11

PROVENANCE: The artist's gift to The Metropolitan Museum of Art, New York, 1891

SELECTED EXHIBITIONS: New York 1888, no. 315; New York 1890b, no. 207 or 220; Indianapolis 1949, no. 23; New York 1976, no. 38; Akron 1982; Seattle–New York 1983–84, p. 84

SELECTED REFERENCES: Bolger 1980, p. 87 (for further exhibitions and references); Gallati 1995, p. 94

This charming picture was the inspired product of a first encounter between the artist and his subject, Mrs. Leslie J. Cotton (1868–1947). As Chase recalled twenty years later, when the young woman visited his studio as a prospective art student, "I saw her only as a splendid model. . . . She consented to sit for me; and I painted that day without interruption, till late in the evening."[1] Chase's rendering of Mrs. Cotton's direct gaze is full of reverence, and his inclusion of a lush pink rose on the table attests to the radiance he sensed in his model.

Early critics savored Chase's more solidly constructed figures over Whistler's atmospheric and sometimes murky likenesses and preferred Chase's sense of "quiet harmony" to the more dramatic and high-strung observations that Sargent seemed to favor, qualities amply evident in this painting.[2] Comparisons of this sort appeared often in print because Chase was a versatile stylist who evidently delighted in echoing and adapting the stylistic flourishes of his peers; in 1887 a critic noted that Chase's pictures constantly recalled the works of others—the Munich school, the Hague school, Velázquez, Alfred Stevens, De Nittis, and Whistler.[3] Sargent was probably an influence on Chase's *Lady in Black*, for the composition and pose recall two of his best-known recent portraits: the hand on hip, elaborate black dress, and luminous curtain echo Sargent's *Lady with the Rose* (cat. 215), while the twisted hand resting on the circular table seems to be a variation on *Madame X* (cat. 218). Chase's *Lady in Black*, much like Sargent's *Lady with the Rose*, was a modern picture that bridged a magnificent imaginary past, an artistic realm dominated by Velázquez's courtly figures.

Mrs. Cotton moved to Paris to study art in 1889, becoming a portraitist who in the course of her career worked in London, Paris, and New York. Sargent later captured her likeness in a pastel portrait (location unknown), which he exhibited at the Pennsylvania Academy of the Fine Arts in 1901. TF

1. Chase 1908, p. 967.
2. See Seattle–New York 1983–84, p. 153.
3. Anon. 1887, p. 20, is a review of Chase's solo exhibition.

206. *(New York only)* Fig. 10.29
William Merritt Chase
Carmencita

1890
Oil on canvas
69⅞ x 40⅞ in. (177.5 x 103.8 cm)
Signed lower right: *Wᵐ M. Chase*
The Metropolitan Museum of Art, New York, Gift of Sir William Van Horne, 1906 06.969

PROVENANCE: Alexander Blumenstiel, New York; sold from his estate by American Art Galleries, New York, 1905; with L. A. Lanthier, New York, 1906; acquired by Sir William Van Horne and donated by him to The Metropolitan Museum of Art, New York, 1906

SELECTED EXHIBITIONS: St. Louis 1891, no. 240; Indianapolis 1949, no. 27; Southampton 1957, no. 66; Washington 1971, no. 33; New York 1976, no. 49

SELECTED REFERENCES: Bolger 1980, pp. 87–89 (for further exhibitions and references); Gallati 1995, p. 46

Carmencita was the stage name of Carmen Dauset (b. 1868), a Spanish dancer whose acrobatic solo performances attracted a cult following of fashionable New York society. After rising to fame in Spain in the early 1880s, she became popular in Paris, then in 1889 embarked on an American tour.[1] In February 1890 she joined the roster of performers at Koster and Bial's concert hall on 23rd Street in New York. Usually five to ten minutes in length, her performance took place midway through a program of burlesque plays and musical skits. Most published reports suggest that her uninhibited athletic release allowed Manhattan's conservative upper crust to sublimate its buttoned-up desires. One writer observed, "In her quick, graceful, and sinuous movements and ever-changing attitudes one loses sight of the technique of art and beholds a flexibility of body, an abandon of the physical that is perfectly astonishing. In the winding, quivering, snake-like motions when her lithe little body bends, waves, and furls, one marvels at her endurance as well as grace."[2]

Chase, Sargent, and their painter friend J. Carroll Beckwith were fanatical about Carmencita and helped to start the fad of hiring her to perform at late-night parties in artists' studios and private houses (for which she charged up to one hundred fifty dollars).[3] Sargent, who was in New York for part of that year producing commissioned portraits, seized the opportunity to undertake an independent picture of Carmencita (cat. 219). He was also eager to share his new enthusiasm with his spirited Boston patron, Isabella Stewart Gardner. Chase proved enormously useful in that regard, because his studio seemed like the perfect setting for a Spanish dancer and her musicians: large, profusely decorated with paintings, sculpture, furniture, textiles, and all manner of artistic bric-a-brac (in Sargent's words, "Your studio would be such a stunning place").[4] News of that private event—a setting

provided by Chase, a performance funded by Mrs. Gardner, and a supper hosted by Sargent—fueled the Carmencita craze. Two days later, however, it was reported in New York's weekly society magazine that "many ladies" were walking out of the dancer's private performances to protest "the sensual exhibition of which they had been made victims."[5] The columnist allowed that Carmencita's "shivers and upheavals" might possibly be construed as art when presented on stage, while insisting that they conveyed "nothing but fatal earthiness" in the context of a domestic setting.

Carmencita danced two more times at Chase's studio and eventually agreed to let him paint her. Chase depicts the dancer in action: she is playing her castanets, kicking lightly with one foot, and twisting her body in a way that sends her sash flying; the audience's excitement is suggested by the gold bangle and flowers that have been thrown to honor her. The pose and costume are similar to those in a publicity photograph with a caption that mentions the *jota*, the traditional dance of the northern Spanish province of Aragon.[6] Avoiding an image of Carmencita's more extreme bodily contortions, the artist envisioned her as a spirited and delightful entertainer. In March 1894 she became the first woman to perform in front of an Edison motion picture camera.[7] TF

1. Ramirez 1890, pp. 116–17.
2. Nell Nelson, in *Sunday World*, quoted in ibid., p. 127. The same book (p. 123) also quotes "a writer in Kate Field's Washington," who remarked, "When inspired by the music, which begins as she enters, she undulates, and twists and turns, and rises and falls, and stands in every possible position except on her head."
3. Gallati 1995, p. 45.
4. Quoted in Bolger 1980, p. 88.
5. Anon. 1890a, p. 2.
6. Dance clipping file on Carmencita, New York Public Library (departmental file, The Metropolitan Museum of Art).
7. The twenty-one-second film, produced by W. K. L. Dickson at Edison's Black Maria studio, is at the Library of Congress, Motion Picture, Broadcasting and Recorded Sound Division. I am indebted to Janice Sorkow for this information.

207. (New York only) Fig. 14.82
William Merritt Chase
An Infanta, A Souvenir of Velázquez

1899
Oil on canvas
30½ x 24⅛ in. (77.5 x 61.3 cm)
Mr. and Mrs. Joel R. Strote

PROVENANCE: Mr. and Mrs. Henry Kirke Porter, Washington, D.C.; Carnegie Institute, Pittsburgh, by 1942; ACA Galleries, New York; purchased by present owner, 1969

SELECTED EXHIBITIONS: Pittsburgh, Carnegie Institute of Art, 1902, "Loan Exhibition," no. 16; New York 1917a, no. 28; Indianapolis 1949, no. 44, repr.; Brooklyn–Richmond–San Francisco 1967–68, no. 63; New York, Hirschl & Adler

Galleries, "The American Impressionists," November 12–30, 1968, no. 72; Seattle–New York 1983–84, p. 127; Washington–Chicago 1987–88, p. 53; Pittsburgh, Frick Art & Historical Center, "Collecting in the Gilded Age," April 6–June 24, 1997; Washington 2000, no. 5

SELECTED REFERENCES: Lauderbach 1917, p. 435, repr.; *Carnegie Magazine* 16 (June 1942), p. 65, repr. p. 67

Alice and William Merritt Chase were the parents of eight children who survived into adulthood. Their fifth daughter, Helen Velasquez Chase, inspired this quietly haunting painting.

Chase depicted his family on numerous occasions and in various guises. In addition to sitting for portraits, his wife modeled in Japanese and Spanish costumes (see cat. 204), and his little girls appeared frequently in the informal landscapes and interiors he produced during visits to their summer home in Shinnecock Hills, Long Island. Chase established the Shinnecock Summer School of Art in 1891 with the support of several wealthy patrons who had transformed nearby Southampton into a summer resort. A year later the Chase family moved into their own stylish summer residence, designed by their New York acquaintances McKim, Mead, and White. As his art attests, Chase thrived in this rural landscape and lively environment.

Shinnecock was a delightful place for learning and diversion thanks to the Chases and the executive committee of the summer school, which included artists Candace Wheeler and Rosina Emmett Sherwood. In addition to classes for students, Chase gave monthly public lectures on art. Social activities included concerts, dances, plays, and *tableaux vivants* in which students and various members of the Chase family dressed and posed in imitation of famous paintings. *Tableaux vivants* had been popular at Alice Gerson's home in the early 1880s, when she and Chase were falling in love, and there are early photographs of the artist in an elaborate "Van Dyck" costume.[1] In the *tableaux vivants* at Shinnecock, Alice Chase posed as a madonna painted by P. A. B. Dagnan-Bouveret, and her young daughter Helen appeared as an infanta painted by her namesake, Velázquez. Chase's friend Mrs. Henry Kirke Porter

asked him to create *An Infanta, A Souvenir of Velázquez* after seeing Helen in costume.

An Infanta balances the artist's affection for his daughter and his admiration for Velázquez, while successfully avoiding sentimentality and clever effects. Chase's cropping of the figure and his plain dark background established a simple framework in which his bravura brushwork could sparkle. Although the large pink ornament on Helen's bodice was probably inspired by a similar adornment in Velázquez's *Infanta Margarita in White and Silver* (Kunsthistorisches Museum, Vienna), the pose, the dress, and the color scheme do not imitate a specific Velázquez painting. As the title suggests, the image was merely a "souvenir" of the Spanish master. Chase's contemporary sensibility governed the final statement. Depicted in a frontal, almost symmetrical pose, the figure's nearness to the picture plane gives a sense of intimacy that is held in check by the girl's thoughtful, averted gaze. These ambiguous and informal notes introduce a modern air that distinguishes Chase's daughter from the historical infantas. This freedom to improvise also reflects Chase's interpretation of Velázquez's technique; after his first visit to the Prado in 1881, Chase had remarked, "[Velázquez] is not like many of the great painters; he never discourages one—but on the contrary—makes you feel that everything is possible to accomplish."[2]

Chase expressed his interest in Velázquez in numerous ways. In 1891, when Sargent's *Beatrice Goelet* (private collection) was on display in New York and widely discussed in the press, Chase told a reporter that "Velásquez never did anything better than that."[3] In 1896 he donated his own copies of two paintings by Velázquez (*Aesop* and *Menippus*; see cats. 75, 76) to New York's Cooper Institute and wrote a short essay about him.[4] In 1905 the Museum of Fine Arts, Boston, published Chase's endorsement of its recently acquired *Philip IV* by Velázquez,[5] and a year later Chase lent to an exhibition in Boston his full-size copies of *Las Meninas* (see fig. 4.13) and *Las Hilanderas* (also called *The Fable of Arachne* or *The Spinners;* see fig. 4.11).[6] In a lecture delivered a few months before his death, Chase recalled that the painterly breadth of the old masters, rather than the painstaking detail of Gérôme, had long been his ideal: "When I went to the Louvre and . . . saw the 'Infanta' [cat. 78] by Velásquez and other things, I said, 'Here is a man of great powers: I would care to do something like that, and I believe I might.'"[7] TF

1. Ronald G. Pisano discusses the parties at the Gerson household and quotes an account that mentions Alice Gerson in a *tableau vivant* "posed as an Indian Maiden, scanning the landscape for her lover." See Seattle–New York 1983–84, p. 46. He also illustrates a photograph of Chase in seventeenth-century Dutch costume (p. 58).
2. Letter from William Merritt Chase to Dora Wheeler, quoted in New York–New Britain 1998–99, p. 56.
3. Anon. 1890c, p. 347.
4. For a partial listing of Chase's copies from the old masters, see Roof 1917, pp. 328–29; Chase's gifts to the Cooper Institute were reported in *Art Amateur* in July 1896. His essay "Velasquez," derived from a lecture delivered to the American Art Association of Paris, was published in *Quartier Latin*; see Chase 1896. The author gratefully acknowledges Barbara Weinberg for providing a copy of the *Quartier Latin* text.

5. Chase was "absolutely satisfied" by the picture and indicated that the "hard edge" was characteristic; he added: "It is as convincing as recognizing a relative." Several of Chase's Impressionist colleagues, including Frank Benson, Joseph DeCamp, Edmund Tarbell, and J. Alden Weir, also gave positive endorsements. See Gilman 1905, p. 20; Washington–Boston 1992, p. 89.

6. The Copley Society organized the exhibition *Copies of Old Masters by Modern Painters*, in which Chase's pictures were hung in the place of honor. See Washington 2000, p. 7.

7. Chase 1916, p. 52. This text is the address Chase gave to the American Federation of Arts, Washington, D.C., in May 1916.

THOMAS EAKINS

Philadelphia, 1844–Philadelphia, 1916

Son of a successful calligrapher and penmanship teacher, Eakins excelled in drawing at Philadelphia Central High School. In 1862 he registered at the Pennsylvania Academy of the Fine Arts in Philadelphia and attended anatomy classes at Jefferson Medical College (1864–65). Sailing for Europe in 1866, Eakins stayed for almost four years. He studied at the École des Beaux-Arts with Jean-Léon Gérôme as well as sculptor Augustin-Alexandre Dumont. In 1869 Eakins took private classes from Léon Bonnat, a painterly realist with a passion for Spanish art who gave the young artist a useful perspective on the polished and strictly academic method of Gérôme. Before returning to Philadelphia, Eakins spent six months in Spain (1869–70), studying the works at the Prado and producing his first large painting (*A Street Scene in Seville* [fig. 10.13]).

Initially supported by his parents, Eakins lived and worked at home for many years. His subjects, most of them associated in some way with Philadelphia, ranged from scenes of outdoor activities to domestic interiors, historical genre pictures set in the early nineteenth century, and portraits of personal acquaintances. In his search for exactitude Eakins mastered a variety of scientific approaches: perspective studies, anatomical dissection, and motion as well as conventional photography; his devotion to intense realism drew strong, often negative critical reactions to his work for most of his life. In 1876 Eakins's monumental and heroic portrait of a surgeon lecturing while performing an operation, *The Gross Clinic* (fig. 10.15), unsettled the art jury of Philadelphia's Centennial Exhibition; at the last minute it was hung in an army hospital on the Centennial fairgrounds. In 1904, however, *The Gross Clinic* won a gold medal at the St. Louis Universal Exposition, indicative of the belated appreciation that came to Eakins and his work.

With his wife (former student Susan Macdowell), Eakins formed the center of a coterie with connections to local scientists, musicians, and the poet Walt Whitman. For eighteen years he taught life drawing and artistic anatomy at various institutions in Philadelphia, New York, Brooklyn, and Washington, D.C. (1879–97). A maverick whose art could be brutally frank and whose actions were often confrontational, Eakins was forced to resign

from the Pennsylvania Academy of the Fine Arts in 1886 and dismissed from Philadelphia's Drexel Institute nine years later. The artist's only solo exhibition (Earles Gallery, Philadelphia, 1896) not only produced no sales but also a minimum of critical response, and during his lifetime only three museums purchased examples of his work.

Portraiture gradually dominated Eakins's output after 1886, mostly likenesses of friends and colleagues, with a few commissions from local academic and religious organizations. Among his ten sculptural works were reliefs for two important public commissions of the early 1890s, the Brooklyn Memorial Arch and the Trenton Battle Monument. At the World's Columbian Exposition in Chicago in 1893 he was represented by eleven paintings and awarded a bronze medal. Eakins lived to see a major shift in American taste that would value his art on its own uncompromising terms. TF

208. *(New York only)* *Fig. 10.20*

Thomas Eakins

The Thinker: Portrait of Louis N. Kenton

1900
Oil on canvas
82 x 42 in. (208.3 x 106.7 cm)
Signed and dated lower right: *Eakins 1900*
The Metropolitan Museum of Art, New York,
John Stewart Kennedy Fund, 1917 17.172

PROVENANCE: With the subject's wife, Elizabeth Macdowell Kenton, Philadelphia, from 1900; purchased by The Metropolitan Museum of Art, New York, 1917

SELECTED EXHIBITIONS: Pittsburgh 1900–1901, no. 70; Buffalo 1901, no. 310; Philadelphia 1901, no. 11; Boston 1902, no. 81; New York 1902a, no. 309; Washington 1902; Worcester [Mass.] Art Museum, 1902, "Summer Exhibition," no. 363; St. Louis 1904, p. 27, no. 220; Detroit 1906; Washington 1907, no. 150; Rome, Esposizione Internationale, 1911; New York 1917b, no. 48;

Philadelphia 1917–18, no. 68; Pittsburgh 1945, no. 90; Washington–Chicago–Philadelphia 1961–62, no. 77; New York 1970b, no. 76; Boston–Washington–Paris 1983–84, pp. 329–30, no. 102; London 1993–94, no. 38; Lubin 1997; Philadelphia–Paris–New York 2001–2, pp. 312–14, pl. 220

SELECTED REFERENCES: Charles H. Caffin, *International Studio* (February 1902), quoted in Spassky et al. 1985, pp. 622–26 (for further exhibitions and references)

Of the thirteen lifesize, full-length portraits of standing figures that Eakins painted, none is as spare and arresting as *The Thinker*. In it he combined notions of ordinariness, thoughtfulness, and austerity to create a quirky icon with broad appeal. In 1930 a Boston art critic described Eakins's lone individual as "A type as purely American as Abraham Lincoln," and more recently art historian Lloyd Goodrich noted, "Here is contemporary man, with no advantage of handsomeness, attire, or prestige. . . . In its completely different way, the painting has attained a meaning as universal as Rodin's *Penseur*."[1]

The artist clearly intuited that this canvas was something of a landmark in his career, for he sent it to at least eleven exhibitions between 1900 and 1911. The compositional strategy of isolating a standing male figure against a plain light background was not particularly inventive: Eakins was probably familiar with the images of Manet's *Fifer* (cat. 151) and Whistler's portrait of Théodore Duret (cat. 224), and he, like those two artists, had learned much from the example set by Velázquez in such works as *The Jester Pablo de Valladolid* (cat. 73).[2] Eakins's stroke of originality was to apply a similarly aggrandizing pictorial formula to a person whose demeanor was awkward, brooding, or shy—the kind of man uncomfortable with striking a showy pose and inviting public scrutiny. If this painting puts anything on a pedestal, it is the retiring attitude of a middle-class "nobody."[3] Eakins gave certain details of the figure an almost palpable presence—the glinting pincenez, stiff shirt collar, pasty skin, and well-buffed plain black shoes—and yet his thin, brushy rendering of the barren room conjures up a ghostly nonplace. As H. Barbara Weinberg observed so succinctly, the man seems "burdened by isolation—the condition from which Eakins himself suffered—and by the search for inner strength."[4]

The subject of the portrait, Louis N. Kenton (1865–1947), was a member of the Philadelphia working class who had entered the white-collar ranks as a clerk. In 1899 he married Elizabeth Macdowell, an artist who was the younger sister of Eakins's wife; one early record indicates that Kenton had a violent temper, which may have precipitated the acrimonious end of their brief union.[5] Regardless of her thoughts about the man, Mrs. Kenton became the owner of her husband's likeness. The picture did not receive its current title until 1917, when the Metropolitan Museum purchased it and found the inscription *Thinker* on the stretcher.[6]

Writing in 1917, Henry McBride observed that the image "is so restrained that it is more like sculpture

than painting,"[7] reminiscent of Eakins's own reaction to the paintings he had studied at the Prado in 1869: "[This Spanish work is] so good so strong so reasonable so free from every affectation."[8] Late in life the artist told an interviewer that American art students needed to "work along the beaten path first and then gradually . . . try to add something new but sane, something which arises out of the new realities of life."[9] *The Thinker* reflects Eakins's debt to the "beaten path" of Velázquez while pointing in a fresh way to those American subjects and ideals that he deemed pressing and timely in 1900. TF

1. William Howe Downes's entry on Eakins in the 1930 edition of *Dictionary of American Biography*, quoted by Carol Troyen in Philadephia–Paris–New York 2001–2, p. 375. Goodrich 1982, vol. 2, pp. 181–82.

2. It is likely that Eakins saw Manet's *Fifer* at the artist's solo exhibition in Paris in 1867 and again when it was exhibited at the National Academy of Design, New York, in 1886.

3. In this respect the portrait might be considered the first in a series of American twentieth-century tributes to "regular guys" by Aaron Copland, George Segal, Andy Warhol, Chuck Close, and others: consider Copland's *Billy the Kid* (1938) and his *Fanfare for the Common Man* (1942), Segal's *The Gas Station* (1963, National Gallery of Canada, Ottawa), Warhol's *The American Male: Watson Powell* (1964, American Republic Insurance Company, Des Moines), and Close's *Keith* (1968, Saint Louis Art Museum).

4. H. Barbara Weinberg in London 1993–94, p. 148. For a stimulating discussion of the varieties of information that Eakins embedded in or omitted from his art, see Leja 2001.

5. In a diary entry Susan Eakins notes that Louis is cruel to his wife and on one occasion "strikes her in the face." Quoted in Philadelphia–Paris–New York 2001–2, p. 421 n. 20. For a biographical profile of Kenton, see Kathleen A. Foster's discussion in ibid., p. 313.

6. Eakins's wife probably made the inscription; see Spassky et al. 1985, p. 622.

7. See the review reprinted in McBride 1975, p. 137.

8. Quoted by H. Barbara Weinberg in Philadelphia–Paris–New York 2001–2, p. 22.

9. As reported in the *Philadelphia Press* (February 22, 1914), quoted in Goodrich 1982, vol. 2, p. 270.

209. (New York only) Fig. 14.89

Thomas Eakins

An Actress (Portrait of Suzanne Santje)

1903
Oil on canvas
79¾ x 59⅞ in. (202.6 x 152.1 cm)
Signed and dated lower right: *Eakins/1903*; inscribed lower left, on letter: *Miss Suzanne Santje/ Roanoke/Va.*
Philadelphia Museum of Art, Gift of Mrs. Thomas Eakins and Miss Mary Adeline Williams, 1929
1929.184.23

PROVENANCE: Siegl 1978, pp. 157–59; The artist; donated to the Philadelphia Museum of Art by the artist's widow and her friend Mary Adeline Williams, 1929

SELECTED EXHIBITIONS: Philadelphia 1917–18; Philadelphia 1930, no. 239; Pittsburgh 1945; New York 1958, no. 57; Philadelphia–Boston 1982,

no. 140; Philadelphia–Paris–New York 2001–2, pp. 323–24

SELECTED REFERENCE: Siegl 1978, pp. 157–59

In the course of his career Eakins depicted a variety of professional women: a singer, two pianists, two actresses, and several artists and educators. Although most of these sitters were from his personal circle, the actress Suzanne Santje was not known to Eakins until he saw her perform in Philadelphia. This emotionally charged portrait was neither sold nor exhibited during Eakins's lifetime: *An Actress* made its debut in 1917, when the artist's widow lent it to his memorial exhibition at the Pennsylvania Academy of the Fine Arts, Philadelphia.

Santje was the stage name of Suzanne Keyser (1873–1947), a native Philadelphian. Traveling to Berlin in 1891 to continue her music studies, she decided to become an actress and attended the Institut Rody, Paris, where she was the first foreigner to be awarded its annual medal of honor. On her return to the United States, she pursued her career for about thirteen years, working in the companies of Augustin Daly (1893–98) and Richard Mansfield (1898–1902), among others. Eakins was moved to paint Santje after seeing her play the fetching Mrs. St. Aubyn in Mansfield's production of *Beau Brummel*, a historical drama written in 1890 by the American playwright Clyde Fitch. Eakins attended *Beau Brummel* in March 1901 but did not complete this portrait until 1903. He signed and dated the canvas in his most handsomely elaborate style, presented in perspective as if it had been painted on the carpet.[1] By 1903 the sitter was a principal in the Coburn-Santje Stock Company; an envelope on the floor of the picture bears the address "Miss Suzanne Santje Roanoke Va.," indicating that the actress was unmarried and based in Virginia.

An Actress parallels many of the artist's male portraits, in which the subject is shrouded in reflective solemnity and placed in a moodily lit, albeit comfortably appointed setting.[2] A few years earlier Eakins had depicted a local art critic in a slumped, daydreaming posture inside a shadowy, book-lined room, with three volumes casually arrayed on the carpet (*Riter Fitzgerald*, 1895, Art Institute of Chicago). Here he posed Santje sitting languidly in a leather-upholstered armchair, mod-

eled after late-seventeenth-century examples; he had used this chair as a prop since the 1870s, finding it an ornate yet ruggedly sculptural foil for his female sitters.[3] The masculine aura of Santje's surroundings is compounded by a gilt-framed portrait of her father, Judge Charles Shearer Keyser, on the wall.[4] Eakins added a dog-eared, softbound script on the floor, as if the actress had wearily or distractedly cast it aside; first inscribing it "Hamlet," he changed the title to "Camille" (referring to dramas by Shakespeare and Alexandre Dumas fils, respectively). By opting for the French play (*La Dame aux Camelias*, 1852), Eakins invoked a modern, sexually nuanced narrative in which Camille, a beautiful, consumptive courtesan, brazenly enjoyed, then sacrificed, her illicit relationship with an aristocratic lover. Suzanne Santje's tea gown—a torrent of pink fabric tempered by wispy gray gauze—signaled ardent allure. But her body language, despite its external splendor, suggested languor, nervousness, and delicacy: the cocked head, the soulful gray eyes, and the tender, hesitant hands.

While Eakins was working on *An Actress*, he painted two full-length likenesses of seated male subjects, which, for quite different reasons, also made striking use of costume and psychological isolation. They were part of his ongoing series of portraits of Roman Catholic clergy: *Sebastiano Cardinal Martinelli* (1902, Armand Hammer Collection, UCLA Hammer Museum, Los Angeles) and *Archbishop William Henry Elder* (1903, Cincinnati Art Museum). Both men wear black robes dramatically enlivened by vividly colored elements such as sashes and jewelry and sit in armchairs, their hands tellingly displayed. All three portraits suggest comparison with Velázquez's celebrated portrait *Pope Innocent X* (see cat. 199), which Eakins would have known in reproduction. Of the three, the image of the actress comes closest to the Spanish precedent: Eakins evokes Velázquez with the subject's florid costume, characterful hands, and the manner in which she occupies the chair as if it were a throne. Unlike Pope Innocent X, Suzanne Santje did not make eye contact with the viewer, but she was no less demanding of attention, and no less intriguing. TF

1. Eakins worked out the perspective for the signature he used in this portrait by making a full-scale graphite drawing; for a reproduction, see Foster 1997, no. 213 (1985.68.28).

2. Goodrich 1982, vol. 2, pp. 53–55.

3. In Eakins's *Sarah Ward Brinton* (1878, private collection) and *Amelia Van Buren* (1891, Phillips Collection, Washington, D.C.) women holding fans are seated in the armchair; in *The Old-Fashioned Dress (Portrait of Helen Montanverde Parker)* (ca. 1908, Philadelphia Museum of Art) the subject stands beside the chair.

4. The proof of the man's identity comes from the Keyser family coat of arms that Eakins painted on the frame of the portrait hanging behind Santje. It is not known if such a portrait of Judge Keyser existed; Eakins may have invented it as a means to include the actress's father in her portrait. The chair, the pot on the mantelpiece, and the carpet were probably all props in Eakins's studio; see the discussion by Marc Simpson in Philadelphia–Paris–New York 2001–2, p. 323.

JOHN SINGER SARGENT

Florence, 1856–London, 1925

Born to an expatriate Philadelphia surgeon and his artistically inclined wife, Sargent moved seasonally with his family between Italy, France, Switzerland, Austria, and Germany. Showing an aptitude for drawing, in 1873 Sargent began formal studies at the Accademia delle Belle Arti in Florence. The following year the family moved to Paris in search of the best professional training for him. He entered the atelier of Carolus-Duran and that fall won admission to the drawing class taught by Adolphe Yvon at the École des Beaux-Arts. In 1877 the Paris Salon accepted his first submission (*Fanny Watts*, Philadelphia Museum of Art). That elegant picture marked the beginning of his career as a society portraitist. Traveling to Spain in 1879, Sargent copied several works by Velázquez at the Prado, and a year later he traveled to Holland to copy portraits by Hals. During his rise to prominence in European and American circles, Sargent judiciously balanced portraiture with a variety of picturesque genre scenes painted in Brittany, Italy, Spain, and Morocco. He risked his reputation at the Salon of 1884 with the audacious *Madame X* (cat. 218), a likeness mocked by the public and faulted by mainstream critics.

Starting in 1881 Sargent made occasional working visits to England, meeting Burne-Jones and Alma-Tadema and developing an interest in the Aesthetic Movement. When his Parisian career foundered, London-based friend Henry James encouraged him to settle in England, which he did in 1886. Although many British viewers initially found Sargent's painterly style "too French," they warmed to his deft borrowings from the old masters, the Impressionists, and other contemporary artists.

Sargent took an active interest in American cultural life. Visiting the United States in 1887–88, he fulfilled portrait commissions in Newport, Boston, and New York. During a second sojourn in 1890, he was selected to produce mural decorations for the new Boston Public Library, a project that occupied him intermittently until 1919. Sargent also designed and executed murals for the Museum of Fine Arts, Boston (1921–25), and Harvard University's Widener Memorial Library (1922), while continuing to do portraiture as well as independent paintings.

After the turn of the century, Sargent's most novel works were the bravura watercolors and oils he painted during holiday travels; in 1909 the Brooklyn Museum of Art purchased eighty-three of the artist's watercolors, inspiring other leading American museums to follow suit. Sargent's art won numerous medals, and he received several honorary degrees. Energetic and highly visible in professional circles, Sargent taught occasional classes at the Royal Academy, London, but did not encourage a circle of students and followers outside personal friendships with a few other painters (including Wilfrid and Jane de Glehn, Adrian Stokes, and Henry Tonks). TF

210. *(New York only)* *Fig. 10.41*

John Singer Sargent

Robert de Cévrieux

1879
Oil on canvas
33¼ x 18⅞ in. (84.5 x 48 cm)
Inscribed lower left: *John Singer Sargent 1879*
Museum of Fine Arts, Boston, The Hayden Collection, Charles Henry Hayden Fund 22.372

CATALOGUE RAISONNÉ: Ormond and Kilmurray 1998, no. 26

PROVENANCE: The sitter's parents; sold by the sitter to Knoedler and Co., New York, 1921; John Levy Gallery, New York, 1922; Copley Gallery, Boston, 1922; purchased by the Museum of Fine Arts, Boston, 1922

SELECTED EXHIBITION: Boston 1925, no. 6

At the 1879 Paris Salon, twenty-three-year-old Sargent won his first professional award, an honorable mention, with a portrait of his debonair teacher Carolus-Duran (Sterling and Francine Clark Art Institute, Williamstown, Mass.). Reproduced on the cover of the weekly magazine *L'Illustration*, *Carolus-Duran* was so widely admired, according to Sargent's father, that it prompted six new commissions from French patrons.[1] This endearing portrait of a boy, Robert de Cévrieux, and his dog doubtless belongs to that group. Little is known about the boy and his family. Although Sargent never requested that the painting be lent to an exhibition, it was clearly a work that met the artist's approval for it entered the collection of the Museum of Fine Arts, Boston, in 1922, during the period when he was most closely involved with the institution.[2]

Sargent's impeccable credentials as an academic artist are evident here. During his student years he had always passed the demanding and intensely competitive semi-annual matriculation exams at the École des Beaux-Arts; in the spring of 1877 he took second place, ranking higher than all previous American applicants. Not surprisingly, then, he showed great confidence when tackling the more difficult passages in this painting, particularly the dog's complicated form and suggested movement in the boy's grasp, the detailed rendering of the child's face, and the texture of the various accessories, from the matte black velvet suit to the glinting silver buttons.

As Carolus-Duran's favorite pupil, Sargent inevitably showed the influence of his master in several early works. Scholars have often noted the similarities between *Robert de Cévrieux* and Carolus-Duran's portrait of his little daughter, Marie-Anne, standing beside her dog in front of a heavy curtain (fig. 10.42).[3] Given Carolus-Duran's passion for Spanish art, it is easy to draw broad visual parallels between his portraits of standing children and those painted by Velázquez and Goya—historical influences that Carolus-Duran transmitted to Sargent. Even though *Robert de Cévrieux* is painted in Sargent's most exacting and conventional manner, it

is appropriate, in considering its Spanish associations, to compare it to Manet's *Boy with a Sword* (cat. 133). Both works isolate a boy in a dark, shallow pictorial space and create the sense of capturing a fleeting glimpse: Manet by means of a walking pose, Sargent by counterbalancing the boy and his squirming pet. TF

1. Letter from Dr. Fitzwilliam Sargent to his brother Tom, Paris, August 15, 1879, quoted in Ormond and Kilmurray 1998, p. 47.
2. By 1922 the Museum of Fine Arts owned an impressive range of works by Sargent, including *The Daughters of Edward Darley Boit* (cat. 216), *An Artist in His Studio* (1904), *The Road* (1918), fifty watercolors, and a decorative cycle in the museum's rotunda.
3. For a discussion of Carolus-Duran's influence on his American pupils, see Weinberg 1991, pp. 189–219; the artist's portrait of his daughter is shown as fig. 214.

211. *(New York only)* *Fig. 10.43*

John Singer Sargent

Las Meninas, Copy after Velázquez

1879
Oil on canvas
43½ x 38½ in. (110.4 x 97.7 cm)
Private collection

PROVENANCE: The artist; his sister Emily Sargent, 1925; to her sister Violet Ormond, 1936; to her son Conrad E. Ormond, 1955; private collection

SELECTED EXHIBITIONS: London 1908b, no. 97; London 1926, no. 364; Washington et al. 1964–65, no. 10; Washington 2000, pp. 4–5

SELECTED REFERENCES: Washington–Boston 1992, pp. 32–33; Ormond and Kilmurray 1998, fig. 7

Late in the summer of 1879 Sargent traveled overland to Spain. He had toured the country with his family when he was twelve (1868), but now he visited as a professional artist eager to study the Spanish masters and to scout out picturesque subject

matter for future Salon pictures. By mid-October he was in Madrid, where he registered at the Prado for permission to copy paintings in the museum's collection, primarily those by Velázquez. He then explored the south, making paintings of the Moorish architecture in Granada and at least one genre drawing in Seville.[1] By the time he crossed to Morocco in December, Sargent had gathered enough material to inspire an enormous Salon painting devoted to the dancing and music of the Spanish gypsies (*El Jaleo* [fig. 10.44]) and a few of the illustrations he contributed to Alma Strettell's book *Spanish & Italian Folk-Songs* (London, 1887). It might be argued, nonetheless, that the most lastingly important works he produced in Spain in 1879 were his paintings after Velázquez, at least ten of which have been documented since Sargent's death. Through the act of copying the Spaniard's canvases, Sargent learned that a great portrait re-creates its subject as an ineffably vivid presence within a pictorial atmosphere. Velázquez's example gave distinction to the painterly technique Sargent would use for his entire career. It also shaped his instinct for a muted palette and taught him how to plot and build certain compositional structures. As Henry James wrote in the essay he devoted to the artist in 1887, "[In Spain] the great Velasquez became the god of his idolatry. . . . It is evident that Mr. Sargent fell on his knees, and that in this attitude he passed a considerable part of his sojourn."[2]

This copy of Velázquez's most famous picture is a little less than one-third the size of the original. It looks darker than the *Las Meninas* we know today (fig. 4.13) because Sargent was seeing a work masked by two centuries of grime and aging (effects not reversed until the picture was cleaned in the 1980s). Although his treatment of the room and its paintings was rather sketchy, Sargent was faithful to Velázquez's magical orchestration of light and luminosity within the grand, dimly lit space. He lovingly captured the strong light framed by the doorway; the mirror's spectral image of the king and queen; and the various areas of bounced light, including the foot of the staircase, the infanta's blonde hair, and the edge of the tall, unframed painting in the foreground.[3] By studying these sophisticated passages in *Las Meninas*, Sargent mastered how to calibrate all the tonalities of a given picture. He also absorbed the asymmetrical system of vertical and horizontal accents that gives this painting such a subtle but powerful pictorial structure. Finally, he learned

much from Velázquez's use of decisive compositional transitions that move the eye from the dog in the foreground past successive groupings to the diminutive figure on the stair.

The lessons of *Las Meninas* were soon apparent in Sargent's work. In addition to his great homage of 1882, *The Daughters of Edward Darley Boit* (cat. 216), he deployed dramatic lighting and intriguingly framed spaces as key ingredients in numerous works in the 1880s. Sargent's early Venetian paintings were often variations on this theme (see, for example, *Venetian Bead Stringers*, ca. 1880, Albright-Knox Art Gallery, Buffalo). Half-lit rooms with open doors or mirrors became settings for several informal portraits, including *Madame Paul Escudier* (ca. 1882, private collection), *The Breakfast Table* (ca. 1883, Fogg Art Museum, Cambridge, Mass.), and *Robert Louis Stevenson and His Wife* (1885, Mrs. John Hay Whitney). TF

1. The early Spanish works include *Court of Myrtles in the Alhambra* (private collection) and *Café Scene, Seville* (Isabella Stewart Gardner Museum, Boston).
2. James 1887, p. 686.
3. Sargent clearly valued his copy of *Las Meninas* for he exhibited it in London in 1908, along with *Lord Ribblesdale* (1902, National Gallery, London). I am grateful to Richard Ormond and Elaine Kilmurray for this information.

212. *Fig. 14.79*

John Singer Sargent
Head of Aesop, Copy after Velázquez

1879
Oil on canvas
18¼ x 14⅝ in. (46.4 x 37.2 cm)
Ackland Art Museum, The University of North Carolina at Chapel Hill, Ackland Fund 75.16.1

PROVENANCE: Auctioned from the artist's estate by Christie, Manson & Woods, London, July 24, 27, 1925, purchased by Agnew, acting for Alvan Tufts Fuller of Boston; transferred to The Fuller Foundation, Inc.; purchased by Agnew in 1961 from The Fuller Foundation, lot 41; purchased by Robert H. Smith, Washington, D.C., from Agnew, 1964; purchased by Agnew from Smith, June 1974; purchased from Agnew by the Ackland Art Museum, University of North Carolina at Chapel Hill, August 1975

SELECTED EXHIBITION: New York 1993a, no. 41

SELECTED REFERENCES: Washington–Boston 1992, pp. 56–57; Seattle 2000–2001, pp. 46–51

Sargent made the head in this picture the same size as that in the original canvas by Velázquez (cat. 75). Rather than attempt a stroke-by-stroke replica, Sargent naturally applied the style he had mastered during his five years in Paris. The result was a vivid, accurate, yet sketchlike rendering of one of Velázquez's most expressive heads.

Carolus-Duran's goal as a teacher was to show pupils how to build the greatest visual impression with the most economical use of a broad style. At the appropriate distance the bold brushstrokes and dashes of paint were intended to blend into a strikingly realistic image. He insisted that students make only the slightest preparatory drawing when beginning a painting. Using charcoal or very thin paint, they were allowed to indicate outlines and proportions in the simplest manner. The next, most crucial step was to block out the main sculptural planes of the face using a broad brush generously loaded with medium-toned flesh color. Once these tones had been loosely sketched in, the darker tones were added, suggesting the play of shadow that modeled the head and distinguished it from the background. Finally, the light tones were added, creating lively highlights that made the brightest parts more palpable. The stages of this technique can be discerned in Sargent's *Head of Aesop*, notably in the brushstrokes that model the cheeks and the highlights that help the lips and chin read so clearly. In this instance Sargent's style was looser than Velázquez's: the difference is especially evident when one compares Sargent's simplified and impressionistic treatment of the hair with the greater detail and the bold tactile sense of the original.

The act of making this copy not only helped Sargent develop a personal technique that he used throughout his career but also shaped his approach to painting dramatically lit heads of older men. Echoes of *Head of Aesop* can be seen in Sargent's great male portraits, including *William M. Chase* (cat. 221), *Henry Lee Higginson* (1903, Harvard University Portrait Collection), and *Henry James* (1913, National Portrait Gallery, London).

TF

213. *(New York only)* *Fig. 11.15*

John Singer Sargent
Dwarf with a Mastiff, Copy after Velázquez

1879–80
Oil on canvas
55⅞ x 42 in. (142 x 106.5 cm)
The Hispanic Society of America, New York
A1960

PROVENANCE: The artist; his estate sale, Christie's, London, 1925, no. 229 (55½ x 41½ in.); Knoedler Gallery, New York; Archer Milton Huntington,

New York; presented by him to The Hispanic Society of America, New York, 1926

SELECTED EXHIBITION: New York 1925

SELECTED REFERENCES: Cortissoz 1925, p. 9; Charteris 1927, p. 281; Boston 1956, p. 22 (showing the work in Sargent's Paris studio, ca. 1884); Carol M. Osborne, "Yankee Painters at the Prado," in New York 1993a, p. 77 n. 41; London–Washington– Boston 1998–99, p. 15 (showing the work in Sargent's Paris studio, ca. 1884); Simpson 1998, p. 3 (showing the work in Sargent's Paris studio, ca. 1884–85)

Sargent traveled to Spain and Morocco in the autumn of 1879, registering on October 14 to copy works by Velázquez in the Prado. His going to Spain very much followed the practice of French artists, who were first inspired in the 1830s and 1840s by the Galerie Espagnole. Sargent's teacher in Paris, Carolus-Duran, had urged his students to copy the works of Velázquez at the Louvre with the cry, "Velasquez, Velasquez, Velasquez, ceaselessly study Velasquez."[1] On the 1879 trip, Sargent finally had the opportunity to study the Spanish master in his native environment.

The present example faithfully reproduces the *Dwarf with a Mastiff* (cat. 80), thought at the time to be by Velázquez but now variously assigned to his workshop or circle.[2] (Another copy of the Prado original is found in the Staatliche Museen, Berlin [no. 413D, since 1879]). As José López-Rey demonstrated, the figure of the mastiff in the Prado picture conforms with one in a work called *The Stag Hunt at Aranjuez* (ca. 1640, Prado), by Juan Bautista Martínez del Mazo, Velázquez's son-in-law and chief assistant from the 1630s. López-Rey declined to attribute the Prado painting to Mazo, but since the picture conforms in technique and conception to Mazo's other portraits, it probably should be given to the younger master.

Given all the riches in the Prado, why would Sargent have chosen to include, among his copies after Velázquez, a work by another hand? Aside from the attraction of the motif—and of course the fact that Sargent believed the work to be Velázquez's own—it may have been the peculiar nature of the brushwork that attracted him. Soon after the Spanish trip, Sargent went to the Netherlands to study the works of Frans Hals. At a later

point in his life, he advised a young artist named J. H. Heyneman to "begin with Frans Hals . . . after that go to Madrid and copy Velasquez, leave Velasquez till you have got all you can out of Frans Hals."[3]

Mazo and Hals both had a tendency to let their brushwork sit upon the surface of the canvas, calling attention to itself as direct, abstract artistic expression, although of course Hals was far better at this than was Mazo. While equally expressive, Velazquez's brushwork always forms part of the illusion, always contributes to the realism of his compositions. One can get incredibly close to a picture by Velázquez before the brushstrokes "break up" into abstract forms. (It is one of the ways works by Mazo can be distinguished from those of his master.) Sargent shares with Velázquez this incredible economy of artistic means. His bravura is seldom gratuitous but rather always harnessed to achieve both aesthetic and illusionistic effects: first Hals, Sargent insisted, then Velázquez.

Indeed, it can be said that parts of Sargent's copy are better than the original. Certainly, the passages around the brim of the hat are far more satisfying in the Hispanic Society canvas than they are in the Prado piece. One might even go so far as to suggest that, at least in these passages, Sargent turned Mazo's derivative work back into a "Velázquez." In any event, as photographs attest, Sargent kept both this copy and another one after Hals in his studio, where they could serve to inspire his own works.

MBB

1. "Velasquez, Velasquez, Velasquez, étudiez sans relâche Velasquez." Quoted in Charteris 1927, p. 28, and cited in H. Barbara Weinberg, "Sargent and Carolus-Duran," in Williamstown 1997, p. 19.
2. We are indebted to Dr. Priscilla E. Muller for prior research on this painting.
3. Miss Heyneman's memories are recounted in Charteris 1927, p. 51.

214. *(New York only)* — Fig. 10.46

John Singer Sargent
Dr. Pozzi at Home

1881
Oil on canvas
80½ x 43⅞ in. (204.5 x 111.4 cm)
Inscribed upper right: *John S. Sargent 1881*
Armand Hammer Collection, UCLA Hammer Museum, Los Angeles AH.90.69

CATALOGUE RAISONNÉ: Ormond and Kilmurray 1998, no. 40 (for further exhibitions and references)

PROVENANCE: The sitter; purchased by Jean Pozzi from his father's estate sale, Galerie Georges Petit, Paris, 1919; sold from his estate by Palais Galliera, Paris, 1970; purchased by Armand Hammer; presented to the Armand Hammer Museum, 1990

SELECTED EXHIBITIONS: London, Royal Academy, 1882, no. 239; Brussels, Les XX, 1884; Venice Biennale, 1897, no. 52; Boston–Washington– Paris 1983–84, no. 81; New York–Chicago 1986–87,

pp. 75, 85–86, fig. 55; New York 1995–96, fig. 54; London–Washington–Boston 1998–99, no. 23

SELECTED REFERENCES: Vernon Lee, letter of June 16, 1882, quoted in Ormond and Kilmurray 1998, p. 54; Émile Verhaeren, *La Libre Revue* (February 1884), quoted in ibid.; James 1887, p. 686

Born in the southwestern French town of Bergerac, Samuel Jean Pozzi (1846–1918) studied medicine in Paris and pursued a highly successful career as a surgeon and a pioneer in the field of gynecology. Keenly interested in the arts, he included among his early friends the actor Mounet-Sully and the poet Leconte de Lisle. He married Thérèse Loth-Cazalis in 1879, and a year later the couple moved to the fashionable place Vendôme. Sargent and Pozzi both associated with the Parisian beau monde of the early 1880s, as did many of their patrons and patients. Pozzi was Sargent's senior by ten years; his glamorous, manly beauty clearly impressed the twenty-five-year-old artist. It was rumored during Pozzi's lifetime that the doctor's flirting led to liaisons with some of his patients, including Sarah Bernhardt.[1]

Dr. Pozzi at Home was Sargent's first full-length, lifesize male portrait. This dramatic debut must have in part stemmed from the artist's eager study of old-master portraits in Spain and Holland in 1879–80. The doctor's courtliness and nonchalance may have reminded Sargent of Van Dyck's male portraits. Henry James observed that Pozzi had posed for Sargent "with the *prestance* of certain figures of Vandyck."[2] The Dutch artist was noted for the gracefully mannered way in which he portrayed hands, and Sargent seems to have sought a similar effect. A portrait by El Greco may have inspired the gesture of the hand placed on the chest.[3]

Although Pozzi's dressing gown connotes the privacy of the boudoir or dressing room, its color recalls the official scarlet robes of cardinals, as depicted in numerous portraits by such eminent artists as Velázquez and Van Dyck. Visual relationships may be drawn between *Dr. Pozzi at Home* and several works by Velázquez, but all are speculative as sources. Perhaps Sargent was cleverly updating

the standing robed figure in *Aesop* (cat. 75) or echoing the red, Turkish-style costume in *The Jester "Barbarroja"* (ca. 1636, Museo del Prado, Madrid). His red-on-red palette may have been inspired by Velázquez's *Pope Innocent X* (see cat. 199), which uses red for the pope's vestments, his chair, and the drape behind him.[4]

The critical reaction to Sargent's *Dr. Pozzi at Home* was not enthusiastic. In 1882, when it became the first painting to represent the artist at the annual exhibition of the Royal Academy, London, it attracted no attention of note. In Brussels two years later, at the initial show of the Belgian avant-garde group Les XX, the portrait aroused several hostile responses, especially concerning its palette. Those who singled it out found the work attention-grabbing and gaudy. The Symbolist poet Émile Verhaeren, presaging the attacks that vanguard modernists would level against Sargent early in the next century, concluded that "[The] portrait has style and swagger, the figure is well placed and commands attention. . . . On reflection, however, one must resist. . . . It is theatrical, affected, [and ultimately] . . . wearying."[5] Perhaps it was the showy "Frenchness" of Sargent's portrait that prompted silence from the British and disdain from the Belgians. Yet when Sargent's friend Vernon Lee (Violet Paget) saw the painting on exhibition in London in 1882, she felt that it outshone most of the works in the exhibition. She wrote to her mother, "John's red picture . . . [is] magnificent, of an insolent kind of magnificence, more or less kicking other people's pictures into bits."[6] Insolence, magnificence, and mastery make an aggressive combination, and they may well have conditioned early commentary on the painting.

Certainly, Sargent's portrait distilled the doctor's charismatic charm. When writing to introduce Pozzi to Henry James in 1885, Sargent quipped, "[He is] the man in the red gown (not always), a very brilliant creature."[7] In 1893 the artist Ralph Curtis called him "the great and beautiful Pozzi," and the aesthete Robert de Montesquiou wrote in his memoirs, "I have never met a man of such peerless charms."[8] Dr. Pozzi's contacts with these singular characters doubtless helped him shape his large and eclectic collection, which ranged from Egyptian, Greek, and Roman sculpture to paintings by Tiepolo and Guardi. In addition to this portrait, Pozzi owned three fine early works by Sargent, including an informal oil portrait of Virginïe Gautreau, the subject of his *Madame X* (cat. 218).[9]

TF

1. See Vanderpooten 1992.

1. See Vanderpooten 1992.

2. James 1887, p. 689.

3. El Greco, *Portrait of a Nobleman* (ca. 1580–85, Museo del Prado, Madrid); see Elaine Kilmurray's catalogue entry in London–Washington–Boston 1998–99, p. 96.

4. For a good survey of these issues, see Reynolds 1986, in which the author compares Sargent's *Pozzi* to Velázquez's *Mariana of Austria* (1652, Museo del Prado, Madrid), noting that the pictures share a sumptuous style, animated brushwork, a great swag of drapery across the background, and a bravura spirit.

5. Émile Verhaeren, writing for *La Libre Revue* (February 1884), p. 233, quoted in Ormond and Kilmurray 1998, p. 54.

6. Letter from Vernon Lee [Violet Paget] to her mother, June 16, 1882, quoted in ibid., p. 54.

7. Letter from John Singer Sargent to Henry James, June 25, 1885, quoted in ibid.

8. Ralph Curtis, letter to Isabella Stewart Gardner, July 29, [18]93, quoted in ibid.; "jamais je n'ai rencontré un homme d'une telle séduction," Montesquiou's memoir of 1923, quoted in ibid.

9. Dr. Pozzi's other Sargents were *Incensing the Veil* (1880, Isabella Stewart Gardner Museum, Boston); *Madame Gautreau Drinking a Toast* (ca. 1883, Isabella Stewart Gardner Museum, Boston); and *Conversation vénitienne* (ca. 1882, possibly the painting *Venetian Street* now in the collection of Rita and Dan Fraad).

215. *(New York only)* *Fig. 10.48*

John Singer Sargent

Lady with the Rose (Charlotte Louise Burckhardt)

1882
Oil on canvas
84 x 44¾ in. (213.4 x 113.7 cm)
Inscribed lower left: *to my friend Mrs Burkhardt/John S. Sargent 1882*
The Metropolitan Museum of Art, New York, Bequest of Mrs. Valerie B. Hadden, 1932 32.154

CATALOGUE RAISONNÉ: Ormond and Kilmurray 1998, no. 55

PROVENANCE: The sitter's mother, Mrs. Edward Burckhardt, until 1899; the sitter's sister, Mrs. Valerie B. Hadden; her bequest to The Metropolitan Museum of Art, New York, 1932

SELECTED EXHIBITIONS: Paris, Salon of 1882, no. 2398; New York 1883, no. 103; Boston 1883, no. 100; Philadelphia 1908, no. 108; New York 1924, no. 2; Boston 1925, no. 19; San Francisco 1959, no. 2; Williamstown 1997, no. 22

SELECTED REFERENCES: Champier 1882, p. 271; Marks 1882, p. 46; Merson 1882, p. 330; Wolff 1882, p. 3; Anon. 1883b, p. 82; Cook 1883, p. 124; *New York*

Times (March 25, 1883), p. 14; James 1887, p. 684; Dixon 1899, p. 115; Cox 1908, p. 88; Bolger 1980, pp. 222–28 (for further exhibitions and references); Simpson 1998, p. 4

Because he won a second-class medal at the Salon of 1881, Sargent was able to exhibit there without approval by the jury. He took immediate advantage of this privilege in 1882 by showing two large, dashingly painted canvases that presented radically different images of women. One was this gentle portrait, the other the dramatically lit image of a dancing gypsy, *El Jaleo* (fig. 10.44). If Sargent intended this odd duo to win him a record amount of attention in the press, he succeeded. Subject matter and point of view gave *Lady with the Rose* its edge over *El Jaleo* with the majority of viewers; the portrait poeticized a well-to-do young woman coyly presenting a white rose, whereas the dance picture unleashed a peculiarly strong and energetic gypsy. Both canvases had splendid passages of sketchlike painting of the sort that Sargent's academic detractors routinely cited as evidence of his "ostentatious cleverness" and "disdain for finish" (in *Lady with the Rose*, however, this bravura technique was restricted to peripheral passages, most notably the mixing of large horizontal and vertical brushstrokes that render the surface of the long white drape).[1] And both of these Salon pictures inspired critics to draw comparisons with Spanish art: numerous writers likened *Lady with the Rose* to Velázquez's portraits, while Goya and Velázquez were cited as forebears of *El Jaleo*'s realism.[2]

When Sargent painted this charming portrait of Louise Burckhardt (1862–1892), she was twenty years old and living with her Swiss father and American mother in Paris. Like Sargent and his family, she was a cultural hybrid raised in Europe. The two families probably became acquainted in the 1870s during Sargent's student years. Prior to making Louise the focus of an ambitious Salon picture, Sargent painted a smaller portrait of her older sister, Valerie, and one of her father. He gave all three works to the senior Burckhardts.[3] A few of Sargent's friends speculated that his friendship with Louise might lead to an engagement in the early 1880s, but Louise wed in 1889 and Sargent never married.[4] In 1885 the family commissioned Sargent to portray Louise and her mother in their Paris apartment (*Mrs. Edward Burckhardt and Her Daughter Louise*, private collection). When the double portrait was shown at the Salon of 1886, it drew a range of responses, including one that pointedly harked back to the "first-rate qualities" of *Lady with the Rose*.[5]

Indeed, *Lady with the Rose* did more than any other picture to build a broad base of support for Sargent. Critics generally adored it when it was exhibited in Paris, New York, and Boston in 1882–83. One New Yorker's response to the picture's technical accomplishments was typical: "[It] is a work of sterling merit. A saucy, assured expression is given to a young woman . . . in a black satin dress that, cut pompadour, fits the bust closely. . . . In action, the picture is perfection. The textures of the gown and the lace above the flesh, the modeling,

532 MANET / VELÁZQUEZ

and the pose are also admirable."[6] Henry James gave it his enduring stamp of approval in 1887 by pronouncing it "the most brilliant of all Mr. Sargent's productions."[7] Twenty-one years later the American classicist painter Kenyon Cox echoed that sentiment: "[Time] has added the last charm to . . . [the picture's] always perfect workmanship and delicate refinement. Mr. Sargent has done more vigorous and more brilliant things since 1882, but never anything lovelier. . . . The richness and quality of the blacks is especially delightful. . . . It is well to be reminded that there was another Sargent, finer in some ways if less forceful."[8]

Sargent's debt to Velázquez in this work was acknowledged from the start. The sober yet richly nuanced palette, the isolation of the subject in an austere setting, and the painterly evocation of the atmosphere around the figure were Spanish hallmarks that Sargent perfected in *Lady with the Rose*. Although the dress reminded a few critics of Watteau, Henry James steered his interpretation toward Spain: "[It] has an old-fashioned air, as if it had been worn by some demure princess who might have sat for Velasquez."[9] More recently, art historians have drawn a connection between Miss Burckhardt's outstretched arm and *The Jester Calabazas* (cat. 71), a portrait by Velázquez that shows a man holding out a portrait miniature.[10]

TF

1. The critical reception of the two pictures is detailed in Fairbrother 1986, pp. 51–61.
2. For a detailed account of the early critical responses that mention Spanish art when discussing *El Jaleo* and *Lady with the Rose*, see Simpson 1998.
3. See entries for all three pictures in Ormond and Kilmurray 1998, nos. 31, 55, 58.
4. The friends most curious about the courtship were Henry James and Vernon Lee, who, like Sargent, never married. In 1889 Louise Burckhardt married a bisexual Englishman; that marriage is discussed frankly in a memoir by her son. See Ackerley 1968.
5. Paul Leroi's review of the Salon of 1886, quoted in Williamstown 1997, p. 150.
6. Anon. 1883b, p. 82. It is worth noting that a portrait attributed to Velázquez was included in this exhibition; the artists running this group clearly wished to invoke him as an aesthetic precursor for the numerous portraits on display in 1883.
7. James 1887, p. 684.
8. Cox 1908, p. 88.
9. James 1887, p. 686. Simpson 1998, p. 5, quotes an unidentified early review that assumes the dress to be "in the Spanish style." According to the critic reviewing the 1882 Salon for *Art Amateur*, Louise Burckhardt was "dressed in mourning in the very latest mode"; quoted in Williamstown 1997, p. 135. A Parisian cartoon published at the time of the Salon joked about the royalist associations of the dress by using the caption "Gare la crinoline! Aux armes, citoyennes!"; see the reproduction in Ormond and Kilmurray 1998, p. 15, fig. 25.
10. Richard Ormond was probably the first to make the comparison; see Ormond 1970, figs. 10, 11. The picture has also been compared to a half-length portrait by Frans Hals in which a woman holds out a rose; see Ormond and Kilmurray 1998, p. 10.

216. *(New York only)* Fig. 10.45

John Singer Sargent
The Daughters of Edward Darley Boit

1882
Oil on canvas
87⅜ x 87¼ in. (221.9 x 221.6 cm)
Inscribed, lower right: *John S. Sargent 1882*
Museum of Fine Arts, Boston, Gift of Mary Louisa Boit, Julia Overing Boit, Jane Hubbard Boit, and Florence D. Boit in memory of their father, Edward Darley Boit, 1919 19.124

CATALOGUE RAISONNÉ: Ormond and Kilmurray 1998, no. 56 (for further exhibitions and references)

PROVENANCE: Mary Louisa Cushing Boit and Edward Darley Boit; to their four daughters, Mary Louisa Boit, Julia Overing Boit, Jane Hubbard Boit, and Florence D. Boit; presented by them to the Museum of Fine Arts, Boston, in memory of their father, 1919

SELECTED EXHIBITIONS: Paris 1882b, no. 95; Paris, Salon of 1883, no. 2165; Boston, St. Botolph's Club, 1888, "John Singer Sargent's Paintings"; Paris, Exposition Universelle, 1889, no. 262; Boston, Museum of Fine Arts, 1916, "Sargent: Bostonian Paintings"; Boston 1925, no. 20; New York 1926, no. 7; Chicago–New York 1954, no. 47; Boston 1956, no. 4; New York 1957, no. 17; Leeds–London–Detroit 1979, no. 10; Boston–Denver–Chicago 1986–87, no. 1; London–Washington–Boston 1998–99, no. 24

SELECTED REFERENCES: Mantz 1882, p. 3; Anon. 1883a, pp. 714–15; Brownell 1883, p. 498; Wright 1883, p. 24; Olson 1986, pp. 97–99, pl. ix; Weinberg 1991, p. 210, pl. 224; Fairbrother 1994, pp. 44–45, 56, 72, repr. p. 42

In recent decades scholars have recognized that this canvas is both a group portrait as well as an artist's personal tribute to Velázquez's *Las Meninas* (fig. 4.13). The monumental scale of the picture, the square format, the grand, dimly lit setting, the mysterious mirror in the background, and the puzzling arrangement of the sitters all rekindle Sargent's experiences at the Prado in 1879 when he copied the Spaniard's masterpiece. When first shown in a small group exhibition at the Galerie Georges Petit late in 1882 and soon thereafter at the Salon of 1883, however, most viewers assumed that it was merely another of Sargent's quirky portraits.

The portrait depicts the children of two independently wealthy Bostonians, the landscape painter Edward Darley Boit and his first wife, Mary Louisa Cushing. Since the early 1870s the Boits had spent much of their time in Europe, where Edward took up painting in his thirties. Sargent produced this picture in the family's Paris apartment at 32 avenue de Friedland. In addition to providing likenesses of the girls, whose ages ranged from four to fourteen, he was clearly eager to portray their luxurious abode. The looming forms of the modern Japanese vases and their cavernous setting provoke the kind of fantasy that Lewis Carroll explored in his tale *Alice's*

Adventures in Wonderland (1865). Although Sargent produced a fetching and empathetic portrait of each girl, including the eldest, to whom he gave a moment of adolescent independence in her turn away from the viewer, each figure seems unaware of the others, and the collective impact evokes psychological isolation. By combining hints of uneasiness and melancholy with touches of playfulness and charm, *The Daughters of Edward Darley Boit* takes an unsentimental, modern approach to its subject.[1]

The early writers who criticized this picture focused primarily on the ways in which it departed from the conventions of group portraiture. Sargent neither treated the girls equally nor did he group them in overt familial harmony. He allowed their vast setting to upstage them, and he took advantage of its geometric divisions to reinforce the solitary condition of the girls. An American reviewing the Salon complained of "Sargent's taste for stiff wooden forms" and lamented his tendency "to do startling things rather than beautiful ones."[2] Only one nineteenth-century critic is known to have discussed the picture's affinities with *Las Meninas*. After invoking Velázquez more generally, William C. Brownell wrote, "One even thinks of the special masterpiece in the Madrid Gallery in which the painter has represented himself at work surrounded by figures of children and the reflection in a mirror of his royal sitters. But it is only because Mr. Sargent has applied the same manner, at once large and sympathetic, to the illustration of his own subject."[3] Certainly Sargent's inclusion of a mirror in the background helped strengthen the picture's connection to *Las Meninas*. In contrast to the enigmatic royal figures captured by Velázquez's mirror, Sargent's glass dimly reflected a window. The American pursued the notion of visual play, however, by flanking his mirror with a second pair of vases. The dramatic shifts in scale between the four vases and the four doll-like girls inspired a French cartoon during the Salon.

Sargent presumably felt free enough to invent such an ambitious and unusual portrait because he was close to his clients. The fact that Edward Boit was an artist may even have encouraged his notion of a tribute to Velázquez. The topic remains intriguing precisely because Sargent's treatment of it was neither obvious nor belabored. In addition to *Las Meninas*, several other Velázquez connections can be discerned here. The pose, diminutive stature, and

staring expression of the youngest girl recall two of Velázquez's paintings of seated dwarves (*Don Sebastián de Morra* [fig. 14.66] and *Don Diego de Acedo, "El Primo"* [cat. 74], both in the Museo del Prado, Madrid). And the contrast in scale between the girls and the vases recalls Velázquez's whimsical juxtaposition of the dwarf and big dog in a portrait that Sargent had copied at the Prado (cats. 80, 213).

The Daughters of Edward Darley Boit reminds us that Sargent was an eclectic stylist with a rare ability to mimic and absorb diverse sources. The picture's most endearing detail—the girl sitting on the carpet—hints at the charm that Carolus-Duran and Millais explored in their most playfully old-fashioned portraits of children.[4] Sargent even mimicked the technique of Frans Hals in several passages, most notably by dragging long, creamy strokes of paint to model the girls' white outfits. He was also aware of the domestic subject matter of the Realists and the Impressionists, for this painting is first and foremost a record of privileged modern children in their own home. Therefore, regardless of the old-master affinities of palette and brushwork, Sargent's imagery may be compared to that of Renoir's *Madame Georges Charpentier and Her Children* (1878, The Metropolitan Museum of Art), a picture he knew from the 1879 Salon, and Monet's *A Corner of an Apartment* (1875, Musée d'Orsay, Paris), which was included in the Impressionists' third exhibition in 1877. His use of a disjointed composition to allude to the complex relationships within a modern family portrait echoes the work of Degas, particularly *The Bellelli Family* (fig. 1.54). The art of Velázquez was just one of the precedents that Sargent invoked when creating his most experimental group portrait. The Spanish connection heightens and complicates the picture's aura of mysteriousness but never interferes with the viewer's ability to encounter each of these four girls in her own space and on her own terms. TF

1. The year before Sargent painted the four sisters, Henry James noted in a letter to Henrietta Reubell, February 9, 1881, that they were delicate creatures: "Those white little maidens were not fitted to struggle with physical ills—their vitality is not sufficiently exuberant." Quoted in Ormond and Kilmurray 1998, p. 66. It also is interesting to note that none of the girls married.
2. Wright 1883, p. 24.
3. Brownell 1883, p. 498.
4. In 1868 Millais painted *A Souvenir of Velázquez* (a broadly brushed image of a girl in an old-fashioned dress holding an orange) as his diploma picture for the Royal Academy, London; Sargent may have seen it when he visited London in 1881. Carolus-Duran's *A Future Doge* (a portrait of a little boy in sixteenth-century costume standing next to a lush arrangement of flowers) was exhibited at the 1881 Salon; Sargent certainly knew it since he had four pictures in the same exhibition. The Carolus-Duran is reproduced in Ormond and Kilmurray 1998, p. 5, fig. 9.

217. *(New York only)* *Fig. 14.83*
John Singer Sargent
Albert de Belleroche

Ca. 1882
27¼ x 19½ in. (70.5 x 49.5 cm)

Partially erased inscription (upper left and center), tentatively deciphered as: *to [baby?] Milbank;* upper right: *John S. Sargent*
Colorado Springs Fine Arts Center, Purchased in memory of Mrs. A. E. Carlton from her friends 61.4

CATALOGUE RAISONNÉ: Ormond and Kilmurray 1998, no. 97

PROVENANCE: The sitter, until 1944; his son, Count William de Belleroche; with Thomas Agnew & Sons, London; purchased by the Colorado Springs Fine Arts Work Center, 1961

SELECTED EXHIBITION: New York 1993a, no. 40

SELECTED REFERENCES: Ormond 1970b, p. 15, fig. 17; Olson 1986, p. 176n; Moss 2001

In addition to striking good looks, the artist Albert de Belleroche (1864–1944) enjoyed wealth and social position.[1] In 1871 his mother remarried and settled with her new husband and her son in Paris. Albert took the name of his stepfather, Milbank, until his thirtieth year, when he assumed the title comte de Belleroche. Sargent, eight years older than Albert, referred to him with the affectionate nickname "Baby" (his inscription, "to baby Milbank," has been partially erased from this portrait). The two met in Paris in 1882 at an annual dinner given in honor of Carolus-Duran by his pupils; eighteen-year-old Albert had recently entered Carolus-Duran's atelier, and Sargent was rapidly becoming its most famous alumnus. In the next year or two Sargent portrayed his new friend in four informal paintings and numerous drawings.[2] In the summer of 1882 or 1883 Sargent took Belleroche and the artist Paul Helleu on a three-day trip to Haarlem, where they studied the paintings of Frans Hals. Sargent sustained the relationship long after he moved from Paris to London. He depicted Belleroche in a lithograph in 1905, and Belleroche, an accomplished lithographer, later took his friend's infrequent efforts in that medium as the focus of his memoir about Sargent.[3]

Sargent's four early paintings of Belleroche are all boldly brushed sketches in which strong light emphasizes the young man's high cheekbones, hooded eyes, and shapely mouth. In three of them, including this example, the artist made dramatic use of the subject's long neck. For this portrait

Belleroche donned a Spanish hat and black cape, possibly souvenirs from Sargent's trip to Spain, and probably props that Sargent had used while developing his plans for his Salon painting of 1882, *El Jaleo* (fig. 10.44).[4] The restrained scheme of the subject's clothing and background served as a striking foil for the strongly modeled head. A comparison with Sargent's copy of the head in Velázquez's *Aesop* (cats. 75, 212) confirms a stylistic debt and demonstrates his increasing audacity when sketching in oils.

Sargent painted one other likeness of Belleroche in costume. Begun as an image of a princely Italian holding an enormous sword, it was eventually cut down by the artist to make a head-and-shoulders composition. Belleroche recalled that Sargent was exploring that Italianate picture at the same time that he was completing what proved to be his most notorious portrait, *Madame X* (cat. 218). It has recently been argued that a drawing Sargent made about 1883 began as a charcoal sketch of Madame Gautreau and was revised in pen and ink to suggest the features of Albert de Belleroche.[5] Such a provocative fusing of a male and a female beauty confirms the intensity of Sargent's imagination and helps explain why, in the case of this painting, a black hat, a cape, and Belleroche as model could jointly inspire a deeply felt evocation of Spain's sensual allure.

TF

1. His father, Edward Charles, marquis de Belleroche, was a scion of a noble French Huguenot family; his mother was born Alice Sidonie Vandenburg Baruch.
2. For the paintings, see Ormond and Kilmurray 1998, nos. 96–98, 100; no. 99 is an ink-and-wash drawing.
3. Belleroche 1926.
4. As noted in Washington–Boston 1992, p. 188.
5. See Moss 2001. Moss also proposes that Belleroche was the model for one or more nude studies that Sargent produced around the turn of the century.

218. *(New York only)* *Fig. 10.47*
John Singer Sargent
Madame X (Madame Pierre Gautreau)

1883–84
Oil on canvas
82½ x 43¼ in. (208.6 x 109.9 cm)
Inscribed, lower right: *John S. Sargent 1884*
The Metropolitan Museum of Art, New York, Arthur Hoppock Hearn Fund, 1916 16.53

CATALOGUE RAISONNÉ: Ormond and Kilmurray 1998, no. 114

PROVENANCE: Sold by the artist to The Metropolitan Museum of Art, New York, 1916

SELECTED EXHIBITIONS: Paris, Salon of 1884, no. 2150; London 1905a, no. 22; London 1908a, no. 344; Berlin 1909, no. 190; Rome, Esposizione Internazionale, 1911, no. 98; San Francisco 1915, no. 3630; New York 1926, no. 10; Brooklyn–Richmond–San Francisco 1967–68, no. 90; New York 1970a, no. 178; Seattle–Washington–St. Louis 1970–71, no. 69; Boston–Washington–Paris 1983–84, no. 822; New York–Chicago 1986–87;

Leeds–London–Detroit 1979, no. 13; Fairbrother 1981; London–Washington– Boston 1998–99, no. 26; Seattle 2000–2001, pp. 72–81

SELECTED REFERENCES: Brownell 1884, p. 494; Comte 1884, p. 290; Fourcaud 1884, pp. 482–84; Merson 1884, p. 286; Péladan 1884, p. 441; Penguin 1884, p. 296; Sharp 1884, pp. 179–80; James 1887, pp. 690–91; Child 1889, p. 504; Montezuma 1889, p. 46; Anon. 1892, p. 105; Fowler 1894, p. 687; Coffin 1896, p. 175; Dixon 1899, p. 118; Bolger 1980, pp. 229–35 (for further exhibitions and references)

Madame Pierre Gautreau, née Virginïe Avegno (1859–1915), emerged as a professional beauty, or *femme du monde*, in Paris during the years of Sargent's successes at the Salon. In 1880, four years before the completion of this notorious portrait, she was illustrious enough to be mentioned in the *New York Herald*, whose correspondent first described her as a flesh-and-blood incarnation of a statue by Antonio Canova, then divulged the names of her couturier and hair stylist.[1] The American artist Edward Simmons recalled pursuing her at Parisian gatherings to gaze on her sculptural perfection: "She walked as Vergil [*sic*] speaks of goddesses—sliding—and seemed to take no steps. Her head and neck undulated like that of a young doe, and something about her gave you the impression of infinite proportion, infinite grace, and infinite balance."[2]

Born in New Orleans to American parents, Virginïe Avegno was a young child when her father died at the Battle of Shiloh (1862) and her mother took her to live in Paris. Even after her marriage to the banker Pierre Gautreau, French society viewed her as an outsider. In 1881, for example, an article in *L'Illustration* noted the rising tide of "Yankees" who were stealing victories in Paris: it cited Madame Gautreau for eclipsing "our" pretty women and Sargent for scooping up one of "our" medals at the most recent Salon.[3] The following year Sargent told a close mutual acquaintance that he thought Virginïe Gautreau was "waiting" for someone to paint her. Taking an entrepreneurial approach, he coached this

friend to say that Sargent's *"prodigious talent"* was available to pay "homage to her beauty."[4] Once she consented to a portrait, Sargent sketched her in a variety of casual postures on a large, Rococo-style sofa, wearing a black dress with revealing bodice held up by diamond-encrusted shoulder straps. Eventually he painted her in a tense, statuesque pose, leaning on a Neoclassical table and flaunting a naked shoulder above a fallen dress strap.

A static figure in a stark, cameo-like setting, the subject of *Madame X* is as much a classical goddess as a mortal Parisian. The crescent of diamonds atop her head is an attribute of Venus or Diana. Perhaps Canova's *Paolina Borghese as Venus Victorious* (1805–8, Galleria Borghese, Rome) inspired Sargent to imagine Gautreau as a modern Venus haughtily turning her head and baring her shoulders. Her fallen shoulder strap echoed the skimpy tunics in numerous historical depictions of Diana the huntress as well as Victorian costumes inspired by Grecian sources, among them Joseph Fagnani's paintings from the late 1860s of nine American women as personifications of the Muses, six of whom wore costumes with the right strap worn off the shoulder.[5] Despite these various classical notes, Sargent avoided the most obvious one, a white dress. Instead, he chose a rich, dark costume that had the daunting sophistication found in certain old-master portraits of black-clad figures, including works by Velázquez and Goya. Sargent detected in Virginïe Gautreau something of the uninhibited behavior that had previously inspired him to paint exotic Italian, Moroccan, and Spanish women.[6] Even though the last female portrait Sargent had exhibited at the Salon took full advantage of a black dress (*Lady with the Rose*, cat. 215), it was a far cry from the willful and extreme fashion statement that inspired *Madame X*.

Sargent agonized over this portrait more than any other. He planned to exhibit it at the Salon in 1883 but failed to meet the deadline. At that time the background was blue green. Just before showing it at the 1884 Salon he painted out the blue with light rose tones. But creating a warm background color did not prevent the mockery and attacks that Sargent apparently feared. The dress was found to be too revealing for a formal portrait, and Sargent's focus on the woman's love of cosmetics led some to compare her to a corpse or a clown.[7] After its rancorous debut Sargent reworked the canvas once more, creating the picture we know today. He made the costume more respectable by painting a new strap properly hooked over the subject's right shoulder, and he made the palette more solemn by cooling the background with a scumbled layer of brownish ochre paint. The decision to employ a flat, dark background to set off the inky black dress followed a formula Sargent knew from portraits by the Spanish masters, Carolus-Duran, Manet, and Whistler. These last adjustments were calculated to make Madame Gautreau look as grand as she was outlandish.

In their efforts to comprehend Sargent's perverse portrait during its farcical debut at the Salon of 1884, European and American critics compared *Madame X* to a wide array of precedents, including Renaissance

profile portraits, especially those by Piero della Francesca; the frank, strongly lit realism of the recently deceased Manet; the flattening stylizations found in heraldic designs and Japanese pictures; and another landmark document of style and fashion, David's *Madame Récamier* (1800, Musée du Louvre, Paris). William C. Brownell, who was generally sympathetic to Sargent's work, saw much to criticize in *Madame X*. In particular he deplored the flat and formless aspect of the heavily made-up flesh, and reserved his praise for the incidental items: "[The artist] has never done anything better than the dress and the table on which the lady leans. . . . As Mr. Sargent's best work often does, the handling recalls Velásquez."[8]

This brief scandal had long-term consequences for Sargent. Commissions from the French declined drastically, and he moved permanently to London in 1886. He did not exhibit *Madame X* again until 1905. It was not until 1916, a year after the sitter's death and during the First World War, that he sold the portrait to The Metropolitan Museum of Art with the wistful endorsement, "I suppose it is the best thing I have done."[9] TF

1. See Elaine Kilmurray's entry in Kilmurray and Ormond 1998, p. 101. Félix Poissineau designed Madame Gautreau's gowns, and his assistant Émile styled her hair.
2. Simmons 1922, p. 127. Simmons studied and worked in France from 1879 to 1886.
3. Column by Perdican, quoted by Albert Boime in New York–Chicago 1986–87, p. 93.
4. Letter from John Singer Sargent to Ben Castillo, 1882, quoted in Kilmurray and Ormond 1998, p. 101.
5. All nine paintings were acquired by the Metropolitan Museum in 1874. Although Sargent may indeed have seen them when he visited the United States in 1876, the Grecian-style costume worn in this way was common in both Neoclassical and Victorian art.
6. For a discussion that connects *Madame X* and *El Jaleo* (fig. 10.44), see Washington–Boston 1992, p. 67. For the Moroccan and Italian connections, see Seattle 2000–2001, pp. 75–77.
7. In a Salon review written for *L'Artiste* in 1884, Joséphin Péladan wrote that Sargent's rendering of *blanc de perle* powder tinged blue by the underlying color of the skin was simultaneously deathlike and clownish ("cadavérique et clownesque"); quoted in Williamstown 1997, p. 141. For an intriguing interpretation of Sargent's response to his subject's use of cosmetics, see Sidlauskas 2001.
8. Brownell 1884, p. 494.
9. Letter from John Singer Sargent to Edward Robinson, January 8, 1916, quoted in Kilmurray and Ormond 1998, p. 102.

219. *(New York only)* *Fig. 10.30*

John Singer Sargent
Carmencita

1890
Oil on canvas
91 ⅛ x 55 ⅞ in. (232 x 142 cm)
Musée d'Orsay, Paris RF 746

PROVENANCE: Sold by the artist to the Musée du Luxembourg, Paris, 1892

SELECTED EXHIBITIONS: Chicago 1890a; New York 1890a; London 1891a; Paris, Société Nationale

des Beaux-Arts, 1892; London 1926, no. 277; Paris 1963a, no. 18; Washington et al. 1964–65, no. 52; Brussels 1967, no. 60; Leeds–London–Detroit 1979, no. 35

SELECTED REFERENCE: Anon. 1890b, p. 3

This portrait of twenty-one-year-old Carmen Dauset was Sargent's most significant treatment of a Spanish subject in the period between his early masterwork *El Jaleo* (fig. 10.44) and his twentieth-century watercolors.[1] Sargent seized the opportunity of the dancer's recent enormously successful engagement at a New York music hall to immerse himself in the drama and passion that drew him to Spanish music and dance. While his friend William Merritt Chase opted to portray her during a happy and spirited performance (cat. 206), Sargent focused on her majestic entrance, the moment when she stepped from the darkness, confronted the audience, and gathered herself before starting to dance. As a contemporary journalist described it, "The dancer seems like a brilliant, scintillating, elusive bird. . . . As she poses there [you see] a brilliant type of Spanish womanhood. But this is only for a moment; she lingers as an orchid before it sways on the breeze, and then as the orchestra strikes into a slow, soft Spanish movement, she begins her dance."[2] Charles Dudley Warner, in a novel published five years later, depicted "a superb figure, clad in a high tight bodice. . . . She seems, in this pose and [bright] light, supernaturally tall. Through her parted lips white teeth gleam, and she smiles. Is it a smile of anticipated triumph, or of contempt?"[3]

Sargent's enthralled response to Carmencita's extravagant outfit and regal aplomb paralleled his obsession with Madame Gautreau's dramatic social entrances, but his brushwork in *Carmencita* was far looser and more impressionistic than that in *Madame X* (cat. 218). And unlike *Madame X*, Carmencita's strikingly whitened face, reddened lips, and blackened eyebrows aroused no angry complaints, confirming that different expectations and standards existed for images of exotic dancers in contrast to portraits of society women.[4]

Carmencita was the most discussed and most prominently displayed painting in the spring 1890 exhibition of the Society of American Artists in New York. After working in Manhattan for four months, Sargent wanted to make a presence at the city's most progressive annual exhibition. He had seven canvases on view, including four portraits and two Impressionist-influenced pictures he had brought with him from London, *Miss Priestley* (ca. 1889, Tate Britain, London) and *A Morning Walk* (1888, private collection). Most critics declared the painterly rendition of Carmencita's spangled costume a tour de force. Velázquez was constantly cited as an influence on the towering figure silhouetted against a dark background as well as the magical simplicity with which dabs of impasto conveyed the costume's shimmering decorations. Some commentators criticized the drawing and the proportions of the figure, failing to perceive that Sargent showed Carmencita with her head thrown back, prior to commencing her dance.

A few critics had begun to tire of Sargent's clever and attention-getting evocations of the old masters. One New Yorker suggested in 1890 that *Carmencita* revealed much more about the artist than the subject: "[Sargent] was thinking of Velásquez and Goya, and Castilian romances and fans and daggers. Consequently, in this white-faced, painted, mysterious, evil-looking beauty . . . he has suggested a whole lot of things that Carmencita herself suggests only vaguely, if at all, and omitted a number of more human and attractive ones that she really possesses. . . . It is amazingly clever; but it is not Carmencita."[5] A year later another critic complained more generally about Sargent's "determined eccentricity": "[As a painter, he] wears so many masks, and plays, with ill-concealed delight, so many tricks that 'tis impossible to guess what sort of pictures he would paint if he were to work on a desolate island with no one to astonish, no one to confound, and no one to assure him that he was born to make Titian and Velásquez forgotten!"[6] Nonetheless, *Carmencita* garnered much attention for the artist in New York, Chicago, and London soon after it was completed. In 1892, immediately after its appearance at the Salon of the Champs de Mars in Paris, the picture was purchased for the French national collection and displayed in the Musée du Luxembourg.

At the time, Sargent was only thirty-six years old. The acquisition of *Carmencita* was doubtless helped by the fact that the previous year the Musée du Luxembourg had bought *Arrangement in Gray and Black, No. 1: The Artist's Mother* (fig. 10.33), by Sargent's older, historically more controversial compatriot, Whistler. In its first twenty years, Whistler's *Mother* had become a classic instance of the muted colors, simple silhouetted forms, and generally austere aestheticism that some modern artists had derived from Velázquez. Sargent's *Carmencita* represented other aspects of the Spaniard's influence, particularly his use of sparkling brushwork to render splendid clothes and his treatment of the standing figure as a majestic, isolated form. The fifty-seven-year-old Whistler was deeply satisfied that such illustrious friends as Stéphane Mallarmé and Théodore Duret

(cat. 224) had encouraged the French government to purchase his early treasure. Sargent, on the other hand, came to regret that he was represented at the Luxembourg by *Carmencita*, which he later described to a young artist as "little more than a sketch."[7]

TF

1. These works include the splendid watercolor made in Granada in 1912, *The Escutcheon of Charles V of Spain* (The Metropolitan Museum of Art).
2. Ramirez 1890, p. 131.
3. Warner 1895, p. 4.
4. *Carmencita* belongs to a period when Sargent painted two actors in stage costume and makeup: *Ellen Terry as Lady Macbeth* (1889, Tate Britain, London) and *Joseph Jefferson in the Part of Dr. Pangloss* (1890, The Players Club, New York). One American critic claimed that his quirky interest in revealing the "mask of the actor" was symptomatic of his larger obsession with capturing weird visual effects. See Fairbrother 1986, pp. 166, 203 n. 34.
5. Anon. 1890b, p. 3.
6. Anon. 1891, p. 212. These comments were made at the end of a negative appraisal of Sargent's portrait of Beatrice Goelet (private collection).
7. Sargent apparently made this comment to the artist Julie Heyneman; reported in Charteris 1927, p. 113.

220. *(New York only)* *Fig. 4.8*

John Singer Sargent
The Holy Trinity, Copy after El Greco

1895
Oil on canvas
31½ x 18½ in. (80 x 47 cm)
Private collection, New York

PROVENANCE: Purchased from the artist's estate sale by Sir Philip Sassoon; to his sister, the marchioness of Cholmondeley, by family descent; Adelson Galleries, Inc., New York; Christie's, London, November 21, 1995, no. 26; to present owner

SELECTED EXHIBITION: London 1926, no. 561

SELECTED REFERENCE: Ormond 1970, pp. 65–66, fig. 27

Sargent was well attuned to shifts in taste, including revivals of interest in particular art-historical movements and individuals. Participating in the growing late-nineteenth-century enthusiasm for Mannerist art, he enjoyed sketching the sculptures of Cellini and Giambologna and was keenly interested in El Greco, whom he extolled in a letter from Spain as "one of the very most magnificent old masters."[1] In the course of his later visits to Spain (1892, 1895, 1902, 1903, 1908, and 1912), Sargent felt an increasing attraction to El Greco's art. By 1895 he had acquired a version of El Greco's *Saint Martin and the Beggar* for his personal collection. He loaned it to a major survey of Spanish art in London in 1895, displayed it prominently in his residence, and included it in the background of his large group portrait of Doctors William Welch, William Osler, William Halsted, and Howard Kelly (1905, Johns Hopkins University School of Medicine, Baltimore).[2] In 1899,

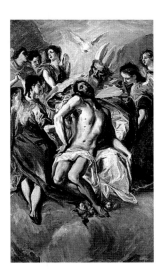

when his friend the American sculptor Augustus Saint-Gaudens made his first visit to Spain, Sargent encouraged him to study all the El Grecos he could find. In 1914 he reportedly said to Paul Helleu, "Ingres, Raphael and El Greco, these are now my admirations, these are what I like."[3] A year later, he corresponded with the duke of Alba about El Greco's mannered elongation of his figures. Taking issue with a new theory that the Spaniard was astigmatic, Sargent argued soundly that his "exaggeration of elegance" was a widespread stylistic trait derived from Michelangelo.[4] In addition, aided by information Sargent learned in Europe, the Museum of Fine Arts, Boston, purchased *Fray Hortensio Félix Paravicino* in 1904, and The Metropolitan Museum of Art, New York, acquired *Portrait of a Man* in 1924.[5]

Registering to copy El Greco's work at the Prado in 1895,[6] Sargent painted *The Holy Trinity* in a broader style than that of the copies after Velázquez he had made sixteen years earlier. The Pietà was probably of special interest to Sargent, as he had been recently preoccupied with his religious mural project at the Boston Public Library. In the spring of 1895 he installed various pagan and Hebraic segments of the scheme and was commencing detailed research on Christian subjects. While studying El Greco's *Holy Trinity* (fig. 4.7), Sargent clearly relished the contrast between the ashen colors of Christ and the brilliant hues of the costumed figures surrounding him. And he was evidently struck by the Spaniard's dramatically sensuous presentation of the limp body. While he copied the awkward yet beautiful twisting of Christ's shoulder, one wonders if Sargent was reminded of his own portrayal of Madame Gautreau's contorted, naked, and magnificent upper body (cat. 218).

Several of Sargent's compositions for the decorations at the Boston Public Library featured male figures in complicated, emotive postures, including *The Sorrowful Mysteries of the Rosary, Gog and Magog, Judgment,* and *Hell.* When developing a composition for a mural he made numerous figure studies from models. The particular

interest that he showed in El Greco's image of the dead Christ recurs in some of these studio drawings. A similar fascination with a strongly illuminated, physically intense posture is evident in *Man Standing, Head Thrown Back.* Sargent's last contribution to the Boston Public Library (*The Church,* installed in 1919) included the dead Christ as a secondary figure. In marked contrast to the transcendent nude painted by El Greco, Sargent covered the crucified body in a heavy robe and propped it between the legs of a seated female personification of the Christian Church. TF

1. Letter from John Singer Sargent to Wilfrid von Glehn, [probably 1902], quoted in Charteris 1927, p. 195.
2. The picture is now attributed to the artist's son, Jorge Manuel Theotocopuli, and is owned by the John and Mable Ringling Museum of Art, Sarasota, Fla. Sargent was a member of the organizing committee for an exhibition of Spanish art in 1895; see Washington–Boston 1992, p. 85.
3. As stated in Charteris 1927, p. 195.
4. The duke of Alba had sent German Beritens's pamphlet about El Greco to Sargent (*El astigmatismo del Greco,* Madrid, 1914). In his reply of August 19, 1915, Sargent discussed his own astigmatism and incorporated his personal knowledge into his argument about El Greco; the entire letter is quoted in Charteris 1927, pp. 195–96. Two years before this exchange Sargent made a fine portrait drawing of the duke of Alba (1913, Palacio de Lyria, Madrid).
5. For more details, see Washington–Boston 1992, pp. 86–87.
6. I am indebted to Mary Anne Goley for confirming that Sargent registered to copy the El Greco at the Prado on July 26, 1895. See also Washington–Boston 1992, p. 102 n. 125.

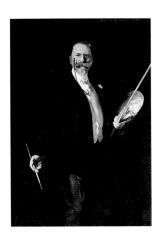

221. *(New York only)* *Fig. 14.88*

John Singer Sargent
William M. Chase

1902
Oil on canvas
62¼ x 41⅜ in. (158.8 x 105.1 cm)
Inscribed and dated upper right (probably by Chase): *Copyright by John S. Sargent 1902*
The Metropolitan Museum of Art, New York, Gift of Pupils of Mr. Chase, 1905 05.33

PROVENANCE: Given by the subject's pupils to The Metropolitan Museum of Art, New York, 1905

SELECTED EXHIBITIONS: New York 1902b; Chicago 1903, no. 336; Cincinnati 1903, no. 1; New York 1903a, no. 335; Philadelphia 1903; St. Louis 1904, no. 671; New York 1926, no. 39; Seattle–New York 1983–84, p. 145

SELECTED REFERENCES: Anon. 1902, p. 12; Boston 1902; Caffin 1903, p. cxv; Bolger 1980, pp. 257–60 (for further exhibitions and references)

In 1902 the students of New York artist William Merritt Chase (1849–1916) commissioned Sargent to paint their teacher, indicating from the outset that they would present the likeness as a gift to The Metropolitan Museum of Art. After working for almost twenty-five years at a variety of institutions, Chase was probably the most widely admired art teacher in the United States. At the time of the portrait commission he served as senior instructor at the New York School of Art, which he had founded in 1896. Sargent was both the logical and the grandest choice of painter: the two men had been close acquaintances since the early 1880s, and Sargent's stature was at its peak. In addition to the seemingly endless coverage of his work in the press and magazines, Sargent's large and comprehensive solo exhibition in Boston in 1899 had been a memorable occasion for American painters.[1] The only other American portraitist whose fame and reputation were comparable to Sargent's was Whistler—but Chase's image of Whistler (cat. 203) had upset its sitter, and the two artists had been estranged for years.

Chase sailed to London in the summer of 1902 to be painted by Sargent. One of his traveling companions was Harrison S. Morris, director of the Pennsylvania Academy of the Fine Arts in Philadelphia, where Chase had been teaching classes since 1896. Morris later reminisced that the artist looked very dapper and acted "on edge" when he went for the first sitting: "His glorious apparel [included] . . . the white carnation in the buttonhole of his frock coat, the eyeglasses on the broad silken leash, the spats, the tuft of the silk necktie clasped with the matchless emerald . . . [and] the crowning high hat."[2] But rather than portray Chase as a flamboyantly cosmopolitan figure, Sargent focused on his stature as a prominent and successful artist. Morris recalled that Chase ended up posing in his "old blue studio coat." The personal adornments that Sargent permitted were the white flower and the emerald adorning his neckwear.

The proud and eager spirit of a hardworking professional became the underlying theme of Sargent's *Chase.* His use of a sober, predominantly black and gray palette enveloped the subject in a dignified atmosphere. Alertly posed, Chase holds the tools of his trade; the cluster of brushes, maulstick, and large palette in Chase's left hand greatly enliven the composition. Powerful lighting directed from the upper left casts dramatic shadows, including a large vertical one on Chase's right cheek. The unusually robust illumination emphasized the subject's rugged demeanor, which Sargent underscored by working in his most

brusque, painterly style. The fact that the work was completed in six sittings may also have contributed to its general air of confidence and vigor.

There is an intriguing ambiguity about the object of Chase's keen gaze. Portrayed with brushes in hand, it might be assumed that he is scrutinizing his canvas or his subject. But Chase stands in a very frontal posture, and his body language recalls that of someone looking into a mirror. Perhaps Sargent was thinking playfully of Velázquez's self-portrait in *Las Meninas* (fig. 4.13), where the artist appeared as a stately, well-dressed figure holding brush and palette. Although the poses and expressions inevitably differ in their details, Sargent's *Chase* and Velázquez's self-portrait are both celebrations of painting as a distinguished profession.

When Sargent's *Chase* had its debut at Knoedler and Company in New York late in 1902, the students' fund-raising effort was announced in the press. The picture was exhibited in Boston, Philadelphia, New York, Cincinnati, Chicago, and St. Louis prior to its formal presentation as a gift to the Metropolitan Museum in 1905. Among the wide acclaim the picture received as an outstanding example of the artist's work, the *New York Times* noted that "From the technical side alone this portrait is the marvel of painters, who linger over the masterly brush strokes that place the modeling of puckered brows, the nose pinched by the glasses, the beard and hands right there—exactly as in life—with the fewest strokes and the least apparent effort. . . . Life and vigor of suspended action, and the fixed, serious look of observation are all here."[3] Charles Caffin, who found the portrait to be an "inexpressibly adroit" example of Sargent's free and certain brushwork, declared it "one of the artist's most notable triumphs."[4]

Several American artists had painted Chase before Sargent. J. Carroll Beckwith, Whistler, and Walter T. Smedley all produced full-length depictions of their colleague wearing very dapper outfits; Whistler said that his likeness showed Chase as a "Masher of the Avenues."[5] Only Eakins had taken the sober sartorial route that Sargent would favor; in his characteristically quiet portrayal, Chase wears a plain dark jacket with an elegant scarf fastener at his neck and a white carnation in his lapel.[6]

TF

1. For more information on the exhibition, see Fairbrother 1986, pp. 190–96.
2. Morris 1930, quoted in Bolger 1980, pp. 257–58.
3. Anon. 1902, p. 12.
4. Caffin 1903, p. cxv.
5. J. Carroll Beckwith, *William Merritt Chase* (1882, Indianapolis Museum of Art); Whistler, *William Merritt Chase* (1885, location unknown; see A. Young et al. 1980, vol. 2, no. 322). Walter T. Smedley's portrait (ca. 1891) is reproduced in Brooklyn–Chicago–Houston 2000–2001, p. 140. For Whistler's comment, see his letter to the *World* (October 13, 1886), quoted in Whistler 1892 (1967 ed.), p. 185.
6. See the catalogue entry by Paul Paret in London 1993–94, pp. 139–41.

JAMES McNEILL WHISTLER
Lowell, Massachusetts, 1834–London, 1903

Whistler's rare creativity as a painter, printmaker, designer, decorator, and writer had a broad impact on late-nineteenth-century European and American art. After a New England boyhood, he lived abroad from his ninth to fifteenth year while his father worked as a civil engineer on the railroad from St. Petersburg to Moscow. He took drawing lessons at the Imperial Academy of Fine Arts, St. Petersburg, and learned to speak French. On visits to London he studied the print collection of his half sister Deborah and her husband Seymour Haden, initiating a lifelong passion for Rembrandt. Entering the U.S. Military Academy at West Point in 1849, he was discharged after three years. The U.S. Coast Survey in Washington, D.C., employed him as a draftsman and etcher until 1855, when he moved permanently to Europe.

In Paris Whistler studied briefly with the Neoclassicist Charles-Gabriel Gleyre, then connected with such vanguard figures as Gustave Courbet, Henri Fantin-Latour, and Alphonse Legros. His early etchings and paintings featured bold realist observation, often tempered by subtle tonal effects and atmospheric mannerisms evocative of Dutch and Spanish seventeenth-century art. Whistler moved to London soon after his first major painting, *At the Piano* (fig. 10.4), was rejected at the 1859 Salon. His inclusion in the Salon des Refusés in 1863 established his reputation as a radical. One of the most provocative works in that infamous display was Whistler's portrait of his mistress, *The White Girl* (later retitled *Symphony in White, No. 1*, 1862, National Gallery of Art, Washington, D.C.), a large painting that had been declined by juries at the Royal Academy and the Salon.

As the decade progressed Whistler abandoned the descriptive and narrative impulses of realism and explored the graceful beauty that he associated with the arts of classical Greece and the Orient. He amassed Japanese screens and woodcuts and built a distinguished collection of Chinese blue-and-white porcelain. Whistler played a major role in the British Aesthetic Movement; his most ambitious design project was the Peacock Room (Freer Gallery of Art, Washington, D.C.), an elaborate painted interior created in the home of a British patron in 1876–77. He also collaborated with the architect E. W. Godwin to design an exhibition stand for the Paris Exposition Universelle of 1878.

Whistler exploited his social pursuits as a dandy and a sharp wit to draw attention to his aesthetic crusades. His riskiest professional move—a libel action against British critic John Ruskin in 1879—bankrupted him. In the brilliantly and vengefully titled *The Gentle Art of Making Enemies* (1890), Whistler wrote about his artistic philosophy. For this characteristically unorthodox and stimulating publication, he combined courtroom statements, polemical letters to the press, a famous lecture, and his own graphic designs.

TF

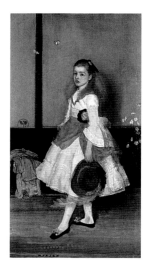

222. *(New York only)* *Fig. 10.8*

James McNeill Whistler
Harmony in Gray and Green: Miss Cicely Alexander

1872–74
Oil on canvas
74⅞ x 38½ in. (190.2 x 97.8 cm)
Signed with butterfly
Tate, London, Bequeathed by W. C. Alexander, 1932
N04622

CATALOGUE RAISONNÉ: A. Young et al. 1980, vol. 2, no. 129

PROVENANCE: Commissioned by W. C. Alexander; bequeathed to the British national collection, 1916, with a life interest to the sitter; acquired by the Tate, London, on her death, 1932

SELECTED EXHIBITIONS: London 1874a, no. 5; London 1881, no. 113; Brussels, Société des XX, 1884, no. 4; Paris, Salon of 1884, no. 2454; Munich 1888, no. 2454; London 1891b, no. 223; London 1892, no. 23; London 1894, no. 136; London 1896a, no. 28; Dublin 1899, no. 79; Paris 1905, no. 18; Chicago–Utica 1968, no. 21; Detroit 1983, no. 68; London–Paris–Washington 1994–95, no. 62

SELECTED REFERENCES: Blackburn 1881, p. 39; Huysmans 1889, pp. 68–69; Whistler 1892, pp. 312–15; Muther 1893–94, vol. 3, p. 530; MacDonald 1995, p. 187 (letter and drawing)

Harmony in Gray and Green is the quintessential expression of Whistler's ability to fuse art-historical allusions, non-Western aesthetics, and experimental modernism. W. C. Alexander, a young London banker, commissioned the portrait in 1872, when his daughter Cicely was six. Requiring over seventy sittings, the picture was not completed until 1874, when it became a key, yet much criticized work in his first solo exhibition, held at the Flemish Gallery, London.

The striking monochromatic interior design that Whistler created for his studio served as the setting for Cicely's portrait. His plain gray walls, black dado

and battens, and subtly checkered mat conjure up an atmosphere that may be read as either oriental simplicity or Velázquez-like restraint. The presence of a few hovering butterflies and a sprig of daisies clearly indicates Whistler's embrace of two fundamentals of Japanese art, simplicity of design and economy of expression. His response to the sitter's firm personality and fanciful costume, however, steered the picture more emphatically in the Spanish direction. After numerous sittings Whistler tired of the dress Cicely had been wearing and designed another. He wrote to the girl's mother that he wanted the dress to be of "fine Indian Muslin," something white, plain, and thin enough for the arms to show through. Asking that the neck be finished with lace or a "fine little ruffle," he also specified several rows of frills for the skirts (which might be "looped up from time to time with bows of pale yellow ribbon").[1] Although his costume followed the conventions of the day in its basic form and length, Whistler added details that alluded to seventeenth-century European courtly fashions. The long feather on the hat and the layered profusion of the skirt point generally to that era; the ribbon hair ornament and the elaborate sashing about the waist specifically recall Velázquez's paintings of the beautiful, blonde-haired Infanta Margarita (see cat. 78).

Whistler considered Velázquez's portraits to be among the finest works in the history of art. He stated that the Spaniard made his subjects "live within their frames," and project, as if by natural right, "all nobility and sweetness, and tenderness, and magnificence." For him, the infantas were "of the same quality as the Elgin Marbles."[2] Although Whistler never visited Madrid (he made one unsuccessful attempt in 1862), his collection included nine photographs of Velázquez's paintings, one of which was a detail of the Infanta Margarita in *Las Meninas* (fig. 10.6).[3] Critics often compared his work with that of Velázquez. In 1860 a writer for the *London Times* wrote warmly of Whistler's portrait of a mother and daughter, *At the Piano* (fig. 10.4): "In [simple, somber] colour and [broad, sketchy] handling this picture reminds me irresistibly of Velasquez."[4] Two decades later the *Magazine of Art* cited this portrait of Miss Alexander in a lethal comparison with the Spaniard: "[It is] posed and painted in a rather distant, if obsequious, imitation of the manner of Velasquez, the great difference being that whereas the Spaniard's work is most remarkable for supreme distinction, the present portrait is uncompromisingly vulgar."[5]

Harmony in Gray and Green was meant to be both a commissioned likeness and an embodiment of Whistler's strong views about what constituted good painting. First and foremost, a painting should be a consciously created two-dimensional design: for him, the business of recording the details of Cicely's appearance was ultimately less important than achieving a successful artistic arrangement, or harmony, in a palette keyed to gray and green. The entire surface was intended to delight the viewer as an artful equilibrium between a few carefully chosen colors and shapes, not unlike certain issues being explored at the time by Whistler's modernist French

peers, particularly the Impressionists. Since Whistler depicted Cicely in a dancelike pose, it is also tempting to speculate that he was responding to recent French images of dancers, especially those produced by Manet and Degas.[6]

Today's viewers may find it hard to believe that many Victorians considered this an unattractive work. In the catalogue of his first retrospective exhibition of paintings in 1891, Whistler excerpted fourteen negative reviews, including the following comments: "A disagreeable presentment of a disagreeable young lady,"[7] and "[A] bilious young lady . . . looking haughty in a dirty white dress."[8] These early viewers were clearly unnerved by a portrait of a child that was unabashedly candid, as opposed to prettified and sentimental. Whistler depicted a girl who was both splendid and unhappy. In midlife Cicely recalled that standing "for hours at a time" in Whistler's studio made her not only "very tired and cross," but often close to tears.[9] TF

1. Letter quoted and the ink drawing reproduced in MacDonald 1995, p. 187.
2. From the artist's Ten O'Clock Lecture (1885), quoted in Whistler 1892 (1967 ed.), pp. 137, 158.
3. Reproduced and discussed in Nigel Thorp, "Studies in Black and White: Whistler's Photographs in Glasgow University Library," in Fine 1987, pp. 85–100, fig. 6.
4. Quoted in A. Young et al. 1980, vol. 1, p. 9.
5. Quoted in Whistler 1892 (1967 ed.), p. 315.
6. Richard Dorment states (without citing evidence) that Whistler deliberately based Miss Alexander's dress and pose on those in Manet's *Lola de Valence* (cat. 138). See Dorment in London–Paris–Washington 1994–95, p. 146.
7. From *Liverpool Weekly Mercury*, quoted in Whistler 1892 (1967 ed.), p. 313.
8. From *Bedford Observer*, quoted in ibid., p. 314.
9. Quoted in Pennell 1908, vol. 1, pp. 173–74.

223. *(New York only)* *Fig. 10.9*

James McNeill Whistler

Arrangement in Black, No. 3: Sir Henry Irving as Philip II of Spain

1876; revised 1885
Oil on canvas
84¼ x 42¼ in. (215.3 x 108.6 cm)
The Metropolitan Museum of Art, New York, Rogers Fund, 1910 10.86

CATALOGUE RAISONNÉ: A. Young et al. 1980, vol. 2, no. 187

PROVENANCE: Purchased from the artist by C. A. Howell, 1878; with Graves and Company, London; owned by Sir Henry Irving by 1897; auctioned by Christie's, London, 1905; A. Howard Ritter, Philadelphia, 1905; George C. Thomas, Philadelphia, 1906; sold by Blakeslee Galleries, New York, to Charles Lang Freer as agent, 1909–10; purchased by The Metropolitan Museum of Art, New York, 1910

SELECTED EXHIBITIONS: London 1877, no. 7 (in West Gallery); London 1897, no. 137; Dublin 1899, no. 78; London 1905b, no. 27; London–New York

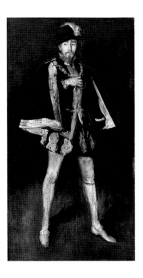

1960, no. 38; London–Paris–Washington 1994–95, no. 64

SELECTED REFERENCES: Alan Cole, quoted in A. Young et al. 1980, vol. 1, p. 109; *Art Journal* 16 (August 1877), p. 244; James 1877, p. 156; *London Times* (May 1, 1877), p. 10; Wilde 1877, p. 124; *London Daily News* (November 26, 1878); Wedmore 1879, p. 338; *Evening News* (May 14, 1889); Whistler 1890b, p. 6; *Art Journal* (July 1897), repr. p. 223; James 1897, pp. 639–40; Purser 1899, p. 156; Terry 1907, p. 135; Spassky et al. 1985, pp. 378–85 (for further exhibitions and references)

Henry Irving was the stage name of John Henry Brodribb (1838–1905). The preeminent Shakespearean actor of his day, Irving was also the director and manager of the Lyceum Theatre in London. He was the first actor to be honored with a knighthood, which Queen Victoria bestowed in 1895.

Whistler asked to paint this portrait while Irving was performing in his own stage adaptation of Tennyson's *Queen Mary Tudor*, a poem published in 1875. The play ran for twenty-three nights, in the spring of 1876. Ellen Terry, a leading player at the Lyceum, recalled that Irving "never did anything better [than King Philip] to the day of his death. Never shall I forget his expression when . . . Queen Mary . . . was pouring out her heart to him. The horrid dead look, the cruel unresponsiveness, the indifference of the creature! While the poor woman protested and wept, he went on polishing up his ring! Then, the tone in which he asked: 'Is dinner ready?' It was the perfection of quiet malignity and cruelty."[1]

The artist was careful not to conflate the handsome, real-life celebrity and the Spanish villain Irving was playing on stage. The man in the portrait might be said to have a calculating and spirited air, but he does not seem heartless or cold. Irving stands in low light against a murky, mysterious void. Somber settings of this type were not uncommon in Whistler's portraits, but in this instance the darkness seems to amplify the ambiguity of the figure. (The paint that Whistler used as a ground has gradually deepened in color, giving the picture an even greater shadowy intrigue than Whistler originally intended.)

In 1866, when Manet completed a portrait of Philibert Rouvière in his celebrated interpretation of Hamlet, he did not use the actor's name in the title, *The Tragic Actor* (cat. 150). The French painter thus not only avoided the criticism of people who might not find it a good likeness of Rouvière but also positioned his picture as a broad statement about the human condition rather than a characterization of one person. Both Manet and Whistler were probably equally mindful of Velázquez's full-length portrait of Pablo de Valladolid, in which the court jester stands in an arrestingly open-hearted posture (cat. 73).

In addition to Irving himself, Whistler took an interest in the historical character of Philip II, who had built an outstanding collection of art. He was a great patron of Titian, who painted him in a celebrated full-length portrait (*Philip II in Armor*, Museo del Prado, Madrid). Moreover, his grandson, King Philip IV, was Velázquez's great benefactor. Never a slavish historicist in his art, Whistler was in his own way much tempted by the charm of the past. In the early 1890s Whistler even included figures of Queen Isabella of Spain and Queen Elizabeth of England in a sketch for an unrealized mural decoration.[2]

A visitor to Whistler's studio in 1876 recalled that the Irving portrait was typical of some new experiments by the artist in rapid painting, in which a full-length portrait would be completed in "two sittings or so."[3] A year later, when Whistler exhibited the picture for the first time, three commentators balked at the appearance of hasty execution. The critic for the *London Times* joked that the "entire absence of details" in Whistler's full-length pictures suggested either ghosts ("materialized spirits") or the presence of London fog.[4] Henry James, in one of his first art reviews, voiced the stock resistance to the artist's experimentalism: "I will not speak of Mr. Whistler's . . . 'Arrangements' . . . because I frankly confess they do not amuse me."[5] Oscar Wilde, then in his early twenties, wrote the most perceptive summary when *Arrangement in Black, No. 3* had its debut. He too made cavalier remarks about sketchiness and "black smudge cloud," but praised the portrait's vivid likeness: "[The] legs are stuck wide apart in a queer stiff position that Mr. Irving often adopts. . . . The figure . . . is so ridiculously like the original that one cannot help almost laughing when one sees it."[6]

The unfinished quality of the picture was shockingly memorable, for it was discussed in the courtroom during Whistler's notorious libel suit against John Ruskin in 1878. When questioned about the portrait's finish, the artist observed, "It is a large impression—a sketch; but it was not intended as a finished picture. It was not exhibited as for sale."[7] Ironically, just before the trial, the impecunious artist had been forced to sell the portrait of Irving, getting in return a sealskin coat and ten pounds. Several years later, pleased with his equally dark and shadowy full-length portrait of Pablo de Sarasate (cat. 225), Whistler wrote Irving to arrange for more sittings so that he could finish his "large impression" of the actor. Thus in 1885 Whistler adjusted the composition to the one we

know today: he gave much more definition to the shoes, added the garter on Irving's left leg and the gold chain around his neck, made the feather in the hat less conspicuous, and altered the contours of the cloak so that it covered most of the sitter's right arm. Some of these changes were achieved with rich, painterly flourishes, including the very wide, fluent strokes of ocher paint that depict the gold edging at the bottom of the cape.

Henry Irving managed to acquire *Arrangement in Black, No. 3* by the mid-1890s, although, according to Ellen Terry, he "never cared much" for it. (The actress suspected that the portrait was "not nearly showy enough" for Irving's taste.)[8] In 1897 the portrait was the centerpiece of a British exhibition that made a historical survey of art connected to music and theater. In a review for *Harper's Weekly* Henry James was far more generous to this portrait than he had been in 1877. Presenting himself as a pious supporter of Whistler's rarefied genius, he lamented the general coarseness of the age and wrote that this "exquisite image of Henry Irving" came from an artistic realm of "distinction, of perception, of beauty and mystery and perpetuity."[9]

TF

1. Terry 1907, p. 134.
2. The proposed mural was for the Boston Public Library. The oil sketch is discussed and illustrated in A. Young et al. 1980, vol. 2, no. 396.
3. Alan Cole, quoted in ibid., vol. 1, p. 109.
4. Quoted in Spassky et al. 1985, p. 379. Marie Spartali Stillman later recalled that "three different outlines of the figure were visible" when the picture was exhibited in 1877; see A. Young et al. 1980, vol. 1, p. 110.
5. James 1877, p. 156, quoted in Spassky et al. 1985, p. 379.
6. Quoted in ibid.
7. Quoted in ibid.
8. Terry 1907, p. 135.
9. Quoted in Spassky et al. 1985, p. 380.

224. *(New York only)* Fig. 10.11
James McNeill Whistler

Arrangement in Flesh Color and Black: Théodore Duret

1883–84
Oil on canvas
76⅛ x 35¼ in. (193.4 x 90.8 cm)
Signed with butterfly
The Metropolitan Museum of Art, New York, Catharine Lorillard Wolfe Collection, Wolfe Fund, 1913 13.20

CATALOGUE RAISONNÉ: A. Young et al. 1980, vol. 1, no. 252

PROVENANCE: Purchased from the artist by Théodore Duret, ca. 1885; sold to The Metropolitan Museum of Art, New York, 1913

SELECTED EXHIBITIONS: Paris, Salon of 1885, no. 2460; Berlin 1904, no. 239; London 1905b, no. 10; Chicago–New York 1954, no. 115; Brooklyn–Richmond–San Francisco 1967–68, no. 89;

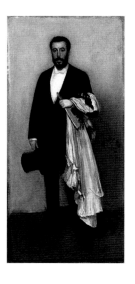

New York–Philadelphia 1971, no. 37; London–Paris–Washington 1994–95, no. 127

SELECTED REFERENCES: Maus 1885, p. 164; Duret 1904, pp. 99–102; letter from Roger Fry to Bryson Burroughs, February 16, 1909, Archives, Metropolitan Museum of Art, New York; Spassky et al. 1985, pp. 385–92 (for further exhibitions and references)

With its unusual props and luscious pink and red, *Arrangement in Flesh Color and Black* proved to be Whistler's most artfully contrived male portrait. It doubtless had a strategic importance in the painter's professional life, for Théodore Duret (1838–1927) was a key figure in the Parisian art world. His large personal collection included contemporary pictures by Courbet, Cézanne, Degas, Monet, Morisot, and Pissarro. In his efforts as a journalist Duret gave early support to the Impressionists and wrote monographs on Manet (1902), Whistler (1904), and Renoir (1924). He was also a connoisseur of Asian art who had toured the Far East in the early 1870s, helping his friend Henri Cernuschi assemble the remarkable collection now housed in the Musée Cernuschi, Paris. In 1894 financial difficulties forced Duret to dispose of his family's brandy business and to sell part of his collection; thereafter he focused on writing and private art sales. He owned several works by Whistler over the years and would eventually be one of the artist's six pallbearers at his funeral in Chiswick in 1903.

Whistler was the second of three major artists who painted Duret's portrait. The first was Manet, who in 1868 captured the diffidence of a dapper young man who was both the heir to a successful company and a fledgling Parisian journalist (cat. 154). In 1912 Vuillard painted the third portrait of Duret (National Gallery of Art, Washington, D.C.), in which the venerable bachelor sits at his writing table with his cat. In contrast to the austere compositions of Manet and Whistler, Vuillard encircled his subject with papers, books, and art; in a charming echo of *Las Meninas* (fig. 4.13), he positioned a mirror in the background so that it showed a reflection of Whistler's *Duret*.

Manet introduced Duret and Whistler in 1881, and it was probably soon after Manet's death, in

the spring of 1883, that Whistler began work on *Arrangement in Flesh Color and Black*. Duret recalled that Whistler asked to paint his portrait a few hours after they had visited a gallery in London. In the exhibition Whistler took a strong dislike to an unspecified male portrait in which the sitter wore a historic red robe of office while sporting a fashionably parted and frizzed hairstyle. Finding this clash of the old and the new awkward and foolish, Whistler argued that modern portraits should show people in the clothes they regularly wear. He then proposed a full-length picture of his friend in evening clothes, clearly intending a sartorially more formal product than Manet's *Duret*. Like Whistler, Duret was a social creature who regularly wore smart evening clothes. Nonetheless, the ponderous shape of the Frenchman posed a potential problem for Whistler's overweening commitment to elegance. To Duret's surprise, Whistler asked him to obtain a pink domino—the baggy cloak with a hood (and possibly a mask) that men and women wore over their elegant attire at masked balls. This, along with a red fan, provided an eccentric solution to the artist's pictorial dilemma.

Whistler used the sumptuous folds of the domino to interrupt and enliven the black silhouette of Duret's portly figure. Other items of apparel—a red fan, a white glove, and a top hat—served to animate the grand, centrally placed figure. For the background Whistler was at his reductive best; a mushroom-brown floor atmospherically blended into a slightly warm gray merely suggests a curtain or wall hanging. Quietly echoing the reds and pinks near the center, Whistler signed the picture with a shapely deep red butterfly monogram, placing the exotic insect at rest on the "curtain" behind Duret.

Perhaps unintentionally, Whistler's choice of colors for this particular *Arrangement* gave it more narrative content than usual. The pink and red accessories that Duret holds either indicate that he was a "peacock" or suggest that he is awaiting an absent woman.[1] It is likely that the artist provided the red fan because he used a similar one as a prop in the early 1880s in a few stunningly sensuous sketches of female models, including *Red and Pink: La Petite Mephisto* (Freer Gallery of Art, Washington, D.C.). As with the quirky still-life grouping in the bottom right of Manet's *Duret*, the feminine accouterments in Whistler's portrait had a crucial pictorial purpose. Duret liked to relate how Manet had painted that still life item by item, as a last-minute gambit to bring color and dynamism to an otherwise somber and static composition. Whistler's red and rosy accents—the fan, the domino, and the butterfly—played a comparable formal role, shining out from their surroundings as if to convey an understated but exceptional personal force, like the red cape and pink waistband in Manet's *A Matador* (cat. 149). On a more abstract level, they also reflected the passion for Asian aesthetics shared by Whistler and Duret. These color notes are perhaps as important as the figure of Duret himself, for they are the most vibrant elements in Whistler's *japoniste* design.

Duret's sympathies for Whistler's exacting working methods intensified in the process of being painted. In his monograph on the artist, Duret detailed Whistler's efforts to maintain the right tonal balance between the black costume and all the other subtle colors, concerns that caused the artist to repaint both the figure and the background about ten times over the course of several months. Ironically, at the portrait's Salon debut in 1885, many viewers ignorantly assumed that such a spare and simple work was a sketch that took little time to execute.[2] In 1909 the artist and critic Roger Fry, who encouraged the Metropolitan Museum to purchase the painting, observed, "It is to my mind one of the most extraordinarily scientific works he ever did. . . . [Having] no charm of subject, it relies upon its art pure and simple. . . . It is classic in its completeness and reserve—almost academic in the best sense of the word."[3]

TF

1 For the dark-toned, full-length portrait of another literary and aesthetic bachelor, *Arrangement in Black and Gold: Comte Robert de Montesquiou-Fezensac* (1891–92, Frick Collection, New York), Whistler had the subject hold a woman's cloak. In this later picture the cape does not have feminine associations: it is gray, heavy in appearance, and held more inconspicuously behind the subject's body. Montesquiou borrowed the chinchilla-lined cloak from his cousin, the comtesse Greffulhe.

2. Duret's recollections are quoted in Spassky et al. 1985, pp. 385–86.

3. Letter from Roger Fry to Bryson Burroughs, February 16, 1909, Archives, Metropolitan Museum of Art, New York.

225. *(New York only)* Fig. 10.10

James McNeill Whistler
Arrangement in Black: Pablo de Sarasate

1884
Oil on canvas
90 x 48 in. (228.6 x 121.9 cm)
Signed with butterfly
Carnegie Museum of Art, Pittsburgh, Purchase, 1896 96.2

CATALOGUE RAISONNÉ: A. Young et al. 1980, vol. 2, no. 315 (for further exhibitions and references)

PROVENANCE: Sold by the artist through the New York dealer E. G. Kennedy to the Carnegie Institute (now Carnegie Museum of Art), 1896

SELECTED EXHIBITIONS: London 1885, no. 350; Brussels, Société des XX, 1886; Paris, Salon of 1886, no. 2450; London 1893a, no. 52; Antwerp, Exposition Universelle, 1894; Hamburg 1894, no. 646; Pittsburgh 1896–97, no. 303; Pittsburgh 1897–98, no. 239; Chicago 1898, no. 60; Boston 1904, no. 54; London 1905b, no. 19; Paris 1905, no. 20; New York 1910a, no. 29; Rome, Esposizione Internazionale, 1911, no. 94; Pittsburgh et al. 1957, no. 54; London–New York 1960, no. 47; Chicago–Utica 1968, no. 35; Berlin 1969, no. 37

SELECTED REFERENCES: *St. James Gazette* (July 7, 1884); *Magazine of Art* (1885), pp. 467–68; Phillips 1885, p. 96; de Kay 1886, p. 2; Lostalot 1886, p. 464; Oscar Wilde, quoted in A. Young et al. 1980, vol. 1, p. 155; Whistler to Sydney Starr, quoted in ibid.; Strazdes 1992, pp. 481–82

The virtuoso Spanish violinist Pablo de Sarasate y Navascues (1844–1908) built a strong international reputation through numerous concert tours and compositions for the violin. In addition to joining the artist's name with that of another celebrity, this portrait gave Whistler the opportunity to paint a man with a distinctly Spanish air and heritage. It is easy, for example, to find models with Sarasate's curly black hair, full moustache, and expressive dark eyes in the paintings of Velázquez, whose unidealized depictions of ordinary Spaniards as mythological characters gave his art a strong appeal to Whistler's friends in the French Realist movement.

For *Arrangement in Black* Whistler took a basic formula from the court portraits of Velázquez and introduced variations characteristic of his own modern tendencies. The prototype was Velázquez's *Philip IV* (Museo del Prado, Madrid), in which the king, clad mostly in black, stands ceremoniously with his right foot and shoulder to the fore, towering over a space that is dark and empty except for a table. Whistler's fascination with the Prado's *Philip IV* is confirmed by the fact that he kept a photograph of it in his studio.[1] He produced his first major portrait of this type in the early 1870s; in *Arrangement in Black: F. R. Leyland* (Freer Gallery of Art, Washington, D.C.) he depicted a British shipping magnate wearing evening clothes, with a gray cape over his right arm, standing on the threshold of impenetrable black shadow. Over a decade later, Whistler's *Sarasate* marked a new exploration of the format.

Whistler positioned Sarasate rather deeply in the pictorial space, perhaps mimicking the effect of the musician isolated on a concert stage. The Spaniard's lively silhouette clearly benefited from the ample setting Whistler gave it. Alert and watchful, Sarasate held his violin and bow as he might when proudly accepting an audience's applause. By placing him slightly to the left of center, Whistler created the space necessary for the instrument to become a magical extension of his body, balancing the pleasing asymmetry of the composition with the diagonal of the bow and the subtle butterfly monogram painted beneath it.

The emblematic clarity of *Arrangement in Black* attests to Whistler's genius as a designer of spare statements. As usual, his full artistic expression extended to the reeded, gilt frame, which in this case is a particularly fine example: he embellished sections of it with a painted fish-scale pattern and signed it with his butterfly monogram. Oscar Wilde joked privately that the portrait was "better than Sarasate," recalling that the violinist "was immensely flattered by the furore his portrait produced. He stayed the whole time in the room where it hung. But he looked shockingly ordinary by the side of it."[2] Whistler told an artist that he had heard people quip that his *Sarasate* showed the violinist "standing in a coal cellar." Responding to such "stupidities," Whistler insisted, "I only know that he looked just as he does in my picture when I saw him play in St. James's Hall."[3] The American critic Charles de Kay claimed that Whistler's *Sarasate* was the finest work in the Paris Salon of 1886: "There was no other picture in that immense building which could equal it in originality, delicacy, and all that is rarest in the painter's work."[4]

Whistler sent *Arrangement in Black: Pablo de Sarasate* to six exhibitions throughout Europe between 1885 and 1894. When it hung in the Salon of 1886 the French critic Alfred de Lostalot memorably described the visual intrigue of the figure hovering in palpable black space: "[Whistler presents] a sort of apparition of the celebrated violinist called up by some medium in a séance of spiritualism."[5] Ten years later, while it was on exhibition in Pittsburgh, Whistler agreed to sell it to the Carnegie Institute, which thus became the first museum in the United States to acquire one of the artist's paintings. In 1904 Thomas Eakins included a copy of this portrait in the background of his own likeness of Hedda van den Beemt, first violinist of the Philadelphia Orchestra (*Music*, Albright-Knox Art Gallery, Buffalo). While this was the only instance in which Eakins quoted another painter's work so pointedly, it cannot be assumed to have been a straightforward homage to Whistler, who had died the previous year. According to his colleagues, Eakins considered Whistler's suave and simplifying style to be "a very cowardly way to paint."[6] Eakins may have intended to equate his own local violinist with an international celebrity. Regardless of his motivation, the act confirms that Whistler's portrait of Sarasate had quickly become an icon. TF

226. *(New York only)* *Fig. 14.87*

James McNeill Whistler
Gold and Brown: Self-Portrait

1896–98
Oil on canvas
24½ x 18¼ in. (62.2 x 46.5 cm)
Signed with butterfly
National Gallery of Art, Washington, D.C.,
Gift of Edith Stuyvesant Gerry 159.3.2

CATALOGUE RAISONNÉ: A. Young et al. 1980, vol. 1, no. 462 (for further exhibitions and references)

PROVENANCE: Sold to George. W. Vanderbilt, Asheville, North Carolina, by 1900; bequeathed to his widow (later Mrs. Edith Stuyvesant Gerry); her donation to the National Gallery of Art, Washington, D.C., 1959

SELECTED EXHIBITIONS: London 1898, no. 179; Boston 1904, no. 54; Paris 1905, no. 20; London–New York 1960, no. 129; London–Paris–Washington 1994–95, no. 204

SELECTED REFERENCES: Pennell 1908, vol. 2, p. 221; Pennell 1921, p. 40

In the last decade of his life Whistler experienced an increasingly perceptive climate of critical support. This included a serious assessment of his debt to Velázquez in both style and composition. In 1895, when the painter and critic R. A. M. Stevenson completed his landmark study, *The Art of Velasquez*, he made more textual references to Whistler than to any other modern artist, including Manet and Sargent. Alluding to the rather noble variety of realism practiced by Whistler and the Spanish master, Stevenson wrote, "Truth is the introducer that bids these two men shake hands across several centuries."[1]

Whistler painted four self-portraits soon after Stevenson's work was published, and hindsight makes it tempting to assert that they are united by a moving and very particular commitment to "truth." The first of these late self-portraits was a full-length image that Whistler started in 1895, around the time that his wife, Beatrice, grew seriously ill (fig. 10.12). After her death in 1896 he began three half-length self-portraits, including this one. His process of self-scrutiny, undertaken during a mournful, anguished period, seems to have given Whistler a new personal connection to the somber, monochromatic portraits of Velázquez that he had long admired. All four of his late self-portraits feature dark, shadowy backgrounds and economical applications of paint that readily recall the Spaniard. But when painting the faces of these self-portraits Whistler used unusually light, impressionistic brushstrokes that may convey something of his unsettled spiritual condition.

Gold and Brown is arguably Whistler's most mellow and endearing autobiographical statement. According to Rosalind Birnie Philip, his sister-in-law and executrix, this is the self-portrait that he "wanted to be remembered by."[2] It includes a few of the ingredients that defined the artist's public image—the white forelock, rakish moustache, and monocle—but these celebrity trademarks are secondary to the picture's more poetic desire to evoke a genial and intelligent being. Whistler shows himself on the verge of a smile; he raises his left hand in the manner of an expressive conversationalist and casts a keen, sensitive glance at the viewer. The accent of red on his lapel is the rosette identifying him as an *officier* of the Légion d'Honneur. Bestowed by the French government in 1892, a few months after the portrait of his mother was purchased for the national collection, this was the professional award of which Whistler was most proud.

Gold and Brown was completed in 1898, in time for the inaugural exhibition of the International Society of Sculptors, Painters and Gravers (ISSPG). The self-portrait's kindly air may have been shaped in part by the fact that the artists in that organization had elected him president. Another influence may have been Whistler's knowledge that the ISSPG's first exhibition would include Giovanni Boldini's recently completed *Portrait of James McNeill Whistler* (Brooklyn Museum of Art, New York). As William Merritt Chase had learned in the previous decade, Whistler was extremely touchy about other artists' depictions of him (cat. 203). Boldini's neurotically intense brand of realism skewered two of Whistler's least lovable traits—the dandy's swagger and the pundit's combativeness—and the American was not amused. All the more reason, then, that Whistler might want *Gold and Brown* to affirm that a considerate and worthy person existed behind his shrill dandy's mask.

As Richard Dorment recently observed, "There is no Victorian painter of . . . [Whistler's] moral stature."[3] Whistler upheld his artistic vision through bankruptcy, considerable professional humiliation, and, in his later years, tremendous loss. A year after the ISSPG's inaugural exhibition, Whistler was still struggling with his bereavement. In 1899 he wrote a friend that work had lost its joy and sleep often eluded him; he noted sadly, "I find myself continually calling out in the solitude of my own sad company!"[4] *Gold and Brown* masks those realities, leaving to posterity the noble "truth" of an inspiring face.

TF

1. The photograph is reproduced and discussed in Washington 1984, p. 112.
2. Quoted in A. Young 1980, vol. 1, p. 155. Sarasate did not purchase his portrait from Whistler, but he did commission the artist to decorate the music room of his luxurious Parisian apartment on the boulevard Malesherbes. A British journalist described the interior in 1887: "It is an arrangement of white and delicate pink and yellow, and all the furniture was designed with due regard to the purpose of the room." See Bendix 1995, pp. 172–73.
3. Quoted in A. Young et al. 1980, vol. 1, p. 155. Whistler made the remark in his London studio to artist Sidney Starr.
4. De Kay 1886, p. 2.
5. Quoted in New York 1995–96, p. 156.
6. Quoted in Goodrich 1982, vol. 2, p. 15.

1. Stevenson 1895, revised in Stevenson 1962, p. 89.
2. Quoted in A. Young et al. 1980, vol. 1, p. 202.
3. London–Paris–Washington 1994–95, p. 20.
4. Letter from James McNeill Whistler to William Heinemann, 1899, quoted in ibid., p. 285.

Bibliography

A Diego Íñiguez Angulo. *Murillo: Catálogo crítico*, vol. 2. Madrid, 1981.

G Marcel Guérin. *L'oeuvre gravé de Manet.* New York and Amsterdam, 1969.

G-G Julián Gállego and José Gudiol. *Zurbarán 1598–1664.* Paris, 1987.

G-W Pierre Gassier and Juliet Wilson. *The Life and Complete Work of Francisco Goya, with a catalogue raisonné of the paintings, drawings, and engravings.* New York, 1971.

H Jan Hulsker. *The New Complete Van Gogh: Paintings, Drawings, Sketches.* Amsterdam and Philadelphia, 1996.

J Lee Johnson. *The Paintings of Eugène Delacroix: A Critical Catalogue.* vol. 1. Oxford, 1981.

LR José López Rey. *Velázquez: Catalogue Raisonné.* vol. 2. Cologne, 1996.

LR-1963 José López Rey. *Velázquez: A Catalogue Raisonné of His Oeuvre.* London, 1963.

PS-S Alfonso de Pérez Sánchez and Nicola Spinosa. *L'opera completa del Ribera.* Milan, 1978.

MR Antonio Martínez Ripoll. *Francisco de Herrera "El Viejo."* Seville, 1978.

R-W Denis Rouart and Daniel Wildenstein. *Édouard Manet: Catalogue Raisonné.* 2 vols. Paris, 1975.

S Edward Sullivan. *Baroque Painting in Madrid: The Contribution of Claudio Coello, with a catalogue raisonné of his work.* Columbia, Miss., 1986.

W Harold E. Wethey. *El Greco and His School.* vol. 2. Princeton, N. J., 1962.

Abbé de Fontenay 1776. Louis-Abel de Bonafons, abbé de Fontenay. *Dictionnaire des artistes.* 2 vols. Paris, 1776.

Abrantès 1835. Laure Saint-Martin Junot, duchesse d'Abrantès. *Memorie contemporanee sulla Spagna e sul Portogallo.* Milan, 1835.

Abrantès 1836. Laure Saint-Martin Junot, duchesse d'Abrantès. *Scènes de la vie espagnole.* 2 vols. Paris, 1836.

Abrantès 1838. Laure Saint-Martin Junot, duchesse d'Abrantès. *Souvenirs d'une ambassade et d'un séjour en Espagne et en Portugal, de 1808 à 1811.* 2 vols. Paris, 1837.

Ackerley 1968. J. R. Ackerley. *My Father and Myself.* London, 1968.

Ackerman 1986. Gerald M. Ackerman. *The Life and Work of Jean-Léon Gérôme with a Catalogue Raisonné.* London, 1986.

Ad. M. 1831. Ad. M. [Adélaïde de Montgolfier]. "Bulletin bibliographique." *Revue Encyclopédique* (Paris) 50 (May 1831), pp. 316–31.

Adelson et al. 1997. Warren Adelson et al. *Sargent Abroad: Figures and Landscapes.* New York, 1997.

Adhémar 1935. Jean Adhémar. "À propos du 'Balcon de Manet.'" *Bulletin des Musées de France* (Paris), no. 10 (1935), pp. 155–56.

Adhémar 1948. Jean Adhémar. *Les "Caprices" de Goya.* Paris, 1948.

Adhémar and Cachin 1973. Jean Adhémar and Françoise Cachin. *Edgar Degas, gravures et monotypes.* Paris, 1973.

Adler 1986. Kathleen Adler. *Manet.* Oxford, 1986.

Adriani 1985. Götz Adriani. *Degas: Pastels, Oil Sketches, Drawings.* Translated by Alexander Lieven. New York, 1985.

Aguado 1843a. *Catalogue de tableaux anciens . . . Galerie de M. Aguado marquis de Las Marismas.* Sale cat. Paris, March 20–28, 1843. Paris, 1843.

Aguado 1843b. *Galerie Aguado: Vente de la 2e partie des tableaux.* Sale cat. Paris, April 18–22, 1843. Paris, 1843.

Águeda 1982. Mercedes Águeda. "La colección de pinturas del infante Don Sebastián Gabriel." *Boletín del Museo del Prado* (Madrid) 3, no. 8 (May–August 1982), pp. 102–17.

Akron 1982. *William Merritt Chase: Portraits.* Exh. cat. Akron [Ohio] Art Museum, June 5–August 29, 1982. Akron, 1982.

Alcalá Galiano 1886. Antonio Alcalá Galiano. *Memorias.* 2 vols. Madrid, 1886.

Alcolea Blanch 1996. Santiago Alcolea Blanch. *The Prado.* Translated by Richard-Lewis Rees and Angela Patricia Hall. Reprint, New York, 1996.

Alexandre 1903. Arsène Alexandre. *Carolus-Duran.* Paris, 1903.

Alfonso 1886. Luis Alfonso. *Murillo, el hombre, el artista, las obras.* Barcelona, 1886.

Algueró et al. 1998. Montse Algueró et al. *Zurbarán: Estudio y conservación de los monjes de la Cartuja de Jerez.* Madrid, 1998.

Allende-Salazar 1925. Juan Allende-Salazar, ed. *Velazquez: Des Meisters Gemälde.* 4th ed. Stuttgart, 1925.

Alpers et al. 1999. Svetlana Alpers et al. *Velázquez.* Barcelona and Madrid, 1999.

Alquier 1825. *Catalogue des antiquités, tableaux, dessins, pierres gravées, médailles, et objets divers, qui composent la collection de M. le baron Alquier.* Sale cat. Paris, Hôtel de Bullion, June 27, 1825. Paris, 1825.

Altamira 1827. *Pictures from Spain: A Catalogue of a Magnificent Collection of Pictures, By the Most Distinguished Italian, Spanish, and Flemish Painters, Being a Considerable Portion of the Gallery of Count Altamira.* Sale cat. London, Stanley, June 1, 1827. London, 1827.

Álvarez Lopera 1987. José Álvarez Lopera. *De Ceán a Cossío: La fortuna crítica del Greco en el siglo XIX.* Madrid, 1987.

Álvarez Lopera 1993. José Álvarez Lopera. *El Greco: La obra esencial.* Madrid, 1993.

Álvarez Lopera 1999a. José Álvarez Lopera. "Fascinados por Velázquez." *Descubrir el Arte* (Madrid), no. 4 (June 1999), pp. 72–81.

Álvarez Lopera 1999b. José Álvarez Lopera. "El siglo de Justi." In Carl Justi, *Velázquez y su siglo,* pp. xi–xlii. Madrid, 1999.

Álvarez Lopera 2001. José Álvarez Lopera. "Fama temprana de Cano en Europa." *Cuadernos de Arte de la Universidad de Granada,* no. 32 (2001), pp. 17–43.

Álvarez Turienzo 1985. Saturnino Álvarez Turienzo. *El Escorial en las letras españolas.* Madrid, 1985.

Amade 1822–23. Amade. *Voyage en Espagne, ou Lettres philosophiques contenant l'histoire générale des dernières guerres de la péninsule, par M. Amade, ancien commissaire des guerres adjoint.* 2 vols. Paris, 1822–23.

Amador de los Ríos 1844. José Amador de los Ríos. *Sevilla pintoresca o descripción de sus más celebres monumentos artísticos.* Seville, 1844.

Amateur 1838. L'Amateur [The Amateur]. "Salon de 1838." *La Quotidienne* (Paris) (March 10, 1838).

Amaury-Duval 1993. Amaury-Duval. *L'atelier d'Ingres* (1878). Edited by Daniel Ternois. Paris, 1993.

Amornpichetkul 1989. Chittima Amornpichetkul. "Berthe Morisot: A Study of Her Development from 1864 to 1886." Master's thesis, Brown University, 1989.

Amsterdam 1998–99. *Schittering van Spanje, 1598–1648: Van Cervantes tot Velázquez.* Exh. cat. by Chris van der Heijden, Marina Alfonso Mola, and Carlos Martínez Shaw. Amsterdam, De Nieuwe Kerk, November 20, 1998–March 8, 1999. Zwolle, 1998.

Andersen 1988. Hans Christian Andersen. *Viaje por España* (1862). Madrid, 1988.

Anes 1996. Gonzalo Anes. *Las colecciones reales y la fundación del Museo del Prado.* Madrid, 1996.

Angrand 1966. Pierre Angrand. "Ingres et Velázquez." *Bulletin du Musée Ingres* (Montauban), no. 19 (July 1966), pp. 7–12.

Angulo Íñiguez 1954. Diego Angulo Íñiguez. "Algunos cuadros españoles en museos franceses." *Archivo Español de Arte* (Madrid), no. 108 (1954), pp. 315–25.

Angulo Íñiguez 1961. Diego Angulo Íñiguez. "Las copias de los cuadros de la Caridad." *Boletín de la Real Academia de la Historia* (Madrid) (1961).

Angulo Íñiguez 1963. Diego Angulo Íñiguez. "Mythology and Seventeenth-Century Spanish Painting." In *Studies in Western Art,* vol. 3, *Latin American Art, and the Baroque Period in Europe,* pp. 36–40. Princeton, N.J., 1963.

Angulo Íñiguez 1966. Diego Angulo Íñiguez. "El 'San Jeronimo,' de Herrera el Viejo, del Museo de Rouen." *Archivo Español de Arte* (Madrid) 39, nos. 154–155 (April–September 1966), pp. 194–95.

Angulo Íñiguez 1971. Diego Angulo Íñiguez. *Pintura del siglo XVII.* Ars Hispaniae, vol. 15. Madrid, 1971.

Angulo Íñiguez 1976a. Diego Angulo Íñiguez. "Casa de Venerables Sacerdotes." *Boletín de Bellas Artes* (Seville) (1976).

Angulo Íñiguez 1976b. Diego Angulo Íñiguez. "Varia. Murillo: *Fray Francisco y la cocina de los angeles* del Museo del Louvre y los *Dos franciscanos* del Museo de Ottawa." *Archivo Español de Arte* (Madrid), no. 194 (1976), pp. 175–76.

Angulo Íñiguez 1981. Diego Angulo Íñiguez. *Murillo.* 3 vols. Madrid, 1981.

Ann Arbor 1969. *Manet and Spain: Prints and Drawings.* Exh. cat. Edited by Joel Isaacson. Ann Arbor, Museum of Art, University of Michigan, January 19–March 2, 1969. Ann Arbor, 1969.

Anon. 1831. Anonymous. "Sancho." *L'Artiste* (Paris) 1 (1831), pp. 39–40.

Anon. 1833. Anonymous. "Salon de 1833." *L'Artiste* (Paris) (1833), pp. 84–85.

Anon. 1834a. Anonymous. "Musée du Louvre. Josef de Ribera, dit l'Espagnolet, peintre espagnol." *Le Magasin Pittoresque* (Paris) 2, no. 45 (1834), pp. 353–54.

Anon. 1834b. Anonymous. "Musée du Louvre. Peintres espagnols. Murillo." *Le Magasin Pittoresque* (Paris) 2, no. 27 (1834), pp. 209–10.

Anon. 1834c. Anonymous. "Peintres espagnols. Francisco Goya y Lucientes." *Le Magasin Pittoresque* (Paris) 2, no. 41 (1834), pp. 324–25.

Anon. 1835a. Anonymous. "Des arts considerées à Paris comme objet de négoce." *Revue de Paris,* n.s. 14 (1835), pp. 196–202.

Anon. 1835b. Anonymous. "La liste civile et les tableaux de M. le maréchal Soult." *L'Artiste* (Paris) 9 (1835), pp. 195–97.

Anon. 1835c. Anonymous. "Revue des arts. Paris, 14 février 1835." *L'Artiste* (February 14, 1835), pp. 27ff.

Anon. 1837a. Anonymous. "Beaux-Arts. Chronique." *Le Cercle* (Paris) 1 (April 4, 1837).

Anon. 1837b. Anonymous. "École de peinture espagnole." *Le Constitutionnel* (Paris) (July 2, 1837; September 1, 1837).

Anon. 1837c. Anonymous. "Ouverture publique des nouveaux musées du Louvre." *Le Temps* (Paris) (January 7, 1837).

Anon. 1837d. Anonymous. "Le nouveau Musée Espagnole." *Journal des Artistes* (Paris) 11 (February 19, 1837; April 4, 1837; June 18, 1837).

Anon. 1837–38. Anonymous. "La Galerie Espagnole." *Le Temps* (Paris) (November 10 and 22, 1837; January 7, 1838; February 4, 1838).

Anon. 1838a. Anonymous. "Beaux-arts: Le Musée espagnol." *Le Constitutionnel* (Paris) (January 21, 1838), pp. 1–3.

Anon. 1838b. Anonymous. "Chronique parisienne." *La Mode* (Paris) (April 28, 1838), pp. 92–93.

Anon. 1838c. Anonymous. "La Galerie Espagnole au Louvre: François Zurbarán." *Le Magasin Pittoresque* (Paris) 6, no. 9 (March 1838), pp. 65–66.

Anon. 1838d. Anonymous. "La Galerie Espagnole au Louvre. Juan de Joanès.—Velasquez de Silva.—

Esteban Murillo." *Le Magasin Pittoresque* (Paris) 6, no. 3 (January 1838), pp. 17–19.

Anon. 1838e. Anonymous. "Le Musée Espagnol." *Vert-Vert,* no. 13 (January 13, 1838).

Anon. 1838f. Anonymous. "Musée Espagnol." *Le Charivari* (Paris) (January 3, 1838), p. 1.

Anon. 1838g. Anonymous. "Salon de 1838." *L'Artiste* (Paris) 15 (1838), pp. 85–89.

Anon. 1841. Anonymous. "Rapport du baron Taylor à la Liste Civile." *Le Charivari* (Paris) (April 16, 1841).

Anon. 1842a. Anonymous. "Le Musée Standish." *Cabinet de l'Amateur et de l'Antiquaire* (Paris) 1 (1842), pp. 209–14.

Anon. 1842b. Anonymous. "Musées et collections particulières des départements: Musée de Nantes, École espagnole." *Le Magasin Pittoresque* (Paris) 10, no. 37 (1842), pp. 292–93.

Anon. 1843. Anonymous. "Vente de la Galerie Aguado." *L'Illustration* (Paris), no. 5 (April 1843), pp. 67–68.

Anon. 1850. Anonymous. "Variedades: Literatura y artes: Esposición de pinturas de 1850." *La Esperanza: Periódico Monarquico* (Madrid), no. 1845 (October 10, 1850), n.p.

Anon. 1864. Anonymous. "À la campagne." *La Vie Parisienne* (June 18, 1864).

Anon. 1865a. Anonymous. "Une dernière visite à la galerie Pourtalès." *La Vie Parisienne* (January 21, 1865; January 28, 1865).

Anon. 1865b. Anonymous. *Chronique des Arts et de la Curiosité* (Paris) 3, no. 100 (April 16, 1865), p. 137.

Anon. 1867a. Anonymous. "Bonaparte en Italia." *Revista de Bellas Artes* (Madrid), no. 16 (January 20, 1867).

Anon. 1867b. Anonymous. "Venta de cuadros españoles." *Revista de Bellas Artes* (Madrid), no. 19 (February 10, 1867).

Anon. 1867c. Anonymous. "Mouvement des arts et de la curiosité: La Galerie Soult, tableaux anciens." *Chronique des Arts et de la Curiosité* (Paris) 5 (April 28, 1867).

Anon. 1874. Anonymous. "Le Musée des Copies: Son catalogue." *Chronique des Arts et de la Curiosité* (Paris) (January 3, 1874), pp. 1–2; (February 7, 1874), p. 31; (February 14, 1874), p. 62.

Anon. 1879. Anonymous. "L'ouverture du Salon." *Le Siècle* (Paris) (May 12, 1879), p. 2.

Anon. 1883a. Anonymous. "Dialogue sur le Salon de 1883." *La Nouvelle Revue* (Paris) 22 (May–June 1883), pp. 714–15.

Anon. 1883b. Anonymous. "Sixth [Society of] American Artists [Exhibition]." *Art Interchange* (New York) 10 (May 29, 1883), p. 82.

Anon. 1885. Anonymous. "Nouvelles diverses." *Journal des Débats* (Paris) (February 22, 1885), p. 2.

Anon. 1886. Anonymous. "A Boston Estimate of a New York Painter." *Art Interchange* (New York) 17 (December 4, 1886), p. 179.

Anon. 1887. Anonymous. "Art Notes." *Art Review* (New York) 1 (February 1887), p. 20.

Anon. 1890a. Anonymous. "The Saunterer." *Town Topics* (New York) 22 (April 3, 1890), p. 2.

Anon. 1890b. Anonymous. "The Society of American Artists Exhibition." *The Art Amateur* (New York) 23 (June 1890), p. 3.

Anon. 1890c. Anonymous. "What the Artists Think of Sargent's 'Beatrice.'" *Harper's Weekly* (New York) 35 (May 9, 1890), p. 347.

Anon. 1891. Anonymous. "The Society of American Artists of New York." *Studio* 6 (May 2, 1891), p. 212.

Anon. 1892. Anonymous. *Art and Criticism* (1892), p. 105.

Anon. 1902. Anonymous. "Remarkable Portrait by Sargent at Knoedler's." *New York Times* (November 2, 1902), p. 12.

Anon. 1917. Anonymous. "Janitor Brother Tells How Chance Aided W. M. Chase." *Indianapolis Star* (March 25, 1917).

Ansón Navarro 1995. Arturo Ansón Navarro. *Goya y Aragón: Familia, amistades y encargos artísticos.* Saragossa, 1995.

Antigüedad 1987a. María Dolores Antigüedad. "José Bonaparte y el patrimonio artístico de los conventos madrileños." *Fragmentos* (Madrid) (January 1987).

Antigüedad 1987b. María Dolores Antigüedad. "La primera colección pública en España: El Museo Josefino." *Fragmentos* (Madrid), no. 11 (February 1987), pp. 67–85.

Antigüedad 1999. María Dolores Antigüedad. *El patrimonio artístico de Madrid durante el gobierno intruso (1808–1813).* Madrid, 1999.

Aranjuez 1989. *El arte en las cortes Europeas del siglo XVIII: Comunicaciones, congreso, Madrid, Aranjuez, 27 o 29 abril 1987.* Madrid, 1989.

Arches 1981. Pierre Arches. "De la porte Saint-Gelais au ministère des arts: L'ascension d'une famille niortaise, les Proust (1681–1881)." *Bulletin de la Société Historique et Scientifique des Deux-Sèvres* (Niort) 14 (1981), pp. 267–336.

Argencourt 1999. Louise d'Argencourt. *The Cleveland Museum of Art Catalogue of Paintings, Part 4: European Paintings of the Nineteenth Century.* Cleveland, 1999.

Arles–Madrid 1990. *Goya, toros y toreros.* Exh. cat. by Pierre Gassier. Arles, Espace Van Gogh, March 3– June 5, 1990; Madrid, Real Academia de Bellas Artes de San Fernando, June 15–July 29, 1990. Madrid, 1990.

Armstrong 1896. Walter Armstrong. *The Life of Velázquez.* London, 1896.

Armstrong 1897. Walter Armstrong. *Velázquez: A Study of His Life and Art.* London, 1897.

Arnáiz 1981. José Manuel Arnáiz. *Eugenio Lucas, su vida y su obra.* Madrid, 1981.

Arnáiz 1987. José Manuel Arnáiz. *Francisco de Goya, cartones y tapices.* Madrid, 1987.

Arras–Quimper–Dublin 2002. *Jules Breton, la chanson des blés.* Exh. cat. by Annette Bourrut Lacouture. Arras, France, Musée des Beaux-Arts, March 16–June 2, 2002; Quimper, France, Musée des Beaux-Arts, June 15– September 2, 2002; Dublin, National Gallery of Ireland, September 23–December 15, 2002. Paris, 2002.

Artola et al. 2002. Miguel Artola et al. *Goya.* Barcelona, 2002.

Asselineau 1869. Charles Asselineau. *Charles Baudelaire, sa vie et son oeuvre.* Paris, 1869.

Astruc 1859. Zacharie Astruc. *Les 14 stations du Salon: 1859. Suivies d'un récit douloureux.* Paris, 1859.

Astruc 1878. *Tableaux anciens et modernes: Aquarelles et sculptures par Zacharie Astruc.* Sale cat. Paris, Hôtel Drouot, April 11–12, 1878. Paris, 1878.

Astruc 1883. Zacharie Astruc. *Romancero de l'Escorial: Poèmes de l'Espagne.* Paris, 1883.

Athanassoglou-Kallmyer 1991. Nina Maria Athanassoglou-Kallmyer. *Eugène Delacroix: Prints, Politics, and Satire, 1814–1822.* New Haven, 1991.

Atlanta–Minneapolis 2001. *Degas and America: The Early Collectors.* Exh. cat. by Ann Dumas and David A. Brenneman. Atlanta, Ga., High Museum of Art, March 3–May 27, 2001; Minneapolis Institute of Arts, June 16–September 9, 2001. Atlanta and Minneapolis, 2000.

Auvray 1873. Louis Auvray. *Le Musée Européen: Copies d'après les grands maîtres au Palais des Champs Élysées.* Paris, 1873.

Baccheschi 1980. Edi Baccheschi. *El Greco: The Complete Paintings.* New York, 1980.

Bäcksbacka 1962. Ingjald Bäcksbacka. *Luis de Morales.* Helsinki, 1962.

Badesco 1957. Luc Badesco. "Baudelaire et la revue *Jean Raisin*: La première publication du *Vin des chiffonniers.*" *Revue des Sciences Humaines* (Lille) (January–March 1957), pp. 55–85.

Bailey 1984. Colin B. Bailey. "Lebrun et le commerce d'art pendant le Blocus continental. Patriotisme et marge bénéficiaire" *Revue de l'Art* (Paris), no. 63 (1984), pp. 35–46.

Bailey 1989. Colin B. Bailey. "The Comte de Vaudreuil: Aristocratic Collecting on the Eve of the Revolution" *Apollo* (London) 130 (July 1989), pp. 19–26.

Bailey 2002. Colin B. Bailey. *Patriotic Taste: Collecting Modern Art in Pre-Revolutionary Paris.* New Haven, 2002.

Baillière 1872. Henri Baillière. *Henri Regnault, 1843–1871.* Paris, 1872.

Bailly-Herzberg 1972. Janine Bailly-Herzberg. *L'eau-forte de peintre au dix-neuvième siècle: La Société des Aquafortistes, 1862–1867.* 2 vols. Paris, 1972.

Baltimore–Houston–Cleveland 1999–2000. *Faces of Impressionism: Portraits from American Collections.* Exh. cat. by Sona Johnston, with Susan Bollendorf. Baltimore Museum of Art, October 10, 1999– January 30, 2000; Houston, Museum of Fine Arts, March 25–May 7, 2000; Cleveland Museum of Art, May 28–July 30, 2000. Baltimore and New York, 1999.

Balzac 1831. Honoré de Balzac. *La peau de chagrin.* Paris, 1831.

Baratech Zalama 1989. María Teresa Baratech Zalama. "La testamentaría del infante Don Sebastián Gabriel de Borbón y Braganza." *Archivo Español de Arte* (Madrid), no. 247 (1989), pp. 372–77.

Barcelona 1910. *Exposición retrospectiva.* Exh. cat. by P. Reig. Barcelona, 1910.

Bardi 1977. Pietro M. Bardi. *La obra pictórica completa de Velázquez.* Barcelona, 1977.

Bardy 1898–99. Henri Bardy. "Le Général Guye, maire de la ville de Saint-Dié du 25 septembre 1829 au 30 octobre 1830." *Bulletin de la Société Philomatique Vosgienne* (Saint-Dié) 25 (1898–99), pp. 132–52.

Barghahn 1993. Barbara von Barghahn. "Goya's Dark Crucible: Amalgams of Ambiguity." *Gazette des Beaux-Arts* (Paris) 122 (December 1993), pp. 253–68.

Barousse 1973. Pierre Barousse. *Catalogue du Musée Ingres.* Montauban, 1973.

Barré et al. 1809. Pierre-Yon Barré, Jean Baptiste Radet, and François-Georges Fouques [Desfontaines]. *Le peintre français en Espagne, ou Le dernier soupir de l'Inquisition, comédie-vaudeville, en un acte.* Paris, 1809.

Barrès 1894. Maurice Barrès. *Du sang, de la volupté et de la mort: Un amateur d'âmes, Voyage en Espagne, Voyage en Italie, etc.* Paris, 1894.

Barrès 1912. Maurice Barrès. *Greco, ou Le secret de Tolède.* Paris, 1912.

Basel 1999. *Manet, Zola, Cézanne: Das Porträt des modernen Literaten.* Exh. cat. Edited by Katharina Schmidt. Basel, Kunstmuseum, February 6–June 21, 1999. Ostfildern-Ruit, 1999.

Baticle 1964. Jeannine Baticle. "Pintura española del siglo XVII en Francia." *Goya* (Madrid), no. 58 (1964), pp. 288–99.

Baticle 1971. Jeannine Baticle. "L'activité de Goya entre 1796 et 1806 vue à travers le 'Diario' de Moratin." *Revue de l'Art* (Paris), no. 13 (1971), pp. 111–14.

Baticle 1972. Jeannine Baticle. "Eugenio Lucas et les satellites de Goya." *Revue du Louvre* (Paris) 22, no. 3 (1972), pp. 163–75.

Baticle 1977. Jeannine Baticle. "Le portrait de la marquise de Santa Cruz par Goya." *Revue du Louvre* (Paris) 27, no. 3 (1977), pp. 153–63.

Baticle 1979. Jeannine Baticle. "Deux tableaux d'Alonso Cano: Essai de reconstitution d'un retable." *Revue du Louvre* (Paris) 39, no. 2 (1979), pp. 123–34.

Baticle 1986. Jeannine Baticle. *Goya d'or et de sang.* Paris, 1986. Translated by Alexander Campbell as *Goya, Painter of Terrible Splendor.* New York, 1994.

Baticle 1998. Jeannine Baticle. "Zurbarán vu par Dauzats en 1836." *Gazette des Beaux-Arts* (Paris) 132 (October 1998), pp. 101–10.

Baticle and Marinas 1981. Jeannine Baticle and Cristina Marinas, eds. *La Galerie Espagnole de Louis-Philippe au Louvre: 1838–1848.* Paris, 1981.

Baudelaire 1868. Charles Baudelaire. *Oeuvres complètes,* vol. 1, *Les fleurs du mal.* Preface by Théophile Gautier. Paris, 1868.

Baudelaire 1887. Charles Baudelaire. *Oeuvres posthumes et correspondances inédites, précédées d'une étude biographique par Eugène Crépet.* Paris, 1887.

Baudelaire 1933. Charles Baudelaire. *Le Salon de 1845.* Edited by André Ferran. Toulouse, 1933.

Baudelaire 1946. Charles Baudelaire. *Curiosités esthétiques.* Paris, 1946.

Baudelaire 1971. Charles Baudelaire. *Écrits sur l'art.* 2 vols. Edited by Yves Florenne. Paris, 1971.

Baudelaire 1973. Charles Baudelaire. *Correspondance.* 2 vols. Edited by Claude Pichois and Jean Ziegler. Paris, 1973.

Baudelaire 1975–76. Charles Baudelaire. *Oeuvres complètes.* 2 vols. Edited by Claude Pichois. New ed. Paris, 1975–76.

Baudelaire 1992. Charles Baudelaire. *Écrits sur l'art.* Edited by Francis Moulinat. Paris, 1992.

Bazin 1958. Germain Bazin. *Musée de l'Ermitage: Les grands maîtres de la peinture.* Paris, 1958.

Bazin 1987. Germain Bazin. *Théodore Géricault: Étude critique, documents et catalogue raisonné.* 7 vols. With appendixes. Paris, 1987.

Bazire 1884. Edmond Bazire. *Manet.* Paris, 1884.

Bean 1995. Tom Bean. "Richard Ford as Picture Collector and Patron in Spain." *The Burlington Magazine* (London) 137 (February 1995), pp. 96–107.

Beauvoir 1837. Roger de Beauvoir. "Beaux-arts: École de peinture espagnole." *Le Constitutionnel* (Paris) (September 1, 1837), pp. 1–3.

Beauvoir 1844a. Roger de Beauvoir. *Les artes en Espagne.* Paris, [1844].

Beauvoir 1844b. Roger de Beauvoir. "Les Espagnols." In *Les Étrangers à Paris,* pp. 469–88. Paris, 1844.

Beckwith Diary. James Carroll Beckwith Diary. National Academy of Design, New York.

Bédarida 1931. Henri Bédarida. "Le romantisme français et l'Espagne." *Revue de l'Université de Lyon* 4, no. 2 (1931), pp. 191–213.

Bédat 1973. Claude Bédat. *L'Académie des Beaux-Arts de Madrid, 1744–1808: Contribution à l'étude des influences stylistiques et de la mentalité artistique de l'Espagne du XVIIIe siècle.* Toulouse-le-Mirail, 1973.

Bégin 1852. Émile-Auguste Bégin. *Voyage pittoresque en Espagne et en Portugal.* Paris, [1852].

Béguin 1969. Sylvie Béguin. "Hommage à Louis La Caze." *Revue du Louvre* (Paris) 19, no. 2 (1969), pp. 115–32.

Belgrade 1981. *Exposición de arte español.* Exh. cat. Belgrade, 1981.

Belgrade–Ljubljana–Zagreb 1987–88. *Hermitage Masterpieces: Paintings and Drawings XV–XVII Centuries.* Exh. cat. Belgrade, 1987.

Belleroche 1926. Albert [de] Belleroche. "The Lithographs of Sargent." *Print Collector's Quarterly* (New York) 13 (February 1926), pp. 31–44.

Bemis Papers. George Bemis Papers. Massachusetts Historical Society, Boston.

Benassar 1998. Bartolomé Benassar and Lucile Benassar. *Le voyage en Espagne: Anthologie des voyageurs français et francophones du XVIe au XIXe siècle.* Paris, 1998.

Bendix 1995. Deanna Marohn Bendix. *Diabolical Designs: Paintings, Interiors, and Exhibitions of James McNeill Whistler.* Washington, D.C., 1995.

Bénédite 1900. Léonce Bénédite. *Alphonse Legros.* Paris, 1900.

Bénédite 1905. Léonce Bénédite. "Whistler." *Gazette des Beaux-Arts* (Paris) 33 (June 1, 1905), pp. 496–511.

Bénédite 1911. Léonce Bénédite. *Courbet.* Paris, 1911.

Bénédite 1912. Léonce Bénédite. *Le Musée du Luxembourg: Les peintures.* Paris, 1912.

Bénédite 1923. Léonce Bénédite. *Le Musée du Luxembourg: Les peintures, école française.* 2d ed. Paris, 1923.

Bénédite 1931. Léonce Bénédite. *Théodore Chassériau, sa vie et son oeuvre.* 2 vols. Paris, 1931.

Benisovich 1948. Michel Benisovich. "Monsieur Ingres as an Art Expert." *Gazette des Beaux-Arts* (Paris) 34 (July 1948), pp. 59–62.

Benisovich 1956. Michel Benisovich. "Sales of French Collections of Paintings in the United States

during the First Half of the Nineteenth Century." *Art Quarterly* 19, no. 3 (Autumn 1956), pp. 288–301.

Benoist de Matougues 1838. L. Benoist de Matougues. "Musée espagnole." *Le Lithographie: Journal des Artistes et des Imprimeurs* (Paris) (1838), pp. 65–79, 105–18.

J. Berger 1991. John Berger. *Velázquez, Äsop: Erzählungen zur spanischen Malerei.* Frankfurt, 1991.

J. Berger 1994. John Berger. "Los enanos cambian de sitio." In *El retrato en el Museo del Prado.* Madrid, 1994, pp. 371–79.

K. Berger 1943. Klaus Berger. "Courbet in His Century." *Gazette des Beaux-Arts* (Paris) 24 (July–December 1943), pp. 19–40.

Berges 1966. Félix Berges. "Un itinéraire du comte Alexandre de Laborde, de Lérida à Saragosse." In *Mélanges à la mémoire de Jean Sarrailh,* vol. 1, pp. 117–27. Paris, 1966.

Bergot et al. 1992. François Bergot, Marie Pessiot, and Gilles Grandjean. *Musée des Beaux-Arts de Rouen: Guide des collections, XVIe–XVIIe siècles.* Paris, 1992.

Berlin 1904. *Katalog der neunten Kunstausstellung der Berliner Secession.* Exh. cat. 2d ed. Berlin, 1904.

Berlin 1906. *Ausstellung der Sammlung Faure.* Exh. cat. Berlin, Paul Cassirer, [Durand-Ruel], September 22–October 22, 1906. Berlin, 1906.

Berlin 1909. *Grosse Berliner Kunstausstellung.* Exh. cat. Edited by Hans Looschen. Berlin, 1909.

Berlin 1928. *Ausstellung Edouard Manet, 1832–1883: Gemälde, Pastelle, Aquarelle, Zeichnungen.* Exh. cat. Berlin, Galerie Matthiesen, February 6–March 18, 1928. Berlin, 1928.

Berlin 1965. *Von Delacroix bis Picasso.* Exh. cat. Berlin, Nationalgalerie, September–October 1965. Berlin, 1965.

Berlin 1969. *James McNeill Whistler (1834–1903).* Exh. cat. by Henning Bock et al. Berlin, National-galerie, October 1–November 24, 1969. Berlin, 1969.

Berlin–Munich 1910. *Edouard Manet: Aus der Sammlung Pellerin.* Exh. cat. Berlin, Paul Cassirer, April 1910; Munich, Moderne Galerie, May 1, 1910. Munich, 1910.

Bern 1973. J. P. Bern. "Un voyageur français dans la première moitié du XIXe siècle: Baron Taylor." Ph.D. diss., Université de Paris X, 1973.

Berne 1994. *150 ausgewählte Kunstwerke des 19. und 20. Jahrhunderts.* Sale cat. Berne, Galerie Kornfeld, June 24, 1994. Berne, 1994.

Berne–Hamburg 1996. *Zeichnen ist Sehen: Meisterwerke von Ingres bis Cézanne aus dem Musée der Bildenden Münste Budapest und aus Schweizer Sammlungen.* Exh. cat. Edited by Judit Geskó et al. Berne, Kunstmuseum, March 29–June 2, 1996; Hamburger Kunsthalle, July 5–September 8, 1996. Ostfildern-Ruit, 1996.

Beroqui 1927. Pedro Beroqui. "Una biografía de Goya escrita por su hijo." *Archivo Español de Arte y Arqueología* (Madrid) 3 (1927), p. 100.

Beroqui 1930. Pedro Beroqui. "El Museo del Prado (notas para su historia)." *Boletín de la Sociedad Española de Excursiones* (Madrid) 38 (1930), pp. 33–48, 112–27, 189–203, 252–69.

Beroqui 1931. Pedro Beroqui. "Apuntes para la historia del Museo del Prado: Cincuenta cuadros para Napoleón." *Boletín de la Sociedad Española de*

Excursiones (Madrid) 39 (1931), pp. 20–34, 94–108, 190–204, 261–74.

Beroqui 1932. Pedro Beroqui. "El Museo del Prado (notas para su historia)." *Boletín de la Sociedad Española de Excursiones* (Madrid) 40 (1932), pp. 7–21, 85–97, 213–20.

Beroqui 1933. Pedro Beroqui. *El Museo del Prado (notas para su historia). 1, El Museo Real 1819–1933.* Madrid, 1933.

Beruete 1898. Aureliano de Beruete. *Velázquez.* Preface by Léon Bonnat. Paris, 1898.

Beruete 1906. Aureliano de Beruete. *Velázquez.* Translated by Hugh E. Poynter. London, 1906.

Beruete 1913. Aureliano de Beruete. "Deux portraits inédits de Goya." *Les Arts* (Paris), no. 136 (April 1913), pp. 1–4.

Beryes 1948. Ignacio de Beryes. *Domenicos Theotocopoulos, El Greco.* 2d ed. Barcelona, 1948.

Beulé 1861a. Ernest Beulé. "Murillo et l'Andalousie." *Revue des Deux Mondes* (Paris) (October 15, 1861), pp. 814–38.

Beulé 1861b. Ernest Beulé. "Velasquez au Musée de Madrid." *Revue des Deux Mondes* (Paris) (July 1, 1861), pp. 165–92.

Beylié 1909. Leon-Marie-Eugène de Beylié. *Le Musée de Grenoble: Peintures, dessins, marbres, bronzes, etc.* Paris, 1909.

Bilbao 1999. *Museo de Bellas Artes de Bilbao: Maestros antiquos y modernos.* Bilbao, 1999.

Bjurström 1962. Per Bjurström. "Jacob Gustaf de la Gardie och Goya." *Meddelanden från Nationalmuseum* (Stockholm) (1962), pp. 77–81.

Blackburn 1881. Henry Blackburn, ed. *Grosvenor Notes: With Facsimiles of Sketches by Artists,* no. 4. London, 1881.

Blanc 1857. Charles Blanc. *Les trésors de l'art à Manchester.* Paris, 1857.

Blanc 1857–58. Charles Blanc. *Le trésor de la curiosité, tiré des catalogues de vente de tableaux, dessins, estampes, livres, marbres . . .* 2 vols. Paris, 1857–58.

Blanc 1863. Charles Blanc. "Vélasquez à Madrid." *Gazette des Beaux-Arts* (Paris) 15 (July 1, 1863), pp. 65–74.

Blanc 1876. Charles Blanc. *Les artistes de mon temps.* Paris, 1876.

Blanc et al. 1861–76. Charles Blanc et al. *Histoire des peintres de toutes les écoles.* 14 vols. Paris, 1861–76.

Blanc et al. 1869. Charles Blanc, Paul Lefort, Paul Mantz, Théophile Thoré (W. Bürger), and Louis Viardot. *Histoire des peintres de toutes les écoles, École espagnole.* Paris, 1869.

Blashfield 1896. Edwin H. Blashfield. "Léon Bonnat." In *Modern French Masters: A Series of Biographical and Critical Reviews by American Artists,* edited by John C. Van Dyke, pp. 45–56. New York, 1896. Reprint, New York, 1976.

Blashfield 1925. Edwin H. Blashfield. "John Singer Sargent—Recollections." *North American Review* (Boston) 221 (June 1925), pp. 641–42.

Blashfield 1927. Edwin H. Blashfield. "John Singer Sargent." In *Commemorative Tributes to Cable, Sargent, Pennell,* pp. 9–44. New York, 1927.

Blayney 1814. Andrew Thomas Blayney. *Narrative of a Forced Journey through Spain and France, as a*

Prisoner of War, in the Years 1810 to 1814. 2 vols. London, 1814.

Blaze de Bury 1837. Henri Blaze de Bury. "La Galerie espagnole au Louvre." *Revue des Deux Mondes* (Paris) 10 (May 15, 1837), pp. 532–42.

Bode 1882. Wilhelm von Bode. *Kaiserliche Gemälde-Galerie der Ermitage in St. Petersburg.* Berlin, 1882.

Bode 1904. Wilhelm von Bode. *The Art Collection of Mr. Alfred Beit at His Residence, 26 Park Lane, London.* Berlin, 1904.

Bodelsen 1968. Merete Bodelsen. "Early Impressionist Sales, 1874–94, in the Light of Some Unpublished 'procès verbaux.'" *The Burlington Magazine* (London) 110 (June 1968), pp. 331–48.

Boggs 1962. Jean Sutherland Boggs. *Portraits by Degas.* Berkeley, 1962.

Boime 1964. Albert Boime. "Le Musée des Copies." *Gazette des Beaux-Arts* (Paris) 64 (October 1964), pp. 237–47.

Boime 1971. Albert Boime. *The Academy and French Painting in the Nineteenth Century.* New York, 1971. Reprint, New Haven, 1986.

Boime 1994–95. Albert Boime. "Maria Deraismes and Eva Gonzalès: A Feminist Critique of *Une Loge aux Théâtre des Italiens.*" *Woman's Art Journal* (Knoxville) 15 (Fall 1994–Winter 1995), pp. 31–37.

Bois 1994. Mario Bois. *Manet tauromachies et autres thèmes espagnols.* Paris, 1994.

Boisdenier 1856. F. B. de Boisdenier. "Théodore Chassériau." *Le Siècle* (Paris) (October 20, 1856).

Bolger 1974. Doreen Bolger. "Velasquez and the Late Nineteenth-Century American Figure Painters: A Study in Art and Admiration." Unpublished ms., City University of New York, 1974.

Bolger 1980. Doreen Bolger. *American Paintings in the Metropolitan Museum of Art,* vol. 3, *A Catalogue of Works by Artists Born between 1846 and 1864.* New York, 1980.

Bologna 1998. *Luci del secolo d'oro spagnolo.* Exh. cat. by Fernando Checa Cremades, Andrea Emiliani, and Édouard Pommier. Bologna, Pinacoteca Nazionale, February 8–April 13, 1998. Paris and Bologna, 1998.

Bonaparte 1812. *Choix de gravures à l'eauforte, d'après les peintures originales et les marbres de la galerie de Lucien Bonaparte.* London, 1812.

Bonaparte 1815. *Catalogue of the Splendid Collection of Pictures Belonging to Prince Lucien Bonaparte.* Sale cat. London, New Gallery, February 6, 1815. London, 1815.

Bonaparte 1840. *Catalogue des tableaux . . . propriété de M. Lucien Bonaparte.* Sale cat. Paris, January 13–16, 1840. Paris, 1840.

Bonaparte 1845. *Catalogue of Valuable Paintings and Statuary, the Collection of the Late Joseph Bonaparte, Count de Survilliers.* Sale cat. Bordentown, N.J., September 17–18, 1845. N.p., 1845.

Bonaparte 1847. *Catalogue of Rare, Original Paintings by the Most Renowned Masters . . . Belonging to the Estate of the Late Joseph Napoleon Bonaparte, ex-King of Spain.* Sale cat. Bordentown, N.J., June 25, 1847. New York, 1847.

Bonn 1999–2000. *Museo del Prado: Velázquez, Rubens, Lorrain: Malerei am Hof Philipps IV.* Exh. cat. by Petra Kruse. Bonn, Kunst- und Ausstellungshalle

der Bundesrepublik Deutschland, October 8, 1999–January 23, 2000. Bonn, 1999.

Bonnat 1898. Léon Bonnat. "Velasquez." *Gazette des Beaux-Arts* (Paris) 19 (March 1898), pp. 177–82. Also published as the preface to Beruete 1898, pp. iii–xi.

Bonnemaison 1827. *Catalogue de tableaux précieux des diverses écoles et autres objets de curiosité, tels qu'émaux de Petitot, dessins, gravures, marbres antiques et modernes, bronzes, meubles de boule, etc., formant le cabinet de feu M. le Cher Féréol Bonnemaison.* Sale cat. Paris, April 2–7, 1827. Paris, 1827.

Boone 1995. M. Elizabeth Boone. "Bullfights and Balconies: Flirtation and *Majismo* in Mary Cassatt's Spanish Paintings of 1872–73." *American Art* (New York) 9, no. 1 (Spring 1995), pp. 55–71.

Boone 1996. M. Elizabeth Boone. "Vistas de España: American Views of Art and Life in Spain, 1860–1898." Ph.D. diss., City University of New York, 1996.

Boone 1999. M. Elizabeth Boone. "American Artists and the Spanish Experience." *American Art Review* (Kansas City) 11, no. 1 (January–February 1999), pp. 120–31.

Borbón y Braganza 1876. *Catalogue abrégé des tableaux exposés dans les salon de l'ancien asile de Pau appartenant aux héritiers de feu Mgr l'infant don Sébastien de Bourbon et Bragance.* Pau, September 1876.

Borbón y Braganza 1890. *Catalogue des tableaux provenant de la Galerie de S.A.R. Don Sébastien Gabriel de Bourbon, Bragance et Bourbon, Infant d'Espagne et de Portugal . . . Formant la Collection du Prince Pierre de Bourbon et Bourbon, Duc de Durcal.* Sale cat. Paris, Hôtel Drouot, February 3, 1890. Paris, 1890.

Bordeaux 1862. *Explication des ouvrages de peinture, sculpture, architecture, gravure et lithographie des artistes vivants.* Exh. cat. Bordeaux, Société des Amis des Arts, March 17–May 13, 1862. Bordeaux, 1862.

Bordeaux 1951. *Goya, 1746–1828.* Exh. cat. by Gilberte Martin-Méry. Bordeaux, Musée des Beaux-Arts, May 16–June 30, 1951. Bordeaux, 1951.

Bordeaux 1955. *L'age d'or espagnol: La peinture en Espagne et en France autour du Caravagisme.* Exh. cat. by Gilberte Martin-Méry. Bordeaux, Galerie des Beaux-Arts, May 16–July 31, 1955. Bordeaux, 1955.

Bordeaux 1963. *Delacroix: Ses maîtres, ses amis, ses élèves.* Exh. cat. by Gilberte Martin-Méry. Bordeaux, Galerie des Beaux-Arts, May 17–September 30, 1963. Bordeaux, 1963.

Bordeaux 1998. *Goya, hommages: Les années bordelaises, 1824–1828.* Exh. cat. Edited by Francis Ribemont and Françoise Garcia. Bordeaux, Galerie des Beaux-Arts, March 6–May 6, 1998. Bordeaux, 1998.

Bordeaux–Paris–Madrid 1979–80. *L'art européen à la cour d'Espagne au XVIIIe siècle.* Exh. cat. Edited by Manuel Jorge Aragoneses et al. Bordeaux, Galerie des Beaux-Arts, May 5–September 1, 1979; Paris, Galeries Nationales d'Exposition du Grand Palais, September 28–December 31, 1979; Madrid, Museo del Prado, January 25–April 25, 1980. Paris, 1979.

Boston 1875. *Catalogue of Pictures Belonging to H.R.H. the Duke of Montpensier.* Exh. cat. Boston, Museum of Fine Arts, 1875. Boston, 1875.

Boston 1878. *Thirteenth Industrial and Art Exhibition.* Exh. cat. Boston, Massachusetts Charitable Mechanic Association, opened September 2, 1878. Boston, 1878.

Boston 1883a. *American Exhibition of Foreign Products, Arts and Manufactures.* Exh. cat. Boston, Mechanics' Building, September 1/3–December 1883. Boston 1883.

Boston 1883b. *Annual Exhibition of the Society of American Artists.* Exh. cat. Boston, 1883.

Boston 1886. *Exhibition of Pictures, Studies and Sketches by Mr. Wm. M. Chase of New York City.* Exh. cat. Boston Art Club, 1886. Boston, 1886.

Boston 1898a. *An Exhibition of Paintings, Pastels, and Etchings by Miss Mary Cassatt.* Exh. cat. Boston, St. Botolph Club, 1898. Boston, 1898.

Boston 1898b. *Loan Exhibition of Pictures by Modern Artists.* Exh. cat. Boston, Copley Hall and Allston Hall, March 7–28, 1898. Boston, 1898.

Boston 1899. *Catalogue of Paintings and Sketches by John Singer Sargent.* Exh. cat. Boston, Copley Hall, February 20–March 13, 1899. Boston, 1899.

Boston 1902. *Second Annual Exhibition of Contemporary Art.* Exh. cat. Boston, Copley Society, 1902. Boston, 1902.

Boston 1904. *Memorial Exhibition of the Works of J. McNeill Whistler. Loan Collection: Oil Paintings, Water Colors, Pastels & Drawings.* Exh. cat. Boston, Copley Hall, February 1904. Boston, 1904.

Boston 1909. *Pictures by Mary Cassatt.* Exh. cat. Boston, St. Botolph Club, 1909. Boston, 1909.

Boston 1925. *A Catalogue of the Memorial Exhibition of the Works of the Late John Singer Sargent: To Be Opened on the Occasion of the Unveiling of Mr. Sargent's Mural Decorations over the Main Stair Case and the Library of the Museum.* Exh. cat. Boston, Museum of Fine Arts, November 3–December 27, 1925. Boston, 1925.

Boston 1956. *A Centennial Exhibition: Sargent's Boston.* Exh. cat. by David McKibbin. Boston, Museum of Fine Arts, January 3–February 7, 1956. Boston, 1956.

Boston 1970. *Masterpieces of Painting in the Metropolitan Museum of Art.* Exh. cat. Boston, Museum of Fine Arts, 1970. Greenwich, Conn., 1970.

Boston–Denver–Chicago 1986–87. *The Bostonians: Painters of an Elegant Age, 1870–1930.* Exh. cat. by Trevor J. Fairbrother et al. Boston, Museum of Fine Arts, June 11–September 14, 1986; Denver Art Museum, October 25, 1986–January 18, 1987; Chicago, Terra Museum of American Art, March 13–May 10, 1987. Boston, 1986.

Boston–Ottawa 1974–75. *The Changing Image: Prints by Francisco Goya.* Exh. cat. by Eleanor A. Sayre. Boston, Museum of Fine Arts, October 24–December 29, 1974; National Gallery of Canada, Ottawa, January 24–March 14, 1975. Boston, 1974.

Boston–Philadelphia–London 1984–85. *Edgar Degas: The Painter as Printmaker.* Exh. cat. by Sue Welsh Reed and Barbara Stern Shapiro. Boston, Museum of Fine Arts, November 14, 1984–January 13, 1985; Philadelphia Museum of Art, February 17–April 14, 1985; London, Hayward Gallery, May 15–July 7, 1985. Boston, 1984.

Boston–Washington–Paris 1983–84. *A New World: Masterpieces of American Painting, 1760–1910.* Exh. cat. by Theodore E. Stebbins, Jr., Carol Troyen, and Trevor J. Fairbrother. Boston, Museum of Fine Arts, September 3–November 13, 1983; Washington, D.C., Corcoran Gallery of Art, December 7, 1983–February 12, 1984; Paris, Grand Palais, March 16–June 11, 1984. Boston, 1983.

Both de Tauzia 1877. Vicomte Both de Tauzia. *Notice des tableaux exposés dans les galeries du Musée national du Louvre. Première partie. Écoles d'Italie et d'Espagne.* Paris, 1877.

Both de Tauzia 1883. Victomte Both de Tauzia. *Notice des tableaux exposés dans les galeries du Musée national du Louvre. Première partie. Écoles d'Italie et d'Espagne.* Paris, 1883.

Bouisset 1926. Félix Bouisset. *Le Musée Ingres: Historique, une visite au musée, la salle du prince Noir.* Montauban, 1926.

Bourbon 1863. Sébastien de Bourbon [Sebastián Gabriel de Borbón y Braganza]. "Des huiles et des vernis employés pour la peinture." *Gazette des Beaux-Arts* (Paris) 15 (August 1, 1863), pp. 175–85.

Bourgeois 1928. Stephan Bourgeois. *The Adolph Lewisohn Collection of Modern French Paintings and Sculptures.* New York, 1928.

Bourgoing 1788. Jean-François de Bourgoing. *Nouveau voyage en Espagne, ou Tableau de l'état actuel de cette monarchie.* 3 vols. Paris, 1788. 2d ed., *Tableau de l'Espagne moderne,* 1797. 3d ed., 1803. 4th ed., rev., 1807.

Bourgoing 1789. Jean-François de Bourgoing. *Travels in Spain: Containing a New, Accurate, and Comprehensive View of the Present State of That Country.* 3 vols. London, 1789.

Bourjot 1838. Auguste Bourjot. "Salon de 1838." *La France Littéraire* (Paris), 2d series (1838).

Boutard 1814. Jean-Baptiste Boutard. "Beaux Arts, Musée Royal: L'Exposition des tableaux de l'école espagnole." *Journal des Débats* (Paris) (August 14, 1814), pp. 1–4.

Boutard 1817. Jean-Baptiste Boutard. "Beaux-Arts. Dictionnaire des peintres espagnols, par F. Q." *Journal des Débats* (Paris) (April 17, 1817).

Bouterwek 1812. Friedrich Bouterwek. *Histoire de la littérature espagnole.* Paris, 1812.

Bouvenne 1887. Aglaus Bouvenne. "Théodore Chassériau." *L'Artiste* (Paris) 2 (September 1887), pp. 161–78.

Boyé 1946. Maurice-Pierre Boyé. *La mêlée romantique.* Paris, 1946.

Boyer d'Agen 1909. Augustin Boyer d'Agen, ed. *Ingres d'après une correspondance inédite.* Paris, 1909.

Brainerd 1988. Andrew W. Brainerd. *The Infanta Adventure and the Lost Manet.* Michigan City, Ind., 1988.

Bréal 1919. Auguste Bréal. *Velázquez.* Paris, 1919.

Bréban 1878. Philbert Bréban. *Livret-guide du visiteur à l'exposition historique du Trocadéro.* New ed. Paris, 1878.

Breeskin 1970. Adelyn Dohme Breeskin. *Mary Cassatt: A Catalogue Raisonné of the Oils, Pastels, Watercolors, and Drawings.* Washington, D.C., 1970.

Bregler Collection. Charles Bregler's Thomas Eakins Collection. Pennsylvania Academy of the Fine Arts, Philadelphia.

Brès 1814. N. Brès. "Nouvelle Exposition." *Mercure de France* (Paris), no. 662 (August 1814), p. 255.

Brey Mariño 1949. María Brey Mariño. *Viaje a España del pintor Henri Regnault (1868–1870).* Valencia, 1949.

Brigstocke 1982. Hugh Brigstocke. *William Buchanan and the 19th-Century Art Trade: 100 Letters to His Agents in London and Italy.* London, 1982.

Brigstocke 1993. Hugh Brigstocke. *Italian and Spanish Paintings in the National Gallery of Scotland.* 2d ed. Edinburgh, 1993.

British Institution 1824. British Institution for Promoting the Fine Arts in the United Kingdom. *An Account of All the Pictures Exhibited in the Rooms of the British Institution, from 1813 to 1823.* London, 1824.

Brooklyn–Chicago–Houston 2000–2001. *William Merritt Chase: Modern American Landscapes, 1886–1890.* Exh. cat. by Barbara Dayer Gallati. Brooklyn Museum of Art, May 26–August 13, 2000; Chicago, Art Institute, September 7–November 26, 2000; Houston, Museum of Fine Arts, December 13, 2000–March 11, 2001. Brooklyn, 1999.

Brooklyn–Minneapolis 1988–89. *Courbet Reconsidered.* Exh. cat. by Sarah Faunce and Linda Nochlin. Brooklyn Museum of Art, November 4, 1988–January 16, 1989; Minneapolis Institute of Arts, February 18–April 30, 1989. Brooklyn and New Haven, 1988.

Brooklyn–Richmond–San Francisco 1967–68. *Triumph of Realism: An Exhibition of European and American Realist Paintings, 1850–1910.* Exh. cat. Edited by Axel von Saldern and Donelson F. Hoopes. Brooklyn Museum of Art, October 3–November 19, 1967; Richmond, Virginia Museum of Fine Arts, December 11, 1967–January 14, 1968; San Francisco, California Palace of the Legion of Honor, February 17–March 31, 1968. Brooklyn, 1967.

J. Brown 1970. Jonathan Brown. "Hieroglyphs of Death and Salvation: The Decoration of the Church of the Hermandad de la Caridad, Seville." *Art Bulletin* (New York) 52 (1970), pp. 265–77.

J. Brown 1974. Jonathan Brown. *Francisco de Zurbarán.* New York, 1973.

J. Brown 1978. Jonathan Brown. *Images and Ideas in Seventeenth-Century Spanish Painting.* Princeton, N.J., 1978.

J. Brown 1982. Jonathan Brown. "Murillo, pintor de temas eróticos, una faceta inadvertida de su obra." *Goya* (Madrid), nos. 169–171 (1982), pp. 35–43.

J. Brown 1986. Jonathan Brown. *Velázquez: Painter and Courtier.* New Haven, 1986. Spanish ed., *Velázquez: Pintor y cortesano.* Madrid, 1986.

J. Brown and Elliott 1980. Jonathan Brown and John Elliott. *A Palace for a King: The Buen Retiro and the Court of Philip IV.* New Haven, 1980.

J. Brown and Elliott 1981. Jonathan Brown and John Elliott. *Un palacio para el rey: El Buen Retiro y la corte de Felipe IV.* Madrid, 1981.

J. Brown and Kagan 1987. Jonathan Brown and Richard L. Kagan. "The Duke of Alcalá: His Collection and Its Evolution." *Art Bulletin* (New York) 69, no. 2 (1987), pp. 231–55.

J. Brown and Mann 1990. Jonathan Brown and Richard G. Mann. *The Collections of the National Gallery of Art Systematic Catalogue: Spanish Paintings of the Fifteenth through Nineteenth Centuries.* Washington, D.C., 1990.

M. Brown 1994. Marilyn R. Brown. *Degas and the Business of Art: A Cotton Office in New Orleans.* University Park, Pa., 1994.

Brownell 1881. William C. Brownell. "The Younger Painters of America. III." *Scribner's Monthly* (New York) 22 (July 1881).

Brownell 1883. William C. Brownell. "American Pictures at the Salon." *Magazine of Art* (London) 6 (1883), pp. 498–99.

Brownell 1884. William C. Brownell. "The American Salon." *Magazine of Art* (London) 7 (1884).

Browse 1945. Lillian Browse, ed. *Constantin Guys, Flushing, 1805: Paris 1892.* London, 1945.

Brunet 1865. Gustave Brunet. *Étude sur Francisco Goya: Sa vie et ses travaux; notice biographique et artistique.* Paris, 1865.

Bruno 1872. Jean Bruno. *Les misères des gueux.* Illustrated by Gustave Courbet. Paris, 1872.

Brussels 1863. *Exposition générale des beaux-arts.* Exh. cat. Brussels, Salon Triennal, July 29–September 28, 1863. Brussels, 1863.

Brussels 1869. *Exposition générale des beaux-arts.* Exh. cat. Brussels, Salon Triennal, July 29–September 30, 1869. Brussels, 1869.

Brussels 1967. *Europa 1900.* Exh. cat. Brussels, Museum voor Schone Kunsten, June 3–September 30, 1967. Brussels, 1967.

Bryant 1991. Keith L. Bryant, Jr. *William Merritt Chase: A Genteel Bohemian.* Columbia, Mo., 1991.

Buchanan 1824. William Buchanan. *Memoirs of Painting, with a Chronological History of the Importation of Pictures by the Great Masters into England since the French Revolution.* 2 vols. London, 1824.

Buenos Aires 1964. *De El Greco a Tiepolo.* Exh. cat. Buenos Aires, Museo Nacional de Bellas Artes, August 24–September 27, 1964. Buenos Aires, 1964.

Buenos Aires 1980. *Panorama de la pintura española desde los Reyes Católicos a Goya.* Exh. cat. Buenos Aires, Palacio del Concejo Deliberante, June–August 1980. Madrid, 1980.

Buffalo 1901. *Pan-American Exposition.* Exh. cat. Buffalo, May 1–November 1, 1901. Buffalo, 1901.

Burckhardt 1837. Jacob Burckhardt. "Über Murillo: Kunststudien aus dem Louvre." *Atlantis* 9 (August 1837), pp. 481–82.

Bürger 1863. W. Bürger [Théophile Thoré]. "Salon de 1863 à Paris." *L'Indépendance Belge* (Brussels) (June 11, 1863).

Bürger 1864a. W. Bürger [Théophile Thoré]. "Galerie de Mm. Pereire." *Gazette des Beaux-Arts* (Paris) 16 (March 1, 1864), pp. 193–213; 16 (April 1, 1864), pp. 297–317.

Bürger 1864b. W. Bürger [Théophile Thoré]. "Salon de 1864 à Paris." *L'Indépendance Belge* (Brussels) (June 15, 1864), p. 2; (June 26, 1864), p. 2.

Bürger 1865. W. Bürger [Théophile Thoré]. *Trésors d'art en Angleterre.* 3d ed. Paris, 1865.

Burke and Cherry 1997. Marcus B. Burke and Peter Cherry. *Collections of Paintings in Madrid, 1601–1755.* 2 vols. Edited by Maria L. Gilbert. Los Angeles, 1997.

Burroughs 1941. Louise Burroughs. "A Portrait of James Tissot by Degas." *Metropolitan Museum of Art Bulletin* (New York) 36 (1941), p. 35–38.

Burty 1860. Philippe Burty. "L'iconographie espagnole de M. Valentin Carderera." *Gazette des Beaux-Arts* (Paris) 6 (April 15, 1860), pp. 93–103.

Burty 1869. Philippe Burty. *Sonnets et eaux-fortes.* Paris, 1869.

Burty 1877. Philippe Burty. *Maîtres et petits maîtres.* Paris, 1877.

Burty 1885. Philippe Burty. "Eva Gonzalès." *La République Française* (Paris) (January 8, 1885), p. 3.

Cabanne 1958. Pierre Cabanne. *Edgar Degas.* Paris and New York, 1958.

Cadbury Papers. Richard T. Cadbury Papers. Friends Historical Library, Swarthmore College, Pennsylvania.

Caffin 1903. Charles H. Caffin. "Exhibition of the Pennsylvania Academy." *International Studio* (London) 19 (May 1903), pp. cxxiii–cxxvi.

Callen 1974. Anthea Callen. "Faure and Manet." *Gazette des Beaux-Arts* (Paris) 83 (March 1974), pp. 157–78.

Calvert 1907. Albert F. Calvert. *Murillo: A Biography and Appreciation.* London, 1907.

Calvert and Hartley 1908. Albert F. Calvert and C. Gasquoine Hartley. *Velázquez: An Account of His Life and Works.* New York, 1908.

Calvert and Hartley 1909. Albert F. Calvert and C. Gasquoine Hartley. *El Greco: An Account of His Life and Works.* London, 1909.

Calvo Castellón 1982. Antonio Calvo Castellón. *Los fondos arquitectónicos y el paisaje en la pintura barroca andaluza.* Granada, 1982.

Calvo Serraller 1995. Francisco Calvo Serraller. *La imagen romántica de España: Arte y arquitectura del siglo XIX.* Madrid, 1995.

Cambon 1881. Armand Cambon. "Histoire et organisation du Musée de Montauban." *Réunion des Sociétés des Beaux-Arts des Départements* (1881), pp. 272–77.

Cambon 1885. Armand Cambon. *Catalogue du Musée de Montauban.* Montauban, 1885.

Cambridge 1931. *Degas: Loan Exhibition Arranged by Students.* Exh. cat. Cambridge, Mass., Fogg Art Museum, Harvard University, May 9–30, 1931. Cambridge, Mass., 1931.

Camón Aznar 1964. José Camón Aznar. *Velázquez.* 2 vols. Madrid, 1964.

Camón Aznar 1970. José Camón Aznar. *Dominico Greco.* 2 vols. 2d ed. Madrid, 1970.

Camón Aznar 1983. José Camón Aznar. *La pintura espanola del siglo XVII.* Summa Artis, vol. 25. 4th ed. Madrid, 1983.

Capmany 1808. Antonio Capmany. *Centinela contra franceses.* Madrid, 1808.

Carderera 1860–63. Valentín Carderera. "François Goya, sa vie, ses dessins et ses eaux-fortes." *Gazette des Beaux-Arts* (Paris) 7 (1860), pp. 215–27; 15 (1863), pp. 237–49.

Carey 1908. Elizabeth Luther Carey. "Recent Accessions of Modern Art in the Wilstach Collection." *International Studio* (London) 35 (July 1908), p. xxxi.

Carr 1982. Raymond Carr. *Spain, 1808–1975.* 2d ed. New York, 1982.

Carrete Parrondo 1979. Juan Carrete Parrondo. "La Compañía para el Grabado de los Cuadros de los Reales Palacios." *Cuadernos de Bibliofilia* 1 (1979), pp. 61–74.

Carrete Parrondo et al. 1987. Juan Carrete Parrondo, Fernando Checa Cremades, and Valeriano Bozal. *El grabado en España (siglos XV al XVIII).* Madrid, 1987.

Carriazo 1929. Juan de M. Carriazo. "Correspondencia de Don Antonio Ponz con el Conde del Águila." *Archivo*

Español de Arte y Arqueología (Madrid), no. 15 (1929), pp. 157–83.

Carrière 1973. Charles Carrière. *Négociants marseillais au XVIIIe siècle: Contribution à l'étude des économies maritimes.* Marseille, 1973.

Castagnary 1892. Castagnary [Jules Antoine Castagnary]. *Salons (1857–1870).* Paris, 1892.

Castres 1992. *Dix ans d'acquisitions des Musées de Castres.* Exh. cat. Castres, 1992.

Castres 1994. *Marcel Briguiboul, 1837–1892.* Exh. cat. Edited by Marie-Paul Romanens. Castres, France, Musée Goya, June 24–September 18, 1994. Castres, 1994.

Castres 1997. *Les peintres français et l'Espagne, de Delacroix à Manet.* Exh. cat. Edited by Eliseo Trenc Ballester. Castres, France, Musée Goya, July 11–October 5, 1997. Castres, 1997.

Castres 1999. *Velázquez et la France: La découverte de Velázquez par les peintres français.* Exh. cat. Essays by Jean-Louis Augé et al. Castres, France, Musée Goya, July 9–October 3, 1999. Castres, 1999.

Caturla 1982. María Luisa Caturla. *Antonio de Puga: Pintor gallego.* La Coruña, 1982.

Caturla 1994. María Luisa Caturla. *Francisco de Zurbarán.* Translated, adapted, and augmented by Odile Delenda. Paris, 1994.

Ceán Bermúdez 1800. Juan Agustín Ceán Bermúdez. *Diccionario histórico de los más ilustres profesores de las bellas artes en España.* 6 vols. Madrid, 1800. Facsimile reprint, with a prologue by Miguel Morán Turina. 6 vols. Madrid, 2001.

Ceán Bermúdez 1804. Juan Agustín Ceán Bermúdez. *Descripción artística de la catedral de Sevilla.* Seville, 1804.

Ceán Bermúdez 1806. Juan Agustín Ceán Bermúdez. *Carta de D. Juan Augustin Cean Bermudez á un amigo suyo, sobre el estilo y gusto en la pintura de la Escuela Sevillana y sobre el grado de perfeccion á que la elevó Bartolomé Estevan Murillo. . . .* Cadiz, 1806. Reprint, Seville, 1968.

Ceballos 1989. Alfonso Rodríguez G. de Ceballos. "Iconografía y Contrarreforma: propósito de algunas pinturas de Zurbarán." I Foloquios de Iconografía (May, 1988), *Cuadernos de Arte e Iconografía*, II-4 (1989), pp. 97–105.

Ceballos-Escalera y Gila 1997. Alfonso de Ceballos-Escalera y Gila. *La orden real de España (1808–1813).* Madrid, 1997.

Cénac-Moncaut 1861. Justin-Édouard-Mathieu Cénac-Moncaut. *L'Espagne inconnue: Voyage dans les Pyrénées, de Barcelone à Tolosa.* Paris, 1861. 2d ed. Paris, 1870.

Cervantes 1836–40. Miguel de Cervantes. *L'ingénieux hidalgo Don Quichotte de la Manche.* 2 vols. Translated by Louis Viardot. Illustrations by Tony Johannot. Paris, 1836–40. 2d ed. Paris, 1845. New ed., with illustrations by Gustave Doré. Paris, 1869.

Cervantes 1847. Miguel de Cervantes. *L'admirable Don Quichotte de la Manche.* 2 vols. Translated by J. Damas Hinard. Paris, 1847.

Cervantes 1982. Miguel de Cervantes. *Novelas ejemplares.* 3 vols. Edited by Juan Bautista Avalle-Arce. Madrid, 1982.

Césena 1837. Amédée de Césena. "Musée espagnol: Voyage de M. Taylor." *Revue Française et Étrangère* (Paris) 2 (1837), pp. 144–56.

Cham 1867. *Cham au Salon de 1867.* Paris, 1867.

Champa 1973. Kermit Champa. *Studies in Early Impressionism.* New Haven, 1973.

Champfleury 1848. Champfleury. "Revue des Beaux-Arts." *Le Pamphlet* (September 28–30, 1848).

Champfleury 1855. Champfleury. "Du réalisme." *L'Artiste* (Paris) 16 (September 2, 1855), pp. 1–5.

Champfleury 1861. Champfleury. *Grandes figures d'hier et d'aujourd'hui: Balzac, Gérard de Nerval, Wagner, Courbet.* Paris, 1861.

Champfleury 1872. Champfleury. *Souvenirs et portraits de jeunesse.* Paris, 1872.

Champfleury 1973. Champfleury. *Le réalisme.* Edited by Geneviève Lacambre and Jean Lacambre. Paris, 1973.

Champfleury 1990. Champfleury. *Son regard et celui de Baudelaire.* Edited by Geneviève Lacambre and Jean Lacambre. New ed. Paris, 1990.

Champier 1882. Victor Champier. "The Salon from the French Critic's Point of View." *Art Journal* (London) (July 1882), p. 271.

Chappuis 1965. Adrien Chappuis. "Cézanne dessinateur: Copies et illustrations." *Gazette des Beaux-Arts* (Paris) 64 (1965), pp. 456–58.

Charcot and Richer 1889. J.-M. Charcot and Paul Richer. *Les difformes et les malades dans l'art.* Paris, 1889.

Chateaubriand 1811. François-Auguste-René de Chateaubriand. *Itinéraire de Paris à Jérusalem et de Jérusalem à Paris, en allant par la Grèce et en revenant par l'Égypte, la Barbarie et l'Espagne.* 3 vols. Paris, 1811.

Charteris 1927. Evan Charteris. *John Sargent.* New York, 1927.

Chartres 1983–84. *Exigences de réalisme dans la peinture française entre 1830 et 1870.* Exh. cat. by Sylvie Douce de La Salle, Albert Boime, and Patric Le Nouëne. Chartres, Musée des Beaux-Arts, November 5, 1983–February 15, 1984. Chartres, 1983.

Chase 1896. William Merritt Chase. "Velasquez." *The Quartier Latin* (Paris) 1 (July 1896), pp. 4–5.

Chase 1897. [William Merritt Chase]. "Some Students' Questions Briefly Answered by Mr. W. M. Chase." *The Art Amateur* (New York) 36 (March 1897), p. 68.

Chase 1906. William Merritt Chase. "Talk on the Old Masters by Mr. Chase, New York School of Art, November 17th, 1906." Typescript, Archives of American Art, Smithsonian Institution, Washington, D.C.

Chase 1908. William Merritt Chase. "How I Painted My Greatest Picture." *The Delineator* (December 1908), pp. 967–69.

Chase 1910a. William Merritt Chase. "The Import of Art: An Interview with Walter Pach." *Outlook* 95 (June 25, 1910).

Chase 1910b. William Merritt Chase. "The Two Whistlers: Recollections of a Summer with the Great Etcher." *The Century Magazine* (New York) 80, no. 2 (June 1910), pp. 218–26.

Chase 1916. William Merritt Chase. "Painting." *American Magazine of Art* (New York) 8, no. 2 (December 1916), pp. 50–53.

Chase Papers. William Merritt Chase Papers. Archives of American Art, Smithsonian Institution, Washington, D.C.

Chasles 1830. Philarète Chasles. "Hernani, drame en cinq actes, en vers, par M. Victor Hugo; Représenté le 25 février 1830 au Théâtre Français." *Revue de Paris* 10 (1830), pp. 204–15.

Chefs-d'oeuvre **1822–27.** *Chefs-d'oeuvre des théâtre étrangers . . . traduits en français.* 25 vols. Paris, 1822–27.

Chenault 1969. Jeanne Chenault. "Ribera in Roman Archives." *The Burlington Magazine* (London) 111 (September 1969), pp. 561–62.

Chennevières 1979. Philippe de Chennevières. *Souvenirs d'un directeur des Beaux-Arts (1883–89).* Paris, 1979.

Cherbourg 1835. *Notice des tableaux composant le Musée de Cherbourg.* Paris, 1835.

Cherbourg 1870. *Notice des tableaux composant le Musée de Cherbourg.* Paris, 1870.

Cherbourg 1912. *Notice des tableaux composant le Musée de Cherbourg.* Paris, 1912.

Chesneau 1863. Ernest Chesneau. "L'art contemporain." *L'Artiste* (Paris) (April 1, 1863), pp. 148–49.

Chevillard 1893. Valbert Chevillard. *Un peintre romantique: Théodore Chassériau.* Paris, 1893.

Chicago 1888. *Catalogue of the Paintings Exhibited by the Inter-State Industrial Exposition: Sixteenth Annual Exhibition.* Exh. cat. Chicago, Inter-State Exposition Building, September 5–October 20, 1888. Chicago, 1888.

Chicago 1890. *Catalogue of the Third Annual Exhibition of American Oil Paintings.* Exh. cat. Chicago, Art Institute, June 9–July 13, 1890. Chicago, 1890.

Chicago 1898. *Loan Collection of Selected Works of Old and Modern Masters Sponsored by the Antiquarians.* Exh. cat. Chicago, Art Institute, January 1–23, 1898. Chicago, 1898.

Chicago 1903. *American Paintings and Sculpture, 16th Annual Exhibition.* Exh. cat. Chicago, Art Institute, October 20–November 25, 1903. Chicago, 1903.

Chicago 1926–27. *Catalogue of a Memorial Collection of the Works of Mary Cassatt.* Exh. cat. Chicago, Art Institute, December 21, 1926–January 24, 1927. Chicago, 1926.

Chicago 1933. *Catalogue of a Century of Progress: Exhibition of Paintings and Sculpture, Lent from the American Collections.* Exh. cat. Chicago, Art Institute, June 1–November 1, 1933. 3d ed. Chicago, 1933.

Chicago 1973. *Paintings by Renoir.* Exh. cat. by John Maxon et al. Chicago, Art Institute, February 3–April 1, 1973. Chicago, 1973.

Chicago–Boston–Washington 1998–99. *Mary Cassatt, Modern Woman.* Exh. cat. Edited by Judith A. Barter. Chicago, The Art Institute, October 10, 1998–January 10, 1999; Boston, Museum of Fine Arts, February 14–May 9, 1999; Washington, D.C., National Gallery of Art, June 6–September 6, 1999. New York, 1998.

Chicago–New York 1954. *Sargent, Whistler and Mary Cassatt.* Exh. cat. by Frederick A. Sweet. Chicago, Art Institute, January 14–February 24, 1954; New York, Metropolitan Museum of Art, March 25–May 23, 1954. Chicago, 1954.

Chicago–Utica 1968. *James McNeill Whistler: Paintings, Pastels, Watercolors, Etching, Lithographs.* Exh. cat. by Frederick A. Sweet. Chicago, Art Institute, January 13–February 25, 1968; Utica, N.Y., Munson-Williams-Proctor Institute, March 17–April 28, 1968. Chicago, 1968.

Child 1889. Theodore Child. *Harper's New Monthly Magazine* (New York) 79 (September 1889), p. 504.

Choiseul 1772. *Catalogue des tableaux qui composent le cabinet de Monseigneur le duc de Choiseul: Dont la vente se sera le lundi 6 avril 1772, de relevée, et jours suivans, en son hôtel, rue de Richelieu.* Sale cat. Paris, April 6, 1772. Paris, 1772.

Chroniques 1964. "Chroniques du laboratoire: Notes sur les radiographies de deux tableaux appartenant aux Musées de Pau et de Rouen." *Bulletin du Laboratoire du Louvre* (Paris) 9 (1964), pp. 47–53.

Chu 1974. Petra ten-Doesschate Chu. *French Realism and the Dutch Masters.* Utrecht, 1974.

Cincinnati 1873. *Exhibition of Paintings, Engravings, Drawings, Aquarelles, and Works of Household Art in the Cincinnati Industrial Exhibition.* Exh. cat. Cincinnati, September 3–October 4, 1873. Cincinnati, 1873.

Cincinnati 1900. *Catalogue of the Seventh Annual Exhibition of American Art.* Exh. cat. Cincinnati Art Museum, 1900. Cincinnati, 1900.

Cincinnati 1903. *Catalogue of the Tenth Annual Exhibition of American Art.* Exh. cat. Cincinnati Art Museum, 1903. Cincinnati, 1903.

Cincinnati–Milwaukee–Sacramento 1978. *Munich and American Realism in the 19th Century.* Exh. cat. by Michael Quick, Eberhard Ruhmer, and Richard V. West. Cincinnati Art Museum, April 20–May 28, 1978; Milwaukee Art Center, July 13–August 27, 1978; Sacramento, E. B. Crocker Art Gallery, October 28–December 10, 1978. Sacramento, Calif., 1978.

Cincinnati–Washington–Elmira 1992–93. *Cavaliers and Cardinals: Nineteenth-Century French Anecdotal Paintings.* Exh. cat. by Eric M. Zafran. Cincinnati, Taft Museum, June 25–August 16, 1992; Washington, D.C., Corcoran Gallery of Art, September 19–November 15, 1992; Elmira, N.Y., Arnot Art Museum, November 21, 1992–January 17, 1993. Cincinnati, 1992.

Circourt 1838a. Albert, comte de Circourt. "Beaux-Arts: Le Musée espagnol." *Revue Française et Étrangère* (Paris) 5 (May 1838), pp. 38–63.

Circourt 1838b. Albert, comte de Circourt. "Le Musée espagnol." *France et Europe* (May 25, 1838), pp. 98–107; (June 25, 1838), pp. 229–45.

Claretie 1867. Jules Claretie. "Courrier de Paris." *L'Indépendance Belge* (Brussels) (June 15, 1867), p. 2.

Claretie 1870. Jules Claretie. *Journées de voyage: Espagne et France.* Paris, 1870.

Claretie 1872. Jules Claretie. "La Salon de 1872." *Le Soir* (May 25, 1872).

Claretie 1882. Jules Claretie. *Peintres et sculpteurs contemporains, première série: Artistes décédés de 1870 à 1880.* Paris, 1882.

Claretie 1885. Jules Claretie. "La vie à Paris." *Le Temps* (Paris) (January 23 1885), p. 2.

Clark 1973. T. J. Clark. *Image of the People: Gustave Courbet and the Second French Republic, 1848–1851.* Greenwich, Conn., 1973.

Clausse 1889. Gustave Clausse. *Espagne, Portugal: Notes historiques et artistiques sur les villes principales de la péninsule ibérique.* Paris, 1889.

Clément de Ris 1859. Louis Clément de Ris. *Le Musée Royal de Madrid.* Paris, 1859.

Clément de Ris 1879. Louis Clément de Ris. "Musée impérial de l'Ermitage à Saint-Pétersbourg."

Gazette des Beaux-Arts (Paris) 19 (April 1879), pp. 342–52.

Clerc 1894. Charles Clerc. *Campagne du maréchal Soult dans les Pyrénées occidentales en 1813–1814.* Paris, 1894.

Cleveland et al. 1980–82. *The Realist Tradition: French Painting and Drawing, 1830–1900.* Exh. cat. by Gabriel P. Weisberg. Cleveland Museum of Art, November 12, 1980–January 18, 1981; Brooklyn Museum, March 7–May 10, 1981; Saint Louis Art Museum, July 23–September 20, 1981; Glasgow Art Gallery and Museum, November 5, 1981–January 4, 1982. Cleveland, 1980.

Codding 2002. Mitchell Codding. "Archer Milton Huntington: Champion of Spain in the United States." In *Spain in America: The Origins of Hispanism in the United States,* edited by Richard L. Kagan, pp. 142–70. Urbana, Ill., 2002.

Coffin 1896. William A. Coffin. "Sargent and His Painting: With Special Reference to His Decorations in the Boston Public Library." *The Century Magazine* (New York) 52, no. 2 (June 1896), pp. 162–78.

Coffin 1899. William A. Coffin. [Review: Boston Art Students' Association]. *New York Sun* (1899), reprinted in *Boston Evening Transcript* (February 21, 1899), p. 7.

Colloque Degas 1989. *Degas inédit: Actes du Colloque Degas, Musée d'Orsay, 18–21 avril 1988.* Paris, 1989.

Collot 1855. *Catalogue raisonné des tableaux de diverses écoles composant le précieux cabinet de feu M. Collot . . . dont la vente aura lieu les mardi 25 et mercredi 26 mai 1852.* Sale cat. Paris, March 29, 1855. Paris, 1855.

Cologne–Zurich–Lyon 1987–88. *Triumph und Tod des Helden: Europäische Historienmalerei von Rubens bis Manet.* Exh. cat. Edited by Ekkehard Mai and Anke Eckert-Repp. Cologne, Wallraf-Richartz-Museum, October 30, 1987–January 10, 1988; Zurich, Kunsthaus, March 4–April 24, 1988; Lyon, Musée des Beaux-Arts, May 18–July 17, 1988. Cologne and Milan, 1987.

Combes 1869. Anacharsis Combes. *Histoire anecdotique de Jean-de-Dieu Soult, maréchal-général, duc de Dalmatie, 1769–1851.* Castres, 1869.

Comte 1884. J. Comte. *L'Illustration* (Paris) 83 (May 3, 1884), p. 290.

Conde 1961. Fabián Conde. "La crítica sobre Zurbarán." *Revista de Estudios Extremeños* (Badajoz) 17 (1961), pp. 387–405.

Conrads 1990. Margaret C. Conrads. *American Paintings and Sculpture at the Sterling and Francine Clark Art Institute.* New York, 1990.

Constans 1995. Claire Constans. *Musée national du Château de Versailles: Les peintures.* 3 vols. Paris, 1995.

Cook 1883. Clarence Cook. "The Society of American Artists Exhibition." *The Art Amateur* (New York) 8 (May 1883), p. 124.

Cook 1886. Clarence Cook. "Mr. William M. Chase's Portrait of James McNeill Whistler." *Studio* 2 (August 1886), p. 21.

Cook 1891. Clarence Cook. "Why Drag in Velasquez?" *Studio* 6 (May 16, 1891), p. 234.

Cooper 2001. Suzanne Fagence Cooper. "The Art Treasures Exhibition, Manchester, 1857." *The Magazine Antiques* (Boston) (June 2001), pp. 926–33.

Copenhagen 1914. *Exposition d'art français du 19ème siècle / Fransk Malerkonst des 19. Jaarhonderts.* Exh. cat.

Copenhagen, Musée Royal de Copenhague, May 15–June 30, 1914. Copenhagen, 1914.

Copenhagen 1989. *Manet.* Exh. cat. by Mikael Wivel. Copenhagen, Ordrupgaardsamlingen, September 15–November 26, 1989. Copenhagen, 1989.

Copenhagen 2000a. *Gloria Victis! Victors and Vanquished in French Art, 1848–1910.* Exh. cat. Edited by Flemming Friborg. Copenhagen, Ny Carlsberg Glyptotek, May 29–October 15, 2000. Milan, 2001.

Copenhagen 2000b. *Goya's Realism.* Exh. cat. by Vibeke Vibolt Knudsen et al. Copenhagen, Statens Museum for Kunst, February 11–May 7, 2000. Copenhagen, 2000.

Cortissoz 1925. Royal Cortissoz. "Some Souvenirs of John Sargent." *New York Herald Tribune* (November 8, 1925), p. 9.

Cortissoz 1928. Royal Cortissoz. "Paintings by Velasquez in America." *International Studio* (London) 90 (May–August 1928).

Cossío 1908. Manuel B. Cossío. *El Greco.* 3 vols. in 2. Madrid, 1908.

Cossío and Cossío de Jiménez 1972. Manuel B. Cossío and Natalia Cossío de Jiménez. *El Greco.* Barcelona, 1972.

Cottini 1851. J. Cottini. *Examen du Musée du Louvre, suivi d'observations sur les expertises en matière de tableaux.* Paris, 1851.

Courbet 1992. Gustave Courbet. *Letters of Gustave Courbet.* Edited and translated by Petra ten-Doesschate Chu. Chicago, 1992.

Courbet 1996. Gustave Courbet. *Correspondance de Courbet.* Edited by Petra ten-Doesschate Chu. Paris, 1996.

Courthion 1987. Pierre Courthion. *Tout l'oeuvre peint de Courbet.* Paris, 1987.

Courthion and Cailler 1960. Pierre Courthion and Pierre Cailler, eds. *Portrait of Manet by Himself and His Contemporaries.* London, 1960.

Cox 1904. Kenyon Cox. "The Art of Whistler." *Architectural Record* (New York) 15, no. 5 (May 1904), pp. 467–81.

Cox 1908. Kenyon Cox. "The Pennsylvania Academy Exhibition." *The Nation* (New York) 86 (January 23, 1908), p. 88.

Criado de Val 1979. Manuel Criado de Val, ed. *La picaresca: Orígines, textos y estructuras: Actas del I congreso internacional sobre la picaresca.* Madrid, 1979.

Crombie 1963. Theodore Crombie. "Velázquez Observed: New Looks at an Old Master." *Apollo* (London) 78 (August 1963), pp. 124–28.

Cruz y Bahamonde 1806–13. Nicolás de la Cruz y Bahamonde. *Viage de Espana, Francia e Italia.* 14 vols. Madrid and Cadiz, 1806–13.

Cruzada Villaamil 1870. Gregorio Cruzada Villaamil. *Los tapices de Goya.* Madrid, 1870.

Cruzada Villaamil 1885. Gregorio Cruzada Villaamil. *Anales de la vida y de las obras de Diego de Silva Velázquez: Escritos con ayuda de nuevos documentos.* Madrid, 1885.

Cumberland 1782. Richard Cumberland. *Anecdotes of Eminent Painters in Spain during the Sixteenth and Seventeenth Centuries.* 2 vols. London, 1782. 2d ed. London, 1787.

Cunningham 1843. Allan Cunningham. *The Life of Sir David Wilkie.* 3 vols. London, 1843.

Curtis 1883. Charles B. Curtis. *Velázquez and Murillo: A Descriptive and Historical Catalogue of the Works of Don Diego de Silva Velázquez and Bartolomé Estéban Murillo.* London, 1883.

Dacier 1949. Émile Dacier. "La curiosité au XVIIIe siècle, Choiseul collectionneur." *Gazette des Beaux-Arts* (Paris) (July–September 1849), pp. 47–64.

Daix 1983. Pierre Daix. *La vie de peintre d'Édouard Manet.* Paris, 1983.

Dalling-Bulwer 1873. *Catalogue of the Valuable Collection of Ancient and Modern Pictures of the Rt. Hon. Lord Dalling and Bulwer, Deceased.* Sale cat. London, Christie, Manson and Wood, February 21, 1873. London, 1873.

Dalrymple 1777. Hew Whiteford Dalrymple. *Travels through Spain and Portugal in 1774.* London, 1777.

Damas Hinard 1841–43. Jean-Joseph-Stanislas-Albert Damas Hinard, trans. *Chefs-d'oeuvre du théâtre espagnol. I. Calderón de la Barca II. Lope de Vega.* 5 vols. Paris, 1841–43.

Damas Hinard 1844. Jean-Joseph-Stanislas-Albert Damas Hinard, trans. *Romancero général, ou Recueil des chants populaires de l'Espagne, romances historiques, chevaleresques et moresques.* 2 vols. Paris, 1844.

Damas Hinard 1858. Jean-Joseph-Stanislas-Albert Damas Hinard, trans. *Poème du Cid.* Paris, 1858.

Darby 1942. Delphine Fitz Darby. "The Magdalen of the Hispanic Society by Jusepe de Ribera." *Art Quarterly* 5 (1942), pp. 223–30.

Darby 1946. Delphine Fitz Darby. "The Gentle Ribera: Painter of the Madonna and the Holy Family." *Gazette des Beaux-Arts* (Paris) 29 (March 1946), pp. 153–74.

Darragon 1989. Éric Darragon. *Manet.* Paris, 1989.

Darragon 1991. Éric Darragon. *Manet.* Paris, 1991.

Daulte 1971. François Daulte. *Auguste Renoir: Catalogue raisonné de l'oeuvre peint,* vol. 1, *Figures: 1860–1890.* Lausanne, 1971.

Dauzats 1869. *Catalogue des tableaux . . . de M. A. Dauzats.* Sale cat. Paris, Hôtel Drouot, February 1–4, 1869. Paris, 1869.

David 1794. Jacques-Louis David. *Second rapport sur la nécessité de la suppression de la commission du Muséum.* Paris, 1794.

Davies 1819. Edward Davies, ed. and trans. *The Life of Bartolomé E. Murillo, Compiled from the Writings of Various Authors.* London, 1819.

Davillier 1874a. Charles Davillier. *L'Espagne.* Illustrations by Gustave Doré. Paris, 1874.

Davillier 1874b. Charles Davillier, ed. and trans. *Mémoire de Velázquez sur quarante et un tableaux envoyés par Philippe IV, à l'Escurial. Réimpression de l'exemplaire unique (1658).* Paris, 1874.

Davillier 1876. Charles Davillier. *Spain.* Illustrated by Gustave Doré. Translated from the French by J. Thomson. New York, 1876.

Dax 1867. Pierre Dax. "Chronique des beaux-arts." *L'Artiste* (Paris) 1 (April 1867), pp. 157–60.

Dayton–Philadelphia–Los Angeles 1976–77. *American Expatriate Painters of the Late Nineteenth Century.* Exh. cat. by Michael Quick. Dayton Art Institute, December 4, 1976–January 16, 1977; Philadelphia, Pennsylvania Academy of the Fine Arts, February 4–March 20, 1977; Los Angeles County Museum of Art, April 12–May 29, 1977. Dayton, Ohio, 1976.

De Angelis 1974. Rita De Angelis. *L'opera pittorica completa di Goya.* Milan, 1974.

de Kay 1886. Charles de Kay. "Whistler: The Head of the Impressionists." *Art Review* (New York) 1 (November 1886), pp. 1–3.

De Leiris 1969. Alain De Leiris. *The Drawings of Edouard Manet.* Berkeley, 1969.

Debeaux-Fournier 1946. Henriette Debeaux-Fournier. "Le Musée Espagnol de Louis-Philippe et sa restitution à la famille royale." *Bulletin des Musées de France* (Paris) (August–September 1946), pp. 50–52.

Decamps 1838. Alexandre Decamps. [Review of Galerie Espagnole.] *Le National* (Paris) (February 15, 1838).

Degas 1931. Edgar Degas. *Lettres de Degas.* Edited by Marcel Guérin. Paris, 1931.

Degas 1945. Edgar Degas. *Lettres de Degas.* Edited by Marcel Guérin. 7th ed. Paris, 1945.

Degas 1948. Edgar Degas. *Letters.* Edited by Marcel Guérin. Translated by Marguerite Kay. Oxford, 1948.

Delacroix 1864. *Catalogue de la vente qui aura lieu par suite du décès de Eugène Delacroix.* Sale cat. Paris, Hôtel Drouot, February 17–29, 1864. Paris, 1864.

Delacroix 1893–95. Eugène Delacroix. *Journal de Eugène Delacroix.* 3 vols. Edited by Paul Flat and René Piot. Paris, 1893–95.

Delacroix 1932. Eugène Delacroix. *Journal de Eugène Delacroix.* 3 vols. Edited by André Joubin. Paris, 1932.

Delacroix 1936–38. Eugène Delacroix. *Correspondance générale d'Eugène Delacroix.* 5 vols. Edited by André Joubin. Paris, 1936–38.

Delacroix 1954. Eugène Delacroix. *Lettres intimes.* Edited by Alfred Dupont. Paris, 1954.

Delacroix 1960. Eugène Delacroix. *Journal de Eugène Delacroix.* 3 vols. Edited by André Joubin. Paris, 1960.

Delacroix 1980. Eugène Delacroix. *Journal, 1822–1863.* Edited by André Joubin. Paris, 1980.

Delacroix 1996. Eugène Delacroix. *Journal, 1822–1863.* Edited by André Joubin. Paris, 1996.

Delacroix 2000. Eugène Delacroix. *Nouvelle lettres.* Edited by Lee Johnson and Michèle Hannoosh et al. Bordeaux, 2000.

Delécluze 1819. Étienne-Jean Delécluze. "Beaux-Arts." *Lycée Français* (Paris) (1819), p. 183.

Delécluze 1838. Étienne-Jean Delécluze. "Feuilleton: Galerie Espagnole au Louvre." *Journal des Débats* (Paris) (February 24, 1838).

Delenda 1993. Odile Delenda. *Velázquez, peintre religieux.* Geneva, 1993.

Delenda 2002. Odile Delenda. "Las santas de Alonso Cano en la colección Soult." *Goya* (Madrid), no. 286 (January–February 2002), pp. 4–9.

Delenda and Garraín Villa 1995. Odile Delenda and Luis J. Garraín Villa. "Zurbarán à Llerena." *Gazette des Beaux-Arts* (Paris) 125 (1995), pp. 17–30.

Delteil 1919. Loys Delteil. *Le peintre-graveur illustré,* vol. 9, *Degas.* Paris, 1919.

Delteil 1922. Loys Delteil. *Le peintre-graveur illustré,* vols. 14–15, *Francisco Goya.* Paris, 1922.

Delteil 1997. Loys Delteil. *Delacroix, the Graphic Work: A Catalogue Raisonné.* Translated and revised by Susan Strauber. San Francisco, 1997.

Demerson 1953. Georges Demerson. "À propos du Saint François d'Assise de Zurbarán." *Bulletin des Musées Lyonnais* 4 (1953), pp. 69–80.

Denney 1993. Colleen Denney. "Exhibitions in Artists' Studios: François Bonvin's 1859 *Salon des Refusés.*" *Gazette des Beaux-Arts* (Paris) (September 1993), pp. 97–108.

Denon 1826. *Vente du cabinet de feu M. le bon V. Denon: Tableaux, dessins et miniatures.* Sale cat. Paris, May 1, 1826. Paris, 1826.

Denon 1999. Vivant Denon. *Vivant Denon, directeur des musées sous le Consulat et l'Empire: Correspondance, 1802–1815.* 2 vols. Edited by Marie-Anne Dupuy, Isabelle Le Masne de Chermont, and Elaine Williamson. Paris, 1999.

Deraismes 1874. Marie Deraismes. "Une exposition particulière de l'École réaliste." *L'Avenir des Femmes* (Paris) (July 5, 1874), n.p.

Desbarrolles and Giraud 1851. Adolphe Desbarrolles and Eugène Giraud. *Two French Artists in Spain.* Translated by Charles Mac Farlane. London, 1851. French ed., *Deux artistes en Espagne.* Paris, 1855.

Deschamps 1864. Pierre Deschamps. "Le testament de Madame de Verrüe." *Gazette des Beaux-Arts* (Paris) 16 (1864), pp. 318–30.

Desessarts 1838. Desessarts. "Salon de 1838. 2e art., sujets religieux." *L'Echo Français* (Paris) (March 10, 1838).

Desnoyers 1863. Fernand Desnoyers, ed. *Salon des Refusés: La peinture en 1863.* Paris, 1863.

Desparmet Fitz-Gerald 1928–50. Xavier Desparmet Fitz-Gerald. *L'oeuvre peint de Goya.* 2 vols. Paris, 1928–50.

Detroit 1906. *Annual Exhibition of American Artists.* Exh. cat. Detroit Institute of Arts, 1906. Detroit, 1906.

Detroit 1983. *The Quest for Unity: American Art between World's Fairs, 1876–1893.* Exh. cat. by David C. Huntington. Detroit Institute of Arts, August 22–October 30, 1983. Detroit, 1983.

A.-J. Dézallier d'Argenville 1745–52. Antoine-Joseph Dézallier d'Argenville. *Abrégé de la vie des plus fameux peintres.* 3 vols. Paris, 1745–52.

A.-N. Dézallier d'Argenville 1757. Antoine-Nicolas Dézallier d'Argenville. *Voyage pittoresque de Paris.* 3d ed. Paris, 1757.

Didier 1836a. Charles Didier. *De 1830 à 1836, o La España desde Fernando VII hasta Mendizabal: Resumen histórico critico.* Madrid, 1836.

Didier 1836b. Charles Didier. "L'Espagne en 1835." *Revue des Deux Mondes* (Paris) 5 (March 15–June 1, 1836), pp. 730–56, pp. 578–603.

Didier 1837a. Charles Didier. *Une année en Espagne.* Paris, 1837. 2d ed. Paris, 1841.

Didier 1837b. Charles Didier. "Souvenirs d'Espagne. I. Souvenirs de Catalogne." *Revue de Paris* 44 (1837), pp. 137–53.

Didier 1837c. Charles Didier. "Souvenirs d'Espagne. II. Route de Saragosse à Madrid." *Revue de Paris* 46 (1837), pp. 64–79.

Didier 1838. Charles Didier. "Saragosse." *Revue de Paris* 48 (October 1838), pp. 153–79.

Didier 1845. Charles Didier. "L'Apuxarra." *Revue des Deux Mondes* (Paris) (August 1, 1845; September 1, 1845).

Diers 1998. Michael Diers. "Manet als Velázquez. Eine unbekannte 'Meninas'-Paraphrase." In *Zeitenspiegelung: Zur Bedeutung von Traditionen in Kunst und Kunstwissenschaft: Festschrift für Konrad Hoffmann ʒum 60. Geburtstag am 8. Oktober 1998*, edited by Peter K. Klein and Regine Prange, pp. 203–15. Berlin, 1998.

Distel 1990. Anne Distel. *Impressionism: The First Collectors.* New York, 1990.

Dixon 1899. M. H. Dixon. *Magaʒine of Art* (London) 23 (January 1899).

Dolent 1888. Jean Dolent. *Amoureux d'art.* Paris, 1888.

Dorival 1946. Bernard Dorival. "Recherches sur les relations picturales franco-espagnoles au XVIIe siècle: Claude Vignon et Juan de Valdés Leal." *Pro Arte et Libris* (Paris) 5 (1946), pp. 50–56.

Dorival 1951. Bernard Dorival. "Callot modèle de Murillo." *Revue des Arts* (Paris) 2 (1951), pp. 94–101.

Druick and Zegers 1983. Douglas Druick and Peter Zegers. "Manet's 'Balloon': French Diversion, The Fête de l'Empereur 1862." *Print Collector's Newsletter* (New York) 14 (May–June 1983), pp. 37–46.

Du Camp 1867. Maxime Du Camp. *Les beaux-arts à l'Exposition universelle et aux Salons de 1863, 1864, 1865, 1866 et 1867.* Paris, 1867.

Dublin 1899. *Catalogue of a Loan Collection of Modern Paintings.* Exh. cat. Dublin, Leinster Hall, April 1–29, 1899. Dublin, 1899.

Ducourau 1988. Vincent Ducourau. *Le Musée Bonnat à Bayonne.* Paris, 1988.

Duflo 1988. Pierre Duflo. *Constantin Guys, fou de dessin, grand reporter: 1802–1892.* Paris, 1988.

Dufilho 1997. Jérôme Dufilho. "Constantin Guys (1802–1892), dessinateur et artiste reporter." Ph.D. diss., Université de Paris I, 1997.

Dumas 1837. Alexandre Dumas. "M. le baron Taylor en Espagne." *La Presse* (Paris) (May 28, 1837), pp. 1–2.

Dumas 1847–48. Alexandre Dumas. *Impressions de voyage: De Paris à Cadix.* 5 vols. Paris, 1847–48.

Dumas 1848–49. Alexandre Dumas. *L'Espagne, le Maroc et l'Algerie.* 4 vols. in 1. Paris, 1848–49.

Dumas 1959. Alexandre Dumas. *Adventures in Spain.* Illustrations by Gustave Doré. Philadelphia, 1959.

Dumas 1989. Alexandre Dumas. *De Paris à Cadix. Impressions de Voyage*, vol. 2. Paris, 1989.

Dunlop 1979. Ian Dunlop. *Degas.* New York, 1979.

Durand-Gréville 1925. Émile Durand-Gréville. *Entretiens de J.-J. Henner: Notes prises par Émile Durand-Gréville après ses conversations avec J.-J. Henner (1878–1888).* Paris, 1925.

Durand-Ruel 1873. *Galerie Durand-Ruel: Recueil d'estampes, gravées à l'eau-forte.* Preface by Armand Silvestre. 300 etchings by various engravers. 3 vols. Paris, 1873.

Duranty 1876. Edmond Duranty. *La nouvelle peinture: À propos du groupe d'artistes qui expose dans les galeries Durand-Ruel.* Paris, 1876.

Duranty 1877. Edmond Duranty. "Réflexions d'un bourgeois sur le Salon de peinture." *Gazette des Beaux-Arts* (Paris) 16 (July 1877), pp. 48–82.

Duret 1902. Théodore Duret. *Histoire de Édouard Manet et son oeuvre, avec un catalogue des peintures et des pastels.* Paris, 1902.

Duret 1904. Théodore Duret. *Histoire de J. McN. Whistler et de son oeuvre.* Paris, 1904.

Duret 1917. Théodore Duret. *Whistler.* Translated by Frank Rutter. London and Philadelphia, 1917.

Duret 1918. Théodore Duret. *Courbet.* Paris, 1918.

Duret 1924. Théodore Duret. *Renoir.* Paris, 1924.

Duret 1927. Théodore Duret. *Manet y España.* Translation and prologue by Ventura García Calderón. Paris, 1927.

Duret 1937. Théodore Duret. *Manet.* Translated by John Flitch. New York, 1937.

Durham 1967. *Four Centuries of Spanish Painting.* Exh. cat. Durham, Bowes Museum Barnard Castle, June 17–September 17, 1967. Durham, 1967.

Durham–Birmingham 1986–87. *French Paintings from the Chrysler Museum.* Exh. cat. by Jefferson C. Harrison. Durham, North Carolina Museum of Art, May 31–September 14, 1986; Birmingham [Alabama] Museum of Art, November 6, 1986–January 18, 1987. Norfolk, Va., 1986.

Duro 1985. Paul Duro. "Le Musée des Copies de Charles Blanc à l'aube de la IIIe République." *Bulletin de la Société de l'Histoire de l'Art Français* (Paris) (1985), pp. 283–313.

Edelein-Badie 1997. Béatrice Edelein-Badie. *La collection de tableaux de Lucien Bonaparte, prince de Canino.* Paris, 1997.

Edinburgh 1951. *Catalogue of an Exhibition of Spanish Paintings from El Greco to Goya.* Exh. cat. Edinburgh, National Gallery of Scotland, August 19–September 8, 1951. Edinburgh, 1951.

Edinburgh 1996. *Velázquez in Seville.* Exh. cat. by David Davies and Enriqueta Harris et al. Edinburgh, National Gallery of Scotland, August 8–October 20, 1996. Edinburgh and New Haven, 1996.

Eisler 1977. Colin Eisler. *Paintings from the Samuel H. Kress Collection: European Schools Excluding Italian.* Oxford, 1977.

Eitner 1959. Lorenz Eitner. "The Sale of Géricault's Studio in 1824." *Gazette des Beaux-Arts* (Paris) 53 (February 1959), pp. 115–26.

El Paso 1961. *The Samuel H. Kress Collection: El Paso Museum of Art.* El Paso, 1961.

Elliot 1884. Frances Minto Elliot. *Diary of an Idle Woman in Spain.* 2 vols. London, 1884.

***Encyclopédie* 1758–68.** *Encyclopédie, ou Dictionnaire raisonné des sciences, des arts et des métiers pour une société de gens de lettres.* 16 vols. 2d ed. Lucques, 1758–68.

Engel 1903. A. Engel. "Inventaire de la 'Casa de Pilatos' in 1752." *Bulletin Hispanique* (Bordeaux) 5, no. 3 (July–September 1903).

Engerand 1901. Fernand Engerand. *Inventaire des tableaux commandés et achetés par la Direction des bâtiments du Roy, 1709–1792.* Paris, 1901.

Escholier 1930. Raymond Escholier. "Delacroix, voyageur." *Revue de l'Art Ancien et Moderne* (Paris) 57 (January–May 1930), pp. 13–48.

Escholier 1932. Raymond Escholier. *Eugène Delacroix et sa "consolatrice."* Paris, 1932.

Estignard 1896. Alexandre Estignard. *Courbet, sa vie, ses oeuvres.* Besançon, 1896.

Eudel 1882. Paul Eudel. *L'Hôtel Drouot en 1881.* Paris, 1882.

Eudel 1886. Paul Eudel. *L'Hôtel Drouot et la curiosité en 1884–1885.* Paris, 1886.

Ezandam and Reinders 1992. Y. Ezandam and Marjan Reinders. "Zoek goed gezelschap . . . ga naar de oude meesters!" *Antiek* (Lochem) (June–July 1992), pp. 5–14.

F. P. 1838. F.P. "Musée espagnol." *Le Moniteur Universel* (Paris) (January 10, 1838), p. 55; (January 22, 1838), pp. 143–44; (February 10, 1838), p. 272; (February 26, 1838), pp. 413–14.

Fahy 1971. Everett Fahy. "A History of the Portrait and Its Painter." *Metropolitan Museum of Art Bulletin* (New York) 29 (June 1971), pp. 453, 457.

Fairbrother 1981. Trevor J. Fairbrother. "The Shock of John Singer Sargent's 'Madame Gautreau.'" *Arts Magazine* (New York) 55, no. 5 (January 1981), pp. 90–97.

Fairbrother 1986. Trevor J. Fairbrother. *John Singer Sargent and America.* New York, 1986.

Fairbrother 1994. Trevor J. Fairbrother. *John Singer Sargent.* New York, 1994.

Farwell 1969. Beatrice Farwell. "Manet's *Espada* and Marcantonio." *Metropolitan Museum Journal* (New York) 2 (1969), pp. 197–207.

Farwell 1981. Beatrice Farwell. *Manet and the Nude: A Study of Iconography in the Second Empire.* New York, 1981.

Faunce 1993. Sarah Faunce. *Gustave Courbet.* New York, 1993.

E. Faure 1904. Elie Faure. *Velázquez: Biographie critique.* Paris, 1904.

J. Faure 1902. Jean-Baptiste Faure. *Notice sur la collection J.-B. Faure, suivi du catalogue des tableaux formant cette collection.* Paris, 1902.

Faviers 1837. *Catalogue de tableaux . . . vente par suite du décès de M. le Bon Mathieu de Faviers.* Sale cat. Paris, April 11, 1837. Paris, 1837.

Félibien 1725. André Félibien. *Entretiens sur les vies et sur les ouvrages des plus excellens peintres anciens et modernes (1666–88).* 6 vols. New ed., rev. and augm. Trévoux, 1725.

Felton 1971. Craig M. Felton. "Jusepe de Ribera: A Catalogue Raisonné." Ph.D. diss., University of Pittsburgh, 1971.

Felton 1976. Craig M. Felton. "More Early Paintings by Jusepe de Ribera." *Storia dell'Arte* (Florence), no. 26 (1976), pp. 31–43.

Fermigier 1971. André Fermigier. *Courbet: Étude biographique et critique.* Geneva, 1971.

Fernández de Moratín 1968. Leandro Fernández de Moratín. *Diario, mayo 1780–marzo 1808.* Edited by René y Mireille Andioc. Madrid, 1968.

Fernández García 1998–99. Ana María Fernández García. "Pintura y comercio: Las relaciones anglo-españolas en el siglo XIX." *Norba-Arte* (Badajoz) 18–19 (1998–99), pp. 231–41.

Fernier 1977–78. Robert Fernier. *La vie et l'oeuvre de Gustave Courbet: Catalogue raisonné.* 2 vols. Lausanne, 1977–78.

Ferran n.d. J. P. Ferran. "La haute bourgeoisie protestante marseillaise à la veille de la Révolution: Étude d'histoire économique et sociale." D.E.S., Faculté des Letters d'Aix-en-Provence, n.d.

Ferrari and Scavizzi 1966. Oreste Ferrari and Giuseppe Scavizzi. *Luca Giordano, l'opera completa.* 3 vols. Naples, 1966.

Ferrari and Scavizzi 1992. Oreste Ferrari and Giuseppe Scavizzi. *Luca Giordano, l'opera completa.* 2 vols. 2d ed. Naples, 1992.

Fezzi 1985. Elda Fezzi. *Tout l'oeuvre peint de Renoir: Période impressionniste, 1869–1883.* Paris, 1985.

Fine 1987. Ruth E. Fine, ed. *James McNeill Whistler: A Reexamination.* Washington, D.C., 1987.

Flat 1891. Paul Flat. *L'art en Espagne.* Paris, 1891.

Fleming 1978. Gordon Fleming. *The Young Whistler, 1834–66.* London, 1978.

Flescher 1978a. Sharon Flescher. "Manet's 'Portrait of Zacharie Astruc': A Study of a Friendship and New Light on a Problematic Painting." *Arts Magazine* (New York) (June 1978), pp. 98–105.

Flescher 1978b. Sharon Flescher. *Zacharie Astruc: Critic, Artist, and Japoniste (1833–1907).* New York, 1978.

Flint 1984. Kate Flint, ed. *Impressionists in England: The Critical Reception.* London, 1984.

Florence 1986. *Da el Greco a Goya.* Exh. cat. Edited by Manuela B. Mena Marqués. Florence, Palazzo Vecchio, September 25–December 14, 1986. Milan, 1986.

Florisoone 1957. Michel Florisoone. "Moratin, Inspirer of Géricault and Delacroix." *The Burlington Magazine* (London) 99 (September 1957), pp. 303–11.

Florisoone 1958. Michel Florisoone. "Comment Delacroix a-t-il connu les 'Caprices' de Goya?" *Bulletin de la Société de l'Histoire de l'Art Français* (Paris) (1958), pp. 131–44.

Florisoone 1963. Michel Florisoone. "La genèse espagnole des Massacres de Scio de Delacroix." *Revue du Louvre et des Musées de France* (Paris), nos. 4–5 (1963), pp. 195–208.

Florisoone 1966. Michel Florisoone. "La raison du voyage de Goya à Paris." *Gazette des Beaux-Arts* (Paris) (December 1966), pp. 327–32.

Fonsmark 1985. Anne-Birgitte Fonsmark. "Absinthdrikkeren." *Meddelelser fra Ny Carlsberg Glyptotek* (Copenhagen) 41 (1985), pp. 5–32 (with English summary).

Fonsmark 1987. Anne-Birgitte Fonsmark. "'The Absinthe Drinker'—and Manet's Picture-Making." *Hafnia* (Copenhagen), no. 11 (1987), pp. 76–91.

Fontaney 1835. Antoine Fontaney. *Scènes de la vie castillane et andalouse.* Paris, 1835.

Fontaney 1925. Antoine Fontaney. *Journal intime.* Edited by René Jasinski. Paris, 1925.

Ford 1843. Richard Ford. "The Life of Diego Rodriguez de Silva y Velázquez." In *Penny Cyclopaedia of the Society for the Diffusion of Useful Knowledge.* London, 1843.

Ford 1845. Richard Ford. *A Hand-book for Travellers in Spain and Readers at Home.* 2 vols. London, 1845. 3d ed., rev. London, 1855. New ed. 3 vols. Edited by Ian Robertson. Carbondale, Ill., 1966. Abridged Spanish ed. *Manual para viajeros por Castilla y lectores en casa.* 2 vols. Translated by Jesús Pardo. Madrid, 1981.

Ford 1852. [Richard Ford]. "Series of Items and Articles on Sale of Marshall Soult Collection in Paris." *The Athenaeum* (London) (May 15, 1852), p. 553; (May 22, 1852), p. 585; (May 29, 1852), pp. 609–10; (June 12, 1852), p. 657; (June 19, 1852), p. 680.

Ford 1853. Richard Ford [attrib.]. "Sale of Louis Philippe and Standish Spanish Pictures." *The Athenaeum* (May 14, 1853), pp. 593–94; (May 21, 1853), pp. 622–23; (May 28, 1853), pp. 655–57; (June 4, 1853), pp. 680–81; (June 11, 1853), pp. 710–11.

Fort Worth 1982–83. *Jusepe de Ribera, lo Spagnoletto, 1591–1652.* Exh. cat. Edited by Craig M. Felton and William B. Jordan. Fort Worth, Kimbell Art Museum, December 4, 1982–February 6, 1983. Fort Worth, 1982.

Fort Worth–Los Angeles 2002. *Bartolomé Esteban Murillo (1617–1682): Paintings from American Collections.* Exh. cat. by Suzanne L. Stratton-Pruitt et al. Fort Worth, Kimbell Art Museum, March 10–June 16, 2002; Los Angeles County Museum of Art, July 14–October 6, 2002. New York and Fort Worth, 2002.

Foster 1972. Kathleen A. Foster. "Philadelphia and Paris: Thomas Eakins and the Beaux-Arts." Master's thesis, Yale University, 1972.

Foster 1982. Kathleen A. Foster. "Makers of the American Watercolor Movement, 1860–1890." 2 vols. Ph.D. diss., Yale University, 1982.

Foster 1997. Kathleen A. Foster. *Thomas Eakins Rediscovered: Charles Bregler's Thomas Eakins Collection at the Pennsylvania Academy of the Fine Arts.* New Haven and Philadelphia, 1997.

Foucart 1987. Bruno Foucart. *Le renouveau de la peinture religieuse en France, 1800–1860.* Paris, 1987.

Foucart 1990. Bruno Foucart, ed. *Adrien Dauzats et "Les voyages pittoresques et romantiques dans l'ancienne France" du Baron Taylor.* Paris, 1990.

Fourcaud 1884. Louis de Fourcaud. "Le Salon de 1884." *Gazette des Beaux-Arts* (Paris) 29 (June 1, 1884), pp. 465–92.

Fowler 1894. F. Fowler. *Review of Reviews* (New York) 9 (June 1894), p. 687.

Francis 1943. Henry S. Francis. "'Mlle Romaine Lacaux' by Renoir." *Bulletin of the Cleveland Museum of Art* 30 (1943), pp. 92–98.

Francis 1965. Henry S. Francis. "Portrait of Jester Calabazas." *Bulletin of the Cleveland Museum of Art* 52 (1965), pp. 117–23.

Frankfurt 1987–88. *Eugène Delacroix: Themen und Variationen.* Exh. cat. by Margret Stuffmann et al. Frankfurt, Städtische Galerie im Städelschen Kunstinstitut, September 24, 1987–January 10, 1988. Frankfurt, 1987.

Frankfurt 1991–92. *Goya und Velázquez: Das königliche Portrait.* Exh. cat. by Julián Gállego and Manuela B. Mena Marqués. Frankfurt, Städtische Galerie im Städelschen Kunstinstitut, October 7, 1991–January 9, 1992. Frankfurt, 1991.

Frati 1973. Tiziana Frati. *L'opera completa di Zurbarán.* Milan, 1973.

Frati 1975. Tiziana Frati. *Tout l'oeuvre peint de Zurbarán.* Paris, 1975.

Freund 1926. F. E. W. Freund. "The Universal Art of Ribera." *International Studio* (London) 34 (July 1926).

Fried 1969. Michael Fried. "Manet's Sources: Aspects of His Art, 1859–1865." *Artforum* (New York) 7 (March 1969), pp. 28–82.

Fried 1994. Michael Fried. "Between Realisms: From Derrida to Manet." *Critical Inquiry* (Chicago) 21, no. 1 (Autumn 1994), pp. 1–36.

Fried 1996. Michael Fried. *Manet's Modernism, or The Face of Painting in the 1860s.* Chicago, 1996.

Frimmel 1914. Theodor von Frimmel. *Lexikon der Wiener Gemäldesammlungen.* Part 2. Munich, 1914.

Gallati 1995. Barbara Dayer Gallati. *William Merritt Chase.* New York, 1995.

Gállego 1962. Julián Gállego. *La peinture espagnole.* Paris, 1962.

Gállego 1978. Julián Gállego. *El cuadro dentro del cuadro.* Madrid, 1978.

Gállego and Gudiol 1976. Julián Gállego and José Gudiol. *Zurbarán, 1598–1664.* Barcelona, 1976.

Gállego and Gudiol 1977. Julián Gállego and José Gudiol. *Zurbarán, 1598–1664: Biography and Critical Analysis.* Translated by Kenneth Lyons. London, 1977.

García de la Rasilla and Calvo Serraller 1987. Isabel García de la Rasilla and Francisco Calvo Serraller, eds. *Goya, nuevas visiones: Homenaje a Enrique Lafuente Ferrari.* Madrid, 1987.

García Felguera 1989a. María de los Santos García Felguera. "Centenarios de artistas en el siglo XIX." *Fragmentos* (Madrid), no. 15 (1989), pp. 71–83.

García Felguera 1989b. María de los Santos García Felguera. *La fortuna de Murillo (1682–1900).* Seville, 1989.

García Felguera 1991. María de los Santos García Felguera. *Viajeros, eruditos y artistas: Los Europeos ante la pintura española del siglo de oro.* Madrid, 1991.

García Mercadal 1952–62. José García Mercadal, ed. *Viajes de extranjeros por España y Portugal.* 3 vols. Madrid, 1952–62.

García Mercadal 1999. José García Mercadal, ed. *Viajes de extranjeros por España y Portugal.* 6 vols. Rev. and augm. Valladolid, 1999.

García-Romeral Pérez 1999. Carlos García-Romeral Pérez. *Bio-bibliografía de viajeros por España y Portugal: Siglo XIX.* Madrid, 1999.

Garrido Pérez 1992. Carmen Garrido Pérez. *Velázquez: Técnica y evolución.* Madrid, 1992.

Gassier 1973. Pierre Gassier. *Les dessins de Goya: Les albums.* Fribourg, 1973. Translated as *The Drawings of Goya: The Complete Albums.* New York, 1973.

Gassier 1975. Pierre Gassier. *The Drawings of Goya: The Sketches, Studies and Individual Drawings.* New York, 1975.

Gassier 1981. Pierre Gassier. "Goya and the Hugo Family in Madrid." *Apollo* (London) 114 (October 1981), pp. 248–51.

Gassier and Wilson 1970. Pierre Gassier and Juliet Wilson[-Bareau]. *Vie et oeuvre de Francisco Goya: L'oeuvre complet illustré.* Edited by François Lachenal. Fribourg, 1970.

Gassier and Wilson 1971. Pierre Gassier and Juliet Wilson[-Bareau]. *Goya: His Life and Work, with a Catalogue Raisonné of the Paintings, Drawings, and Enravings.* Edited by François Lachenal. London, 1971.

Gauffin 1923. Axel Gauffin. *Gustave Courbet, Honoré Daumier, Constantin Guys.* Föreningen Fransk Konst Utställningar 5. Stockholm, 1923.

Gautier 1836. Théophile Gautier. "Envois de Rome." *Le Presse* (Paris) (August 30, 1836).

Gautier 1837. Théophile Gautier. "Beaux-Arts: Collection de tableaux espagnols." *La Presse* (Paris) (September 24, 1837).

Gautier 1838a. Théophile Gautier. "Les Caprices de Goya." *La Presse* (Paris) (July 5, 1838). Reprinted with alterations in Gautier 1842; and as "Portrait d'artistes: Goya," *L'Artiste* (Paris) 1 (June 22, 1845), pp. 113–16.

Gautier 1838b. Théophile Gautier. "Exposition du Louvre." *La Presse* (Paris) (April 13, 1838).

Gautier 1838c. Théophile Gautier. "Exposition du Louvre: M. Ziegler." *La Presse* (Paris) (March 16, 1838).

Gautier 1839. Théophile Gautier. "Salon de 1839." *La Presse* (Paris) (March 30, 1839).

Gautier 1840. Théophile Gautier. "Salon de 1840. III." *La Presse* (Paris) (March 20, 1840).

Gautier 1842. Théophile Gautier. "Fran^{co} Goya y Lucientes." *Cabinet de l'Amateur et de l'Antiquaire* (Paris) 1 (September 1842), pp. 537–66.

Gautier 1843. Théophile Gautier. *Tra los montes.* Paris, 1843.

Gautier 1844a. Théophile Gautier. "Poésie: Le souvenir du More." *L'Artiste* (Paris) 5 (1844), p. 15.

Gautier 1844b. Théophile Gautier. "Salon de 1844." *La Presse* (Paris) (March 27, 1844).

Gautier 1845a. Théophile Gautier. *España,* in *Poésies complètes,* vol. 2. Paris, 1845.

Gautier 1845b. Théophile Gautier. "Salon de 1845. Quatrième article." *La Presse* (Paris) (March 20, 1845).

Gautier 1845c. Théophile Gautier. *Voyage en Espagne.* 2d ed. Paris, 1845.

Gautier 1846. Théophile Gautier. "Salon de 1846." *La Presse* (Paris) (April 3–4, 1846).

Gautier 1846–47. Théophile Gautier. "Voyage en Espagne (10 octobre 1846)." *Musée des Familles* (Paris) (December 1846; January 1847).

Gautier 1847a. Théophile Gautier. *Les fêtes de Madrid.* Paris, 1847.

Gautier 1847b. Théophile Gautier. *Militona.* Paris, 1847.

Gautier 1847c. Théophile Gautier. *Salon de 1847.* Paris, 1847.

Gautier 1848a. Théophile Gautier. "Marilhat." *Le Presse* (Paris) (July 1, 1848).

Gautier 1848b. Théophile Gautier. "Salon de 1848." *La Presse* (Paris) (April 28, 1848).

Gautier 1850. Théophile Gautier. "Galerie Espagnole." *La Presse* (Paris) (August 27–28, 1850), pp. 1–2.

Gautier 1853a. Théophile Gautier. *Émaux et camées.* 2d ed., rev. and augm. Paris, 1853.

Gautier 1853b. Théophile Gautier. *Wanderings in Spain.* London, 1853. Translation of *Voyage en Espagne* (1845).

Gautier 1855–56. Théophile Gautier. *Les beaux-arts en Europe.* 2 vols. Paris, 1855–56.

Gautier 1857. Théophile Gautier. "Atelier de feu Théodore Chassériau." *L'Artiste* (Paris) 3, no. 14 (March 15, 1857), pp. 209–11.

Gautier 1861. Théophile Gautier. "Le Salon de 1861." *Le Moniteur Universel* (Paris) (July 3, 1861), p. 1017.

Gautier 1864. Théophile Gautier. *Le Moniteur Universel* (Paris) (August 18, 1864; September 24, 1864; October 19, 1864).

Gautier 1865. Théophile Gautier. *Loin de Paris.* Paris, 1865.

Gautier 1880. Théophile Gautier. *Tableaux à la plume.* Paris, 1880.

Gautier 1882. Théophile Gautier. *Guide de l'amateur au Musée du Louvre, suivi de la vie et des oeuvres de quelques peintres.* 2d ed. Paris, 1882.

Gautier 1890. Théophile Gautier. *Oeuvres de Théophile Gautier. Poésies.* 3 vols. Paris, 1890.

Gautier 1916–19. Théophile Gautier. *Poésies complètes.* 2 vols. Paris, 1916–19.

Gautier 1929. Théophile Gautier. *L'"España" de Th. Gautier.* Edited by René Jasinski. Paris, 1929.

Gautier 1932. Théophile Gautier. *Poésies complètes.* 3 vols. Edited by René Jasinski. Paris, 1932.

Gautier 1946. Théophile Gautier. Preface to *Mademoiselle de Maupin* (1834). Paris, 1946.

Gautier 1961. Théophile Gautier. *Tra los montes, Voyage en Espagne.* Paris, 1961.

Gautier 1981. Théophile Gautier. *Voyage en Espagne.* Edited by Jean-Claude Berchet. Paris, 1981.

Gautier 1985–2000. Théophile Gautier. *Correspondance générale.* 12 vols. Edited by Claudine Lacoste-Veysseyre. Geneva, 1985–2000.

Gautier 1992. Théophile Gautier. *Exposition de 1859.* Edited by Wolfgang Drost and Ulrike Henninges. Heidelberg, 1992.

Gautier 1994. Théophile Gautier. *Critique d'art: Extraits des salons, 1833–1872.* Edited by Marie-Hélène Girard. Paris, 1994.

Gautier et al. 1864. Théophile Gautier, Arsène Houssaye, and Paul de Saint-Victor. *Les dieux et les demi-dieux de la peinture.* Paris, 1864.

Gavard and Viardot 1839. Charles Gavard and Louis Viardot. *Galerie Aguado, choix des principaux tableaux de la galerie de M. le marquis de las Marismas del Guadalquivir.* Paris, 1839.

Gay 1930. Walter Gay. *Memoirs of Walter Gay.* New York, 1930.

Gaya Nuño 1948. Juan Antonio Gaya Nuño. *Zurbarán.* Barcelona, 1948.

Gaya Nuño 1958. Juan Antonio Gaya Nuño. *La pintura española fuera de España.* Madrid, 1958.

Gaya Nuño 1961a. Juan Antonio Gaya Nuño. *Luis de Morales.* Madrid, 1961.

Gaya Nuño 1961b. Juan Antonio Gaya Nuño. "Velázquez y lo Velazqueño." *L'Oeil* (Paris) (February 1961).

Gaya Nuño 1969. Juan Antonio Gaya Nuño. *Historia del Museo del Prado.* Madrid, 1969.

Gaya Nuño 1978. Juan Antonio Gaya Nuño. *La obra pictórica completa de Murillo.* Barcelona, 1978.

Géal 1998. Pierre Géal. "Recherches sur la naissance des musées d'art en Espagne de Charles III à Isabelle II." Ph.D. diss., Sorbonne, 1998.

Géal 1999. Pierre Géal. "L'invention de l'École espagnole de peinture aux XVIIIe et XIXe siècles." *Cahiers du GRIMH* (Lyon), no. 1 (1999), pp. 293–303.

Geffroy 1906. Gustave Geffroy. "Gustave Courbet." *L'Art et les Artistes* (Paris) (October 1906), pp. 257–62.

Geffroy 190?. Gustave Geffroy. *Le musées d'Europe: Londres, la National Gallery.* Paris, 190?.

Geffroy 192?. Gustave Geffroy. *Le Louvre: La peinture étrangère.* Paris, 192?.

Genet 1914. Henri-Émile Genet. "Notes d'art, deux expositions retrospectives: Eva Gonzalès et Berthe Morisot." *La République Française* (Paris) (April 9, 1914).

Geneva 1939. *Les chefs-d'oeuvre du Musée du Prado.* Exh. cat. Geneva, Musée d'Art et d'Histoire, June–August 1939. Geneva, 1939.

Geneva 1980–81. *Fantin-Latour: Lithographies.* Exh. cat. Geneva, Cabinet des Estampes du Musée d'Art et d'Histoire, December 19, 1980–February 22, 1981. Geneva, 1980.

Geneva 1989. *Du Greco à Goya: Chef d'oeuvres du Prado et de collections espagnoles. 50e aniversaire de la sauvegarde du patrimoine artistique espagnol, 1939–1989.* Exh. cat. Geneva, Musée d'Art et d'Histoire, June 16–September 24, 1989. Geneva, 1989.

Gensel 1905. Walther Gensel. *Velázquez: Des Meisters Gemälde in 146 Abbildungen.* Stuttgart, 1905.

C. Georgel 1998. Chantal Georgel. *1848, la République et l'art vivant.* Paris, 1998.

P. Georgel 1995. Pierre Georgel. *Courbet, le poème de la nature.* Paris, 1995.

Gerard-Powell 1998. Véronique Gerard-Powell. "Joseph Bonaparte et la collection des Bourbons d'Espagne." In *Curiosité: Études d'histoire de l'art en l'honneur d'Antoine Schnapper,* edited by Olivier Bonfait, Véronique Gerard-Powell, and Philippe Sénéchal, pp. 407–14. Paris, 1998.

Gerard-Powell 2000. Véronique Gerard-Powell. *Autour de Zurbarán: Catalogue raisonné des peintures de l'école espagnole du XVe au XIXe siècles du Musée de Grenoble.* Paris, 2000.

Gerdts 1979. William H. Gerdts. "Thomas Eakins and the Episcopal Portrait: Archbishop William Henry Elder." *Arts Magazine* (New York) 53, no. 9 (May 1979), pp. 154–57.

Géricault 1824. *Notice de tableaux, esquisses, dessins . . . appartenant à la succession de feu Géricault.* Sale cat. Paris, November 2–3, 1824. Paris, 1824.

Germond de Lavigne 1866. Alfred Germond de Lavigne. *Itinéraire descriptif, historique et artistique de l'Espagne et du Portugal.* 2d ed., rev. Paris, 1866.

Gerstenberg 1957. Kurt Gerstenberg. *Diego Velázquez.* Munich, 1957.

Gestoso y Pérez 1889–92. José Gestoso y Pérez. *Sevilla monumental y artistica.* 3 vols. Seville, 1889–92.

Gestoso y Pérez 1912. José Gestoso y Pérez. *Catálogo de las pinturas y esculturas del Museo Provincial de Sevilla.* Madrid, 1912.

Gestoso y Pérez 1916. José Gestoso y Pérez. *Biografía del pintor sevillano Juan de Valdés Leal.* Seville, 1916.

Gil 1986. Rafael Gil. "Asensio Juliá y Goya." *Goya* (Madrid), no. 192 (1986), pp. 348–54.

Gil 1990. Rafael Gil. *Asensi Julià: El deixeble de Goya.* Valencia, 1990.

Gilman 1905. Benjamin Ives Gilman. "Report of Facts and Opinions Regarding the New Velazquez." *Museum of Fine Arts Bulletin* (Boston) 3 (June 1905), pp. 17–24.

Gintrac 1834. Jean-Louis Gintrac. "Le Mariage burlesque." *L'Artiste* (Paris) 8 (December 1834), p. 236.

Glendinning 1964. Nigel Glendinning. "Goya and England in the Nineteenth Century." *The Burlington Magazine*, vol. 106, no. 730 (January 1964), pp. 4–14.

Glendinning 1976. Nigel Glendinning. "Variations on a Theme by Goya: *Majas on a Balcony.*" *Apollo* (London) (January 1976), pp. 40–47.

Glendinning 1977. Nigel Glendinning. *Goya and His Critics.* New Haven, 1977.

Glendinning 1986. Nigel Glendinning. "Goya's Country House in Madrid: The Quinta del Sordo." *Apollo* (London) (February 1986), pp. 102–9.

Glendinning 1989a. Nigel Glendinning. "Nineteenth-Century British Envoys in Spain and the Taste for Spanish Art in England." *The Burlington Magazine* (London) 131 (February 1989), pp. 125–30.

Glendinning 1989b. Nigel Glendinning. "Nineteenth-Century Editions of Goya's Etchings: New Details of Their Sales Statistics." *Print Quarterly* (London) 6, no. 4 (1989), pp. 394–403.

Glendinning 1994. Nigel Glendinning. "Spanish Inventory References to Paintings by Goya, 1800–1850: Originals, Copies, and Valuations." *The Burlington Magazine* (London) 135 (February 1994), pp. 100–110.

Glendinning et al. 1999. Nigel Glendinning, Enriqueta Harris, and Francis Russell. "Lord Grantham and the Taste for Velázquez: 'The Electrical Eel of the Day.'" *The Burlington Magazine* (London) 141 (1999), pp. 598–605.

Glendinning et al. 2002. Nigel Glendinning et al. *Goya 1900: Catálogo ilustrado y estudio de la exposición en el Ministerio de Instrucción Pública y Bellas Artes.* 2 vols. Madrid, 2002.

Glover 1974. Michael Glover. *The Peninsular War, 1807–1814.* London, 1974.

Godet 1872. Jules-Michel Godet (photographer). "Oeuvres de M. Ed. Manet (24 photographies)." *Bibliographie de la France* (Paris), no. 189 (April 20, 1872).

Godoy 1836–37. Manuel de Godoy. *Mémoires du Prince de la Paix, Don Manuel Godoy.* 4 vols. Paris, 1836–37.

Godoy 1836–42. Manuel de Godoy. *Cuenta dada de su vida política por Don Manuel de Godoy, Príncipe de la Paz, ó sea Memorias críticas y apologéticas para la historia del reinado del Señor D. Carlos IV de Borbón.* 6 vols. Madrid, 1836–42.

Goethe 1828. Johann Wolfgang von Goethe. *Faust.* Illustrations by Eugène Delacroix. Paris, 1828.

Goldscheider 1938. Ludwig Goldscheider. *El Greco.* New York, 1938.

Gómez Ímaz 1896. Manuel Gómez Ímaz. *Inventario de los cuadros sustraídos por el gobierno intruso en Sevilla (año 1810).* Seville, 1896. 2d ed., Seville, 1917.

Gómez Ímaz 1910. Manuel Gómez Ímaz. *Los periódicos durante la guerra de la Independencia (1808–1814).* Madrid, 1910.

Goncourt 1887–96. Edmond and Jules de Goncourt. *Journal des Goncourt: Mémoires de la vie littéraire.* 9 vols. Paris, 1887–96.

Goncourt 1956–58. Edmond and Jules de Goncourt. *Journal des Goncourt: Mémoires de la vie littéraire.* 22 vols. Edited by Robert Ricatte. Monaco, 1956–58.

Goncourt 1989. Edmond and Jules de Goncourt. *Journal des Goncourt: Mémoires de la vie littéraire.* 3 vols. Edited by Robert Ricatte. Paris, 1989.

Gonse 1884. Louis Gonse. "Manet." *Gazette des Beaux-Arts* (Paris) 29 (February 1884), pp. 133–52.

Gonse 1900. Louis Gonse. *Les chefs-d'oeuvre des musées de France: La peinture.* Paris, 1900.

Gonzalès 1885. *Catalogue de vente des tableaux, pastels, aquarelles par Eva Gonzalès.* Sale cat. Preface by Edmond Bazire. Paris, Hôtel Drouot, February 20, 1885. Paris, 1885.

González de León 1844. Félix González de León. *Noticia artística, histórica y curiosa de todos los edificios públicos, sagrados y profanos de esta ciudad de Sevilla.* 2 vols. Seville, 1844.

Goodrich 1982. Lloyd Goodrich. *Thomas Eakins.* 2 vols. Cambridge, Mass., 1982.

Goodrich Papers. Lloyd Goodrich Papers. Philadelphia Museum of Art.

Gotteri 1993. Nicole Gotteri. "Deux tableaux offerts au maréchal Soult par le chapitre de la cathédrale de Séville." *Revue du Louvre* (Paris) (April 1993), pp. 44–52.

Gotteri 2000. Nicole Gotteri. *Le Maréchal Soult.* 2d ed., rev. and enl. Paris, 2000.

Gould 1965. Cecil Gould. *Trophy of Conquest: The Musée Napoléon and the Creation of the Louvre.* London, 1965.

Gower 1885. Ronald Charles Sutherland, Lord Gower. *The Northbrook Gallery: An Illustrated, Descriptive and Historic Account of the Collection of the Earl of Northbrook.* London, 1885.

Goya 1824. Francisco de Goya y Lucientes. *Caricatures espagnoles "ni plus ni moins" par Goya.* Paris, 1824.

Goya 1868. Francisco de Goya y Lucientes. [Etching of *Caprichos* no. 10, by Alphonse Hirsch]. *Gazette des Beaux-Arts* (Paris) 24 (April 1, 1868), p. 388.

Goya 1981. Francisco de Goya y Lucientes. *Diplomatario.* Edited by Ángel Canellas López. Saragossa, 1981.

Goya 1982. Francisco de Goya y Lucientes. *Cartas a Martín Zapater.* Edited by Mercedes Águeda and Xavier de Salas. Madrid, 1982.

Goya 1999. Francisco de Goya y Lucientes. *El libro de los Caprichos.* Edited by Javier Blas, José Manuel Matilla, and José Miguel Medrano. Madrid, 1999.

Goya 2000. Francisco de Goya y Lucientes. *El libro de los Desastres de la Guerra.* 2 vols. Edited by Javier Blas and José Manuel Matilla. Madrid, 2000.

Goya 2001. Francisco de Goya y Lucientes. *El libro de la Tauromaquia.* Edited by José Manuel Matilla and José Miguel Medrano. Madrid, 2001.

Gozlan 1837. Léon Gozlan. "Musée espagnol à Paris." *Revue de Paris,* n.s. 41 (1837), pp. 107–20, 283–96.

Granada 1953. *Zurbarán.* Exh. cat. Granada, Palacio de Carlos V, June 1953. Madrid, 1953.

Granada 1976–78. *Actas del XXIII Congreso internacional de historia del arte: España entre el Mediterráneo y el Atlántico, Granada, 1973.* 3 vols. Granada, 1976–78.

Granville 1975. Pierre Granville. "'Notre-Dame-de-Lorette' et l'effusion spirituelle chez J.-F. Millet." *Revue du Louvre et des Musées de France* (Paris), nos. 5–6 (1975), pp. 344–53.

Gros 2000. Fabienne Gros. "La collection de peinture espagnole des frères Pereire vendue à Paris en 1868 et 1872." Thesis, Sorbonne, 2000.

Grunchec 1976. Philippe Grunchec. "L'inventaire posthume de Théodore Géricault (1791–1824)." *Bulletin de la Société de l'Histoire de l'Art Français* (Paris) (1976), pp. 395–420.

Gruyer 1891. F.-A. Gruyer. *Voyage autour du Salon carré au Musée du Louvre.* Paris, 1891.

Gudiol 1970/1980. José Gudiol. *Goya, 1746–1828.* 4 vols. Barcelona, 1970. Rev. and renumbered ed. 2 vols. Barcelona, 1980.

Gudiol 1971. José Gudiol. *Doménikos Theotokópoulos: El Greco, 1541–1614.* Barcelona, 1971.

Gudiol 1973. José Gudiol. *Velázquez, 1599–1660: Historia de su vida, catálogo de su obra, estudio de la evolución de su técnica.* Barcelona, 1973.

Gudiol 1974. José Gudiol. *Velázquez, 1599–1660.* Translated by Kenneth Lyons. New York, 1974.

Guégan 2000. Stéphane Guégan. "La dame aux éventails par Édouard Manet." *Beaux-Arts* 193 (2000), pp. 98–99.

Guégan and Haddad 1996. Stéphane Guégan and Michèle Haddad. *L'ABCdaire de Courbet et le réalisme.* Paris, 1996.

Guérin 1933. Marcel Guérin. "Le portrait du chanteur Pagans et de M. de Gas père, par Degas." *Bulletin des Musées de France* (Paris) 3 (March 1933), pp. 33–35.

Guérin 1944. Marcel Guérin. *L'oeuvre gravé de Manet.* Paris, 1944. New ed. New York and Amsterdam, 1969.

Gueullette 1863. Charles Gueullette. *Les peintres espagnols.* Paris, 1863.

Guiffrey 1929. Jean Guiffrey, ed. *La peinture au Musée du Louvre.* 2 vols. Paris, 1929.

Guinard 1939. Paul Guinard. "Zurbarán et la 'découverte' de la peinture espagnole en France sous Louis-Philippe." In *Hommage à Ernest Martinenche,* pp. 23–33. Paris, 1939.

Guinard 1946–49. Paul Guinard. "Los conjuntos dispersos o desaparecidos de Zurbarán: Anotaciones a Ceán Bermúdez." *Archivo Español de Arte* (Madrid) 19 (1946), pp. 249–73; 20 (1947), pp. 161–201; 22 (1949), pp. 1–38.

Guinard 1960. Paul Guinard. *Zurbarán et les peintres espagnols de la vie monastique.* Paris, 1960.

Guinard 1961a. Paul Guinard. "Pharamond Blanchard." *Goya* (Madrid), no. 46 (January–February 1961), pp. 280–88.

Guinard 1961b. Paul Guinard. "Velasquez vu par quelques écrivains français." *Jardin des Arts* (Paris) 75 (February 1961), pp. 45–51.

Guinard 1961c. Paul Guinard. "Zurbarán en Francia." *Revista de Estudios Extremeños* (Badajoz) 17 (February 1961), pp. 363–77.

Guinard 1962. Paul Guinard. "Romantiques français en Espagne." *Art de France* (Paris) 2 (1962), pp. 179–98.

Guinard 1967a. Paul Guinard. "Baudelaire, le Musée Espagnol et Goya." *Revue d'Histoire Littéraire de France* (Paris) 67 (April–June 1967), pp. 310–28.

Guinard 1967b. Paul Guinard. *Dauzats et Blanchard: Peintres de l'Espagne romantique.* Paris, 1967.

Guinard 1967c. Paul Guinard. *Les peintres espagnols.* Paris, 1967.

The Hague–Paris 1970. *Goya.* Exh. cat. The Hague, Royal Gallery of Paintings, Mauritshuis, July 4–September 13, 1970; Paris, Orangerie des Tuileries, September 25–December 7, 1970. Paris, 1970.

Hamburg 1894. *Grossen Kunst-Ausstellung des Kunst-Vereins.* Exh. cat. Hamburg, Kunsthalle, 1894. Hamburg, 1894.

Hamburg–Frankfurt 1978–79. *Courbet und Deutschland.* Exh. cat. Edited by Werner Hofmann. Hamburger Kunsthalle, October 19–December 17, 1978; Frankfurt, Städtische Galerie im Städelschen Kunstinstitut, January 17–March 18 1979. Cologne, 1978.

Hamilton 1969. George Heard Hamilton. *Manet and His Critics.* New York, 1969.

Hamilton 1986. George Heard Hamilton. *Goya and His Critics.* New Haven, 1986.

Hanson 1970. Anne Coffin Hanson. "Edouard Manet, 'Les Gitanos,' and the Cut Canvas." *The Burlington Magazine* (London) 112 (March 1970), pp. 158–66.

Hanson 1977. Anne Coffin Hanson. *Manet and the Modern Tradition.* New Haven, 1977.

Haraszti-Takács 1966. Marianne Haraszti-Takács. *Spanish Masters: Budapest Museum of Fine Arts.* Translated by Eva Rácz. Budapest, 1966.

Haraszti-Takács 1968. Marianne Haraszti-Takács. *Murillo.* Budapest, 1968.

Haraszti-Takács 1977. Marianne Haraszti-Takács. *Murillo.* Budapest, 1977.

Haraszti-Takács 1978. Marianne Haraszti-Takács. "Deux peintures espagnols ayant servi de modèles à Manet." *Actae Historiae Artium* (Budapest) 24 (1978), pp. 397–403.

Haraszti-Takács 1982. Marianne Haraszti-Takács. *Spanyol festészet a primitivekt?l* (Pintura española desde los primitivos a Ribera). 3d ed. Budapest, 1982.

Haraszti-Takács 1983. Marianne Haraszti-Takács. *Spanish Genre Painting in the Seventeenth Century.* Translated by Alfréd Falvay. Budapest, 1983.

E. Harris 1963. Enriqueta Harris. "Spanish Painting in Paris." *The Burlington Magazine* (London) 105 (1963), pp. 321–25.

E. Harris 1964a. Enriqueta Harris. "A Contemporary Review of Goya's 'Caprichos.'" *The Burlington Magazine* (London) 106 (January 1964), pp. 38–43.

E. Harris 1964b. Enriqueta Harris. "Sir William Stirling-Maxwell and the History of Spanish Art." *Apollo* (London) 79, no. 23 (1964), pp. 73–77.

E. Harris 1982. Enriqueta Harris. *Velázquez.* Ithaca, N.Y., 1982.

E. Harris 1982–83. Enriqueta Harris. "Murillo en Inglaterra." *Goya* (Madrid), nos. 169–174 (1982–83), pp. 7–17.

E. Harris 1987. Enriqueta Harris. "Velázquez and Murillo in Nineteenth-Century Britain: An Approach through Prints." *Journal of the Warburg and Courtauld Institutes* (London) 50 (1987), pp. 148–59.

E. Harris 1991. Enriqueta Harris. *Velázquez.* Vitoria-Gasteiz, 1991.

J. Harris 1970. Jean C. Harris. *Edouard Manet: Graphic Works: A Definitive Catalogue Raisonné.* New York, 1970. Rev. ed. *Edouard Manet: The Graphic Work: A Catalogue Raisonné.* Edited by Joel M. Smith. San Francisco, 1990.

T. Harris 1964. Tomás Harris. *Goya: Engravings and Lithographs.* 2 vols. Oxford, 1964.

Harrison 1991. Jefferson C. Harrison. *The Chrysler Museum: Handbook of the European and American Collections.* Norfolk, Va., 1991.

Hartmann 1910. Sadakichi Hartmann. *The Whistler Book: A Monograph on the Life and Position in Art of James McNeill Whistler, Together with a Careful Study of His More Important Works.* Boston, 1910.

Haskell 1976. Francis Haskell. *Rediscoveries in Art: Some Aspects of Taste, Fashion, and Collecting in England and France.* Ithaca, N.Y., 1976.

Haskell 1991. Francis Haskell. "William Coningham and His Collection of Old Masters." *The Burlington Magazine* (London) 133 (October 1991), pp. 676–81.

Haskell 2000. Francis Haskell. *The Ephemeral Museum: Old Master Paintings and the Rise of the Art Exhibition.* New Haven, 2000.

Haskell and Penney 1981. Francis Haskell and Nicholas Penney. *Taste and the Antique: The Lure of Classical Sculpture, 1500–1900.* New Haven, 1981.

Haskins 1993. Susan Haskins. *Mary Magdalen: Myth and Metaphor.* London, 1993.

Haussard 1838. Prosper Haussard. "Salon de 1838." *Le National* (March 15, 1838).

Haussard 1848. Prosper Haussard. "Beaux-Arts. Salon de 1848." *Le National* (Paris) (June 15, 1848).

Hautecoeur 1926. Louis Hautecoeur. *Musée National du Louvre: Catalogue de peintures exposées dans les galeries. II. École italienne et École espagnole.* Paris, 1926.

Havemeyer 1993. Louisine W. Havemeyer. *Sixteen to Sixty: Memoirs of a Collector.* Edited by Susan Alyson Stein. New York, 1993.

Head 1848. Sir Edmund Head. *A Hand-book of the History of the Spanish and French Schools of Painting.* London, 1848.

Heaton 1923. Augustus George Heaton. "Léon Bonnat." *Nutshell* 8 (January–March 1923).

Held 1964. Jutta Held. *Farbe und Licht in Goyas Malerei.* Berlin, 1964.

Heller 2000. Nancy G. Heller. "What's There, What's Not: A Performer's View of Sargent's *El Jaleo.*" *American Art* (New York) 14, no. 1 (Spring 2000), pp. 8–23.

Hendricks 1974. Gordon Hendricks. *The Life and Work of Thomas Eakins.* New York, 1974.

Henri 1984. Robert Henri. *The Art Spirit: Notes, Articles, Fragments of Letters and Talks to Students, Bearing on the Concept and Technique of Picture Making, the Study of Art Generally, and on Appreciation* (1923). Compiled by Margery Ryerson. New York, 1984.

Herdrich and Weinberg 2000. Stephanie L. Herdrich and H. Barbara Weinberg. *American Drawings in The Metropolitan Museum of Art: John Singer Sargent.* New York, 2000.

Hermitage 1838. *Livret de la Galerie Impérial de l'Ermitage de Saint-Pétersbourg, contenant l'explication des tableaux qui la composent, avec de courtes notices sur les autres objets d'art ou de curiosité qui y sant exposés.* St. Petersburg, 1838.

Hermitage 1958. *Catalogue des peintures, Musée de l'Ermitage.* 2 vols. Moscow, 1958.

Hermitage 1976. *Zapadnoevropeiskaia zhivopis: Katalog / Peinture de l'Europe occidentale,* vol. 1, *Italiia, Ispaniia, Frantsiia, Shveitsariia.* Edited by V. F. Levinsona-Lessinga. Leningrad, 1976.

Herrero García 1966. Miguel Herrero García. *Ideas de los españoles del siglo XVII.* Madrid, 1966.

Hispanic Society 1926. *Ribera in the Collection of the Hispanic Society of America.* New York, 1926.

Hispanic Society 1927. *El Greco in the Collection of the Hispanic Society of America.* New York, 1927.

Hispanic Society 1938. *The Hispanic Society of America Handbook.* New York, 1938.

Hoffmann 1961. Léon-François Hoffmann. *Romantique Espagne: L'image de l'Espagne en France entre 1800 et 1850.* Princeton, N.J., and Paris, 1961.

Holt 1981. Elizabeth Gilmore Holt, ed. *The Art of All Nations, 1850–1873: The Emerging Role of Exhibitions and Critics.* Garden City, N.Y., 1981.

Homer 1969. William Innes Homer. *Robert Henri and His Circle.* Ithaca, N.Y., 1969.

Homer 1992. William Innes Homer. *Thomas Eakins: His Life and Art.* New York, 1992.

Horsin-Déon 1861. Léon Horsin-Déon. "Les cabinets d'amateurs à Paris." *L'Artiste* (Paris) 12 (1861), pp. 243–49.

Horsin-Déon 1866. Léon Horsin-Déon. *Catalogue raisonné des tableaux de la galerie de feu M. le Maréchal-General Soult, Duc de Dalmatie.* Paris, 1866.

Horsin-Déon et al. 1860–62. Léon Horsin-Déon et al. "Notices sur les cabinets d'amateurs." *Annuaire des Artistes et des Amateurs* (Paris) 1 (1860), pp. 156–70; 2 (1861), pp. 117–41; 3 (1862), pp. 124–48.

Hoskins 1851. George A. Hoskins. *Spain, as it is.* 2 vols. London, 1851.

Hosotte 1927. Louis Hosotte. "Un général comtois du premier empire, Nicolas-Philippe Guye (1773–1845)." *Bulletin de l'Académie des Sciences, Belles-Lettres et Arts de Besançon,* 2d trimestre (1927), pp. 57–75.

Huard 1838. Étienne Huard. "Le Musée Espagnol." *Journal des Artistes* (Paris) (July 8, 1838), p. 26.

Huard 1839–41. Étienne Huard. *Vie complète des peintres espagnols et histoire de la peinture espagnole.* 2 vols. Paris, 1839–41.

Hubbard 1949. R. H. Hubbard. "A Murillo for the National Gallery of Canada." *The Connoisseur* (London) 123 (March–June 1949), p. 49.

A. Hugo 1833a. Abel Hugo. "Souvenirs sur Joseph Napoléon. Première partie." *Revue des Deux Mondes* (Paris) 1 (February 1, 1833), pp. 260–84.

A. Hugo 1833b. Abel Hugo. "Souvenirs sur Joseph Napoléon, sa cour, l'armée française et l'Espagne, en 1811, 1812 et 1813. Deuxième partie." *Revue des Deux Mondes* (Paris) 2 (1833).

H. Hugo 1957. Howard E. Hugo, ed. *Portable Romantic Reader.* New York, 1957.

V. Hugo 1828. Victor Hugo. *Odes et ballades.* Illustrated by Louis Boulanger. 2 vols. 5th ed. Paris, 1828.

V. Hugo 1830. Victor Hugo. *Hernani, ou L'honneur castillan.* Paris, 1830.

V. Hugo 1831a. Victor Hugo. *Les feuilles d'automne.* Paris, 1831.

V. Hugo 1831b. Victor Hugo. *Notre-Dame de Paris.* Paris, 1831.

V. Hugo 1838. Victor Hugo. *Ruy Blas.* Paris, 1838.

V. Hugo 1859. Victor Hugo. *Le légende des siècles.* Paris and Brussels, 1859.

V. Hugo 1904. Victor Hugo. *Notre-Dame de Paris.* Oeuvres complètes, vol. 2. Edited by Paul Meurice. Paris, 1904.

V. Hugo 1987. Victor Hugo. *Oeuvres complètes,* vol. 6, *Histoire: Napoléon le Petit, Histoire d'un crime, et Choses vues.* Edited by Guy Rosa. Paris, 1987.

A. Huntington 1898. Archer M. Huntington. *A Note-Book in Northern Spain.* New York, 1898.

C. Huntington 1896. Collis Potter Huntington. *Description of Pictures Belonging to Collis Potter Huntington.* 3 vols. New York, 1896.

Huntington Papers. Archer M. Huntington Papers. The Hispanic Society of America Library, New York.

Huth 1946. Hans Huth. "Impressionism Comes to America." *Gazette des Beaux-Arts* (Paris) 29 (January 1946), pp. 225–52.

Huysmans 1883. J. K. Huysmans. *L'art moderne.* Paris, 1883.

Huysmans 1889. J. K. Huysmans. *Certains. . . .* Paris, 1889.

Ideville 1878. Henri Amédée le Lorgne, comte d'Ideville. *Gustave Courbet: Notes et documents sur sa vie et son oeuvre, avec huit eaux-fortes par A.-P. Martial et un dessin par Édouard Manet.* Paris, 1878.

Imbert 1875. Pierre-Léonce Imbert. *L'Espagne, splendeurs et misères: Voyage artistique et pittoresque . . . Illustrations d'Alexandre Prévost.* Paris, 1875. 2d ed. Paris, 1876.

Inaga 1994. Shigemi Inaga. "Essai d'une reconstitution de la collection Théodore Duret." *Bulletin de l'Esthétique et de l'Histoire de l'Art* (Nagoya), no. 12 (1994). In Japanese.

Indianapolis 1949. *Chase Centennial Exhibition.* Exh. cat. Indianapolis, John Herron Art Institute, November 1–December 11, 1949. Indianapolis, 1949.

Indianapolis et al. 1909. *A Collection of Oil Paintings by William Merritt Chase, N.A.* Exh. cat. Indianapolis, John Herron Art Museum; Buffalo, Albright Art Gallery; Cincinnati Art Museum; Saint Louis Museum of Fine Arts, 1909. Indianapolis, 1909.

Indianapolis–New York 1996–97. *Painting in Spain in the Age of Enlightenment: Goya and His Contemporaries.* Exh. cat. Edited by Ronda Kasl and Suzanne L. Stratton. Indianapolis Museum of Art, November 23, 1996–January 19, 1997; New York, The Spanish Institute, spring 1997. Indianapolis and New York, 1997.

Ingamells 1985. John Ingamells. *The Wallace Collection: Catalogue of Pictures,* vol. 1, *British, German, Italian, Spanish.* London, 1985.

Ingelheim 1977. *Edouard Manet: Das graphische Werk.* Exh. cat. by Juliet Wilson[-Bareau] et al.

Ingelheim, International Tage, April 30–June 19, 1977. Ingelheim am Rhein, 1977.

Irving 1828. Washington Irving. *A History of the Life and Voyages of Christopher Columbus.* 4 vols. New York and Paris, 1828.

Irving 1829. Washington Irving. *A Chronicle of the Conquest of Granada.* 2 vols. London and Philadelphia, 1829.

Irving 1832. Washington Irving. *The Alhambra: A Series of Tales and Sketches of the Moors and Spaniards.* Philadelphia and London, 1832.

"Ishmael" 1891. "Ishmael." "Through the New York Studios—William Merritt Chase." *The Illustrated American* (New York) 5 (February 14, 1891), p. 618.

Israëls 1900. Josef Israëls. *Spain: The Story of a Journey* (1898). Translated from Dutch by Alexander Teixeira de Mattos. London, 1900.

Ives 1980. Colta Ives. "Prints and Photographs." In *Notable Acquisitions/The Metropolitan Museum of Art, 1980–1981.* New York, 1980.

J.L. 1850. J.L. "Exposición de Bellas Artes en la Real Academia de San Fernando." *La Ilustración: Periódico Universal* (Madrid), no. 39 (September 28, 1850), p. 206.

Jamar-Rolin 1956. Luce Jamar-Rolin. "La vie de Guys et la chronologie de son oeuvre." *Gazette des Beaux-Arts* (Paris) (July–August 1956), pp. 69–112.

James 1877. Henry James. "The Picture Season in London." *The Galaxy* (New York) 24 (August 1877), pp. 149–61.

James 1887. Henry James. "John S. Sargent." *Harper's Monthly Magazine* (New York) 75 (October 1887).

James 1893. Henry James. *Picture and Text.* New York, 1893.

James 1897. Henry James. "London, June 1st 1897." *Harper's Weekly* (New York) (June 26, 1897), pp. 639–40.

James 1956. Henry James. *The Painter's Eye: Notes and Essays on the Pictorial Arts.* Edited by John L. Sweeney. London, 1956.

Jameson 1844. Anna Jameson. *Companion to the Most Celebrated Private Galleries of Art in London.* London, 1844.

Jameson 1848. Anna Jameson. *Sacred and Legendary Art.* 2 vols. London, 1848.

Jameson 1852. Anna Jameson. *Legends of the Monastic Orders as Represented in the Fine Arts.* 2d ed. London, 1852. 4th ed., 1867.

Jameson 1857. Anna Jameson. *Legends of the Madonna as Represented in the Fine Arts.* 2d ed. London, 1857.

Jamot 1928. Paul Jamot. "Acquisitions récentes du Louvre." *L'Art Vivant* (Paris) (March 1, 1928), pp. 175–76.

Javel 1885. Firmin Javel. "L'exposition Eva Gonzalès." *L'Événement* (Paris) (January 23, 1885), p. 3.

Joanne 1860. Adolphe Joanne. *Guide du voyageur en Europe: France, Belgique, Hollande, . . . Espagne, Portugal.* 2d ed. Paris, 1860.

Joanne 1863. Adolphe Joanne. *Paris illustré: Nouveau guide de l'étranger et du Parisien.* Paris, 1863.

Jobert 1997. Barthélémy Jobert. *Delacroix.* Paris, 1997.

Johnson 1963. Lee Johnson. "The Delacroix Centenary in France." *The Burlington Magazine* (London) 105 (1963), pp. 297–305.

Johnson 1977. Lee Johnson. "A New Source for Manet's 'Execution of Maximilian.'" *The Burlington Magazine* (London) 119 (August 1977), pp. 560–64.

Johnson 1981–89. Lee Johnson. *The Paintings of Eugène Delacroix: A Critical Catalogue, 1816–1831.* 6 vols. Oxford, 1981–89.

Johnson 1987. Lee Johnson. *The Paintings of Eugène Delacroix: A Critical Catalogue, 1816–1831.* 2 vols. Corrected ed. Oxford, 1987.

Jornadas 1991. *Velázquez y el arte de su tiempo: V Jornadas de Arte.* Madrid, 1991.

Jouin 1888. Henry Jouin. *Musée de portraits d'artistes.* Paris, 1888.

Jovellanos 1984–94. Gaspar Melchor de Jovellanos. *Obras completas de Jovellanos.* 6 vols. Edited by José Miguel Caso González. Oviedo, 1984–94.

Jowell 1971. Frances Suzman Jowell. "Thoré-Bürger and the Art of the Past." Ph.D. diss., Harvard University, 1971.

Jowell 1977. Frances Suzman Jowell. *Thoré-Bürger and the Art of the Past.* New York, 1977.

Jubinal 1837. Achille Jubinal. *Notice sur M. le baron Taylor et sur les tableaux espagnols achetés par lui d'après les ordres du roi.* Paris, 1837.

Juderías 1997. Julián Juderías. *La leyenda negra: Estudios acerca del concepto de España en el extranjero* (1914). Castilla y León, 1997.

Junot 1817. *A Catalogue . . . of the . . . Gallery . . . of Field Marshal Junot.* Sale cat. London, Christie's, June 7, 1817. London, 1817.

Junot 1818. *A Catalogue of a Capital and Very Valuable Assemblage . . . Which Formed a Part of the Celebrated Gallery of Field Marshal Junot, Duke of Abrantes.* Sale cat. London, Christie's, May 4, 1818. London, 1818.

Juretschke 1970–. Hans Juretschke, ed. *Berichte der diplomatischen Vertreter des Wiener Hofes aus Spanien in der Regierungszeit Karls III. (1759–1788) / Despachos de los representantes diplomáticos de la Corte de Viena acreditados en Madrid durante el reinado de Carlos III (1759–1788).* 18 vols. Madrid, 1970–.

Justi 1888. Carl Justi. *Diego Velázquez und sein Jahrhundert.* 2 vols. Bonn, 1888. New ed. *Velázquez y su siglo.* Contributions by Karin Hellwig and José Álvarez Lopera. Madrid, 1999.

Justi 1889. Carl Justi. *Diego Velázquez and His Times.* Translated by A. H. Keane. Rev. ed. London, 1889.

Justi 1891. Carl Justi. "Murillo." *Zeitschrift für Bildende Kunst* (Leipzig) 2 (1891), pp. 153–62, 261–75.

Justi 1892. Carl Justi. *Murillo.* Leipzig, 1892.

Justi 1904. Carl Justi. *Murillo.* 2d ed. Leipzig, 1904.

Kagané 1977. Ludmila L. Kagané. *Ispanskaia zhivopis' shestnadtsatogo–vosemnadtsatogo vekov v Ermitazhe.* 2d ed. Leningrad, 1977.

Kagané 1995. Ludmila L. Kagané. *Bartolomé Esteban Murillo, 1617–1682.* Paris, 1995.

Kagané 1997. Ludmila L. Kagané. *Spanish Painting: Fifteenth to Nineteenth Centuries.* The Hermitage Catalogue of Western European Painting, vol. 4. Moscow, 1997.

Karge 1991. Henrik Karge, ed. *Vision oder Wirklichkeit: Die spanische Malerei der Neuzeit*. Munich, 1991.

Karuizawa 2001. *Le chemin de Millet*. Exh. cat. Karuizawa, Musée d'Art Mercian, July 18–November 11, 2001. Paris, 2001.

Katow 1885. Paul de Katow. "L'exposition Eva Gonzalès, Salons de la Vie Moderne." *Gil Blas* (Paris) (January 17, 1885), p. 3.

Kehrer 1918. Hugo Kehrer. *Francisco de Zurbarán*. Munich, 1918.

Kehrer 1966. Hugo Kehrer. *Alemania en España: Influjos y contactos a través de los siglos*. Madrid, 1966. Originally published as *Deutschland in Spanien: Beziehung, Einfluss und Abhängigkeit*. Munich, 1953.

Kendall 1987. Richard Kendall, ed. *Degas por si mismo*. Barcelona, 1987. Translated as *Degas by Himself: Drawings, Prints, Paintings, Writings*. London, 1987.

Kératry 1822. Auguste-Hilarion de Kératry. *Du beau dans les arts d'imitation*. Paris, 1822.

Kinkead 1978. Duncan T. Kinkead. *Juan de Valdes Leal (1622–1690): His Life and Work*. New York, 1978.

Kinkead 1986. Duncan T. Kinkead. "The Picture Collection of Don Nicolás Omazur." *The Burlington Magazine* (London) 128 (February 1986), pp. 132–44.

Knackfuss 1896. Hermann Knackfuss. *Velazquez*. Bielefeld, 1896.

Kubler and Soria 1959. George Kubler and Martin S. Soria. *Art and Architecture in Spain and Portugal and Their American Dominions, 1500 to 1800*. Harmondsworth, 1959.

Kugler 1848. Franz Kugler. *Handbuch der Kunstgeschichte* (1841). 2d ed. Stuttgart, 1848.

La Tourette 1931. Gilles de La Tourette. "Peintures et dessins algériens de Théodore Chassériau." *L'Art et les Artistes* (Paris) 22 (March 1931), pp. 181–91.

Laborde 1806–20. Alexandre de Laborde. *Voyage pittoresque et historique de l'Espagne*. 2 vols. in 4. Paris, 1806–20.

Laborde 1809a. Alexandre de Laborde. *Itinéraire descriptif de l'Espagne*. 5 vols. 2d ed. Paris, 1809.

Laborde 1809b. Alexandre de Laborde. *A View of Spain*. 5 vols. 2d ed. London, 1809.

Lacambre 1975. Geneviève Lacambre and Jean Lacambre. "Tableaux religieux de Boissard de Boisdenier." *Revue de l'Art* (Paris), no. 27 (1975), pp. 52–57.

Lacambre 1998. Geneviève Lacambre. "La *Galatée* de Gustave Moreau entre au Musée d'Orsay." *48/14: Revue du Musée d'Orsay* (Paris), no. 6 (Spring 1998), pp. 48–61.

Lafond 1902. Paul Lafond. *Goya*. Paris, 1902.

Lafond 1909. Paul Lafond. *Ribera et Zurbaran*. Paris, 1909.

Lafond 1918–19. Paul Lafond. *Degas*. 2 vols. Paris, 1918–19.

Laforge 1859. Édouard Laforge. *Des arts et des artistes en Espagne jusqu'à la fin du XVIIIe siècle*. Lyon, 1859.

Lafuente Ferrari 1944. Enrique Lafuente Ferrari. *Velázquez*. Barcelona, 1944.

Lagrange 1863. Léon Lagrange. "La galerie de M. le duc de Morny." *Gazette des Beaux-Arts* (Paris) 14 (May 1, 1863), pp. 385–401.

Langle 1786. Marquis de Langle [Jérôme-Charlemagne Fleuriau]. *A Sentimental Journey Through Spain*. 2 vols. London, 1786.

Lannau-Rolland 1864. A. Lannau-Rolland. *Nouveau guide général du voyageur en Espagne et en Portugal* (Guide Garnier). Paris, 1864.

Lannoy 1986. Isabelle de Lannoy. "Jean-Jacques Henner, 1829–1905: Essai de catalogue." Typescript, Paris, École du Louvre, 1986.

Lannoy 1990. Isabelle de Lannoy. *Musée National Jean-Jacques Henner: Catalogue des peintures*. Paris, 1990.

Lanzac de Laborie 1912. Léon de Lanzac de Laborie. "Le musée du Louvre au temps de Napoléon d'après des documents inédits." *Revue des Deux Mondes* (Paris) 10 (August 1, 1912), pp. 608–43.

Lanzac de Laborie 1913. Léon de Lanzac de Laborie. *Paris sous Napoléon*, vol. 8, *Spectacles et musées*. Paris, 1913.

Lapauze 1918. Henry Lapauze. *La renaissance de l'art français et des industries de luxe. 1re année*. Paris, 1918.

Lapeyrière 1817. *Catalogue d'une collection précieuse . . . composant le cabinet de M. L***[Lapeyrière] dont la vente aura lieu le 14 avril 1817*. Sale cat. Paris, April 14, 1817. Paris, 1817.

Lapret 1902. Paul Lapret. *Catalogue des peintures et dessins: Musée Jean Gigoux à Besançon*. Besançon, 1902.

Larra 1835. Mariano José de Larra. "Conventos españoles: Tesoros artísticos encerrados en ellos." *Revista Española* (Madrid) (August 3, 1835).

Laskin and Pantazzi 1987. Myron Laskin, Jr., and Michael Pantazzi. *Catalogue of the National Gallery of Canada, Ottawa: European and American Painting, Sculpture, and Decorative Arts*. Ottawa, 1987.

Lassaigne 1945. Jacques Lassaigne. "Lettres d'Édouard Manet sur son voyage en Espagne." *Arts* (Lyon) (March 16, 1945).

Latouche 1831. Henri de Latouche. *La reine d'Espagne*. Paris, 1831.

Latour 1855. Antoine de Latour. *Études sur l'Espagne: Séville et l'Andalousie*. 2 vols. Paris, 1855.

Lauderbach 1917. Frances Lauderbach. "Notes from Talks by William M. Chase, Summer Class, Carmel-by-the-Sea, California: Memoranda from a Student's Note Book." *American Magazine of Art* (New York) 8 (September 1917), pp. 432–38.

Laurens 1901. Jules Laurens. *La légende des ateliers*. Carpentras, 1901.

H. Laurent 1812. Henri Laurent. *Le Musée Napoléon*. Paris, 1812.

H. Laurent 1816–18. Henri Laurent. *Le Musée royal*. 2 vols. Paris, 1816–18.

J. Laurent 1863. Jean Laurent. *Catálogo de las fotografías que se venden en casa de J. Laurent*. Madrid, 1863.

Lavallée 1804–28. Joseph Lavallée, ed. *Galerie du Musée Napoléon*. 11 vols. Paris, 1804–28. Vols. 5–11 titled *Galerie du Musée de France*.

Laverdant 1842. Désiré Laverdant. "Salon de 1842." *La Phalange* (Paris) (May 8, 1842).

Lavergne-Durey 1992. Valérie Lavergne-Durey. *Chefs-d'oeuvre de la peinture italienne et espagnole*. Lyon, 1992.

Lavergne-Durey 1993. Valérie Lavergne-Durey. *Catalogue sommaire illustré des peintures du Musée des Beaux-Arts de Lyon*, vol. 1, *Écoles étrangères XIIIe–XIXe siècles: Allemagne, Espagne, Italie et divers*. Lyon, 1993.

Le Breton 1881. Gaston Le Breton. *Attributions données à des tableaux du musée de Rouen*. Paris, 1881.

Lebrun 1809. J. B. P. Lebrun. *Recueil de gravures au trait, à l'eau forte, et ombrées, d'après un choix de tableaux de toutes les écoles, recueillis dans un voyage fait en Espagne, au Midi de la France et en Italie, dans les années 1807 et 1808*. 2 vols. Paris, 1809.

Lebrun 1811. *Vente et ordre de la rare et précieuse collection de M. Lebrun*. Sale cat. March 20–24, 1810. Paris, 1810.

Lécuyer 1939. Raymond Lécuyer. "Le Musée Ingres à Montauban." *L'Illustration* (Paris) 17 (June 1939).

Lécuyer 1949. Raymond Lécuyer. *Regards sur les musées de province*. Paris, 1949.

Lee 1884. Vernon Lee [Violet Paget]. *Euphorion: Being Studies of the Antique and the Mediaeval in the Renaissance*. 2 vols. London, 1884.

Leeds–London–Detroit 1979. *John Singer Sargent and the Edwardian Age*. Exh. cat. by James Lomax and Richard Ormond. Leeds Art Galleries, April 5–June 10, 1979; London, National Portrait Gallery, July 6–September 9, 1979; Detroit Institute of Arts, October 17–December 9, 1979. Leeds and Detroit, 1979.

Lefort 1867–68. Paul Lefort. "Essai d'un catalogue raisonné de l'oeuvre gravé et lithographié de Francisco Goya." *Gazette des Beaux-Arts* (Paris) 22 (February 1, 1867), pp. 191–205; 22 (April 1, 1867), pp. 382–95; 24 (February 1, 1868), pp. 169–86; 24 (April 1, 1868), pp. 385–99; 25 (August 1, 1868), pp. 165–80.

Lefort 1877. Paul Lefort. *Francisco Goya: Étude biographique et critique, suivie de l'essai d'un catalogue raisonné de son oeuvre gravé et lithographié*. Paris, 1877.

Lefort 1879–84. Paul Lefort. "Velazquez" (11-part series). *Gazette des Beaux-Arts* (Paris) 19 (1879), pp. 415–29; 20 (1879), pp. 229–39, pp. 416–26; 21 (1880), pp. 122–30, pp. 525–33; 22 (1880), pp. 176–85; 23 (1881), pp. 112–20; 24 (1881), pp. 403–10; 26 (1882), pp. 161–65; 27 (1883), pp. 327–41; 29 (1884), pp. 18–28.

Lefort 1882a. Paul Lefort. "Charles Blanc." *Gazette des Beaux-Arts* (Paris) 25 (February 1, 1882), pp. 121–24.

Lefort 1882b. Paul Lefort. "Ribera et son tableau du 'Pied-bot' au Louvre." *Gazette des Beaux-Arts* (Paris) 25 (January 1, 1882), pp. 40–43.

Lefort 1888. Paul Lefort. *Velasquez*. Paris, 1888.

Lefort 1892. Paul Lefort. *Murillo et ses élèves, suivi du catalogue raisonné de ses principaux ouvrages*. Paris, 1892.

Lefort 1893. Paul Lefort. *La peinture espagnole*. Paris, 1893.

Lefort et al. 1896. Paul Lefort, Henri Huymans, Alfred de Lostalot, Léopold Mabilleau, and Maurice Maindron. *Les musées de Madrid: Le Prado, San Fernando, L'Armeria*. Paris, 1896.

Legendre and Hartmann 1937. Maurice Legendre and A. Hartmann. *Domenico Theotocopouli dit El Greco*. Paris, 1937.

Léger 1920. Charles Léger. *Courbet selon les caricatures et les images.* Paris, 1920.

Léger 1948. Charles Léger. *Courbet et son temps.* Paris, 1948.

Leja 2001. Michael Leja. "Eakins and Icons." *Art Bulletin* (New York) 83, no. 3 (September 2001), pp. 479–97.

Lelièvre 1969. Pierre Lelièvre. "La mission de Vivant Denon en Espagne (Novembre 1808–Janvier 1809)." *Archives de l'Art Français* (Paris) 24 (1969), pp. 365–72.

Lelièvre 1993. Pierre Lelièvre. *Vivant Denon, homme des Lumières, "ministre des arts" de Napoléon.* Paris, 1993.

Lemoinne 1858. John-Émile Lemoinne. "Quelques jours en Espagne." *Revue des Deux Mondes* (Paris) (July 15, 1858).

Lemoisne 1946–49. Paul-André Lemoisne. *Degas et son oeuvre.* 4 vols. Paris, 1946–49.

Lemoisne 1984. Paul-André Lemoisne. *Degas et son oeuvre.* 4 vols. and supplement compiled by Phillip Brame and Theodore Reff. New York, 1984.

Lemonnier 1868. Camille Lemonnier. *G. Courbet et son oeuvre.* Paris, 1868.

Lemonnier 1888. Camille Lemonnier. *Les peintres de la vie.* Paris, 1888.

Lenaghan et al. 2000. Patrick Lenaghan et al., eds. *The Hispanic Society of America: Tesoros.* New York, 2000.

Leningrad 1984. *Muril'o i khudozhniki Andalusii XVII veka v sobranii Ermitazha.* Exh. cat. Edited by Ludmila L. Kagané. Leningrad, Hermitage Museum, 1984. Leningrad, 1984.

Leroy 1865. Louis Leroy. "Salon de 1865. I. Le tohu-bohu du premier jour." *Le Charivari* (Paris) (May 5, 1865).

Leroy 1867. Louis Leroy. "Les expositions de MM. Courbet et Manet." *Le Charivari* (Paris) (June 13, 1867).

Lesage 1788. Alain-René Lesage. *Histoire de Gil Blas de Santillane* (1715–35). 4 vols. Rouen, 1788.

Levey 1971. Michael Levey. *National Gallery Catalogues: The Seventeenth and Eighteenth Century Italian Schools.* London, 1971.

M. Lewis 1796. Matthew Gregory Lewis. *The Monk.* London, 1796. French ed., *Le Moine.* Paris, 1799.

O. Lewis 1938. Oscar Lewis. *The Big Four: The Story of Huntington, Stanford, Hopkins, and Crocker, and of the Building of the Central Pacific.* New York, 1938.

Licht 1998. Fred Licht. *Manet.* Milan, 1998, pp. 42–59.

Liedtke 1988. Walter Liedtke. "Zurbarán's Jerez Altarpiece Reconstructed." *Apollo* (London) 127 (1988), pp. 152–62.

Lille–Martigny 2002. *Berthe Morisot, 1841–1895.* Exh. cat. by Hélène Maratray and Sylvie Patry. Lille, Palais des Beaux-Arts, March 10–June 9, 2002; Martigny, Fondation Pierre Gianadda, June 20–November 19, 2002. Paris, 2002.

Lille–Philadelphia 1998–99. *Goya: Un regard libre / Goya: Another Look.* Exh. cat. Lille, Palais des Beaux-Arts, December 12, 1998–March 14, 1999; Philadelphia Museum of Art, April 17–July 11, 1999. Paris, 1998; Philadelphia, 1999.

Lindsay 1973. Jack Lindsay. *Gustave Courbet: His Life and Art.* New York, 1973.

Lipschutz 1963–67. Ilse Hempel Lipschutz. "El pintor y los poetas: Goya y las imágenes del Romanticismo francés." *Arte Español* (Madrid), no. 3 (1963–67), pp. 134–53.

Lipschutz 1972. Ilse Hempel Lipschutz. *Spanish Painting and the French Romantics.* Cambridge, Mass., 1972.

Lipschutz 1980. Ilse Hempel Lipschutz. "Théophile Gautier et son Espagne retrouvée dans l'oeuvre gravé de Goya." *Bulletin de la Société Théophile Gautier* (Montpellier), no. 2 (1980), pp. 9–34.

Lipschutz 1983. Ilse Hempel Lipschutz. "Théophile Gautier, Le Musée Espagnol et Zurbarán." In *Théophile Gautier, l'art et l'artiste: Actes du colloque international, septembre 1982,* vol. 1, pp. 107–20. Montpellier, 1983.

Lipschutz 1984. Ilse Hempel Lipschutz. "Murillo y 'la brune aux longs cils noirs et aux yeux de velours.'" *Fragmentos* (Madrid), no. 1 (1984), pp. 4–20.

Lipschutz 1988. Ilse Hempel Lipschutz. *La pintura española y los románticos franceses.* Madrid, 1988. Rev. ed. of *Spanish Painting and the French Romantics* (1972).

Liverpool 1990–91. *Murillo in Focus.* Exh. cat. by Xanthe Brooke. Liverpool, Walker Art Gallery, November 16, 1990–January 13, 1991. Merseyside, 1990.

Lleó 1987. Vicente Lleó. "El jardín arqueológico del primer Duque de Alcalá." *Fragmentos* (Madrid), no. 11 (1987), pp. 21–32.

Lleó 1989. Vicente Lleó. "The Art Collection of the Ninth Duke of Medinaceli." *The Burlington Magazine* (London) 131 (1989), pp. 108–17.

Lobstein 2002. Dominique Lobstein. "La gravure et la lithographie d'inspiration espagnole au Salon, 1820–1880." *48/14: Revue du Musée d'Orsay* (Paris), no. 15 (Autumn 2002).

Locke 1991. Nancy Locke. "New Documentary Information on Manet's 'Portrait of the Artist's Parents.'" *The Burlington Magazine* (London) 133 (April 1991), pp. 249–52.

Lockman Papers. [DeWitt McClellan] Lockman Papers. New-York Historical Society. Microfilm, Archives of American Art, Smithsonian Institution, Washington, D.C.

Loga 1913. Valerian von Loga. "Los cuadros de la 'Hispanic Society of America.'" *Museum* (Barcelona) 3 (1913), pp. 119–35.

Loga 1921. Valerian von Loga. *The Work of Velasquez.* New York, 1921.

Loga 1923. Valerian von Loga. *Die Malerei in Spanien vom XIV. bis XVIII. Jahrhundert.* Berlin, 1923.

London 1828. *Catalogue of Pictures by Italian, Spanish, Flemish, and Dutch Masters.* Exh. cat. London, British Institution, 1828. London, 1828.

London 1836. *Catalogue of Pictures by Italian, Spanish, Flemish, Dutch, and French Masters.* Exh. cat. London, British Institution, May 1836. London, 1836.

London 1840. *Catalogue of Paintings from the Collection of Maréchal Soult, Duc de Dalmatie, and Other Celebrated Galleries, Lately Purchased in France and Italy.* Exh. cat. London, [William Buchanan's] Gallery, 1840. London, 1840.

London 1853. *Catalogue of Pictures by Italian, Spanish, Flemish, Dutch, French, and English Masters.* Exh. cat. London, British Institution, June 1853. London, 1853.

London 1855. *Catalogue of Pictures by Italian, Spanish, Flemish, Dutch, French, and English Masters.* Exh. cat. London, British Institution, June 1855. London, 1855.

London 1870. *Exhibition of Works of the Old Masters.* Exh. cat. London, Royal Academy, 1870. London, 1870.

London 1872a. *Exhibition of Works of the Old Masters.* Exh. cat. London, Royal Academy, 1872. London, 1872.

London 1872b. *Third Exhibition by the French Society of Artists.* Exh. cat. London, Durand-Ruel, spring 1872. London, 1872.

London 1872c. *Fourth Exhibition by the French Society of Artists.* Exh. cat. London, Durand-Ruel, summer 1872. London, 1872.

London 1873. *Sixth Exhibition by the French Society of Artists.* Exh. cat. London, Durand-Ruel, 1872. London, 1872.

London 1874a. *Mr. Whistler's Exhibition.* Exh. cat. London, Flemish Gallery, June 1874. London, 1874.

London 1874b. *Eighth Exhibition by the Society of French Artists.* Exh. cat. London, Durand-Ruel, spring 1874. London, 1874.

London 1877. *First Summer Exhibition.* Exh. cat. London, Grosvenor Gallery, May 31–July 1877. London, 1877.

London 1881. *Fifth Summer Exhibition.* Exh. cat. London, Grosvenor Gallery, 1881. London, 1881.

London 1883. *Paintings, Drawings and Pastels by Members of La Société des impressionnistes.* Exh. cat. London, Durand-Ruel, Dowdeswell's Galleries, spring–summer 1883. London, 1883.

London 1885. *Sixty-second Annual Exhibition.* Exh. cat. London, Society of British Artists, 1885. London, 1885.

London 1887. *Winter Exhibition: Works of the Old Masters.* Exh. cat. London, Royal Academy, 1887. London, 1887.

London 1891a. *Catalogue of the 123rd Exhibition.* London, Royal Academy, 1891. London, 1891.

London 1891b. *Catalogue of the First Exhibition.* London, Society of Portrait Painters, 1891. London, 1891.

London 1891c. *Winter Exhibition, Twenty-second Year: Exhibition of Works of the Old Masters.* Exh. cat. London, Royal Academy, 1891. London, 1891.

London 1892. *Whistler: Nocturnes, Marines and Chevalet Pieces: Small Collection Kindly Lent by Their Owners.* Exh. cat. London, Goupil Gallery, March 1892. London, 1892.

London 1893a. *Catalogue of the Third Exhibition of the Society of Portrait Painters.* Exh. cat. London, Society of Portrait Painters, May 1893. London, 1893.

London 1893b. *Exhibition of Works by the Old Masters.* Exh. cat. London, Royal Academy, winter 1893. London, 1893.

London 1894. *Descriptive Catalogue of the Loan Collection of Pictures.* Exh. cat. by A. G. Temple. London, Guildhall Art Gallery, 1894. London, 1894.

London 1895–96. *Exhibition of Spanish Art under the Patronage of Her Majesty the Queen Regent of Spain.* Exh. cat. London, New Gallery, 1895–96. London, 1895.

London 1896a. [Eakins exhibition]. Exh. cat. London, Campden House, 1896. London, 1896.

London 1896b. *Winter Exhibition, Twenty-seventh Year: Exhibition of Works of the Old Masters.* Exh. cat. London, Royal Academy, January 6–March 14, 1896. London, 1896.

London 1897. *Dramatic and Musical Art.* Exh. cat. London, Grafton Galleries, April 1897. London, 1897.

London 1898. *Catalogue of the Exhibition of International Art, Knightsbridge.* Exh. cat. London, International Society of Sculptors, Painters and Gravers, May 1898. London, 1898.

London 1901. *Descriptive and Biographical Catalogue of the Exhibition of the Works of Spanish Painters.* Exh. cat. by A. G. Temple. London, Guildhall Art Gallery, April 30–July 31, 1901. London, 1901.

London 1905a. *Catalogue of a Loan Exhibition of Water-Colours by John S. Sargent, R.A.* Exh. cat. London, Carfax and Co., Ltd., April 1905. London, 1905.

London 1905b. *Memorial Exhibition of the Works of the Late J. McNeill Whistler, First President of the International Society of Sculptors, Painters, and Gravers.* Exh. cat. London, New Gallery, February 22–March 31, 1905. London, 1905.

London 1905c. *A Selection from the Pictures by Boudin, Cézanne, Degas, Manet, Monet, Morisot, Pissarro, Renoir, Sisley.* Exh. cat. London, Grafton Galleries, 1905. Paris, 1905.

London 1906. *Exhibition of Paintings and Water-colours by Manet (Faure Collection).* Exh. cat. London, Durand-Ruel, Sulley and Co's Galleries, June 11–30 (extended to July 7), 1906. London, 1906.

London 1908a. *A Catalogue of the Pictures, Drawings, Prints and Sculpture in the Exhibition of Fair Women.* Exh. cat. London, International Society of Sculptors, Painters and Gravers, New Gallery, February–March 1908. London, 1908.

London 1908b. *Spring Exhibition.* Exh. cat. London, Whitechapel Art Gallery, March 12–April 26, 1908. London, 1908.

London 1919. *Catalogue of Pictures by Old Masters.* Sale cat. London, Christie, Manson and Woods, December 12, 1919. London, 1919.

London 1920–21. *An Exhibition of Spanish Paintings.* Exh. cat. London, Royal Academy, November 1920–January 1921. London, 1921.

London 1925. *Catalogue of a Loan Exhibition.* London, Magnasco Society, 1925. London, 1925.

London 1926. *Exhibition of Works by the Late John S. Sargent, R.A.* Exh. cat. London, Royal Academy, January 1926. London, 1926.

London 1938. *Catalogue of the Exhibition of 17th Century Art in Europe.* Exh. cat. London, Royal Academy, January 3–March 12, 1938. 2d ed. London, 1938.

London 1971. *Art into Art: Works of Art as a Source of Inspiration . . . Presented by the Burlington Magazine at Sotheby and Co.* Exh. cat. London, Sotheby and Co., January 2–22, 1971. London, 1971.

London 1974. *Richard Ford in Spain.* Exh. cat. by Brinsley Ford. Introduction by Denys Sutton. London, Wildenstein Gallery, June 5–July 12, 1974. London, 1974.

London 1976. *The Golden Age of Spanish Painting.* Exh. cat. London, Royal Academy, January 10–March 14, 1976. London, 1976.

London 1981. *El Greco to Goya: The Taste for Spanish Paintings in Britain and Ireland.* Exh. cat. by Allan Braham. London, National Gallery, September 16–November 29, 1981. London, 1981.

London 1986. *The Hidden Face of Manet: An Investigation of the Artist's Working Processes.* Exh. cat. by Juliet Wilson-Bareau. London, Courtauld Institute Galleries, April 23–June 15, 1986. London, 1986.

London 1990–91. *Art in the Making: Impressionism.* Exh. cat. by David Bomford et al. London, National Gallery, November 28, 1990–April 21, 1991. London and New Haven, 1990.

London 1992. *Manet: The Execution of Maximilian: Painting, Politics, and Censorship.* Exh. cat. by Juliet Wilson-Bareau et al. London, National Gallery, July 1–September 27, 1992. London, 1992.

London 1993–94. *Thomas Eakins (1844–1916) and the Heart of American Life.* Exh. cat. Edited by John Wilmerding. London, National Portrait Gallery, October 8, 1993–January 23, 1994. London, 1993.

London 1995. *Spanish Still Life from Velázquez to Goya.* Exh. cat. by William B. Jordan and Peter Cherry. London, National Gallery, February 22–May 21, 1995. London and New Haven, 1995.

London 1996. *Gustave Caillebotte: The Unknown Impressionist.* Exh. cat. by Anne Distel et al. London, Royal Academy, March 28–June 23, 1996. London, 1996.

London 2000. *The Image of Christ.* Exh. cat. by Gabriele Finaldi. London, National Gallery, February 20–May 7, 2000. London, 2000.

London 2001. *Goya: Drawings from His Private Albums.* Exh. cat. by Juliet Wilson-Bareau. London, Hayward Gallery, February 22–May 13, 2001. London, 2001.

London–Chicago 1996–97. *Degas: Beyond Impressionism.* Exh. cat. by Richard Kendall. London, National Gallery, May 22–August 26, 1996; Chicago, Art Institute, September 28, 1996–January 5, 1997. London, 1996.

London–Manchester 1984–85. *James Tissot.* Exh. cat. Edited by Krystyna Matyjaszkiewicz. London, Barbican Art Gallery, November 15, 1984–January 20, 1985; Manchester, Whitworth Art Gallery, February 1–March 16, 1985. London, 1984.

London–Munich 2001. *Murillo: Scenes of Childhood.* Exh. cat. by Xanthe Brooke and Peter Cherry. London, Dulwich Picture Gallery, February 14–May 13, 2001; Munich, Alte Pinakothek, May 23–August 26, 2001. London, 2001.

London–New York 1960. *James McNeill Whistler: An Exhibition of Paintings and Other Works.* Exh. cat. London, Arts Council Gallery, September 1–24, 1960; New York, Knoedler Galleries, November 2–30, 1960. London, 1960.

London–Paris 1991–92. *Toulouse-Lautrec.* Exh. cat. London, Hayward Gallery, October 10, 1991–January 19, 1992; Paris, Galeries Nationales du Grand Palais, February 21–June 1, 1992. London and Paris, 1991.

London–Paris–Boston 1985–86. *Renoir.* Exh. cat. London, Hayward Gallery, January 30–April 21, 1985; Paris, Galeries Nationales du Grand Palais, May 14–September 2, 1985; Boston, Museum of Fine Arts, October 9, 1985–January 5, 1986. London, 1985.

London–Paris–Washington 1994–95. *James McNeill Whistler.* Exh. cat. by Richard Dorment and Margaret F. MacDonald. London, Tate Gallery, October 13, 1994–January 8, 1995; Paris, Musée d'Orsay, February 6–April 30, 1995; Washington, D.C., National Gallery of Art, May 28–August 20, 1995. London, 1994.

London–Washington–Boston 1998–99. *John Singer Sargent.* Exh. cat. Edited by Elaine Kilmurray and Richard Ormond. London, Tate Gallery, October 15, 1998–January 17, 1999; Washington, D.C., National Gallery of Art, February 21–May 31, 1999; Boston, Museum of Fine Arts, June 23–September 26, 1999. London, 1998.

López-Rey 1950. José López-Rey. "A Pseudo-Velázquez: The Picture of a Dwarf with a Dog." *Gazette des Beaux-Arts* (Paris) 37 (October–December 1950), pp. 275–84.

López-Rey 1953. José López-Rey. *Goya's Caprichos: Beauty, Reason and Caricature.* 2 vols. Princeton, N.J., 1953.

López-Rey 1963. José López-Rey. *Velázquez: A Catalogue Raisonné of His Oeuvre.* London, 1963.

López-Rey 1967. José López-Rey. "Velázquez's *Calabazas* with a Portrait and a Pinwheel." *Gazette des Beaux-Arts* (Paris) 70 (1967), pp. 219–26.

López-Rey 1979. José López-Rey. *Velázquez: The Artist as a Maker, with a Catalogue Raisonné of His Extant Works.* Lausanne, 1979.

López-Rey 1987. José López-Rey. "Views and Reflections on Murillo." *Gazette des Beaux-Arts* (Paris) 109 (1987), pp. 1–34.

López-Rey 1996. José López-Rey. *Velázquez.* 2 vols. Cologne and Paris, 1996.

Los Angeles–Paris 1988–89. *Politique et polémique: La caricature française et la Révolution, 1789–1799.* Exh. cat. Los Angeles, Wight Art Gallery, University of California, November 1–December 18, 1988; Paris, Bibliothèque Nationale de France, March 15–April 30, 1989. Los Angeles and Paris, 1988.

Los Angeles–Washington 1981–82. *American Portraiture in the Grand Manner, 1720–1920.* Exh. cat. Essays by Michael Quick et al. Los Angeles County Museum of Art, November 17, 1981–January 31, 1982; Washington, D.C., National Portrait Gallery, March 17–June 6, 1982. Los Angeles, 1981.

Lostalot 1886. Alfred de Lostalot. "Salon de 1886, I," *Gazette des Beaux-Arts* (Paris) 33 (June 1, 1886), pp. 453–79.

Louis-Philippe 1851. *Domaine d'Orléans. Catalogue de tableaux modernes, portraits historiques, dessins, gouaches, pastels, statues et bustes en marbre et en bronze, provenant des collections du feu Roi Louis-Philippe, dont la vente aura lieu le lundi 28 avril 1851 et jours suivants, heure de midi, a l'hôtel des ventes rue de Jeuneurs, no. 42, salle no. 1.* Sale cat. Paris, April 28–30, May 2, 1851. Paris, 1851.

Louis-Philippe 1853. *Catalogue des tableaux, formant la célèbre Galerie Espagnole de S.M. feu le roi Louis Philippe / Catalogue of the Pictures Forming the Celebrated Spanish Gallery of His Majesty the Late King Louis Philippe.* Sale cat. London, Christie and Manson, May 6–7, 13–14, 20–21, 1853. London, 1853.

Louvre 1979–. *Catalogue sommaire illustré des Peintures du Musée du Louvre. . . .* 5 vols. Paris, 1979–.

Louvre 1981. *Catalogue sommaire illustré des peintures du Musée du Louvre,* vol. 2, *Italie, Espagne, Allemagne,*

Grande-Bretagne et divers. Coordinated by Arnauld Brejon de Lavergnée and Dominique Thiébaut. Paris, 1981.

Louvre 1983. *Nouvelles acquisitions du Département des peintures, Musée du Louvre.* Paris, 1983.

Louvre 1986. *Catalogue sommaire illustré des peintures du Musée du Louvre,* vol. 3, *École française.* Edited by Isabelle Compin and Anne Roquebert. Paris, 1986.

Louvre 2002. *Écoles espagnole et portugaise, Musée du Louvre, Département des Peintures.* Paris, 2002.

Lovett 1965. Gabriel H. Lovett. *Napoleon and the Birth of Modern Spain.* 2 vols. New York, 1965.

Low 1910. Will H. Low. *A Painter's Progress; Being a Partial Survey Along the Pathway of Art in America and Europe.* New York, 1910. Reprint, New York, 1977.

Low 1935. Will H. Low. "The Primrose Way." Typescript, revised and edited from the original manuscript by Mary Fairchild Low, with the collaboration of Berthe Helene MacMonnies. Albany [N.Y.] Institute of History and Art, 1935.

Loyrette 1989. Henri Loyrette. "Degas entre Gustave Moreau et Duranty: Notes sur les portraits, 1859–1876." *Revue de l'Art* (Paris), no. 86 (1989), pp. 16–27.

Loyrette 1991. Henri Loyrette. *Degas.* Paris, 1991.

Loyrette 2002. Henri Loyrette. "Manet pour Duret, Duret pour Manet." In *Mélanges en hommage à Françoise Cachin,* pp. 119–25. Paris, 2002.

Lubin 1997. David M. Lubin. "Modern Psychological Selfhood in the Art of Thomas Eakins." In *Inventing the Psychological: Toward a Cultural History of Emotional Life in America,* edited by Joel Pfister and Nancy Schnog, pp. 133–66. New Haven, 1997.

Luna 1988. Juan J. Luna. "John Singer Sargent y el Museo del Prado." *Historia 16* (Madrid) 13 (1988), pp. 100–107.

Luxembourg 1884. *Livret illustré du Musée du Luxembourg.* Paris, 1884.

Luxenberg 1990. Alisa Luxenberg. "Léon Bonnat (1833–1922)." Ph.D. diss., New York University, 1990.

Luxenberg 2001. Alisa Luxenberg. "Buenos días, Señor Courbet: The Artist's Trip to Spain." *The Burlington Magazine* (London) 143 (November 2001), pp. 690–93.

McBride 1975. Henry McBride. *The Flow of Art: Essays and Criticisms of Henry McBride.* Edited by Daniel Catton Rich. New York, 1975.

MacCartney 1999. Hilary MacCartney. "The Collection of a Scholar: Notes on the Art History and Collecting of Sir William Stirling-Maxwell." *Espacio, Tiempo y Forma: Serie VII* (Madrid) 13 (1999), pp. 303–9.

McCauley 1985. Elizabeth Anne McCauley. *A. A. E. Disdéri and the Carte de Visite Portrait Photograph.* New Haven, 1985.

McClellan 1994. Andrew McClellan. *Inventing the Louvre: Art, Politics, and the Origins of the Modern Museum in Eighteenth-Century Paris.* Cambridge, 1994.

MacDonald 1995. Margaret F. MacDonald. *James McNeill Whistler: Drawings, Pastels, and Watercolours.* New Haven, 1995.

Mack 1951. Gerstle Mack. *Gustave Courbet.* New York, 1951.

MacLaren 1970. Neil MacLaren. *National Gallery Catalogues: The Spanish School.* 2d ed., rev. by Allan Braham. London, 1970.

McMullen 1984. Roy McMullen. *Degas: His Life, Times, and Work.* Boston, 1984.

McVan 1945. Alice Jane McVan. "The Alameda of the Osunas." *Notes Hispanic* (New York) 5 (1945), pp. 113–32.

McWilliam 1993. Neil McWilliam. *Dreams of Happiness: Social Art and the French Left, 1830–1850.* Princeton, N.J., 1993.

Machado 2000. Manuel Machado. *Alma, Caprichos, El mal poema.* Edited by Rafael Alarcón Sierra. Madrid, 2000.

F. Madrazo 1836. Federico de Madrazo. "El Barón Taylor. Mr. Dauzats." *El Artista* (Madrid) 3, no. 4 (January 1836), pp. 47–48.

F. Madrazo 1994. Federico de Madrazo. *Epistolario.* 2 vols. Edited by José Luis Díez. Madrid, 1994.

J. Madrazo 1826–32. José de Madrazo. *Colección lithográphica de cuadros del Rey de España el Señor Don Fernando VII, que se conservan en sus reales palacios, Museo y Academia de San Fernando, con inclusion de los del real monasterio del Escorial.* 3 vols. Madrid, 1826–32.

M. Madrazo 1945. Mariano de Madrazo. *Historia del Museo del Prado, 1818–1868.* Madrid, 1945.

P. Madrazo 1843. Pedro de Madrazo. *Catálogo de los cuadros del real museo de pintura y escultura de S[ua] M[ajestad].* Madrid, 1843.

P. Madrazo 1872. Pedro de Madrazo. *Catálogo descriptivo e histórico, de los cuadros del Museo del Prado de Madrid. Parte primera. Escuelas italianas y españolas.* Madrid, 1872.

P. Madrazo 1873. Pedro de Madrazo. *Catálogo de los cuadros del Museo del Prado de Madrid por D. Pedro de Madrazo de las Reales Academias de San Fernando y de la Historia. Compendio del Catálogo oficial descriptivo e histórico redactado por el mismo autor.* Madrid, 1873.

P. Madrazo 1889. Pedro de Madrazo. *Catálogo de los cuadros del museo del Prado de Madrid.* Madrid, 1889.

Madrid 1819. Luis Eusebi, ed. *Catálogo de los cuadros de Escuela Española que existen en el Real Museo del Prado.* Madrid, 1819.

Madrid 1821. Luis Eusebi, ed. *Catálogo de los cuadros que existen colocados en el Real Museo del Prado.* Madrid, 1821.

Madrid 1823. Luis Eusebi, ed. *Notice des tableaux exposés jusqu'à présent dans le Musée Royal de peinture au Prado.* N.p., 1823.

Madrid 1824. Luis Eusebi, ed. *Catálogo de los cuadros que existen colocados en el Real Museo de pinturas del Prado.* Madrid, 1824.

Madrid 1828a. Luis Eusebi, ed. *Notice des tableaux exposés jusqu'à présent dans la galerie du Musée du Roi.* Madrid, 1828.

Madrid 1828b. Luis Eusebi, ed. *Noticia de los cuadros que se hallan colocados en la galería del Museo del Rey, Nuestro Señor, sito en el Prado de esta Córte.* Madrid, 1828.

Madrid 1896. *Catálogo de los cuadros, esculturas, grabados, y otros objetos artísticos de la antigua casa ducal de Osuna.* Exh. cat. by Narciso Sentenach y Cabañas. Madrid, Palacio de la Industria y de las Artes, April 15–May 10, 1896. 2d ed. Madrid, 1896.

Madrid 1900. *Catálogo de las obras de Goya.* Exh. cat. Madrid, Ministerio de Instrucción Pública y Bellas Artes, May 1900. Madrid, 1900.

Madrid 1928a. *Centenario de Goya: Exposición de pinturas.* Exh. cat. by Enrique Lafuente [Ferrari]. Madrid, Museo del Prado, April–May 1928. Madrid, 1928.

Madrid 1928b. *Catálogo ilustrado de la exposición de pinturas de Goya celebrada para conmemorar el primer centenario de la muerte del artista.* Souvenir exh. cat. by Enrique Lafuente [Ferrari]. Madrid, Museo del Prado, April–May 1928. Madrid, 1928.

Madrid 1960–61. *Velázquez y lo velazqueño.* Exh. cat. Madrid, Casón del Buen Retiro, December 10, 1960–February 23, 1961. Madrid, 1960.

Madrid 1964–65. *Exposición Zurbarán en el III centenario de su muerte.* Exh. cat. Texts by María Luisa Caturla et al. Madrid, El Casón del Buen Retiro, November 1964–February 1965. Madrid, 1964.

Madrid 1980. *El arte europeo en la corte de España durante el siglo XVIII.* Exh. cat. Madrid, Museo del Prado, February 1–April 27, 1980. Madrid, 1980.

Madrid 1981a. *Imagen romántica de España.* Exh. cat. 2 vols. Madrid, Palacio de Velázquez, Parque del Retiro, October–November 1981. Madrid, 1981.

Madrid 1981b. *Pintura española del siglo XVII en los museos provinciales de Francia.* Exh. cat. Madrid, Museo del Prado, March 13–April 23, 1981. Madrid, 1981.

Madrid 1981–82a. *El arte en la época de Calderón.* Exh. cat. Madrid, Palacio de Velázquez, December 1981–January 1982. Madrid, 1981.

Madrid 1981–82b. *Pintura española de los siglos XVI al XVIII en colecciones centroeuropeas.* Exh. cat. Madrid, Museo del Prado, December 1981–January 1982. Madrid, 1981.

Madrid 1984. *Estampas de la Calcografía Nacional: La Colección Real de Pintura, 1791/1798.* Exh. cat. Madrid, Real Academia de Bellas Artes de San Fernando, Calcografía Nacional, 1984. Madrid, 1984.

Madrid 1986. *Monstruos, enanos y bufones en la corte de los Austrias.* Exh. cat. Edited by Manuela B. Mena Marqués. Madrid, Museo del Prado, June 20–August 31, 1986. Madrid, 1986.

Madrid 1988a. *La Alianza de dos monarquías: Wellington en España.* Exh. cat. Madrid, Museo Municipal, October 19–December 11, 1988. Madrid, 1988.

Madrid 1988b. *Eugène Delacroix.* Exh. cat. Madrid, Museo del Prado, March 2–April 20, 1988. Madrid, 1988.

Madrid 1988c. *Zurbarán.* Exh. cat. Madrid, Museo del Prado, May 3–July 30, 1988. Madrid, 1988.

Madrid 1989. *El siglo de oro de las tauromaquias: Estampas taurinas, 1750–1868.* Exh. cat. Madrid, Calcografía Nacional, Real Academia de Bellas Artes de San Fernando, May–June 1989. Madrid, 1989.

Madrid 1990a. *Orígen de la litografía en España: El Real Establecimiento Litográfico.* Exh. cat. by Jesusa Vega. Madrid, Museo Casa de la Moneda, October–December 1990. Madrid, 1990.

Madrid 1990b. *Velázquez.* Exh. cat. by Antonio Domínguez Ortiz, Alfonso E. Pérez Sánchez, and Julián Gállego. Madrid, Museo del Prado, January 23–March 31, 1990. Madrid, 1990.

Madrid 1992. *Sorolla-Zorn.* Exh. cat. by Brigitta Sandström. Madrid, Centro Nacional de Exposiciones, March 4–May 3, 1992. Madrid, 1992.

Madrid 1994a. *El "cuaderno italiano," 1770–1786: Los orígenes del arte de Goya.* Exh. cat. 2 vols. Texts by Manuela B. Mena Marqués and Jesús Urrea. Madrid, Museo del Prado, 1994. Madrid, 1994.

Madrid 1994b. *Obras maestras de la Real Academia de San Fernando.* Exh. cat. Madrid, Real Academia de Bellas Artes de San Fernando, 1994. Madrid, 1994.

Madrid 1994c. *Pintores del reinado de Felipe IV.* Exh. cat. Madrid, Museo del Prado, September–October 1994. Madrid, 1994.

Madrid 1995. *Zurbarán: Las doce tribus de Israel, Jacob y sus hijos.* Exh. cat. by Gabriele Finaldi and Benito Navarrete Prieto. Madrid, Museo del Prado, February 16–April 30, 1995. Madrid, 1995.

Madrid 1996a. *Estampas de la guerra de la independencia: Colecciones Museo Municipal (Madrid), Antonio Correa (Madrid), Calcografía Nacional (Madrid), Arteclio (Pamplona), British Museum (Londres).* Exh. cat. Madrid, Calcografía Nacional, Real Academia de Bellas Artes de San Fernando, 1996. Madrid, 1996.

Madrid 1996b. *Goya: 250 aniversario.* Exh. cat. by Juan J. Luna and Margarita Moreno de las Heras. Madrid, Museo del Prado, March 30–June 2, 1996. Madrid, 1996.

Madrid 1996c. *Tapices y cartones de Goya.* Exh. cat. by Concha Herrero, José Luis Sancho, and Juan Martínez Cuesta. Madrid, Palacio Real, May–July 1996. Madrid and Barcelona, 1996.

Madrid 1996d. *Visiones de El Prado: La colección real de pintura: El Museo del Prado visto por 12 artistas contemporáneos.* Exh. cat. Madrid, Calcografía Nacional, 1996. Madrid, 1996.

Madrid 1996e. *Ydioma universal: Goya en la Biblioteca Nacional.* Exh. cat. Edited by Juliet Wilson-Bareau and Elena Santiago. Madrid, Biblioteca Nacional, September 19–December 15, 1996. Madrid and Barcelona, 1996.

Madrid 1997. *Artistas pintados: Retratos de pintores y escultores del siglo 19 en el Museo del Prado.* Exh. cat. Edited by Julián Gállego and José Luis Díez. Madrid, Museo del Prado, 1997. Madrid, 1997.

Madrid 1998–99. *Felipe II, un monarca y su época: Un príncipe del renacimiento.* Exh. cat. Madrid, Museo del Prado, October 13, 1998–January 10, 1999. Madrid, 1998.

Madrid 2000. *Velázquez en blanco y negro.* Exh. cat. by José Manuel Matilla. Madrid, Museo del Prado, June–July 2000. Madrid, 2000.

Madrid 2001. *Niños de Murillo.* Exh. cat. Texts by Javier Portús Pérez et al. Madrid, Museo del Prado, September 23–December 9, 2001. Madrid, 2001.

Madrid 2002a. *Alonso Cano: La modernidad del Siglo de Oro español.* Exh. cat. Texts by Ignacio Henares Cuéllar, Odile Delenda et al. Madrid, Fundación Santander Central Hispano, April 1–May 26, 2002. Madrid, 2002.

Madrid 2002b. *La sala reservada y el desnudo en el Museo del Prado.* Exh. cat. by Javier Portús Pérez. Madrid, Museo del Prado, June 28–September 29, 2002. Madrid, 2002.

Madrid–Bilbao 1996–97. *Obras maestras del arte español: Museo de Bellas Artes de Budapest.* Exh. cat. by Éva Nyerges. Madrid, Banco Bilbao Vizcaya, December 1996–February 1997; Bilbao, Museo de Bellas Artes, February–April 1997. Madrid, 1996.

Madrid–Bilbao–Seville 2000–2001. *De Goya a Zuloaga: La pintura española de los siglos XIX y XX en*
The Hispanic Society of America. Exh. cat. Madrid, Sala de Exposiciones BBVA, October–December 2000; Bilbao, Sala de Exposiciones BBVA, December 2000–February 2001; Seville, Fundación Focus-Abengoa, March–May 2001. Madrid, 2000.

Madrid–Boston–New York 1988–89. *Goya y el espíritu de la Ilustración/Goya and the Spirit of Enlightenment.* Exh. cat. by Alfonso E. Pérez Sánchez and Eleanor A. Sayre. Madrid, Museo del Prado, October 6–December 18, 1988; Boston, Museum of Fine Arts, January 18–March 26, 1989; New York, Metropolitan Museum of Art, May 9–July 16, 1989. Madrid and Boston, 1988.

Madrid–London 1982–83. *Bartolomé Esteban Murillo, 1617–1682.* Exh. cat. Madrid, Museo del Prado, October 8–December 12, 1982; London, Royal Academy, January 15–March 27, 1983. Madrid, 1982.

Madrid–London–Chicago 1993–94. *Goya, Truth and Fantasy: The Small Paintings.* Exh. cat. Edited by Juliet Wilson-Bareau and Manuela B. Mena Marqués. Madrid, Museo del Prado, November 18, 1993–February 27, 1994; London, Royal Academy, March 17–June 12, 1994; Chicago, Art Institute, July 16–October 16, 1994. New Haven, 1994.

Madrid–Washington 2001–2. *Goya: Images of Women.* Exh. cat. Edited by Janis Tomlinson. Madrid, Museo del Prado, October 30, 2001–February 9, 2002; Washington, D.C., National Gallery of Art, March 10–June 2, 2002. Washington, D.C., and New Haven, 2002.

Magalotti 1933. Lorenzo Magalotti. *Viaje de Cosme de Médicis por España y Portugal (1668–1669).* Edited by Angel Sánchez Rivero and Angela Mariutti de Sánchez Rivero. Madrid, 1933.

Maingot 1963. Éliane Maingot. *Le Baron Taylor.* Paris, 1963.

Maire 1869. A. Maire. "Revue de l'exposition de la Société artistique. À Madame . . . troisième lettre." *Courrier de Marseille* (January 21, 1869), p. 2.

Mâle 1931. Emile Mâle. *L'art religieux du XIIIe siècle en France.* 7th ed. Paris, 1931.

Mâle 1932. Emile Mâle. *L'art religieux après le Concile de Trente.* Paris, 1932.

Malitskaia 1947. K. M. Malitskaia. *Ispanskaia zhivopis.* Moscow, 1947.

Mallarmé 1962. Stéphane Mallarmé. *Les "gossips" de Mallarmé, "Athenaeum" 1875–1876.* Edited by Henri Mondor and Lloyd James Austin. Paris, 1962.

Mallory 1991a. Nina Ayala Mallory. *Del Greco a Murillo: La pintura española del Siglo de Oro, 1556–1700.* Madrid, 1991.

Mallory 1991b. Nina Ayala Mallory. "Juan Bautista Martínez del Mazo: Retratos y paisajes." *Goya* (Madrid), no. 221 (1991), pp. 265–76.

Manchester 1857. *Catalogue of the Art Treasures of the United Kingdom, Collected at Manchester in 1857.* Exh. cat. Manchester, Museum of Ornamental Art, opened May 5, 1857. London, 1857.

Manchester–Cambridge 1987. *The Private Degas.* Exh. cat. by Richard Thomson. Manchester, Whitworth Art Gallery, January 20–February 28, 1987; Cambridge, Fitzwilliam Museum, March 17–May 3, 1987. London, 1987.

Manet 1884. *Catalogue de tableaux . . . par Édouard Manet.* Sale cat. Paris, Hôtel Drouot, February 4–5, 1884. Paris, 1884.

Manet 1928. Édouard Manet. *Lettres de jeunesse 1848–1849: Voyage à Rio.* Paris, 1928.

Manet 1935. Édouard Manet. *Une correspondance inédite d'Édouard Manet: Les lettres du siège de Paris (1870–1871).* Edited by Adolphe Tabarant. Paris, 1935.

Manet 1988. Édouard Manet. *Voyage en Espagne.* Edited by Juliet Wilson-Bareau. Caen, 1988.

Manet 1991. Édouard Manet. *Manet par lui-même.* Edited by Juliet Wilson-Bareau. Paris, 1991. English ed., *Manet by Himself.* London, 1991.

Mannheim 1909. *Ausstellung von Werken der Malerei des 19. Jahrhunderts.* Exh. cat. Mannheim, Kunsthalle, December 1909. Mannheim, 1909.

Mannheim 1992–93. *Edouard Manet: Augenblicke der Geschichte.* Exh. cat. Edited by Manfred Fath and Stefan Germer. Mannheim, Städtische Kunsthalle, October 18, 1992–January 17, 1993. Munich, 1992.

Manrique de Lara 1921. Manuel Manrique de Lara. "Velázquez en el Museo del Louvre." *Revue Hispanique* (Paris) 51 (February 1921), pp. 183–210.

Mantz 1863. Paul Mantz. "Exposition du boulevard des Italiens." *Gazette des Beaux-Arts* (Paris) 14 (April 1, 1863), pp. 380–84.

Mantz 1865. Paul Mantz. "La Galerie Pourtalès, IV. Les peintures espagnoles, allemandes, hollandaises, flamandes et françaises." *Gazette des Beaux-Arts* (Paris) 18 (February 1, 1865), pp. 97–117.

Mantz 1868. Paul Mantz. "Salon de 1868, II." *L'Illustration* (Paris) (June 6, 1868), p. 362.

Mantz 1870. Paul Mantz. "La collection La Caze au Musée du Louvre." *Gazette des Beaux-Arts* (Paris) 3 (May 1, 1870), pp. 393–406.

Mantz 1874. Paul Mantz. "Exposition en faveur de l'oeuvre des Alsaciens et Lorrains" (part 3). *Gazette des Beaux-Arts* (Paris) 10 (October 1, 1874), pp. 289–309.

Mantz 1882. Paul Mantz. "Exposition de la Société Internationale." *Le Temps* (Paris) (December 31, 1882), p. 3.

Maravall 1960. José Antonio Maravall. *Velázquez y el espíritu de la modernidad.* Madrid, 1960.

Marcillac 1805. Louis de Marcillac. *Nouveau voyage en Espagne.* Paris, 1805.

Marcille 1876. *Catalogue de tableaux et dessins formant la collection de feu M. Camille Marcille.* Sale cat. Paris, Hôtel Drouot, March 6–9, 1876. Paris, 1876.

Marcy 1867. Pierre Marcy. *Guide populaire dans les Musées du Louvre.* Paris, 1867.

Marggraff 1869. Rudolf Marggraff. *Die ältere königliche Pinakothek zu München.* 2d ed. Munich, 1869.

Marggraff 1878. Rudolf Marggraff. *Catalogue of the Pictures in the Old Royal Pinakothek at Munich.* 2d ed. Munich, 1878.

Marías 1999. Fernando Marías. *Velázquez: Pintor y criado del rey.* Madrid, 1999.

Mariette 1851–60. Pierre-Jean Mariette. *Abecedario.* 6 vols. Paris, 1851–60.

Marinas 1983. Cristina Marinas. "La Galería Española del Rey Luis Felipe." *Academia: Boletín de la Academia de Bellas Artes de San Fernando* (Madrid) 57 (1983), pp. 127–52.

Marks 1882. Montague Marks. "American Art in the Paris Salon." *The Art Amateur* (New York) 7, no. 3 (August 1882), p. 46.

Marling 1978. Karal Ann Marling. "Portrait of the Artist as a Young Woman: Miss Dora Wheeler." *Bulletin of the Cleveland Museum of Art* 65, no. 2 (February 1978), pp. 46–57.

Marquet de Vasselot 1927. Jean-Joseph Marquet de Vasselot. *Répertoire des catalogues du Musée du Louvre (1793–1926).* 2d ed., rev. and augm. Paris, 1927.

Marrinan 1988. Michael Marrinan. *Painting Politics for Louis-Philippe: Art and Ideology in Orléanist France, 1830–1848.* New Haven, 1988.

Marseille 1961. *Manet.* Exh. cat. Preface by Germain Bazin. Marseille, Musée Cantini, May 16–July 31, 1961. Marseille, 1961.

Marseille 1979. *Daumier et ses amis républicains.* Exh. cat. Marseille, Musée Cantini, June 1–August 31, 1979. Marseille, 1979.

Martigny 1996. *Manet.* Exh. cat. by Ronald Pickvance. Martigny, Fondation Pierre Gianadda, June 5–November 11, 1996. Martigny, 1996.

Martín García 1993. Fernando A. Martín García. "Notas sobre un Inventario del Real Alcázar de Sevilla del año 1838." *Archivo Hispalense* (Seville), no. 232 (1993), pp. 123–30.

Martín González 1960. Juan José Martín González. "Algunas sugerencias acerca de los bufones de Velázquez." In *Varia Velazqueña: Homenaje a Velázquez en el III centenario de su muerte, 1660–1960,* edited by Antonio Gallego y Burín, vol. 1, pp. 250–56. Madrid, 1960.

Martínez Caviro 1985. Balbina Martínez Caviro. "Los Grecos de don Pedro Laso de la Vega." *Goya* (Madrid), no. 184 (January–February 1985), pp. 216–26.

Martínez Friera 1942. Joaquín Martínez Friera. *Un museo de pinturas en el Palacio de Buenavista: Proyecta de la Real academia de las nobles artes de San Fernando.* Madrid, 1942.

Martínez Ripoll 1976. Antonio Martínez Ripoll. *La iglesia del Colegio de San Buenaventura.* Seville, 1976.

Martínez Ripoll 1978. Antonio Martínez Ripoll. *Francisco de Herrera "el Viejo."* Seville, 1978.

Martínez Ripoll 1990. Antonio Martínez Ripoll. "El Conde-Duque con una vara en la mano, de Velázquez, o la Praxis olivarista de la razón de estado, en torno a 1625." In *La España del Conde Duque de Olivares,* edited by John Elliott and Angel García Sanz, pp. 47–64. Valladolid, 1990.

Marx 1886. Roger Marx. *Henri Regnault, 1843–1871.* Paris, 1886.

Masque 1885. Le Masque de Fer. "À travers Paris." *Le Figaro* (Paris) (February 21, 1885), p. 1.

Massarani 1880. Tullo Massarani. *L'art à Paris.* 2 vols. Paris, 1880.

Matheron 1858. Laurent Matheron. *Goya.* Paris, 1858.

Matheron 1996. Laurent Matheron. *Goya.* French-Spanish ed., with contributions by Enrique Lafuente Ferrari, Nigel Glendinning, and Xavier de Salas. Madrid and Bordeaux, 1996.

Mathews 1984. Nancy Mowll Mathews, ed. *Cassatt and Her Circle: Selected Letters.* New York, 1984.

Mathews 1987. Nancy Mowll Mathews. *Mary Cassatt.* New York, 1987.

Mathieu 1991. Pierre-Louis Mathieu. *Tout l'oeuvre peint de Gustave Moreau.* Paris, 1991.

Matilla Tascón 1982. Antonio Matilla Tascón. "La real posesión de Vista Alegre, residencia de la reina Doña María Cristina y el duque de Riansares." *Anales de Instituto de Studios Madrileños* (Madrid) 19 (1982), pp. 283–348.

Matute y Gaviria 1887. Justino Matute y Gaviria. *Anales eclesiásticos y seculares de la muy noble y muy leal ciudad de Sevilla metrópoli de la Andalucía.* 3 vols. Seville, 1887.

Maus 1885. Octave Maus. *L'Art Moderne* (May 24, 1885), p. 164.

Mayer 1908. August L. Mayer. *Jusepe de Ribera (Lo Spagnoletto).* Leipzig, 1908.

Mayer 1913a. August L. Mayer. *Geschichte der spanischen Malerei.* 2 vols. Leipzig, 1913.

Mayer 1913b. August L. Mayer. *Murillo.* Stuttgart, 1913.

Mayer 1916. August L. Mayer. "Paintings by El Greco in America." *Art in America* (New York) 4, no. 5 (August 1916), pp. 248–53.

Mayer 1922. August L. Mayer. *Geschichte der spanischen Malerei.* 2d ed. Leipzig, 1922.

Mayer 1923a. August L. Mayer. *Jusepe de Ribera (Lo Spagnoletto).* 2d ed. Leipzig, 1923.

Mayer 1923b. August L. Mayer. *Murillo.* 2d ed. Stuttgart, 1923.

Mayer 1924. August L. Mayer. *Diego Velázquez.* Berlin, 1924.

Mayer 1926a. August L. Mayer. *Dominico Theotocopuli El Greco.* Munich, 1926.

Mayer 1926b. August L. Mayer. "Three Paintings by Murillo." *The Burlington Magazine* (London) 48 (May 1926), p. 251.

Mayer 1931a. August L. Mayer. *El Greco.* Berlin, 1931.

Mayer 1931b. August L. Mayer. "Tableaux de l'école espagnole conservés dans les musées français." *Gazette des Beaux-Arts* (Paris) 6 (1931), pp. 95–97.

Mayer 1935. August L. Mayer. "Notes sur quelques tableaux du musée de Grenoble." *Gazette des Beaux-Arts* (Paris) 13 (1935), p. 121.

Mayer 1936. August L. Mayer. *Velázquez: A Catalogue Raisonné of the Pictures and Drawings.* London, 1936.

Mayer 1938. August L. Mayer. "Murillo und seine Italienischen Barockvorbilder." *Critica d'Arte* (Florence) 15 (1938).

Mayer 1947. August L. Mayer. *Historia de la pintura española.* 3d ed. Madrid, 1947.

Meier-Graefe 1908. Julius Meier-Graefe. *Modern Art; Being a Contribution to a New System of Aesthetics.* 2 vols. Translated by Florence Simmonds and George W. Chrystal. London, 1908.

Mellado 1864. Francisco de P. Mellado. *Guía del viajero en España.* 10th ed. Madrid, 1864.

Meller 2002. Peter Meller. "Manet in Italy: Some Newly Identified Sources for His Early Sketchbooks." *The Burlington Magazine* (London) 144 (February 2002), pp. 68–110.

Memoria 1845. *Memoria comprensiva de los trabajos verificados por las comisiones de Monumentos históricos y artísticos del Reino desde 1º de Julio de 1844 hasta igual fecha de 1845.* Madrid, 1845.

Mena Marqués 2000. Manuela B. Mena Marqués. "Velázquez en la Torre de la Parada." In *Velázquez y Calderón: Dos genios de Europa,* edited by José Alcalá-Zamora and Alfonso E. Pérez Sánchez, pp. 101–55. Madrid, 2000.

Mercader Riba 1971. Juan Mercader Riba. *José Bonaparte, rey de España, 1808–1813: Historia externa del reinado.* Madrid, 1971.

Mercader Riba 1983. Juan Mercader Riba. *José Bonaparte, rey de España, 1808–1813: Estructura del estado español bonapartista.* Madrid, 1983.

Mercey 1838. Frédéric de Mercey. "Salon de 1838." *Revue des Deux Mondes* (Paris) 14 (May 1, 1838), pp. 367–408.

Mercey 1852. Frédéric de Mercey. "La Galerie du Maréchal Soult." *Revue des Deux Mondes* (Paris) 6 (May 15, 1852), pp. 807–16.

Mérimée 1825. Prosper Mérimée. *Le Théâtre de Clara Gazul, comédienne espagnole.* Paris, 1825.

Mérimée 1830. Prosper Mérimée. *La Perle de Tolède.* Paris, 1830.

Mérimée 1831a. Prosper Mérimée. "Le exécution." *Revue de Paris* 22 (January 2, 1831), pp. 30–43.

Mérimée 1831b. Prosper Mérimée. "Les combats de taureaux." *Revue de Paris* 24 (March 13, 1831), pp. 93–106.

Mérimée 1831c. Prosper Mérimée. "Le Musée de Madrid." *L'Artiste* (Paris) 1 (March 1831), pp. 73–75. Also published in Mérimée 1927 and Madrid 1981a.

Mérimée 1832. Prosper Mérimée. "Les voleurs en Espagne." *Revue de Paris* 41 (August 19, 1832), pp. 211–23.

Mérimée 1833a. Prosper Mérimée. *Lettres sur l'Espagne,* in *Mosaïque.* Paris, 1833.

Mérimée 1833b. Prosper Mérimée. "Les sorcières espagnoles." *Revue de Paris* 57 (December 29, 1833), pp. 288–99.

Mérimée 1846. Prosper Mérimée. *Carmen.* Paris, 1846. Translated and edited by Ramón Buenaventura. Madrid, 1986. Edited by Adrien Goetz. Paris, 2000.

Mérimée 1848. Prosper Mérimée. "Sur le peinture espagnole." *Revue de Deux Mondes* (Paris) (November 15, 1848), pp. 642–43. Also published in Madrid 1981a.

Mérimée 1927. Prosper Mérimée. *Lettres d'Espagne (1830–1833).* Edited by Maurice Levaillant. Paris, 1927.

Mérimée 1989. Prosper Mérimée. *Lettres d'Espagne.* Edited by Gérard Chaliand. Brussels, 1989.

Merlin 1852. *Notice de tableaux de Mme la Ctesse Merlin.* Sale cat. Paris, May 18, 1852. Paris, 1852.

Merson 1882. Olivier Merson. *Le Monde Illustré* (Paris) 26 (May 27, 1882), p. 330.

Merson 1884. Olivier Merson. *Le Monde Illustré* (Paris) 28 (May 3, 1884), p. 286.

Meslay 2001. Olivier Meslay. "Murillo and 'Smoking Mirrors.'" *The Burlington Magazine* (London) 143 (February 2001), pp. 73–79.

Mesonero Romanos 1899. Manuel Mesonero Romanos. *Velázquez fuera del Museo del Prado.* Madrid, 1899.

Mesonero Romanos 1995. Ramón de Mesonero Romanos. *Memorias de un setentón.* 2 vols. Madrid, 1995.

Mesuret 1954. Robert Mesuret. "La peinture toulousaine et l'Espagne." *Bulletin de l'Institut Français en Espagne* (Madrid), no. 77 (1954).

Mexico City 1991. *Pintura mexicana y española de los siglos XVI al XVIII.* Exh. cat. by Mercedes Meade and Alfonso E. Pérez Sánchez. Mexico City, Palacio Nacional de Esposiciones, 1991. Madrid, 1991.

Mexico City 1994a. *De la creación a la copia: Siglos XVI–XX.* Exh. cat. Mexico City, Museo Nacional de San Carlos, 1994. Mexico City, 1995.

Mexico City 1994b. *Obras maestras de los pintores españoles en los museos de Francia.* Exh. cat. Mexico City, Museo Nacional de San Carlos, 1994. Mexico City, 1994.

Mihan 1944. George Mihan. "Masterpieces Collected for the Hermitage by Catherine II and Her Successors." *Apollo* (London) 39 (April 1944), pp. 87–91.

Milgrome 1969. Abraham David Milgrome. "The Art of William Merritt Chase." Ph.D. diss., University of Pittsburgh, 1969.

Millet 1894. *Catalogue de dessins, tableaux et esquisses . . . de la succession de Mme veuve J. F. Millet.* Sale cat. Preface by Thiébault Sisson. Paris, Hôtel Drouot, April 24–25, 1894. Paris, 1894.

Milroy 1986. Elizabeth Milroy. "Thomas Eakins's Artistic Training, 1860–1870." Ph.D. diss., University of Pennsylvania, 1986.

Milroy 1987. Elizabeth Milroy. "Points of Contact: Thomas Eakins, Robert Harris, and the Art of Léon Bonnat." *Canadian Journal of History* (Saskatoon) 10 (1987), pp. 84–102.

Milroy 1989. Elizabeth Milroy. "'Consummatum est . . .': A Reassessment of Thomas Eakins's *Crucifixion* of 1880." *Art Bulletin* (New York) 71, no. 2 (June 1989), pp. 269–84.

Milton 1816. Henry Milton. *Letters on the Fine Arts, Written from Paris, in the Year 1815.* London, 1816.

Minervino 1974. Fiorella Minervino. *Tout l'oeuvre peint de Degas.* Paris, 1974.

Minet 1908. Émile Minet. *Catalogue Musée des Beaux-Arts de Rouen.* Paris, 1908.

Minor 1882. Ellen E. Minor. *Murillo.* London, 1882.

Mirecourt 1854. Eugène de Mirecourt. *Le baron Taylor.* Paris, 1854.

Miura 1988. Atsushi Miura. "La vision photographique dans *Combat de taureaux* de Manet." *Revue de l'Art* (Paris), no. 79 (1988), pp. 73–75.

Miura 1994. Atsushi Miura. "Un double portrait par Carolus-Duran: Fantin-Latour et Oulevay." *Gazette des Beaux-Arts* (Paris) 124 (July–August 1994), pp. 25–34.

Moffett 1979. Charles S. Moffett. *Degas Paintings in the Metropolitan Museum of Art.* New York, 1979.

Moffett 1985. Charles S. Moffett. *Impressionist and Post-Impressionist Paintings in the Metropolitan Museum of Art.* New York, 1985.

Moffitt 1982. John F. Moffitt. "Velázquez, Fools, Calabacillas and Ripa." *Pantheon* (Munich) 40, no. 4 (1982), pp. 304–9.

Moinet 1996. Éric Moinet. "Au musée des Beaux-arts d'Orléans: Une étude pour les *Massacres de Scio, Tête de vieille femme grecque* (1824) par Eugène Delacroix." *Revue du Louvre* (Paris) 46, no. 4 (October 1996), p. 21.

Momméja 1891. Jules Momméja. "Les dessins d'Ingres au Musée de Montauban." *Réunion des Sociétés des Beaux-Arts des Départements* (1891), pp. 555–92.

Momméja 1893. Jules Momméja. "Ingres à Montauban: Le Musée Ingres." *L'Art* 54 (1893).

Mongan 1996. Agnes Mongan. *David to Corot: French Drawings in the Fogg Art Museum.* Edited by Miriam Stewart. Cambridge, Mass., 1996.

Montauban 1953. *Exposition: Peintures, dessins, sculptures.* Exh. cat. by Daniel Ternois. Montauban, Musée Ingres, October 18–November 8, 1953. Montauban, 1953.

Montauban–Besançon 1999–2000. *Les élèves d'Ingres.* Exh. cat. Edited by Marie-Hélène Lavallée and Georges Vigne. Montauban, Musée Ingres, October 8, 1999–January 2, 2000; Besançon, Musée des Beaux-Arts et d'Archéologie, January 29–May 8, 2000. Montauban, 1999.

Montclair 2000–2001. *Lyrical Visions.* Exh. cat. Montclair [N.J.] Art Museum, September 17, 2000–January 7, 2001. Montclair, 2000.

Montesa 1927. Marques de Montesa. "La exportación de obras de arte en tiempos de Carlos III." *Arte Español* (Madrid), no. 4 (1927), p. 301.

Montezuma 1889. Montezuma [pseud.] "My Notebook." *The Art Amateur* (New York) 21 (August 1889), p. 46.

Montifaud 1868. Marc de Montifaud. "Salon de 1868. II." *L'Artiste* (Paris) 5 (May 1868), pp. 246–57.

Montoto 1923. Santiago Montoto. *Bartolomé Esteban Murillo: Estudio biográfico-crítico.* Seville, 1923.

Montoto 1945. Santiago Montoto. "Nuevos documentos de Bartolomé Esteban Murillo." *Archivo Hispalense* (Seville) (1945), p. 319.

Montpensier 1866. *Catálogo de los cuadros y esculturas pertenecientes a la galería de S.S.A.A.R.R. los Serenísimos Infantes de España, Duques de Montpensier.* Seville, 1866.

Montreal 1933. *A Selection from the Collection of Paintings of the Late Sir William Van Horne, K.C.M.G., 1843–1915.* Exh. cat. Art Association of Montreal, 1933. Montreal, 1933.

Morales y Marín 1979. José Luis Morales y Marín. *Los Bayeu.* Saragossa, 1979.

Morales y Marín 1994. José Luis Morales y Marín. *Goya: Catálogo de la pintura.* Saragossa, 1994.

Moreau 1873. Adolphe Moreau. *E. Delacroix et son oeuvre.* Paris, 1873.

Moreau 2002. Gustave Moreau. *Correspondance d'Italie.* Edited by Luisa Capodieci. Paris, 2002.

Moreau-Nélaton 1921. Étienne Moreau-Nélaton. *Millet, raconté par lui-même.* 3 vols. Paris, 1921.

Moreau-Nélaton 1926. Étienne Moreau-Nélaton. *Manet, raconté par lui-même.* 2 vols. Paris, 1926.

Moreau-Nélaton 1927. Étienne Moreau-Nélaton. *Bonvin raconté par lui-même.* Paris, 1927.

Moreau-Vauthier 1906. Charles Moreau-Vauthier. *Gérôme: Peintre et sculpteur: L'homme et l'artiste d'après sa correspondance, ses notes, les couvenirs de ses élèves et de ses amis.* Paris, 1906.

Moreno Alonso 1995. Manuel Moreno Alonso. *Sevilla napoleónica.* Seville, 1995.

Moreno de las Heras 1997. Margarita Moreno de las Heras. *Goya: Pinturas del Museo del Prado.* Madrid, 1997.

Moreno Villa 1939. José Moreno Villa. *Locos, enanos, negros y niños palaciegos: Gente de placer que tuvieron los Austrias en la corte española desde 1563 a 1700.* Mexico City, 1939.

Morisot 1950. Berthe Morisot. *Correspondance de Berthe Morisot avec sa famille et ses amis.* Edited by Denis Rouart. Paris, 1950.

Morny 1865. *Catalogue des tableaux anciens et modernes, objets d'art et de curiosité, composant les collections de feu M. le duc de Morny.* Sale cat. Paris, May 31–June 12, 1865. Paris, 1865.

Morris 1930. Harrison S. Morris. *Confessions in Art.* New York, 1930.

Moss 2001. Dorothy Moss. "John Singer Sargent, 'Madame X' and 'Baby Millbank.'" *The Burlington Magazine* (London) 143 (May 2001), pp. 268–75.

Mount 1963. Charles Merrill Mount. "Carolus-Duran and the Development of Sargent." *Art Quarterly* 26, no. 4 (1963), pp. 385–417.

Mulcahy 1996. Rosemarie Mulcahy. "Alonso Sánchez Coello and Grand Duke Ferdinando I de' Medici." *The Burlington Magazine* (London) 138 (1996), pp. 517–21.

Muller 1971. Priscilla Muller. "Goya's Portrait of Gen. Nicolas Guye." *Artnews* (New York) 70, no. 8 (December 1971), pp. 29, 51.

Munich 1869. *Katalog der I. Internationalen Kunstausstellung.* Exh. cat. Munich, Glaspalast, July 20–October 31, 1869. Munich, 1869.

Munich 1888. *Die dritte Internationale Kunstausstellung.* Exh. cat. Munich, 1888.

Munich 1907. *Manet-Monet-Ausstellung.* Exh. cat. Munich, Galerie Heinemann, [Durand-Ruel], January 1907. Munich, 1907.

Munich 1958. *München, 1869–1958, Aufbruch zur modernen Kunst: Rekonstruktion der ersten internationalen Kunstausstellung 1869.* Exh. cat. Munich, Haus der Kunst, June 21–October 5, 1958. Munich, 1958.

Munk 1993. Jens Peter Munk. *Katalog Postimpressionisme: Ny Carlsberg Glyptotek.* Copenhagen, 1993.

Murdoch 1917. W. G. Blaikie Murdoch. "The Hispanic Museum, New York." *The Connoisseur* (London) 49 (September 1917), pp. 23–30.

Murphy 1985. Alexandra R. Murphy. *European Paintings in the Museum of Fine Arts.* Boston, 1985.

Musset 1830. Alfred de Musset. *Contes d'Espagne et d'Italie.* Paris, 1830.

Muther 1893–94. Richard Muther. *Geschichte der Malerei im XIX. Jahrhundert.* 3 vols. Munich, 1893–94.

Nahum 1993. Katherine C. H. Nahum. "The Importance of Velázquez to Goya, Manet and Sargent." Ph.D. diss., Boston University, 1993.

Nantes–Paris 1995–96. *Les années romantiques: La peinture française de 1815 à 1850.* Exh. cat. Nantes, Musée des Beaux-Arts, December 4, 1995–March 17, 1996; Paris, Galeries Nationales du Grand Palais, April 16–July 15, 1996. Paris, 1995.

Naples–Madrid–New York 1992. *Jusepe de Ribera, 1591–1652.* Exh. cat. by Alfonso E. Pérez Sánchez and Nicola Spinosa. Naples, Castel Sant'Elmo, Certosa di San Martino, and Cappella del Tesoro di San Gennaro, February 27–May 17, 1992; Madrid, Museo del Prado,

June 2–August 16, 1992; New York, Metropolitan Museum of Art, September 18–November 29, 1992. New York, 1992.

Nara–Okayama–Kumamoto 1991. *Master Paintings from the Hermitage Museum.* Exh. cat. Nara Prefectural Museum of Art and other venues. Nara, 1991.

Navarrete Martínez 1999. Esperanza Navarrete Martínez. *La Academia de Bellas Artes de San Fernando y la pintura en la primera mitad del siglo XIX.* Madrid, 1999.

Navarrete Prieto 1998. Benito Navarrete Prieto. *La pintura andaluza del siglo XVII y sus fuentes grabadas.* Madrid, 1998.

Nerval 1845. Gérard de Nerval. "Les dieux inconnus." *La Presse* (Paris) (June 29, 1845).

New York 1874. *Catalogue of the Annual Exhibition.* Exh. cat. New York, National Academy of Design, 1874. New York, 1874.

New York 1883a. *Catalogue of the Pedestal Fund Art Loan Exhibition.* Exh. cat. New York, National Academy of Design, December 1–15, 1883. New York, 1883.

New York 1883b. *Catalogue of the Fourth Exhibition.* Exh. cat. New York, Society of American Artists, 1883. New York, 1883.

New York 1886. *Works in Oil and Pastel by the Impressionists of Paris.* Exh. cat. New York, American Art Association, April 10–28, 1886, and National Academy of Design, May 25–June 30, 1886. New York, 1886.

New York 1887. *Catalogue of Paintings, Water Color Drawings and Pastels.* Exh. cat. New York, Moore's Art Galleries, 1887. New York, 1887.

New York 1888. *Illustrated Catalogue of the Sixty-third Annual Exhibition.* Exh. cat. New York, National Academy of Design, April–May 1888. New York, 1888.

New York 1890a. *Catalogue of the Tenth Exhibition.* Exh. cat. New York, Society of American Artists, 1890. New York, 1890.

New York 1890b. *Catalogue of Paintings Exhibited by . . . J. W. Champney, W. M. Chase. . . .* Exh. cat. New York, American Art Association, 1890. New York, 1890.

New York 1895a. *Exposition of Paintings by Édouard Manet.* Exh. cat. New York, Durand-Ruel Galleries, March 1895. New York, 1895.

New York 1895b. *Exposition of Paintings, Pastels, and Etchings by Miss Mary Cassatt.* Exh. cat. New York, Durand-Ruel Galleries, 1895. New York, 1895.

New York 1895c. *Women's Art Club Show.* Exh. cat. New York, Klackner's Gallery, February 17, 1895. New York, 1895.

New York 1902a. *Illustrated Catalogue of the Seventy-seventh Annual Exhibition.* Exh. cat. New York, National Academy of Design, 1902. New York, 1902.

New York 1902b. Exh. cat. New York, M. Knoedler and Co., 1902. New York, 1902.

New York 1903a. *Annual Exhibition of the Society of American Artists.* Exh. cat. New York, 1903.

New York 1903b. *Exposition of Paintings and Pastels by Miss Mary Cassatt.* Exh. cat. New York, Durand-Ruel Gallery, 1903. New York, 1903.

New York 1910a. *Paintings in Oil and Pastel by James A. McNeill Whistler.* Exh. cat. New York, Metropolitan Museum of Art, March 15–May 31, 1910. New York, 1910.

New York 1910b. *William Merritt Chase Retrospective Exhibition.* Exh. cat. New York, National Arts Club, 1910. New York, 1910.

New York 1913. *Loan Exhibition of Paintings by Édouard Manet, 1832–1883.* Exh. cat. New York, Durand-Ruel Galleries, November 29–December 13, 1913. New York, 1913.

New York 1915. *Loan Exhibition of Paintings by El Greco and Goya: For the Benefit of the American Women War Relief Fund and the Belgian Relief Fund.* Exh. cat. New York, M. Knoedler & Co., January 1915. New York, 1915.

New York 1917a. *Loan Exhibition of Paintings by William M. Chase.* Exh. cat. New York, Metropolitan Museum of Art, February 19–March 18, 1917. New York, 1917.

New York 1917b. *Loan Exhibition of the Works of Thomas Eakins.* Exh. cat. New York, Metropolitan Museum of Art, November 5–December 3, 1917. New York, 1917.

New York 1919. *Loan Exhibition of the Works of Gustave Courbet.* Exh. cat. New York, Metropolitan Museum of Art, April 7–May 18, 1919. New York, 1919.

New York 1924. *Retrospective Exhibition of Important Works of John Singer Sargent.* Exh. cat. New York, Grand Central Art Galleries, February 23–March 22, 1924. New York, 1924.

New York 1925. *Exhibition of Paintings by the Late John Singer Sargent.* Exh. cat. New York, Knoedler & Co., 1925. New York, 1925.

New York 1926. *Memorial Exhibition of the Work of John Singer Sargent.* Exh. cat. New York, Metropolitan Museum of Art, January 4–February 14, 1926. New York, 1926.

New York 1928. *Catalogue of an Exhibition of Spanish Paintings from El Greco to Goya.* Exh. cat. New York, Metropolitan Museum of Art, February 17–April 1, 1928. New York, 1928.

New York 1937. *Exhibition of Masterpieces by Degas . . . for the Benefit of the Public Education Association.* Exh. cat. New York, Durand-Ruel Galleries, March 22–April 10, 1937. New York, 1937.

New York 1940. *Catalogue of European and American Paintings, 1500–1900: Masterpieces of Art.* Exh. cat. New York World's Fair, May–October 1940. New York, 1940.

New York 1952–53. *Art Treasures of the Metropolitan.* Exh. cat. New York, Metropolitan Museum of Art, November 7, 1952–September 7, 1953. New York, 1952.

New York 1955. *Goya: Drawings and Prints.* Exh. cat. (supplement). New York, Metropolitan Museum of Art, May 4–30, 1955. Washington, D.C., 1955.

New York 1957. *The American Vision: Paintings of Three Centuries.* Exh. cat. New York, Wildenstein & Co., October 23–November 16, 1957. New York, 1957.

New York 1958. *Thomas Eakins, 1844–1916: Exhibition of Paintings and Sculpture.* Exh. cat. New York, American Academy of Arts and Letters, January 16–February 16, 1958. New York, 1958.

New York 1960. *Degas: Loan Exhibition for the Benefit of the Citizens' Committee for Children of New York, Inc.* Exh. cat. New York, Wildenstein Gallery, April 7–May 7, 1960. New York, 1960.

New York 1964. *Four Centuries of American Masterpieces.* Exh. cat. New York World's Fair, Gallery of the Better Living Center, May 22–October 18, 1964. New York, 1964.

New York 1970a. *19th-Century America, Paintings and Sculpture.* Exh. cat. New York, Metropolitan Museum of Art, April 16–September 7, 1970. New York, 1970.

New York 1970b. *Thomas Eakins: A Retrospective Exhibition.* Exh. cat. by Lloyd Goodrich. New York, Whitney Museum of American Art, Fall 1970. New York, 1970.

New York 1971. *The Painter's Light.* Exh. cat. by John Walsh. New York, Metropolitan Museum of Art, October 5–November 10, 1971. New York, 1971.

New York 1976. *William Merritt Chase (1849–1916).* Exh. cat. by Ronald G. Pisano. New York, M. Knoedler and Company, May 7–June 5, 1976. New York, 1976.

New York 1977. *Degas in the Metropolitan.* Exh. cat. by Charles S. Moffett. New York, Metropolitan Museum of Art, February 26–September 4, 1977. New York, 1977.

New York 1980a. *John Singer Sargent: His Own Work.* Exh. cat. by Warren Adelson. New York, Coe-Kerr Gallery, May 28–June 27, 1980. New York, 1980.

New York 1980b. *Walter Gay: A Retrospective.* Exh. cat. by Gary A. Reynolds. New York, Grey Art Gallery and Study Center, September 16–November 1, 1980. New York, 1980.

New York 1984. *Van Gogh in Arles.* Exh. cat. by Ronald Pickvance. New York, Metropolitan Museum of Art, October 18–December 30, 1984. New York, 1984.

New York 1989–90. *Velázquez.* Exh. cat. by Antonio Domínguez Ortiz, Alfonso E. Pérez Sánchez, and Julián Gállego. New York, Metropolitan Museum of Art, October 3, 1989–January 7, 1990. New York, 1989.

New York 1990. *Victor Hugo and the Romantic Vision.* Exh. cat. New York, Jan Krugier Gallery, May 4–July 27, 1990. New York, 1990.

New York 1993a. *Spain, Espagne, Spanien: Foreign Artists Discover Spain, 1800–1900.* Exh. cat. Edited by Suzanne L. Stratton. New York, The Equitable Gallery, July 2–September 18, 1993. New York, 1993.

New York 1993b. *Splendid Legacy: The Havemeyer Collection.* Exh. cat. by Alice Cooney Freylinghuysen et al. New York, Metropolitan Museum of Art, March 27–June 20, 1993. New York, 1993.

New York 1995. *Goya in the Metropolitan Museum of Art.* Exh. cat. by Colta Ives and Susan Alyson Stein. New York, Metropolitan Museum of Art, September 12–December 31, 1995. New York, 1995.

New York 1995–96. *Whistler and Montesquiou: The Butterfly and the Bat.* Exh. cat. by Edgar Munhall. New York, Frick Collection, November 14, 1995–January 28, 1996. New York and Paris, 1995.

New York 1997–98. *The Private Collection of Edgar Degas: A Summary Catalogue.* Exh. cat. Compiled by Colta Ives, Susan Alyson Stein, and Julie A. Steiner. New York, Metropolitan Museum of Art, October 1, 1997–January 11, 1998. New York, 1997.

New York 1999. *Manet's* The Dead Toreador *and* The Bullfight: *Fragments of a Lost Salon Painting Reunited.* Exh. cat. by Susan Grace Galassi, with Ann

Hoenigswald, Malcolm Park, and Juliet Wilson-Bareau. New York, Frick Collection, May 25–August 22, 1999. New York, 1999.

New York 1999–2000. *Velázquez in New York Museums.* Exh. cat. New York, Frick Collection, November 16, 1999–January 16, 2000. New York, 1999.

New York–Chicago 1986–87. *John Singer Sargent.* Exh. cat. by Patricia Hills et al. New York, Whitney Museum of American Art, October 7, 1986–January 4, 1987; Chicago, Art Institute, February 7–April 19, 1987. New York, 1986.

New York et al. 1994–95. *American Impressionism and Realism: The Painting of Modern Life, 1885–1915.* Exh. cat. by H. Barbara Weinberg, Doreen Bolger, and David Park Curry. New York, Metropolitan Museum of Art, May 10–July 24, 1994; Fort Worth, Amon Carter Museum, August 21–October 30, 1994; Denver Art Museum, December 3, 1994–February 5, 1995; Los Angeles County Museum of Art, February–May 14, 1995. New York, 1994.

New York–New Britain 1998–99. *España: American Artists and the Spanish Experience.* Exh. cat. by M. Elizabeth Boone. New York, Hollis Taggart Galleries, November 12, 1998–January 16, 1999; New Britain [Conn.] Museum of American Art, January 30–April 4, 1999. New York, 1998.

New York–Paris 1987–88. *Zurbarán.* Exh. cat. by Jeannine Baticle. New York, Metropolitan Museum of Art, September 22–December 13, 1987; Paris, Galeries Nationales du Grand Palais, January 14–April 11, 1988. New York, 1987.

New York–Philadelphia 1971. *From Realism to Symbolism: Whistler and His World.* Exh. cat. New York, Wildenstein Gallery, March 4–April 3, 1971; Philadelphia Museum of Art, April 15–May 23, 1971. New York, 1971.

New York–Roslyn 1998. *Gustave Courbet (1819–1877): Later Paintings.* Exh. cat. New York, Salander-O'Reilly Galleries, January 6–February 28, 1998; Roslyn Harbor, N.Y., Nassau County Museum of Art, March 7–May 29, 1998. New York and Roslyn Harbor, 1998.

Nice 1986. *Delacroix: Peintures et dessins d'inspiration religieuse.* Exh. cat. Nice, Musée National Message Biblique Marc Chagall, July 5–October 6, 1986. Paris, 1986.

Nicolle 1920. Marcelle Nicolle. *Le Musée de Rouen: Peintures.* Paris, 1920.

Nicolson 1958. Benedict Nicolson. "Richard Ford and Spanish Painting." *The Burlington Magazine* (London) 100 (August 1958), pp. 263–64.

Niculescu 1970. Remus Niculescu. "Georges de Bellio, l'ami des Impressionnistes." *Paragone* (Florence) 21, no. 247 (September 1970), pp. 25–66; no. 249 (November 1970), pp. 41–85.

Nodier et al. 1820–78. Charles Nodier, Isidore-Justin-Séverin Taylor, and Alphonse de Cailleux. *Voyages pittoresques et romantiques dans l'ancienne France.* 18 vols. Paris, 1820–78.

***Notices* 1856.** *Notices by Different Authors and Artists Extracted from Several Publications of 1856 on the Picture of St. Peter Weeping, by Murillo.* N.p., 1856.

Núñez de Arenas 1950. Manuel Núñez de Arenas. "Goya en Francia." *Bulletin Hispanique* (Bordeaux) 52 (1950), pp. 229–73.

Nyerges 1996. Éva Nyerges. *Pintura española.* Budapest, 1996.

Oertel 1907. Richard Oertel. *Francisco de Goya.* Bielefeld, 1907.

Okayama et al. 1996–97. *Forukuvangu bijutsukan ten = Meisterwerke des Museum Folkwang, Essen.* Exh. cat. by Georg-W. Költzsch et al. Okayama Prefectural Museum of Art, April 5–May 19, 1996, and other venues in Japan through 1997. Tokyo, 1996.

Olson 1986. Stanley Olson. *John Singer Sargent: His Portrait.* New York, 1986.

Orienti 1967. Sandra Orienti. *The Complete Paintings of Manet.* New York, 1967.

Orienti 1970. Sandra Orienti. *Tout l'oeuvre peint d'Édouard Manet.* Paris, 1970.

Orléans 1997–98. *Le temps des passions: Collections romantiques des Musées d'Orléans.* Exh. cat. Orléans, Musée des Beaux-Arts, November 7, 1997–March 31, 1998. Orléans, 1997.

Ormond 1970. Richard Ormond. *John Singer Sargent: Paintings, Drawings, Watercolors.* New York, 1970.

Ormond and Kilmurray 1998. Richard Ormond and Elaine Kilmurray. *John Singer Sargent: Complete Paintings,* vol. 1, *The Early Portraits.* New Haven, 1998.

Ormsby 1809. James Wilmot Ormsby. *An Account of the Operations of the British Army and of the State and Sentiments of the People of Portugal and Spain during the Campaigns of the Years 1808 and 1809, in a Series of Letters.* 2 vols. London, 1809.

Orozco Díaz 1949. Emilio Orozco Díaz. "El 'Soldado muerto' de la National Gallery y su atribución." *Arte Español* 18 (1949), pp. 191–94.

Orozco Díaz 1977. Emilio Orozco Díaz. *Mística, plástica y barroco.* Madrid, 1977.

Ortiz de Zúñiga 1795–96. Diego Ortiz de Zúñiga. *Anales eclesiásticos y seculares de la muy noble y muy leal ciudad de Sevilla, metrópoli de la Andalucía . . . ilustrados y corregidos por Antonio María Espinosa y Carçel.* 5 vols. Madrid, 1795–96.

Osaka 1970. *Discovery of Harmony.* Exh. cat. Osaka, Expo Museum of Fine Arts, March 15–September 13, 1970. Osaka, 1970.

O'Shea 1865. Henry O'Shea. *A Guide to Spain.* London, 1865.

Ottawa–Chicago–Fort Worth 1997–98. *Renoir's Portraits: Impressions of an Age.* Exh. cat. Ottawa, National Gallery of Canada, June 27–September 14, 1997; Chicago, Art Institute, October 17, 1997–January 4, 1998; Forth Worth, Kimbell Art Museum, February 8–April 26, 1998. Ottawa, 1997.

Oudry 1869. *Galerie de feu M. Alphonse-Oudry . . . catalogue de tableaux anciens.* Sale cat. Paris, April 16–17, 1869. Paris, 1869.

Oudry 1876. *Catalogue des tableaux . . . succession Oudry.* Sale cat. Paris, Hôtel Drouot, April 10, 1876. Paris, 1876.

Oviedo 1999–2000. *En torno a Velázquez: Pintura española del siglo de oro.* Exh. cat. Edited by Hugh Brigstocke and Zahira Veliz. Oviedo, Spain, Museo de Bellas Artes de Asturias, Palacio de Valarde, May 20, 1999–January 30, 2000. London, 1999.

Palm 1967. Erwin Walter Palm. "Diego Velázquez: Äesop und Menipp." In *Lebende Antike: Symposion für Rudolf Sühnel,* edited by Horst Meller and Hans-Joachim Zimmermann, pp. 207–17. Berlin, 1967.

Palomino 1724. Antonio Palomino. *El museo pictórico, y escala optica,* vol. 3, *El parnaso español pintoresco laureado, con las vidas de los pintores y estatuarios eminentes españoles.* Madrid, 1724. Abridged ed. *Las vidas de los pintores y estatuarios eminentes españoles.* London, 1742. New ed. *El Museo pictórico, y Escala óptica.* Madrid, 1947. New ed. *Vidas de los pintores y estatuarios eminentes españoles.* Edited by Nina Ayala Mallory. Madrid, 1986. English ed. *Lives of the Eminent Spanish Painters and Sculptors.* Translated by Nina Ayala Mallory. Cambridge, 1987.

Palomino 1749. Antonio Palomino. *Histoire abrégée des plus fameux peintres, sculpteurs et architectes espagnols.* Paris, 1749.

Pantorba 1947. Bernardino de Pantorba. *Murillo.* Madrid, 1947.

Pantorba 1953. Bernardino de Pantorba. *70 obras maestras del Greco.* Madrid, 1953.

Pantorba 1955. Bernardino de Pantorba. *La vida y la obra de Velázquez: Estudio biográfico y crítico.* Madrid, 1955.

Papillon de la Ferté 1776. Denis-Pierre-Jean Papillon de la Ferté. *Extrait des différens ouvrages publiés sur la vie des peintres.* 2 vols. Paris, 1776.

Pardo 1989. Arcadio Pardo. *La visión del arte español en los viajeros franceses del siglo XIX.* Valladolid, 1989.

Pardo Bazán 1895. Emilia Pardo Bazán. *Por la España pintoresca: Viajes.* Barcelona, 1895.

Pardo Canalís 1979. Enrique Pardo Canalís. "Una visita a la galería del Príncipe de la Paz." *Goya* (Madrid), nos. 148–150 (1979), pp. 301–11.

Paris 1793. *Catalogue des objets contenus dans la galerie du Muséum français, décrété par la Convention nationale, le 27 juillet 1793, l'an second de la République français.* Paris, 1793.

Paris 1801. *Notice des tableaux des écoles française et flamande, exposés dans la grande Galerie, dont l'ouverture a eu lieu le 18 germinal an VII; et des tableaux des écoles de Lombardie et de Bologne, dont l'exposition a eu lieu le 25 messidor an IX.* Paris, 1801.

Paris 1803. *Notice de plusieurs précieux tableaux recueillis à Venise, Florence, Naples, Turin et Bologne, exposés dans le grand salon du Musée ouvert le 27 Thermidor an XI.* Paris, 1803.

Paris 1810. *Notice des tableaux exposés dans la Galerie Napoléon.* Paris, 1910.

Paris 1811. *Notice des tableaux exposés dans la Galerie Napoléon.* Paris, 1911.

Paris 1814a. *Notice des tableaux des écoles primitives de l'Italie, de l'Allemagne et de plusieurs autres tableaux de différentes écoles, exposés dans le grand salon du Musée Royal, ouvert le 25 juillet 1814.* Paris, 1814.

Paris 1814b. *Notice des tableaux exposés dans la Galerie Napoléon.* 4th ed. Paris, 1814.

Paris 1815a. *Notices des statues, bustes et bas-reliefs, de la galerie des antiques du Musée, ouverte pour le première fois le 18 Brumaire an 9.* Paris, 1815.

Paris 1815b. *Notice des tableaux des écoles primitives de l'Italie, de l'Allemagne et de plusieurs autres tableaux de différentes écoles, exposés dans le grand salon du Musée Napoléon.* Paris, 1815.

Paris 1815c. *Notice des tableaux exposés dans la Galerie Napoléon.* Paris, 1815.

Paris 1816. *Notice des tableaux exposés dans la Galerie du Musée Royal.* Paris, 1816.

Paris 1820. *Notice des tableaux exposés dans la Galerie du Musée Royal.* Paris, 1820.

Paris 1823. *Notice des tableaux exposés dans la Galerie du Musée Royal.* Paris, 1823.

Paris 1826. *Notice des tableaux exposés dans la Galerie du Musée Royal.* Paris, 1826.

Paris 1831. *Notice des tableaux exposés dans le Musée Royal.* Paris, 1831.

Paris 1836. *Notice des tableaux exposés dans le Musée Royal.* Paris, 1836.

Paris 1838. Isidore-Justin-Séverin Taylor. *Notice des tableaux de la Galerie Espagnole exposés dans les salles du Musée Royal au Louvre.* Paris, 1938.

Paris 1856. *Visites et études de S.A.I. le prince Napoléon au Palais des Beaux-Arts, ou Description complète de cette Exposition [Universelle 1855] (peinture, sculpture, gravure, architecture).* Exh. cat. Paris, Palais des Beaux-Arts, May 15–November 15, 1855. Paris, 1856.

Paris 1857. *Explication des ouvrages de peinture, sculpture, gravure, lithographie et architecture des artistes vivants exposés au Palais des Champs-Élysées le 15 juin 1857.* Paris, 1857.

Paris 1863. *26. Boulevard des Italiens: Exposition de tableaux anciens et modernes.* Exh. cat. Paris, Galerie Martinet, March 1–April 1863. Paris, 1863.

Paris 1864. *Exposition des oeuvres d'Eugène Delacroix.* Exh. cat. Paris, Société Nationale des Beaux-Arts, 1864. Paris, 1864.

Paris 1865. *Exposition des oeuvres inédites des sociétaires.* Exh. cat. Paris, Société Nationale des Beaux-Arts, Galerie Martinet, February 20, 1865. Paris, 1865.

Paris 1867. *Catalogue des tableaux de M. Édouard Manet exposés avenue de l'Alma en 1867.* Exh. cat. Paris, Avenue de l'Alma, May 24–October 1867. Paris, 1867.

Paris 1868. *Tableaux anciens provenant de l'ancien Musée espagnol au Louvre, de la Galerie Coesvelt, à Londres, de la Galerie Urzaiz, à Madrid, etc.* Sale cat. Paris, Hôtel Drouot, January 30–31, 1868. Paris, 1868.

Paris 1872. *Oeuvres de Henri Regnault.* Exh. cat. Text by Théophile Gautier. Paris, École des Beaux-Arts, March 1872. Paris, 1872.

Paris 1874. *Notice sommaire des objets d'art exposés dans le Palais de la Présidence du Corps Législatif, le 23 avril 1874, au profit des Alsaciens-Lorrains en Algérie.* Exh. cat. Paris, Palais de la Présidence du Corps Législatif, April 23, 1874. Paris, 1874.

Paris 1880. *Th. Ribot: Exposition générale de ses oeuvres.* Exh. cat. Text by Eugène Véron. Paris, Galerie de L'Art, 1880. Paris, 1880.

Paris 1882a. *Exposition des oeuvres de Gustave Courbet.* Exh. cat. Preface by Jules-Antoine Castagnary. Paris, École des Beaux-Arts, May 1882. Paris, 1882.

Paris 1882b. *Société Internationale des Peintres et Sculpteurs, Première Exposition.* Exh. cat. Paris, Galerie Georges Petit, 1882. Paris, 1882.

Paris 1883. *Catalogue de l'exposition de portraits du siècle (1783–1883) ouverte au profit de l'oeuvre à l'École des Beaux-Arts.* Exh. cat. Paris, Société Philanthropique, École Nationale des Beaux-Arts, April 25, 1883. Paris, 1883.

Paris 1884. *Exposition des oeuvres d'Édouard Manet.* Exh. cat. Preface by Émile Zola. Paris, École Nationale des Beaux-Arts, January 1884. Paris, 1884.

Paris 1885. *Exposition Eugène Delacroix: Au profit de la souscription destinée à élever à Paris un monument à sa mémoire.* Exh. cat. Paris, École Nationale des Beaux-Arts, March 6–April 15, 1885. Paris, 1885.

Paris 1887. *Catalogue général des photographies inaltérable au charbon et héliogravures.* Paris, 1887.

Paris 1890. *Exposition T. Ribot: Catalogue raisonné des oeuvres exposées.* Exh. cat. Paris, Galerie Bernheim-Jeune, June–July 1890. Paris, 1890.

Paris 1892. *Exposition Th. Ribot.* Exh. cat. Paris, Palais National de l'École des Beaux-Arts, May 3–May 31, 1892. Paris, 1892.

Paris 1893. *Exposition de tableaux, pastels et gravures de Mary Cassatt.* Exh. cat. Paris, Galeries Durand-Ruel, November–December 1893. Paris, 1893.

Paris 1905. *L'oeuvre de James MacNeill [sic] Whistler . . . réunis à l'occasion de l'exposition commémorative.* Exh. cat. by Léonce Bénédite. Paris, Palais de l'École des Beaux-Arts, May–June 1905. Paris, 1905.

Paris 1906. *Exposition de 24 tableaux et aquarelles par Manet formant la collection Faure.* Exh. cat. Paris, Galeries Durand-Ruel, March 1–31, 1906. Paris, 1906.

Paris 1910a. *Exposition de chefs-d'oeuvre de l'École française: Vingt peintres du XIXe siècle.* Exh. cat. Paris, Galerie Georges Petit, May 2–31, 1910. Paris, 1910.

Paris 1910b. *Manet: Trente-cinq tableaux de la collection Pellerin.* Exh. cat. Text by Théodore Duret. Paris, Galerie Bernheim-Jeune, June 1–17, 1910. Paris, 1910.

Paris 1912a. *Exposition d'art moderne: [Rodin, Cézanne, Manet, Degas, etc.].* Exh. cat. Paris, Galerie Manzi-Joyant, 1912. Paris, 1912.

Paris 1912b. *La musique, la danse: Exposition rétrospective organisée par la Société Nationale des Beaux-Arts.* Exh. cat. Paris, Château de Bagatelle, May 15–July 15, 1912. Évreux, 1912.

Paris 1922. *Cent ans de peinture française.* Exh. cat. Paris, Musée des Arts Décoratifs, March 15–April 20, 1922. Paris, 1922.

Paris 1925. *Exposition d'art ancien espagnol.* Exh. cat. Paris, Hôtel Jean Charpentier, June 6–July 6, 1925. Paris, 1925.

Paris 1931. *Degas, portraitiste, sculpteur.* Exh. cat. Paris, Musée de l'Orangerie, 1931. Paris, 1931.

Paris 1933a. *Les achats du Musée du Louvre et les dons de la Société des Amis du Louvre, 1922–1932.* Exh. cat. Paris, Musée de l'Orangerie, 1933. Paris, 1933.

Paris 1933b. *Exposition Chassériau, 1819–1856.* Exh. cat. by Charles Sterling. Paris, Musée de l'Orangerie, 1933. Paris, 1933.

Paris 1933c. *Exposition Renoir, 1841–1919.* Exh. cat. by Charles Sterling. Paris, Musée de l'Orangerie, 1933. Paris, 1933.

Paris 1935a. *Chefs-d'oeuvres du Musée de Grenoble.* Exh. cat. by Germaine Barnaud. Paris, Petit Palais, November 19, 1935. Paris, 1935.

Paris 1935b. *Goya: Exposition de l'oeuvre gravé, de peintures, de tapisseries et de cent dix dessins du Musée du Prado.* Exh. cat. by Jean Adhémar. Paris, Bibliothèque Nationale de France, Cabinet des Estampes, 1935. Paris, 1935.

Paris 1937a. *Degas.* Exh. cat. Paris, Musée de l'Orangerie, March–April 1937. Paris, 1937.

Paris 1937b. *Un peintre de la vie au XIXe siècle: Constantin Guys, 1802–1892.* Exh. cat. Paris, Musée des Arts Décoratifs, January–February 1937. Paris, 1937.

Paris 1938. *Peintures de Goya des collections de France.* Exh. cat. by Charles Sterling. Paris, Musée de l'Orangerie, January 1938. Paris, 1938.

Paris 1946. *Les Goncourt et leur temps.* Exh. cat. Paris, Musée des Arts Décoratifs, 1946. Paris, 1946.

Paris 1947. *Cinquantenaire des Amis du Louvre, 1897–1947.* Exh. cat. Paris, Orangerie des Tuileries, 1947. Paris, 1947.

Paris 1953. *Donations de D. David-Weill aux musées français.* Exh. cat. Paris, Musée de l'Orangerie, May 6–June 7, 1953. Paris, 1953.

Paris 1955. *Gustave Courbet.* Exh. cat. Paris, Petit Palais, opened January 11, 1955. Paris, 1955.

Paris 1957. *Alfred de Musset, 1810–1857: Exposition organisée pour le centenaire de sa mort.* Exh. cat. Paris, Bibliothèque Nationale, Galerie Mazarine, May 31–August 31, 1957. Paris, 1957.

Paris 1963a. *John S. Sargent, 1856–1925.* Exh. cat. Paris, Centre Culturel Américain, February 15–March 30, 1963. Paris, 1963.

Paris 1963b. *Trésors de la peinture espagnole: Églises et musées de France.* Exh. cat. Edited by Michel Laclotte, Jeannine Baticle, and Robert Mesuret. Paris, Musée du Louvre, Musée des Arts Décoratifs, January–April 1963. Paris, 1963.

Paris 1963c. *Velázquez, son temps, son influence: Actes du colloque tenu à la Casa de Velázquez les 7, 9 et 10 décembre 1960.* Paris, 1963.

Paris 1968–69. *Baudelaire.* Exh. cat. Paris, Petit Palais, November 23, 1968–March 17, 1969. Paris, 1968.

Paris 1969. *Degas: Oeuvres du Musée du Louvre.* Exh. cat. Paris, Musée de l'Orangerie, June 27–September 15, 1969. Paris, 1969.

Paris 1973. *Autoportraits de Courbet.* Exh. cat. by Marie-Thérèse de Forges. Paris, Musée du Louvre, January 13–April 23, 1973. Paris, 1973.

Paris 1974. *Le Musée du Luxembourg en 1874: Peintures.* Exh. cat. Edited by Geneviève Lacambre and Jacqueline de Rohan-Chabot. Paris, Galeries Nationales du Grand Palais, May 31–November 18, 1974. Paris, 1974.

Paris 1974–75. *De David à Delacroix: La peinture française de 1774 à 1830.* Exh. cat. by Frederick Cummings, Robert Rosenblum, and Antoine Schnapper. Paris, Galeries Nationales du Grand Palais, November 16, 1974–February 3, 1975. Paris, 1974.

Paris 1976. *La peinture espagnole du siècle d'or: De Greco à Velázquez.* Exh. cat. Paris, Petit Palais, April–June 1976. Paris, 1976.

Paris 1977–78. *Gustave Courbet (1819–1877).* Exh. cat. Paris, Grand Palais, September 30, 1977–January 2, 1978. Paris, 1977.

Paris 1978. *Manet: Dessins aquarelles eaux-fortes lithographies correspondance.* Exh. cat. by Juliet Wilson-Bareau. Paris, Galerie Huguette Berès, opened June 2, 1978. Paris, 1978.

Paris 1982. *Collection Thyssen-Bornemisza: Maîtres anciens.* Exh. cat. Paris, Musée du Petit Palais, January 7–March 28, 1982. Paris, 1981.

Paris 1983. *Murillo dans les musées français.* Exh. cat. Edited by Claudie Ressort. Paris, Musée du Louvre, June 16–October 24, 1983. Paris, 1983.

Paris 1983–84. *Raphaël et l'art français.* Exh. cat. Edited by Jean-Paul Boulanger and Geneviève Renisio. Paris, Galeries Nationales du Grand Palais, November 15, 1983–February 13, 1984. Paris, 1983.

Paris 1985. *James Tissot, 1836–1902.* Exh. cat. by Roselyne Huret. Paris, Petit Palais, April 5–June 30, 1985. Paris, 1985.

Paris 1987–88. *Cinq siècles d'art espagnol,* vol. 1, *De Greco à Picasso.* Exh. cat. Paris, Musée du Petit Palais, October 10, 1987–January 3, 1988. Madrid and Paris, 1987.

Paris 1988. *Zurbarán.* Exh. cat. by Jeannine Baticle. Paris, Galeries Nationales du Grand Palais, January 14–April 11, 1988. Paris, 1988.

Paris 1991. *De Corot aux impressionnistes: Donations Moreau-Nélaton.* Exh. cat. Paris, Galeries Nationales du Grand Palais, April 30–July 22, 1991. Paris, 1991.

Paris 1995–96. *Manet, Gauguin, Rodin—chefs-d'oeuvre de la Ny Carlsberg Glyptotek de Copenhague.* Exh. cat. Edited by Anne-Birgitte Fonsmark. Paris, Musée d'Orsay, October 9, 1995–January 28, 1996. Paris, 1995.

Paris 1997. *Théophile Gautier, la critique en liberté.* Exh. cat. Edited by Stéphane Guégan. Paris, Musée d'Orsay, February 18–May 18, 1997. Paris, 1997.

Paris 1997–98. *La collection Havemeyer: Quand l'Amérique découvrait l'Impressionnisme.* Exh. cat. Edited by Sylvie Patin and Gary Tinterow. Paris, Musée d'Orsay, October 20, 1997–January 18, 1998. Paris, 1997.

Paris 1998. *Delacroix: Le trait romantique.* Exh. cat. Edited by Barthélémy Jobert. Paris, Bibliothèque Nationale, April 6–July 12, 1998. Paris, 1998.

Paris 1998–99. *Mallarmé, 1842–1898: Un destin d'écriture.* Exh. cat. by Luce Abélès and Yves Peyré. Paris, Musée d'Orsay, September 29, 1998–January 3, 1999. Paris, 1998.

Paris 1999–2000. *Dominique-Vivant Denon: L'oeil de Napoléon.* Exh. cat. Edited by Marie-Anne Dupuy. Paris, Musée du Louvre, October 20, 1999–January 17, 2000. Paris, 1999.

Paris 2000. *La dame aux éventails: Nina de Callias, modèle de Manet.* Exh. cat. by Luce Abélès. Paris, Musée d'Orsay, April 17–July 16, 2000. Paris, 2000.

Paris 2002–3. *Manet Velázquez: La manière espagnole au XIXe siècle.* Exh. cat. Edited by Geneviève Lacambre and Gary Tinterow. Paris, Musée d'Orsay, September 16, 2002–January 5, 2003. Paris, 2002.

Paris–Baltimore 2000–2001. *Manet: Les natures mortes.* Exh. cat. Edited by George Mauner and Henri Loyrette. Paris, Musée d'Orsay, October 9, 2000–January 7, 2001; Baltimore, Walters Art Gallery, January 30–April 22, 2001. Paris, 2000.

Paris–Chicago 1994–95. *Gustave Caillebotte 1848–1894.* Exh. cat. Paris, Galeries Nationales du Grand Palais, September 12, 1994–January 9, 1995; Chicago, Art Institute, February 15–May 28, 1995. Paris, 1994.

Paris–London 1975–76. *Jean-François Millet.* Exh. cat. by Robert Herbert. Paris, Réunion des Musées Nationaux, October 17, 1975–January 5, 1976; London, Hayward Gallery, January 22–March 7, 1976. Paris, 1975.

Paris–Milan 1988–89. *Seicento: Le siècle de Caravage dans les collections françaises.* Exh. cat. Paris, Galeries Nationales du Grand Palais, October 11, 1988–January 2, 1989; Milan, Palazzo Reale, March–April 1989. Paris, 1988.

Paris–New York 1983. *Manet, 1832–1883.* Exh. cat. Edited by Françoise Cachin and Charles S. Moffett.

Paris, Galeries Nationales du Grand Palais, April 22–August 1, 1983; New York, Metropolitan Museum of Art, September 10–November 27, 1983. New York, 1983.

Paris–New York 1994–95. *Origins of Impressionism / Impressionnisme: Les origines, 1859–1869.* Exh. cat. by Gary Tinterow and Henri Loyrette. Paris, Galeries Nationales du Grand Palais, April 19–August 8, 1994; New York, Metropolitan Museum of Art, September 27, 1994–January 8, 1995. New York, 1994.

Paris–Ottawa–New York 1988–89. *Degas.* Exh. cat. Texts by Henri Loyrette, Michael Pantazzi, Gary Tinterow, and Jean Sutherland Boggs. Paris, Galeries Nationales du Grand Palais, February 9–May 16, 1988; Ottawa, National Gallery of Canada, June 16–August 28, 1988; New York, Metropolitan Museum of Art, September 27, 1988–January 8, 1989. Paris, 1988.

Paris–Ottawa–New York 1996–97. *Corot.* Exh. cat. by Gary Tinterow, Michael Pantazzi, and Vincent Pomarède. Paris, Grand Palais, February 27–May 27, 1996; Ottawa, National Gallery of Canada, June 21–September 22, 1996; New York, Metropolitan Museum of Art, October 22, 1996–January 19, 1997. New York, 1996.

Paris–Philadelphia 1998–99. *Delacroix: Les dernières années.* Exh. cat. Paris, Galeries Nationales du Grand Palais, April 7–July 20, 1998; Philadelphia Museum of Art, September 10, 1998–January 3, 1999. Paris, 1998.

Paris–Pittsburgh 1998–99. *François Bonvin, the Master of the "Realist School," 1817–1887.* Exh. cat. Paris, Galerie Berès, November 19, 1998–January 9, 1999 (under the title *François Bonvin, 1817–1887*); Pittsburgh, Frick Art and Historical Center, February 3–April 11, 1999. Paris and Pittsburgh, 1999.

Paris–Strasbourg–New York 2002–3. *Chassériau: Un autre romantisme/Chassériau: An Unknown Romantic.* Exh. cat. by Stéphane Guégan, Vincent Pomarède, and Louis-Antoine Prat. Paris, Galeries Nationales du Grand Palais, February 26–May 27, 2002; Strasbourg, Musée des Beaux-Arts, June 19–September 21, 2002; New York, Metropolitan Museum of Art, October 21, 2002–January 5, 2003. Paris, Strasbourg, and New York, 2002.

Paris–Versailles 1989–90. *Jacques-Louis David, 1748–1825.* Exh. cat. Edited by Antoine Schnapper and Arlette Sérullaz. Paris, Musée du Louvre, and Versailles, Musée National du Château, October 26, 1989–February 12, 1990. Paris, 1989.

Paris–Washington 1998. *Manet, Monet, la gare Saint-Lazare / Manet, Monet, and the Gare Saint-Lazare.* Exh. cat. by Juliet Wilson-Bareau. Paris, Musée d'Orsay, February 9–May 17, 1998; Washington, D.C., National Gallery of Art, June 14–September 20, 1998. Paris and New Haven, 1998.

Pasadena 1989. *Masterpieces from the Norton Simon Museum.* Pasadena, 1989.

Péladan 1884. Joséphin Péladan. "Salon de 1884." *L'Artiste* (Paris) 54 (June 1884), p. 441.

Peltre 2001. Christine Peltre. *Théodore Chassériau.* Paris, 2001.

Pemán 1950. César Pemán. "La reconstrucción del retablo de la Cartuja de Jerez de la Frontera." *Archivo Español de Arte* (Madrid) 23 (1950), pp. 203–27.

Pemán 1961. César Pemán. "Zurbarán en la hora actual." *Revista de Estudios Extremeños* (Badajoz) 17 (1961), pp. 271–85.

Penguin 1884. Penguin [pseud.]. *American Architect and Building News* (Boston) 15 (June 21, 1884), p. 296.

Pennell 1908. Elizabeth R. Pennell and Joseph Pennell. *The Life of James McNeill Whistler.* 2 vols. London, 1908.

Pennell 1919. Elizabeth R. Pennell and Joseph Pennell. *The Life of James McNeill Whistler.* 6th ed., rev. London, 1919.

Pennell 1921. Elizabeth R. Pennell and Joseph Pennell. *The Whistler Journal.* Philadelphia, 1921.

Pereire 1868. *Tableaux anciens provenant de l'ancien Musée espagnol du Louvre, de la Galerie Coesvelt, à Londres, de la Galerie Urzaiz, à Madrid.* Sale cat. for Pereire brothers collection. Paris, Hôtel Drouot, January 30–31, 1868. Paris, 1868.

Pereire 1872. *Galerie de MM. Pereire: Catalogue des tableaux anciens et modernes des diverses écoles.* Sale cat. Paris, Hôtel Drouot, March 6–9, 1872. Paris, 1872.

Pérez de Guzmán 1900. Juan Pérez de Guzmán. "Las colecciones de cuadros del príncipe de la Paz." *La España Moderna* (Madrid) (August 1900), pp. 95–126.

Pérez Sánchez 1977. Alfonso E. Pérez Sánchez. *Pasado, presente y futuro del Museo del Prado.* Madrid, 1977.

Pérez Sánchez 1985. Alfonso E. Pérez Sánchez. *Juan Carreño de Miranda, 1614–1685.* Avilés, 1985.

Pérez Sánchez 1992. Alfonso E. Pérez Sánchez. *Pintura barroca en España (1600–1750).* Madrid, 1992.

Pérez Sánchez 1993. Alfonso E. Pérez Sánchez. *Zubarán.* Madrid, 1993.

Pérez Sánchez 1999. Alfonso E. Pérez Sánchez, ed. *Zurbarán ante su centenario (1598–1998): Textos de las ponencias presentadas en el Seminario de Historia de Arte, en Soria, del 21 al 25 de julio de 1997.* Valladolid, 1999.

Pérez Sánchez and Spinosa 1978. Alfonso E. Pérez Sánchez and Nicola Spinosa. *L'opera completa del Ribera.* Milan, 1978.

Pérez Sánchez et al. 1991. Alfonso E. Pérez Sánchez et al. *El Siglo de Oro de la pintura española.* Madrid, 1991.

Perrin de Boussac 1983. Henri Perrin de Boussac. *Charles Jean-Marie Alquier, 1752–1826: Un témoin de la Révolution et de l'Empire.* La Rochelle, 1983.

Perutz 1993. Vivien Perutz. *Édouard Manet.* Lewisburg, Pa., and London, 1993.

Pesenti Campagnoni and Tortonese 2001. Donata Pesenti Campagnoni and Paolo Tortonese, eds. *Les arts de l'hallucination.* Paris, 2001.

Pesquidoux 1857. Léonce de Pesquidoux. *Voyage artistique en France.* Paris, 1857.

Petit 1877. Fernand Petit. *Notes sur l'Espagne artistique.* Lyon, 1877.

Philadelphia 1878. *Forty-ninth Annual Exhibition.* Exh. cat. Philadelphia, Pennsylvania Academy of the Fine Arts, 1878. Philadelphia, 1878.

Philadelphia 1896. *Annual Exhibition.* Exh. cat. Philadelphia, Pennsylvania Academy of the Fine Arts, 1896.

Philadelphia 1901. *Annual Exhibition.* Exh. cat. Philadelphia, Pennsylvania Academy of the Fine Arts, 1901.

Philadelphia 1903. *Annual Exhibition.* Exh. cat. Philadelphia, Pennsylvania Academy of the Fine Arts, 1903. Philadelphia, 1903.

Philadelphia 1907. *102nd Annual Exhibition of Painting and Sculpture.* Exh. cat. Philadelphia, Pennsylvania Academy of the Fine Arts, 1907. Philadelphia, 1907.

Philadelphia 1908. *Annual Exhibition.* Exh. cat. Philadelphia, Pennsylvania Academy of the Fine Arts, 1908.

Philadelphia 1917–18. *Memorial Exhibition of the Works of the Late Thomas Eakins.* Exh. cat. Philadelphia, Pennsylvania Academy of the Fine Arts, December 23, 1917–January 13, 1918. Philadelphia, 1917.

Philadelphia 1930. *Thomas Eakins.* Exh. cat. by Lloyd Goodrich. Philadelphia, Pennsylvania Museum of Art, March 1930. Philadelphia, 1930.

Philadelphia 1985. *Mary Cassatt and Philadelphia.* Exh. cat. by Suzanne G. Lindsay. Philadelphia Museum of Art, February 17–April 14, 1985. Philadelphia, 1985.

Philadelphia–Boston 1959–60. *Gustave Courbet, 1819–1877.* Exh. cat. Philadelphia Museum of Art, December 17, 1959–February 14, 1960; Boston, Museum of Fine Arts, February 26–April 14, 1960. Boston, 1960.

Philadelphia–Boston 1982. *Thomas Eakins: Artist of Philadelphia.* Exh. cat. by Darrel Sewell. Philadelphia Museum of Art, May 29–August 1, 1982; Boston, Museum of Fine Arts, September 22–November 28, 1982. Philadelphia, 1982.

Philadelphia–Chicago 1966–67. *Édouard Manet, 1832–1883.* Exh. cat. by Anne Coffin Hanson. Philadelphia Museum of Art, November 3–December 11, 1966; Chicago, Art Institute, January 13–February 19, 1967. Philadelphia, 1966.

Philadelphia–Detroit–Paris 1978–79. *The Second Empire, 1852–1870: Art in France under Napoleon III.* Exh. cat. Philadelphia, Philadelphia Museum of Art, October 1–November 26, 1978; Detroit Institute of Arts, January 15–March 18, 1979; Paris, Galeries Nationales du Grand Palais, April 24–July 2, 1979. Philadelphia and Detroit, 1978.

Philadelphia–Paris–New York 2001–2. *Thomas Eakins.* Exh. cat. Edited by Darrel Sewell. Philadelphia Museum of Art, October 4, 2001–January 6, 2002; Paris, Musée d'Orsay, February 5–May 12, 2002; New York, Metropolitan Museum of Art, June 18–September 15, 2002. Philadelphia, 2001.

Phillips 1885. Claude Phillips. "Expositions de la Royal Academy et la Grosvenor Gallery." *Gazette des Beaux-Arts* (Paris) 32 (July 1, 1885), pp. 90–96.

Pichois 1968. Claude Pichois. "Baudelaire jeune collectionneur." In *Humanisme actif: Mélanges d'art et de littérature offerts à Julien Cain,* vol. 1, pp. 207–11. Paris, 1968.

Pichois 1973. Claude Pichois, ed. *Lettres à Charles Baudelaire.* Neuchâtel, 1973.

Pichois 1976. Claude Pichois. *Baudelaire: Études et témoignages.* New ed., rev. and augm. Neuchâtel, 1976.

Pichois and Ziegler 1987. Claude Pichois and Jean Ziegler. *Baudelaire.* Paris, 1987.

Pigler 1967. Andor Pigler. *Museum der Bildenden Künste, Szépművészeti Múzeum, Budapest. Katalog der Galerie Alter Meister.* 2 vols. Translation of *A Régi Képtár katalógusa.* Budapest, 1967.

Piles 1715. Roger de Piles. *Abrégé de la vie des peintres* (1699). 2d ed. Paris, 1715.

Pinakothek 1982. *Neue Pinakothek: Erläuterungen zu den ausgestellten Werken.* 4th ed. Munich, 1982.

Pinette and Soulier-François 1992. Matthieu Pinette and François Soulier-François. *De Bellini à Bonnard: Chefs-d'oeuvre de la peinture du Musée des Beaux-Arts et d'Archéologie de Besançon.* Paris, 1992.

Pisano 1979. Ronald G. Pisano. *William Merritt Chase.* New York, 1979.

Pita Andrade 1952. José Manuel Pita Andrade. "Los cuadros de Velázquez y Mazo que poseyó el Marqués del Carpio." *Archivo Español de Arte* (Madrid) 25 (1952), pp. 223–36.

Pittsburgh 1896–97. *Catalogue of the First Annual Exhibition.* Exh. cat. Pittsburgh, Carnegie Institute, November 5, 1896–January 1, 1897. Pittsburgh, 1896.

Pittsburgh 1897–98. *Catalogue of the Second Annual Exhibition.* Exh. cat. Pittsburgh, Carnegie Institute, November 4, 1897–January 1, 1898. Pittsburgh, 1897.

Pittsburgh 1900–1901. *Catalogue of the Fifth Annual Exhibition.* Exh. cat. Pittsburgh, Carnegie Institute, November 1, 1900–January 1, 1901. Pittsburgh, 1900.

Pittsburgh 1902–3. *Catalogue of a Loan Exhibition of Paintings.* Exh. cat. Pittsburgh, Carnegie Institute, November 6, 1902–January 1, 1903. Pittsburgh, 1902.

Pittsburgh 1945. *Thomas Eakins Centennial Exhibition, 1844–1944.* Exh. cat. Pittsburgh, Carnegie Institute, April 26–June 1, 1945. Pittsburgh, 1945.

Pittsburgh et al. 1957. *American Classics of the Nineteenth Century.* Exh. cat. Pittsburgh, Carnegie Institute; Utica, N.Y., Munson-Williams-Proctor Institute; Richmond, Virginia Museum of Fine Arts; Baltimore Museum of Art; Manchester, N.H., Currier Gallery of Art, 1957. Pittsburgh, 1957.

Planche 1855. Gustave Planche. *Études sur l'École française (1831–1852): Peinture et sculpture.* Paris, 1855.

Plazaola 1989. Juan Plazaola. *Le baron Taylor, portrait d'un homme d'avenir.* Paris, 1989.

Pollock 1988. Griselda Pollock. *Vision and Difference: Femininity, Feminism, and Histories of Art.* London, 1988.

Pollock 1998. Griselda Pollock. *Mary Cassatt: Painter of Modern Women.* London, 1998.

Ponz 1776–94. Antonio Ponz. *Viage de España, en que se da noticia de las cosas mas apreciables, y dignas de saberse, que hay en ella.* 18 vols. Madrid, 1776–94. New ed. *Viaje de España.* Edited by Casto María del Rivero. Madrid, 1947; reprint, Madrid, 1988.

Popovitch 1967. Olga Popovitch. *Catalogue des peintures du Musée des Beaux-Arts de Rouen.* Paris, 1967.

Portús Pérez 1994a. Javier Portús Pérez. *Museo del Prado: Memoria escrita, 1819–1994.* Madrid, 1994.

Portús Pérez 1994b. Javier Portús Pérez, ed. *El retrato en el Museo del Prado.* Madrid, 1994.

Portús Pérez 1998. Javier Portús Pérez. *La sala reservada del Museo del Prado y el coleccionismo de pintura de desnudo en la Corte Española, 1554–1838.* Madrid, 1998.

Portús Pérez 2000. Javier Portús Pérez. *Entre dos centenarios: Bibliografía crítica y antología de Velázquez, 1962–1999.* Seville, 2000.

Portús Pérez 2001. Javier Portús Pérez. *Pintura barroca española: Guía Museo del Prado.* Madrid, 2001.

Posse 1929. Hans Posse, ed. *Die Staatliche Gemäldegalerie zu Dresden,* vol. 1, *Die romanischen Länder.* Berlin, 1929.

Pourtalès-Gorgier 1865. *Catalogue des tableaux anciens et modernes, dessins qui composent les collections de feu M. le comte de Pourtalès-Gorgier et dont la vente aura lieu.* Sale cat. Paris, March 27–April 4, 1865. Paris, 1864.

Prado 1990–91. *Museo del Prado: Inventario general de pinturas.* 2 vols. Madrid, 1990–91.

Prado 1996. *Museo del Prado: Catálogo de pinturas.* Rev. ed. Madrid, 1996.

Prat 1988. Louis-Antoine Prat. *Dessins de Théodore Chassériau, 1819–1856.* 2 vols. Paris, 1988.

Princeton 1976–77. *Murillo and His Drawings.* Exh. cat. by Jonathan Brown. Princeton University Art Museum, December 12, 1976–January 30, 1977. Princeton, N.J., 1976.

Princeton–Cambridge 1973–74. *Jusepe de Ribera: Print and Drawings.* Exh. cat. by Jonathan Brown. Princeton University Art Museum, October–November 1973; Cambridge, Mass., Fogg Art Museum, Harvard University, December 1973–January 1974. Princeton, N.J., 1973.

Princeton–Detroit 1982. *Painting in Spain, 1650–1700, from North American Collections.* Exh. cat. by Edward J. Sullivan and Nina Ayala Mallory. Princeton University Art Museum, April 18–June 20, 1982; Detroit Institute of Arts, July 18–September 19, 1982. Princeton, N.J., 1982.

Proske 1963. Beatrice G. Proske. *Archer Milton Huntington.* New York, 1963.

Proust 1897. Antonin Proust. "Édouard Manet. Souvenirs." *Revue Blanche* (Paris) (February–May 1897), pp. 125–35, 168–80, 201–7, 306–15, 413–24.

Proust 1901. Antonin Proust. "L'art d'Édouard Manet." *Le Studio* 21, no. 94 (January 15, 1901), suppl., no. 28, pp. 71–77. Reprinted in Proust 1988/1996, pp. 85–102.

Proust 1913. Antonin Proust. *Édouard Manet: Souvenirs.* Paris, 1913.

Proust 1988/1996. Antonin Proust. *Édouard Manet: Souvenirs* (1897). Caen, 1988. Reprint, Paris, 1996.

Providence 1981. *Edouard Manet and the Execution of Maximilian.* Exh. cat. Essays by Paula Jones et al. Providence, R.I., Bell Gallery, Brown University, February 21–March 22, 1981. Providence, 1981.

Purser 1899. S. H. Purser. "French and English Pictures in Dublin." *Art Journal* (London) (May 1899), pp. 155–56.

Quatremère de Quincy 1837. Quatremère de Quincy. *Essai sur l'idéal dans ses applications pratiques aux oeuvres de l'imitation propre des arts du dessin.* Paris, 1837.

Quilliet 1809. Frédéric Quilliet. *Bonaparte demasqué.* Madrid, 1809.

Quilliet 1815–16. Frédéric Quilliet. "Les Beaux-Arts in Espagne." *Mercure de France* 65 (1815), pp. 104–13, 209–16, 370–73, 412–19, 503–4, 610–13; 66 (1815), pp. 82–89, 234–36; 67 (1816), pp. 184–85, 457–59; 68 (1816), pp. 30–34, 131–33, 224–27, 272–75, 368–72.

Quilliet 1816. Frédéric Quilliet. *Dictionnaire des peintres espagnols.* Paris, 1816.

Quilliet 1818. *Notice d'une collection de tableaux, estampes, sculptures en marbre, bronze, albâtre, etc; meubles de luxe et autres objets de curiosité, composant le fonds de commerce de M. Quilliet.* Sale cat. Paris, April 15–17, 1818. Paris, 1818.

Quilliet 1825a. Frédéric Quilliet. *Le arti italiane in Ispagna, ossia Storia di quanto gli artisti italiani contribuirono ad abbellire le Castiglie.* Rome, 1825.

Quilliet 1825b. Frédéric Quilliet. *Les arts italiens en Espagne, ou Histoire des artistes italiens qui contribuèrent à embellir les Castilles.* Rome, 1825.

Quilliet 1837–38. Frédéric Quilliet. *Guide méthodique de Rome et de ses environs.* Rome, 1837–38.

Quinet 1846. Edgar Quinet. *Mes vacances en Espagne.* Paris, 1846.

Quynn 1945. Dorothy MacKay Quynn. "The Art Confiscation of the Napoleonic Wars." *American Historical Review* (Washington, D.C.) 50 (April 1945), pp. 437–60.

R.S.N. 1867. R.S.N. [Ramón Sanjuanena y Nadal]. "Galería Salamanca." *El Arte en España* (Madrid) 6 (1867), pp. 161–66.

Raffaëlli 1913. Jean-François Raffaëlli. *Mes promenades au Musée du Louvre.* 2d ed. Paris, 1913.

Ramirez 1890. James Ramirez. *Carmencita: The Pearl of Seville.* New York, 1890.

Randall 1995. Angela Randall. "Théodore Chassériau." *Christie's International Magazine* (London) 12 (June–July 1995), pp. 48–49.

Randon 1867. G. Randon. "L'Exposition d'Édouard Manet." *Le Journal Amusant* (Brussels) (June 29, 1867), pp. 6–8.

Raphaël 1837. J. Raphaël. "Le Musée espagnol." *La France Littéraire* (Paris) (September–December 1837), pp. 336–45.

Réau 1912. Louis Réau. *Les musées de Saint-Pétersbourg.* Paris, 1912.

Réau 1955–59. Louis Réau. *Iconographie de l'art chrétien.* 3 vols. Paris, 1955–59.

Reff 1962. Theodore Reff. "The Symbolism of Manet's Frontispiece Etchings." *The Burlington Magazine* (London) 104 (June 1962), pp. 182–87.

Reff 1963. Theodore Reff. "Degas's Copies of Older Art." *The Burlington Magazine* (London) 105 (June 1963), pp. 241–51.

Reff 1964a. Theodore Reff. "Copyists in the Louvre, 1850–1870." *Art Bulletin* (New York) 46 (December 1964), pp. 552–59.

Reff 1964b. Theodore Reff. "New Light on Degas's Copies." *The Burlington Magazine* (London) 106 (June 1964), pp. 250–59.

Reff 1968. Theodore Reff. "The Pictures within Degas's Pictures." *Metropolitan Museum Journal* (New York) 1 (1968), pp. 125–66.

Reff 1969. Theodore Reff. "Manet's Sources: A Critical Evaluation." *Artforum* (New York) 8 (September 1969), pp. 40–48.

Reff 1970a. Theodore Reff. "Degas and the Literature of His Time." *The Burlington Magazine* (London) 112 (September 1970), pp. 575–89.

Reff 1970b. Theodore Reff. "Manet and Blanc's 'Histoire des Peintres.'" *The Burlington Magazine* (London) 112 (July 1970), pp. 456–58.

Reff 1975. Theodore Reff. "Manet's Portrait of Zola." *The Burlington Magazine* (London) 117 (January 1975), pp. 35–44.

Reff 1976a. Theodore Reff. *Degas: The Artist's Mind.* Oxford, 1976.

Reff 1976b. Theodore Reff. *The Notebooks of Edgar Degas.* 2 vols. New York, 1976.

Regnault 1872. Henri Regnault. *Correspondance de Henri Regnault . . . suivie du catalogue complet de l'oeuvre.* Edited by Arthur Duparc. Paris, 1872.

Rehfues 1811. Philipp Joseph von Rehfues. *L'Espagne en 1808.* 2 vols. Paris, 1811.

Reims 1874. *Ouvrages de peinture, sculpture . . . et photographie exposés . . . par la Société des Amis des Arts de Reims.* Exh. cat. Reims, Société des Amis des Arts, Le Cirque, Boulevard des Promenades, February 7–March 23, 1874. Reims, 1874.

Reiset 1863. Frédéric Reiset. *Notice des tableaux du Musée Napoléon III exposés dans les salles de la Colonnade au Louvre.* Paris, 1863.

Reiset 1871. Frédéric Reiset. *Notice des tableaux legués au Musée National du Louvre par M. Louis La Caze.* Paris, 1871.

Réveil 1828–34. Achille Réveil. *Musée de peinture et de sculpture, ou Recueil des principaux tableaux, statues et bas-reliefs des collections publiques et particulières de l'Europe; dessiné et gravé à l'eau-forte par Réveil, avec des notices descriptives, critiques et historiques par Duchesne aîné.* 16 vols. Paris, 1828–34.

Reynolds 1986. Gary A. Reynolds. "Sargent and the Grand Manner Portrait." *The Magazine Antiques* 130, no. 5 (November 1986), pp. 980–93.

Riat 1906. Georges Riat. *Gustave Courbet, peintre.* Paris, 1906.

Ribot 1896. *Vente aux enchères de tableaux, études, aquarelles, dessins par Théodule Ribot.* Sale cat. Paris, Hôtel Drouot, May 30, 1896. Paris, 1896.

Ricci 1913. Seymour de Ricci. *Description raisonnée des peintures du Louvre.* Paris, 1913.

Rio de Janeiro 2000. *Esplendores de Espanha: De El Greco a Velázquez.* Exh. cat. Rio de Janeiro, Museu Nacional de Belas Artes, July 11–September 24, 2000. Madrid, 2000.

Riordan 1886. Roger Riordan. "The Impressionist Exhibition." *The Art Amateur* (New York) 15 (June 1886).

Rivas Ramírez 1999. Rosa Rivas Ramírez. "Una real posesión poco conocida: Vista Alegre." *Reales Sitios* (Madrid) 36 (1999), pp. 48–59.

Robaut 1885. Alfred Robaut. *L'oeuvre complet de Eugène Delacroix.* Paris, 1885.

Robaut 1905. Alfred Robaut. *L'oeuvre de Corot.* 5 vols. in 4. Paris, 1905.

K. Roberts 1982. Keith Roberts. *Degas.* Rev. ed. Oxford, 1982.

R. Roberts 1860. Richard Roberts. *An Autumn Tour in Spain in the Year 1859.* London, 1860.

Rochefort 1862. Henri Rochefort. "Petits mystères de l'Hôtel des ventes." *Le Charivari* (Paris) (March 20, 1862).

Roger-Marx 1950. Claude Roger-Marx. *Eva Gonzalès.* Saint-Germain-en-Laye, 1950.

Rolland 1952. Romain Rolland. *Le cloître de la rue d'Ulm: Journal de Romain Rolland à l'École Normale, 1886–1889.* Paris, 1952.

Roman d'Amat 1987. Ariane Roman d'Amat. "La représentation des peintres anciens par les peintres aux Salons parisiens de 1780 à 1880." Typescript, Paris, École du Louvre, 1987.

Rome 1969–70. *Gustave Courbet.* Exh. cat. Rome, Accademia di Francia, Villa Medici, October 28, 1969–January 6, 1970. Rome, 1969.

Rome 1980. *Constantin Guys, il pittore della vita moderna.* Exh. cat. Rome, Palazzo Braschi, September 10–October 5, 1980. Milan, 1980.

Rome 1984–85. *Degas e l'Italia.* Exh. cat. Rome, Villa Medici, December 1, 1984–February 10, 1985. Rome, 1984.

Rome 1991–92. *La pittura madrilena del secolo XVII.* Exh. cat. Rome, Palazzo delle Esposizioni, December 11, 1991–January 31, 1992. Rome, 1991.

Rome 2001. *Velázquez.* Exh. cat. Edited by Felipe V. Garín Llombart and Salvador Salort Pons. Rome, Fondazione Memmo, March 30–June 30, 2001. Milan, 2001.

Roof 1917. Katharine Metcalf Roof. *The Life and Art of William Merritt Chase.* New York, 1917. Reprint, New York, 1975.

Rose 1981. Isadora Rose. "Un proyecto dieciochesco malogrado: El plan de reproducir en grabados los cuadros principales existentes en las colecciones reales españolas." *Academia: Boletín de la Real Academia de Bellas Artes de San Fernando* (Madrid) 53 (1981), pp. 171–81.

Rose-De Viejo 1997. Isadora Rose-De Viejo. "Goya's Still Lifes." *The Burlington Magazine* (London) 139 (June 1997), p. 406.

Rose-De Viejo et al. 2001. Isadora Rose-De Viejo, Emilio La Parra López, and Enrique Giménez López. *La imagen de Manuel Godoy.* Mérida, 2001.

Rose Wagner 1983. Isadora Joan Rose Wagner. "Manuel Godoy. Patrón de las artes y coleccionista." 2 vols. Ph.D. diss., Universidad Complutense de Madrid, 1983.

Rosenthal 1914. Léon Rosenthal. *Du romantisme au réalisme: Essai sur l'évolution de la peinture en France de 1830 à 1848.* Paris, 1914.

Rosny 1889. Léon de Rosny. *Taureaux et mantilles: Souvenirs d'un voyage en Espagne et en Portugal.* 2 vols. Paris, 1889.

Rosny and Lesouëf 1882. Léon de Rosny and A. Lesouëf. *Souvenirs du voyage en Espagne et en Portugal.* 2 vols. Paris, 1882.

Rossi Bortolatto 1984. Luigina Rossi Bortolatto. *Tout l'oeuvre peint de Delacroix.* New ed. Paris, 1984.

Rostrup 1967. Haavard Rostrup. "Studier i Fransk Portraetmaleri, Courbet og Manet." *Meddelelser fra Ny Carlsberg Glyptotek* (Copenhagen) 24 (1967), p. 35.

Rostrup 1981. Haavard Rostrup. *Histoire du Musée d'Ordrupgaard, 1918–1978, d'après des documents inédits.* Copenhagen, 1981.

Rostrup 1982. Haavard Rostrup. "Wilhelm Hansen et sa collection de tableaux impressionnistes du musée d'Ordrupgaard." *Gazette des Beaux-Arts* (Paris) 99 (March 1982), 101–8.

Rouart and Wildenstein 1975. Denis Rouart and Daniel Wildenstein. *Édouard Manet: Catalogue raisonné.* 2 vols. Lausanne, 1975.

Rouchès 1930a. Gabriel Rouchès. "L'école espagnole." In *Histoire des collections de peintures au Musée du Louvre,* pp. 67–77. Paris, 1930.

Rouchès 1930b. Gabriel Rouchès. "Les premières publications françaises sur la peinture espagnole." *Bulletin de la Société de l'Histoire de l'Art Français* (Paris) (1930), pp. 35–48.

Rouen 1858. *Catalogue des tableaux, statues et objets d'art exposés au Musée de Rouen, augmenté de notices sur*

la vie et les ouvrages des principaux maîtres de chaque école, ainsi que sur les personnages célèbres dont les portraits figurent dans la collection. Rouen, 1858.

Rouen 1998. *Delacroix: La naissance d'un nouveau romantisme.* Exh. cat. Rouen, Musée des Beaux-Arts, April 4–July 15, 1998. Paris, 1998.

Rudd 1994. Peter Rudd. "Reconstructing Manet's 'Velázquez in His Studio.'" *The Burlington Magazine* (London) 136 (November 1994), pp. 747–51.

Ruis 1894. Jules Ruis. [Goya entry]. *Revue Encyclopédique* (Paris) (October 1, 1894).

Ruskin 1851–53. John Ruskin. *The Stones of Venice.* 3 vols. London, 1851–53.

Rutter 1930. Frank Rutter. *El Greco (1541–1614).* New York, 1930.

S.-C. 1836. S.-C. [Alexandre de Saint-Chéron?]. "Galerie de tableaux du Maréchal Soult. Murillo." *L'Artiste* (Paris) 11 (1836), pp. 38–42.

Sainsaulieu and Mons 1990. Marie-Caroline Sainsaulieu and Jacques de Mons. *Eva Gonzalès, 1849–1883: Étude critique et catalogue raisonné.* Paris, 1990.

Saint-Cloud 1991–92. *Henri Regnault (1843–1871).* Exh. cat. Saint-Cloud, Musée Municipal, October 16, 1991–January 5, 1992. Saint-Cloud, 1991.

St. Louis 1891. *Catalogue of the Art Collection . . . Annual Exhibition.* Exh. cat. St. Louis Exposition and Music Hall Association, 1891. St. Louis, 1891.

St. Louis 1892. *Catalogue of the Art Collection . . . Annual Exhibition.* Exh. cat. St. Louis Exposition and Music Hall Association, 1892. St. Louis, 1892.

St. Louis 1904. *Official Catalogue of Exhibitors: Universal Exposition, St. Louis, U.S.A., 1904.* Exh. cat. Rev. ed. St. Louis, Louisiana Purchase Exhibition, 1904. St. Louis, 1904.

Saint-Santin 1867. M. de Saint-Santin [Philippe de Chennevières]. "M. Heim (François Joseph Heim)." *Gazette des Beaux-Arts* (Paris) (January 1867), pp. 40–62.

Saint-Victor 1863. Paul de Saint-Victor. "Salon de 1863." *La Presse* (Paris) (April 27, 1863).

Saint-Victor 1882. *Catalogue des tableaux . . . objets d'art et de curiosité . . . composant la collection de M. Paul de Saint-Victor.* Sale cat. Paris, Hôtel Drouot, January 23–24, 1882. Paris, 1882.

Salamanca 1867. *Catalogue des tableaux anciens des écoles Espagnole, Italienne, Flamande & Hollandaise composant la galerie de M. le M[arqu]is de Salamanca vente en son Hôtel, à Paris, rue de la Victoire, 50.* Sale cat. Paris, June 3–6, 1867. Paris, 1867.

Salamanca 1875. *Collection Salamanca: Tableaux anciens des Écoles Espagnole, Italienne, Flamande et Hollandaise.* Sale cat. Paris, Hôtel Drouot, January 25–26, 1875. Paris, 1875.

Salas 1931. Xavier de Salas. "Lista de cuadros de Goya hecha por Carderera." *Archivo Español de Arte* (Madrid) 21 (1931), pp. 174–78.

Salas 1964a. Xavier de Salas. "A Group of Bullfighting Scenes by Goya." *The Burlington Magazine* (London) 106 (January 1964), pp. 36–38.

Salas 1964b. Xavier de Salas. "Sur les tableaux de Goya qui appartinrent à son fils." *Gazette des Beaux-Arts* (Paris) (February 1964), pp. 99–110.

Salas 1968–69. Xavier de Salas. "Ingres y las morenas." *Arte Español* (Madrid) 26 (1968–69), pp. 25–26.

Salas 1977. Xavier de Salas. *Rubens y Velázquez.* Madrid, 1977.

Salles 1866. Jules Salles. *L'Andalousie, l'art arabe et le peintre Murillo, fragment d'un voyage en Espagne.* Paris, 1866.

Salon 1865. *L'Autographe au Salon de 1865 et dans les ateliers: 104 pages de croquis originaux . . . 430 dessins par 352 artistes.* Paris, 1865.

Saltillo 1926. Miguel Lasso de la Vega, marqués de Saltillo. "El Gobierno intruso y la riqueza artística de Sevilla." *Boletín de la Real Academia Sevillana de Buenas Letras,* no. 53 (1926), pp. 41–48.

Saltillo 1933. Miguel Lasso de la Vega, marqués de Saltillo. *Mr. Frédéric Quilliet, comisario de bellas artes del gobierno intruso (1809–1814).* Madrid, 1933.

Sambricio 1946. Valentín de Sambricio. *Tapices de Goya.* Madrid, 1946.

San Francisco 1915. *Catalogue De Luxe of the Department of Fine Arts.* Exh. cat. Edited by John E. D. Trask and J. Nilsen Laurvik. San Francisco, Panama-Pacific International Exposition, February 20–December 4, 1915. San Francisco, 1915.

San Francisco 1959. *Sargent and Boldini.* Exh. cat. San Francisco, California Palace of the Legion of Honor, October 24–November 29, 1959. San Francisco, 1959.

Sanchez and Seydoux 1998. Pierre Sanchez and Xavier Seydoux. *Les estampes de L'Artiste, 1831–1904.* 2 vols. Paris, 1998.

Sánchez Cantón 1930. Francisco J. Sánchez Cantón. *Goya.* Paris, 1930.

Sánchez Cantón 1937a. Francisco J. Sánchez Cantón. "La venta de los cuadros en 1801: 'La Concepción de Aranjuez' y 'El Descendimiento' de Montpellier." *Archivo Español de Arte* (Madrid) (January 1937), pp. 165–67.

Sánchez Cantón 1937b. Francisco J. Sánchez Cantón. "Mas sobre Luciano Bonaparte coleccionista." *Archivo Español de Arte y Arqueología* (Madrid) (February 1937), pp. 261–62.

Sánchez Cantón 1940. Francisco J. Sánchez Cantón. "La Inmaculada Soult en Madrid." *Semana* (Madrid) 24 (1940).

Sánchez Cantón 1942. Francisco J. Sánchez Cantón. *Museo del Prado: Catálogo de los cuadros.* Madrid, 1942.

Sánchez Cantón 1946. Francisco J. Sánchez Cantón. "Cómo vivía Goya." *Archivo Español de Arte* (Madrid) 19 (1946), pp. 73–109.

Sánchez Cantón 1951. Francisco J. Sánchez Cantón. *Vida y obras de Goya.* Madrid, 1951.

Sancho 2001. José Luis Sancho. "Cuando Palacio era el Museo Real: La colección real de pintura en el Palacio Real de Madrid organizada por Mengs, y la *Description des tableaux du palais de S.M.C.* por Fréderic Quilliet (1808)." *Arbor* (Madrid) 169 (May 2001), pp. 83–141.

Sancho-Corbacho 1949. Antonio Sancho-Corbacho. "El monasterio de San Jerónimo de Buenavista." *Archivo Hispalense* (Seville) 10 (1949), pp. 9–33, 125–69.

Sand 1926. George Sand. *Journal intime.* Published by Aurore Sand. 2d ed. Paris, 1926.

Sandoz 1967–68. Marc Sandoz. "El pintor Théodore Chassériau (1819–1856) y el Mundo Ibérico." *Goya* (Madrid), nos. 79–84 (1967–68), pp. 76–83.

Sandoz 1974. Marc Sandoz 1974. *Théodore Chassériau, 1819–1856: Catalogue raisonné des peintures et estampes.* Paris, 1974.

Sandoz 1982. Marc Sandoz. "Théodore Chassériau et la peinture espagnole." *Cahiers Théodore Chassériau* (Paris), no. 1 (1982), pp. 17–32.

Sanjuanena y Nadal 1866. Ramón Sanjuanena y Nadal. "Otro Velázquez apócrifo." *El Arte en España* (Madrid) 5 (1866), pp. 49–53.

Santos 1667. Francisco de los Santos. *Descripción breve del monasterio de S. Lorenzo el Real del Escorial.* Madrid, 1667.

Santos 1681. Francisco de los Santos. *Descripción breve del monasterio de S. Lorenzo el Real del Escorial.* Madrid, 1681.

Santos 1698. Francisco de los Santos. *Descripción breve del monasterio de San Lorenzo el Real del Escorial.* 2d ed. Madrid, 1698.

Saragossa 1996. *Goya y el infante don Luis de Borbón: Homenaje de la "Infanta doña María Teresa de Vallabriga."* Exh. cat. Saragossa, Palacio de Zaporta, Patio de La Infanta, October 14–December 30, 1996. Saragossa, 1996.

Sargent 1880. John Singer Sargent. "Nos gravures: Portrait de M. Carolus Duran par M. Sargent." *L'Illustration* (Paris) 74 (January 17, 1880), p. 42.

Sargent 1925. *Catalogue of Pictures and Water Colour Drawings . . . the Property of John Singer Sargent.* Sale cat. London, Christie, Manson and Woods, July 24, 27, 1925. London, 1925.

Sargent Papers. John Singer Sargent Papers. Special Collections, Miller Library, Colby College, Waterville, Maine.

Saunier 1902. Charles Saunier. *Les conquêtes artistiques de la Révolution et de l'Empire, reprises et abandons des alliés en 1815, leurs conséquences sur les musées d'Europe.* Paris, 1902.

Savignac 1838. Alida de Savignac. "Beaux-Arts. Musée Espagnol." *Journal des Demoiselles* (Paris) 6 (January 1838), pp. 59–61.

Sayre 1966. Eleanor A. Sayre. "Goya's Bordeaux Miniatures." *Boston Museum Bulletin* 64, no. 337 (1966), pp. 84–123.

Sayre 1971. Eleanor A. Sayre. *Late Caprichos of Goya: Fragments from a Series.* New York, 1971.

Schiff 1988. Gert Schiff, ed. *German Essays on Art History.* New York, 1988.

Schopp 1993. Claude Schopp, ed. *Frères d'armes de la révolution romantique: Lettres d'Alexandre Dumas au baron Taylor et à Adrien Dauzats.* Paris, 1993.

Scott 1873. William Bell Scott. *Murillo and the Spanish School of Painting: Fifteen Engravings on Steel and Nineteen on Wood, with an Account of the School and Its Great Masters.* London, 1873.

Séailles 1885. Gabriel Séailles. *Alfred Dehodencq, histoire d'un coloriste.* Paris, 1885.

Séailles 1910. Gabriel Séailles. *Alfred Dehodencq, l'homme et l'artiste.* Paris, 1910.

Seattle 2000–2001. *John Singer Sargent: The Sensualist.* Exh. cat. by Trevor J. Fairbrother. Seattle Art Museum, December 14, 2000–March 18, 2001. Seattle and New Haven, 2000.

Seattle–New York 1983–84. *A Leading Spirit in American Art: William Merritt Chase, 1849–1916.*

Exh. cat. by Ronald G. Pisano. Seattle, Henry Art Gallery and the University of Washington, autumn 1983; New York, Metropolitan Museum of Art, spring 1984. Seattle, 1983.

Seattle–Washington–St. Louis 1970–71. *Great American Paintings from the Boston and Metropolitan Museums.* Exh. cat. by Thomas N. Maytham. Seattle Art Museum; Washington, D.C., National Gallery of Art; St. Louis, City Art Museum, 1970–71. New York, 1971.

Sébastiani 1851. *Catalogue du riche mobilier . . . de tableaux anciens . . . d'une belle argenterie . . . et de vins fins d'Espagne . . . succession de M. le maréchal Sébastiani.* Sale cat. Paris, November 24–28, 1851. Paris, 1851.

Ségoïllot 1866. Hadrian Ségoïllot. "Goya au musée du Louvre." *L'Artiste* (Paris) (July 15, 1866), pp. 221–24.

Seignac 1898. Ph. de Seignac. "Histoire anecdotique du musée de Cherbourg." *La Croix* (La Manche) (July 7, 1898), n.p.

Seitz 1913. Don C. Seitz, comp. *Whistler Stories.* New York, 1913.

Sensier 1881. Alfred Sensier. *La vie et l'oeuvre de J.-F. Millet.* Paris, 1881.

Serrera 1999. Juan Miguel Serrera. "Varia Murillesca, expolios y restauraciones." *Archivo Hispalense* (Seville), no. 251 (1999), pp. 143–51.

Sertat 1892. Raoul Sertat. "Littérature et beaux-arts: Théodule Ribot." *Revue Encyclopédique* (Paris) (August 1, 1892).

Sérullaz 1961. Maurice Sérullaz. "Velázquez, précurseur de l'Impressionnisme." *Jardin des Arts* (Paris), no. 75 (February 1961), pp. 36–40.

Sérullaz 1963. Maurice Sérullaz. *Mémorial de l'exposition Eugène Delacroix.* Paris, 1963.

Sérullaz 1984. Maurice Sérullaz. *Dessins d'Eugène Delacroix, 1798–1863.* 2 vols. Paris, 1984.

Seville 1991–92. *La pintura sevillana de los Siglos de Oro.* Exh. cat. by Enrique Valdivieso and José Fernández López. Seville, Hospital de los Venerables, 1991–92. Madrid, 1991.

Seville 1998. *Francisco de Zurbarán: Guía de la exposición conmemorativa del IV centenario de su nacimiento 1598–1998.* Exh. cat. Seville, Museo de Bellas Artes, October 9–December 9, 1998. Seville, 1998.

Seville 1999. *Velázquez y Sevilla.* Exh. cat. Edited by Alfredo J. Morales. Seville, Monasterio de la Cartuja de Santa Ma Cuevas, Salas del Centro Andaluz de Arte Contemporáneo, October 1–December 12, 1999. Seville, 1999.

Seville–Madrid 1991. *Valdés Leal.* Exh. cat. by Enrique Valdivieso. Seville, Museo de Bellas Artes, and Madrid, Museo del Prado, 1991. Madrid, 1991.

Seville–Madrid 1996–97. *Pintura española recuperada por el coleccionismo privado.* Exh. cat. by Alfonso E. Pérez Sánchez and Benito Navarrete Prieto. Seville, Hospital de los Venerables, December 1996–February 1997; Madrid, Real Academia de Bellas Artes de San Fernando, February–April 1997. Seville, 1996.

Seymour 1906. Frederick H. A. Seymour. *Saunterings in Spain: Barcelona, Madrid, Toledo, Cordova, Seville, Granada.* London, 1906.

Sharp 1884. William Sharp. "The Paris Salon." *Art Journal* (London) (1884), pp. 179–80.

Sherwood 1928. Herbert F. Sherwood, ed. *H. Siddons Mowbray: Mural Painter, 1858–1928.* Stamford, Conn., 1928.

Shizuoka et al. 1994. *The Human Figure in the West, 1850–1950.* Exh. cat. Shizuoka Prefectural Museum of Art, April 23–May 29, 1994, and other venues in Japan. Shizuoka, 1994.

Sidlauskas 2001. Susan Sidlauskas. "Painting Skin: John Singer Sargent's *Madame X.*" *American Art* (New York) 15, no. 3 (Fall 2001), pp. 8–33.

Siegl 1978. Theodor Siegl. *The Thomas Eakins Collection [in the Philadelphia Museum of Art].* Handbooks in American Art, no. 1. Philadelphia, 1978.

A. Silvestre 1879–80. Armand Silvestre. "Les tambourins de la 'Vie moderne.'" *La Vie Moderne* (Paris) (December 20, 1879; January 3, 1880).

A. Silvestre 1882. Armand Silvestre. "Le monde des arts: Le Salon de 1882." *La Vie Moderne* (Paris) 22 (June 3, 1882).

T. Silvestre 1856. Théophile Silvestre. *Histoire des artistes vivants français et étrangers: Études d'après nature.* Paris, 1856.

T. Silvestre 1867. Théophile Silvestre. "Vente des galeries Pommersfelden et Salamanca." *Le Figaro* (Paris) (May 26, 1867), p. 3.

Simmons 1922. Edward Simmons. *From Seven to Seventy: Memories of a Painter and a Yankee.* New York, 1922.

Simpson 1998. Marc Simpson. "Sargent, Velázquez, and the Critics: 'Velasquez Come to Life Again.'" *Apollo* (London) 148 (September 1998), pp. 3–12.

Smith 1887. F. Hopkinson Smith. *Well-Worn Roads in Spain, Holland, and Italy: Traveled by a Painter in Search of the Picturesque.* Boston, 1887.

Sobral 1976. Luís de Moura Sobral. "Juan de Valdés Leal." Ph.D. diss., University of Louvain, 1976.

Sofia 1989. *La pintura española en su Siglo de Oro.* Exh. cat. Sofia, Fundación Internacional Ludmila Yívkova, 1989. Sofia, 1989.

Solkin 1975. David H. Solkin. "Philibert Rouvière: Édouard Manet's l'acteur tragique." *The Burlington Magazine* (London) 117 (1975), pp. 702–9.

Solvay 1887. Lucien Solvay. *L'art espagnol, précédé d'une introduction sur l'Espagne et les espagnols.* Paris, 1887.

Somov 1859. Andrei Somov. *Kartiny Imperatorskago Ermitazha dlia posetitelei etoi gallerei* (Paintings in the Imperial Hermitage). St. Petersburg, 1859.

Somov 1869–71. Andrei Somov, ed. *Ermitage Impérial: Catalogue de la galerie des tableaux.* 2 vols. 2d ed. St. Petersburg, 1869–71.

Somov 1901–3. Andrei Somov, ed. *Ermitage Impérial: Catalogue de la galerie des tableaux.* 3 vols. St. Petersburg, 1901–3.

Soria 1944. Martin S. Soria. "Zurbarán, Right and Wrong." *Art in America* (New York) 32 (1944), pp. 127–40.

Soria 1948. Martin S. Soria. "Some Flemish Sources of Baroque Painting in Spain." *Art Bulletin* (New York) 30 (1948), pp. 249–59.

Soria 1953. Martin S. Soria. *The Paintings of Zurbarán.* London, 1953.

Soullié 1900. Louis Soullié. *Peintures, aquarelles, pastels, dessins de Jean-François Millet, relevés dans les catalogues de vente de 1849 à 1900.* Paris, 1900.

Soult 1852a. *Catalogue raisonné des tableaux de la galerie de feu M. le Maréchal-Général Soult, Duc de Dalmatie.* Sale cat. Paris, May 19, 21, 22, 1852. Paris, 1852.

Soult 1852b. *La vente aux enchères publiques de la magnifique galerie de tableaux de feu M. le Maréchal-Général Soult, Duc de Dalmatie.* Sale cat. Paris, initially scheduled May 24–26, held May 19–22, 1852. Paris, 1852.

Soult 1854. Nicolas-Jean de Dieu Soult. *Mémoires du maréchal-général Soult, duc de Dalmatie. Première partie: Histoire des guerres de la Révolution.* 3 vols. Paris, 1854.

Soult 1867. *Catalogue de tableaux provenant de la Galerie de . . . M. le Maréchal-Général Soult.* Sale cat. Paris, Hôtel Drouot, April 17, 1867. Paris, 1867.

Southampton 1957. *William Merritt Chase, 1849–1916: A Retrospective Exhibition.* Exh. cat. Southampton, N.Y., Parrish Art Museum, June 30–July 27, 1957. Southampton, N.Y., 1957.

Southampton–New York 1986. *In Support of Liberty: European Paintings at the 1883 Pedestal Fund Art Loan Exhibition.* Exh. cat. by Maureen C. O'Brien. Southampton, N.Y., Parrish Art Museum, June 29–September 1, 1886; New York, National Academy of Design, September 18–December 7, 1986. Southampton, N.Y., 1986.

Southampton–New York 1997. *The Tenth Street Studio Building: Artist-Entrepreneurs from the Hudson River School to the American Impressionists.* Exh. cat. by Annette Blaugrund. Southampton, N.Y., Parrish Art Museum, June 8–August 10, 1997; New York, National Academy of Design, August 21–November 16, 1997. Southampton, N.Y., 1997.

Spadafore 1984. Anita L. Spadafore. *The Voyage pittoresques: Baron Taylor's Letters to Adrien Dauzats.* Sherbrooke, Quebec, 1984.

Spassky et al. 1985. Natalie Spassky et al. *American Paintings in the Metropolitan Museum of Art,* vol. 2, *A Catalogue of Works by Artists Born between 1816 and 1845.* New York, 1985.

Spuller 1867. Eugène Spuller. "M. Édouard Manet et sa peinture." *Le Nain Jaune* (Paris) (June 9, 1867), p. 4.

Standish 1840. Frank Hall Standish. *Seville and Its Vicinity.* London, 1840.

Standish 1842. Frank Hall Standish. *Catalogue des tableaux, dessins et gravures de la collection Standish.* Paris, 1842.

Standish 1853. *Catalogue of the Pictures Forming the Celebrated Standish Collection, Bequeathed to His Majesty, the Late King Louis Philippe, by Frank Hall Standish, Esq.* Sale cat. London, Christie & Manson, May 28–30, 1853. London, 1853.

Starkweather 1926. W. E. B. Starkweather. "A Man and His Museum." *The Mentor* 14 (February 1926), pp. 29–38.

Steinberg 1965. Leo Steinberg. [Review of José López-Rey, *Velázquez.*] *Art Bulletin* (New York) 47 (1965), pp. 274–94.

Stendhal 1838. Stendhal [Henry Beyle]. *Mémoires d'un touriste.* 2 vols. Paris, 1838.

Sterling 1938. Charles Sterling. "Les peintures de Goya des collections de France: Exposition au Musée de l'Orangerie." *Bulletin des Musées de France* (Paris) 10 (January–February 1938), pp. 1–5.

Sterling and Adhémar 1958–61. Charles Sterling and Hélène Adhémar. *Musée du Louvre: Peintures: École française, XIXe siècle.* 4 vols. Paris, 1958–61.

Sterling and Salinger 1967. Charles Sterling and Margaretta M. Salinger. *French Paintings: A Catalogue of the Collection of the Metropolitan Museum of Art,* vol. 3, *XIX–XX Centuries.* New York, 1967.

Stevenson 1895. R. A. M. Stevenson. *The Art of Velasquez.* London, 1895.

Stevenson 1962. R. A. M. Stevenson. *Velázquez.* New ed. with contributions by Denys Sutton and Theodore Crombie. London, 1962.

Stirling-Maxwell 1848. William Stirling-Maxwell. *Annals of the Artists of Spain.* 4 vols. London, 1848. 2d ed., rev. and enl. 4 vols. London, 1891.

Stirling-Maxwell 1855. William Stirling-Maxwell. *Velázquez and His Works.* London, 1855. Published in French as "Velasquez," *Revue Britannique* (Paris) 27 (May 1855), pp. 127–51; 27 (June 1855), pp. 323–52; and "Histoire de la peinture en Espagne: Velasquez et ses oeuvres," *Revue Britannique* 29 (October 1855), pp. 463–79; 30 (November 1855), pp. 207–32; 30 (December 1855), pp. 395–436. Translated by Gustave Brunet as *Velasquez et ses oeuvres.* Paris, 1865. Bilingual ed., with contributions by Enriqueta Harris and Juan Carrete Parrondo, *La vida y la obra de Diego Velázquez.* Madrid, 1999.

Stirling-Maxwell 1873. William Stirling-Maxwell. *Essay Towards a Catalogue of Prints Engraved from the Works of Diego Rodriguez de Silva y Velázquez and Bartolomé Estéban Murillo.* London, 1873.

Stockholm 1922. *Édouard Manet, 1832–1883.* Exh. cat. Stockholm, Nationalmuseum, February 28–March 18, 1922. Föreningen Fransk Kunst, 4. Stockholm, 1922.

Stockholm 1959–60. *Stora spanska mästare.* Exh. cat. Edited by Carl Nordenfalk and Pontus Grate. Stockholm, Nationalmuseum, December 12, 1959–March 13, 1960. Stockholm, 1960.

Stockholm 1985. *Manet i närbild.* Exh. cat. by Ragnar von Holten. Stockholm, Nationalmuseum, 1985. Stockholm, 1985.

Stowe 1894. Edwin Stowe. *Velázquez.* London, 1894.

Strettell 1887. Alma Strettell, trans. *Spanish & Italian Folk-Songs.* Illustrations by John Singer Sargent and others. London, 1887.

Stromer 1879. Theodor Stromer, ed. *Murillo, Leben und Werke.* Translated from Francisco M. Tubino's *Murillo, su época, su vida, sus cuadros.* Berlin, 1879.

Strazdes 1992. Diana J. Strazdes. *American Paintings and Sculpture to 1945 in the Carnegie Museum of Art.* New York, 1992.

Stratton 1994. Suzanne L. Stratton. *The Immaculate Conception in Spanish Art.* Cambridge, 1994.

Stuckey 1983. Charles F. Stuckey. "Manet Revised: Whodunit?" *Art in America* (New York) 71 (November 1983), pp. 159–77.

Stuttgart 1906. *Manet-Monet-Ausstellung: Sammlung des Französischen Opernsängers Faure.* Exh. cat. Stuttgart, [Durand-Ruel], November 9–December 1906. Stuttgart, 1906.

Stuttgart 2002–3. *Édouard Manet und die Impressionisten.* Exh. cat. Edited by Ina Conzen. Stuttgart, Staatsgalerie, September 21, 2002–February 9, 2003. Ostfildern-Ruit, 2002.

Suida 1949. William E. Suida. *A Catalogue of Paintings in the John & Mable Ringling Museum of Art.* Sarasota, 1949.

Sullivan 1986. Edward J. Sullivan. *Baroque Painting in Madrid: The Contribution of Claudio Coello, with a Catalogue Raisonné of His Works.* Columbia, Mo., 1986.

Sutton 1964. Denys Sutton. *Nocturne: The Art of James McNeill Whistler.* Philadelphia, 1964.

Sutton 1986. Denys Sutton. *Edgar Degas: Life and Work.* New York, 1986.

Tabarant 1931. Adolphe Tabarant. *Manet: Histoire catalographique.* Paris, 1931.

Tabarant 1947. Adolphe Tabarant. *Manet et ses oeuvres.* Paris, 1947.

Taillasson 1807. Jean-Joseph Taillasson. *Observations sur quelques grands peintres.* Paris, 1807.

Taine 1990. Hippolyte Taine. *Voyage en Italie* (1866). 3 vols. Paris, 1990.

A. Tardieu 1885. Ambroise Tardieu. *Un mois en Espagne: Voyage artistique à Madrid, l'Escorial, Tolède, Cordoue, Grenade, Séville, Cadix, Barcelone, etc.* Herment [Puy-de-Dôme], 1885.

M. Tardieu 1997. Marc Tardieu. *Goya à Bordeaux.* Paris, 1997.

Taylor 1826–32. Isidore-Justin-Séverin Taylor. *Voyage pittoresque en Espagne, en Portugal et sur la côte d'Afrique, de Tanger à Tétouan.* 3 vols. Paris, 1826–32.

Taylor 1827. Isidore-Justin-Séverin Taylor. *A Picturesque Tour of Spain, Portugal, and along the Coast of Africa, from Tangiers to Tetuan.* London, 1827.

Taylor 1837. Isidore-Justin-Séverin Taylor. *The Spectator* (London) 10 (1837), pp. 763–64.

Taylor 1846. Isidore-Justin-Séverin Taylor. "Quelques détails sur Murillo et ses oeuvres." *Moniteur des Arts* (Paris) (September 27, 1846).

Taylor 1853. Isidore-Justin-Séverin Taylor. *L'Alhambra.* Drawings and lithographs by Asselineau. Paris, 1853.

Tenint 1841. Wilhelm Tenint. *Album du Salon de 1841.* Paris, 1841.

Terbecq 1877. *Catalogue de tableaux anciens . . . collection de M. le comte de *** [Terbecq].* Sale cat. Paris, Hôtel Drouot, May 25–26, 1877. Paris, 1877.

Térey 1923. Gabor Térey. "Die Murillo-Bilder der Sammlung Eugene Boross in Larchmond." *Der Cicerone* (Leipzig) 15 (1923), pp. 769–74.

Ternois 1959. Daniel Ternois. *Guide du Musée Ingres.* Montauban, 1959.

Ternois 1962. Daniel Ternois. "Les collections d'Ingres." *Art de France* (Paris) 2 (1962).

Ternois 1965. Daniel Ternois. *Musée Ingres. Peintures: Ingres et son temps.* Paris, 1965.

Ternois 1966. Daniel Ternois. "Note sur un portrait espagnol de la collections Ingres." *Bulletin du Musée Ingres* (Montauban), no. 19 (July 1966), pp. 13–14.

Ternois 1975. Daniel Ternois. "Les tableaux des églises et des couvents de Lyon." In *L'art baroque à Lyon: Actes du colloque / Institute d'Histoire de l'Art.* Lyon, 1975.

Terry 1907. Ellen Terry. "Recollections of Henry Irving." *McClure's Magazine* (New York) 30, no. 2 (December 1907), pp. 130–48.

Thacher 1937. John S. Thacher. "The Paintings of Francisco de Herrera, the Elder." *Art Bulletin* (New York) 19 (September 1937), pp. 325–80.

Thoré 1834. Théophile Thoré. "Murillo." *L'Artiste* (Paris) 8 (December 1834), pp. 165–66.

Thoré 1835a. Théophile Thoré. "Études sur la peinture espagnole: Galerie du Maréchal Soult." *Revue de Paris* 21 (1835), pp. 201–20; 22 (1835), pp. 44–64.

Thoré 1835b. Théophile Thoré. "Zurbaran. Le Caravage espagnol." *L'Artiste* (Paris) 9 (1835), pp. 225–26.

Thoré 1837. Théophile Thoré. "Artistes contemporains: Eugène Delacroix." *Le Siècle* (Paris) (February 24, 1837). Reprinted by M. Du Seigneur, "Eugène Delacroix and Théophile Thoré," *Journal des Arts* (Paris) (October 24, 1890).

Thoré 1838. Théophile Thoré. "Salon de 1838," *Revue de Paris* 52 (1838).

Thoré 1842. Théophile Thoré. "Musée Standish." *Cabinet de l'Amateur et de l'Antiquaire* (Paris) 1 (1842), pp. 209–14.

Thoré 1868. Théophile Thoré. *Salons de T. Thoré, 1844, 1845, 1846, 1847, 1848.* Paris, 1868.

Thoré 1870. Théophile Thoré. *Salons de W. Bürger, 1861 à 1868.* 2 vols. Paris, 1870.

Timbal 1881. Charles Timbal. *Notes et causeries sur l'art et sur les artistes.* Paris, 1881.

Tokyo 1980. *Velázquez y la pintura española de su tiempo.* Exh. cat. Tokyo National Museum, 1980. Tokyo, 1980.

Tokyo 1991. *Visages du Louvre: Chefs-d'oeuvre du portrait dans les collections du Louvre.* Exh. cat. Tokyo, Musée National d'Art Occidental, September 18–December 1, 1991. Tokyo, 1991.

Tokyo–Fukuoka–Osaka 1986. *Mane ten = Édouard Manet.* Exh. cat. by Charles F. Stuckey and Juliet Wilson-Bareau. Tokyo, Isetan Museum of Art, June 26–July 29, 1986; Fukuoka Art Museum, August 2–31, 1986; Osaka, Municipal Museum of Art, September 9–October 12, 1986. Tokyo, 1986.

Toledo 1912. *Catalogue of the Inaugural Exhibition.* Exh. cat. Toledo [Ohio] Museum of Art, January 17–February 12, 1912. Toledo, 1912.

Toledo 1941. *Spanish Painting.* Exh. cat. by José Gudiol. Toledo [Ohio] Museum of Art, March 16–April 27, 1941. Toledo, 1941.

Tollemache 1870. Marguerite Tollemache. *Spanish Towns and Spanish Pictures: A Guide to the Galleries of Spain.* London, 1870.

Tomlinson 1989. Janis Tomlinson. *Francisco Goya: The Tapestry Cartoons and Early Career at the Court of Madrid.* Cambridge, 1989.

Tomlinson 1993. Janis Tomlinson. "A Report from Anton Raphael Mengs on the Spanish Royal Collection." *The Burlington Magazine* (London) 135 (1993), pp. 97–99.

Tomlinson 1994. Janis Tomlinson. *Francisco Goya y Lucientes, 1746–1828.* London, 1994.

Tomlinson 1996. Janis Tomlinson. "Evolving Concepts: Spain, Painting, and Authentic Goyas in Nineteenth-Century France." *Metropolitan Museum Journal* (New York) 31 (1996), pp. 189–202.

Tormo y Monzó 1909. Elías Tormo y Monzó. "El despojo de los Zurbaranes de Cádiz, el viaje de Taylor

y la efímera Galería Española del Louvre." *Cultura Española* (Madrid) 7 (1909), pp. 25–39.

Torre Farfán 1666. Fernando de la Torre Farfán. *Fiestas que celebro la Iglesia de Santa María la Blanca.* Seville, 1666.

Torre Farfán 1671. Fernando de la Torre Farfán. *Fiestas de la S. Iglesia Metropolitana, y Patriarcal de Sevilla.* Seville, 1671.

Torres Martín 1963. Ramón Torres Martín. *Zurbarán: El pintor gótico del siglo XVII.* Seville, 1963.

Tourneux 1919. Maurice Tourneux. *Salons et expositions d'art à Paris, 1801–1870: Essai bibliographique.* Paris, 1919.

Townsend 1791. Joseph Townsend. *A Journey through Spain in the Years 1786 and 1787.* 3 vols. London, 1791.

Trapier 1925. Elizabeth du Gué Trapier. *El Greco.* New York, 1925.

Trapier 1929. Elizabeth du Gué Trapier. *Catalogue of Paintings in the Collection of the Hispanic Society of America,* vol. 2, *16th, 17th, and 18th Centuries.* New York, 1929.

Trapier 1940. Elizabeth du Gué Trapier. *Eugenio Lucas y Padilla.* New York, 1940.

Trapier 1948. Elizabeth du Gué Trapier. *Velázquez.* New York, 1948.

Trapier 1952. Elizabeth du Gué Trapier. *Ribera.* New York, 1952.

Trapier 1958. Elizabeth du Gué Trapier. *El Greco: Early Years at Toledo, 1576–1586.* New York, 1958.

Trapier 1960. Elizabeth du Gué Trapier. *Valdés Leal, Spanish Baroque Painter.* New York, 1960.

Trapier 1964. Elizabeth du Gué Trapier. *Goya and His Sitters: A Study of His Style as a Portraitist.* New York, 1964.

Trapier 1966. Elizabeth du Gué Trapier. "A Ribera Painting Restored." *Pantheon* (Munich) 24 (1966), pp. 165–69.

Tromans 1996. Nicholas Tromans. "The Iconography of Velázquez's Aesop." *Journal of the Warburg and Courtauld Institutes* (London) 59 (1996), pp. 332–36.

Tromans 1998. Nicholas Tromans. "Le baron Taylor à Londres en 1837." *Revue du Louvre et des Musées de France* (Paris) (June 1998), pp. 66–69, 119.

Tromans 2001. Nicholas Tromans. "Un museo en Sevilla en 1822." *Goya* (Madrid), no. 282 (May–June 2001), pp. 156–60.

Troyes 1989. *Prédilections académiques: Peintures et sculptures du XIXe siècles des collections du musée.* Exh. cat. Troyes, Musée des Beaux-Arts, March 25–May 29, 1989. Troyes, 1989.

Tubino 1864. Francisco M. Tubino. *Murillo, su época, su vida, sus cuadros.* Seville, 1864.

Tulard 1987. Jean Tulard, ed. *Dictionnaire Napoléon.* Paris, 1987.

Twiss 1775. Richard Twiss. *Travels through Portugal and Spain in 1772 and 1773.* 2 vols. Dublin, 1775.

United States–Mexico–Canada 1975–76. *Master Paintings from the Hermitage and the State Russian Museum, Leningrad.* Exh. cat. Traveling exhibition to various institutions in the United States, Mexico, and Canada, 1975–76. New York, 1975.

Vaillat 1907. Léandre Vaillat. "Chassériau." *L'Art et les Artistes* (Paris) 3 (July 5, 1907), pp. 177–88.

Vaisse 1976. Pierre Vaisse. "Charles Blanc und das 'Musée des Copies.'" *Zeitschrift für Kunstgeschichte* (Berlin) 39, no. 1 (1976), pp. 54–66.

Valdivieso 1986. Enrique Valdivieso. *Historia de la pintura sevillana: Siglos XIII al XX.* Seville, 1986.

Valdivieso 1988. Enrique Valdivieso. *Juan de Valdés Leal.* Seville, 1988.

Valdivieso 1990. Enrique Valdivieso. *Murillo: Sombras de la tierra, luces del cielo.* Madrid, 1990.

Valencia 2000. *Pintura española en el Museo Nacional de San Carlos, México.* Exh. cat. by Alfonso E. Pérez Sánchez. Valencia, Museo de Bellas Artes, June 29–September 3, 2000. Valencia, 2000.

Valencia 2002. *Goya y Maella en Valencia: Del boceto al cuadro de altar.* Exh. cat. Edited by Fernando Benito Doménech and Manuela B. Mena Marqués. Valencia, Museo de Bellas Artes, March–May 5, 2002. Valencia, 2002.

Valentin 1846. François Valentin. *Les peintres célèbres.* 4th ed. Tours, 1846.

Valladolid 1978. *Actas del II Congreso español de historia del arte: El arte del siglo XIX.* Valladolid, 1978.

Vallentin 1955. Antonina Vallentin. *El Greco.* Garden City, N.Y., 1955.

Van Dyke 1896. John C. Van Dyke, ed. *Modern French Masters: A Series of Biographical and Critical Reviews by American Artists.* New York, 1896.

Van Rensselaer 1886. Mariana Griswold Van Rensselaer. *Book of American Figure Painters.* Philadelphia, 1886.

Vanderpooten 1992. Claude Vanderpooten. *Samuel Pozzi: Chirurgien et ami des femmes.* Ozoir-la-Ferrière, France, 1992.

Varela de Vega 1993. Juan Bautista Varela de Vega. "Pablillos de Valladolid, bufón músico de Felipe IV." *Boletín de la Real Academia de la Purísima Concepción de Valladolid* 28 (1993), pp. 149–53.

Varia Velazqueña 1960. *Varia Velazqueña: Homenaje a Velázquez en el III centenario de su muerte, 1660–1960.* 2 vols. in 4. Edited by Antonio Gallego y Burín. Madrid, 1960.

Vaudoyer 1930. Jean-Louis Vaudoyer. *Alice Ozy, ou L'aspasie moderne.* Paris, 1930.

Vaudreuil 1784. *Catalogue raisonné d'une très-belle collection de tableaux des écoles d'Italie, de Flandre et de Hollande, qui composaient le cabinet de M. le Comte de Vaudreuil.* Sale cat. Paris, November 24, 1784. Paris, 1784.

Vega 1995. Jesusa Vega. "Goya's Etchings after Velázquez." *Print Quarterly* (London) 12, no. 2 (June 1995), pp. 145–63.

Vega et al. 2000. Jesusa Vega, Nigel Glendinning, and Javier Portús Pérez. *Estudiar a los maestros: Velázquez y Goya.* Saragossa, 2000.

Velázquez 1963. María del Carmen Velázquez. *La España de Carlos III de 1764 a 1776 según los embajadores austriacos: Documentos.* Mexico City, 1963.

Velázquez y Sánchez 1864. José Velázquez y Sánchez. *La cruz del rodeo: Estudio histórico.* Seville, 1864.

Velázquez y Sánchez 1994. José Velázquez y Sánchez. *Anales de Sevilla de 1800 a 1850 (1872).* Edited by Antonio Miguel Bernal. Seville, 1994.

Venturi 1939. Lionello Venturi, ed. *Les archives de l'Impressionnisme: Lettres de Renoir, Monet, Pissarro, Sisley et autres. Mémoires de Paul Durand-Ruel.* 2 vols. Paris and New York, 1939.

Vergeest 2000. Aukje Vergeest. *The French Collection: Nineteenth-Century French Paintings in Dutch Public Collections.* Amsterdam, 2000.

Véron 1879. Eugène Veron. "La peinture au Salon du Paris, 1879." *L'Art* 17 (1879).

Viardot 1834. Louis Viardot. "Le musée de Madrid." *Revue Républicaine* (Paris) (December 1834), pp. 303–47.

Viardot 1835. Louis Viardot. *Études sur l'histoire des institutions, de la littérature, du théâtre et des beaux-arts en Espagne.* Paris, 1835.

Viardot 1838. Louis Viardot. "L'abside de La Madeleine." *Le Siècle* (Paris) (August 10, 1838).

Viardot 1839. Louis Viardot. *Notice sur les principaux peintres de l'Espagne.* Paris, 1839.

Viardot 1843. Louis Viardot. *Les musées d'Espagne, d'Angleterre et de Belgique.* Paris, 1843.

Viardot 1844. Louis Viardot. *Les musées d'Allemagne et de Russie.* Paris, 1844.

Viardot 1852. Louis Viardot. *Les musées d'Espagne.* Paris, 1852. 3d ed., Paris, 1860.

Viardot 1860a. Louis Viardot. *Les musées d'Angleterre, de Belgique, de Hollande et de Russie.* 3d ed. Paris, 1860.

Viardot 1860b. Louis Viardot. *Les musées de France: Paris.* 2d ed. Paris, 1860.

Viardot 1863. *Catalogue des tableaux anciens et dessins formant la belle collection de M. Louis Viardot.* Sale cat. Paris, 1863.

Vienna 1910. *Manet-Monet.* Exh. cat. Vienna, Galerie Miethke, May 1910. Vienna, 1910.

Viguier 1993. Florence Viguier. *Musée Ingres: Les peintures anciennes (XIVe–XVIIIe siècles): Espagne, Flandres, France, Italie, Pays-Bas.* Montauban, 1993.

Villa 1979. Nicole Villa. *Collection de Vinck: Inventaire analytique,* vol. 6, *La Révolution de 1830 et la Monarchie de Juillet.* Paris, 1979.

Villot 1849. Frédéric Villot. *Notice des tableaux exposés dans les galeries du Musée National du Louvre, 1re partie, Écoles d'Italie et d'Espagne.* Paris, 1849.

Villot 1852. Frédéric Villot. *Notice des tableaux exposés dans les galeries du Musée National du Louvre. 2e partie. Écoles allemande, flamande et hollandaise.* Paris, 1852.

Villot 1853. Frédéric Villot. *Notice des tableaux exposés dans les galeries du Musée impérial du Louvre.* Paris, 1853.

Villot 1855. Frédéric Villot. *Notice des tableaux exposés dans les galeries du Musée impérial du Louvre. 1re partie. Écoles d'Italie et d'Espagne.* Paris, 1855.

Villot 1864. Frédéric Villot. *Notice des tableaux exposés dans les galeries du Musée national du Louvre, 1re partie. Écoles d'Italie et d'Espagne.* 14th ed. Paris, 1864.

Villot 1872. Frédéric Villot. *Notice des tableaux exposés dans les galeries du Musée impérial du Louvre, 1re partie. Écoles d'Italie et d'Espagne.* 16th ed. Paris, 1872.

Viñaza 1887. Cipriano Muñoz y Manzano, conde de la Viñaza. *Goya: Su tiempo, su vida y sus obras.* Madrid, 1887.

Viñaza 1889–94. Cipriano Muñoz y Manzano, conde de la Viñaza. *Adiciones al Diccionario histórico de los más ilustres profesores de las bellas artes en España de D. Juan Agustín Ceán Bermúdez.* 4 vols. Madrid, 1889–94.

Vischer 1997. Bodo Vischer. "Goya's Still Lifes in the Yumuri Inventory." *The Burlington Magazine* (London) 139 (February 1997), pp. 121–23.

Volk 1981. Mary Crawford Volk. "Rubens in Madrid and the Decoration of the King's Summer Apartment." *The Burlington Magazine* (London) 113 (1981), pp. 513–29.

Waagen 1838. Gustav Friedrich Waagen. *Works of Art and Artists and England.* 3 vols. London, 1838.

Waagen 1854. Gustav Friedrich Waagen. *Treasures of Art in Great Britain: Being an Account of the Chief Collections of Paintings, Drawings, Sculptures, Illuminated mss., &c. &c.* 3 vols. London, 1854.

Waagen 1857. Gustav Friedrich Waagen. *Galleries and Cabinets of Art in Great Britain: Being an Account of More than Forty Collections . . . Visited in 1854 and 1856.* London, 1857.

Waagen 1864. Gustav Friedrich Waagen. *Die Gemäldesammlungen in der Kaiserlichen Ermitage zu St. Petersburg: Nebst Bemerkungen über andere dortige Kunstsammlungen.* Munich, 1864.

Waldmann 1995. Susann Waldmann. *Der Künstler und sein Bildnis im Spanien des 17. Jahrhunderts: Ein Beitrag zur spanischen Porträtmalerei.* Frankfurt, 1995.

Wallens 2001. Gérard de Wallens. "Corot as a Copyist at the Louvre." *The Burlington Magazine* (London) 143 (November 2001), pp. 685–86.

Walsh 1996. Amy Walsh. "Pierre-Jean Mariette." In *Grove Dictionary of Art*, vol. 20, p. 417. London, 1996.

Warner 1883. Charles Dudley Warner. "The Bullfight." *The Century Magazine* (New York) 27 (November 1883), pp. 3–13.

Warner 1895. Charles Dudley Warner. *The Golden House.* New York, 1895.

Washington 1902. *Catalogue of the Annual Exhibition.* Exh. cat. Washington, D.C., Society of Washington Artists, 1902. Washington, D.C., 1902.

Washington 1907. *Oil Paintings by Contemporary American Artists.* Exh cat. Washington, D.C., Corcoran Gallery of Art, February 7–March 9, 1907. Washington, D.C., 1907.

Washington 1971. *Portraits of the American Stage, 1771–1971.* Exh. cat. Washington, D.C., National Portrait Gallery, Smithsonian Institution, 1971. Washington, D.C., 1971.

Washington 1982–83. *Manet and Modern Paris.* Exh. cat. by Theodore Reff. Washington, D.C., National Gallery of Art, December 5, 1982–March 6, 1983. Washington, D.C., 1982.

Washington 1984. *James McNeill Whistler at the Freer Gallery of Art.* Exh. cat. by David Park Curry. Washington, D.C., Freer Gallery of Art, May 11–November 5, 1984. Washington, D.C. and New York, 1984.

Washington 1985–86. *The Prints of Edouard Manet.* Exh. cat. by Jay McKean Fisher. Organized and circulated by the International Exhibitions Foundation, Washington, D.C.; held at the Detroit Institute of Arts and four other museums, 1985–86. Washington, D.C., 1985.

Washington 1995. *In Pursuit of the Butterfly: Portraits of James McNeill Whistler.* Exh. cat. by Eric Denker.

Washington, D.C., National Portrait Gallery, April 7–August 13, 1995. Washington, D.C., 1995.

Washington 2000. *The Influence of Velasquez on Modern Painting: The American Experience.* Exh. cat. by Mary Anne Goley. Washington, D.C., Federal Reserve Board Building, July 3–December 1, 2000. Washington, D.C., 2000.

Washington–Boston 1992. *John Singer Sargent's* El Jaleo. Exh. cat. by Mary Crawford Volk. Washington, D.C., National Gallery of Art, March 1–August 2, 1992; Boston, Isabella Stewart Gardner Museum, September 10–November 22, 1992. Washington, D.C., 1992.

Washington–Chicago 1987–88. *William Merritt Chase: Summers at Shinnecock, 1891–1902.* Exh. cat. by D. Scott Atkinson and Nicolai Cikovsky, Jr. Washington, D.C., National Gallery of Art, September 6–November 29, 1987; Chicago, Terra Museum of American Art, December 11, 1987–February 28, 1988. Washington, D.C., 1987.

Washington–Chicago–Philadelphia 1961–62. *Thomas Eakins: A Retrospective Exhibition.* Exh. cat. Washington, D.C., National Gallery of Art, October 8–November 12, 1961; Chicago, Art Institute, December 1, 1961–January 7, 1962; Philadelphia Museum of Art, February 1–March 18, 1962. Washington, D.C., 1961.

Washington et al. 1964–65. *The Private World of John Singer Sargent.* Exh. cat. by Donelson F. Hoopes. Washington, D.C., Corcoran Gallery of Art, April 18–June 14, 1964; Cleveland Museum of Art; Worcester [Mass.] Art Museum; Utica, N.Y., Munson-Williams-Proctor Institute, 1964–65. Washington, D.C., 1964.

Washington–St. Louis 1972. *Old Master Drawings from Christ Church, Oxford: A Loan Exhibition.* Exh. cat. by James Byam Shaw. Circulated by the International Exhibitions Foundation to the National Gallery of Art, Washington, D.C., Saint Louis Art Museum, and other venues. Washington, D.C., 1972.

Waterhouse 1962. Ellis Waterhouse. *Italian Baroque Painting.* London, 1962.

Watt 1939. Alexander Watt. "Notes from Paris." *Apollo* (London) 29 (January 1939), pp. 27–29.

Weale and Richter 1889. W. H. James Weale and Jean Paul Richter. *A Descriptive Catalogue of the Collection of Pictures Belonging to the Earl of Northbrook.* London, 1889.

Wedmore 1879. Frederick Wedmore. "Mr. Whistler's Theories and Mr. Whistler's Art." *The Nineteenth Century* (New York) 6 (August 1879), pp. 334–43.

Wehle 1934. Harry B. Wehle. "A Painting by Jusepe Ribera." *Metropolitan Museum of Art Bulletin* (New York) 29 (July 1934), pp. 119–22.

Weinberg 1991. H. Barbara Weinberg. *The Lure of Paris: Nineteenth-Century American Painters and Their French Teachers.* New York, 1991.

Weisbach 1928. Werner Weisbach. "Der sogennante Geograph von Velazquez und die Darstellungen des Demökrit und Heraklit." *Jahrbuch der Preuszischen Kunstsammlungen* (Berlin) 49 (1928), pp. 141–58.

Weisberg 1970. Gabriel P. Weisberg. "François Bonvin and an Interest in Several Painters of the Seventeenth and Eighteenth Centuries." *Gazette des Beaux-Arts* (Paris) 76 (December 1970), pp. 359–66.

Weisberg 1976. Gabriel P. Weisberg. "Théodule Ribot: Popular Imagery and the Little Milkmaid."

Bulletin of the Cleveland Museum of Art 63 (October 1976), pp. 253–63.

Weisberg 1978. Gabriel P. Weisberg. "The Traditional Realism of François Bonvin." *Bulletin of the Cleveland Museum of Art* 65 (November 1978), pp. 280–98.

Weisberg 1979a. Gabriel P. Weisberg. *Bonvin.* Paris, 1979.

Weisberg 1979b. Gabriel P. Weisberg. "French Realism and Past Traditions." In *Malerei und Theorie: Das Courbet-Colloquium*, edited by Klaus Gallwitz and Klaus Herding, pp. 139–52. Frankfurt, 1979.

Weitzenhoffer 1981. Frances Weitzenhoffer. "First Manet Paintings to Enter an American Museum." *Gazette des Beaux-Arts* (Paris) 97 (March 1981), pp. 125–29.

Wentworth 1984. Michael Wentworth. *James Tissot.* Oxford, 1984.

Wethey 1955. Harold E. Wethey. *Alonso Cano: Painter, Sculptor, Architect.* Princeton, N.J., 1955.

Wethey 1962. Harold E. Wethey. *El Greco and His School.* 2 vols. Princeton, N.J., 1962.

Wethey 1983. Harold E. Wethey. *Alonso Cano: Pintor, escultor, arquitecto.* Madrid, 1983.

Whistler 1890a. James McNeill Whistler. *The Gentle Art of Making Enemies.* Edited by Sheridan Ford. New York, 1890 (edition suppressed by Whistler).

Whistler 1890b. James McNeill Whistler. *The Gentle Art of Making Enemies.* London, 1890.

Whistler 1892. James McNeill Whistler. *The Gentle Art of Making Enemies.* 2d ed. London, 1892. Reprint, New York, 1967.

Widdrington 1844. Samuel Edward Widdrington. *Spain and the Spaniards, in 1843.* 2 vols. London, 1844.

Wilde 1877. Oscar Wilde. "The Grosvenor Gallery." *Dublin University Magazine* 90 (1877), p. 124.

Wildenstein 1996. Daniel Wildenstein. *Monet.* 4 vols. Cologne, 1996.

Willesme 1987. Jean-Pierre Willesme. "Hotel de Talleyrand-Périgord, puis Soult." In *Le faubourg Saint-Germain, rue de l'Université*, pp. 103–22. Paris, 1987.

Williamstown 1997. *Uncanny Spectacle: The Public Career of the Young John Singer Sargent.* Exh. cat. by Marc Simpson et al. Williamstown, Mass., Sterling and Francine Clark Art Institute, June 15–September 7, 1997. New Haven and Williamstown, Mass., 1997.

Wilson-Bareau 1981. Juliet Wilson-Bareau. *Goya's Prints: The Tomás Harris Collection in the British Museum.* London, 1981.

Wilson-Bareau 1984. Juliet Wilson-Bareau. "The Portrait of Ambroise Adam by Edouard Manet." *The Burlington Magazine* (London) 126 (December 1984), pp. 750–58.

Wilson-Bareau 1989. Juliet Wilson-Bareau. "L'année impressionniste de Manet: Argenteuil et Venise en 1874." *Revue de l'Art* (Paris), no. 86 (1989), pp. 28–34.

Wilson-Bareau 1991. Juliet Wilson-Bareau. "London, National Gallery: Art in the Making. Impressionism." *The Burlington Magazine* (London) 133 (February 1991), pp. 127–29.

Wilson-Bareau 1996a. Juliet Wilson-Bareau. "Goya and the X Numbers: The 1812 Inventory and Early Acquisitions of 'Goya' Pictures." *Metropolitan Museum Journal* (New York) 31 (1996), pp. 159–74.

Wilson-Bareau 1996b. Juliet Wilson-Bareau. "Goya in the Metropolitan Museum." *The Burlington Magazine* (London) 138 (February 1996), pp. 95–103.

Woermann 1890. K. Woermann. "Jusepe di Ribera." *Zeitschrift für Bildende Kunst* (Leipzig) 1 (1890), pp. 177–84.

Wolff 1879. Albert Wolff. "Le Salon." *Le Figaro* (Paris) (May 23, 1879), p. 2.

Wolff 1882. Albert Wolff. "Le Salon." *Le Figaro* (Paris) (May 1882), p. 3.

Wolff 1886. Albert Wolff. *Le capitale de l'art.* Paris, 1886.

Wormser 1955. Simone Olivier Wormser. "Tableaux espagnols à Paris au XIXe siècle." Thesis, Université de Paris, 1955.

Wright 1883. Margaret Bertha Wright. "American Art at the Paris Salon." *The Art Amateur* (New York) 9 (July 1883), p. 24.

Wright 1984. D. G. Wright. *Napoleon and Europe.* London, 1984.

Wyzewa 1891. Teodor de Wyzewa. *Les grands peintres de l'Espagne et de l'Angleterre.* Paris, 1891.

Ximénez 1764. Andrés Ximénez. *Descripción del Real Monasterio de San Lorenzo del Escorial: Su magnifico templo, panteon, y palacio.* Madrid, 1764.

Yebes 1955. Carmen Muñoz de Figueroa, condesa de Yebes. *La condesa-duquesa de Benavente: Una vida en unas cartas.* Madrid, 1955.

A. Young et al. 1980. Andrew McLaren Young, Margaret F. MacDonald, and Robin Spencer, with the assistance of Hamish Miles. *The Paintings of James McNeill Whistler.* 2 vols. New Haven, 1980.

D. Young 1960. Dorothy Weir Young. *The Life and Letters of J. Alden Weir.* New York, 1960. Reprint, New York, 1971.

E. Young 1976. Eric Young. "Antonio Puga: His Place in Spanish Painting and the Pseudo-Puga." *J. Paul Getty Museum Journal* (Malibu) 3 (1976), pp. 47–65.

E. Young 1988. Eric Young. *Catalogue of Spanish Paintings in the Bowes Museum.* 2d ed. Durham, 1988.

Yriarte 1867. Charles Yriarte. *Goya: Sa biographie, les fresques, les toiles, les tapisseries, les eaux-fortes et le catalogue de l'oeuvre.* Paris, 1867.

Yriarte 1877. Charles Yriarte. "Goya aquafortiste." *L'Art* 9 (1877), pp. 3–10, 34–40, 56–60, 78–83.

Zampetti 1967. Pietro Zampetti. *Note sparse sul'600.* Venice, 1967.

Zapater y Gómez 1863. Francisco Zapater y Gómez. *Apuntes histórico-biográficos acerca de la escuela aragonesa de pintura.* Madrid, 1863.

Zapater y Gómez 1868. Francisco Zapater y Gómez. *Goya: Noticias biográficas.* Saragossa, 1868.

Zarco del Valle 1864. M. R. Zarco del Valle. "Correspondance." *Chronique des Arts et de la Curiosité* (Paris) 2 (April 25, 1864), pp. 180–81.

Zervos 1932. Christian Zervos. "À propos de Manet." *Cahiers d'Art* (Paris) 7 (1932), pp. 309–25.

Znamerovskaia 1955. T. P. Znamerovskaia. *Tvorchestvo Khusepe Ribery i problema narodnosti ispanskogo realisticheskogo iskusstva* (The Work of Jusepe Ribera and the Problem of Folk Origins in Spanish Realistic Art). Leningrad, 1955.

Zola 1867a. Émile Zola. *Ed. Manet: Étude biographique et critique.* Paris, 1867.

Zola 1867b. Émile Zola. "Une nouvelle manière en peinture: Édouard Manet." *Revue du XIXe Siècle* (Paris) (January 1, 1867).

Zola 1877. Émile Zola. *L'assommoir.* Paris, 1877.

Zola 1959. Émile Zola. *Salons.* Edited by F.W.J. Hemmings and Robert J. Niess. Geneva, 1959.

Zurich–Tübingen 1994–95. *Degas Portraits.* Exh. cat. Edited by Felix Baumann and Marianne Karabelnik. Zurich, Kunsthaus, December 2, 1994–March 5, 1995; Tübingen, Kunsthalle, March 18–June 18, 1995. London, 1995.

Index

Note: Page numbers in *italics* refer to illustrations. **Boldface** page numbers refer to catalogue descriptions.

Photograph Credits

Antwerp, Musées d'Angers: Pierre David, fig. 1.35

Avignon, Musée Calvet: André Guerrand, fig. 9.88

Budapest, Szépművészeti Múzeum: András Rászó, fig. 14.15

Castres, Musée Goya: J. C. Ouradou, fig. 9.20

Dresden, Staatliche Kunstsammlungen: Estel/Klut, fig. 13.5, Klut, figs. 7.14, 13.1, Weniger, figs. 13.4, 13.6–13.8

Fort Worth, Texas, Michael Bodycomb: fig. 7.16

Montepellier, Musée Fabre: Frédéric Jaulmes, fig. 14.30

London, Juliet Wilson-Bareau: figs. 9.3, 9.19, 9.53, 9.64–9.66, 14.65

Lyon, Musée des Beaux-Arts: Studio Basset, fig. 2.2

Madrid, Biblioteca Nacional: fig. 4.14; Museo Nacional del Prado: José Baztán y Alberto Otero, figs. 1.57, 1.18

Manchester, U.K., Manchester Central Public Library: P. H. de la Motte, fig. 14.58

Mannheim, Kunsthalle Mannheim: Margarita Wickenhäuser, fig. 9.72

Nantes, Ville de Nantes Musée des Beaux-Arts: P. Jean, fig. 8.2

New York, Christie's Images, Inc.: figs. 9.8, 9.9; Frick Art Reference Library: fig. 10.24; The Hispanic Society of America: fig. 1.36; The Metropolitan Museum of Art: fig. 1.28; H. Barbara Weinberg: fig. 10.14

Paris, Direction des Musées de France: fig. 1.8; Institut Wildenstein: fig. 9.93; Musées de la Ville de Paris: figs. 1.10, 6.19, COARC, Emmanuel Michot, fig. 1.29; Musée des Arts Décoratifs: Laurent-Sully Jaulmes, fig. 14.57; Réunion Musées Nationaux: figs. 2.4, 2.17, 7.2–7.4, 9.2, Daniel Arnaudet, figs. 1.15, 2.21, 5.4, 7.10–7.13, 7.23, 9.44, 14.5, 14.6, 14.29, 14.52, 14.56, 14.64, M. Bellot, figs. 5.28, 14.27, J. G. Berizzi, figs. 2.6, 2.7, 2.20, 7.5, 14.2, P. Bernard, figs. 1.26, 1.33, 1.37, 1.38, 5.35, 7.18, 14.44, Gérard Blot, figs. 1.7, 1.13, 1.27, 1.54, 2.9, 2.18, 2.25, 2.28, 4.17, 6.21, 7.7, 7.8, 9.5, 10.30, 14.9, 14.12, 14.24, 14.36, 14.38, 14.53, 14.59, 14.60, 14.75, 14.84, Gérard Blot/C. Jean, figs. 1.2, 14.3, Gérard Blot/J. Schor, fig. 2.26, Bulloz, figs. 9.89, 10.16, 14.35, Quecq d'Henripret, figs. 14.76, 14.77, C. Jean, figs. 1.3, 1.4, 14.40, 14.68, Hervé Lewandowski, figs. 1.42–1.44, 1.46, 1.60–1.62, 2.24, 2.27, 9.52, 9.68, 9.80, 9.82, 9.83, 9.91, 10.3, 10.39, 14.1, 14.10, 14.33, 14.85, Le Mage, figs. 5.30, 14.26, R. G. Ojeda, figs. 1.11, 1.39, 5.1, 14.39, 14.49, 14.55, Franck Raux, figs. 2.11, 7.6, Jean Schormans, figs. 1.48, 2.5, 10.33, 14.4, 14.13

Philadelphia, Philadelphia Museum of Art: Graydon Wood, fig. 14.41

Richmond, Virginia Museum of Fine Arts: Ron Jennings, fig. 5.10

Rome, Alessandro Vasari: fig. 2.3

Rouen, Musées de la Ville de Rouen: Didier Tragin/Catherine Lancien, fig. 2.16, Catherine Lancien, fig. 14.47

São Paulo, Museu de Arte de São Paulo Assis Chateaubriand: Luiz Hossaka, fig. 9.92

Seville, Pedro Feria: fig. 3.1; Fotografía Arenas: figs. 3.3, 3.4, 3.7, 3.16